THE OXFORD HANDBOOK OF

MODERNISMS

THE OXFORD HANDBOOK OF

MODERNISMS

Edited by

PETER BROOKER,

ANDRZEJ GĄSIOREK,

DEBORAH LONGWORTH,

and

ANDREW THACKER

OXFORD

UNIVERSITY PRESS

OXFORD
UNIVERSITY PRESS

Great Clarendon Street, Oxford OX2 6DP

Oxford University Press is a department of the University of Oxford.
It furthers the University's objective of excellence in research, scholarship,
and education by publishing worldwide in

Oxford New York

Auckland Cape Town Dar es Salaam Hong Kong Karachi
Kuala Lumpur Madrid Melbourne Mexico City Nairobi
New Delhi Shanghai Taipei Toronto

With offices in

Argentina Austria Brazil Chile Czech Republic France Greece
Guatemala Hungary Italy Japan Poland Portugal Singapore
South Korea Switzerland Thailand Turkey Ukraine Vietnam

Oxford is a registered trade mark of Oxford University Press
in the UK and in certain other countries

Published in the United States
by Oxford University Press Inc., New York

© Oxford University Press 2010

The moral rights of the authors have been asserted
Database right Oxford University Press (maker)

First published 2010

British Library Cataloguing in Publication Data

Data available

Library of Congress Cataloging in Publication Data

Data available

Typeset by SPI Publisher Services, Pondicherry, India
Printed in Great Britain
on acid-free paper by
MPG Books Group, Bodmin and King's Lynn

ISBN 978–0–19–954544–5

1 3 5 7 9 10 8 6 4 2

ACKNOWLEDGEMENTS

THE editors would like to express their immense debt and gratitude to James Barnett and Alice Reeve-Tucker for their thorough and conscientious work in preparing the Select Bibliography, and to Nathan Waddell for his meticulous help in preparing the final manuscript—considerable tasks which all three saw through with enviable good humour. Heartfelt thanks to Staś Kuźmierkiewicz for doing such a wonderful job in preparing the index to this book.

We would also like to thank the following for permission to reproduce copyright material. Cover: Cyril Power, *Whence and Whither?*, 1930, © Osborne Samuel Ltd, London/The Bridgeman Art Library. Fig. 18.1: George Sprod, Cartoon on the *Lady Chatterley's Lover* trial, *Punch* (9 November 1960), courtesy of Punch Ltd. Figs 29.1 and 29.2: Paul Strand, *Abstraction, Bowls*, Twin Lakes, Connecticut, 1916, and Paul Strand, *Blind*, New York, 1916, ©Aperture Foundation Inc., Paul Strand Archive. Fig. 29.3: Eadweard Muybridge, *'Abe Edington' Trotting at a 2:24 Gait*, 15 June 1878, Iris and B. Gerald Cantor Center for Visual Arts, Stanford University, Stanford Family Collections. Fig. 30.1: Umberto Boccioni, *The Street Enters the House*, 1911, © Sprengel Museum, Hanover. Fig. 30.2: Édouard Manet, *Olympia*, 1863, © Musée d'Orsay, Paris, 2009. Fig. 30.3: Jacob Epstein, *Torso in Metal from the 'Rock Drill'*, 1913–16, © Tate London, 2008. Fig. 30.4: Wassily Kandinsky, *Cossacks*, 1910–11, Tate Gallery, London, © ADAGP, Paris, and DACS, London, 2009. Fig. 30.5: Vanessa Bell, *Rug or Table-Top Design*, 1913–14, The Samuel Courtauld Trust, Courtauld Institute of Art, © Estate of Vanessa Bell, courtesy of Henrietta Garnett. Fig. 30.6: Alfred Hamilton Barr, Jr, Cover of the exhibition catalogue *Cubism and Abstract Art* (MoMA, 1936), The Museum of Modern Art Library, New York, MA143, © 2009 Digital image, The Museum of Modern Art, New York/Scala, Florence. Fig. 30.7: Henri Gaudier-Brzeska, *Red Stone Dancer*, 1913, © Kettle's Yard, Cambridge. Fig. 30.8: Barbara Hepworth, *Three Forms*, 1935, Tate Gallery, London, © Bowness, Hepworth Estate. Fig. 31.1: Mary Wigman in *Hexentanz*, 1914, courtesy of Deutsches Tanzarchiv Köln. Fig. 31.2: Valentine Gross, 'Drawing of *Sacre du Printemps*', reproduced in *Comoedia Illustre* (1913), © ADAGP, Paris, and DACS, London, 2009. Fig. 33.2: Igor Stravinsky, opening of 'Danse sacrale (L'Élue)' from *Le Sacre du printemps* (1912), © 1912, 1921 by Hawkes & Son (London) Ltd. Figs. 33.3, 33.4, 33.5, 33.6, 33.7: Elliott Carter, *String Quartet No. 1*, © 1995 by G. Schirmer, Inc. (ASCAP). Fig. 55.1: Hanaya Kanbee, 'Woman and Glass', 1933, courtesy of Mr Kuwata Masashi and Ashiya City Museum of Art and History.

Contents

PART I. FRAMEWORKS

PART II. PRACTICES AND PERSPECTIVES

PART III. CONTEXTS AND CONDITIONS

PART IV. IMAGE, PERFORMANCE, AND THE NEW MEDIA

LIST OF ILLUSTRATIONS

LIST OF CONTRIBUTORS

Michael Bell University of Warwick

Timothy O. Benson Los Angeles Museum of Modern Art

Prudence Black University of Sydney

Peter Brooker University of Nottingham

Sascha Bru University of Leuven

Ramsay Burt De Montfort University

Robert L. Caserio Penn State University

Supriya Chaudhuri Jadavpur University

Suzanne W. Churchill Davidson College

Debra Rae Cohen University of South Carolina

John Xiros Cooper University of British Columbia

Christopher Crouch Edith Cowan University

Nicholas Daly University College Dublin

James Donald University of New South Wales

Stephanie Hemelryk Donald RMIT University

Laura Doyle University of Massachusetts

Matt ffytche Essex University

Emily Finer University of St Andrews

Finn Fordham Royal Holloway, University of London

Andrzej Gąsiorek University of Birmingham

Elena Gualtieri University of Sussex

Anker Gemzøe Aalborg University

Jonathan W. Gray John Jay College, City University of New York

Dave Gunning University of Birmingham

Martin Halliwell University of Leicester

Robert Hampson Royal Holloway, University of London

Andrew Hussey University of London Institute, Paris

Dean Irvine Dalhousie University

Aaron Jaffe Louisville University

David James University of Nottingham

Deborah Longworth University of Birmingham

Roger Luckhurst Birkbeck, University of London

Scott McCracken University of Keele

Margery Palmer McCulloch University of Glasgow

Marina MacKay Washington University

Vera Mackie University of Woollongong

Adam McKible John Jay College, City University of New York

Will Montgomery Royal Holloway, University of London

Daniel Moore University of Birmingham

Michael Valdez Moses Duke University

Stephen Muecke University of New South Wales

Alan Munton University of Exeter

Richard J. Murphy University of Sussex

Peter Osborne Kingston University

Donald L. Shaw University of Virginia

Simon Shaw-Miller Birkbeck, University of London

Kirsten E. Shepherd-Barr University of Oxford

Morag Shiach Queen Mary, University of London

Carol Taaffe Trinity College Dublin

Andrew Thacker De Montfort University

Sarah Victoria Turner University of York

Nathan Waddell University of Birmingham

John J. White Kings, University of London

Michael H. Whitworth University of Oxford

Daniel G. Williams Swansea University

Joanne Winning Birkbeck, University of London

Michael Wood Princeton University

Tim Woods Aberystwyth, University of Wales

Tim Youngs Nottingham Trent University

Yi Zheng University of Sydney

INTRODUCTION

PETER BROOKER

ANDRZEJ GĄSIOREK

DEBORAH LONGWORTH

ANDREW THACKER

THE field of modernist studies has changed enormously over recent years and the aim of this Handbook is to take the measure of this new terrain. A number of factors have contributed to the ongoing redefinition of what we now understand by the term 'modernism'. The impact of postmodernism has led to a re-evaluation of the entity supposedly left behind, and has resulted in a resurgence of interest in the variety of modernisms and a relative decline in discussion of postmodernism. Challenges to earlier accounts of modernism as a pre-eminently masculine enterprise (with one or two honorary women writers included at the margins) have been made by feminist scholars who have radically altered the ways in which modernism is now conceived. This is a question not just of including once forgotten (or marginalized) writers, texts, and movements but of rethinking the frames of reference according to which such forgetting and marginalizing occurred in the first place.

Exactly the same point must be made about the post-colonial critique of earlier theorizations of modernism, or about the questions addressed to modernism from lesbian or queer perspectives. No less important has been the renewed attention given in recent years to modernism's transnational configurations (perhaps especially to the geographical criss-crossings of the international avant-gardes), which, it is now clear, cannot be restricted primarily to Europe or to the United States. Much of the work done on modernism's multiple and shifting locations has been interdisciplinary in orientation, drawing on such diverse disciplines as anthropology, architecture, art

history, book history, design, film studies, performance and theatre studies, philosophy, photography, and theology. This interdisciplinarity points to a key feature of this Handbook: its recognition that no account of modernism can hope to be fully comprehensive, but that any account must register its overdetermined, cross-disciplinary, international, and institutional affiliations.

Research in modernist studies since the late 1980s has moved away from an earlier emphasis on the aesthetic and towards a more culturally 'thick' sense of modernism's multiple connections to a wide variety of non-aesthetic practices. This doesn't mean that the aesthetic, which was championed in different ways by various modernists, as well as by such influential critics as Clement Greenberg and Theodor Adorno, has been bracketed off or jettisoned, but rather that it is no longer assumed to be the principal issue at stake in discussions of modernism and its legacies. No less important is the need to grasp where modernism(s) emerged; how they developed; by what means they were produced, disseminated, and publicized; in what relationship they stood to other artistic and cultural forms, which might be (or might in the past have been) regarded as non-modernist; which institutions (publishing houses, magazines, newspapers, galleries, museums, educational establishments, etc.) put modernism on view, promoted its claims, and constructed it as a corpus of works, an artistic entity with an identifiable—if not always coherent or unified—identity.

Research motivated by these concerns attempts to situate modernism within the sociocultural matrix out of which it emerged. It attends to the history of the book, the growth of the mass media, especially the rise of the newspaper, and censorship and propaganda; to the work of literary agents, publishing houses, advertisers, and reviewers; to systems of patronage, group dynamics, private and public networking, book contracts; to the public spaces in which writers forged alliances and fought cultural battles; to the ways in which emerging writers and artists fashioned careers for themselves by engaging with specific markets; and to the history of 'little magazines', by means of which so much modernist work was initially disseminated.[1] As Aaron Jaffe has argued, by focusing on the material, economic, and institutional forging of modernism, we are enabled to see that 'modernist cultural production is, in fact, cultural production . . . As producers of culture, modernists were keenly involved with the exigencies of making a place for themselves in the world and for their products in the cultural marketplace.'[2] They were also in many cases concerned to withstand what they saw as the reification of social reality and the debasement of

[1] See Kevin Dettmar and Stephen Watt, *Marketing Modernisms: Self-Promotion, Canonization, Rereading* (Ann Arbor: University of Michigan Press, 1996); Peter D. McDonald, 'Modernist Publishing: "Nomads and Mapmakers"', in David Bradshaw (ed.), *A Concise Companion to Modernism* (Oxford: Blackwell, 2003), 221–42; Elizabeth Outka, *Consuming Traditions: Modernity, Modernism, and the Commodified Aesthetic* (Oxford: Oxford University Press, 2009); Lawrence Rainey, *Institutions of Modernism: Literary Elites and Public Culture* (New Haven: Yale University Press, 1998); Catherine Turner, *Marketing Modernism Between the Two World Wars* (Amherst: University of Massachusetts Press, 2003); and Joyce Piell Wexler, *Who Paid for Modernism? Art, Money, and the Fiction of Conrad, Joyce, and Lawrence* (Fayetteville: University of Arkansas Press, 1997).

[2] Aaron Jaffe, *Modernism and the Culture of Celebrity* (Cambridge: Cambridge University Press, 2005), 7.

the public sphere. In this respect, as well as being preoccupied with personal and group self-promotion (a necessary feature of the struggle for cultural visibility and economic survival), many modernists were no less anxious to contribute to the creation and sustenance of various counter public spheres.[3]

Attention to such questions has returned scholars to various archives in a search for neglected empirical evidence (see especially Chapters 3 and 18, by Fordham and Jaffe). But it has also encouraged us to see more clearly the conceptual presuppositions that underpinned earlier accounts of modernism and thus to grasp how and why these presuppositions operated to exclude or to marginalize practices that are now acknowledged as key features of modernity and its aesthetic and cultural manifestations. Joan Wallach-Scott rightly points out that consideration of 'the exclusions involved in one's own project' should produce 'a reflexive, self-critical approach [that] makes apparent the particularistic status of any historical knowledge and the historian's active role as a producer of knowledge'.[4]

One obvious consequence of this self-reflexive approach to literary history is that the modernist canon has been subjected to various kinds of revisionism. At the most obvious level (and as noted above) this revisionism depends on the discovery (or rediscovery) of cultural producers, works, and movements that have either been written out of literary history or never been included in it in the first place. But of course all claims made on behalf of supposedly neglected writers, artists, and practices depend on prior theoretical assumptions about modernism. Such revisionism either identifies figures whose work, the critic argues, can be shown to conform to existing definitions of modernism, or it introduces types of work that challenge inadequate accounts of modernism and thus require it to be reconceptualized. The first strategy is a fairly straightforward empirical one (and it has performed much valuable recovery work), whereas the second approach aims to expose the hegemonic critical paradigms that have underpinned earlier understandings of modernism.

If scholarship over the last twenty to twenty-five years has asked us to reconsider what we thought we knew about modernism, then it has done so by opening up and expanding the field both theoretically and empirically. Put simply, modernism has been (and continues to be) reconfigured in an ongoing process of redefinition that takes its cue from analyses of a modernity that is increasingly seen in globalizing and thus transnational terms. When 'modernity' is the prior term, 'modernism'—of whatever kind—becomes its expression, though this slightly awkward formulation is not to be understood in 'reflective' terms. If modernism expresses modernity in some sense, then this notion is to be conceived not on a base–superstructure model

[3] For more on this issue, see Patrick Collier, *Modernism on Fleet Street* (Aldershot: Ashgate, 2006); Edward P. Comentale, *Modernism, Cultural Production, and the British Avant-Garde* (Cambridge: Cambridge University Press, 2004); Lois Cucullu, *Expert Modernists, Matricide, and Modern Culture* (Houndmills: Palgrave Macmillan, 2004); Melba Cuddy-Keane, *Virginia Woolf, the Intellectual, and the Public Sphere* (Cambridge: Cambridge University Press, 2003); Celia Marshik, *British Modernism and Censorship* (Cambridge: Cambridge University Press, 2006).

[4] Joan Wallach-Scott, *Gender and the Politics of History* (New York: Columbia University Press, 1988), 7.

but on the principle of multiple interactions across social and geographical locations and of a non-linear, non-progressivist view of temporality. Modernism is not determined by a modernity that precedes it but is imbricated in it, is inseparable from the self-reflexive nature of the modern life-forms into which it is bound. Modernism is then to be seen in terms of overlapping, criss-crossing, and labile networks.[5] This model complicates our understandings of causality and diachrony because it insists that the history of modernity (and thus of modernism) should be seen as geographically and temporally 'uneven': modernity is not 'singular' but 'multiple', its development is intermittent, not smoothly progressive, and it takes diverse forms depending on time and place, and on different agents' specific interventions, in particular sociocultural circumstances. Thinking about modernity and modernism along these lines gives rise to what Ian Hacking has described as 'a local historicism, attending to particular and disparate fields of reflection and action' that 'discourages grand unified accounts' (totalizing theories), replacing them with scrupulous attention to specific sociocultural contexts.[6]

The Handbook draws on this understanding of history, which informs so much recent work in modernist studies, in order to situate literary modernisms and the modernist arts in a series of unfolding relations with society and culture in both national and transnational settings. To this end, chapters in the volume draw upon a variety of interdisciplinary approaches from, for example, anthropology, architecture, cultural history, genetic textual studies, post-colonial studies, queer theory, visual and material culture, and critical literary geographies. One aim of this Handbook is to update previous synoptic guides such as Bradbury and McFarlane's influential *Modernism* (1975) and to take account of the past thirty years of research, during which the field of modernist studies has undergone an extraordinary number of changes. In keeping with the ways in which modernism has been retheorized and its canon of works opened up by rereadings of generally accepted 'classics' and the incorporation of once excluded texts and/or practices, the Handbook also tries to avoid the standard teleological chronology and periodization which sets one 'ism' after another, climbing to and descending from high modernism. It replaces this implicitly progressivist approach with emphasis on the sheer range of modernisms contemporary scholars have uncovered and to which they continue to direct our attention. Any understanding of the innovations and experiments of modernism must take account of work in several areas if it wishes to delineate the aesthetic, intellectual, cultural, and material formations that link the various arts which comprise the practices we continue to group under the aegis of this concept. A number of the chapters in this volume thus examine the interactions among various intellectual traditions, cultures, and genres; explore the interplay between social,

[5] For some cautionary thoughts about the implications of this move away from the base–superstructure model towards that of the 'network', with specific reference to the category of class, see Peter Nicholls, 'State of the Art: Old Problems and the New Historicism', *Journal of American Studies*, 23/3 (1989), 423–34.

[6] Ian Hacking, 'Two Kinds of "New Historicism" for Philosophers', *New Literary History*, 21 (1989–90), 345.

economic, and technological developments and the artistic practices of modernism; assess the numerous links and mutual influences among visual cultures (such as art, sculpture, photography) and other media and/or modes (such as cinema, dance, radio, theatre); and consider the impact of 'theory', both on modernists themselves and on later constructions of the term.

Much recent thinking about modernism has addressed itself to the question (which goes back to arguments among Adorno, Benjamin, Brecht, Lukács, and Marcuse) of how far modernism was, or can still be, oppositional, interventionist, politically engaged. And any attempt to debate this vexed issue needs to consider the relationship between modernism and that which supposedly superseded it: post-modernism.[7] It has been questioned whether postmodernism—as used to be argued—ever represented a conceptual or historical 'break' with modernism, and this has led to a series of returns to the scene of the modern, which, as this Handbook shows, is now understood in a much expanded sense. It is widely agreed that problems of delimitation and definition continue to bedevil modernist studies, though this instability should not necessarily be seen as a cause for concern, since it is a concomitant of the very 'opening up' that has so reinvigorated the field.

That said, there is clearly a degree of anxiety around the question of how modernism is to be defined (see especially Chapter 1 by Shiach). Some critics take the view that though we shouldn't make too many assumptions about what modernism *is* exactly, this, in fact, is what most accounts of it do. Geoff Gilbert, for example, observes that recent emphasis on a plurality of modernisms or on distinctions between early, high, and late modernisms tends to rely on an implicit assumption that modernism displays 'a prior coherence' from which 'multiple versions can be ranged, or out of which fractions can be divided'.[8] That is to say, it is only when there is already some idea or concept of 'modernism' in place that its differentiation into discrete phases or sundry manifestations becomes a viable critical move. Gilbert's point is that as a culturally complex phenomenon, modernism shouldn't be restricted to formally innovative work—as though experimentation were its sine qua non—since this view of it excludes all kinds of engagements with modernity that might no less plausibly be seen as 'modernist'. A similar point has been made by Morag Shiach, who has suggested that past critical accounts of modernism 'have tended to iron out the complexity of competing styles at any given historical moment in favour of a map which identifies particular forms of artistic experimentation as more truly expressive of their moment'.[9] Ann L. Ardis, in turn, has argued that with the questioning of

[7] Though not, we must remember, in Lyotard's influential formulation: 'A work can become modern only if it is first postmodern. Postmodernism thus understood is not modernism at its end but in the nascent state, and this state is constant' (Jean-François Lyotard, *The Postmodern Condition: A Report on Knowledge*, trans. Geoff Bennington and Brian Massumi (Manchester: Manchester University Press, 1984), 79).

[8] Geoff Gilbert, *Before Modernism Was: Modern History and the Constituency of Writing* (Houndmills: Palgrave Macmillan, 2004), 168.

[9] Morag Shiach, *Modernism, Labour and Selfhood in British Literature and Culture, 1890–1930* (Cambridge: Cambridge University Press, 2004), 135.

previously established 'period' boundaries around modernism, and with our increased awareness of how modernism may in part be seen as a response to the professionalization of socio-economic life and to the creation of ever more specialized disciplines, we need to accept that 'literature functioned as an "open field" at the turn of the century—a varied, highly unstable, and fiercely contested discursive territory'.[10]

Recent work on modernism calls earlier assumptions about its inner integrity, stylistic coherence, period boundaries, and principal geographical and social locations into question. It might fairly be said, indeed, that in reaction against the kind of flattening out described by Shiach there is such a concern to emphasize the multiplicity, diversity, and stylistic range of modernism that the term risks losing any conceptual or historical usefulness altogether.[11] Patricia Chu has argued that inasmuch as it might be agreed that modernism cannot and should not be reduced to questions of style alone (and specifically to *innovations* in style), it should nonetheless still be seen as 'an aesthetic commitment, despite our lack of critical agreement on the nature of that commitment'.[12] This view is shared by Martin Halliwell, who follows Peter Nicholls by claiming that 'the modernist tradition is . . . pluralistic and diverse. Lines of influence and coherent cultural and national groupings are identifiable, but there is no one broad intellectual current that can be traced throughout modernism that neatly aligns writers with each other, unless it is what Nicholls describes as a general shift from "representational" to "transformative" art.'[13] Emphasis on a shift of this kind is also clear in Astradur Eysteinsson's definition of modernism as that which denotes a break with tradition, though his view of the forms this 'break' might take is a complex and nuanced one.[14]

These critics are all attuned to recent changes in modernist studies, and their work cannot be aligned with New Critical formalism, but it is worth noting that the emphasis on aesthetic innovation derives from the writing of pioneering critics such as Clement Greenberg, some of whose formulations took place in the 1930s and which he defended against the claims of postmodernism in the 1980s.[15] In an early intervention in debates about the significance of postmodernism, Greenberg suggested that 'it remains to Modernism alone to resist decline and maintain the

[10] Ann L. Ardis, *Modernism and Cultural Conflict, 1880–1922* (Cambridge: Cambridge University Press, 2002), 175.

[11] See Comentale, *Modernism, Cultural Production, and the British Avant-Garde*, 2–3.

[12] Patricia E. Chu, *Race, Nationalism and the State in British and American Modernism* (Cambridge: Cambridge University Press, 2006), 16.

[13] Martin Halliwell, *Transatlantic Modernism: Moral Dilemmas in Modernist Fiction* (Edinburgh: Edinburgh University Press, 2006), 7.

[14] Astradur Eysteinsson, *The Concept of Modernism* (Ithaca, NY: Cornell University Press, 1990), ch. 1.

[15] Most obviously in Clement Greenberg, 'Avant-Garde and Kitsch', *Partisan Review*, 6/5 (Fall 1939), 34–49, and 'Towards a Newer Laocoön', *Partisan Review*, 7/4 (Aug. 1940), 296–310. For an account of Greenberg's career, see Caroline A. Jones, *Eyesight Alone: Clement Greenberg's Modernism and the Bureaucratization of the Senses* (Chicago: University of Chicago Press, 2005). Jones argues that 'Avant-Garde and Kitsch' depicted 'the artist as an alienated, apolitical bohemian whose goals could only be aesthetic', while 'Laocoön' severed radical art from both the masses and 'revolutionary' intellectuals alike. See Jones, *Eyesight Alone*, 35, 37.

vitality of high art', and he insisted that the 'vitality of art means the upholding of esthetic standards'.[16] These 'standards' were not statically conceived in Greenberg's account, but were thought of in terms of an ongoing process of artistic renewal and cultural regeneration through aesthetic *change*. Whereas postmodernism was empty pastiche, an admission of cultural defeat, modernism was a vibrant force that sought 'to rescue and maintain the best standards of the past', which, Greenberg insisted, it had always sought to do 'only by innovation'.[17] Innovation, then, didn't mean that the arts of the past were rejected, but that they were reworked and revisioned. Tradition becomes a site of contestation (not a source of passive admiration) in this account. And this insistence on a *productive* relationship with the past informs much recent thinking about modernism. Stan Smith, for example, suggests that modernism's much vaunted originality lay in its emphasis on 'the transformative act of translation, adaptation, repetition' and that to be original in this context was 'to reproduce, or re-produce, that which is there already', while Jeffrey M. Perl has claimed that 'the process of return could almost stand as a definition of modernism' because it offered a way to grapple with history.[18]

But the persistent association of modernism with the aesthetic—especially when the aesthetic is conceived in formalist terms, as in Greenberg's work or that of the New Critics—has been objected to by those who see modernism as thoroughly imbricated in the social realm and who want to reconnect it with the popular, or 'mass', culture against which it has so often been defined. Robert Scholes has argued that in the Anglo-American context modernism became codified and gained an institutional presence in the academy as a result of the New Critical hegemony from the 1940s through to the 1960s. The formalist approach to literature and the visual arts was perfectly suited to linguistically complex writing and to abstract painting, and was thus to a great extent responsible for the critical valorization of modernism, out of which the New Criticism had itself emerged.[19] This valorization was predicated upon the rejection of popular, or 'mass', culture and thus performed significant intellectual work: it insisted on a hierarchy of aesthetic values that sought to operate with 'clear distinctions where clear distinctions cannot—and should not—be made'.[20] For Scholes the divide between 'high' and 'low' represents 'a basic

[16] Clement Greenberg, 'To Cope with Decadence', in Benjamin H. D. Buchloh, Serge Guilbaut, and David Solkin (eds), *Modernism and Modernity: The Vancouver Conference Papers* (Halifax: Press of the Nova Scotia College of Art and Design, 2004), 164.

[17] Ibid., 'General Panel Discussion', 268.

[18] Stan Smith, *The Origins of Modernism: Eliot, Pound, Yeats and the Rhetorics of Renewal* (Hemel Hempstead: Harvester Wheatsheaf, 1994), 6, 5, and Jeffrey M. Perl, *The Tradition of Return: The Implicit History of Modern Literature* (Princeton: Princeton University Press, 1984), 14. For a good discussion of the complexity of the term 'tradition', see Giovanni Cianci and Jason Harding (eds), *T. S. Eliot and the Concept of Tradition* (Cambridge: Cambridge University Press, 2007).

[19] This was first mooted as a possibility just after the Second World War, in the context of the impact on academic life of 'little magazines'. See Frederick J. Hoffman, Charles Allen, and Carolyn F. Ulrich (eds), *The Little Magazine: A History and a Bibliography* (Princeton: Princeton University Press, 1947), 224. The individuals that Hoffman et al. had in mind were Norman Macleod, Yvor Winters, Robert Penn Warren, R. P. Blackmur, and John Crowe Ransom.

[20] Robert Scholes, *Paradoxy of Modernism* (New Haven: Yale University Press, 2006), p. xi.

element of Modernist critical theory and Modernist pedagogy', and he argues that the 'attempt to exclude the middle can be seen as the engine driving Modernist paradox itself'.[21] As interpreted and disseminated by its initial promoters, then, modernism was in an important sense separated out from the wider cultural field from which it emerged and which it in turn disavowed in an attempt to assert its originality and value.

We have already suggested that a feature of recent scholarship has been a renewed attention to cultural and material factors, to what Peter Brooker has described as 'the situated sociality of modernist art'.[22] This goes some way to addressing Scholes's objections to a formalist-inspired modernist hermeticism. But critics like Scholes are also concerned with the hierarchies of value instantiated by earlier accounts of modernism. The argument here objects not just to the high value placed on modernist artefacts (to the exclusion of derided 'others', which in this paradigm function to buttress the claims made on modernism's behalf) but on the equation of artistic quality with a narrowly conceived conception of the aesthetic as a repository of value. A related critique directs itself against the oft-heard claim that modernism can be read as a form of resistance to modernity, a set of disparate interventions that—in their 'radical' forms, at least—oppose global capital and the socio-economic systems it puts into place. The avant-gardes, perhaps especially Dada and Surrealism, but also some modernists (Beckett, Brecht, Kafka), are here read as movements and figures that interrupt and challenge the seemingly inexorable unfolding of global capital and the peculiarly modern economic, social, and political structures it produces. On this view, modernism and the avant-gardes are indeed thoroughly imbricated in society—certainly, they are not seen as standing 'outside' it in any crude sense—but they try to distance themselves from it. They seek to expose its flaws and contradictions, even if this can only take the form of partial, elliptical, and intermittent critique. For Adorno, such critique famously takes a 'negative' form; it acts as an implicit and coded denial that has nothing to do with overt cultural commentary or direct social intervention. In a similar way, Marcuse insisted that the avant-gardes, 'far from playing down alienation, enlarge it and harden their incompatibility with the given reality' in order to 'confront man with the dreams he betrays and the crimes he forgets'.[23] This argument, in other words, rests on the assumption that under the conditions of capitalist modernity, viable critique can only be generated by exaggerating the reification of everyday life in the very formal features of the artwork itself.

Within this understanding of modernism, it can be read as 'a protest at the reign of instrumental reason and market culture which attempts to preserve or to create a space for individuality, creativity, and aesthetic value in an increasingly homogenous and bourgeois world' or as 'a cultural expression of the intense development of key aspects of modernity, to the point where they are reconfigured as an internal

[21] Robert Scholes, *Paradoxy of Modernism* (New Haven: Yale University Press, 2006), 22, 26.

[22] Peter Brooker, *Bohemia in London: The Social Scene of Early Modernism* (Houndmills: Palgrave Macmillan, 2007), 131.

[23] Herbert Marcuse, 'Art as Form of Reality', *New Left Review*, 74 (July–Aug. 1972), 56, 57.

critique'.[24] An alternative reading, articulated from both leftist and neo-conservative standpoints, maintains the exact opposite: modernism is nothing more than the cultural embodiment of capitalism itself. Modernism is produced by capitalism in the sense that it could only have emerged under its socio-economic conditions and it then reproduces capitalist logics in its drive to break with earlier traditions, to seek new expressive modes, to innovate, to 'make it new'. Thus, for Gerald Graff, in an early statement of this view, 'the real "avant-garde" is advanced capitalism, with its built-in need to destroy all vestiges of tradition, all orthodox ideologies, all continuous and stable forms of reality in order to stimulate higher levels of consumption'.[25] More recently, John Xiros-Cooper has suggested that whereas modernists saw themselves as protesting against bourgeois culture, modernism was in fact 'the culture of capitalism' and capital was from the outset 'the avant-garde of economic and political history'.[26]

If modernism is the expression of capitalism itself, then its much-vaunted critical capacity is simply a chimera, a fantasy invested in by critics and intellectuals who fail to grasp that modernist autonomy is an illusion and that modernist experimentation perfectly accords with capitalism's demand for the ever new. The modernist aesthetic, then, simply comes to occupy 'the lost terrain of social representation' from which agency and critique have effectively been expunged, and this strange process of substitution strips modernism of its alleged critical capacity. T. J. Clark objected to Greenberg's work on precisely these grounds, suggesting that Greenberg mistakenly believed 'that art can substitute *itself* for the values capitalism has made valueless', and arguing that this was a thoroughly formalist account of the aesthetic which severed it from social reality. Xiros-Cooper extends this line of thought in his critique of modernist 'radicalism': 'It is this peculiar logic of ascribing to modernist works of art a kind of negative historical agency (but calling it autonomy) that becomes an important constitutive moment of modernism.'[27]

The arguments made by Graff and Xiros-Cooper offer a riposte to critics who view modernism as at least potentially an oppositional practice. But these arguments are in certain respects too monolithic, both about capitalism and about modernism. They don't differentiate enough among the multiple cultural, economic, social, historical, and geographic trajectories and formations of modernity. There is a tendency to see capitalism as a huge overarching system in control of all sites of

[24] Tim Armstrong, *Modernism: A Cultural History* (Cambridge: Polity Press, 2005), 4; Shiach, *Modernism, Labour and Selfhood in British Literature and Culture*, 1.

[25] Gerald Graff, *Literature Against Itself: Literary Ideas in Modern Society* (Chicago: University of Chicago Press, 1979), 8. See also Suzy Gablik, *Has Modernism Failed?* (London: Thames & Hudson, 1984). For the view that modernism was in the past partially able to resist capitalism but is now fully incorporated into it, see Perry Anderson, *A Zone of Engagement* (London: Verso, 1992), 54. Anderson is here returning to his earlier debate with Marshall Berman. See Perry Anderson, 'Modernity and Revolution', *New Left Review*, 144 (Mar.–Apr. 1984), 96–113, and Marshall Berman, 'The Signs in the Street: A Response to Perry Anderson', *New Left Review*, 144 (Mar.–Apr. 1984), 114–23.

[26] John Xiros-Cooper, *Modernism and the Culture of Market Society* (Cambridge: Cambridge University Press, 2004), 23.

[27] Ibid. 109.

resistance and to view modernism as straightforwardly homologous to it.[28] This was very much the point Marshall Berman made against Anderson's analysis of the situation in the early 1980s:

I'm writing more about the environments and public spaces that are available to modern people, and the ones they create, and the ways they act and interact in these spaces in the attempt to make themselves at home. I'm emphasizing those modes of modernism that seek to take over or to remake public space, to appropriate and transform it in the name of the people who are its public.[29]

This Handbook suggests that modernism should be thought of as an overdetermined, overlapping, and multiply networked range of practices that were always caught up in a dialectical process of affirmation and negation.[30] Modernism can productively be regarded in terms of theories of 'uneven development', which in turn inform accounts of 'alternative modernities'.[31] Critical work done from this kind of perspective is attentive not just to the 'episodic' (in T. J. Clark's sense) and temporally fragmented nature of modernism but also to its geographical dispersal, its multiple sites and contexts. It's not just that modernism is thereby shown to arise in various locations and to take numerous forms but that it is also rendered unstable as a category. Modernism, Tim Armstrong argues, should thus be seen in terms of 'notions of temporality which overlap, collide, and register their own incompletion . . . the dynamization of temporality is one of the defining features of modernism: past, present, and future exist in a relationship of crisis'.[32]

Awareness of this complex geographical and historical nexus moves us decisively away from simple periodizations and teleological accounts of modernism's 'efflorescence', which is then followed by its inevitable 'decline' and 'fall', but it also forces us to acknowledge the transnational dimensions of modernism and modernity. The stress on transnationality, in turn, requires us to confront modernism's complex relations with imperialism. Patrick Williams offers a useful summary of the issues at stake:

A 'combined and uneven' development perspective on modernism and imperialism would also want to register the ways in which they display relations of continuity and discontinuity, both internally and . . . between one another. These would include, for instance, modernism's modes of connection to and disconnection from imperialism in terms of geographical location, political positionality, trajectory and temporality, as well as its internal

[28] Thus Xiros-Cooper: 'Capitalism, as it is embodied in market society, emerges from the same gene pool as modernism; they are, to repeat, one and the same' (Ibid. 23).

[29] Berman, 'The Signs in the Street', 122.

[30] See Thomas Crow, 'Modernism and Mass Culture in the Visual Arts', in Buchloh et al., *Modernism and Modernity*, 247.

[31] See Arjun Appadurai, *Modernity at Large: Cultural Dimensions of Globalization* (Minneapolis: University of Minnesota Press, 1996); Paul Gilroy, *The Black Atlantic: Modernity and Double Consciousness* (Cambridge, Mass.: Harvard University Press, 1993); Dilip Parameshwar Gaonkar, 'On Alternative Modernities', in Gaonkar (ed.), *Alternative Modernities* (Durham, NC: Duke University Press, 2001), 1–23.

[32] Armstrong, *Modernism*, 9. See also Brooker, *Bohemia in London*, 41, 131.

(dis)continuities: assimilated by or resisting modernity; enormously assimilative in its turn, or isolationist and defensive. Such a perspective also makes clear why, in the combined and uneven context that imperialism offers on a world scale, modernity and modernist responses to it emerge and subside at very different moments, and with their own particular rhythms and according to their own particular agendas—[33]

Williams not only highlights the numerous manifestations of modernism as it emerged in and engaged with different national and political sites, but also insists that human agency was always at work in these contexts, that specific choices were enacted under conditions that could not themselves be chosen. Dilip Gaonkar describes such choices as forms of 'creative adaptation' that do not do away with the Enlightenment account of modernity but rather interrogate and rework it, not least in order to expose the ways in which its putatively emancipatory project has—in the contexts of colonialism and imperialism—failed to deliver on its universalist promises.[34] For Gaonkar, 'in the face of modernity one does not turn inward, one does not retreat; one moves sideways, one moves forward'. This 'creative adaptation' produces a 'double relationship between convergence and divergence' and 'makes the site of alternative modernities also the site of double negotiations—between societal modernization and cultural modernity, and between hidden capacities for the production of similarity and difference'.[35]

As several of the chapters in this Handbook show, the dialectic between difference and similarity that lies at the heart of 'creative adaptation' takes wildly divergent forms. Modernism is embraced, appropriated, redefined, parodied, and rejected. It is echoed, ridiculed, borrowed from, and turned inside out. It is caught up in the dynamics of colonialism and bound into strategies of post-colonial critique. Most importantly, perhaps, the various uses to which modernism is put by writers and artists working outside Europe and the United States challenge the widespread notion that modernism is 'centrally' a European and North American phenomenon.[36] Kwame Anthony Appiah argues that: 'If there is a lesson in the broad shape of this circulation of cultures, it is surely that we are all already contaminated by each other, that there is no longer a fully autochthonous *echt*-African culture awaiting salvage by our artists (just as there is, of course, no American culture without African roots).'[37] Scholars have long acknowledged the dependence of European–American

[33] Patrick Williams, '"Simultaneous Uncontemporaneities": Theorising Modernism and Empire', in Howard J. Booth and Nigel Rigby (eds), *Modernism and Empire* (Manchester: Manchester University Press, 2000), 32.

[34] For more on this contradiction between Enlightenment ideals and colonialism, see Simon Gikandi (ed.), *Encyclopedia of African Literature* (London: Routledge, 2003), 336–40, and Vasant Kaiwar and Sucheta Mazumdar, 'Race, Orient, Nation in the Time-Space of Modernity', in Kaiwar and Mazumdar (eds), *Antinomies of Modernity: Essays on Race, Orient, Nation* (Durham, NC: Duke University Press, 2003), 285–7.

[35] Gaonkar, *Alternative Modernities*, 22, 23.

[36] See Laura Doyle and Laura Winkiel (eds), *Geomodernisms: Race, Modernism, Modernity* (Bloomington: Indiana University Press, 2005).

[37] Kwame Anthony Appiah, 'Is the Post- in Postmodernism the Post- in Postcolonial?', *Critical Inquiry*, 17 (Winter 1991), 354.

modernism on the cultures and arts it encountered through the histories of colonialism and imperialism.[38] In one argument, modernism is the *product* of colonialism, which came into being through its various appropriations of the 'exotic' and the 'primitive', and which deployed these (always ambiguous and ambivalent) appropriations as a means to renew a society that was feared to be in danger of degeneration and atrophy.[39]

It has been argued that modernism should be seen as a response to a profound crisis of values instigated by these encounters.[40] For Simon Gikandi: 'The moment of English modernism, in spite of a certain canonical insistence on its ahistorical and hermetical character, was generated by a crisis of belief in the efficacy of colonialism, its culture, and its dominant terms—a progressive temporality, a linear cartography, and a unified European subject.'[41] Equally important here is to take note of Gikandi's point that by appropriating discourses such as those of modernism colonial subjects could gain 'the authority not only to subvert the dominant but also to transform its central notions'.[42] From this perspective, it is not just that modernism is influenced by 'other' cultures—a view that does little to destabilize the centre–margin binary—but that it is completely overhauled by writers and artists who re-create and redeploy modernism in their own culturally specific terms and for their own distinctive purposes. As Patricia Chu has noted, in many accounts of modernism the 'other' is simply incorporated into existing models, a strategy that simply repeats 'the logic of imperial economics: metropolitans use raw materials from the periphery to manufacture finished goods'.[43] This approach to modernism not only denies agency to those who would rework it but also leaves the category of 'modernism' untouched: 'In reading "other" modernisms according to the predefined identity categories of its authors, modernist studies commits itself to an understanding of a primary (unmarked) modernism surrounded by (raced and gendered) satellite artists.'[44]

Several of the chapters in this Handbook show that this notion of an 'unmarked' modernism must be (and is) contested. What chapters on various transnational modernisms show beyond any doubt is that European models of modernism can no longer be regarded as hegemonic; they may well be utilized in non-European contexts (though they often are not), but they don't take precedence over alternative understandings of the forms modernism might take. Equally importantly, chapters

[38] See e.g. Richard Begam and Michael Valdez Moses (eds), *Modernism and Colonialism: British and Irish Literature, 1899–1939* (Durham, NC: Duke University Press, 2007).

[39] See e.g. Fredric Jameson, *The Political Unconscious: Narrative as a Socially Symbolic Act* (Ithaca, NY: Cornell University Press, 1981), and Simon Gikandi, *Maps of Englishness: Writing Identity in the Culture of Colonialism* (New York: Columbia University Press, 1996).

[40] See Stephen Slemon, 'Modernism's Last Post', in Ian Adam and Helen Tiffin (eds), *Past the Last Post* (Hemel Hempstead: Harvester Wheatsheaf, 1991), 1–11; Terry Eagleton, Fredric Jameson, and Edward Said, *Nationalism, Colonialism, and Literature* (Minneapolis: University of Minnesota Press, 1990); Joseph Bristow, *Empire Boys: Adventures in a Man's World* (London: HarperCollins, 1991), 123.

[41] Gikandi, *Maps of Englishness*, 161. [42] Ibid., p. xv.

[43] Chu, *Race, Nationalism and the State*, 13. [44] Ibid. 14.

on Irish, Welsh, and Scottish modernism suggest that urban experience cannot be regarded as representative of modernity. These disparate modernisms were often self-consciously 'regional' and their explorations of non-metropolitan locations and forms of life challenged notions of a shared (and predominantly urban) national culture.[45] Borrowing from James Clifford, we may suggest that what has been decisively overturned is the Eurocentric and metropolitan view that 'certain classes of people are cosmopolitan (travelers) while the rest are local (natives)'. This view, Clifford reminds us, represents 'the ideology of one (very powerful) traveling culture', which, when applied to our theorizations of modernism, denies various 'other' cultures any access to a modernism of their own.[46]

[45] For more on this point, see Jed Esty, *A Shrinking Island: Modernism and National Culture in England* (Princeton: Princeton University Press, 2004); John Marx, *The Modernist Novel and the Decline of Empire* (Cambridge: Cambridge University Press, 2005), esp. ch. 5; and Steven Matthews, *Modernism* (London: Arnold, 2004), esp. ch. 2.

[46] See James Clifford, 'Travelling Cultures', in Lawrence Grossberg, Cary Nelson, and Paula A. Treichler (eds), *Cultural Studies* (London: Routledge, 1992), 108.

PART I

FRAMEWORKS

CHAPTER 1

···

PERIODIZING MODERNISM

···

MORAG SHIACH

THIS chapter explores different approaches to understanding how modernism as a literary movement can be connected to the historical period in which it was created. 'Periodizing' refers to this process of embedding modernism within a broader historical context. It also raises more specific questions about when modernism is understood to have begun, when its most significant texts were produced, and when it is thought to have come to an end. The chapter begins by considering some of the challenges (and for some critics even the impossibility) of anchoring modernism securely within a defined historical period. It then explores a number of influential answers to the question of when modernism began and ended, and maps the connections between these answers and broader assumptions about the relations between culture and society. Its overall aim is to suggest some of the strategies that might be deployed to understand modernism historically and to indicate the larger set of issues raised by the aspiration to periodize modernism.

A CAUTIONARY NOTE

···

Modernism is constructed through its own contradictions: it is rooted in tradition and classicism but fascinated by the impulse towards the 'new'; it aspires to aesthetic integrity but finds increasingly ingenious ways to capture fragmentation; it presses

towards the intensity of the moment but also reaches towards the infinite. An example of this last contradiction can be found in Ezra Pound's discussion of the nature and significance of the image within Imagist poetry. For Pound, the poetic image presents itself as 'an intellectual and emotional complex in an instant of time', that is to say as a moment of intensity of meaning and feeling. Yet Pound also says that 'it is the presentation of such a "complex" instantaneously which gives the sense of sudden liberation; that sense of freedom from time limits and space limits'.[1] Within Imagism for Pound, then, is the intensity of the instant as well as the liberation from both space and time that we might more closely associate with infinity. Modernism thus, at least as understood through Pound's Imagism, appears to invoke and to inhabit two radically different temporalities.

That these key contradictions within modernism should be so powerfully concerned with temporality is one of the reasons that periodizing modernism, locating it within a defined historical period, is both so intriguing and so challenging. Any cultural category we deploy in literary criticism or in cultural history is to an important extent retrospective: the capacity to group together cultural texts and historical events as part of a movement is almost never possible in the moment of their creation. We recognize both in literary criticism and in cultural history that we move between the complexity and even the messiness of a lived moment or of an individual text and the retrospective narration of that moment or text as part of something larger: a narration that carries with it imputations of cause, of development, and growth, and perhaps even of ethical or political value. It is interesting in relation to this retrospective quality of cultural categories such as 'modernism' to note that Pound's capturing of the constitutive contradictions of Imagism cited above comes from an essay that deliberately signals its own retrospective quality, naming itself consciously as 'A Retrospect' (1918).

To say that modernism is a cultural moment or period, as well as an artistic movement, is thus a retrospective judgement that also embodies a set of assumptions about the nature of modernism. Deciding when modernism began or ended is connected to a view of what modernism was, or could have been. Tyrus Miller makes this point in his important and influential study *Late Modernism: Politics, Fiction and the Arts Between the World Wars*.[2] He argues that 'insofar as terms like "modernism" ... are used historically to situate a selection of artists and works within a certain geography and time span, they are subject to the conceptual, narrative, and figural parameters that shape all historical writing'.[3] Miller's study carries its own polemic, and is shaped by a powerful sense that the artists he considers most important within the broad context of modernism, such as Djuna Barnes, Wyndham Lewis, and Samuel Beckett, are simply too little read because they do not

[1] Ezra Pound, 'Imagism: A Retrospect' (1918), in T. S. Eliot (ed.), *The Literary Essays of Ezra Pound* (London: Faber and Faber, 1954), 305.

[2] Tyrus Miller, *Late Modernism: Politics, Fiction and the Arts Between the World Wars* (Berkeley: University of California Press, 1999); in particular, see pt I: 'Theorizing Late Modernism'.

[3] Ibid. 4.

fit within the understanding of modernism that shapes most anthologies, curricula, and critical studies. Miller points out that thinking of modernism historically, or thinking of modernism as historical, involves generating a story about its beginnings, its genealogies, its connections to other historical events, its heroes, and its villains. In doing this, he suggests, literary critics and cultural historians seem to have been powerfully influenced by what Miller understands as 'the ideology of modernist aesthetics'.[4] This ideology is expressed in a radical commitment to new forms of cultural expression, and to a repudiation of what are understood to be the cultural values of the preceding period. For Miller, this leads to an excessive critical fascination with movements such as Vorticism and Imagism, with their clear articulation of radical innovation through manifestos and essays as well as in their creative practice of rebellion and radical reinvention. There is, Miller suggests, an unhelpfully hermetic quality to such attempts at historicization, which draw their terms too readily from the internal logic of the very cultural project they aspire to analyse.

The powerful modernist commitment to 'making it new' to which Miller refers can be found, for example, in Filippo Tommaso Marinetti's 'The Founding and Manifesto of Futurism', which was originally published in the French newspaper *Le Figaro* in 1909. Marinetti articulated a series of attitudes, aesthetic choices, and cultural values that were represented as defining elements of a Futurist cultural practice, stating: 'Courage, audacity, and revolt will be the essential elements of our poetry' and 'Up to now, literature has exalted a pensive immobility, ecstasy, and sleep. We intend to exalt aggressive action, a feverish insomnia, the racer's stride, the mortal leap, the punch and the slap.'[5] Marinetti here offers precisely that powerful sense of radical change, and also of compellingly collective cultural project (note his use of 'our' and 'we') that Tyrus Miller argues has exerted such a pervasive but ultimately limiting influence on critical understandings of modernism up to the present day. Marinetti's Futurism is presented as having a clear moment of creation, which is a radical break with and repudiation of what came before (immobility and slumber). It thus generates its own discrete set of aesthetic norms and values that leap and punch, but surely cannot survive much beyond their moment of explosive birth.

Geoff Gilbert addresses the considerable power of such radically transformative and collective aspirations within key modernist texts, and considers their afterlives in literary criticism and in cultural history in his study *Before Modernism Was: Modern History and the Constituency of Writing*.[6] As exemplar of modernism as heroic and revolutionary cultural project, Gilbert cites Wyndham Lewis (surprising perhaps given that for Miller, as we have seen above, Lewis was one of the writers marginalized by the prevalence of this very ideology). It is worth noting, once more, that the text cited by Gilbert is a consciously retrospective one, in which Lewis looks back

[4] Ibid. 5.

[5] Filippo Tommaso Marinetti, 'The Founding and Manifesto of Futurism', *Le Figaro*, 20 Feb. 1909, in Vassiliki Kolocotroni, Jane Goldman, and Olga Taxidou (eds), *Modernism: An Anthology of Sources and Documents* (Edinburgh: Edinburgh University Press, 1998), 251.

[6] Geoff Gilbert, *Before Modernism Was: Modern History and the Constituency of Writing* (Houndmills: Palgrave Macmillan, 2004).

from the vantage point of the 1930s on what he then sees as the failure of the modernist project:

We are not only 'the last men of an epoch'... we are more than that, or we are that in a different way to what is most often asserted. *We are the first men of a future that has not 'come off'.* ... All that is 'advanced' moves backwards, now, towards that impossible goal of the pre-war dawn.[7]

The temporal complexity of this passage is striking. Lewis is looking back on a movement that was apparently both the end of an era and also the agency of a new future (which did not, however, 'come off'). The avant-garde of this movement, which should be pushing forwards, instead 'moves backwards', but does so towards a moment that is also an 'impossible goal'. For Gilbert, this is the archetype of his understanding of modernism as 'practical failure', which for him haunts all subsequent efforts to narrate the emergence and development of modernism, or to locate it confidently within a defined historical period.

Gilbert argues that the temporal dislocations inherent within modernism, present as he would argue even 'before modernism was', pose serious problems for the critic and the reader, who will both struggle to identify the historical core of the modernism project or the defining quality of the modernist text:

The problem with 'modernism' is that it does not mean very strongly. The term does not have the focus or the force definitively to include or to exclude any particular evidence, on either formal or historical grounds. This has led to critics multiplying and dividing modernism into modernisms, in an attempt to find something stable there. But that search for a solid and material starting point is doomed to failure: the only history that 'modernism' has is an institutional history. This would not matter if the institutional history of 'modernism' in the Anglo-American academy had arrived at an internal coherence.[8]

Gilbert's position here is of course polemical, and always in some tension with the broader aim of his work to engage and to situate the productive and fascinating richness of the modernist literary text. Indeed, he is himself not immune from the aspiration to map some kind of common historical ground or shared set of concerns for the modernism project, commenting, for example, that Sigmund Freud and Henri Bergson are 'two of the great modern theorists of memory and time' or that 'the hatred of badly made things is a recognisable period concern'.[9] The need to connect texts in order better to understand them, the urge to pull out key ideas and concerns such as 'time' and 'memory' as part of reading the texts of modernism, and the temptation to identify the 'concerns' of a particular period are all powerfully present even within a text such as Gilbert's whose aspiration is to disavow the possibility of periodizing modernism at all.

[7] Wyndham Lewis, *Blasting and Bombardiering* (London: John Calder, 1982), 256; cited in Gilbert, *Before Modernism Was*, p. ix.
[8] Gilbert, *Before Modernism Was*, p. xiii.
[9] Ibid., pp. viii, x.

'ON OR ABOUT DECEMBER 1910'

As has been argued above, for many theorists and historians of literary modernism, the early years of the twentieth century were the moment when an important and influential series of literary experimenters and revolutionaries emerged, who fundamentally transformed literary aesthetics as well as the social meanings and potential of culture. Dadaism, Futurism, Vorticism, and Imagism all offered themselves as a radical break from the past and as a challenge to the dominant institutions of literary culture. For many critics of modernism this kind of literary experimentalism has subsequently come to define the particular quality of modernism as a broader movement.

Modernism, when understood in this way as a fundamentally transformative cultural movement, begins, roughly, in 1910. So at least said the critic Graham Hough, some fifty years ago in his important study *Image and Experience: Studies in a Literary Revolution*. Hough wrote that 'the years between 1910 and World War Two saw a revolution in the literature of the English language as momentous as the Romantic one of a century before'.[10] Hough is quite specific here about both the year 1910 as well as the revolutionary character of modernism.

Later critics have also seen the year 1910 as the moment of modernism's birth. Peter Faulkner's introductory study *Modernism*, published in 1977, has a section on modernism between 1910 and 1930, and this periodization is also reproduced in his later collection *A Modernist Reader: Modernism in England 1910–1930*.[11] Writing much more recently, the critic Jane Goldman also chooses 1910 as her inaugural year. In *Modernism 1910–1945: Image to Apocalypse*, she provides a rich and complex mapping of modernism, which begins with an introduction entitled 'Making It New': a phrase derived of course from Ezra Pound,[12] but signalling Goldman's commitment to the origins of modernism in a moment of radical cultural transformation.[13] Similarly, John Smart privileges the year 1910 in his collection of materials on modernism in its historical context *Modernism and After: English Literature 1910–1939*, published in 2008.[14]

But perhaps the most famous proponent of the idea that 1910 was the year in which culture and society changed in ways that were both profound and irrevocable was Virginia Woolf. She advances this proposition, or, as she says, 'hazards this assertion',

[10] Graham Hough, *Image and Experience: Studies in a Literary Revolution* (London: Duckworth, 1960), 5; see also an interesting discussion of Hough's view in Lawrence Rainey (ed.), *Modernism: An Anthology* (Oxford: Blackwell, 2005), pp. xx–xxi.

[11] Peter Faulkner, *Modernism* (London: Methuen, 1977), 13–65, and *A Modernist Reader: Modernism in England 1910–30* (London: Batsford, 1986).

[12] Pound frequently invokes this phrase, which he also used as the title for a collection of his essays published in 1934.

[13] Jane Goldman, *Modernism 1910–1945: Image to Apocalypse* (Basingstoke: Palgrave, 2004).

[14] John Smart, *Modernism and After: English Literature 1910–1939* (Cambridge: Cambridge University Press, 2008).

in a lecture given in 1924. I quote the relevant passage at some length below, as its precise terms are important:

On or about December 1910 human character changed. I am not saying that one went out, as one might into a garden, and there saw that a rose had flowered, or a hen had laid an egg. The change was not sudden and definite like that. But a change there was, nevertheless; and since one must be arbitrary, let us date it about the year 1910. . . . In life one can see the change, if I may use a homely illustration, in the character of one's cook. The Victorian cook lived like a leviathan in the lower depths, formidable, silent, obscure, inscrutable; the Georgian cook is a creature of sunshine and fresh air; in and out of the drawing room, now to borrow the *Daily Herald*, now to ask advice about a hat. . . . All human relations have shifted—those between masters and servants, husbands and wives, parents and children. And when human relations change there is at the same time a change in religion, conduct, politics and literature. Let us agree to place one of these changes about the year 1910.[15]

The claim Woolf makes here may appear unconvincing and even irresponsible. Surely mapping a cultural history onto 'the character of one's cook' as Woolf does here cannot be taken completely seriously. Subsequent critics have certainly sought to reduce the audacity of Woolf's claims. They have pointed out that the very moment that Woolf has made the bold claim that human character changed 'on or about December 1910' she immediately draws back by saying that of course it could never actually have been so sudden or complete a change as this suggests: cultural history is not, Woolf says, made up of sudden discrete actions like the blooming of a rose or the hen's laying of an egg. Similarly, critics have pointed out that 'December 1910' is actually a shorthand for various much more public and unarguably influential events such as the death of King Edward VII (and thus the end of the Edwardian era), or the staging of the first Post-Impressionist Exhibition in London by Roger Fry.

The year 1910 can indeed mean many different things. But Woolf's argument above is nonetheless a serious attempt to articulate the various facts that can lead to a new cultural moment, or a new cultural movement, such as modernism. The changing character of the cook is Woolf's figure for a complex series of social changes that modify the geography of the home as well as various interpersonal relations structured by class and gender. Woolf's modern cook can cross social boundaries, moving freely about the house when her predecessor stayed firmly in one place ('the lower depths'); she is literate; and she is also a consumer, engaged in the commerce of fashion. Class mobility, changes in education, and the development of commercial capitalism are the factors that underpin Woolf's claims for the radical shift she observes in human relations, both at work and within the family. These shifts lead, necessarily she suggests, to transformations in 'religion, conduct, politics and litera-ture', lead, in fact, to modernism 'on or about 1910'.

[15] Virginia Woolf, 'Character in Fiction', in *Virginia Woolf: Selected Essays*, ed. David Bradshaw (Oxford: Oxford University Press, 2008), 38.

A NINETEENTH-CENTURY MODERNISM?

In all the critical discussions I have considered so far, there is an assumption that modernism, or at least literary modernism, is a phenomenon of the first half of the twentieth century: beginning 'on or about 1910' and lasting some twenty to thirty years thereafter. Modernism appears in this account to have developed rather suddenly, to have had a brief period of creative flowering, and then to have dwindled well before the end of the Second World War.

The rigidity of this sort of periodization, with its suggestion that modernism emerges as an explosive repudiation of all that has come before, has not seemed helpful or persuasive to all modernist critics, however. Firstly, as Tyrus Miller has suggested, this is because such an approach tends to reproduce the radical aspirations of early experimenters rather uncritically. Just because Pound or Marinetti, or indeed Woolf, tell us, frequently and emphatically, that what they are doing is completely new, this should not necessary stop us asking, particularly at this distance in time, whether that is the whole story. Might the connections to earlier periods in fact not be stronger than these artists were able to discern in the urgency of their creative projects; and might there not thus be moments of modernism to be found well before the twentieth century?

A periodization of modernism that names one year, or one month, as its point of origin carries within it a theory of cultural change that cannot account for the unevenness that has often been thought to characterize profound social transformation. In the non-literary domain, for example, Karl Marx's observations about the uneven development of new forms of economic relations, where both 'backward' and modern forms of economic and social relationship could exist simultaneously, have been very influential for a wide range of social theorists.[16] Marx's point was that changes in economic, as in human, relationships, even when they were massive and significant, were neither sudden nor total. The same point is developed by the critic Raymond Williams in relation to literary and broader cultural change. In *Marxism and Literature*, for example, he argues that cultural change is dynamic and uneven, and that at any given moment one will find some dominant forms of culture and relationship, but also traces of older forms and practices (the residual) and inklings of new forms to come (the emergent).[17] If modernism is thought of in relation to this more dynamic and uneven periodization, both the moment of its birth and the alleged fact of its death become open to question.

One striking recent tendency among critics of modernism has been to push backwards into the nineteenth century to find its emergent historical forms. In *Modernisms: A Literary Guide* (1995), for example, Peter Nicholls stresses the diversity

[16] See e.g. Karl Marx, *Capital: Critique of Political Economy*, i, trans. Ben Fowkes (London: Penguin, 1976), ch. 27, and *Grundrisse: Foundations of the Critique of Political Economy*, trans. Martin Nicolaus (London: Penguin, 1973), 361.

[17] Raymond Williams, *Marxism and Literature* (Oxford: Oxford University Press, 1977), 120–7.

of the various cultural innovations that have come to be understood as different sorts of modernism. Nicholls describes the beginning of modernism in a way that stresses the uneven quality of its development: 'The beginnings of modernism, like its endings, are largely indeterminate, a matter of traces rather than of clearly defined historical moments.'[18] Not only does this suggest an origin that is impossible to fix, it also argues for a multiplicity of beginnings, each of which is indeterminate and locatable only through a careful reading of its traces.

For Nicholls, the historical traces of various modernisms need to be deciphered and their connections mapped before a picture of the cultural impact of modernism can be discerned. On this model modernism is thought of as a gradually realized and complexly connected set of cultural transformations. Yet Nicholls cannot completely resist the appeal of a moment of origin, and he does suggest one possible historical moment at which these traces can first be glimpsed:

In pursuit of those traces of modernism, then, we might return to Paris in the early 1840s, and specifically to a moment when visitors to the Champs-Elysées were entertained by the music of two young girls who begged their way between cafés, singing and playing the guitar. The striking beauty of one of them fascinated the writers and artists who frequented this part of the city.[19]

Nicholls's 'trace' of modernism evoked here is a momentary encounter between young women begging in the streets of Paris and the artistic sensibilities of 'writers and artists', including, it is clear, the French writer Charles Baudelaire. Baudelaire's aesthetic responses to the modern city, to the social figure of the outcast, and to the sensation of beauty and its momentary passing are all read by Nicholls as part of the story of modernism's beginnings. For Nicholls, although this story of modernism's historical traces begins with a social encounter in the streets of Paris, its meaning is finally found not in this encounter, but in the development of a distinctive literary style. Nicholls writes of Baudelaire that his 'early work already shows traces of what we might think of as a distinctively "modern" style. This is partly an effect of the glimpses the poem gives us of the new urban scene, and of the poet as one of its déclassé inhabitants; but mostly, I think, it has to do with a certain *tone*.'[20]

For Nicholls, modernism begins, or at least it has one of its beginnings, when poetic writing develops a specific capacity for ironic distance, and this change Nicholls locates in nineteenth-century France. This is, of course, just one of many traces. Other stories could be told that begin with different encounters in different places. And yet, within Nicholls's overall argument this beginning is not arbitrary: it is the moment when achieved aesthetic form has to give, to modify, under the pressure of new social experience. The story Nicholls tells is of a cultural form that is driven by new forms of social experience, that responds to this through the creation of new kinds of poetic diction and idiom, and thus produces a literary text that can be read as distinctively modernist.

[18] Peter Nicholls, *Modernisms: A Literary Guide* (London: Macmillan, 1995), 1.
[19] Ibid. [20] Ibid.

Nicholls is by no means alone in seeking to push the beginnings of modernism back well before 1910. One of the most influential English-language accounts of European literary modernism, Malcolm Bradbury and James McFarlane's *Modernism: A Guide to European Literature*, locates modernism's beginnings in the late-nineteenth century, in 1890 to be precise. This relatively early beginning is the product of their interest in the broad canvas of European literature, rather than of any methodological or theoretical difficulty with the idea of a distinct moment of origin or birth for modernism. Indeed, in their introductory essay, entitled 'The Name and Nature of Modernism', Bradbury and McFarlane write very powerfully of modernism as one of 'those cataclysmic upheavals of culture, those fundamental convulsions of the creative human spirit that seem to topple even the most solid and substantial of our beliefs and assumptions, leave great areas of the past in ruins … question an entire civilization or culture'.[21]

Many critics have been struck by the ways in which a range of late nineteenth-century texts display characteristics they might wish to describe as modernist. For example, Oscar Wilde, Joseph Conrad, and Henry James have all been seen as stylistically modernist to some extent, stressing as they do the opacity of language, the complexity of subjectivity, the power of the image, and the grip of the unconscious.[22] Similarly, 'New Woman' novels from the end of the nineteenth century have been seen as part of the landscape of modernism, some for stylistic reasons but mostly because thematically they engage with the hugely distorting impact of modern institutions on individual character, and also chart the radical impasse of gender relations in the late nineteenth century in a way that prefigures literary experimentation with gender and with sexual identities within the texts of modernism.[23]

An interesting analysis that explores how the literary innovations of modernism carry within them the legacy of nineteenth-century culture can be found in Suzanne Raitt's biographical study *May Sinclair: A Modern Victorian*.[24] The novelist and poet May Sinclair was born in 1863, and was thus formed by late Victorian culture and institutions, but her writing career carries on well into the twentieth century, and a number of her texts are indisputably 'modernist'. She it was, indeed, who introduced the phrase 'stream of consciousness' (which has been so key in designating the distinctive characteristics of modernist prose) to literary discussions in a critical essay on Dorothy Richardson published in 1918.[25] She was also profoundly involved in the early formation of psychoanalysis as a body of thought as well as a community of

[21] Malcolm Bradbury and James McFarlane, 'The Name and Nature of Modernism', in Bradbury and McFarlane (eds), *Modernism: A Guide to European Literature 1890–1930* (Harmondsworth: Penguin, 1976), 20.

[22] See e.g. Peter Brooker, 'Early Modernism', and Jeremy Hawthorn, 'Joseph Conrad's Half-Written Fictions', in Morag Shiach (ed.), *The Cambridge Companion to the Modernist Novel* (Cambridge: Cambridge University Press, 2007), chs 2, 10.

[23] Ann L. Ardis, *New Women, New Novels: Feminism and Early Modernism* (Piscataway, NJ: Rutgers University Press, 1991).

[24] Suzanne Raitt, *May Sinclair: A Modern Victorian* (Oxford: Oxford University Press, 2000).

[25] May Sinclair, 'The Novels of Dorothy Richardson', *The Egoist*, 5 (Apr. 1918), 57–9, and the *Little Review*, 4 (Apr. 1918), 3–11.

practice in the early years of the twentieth century. Yet Raitt argues very convincingly that she cannot ever be understood simply as a twentieth-century writer, because so many of the texts, ideas, and dilemmas of the Victorian period resonate within her life and her writing to the end. The biographical focus of Raitt's reading of Sinclair helps to remind us that while literary texts may be conveniently located within one movement or moment, the lives of their authors very rarely can: too rigid a periodization may not simply reduce the complexity and dynamism of cultural change, it may also truncate the potentially productive relations between biography and literary text that so many modernist texts seek precisely to set in play.

A MATTER OF DISCIPLINE

One of the striking things about 'modernism' as a cultural term is that it is so crucial within such a wide range of discrete areas of cultural production and analysis, including architecture, art, and music. Within each of these disciplines, there is a very different sense of when modernism began, how it developed and when (or even if) it ended.

In the field of visual culture, the word 'modernism' is in fact rarely used, and the concept of 'modern art' is preferred. This latter term is substantially more expansive in its historic range, and also perhaps even more inclusive in relation to the diverse aesthetic styles it accommodates. 'Modern art' is commonly understood to include Impressionism, which developed in the 1860s; to encompass Cubism, Post-Impressionism, and Dadaism from the early years of the twentieth century; but also to include movements such as Abstract Expressionism from the 1940s or the development of Pop Art in the 1960s. Thinking these diverse forms of artistic practice together in relation to the 'modern' is something that emerges only through their institutionalization within galleries of modern art, for example in New York's Museum of Modern Art, which was established in the late 1920s. The many galleries of modern art that have been established since then have broadly preserved this kind of periodization, with an origin in the 1860s and a particular flourishing in the early years of the twentieth century, although often allowing a very porous boundary between the 'modern' and the 'contemporary' that is not typically found in relation to the literary, where modernism is rarely invoked for any text produced after the Second World War.

Yet the apparent stability of this periodization of 'modern art' may also be illusory. T. J. Clark's illuminating study of artistic modernism, *Farewell to an Idea: Episodes from a History of Modernism*, begins by discussing the temporal complexity of modernism and its troubling concatenation of the 'not yet' and the 'too late':

Already the modernist past is a ruin, the logic of whose architecture we do not remotely grasp. This has not happened, in my view, because we have entered a new age. This is not what the

book's title means. On the contrary, it is just because the 'modernity' which modernism prophesied has finally arrived that the forms of representation it originally gave rise to are now unreadable. . . . Modernism is unintelligible now because it had truck with a modernity not yet fully in place.[26]

Clark's response to this temporal complexity is to develop a mapping of modernism in art that is not woven round 'limit cases like Pissarro in 1891 or Malevich in 1920 or Pollock from 1947 to 1950' but is rather conceived in terms of 'a distinctive patterning of mental and technical possibilities'.[27] Concentrating on possibilities rather than on canonical modernist texts takes Clark back to a much earlier moment of inauguration of the modernist project. He writes: 'my candidate for the beginning of modernism—which at least has the virtue of being far-fetched—is 25 Vendémiaire Year 2 (16 October 1793, as it came to be known)'.[28] This is the date on which Jacques-Louis David's painting *Death of Marat*, an image of the martyred hero of the French Revolution, was first exhibited.

Locating the origin of modernism in the late eighteenth century is both counter-intuitive and deliberately scandalous. Yet this moment of modernist birth is crucial to the analysis Clark goes on to develop of the more familiar modernist landscape of Cézanne, Picasso, and Abstract Expressionism. Clark is making a quite particular argument here about the history of modernism and the history of socialism, which inflects the story he seeks to tell about the origins of modernism and generates the paradox of a modernism of the late eighteenth century. Clark's claim both is and is not, as he would put it, 'far-fetched': it challenges the historical boundaries of 'modernism' to an almost ludicrous extent while simultaneously offering a profound and illuminating reading of the underlying logic of the modernist project with origins precisely in this historical moment of revolution and of failure. Clark's very challenging historical claims about the origins of artistic modernism certainly demonstrate the close connection between periodization, theoretical understanding, and aesthetic preferences that have emerged throughout this chapter.

Turning from art to architecture, one finds a less radical discrepancy between its temporal narratives of modernism and the periodization of modernism offered within literary studies, but the two still do not map particularly comfortably or neatly. 'Modern' architecture is of course thought about very differently within different national traditions. The colourful exuberance and frantic individualism of the Catalan *modernismo* of Gaudí that emerged towards the end of the nineteenth century is generally understood to have achieved its most distinctive form in the early years of the twentieth. The more austere forms of modernist architecture, however, with their emphasis on buildings as 'machines for living in', associated with the work of Gropius, Le Corbusier, and Mies van der Rohe, emerge in a slightly later cultural moment, and are considered to be at their most intense and original in the period

[26] T. J. Clark, *Farewell to an Idea: Episodes from a History of Modernism* (New Haven: Yale University Press, 1999), 2–3.
[27] Ibid. 7. [28] Ibid. 15.

between the two world wars. In architecture, far more than in literature, the moment of modernism's ending is a disputed one. For many critics, modernism indeed remains the cultural dominant, for better or for worse, within architecture—a project that has not yet reached its conclusion.

THE END OF MODERNISM?

The institutionalization of modernism began as early as the 1930s, when books such as Edmund Wilson's *Axel's Castle* offered a mapping of the key literary and intellectual innovations of the years between 1870 and 1930.[29] Wilson's main focus was in fact 'Symbolism' rather than modernism, but his corpus of texts included W. B. Yeats, T. S. Eliot, Gertrude Stein, and James Joyce, as well as Marcel Proust and Paul Valéry, and thus overlapped considerably with what we would now think of as the canon of modernism. In seeing Symbolism as the key driver of the aesthetic changes he was mapping, Wilson was implicitly presenting a movement already coming to an end, whose centre of gravity lay somewhere between 1890 and 1914.

This impulse from the 1930s onwards to write of modernism retrospectively and elegiacally, as a movement whose key moments and key figures were in the past, created some challenges for the writers of what is now commonly described as the 'late modernist' period: broadly understood as the years after 1930. Tim Armstrong discusses this in *Modernism: A Cultural History*, where he argues that 'the emerging hegemony of the "Men of 1914" created a problem for those who followed: the problem of belatedness. What cultural space was available to "make it new" *again*?'[30] For writers in the 1930s, or even in the 1950s, who sought to engage with the radical energies of modernism or to connect their work to its aesthetic innovations, there was always a risk of feeling that it was too late, that the moment of modernism was behind them.

The problem of 'belatedness', it could be argued, is particularly likely to impact on those writers who are for some reason outside the mainstream of the heroic modernist project discussed above and captured so powerfully in studies such as Hugh Kenner's *The Pound Era* and Erik Svarny's *The Men of 1914*.[31] Bonnie Kime Scott's influential collection *The Gender of Modernism* highlighted the fact that the pervasiveness of the version of modernism as iconoclastic, revolutionary, and short-lived had the effect of marginalizing the work of many women modernists. Her anthology

[29] Edmund Wilson, *Axel's Castle: A Study of the Imaginative Literature 1870–1930* (New York: Charles Scribner's Sons, 1931).

[30] Tim Armstrong, *Modernism: A Cultural History* (Cambridge: Polity Press, 2005), 35.

[31] Hugh Kenner, *The Pound Era* (Berkeley: University of California Press, 1973), and Erik Svarny, *The Men of 1914: T. S. Eliot and Early Modernism* (London: Open University Press, 1988).

staked the claims, for example, of Djuna Barnes, of Mina Loy, and of Marianne Moore both to be more widely read and also to be more fully embedded within the critical idea of 'modernism'.[32] Scott argues in the introduction to her anthology that periodization needs to be rethought if this larger and richer modernist canon is to be fairly considered:

The year 1940 has served as a typical terminal date for studies of modernism (some end with 1930). By that time, the major experimental works, such as *The Waste Land, Tender Buttons, The Waves*, and *Finnegans Wake* had appeared and death had claimed Lawrence, Mansfield, and Yeats. . . .Rhys, Barnes and Warner resurfaced with late, much-revised work, as attested in this anthology. West never stopped publishing, though she lost her visibility with American audiences and turned away from her early radicalism. . . . Interrupted careers, like interrupted influence, tell us a great deal about the politics of literary production.[33]

Scott suggests, then, that the problem of 'belatedness' is also a problem of politics. Mapping modernism, choosing the stories to tell about its origins and its ends, is simultaneously to make a political judgement about power and influence. Scott's anthology seeks to tell a different story and to introduce a broader range of writers, and a longer historical period, into the canon of literary modernism. The impact of this work has been very significant within literary studies and many of the writers championed in Scott's anthology are now fully embedded in literary and cultural debates about the nature of modernism. Scott has also developed this work of recovery further in a second anthology, *Gender in Modernism*, which extends the canon both historically and generically, including as it does the work of journalists, suffragettes, dancers, and dramatists.[34]

The moment of modernism's death, then, is disputed, with some critics seeing texts from the 1950s or even the 1960s as part of the modernist project: it is hard to deny, surely, the claims of Beckett to be part of the modernist movement, yet his trilogy of *Molloy, Malone Dies*, and *The Unnamable* was not published until the 1950s. But even if modernism's death is conceded, it still, it would seem, has a significant claim to an afterlife. Tim Armstrong argues that 'it is worth noting the afterlife of modernism. It is remarkable how many late-modernists had interrupted careers, going underground for decades between the 1930s and the 1960s,' and he cites in particular George Oppen, Basil Bunting, and David Gascoyne, who 'began to write again out of a discontinuous history into which they were already written'.[35]

In addition to this kind of 'afterlife' modernism also, of course, has created a formidable literary legacy. Laura Marcus writes powerfully of this legacy, indicating the ways in which writers as diverse as B. S. Johnson, Doris Lessing, Angela Carter, Salman Rushdie, Zadie Smith, and Michael Cunningham are 'engaging with

[32] Bonnie Kime Scott (ed.), *The Gender of Modernism: A Critical Anthology* (Bloomington: Indiana University Press, 1990).

[33] Ibid. 6–7.

[34] Bonnie Kime Scott (ed.), *Gender in Modernism: New Geographies, Complex Intersections* (Urbana: University of Illinois Press, 2007).

[35] Armstrong, *Modernism*, 40.

modernist fiction and its creators'.[36] Marcus's focus is on the ways in which these novelists engage specifically with the stylistic legacy of particular modernist writers. This is a rich field, because so many contemporary writers, both in poetry and in prose, cite the texts of modernism directly, and write with a conscious sense of their place in relation to that movement and that moment. The texts of modernism, and the urgency of the modernist project, thus resonate within a wide range of literary texts up to the present day. Understood in that sense, modernism has not yet come to an end, and its periodization remains, necessarily, incomplete.

[36] Laura Marcus, 'The Legacies of Modernism', in Morag Shiach (ed.), *The Cambridge Companion to the Modernist Novel* (Cambridge: Cambridge University Press, 2007), ch. 5.

CHAPTER 2

..

MODERNISM BEFORE AND AFTER THEORY

..

SASCHA BRU

ONLY Siamese twins can always be certain of consanguineous kinship. This certainty about identity might explain why Siamese twins do not often take centre stage in modernism. When they do appear, their context of inscription is frequently suspicious. Siamese twins come as human aberrations in heterotopic circuses, vaudevilles, and sideshows, almost within reach in Djuna Barnes's *Nightwood* (1936) and considered from up close in Eudora Welty's 'Petrified Man' (1939) and Tod Browning's American film *Freaks* (1932). In Spanish modernist Ramón Gómez de la Sernas's experimental book *The Novelist* (1923) Siamese twins surface as female characters whose distinct personalities are not recognized, reminding us of modernism's frequent gender intolerance. On a poster El Lissitsky designed for the Russian Exhibition in Zurich in 1929, they even come to announce powerful counter-tendencies of modernism. Based on a montage of superimposed photographs, Lissitsky's poster showed a young woman and man's head conjoined, their gaze, unusually for Siamese twins, cast forward in the same direction. Red capitals 'USSR' covered their forehead, the entire poster hinting at the arrival of socialist realism.

Siamese twins can also be said to represent the boundaries between self and other, yet despite modernism's preference for doubles and ambiguity they are marginal *within* the modernist archive. However, *outside* the archive the disciplines of modernist studies and twentieth-century literary theory maintain a relationship that is perhaps best described as that of conjoined twins. Tacitly or overtly many major theories of literature presented in the twentieth century had a stake in modernism.

Theories focusing on literature's context, in particular the cultural materialism developed in the tradition of Marxist and post-Marxist criticism, provide ample illustrations of such stakes.[1] So does the text-oriented lineage in theory from Russian Formalism and New Criticism through structuralism to poststructuralism, which I will primarily focus on in this chapter. New Criticism's general claims about literature and the act of reading, for example, bore a close resemblance to modernist poetics.[2] As an instrument facilitating the study of modernist writing, theory has always been part and parcel of modernist studies. Explicitly or implicitly many ground-breaking readings of modernism too have been informed by a shift in theoretical perspective. Theory (or at least *a* theory) always shapes our gaze, and with differing theories of literature come divergent readings of modernism.

Nowhere is this more apparent than in the study of individual modernists. Taking stock of the history of criticism on canonized modernists always in part means charting the history of literary theory as well. To leaf through studies of Virginia Woolf since the 1970s, for example, is to an extent also to go through the subsequent phases of more recent feminist theory.[3] Anglo-American Joyce criticism is another case that comes to mind. Joyce studies began with Joyce himself, as he personally inspired or supervised almost all major studies on his work during his lifetime. After his death Joyce criticism established itself by taking its cue from psychology, genetic studies, biography, and the study of literary symbols. The author's work notoriously managed to escape the gaze of New Critics—John Crowe Ransom's appraisal of *Finnegans Wake* being one of few exceptions;[4] the *Wake*'s anarchic linguistic experimentation having made the book a modernist *bête noire* for Ezra Pound and Wyndham Lewis as well. Joyce was read in terms of formalist structuralism, however, as it was introduced in the 1960s in the US with translations of the early Roland Barthes, the Russian Formalists, and the work of Roman Jakobson. In *Structuralism in Literature* (1974) Robert Scholes, for example, championed the writer of the last chapters of *Ulysses* and *Finnegans Wake* as an intellectual who 'had adopted an essentially structuralist view of the world'.[5] Interested primarily in 'narrative literature...in terms of the working of a generic system',[6] and drawing on Ferdinand de Saussure and Jean Piaget, Scholes's reading foregrounded mainly formal aspects in Joyce, which laid out both the possibilities and confines of narrative fiction. *Ulysses*, Scholes concluded, was a self-regulating and finite whole, and with this the

[1] For a survey of more contextual approaches to modernism, see Sascha Bru, 'A Map of Possible Paths: Modernism After Marxism', in Astradur Eysteinsson and Vivian Liska (eds), *Modernism* (Amsterdam: John Benjamins, 2007), i. 107–24.

[2] See A. Walton Litz, Louis Menand, and Lawrence Rainey (eds), *Modernism and the New Criticism* (Cambridge: Cambridge University Press, 2000).

[3] For a concise overview, consult Makiko Minow-Pinkney, 'Feminist Approaches', in Anna Snaith (ed.), *Palgrave Advances in Woolf Studies* (New York: Palgrave Macmillan, 2007).

[4] John Crowe Ransom, 'The Aesthetic of *Finnegans Wake*', *Kenyon Review*, 1 (Autumn 1939), 424–8.

[5] Robert Scholes, *Structuralism in Literature* (New Haven: Yale University Press, 1974), 181.

[6] Ibid. 209.

structuralist Joyce in Scholes's book was promoted to a writer whose work spelled out both the constraints and 'fictional universals' of narrative as such.[7]

The Joyce of Scholes could hardly have differed more from the Joyce who emanated almost simultaneously from Stephen Heath's work in the early 1970s and Colin MacCabe's *James Joyce and the Revolution of the Word* (1978). Like Scholes, both MacCabe and Heath used Joyce as 'something of a "touchstone"' to lay claim to the nature of writing in general.[8] Yet whereas Scholes's reading was composed in the spirit of Russian Formalism and structuralism, the theorists Heath and MacCabe called upon were Louis Althusser (first and foremost), Jacques Lacan, Julia Kristeva, and Jacques Derrida. To Heath, who published essays about Joyce in the French journal *Tel Quel* when poststructuralism got into its stride, the later Joyce created anything but finite structures. Turning to aspects of the writer's œuvre that Scholes had downplayed, Heath showed Joyce's work to have been a stuttering, hesitant attempt to illustrate that meaning and reference in language are always forestalled. The later Joyce was understood as demonstrating that what we take to be the 'real' world is actually an infinite intertext. Like all pieces of writing, his œuvre harnessed countless openings that exposed the artifice of conventional modes of representation and ideological constraints. Raising the stakes, MacCabe used Joyce as a stepping stone to attack traditional literary criticism in British universities as such. As the later Barthes had done in France a decade earlier, he argued for the liberation of the reader. MacCabe argued how Joyce's prose constantly subverts notions of centred and Cartesian subjectivity and how his self-referential fictional universe continually deconstructs any possible author, origin, or end. And with these claims the later Joyce was at once celebrated as the champion of poststructuralism and in *Finnegans Wake* as the herald of postmodernism.[9]

These different readings hinted at what some describe, often with nostalgia, as the 'age of Theory', the age during which structuralism was succeeded by poststructuralism. Derek Attridge, at this point drawing on Derrida rather than Jakobson, began a more strictly Derridean rewriting of Joyce, culminating in his *Peculiar Language* (1988), an ambitious attempt to rethink British literature from a Derridean perspective. Along with other examples, Attridge's work played an important role in the impressive wave of poststructuralist-inspired feminist rereadings of Joyce in the 1980s. Jennifer Levine, Shari Benstock, Suzette Henke, Karen Lawrence, Marilyn French, Christine van Boheemen, and Bonnie Kime Scott were the major critics whose work paved the way for yet another interpretation of Joyce in which gynocriticism and deconstruction often go hand in hand. These readings in turn led to revisions in feminist theory, which in various respects had already been announced by Hélène Cixous's work on Joyce in the late 1960s and 1970s. Questions of identity in

[7] Ibid. 95. Note that in his more recent *Paradoxy of Modernism* (New Haven: Yale University Press, 2006) Scholes subjects his earlier thinking to revision.

[8] Stephen Heath, *The Nouveau Roman: A Study in the Practice of Writing* (London: Elek, 1972), 204.

[9] See Christopher Butler, *After the Wake: An Essay on the Contemporary Avant-Garde* (Oxford: Clarendon Press, 1980).

Joyce have more recently led to a reinterpretation of his œuvre from a post-colonial perspective as well, with Derek Attridge and Marjorie Howes's essay collection *Semicolonial Joyce* (2000) signalling what may well be the institutionalization of post-colonialism in Joyce studies.

This by no means exhaustive survey of Joyce criticism[10] demonstrates that our understanding of canonized modernists constantly changes as shifts in theory occur. Joyce has appeared as an 'authentic symptom of his and our historical moment'[11] at nearly every phase of the development in twentieth-century literary theory. His work has been approached with divergent theoretical premises that have enriched and deepened our interpretation of just about every passage. Joyce criticism and its indebtedness to shifts in literary theory also allow us to witness the divergent receptions of Continental theory in Britain and the United States. Yet perhaps above all Joyce criticism seems to flesh out Terry Eagleton's words: 'It is always worth testing out any literary theory by asking: How would it work with Joyce's *Finnegans Wake?*'[12]

Indeed, as part of an experimental modernist avant-garde matched on the Continent by the so-called historical avant-gardes of Futurism, Dada, Expressionism, and Surrealism, the writing of modernists such as Joyce is regularly taken as a *cas limite* in theory. Modernism, as a body of texts that is, for better or worse, associated with a sense of 'difficulty', has very often been a test case in literary theory, both in Anglo-American and European academia.[13] For example, Lacan's much-debated questioning of his own theory and method in his twenty-third *séminaire* 'Le Sinthome' (1975–6) on the later Joyce[14] and the continuous reappearance of Joyce in Derrida's writings from the 1950s onward[15] signal how on the Continent as well Joyce played a vital role in more general developments in theory. Twentieth-century literary theory, in brief, has to an extent always been a peculiar branch of modernist studies. The main difference between them lies in the agenda pursued: modernist studies aim to advance our understanding of modernism; literary theory, as the example of Joyce suggests, frequently uses modernism, but its aim is to further research on the nature of writing in general. What nonetheless ties both fields inextricably together as Siamese twins is that both have modernism running through their blood.

The extent to which twentieth-century theory is indebted to modernism is hard to overlook when we turn to theories of textuality developed on the Continent. Even a

[10] For a comprehensive survey, see Geert Lernout, *The French Joyce* (Ann Arbor: University of Michigan Press, 1990); Alan Roughley, *James Joyce and Critical Theory: An Introduction* (Ann Arbor: University of Michigan Press, 1991); and Joseph Brooker, *Joyce's Critics: Transitions in Reading and Culture* (Madison: University of Wisconsin Press, 2004).

[11] Patrick McGee, *Paperspace: Style and Ideology in Joyce's* Ulysses (Lincoln: University of Nebraska Press, 1988), 2.

[12] Terry Eagleton, *Literary Theory: An Introduction* (London: Blackwell, 1983), 82.

[13] Leonard Diepeveen, *Difficulties of Modernism* (New York: Routledge, 2003).

[14] For an overview of the debate about the seminar, see Luke Thurston (ed.), *Re-inventing the Symptom: Essays on the Final Lacan* (New York: Other Press, 2002).

[15] See Lernout, *The French Joyce*, 57–71.

selective survey of such theories is enough to illustrate that what we call a literary text today is in part a naturalized conglomeration of features displayed in modernist writing. Perhaps more openly than in New Criticism, for example, many canonical texts of early twentieth-century Russian Formalism remind us of the fact that Formalism concurred with modernism. Today it is stating the obvious to say that the ideas of 'estrangement' and 'defamiliarization' originate from the Formalists' response to Russian Futurism, for instance. The Formalists themselves made no secret of their close ties to modernism, neither in practice—publishing in modernist journals, or, as in the case of Jakobson, even working with them as a poet under the pseudonym Aljagrov—nor in their analytical work. Boris Eichenbaum in *Melodies of Russian Lyrical Verse* (1922) and Jury Tynianov in *The Problem of Verse Language* (1924) explicitly referred to Futurism as their inspiration. So did Viktor Shklovsky, while Jakobson's work 'only properly took off in the wake of the avant-garde'.[16] Indeed, we know that Jakobson and others were friends with poets such as Velimir Khlebnikov and Aleksei Kruchenych, who together with Vladimir Mayakovsky are commonly regarded as the most important figures in Russian Futurism.[17] Formalism, however, also frequently turned to Dada and (later) to Surrealism and various other movements and canonized writers of modernism.[18] In other words, Formalism in Russia can be read as the first comparative modernist theory proper.

Today we remember Russian Formalism above all as a general theory of literature, because its practitioners quickly began defining literature as a whole as a special type of language foregrounding its own materiality or 'literariness'. They thus generalized features first encountered in modernism, highlighting nearly all of the formal techniques commonly attributed today to the modernist avant-gardes; from phonemic and syntactical play to collage and montage and generic experimentation.[19] These semiotic and largely anti-mimetic modulations (or 'grammatical games', as Mikhail Bakhtin polemically called them[20]) drew attention to conventional *devices* in literary language at large. Classical realism, so it became clear to Formalists *through modernism*, was merely one system, code, or style harnessing conventionalized *procédés*. Romanticism equally housed a number of such reiterated devices. This illustrated that modern literature is a textual entity in its own right, different in structure and organization from, yet akin to, everyday speech. Like everyday language, literature at times manages to convey a mimetic or referential moment, for instance. But it does so through special semiotic structures, showing us how 'meaning' in literature is a symbolic construction or reiteration.

[16] Dora Vallier, 'Dans le vif de l'avant-garde', *L'Arc*, 2 (Apr. 1990), 10; my trans.

[17] See Kristina Pomorska, *Russian Formalism and its Poetic Ambivalence* (The Hague: Mouton, 1968), 93–118.

[18] Richard Bradford, *Roman Jakobson: Life, Language, Art* (London: Routledge, 1994), 36, 113.

[19] See František William Galan, *Historic Structures: The Prague School Project, 1928–1946* (London: Croom Helm, 1985).

[20] Mikhail Bakhtin and P. N. Medvedev, *The Formal Method in Literary Scholarship: A Critical Introduction to Sociological Poetics*, trans. A. J. Wehrle (Baltimore: Johns Hopkins University Press, 1978), 57–9.

With these and other insights Russian Formalism informed a large number of later currents in literary theory, most of which are still operative today. Unlike the prevalent tradition in nineteenth-century literary studies to limit inquiries to national literatures, Formalism during the 1910s and 1920s lay at the heart of a 'Europeanization of...literary scholarship'[21] and cleared the path for a truly comparative approach to literature, a prerequisite for making claims about literature in general. The Leningrad OPAIAZ group and its Moscow companion would in the 1930s flow into structuralism in Prague,[22] to find an ally later in Anglo-American New Criticism, and thence to form the basis of semiological approaches to literature after the Second World War.[23] Czech structuralism, to select one example, owed much to Russian Formalism. It developed a number of tools that specifically helped to refine literary historiography. Here I need but refer to Tynianov's *Archaisty i novátory* of 1929 and its symptomatic Italian translation as *Avanguardia e tradizione*.[24] With Tynianov's Formalist study, the term 'avant-garde'—or better: 'avant-gard-ism'—began to denote literature's perpetual game of distinction, its incessant tendency to denaturalize or defamiliarize existing literary codes and systems. Structuralists as well as other critics to this day reiterate the idea that modernism estranges or denaturalizes,[25] that is, it prevents us from seeing the text *as* natural or *in* a 'natural' way. 'Natural' here can be understood in a double sense, however. To the early Formalists, who tried to oppose the historicist trend in literary scholarship, 'natural' was regarded in a synchronic fashion, as 'mimetic' or 'conventionalized, everyday'—and thus also as realist conventions. The emphasis on the diachronic came later, in a perspective which saw the 'natural' as synonymous with 'traditional'. Favouring this second historical sense, structuralists promoted avant-garde denaturalization, or avant-gardism, to a conceptual model of use to the historiography of modern literature since the emergence of Romanticism. Modernist literature's consciously and continuously differentiating reactions to its predecessors—Jury Lotman's 'aesthetics of opposition'—quickly showed itself to be at work in non-modernist writing as well.[26] Notions such as 'defamiliarization' or 'avant-gardism', when used today, thus perform an ambiguous function. On the one hand we know they originated from singular responses to experimental modernist texts. Yet on the other hand they have come to function as 'naturalized' concepts in a general theory of literature and in the practice of literary history.

[21] From an essay in Russian by N. I. Efimov, quoted in Victor Erlich's translation from *Russian Formalism: History, Doctrine* (Paris: Mouton, 1955), 286.

[22] Peter Steiner, *Russian Formalism: A Metapoetics* (Ithaca, NY: Cornell University Press, 1984).

[23] Thomas Sebeok, *Style in Literature* (Cambridge, Mass.: MIT Press, 1960).

[24] Jurij Tynjanov, *Avanguardia e tradizione*, introd. Viktor Sklovskij, trans. Sergio Leone (Bari: Dedalo Libri, 1968).

[25] See e.g. Vladimir Krysinski, 'Les Avant-gardes d'ostentation et les avant-gardes de faire cognitif', in Christian Berg, Frank Durieux, and Geert Lernout (eds), *The Turn of the Century: Modernism and Modernity in Literature and the Arts* (Berlin: de Gruyter, 1995), 17–32.

[26] Peter Zima illustrates that the idea of 'avant-gardism' encountered here can be traced in all later structuralist theory. See Peter V. Zima, *The Philosophy of Modern Literary Theory* (London: Athlone Press, 1999), 63.

Perhaps some of the historical avant-garde's exponents already recognized this ambiguity when they criticized Formalism. In the West, Surrealist André Breton, for instance, firmly protested against the execution of Zavis Kalandra, a critic who, under Stalin, had dared to question the Formalist-inspired work of Jan Mukarovsky and Czech structuralism for their *more geometrico* (deductive method).[27] In the East, structuralism indeed turned increasingly sterile, mainly because of the steady rise of totalitarianism. As offsprings of Eastern structuralism cropped up in the centre (Prague) and the north (the Tartu School) of Europe,[28] structuralism also gradually had to defend itself against critics within the academic institution. Take the case of the already mentioned Mukarovsky. In his famous essay 'Art as a Semiotic Fact' (1934) he noted: 'The surrealist poem makes it incumbent upon the reader to imagine virtually the entire contexture of the theme, whereas the classical poem all but precludes the free-play of subjective associations due to its exactness of expression.'[29] Remarkable in this passage is the almost gratuitous way in which Mukarovsky universalized his personal reader response to the Surrealist text. Mukarovsky indeed grounded his poetic or aesthetic reading of a single Surrealist poem in a 'uniform, collective conscience'.[30] Later structuralists like Michael Riffaterre questioned this universalization, and pointed to the complexity of readers' responses to such texts. In his essay 'Compulsory Reader Response: The Intertextual Drive' (1990), also discussing a poetic text by André Breton, Riffaterre substituted for Mukarovsky's 'universal consciousness' the concept of 'intertextuality', which explained 'above all that the most important component of the literary work of art, indeed the key to the interpretation of its significance, should be found outside that work, beyond its margins'.[31] Whether Breton would have approved of Riffaterre's correction of Mukarovsky is an issue we can only speculate about. What we can say with certainty is that Riffaterre's stress on intertextuality was evidence of poststructuralism's influence in bending the rules of interpretation.

Poststructuralists, like Formalists before them, made no secret of their indebtedness to modernism. It is well known that Jacques Lacan's psychoanalytic views throughout his career were considerably influenced by Surrealism, and that Lacan at a young age, like his Russian companions, often frequented modernist circles.[32] Yet the majority of poststructuralists were not contemporaries of modernism. They saw themselves post

[27] Galan, *Historic Structures*, 61.

[28] For the geographical spread of Formalism and structuralism, see Ann Shukman, *Literature and Semiotics* (Amsterdam: North-Holland, 1977), 8–37.

[29] Jan Mukařovský, 'Art as a Semiotic Fact', in Mukařovský, *Structure, Sign, and Function*, ed. John Burbank and Peter Steiner (New Haven: Yale University Press, 1978), 84.

[30] Ibid.

[31] Michael Riffaterre, 'Compulsory Reader Response: The Intertextual Drive', in Michael Worton and Judith Still (eds), *Intertextuality: Theories and Practices* (Manchester: Manchester University Press, 1990), 76.

[32] Lacan's encounter with Salvador Dalí in 1930 was crucial to his early writings. Other Surrealists, including René Crevel, Georges Bataille, and Roger Caillois, also influenced his subsequent thinking. See Élisabeth Roudinesco, *Jacques Lacan & Co.: A History of Psychoanalysis in France, 1925–1985* (London: Free Association Books, 1990), and Carolyn Dean, *The Self and its Pleasures: Bataille, Lacan and the History of the Decentered Self* (Ithaca, NY: Cornell University Press, 1992).

factum as affiliates of experimental modernists. Various scholars working in (the wake of) poststructuralism identify explicitly with the modernist avant-gardes. Whereas Thomas Docherty in *After Theory* (1990) has the 'pretentions...to be in a kind of avant-garde',[33] Jean-Michel Rabaté goes a step further to argue not for a 'theory *of* literature but *as* literature'.[34] Even Hayden White at one point proposed that literary historians examine 'the possibility of using . . . surrealists' modes of representation'.[35] As Valentine Cunningham observes, the European avant-garde is thus to be regarded as the true 'pre-history' of poststructuralism.[36] And, as Gregory Ulmer aptly summarizes, poststructuralism was to the theory of literary criticism what modernism was to the history of literature. 'The break with the assumptions of "realism"', declared Ulmer, 'is now underway (belatedly) in criticism.'[37]

Twentieth-century Continental theories of textuality succeeding Formalism indeed mostly stuck to the parameters Formalists had set out: *(anti-)mimesis* and *semiosis*, literature's ability to unmask the self-evidence of reference through its violation of linguistic convention. This was mainly because Russian Formalism, complemented by the semiology of Saussure in structuralism, later on also provided a breeding ground not only for Claude Lévi-Strauss, Barthes, and French narratology, but also for Lacan and Derrida.[38] Both the continuity and rupture presented by these later thinkers can be concisely illustrated by looking at the French journal *Tel Quel*, which flourished in the 'age of Theory', between 1960 and 1982.[39] *Tel Quel*, says Susan Rubin Suleiman, 'for a few years came closest to espousing the . . . revolutionary project of the historical avant-garde',[40] and highlights how poststructuralist theory first took a step backward in order to move forward. While its littérateurs gradually turned against their modernist predecessors in an act of avant-gardism, its theoreticians in the end got the better of its writers by correcting Formalist readings of these same modernist predecessors.

Tel Quel initially disseminated a theory and practice of literary structuralism. Structuralism, at the risk of stating the obvious, found its inspiration not just in Formalism but in part also in the linguistics of Saussure. Saussure had claimed that words are meaningful not because they refer to something *outside* language, but because of the way they relate to each other *within* language, in binary oppositions ('strong' as opposed to 'weak') and in other relationships of difference (not 'd' but 't',

[33] Thomas Docherty, *After Theory: Postmodernism/Postmarxism* (London: Routledge, 1990), 1.

[34] See Jean-Michel Rabaté, *The Future of Theory* (London: Blackwell, 2002), 117–40.

[35] White as quoted in Gregory Ulmer, 'The Object of Post-Criticism', in Hal Foster (ed.), *The Anti-Aesthetic: Essays on Postmodern Culture* (Washington, DC: Bay Press, 1982), 83.

[36] Valentine Cunningham, *Reading After Theory* (London: Blackwell, 2002), 80.

[37] Ulmer, 'The Object of Post-Criticism', 83.

[38] J. G. Merquior, *From Prague to Paris: A Critique of Structuralist and Post-Structuralist Thought* (London: Verso, 1986).

[39] I rely on three historical accounts of the journal here: Niilo Kauppi, *The Making of an Avant-Garde: Tel Quel* (Berlin: Mouton & de Gruyter, 1994); Philippe Forest, *Histoire de Tel Quel* (Paris: Seuil, 1995); and Patrick Ffrench (ed.), *From Tel Quel to L'Infini: The Avant-Garde and After* (London: Parallax, 1998).

[40] Susan Rubin Suleiman, *Subversive Intent: Gender, Politics and the Avant-Garde* (New Haven: Yale University Press, 1990), 33–4.

etc.). In the wake of Saussure, structuralism set out to devise a 'Grand Theory' of language, an exhaustive description of the *langue*, the structure or system grounding humanity's knowledge as shaped through its linguistic perception of the world. In line with structuralism *Tel Quel* initially saw the relationship between language and what it referred to as arbitrary, and it set itself the task of promoting texts which could make this felt. *Tel Quel*'s editors, led by Philippe Sollers, made room for a discussion of the *nouveau roman* and gave a platform to Francis Ponge. In the course of the early 1960s the editors also began questioning the very nature of literature, that is to say, of 'literariness', seeing the European avant-gardes and Russian Formalists as precursors of a theory of the system grounding literary language. Only then, from the mid-1960s onward, could a more radical poststructuralist stance take shape in the review's columns.

Whereas the advent of structuralism is now frequently called the 'linguistic turn',[41] poststructuralism could be called a 'cultural turn', since the latter radically thought through the implications of structuralist linguistics in the broader terms of history and culture. In many ways poststructuralism turned (structuralism) against structuralism, most notably by exposing that its attempt to devise a 'Grand Theory' of language for the emancipation of humanity was a fallacy. Thinking through structuralism's premises, poststructuralists logically pointed out that outside the language system there could be no such thing as 'mankind' or 'humanity', and they thus appeared to undermine the humanist dimension in structuralism.

Poststructuralism further questioned the rigidity of binary logic in structuralism. If 'strong' or 'd' has a function or meaning only through its difference with 'weak' or 't', then 'strong' ('d') always implies 'weak' ('t') as well and thus carries at least a 'trace' of its counterpart within itself. Accordingly, Jacques Derrida's insight of 'différance' shifted attention to the (written) context of the enunciation of words and sounds, since only there could the inherent 'undecidability' of the language system or structure be exposed. Poststructuralism, in short, was not so much concerned with systems or structures as it was with the processes and forces which opened these systems up. And it proved quite successful at this, as it drew on and re-evaluated Russian Formalism to elevate the concept of 'literariness' to a model of language in general. Or as Derrida phrased it in *Dissemination* (1972): 'This is no—or hardly any, ever so little—literature.'[42]

Poststructuralism's continued inquiry into literature's (anti-)mimetic and semiotic qualities also brought about a far more radical attitude towards realism. For poststructuralists, and not least for those working in and around *Tel Quel*,

Realism [was...a] form of representation, constructed and constructing practices, that characteristically (like the accompanying panoply of legitimating theoretical ideas) presented

[41] The linguistic turn is of course often located earlier in modernism too. See Michael Bell, 'The Metaphysics of Modernism', in Michael Levenson (ed.), *The Cambridge Companion to Modernism* (Cambridge: Cambridge University Press, 1999), 16 ff.

[42] Jacques Derrida, *Dissemination*, trans. Barbara Johnson (Chicago: University of Chicago Press, 1991), 174.

the forms as if they were substances or, in the well-known . . . formulation, 'convert culture into nature.' Literary realism in short was the cultural brother of ideology or more accurately was itself an ideological operator performing the primary task of ideology: naturalising socially and historically produced systems of meaning.[43]

More than their structuralist forerunners, poststructuralists thus saw realism as coinciding with a dominant mode of perception embedded in modern culture. They thereby elevated realism from a literary code or style (as in Formalism) to a mode of perception characteristic of everyday speech and common-sense ideology as such, and their objective, unsurprisingly, became to show that even classical realist texts in fact form part of an intertextual field that makes mimetic or referential closure impossible. Creating the illusion of 'presence' outside of language, realism in culture came to be regarded as the medium of ideology par excellence, the critical problem being that 'presence' is no more than one of many textual effects. Showing that realist writing conventions, tying in with everyday common sense, were not at all that commonsensical (if not often nonsensical): this became a primary concern of *Tel Quel*. It desired to show that, in one way or another, texts always imply a crisis in their attempts to refer to 'reality'; a gap, a moment of undecidability in re-presenting or reinscribing the singular text back into conventionalized modes of discourse. Not so much 'literariness' per se but '*meta*-literature' thereby became an issue; not the way in which literature foregrounds the materiality of its components *in* literature, but the way it 'systematically flaunts its own condition of artifice' *as* literature,[44] thereby creating a meaningful surplus that marks 'the literary', in literature but also in all other linguistic manifestations. For poststructuralists, the value of vanguard modernists lay precisely in their candid exposure of writing as writing (*écriture*) and of its own artifice as literature ('meta-literature').[45] Thus, as 'classic realism' was seen by poststructuralists as the dominant 'paradigm' of modern culture in general, the largely anti-realist 'paradigm of modernism',[46] accordingly, became the counter-cultural norm. Once again, but now on a cultural scale, poststructuralists thereby universalized features of modernism.

Although these insights appear commonplace today, they seemed fresh and ground-breaking in *Tel Quel*. In its 1965 special issue devoted to the Surrealist Antonin Artaud, the young Derrida published one of his first influential essays, 'La Parole soufflée'. Derrida, however, was not the only new voice to be heard in the avant-garde's parlour. With *Théorie d'ensemble*, a volume composed in the autumn of 1968,

[43] Christopher Prendergast, *The Triangle of Representation* (New York: Columbia University Press, 2000), 120.

[44] Robert Alter, *Partial Magic: The Novel as a Self-Conscious Genre* (London, England: University of California Press, 1975), p. x.

[45] For discussions of the notion 'meta-fiction' that also illustrate how outside France the dialogue between poststructuralism and the Continental avant-gardes evolved via a detour through postmodernism, see Patricia Waugh, *Metafiction: The Theory and Practice of Self-Conscious Fiction* (London: Methuen, 1984), 102, and Mark Currie's introduction to his anthology *Metafiction* (London: Longman, 1995), 5–6.

[46] As Astradur Eysteinsson defines modernism in its broadest sense, in *The Concept of Modernism* (Ithaca, NY: Cornell University Press, 1990).

Tel Quel also highlighted the key roles of Michel Foucault and Barthes, Lacan, and Althusser, as well as a set of key words including 'writing', 'text', 'the unconscious', 'history', 'work', 'trace', 'production', 'scene', each referring to a particular site of enunciation.[47] As the programme of the 'Tel Quelians' in the volume announced, their objective henceforth would be 'to go back to a first "break" in history, not stopping at the avant-garde of the 1920s (Surrealism and Formalism relayed by structural linguistics), but rethinking the emblematic names of Lautréamont, Mallarmé, Marx and Freud'.[48]

It is clear that these theorists differed in many respects from Russian Formalism and its structuralist outgrowths. Less certain, however, is whether the literary 'Tel Quelians' also moved *beyond* the modernist avant-gardes. It would appear rather that theory came to overshadow its literary counterpart. From *Tel Quel*'s revised programme to scrutinize a number of 'grand narratives' there resulted some memorable literary experiments that did not break away from modernism so much as refine some of its currents—during its last years *Tel Quel*, for instance, helped publish Pierre Guyotat. Yet today, what has survived from the poststructuralist heritage is not so much the literature itself as the readings of literary texts—where these are readings, it should be added, not only of modernists or contemporary literature, but also of canonized authors such as Dante Alighieri, John Donne, and Victor Hugo. It is not Sollers's *Nombres* (1968) but Derrida's essay 'Dissemination' on *Nombres* that is often reread today, identifying the novel with a purely textual universe.[49] Again, Sollers's great anti-realist programme or experiments testing the boundaries of redundancy in literature are little remembered today. What we remember above all is theory's anti-realism, its rage against the metaphysics of presence, expressed perhaps most convincingly in Barthes's *S/Z*, which was published in the periodical's now classic book series in 1970.

Works characterized by implications of 'différance' by no means restrict themselves to modernism of course, but these very implications clearly owe much to modernism. Poststructuralist theory also therefore demonstrates that theory is always largely the effect of the object it scrutinizes, but that over time this indebtedness is erased through a conceptual sedimentation of the notions which it puts to use, which in turn influence our understanding of 'literature'. We have come to accept that literature in general is both a 'peculiar language', as Attridge puts it, recalling the Formalists,[50] and a heteroglossic language continuously articulating itself in relation to other, non-literary texts, which is a point poststructuralists would insist on.[51] It is

[47] Philippe Sollers (ed.), *Tel Quel: Théorie d'ensemble* (Paris: Seuil, 1975), 7.

[48] Rabaté, *The Future of Theory*, 84. My assessment of the fate of *Tel Quel*'s literary exponents is much indebted to Rabaté's book.

[49] Derrida, *Dissemination*, 173–286, 289–366. For the other readings mentioned here, see the issues of *Tel Quel* itself and the studies of the journal mentioned in n. 39.

[50] Derek Attridge, *Peculiar Language: Literature as Difference from the Renaissance to James Joyce* (London: Routledge, 1988).

[51] The work of Bakhtin, as it was introduced by Julia Kristeva in *Tel Quel*, played a key role here as well.

an at once banal and baffling observation, therefore, that we owe these common-places largely to (a small number of) modernist texts. As a corollary, features once intensely displayed by modernist writing have now been generalized and made to pertain to literature as such.

'Avant-garde: to each his/her reader', a critic once claimed.[52] The 'writerly' texts so central in modernist studies played a crucial role in the poststructuralist emancipa-tion of the reader as well. Whether we turn to Barthes's classic essay 'Death of the Author' (1966), Derrida's writings on Edmond Jabès or Artaud in *Writing and Difference* (1967), to Foucault's *Raymond Roussel* (1963),[53] or to Jean-François Lyo-tard's recurrent return to the avant-gardes, we find modernists constantly cham-pioned as writers who endow readers with freedom. With its highly diverse idiosyncratic texts the modernist avant-garde produced a form of writing that showed how, against the prevalent cultural paradigm of realism in modernity, the radical Enlightenment project and perhaps even the humanist tradition could be continued in culture. It underlined that the subject, far from being 'dead', was a symbolical cultural construction, a discursive reiteration, which could always be questioned and opposed in discourse or language. Modernist experimentation and the 'jouissance' it displayed, in brief, also marked (wo)man's freedom.

Because of its proximity to modernist poetics many have maintained that with poststructuralist theory we now have both a practice and a theory of modernism ready to deal with its complex performative texts.[54] The poststructuralist Joyce would appear to be evidence of this. Poststructuralism's authority today most certainly tends to outweigh that of Formalist and structuralist critics, and this is not just the case within modernist studies. The fate of the 'Tel Quelian' literary avant-garde, however, warns modernist studies against pointing its gaze in the same direction as theory, because the latter always comes with the risk of outvoting (modernist) literature as well. Unlike Lissitsky's Siamese twins, theory and modernist studies thus benefit from pursuing different futures, since modernism is more than what theory has made of it. Yet once again, like its Formalist and structuralist forerunners, poststructuralism too reminds us of the fact that, as contemporary readers, we are always in part implicated in the literature of modernism, even when we look at other literary historical artefacts. As I suggest above, a survey of twentieth-century cultural materialist theories of literature, too, would underline the pivotal role played by modernist poetics and politics. For lack of space I cannot go into these theories here.

[52] Title of an essay by Silvia Contarini published in *Revue des Études Italiennes*, 43/1–2 (1997), 95–107; my trans.

[53] Jacques Derrida, *Writing and Difference*, trans. Alan Bass (Chicago: University of Chicago Press, 1980); Michel Foucault, *Death and the Labyrinth: The World of Raymond Roussel*, trans. Charles Ruas (New York: Continuum, 2007). On Foucault's complex ties to the avant-garde, see Simon During, *Foucault and Literature: Towards a Genealogy of Writing* (London: Routledge, 1992), ch. 3.

[54] See Ronald Schleifer's *Rhetoric and Death: The Language of Modernism and Postmodern Discourse Theory* (Urbana: University of Illinois Press, 1990), Eysteinsson's remarks in *The Concept of Modernism*, 135, and Helmut Lethen, 'Modernism Cut in Half: The Exclusion of the Avant-Garde in the Debate on Postmodernism', in Douwe W. Fokkema and Hans Bertens (eds), *Approaching Postmodernism* (Amsterdam: John Benjamins, 1986), 233–8.

Even so, we can wonder: how would we be reading today as poststructuralists or cultural materialists if modernism had not come about?

A history of twentieth-century theory's indebtedness to modernist literature has not yet been written. It should be. Such a history would open with the observation that modernism and literary theory, as a distinct academic discipline within the humanities, came about almost simultaneously. Early twentieth-century literary studies, Ezra Pound once noted, consisted only of 'allegedly scientific methods'.[55] Pound's note was symptomatic of a widespread malaise in literary studies around the turn of the century. Allen Tate, drawing on T. E. Hulme, claimed that 'historicism, scientism, psychologism, biologism, in general the confident use of scientific vocabularies in the spiritual realm, ha[d] created or at any rate [wa]s the expression of a spiritual disorder. That disorder may be briefly described as a dilemma.'[56] Tate's dilemma derived from a lack of confidence the humanities displayed when faced with critiques coming from 'hard' scientists questioning the humanities' methods. It further alluded to the paradoxical way in which literary studies in particular had legitimized itself in the past; since around 1900 it lacked any method or theory of its own. Literary studies in the course of the nineteenth century had indeed mainly drawn on other disciplines in the humanities. Linguistics had allowed for a 'reduction' of literature to what fell within the confines of single or 'natural' languages; while (Romantic) politics and (positivist) history had led to a restriction of literature's scope to 'natural' national boundaries, canons, and histories.

Despite the tension between nationalism and cosmopolitanism in modernism, it clearly questioned the tenets of nineteenth-century linguistics from outside academia. Firmly rooted within academia, yet increasingly disappointed by modernism's failure after the First World War to bring about a truly cross-cultural dialogue in the public realm,[57] I. A. Richards argued in *Poetry and Science* (1923) that literature required its own method of study. His assertion was arguably not novel. What was distinctive was how Richards, along with other New Critics on both sides of the Atlantic, defined his model: he performed a *mise en abyme*, creating a space in the university where texts could be studied in a way 'equivalent to the scientist's escape from life into the laboratory'.[58] 'This scientific pose, conscious or unconscious . . . constituted one of the main strengths of New Criticism' as it launched literary studies as a distinct 'scientific' or academic discipline within Anglo-American academia.[59] Meanwhile, on the other side of the globe, Russian Formalists too, by isolating

[55] Ezra Pound, *Literary Essays of Ezra Pound*, ed. T. S. Eliot (London: New Directions, 1954), 19.

[56] Allen Tate, 'The Present Function of Literary Criticism', in *On the Limits of Poetry: Selected Essays, 1928–1948* (New York: Swallow Press, 1948), 4. On the relationship between Hulme and modernist literature, see Edward P. Comentale and Andrzej Gąsiorek (eds), *T. E. Hulme and the Question of Modernism* (Aldershot: Ashgate, 2006).

[57] See Rodney Koeneke, *Empires of the Mind: I. A. Richards and Basic English in China, 1929–1979* (Stanford, Calif.: Stanford University Press, 2004).

[58] Alfred Kazin, *On Native Grounds: An Interpretation of Modern American Prose Literature* (New York: Reynal and Hitchcock, 1942), 357.

[59] J. H. Raleigh, 'The New Criticism as an Historical Phenomenon', *Comparative Literature*, 11/1 (Winter 1959), 23.

literary language within everyday speech, responded to their academic culture, which was pervaded by positivism and a tendency to read literary (especially realist) texts as secondary historical documents.[60] Both in the West and in the East literary theory thus established itself in the shadow of modernism as a scholarly field in its own right, prefiguring the later formula 'literary study should be specifically literary'.[61] If so, it need not necessarily take the shape Formalists, New Critics, or (post)structuralists prescribed. The multiple literary theories that have become embedded in our shared intellectual landscape as shaped by modernism show that theory, like Marcel Duchamp's ready-mades, has always been telling us what literature *should* or *could be*, rather than what it actually *is*. For this reason theory deserves to be treated as the twin to which modernist studies are inextricably connected, since it gives them depth and history, and incites a return to modernist texts without inhibitions. For modernism, clearly, has always come both before and after theory.

[60] See Bakhtin and Medvedev, *The Formal Method*, 57–9.
[61] René Wellek and Austin Warren, *Theory of Literature* (London: Harcourt, 1955), p. v.

...

THE MODERNIST ARCHIVE

...

FINN FORDHAM

As with the term 'modernism', 'archive' is currently a highly contested term, and for a similar reason—that it has come under increasingly intense scrutiny in recent years. Archives, just like everything else, are used and talked about more than ever before. This chapter will present different definitions of the archive and reasons for its contestation and scrutiny. It will also outline two quite distinct roles ascribed to the archive, firstly, as a practical resource for scholarship and, secondly, as a conceptual metaphor for critique. Modernist studies use different kinds of archive in a variety of ways against a critical backdrop, I will suggest, of suspicion and hostility towards the archive, since, as a symptom of modernity, it is seen as a branch of state power. Finally, I will provide some instances within modernist texts where representations of archives indicate different 'modernist' attitudes towards them.

There are, then, on the one hand, narrow and specific definitions of 'archives', such as the following found on the Canada Archives website:

Libraries collect published material, also known as secondary sources. The holdings of one library may be duplicated in whole or in part by the holdings of another. If a book is lost or stolen it probably can be replaced.

Archives collect original unpublished material or primary sources. The records held by archives are unique and irreplaceable. By their very nature archival materials are fragile and vulnerable to improper handling. If an archival document is lost, stolen, or irreparably damaged, the information it contains is lost forever.[1]

[1] Library and Archives Canada, 'Archives and Libraries: The Fundamental Difference', in *Using Archives*, <http://collectioncanada.ca/04/0416_e.html#difference>.

On the other hand, there are definitions of '*the* archive', something more broadly and vaguely conceived, as a gathering of all material (whether primary or secondary), that can be grouped under one specific name or topic. In such an archive you can, ideally, find everything that belongs to a certain 'subject field'. Thus, Jerome McGann defines the archive relating to a given 'work': 'It must be understood the archive includes not just original MSS, proofs, and editions, but all the subsequent textual constitutions which the work undergoes in its historical passages.'[2] Similar uses of the term 'archive' abound. Here is Sean Latham's observation about the immense amount of Joyce criticism, enough to constitute an archive: 'Novice Joyce scholars, in particular, must first confront the sheer volume of Joyce criticism to be searched and read—an archive now grown so substantial that it threatens to overwhelm even the most earnest scholar hoping to launch his or her own research into Joyce.'[3] And beyond these textual conventions of the 'archive' lies a non-textual realm which, as it becomes an object of study, becomes textualized: 'The landscape is an object of memory, a mental map. Another way in which it acts is to serve as a source of knowledge, an archive of living and material things.'[4]

Following through with the metaphor might imply that the landscape has been sorted and categorized and requires preservation. The definitions spread: just as one sense of the term makes 'the archive' an emblem in itself of distension, the term too becomes bloated. The fixation on the archive comes from attempts to deal with an increasing accessibility to a field of information which swells before our eyes just as it swells beyond our field of perception.

These definitions produce a polarity in the kinds of their potential referents: minimal and maximal. So what 'the Modernist Archive' refers to could be either: primary documents belonging to anyone ever described as a 'modernist'—mostly located in America—or everything that still exists from the period as it is marked by whichever dates are chosen for the modernist era (for instance, 1880–1968 or 1910–23)—and these could be located anywhere. What is common to the two definitions of 'archives' is the fact of a gathering together under a classifying name. The fact of gathering confers an authority on the material gathered, on the classifying name, and the institution which has gathered and named the contents. But the functions imagined for these archives vary: for the Canadian archivist, on one hand, the immediate purpose is to preserve primary materials that may be unique or vulnerable or both, from which follows a justification of restrictions on the handling of the material. For Jerome McGann, on the other, the purpose of the archive is rather to assist in a proliferation of narratives relating to a given 'work', from which follows a positive evaluation of indeterminacy: 'The indeterminacy of the textual situation

[2] Jerome McGann, 'What Is Critical Editing?', *Text*, 5 (1991), 24.
[3] Sean Latham, 'Hating Joyce Properly', *Journal of Modern Literature*, 26/1 (Fall 2002), 119–31, *Literature Online*, <http://lion.chadwyck.co.uk/marketing/index.jsp>.
[4] Pierre Nora, *Rethinking France*, ii: *Space*, trans. David P. Jordan and Mary Seidman Trouille (Chicago: University of Chicago Press, 2001), 343.

fluctuates in relation to the size and complexity of the surviving body of textual materials: the larger the archive, the greater the room for indeterminacy.'[5]

Such a positive evaluation of indeterminacy can, arguably, be traced back to a chapter in Foucault's *The Archaeology of Knowledge* where he proposes an ideal archive and a style of analysis for it that he calls 'archaeology'. This emphasizes discontinuity over closure. It 'deprives us of our continuities; it dissipates that temporal identity in which we are pleased to look at ourselves when we wish to exorcise the discontinuities of history; it breaks the thread of transcendental tele- ologies; and where anthropological thought once questioned man's being or subjec- tivity, it now bursts open the other, and the outside'.[6]

This ideal archive is not, as a rule, embodied in any traditional archive which he has defined, dismissively, a few pages before.[7] Though Foucault's role in the 'critique' and re-evaluation of the archive is well known, I will be returning to him later. For the moment what's necessary is an acknowledgement of his contribution to the 'historical turn' in criticism which helped bring about the intense scrutiny of the capacities and meanings of the archive. As James Knapp observed recently, 'a new materialism in literary and cultural criticism has regrounded much scholarly debate in the archive as a corrective to ahistorical theorizing'.[8] Knapp goes on to talk of a future when 'cultural history moves into its next phase—beyond the return to the archive'.[9] This prophecy is ambivalent: does 'beyond the return' mean there'll be further involutions in the very same direction, or rather a withdrawal from them? The idea of a withdrawal is surely unlikely, for archives and 'the archive' are under increased scrutiny not only because of historical and materialist turns, but also because of the technological revolution which is currently under way and gathering momentum through the digitization of knowledge and of archives in particular. Once clichéd associations with the archive—dustiness, sexlessness, unworldiness, bureaucracy—are being banished by the prospect of digitized textual utopias, of radiant research capacities, the liberation of potential truth into kinetic forms. The attention this brings to historical materials does make it appear as though historical approaches have become more prominent, but this apparent triumph may have had more to do with its being harnessed to and by the new technology than with its having shaped the forms the technology has taken. Digital technology has rather, I would suggest, given the warring factions more interesting things to do than snipe at each other and has even provided common ground on which they can meet. Indeed, in the context of modernist studies it is questionable whether there was ever much of a 'historical turn', since there had always been historical approaches within them and archives had been used to construct several bodies of knowledge, especially

[5] Jerome McGann, *The Textual Condition* (Princeton: Princeton University Press, 1991), 62.

[6] Michel Foucault, *The Archaeology of Knowledge*, trans. A. M. Sheridan Smith (London: Routledge, 2002), 147.

[7] Ibid. 142.

[8] James A. Knapp, '"Ocular Proof": Archival Revelations and Aesthetic Response', *Poetics Today*, 24/4 (Winter 2003), 695.

[9] Ibid.

the biographical, before and during the rise of 'theory'. But even if archives had always been a resource, a general 'archival turn' is nonetheless altering the shape of modernist studies.

In the broader field of cultural studies, the historical turn is combining with the digital revolution and several large-scale archive-digitization projects, to make the archive an object of fascination. Many are relevant to modernist studies if this is broadly conceived. One of the first of these was the Hulton Picture Library (now part of Getty Images), which, though impressive, is commercial and its meta-data are not that well geared towards academic researchers. In the UK, sponsorship from the Joint Informations Systems Committee has been helping to digitize a First World War poetry archive, a British cartoon archive, various sound archives, the Fürer-Haimendorf Archive (comprising inter-war anthropological pictures), the British Library 19th Century Periodicals, and Cabinet Papers from 1914 to 1975.[10] In the United States, material from several collections can now be seen online: the New York Public Library has digitized its Whitman manuscripts; the Beinecke at Yale has digitized the copy it has of Conrad's *Heart of Darkness* draft; Iowa has a superb 'Dada' website;[11] in Europe there are digitization projects of archival material of writings by Nietzsche, Beckett, and Wittgenstein. Not to be overlooked is the digitization of rare material which Google Books makes available: J. W. Graham's monumental transcription of Woolf's *The Waves* holograph manuscripts, for instance, is now fully searchable online. Above all, catalogues are now available (see, for example, the Harry Ransom Center at Austin, Texas, or, at Cambridge, the King's College Library collection). Such activities and the prospect of others have raised expectations so that somewhat utopian visions can spring up: 'The real boon of the digital archive is the multiplicity, the fact that it can amass all material archives and make them accessible to anyone at any time.'[12]

The reality is more prosaic, but how could it not be? This claim conjures up, unwittingly, an impossible ideal reader who could somehow consume or make use of everything in 'all material archives . . . any time' which not even an ideal insomniac could make use of. Though there is a shift going on, as a paradigm shift it is still unfolding. We are not 'beyond an archival turn', but within the force of its swerve, and so we shall be for some time. This is a condition we should not only get used to, but also one we should respond to by imagining, finding out, and testing different ways of making use of it.

Even though the digitization of 'all material archives' must be far away on a utopian horizon, the digitization of at least some of them draws attention to their general existence. This attention can result in two distinct roles imagined for archives or 'the archive'. The first, obviously enough, is as a resource of new scholarship and

[10] See JISC, *Digitisation and e-Content*, <http://www.jisc.ac.uk/whatwedo/programmes/digitisation. aspx>.

[11] See University of Iowa Libraries, *International Dada Archive*, <http://www.lib.uiowa.edu/dada/>.

[12] Stephen J. Mexal, 'Material Knowledge: Democracy and the Digital Archive', *English Language Notes*, 45/1 (Spring–Summer 2007), 129.

research; the second is the analysis of the archive as a set of practices and procedures which can be treated metaphorically and which can, in turn, be examined critically and even ethically. This approach features in theoretical aspects of 'archive studies', itself a growth industry. Distinct approaches to these different roles are as distinct as 'practice' and 'theory', which means the two can meet but tend not to, or not as often as they should.

Using the Archive 1: As a Resource

As mentioned, modernist studies, since its inception, has always known of scholars turning to archives, whether for editions of letters, for biographical work, or for genetic studies. Modernist critics, like Hugh Kenner and Richard Ellmann, now even have archives organized under their names. There can, however, be hostility to the very industry of which the critics are a part. The nine volumes of Conrad's letters, for instance, published between 1983 and 2008, represent a high-water mark of intensive archival work carried out in pursuit of fairly traditional philological goals. This edition is distinguished by its use of archival methods from social history, where there has always tended to be a greater familiarity with what archives can produce than in literary studies. A list of archives used in these letters, including personal and institutional collections, runs to a staggering fifty-seven different resources. But a patronizing review by John Sutherland feared it represented 'a genre of scholarship whose time...has passed'.[13] Some of the kind of scholarship that Sutherland scorned—the triviality of the material, the elite minority interest the project would stir up beside its expensive, unremunerative nature—had, however, only five years before crucially informed one of the most influential books on modernism in the last ten years. *Institutions of Modernism*, Lawrence Rainey's 1998 study, drew on material from archives in Austin, Buffalo, Princeton, Rimini, and Yale, and produced provocative new narratives about classic modernist texts and contexts which, as Edward Bishop claimed in a review, made 'the archives themselves a space of contention'.[14] Rainey's materialist methodology also at times shaped a socially materialist agenda of resisting the systems of elite coteries and private patronage which Rainey presented as providing impulses for modernist practices. Seeking 'counter-narratives', Rainey's exploitation of the archive proved at times to be contentious, and lacked, for some critics, the kind of scrupulous attitude to the archive, for the triviality of which Sutherland had censured the editors of Conrad's letters. A note of caution struck by Alexis Weedon, the historian of publishing, is relevant here: 'Researchers may be put

[13] John Sutherland, 'Doughy', *London Review of Books* (4 Dec. 2003), 14–15.
[14] Edward Bishop, Review of Lawrence Rainey, *Institutions of Modernism: Literary Elites and Public Culture*, *Modern Philology*, 99/3 (Feb. 2002), 489.

off looking at the economics of literary production because the skills of interpreting what are essentially business documents, and extracting from them data which can produce sound statistical analysis, are not common among literary critics.'[15] Given an enduring nerdophobia and the hermeneutic challenges, the user of the archive seems to have the index cards stacked against them.

Weedon's remark cautions against the most powerful myth of the archive: that it contains exciting revelations about truth and identity, a myth fed by the TV genealogy show *Who Do You Think You Are?* Narratives of suppression and repression, of secrets and codes, of exile and return, of institutions and power, and of keyholders or gatekeepers to the archive, which figures as a labyrinth concealing hoards of treasure within, are crucial in this mythic evaluation. The organizational and controlling principles of archives give a false impression of the organization of state power which is in fact always more chaotic than our paranoia allows our minds to imagine it as being. Archives, like that of the Stasi in the film *The Lives of Others* (2006), provide an image of totalization for organizations, which only have the appearance of an organization that the structure of their archives may have in reality. Documents are, after all, easier to pigeonhole than people.

But a complete knowledge of an archive is, as a rule, in excess of what users or custodians could ever realistically have. Archives also contain the threat of being used against those who have gone to the effort to file or conceal contents within them. The image which is supposed to conjure up awe at the machinery and the power of an institution ends up producing a distracted fear of the institutional desire for totalization. Resistance to archives can come from the insight that the proliferation of materials in them will subvert the expectations of revelation: the truth seen through the archive threatens to become complex but also flattened, fragmentary but in an undramatic way, a bit of a non-story rather than a powerful counter-narrative.

The proliferation of material can, however, be given a positive spin, because of the way it can contribute to indeterminacy, and unsettle anything definitive: as George Bornstein writes, 'the literary work might be said to exist not in any one version, but in all versions put together'.[16] So theories of textual indeterminacy within editorial practice have prompted burrowing into archives in particular to see early drafts of poems as well as subsequent revised versions. This kind of archival material, as Genetic Criticism has repeatedly shown, can provide narratives about the making of a work, tell us things about the meaning of process, a writer's sources, contribute to the destabilization of a text, and also contribute to our sense of a life. The well-earned if clichéd association linking modernism to formal experimentation leads inevitably in the direction of formation itself. Publication of *The Waste Land* drafts were an early instance of this and are open-ended enough to keep fuelling debate. Difficulties of form and of reading conjure up a sense of struggle in the processes of

[15] See Alexis Weedon, *Victorian Publishing: The Economics of Book Production for a Mass Market 1836–1916* (Aldershot: Ashgate, 2003), 5–30, <http://www.victorianresearch.org/weedonguide.pdf>.

[16] George Bornstein, *Material Modernism: The Politics of the Page* (Cambridge: Cambridge University Press, 2001), 6.

composition, and indeed textual archives reveal many such narratives of conflict between a writer and the material of language: this is emerging through recent studies that examine and compare the manuscripts and notebooks of Eliot, Joyce, Conrad, Woolf, Hopkins, Yeats, Beckett, Proust, Mann, and Henry James, many of which have been or are being made available.[17] The ephemeral fugitive processes of writing are gradually being uncovered from within the folds of archived manuscripts. Moreover, the textual archive and the biographical archive are being brought together in exciting ways. Several recent biographies (of Yeats and Woolf, for instance) return to the drafts of a work to show the meaning of its making within the life of the subject, the draft being closer to the life which is their context than its form at publication.

Beyond the textual evidence of the work, there are biographical archives which are invoked in battles over writers' reputations, sullying or cleansing them. One paradox here is that, on occasion, the more control a literary estate wields over the materials relating to an artist's archive, the longer the reputation remains in question, the stains of rumour remain unerased. Thus, for example, issues such as T. S. Eliot's supposed homosexuality or anti-Semitism or the relations between the children in the Joyce family might all have their record straightened, to a degree, if the estates interfered less and let biographers use archival material more.[18] On the other hand, material from the archives can still provide the prurient thrill of bringing to light 'bad behaviour', as Terry Castle called it, in her review of Janet Malcolm's detective work on Stein and Toklas which in part attempted to uncover what the pair knew about the collaborationist background of their protector during the war.[19]

So much for literary archives. But modernist studies, since at least Michael North's *Reading 1922*, has branched out to reach over a broader cultural field.[20] Rita Felski noted that 'new work on the culture of modernity is clearly indebted to two key ideas of cultural studies that are often ignored or misunderstood: an expanded notion of the aesthetic field and a theory of articulation'.[21] At the same time modernist scholarship has, she claims, steered 'clear of its ... indifference to the archive'.[22] Latham argues that the 'availability' provided by digital archives is 'the condition of possibility for cultural studies itself'.[23] Latham's illustration is from the modernist

[17] See Dirk van Hulle, *Textual Awareness: A Genetic Study of Late Manuscripts by Joyce, Proust, and Mann* (Ann Arbor: University of Michigan Press, 2003); Matthew Feldman, *Samuel Beckett: The Inter-War Notebooks* (London: Continuum, 2006); and Finn Fordham, *I do, I undo, I redo: The Textual Genesis of Modernist Selves* (Oxford: Oxford University Press, 2010).

[18] See e.g. Ranen Omer-Sherman, 'Rethinking Eliot, Jewish Identity and Cultural Pluralism', *Modernism/Modernity*, 10/3 (Sept. 2003), 439–45.

[19] Terry Castle, 'Husbands and Wives', *London Review of Books* (13 Dec. 2007), 11–16.

[20] Michael North, *Reading 1922: A Return to the Scene of the Modern* (Oxford: Oxford University Press, 1999).

[21] Rita Felski, 'Modernist Studies and Cultural Studies: Reflections on Method', *Modernism/Modernity*, 10/3 (Sept. 2003), 501.

[22] Ibid. 504.

[23] Sean Latham, 'New Age Scholarship: The Work of Criticism in the Age of Digital Reproduction', *New Literary History*, 35/3 (Summer 2004), 413.

journal the *New Age*. The archive resources for cultural studies devoted to the
contemporary, being histories of the present, could comprise the High Street,
YouTube, recycling centres. The archive for modernist *material* cultural studies is
meanwhile distributed among such special collections as the Bakken Library and
Museum in Minnesota;[24] the as yet unmined John Johnson Collection at the Bod-
leian Library in Oxford (currently undergoing a process of digitization);[25] the
Pinkerton Archive (relating to the detective agency) at the Library of Congress; or
the pre-war BBC archives.[26] And this is to name only a tiny selection, for while there
are updated and exhaustive literary research guides, with whole chapters devoted to
archives and information gateways, such guides for cultural studies trail behind.[27]
This is understandable, since cultural studies, in theory, comprises all of culture and
therefore might potentially wish to draw on every kind of archive—whether it visits
collections devoted to board games, ballroom dancing, the illicit production of
alcohol, travelling circuses, early cinema, rotarian societies, or papers of psychiatric
hospitals. But such archives, in so far as they contain cultural ephemera, can provide
critical context, especially when so many modernist works deal in and with such
ephemera: whether in advertisements for soap, obscure ragtime songs, the price of
tea at a Lyons tea shop, the construction of shopping arcades, or reports commis-
sioned on trade in Central Africa or education in India.

The last two of these allows us to make a distinction within cultural studies,
however temporary such a distinction ought to be, between purely 'cultural' docu-
ments, on one hand, and 'political' documents, on the other.[28] An instance of the use
of political documents from the archives occurred after an 'Open Government'
policy in Britain in 1998 made available material which wasn't supposed to come
out until 2037. Alan Travis, in *Bound and Gagged*, trawled through several Home
Office files and uncovered official material relating to D. H. Lawrence, Isadora
Duncan, Radclyffe Hall's *Well of Loneliness*, and F. R. Leavis's plan in 1926 to teach
Ulysses at Cambridge. The Home Office bundle numbered 144/20071 shows that
Leavis was considered a 'dangerous crank', and that Sir Archibald Bodkin, the
Director of Public Prosecutions, sought to find out from the police 'who and what'
Leavis was and tried to bring pressure to bear on the vice-chancellor at the time to

[24] See <http://www.thebakken.org/research/research.htm>. Several important works using this archive have influenced concepts of modernism, such as Tim Armstrong's *Modernism, Technology and the Body: A Cultural Study* (Cambridge: Cambridge University Press, 1998).
[25] See Bodleian Library, *John Johnson Collection of Printed Ephemera*, <http://www.bodley.ox.ac.uk/johnson/johnson.htm>.
[26] See Todd Avery, *Radio Modernism: Literature, Ethics, and the BBC, 1922–1938* (Aldershot: Ashgate, 2006).
[27] See James L. Harner (ed.), 'Guides to Manuscripts and Archives', in *MLA Literary Research Guide*, 5th edn (New York: MLA, 2008), 33–42.
[28] To some extent this split maps onto a useful archival distinction: 'Archivists distinguish between record groups and manuscript groups. A record group would include the various media created as part of its activities by a business, government or other institution. A manuscript group refers to the papers of an individual or private agency.' See Library and Archives Canada, *Using Archives*, <http://www.collectionscanada.gc.ca/04/0416_e.html>.

stop *Ulysses* appearing on the Tripos.[29] The relation between government education policy and the teaching of literature, especially 'modernist' literature, at the time when it was contemporary, is a topic, still relatively untouched, which could be enriched by looking through the 'political' archives at the Home Office or the BBC.

USING THE ARCHIVE 2: AS METAPHOR

A function that is distinct from these various practical applications comes from its metaphoric possibilities: its structure and construction, its principles of arrangement, order, and organization, and its relation to institutions of power are all key in these approaches. Recently the archive, despite its atmosphere of tidiness and calm, is often drawn on as the structure which underlies and underpins aggressive modernities. This opens it up as an object for critique within postmodernism and poststructuralism. This is relevant to modernism in so far as such critiques of modernity can be thought of as having originated within certain modernist practices and representations, and I will briefly refer to some of these in my final section. My arguments at this point are simple enough: firstly, the critique of the archive and of modernity draws on gothic and fantastical constructions of an illimitable power, which form the nightmare flipside of modernity's always foiled fantasies of omnipotence. Secondly, any tracing back of such attitudes to within modernism misses the extent to which many modernist artworks consistently show that they can capture imaginatively, and even protect, a subjective dimension of life, which archives can never catch. Modernist artworks gather primary material of subjectivity haphazardly into an incomplete archive. Postmodernism is predominantly frightened of the capacities of archives, whereas modernism, not only showing a greater variety of attitudes, is predominantly dismissive of their contents. If both views are equally justified, then there has perhaps been a shift in how the state has managed representations of the effectiveness of its archives. But aside from their relative accuracy, modernism's dismissal is a more empowering critique or attitude.

The key historical dates in the establishment of British archives show stepping stones through modernity: His Majesty's Stationery Office (1786), the Public Record Office (1838), the Royal Commission on Historical Manuscripts (1869), all brought together in 2002 under one name, the National Archive. As a symptom and an engine of modernity, what the archive as a metaphor gathers together includes inscription and architecture, governance and centralization, and a surplus of wealth that an institution considers sufficient for investing in the storage of information. The information can cover not only records of laws, regulations, values, and judgements, etc., but the processes by which decisions were reached about all these. Archives hope to ensure

[29] Alan Travis, *Bound and Gagged: A Secret History of Obscenity in Britain* (London: Profile Books, 2000), 18–45, 319.

their protection and endurance, creating a mirror of permanence for the institution and its values. They come to be seen as the source of truths, knowledge, power, but may also contain records of elements that have been repressed. For Foucault the importance of the archive was in its classificatory function. 'The archive . . . determines that all these things . . . are grouped together in distinct figures, composed together in accordance with multiple relations, maintained or blurred in accordance with specific regularities.'[30] This means the archive is at the origin of the order of things. Lyotard, in *The Inhuman*, writes of how 'the political city . . . provides residences for the presidents of families, the *domini*, it bends them to egalitarian citizenship, to the workforce and to another memory, the public archive, which is written, mechanographically operated, electronic'.[31] Derrida investigates the archive as 'an origin' and the way archives, he says, take place in a 'house arrest'.[32] This blurs the line between the asylum (said to be designed to protect what exists within) and the prison (said to be designed to protect what exists without), a similar blurring that Foucault enacted in *Histoire de la folie*. Those who guard the documents 'do not only ensure the physical security of what is deposited and of the substrate. They are also accorded the hermeneutic right and competence. They have the power to interpret the archives.'[33] But the roles of the archivist do not necessarily stretch this far beyond protection to interpretation. In general, interpretation for an archivist is limited to the classification of the documents—their 'tagging', as the process is now described and agonized over within theories of the archive. The hermeneutic right is given to anyone who is allowed to read and interpret the documents. The restrictions on who is allowed to look at and interpret them may be based on the vulnerability of the material as much as the sensitivity of the document. When Derrida adds that 'there is no political power without power over the archive', the archive is put on a level with weaponry.[34] The archivist stands at the door of an arsenal.

Such criticisms from three main whetstones of theory have shaped recent critical views within an emerging 'archive theory'. Literary scholars and cultural historians see themselves as offering resistance to the presumptions of the archive and of archivists. Gary Radford argued that the outdated 'positivist epistemology' implicit in the archive could be replaced by literary perspectives. As he writes: 'The usefulness of considering the library experience from the perspective of literary criticism lies in its ability to provide an alternative perspective from which the rationalistic assumptions of a positivist epistemology can be foregrounded, transcended, and critiqued along with the conception of the library it supports.'[35]

[30] Foucault, *Archaeology of Knowledge*, 128.
[31] Jean-François Lyotard, *The Inhuman: Reflections on Time*, trans. Geoffrey Bennington and Rachel Bowlby (Stanford, Calif.: Stanford University Press, 1991), 193–4.
[32] Jacques Derrida, *Archive Fever: A Freudian Impression*, trans. Eric Prenowitz (Chicago: University of Chicago Press, 1996), 2.
[33] Ibid. [34] Ibid. 4 n. 1.
[35] Gary P. Radford, 'Flaubert, Foucault and the Bibliothèque Fantastique: Toward a Postmodern Epistemology for Library Science', *Library Trends* (Spring 1998), 616.

Helen Freshwater contends that the 'allure of the archive . . . obscures the contingency of its construction, its destructive powers, and the way in which its contents remain vulnerable to interpretative violence', a violence which Freshwater, it seems, knows how to avoid.[36] More recently Will Slocombe, in a suggestive article co-authored with an archivist, strategically emphasized an 'us' and 'them' split: 'Literary scholars', he writes, 'would be concerned at archivists' claims that archives are "true" (re-)presentations of the past, although this is traditionally thought of as the cornerstone of archival practice.'[37]

But this claim is not especially a 'cornerstone' of archival practice. Archivists know as well as their archive users—probably better—the inadequacies and contingencies of the archive and, in particular, problems related to claims of provenance. But are archivists aware that they are maintaining and *determining* the power relations of a society? Slocombe writes: 'Archives clearly both maintain the current power relations of a society (determined by the archivist's act of appraisal) and allow us, through the inclusion of materials emblematic of particular social trends, to recapture those spectral figures made invisible and voiceless by a dominant canon.'[38]

In Slocombe's reading, those who work for archives, unlike those independent souls who work for universities and recapture voiceless figures, are in part servants of repression. But doesn't this make archivists themselves invisible and voiceless here? This construction of archives as repressive equipment of the state enables pious reflections on the righteousness of a seemingly radical ethics. When the archive is figured as a symptom of power and modernity, such a narrow figuring may itself be a symptom of a political posturing.

ARCHIVES IN MODERNISM

Similar visions that connect archives to power, tradition, and repression, but which lead to pessimism rather than pious injunctions of redemptive resistance, can be found in late modernism: in Orwell's *1984* and, before that, in Auden's 'The Unknown Citizen'. Both raise spectres of an awesome machinery of state power underpinned by state knowledge:

(To JS/07/M/378
This Marble Monument Is Erected by the State)

He was found by the Bureau of Statistics to be
One against whom there was no official complaint.[39]

[36] Helen Freshwater, 'The Allure of the Archive', *Poetics Today*, 24/4 (2003), 729.

[37] Will Slocombe and Jennie Hill, 'Archive-Text: An Interdisciplinary Dialogue', *English Language Notes*, 45/1 (2007), 27.

[38] Ibid. 23.

[39] W. H. Auden, *Collected Poems* (London: Faber, 1976), 252.

Auden and Orwell, part of the generation which succeeded the modernists, differentiate themselves partly through such characterizations of the state as something which destroys the individual in so far as it amasses knowledge about it. Objectifying official archives become a means of displaying a politicized commitment. While pitching the individual against established institutions is hardly rare in modernist texts (Stephen Dedalus against the Catholic Church; Septimus Smith against Harley Street psychiatry), the archive is not demonized in the same way. Perhaps the difference can be explained through invoking the eruption of an official and normative language, as it was being developed, emitted, and stored by the BBC. Rather than being demonized, the archive is critiqued within modernism through its failures, its deadness, and its rigidity: art offers alternative archives, as we can see in a selection of allusions to the archive, though there isn't the time to make this thorough or organized along the lines provided by the supreme model of a well-organized working archive.

The modernist archive begins with *The Aspern Papers*. There Henry James aimed a powerful and sharp critique at the biographical drive towards archival material. This drive was shaped by a growing cult of literary celebrity, itself shaped by the growth of a literary marketplace in the nineteenth century. Everyone in the story is punished for attempting to trade sexuality and textuality for each other. The marketplace in which James's unnamed narrator fails spectacularly will develop into the marketplace of celebrity in which modernist artists would have to negotiate a position that would resist while it exploited the forces of the market that had shaped the biographical 'Aspern' project. Such a character then becomes a figure within modernism, resurfacing as an enemy in *Finnegans Wake* (where he is the 'biografiend' or one of the 'nazi priers', the nosy, prying, nasty control freaks) or toyed with by Virginia Woolf's comical counter-biographies, like *Orlando* and *Flush* (though she did a serious biographical study of the painter Roger Fry).

But this hostility to the commodification of elements which related to a writer's life rather than a writer's work encounters a pacifying impulse flowing in an opposite direction. Mallarmé's declaration that 'Tout, au monde, existe pour aboutir à un livre,' that 'Everything in the world only exists so it can end up in a book,' suggests the allure of a textual totality, of a turn away from selective exclusion on any principles including prudery or privacy.[40] Such an ultimate book will be a utopian archive recording reality in its entirety, public and private, social and subjective, an ark to protect its contents from the world which it documents. The allure of totality had already been a feature of nineteenth-century realist fiction (and as such is perhaps being mocked by Mallarmé) in novels attempting to be a mirror, not just walking down a main road, as Stendhal had described them to be, but trained on all of society, inserting their beams into every domestic corner, however dark they might be. Tolstoy's *War and Peace*, Dostoevsky's *The Brothers Karamazov*, Hugo's *Les Misérables*, Balzac's *Comédie humaine*, Zola's *Rougon-Macquart* series, George Eliot's

[40] Stéphane Mallarmé, 'Le Livre, instrument spirituel', in *Œuvres complètes*, ii (Paris: Éditions Gallimard, 2003), 224.

Middlemarch, Dickens's *Bleak House*, in their incorporation of details from the widest possible social spectrum, feed off a desire to contain a totality of things and people arranged into the invisible taxonomy of narrative. They are, to reuse Jacques Neefs's phrase in a slightly different sense, 'romans d'archives'—archival novels.[41]

This sublime and inclusive ideal will be flirted with by Pound in his massive *Cantos*, containing all of history, and by Joyce in his last two colossal encyclopedic works, brought analytically down to earth by the sharp brevity of two of Borges's stories, mocked by Wyndham Lewis, shown to be in ruins by Eliot, pathologized by Walter Benjamin.

Pound's one allusion to 'the archives' in *The Cantos* sees them as an official rubbish bin in which damning social reports are thrown to be forgotten. In Canto XXXIII he refers to Marx's angry citation of a report about child labour. For a surprising moment, Marx is, ideologically, a father for Pound's generation.

> (Das Kapital) denounced in 1842 still continue
> (today 1864) report of '42 was merely chucked into the
> archives and remained there while these boys were ruined
> and became fathers of this generation.[42]

The archive is a bin, but Pound has projected his work as an alternative archive, as a wide-ranging collection studying documents that examine the relation between culture and money, a resource through which the significance of such painful and shaming details hidden in the archive can be reappraised. Art can thus redeem the contents of the archive by bringing its contents to the surface. But this would not have been possible without the archive as a resource which protects the material in the first place. Such redemptive roles for documents, that are initially chucked out like so much waste but then rescued through archival acts of art, are mocked as a form of fetishization in *Finnegans Wake*, as it moves between valuations of itself as a highly significant *letter* or totally insignificant *litter*. Joyce knew also the associations between the archive and power, alluding in the 'filest archives'[43] to the fact that an archive's files can hold the vilest secrets, and that such material, though filed away, can 'file' (in the sense of 'defile'). Elsewhere Shaun, the hypocritical priest, condemns his brother Shem, the exiled artist, for, among other things, gleefully prophesying 'the dynamitisation of colleagues, the reducing of records to ashes, the levelling of all customs by blazes'.[44] One allusion here is to the Dublin Customs House, where vast quantities of primary materials were archived, burnt down by Republicans in 1921 during the Anglo-Irish War. Shem, the artist, is akin to an anarchist republican threatening the knowledge base that underpins power. But this myth of the artist is Shaun's construction and perhaps the state he hopes to protect from such an artist is too.

[41] Jacques Neefs and Raymonde Debray-Genette, *Romans d'archives* (Lille: Universitaires Presses, 1989).

[42] Ezra Pound, Canto XXXIII, in *Cantos* (New York: New Directions, 1987), 162.

[43] James Joyce, *Finnegans Wake* (London: Faber, 1973), 398.12.

[44] Ibid. 189.35–6.

The flirtation with the power of a total text is mocked by Borges's thought experiments in both 'The Library of Babel' and 'The Analytical Language of John Wilkins'. In the former the universe is a library of every conceivable text—a place where any promise of meaningfulness, such as that held forth mythically by the archive, is eternally unfulfillable. The latter is a satire not aimed strictly at archives, but at those processes of classification and taxonomy without which archives cannot be formed.

The exhaustive pursuit of the undiscovered life and the augmentations of its significance, aspects of the realist project out of which and beyond which Joyce grew, are resisted by writers like Wyndham Lewis, as Ella Ophir points out. In the late work *Self Condemned*, Lewis's protagonist Harding, while crossing the Atlantic by boat, loses patience with *Middlemarch*, concluding that 'the historic illusion, the scenes depicted... could be preserved in some suitable archive; but should not be handed down as a living document. It is a part of *history*... swinging his arm back [he] hurled the heavy book out to sea.'[45] Harding opposes fiction (as living documents) with archives (as dead documents).

The accumulative constructions of modernist encyclopedism, of books as alternative archives in Pound and Joyce, fleetingly but nevertheless insistently include fragmentation as part of the 'everything in the world' that is destined to end up in one book. *The Waste Land*, by contrast, foregrounds this process, showing us the textual fragments of a blasted archive. In 'The Love Song of J. Alfred Prufrock' the streets of the city are full of dead documents. Eliot's criticism replies to this sense of ruination, suggesting a need to reconstruct an archive whose documents will be renewed through their recontextualization within reinvigorated canons of world literature. Unlike Eliot, Walter Benjamin's interests in collection, which found paradigms in Baudelaire's attention to ephemera, are seduced by the city space of the street as an archive, which are just as alive with evidence as the textual archives of the Bibliothèque Nationale, where he gathered material for his 'arcades' project.[46] The archive of the streets lies waiting for detectives to uncover its 'records of barbarity': 'No matter what trail the *flâneur* may follow, every one of them will lead him to a crime.'[47] The *flâneur* is an archive user who is compelled to become a detective investigating the crimes of capital.

I will conclude with one final and brilliant constellation of issues about archives, and the relation between them and the artwork, which shines forth in that high-modernist classic of the silver screen *Citizen Kane*. There the attempt of journalists to commodify the significance of the intimate detail by uncovering it as the ultimate sign—who or what did 'Rosebud' mean—draws the archive into its strategies. In two brief scenes, on either side of an internal narrative, the archive appears as a place of

[45] Quoted in Ella Zohar Ophir, 'Toward a Pitiless Fiction: Abstraction, Comedy, and Modernist Antihumanism', *Modern Fiction Studies*, 52/1 (2006), 111.

[46] See Ursula Marx et al. (eds), *Walter Benjamin's Archive: Images, Texts, Signs*, trans. Esther Leslie (London: Verso, 2007).

[47] Walter Benjamin, *Charles Baudelaire: A Lyric Poet in the Era of High Capitalism*, trans. Harry Zohn (New York: Verso, 1997), 41.

pompous power, of protection, and policed limits, of meandering digressive narra-tives that reveal everything except the thing that is sought, a place of disappointment, sexlessness, and futile transgression. Here is an excerpt from the first of these scenes:

BERTHA [the archivist] (*hangs up and looks at Thompson*). The directors of the Thatcher Library have asked me to remind you again of the condition under which you may inspect certain portions of Mr. Thatcher's unpublished memoirs. Under no circumstances are direct quotations from his manuscript to be used by you.... (*To the guard*) Pages eighty-three to one hundred and forty-two, Jennings.... (*To Thompson*) You will confine yourself, it is our understanding, to the chapter dealing with Mr. Kane.[48]

Here is the second, which follows on from the sequence that has concretized Thompson's reading of Thatcher's memoirs:

(*Thompson—at the desk. With a gesture of annoyance, he is closing the manuscript.*)
BERTHA. You have enjoyed a very rare privilege, young man. Did you find what you were looking for?
THOMPSON. No. Tell me something, Miss Anderson. You're not Rosebud, are you?[49]

Over the course of the film, Thompson of course visits several people, but never finds what he is looking for. But what the researching journalist cannot find, art can always know and choose to reveal, if it so wishes, concealing its potential smugness behind its actual sense of the tragic. 'Rosebud' turns out to be the name of the sledge which the 6-year-old Kane had been playing with when Thatcher came to take him from his mother. As it burns in the final scene of the film, the meaning is repressed for ever from the world of the film, but gained for the world of the audience—a very rare privilege.

A knowing modernist confidence in art's superiority to any archive is able to construct the possibility of knowing an ultimate truth about a human being. For Welles it is a modernist Freudian truth, since the sledge is an object of pleasure and a weapon he uses to turn on Thatcher—the bad, strong father. The surveillant inner eye of the modernist artist is an alternative researcher and archivist, turned on the archive of a subject's all but lost subjectivity. This eye—and ear—collects and gathers detritus from reality, both internal and external, and organizes it in a discrete system of its own devising. It reflects, sometimes sceptically, on its power to imagine what it cannot know. Art has arrived at the epistemological crisis long before the researcher who is distressed at the point of arrival: 'The instability of human knowledge is one of our few certainties...Almost everything we know we know incompletely at best.'[50] Art has found time to become comfortable with this situation and with the possibilities it creates for open-ended narratives, and can even relax in the feeling that, because it has the simple power of imaginative reconstruction, it never needs to

[48] Herman Mankiewicz and Orson Welles, *Citizen Kane: The Complete Screenplay* (London: Methuen, 2002), 178.
[49] Ibid. 192.
[50] Castle, 'Husbands and Wives', 16.

look beyond impassable limits of knowledge. Modernism could thus always refer to the archive without always having to refer back to a fear of the archive's relation to a power which only ever *claims* to know without finally knowing. And this, I suggest, is the proper spirit—sceptical, fearless, rational, imaginative—with which modernist studies should enter into the expanding, searchable, and radiating labyrinth of modernist archives.

PART II

PRACTICES AND PERSPECTIVES

CHAPTER 4

..

INNOVATIONS IN POETRY

..

ROBERT HAMPSON

WILL MONTGOMERY

THE history of modernist poetry is a history of radical innovation in form, prosody, and language. As Pound put it, 'To break the pentameter, that was the first heave.'[1] In the Anglo-American tradition, modernism initially involved a break from conventional poetic verse-forms, experimentation with other forms of prosody, and a rejection of the conventional poetic language of the 1890s (and earlier). In pursuit of these aims, the early Anglo-American modernist poets explored contemporary developments in French poetry, recently published poetic fragments by Sappho, Japanese poetry, and Chinese poetry. Anglo-American modernist poetry, from the outset, not only involved an intimate dialogue between British and American poets; these poets were also self-consciously open to other cultures to perform a critique of their own. Internationalism, cosmopolitanism, multiculturalism are integral to the tradition. Modernist poets were also aware of developments in the other arts, and these frequently impacted on their own practice: collage, montage, and, later, serial form, for example. Modernist poetry has seen over a century of formal, prosodic, and linguistic experimentation: it was not a movement that flowered briefly in the early decades of the twentieth century; it is an ongoing tradition that is still vibrant in the twenty-first with successive generations of poets consciously writing within it, in dialogue and argument with their predecessors.

[1] Ezra Pound, Canto LXXXI, in *The Cantos* (London: Faber, 1964), 518.

IMAGISM

In the British Museum tearoom, in spring 1912, Ezra Pound 'corrected' H.D.'s poem 'Hermes of the Ways', signed it 'H.D. Imagiste', and thereby launched Imagisme.[2] In October 1912, when his *Riposte* was published, Pound included, as an appendix, 'The Complete Poetical Works of T. E. Hulme', with a playful preface which introduced the mysterious 'Imagistes' to a wider public. When Richard Aldington's work appeared in the influential American magazine *Poetry*, in November 1912, the explanatory note described Aldington as 'one of the "Imagistes", a group of ardent Hellenists who are pursuing interesting experiments in vers libre; trying to attain in English certain subtleties of cadence'.[3] Hellenism reflected the interests and practice of Aldington and H.D., but was not a Poundian requirement. By March 1913, when F. S. Flint's 'Imagisme' (written under Pound's direction) appeared in *Poetry*, Imagisme had acquired a clearly articulated programme, which included 'direct treatment of the thing'; the excision of any word that did not 'contribute to the presentation'; and composition 'in sequence of the musical phrase'. Pound's new objectivism meant an end to archaisms, abstractions, excessive use of adjectives, and ornamental metaphor.

Imagisme, however, did not spring fully formed from Pound's head. When he first arrived in London in August–September 1908, he had already served 'an apprenticeship to the Yeatsian tradition', and he wanted to 'sit at Yeats's feet, and learn what he knew'.[4] From 1902 to 1908 he had read Symons, Dowson, and Yeats; as was evident from his poetry, his apprenticeship had also included Browning, Swinburne, and the Pre-Raphaelites. As it happened, he did not meet Yeats until April 1909, but, in the meantime, he was introduced to Ford Madox Ford, who provided one of the necessary correctives that enabled Pound to modernize his poetry. From Ford, Pound learned the importance of precise language, contemporary speech rhythms, and composition by cadence. Ford impressed upon him his own 'unflinching aim', namely 'to register my own times in terms of my own times', and persuaded him that 'no good poetry is ever written in a manner twenty years old'.[5]

Pound's major achievement of this period, the translations of *Cathay*, where verbal precision is combined with the subtle rhythmic control of lines of varying length to register the delicacy and complexity of various emotional moods, is a clear indication of what Pound had learned from Ford. However, while Ford's emphasis upon the conversational had helped Pound free himself from the 'crust of dead English', Ford's impressionist poetry now seemed too 'leisurely', 'low-toned', and susceptible to

[2] An alternative 'birthplace' was a tea shop in Kensington, but with the same group present: Pound, Aldington, and H.D. For a full account of Imagism, see Helen Carr, *The Verse Revolutionaries: Ezra Pound, H.D. and the Imagists* (London: Jonathan Cape, 2009).

[3] Pound was annoyed at this editorial misrepresentation of his movement; see Carr, *Verse Revolutionaries*, 530–1.

[4] Peter Makin, *Pound's Cantos* (London: Allen & Unwin, 1988), 7.

[5] Ford Madox Hueffer, 'Preface' to *Ancient Lights* (London: Chapman & Hall, 1911); Ezra Pound, 'Prolegomena', *Poetry Review*, 1 (Feb. 1912), 72–6.

lapsing 'into description'.[6] Pound introduced a new valorization of speed and concentration, and emphasized language 'charged with meaning to the utmost possible degree'.[7] In retrospect, it is possible to see that Pound was moving towards the poetics of *The Cantos* from as early as December 1911, when he reworked Ford's emphasis on concrete details into his own concept of the 'luminous detail'.[8] This is a matter not of concrete details as part of an impression, but of 'facts' that give insight 'into circumjacent conditions, into their causes, their effects, into sequence and law'.[9] By spring 1914, when Pound gave the lecture that was to become his essay 'Vorticism', Imagisme was now being presented as a critical, rather than a creative, movement: it had helped clear away an 1890s conception of 'intensity', which now needed to be replaced by a modern one. The redefinition of the image as 'a radiant node or cluster . . . a VORTEX, from which and through which, and into which, ideas are constantly rushing',[10] provided an escape from the passively receptive implications of Impressionism and the static image of Imagisme; it empowered Pound to place the poet's 'interpretative intention' at the centre of the work.[11]

In the twelve years Pound spent in London, between 1908 and 1920, he himself could be seen as a vortex, through which ideas were constantly rushing. His own poetics underwent a rapid series of changes through interactions with Ford, Hulme, Flint, Gaudier-Breszka, and others (including his engagement with the late Ernest Fenollosa). In 1913 Pound was given Fenollosa's notebooks on Noh plays and Chinese poetry by his widow. He put Fenollosa's translations of Noh plays into publishable form; drew on his notes on Chinese poetry for *Cathay*; and edited his essay 'The Chinese Written Character as a Medium for Poetry'.[12] Fenollosa's notion of the pictorial, shorthand nature of the ideogram and his emphasis on the sentence as the transfer of energy had a major impact on Pound's poetic development.

However, there is another history of Imagism that assigns the origins of the movement to the Poets' Club set up by T. E. Hulme in 1909.[13] The group's discussions centred on *vers libre* and 'the image' long before Pound was interested in either. Flint notes Hulme's emphasis on 'accurate presentation' and 'no verbiage', and describes Hulme's 'Autumn' as the first Imagist poem. However, the opening line of the poem ('A touch of cold in the Autumn night'), though admirably direct, is closer to Ford's

[6] Ezra Pound, 'Guido's Relations', *Dial*, 86/7 (July 1929), 561, and 'Mr Hueffer and the Prose Tradition in Verse', *Poetry*, 4/3 (June 1914), 111–20; Ezra Pound and Ford Madox Ford, *Pound/Ford: The Story of a Literary Friendship*, ed. Brita Lindberg-Seyersted (New York: New Directions, 1982), 12.

[7] Ezra Pound, *ABC of Reading* (London: Faber and Faber, 1961), 28.

[8] Ezra Pound, 'I Gather the Limbs of Osiris', in *Selected Prose*, ed. William Cookson (London: Faber, 1973), 21–43, *passim*.

[9] Ibid. 22.

[10] Ezra Pound, *Gaudier-Brzeska: A Memoir* (Hessle: Marvell Press, 1960), 92.

[11] Ezra Pound, *The Spirit of Romance* (New York: New Directions, 1968), 87.

[12] For an account of *Cathay*, see Hugh Kenner, *The Pound Era* (London: Faber and Faber, 1972), 192–231, and A. David Moody, *Ezra Pound, Poet: A Portrait of the Man and His Work*, i: *The Young Genius, 1885–1920* (Oxford: Oxford University Press, 2007), 266–75. 'The Chinese Written Character' was published in *Instigations* (New York: Boni and Liveright, 1920).

[13] See F. S. Flint, 'A History of Imagism', *The Egoist* (1 May 1915), 70–1.

Impressionism, and the subsequent similes ('the ruddy moon' leaning over a hedge 'like a red-faced farmer' and the 'wistful stars | With white faces like town children'), with their anti-romantic treatment of familiar poetic themes and strong visual images, are very far from the economy and condensation of Poundian Imagisme. As Helen Carr suggests, Flint also modestly underplays his own contribution: his early translations of haiku, like Hulme's theorizing of the 'image', fed into Imagism. It was also Flint, rather than Pound, who was aware of contemporary developments in French poetry and championed *vers libre*. His 1910 review of Pound's *Personae & Exultations* asserted that 'the old devices of regular metrical beat and regular rhyming are worn out' and 'verse must be free from all the restraints of a regular return and a squared-up frame'.[14] As Carr shows, Flint, Hulme, and their circle played a major part in the development of both Imagisme and Imagism.

PARIS: MINA LOY, GERTRUDE STEIN, HOPE MIRRLEES

If Imagisme can be seen as a necessary discipline to strip down and re-energize poetic language, to make it 'harder . . . saner . . . nearer the bone', it can also be seen (despite H.D.'s involvement) as a distinctly masculinist project.[15] Mina Loy, Gertrude Stein, and Hope Mirrlees provide alternative genealogies for modernist innovation.

As Julia Briggs has noted, the work of Stein, Loy, and Mirrlees came out of the same cultural and artistic milieu: early twentieth-century Paris.[16] Key components of this milieu were the emergence of Cubism and the Simultaneist desire for new aesthetic means to embrace the whole of experience. This involved what Redell Olsen has called the 'scripto-visual': a simultaneous attention to the visual and semantic dimensions of print, and an awareness of the materiality of language.[17] These have been constant components of the modernist poetry tradition.

As Peter Nicholls notes, the emergence of Cubism after 1907 gave French modernism 'a strong anti-representational bias' that had an impact on both visual and literary arts.[18] Cubism involved 'the abandonment of unitary perspective' and an emphasis on simultaneity.[19] A key figure in the literary response to Cubism was

[14] F. S. Flint, 'Verse', *New Age* (6 Jan. 1910), 234.

[15] Ezra Pound, 'A Retrospect', in *Literary Essays of Ezra Pound*, ed. T. S. Eliot (London: Faber and Faber, 1974), 12.

[16] Julia Briggs, 'Hope Mirrlees and Continental Modernism', in Bonnie Kime Scott (ed.), *Gender in Modernism: A Critical Anthology* (Urbana: University of Illinois Press, 2007), 261–9.

[17] Redell Olsen, 'Scripto-Visualities: Contemporary Poetics and Innovative Women's Writing', Ph.D. diss., University of London, 2002.

[18] Peter Nicholls, *Modernisms: A Literary Guide* (Basingstoke: Macmillan, 1995), 112.

[19] Ibid. 113.

Guillaume Apollinaire, who began his involvement with Picasso in 1905. The Cubist fragmentation of the object, the replacement of the perspectival representation of the object by a reconstruction of the visual image, shifted the focus from representation to the articulation of perception through the tensions of the picture plane. For Apollinaire, the Cubist interrogation of the object (and the relation of object to expression) becomes an interrogation of language. In *Alcools* (1912), which marked Apollinaire's movement away from the French Symbolists towards a new modernity, punctuation was abandoned in favour of a fluid syntax which foregrounded the role of the reader. In 'Zone', for example, the lack of punctuation and the use of parataxis demand the active involvement of the reader while fragmenting the speaker's identity across multiple contexts. In a mode developed later by Frank O'Hara, the poet's simultaneous movements through the spaces of the modern city, memory, and literary conventions produces, as Timothy Mathews suggests, a 'continuously shifting present' and 'continual revaluations of the past'.[20]

Stein took up residence in Paris in 1903. Her early works in prose (*Three Lives*, written in 1904–5; *The Making of Americans*, written in 1906–8; and her first verbal portraits) were followed by the poetic prose of *Tender Buttons* (written in 1911) and the poetry of *Lifting Belly* (written in 1915–17). Picasso's 1906 portrait of Stein marked his transition to Cubism, and Cubism is the obvious point of reference for the anti-mimetic form of writing of *Tender Buttons*, where 'words do not evoke concepts of things so much as things provoke patterns of words'.[21] The Cubist artwork offers a multiplicity of perspectives simultaneously, through which it emphasizes 'the artistic object as a conceptual object—an object that inaugurates experience . . . as well as a critical self-consciousness in experience'.[22] Stein's verbal artefact endows an object status to language, replaces product by process, and initiates a close investigation of grammar and meaning. Through an attentive close reading of her poetry, Peter Quartermain has shown how, through repetitions and variations, through a play of referentiality and opacity, Stein's writing foregrounds its investigation of the formal elements of language, its play with reader expectations, and its reorientation of reading from reference to the play of language and meaning.[23]

After studying art in London, Munich, and Paris, Loy made contact with the Italian Futurists in 1913 and underwent a 'conversion to futurism'.[24] As well as the aggressive assertion of selfhood in poetry, and in particular the sexual dimension of self, this led her to formal and typographic experiments, the elimination of punctuation, and the conscious destruction of syntax. A personal introduction to Stein in 1911 had already encouraged Loy to turn to writing. Stein's practice, in *The Making of*

[20] Timothy Mathews, *Reading Apollinaire: Theories of Poetic Language* (Manchester: Manchester University Press, 1987), 91.

[21] Nicholls, *Modernisms*, 208.

[22] Mathews, *Reading Apollinaire*, 109.

[23] See Peter Quartermain, *Disjunctive Poetics: From Gertrude Stein and Louis Zukofsky to Susan Howe* (Cambridge: Cambridge University Press, 1992), 21–43.

[24] For a fuller account of Loy, see Carolyn Burke, *Becoming Modern: The Life of Mina Loy* (New York: Farrar, Straus, Giroux, 1996).

Americans, of placing the individual within a larger personal and social history and Marinetti's focus on the complex of self and world chimed with Loy's own concerns.[25] The Futurists' replacement of the Cubist still life with objects in motion and their move beyond *vers libre* to *parole in libertà* ('words in freedom') liberated Loy from conventionally linear language use. In 'The Costa San Giorgio', she engages with 'the passionate Italian life-traffic' of the busy street scene through a montage of fragmentary details presented through unpunctuated and grammatically unsubordinated statements, the free-verse lines opened through spaces within the line and dynamized through the use of capitals ('Shaving | ICE CREAM | Licking is larger than mouths').[26] Similarly, in the sequence 'Love Songs to Joannes' (published in *Others* in 1916), Loy undertakes an open-ended exploration of sex and the sex war through unpunctuated stanzas, lines with internal spaces, and an alternative syntax of juxtaposed phrases and startling images. The opening poem confronts the reader with the anti-romantic 'Pig Cupid | His rosy snout | Rooting erotic garbage'. Later sections present a dynamic collage of phrases ('Laughter in solution | Stars in a Stare | Irredeemable pledges'), the lyric voice fractured by parataxis.[27]

As Briggs has argued, Hope Mirrlees's *Paris* (1920) is 'modernism's lost masterpiece': it is both 'confidently experimental' in style and 'alert and responsive to its political moment'.[28] Working in a typographic tradition that began with Mallarmé's *Un Coup de dés* (1897), that was given a distinctive public character by the Futurists and was developed into visual poetry by Apollinaire's *Calligrammes* (1918), Mirrlees exploits the visual language of roman and italic script, capital letters, and blank space as a form of punctuation, combined with bars of music and words vertically down the page. She might perhaps have seen full-page and double-page visual poems by Agnes Ernst Mayer and Katherine N. Rhoades (1915), which had a female narrator and made graphic use of vertical and horizontal text, or Juliet Roche's 'Brevoort' (1917), a celebration of the Brevoort Café in Greenwich Village that uses typographic displays across the page space, dispersed lines of text intersecting vertically and horizontally, different sizes of typeface, and a mixture of French and English.[29] *Paris*, however, is a more ambitious project: it is both a topographical poem, moving through identifiable Parisian spaces, and a historical poem. It registers the daily life of the city, with its metro stations, street signs and advertisements, and bar tabac conversations, but also the war widows, demobbed soldiers, and the ongoing Paris Peace Conference, set against evocations of Paris's violent past.

[25] See e.g.Loy's sequence 'Anglo-Mongrels and the Rose: 1923–1925', in *The Last Lunar Baedeker* (Manchester: Carcanet, 1985), 109–75.

[26] Loy, 'The Costa San Giorgio', in *The Last Lunar Baedeker*, 44–6.

[27] Ibid. 19, 101.

[28] Briggs, 'Hope Mirrlees and Continental Modernism', 261. *Paris*, written in 1919, was published by the Hogarth Press in 1920 in an edition of 175 copies. After her conversion to Catholicism, Hope Mirrlees refused to allow the work to be republished.

[29] See Dickran Tashjian, 'Authentic Spirit of Change: The Poetry of New York Dada', in Francis M. Naumann and Beth Venn (eds), *Making Mischief: Dada Invades New York* (New York: Whitney Museum of American Art, 1996), 266–71. These poems were published in Stieglitz's magazine *291*. This had reprinted Apollinaire's calligrammatic 'Voyage' in its first issue.

'NO IDEAS BUT IN THINGS'

When Pound wrote about 'direct treatment of the thing', by 'the thing' he meant what James or Ford would call 'the affair' not the object. However, poetic innovators in Anglophone modernist poetry after Imagism were much preoccupied with the category of the object. Poets sought both to track the cognitive response to the object within the poem and to conceptualize the poem itself as a kind of object. William Carlos Williams played a distinctive role in this development.

Williams's early poetry, published privately as *Poems* (1909), was Keatsian in derivation; his second volume, *The Tempers* (1913), shows the influence of Pound's early poetic enthusiasms. However, the poems he published subsequently began to reflect a commitment to the idea of the object that paralleled that of Pound, with whom he was corresponding, but inflected through Williams's active participation in the New York avant-garde. He claimed in his *Autobiography* that the International Exhibition of Modern Art of 1913, which took place at the 69th Regiment Armory in New York and is often seen as the inaugural event of American modernism, was an important influence on him.[30] The Armory show not only introduced Cubism, Futurism, and Post-Impressionism to the American public, it also gave American artists the sense of a self-consciously modern art project. The photographer Alfred Stieglitz had already laid the ground for this work through his 291 Gallery, which had opened in 1905 as a photography gallery but, from 1908, was also showing radical new artwork by Matisse, Cézanne, and Picasso. Stieglitz also published the magazines *Camera Work* and *291*, through which he continued the exploration of Cubism and Simultaneism and the translation of art practices into other media. In 1912 a special issue of *Camera Work* carried Stein's essays on Matisse and Picasso as an example of literary Cubism, while a later issue published Loy's 'Aphorisms on Futurism'.

From Imagism Williams learned the importance of the clearly delineated image, the use of colloquial language, the avoidance of metaphor, and the need to escape from conventional rhythm and rhyme. From Stieglitz and from Cubism he learned to focus on the object and to do justice to it.[31] A poem such as 'March' (1916) in his next volume, *Al Que Quiere*, shows the visual emphasis of Williams's work. Indeed, the pictorial analysis of objects is, as here, frequently related to *ekphrasis*: not only does he describe existing artworks, the Great Lion Hunt reliefs from King Ashurbanipal's palace and Fra Angelico's Annunciation fresco, but the description enacts the visual experience. In *Kora in Hell* (1920), Williams explores simultaneity through juxtaposing disparate sense impressions and a polyphony of voices. 'The Great Figure', which was published in *Sour Grapes* (1921), similarly explores simultaneity, but this time through a very precise visual and aural notation:

[30] William Carlos Williams, *The Autobiography of William Carlos Williams* (New York: Random House, 1951), 134.
[31] See Bram Dijkstra, *Cubism, Stieglitz, and the Early Poetry of William Carlos Williams* (Princeton: Princeton University Press, 1969).

Among the rain
and lights
I saw the figure 5
in gold
on a red
firetruck.

The tight focus on the complex of a single moment and the careful selection of precise details combines with an attention to the material qualities of each word in its placement on the page that turns the poem itself into a quasi-autonomous object.

Williams's poetry thus followed the Poundian–Hulmean impulse to strip away extraneous detail. We can also see in his work an embrace of the concrete details of lived experience that follows from Pound's injunction to 'go in fear of abstractions'.[32] However, he takes that impulse in a very different direction. For the Williams of *Spring and All*, poetry had become too bound up with representing the world. What it needed to do was to enact the 'movements of the imagination': in a series of distinctions drawn between prose and poetry he recommends a 'leap' from 'the simulations of present experience to the facts of the imagination'.[33] While prose stands outside reality, poetry is 'new form dealt with as a reality in itself'.[34] For the Williams of this period, the work of poetic imagination 'is not "like" anything but transfused with the same forces which transfuse the earth'.[35] An example of an almost teasing refusal to engage in symbolism or 'strained associations' is the most antholgized Williams poem from this (or any other) period, 'The Red Wheelbarrow'.[36] While the poem's relationship with Imagism is clear, its opening words—'so much depends upon'—mark a distinct break with the pictorial clarity and juxtapositional logic of that mode. Instead the poem's observation of the world unfolds within the atmosphere of the unresolved speculation that opens the poem. As with the Objectivism of the 1930s, a cognitive dynamization that recalls the energies of Pound's Vorticism enters the encounter between mind and object.

However, it is in the repetitive and apparently unfocused prose sections of *Spring and All* that Williams showed how he might rethink the nature and potential of poetic form. *Spring and All* was first published in Paris in an edition of 300 in 1923. It is a foundational American modernist text that set out to redirect the energies of the European avant-garde into a specifically American idiom. However, as with some other modernist works, it is remarkable too because of the deferred impact of the volume: in its original form it combined prose and poetry, but, until the posthumous edition of 1970, subsequent editions reprinted only the poems. *Spring and All*, then, shares a quality of 'afterwardsness' with Objectivism: both arguably had a more decisive impact on the 1970s generation of late-modernist writers than they did on the writers of pre-war modernism. Poems that have long stood on their own in

[32] Ezra Pound, 'A Retrospect', in *Literary Essays*, 5.
[33] Williams, *Spring and All*, in *Imaginations* (New York: New Directions, 1970), 133–4.
[34] Ibid. 133. [35] Ibid. 121. [36] Ibid. 102.

anthologies take on a different resonance in the context of the improvisatory spec-
ulations on imagination and reality that comprise the prose sections.

David Ayers suggests that the poetic currents set in motion by Imagism find their
most complex articulation in Pound's *Pisan Cantos*, but Williams's long poem
Paterson is a similarly substantial—and very different—example of the afterlife of
Imagism.[37] It is here that we find the fullest poetic expression of Williams's famous
axiom 'No ideas but in things'. The phrase is ambiguous in isolation: is it an observa-
tion or an injunction? A passage from his *Autobiography* clarifies his position, aligning it
with the poetics he himself practises: 'The poet . . . does not . . . permit himself to
go beyond the thought to be discovered in the context of that with which he is dealing;
no ideas but in things. The poet thinks with his poem, in that lies his thought, and
that in itself is the profundity. The thought is *Paterson*, to be discovered there.'[38]

In *Paterson*, Williams achieved his most successful extended development of his
anti-metaphysical aesthetic. However, the language he uses is ever apt to throw a
spanner into the works of his apparently streamlined 'machine made of words' (his
term for poetry in the introduction to his 1944 volume *The Wedge*). Despite his
suggestion that his machines should have 'no part, as in any other machine, that is
redundant' (an echo of Pound's 1912 commitment to 'use absolutely no word that does
not contribute to the presentation'), it may certainly be argued that, with its cultivated
looseness of structure, its moments of lyric effusion, and its use of various kinds of
prose (letters, newspaper articles, archival material), *Paterson* departs significantly
from the rigours of Imagisme and provides a hybrid model that other poets, most
obviously the English poet Roy Fisher in *City* (1961), have productively followed.

The second major development in post-Imagist poetics came from a group of
1930s poets. The equivocal prime mover in gathering the group, Louis Zukofsky,
certainly looked to both Pound and the Williams of *Spring and All*. Pound was
instrumental in naming the Objectivists—it was he who recommended Zukofsky to
Harriet Monroe as editor for a special issue of *Poetry* magazine. Zukofsky, under
pressure from Monroe to promote a 'group', chose 'Objectivists' as a label for the
supposed new tendency.[39] Zukofsky edited the issue of *Poetry* magazine (February
1931) and published *An 'Objectivists' Anthology* the following year. His essays 'Sincer-
ity and Objectification' and 'Recencies in Poetry', which appeared in these publica-
tions, are the nearest we have to a programmatic statement of Objectivist poetics.
However, it is unlikely that any of the poets now considered 'Objectivists'—Louis
Zukofsky, George Oppen, Carl Rakosi, Charles Reznikoff, and Lorine Niedecker—
would have subscribed to all of Zukofsky's views.[40] Nevertheless, there were aesthetic
ties between these poets, who shared an interest in the austere, clean-lined modernist
experimentation of Pound and Williams. Other links seem equally pertinent: all

[37] David Ayers, *Modernism: A Short Introduction* (Oxford: Blackwell, 2004), 11.
[38] Williams, *Autobiography*, 391.
[39] For a succinct account of the theory of objectivism, see Peter O'Leary, 'The Energies of Words',
<http://www.poetryfoundation.org/journal/article.html?id=181672>.
[40] Neidecker was in neither the 1931 issue of *Poetry* nor the 1932 anthology but was inspired by the
former to make contact with Zukofsky.

inclined to the politics of the left; and all (bar Niedecker) had Jewish ancestry; Rakosi, Zukofsky, and Reznikoff, moreover, grew up in households in which English was not the first language.[41]

Objectivism, then, is a dissident modernism, marking a significant break from the alignment in Pound and Eliot of modernist poetics and right-wing politics. Early sections of Zukofsky's long poem *A* engaged with Marxist economics, while Oppen and Rakosi were active members of the Communist Party, who gave up poetry to concentrate respectively on political activism and social work for many years. It is hard, however, to generalize about the poetry of the Objectivists. This body of work is very diverse, encompassing poems as different from one another as the baroque elaborations of Zukofsky's life poem *A*, Reznikoff's politicized poetical reworking of lawcourt documents in *Testimony*, Oppen's precise notation and interrogation of perceptions, and Niedecker's minimal refractions of folk forms.

Despite these differences, there are similarities between these poets in the orientation towards the poem and in procedure. In Objectivism, as with Vorticism, a more dynamic encounter with external reality than that realized in Imagism was envisaged. The poem needed to be capable of absorbing the energy and contradictions of industrial modernity. This 'imagism with wheels on' (to use Andrew McAllister's phrase) revised or complicated the Imagist ideals of directness and clarity in various ways.[42] Objectivism, like the writing of Williams, was notionally concerned with the 'direct treatment of the thing'. Yet, for the Objectivists, 'direct treatment' was rarely straightforward: their writing tended to problematize both the perceptual process and the minute details of the poetic speech that sought to document that process. Oppen, as Nicholls relates, decried the 'falsity' and 'posed tableau' of the Imagist poem, recommending 'a realist art in that the poem is concerned with a fact which it did not create'.[43] The oblique perspectives that characterize Objectivist writing might be viewed as a seizing of the relevant detail, the salient 'fact'. This is captured (in terms that Oppen would often cite) in Reznikoff's couplet 'Among the heaps of brick and plaster lies | a girder, still itself among the rubble.'[44] The intricacies of Oppen's 'realist art', a meeting of thought and 'fact', are based, as Nicholls suggests, on an objectification of thought: 'Things present themselves for reflection, but it is thought which, instead of conforming them to its own demands, now grasps itself in the object.'[45]

In the poems of *Discrete Series*, Oppen achieves effects of radical condensation as he glancingly delineates a reality that is consistently problematized by the hesitant syntax that he uses. This reality is industrialized, typically urban and thoroughly

[41] See Burt Hatlen, 'A Poetics of Marginality and Resistance: Objectivist Poets in Context', in Rachel Blau DuPlessis and Peter Quartermain (eds), *The Objectivist Nexus: Essays in Cultural Poetics* (Tuscaloosa: University of Alabama Press, 1999), 44–6. Hatlen suggests that Zukofsky, Oppen, Rakosi, and Reznikoff shared a 'specifically Jewish sense of language' (ibid. 46).

[42] Andrew McAllister, 'Introduction', in *The Objectivists* (Newcastle: Bloodaxe 1996), 11.

[43] Peter Nicholls, *George Oppen and the Fate of Modernism* (Oxford: Oxford University Press, 2007), 9.

[44] Charles Reznikoff, 'Jerusalem the Golden', sect. 69, in *Poems*, I (Boston: Black Sparrow Press, 2005), 121; first pub. by George and Mary Oppen's Objectivist Press (1934).

[45] Nicholls, *George Oppen and the Fate of Modernism*, 128.

modern, but it is presented in an impacted language that seems to deflect readerly involvement as much as it invites it. Michael Davidson suggests that in Oppen's work, 'the poem does not represent the mind thinking; it is the mind thinking itself'.[46] Such writing is engaged in the capture or enactment of experiential and cognitive processes, what Oppen described in his 'Daybook' as a lifelong desire 'to trace, to re-produce, the act of the world upon the consciousness'.[47]

Surrealism and its Legacy

The term 'Surrealism' was coined by Apollinaire.[48] His poetry registered the fragmentation, incoherence, and increased speed of modern urban life but also the marvellous latent in the everyday. The Surrealists learned from him and, in turn, created a rich heritage of techniques and practices: 'automatic writing, collaborations, experiments with random assemblages, simulations of paranoid states, dream journals, party games'.[49] From the outset Surrealism focused on 'the unconscious, the marvellous, the dream, madness, hallucinatory states'.[50] *The Magnetic Fields*, experiments with automatic writing carried out by André Breton and Philippe Soupault in 1919, produced a flow of highly charged images that have slipped the chains of logic but create sense at other levels. The Surrealists aimed at the liberation of desire, a revolution of consciousness and the total transformation of life. In this programme, poetry figured as a method of self-discovery working through images and transitions generated by the unconscious.

David Gascoyne records how, as a schoolboy, he had picked up copies of *La Révolution Surréaliste* (1924–9) and *Le Surréalisme au service de la révolution* (1930–3) in Zwemmer's on London's Charing Cross Road.[51] In 1933 he published 'And the Seventh Dream Is the Dream of Isis', his first attempt to write a Surrealist poem. From the semantic collision of the opening line with the characteristically Surrealist use of hyperbaton ('white curtains of infinite fatigue'), the poem builds through repetition with variation ('white curtains of tortured destinies') and parataxis ('she was standing at the window clothed only in a ribbon | she was burning the eyes of snails in a candle'). In 1935, after closer contact with the Surrealists, he went on

[46] Michael Davidson, *Ghostlier Demarcations: Modern Poetry and the Material Word* (Berkeley: University of California Press, 1997), 70.

[47] Cited in Nicholls, *George Oppen and the Fate of Modernism*, 12.

[48] Roger Cardinal and Robert Stuart Short, *Surrealism: Permanent Revelation* (London: Studio Vista, 1970), 12.

[49] Roger Shattuck, 'Introduction', in Maurice Nadeau, *The History of Surrealism* (Harmondsworth: Penguin, 1978), 27.

[50] Nadeau, *The History of Surrealism*, 86.

[51] David Gascoyne, 'Introductory Notes', in *Collected Poems, 1988* (Oxford University Press, 1988), p. xiv.

to produce *A Short Survey of Surrealism*, which concluded with translations of work by a range of poets including René Char, Paul Éluard, and Benjamin Péret. In 1936 he published his own collection of Surrealist poems, *Man's Life Is This Meat*, and was involved in organizing the London International Surrealist Exhibition.

Another participant in the London Surrealist Exhibition was the young Dylan Thomas. In his first volume, *18 Poems* (1934), in poems like 'The Force That Through the Green Fuse Drives the Flower', Thomas combines strikingly concrete imagery with an apparently simple diction and uses regular stanzaic forms with a play of assonance and alliteration, internal rhyme and half-rhyme, derived from the Welsh *cynghanedd*. The later poem 'Fern Hill' (1945) works in a similar way. The regular stanza forms provide the basis for patterns of rhetorical repetition with variation, but the simple language is freighted with echoes of popular saying and liturgy ('honoured among wagons'), folk tale and fairy tale ('once below a time'), subtly turned in a lyrical and sensuous evocation of childhood that has picked up on the spontaneous and irrational associations of Surrealism.

With the coming of war in 1939, Breton moved to the United States, and the Surrealist movement's historic period effectively came to an end.[52] However, there continued to be Surrealists, and the legacy of Surrealism remained to be developed by other poets. John Ashbery, for example, picked up on the need to divert linguistic material from its habitual usage in order to explore possibilities of alternative coherences, and to open up new areas of consciousness and other ways of meaning. Marjorie Perloff has drawn attention to the fluid 'dream content' of Ashbery's poetry.[53] In his early volume *Rivers and Mountains* (1966), for example, the title poem offers an indistinct narrative of would-be assassins and warfare which is constantly obscured by digressive concrete images and elaborations of uncertain status ('these moonless nights spent as on a raft | In the seclusion of a melody heard | As though through trees'). Site and map, event and its representation, constantly displace each other; conjunctions ('as on', 'as though') assert and with-draw their propositions; there are gestures towards a narrative but the narrative logic is frustrated and unfulfilled. In 'These Lacustrine Cities', in the same volume, Ashbery similarly plays with a show of logic that creates expectations of a connect-edness that are never fulfilled. Instead, the reader is confronted with false analogues, indeterminate conjunctions and pronouns, 'parts that belong to no whole, an absent totality'.[54] Pierre Reverdy commented on the Surrealists' use of Imagistic collisions: 'the more distant and apt are the relations between the two entities brought together, the stronger will be the image—the more emotive power and poetic reality will it have'.[55] A similar performative aesthetic operates in Ashbery's work: the poem

[52] Surrealist wartime and post-war activities in Britain are discussed in Michel Remy, *Surrealism in Britain* (Aldershot: Ashgate, 1999). For an account of the American dimension, see Dickran Tashjian, *A Boatload of Madmen: Surrealism and the American Avant-Garde, 1920–1950* (New York: Thames & Hudson, 1995).
[53] Marjorie Perloff, ' "Fragments of a Buried Life": John Ashbery's Dream Songs', in David Lehman (ed.), *Beyond Amazement: New Essays on John Ashbery* (Ithaca, NY: Cornell University Press, 1980), 66–86.
[54] Ibid. 81.
[55] Pierre Reverdy, cited by Cardinal and Short, *Surrealism*, 13.

becomes an arena for reflections, digressions, fragments of dialogue, hints at narra-tives, and the focus is on the text as performance as it simultaneously presents and reviews its materials.

Neither Ashbery nor Frank O'Hara would have thought of themselves as Surreal-ists—there were American Surrealists such as Charles Henri Ford and Parker Tyler who had consciously worked in the 1930s to bring French Surrealism into American poetry—but both Ashbery and O'Hara drew on the permissions granted by Surreal-ism in developing their own poetic innovations.[56] O'Hara is best known today for poems such as 'The Day Lady Died', based on a lunchtime walk through New York, where cultural diversity is registered through an ongoing accumulation of percep-tions in a colloquial mode derived from Williams.[57] However, elsewhere O'Hara draws on the Surrealist legacy for self-exploration. O'Hara had read fairly widely in French Surrealist poetry at Harvard before he met Ashbery and had produced Surreally inspired prose poems such as 'Oranges' and 'Meditations on Max Ernst's *Histoire Naturelle*', where surreal opacity allowed for the veiled exploration of family ghosts and homosexual desire.[58] In later poems such as 'Easter' or 'Hatred' (both written in 1952), O'Hara takes off from bizarre disjunctive images ('The razzle dazzle maggots are summary') to explore the urban landscape of gay cruising and sexual guilt respectively.[59] Formally, O'Hara found in Surrealism a way into the longer poems he wanted to write, using, for example, automatic writing and subconscious linkages for 'Second Avenue' and dream material in 'In Memory of My Feelings'. In poems such as these, O'Hara drew on Surrealist practices not for the purposes of pastiche but to develop a poetic form and language to engage with contemporary American culture and the more personal issues of memory, identity, and desire.

Like O'Hara, the English poet Lee Harwood found in Dada and Surrealism a means to develop his own distinctive poetic practice. At the start of his career, he had learned from Pound, Tristan Tzara, and Ashbery to work with 'the complexity of language and life' and to relish 'all their contradictions'; above all, he had learned to use language 'precisely and clearly', while remaining aware of its limitations.[60] The early poem 'As your eyes are blue . . . ' (1965) is collaged from fragments of memory, remembered conversations, disjunctive connections, but with a sense of quiet reflec-tion quite alien to the exclamatory practices of Surrealism. Later collections, like *HMS Little Fox* (1975), *Boston–Brighton* (1977), and *Old Bosham Bird Watch* (1977) collage 'the small daily details'[61] in an attentive mapping of the process by which a

[56] See Brad Gooch, *City Poet: The Life and Times of Frank O'Hara* (New York: Knopf, 1993), 146, for Ashbery's gloss on their role as 'fellow-travellers' of Surrealism.

[57] For a broader engagement with O'Hara's work, see Robert Hampson and Will Montgomery (eds), *Frank O'Hara Now: New Essays on the New York Poet* (Liverpool: Liverpool University Press, 2010).

[58] See Marjorie Perloff, *Frank O'Hara: Poet Among Painters* (Austin: University of Texas Press, 1979), 34, 38–42.

[59] 'Easter', in *The Collected Poems of Frank O'Hara* (Berkeley: University of California Press, 1995), 96.

[60] Lee Harwood, 'Foreword', in *Collected Poems 1964–2004* (Exeter: Sheersman, 2004), 12.

[61] Harwood, *Collected Poems*, 212.

reality is constructed, including movements between past and present, notations of observations, fragments of conversation, and citations from texts.[62]

MAINSTREAM MODERNISM: THE LONG POEM

One of the characteristic forms of the modernist tradition is the non-narrative long poem. It has been central to modernism from Pound and Eliot through to the present day. The modernist long poem has been conceived of as a revaluation of the epic, as an extended research project, or as a lifework. Pound's *Cantos* provided the model for all three.

From as early as 1904, Pound was planning a modern epic. He began the first draft of *The Cantos* in 1911; the poem ended with his death in 1972. *The Cantos* begins with the *Odyssey*, but the first canto approaches the oldest part of the *Odyssey* through a Renaissance Latin translation expressed in the rhythms and alliterative style of Old English poetry. Pound thus produces a celebration of cultural beginnings through the layering of historical instances. Subsequent early cantos invoke Browning, Ovid, Camoens, Dante, Provençal and Chinese poets, Flaubert, and Henry James, and bring in a range of historical figures. Through these devices of subject rhymes and the use of significant historical individuals, Pound produces his modernist epic as a poem containing history and as a form of cultural critique. He also places cosmo-politanism and an openness to non-European cultures at the centre of his project. As the cantos develop, Pound strives to articulate a vision of an earthly paradise through ideals of social and artistic order, and struggles to make this range of materials cohere, but the lasting power of *The Cantos* derives precisely from the failure to achieve closure and the engagement, instead, with uncertainty through the devices it deploys—the poetics of ellipsis and fragment, the suggestive collisions of the ideo-grammatic method, and the speaking through citation and the voices of others.

Pound knew that a Dantean schema was inappropriate for a modern epic: the model he provided foregrounded exploration, openness, and provisionality. The first showing of this project was entitled *A Draft of XVI Cantos*. There is a similar emphasis on the provisional and fragmentary deriving from the conception of the long poem as a major research project, as a lifework, in the writings of David Jones. During his lifetime he published *The Anathemata* (1952) and *The Sleeping Lord and Other Fragments* (1974), while *The Kensington Mass* (1975) appeared posthumously. *The Anathemata* has the subtitle 'Fragments of an Attempted Writing'; *The Sleeping Lord* volume similarly advertises its fragmentary nature; while *The Kensington Mass*

[62] Robert Sheppard suggests Harwood's collage method should be compared to the use of montage (and other experiments) in contemporary (*Nouvelle Vague*) French film. See his *The Poetry of Saying: British Poetry and its Discontents, 1950–2000* (Liverpool: Liverpool University Press, 2005), 104.

was published as an 'unfinished draft'. When Jones died in 1974, he left behind some 1,300 pages of unpublished manuscript, and it became apparent that everything he had written since 1935 was part of a single, wide-ranging work.[63] Like Pound and Eliot, Jones draws on the comparative method of Frazerian anthropology, but has turned it inside out to replace Frazer's relativism with the idea of eternal truths ('Bough-bearer, harrower').[64] Jones aims to 'show forth' his cultural inheritance—a mixture of Celtic, Germanic, and Latin history, myth, and legend—and to show it through a complexity of 'formal arrangement and contextual allusion' underpinned by biblical and liturgical patterns.[65]

For many, however, The Waste Land is the iconic modernist long poem. Its urban subject matter, its apparent impersonality, its collaging of pre-existing texts, and its deployment of the 'mythic method' have made it seem an exemplary modernist text. Marjorie Perloff has noted how 'The Love Song of J. Alfred Prufrock' laid the groundwork for The Waste Land with its shifting, multiple views of its subject; the 'attenuated hypotaxis' of its syntax; its mixing of discourses and registers; and its attentiveness to the semantic possibilities of sound.[66] Indeed, Perloff has argued that The Waste Land, with its fragmentation, parataxis, and collage method, should be seen as 'the brilliant culmination of the poetic revolution that began with "Prufrock"'[67] rather than as a new beginning. Eliot himself regarded Four Quartets (published between 1935 and 1942) as his major work. These are four meditations on time, death, and meaning organized around four locations, the four seasons, and the four elements (earth, air, fire, water). From his experience writing verse drama, Eliot had developed a flexible free-verse line and a high style capable of moving from abstract, philosophical meditation to the precise evocation of particular moments ('the evening circle in the winter gaslight'), from the quasi-biblical to the colloquial. Thus, the opening of 'Burnt Norton' shifts between meditative long lines (adapted from a dramatic speech) and intensely imagistic shorter lines (prompted by a line from Mallarmé), while the poem moves from the superimposition of childhood memories upon the experience of a deserted country house to an account of the London Underground abstracted to a mythic, spiritual level.

The most influential post-war engagement with the modernist long poem was Charles Olson's The Maximus Poems. This was started in 1950 and became a research project that occupied the last twenty years of Olson's life. Like Williams's Paterson, The Maximus Poems focuses on a particular place (Gloucester, Massachusetts), but Olson uses that concentration on the local as a way of engaging with the intellectual

[63] See Harman Grisewood and René Hague (eds), The Roman Quarry (London: Agenda Editions, 1981), p. xiv.

[64] See Robert Fraser (ed.), Sir James Frazer and the Literary Imagination (Basingstoke: Macmillan, 1990).

[65] David Jones, 'Preface' to The Anathemata (London: Faber, 1952), 12.

[66] Marjorie Perloff, 21st-Century Modernism (Oxford: Blackwell, 2002), 24ff. 'Attenuated hypotaxis' is Brian Reed's term for the 'tenuously interconnected' clauses and phrases of Hart Crane's poetic syntax; see 'Hart Crane's Victrola', Modernism/Modernity, 7 (Jan. 2000), 99–125.

[67] Perloff, 21st-Century Modernism, 39.

bases of Western culture. He explores Gloucester's history back to its 1623 founding and takes European philosophy back to the pre-Socratics. The poem engages in an act of self-investigation and self-making, at the same time as it explores the possibility for a meaningful political life. Olson encountered the serial music of Pierre Boulez in 1951, and this enabled the conceptualization of his long poem as a serial poem, in which each section would have its own structure and method.[68] The poem begins as a succession of 'letters' addressed to the poet Vincent Ferrini in Gloucester: as a result it focuses, from the start, on the here and now and the poem's own process of discovery. Olson's major contribution to the development of the long poem came from his conception of 'projective verse'.[69] This was a poetic theory based on the body and breath of the poet: its importance resided, in part, in the notion of the line length determined by the poet's breath and, in part, in the resulting expressive use of the page space. This led to the 'open field' poetics of the 1960s and 1970s and a renewed interest among poets in textual layout and typography.

Zukofsky's A is, with The Cantos, Paterson, and Maximus, one of the major achievements of modernist long-form poetry. This twenty-four-part poem was written between 1928 and 1974 and finally published as a single volume in 1978, shortly after the poet's death. In the words of Zukofsky scholar Mark Scroggins, this uncompromisingly difficult poem is 'a work in which the multifarious and oddly dovetailing particulars of contemporary history, of the events of the past, and of the whole pageant of human language, literature, and culture have been filtered and ordered through the consciousness of a single thoughtful, stubborn, sensitive and endlessly imaginative poet'.[70] A incorporates an exhilarating array of vocabularies, networks of meaning and association, styles of poetry, and intellectual currents. It is squarely in the Poundian line of descent: wedding a compendious intellectual ambition to an instinct for hard, clean-lined poetry. However, in the early stages of A, Zukofsky substituted Marxian economic theory for Pound's fulminations against usury in The Cantos: A 8 and A 9 notably engage with Marx's Capital, with A 9 interweaving sections of Capital and Cavalcanti's formally intricate love poem 'Donna mi prega' (which Pound had translated on three occasions). Later in the poem, Spinoza is the presiding intellectual spirit and Zukofsky's family life takes precedence over his social concerns. By the very end of the poem, in A 22 and 23, Zukofsky presents dense five-word lines that combine a staggering range of allusion, citation, paraphrase, and translation. For Zukofsky, poetry is driven as much by sound as by meaning. His writing is thus resistant to conventional exegesis. A 23, for example, opens with the following stanza:

[68] George F. Butterick, A Guide to the Maximus Poems of Charles Olson (Berkeley: University of California Press, 1978), p. xv.

[69] Charles Olson, 'Projective Verse', in Selected Writings, ed. Robert Creeley (New York: New Directions, 1966), 15–26.

[70] Mark Scroggins, The Poem of a Life: A Biography of Louis Zukofsky (Emeryville, Calif.: Shoemaker & Hoard, 2007).

An unforeseen delight a round
beginning ardent; to end blest
presence less than nothing thrives:
a world worn in whose
happiest reins preempt their histories.

Such work has proved a powerful model for later experimental writers.

Olson's Black Mountain College student Edward Dorn produced his own distinc-
tive contribution to this tradition with his long poem *Slinger* (1975), a counter-
cultural and philosophical comic–western epic poem.[71] The areal explorations of
earlier poems such as *Idaho Out* and *The North Atlantic Turbine* give way to a
fantastic quest by stagecoach from Mesilla, New Mexico, to Las Vegas with a
representative range of characters including 'the gaudy Madam', Miss Lil (Mae
West raised to mythic status), and the talking (and stoned) horse Claude Lévi-
Strauss.[72] The most unsettling of these is 'I': the reader is caught between reading
'I' as first and third person. His death early in Book II produces a certain amount of
pronominal confusion ('But it makes me sad | to see I go, he was, | I mean I was so
perplexed'), and, when he subsequently leaves the coach 'unaided', after being filled
with five gallons of LSD, it is, as Slinger observes, 'an original moment | in ontologi-
cal history', an enactment of Olson's injunction to find an alternative to 'the ego-
position'.[73] Conventions of narrative, character, and plot are overturned by a con-
stant alertness to the potentialities of language—puns, palindromes, specialist regis-
ters, typographic play—in an extended exploration of the relations between
language, meaning, thinking, being, and consciousness.[74]

The contemporary British poet who has most obviously worked in this tradition of
the long poem as a major research project is Allen Fisher. During the 1970s, Fisher
worked on *Place*.[75] As the title suggests, Fisher's work had its roots in Olson's
projective verse and poetic investigation of place, but Fisher complicated the project
by adding an interest in procedure to the Olsonian emphasis on process. Robert
Sheppard argues that in *Place* Fisher explores 'linguistic re-orderings of experience'
through juxtaposition and collage, but he also draws on the wide range of reading
that constitutes a major part of his research, combined with a disruption of sequence
and opening out of linkages, 'to create a divergent' and deliberately contradictory
'patterning of self and place'.[76] After the ten-year project *Place*, Fisher began the

[71] Edward Dorn, *Slinger* (Berkeley: Wingbow Press, 1975). *Gunslinger*, books I and II, was published by
Black Sparrow Press in 1968 and 1969; *The Cycle* and *Gunslinger* book III by Frontier Press in 1971 and
1972.

[72] Edward Dorn, *Idaho Out* (London: Fulcrum Press, 1965), and *The North Atlantic Turbine* (London:
Fulcrum Press, 1967). Both are included in Edward Dorn, *The Collected Poems, 1956–1974* (Bolinas, Calif.:
Four Seasons Foundation, 1975).

[73] Olson, *Selected Writings*, 83.

[74] See Robert von Hallberg, *American Poetry and Culture, 1945–1980* (Cambridge, Mass.: Harvard
University Press, 1985), 218–21.

[75] Allen Fisher, *Place* (Hastings: Reality Street Editions, 2005).

[76] Sheppard, *The Poetry of Saying*, 62, 63. See also Peter Barry, *Contemporary British Poetry and the City*
(Manchester University Press, 2000), 179–85.

twenty-three-year project *Gravity as a Consequence of Shape* (1982–2005). With this project, Fisher moves away from Pound and Olson to foreground procedure and the display of procedure. Collage is used to produce a multivocal text, a play of discourses questioning each other's limits and authority, discontinuities that are also 'creative linkages'.[77] Transformative procedures, mirroring with variations, work to similar effect, emphasizing textuality and proliferating linkages beyond any possibility of totalization.

In the American poet Susan Howe's work of the 1980s and early 1990s, a version of the long poem emerges that displays a critical relationship to Howe's antecedents. This work can be seen as a kind of 'serial poem' that makes a point of resisting the legislating voices that drive the epics of Olson and Pound. Howe, moreover, pushes further than her precursors into the realm of unintelligibility. As Peter Nicholls remarks, Howe's work implies a 'fundamental reformulation of Poundian principle' because of its emphasis on the 'unreadable' in history.[78] What is made manifest in Olson (and, behind him, Pound) remains ultimately hidden for Howe as the intransigence of the historical fragment blocks the interpretative impulse. In Howe's writing there is sometimes an explicit gendering of the hesitancy that affects the formal contours of the work. For Howe, moreover, the modernist long poem brings a problem of scale. Her own work can be read at many interlocking levels: the single page; facing pages; the discrete sequence within the serial poem; the serial poem itself; the book containing three or four related serial poems. Works such as *A Bibliography of the King's Book, or, Eikon Basilike* and *Melville's Marginalia* combine a radical vision of historical method with a reappraisal of the book as poetic object. As a result, in this sceptical extension of the tradition the great ambition of the modernist long poem is both preserved and negated.

LATE MODERNISM

Objectivism (and the objectivist poets) subsided into semi-obscurity after their brief efflorescence in the early 1930s. Zukofsky and Reznikoff continued to publish, but Oppen and Rakosi had both stopped. Niedecker, who worked as a hospital cleaner for many years, published nothing for fifteen years after *The New Goose* (1941). However, Objectivism had a remarkable second life in the 1960s. One important factor in the rediscovery of this writing was Donald Allen's influential anthology *The New American Poetry* (1960), whose confluence of Beat, New York School, and Black Mountain poets heralded a new generation of modernist writing in North America.

[77] Sheppard, *The Poetry of Saying*, 200.
[78] Peter Nicholls, 'Beyond *The Cantos*: Pound and American Poetry', in Ira Nadel (ed.), *The Cambridge Companion to Ezra Pound* (Cambridge: Cambridge University Press, 1999), 155–6.

In his Preface, Allen begins by noting the major post-war achievements of the first generation of modernist poets, including Williams's *Paterson*, Pound's *Pisan Cantos*, and H.D.'s *Helen in Egypt*. The 'New American Poetry' marked a resurgence of modernism and a revaluation of its traditions. Cid Corman's *Origin* magazine dedicated issues to both Niedecker and Zukofsky. Oppen embarked on a major new phase of creativity, even winning the Pulitzer Prize with his 1968 collection *Of Being Numerous*; Reznikoff published his monumental *Testimony* in 1965 and 1968; Zukofsky published his collected shorter poems and various sections of *A*; while Niedecker's work was published by the UK small presses Wild Hawthorn and Fulcrum.

As this publication history suggests, there was a similar resurgence of modernism in the UK.[79] The interest of the English poet Andrew Crozier prompted Rakosi to return to writing. Similarly, the friendship between Basil Bunting and the young Tom Pickard prompted Bunting to write his major work *Briggflatts* (1966). Bunting had worked with Ford on the *transatlantic review* and was included in Zukofsky's *An 'Objectivist' Anthology*, but had written nothing during the thirteen years before *Briggflatts*. Attention to sound, cadence and rhythm, and a use of musical form have always been a feature of Bunting's poetry. Bach and the idea of the long poem as a series of musical movements are important for *A*, and Eliot had used musical form in *The Four Quartets*—working various themes through four parallel structures, resolving each quartet and the whole sequence through a final restatement. Bunting, who was fascinated by Scarlatti's sonatas, similarly conceived of the separate sections of *Briggflatts* as musical movements: thematic fragments are stated, repeated, interwoven through the six sections of the poem, gaining resonance and nuance through repetition. The poem's musicality works down to the micro level of consonant and vowel, while the interwoven motifs perform an evaluation of a poet's life, an evocation of memory and place, an exploration of the relation between life and art. Nostalgia also becomes the vehicle for an assertion of a specific local, Northumbrian culture through landscape, vocabulary, and historical reference.

Michael Shayer and Gael Turnbull through *Migrant* magazine (1959–60) and the related Migrant Press provided a conduit between British and North American late modernists. Migrant Press also published one of the most influential English modernist poems of the 1960s, Roy Fisher's *City* (1961). Fisher's revisiting of European modernism reasserted the continuing validity of that tradition for late twentieth-century poetry. More importantly, he showed a way to handle urban material and to give language to provincial working-class life. Through an assemblage of alternated poems and prose sections, he explored the dynamics of his city—at times as quasi-documentary reportage, but more often through Surrealist techniques of association and hallucination. Fisher's perceptual and conceptual games aim 'to make the city strange' for himself and the reader.[80]

[79] See Eric Mottram, 'The British Poetry Revival, 1960–1975', in Robert Hampson and Peter Barry (eds), *New British Poetries: The Scope of the Possible* (Manchester University Press, 1993), 15–50.

[80] See Sheppard, *The Poetry of Saying*, 77–102.

Turnbull and Roy Fisher (along with Tom Raworth, Barry MacSweeney, Bill Griffiths, Lee Harwood, and Allen Fisher) are some of the leading figures in what Eric Mottram termed the British Poetry Revival.[81] This was a loose grouping of poets who consciously situated themselves in the modernist tradition and saw in that tradition the permission for radical experimentation with form and language. One of the important centres for that activity in London was Bob Cobbing's Writers' Forum workshop (which began in 1952 and still continues). Cobbing's own practice had worked through the collaging and cutting up of found textual materials and through various forms of permutational writing to the exploration of visual and sound poetries. Visual poetry has a continuous twentieth-century history from Apollinaire and the Futurists through concrete poetry and lettrism, Steve McCaffery and Johanna Drucker, to contemporary digital and networked media work, while sound poetry can be tracked back to Dada performance. Cobbing's foregrounding of performance, his exploration of polyphonic composition through collaboration, and his attention to visual poetics were developed further by various workshop graduates such as cris cheek, Lawrence Upton, Ulli Freer, and Maggie O'Sullivan. Others, such as Gilbert Adair, Robert Sheppard, and Adrian Clarke, were instrumental in the naming and development of Linguistically Innovative Poetry, an explicitly theoretically informed engagement with the poetry of the British Poetry Revival that explored, in its own practice, the implications of poststructuralist theories of language and subjectivity.

Since the 1960s, another site for some of the most significant late modernist poetry has been Cambridge, though this descriptor does not necessarily designate either the university or the town itself. 'Cambridge' is best understood as an axis or nexus for which the work of the poet J. H. Prynne is of particular significance (the very existence of a 'Cambridge school' is, as with many such groupings, disputed by those who are supposed to belong to it). In the late 1960s, the informal magazine the *English Intelligencer* (co-edited by Peter Riley and Andrew Crozier) became the focus for an upsurge of poetic activity. Others participating included Douglas Oliver, Tom Raworth, John James, John Riley, Tom Pickard, Barry MacSweeney, and Prynne himself. All of these writers shared an interest in the New American Poetry and a dislike of the 'Movement', the parochial and conservative orthodoxy in post-war English poetry. They were, as Crozier and Tim Longville suggest, interested in the modernist tradition of Pound and Williams, not Pound and Eliot.[82] For Prynne himself, Olson was of vital importance (Prynne corresponded with Olson at some length). For others, such as John James, Frank O'Hara was of more immediate interest. Cambridge was one of the regional centres of the British Poetry Revival, but 'Cambridge poetry' has developed its own tradition subsequently. Unlike London poetry, for example, much Cambridge writing has retained a vestigial commitment to lyric, albeit of an involuted, radical

[81] A term first used by Tina Morris and Dave Cunliffe and subsequently popularized by Mottram (Sheppard, *The Poetry of Saying*, 35). See Mottram's section of Gillian Allnutt, Fred D'Aguiar, Ken Edwards, and Eric Mottram (eds), *The New British Poetry* (London: Paladin, 1988), 131–261.

[82] Andrew Crozier and Tim Longville (eds), *A Various Art* (London: Paladin, 1990), 'Introduction', 12.

kind: the writing is dense, alert to numerous philosophical, psychological, and poetic engagements, both contemporary and historical. Poets associated with this Cambridge school include John Wilkinson, Geoff Ward, Denise Riley, D. S. Marriott, Ian Patterson, Rod Mengham, Drew Milne, Simon Jarvis, Andrea Brady, and Keston Sutherland.[83] Unlike the roughly contemporaneous language writers of the US, poets of the Cambridge axis have engaged in relatively little theorization of 'poetics' (though many have published academic criticism). An obvious exception is Veronica Forrest Thomson, whose *Poetic Artifice* (1978) argued that, through artifice, poetry challenged 'ordinary linguistic orderings of the world' and induced us to consider 'its alternative linguistic orders as a new way of viewing the world'.[84] From this Wittgensteinian basis, Forrest Thomson explored, in both her poetry and her theoretical work, the linguistic construction of the subject and of experience.[85] Denise Riley, too, has explored the nexus of language, subjectivity, gender, and politics in both poetry and theory.[86]

The writing of Prynne has changed considerably since the 1960s, but it has its basis in classic modernist techniques 'such as multiplicity of discourses and the absence of a consistent speaking subject'.[87] The poetry engages the reader through its linguistic shifts and juxtapositions and through its rigorous negotiation of the human and inhuman, and of bodily and linguistic processes. More recent work frequently uses multiple vocabularies to monitor the ethical impasses that confront the individual enmeshed in the signifying systems of late capitalism. Embodiment and subjective agency are alike problematized in terms that draw on specialized languages as diverse as those of geology, economics, meteorology, and computing, among numerous other possibilities. Prynne's critical engagement with Olson has produced an influential post-Olsonian poetics and a 'post-phenomenological inquiry into knowledge and language'.[88]

The best-known late modernist development is North American 'Language Poetry'.[89] Language writing was a self-consciously avant-garde movement, loose, like Objectivism, but, unlike the 1930s grouping, enduringly collective in nature. Influential language writing magazines included *This* (edited by Robert Grenier and

[83] For a recent international anthology of contemporary modernist poetry as seen from this perspective, see Rod Mengham and John Kinsella (eds), *Vanishing Points: New Modernist Poems* (Cambridge: Salt, 2004).

[84] Veronica Forrest Thomson, *Poetic Artifice: A Theory of Twentieth Century Poetry* (Manchester: Manchester University Press, 1978), p. xi.

[85] See Alison Mark, *Veronica Forrest Thomson* (Tavistock: Northcote House, 2001).

[86] See e.g. Denise Riley, *The Words of Selves: Identification, Solidarity, Irony* (Stanford, Calif.: Stanford University Press, 2000).

[87] N. H. Reeve and Richard Kerridge, *Nearly Too Much: The Poetry of J. H. Prynne* (Liverpool: Liverpool University Press, 1995), 1.

[88] Drew Milne, 'The Art of Wit and the Cambridge Science Park', in Robert Crawford (ed.), *Contemporary Poetry and Contemporary Science* (Oxford: Oxford University Press, 2006), 183. See also Anthony Mellors, *Late Modernist Poetics from Pound to Prynne* (Manchester: Manchester University Press, 2005).

[89] See Ron Silliman (ed.), *In the American Tree* (Maine: National Poetry Foundation, 1986), and Bruce Andrews and Charles Bernstein (eds), *The L=A=N=G=U=A=G=E Book* (Carbondale: Southern Illinois University Press, 1984).

Barrett Watten), *Hills* (edited by Bob Perelman), *Poetics Journal* (edited by Watten and Lyn Hejinian) and *L=A=N=G=U=A=G=E* (edited by Charles Bernstein and Bruce Andrews). As it evolved, language writing was often theoretical in nature, consistently discussing poetics in relation to Marxism and the postmodern theory that was then in the ascendant in the academy. Other important influences were Gertrude Stein, Russian Constructivism, the linguist V. N. Volosinov, Carlos Williams, Zukofsky, and the New York and Black Mountain schools of poetry. Although the language writers were diverse in their methods, they shared a scepticism about the uninterrogated subjectivity of the voices that speak in the poems of what Charles Bernstein calls 'official verse culture'.[90] For the language writers, uncomplicated representations of experience, mediated by the fastidiously observed 'lyric "I"', failed to reflect on language itself and its constitutive role in both individual and social being. A mode of writing that reflected on and questioned the operations of language became, in some versions, a counter-hegemonic tool, a means of loosening the stranglehold of late capitalism on modes of representation. Other concerns of language writers were shared by their British contemporaries: these included artifice, referential indeterminacy, process, and polyvocality. Frequently, these were combined with ludic elements as well as an intellectual self-consciousness. While critics tended to see their writing as anti-referential, language writers preferred to point to an expanded notion of reference. Protagonists among what would become a major literary movement include Charles Bernstein, Barrett Watten, Bruce Andrews, Bob Perelman, Lyn Hejinian, Rae Armantrout, Steve Benson, and Carla Harryman, but the range of writing is too wide to be summarized here.

In *Poetic Artifice*, Veronica Forrest Thomson drew attention to the paradox of 'a tradition of innovation',[91] but that is what 'modernism' has become for poetry—not a set of conventions, but a permission to experiment with form and language, to explore the materiality of the medium, to engage with the means of distribution or delivery, that is valid for both the written word and new technologies of writing.

[90] Charles Bernstein, 'The Academy in Peril', in *Content's Dream* (Los Angeles: Sun & Moon Press, 1986), 247–9. The term had been used earlier by Mottram.

[91] Thomson, *Poetic Artifice*, 125.

CHAPTER 5

..

MODERNIST NARRATIVES

REVISIONS AND REREADINGS

..

DAVID JAMES

'WHAT stimulates him is *new ways of doing*, and technical processes, and not *things to be done*.' Wyndham Lewis here is talking about Joyce, homing in on a trait that 'shows a true craftsman's impartiality'.[1] But Lewis also indexes an impulse in modernism at large by emphasizing the way technique has become a source of stimulation, no longer serving functional ends, proving that 'processes' are more important than the product that eventually gets 'done'. In the same vein, albeit in a later twentieth-century moment, the novelist and critic William H. Gass positions himself as a leading inheritor of one of modernism's most iconic experimenters, Gertrude Stein, by asserting that an 'artist's fundamental loyalty must be to form, and his energy employed in the activity of making'.[2] Gass's sentiment, like Lewis's, has a considerable back story, one that pre-dates modernist fiction as we retrospectively frame it. For that notion of 'loyalty' to form returns us to the classical understanding of *poiesis*, where form alone is defined in equally dynamic terms. Again it denotes there a procedure of doing and form*ing* rather than surface decoration. And although Gass looks to high modernism's more pyrotechnic instances for support, his sense of the vivacity of form extends a defence of the writer-as-maker that spans centuries:

[1] Wyndham Lewis, *Time and Western Man*, ed. Paul Edwards (Santa Rosa, Calif.: Black Sparrow Press, 1993), 88.
[2] William H. Gass, *Finding a Form* (New York: Knopf, 1996), 35.

from Sidney's notion of the poet building 'a speaking picture', to Schiller's organic model of composition where technique should ideally efface itself, emerging without contrivance to ensure the artwork operates as a 'living form'.[3] It's a defence that Ben Jonson rehearses too, reminding us in *Discoveries* that by accepting the poem itself as 'the end and fruit of [the poet's] labour' we can begin to recognize that 'Poesy is his skill or craft of making; the very fiction itself, the reason or form of the work.'[4]

Recognition of the way form's vitality elevates it above the scaffold of practical devices or compositional rules evades convenient periodization, connecting disparate writers and genres across time. Yet although this imperative to think of form as something processual rather than prescribed isn't the sole preserve of literary modernism, it acquired a new currency for early twentieth-century writers who irrevocably changed what fictional narration could do.

So while Lewis may have complained in *Time and Western Man* (1927) that 'We have turned away from the what is *in-the-making*, from the "becoming", the world of *action*,'[5] the prospect of fiction's malleability, its amenability to being remade, provoked writers of his generation to reach new frontiers in subject matter and style. If we move a year on from Lewis's rather resigned warning, we find Rebecca West echoing in a more positive light Jonson's distinctions between 'fruit' and 'craft', between 'the thing done, the doing, and the doer'.[6] In *The Strange Necessity* (1928) West asserts that literary expressions of inner mental states 'cannot be arranged according to a mechanical symmetry'. Instead, she writes, it's only by 'passing... material through his imagination and there experiencing it' that the writer 'achieves the same identity with what he makes'.[7]

Equivalences between experience and making, sensibility and style, will loom large throughout my synoptic discussion here. While the following sections do move chronologically, I also want to read against the grain of that scheme in which modernist fiction progresses neatly in a series of stages, with each new step outmoding previous advances. Rather, I will be emphasizing connections between techniques that show writers reaching back in time even while setting fresh goals, a dialectic between tradition and experiment that helps us to correct the notion that fiction can be 'modernist' only if it proves itself to be unprecedented. That's why I have opened by emphasizing how certain dynamics of technique—pointing either to allegiances between writers or to self-differentiating enterprises—can offer discrete touchstones within a bigger picture of fiction's development through the modernist period.

[3] Sir Philip Sidney, *A Defence of Poetry*, ed. J. A. van Dorsten (Oxford: Oxford University Press, 1966), 25; Friedrich Schiller, 'Kallias, or, Concerning Beauty: Letters to Gottfried Körner', 23 Feb. 1793, in *Classical and Romantic German Aesthetics*, ed. J. M. Bernstein (Cambridge: Cambridge University Press, 2003), 165.

[4] Ben Jonson, *Timber, or, Discoveries*, in *The Oxford Authors: Ben Jonson*, ed. Ian Donaldson (Oxford: Oxford University Press, 1985), 583.

[5] Lewis, *Time and Western Man*, 409.

[6] Jonson, *Discoveries*, 583.

[7] Rebecca West, 'The Strange Necessity' (1928), in *The Strange Necessity: Essays and Reviews*, introd. G. Evelyn Hutchinson (London: Virago, 1987), 17, 16.

My effort here will be to coordinate micro-analyses of form as a way of telling a macro-historical story of key narrative transformations. This is an attempt to bring a certain precision to bear on individual cases of experimentation, while rescaling such localized evaluations to deal with kinships across internally variegated decades. My movement between stylistic detail and synoptic affinities has something in common with the work of world literature theorists, who point out that historical phases should be conceptualized in fractal rather than linear terms, phases defined by *moments* of innovation that may also resist preconceived national paradigms. This chapter's Anglo-American corpus of representative writers may not exactly complement current approaches to modernism's global development, which urge us to adopt a more 'spatialized' way of reading modernist practices as they take the 'form of cultural translation' or international exchange.[8] That said, I take from this transcultural kind of critical persuasion the refusal of 'a bird's-eye view' of artistic change, refusing it in favour of what Wai Chee Dimock calls 'a ground-level analysis of the complex membership of individual texts, focusing on words and syntax'.[9] To work at that level is to plot a journey through early to mid-twentieth-century fiction that connects specific formal elements to a larger sense of modernism's periodic evolution. While it remains but one mode of inquiry among many, to see the growth of narrative form not as evenly progressive but as marked by transitions in which recapitulation and rupture, tradition and innovation, often go hand in hand, we can facilitate a diachronic account of the development of modernist fiction that also shows just how *episodic* that development was.

If we want to view new procedures in modernist fiction as a matter of episodes, however, we need to locate where certain advances were born out of coalescences between writers whose aims seem implicitly at odds. Dorothy Richardson intimates this sense of collective endeavour when reflecting on the new territory her contemporaries were mapping. Richardson was prescient about the question I posed above of how we might explain modernist fiction's internal variation without losing touch with the distinctiveness of individual works. 'An interesting point for the critic', she wrote in 1934, 'who finds common qualities in the work of Proust, James Joyce, Virginia Woolf & D.R. is the fact that they were all using "the new method", though very differently, simultaneously.'[10] Making, at the same time, but in diverse ways—such was the creative climate of the period, implies Richardson. If anything unites the writers I consider below, it's the implication that doing different things with 'common qualities' revealed again how form

[8] See Susan Stanford Friedman, 'Periodizing Modernism: Postcolonial Modernities and the Space/Time Borders of Modernist Studies', *Modernism/Modernity*, 13/3 (2006), 430. See also Sara Blair, 'Local Modernity, Global Modernism: Bloomsbury and the Place of the Literary', *ELH* 71 (2004), 813–38; Laura Doyle and Laura Winkiel (eds), *Geomodernisms: Race, Modernism, Modernity* (Bloomington: Indiana University Press, 2005); and Anita Patterson, *Race, American Literature and Transnational Modernisms* (Cambridge: Cambridge University Press, 2008).
[9] Wai Chee Dimock, 'The Egyptian Pronoun: Lyric, Novel, the *Book of the Dead*', *New Literary History*, 39 (2008), 620.
[10] Dorothy Richardson, letter to Sylvia Beach, Dec. 1934, in *Windows on Modernism: Selected Letters of Dorothy Richardson*, ed. Gloria G. Fromm (Athens: University of Georgia Press, 1995), 282.

was scarcely static or ornamental. It became instead a stage set for demonstrating where individuality and affiliated ambition, personalized ingenuity and public prestige, mutually *in*formed one another, as writers watched each other's variants of that 'new method' emerge. Among those who first took the limelight on that stage, there is no better person to start with than Henry James: the novelist who seemed to treat form as coexistent with the dramatic content of his work, who was subsequently so amenable to the New Critics' institutionalized formalism, yet who ultimately resisted, paradoxically, the implication that form should be an end in itself—or, for that matter, a suitable point of departure.

Form, asserted James in 1884, 'is to be appreciated after the fact: then the author's choice has been made, his standard has been indicated; then we can follow lines and directions and compare tones and resemblances'.[11] The rise of the art novel in early modernism grew out of this paradox: that fiction should be the product of care and industriousness, of a writer's heightened and honed sense of 'choice', while at the same time possessing an 'infinite' 'elasticity', in James's terms, that exceeds all predeterminations or benchmarks of success. More often than not, James waxed commonsensical about this contradictory marriage of method and freedom by highlighting their interdependency as essential: 'The story and the novel, the idea and the form, are the needle and thread, and I never heard of a guild of tailors who recommend the use of the thread without the needle, or the needle without the thread.'[12] This anecdote points to that tension between design and organicism which remained so productive for James, a tension that compels the writer to tread a middle road with artifice on one side and fiction's own 'free character' on the other.[13] As James would later reiterate on the threshold of the new century, the novel 'has the extraordinary advantage . . . that, while capable of giving an impression of the highest perfection and the rarest finish, it moves in a luxurious independence of rules and restrictions'.[14] It is here that we begin with the first phase of modernist narrative: with relations between the novel's capaciousness as a form and devotion to evoking the nature of perception.

VALENCES OF IMPRESSIONISM

The fiction we will encounter in this phase, however, might arguably be seen as distinct from, rather than logically preceding, the era of experimentalism that matures in high modernism. It should be said that the more familiar language of fracture peaking in the 1920s and 1930s seems incompatible with the figures I discuss here (from the end of the

[11] Henry James, 'The Art of Fiction', in Leon Edel (ed.), *Literary Criticism: Essays on Literature, American Writers, English Writers* (New York: Library of America, 1984), 50.
[12] Ibid. 60. [13] Ibid. 61.
[14] Henry James, 'The Future of the Novel', in Edel (ed.), *Literary Criticism*, 105.

nineteenth century to the First World War), who were inclined to extend traditional means rather than to overturn them. With its reputation for making a supreme craft out of the depiction of mentation, it's easy to set Impressionism's apparent meticulousness apart from the exuberance of the following decades. Nevertheless, in their commitment to representing mental processes, and in their conversations about the experimenter's responsibility to his or her subject, this group of novelists looked ahead to debates about the social, ethical, and epistemological *work* of fiction which fuelled aspirations of a more revolutionary kind in years to come.

Yet if Impressionism contained the kernel of priorities still to flourish, it was also a phase for the refinement and extension of concerns already circulating for Victorian writers—a rearward reach that prompts us again to reassess the way we periodize modernism's aesthetic beginnings. James's assertion that 'impressions *are* experience'[15] directs us to a cluster of analogies between feeling and form that punctuated the critical writings of novelists after James who developed affinities—sometimes elective, frequently contentious—with the artistic and philosophical aims of Impressionism at large. Again, James wasn't the first to claim that 'A novel is in its broadest definition a personal, a direct impression of life.'[16] The idea was talismanic for Hardy, too, who in his defence of *Tess of the D'Urbervilles* (1891) asserted 'that a novel is an impression, not an argument; and there the matter must rest'.[17] For Hardy, this connection between narration and the impression's ephemerality served an incendiary purpose, enabling him to preserve *literary* fiction from being reduced to didactic ends. James was wary of such instrumentalism as well. And we have already seen how, in 'The Art of Fiction', James anticipates his New York edition prefaces by making a clear case for the novel's resistance to prescriptive rules, a resistance with one significant exception: the rule of perspective. If, in Hardy's view, the novel surpassed logical, ordered argumentation because it sought to express the contradictions and obliquities of perception, so for James perspectivism served a dramatic as well as stylistic purpose. Point of view could provide thematic as well as purely formal interest, revealing how the impression was not merely part of the texture of free indirect discourse but also operated at the level of diegetic action.

This notion that observations and the perspectival way in which they are recorded could function dramatically while being a constitutive element of form is addressed in James's Preface to *The Portrait of a Lady*: 'The spreading field, the human scene, is the "choice of subject"; the pierced aperture, either broad or balconied or slit-like and low-browed, is the "literary form"; but they are, singly or together, as nothing without the posted presence of the watcher—without, in other words, the consciousness of the artist.'[18] James is not advocating the complete depersonalization of the author. Far from wanting to efface himself, this ideal compositional scenario depends

[15] James, 'The Art of Fiction', 53. [16] Ibid. 50.

[17] Thomas Hardy, 'Preface to the Fifth and Later Editions' (1892), in *Tess of the D'Urbervilles*, ed. Juliet Grindle and Simon Gatrell (Oxford: Oxford University Press, 2005), 5.

[18] Henry James, 'Preface' to *The Portrait of the Lady*, in *The Art of the Novel: Critical Prefaces*, ed. Richard P. Blackmur (New York: Scribner, 1934), 46.

on the capacity of the writer as 'watcher' to choreograph the synthesis of location and observation, 'scene' and 'aperture'. Form is here analogically aligned with a camera obscura, endlessly reshaped to frame different kinds of picture planes, from the panoramic to the pinhole view. In *The Ambassadors* (1903), it is as though Strether is perpetually falling foul of such shifts from full visibility to self-doubt, as James switches from that 'broad' perspective to 'slit-like' snapshots, from the impression as lingering mental image to the idea of the impression as glance, fleetingly captured and lost with equal suddenness. Indeed, the inadequacy of visual discernment becomes a recurrent motif for *The Ambassadors*, part of James's persistent questioning of the supremacy of sight. He angles this inquiry towards his focalizing protagonist as 'Strether, at his glass, finished dressing; consulting that witness moreover on this last question. *Was* he looking preternaturally fit? There was something in it perhaps for Chad's wonderful eye, but he had felt himself for hours rather in pieces.'[19] It's a moment of self-scrutiny rendered more touching than forensic by the free indirect style in which Strether's self-inspection is relayed, exemplifying the rewards of substituting the *telling*, as Percy Lubbock would recommend, with a mode of *showing*, where 'in one case the reader faces toward the storyteller and listens to him, in the other he turns toward the story and watches it'.[20] This impulse to show rather than tell doesn't lend itself to every Impressionist narrative. With James at our side and Lubbock's *The Craft of Fiction* as our guide, we wouldn't be mistaken in thinking that what Impressionism gave to the early modernist novel was a predominantly visual register of (mis)apprehension. But despite the rhetoric of indirectness we expect from James, the role of the teller cannot be neglected so easily in the work of writers who followed in his wake.

'I have, I am aware, told this story in a very rambling way so that it may be difficult for anyone to find their path through what may be a sort of maze. I cannot help it.'[21] So admits Dowell in the famous reprise of his priorities as a narrator that opens the fourth section of Ford Madox Ford's *The Good Soldier* (1915). This kind of modesty topos, with its admission of inconsistency, punctuates Dowell's path as a storyteller throughout. Confessional self-evaluation becomes the chosen mode, as he shuttles between having confidence in his own recollections and the concession that past experiences never return for any of us in an incontrovertible form. When 'one discusses an affair—a long, sad affair—one goes back, one goes forward'.[22] Inevitably, that process of telling and uncertainty, plot advancement and self-withdrawal, shapes the novel's anatomy. As Dowell acknowledges: 'One remembers points that one has forgotten and one explains them all the more minutely since one recognises that one has forgotten to mention them in their proper places and that one may have given, by omitting them, a false impression.'[23] Here, it's as though Dowell's 'maze' of remembrance is projected

[19] Henry James, *The Ambassadors*, ed. Christopher Butler (Oxford: Oxford University Press, 1998), 223.
[20] Percy Lubbock, *The Craft of Fiction* (London: Jonathan Cape, 1921), 111.
[21] Ford Madox Ford, *The Good Soldier*, ed. Martin Stannard (New York: Norton, 1995), 119.
[22] Ibid. 120. [23] Ibid.

outward and manifested extra-textually as an aspect of our own engagement with the novel. That is to say, Ford's reader comes to recognize how interpretation is subject to the same labyrinthine route taken by the character who addresses us and beyond whose self-enclosure the first-person narrative allows us no access.

The reader was always important for Ford. His founding essay 'On Impressionism' (1914) tackles the question of what impressions can do for fiction from the perspective of how they are *received*, in addition to how they are produced. Pitching his discussion of Impressionism in pragmatic instead of compositional terms, Ford measures the mode's effectiveness by referring to his putative readership, rather than celebrating the impression as a component of some new-found device for furthering modern novelists' cutting-edge aims. 'Always consider the impressions that you are making upon the mind of the reader', advises Ford, 'and always consider that the first impression with which you present him will be so strong that it will be all that you can ever do to efface it.'[24] In so far as Ford's insistence on getting it right first time around sounds like an endorsement of verbal precision, of careful selection, it invites us to account for a mode of Impressionist prose whose directness seems altogether different from the obliquity and ornamentation into which James's late fiction evolved. Max Saunders writes of the *Parade's End* tetralogy that Ford's books retain 'a formal clarity, a monumental simplicity, which makes them more expressive than they could otherwise be'.[25] Less-is-more remained Ford's maxim, the basis for working with a style that could evoke something of the digressiveness of quotidian perceptions, but without aestheticizing impressions for the purpose of displaying his own writerly panache.

For Ford, the kind of formal characteristics attributed to literary Impressionism were hardly unprecedented, still less a benchmark of originality. And his aim as a commentator was to emphasize the heritage underlying successive generations. As practitioner and critic, he voiced what Rod Rosenquist has called that 'modernist link between the creative and forward-looking artist, devoted to the new, and the traditional and historically minded critic, concerned largely with endurance and institutions'.[26] Two decades into the new century, Ford saw that the point was to gauge whether 'there was any resultant literary movement' carrying forward the example of late Victorians like Hardy, James, and Crane—figures whom Ford praised as emblematic 'conscious artists'.[27] In this account, the novel emerges as a perpetually changing form, brightening the prospects for a new era of younger writers. And by offering discriminating surveys of the past while refusing to approach literary history in terms of a monolithic canon of masters, Ford provided an anterior vision of modern fiction's inheritance that refused any recourse to monumental precedents.

[24] Ford Madox Ford, 'On Impressionism', *Poetry and Drama*, 2 (1914), 172.

[25] Max Saunders, *Ford Madox Ford: A Dual Life*, 2 vols (Oxford: Oxford University Press, 1996), ii. 214.

[26] Rod Rosenquist, *Modernism, the Market and the Institution of the New* (Cambridge: Cambridge University Press, 2009), 7.

[27] Ford Madox Ford, *The English Novel: From the Earliest Days to the Death of Joseph Conrad* (Manchester: Carcanet, 1983), 3.

Despite his cautiousness about the term, Ford saw the technical hurdles that accompanied the Impressionist work as having generally positive influence on the development of contemporary fiction. That influence was both aesthetic and thematic. Impressionism both inspired and required narratological ambitions that intensified the novel's philosophical preoccupations with questions of knowing. As Jesse Matz points out, 'To get in the impression not just sense perception but sense that is thought, appearances that are real, suspicions that are true and parts that are whole—this was the "total" aspiration of the Impressionist writer.'[28] Achieving that totality was a writer whom Ford often regarded as the most tenaciously and exactingly self-reflexive of his generation in terms of the criticism he offered his own practice, even in the process of setting himself new goals. He was also the novelist whose work exploited, in Matz's phrase, 'the impression's strange perceptual status to extend, connect, and analogize moments that lead from pictures and sense to meaning'.[29] It was this practice of connection—registering the world of sensation in ways that could be rich in semantic implication—that remained Joseph Conrad's self-appointed 'task'. He reflected on this goal in the Preface to *The Nigger of the 'Narcissus'* (1897), reminding us of his long-standing ambition to utilize 'the power of the written word to make you hear, to make you feel', and 'before all, to make you see'.[30]

The problem of trying to redescribe precisely how we encounter the world through a variety of senses entered the very fibre of Conrad's work. His imperative to make us see—to align our reading experience, in turn, with the epistemic uncertainties that threaten links between observation and understanding—arguably reaches its early apotheosis in the novella *Heart of Darkness* (1899), and persists throughout Conrad's mature work, not only where Marlow reappears, as in *Chance* (1913), but in his later reprise of the maritime theme in *The Shadow-Line* (1917). Of the many things Impressionism facilitated for Conrad, it was the notion that perception could be both problematic for, and productive of, description that motivated him to attempt new experiments in first-person narration. 'The man presented himself as a voice,' recalls Marlow, speaking of Kurtz; but he could equally have been describing his own narratorial demeanour, sitting as he does 'with an aspect of concentrated attention'.[31] This concentration also became, stylistically speaking, Conrad's defining idiom; in contrast to James, for whom the drama was all in the showing, Conrad saw that levels of intradiegetic tension could be amplified by the telling. In *Heart of Darkness* Marlow often seems to exhaust the storytelling medium over which he presides, especially when the condensation of scenic details compromises the very act of

[28] Jesse Matz, *Literary Impressionism and Modernist Aesthetics* (Cambridge: Cambridge University Press, 2001), 1.

[29] Ibid. 6.

[30] Joseph Conrad, 'Preface' to *The Nigger of the 'Narcissus'* (1897), in *Conrad's Prefaces to His Works*, ed. Edward Garnett (New York: Haskell House, 1971), 52.

[31] Conrad, *Heart of Darkness* (1899), in *Heart of Darkness and Other Tales*, ed. Cedric Watts (Oxford: Oxford University Press, 2002), 152.

describing his topographical memories. To Marlow, that remembered environment is still overwhelming, his lasting impression of scale still evading the spoken word. This disrupts his ongoing aim to sustain an efficient backdrop to the story he recalls, and ordered spatial pictures intermittently fracture. By listing 'Trees, trees, millions of trees, massive, immense, running up high',[32] Conrad allows narration to give way and dissolve into a catalogue; or rather, he allows the narrative's slide into enumeration to pre-empt, through its very grammar, Marlow's subsequent admission that 'We were cut off from the comprehension of our surroundings.'[33]

Impressionist fiction, then, not only foregrounds epistemic problems merely as a source of occasional interest, but also turns the questionable validity of the knowledge impressions yield into a principle of style itself. The basic issue of how certain we can be about the veracity of what we know—and how our present intuitions constantly change in light of reassessing past experiences—became for Conrad a way of squaring the drama of epistemology with the demands of artistic expression. Arguably he struck this balance more frequently and precisely than James ever did in his elaborate late prose. Yet by turning consciousness into a stylistic catalyst in this way, *Heart of Darkness* fulfilled Conrad's Jamesian pronouncement that 'All art . . . appeals primarily to the senses, and the artistic aim when expressing itself in written words must also make its appeal through the senses, if its high desire is to reach the secret spring of responsive emotions.'[34]

Put like this, the Impressionist endeavour appears an interiorized one indeed. But experiments with the depiction of mental processes are not politically unreflective. Michael Valdez Moses suggestively points out that Conrad's brand of Impressionism 'not only provides a sustained and unflinching exposé of European colonialism and imperialism at its worst . . . but also attempts to generate in the reader a cognitive and emotional dissonance that is the experiential "aesthetic" correlative of the shock felt by Conrad's characters when confronted with the unsavoury realities of Western imperialism'.[35] For Moses, the proliferation of abstract nouns, 'diluted' parataxis, and adjectival multiplication, all evince Conrad's inventive response to that 'crisis of language that is integral to the disorienting experience of the Western colonialist at the fringes of empire'.[36] It would seem that Impressionism provides through 'its movement, its form, its colour' the indices to world-historical events, whose impact is felt in what Conrad called the very 'stress and passion within the core of each convincing moment'.[37]

[32] Ibid. 138. [33] Ibid. 139.
[34] Conrad, 'Preface' to *The Nigger of the 'Narcissus'*, 51.
[35] Michael Valdez Moses, 'Disorientalism: Conrad and the Imperial Origins of Modernist Aesthetics', in Michael Valdez Moses and Richard Begam (eds), *Modernism and Colonialism: British and Irish Literature, 1899–1939* (Durham, NC: Duke University Press, 2007), 47.
[36] Ibid. 54.
[37] Conrad, 'Preface' to *The Nigger of the 'Narcissus'*, 52.

ECONOMIES OF SHORT FICTION

While the long-standing critical commonplace is that Joyce's 'The Dead' remains the finest short story written in English, any consideration of this mode, however brief, would be impoverished without some account of his quiet fable of loss and belated self-knowledge. Yet it can often seem as though the story's distinction rests, as much as anything else, on its tendency to attract readings that either isolate it from the rest of *Dubliners* (1914), or celebrate it as a closing tale that's thematically representative of the collection as a whole. In many ways, this is part of the challenge posed by rereading Joyce's narratives, a challenge that may have less to do with interpretive difficulties per se than with the scholarly industry that shadows our every effort to read Joyce afresh. Derek Attridge offers a warning here, implying that we should separate the body of Joyce's work from the magnitude of its academic reception, so as to entertain the possibility of re-encountering those texts in ways that restore their affective appeal rather than reinforce their canonicity. For Attridge, the way that Joyce 'accumulates details, multiplies structures, and overdetermines interpretation' renders his corpus distinct from other trends in modernist fiction and connects his work 'to our own cultural moment', as his 'major texts *allow* meaning to arise out of that mass [of detail] by the operations of chance'.[38]

Turning Joyce into a postmodernist isn't entirely helpful either; it may only increase his liability to the kind of theoretical co-option that Attridge advises us against. Instead of exacerbating Joyce's seemingly limitless propensity to being framed by the latest critical fashions, we would do better to remind ourselves of Joyce's capacity to surprise, in so far as it's often his sudden simplicity which produces events that are the most arresting and resistant to serviceable theorization. *Dubliners* paves the way for this resistance, precisely in the sense that Joyce's virtuosity emerges out of restraint. The rhetorical criterion for this collection is surely compression: a trait that Joyce exploits to elaborate depictions of his characters' unspoken thoughts, often in grammatically simple sentences. Joyce himself would recall his aim as that of sustaining 'a style of scrupulous meanness',[39] and Gabriel's building reflections on the charade of his marriage epitomizes this compelling concision:

She was asleep.

Gabriel, leaning on his elbow, looked for a few moments unresentfully on her tangled hair and half-open mouth, listening to her deep-drawn breath. So she had had that romance in her life: a man had died for her sake. It hardly pained him now to think how poor a part he, her husband, had played in her life. He watched her while she slept as though he and she had never lived together as man and wife. His curious eyes rested long upon her face and on her hair:

[38] Derek Attridge, *Joyce Effects: On Language, Theory, and History* (Cambridge: Cambridge University Press, 2000), 120.

[39] Joyce, letter to Grant Richards, 5 May 1906, in *The Letters of James Joyce*, ed. Richard Ellmann, ii (London: Faber & Faber, 1962–6), 134.

and, as he thought of what she must have been then, in that time of her first girlish beauty, a strange friendly pity for her entered his soul.[40]

Joyce saw no incompatibility between economy and intensity. And while Woolf would compare Joyce's moments of overt psychological introspection with 'being in a bright and yet somehow strictly confined apartment',[41] in *Dubliners* we have some proof of his early concern with balancing perceptually mediated forms of narration with crystalline depictions of the outside world. In the passage above, Joyce balances Gabriel's introspection with a more pictorial register, offering for 'a few moments' a tableau of this pathetic vigil. In effect, Joyce counterbalances Gabriel's inner distress with the stillness of this nocturnal background. He alternates nimbly, from one sentence to the next, between Gabriel's acknowledgement of his wife's deception and the affecting simplicity of watching her 'unresentfully' sleep.

Seamus Deane calls this 'the Joycean method of counterposing that which is undeniably real . . . to something which is undeniably fake and then, rather than ratifying the "real", showing that it can be swallowed up in the illusory world surrendered to it, by those who are . . . hungry for illusion'.[42] The impulse to expose illusions, especially those of class distinction and self-differentiation, runs throughout Katherine Mansfield's stories too. Here, the genre's economy serves to intensify Mansfield's satire, as the quick succession of events often juxtaposes scenes of decorum with intervening episodes that unveil the hypocrisy of the individuals involved. In 'The Garden Party' (1922), this satirical tone is accentuated by Mansfield's use of the second-person 'you'. What first appears like a rudimentary section for indicating time and place modulates into a more sardonic sequence that tracks characters oblivious of their own liberty at leisure: 'Wherever you looked there were couples strolling, bending to the flowers, greeting, moving on over the lawn.'[43] An atmosphere of serenity is established only to be ridiculed: 'Ah, what happiness it is to be with people who all are happy, to press hands, press cheeks, smile into eyes.'[44] This opening shows how pointedly Mansfield adapted the subjectivism of free indirect discourse, mimicking vanities and pleasantries to arrive at satirical indictments. She aligns us, tonally, with the jaunty contentment of greetings and smiles, precisely to establish her grounds for putting her most privileged characters on trial as the story comes to a close. There, we switch to Laura's point of view as she visits the working household of the neighbouring man accidentally killed as the party reached full swing. That earlier repartee is here not only refracted but also condemned by Laura's stunned recognitions, the party itself reduced to a taxonomy of frivolous props:

[40] Joyce, 'The Dead', in *Dubliners*, ed. Jeri Johnson (Oxford: Oxford University Press, 2008), 175.

[41] Woolf, 'Modern Novels', in *The Essays of Virginia Woolf*, ed. Andrew McNeillie, 6 vols (London: Hogarth Press, 1986–94), iii. 34.

[42] Seamus Deane, 'Dead Ends: Joyce's Finest Moments', in Derek Attridge and Marjorie Howes (eds), *Semicolonial Joyce* (Cambridge: Cambridge University Press, 2000), 23.

[43] Katherine Mansfield, 'The Garden Party', in *The Collected Stories of Katherine Mansfield* (Harmondsworth: Penguin, 1981), 256.

[44] Ibid. 257.

What did garden-parties and baskets and lace frocks matter to him? He was far away from all those things. He was wonderful, beautiful. While they were laughing and while the band was playing, this marvel had come to the lane. Happy . . . happy. . . . All is well, said that sleeping face. Laura gave a loud childish sob.

'Forgive my hat,' she said.[45]

Mansfield's use of free indirect style to articulate social critique matched Joyce's way of balancing introspection and focalization with pictorial descriptions of space. 'At the Bay' (1922) is exemplary in this respect, its telescopic opening offering more than a functional backdrop as it anthropomorphizes the physical environment. It's as though the eponymous locale momentarily becomes the protagonist:

Ah-Aah! sounded the sleepy sea. And from the bush there came the sound of little streams flowing, quickly, lightly, slipping between the smooth stones, gushing into ferny basins and out again; and there was the splashing of big drops on large leaves, and something else—what was it?—a faint stirring and shaking, the snapping of a twig and then such silence that it seemed some one was listening.[46]

Sibilant nouns and adverbs ripple across the evocation of natural activity to such an extent that Mansfield alerts us to the self-consciousness of her own descriptions yet without compromising our mental vision of surface water and drenched undergrowth. The scene pushes at the limits of topographical mimesis, intentionally so. As Mansfield wrote after the First World War: '*Art* is not an attempt to reconcile existence with the [writer's–artist's] vision: it is an attempt to create his own word *in* this world. That which suggests the subject to the artist is the *unlikeness* of it to what we accept as reality. We single out, we bring into the light, we put up higher.'[47] Significantly, in light of her animistic approach to describing landscapes, Mansfield echoes Hardy's conviction, speaking of his own rural environments in 1890, that 'Art is a disproportioning—(i.e., distorting, throwing out of proportion)—of realities, to show more clearly the features that matter in those realities, which, if merely copied or reported inventorially, might possibly be observed, but would more probably be overlooked.' If '"realism" is not Art' for Hardy,[48] neither was it for Mansfield. The compression and pace of short fiction offered her a medium in which to foreground the artifice of basic diegetic properties in ways that create a new kind of reading experience, one that can still be immersing while also piquing our awareness of *how* those events are focalized.

This idea of turning the short story into an arena for experimenting with varying levels of narrative self-reflexivity, while including the reader in that process as well, burgeons throughout Mansfield's correspondence and early essays for the journal *Rhythm*. In 'The Meaning of Rhythm' she claims that 'Freedom, reality, and individuality are three names

[45] Mansfield, 'The Garden Party', 261.

[46] Katherine Mansfield, 'At the Bay', in *The Collected Stories*, 205.

[47] Katherine Mansfield, *The Katherine Mansfield Notebooks*, ed. Margaret Scott, ii (Canterbury: Lincoln University Press; Wellington: Daphne Brasell Associates, 1997), 267.

[48] Thomas Hardy, *The Life and Work of Thomas Hardy*, ed. Michael Millgate (London: Macmillan, 1984), 239.

for the ultimate essence of life. They are three qualities of the artist.'[49] Despite her idealistic tone, we can still appreciate how her emphasis on grasping the *essence* of organic things through their aesthetic outline continues into her mature work. Similarly, her imperative to see beyond the visible, beyond empirical experience, in order to cast the everyday in a defamiliarizing light, emerges strongly in her forthright letters. As she phrased it for Sydney and Violet Schiff in 1920: 'Delicate perception is not enough; one must find the exact way in which to convey the delicate perception.'[50]

Mansfield's premature death meant that she had a short career in which to search for, test, and extend means of narrating the 'delicate perception' she cherished. She admitted that she was 'a powerful stickler for form',[51] and yet she had little time in which to consolidate her prestige as a writer who demonstrated how multifarious the short story could be alongside dominant experiments in the novel. Neither was Mansfield interested in form for its own sake. Writing was always more than a process of self-perfection; it entailed a consuming level of industry that became harder to sustain as her health deteriorated. She wrote in 1920 that '*Work*, real work— the longing and desire to work is all that matters.'[52] And she later complained that the urgency of wanting to commence writing, but being unable to, had itself become almost unendurable: 'I wish I could begin real creative work. I haven't yet. It's the atmosphere, the . . . tone which is hard to get. And without it nothing is worth doing.'[53] Atmosphere and tone: two properties at the centre of Mansfield's aesthetic, properties she blended in narratives that often seem to oscillate between satirical and painterly objectives, but which are united by the urge to delineate alternative ways of seeing. Accessing in the most mundane moments what Hardy called 'that deeper reality underlying the scenic',[54] Mansfield thus explored a substratum of social being while reflexively deducing the possibilities of enlarging our understanding of the known world through its sensuous yet economical redescription.

NOVEL MOMENTS: INTERIORITY, THE EVENT, AND THE FATE OF SYNTAX

While Ford described literary Impressionism as 'the record of the impression of a moment',[55] his definition also extends to encompass other modes, pointing as it does

[49] Katherine Mansfield and Richard Murray, 'The Meaning of Rhythm' (1912), in *The Critical Writings of Katherine Mansfield*, ed. Clare Hanson (Basingstoke: Macmillan, 1987), 22.

[50] Katherine Mansfield, *Collected Letters of Katherine Mansfield*, ed. Vincent O'sullivan and Margaret Scott, 4 vols (Oxford: Clarendon Press, 1984–96), iv. 4.

[51] Ibid. i. 124. [52] Ibid. iv. 9. [53] Ibid. iv. 50.

[54] Hardy, *The Life and Work*, 192. [55] Ford, 'On Impressionism', 174.

to a cluster of features that I've been tracing across the novel, novella, and short story. The impulse to 'record' events—not only as and when they are perceived, but in ways that express how they are perceptually discerned—made 'the moment' emblematic for the modernists of the 1920s and beyond. Yet it was also an impulse that, taken to its experimental extreme, threatened fiction's referential functions. Such was Ford's worry, whose concerns about the fate of narration were more audible than most. In his *envoi* to *The English Novel*, Ford warns that in a future 'world tired of the really well constructed novel[,]every word of which carries its own story forward', we will face 'a movement towards diffuseness, backboneless sentences, digressions, and inchoateness'.[56] That movement, of course, had already begun in 1927, with the appearance of the little magazine *transition*. In his manifesto in the June issue of 1929, Eugene Jolas championed the 'Revolution of the Word' not only as a new tendency among a select group of innovators but also as a series of artistic commandments, offering a typology of virtues for moving against what he saw as the banality of verisimilitude. His list implied a disregard for the tenets of transparency, accessibility, and especially the idea that communicating to the reader should in any way hinder a writer's adventures in expression.

Over the course of eleven years, *transition* fostered Joyce's new work, holding it up as a paragon of emancipation from formal and grammatical strictures. In the face of growing public scepticism about the experimental direction in which Joyce was moving as he worked on the *Wake*, Jolas's support turned out to be more than convenient publicity. And although the affinities between Joyce's own style and Jolas's programme for the 'Revolution of the Word' weren't completely elective, *transition*'s association in public eyes with Surrealism—and particularly the verbal lawlessness that André Breton envisaged for automatic writing—provided, nevertheless, a suitably dissident forum for giving exposure to Joyce's emerging novel.[57] It would be simplistic to detect in Ford's unease about fiction's increasing 'inchoateness' a flavour of the wider hostility towards Joyce, now freed on the pages of *transition*, freed especially, in Michel Delville's words, from the 'precepts concerning art's representational vocation'.[58] But there is surely something more than coincidental about Ford's sense of a new generation's 'movement toward diffuseness' and that internal turn towards innovation as *de*formation represented by a writer like Joyce who, significantly, spans several chapters of the novel's early to mid-twentieth-century development. That is to say, if we contextualize Ford's cagey warnings about the implications of taking syntactical infringements to the extreme, we can gauge the extent to which they reveal much about what modernist fiction was leaving behind in the 1920s and 1930s. Rather than being prophetic of the novel's later twentieth-century futures, Ford's remarks look proleptically ahead only to register

[56] Ford, *The English Novel*, 142.
[57] For a discussion of Joyce and Jolas, see Jean-Michel Rabaté, 'Joyce and Jolas: Late Modernism and Early Babelism', *Journal of Modern Literature*, 22/2 (1999), 246.
[58] Michel Delville, *The American Prose Poem: Poetic Form and the Boundaries of Genre* (Gainesville: University Press of Florida, 1998), 43.

a very contemporary transitional phase, a phase which saw writers moving away from organic coherence towards a more deliberate unhinging of form and content.

Ford's disquiet, then, is all the more revealing for *not* being as prophetic as he might have intended it to be. While taking stock of new trends, his endorsements fell on that earlier vein of modernist prose characterized by stylistic discretion and authorial self-effacement. Here we might well place the 'scrupulous meanness' of a younger Joyce alongside Ford's preference for the 'minimum of artistry' to create lasting effects.[59] These were the hallmarks of the Impressionist obliquity that Ford practised and with which he often, if only implicitly, measured the success of narrational novelties. Yet the tenor of things would change through the 1920s and the harvest of this phase came in the following decade, with the appearance of novels as diverse in mode and focus as Woolf's *The Waves* (1931), Jean Rhys's *Voyage in the Dark* (1934), Djuna Barnes's *Nightwood* (1936), Zora Neal Hurston's *Their Eyes Were Watching God* (1937), and Joyce's *Finnegans Wake* (1939). These key works are iconic today not simply because they stretched the novel's capability to probe greater psychological depths. They also inaugurated new interpretative conditions, presenting their readers with increasingly varied challenges, challenges that Joseph Frank traced in *Nightwood*, where Barnes asks her audience 'only to accept the work of art as an autonomous structure giving us an individual vision of reality'.[60]

Given these advances, it can be surprising to see who was offering the counter-arguments to strident experimentalism. In her 1924 lecture 'Character and Fiction', Woolf noted that Joyce epitomized the eager 'smashing and crashing' to which the novel had been subjected. Even though this process of structural dismantling arose 'from the most honourable motives',[61] it had its side-effects, especially where readerly pleasures were concerned. Woolf's cautionary sentiments extend those of another essay, 'Hours in a Library' (1917), where she assumes a register of acceptance, tinged with nostalgia for the loss of the idea of abandoning oneself to plot: 'New books may be more stimulating and in some ways more suggestive than the old, but they do not give us that absolute delight' supplied by the canonical pillars of tradition.[62] Twenty years later Ford would strike a different note. In *Mightier Than the Sword* (1938) he mixes self-depreciation and mild sententiousness to cast a prediction in which future readers will be favouring elegance rather than rupture. In this prophecy, Ford sees the main threat to the novel as the dilution of all risk and transgression, where the maintenance of eloquence overrules any genuine gains in technique. 'I may be wrong', writes Ford, but the 'day may come when, tired by verbal felicities and explosive progressions, the mind of man may crave once more for the immense, immense *longueurs*, the Greek-derived and out-worn poeticisms, the incredible syntax, the superfluous words dragged in to make up a metre'.[63]

[59] Ford, *The English Novel*, 11.
[60] Joseph Frank, 'Spatial Form in Literature', in *The Widening Gyre: Crisis and Mastery in Modern Literature* (Bloomington: Indiana University Press, 1963), 28.
[61] Virginia Woolf, 'Character in Fiction', in *Essays*, iii. 515.
[62] Virginia Woolf, 'Hours in a Library', in *Essays*, ii. 60.
[63] Ford Madox Ford, *Mightier Than the Sword* (London: George Allen & Unwin, 1938), 287.

Ford and Woolf represent that ambivalent and often polarized response to techni-
cal innovation, where the most adventurous practitioners seem to pause and ponder
what they, or their contemporaries, have done to fiction through its formal dissolu-
tion. 'Poor old novel,' mocked Lawrence in his own essay on the genre's future: 'it's in
a rather dirty, messy tight corner. And it's either got to get over the wall, or knock a
hole through it.'[64] Lawrence's binary options for redeeming fiction express, through
their calculated crudity, a creative dilemma that casts a derogatory shadow over the
condition of the modern writer. Lawrence insinuates that novelists are under increas-
ing pressure to experiment impeccably yet vigorously, but are also obliged not to
forgo fiction's capacity for extending the social or sexual imagination. That decision
of whether to 'get over' existing tendencies by surpassing them or to create new
modes by rupturing what's already there was a 'choice' that Dorothy Richardson
faced when writing the sequence that would become *Pilgrimage* (1915–67). Consider-
ing the background to her commencing this four-volume work, Richardson com-
ments in a 1938 Foreword that while 'looking around for a contemporary pattern' she
'was faced with the choice between following one of her regiments and attempting to
produce a feminine equivalent of the current masculine realism'.[65] As she proposes,
this idiom would be closer to the undulations of perceptual experience, since
'Feminine prose . . . should properly be unpunctuated, moving from point to point
without formal obstructions'.[66] As we have seen, this impulse to relinquish prescriptions
in an effort to meld syntax with inner thought can be retraced to James's exaltation of
fiction's 'luxurious independence of rules' and forward again in time to Faulkner's
characteristic desire 'to say it all in one sentence'.[67] Yet just as the motivations behind
Richardson's feminine sentence affiliate writers from historically and nationally discrete
phases of modernism, so she saw her own work moving between alternative narrato-
logical lines of development: 'between two methods, the direct method (what the critics
call the indirect method, but we know as the method of direct unmediated experience)
& the method of statement'.[68] Richardson echoes Lubbock's qualitative distinction
between novelists who *tell* and those who (more expertly) *show*. Yet she also calls
attention to the realization for modernist writers that they work at a confluence of
'experience' and 'statement', interiority and third-person externalism, focalization and
naturalistic description. This implies, in turn, that they stand where two legacies meet,
as they mediate between the sensuousness of early-century Impressionism and the
moral or philosophical pretensions of Victorian realism.

This implied negotiation between evoking mental states and social situations, sub-
jectivism and directness, invites us to frame Richardson and Woolf—along with their
Impressionist predecessors Ford and Conrad—as representative of an intriguingly

[64] D. H. Lawrence, 'The Future of the Novel', in *Study of Thomas Hardy and Other Essays*, ed. Bruce
Steele (Cambridge: Cambridge University Press, 1985), 153.
[65] Dorothy Richardson, 'Foreword', in *Pilgrimage*, i (London: J. M. Dent, 1967), 9.
[66] Ibid. 12.
[67] William Faulkner, letter to Malcolm Cowley, Nov. 1944, in Cowley, *The Faulkner–Cowley File:
Letters and Memories 1944–1962* (Harmondsworth: Penguin, 1978), 14.
[68] Richardson, letter to P. Beaumont Wadsworth, 30 Apr. 1923, in *Windows on Modernism*, 68.

conciliatory path that novelistic innovation took through high modernism. Certainly, their methods of syncretizing heritage and renewal were unlikely to satisfy what Lawrence had in mind for the future of fiction. We need to look elsewhere for the seam of modernist narrative that surfaced ostentatiously out of its own rupture with existing (let alone inherited or persisting) conventions. And the writer who, in retrospect, most explicitly took up Lawrence's suggestion of knocking straight through current restrictions was Gertrude Stein. For Stein, the novel's reformation could only begin at the level of the stylized sentence. With a popularity that survived despite the opacity and grammatical recalcitrance of her later work, she proceeded to draw moments of audacious expressivity from the most everyday scenarios. It's as though she was receptive to Woolf's celebrated desire to capture experience as 'an incessant shower of innumerable atoms',[69] while also (and unlike Woolf) matching those unceasing sensations through the principle of extreme, fugue-like or contrapuntal repetition. Moving from recognizable subject matter to narrative modes consisting of purely acoustic or phonetic combinations, Stein made the *procedural* nature of composition both the inspiration and the end-point of her writing. In so doing, she reverses our customary expectations of narrative description: namely, that depictions of setting, people, or objects should conceal their constitutive methods in order to do justice to the pictured thing or person in question. In a similar way, the self-advertising construction of her work is mirrored in her understanding of artistic *genius* which, as Barbara Will has pointed out, remains for Stein 'a contradictory or heterogeneous mode of "being": at once the essential, autonomous authorial subject creating absolutely new and original works of art, and at the same time a way of existing and relating in language that is open-ended, processual, collaborative, and resistant to any final symbolic or authorial containments'.[70]

Stein's attention to her own heterodox craft might be seen to flourish out of a longer-standing heritage of conscious artistry which extends the core beliefs of writers from whom Stein herself is often assumed to depart. In this sense, she is simply fulfilling what James had projected for the novel of years to come: a state of 'luxurious independence of rules and restrictions'. Of course, James could not have envisaged the way Stein accomplished that unruliness, and comparisons between them continue to appear improbable. Yet although Stein remains one of James's unlikely heirs, his assurance that the novelist should 'Try to be one of the people on whom nothing is lost'[71] is directly in tune with her own definition of genius: 'I once said and I think it is true', remarks Stein, 'that being a genius is being one who is one at one and at the same time telling and listening to anything or everything.'[72]

Listening to perpetual storytelling is indeed close to the experience of reading Stein's mature prose. Introducing the original Chicago volume of Stein's lectures,

[69] Virginia Woolf, 'Modern Novels', in *Essays*, iii. 33.

[70] Barbara Will, *Gertrude Stein, Modernism, and the Problem of 'Genius'* (Edinburgh: Edinburgh University Press, 2000), 1.

[71] James, 'The Art of Fiction', 53.

[72] Gertrude Stein, 'Narration: Lecture 3', in *Narration: Four Lectures by Gertrude Stein*, introd. Thornton Wilder (Chicago: University of Chicago Press, 1935), 34.

Narration, in 1935, Thornton Wilder emphasizes the importance of reflecting on this experience as part of her challenge to the interpretative comforts of mimesis. His implication is that a degree of intensive and rigorous self-consciousness is something as applicable to encountering Stein's prose as it is to her metalinguistic experiments. Wilder observes that 'Miss Stein pays her listeners the high compliment of dispensing for the most part with that apparatus of illustrative simile and anecdote that is so often employed to recommend ideas.'[73] The embedded analogy here between reading and listening chimes with Stein's endeavour to take words beyond their familiar uses by highlighting curious affiliations at the level of the syllable, affiliations of a primarily phonetic rather than semantic kind. At the same time as he emphasizes the dynamic roles played by Stein's putative reader, Wilder draws our attention to the writing process, a process that's never pristinely self-satisfying, but which seems instead less interested in achieving mastery over diction or form than in reflecting discursively on its own procedures. For Wilder, Stein does this with the help of successive paragraphs 'dealing with the psychology of the creative act as the moment of "recognition".'[74] The *doing*, to echo Ben Jonson, was more important than the *thing done*: a sentiment that underpins 'Composition as Explanation' (1926), where she assures us that 'The only thing that is different from one time to another is what is seen and what is seen depends upon how everybody is doing everything.'[75]

What Stein did in a work like *Tender Buttons* (1914) was to leave description unanchored from reference. As David Lodge has pointed out, Stein shifted emphasis at the level of the sentence, progressing 'from length to brevity, from verbs to nouns' in a fashion that takes her structural manner 'much closer to surrealism' than one might expect.[76] Her impulse to strip narrative back to its constituent elements, and to employ repetition in place of qualifiers or other adjectival variations, would influence Ernest Hemingway's own skeletal concentration on presenting moments strictly without elaborative details. Equally, though, we could see Stein's syntax radically extending again that earlier, Impressionist impulse to fashion phrases that simulate the pace and digressions of perception. Language may never be a transparent medium for self-expression in Stein's universe; yet she nevertheless reprises the Conradian investment in crafting clauses that complement in grammatical as well as lexical respects the processes of visual apprehension and emotional reflection. As Stein put it in an essay which itself was named after James: 'In reading and writing, you may be, without doubt, attached to what you are saying, or you may not. Attached in the sense of being connected to it.'[77] Creating attachments between the register and reader to forge in turn a new experience of engagement with the most ordinary domestic scenes is a task Stein attempts in *Q.E.D.* (1903). Here she often

[73] Thornton Wilder, 'Introduction', in Stein, *Narration*, p. vii.
[74] Ibid.
[75] Gertrude Stein, 'Composition and Explanation' (1926), in *Stein: Writings*, ed. Catherine R. Stimpson and Harriet Chessman, 2 vols (New York: Library of America, 1998), i. 520.
[76] David Lodge, *The Modes of Modern Writing: Metaphor, Metonymy, and the Typology of Modern Literature* (London: Edward Arnold, 1977), 151–2.
[77] Gertrude Stein, 'Henry James', in *Stein: Writings*, ii. 150.

disseminates characters from the outside in, when we're told that a domestic room's 'atmosphere consisted in Mabel's personality', while her 'passions in spite of their intensity failed to take effective hold on the objects of her desire'.[78] By the same stroke, this exteriorized kind of characterological dissemination doesn't prevent Stein from offering insights about the interior events of consciousness. That is, the epiphanic *moment* still survives in early Stein. Sat 'in Helen's room the eve of her departure', Adele and Helen 'remained there together in an unyielding silence'. Stein devotes a paragraph to the sullen inertia of this episode, where helpless characters are caught in the predictable yet unavoidable frustrations of mutual presumption and incommunicability. Stein steps back from the scene, dropping into a series of queries and qualifications as we hold in mind the image of the two women in silence: 'When an irresistible force meets an immovable body what happens? Nothing. The shadow of a long struggle inevitable as their different natures lay drearily upon them. This incident however decided was only the beginning.'[79] We are led from domestic description, reported speech, to a distanced rhetorical question that presents itself as an anecdote about inertia and forceful desire, before finally ending in a proleptic gesture about what this tableau of two characters anticipates. Stein thus works through different registers to combine a frank yet intimate picture of Adele and Helen poised on parting while creating a valuable degree of suspense. The scene may be static, but the agile narrator keeps us watching.

It's tempting to isolate Stein's fusion of self-cultivated genius and her extreme avoidance of referential prose as the pinnacle of what made modernist fiction truly *modernist*. Moreover, Stein's self-consciousness certainly motions ahead to key figures in post-war metafiction, containing as it does the seeds of textual self-investigation that would flourish in Christine Brooke-Rose's diffused voices and oscillating tenses, B. S. Johnson's insistence on the semantic importance of typographical devices, and William Burroughs's famous 'cut-up' strategy. But this is just one genealogy of what experiment meant to modernists and to writers who followed their example, a genealogy that is in danger of programmatically sidelining other strands of virtuosity on show. For Stein presents us with an *idea*, rather than the high-watermark, of what innovation could involve. As daring in their own way, we might say, were Mansfield's anthropomorphized sceneries and Conrad's syntactically ambitious, enumerative, and often totalizing use of visual description. Yet more than in the work of either of these figures, Stein's syntax *is* distinctive for the way it invites us to engage in a medium that not only interrogates its own construction but also turns that interrogation into a principle of composition. Stein's sentences, in effect, pose questions to their own structure concurrently with their execution. This was the contiguity between self-dissemination and demonstrative flair that Stein consistently reached for. This dual impulse would be fostered by a subsequent generation of (late) modernist novelists, who offered their own escape from the task of representing felt impressions, who turned fiction's interiority inside out, and who revised the high

[78] Gertrude Stein, *Q.E.D.*, in *Stein: Writings*, i. 15–16.
[79] Ibid. 31.

modernist ethos of authorial impersonality to produce a more satirical and aggres-
sively detached sense of what literary experiment was for.

TECHNIQUES OF DETACHMENT

As our sense of modernism's aesthetic development becomes more historically nuanced
and extensive, the idea that formal originality started to trail off in the 1930s has in turn
become increasingly tenuous—at worst, reconsolidating the monolithic view of 1922 as
the peak of everything new. And if it's inadequate to presume that experiments in
narrative form dwindled in the inter-war years, in this final section I want to indicate
some of the reasons why that might be so, while being mindful that 'late modernism'
may be an insufficient category for particularizing this diverse period of innovation. I
will proceed by turning to Wyndham Lewis, who has become something of an insignia
for much recent work on late modernism, or modernist 'latecomers' as Rosenquist has
called them.[80] But our interest in Lewis might include not only the problems of labelling
his connection to different modernist 'generations', but also the issues I've been high-
lighting throughout to do with how we periodize specific narrative techniques within
particular time-frames. The reward, indeed, of rereading Lewis is the opportunity to
observe the way our own *expectations* of formal innovation are revised when we
confront a writer who sets new standards for modern fiction by detaching himself
from the signal commitments of high modernism.

It would be crude to suggest that Lewis was representative of a trend towards
complete disinheritance. His emphasis, for instance on attaining 'A strong and
significant design', one that a writer can 'control, order and reshape', is hardly a
counterpoint to Ford's own reflection that the 'struggle—the aspiration—of the
novelist down the ages has been to evolve a water-tight convention for the framework
of the novel'.[81] Lewis requires a more transitional conception of where high modernist
aesthetics went next, as he alternately inherited, retested, and parodied their lessons in
form. And though Lewis might not altogether have been sympathetic to James's ideas
about the organic synthesis of idea and manner, style and sensory cognition, *Tarr*
(1918) nonetheless provides its own take on formal integration, while anticipating the
fully intensified sardonic idiom of Lewis's later prose. In fact, despite his attraction to
exteriorized and self-analysing forms of narratorial commentary, Lewis's perspec-
tivism in *Tarr* has the appeal that Richardson identified in relation to James's
character-reflectors: the effect of 'keeping the reader incessantly watching the conflict

[80] See Rosenquist, 'Introduction', in *Modernism, the Market and the Institution of the New*.
[81] Wyndham Lewis, 'Prevalent Design', in *Creatures of Habit and Creatures of Change: Essays on Art, Literature and Society*, ed. Paul Edwards (Santa Rosa, Calif.: Black Sparrow Press, 1989), 53; Ford, *The English Novel*, 79.

of human forces through the eye of a single observer'.[82] Searching for precisely the right register of observation, Lewis entered into a dialogue with James. While lightly mimicking the master's solemnity, Lewis heeds James's lessons in 'contrast[ing] . . . the *outside* with the *inside* method': 'If you *must* approach things in this external manner, he says, then do so in the spirit of scientific enquiry!'[83]

Lewis's admiration is audible enough; but so are his own preferences with regard to the kind of oblique 'ratiocination' that, in his view, led James into 'a twilit feminine universe'. For Lewis, there were clear benefits to standing proud of characters' inner perceptions of one another, to retaining some purchase on that 'sensorium in the midst of which they function'. So where James's super-subtle reflectors are concerned, Lewis seems adamant that 'there is not one of them that would not have been a more compelling personage if approached from that end—the externalist end'.[84] This commitment to externalism underpinned Lewis's understanding of the satirical force of narrative perspective. In *Tarr* his effort to braid mode and perception together can be witnessed in the way the novel's denatured vision of everyday encounters is reflected in its stripped-back, percussive use of functional scenery and spotlighted faces:

> Tarr was shy and the reverse by turns. He was alone. The individual is rustic.
> For distinguishing features Hobson possessed a distinguished absence of personality.
> Tarr gazed on this impersonality, of crowd origin, with autocratic scorn.[85]

Absent here is the level of focalization that channels our attention in James, Conrad, and Woolf, as we zoom in on the delicately filtered mindsets of Strether, Marlow, and Clarissa Dalloway. In place of the Impressionist's telescopic lens, refracting consciousness minute by minute, Lewis's characterizations evolve piecemeal. So although Tarr regards 'impersonality' with 'scorn', depersonalization is nevertheless Lewis's adopted mode—both in terms of his narratorial self-effacement and on a thematic level, where his concerns lie with dismembering the internal coherence of personhood itself while at the same time projecting a version of considered independence that refuses to consign all notions of embodiment to automatism or technological determination. Tarr's 'message', Lewis asserted in his 1915 Prologue, is that 'Under the camouflage of a monotonous intrigue he points a permanent opposition, of a life outstripped, and art become lonely. He incidentally is intended to bring some comfort of analysis amongst less sifted and more ominous complexities of our time.'[86] While 'comfort' is rarely the appropriate adjective for the experience of reading Lewis's depersonalized and forensic prose, that sense of unsettlement is precisely what he was aiming to sustain.

In an effort to undo our moral preconceptions, Lewis invites us to engage with a register that seems to resist anything but a phenomenally edgy, agitated process of

[82] Richardson, 'Foreword', 11.

[83] Wyndham Lewis, *Men Without Art*, ed. Seamus Cooney (Santa Rosa, Calif.: Black Sparrow, 1987), 120, 121.

[84] Ibid. 123.

[85] Wyndham Lewis, *Tarr: The 1918 Version*, ed. Paul O'Keeffe (Santa Rosa, Calif.: Black Sparrow Press, 1990), 29.

[86] Wyndham Lewis, 'Prologue', in *Tarr* (London: Egoist Press, 1918), p. xi.

readerly engagement. Approaching the opposite poles of the modernist period, *Tarr*
and *Snooty Baronet* (1932) offer coldly removed, objectifying, seemingly individuated
perspectives, and they can have the effect of distracting us from the ways in which
Lewis's strategies open out to wider, collective points of cultural critique. Lewis
utilized style in oppositional terms, especially to distance his work from the subjec-
tivism of high modernist fiction. 'Impersonal detachment' overtook that interest in
simulating the cognitive and affective textures of interior experience.[87] What it
means to be 'detached', as he catalogued it in the memoir *Rude Assignment* (1950),
should be understood as that 'sense of habitually reserving judgement, and not
expressing oneself by action, and, in perhaps the most important things, holding
to the deliverances of reason'.[88] At its most extreme, the political implications of this
glacial style are dehumanized, to say the least. Yet Lewis scholars like Andrzej
Gąsiorek have made a nuanced case for seeing his work as anticipating what we
would recognize today as a genuinely multi-perspectival—if not cross-disciplinary—
form of inquiry, one that slices back and forth between fiction and the social. As 'a
dialogical thinker and writer', writes Gasiorek, Lewis 'becomes a symbol of the
Vortex, a (critical) nodal point for the cultural practices of his day, a figure through
whom ideas (his own and those of his contemporaries) are constantly rushing, ideas
that he tries to sift for what is of value and what is to be discarded'.[89]

 Lewis's sifting and discarding makes an aesthetic practice out of a very impersonal
will to dismemberment. To this extent, his fiction takes us some distance from the
kind of perspectivism that we have traced from James and Ford, through Conrad,
and finally to Richardson and Woolf. And just as we are scathingly told in *Tarr* that
Lowndes 'had an Impressionist's horror of change',[90] so Lewis himself reinforced
through the inter-war years a tone of address that, from our point of view, resounds
dissonantly against the legacies of those writers with whom this chapter began.
Refusing to be seduced by the prospect of recording experience as 'a shower of
innumerable atoms', Lewis went on to epitomize the late modernist drive towards
giving the novel a more satirically sharpened voice. It was a voice that nonetheless
shows how formal aspects of narration remained the primary 'energy', to recall
William Gass, behind all 'activity'—an energy as vital, as we have seen, for those
predecessors against whom Lewis occasionally rebelled. And Lewis's attempt,
through his commitment to externalism, to escape the burden of high modernist
artistry also dovetails with Joyce's own language of release when he stands back from
work he is finishing at the close of the 1930s to call the *Wake* 'a mighty mother . . . now
at last making ready to take her slide into the unsuspecting sea'.[91] Such connections
are more than anecdotal. Joyce's sense of letting go of what he has finally made
speaks to a broader climate of literary creation in which perfectionism and

[87] Wyndham Lewis, *Rude Assignment: An Intellectual Autobiography*, ed. Toby Foshay (Santa Barbara,
Calif.: Black Sparrow Press, 1984), 76.
[88] Ibid.
[89] Andrzej Gąsiorek, *Wyndham Lewis and Modernism* (Tavistock: Northcote House, 2004), 3.
[90] Lewis, *Tarr*, 49.
[91] Joyce, letter to Count Carlow, 8 Sept. 1938, in *The Letters of James Joyce*, iii. 427.

dispassion, self-elevation and incurable dissatisfaction, orbit one another in close proximity. It would seem that this curious need to exist both within and beyond the crafted medium, to cultivate new designs and yet remain critically detached from them, encapsulates the twin vectors that reach across the modernist period. Vectors of creativity and correction: they ultimately required the writer, as the maker and potential legislator of the modern, to exercise *new ways of doing* while simultaneously reflecting on how the remaking of fiction might otherwise be done.

CHAPTER 6

··

THE MODERNIST
NOVEL IN EUROPE

··

MICHAEL WOOD

In the early pages of James Joyce's *Ulysses* (1922) a confident Englishman makes an assumption about the state of Stephen Dedalus's unbelief. 'Either you believe or you don't,' he says. 'Personally I couldn't stomach that idea of a personal God. You don't stand for that, I suppose?' Stephen says 'with grim displeasure', 'You behold in me a horrible example of free thought.'[1] 'Free thought' as a name for atheism would have been a little archaic in 1904, the time of the book's setting, and positively quaint by 1917, when this chapter found its first public. But Stephen is not denying his lapse from faith, only making a dark joke about relative freedoms, and expressing his annoyance at the Englishman's failure to understand either cost or context.

We could imagine a similar dialogue involving the book itself. A confident critic says 'You don't stand for all that plodding mimesis, solidity of specification and the whole realistic apparatus of the nineteenth-century novel, I suppose?' The book replies, 'You behold in me a shining example of the modernist novel.' Its mood, perhaps, is complex pride rather than grim displeasure, but it wants us to know that things are not so simple. Still, *Ulysses* might say this, is saying this, and so are *Mrs Dalloway* (1925), *The Waves* (1931), and *Absalom, Absalom!* (1936). No European novel says anything of the kind, and indeed a first glance at the terrain suggests there are no modernist novels in continental Europe, only lingering relics of old forms like *The Magic Mountain* (1924), *In Search of Lost Time* (1913–27), and *The Man Without Qualities* (1930, 1932, 1943). Of course these *are* the great European modernist novels, or they are among them, but they don't announce themselves as such, and their appearance of belatedness is a clue as well as an illusion.

[1] James Joyce, *Ulysses* (London: Bodley Head, 1960), 23.

Even Thomas Mann was a little slow to understand the full critical story. In 1944, living in Pacific Palisades, Los Angeles, and at work on his *Dr Faustus* (1947), he paused to read a book on Joyce, Harry Levin's brief introduction published by New Directions (1941). Up to this moment Mann had assumed there were, apart from fame and talent, only differences between himself and Joyce, but now he began to see resemblances. He was much taken with Levin's claim that 'He has enormously increased the difficulties of being a novelist,' as well as his view that 'The best writing of our contemporaries is not an act of creation, but an act of evocation, peculiarly saturated with reminiscences.'[2] Mann himself, in his Joseph novels (1933–42), had used what T. S. Eliot called 'the mythical method',[3] and his irony had often separated him, however stealthily, from the very conventions he was using. The question, he says, continuing his reflections, is 'whether it does not seem as if one can consider, in the domain of the novel, only works which are no longer novels'.[4] 'Stylistically', he told his diary, 'I now really know only parody. In this close to Joyce.'[5] 'Now' was still 1944, but it went back a long way; if not all the way to *Buddenbrooks* (1901), then at least as far as *The Magic Mountain*.

'Not every story happens to everybody,'[6] the narrator of that novel says at the outset, parting company with the representative ambitions of much nineteenth-century fiction. If Flaubert could assert that his 'poor Bovary' was weeping in a thousand villages in France, and Balzac and Zola could aspire to being, respectively, the secretary and genealogist of modern society, Mann is saying there is only one Hans Castorp, and his tale belongs to a very particular time, and nation, and class— even if all of those conditions turn out to be extraordinarily hard to define or describe. This story takes place, he says, 'long ago, in the old days', but not because it is distant in historical time, only because its events occurred just before the First World War, 'with whose beginning so many things began whose beginnings, it seems, have not yet ceased'.[7] The past itself, he says, in a truly bewildering sentence, is all the more past for being so recent, because it is glimpsed across a gulf—the nearer to the gulf it comes, the more thoroughly over, *vergangen*, it seems. 'But is not the pastness of a story that much more profound, more complete, more like a fairy tale, the tighter it fits up against the "before"?'[8]

With practice we can become quite skilled at reading this tone and these modes of thought, which in their way are as difficult as any of Joyce's formal experiments with style, and they run all the way through the book. A late chapter floats the question of whether one can 'narrate time—time as such, in and of itself',[9] only to reveal a page or so later that the question was just an excuse for talking about time as both subject

[2] Thomas Mann, *Die Entstehung des Doktor Faustus*, in *Doktor Faustus* (Frankfurt am Main: Fischer Verlag, 1967), 741; my trans.

[3] T. S. Eliot, '*Ulysses*, Order and Myth', in *Selected Prose*, ed. Frank Kermode (New York: Harcourt Brace Jovanovich, 1975).

[4] Mann, *Doktor Faustus*, 741.

[5] Ibid. 716.

[6] Thomas Mann, *The Magic Mountain*, trans. John E. Woods (New York: Vintage, 1996), p. xi.

[7] Ibid., pp. xi–xii. [8] Ibid., p. xii. [9] Ibid. 531.

and medium. Both Mann (outside the text) and the narrator call *The Magic Moun-tain* a 'time-novel'. The modernist writer imitates the old-fashioned, mildly garrulous storyteller, hollowing out the genre of the novel as he goes, and the act is so subtle that many readers, perhaps most of Mann's readers, including critics as distinguished as Georg Lukács, have thought he really was what he was only impersonating. Mann himself indeed wanted at least some of his readers to think this, and perhaps believed it himself for longer than he should have.

Adrian Leverkühn, the composer–hero of *Dr Faustus*, has a powerful, despairing theory that illuminates this dilemma and this strategy. The very idea of the work, he thinks, 'the work as such, as a self-sufficient and harmonically self-contained struc-ture', is an illusion, or more precisely 'something the bourgeoisie wants to believe still exists'.[10] The great overt modernist achievements, like Leverkühn's own music or *Les Demoiselles d'Avignon* or Mallarmé's *Un Coup de dés jamais n'abolira le hasard*, arise from the explosion of this illusion, and as these examples suggest, there is no shortage of programmatic modernism in Europe outside of the novel. But this is precisely where European novelists swerve away from their English and American counter-parts. They know as well as anyone that what Leverkühn calls the work is an illusion, but they see that illusion itself as the fabric of their fiction. That's what a novel is for them: the elaborate embodiment of something that no longer exists. It's not that they are pandering to the wishes of the bourgeoisie, although a more bluntly radical reader might think they are. They are tracking those wishes through the realm of illusion, and they suggest, as more mould-breaking artists do not, that even the bourgeoisie knows the game is up. That's why it wants to believe in what's gone, and the true name of cultural conservatism is not tradition but nostalgia.

The modernist novel in Europe, then, can be seen as a sort of secret agent of literature, as Benjamin said Baudelaire was for the society of an earlier time, and in this perspective both Proust and Musil are Mann's close companions. There are differences, of course. Neither Proust nor Musil work primarily through irony, and shifting or elusive tones are not a major feature of their style. They undermine the novel through theory. That is, they pretend, and to some extent perhaps believe, that they are writing old-fashioned novels full of place, and class, and history, and Proust's narrator indeed says that 'a work in which there are theories is like an object with its price-tag still attached'.[11] Musil tells himself that his 'particular danger is to get caught up in theory', and feels 'depressed about the way the novel (*The Man Without Qualities*) is overburdened with essayistic material that is too fluid and does not stick'.[12] Yet these comments and complaints don't stop them for a moment from writing the way they do, and intuitively know they must.

Both of them turn theory into a novel, that is, place the mind's adventures where the old form used to situate material action, just as the more openly Impressionistic works of Woolf and Joyce do, except that the minds in Proust and Musil are,

[10] Thomas Mann, *Dr Faustus*, trans. John E. Woods (New York: Vintage, 1999), 192.
[11] Marcel Proust, *In Search of Lost Time*, vi, trans. Ian Paterson (London: Allen Lane, 2002), 190.
[12] Robert Musil, *Diaries 1899–1941*, trans. Philip Payne (New York: Basic Books, 1999), 425, 411.

precisely, theoretical, endlessly speculating about and rewriting the world. William Empson says that 'much of Proust reads like the work of a superb, appreciative critic upon a novel which has unfortunately not survived'.[13] But then something, the substantial ghost of an old form, has survived the novel, and Empson also uses the notion of parody in this context ('parodies are appreciative criticisms'), sending us back to Mann's sense of his own style. And if Mann parodies the traditional narrator as dithering storyteller, Proust and Musil parody him in his role of generalizing commentator. They write up the modern mind's adventures in the manner of Tolstoy or George Eliot; they turn the commentary into the plot. 'The writer's task and duty', Proust's narrator says, 'are those of a translator.'[14] The language of the translation is that of the still recognizable but thoroughly compromised old-fashioned novel.

'Everything is in the mind,' the same figure claims, but we need to be careful in our understanding of this extreme proposition. He doesn't mean everything is *only* in the mind, and when he writes, a few sentences earlier, of 'the purely mental nature of reality', he sounds like more of a solipsist than he is.[15] There is, for Proust and his characters, a great deal outside the mind—other people, the conviction, imprisonment, and rein-statement of Alfred Dreyfus, a whole collapsing social structure—but none of it has meaning, or in Proust's rather specialized usage, reality, until a mind has committed itself to its exploration, has become the hero, let's say, of a novel about a lost world.

The Magic Mountain recounts the thoughts and emotional adventures of an ordi-nary-seeming young man who leaves his Hamburg world of shipyards and commerce for the dreamlike zone of a Swiss sanatorium, where he falls in love with an impossible woman, or rather with impossibility itself. He also falls in love with death and disease, and barely survives to die or not die in that war where so many things began. Adrian Leverkühn in *Dr Faustus* sells his soul to the Devil in return for a musical breakthrough, and acts out a curious allegory of modern Germany in the process—an allegory that is both irresistible and consistently askew. Hitler probably didn't have a soul he could sell to the Devil, and he certainly didn't invent the twelve-tone row that Mann has borrowed from Schoenberg for his book. What is striking about these novels, and indeed about all of Mann's works, is the curious double sense he manages to create. As I have suggested, every case is unique, old ideas of type and representation are far away. And yet every case *is a case*, an oblique symptom, has to be read for meanings it does not contain within itself. This is not the mode of realism, where a mass of details forms a set of metonymies, of ways into a larger but still contiguous world. It is the mode of what we may think of as historically based metaphor, where quite specific stories invite us to cross over into parallel stories set in the same or in another period.

In Search of Lost Time portrays the childhood, social, and emotional coming of age, and ultimate encounter with a vocation of a person who closely resembles the author, and who at certain intriguing moments appears to share his first name. He has no second name, and there is an air of mystery even about the sketchy suggestions of his

[13] William Empson, *Seven Types of Ambiguity* (New York: New Directions, 1966), 249.
[14] Proust, *In Search of Lost Time*, vi. 199.
[15] Ibid. 223.

first ('if we give the narrator the same name as the author of this book').[16] It is often thought that the book this person plans to write as we reach the end of his story—the book he has taken the whole book to discover in himself—is the one we are just finishing reading. There is a satisfying circularity in the idea, but it misses too much of the anxious tone of the closing pages of the novel, one of our major clues to its modernity. The narrator has the idea of his book, but he hasn't written it, and he doesn't know—this too, like *The Magic Mountain*, is a 'time-novel'—whether he will have time enough in one sense to write about time in another. The doubleness in Proust's work is quite different from the doubleness in Mann, but it is just as complex and suggestive. There is an epiphany, a complete sense of redemption through involuntary memory, a happy end that the narrator explicitly compares to that of a fairy tale. But the book goes on for 150 pages after that, and its last sentence begins, 'Therefore, if enough time was left to me to complete my work . . .'.[17] Time can be conquered but only by those who live in time. No one else would need to conquer it, of course; and no one else could succumb to it, through disease or accident, at just the wrong moment.

The Man Without Qualities is set in 1913, in Vienna, where the Dual Monarchy of Austria-Hungary is preparing a vast celebration of its history and renown for the year 1918. No one in the novel knows what every reader knows: that 1914 will make the once anticipated 1918 unrecognizable, and bring only a violent substitute for the missing future—a mirror image of the narrator's sense of the past in *The Magic Mountain*. 'This grotesque Austria', Musil writes in a notebook, 'is nothing but a particularly clear-cut case of the modern world'[18]—a world, that is, which portrays itself in its every gesture but doesn't recognize the portrait. Ulrich, the man without qualities—the German word *Eigenschaften* could also be translated as attributes or properties—seeks to escape this blindness, to convert his lack into an opportunity, a chance of becoming a new man, or a man for a new world. 'Ulrich was not in the least minded to consider . . . the world an illusion, and yet it seemed to him admissible to speak not only of an altered picture of the world but also of another world . . .'.[19] This is a version of Proust's narrator's 'purely mental nature of reality', although Ulrich's mind is markedly more utopian. The unfinished novel—before his death in 1942 Musil gave twenty new chapters to the printers then withdrew them—cannot untangle the unthought- of possibilities repre- sented by the love for each other of Ulrich and his sister Agathe and the all too heard- of possibilities incarnate in the person of the psychotic killer Moosbrugger, but its very failure is in many ways emblematic. 'I have never taken anything beyond the opening stages,' Musil wrote late in life.[20] But he also hated completion. He both knew and did not know that opening stages can be lifelong and definitive, and that they were to be a major form for the modernist novel in Europe.

[16] Marcel Proust, *In Search of Lost Time*, v, trans. Carol Clark (London: Allen Lane, 2002), 64.
[17] Proust, *In Search of Lost Time*, vi. 358.
[18] Musil, *Diaries*, 209.
[19] Robert Musil, *The Man Without Qualities*, ii, trans. Sophie Wilkins (New York: Vintage, 1996), 1302.
[20] Musil, *Diaries*, 462.

It's time at this point to add a little nuance to the proposition that the European form doesn't look modernist by Anglo-American standards. Several very great novels do look curiously old-fashioned, indeed antique if we miss their aspects of parody and excess, and there are, within the genre, no emphatic bids for difference along the lines of *Ulysses* and *The Waves*. But we can complicate this picture in two ways. Firstly, there are after all some discreet claimants to the practice of modernism in the novel in the programmatic sense; and secondly, there are forms of modernism that do not refuse or resemble the cross-ocean standards, but pursue different goals altogether. The first suggestion invites us to look at writers like André Gide and Hermann Broch; and the second leads us straight to Franz Kafka, whose very name has become a synonym for a mode of the anguished European imagination in the twentieth century. Virginia Woolf could see Proust as a precursor, but no thoughtful writer has ever seen Kafka as anything other than the master of his own incomparable fictional country.

Gide described *The Counterfeiters* (1925) as his first novel, although he had been writing fiction for more than twenty years. He was the celebrated author of, among other works, *The Immoralist* (1902), *Strait is the Gate* (1909), *Lafcadio's Adventures* (1914), and *The Pastoral Symphony* (1919). Most of these he thought of as *récits*, narratives, lacking the density and reach he associated with novels, the Balzacian scope. This line of thought is consistent with Proust's practice and the backward-looking gaze I have described and shall return to. It could have led Gide to parody or a distension, or a hollowing out of the genre. It didn't, though. It led him into territory not unlike that of the exactly contemporary *Mrs Dalloway*. And yet.

The Counterfeiters has an unstable narrative point of view, a large cast of semi-satirized characters, a novel within the novel (and a novelist who keeps a diary), literal counterfeiters as well as metaphorical ones, and an intricate plot that allows Gide to show a whole Parisian social class, or rather the professional middle class with its aristocratic edges, at work and play. There is an element of the *roman-à-clef*, and the diabolical Comte de Passavant is usually taken to represent Jean Cocteau. Gide certainly saw himself as modernizing a genre, so why did he name the old mode in a way that suggests a delayed homage rather than a new departure, or rather that suggests a new departure only for him: 'my first novel'? The answer, I think, lies in Gide's curious combination of the experimental and the traditional—in his wanting to experiment traditionally, so to speak—and although there is far more edginess, and indeed social modernity, by way of sexual manners and intellectual preoccupations, in *The Counterfeiters* than there is in *Mrs Dalloway*, Gide does in the end picture youthful content in an elderly form. The form is not parodic or spaciously spectral, as in Mann or Proust, but its classical clarity and elegance do seem to place it in another time. To put this another way, no one in the novel, except the out-of-it members of the older generation, is as stuffy as Clarissa Dalloway and her crowd; but equally no one in the novel is going to worry about language and the very possibilities of narrative and meaning, as Woolf's narrator does on her stuffy characters' behalf.

Broch had made some experimental moves—towards parody and towards the essayism of Proust and Musil—in his trilogy *The Sleepwalkers* (1932), but it is in his

great novel *The Death of Vergil* (1945) that he strikes out towards modernism in the manner of Joyce and Woolf. The novel recounts, in the third person but through the mind of the protagonist, the last eighteen hours in the life of Virgil, dying in Brindisi. The poet remembers Rome, reflects on death, gives orders for the *Aeneid* to be destroyed, sinks into feverish dreams in which sleeping and waking worlds form what Broch called a 'magical unity'. Broch himself thinks of Joyce, but only to deny a close connection. Joyce cannot be imitated, Broch says; and in any case he himself is doing something different. He is doing it through an interior monologue, to be sure, but his interest is not in what he calls Joyce's pointillism, the mind at its daily work of erratic and elaborate associative thought, but in extreme, clarified consciousness, the artistic logic that transcends the illogicality of the everyday. He also disclaims any affinity with Proust or Mann, and says he is after something thoroughly new, *etwas durchaus Neues*, namely a 'lyrical self-commentary', a poet's prose that might be a prelude to a poem—or in this case, although this is not what Broch says, a postlude.[21] He mentions Rilke's *Duino Elegies* as working in something of the same genre. An English speaker might think of *The Waves*. There is something problematic about Broch's ambition, partly because of the conservatism lurking in his claim for novelty (his solution is new, he says, but the problem is age-old), and partly because, as Erich Heller says, *The Death of Vergil* is the literary expression of a 'deep revulsion' from literature. But we can't deny the intriguing modernity of this classically high-minded work, and the implied paradox reminds us of an important strand in modernism in many places. Pound's slogan 'Make it new' often meant, as in his own poems about medieval Provence, 'Dig up the old and learn how new it is.'

The great difference between the modernism of European novels and that of their Anglo-American counterparts, which encompasses the other differences I have been noting, although it is harder to detect and describe, has to do with realism. To a great extent the formal revolts and rebellions of Joyce, Woolf, Faulkner, and others were made against an enfeebled or routine realism and in quest of a better, deeper fidelity to the real. This is in part why even *Ulysses*, if it answered critics' questions, would not simply disavow the old novel and its apparatus. What Peter Nicholls calls 'the quarrel with mimesis'[22] is a complicated affair, wherever it takes place. A revolt very similar to the Anglo-American one characterizes the writers who in France in the 1950s came to be known as the New Novelists (principally Michel Butor, Alain Robbe-Grillet, Nathalie Sarraute, Claude Simon), which is why it can seem as if modernism merely arrived very late in Europe—late enough to be confused with postmodernism. Robbe-Grillet, like Woolf, wrote manifestos in favour of the new realism, although he was attacking big game like Balzac rather than modest masters of convention like Bennett and Galsworthy.

Of course all writers, even those dedicated to fantasy, seek some sort of intimacy with the real, but the realism in question here is more immediate: the ways things are,

[21] Hermann Broch, 'Kommentare', in *Der Tod des Vergil* (Frankfurt am Main: Suhrkamp, 1976), 470, 474; my trans.
[22] Peter Nicholls, *Modernisms: A Literary Guide*, 2nd edn (Basingstoke: Palgrave Macmillan, 2009), 13.

and if modernist things are mainly in the mind, then realism will follow them into the mind. The European writers I have been discussing do not exactly reject this version of the project, any more than they reject its earlier forms. But they are animated by a scepticism much deeper, I think, than anything to be found in an English-speaking tradition. Dr Johnson refuted, or thought he had refuted, Bishop Berkeley by kicking a stone. Modernists like Woolf and Joyce refute him with Impressionist haloes, deaths in parenthesis, and the irrefutable Molly Bloom. Modernist novelists in Europe don't refute him at all; they make a home for him among the spaces of a reality always under threat of verbal extinction.

This threat is the subject of Hugo von Hofmannsthal's *Chandos Letter* (1902), an essay in the form of a fictional communication from Philip, Lord Chandos, to Francis Bacon. The letter has made a relatively recent appearance in J. M. Coetzee's *Elizabeth Costello* (2003), where Chandos's wife, with the assistance of Coetzee, also writes to Bacon. But Coetzee's inflection of Chandos's concern—in his wife's mind the problem is that their whole life is falling away into metaphor, that they can't talk literally about anything any more, even about something as fundamental as the word (and concept) 'home'—picks up only part of the anxiety that Hofmannsthal is dramatizing. What makes this text such a founding document for European literature, and especially for the novel, where its implications encounter the most resistance and do the most damage, is Chandos's sense that the world is both irremediably real and utterly indescribable. In a sentence of extraordinary pathos he tells Bacon not that there is no language to account for reality but that he does not, and cannot, know the language there is 'because the language in which it might be given to me not only to write but also to think, is neither Latin nor English nor Italian nor Spanish, but a language of whose words not one is known to me, a language in which dumb things speak to me and in which I shall perhaps once I am in the grave answer to an unknown judge'.[23]

The dumb things do speak, if in vain, and perhaps Chandos is an empiricist in spite of himself, too prone to think of 'things'. Consider, for example, the German phrase in Wittgenstein's *Philosophical Investigations* which is translated as 'the facts': *wie es sich verhält*.[24] The translation is idiomatic and accurate. If Wittgenstein had been writing in English, this is no doubt what he would have said. Another idiomatic version would be the phrase I used a little earlier: 'the way things are'. But there are no facts or things among the German words, only a reflexive condition: the relations that obtain, or to use a famous earlier phrase from Wittgenstein, what is the case. Kafka also uses *wie es sich verhält* in exactly this sense, and indeed any German speaker could. It's a way of saying what's real without smuggling in even nouns, let

[23] Hugo von Hofmannsthal, *Ein Brief: Reitergeschichte* (Stuttgart: Ernst Kett Verlag, 1981), 15–16; my trans. The German reads: 'weil die Sprache, in welcher nicht nur zu schreiben, sondern auch zu denken mir vielleicht gegeben wäre, weder die lateinische noch die englische noch die italienische und spanische ist, sondern eine Sprache, von deren Worten mir auch nicht eines bekannt ist, eine Sprache, in welcher die stummen Dinge zu mir sprechen und in welcher ich vielleicht einst im Grabe vor einem unbekannten Richter mich verantworten werde'.

[24] Ludwig Wittgenstein, *Philosophical Investigations*, trans. G. E. M. Anscombe (Oxford: Blackwell, 1967), 37.

alone objects. This doesn't make reality any less elusive, but it allows some writers to keep writing.

In the first paragraph of Franz Kafka's *The Castle* (1926), a man who is as yet nothing more than an initial arrives in a location that has a long way to go before it will become much of a place:

It was late in the evening when K. arrived. The village was deep in snow. The Castle hill was hidden, veiled in mist and darkness, nor was there even a glimmer of light to show that a castle was there. On the wooden bridge leading from the main road to the village K. stood for a long time gazing up into the illusory emptiness above him.[25]

The snow and the bridge are real, and the time of day is what it is. The rest of the description hovers between the omniscience of a narrator who knows there is a castle here even if no one can see it, and the ambiguous position of K., who is either looking upwards for a castle he can't see or just looking upwards. The Muirs' choice of the word 'illusory' for *scheinbar* tips the scales a little—all the word literally says is 'seeming' or 'apparent'. The emptiness is only apparent: there is a castle here. But the appearance is also real: all there is to see is mist and darkness, without 'a glimmer of light'. As the novel unfolds, K. will get to see the castle, but the sight of it is all he gets. He will never arrive there, or have any kind of meaningful communication with any of its officials, that is, never gain the recognition he came to this region to seek, or—another just as plausible interpretation—never gain the recognition he has decided he wants from the authorities of the region he wandered into by accident. The ambiguity of his quest is perfectly balanced in his answer to the suggestion that he might just leave the place and live somewhere else. 'What could have enticed me to this desolate country except the wish to stay here?'[26] The wish to stay creates the idea of home, and the desolation reinforces the idea that home is everything—no other attractions are needed or available. K. learns in the course of the novel that the castle is something like the secret structure of social life itself, the all-powerful projection by a society's members of the rules of their own subjugation. A family K. gets to know fails to survive its disgrace—the disgrace arises because one of the girls in the family refuses the lascivious advances of a castle official—not because the family is ostracized (although it is) but because it cannot believe its ostracism will ever end. Compared with such subtleties the later, much-canvassed idea that everything is a social construction seems simplistic, or at best an easy start on a difficult question. For Kafka, in *The Castle* as in his earlier novels *Amerika* (1927) and *The Trial* (1925), everything is certainly a social construction; the difficulty is to understand how these flimsy products of our own making can so shape our lives, how habits and prejudices and idioms can turn out to be so much more solid and durable than cities or churches or landscapes.

[25] Frank Kafka, *The Castle*, trans. Edwin and Willa Muir, in *The Complete Novels* (New York: Vintage, 1999), 277.

[26] Ibid. 353.

Kafka, like Musil, was a master of the opening stages. He completed a number of now famous stories, but published only some of them. Like Broch's Virgil he gave instructions for much of his work to be destroyed—his friend Max Brod was his disobeying Augustus. And he never finished a novel. The very title of the Vintage collection of these works (*The Complete Novels*) is a sort of oxymoron. We shouldn't over-allegorize these stories of inconclusion, of course. Every psychology is different, and no doubt every failure to reach an ending has a different pathos and pathology. But it's hard to resist, and perhaps not entirely necessary to resist, the thought that Kafka saw in the genre of the novel a model of what could not be finished. If Mann and Proust suggest that the novel is over before they start on it, Kafka suggests that the novel is what will never get beyond starting. These positions are perhaps not as different as they seem. 'The Messiah will not come on the last day', Kafka wrote in a notebook, 'but on the very last day of all' ('Der Messias . . . wird nicht am letzten Tag kommen, sondern am allerletzten').[27] The sentence is a riddle, barely intelligible. But we glimpse a form of lateness beyond any kind we can coherently comprehend, something like the idea of the worst beyond the worst that we encounter in *King Lear*, or rather that Edgar knows he can't encounter: 'The worst is not, | So long as we can say "This is the worst".[28] On the last day Franz Kafka will be already dead or still writing; on the last day of all, if he still breathes, he will finish a novel.

If, seeking range as well as nuance, we now enlarge our view beyond novels written in French and German, which is all we have seen so far, we find, curiously perhaps, a confirmation of my initial proposition about parody and belatedness, and less curiously, some startlingly original work even with a tradition of ghosts and irony and repetition. I am thinking of works in Russian, Italian, and Portuguese, and in particular of Andrey Biely's *St Petersburg* (1912), Carlo Emilio Gadda's *That Awful Mess on Via Merulana* (1957), and Fernando Pessoa's *Book of Disquiet* (1930–1), the diary of an imaginary double of the author. Pessoa, whose name means 'person' in Portuguese, dedicated much of his writing life to multiplying identity to the point of apparent madness, and even his remarkable poems ask to be read in the light of the elaborate 'novel' that shelters them, his complex creation of the world of what he called his heteronyms.

Biely's *St Petersburg* is often compared to *Ulysses* because of its concentration on a city and its restricted time-frame—a little more than two days, apart from its epilogue. The comparison is helpful, and both books certainly represent important engagements of the literary imagination with modern urban life, with urban life as a kind of paradigm of modernity. It's also true that both novels carry strong echoes of European Symbolism, even if those echoes tend towards pastiche in Biely and towards a kind of collision of the literal and metaphorical in Joyce. But the overall mood and style of *St Petersburg* are perhaps closest to the stealthy, ongoing irony we have found in Mann—or at least in the Mann we discovered through his discovery of his affinities with Joyce. The first chapter plays with the very idea of story and lineage,

[27] Franz Kafka, *Hochzeitsvorbereitungen auf dem Lande* (Frankfurt: Fischer, 1991), 67; my trans.
[28] William Shakespeare, *King Lear* (New York: Random House, 1964), IV. i. 148.

introducing one of the novel's principal characters as a descendant of Adam: 'very good stock', as the narrator says, but hardly a distinguishing historical detail. Shem was another ancestor, but after these two names the narrator abruptly gives up the game. He says: 'At this point we can transfer our attention to ancestors of a less remote epoch.' Within two sentences we are in the first years of the twentieth century: 'A lackey attired in gray trimmed with gold galloon was dusting the writing desk with a feather-duster . . .'.[29]

The novel traces the adventures and conspiracies of Adam's descendant and his son, respectively a senior government official and a would-be terrorist, and an important aspect of the portrait is the curious resemblance between these two men, none the nearer to understanding each other just because they are alike. Above all, though, we live with them through a time (the year is 1905) which is both phantasmagoric and alarmingly real, a sort of revolutionary version of the condition Hofmannsthal's Chandos identifies. Situated somewhere between a projected Western future and a mythified Oriental past, Russia is a world of shadows that assume a violent existence without in any way giving up the privileges of non-existence accorded to all shadows. 'Thoughts too have their own particular existence,' the narrator says, announcing the accession of one of these shadows to the materiality of flesh and blood.[30]

At the other end of Europe, and beyond the end of the period we usually associate with modernism, we meet one of the greatest, and funniest, modernist novels of all, Carlo Emilio Gadda's *That Awful Mess on Via Merulana* (1957, although parts were published as early as 1946). This is a murder story which is also, like *Ulysses* and *St Petersburg*, a portrait of a place and a time: Rome in 1927, one of Mussolini's early years in power. But the detective here is a policeman, not an amateur like Sherlock Holmes and so many other stalwarts of the genre, and he is also a philosopher. One of the first things we learn about him is that he thinks we need to 'reform within ourselves the meaning of the category of cause', because no crime ever results from anything as simple as a motive put into execution. On the contrary, a crime is 'the effect of a whole list of motives which had blown on it in a whirlwind . . . and had ended by pressing into the vortex of the crime the enfeebled "reason of the word"'.[31] A perfect confirmation of the detective's view appears almost instantly. There is a robbery at an apartment house on the Via Merulana, a gun is fired, although no one is hurt. All the locals keep speaking of the intruder as a 'murderer', and the third-person narrator quickly, in a discreet slippage into *style indirect libre*, takes over the term. Then there is a murder in the same building, the hyperbole has turned literal, and the investigation has a quite different tone. There is much brilliant sleuthing, a seething cast of characters, and some extraordinary pictures of Roman life, but there is, as the detective's philosophy half-promises, no solution to the crime and no real

[29] Andrey Biely, *St Petersburg*, trans. John Cournos (New York: Grove Press, 1989), 3.
[30] Ibid. 38.
[31] Carlo Emilio Gadda, *That Awful Mess on Via Merulana*, trans. William Weaver (London: Quartet Books, 1985), 5, 6.

end to the novel. Italo Calvino suggests that Gadda had conventional literary tastes and radical habits, a combination that shouldn't surprise us by now. 'He envisioned constructing solid novels that observed all the rules, but he never succeeded in carrying his plans through to the end.'[32] There is more to the story, though—more trouble with the meaning of the category of cause—since, as Calvino reminds us, Gadda actually suppressed a chapter that cleared up the novel's central mystery. William Weaver, the translator of Gadda's novel into English, says we might suspect 'that his novels were born to be fragments, like certain imaginary ruins in Venetian painting, perfect parts of impossible wholes'.[33] Here we have to think again of *The Man Without Qualities*, with its exhaustive detail and its inability to end, and indeed the philosophical grounds of both novels are very similar. For Gadda what's interesting about the world is not some kind of existentialist absence of reason but a florid proliferation of reasons; for Musil every reason is a fiction, invented for the consolation of those who can't bear the brutal accidents of reality.

Fernando Pessoa published *Mensagem* (1934), a magnificent volume of haunting, cryptic verse, under his own name, but he also wrote poetry under three other names and prose under yet another. He saw these names not as pseudonyms, that is, disguises for his own writing self, but as what he called heteronyms, the names of other selves, and he invented biographies for each of these persons.

The plain pastoral poet Alberto Caeiro was a frail, modest man, had only an elementary education, lived in the country, died of tuberculosis; the classically minded Ricardo Reis, educated by the Jesuits, was a doctor and a monarchist, who emigrated to Brazil in 1919 after the failure of a royalist uprising; the futurist Alvaro Campos was a naval engineer with a degree from Glasgow and had travelled in the East. Pessoa saw these figures as if he knew them: Caeiro was blond, of medium height, had blue eyes; Reis was shorter, dark-complexioned; Campos was tall, thin, tended to slouch, wore a monocle. It is important to remember that the poems came first, that the biographies are a form of deeply earnest mischief, fragments of the novel that Pessoa found for his poems to live in. His existence as a poet (as the poet Fernando Pessoa among other poets) rests on something like the actual experience of being the writer(s) he cannot be. Variants of this paradox recur all over Pessoa's work, like the footsteps heard in Eliot's 'Burnt Norton' down the passage that no one took.

'Only when I'm disguised', the narrator says in *The Book of Disquiet*, 'am I really myself.' And: 'I turned myself into the fiction of myself.'[34] *The Book of Disquiet* is a prose work written over the last twenty years of Pessoa's career. Bernardo Soares, the imaginary author of these 'disconnected impressions',[35] has an early life different from Pessoa's, but he has Pessoa's job ('Assistant Bookkeeper in the City of Lisbon'), wit, style, and passion for watching the people of Lisbon. Indeed, in the early pages of his book Soares meets someone who seems to be Pessoa himself, a man whose 'pale,

[32] Ibid., p. x. [33] Ibid., p. xviii.
[34] Fernando Pessoa, *The Book of Disquiet*, trans. Alfred Mac Adam (Boston: Exact Exchange, 1998), 55.
[35] Ibid. 6.

uninteresting face' suggests suffering but not of a compelling or even identifiable kind.[36] The two men timidly confess that they are both writers and pretty much friendless, but we never hear of their meeting again. Pessoa said Soares was only a 'semi-heteronym because while he doesn't actually have my personality, his personality is not different from mine, rather a simple mutilation of it. Me minus ratiocination and affection.'[37]

Soares is stuffy and fastidious about the raw banality of the life around him, scared and scornful of women, unless they are idealized in a frantic retreat from disgust, eager to confess his lack of interest in anything other than his own perceptions. This is a book of disquiet because everything shifts and nothing settles. There are brilliant miniature allegories: 'I am the outskirts of a nonexistent town, a prolix commentary on an unwritten book'; 'I am a kind of playing card, from an old, unknown deck, the only card left from that lost pack'; "I am a widowed house, cloistered in itself, haunted by timid, furtive ghosts'; 'I was the digression from what I wanted to be, my dream began in my will, my intention was always the first fiction of what I never was.' 'I continue,' Soares writes, commenting on all of this, 'uncertain and allegorical, sentient but unreal.'[38]

In *The Book of Disquiet*, particularly if we look at it alongside the work of Pessoa's several personalities as a poet, we find something like a summary of a modernism that has come to know itself a little too well, as if a character from T. S. Eliot's poem had stumbled into a late novel by Thomas Mann. Pessoa's complex fictions take the doubt and anguish and experiment of the movement as a language, a form of life, and when they cast themselves as an imaginary journal, they place the novel at some sort of terminal risk, suspend it on the edge of a last silence.

We hear that silence everywhere in Samuel Beckett's three French novels, *Molloy* (1951), *Malone Dies* (1951), and *The Unnamable* (1953), in which a sequence of figments of an unstoppable imagination seek to die by writing themselves to death. If they could succeed, European modernism would be over. They themselves, though, must linger in these anxious spaces, waiting for the always delayed relief of the death of language and/or consciousness. Anglo-American modernism can end; has ended. European modernism in the novel, because it never existed in quite the empirical, identifiable way its English-speaking cousin did, is very slow to abandon the life it didn't quite have.

But of course it can fade away, and we have elegant evidence of its fading in the writing of Roland Barthes and Italo Calvino, figures who must be postmodernists if anyone is, and yet whose works are full of longing for modernism and what came before it, for the novel they know can no longer be written. They are not the bourgeoisie Adrian Leverkühn evoked. They don't wish to believe the old work of high art still exists; they know it's gone for good. But they love its memory, and this memory is part of who they are as writers. Barthes writes frequently about his

[36] Fernando Pessoa, *The Book of Disquiet*, trans. Alfred Mac Adam (Boston: Exact Exchange, 1998), 6.
[37] Ibid., p. xiii. [38] Ibid. 18, 153, 108, 143, 130.

contemporaries but identifies deeply with Proust and dreams of Tolstoy. Calvino's *If On a Winter's Night a Traveller* is a parodic tale of novels that can only start, and an elegy for novels no one now can write, a fictional form of Leverkühn's music but saturated in reminiscences of an old order of reading. His emblem is Mr Cavedagna, 'a little man, shrunken and bent', who (like Calvino) works at an Italian publishing house. Calvino has used these terms to describe him

not because he is more of a little man, more shrunken, more bent than so many others, or because the words 'little man, shrunken and bent' are part of his way of expressing himself, but because he seems to have emerged from a world where they still—no: he seems to have emerged from a book where you still encounter—you've got it: he seems to come from a world in which they still read books where you encounter 'little men, shrunken and bent.'[39]

There isn't any actual nostalgia here, the wit is too delicate and too firm for that. What Calvino is suggesting—and in this he is saying goodbye not only to the nineteenth-century novel but to all its twentieth-century ghosts, who, from Mann and Proust to Beckett, kept going on when they couldn't go on—is not that we still want to read novels about little men, shrunken and bent, or live in a world where people read such books, but that such worlds and such books cry out for our respect, even our tenderness, precisely because we are willing to let them go. We can't bring them back to life because we have transferred our allegiance to other styles and modes. And in this light perhaps we may come to believe that the European modernist novel—that long act of resurrection—really has found the rest Beckett couldn't give it. Its time would have been over not when it died but when it finally couldn't be born again.

[39] Italo Calvino, *If on a Winter's Night a Traveler*, trans. William Weaver (London: Picador, 1982), 79.

CHAPTER 7

..

STAGING MODERNISM
A NEW DRAMA

..

KIRSTEN E. SHEPHERD-BARR

IN 1896 Alfred Jarry's scatological and violent *Ubu Roi* caused an uproar in the theatre in Paris where it was first performed. W. B. Yeats was in the 'screaming, whistling, fist-shaking' audience,[1] and later wrote: 'What more is possible? After us the Savage God.'[2] The play features an obese tyrant called Père Ubu, who fancies himself king and does battle to usurp the crown, aided by his equally grotesque wife, Mère Ubu, with whom he battles just as violently. The pair are Grand Guignol, Punch-and-Judy types made flesh. Ubu's trademarks are the huge target painted on his stomach (anticipating Picasso's whorls in the costumes and sets of *Parade* in 1922) and the toilet brush he carries for a royal scepter. He opens the play by exclaiming 'Merdre!', a thinly disguised version of 'Merde!' ('Shit!'), and for decades the standard narrative about this production has been that this single word triggered a fifteen-minute riot in a theatre full of offended bourgeois spectators.[3] But in fact, the audience at this first night were rival groups of artists, critics, and intellectuals who knew Jarry's work and came geared for debate about it. In fact, it wasn't the language that offended so much as the staging. The scenery had been painted by a group of Post-Impressionist avant-garde artists who called themselves the Nabis (Prophets) and included Vuillard,

I am indebted to my colleague Sos Eltis for reading this chapter and offering suggestions and comments. Any errors are entirely my own.

[1] Simon Watson Taylor, 'Introduction', in Alfred Jarry, *The Ubu Plays*, trans. Cyril Connolly and Simon Watson Taylor (New York: Grove Weidenfeld, 1968), 12.

[2] W. B. Yeats, *Autobiographies* (London: Macmillan, 1955), 349.

[3] See Thomas Postlewait, *The Cambridge Introduction to Theatre Historiography* (Cambridge University Press, 2009), ch. 2.

Bonnard, Sérusier, Denis, and Ranson. Instead of discrete scenes they painted one continuous, colorful backdrop with incongruously juxtaposed images, in itself a radical scenic departure from theatrical convention. And against this unusual backdrop, a simple gesture made by the actor playing Ubu—his turning of an imaginary key in a "lock" represented by an actor's hand, while uttering the sound "cric-crac"—triggered the confrontation between the artists and intellectuals who supported the play and those who opposed it.[4]

Ubu Roi is an amalgamation of *Macbeth* and Jarry's own theatrical juvenilia, and contains the seeds of much of subsequent drama and theatre in its devices, characters, linguistic play, parody, bawdy and profane gestures, and metonymy (a lone soldier for an army, for example). Like much modernist art it has sometimes been dismissed as a schoolboy prank, and although the play has a starring role in most theatre histories as ushering in modernism on stage, it is rarely mentioned in histories of modernism generally. Yet Jarry's work is animated by the same spirit as that of avant-garde artists like Marcel Duchamp—there's not much distance between Duchamp's urinal and Jarry's toilet brush. The key difference is in the collaborative effort behind the play. *Ubu Roi* richly demonstrates that modernism on stage is the history of directors, actors, designers, and above all of theatrical collaborations, and that theatrical modernism constantly crosses boundaries. Terms can therefore be very difficult to define. The best we can do is highlight the key works and figures that represent and give meaning to the main currents of modernist work in the theatre. Realism, naturalism, Symbolism, Expressionism, the avant-garde, Dada and Surrealism, and so on—modernism in the theatre encompasses so many 'isms' that it is impossible to order it in some meaningful and useful way; it simply refuses to fit neatly into the kinds of temporal, geographic, or even generic categories that one normally applies to modernism generally.

In what Raymond Williams called 'the selective version of Modernism' that we usually get, theatre barely figures. He is hardly the only critic to notice this. As Christopher Innes writes, 'drama has been conspicuous by its absence' from the historiography of modernism, perhaps because modernism on stage 'has produced extremely diverse work ... so any discussion of dramatic Modernism must take a wide focus in following a multifaceted development'.[5] Elin Diamond notes that 'modern drama ... is nearly absent from current scholarship investigating the times, spaces, and practices of Western modernity and modernism' and points to the dominance of New Criticism as one of the main reasons why, as she succinctly puts it, 'modern drama has been excluded from the received canons of modernism'.[6]

[4] Frantisek Deak, *Symbolist Theater* (Baltimore: Johns Hopkins University Press, 1993), 234.

[5] Christopher Innes, 'Modernism in Drama', in Michael Levenson (ed.), *The Cambridge Companion to Modernism* (Cambridge: Cambridge University Press, 1999), 130.

[6] Elin Diamond, 'Modern Drama/Modernity's Drama', *Modern Drama*, 44/1 (Spring 2001), 4 (this is the second of *Modern Drama*'s two consecutive special issues entitled *Defining the Field of Modern Drama*). For an assessment of the historiography of modernism vis-à-vis the theatre, see Kirsten Shepherd-Barr, 'Modernism and Theatrical Performance', *Modernist Cultures*, 1 (Apr. 2005), 58–69 (<http://www.js-modcult.bham.ac.uk/index.asp>).

The New Critical insistence on the primacy of the text pushes performance to the margins in the vexed issue of theatrical 'evidence'. Textuality was the bugbear of modernist theatre, yet texts, paradoxically, are what remain as the artefacts that we study when we study modernism on stage. James Harding notes that 'textuality... has become perhaps the most pervasive of analytical paradigms'.[7] Often the plays of Ibsen, Strindberg, Chekhov, Synge, Shaw, Brecht, Beckett, and others are mentioned in histories of modernism, but in a literary context. The essential ephemerality of the theatre drives historians to cling to textuality, leaving an enormous gap in the story of modernist theatre.

The theatre underwent a series of astonishing revolutions in the span of a few decades, mainly owing to radical experiments in staging, which challenged the role of the actor, the audience, the director, the designer, indeed almost everything people thought they knew about the theatre as an art form. At one end of the spectrum was the development of the fourth wall, the 'darkened and hushed auditorium opposite a brightly-lit and busy stage'—seen as highly innovative at the time, in the 1880s—and, at the other end, the reaction against this kind of illusion of realism as shown by Brecht and Pirandello and carried on through the Absurdists.[8] Thus, very quickly there was a reaction *against* what was originally a breakthrough; 'the Brechtian rejection of theatrical illusion marks one of the truly original innovations in the entire history of drama'.[9] Another major revolution was the changing nature of the relationship between the audience and the work on stage which became more oppositional to the audience in both subject matter and form.[10] A new edge of hostility replaces the keenness to please that characterizes much previous drama. No longer interested in wooing and winning an audience, modernist theatre is largely *defined* by this change. We think of this now as a cliché—the modernist theatre took its pleasure in insulting its bourgeois audiences, and playwrights like Ibsen were largely responsible for this change by deliberately unsettling the viewer largely by reflecting his or her own world. This hostility to the audience increases in intensity the further you get into modernism. In 1911 Marinetti writes in his Futurist manifesto that 'among all literary forms, the one that can serve futurism most effectively is certainly the theatre', so long as we 'sweep away all the dirty prejudices that crush authors, actors and the public. We futurists, above all, teach authors to *despise the audience*.'[11] This contemptuous attitude to the audience continues to be a defining feature of later theatre as in the works of Ionesco, Genet, and Handke and then

[7] James Harding, 'Introduction', in *Contours of the Theatrical Avant-Garde: Performance and Textuality* (Ann Arbor: University of Michigan Press, 2000), 2.

[8] John Fletcher and James McFarlane, 'Modernist Drama: Origins and Patterns', in Malcolm Bradbury and James McFarlane (eds), *Modernism: A Guide to European Literature 1890–1930* (Harmondsworth: Penguin, 1976), 510.

[9] Ibid.

[10] See e.g. Neil Blackadder, *Performing Opposition: Modern Theater and the Scandalized Audience* (Oxford: Praeger, 2003).

[11] Quoted in Claude Schumacher (ed.), *Naturalism and Symbolism in European Theatre, 1850 to 1918* (Cambridge: Cambridge University Press, 1997), 470.

much of experimental postmodern theatre and performance. But, as the theatre historiography on *Ubu Roi* indicates, clichés about modernist theatre and its audiences need to be re-examined.

A third revolution was the rise of the director, one of the paradigmatic shifts in modern drama. This in turn encouraged more collaborative and cross-cultural enterprises. Key early modernist theatre directors include André Antoine, Aurélien Lugné-Poe, Elizabeth Robins, Edith Craig, Harley Granville-Barker, Max Reinhardt, Jacques Copeau, Adolphe Appia, Edward Gordon Craig, Constantin Stanislavsky, Vsevolod Meyerhold, Bertolt Brecht, and Samuel Beckett (directing seminal productions of his own work), who collectively reconceptualized drama and theatre through performance strategies that experimented with how to utilize and deploy the possibilities inherent in an empty space. Yet even here the terms become problematic, because so many of these directors were also playwrights, designers, and actors. The blurring of sharp distinctions is one of the defining characteristics of the modern theatre.

Thus, the radical, revolutionary changes in Western drama were fuelled by developments in the circumstances of the theatrical profession as much as by individual dramatists and their plays. Even the texts that define modern drama—the plays of Ibsen, Chekhov, Wilde, Strindberg, Maeterlinck, Shaw, Granville-Barker, Brecht, Pirandello, Robins, Glaspell, O'Neill, and so on—rely centrally on their various performance strategies for the themes and 'issues' that they raise. While a sense of chronological development is essential, it doesn't convey the complexity of often simultaneous and deeply contrasting strands of modernist activity in the theatre. Even within a single movement or representative figure there are often huge contradictions or tendencies. Playwrights like Ibsen and Strindberg experimented with many different genres and styles of dramaturgy, and their best work is often an amalgam of modes, as in Ibsen's *The Master Builder* or *When We Dead Awaken* (beloved of the young James Joyce). Directors were the same, moving swiftly from one style to another, as in the case of Max Reinhardt, who in his earlier work experimented with art theatre and only later became famous for staging epic dramas with casts of hundreds. It is therefore useful to think of the various 'isms' of modernism on stage as generally overlapping rather than strictly consecutive. The various strands get entangled in complicated ways. For instance, the establishment of the concept of 'intimate theatre' happens around the turn of the century but takes radically different forms: Reinhardt's Kammerspielhaus, with its experimental productions of Ibsen and others with backdrops by artists like Edvard Munch on occasion, was truly an 'art' theatre; so was Strindberg's Intimate Theatre, staging his later plays often before a tiny audience; and Stanislavsky's Moscow Art Theatre catering to (and simultaneously creating) both the actors and consumers of the kind of psychological realism that still dominates the stage today. Each of these was a separate entity, of course, but it is their collective influence on the development of modern drama and theatre that is of primary relevance.

Already in the 1830s Georg Büchner produced the unfinished and fragmentary drama *Woyzeck,* hailed ever since as protomodernist in its subject matter—the

dehumanization of man as the subject of scientific experimentation, the depiction of lurid sexual jealousy and murder—and its stylized, episodic treatment (forerunner of several strikingly different modernist developments including the work of Brecht, discussed below). For all these reasons the lineage of modern drama can be traced right back to *Woyzeck*, which only became more widely known once it was heavily reworked and published in 1879 and which only received its first performance in 1913. Modern drama in Europe really takes off in the 1880s, through the almost simultaneous developments of realism and naturalism, mainly in France and Germany. But neither of these movements simply happened; they were brought about by the complex interaction of several key events spanning all areas of drama.

Trying to disentangle realism and naturalism and make sense of them as distinct movements, or even consecutive ones, reveals how complex and problematic these terms are. To begin with, they each mean different things on the page and on the stage. Realist plays, like Ibsen's *A Doll's House*, have their roots in the dominant dramatic form of the nineteenth century: the well-made play (*pièce bien faite*), imported from France to England and exemplified by Dumas *fils*, Scribe, and Sardou. The well-made play was intricately plotted, beginning with exposition scenes that presented the characters and the main obstacles in their way, moving towards a climax, and offering a resolution, or dénouement, that left all the ends tied up and the audience satisfied. There was usually a *raisonneur*, a detached and common-sense character commenting helpfully on the drama even while implicated in it, as well as other recognizable character types, and liberal use of asides, *deus ex machina*, and other non-realistic devices.

Well-made plays tended to depict the upper classes and their problems and to feature a large number of objects such as handkerchiefs, letters, and jewellery on which the plot turned, for example revealing identities that had been hidden. Oscar Wilde turns this convention on its head in his 1895 farce *The Importance of Being Earnest* (the manuscript and the baby being confused, the handbag, the cucumber sandwiches, and Cecily's string of objects with which she helps to concoct her engagement to Algernon); likewise Elizabeth Robins's *Votes for Women* (1907) hinges on the stock-in-trade devices of the well-made play such as the accidental discovery of a monogrammed handkerchief and, above all, a Fallen Woman (or Woman with a Past). Prior to this popular formula, two dominant forms of nineteenth-century theatre were melodrama and the domestic drama (or 'cup and saucer' drama) as practised by T. W. Robertson in England.[12]

Audiences flocked to well-made plays on both sides of the Channel (the British versions usually cleansed of any risqué sexual content)—and this was a bourgeois audience, newly literate, newly moneyed, and increasingly in search of entertainment

[12] For background on nineteenth-century drama and theatre, see e.g. Michael R. Booth, *Theatre in the Victorian Age* (Cambridge: Cambridge University Press, 1989); Russell Jackson (ed.), *Victorian Theatre* (London: A. & C. Black, 1989); Kerry Powell (ed.), *The Cambridge Companion to Victorian and Edwardian Theatre* (Cambridge: Cambridge University Press, 2004); and Elaine Hadley, *Melodramatic Tactics* (Stanford, Calif.: Stanford University Press, 1995).

that reflected their own lives. Moving away from melodramatic spectacle, the theatre began to feature domestic interiors, bourgeois characters of some psychological depth, speech and dialogue that sounded like everyday talk, and themes and issues to which this new audience could closely relate, such as marital and financial crises. This exactly describes Ibsen's *A Doll's House* (1879), which is in one sense about the social forces behind the disintegration of a marriage and family in the face of financial burdens. Ibsen's innovation is to focus on the woman's experience of this and to point up the crippling lack of opportunities for her within contemporary society. But for a playwright like Ibsen to be able to write such a play, certain theatrical circumstances had to be in place.

In the theatre, the advent of electricity meant that you could manipulate the audience by plunging it in darkness and pretending it wasn't there, so that they became the aforementioned 'fourth wall' of the stage. Quite apart from the role of eavesdropper and voyeur that this assigned to the spectator, it also produced a quiet audience—a radical break from the gigantic, cavernous, and noisy theatres of melodrama and spectacle that dominated the nineteenth century and its styles of playwriting and of declamatory acting. The new, smaller, electrically lit theatres also made it safer and more respectable for actors, especially women, to go on stage: the profession became more hospitable for women, even as women were also beginning to challenge societal expectations of their roles, and this in turn was being reflected in the kind of dramatic writing of the late nineteenth century.[13] Publication made a difference, too. The introduction of dramatic copyright (the Berne Convention of 1887) finally made it financially secure for playwrights to publish their work, which in turn led to a readership and a whole new market for drama; a result of this is the extensive narrative stage directions that start to appear in plays of the late nineteenth century (e.g. Shaw and Wilde). The establishment of psychology as a science and a legitimate field of study also meant playwrights could bring more depth and nuance to characters, and plays begin to reflect this as they move away from the more starkly delineated character types of melodrama.

So much of this can be traced back to Ibsen, who radically broke with the Scandinavian and Germanic tradition of verse drama by embracing prose as the new language of the theatre and championing Georg Brandes's doctrine that 'modern literature must put problems into debate'.[14] Ibsen's plays represent a sustained interest in gender as the main problem in contemporary society, particularly the

[13] For insight into women in nineteenth-century theatre, see e.g. Kerry Powell, *Women and the Victorian Theatre* (Cambridge: Cambridge University Press, 1998); Tracy C. Davis, *Actresses as Working Women: Their Social Identity in Victorian Culture* (London: Routledge, 1991); and Tracy C. Davis and Ellen Donkin (eds), *Women and Playwriting in Nineteenth-Century Britain* (Cambridge: Cambridge University Press, 1999). See also Katherine E. Kelly (ed.), *Modern Drama by Women, 1880s–1930s: An International Anthology* (London: Routledge, 1996).

[14] Georg Brandes, *Hovedstrømninger i det 19de Aarhundredes Litteratur* ('Main Currents in Nineteenth Century Literature') (Copenhagen: Gyldendal, 1872), 15. James McFarlane notes that 'in the history of comparative literature studies, it is one of the great seminal works' ('Cultural Conspiracy and Civilizational Change: Henrik Ibsen, Georg Brandes, and the Modern European Mind', *Journal of European Studies*, 9 (1979), 155–73).

narrow opportunities for women; in play after play he develops and probes this idea from different angles. This all sounds very textual, and indeed it is at first glance. Shaw's *The Quintessence of Ibsenism* (1891) steered critics and scholars to focus on the structure, themes, and characterization in Ibsen's plays, for example seeing Ibsen's modification of the well-made play formula (replacing the dénouement, or resolution, with a sustained discussion scene that offered no easy solution) as his central contribution to modern drama. But recent work on Ibsen's radicalism has shown us afresh how a theatrical self-consciousness, an awareness of performance, permeates all his major plays. Toril Moi in *Henrik Ibsen and the Birth of Modernism* effectively rescues Ibsen from a mistakenly dusty area of theatre history called 'realism' and shows how centrally he figures for the developments of modernism, particularly its theatricality and its rejection of an idealism that still continued to dominate the arts throughout the nineteenth century.[15]

It should be obvious by now that there are no neat and tidy definitions of the terms 'realism' and 'naturalism'. At best such 'isms' are rough critical tools. Ibsen's *Ghosts* (1881), following immediately on *A Doll's House*, exemplifies both tendencies—it is realist in its structure, characters, and setting, but naturalist in its frank treatment of a sexual theme (syphilis) and the dilemma of euthanasia. *Ghosts* was reviled by critics in the first of many such events in the history of modern drama, a forerunner to the reactions to Edward Bond's *Saved* and Sarah Kane's *Blasted*: 'an open drain; a loathsome sore unbandaged; a dirty act done publicly . . . gross, almost putrid indecorum' were the comments of the *Daily Telegraph* on the play's London premiere in 1891.[16]

In fact, one could argue that nothing Ibsen *wrote* was really doctrinaire naturalist, but was interpreted so *theatrically*. Stage naturalism was typically achieved by replacing painted backdrops with the real thing (e.g. real meat hanging from meat hooks, dripping blood, rather than painted on the wall to depict a butcher's shop). Naturalism in the drama stems from Zola, who gets his inspiration from the positivists Taine, Sainte-Beuve, and Comte and their emphasis on race, milieu, and moment as the determining factors of a person's life. Zola explored this in novels like *Thérèse Raquin* (which he adapted for the stage in the 1870s), and there are several key manifestos of naturalism by Zola, Antoine, and Strindberg (the Preface to *Miss Julie* in particular)—all indicating how vexed the issue was.[17] Zola, Gerhardt Hauptmann (*The Weavers*), Ibsen in *Ghosts*, Strindberg (*Miss Julie*, *The Father*), and Maxim Gorky (*The Lower Depths*) exemplify naturalist drama that tended to focus on the seedier, seamier undersides of society, depicting the poverty-stricken lower class and often dealing with sexual themes. Europe raged with the 'degeneracy' debate prompted by such works and represented by Max Nordau's reactionary 1895 book *Degeneration*. The drama was seen as degenerate not only in its subject matter but as

[15] Toril Moi, *Henrik Ibsen and the Birth of Modernism* (Oxford: Oxford University Press, 2006).

[16] Michael Meyer, *Ibsen* (London: Cardinal, 1971), 686. See also Michael Egan (ed.), *Ibsen: The Critical Heritage* (London: Routledge & Kegan Paul, 1972).

[17] These have all been gathered in Claude Schumacher's invaluable compendium *Naturalism and Symbolism in European Theatre, 1850 to 1918*.

an art form, and, of course, all the more dangerous because witnessed in live performance by an audience. You thus have a dynamic that comes increasingly to characterize modern drama: on the one hand, theatre is dismissed as marginal, frivolous, and unworthy of serious critical attention, and, on the other, it is reviled as dangerous and undermining the social fabric.

By the turn of the century, a reaction against the sordid drabness of stage naturalism prompted a 'New Stagecraft', engaging some of the leading figures of European modernism in collaborative theatrical experiments.[18] But even earlier than this, in reaction to the perceived ugliness of so many naturalist plays, Symbolism emerged, also a largely Francophone impulse stemming from Baudelaire and his idea of 'correspondances' (closely related as well to Wagner's *Gesamtkunstwerk*, or 'total art' theory, fusing all the arts together). Maurice Maeterlinck, Stephane Mallarmé, and others took Baudelaire's ideas further. No sooner had realism and naturalism taken hold than they were discarded by the theatrical avant-garde, distrusting the limited aesthetic conditions the form seemed to impose as well as its political implications; how could one playwright presume to represent 'everyone's' reality? Attempts to break with or challenge realism and naturalism yielded some of the most productive, imaginative moments of modernism. Symbolism—which shot like a comet over the 1890s, only to peter out by the turn of the century—was one of the earliest of these concerted attempts, and the director Lugné-Poe (who had first staged Jarry's *Ubu Roi*) was its theatrical pioneer. Yet, as his work shows, Symbolist plays pale in comparison with their performances. With a few exceptions like Ibsen's *The Master Builder*, Lugné-Poe's productions of Symbolist drama in the 1890s were notable more often for their theatrical innovations and techniques than for their dramatic texts. His Théâtre de l'Œuvre in Paris made a radical break with realism and naturalism, having the actors chant their lines in a hieratic monotone accompanied by highly stylized, slow-motion movement, all presented behind a translucent scrim with its attendant lighting possibilities. Something dreamlike, indefinable, and abstract, beyond the realm of the quotidian, was being hinted at; Maeterlinck hailed the way one sensed a 'dialogue of the second degree' emerging beneath the spoken dialogue in Lugné-Poe's production of *The Master Builder*.[19]

Lugné-Poe's predecessor Paul Fort, in his short-lived Théâtre d'Art, produced a remarkable attempt at Baudelairean 'correspondances' on stage in an 1891 performance of the biblical *Song of Songs*. He placed young Symbolist poets throughout the auditorium, who pumped scents into the audience on cue, the idea being that these aromas would scientifically correspond with the simultaneous visual and aural elements on stage (e.g. purple to complement certain words or sounds along with 'purple' scents and

[18] Frederick J. Marker and Lise-Lone Marker, 'Ibsen and the Twentieth-Century Stage', in James McFarlane (ed.), *The Cambridge Companion to Ibsen* (Cambridge: Cambridge University Press, 1994), 183.

[19] See e.g. Deak, *Symbolist Theater*, and Kirsten Shepherd-Barr, *Ibsen and Early Modernist Theatre, 1890–1900* (Westport, Conn.: Greenwood Press, 1997), 117–45. Maeterlinck's identification of Ibsen's unspoken dialogue, the words beneath the spoken text, was prescient; later writers continued to comment on the way Ibsen magnified microscopic things in human nature, excavating the 'subterranean'. See James McFarlane (ed.), *Henrik Ibsen: A Critical Anthology* (London: Penguin, 1970), 214–15.

music) and prompt a certain emotion in the audience. The perfume venture is an interesting case because by all accounts it would seem to have been a resounding flop. You couldn't corral scents once they'd been disseminated, so the audience was left choking and giggling with the heady combination of smells. It didn't merit many repeat performances and certainly didn't blaze the way to a fuller experimentation with scent in the theatre (one has to fast-forward to the similarly risible instance of 'smell-o-rama' in the cinema a few decades ago as perhaps the nearest thing to this idea).[20]

Like so many of the ground-breaking and notable modernist theatre events, it was not so much in the execution as in the conception that the event was significant, and of course this goes radically against the criteria for inclusion in artefact-based historiography, where the immutable object is key. But the concept of failure stands very much at the heart of theatrical modernism (one thinks of Beckett's injunction to his disheartened actors: 'Fail again . . . Fail better'). Modernism shouts its triumphs: Joyce's *Ulysses*, Woolf's novels, Picasso's paintings, Stravinsky's music. Most met with initial resistance, but were eventually accepted and then finally canonized. Many of the dramatic texts and live performances that have helped to define theatrical modernism were deemed failures by the wider contemporary critics and audiences: the Symbolist performances, Wedekind's *Spring Awakening*, Apollinaire's Cubist, *Ubu*-inspired *Les Mamelles de Tirésius*, Copeau's short-lived Vieux-Colombier theatre, the Dada cabarets, and even Brecht's didactic *Lehrstücke* (which he later saw as most closely realizing his vision of theatre). So often, these ventures were fleeting, misunderstood, and/or left behind precious little in the way of a material record of their existence, being one-off, fringe efforts, shown to a coterie audience, sometimes not even in a 'proper' theatre (in London this happened a lot, mainly to get around censorship by holding performances 'by subscription' that were essentially private). John Stokes's book on the small groups that 'organized the theatre' in the late nineteenth century shows that much of the radical activity happening in the early modernist theatre was fringe and, he admits, by all accounts 'resistible' (paraphrasing Ruskin's injunction to 'organize the theatre; the theatre is irresistible').[21] The Joint Management company formed by the actresses Elizabeth Robins and Marion Lea, the Independent Theatre of the 1890s, later the Stage Society, and also Edith Craig's Pioneer Players are just a few of the leading small independent companies in London. Yeats's Cúchulain play of 1916 *At the Hawk's Well* was 'privately performed in two London drawing rooms with small, exclusive audiences (among them T. S. Eliot)' and with its stylized, Noh-inspired acting and emphasis on masks.[22] The little theatre movement in America began in the 1910s with such enterprises as the Provincetown Players, founded by Glaspell, O'Neill, and their circle of writers and artists, which exerted a long-term impact on subsequent drama despite incongruously modest

[20] See K. Shepherd-Barr, 'Mise en Scent: The Théâtre d'Art's *Song of Songs* and the Use of Smell as a Theatrical Device', *Theatre Research International*, 24/2 (Summer 1999), 152–9.

[21] John Stokes, *Resistible Theatres: Enterprise and Experiment in the Late Nineteenth Century* (London: Paul Elek, 1972).

[22] Charles Carpenter, *Modernist Theatre Timeline*, <http://www.moderndrama.com/crc/chrono/gateway.php>.

beginnings in a rickety, run-down wharf theatre that eventually collapsed into the sea.[23]

These examples demonstrate how limited and confined such theatrical experiments often were, staged in private homes or in 'intimate theatres' for tiny, like-minded and thus appreciative audiences. Conversely, certain ideas of the theatre never really came to fruition, yet have exerted a lasting influence, such as the 'drama of the interior' theorized by Mallarmé and Yeats, and practised by many dramatists like Maeterlinck and Synge and beyond. Mallarmé's ideas about theatre retreat from physicality into interior monologue and metaphysics, almost impossible to realize on stage because directly antithetical to its physical methods and resources.[24] In addition, some of the key productions that we identify as defining modernist theatre were one-off events, never to be repeated or at least not in the same way (e.g. the original *Ubu Roi* and its revival in the 1920s). The history of modernist theatre is studded with such gems of 'failed' experimentation.

In Expressionist theatre, emerging from Germany and Scandinavia but spreading quickly throughout Western drama, the stage becomes a representation of interiority, of emotion, and liberates itself from the confines of realistic plot and characters by dealing in archetypes and in dream states. Expressionist drama differs from the much more abstract notion of the interior drama of Mallarmé in having recognizable characters, action, and plot; it is not static. One of the best examples of this is Strindberg's *A Dream Play*, in which Indra's daughter is sent down from heaven to investigate why mankind is so unhappy. There is heavy use of symbols, such as a growing castle, a burning chrysanthemum, a white shawl that grows heavy with the accumulated woes of mankind, and Fair and Foul Strand symbolizing heaven and hell. The characters are generally not individually named but are simply the Lawyer, the Soldier, the Actor, the Four Deans of the University, and so on. Other examples of Expressionist drama include Wedekind's *Spring Awakening*, Sophie Treadwell's *Machinal*, and Elmer Rice's *The Adding Machine*. Arthur Miller's *Death of a Salesman* (originally entitled *The Inside of His Head*) blends realism with Expressionist techniques, as in the 'timebends' evoking powerful emotional moments of the past and Jo Mielziner's original staging in which Willy Loman's house, with its huge blinking windows and front door facing the audience yet open to its probing eyes, symbolizes his 'head' and stages his thoughts and memories.

Many of the examples described so far are part of the more radical developments of modern drama, what we might call the theatrical avant-garde, which emphasized performance over textuality; 'the rise of avant-garde performance is premised upon

[23] See Linda Ben-Zvi (ed.), *Susan Glaspell: Essays on Her Theater and Fiction* (Ann Arbor: University of Michigan Press, 1995); June Schlueter (ed.), *Modern American Drama: The Female Canon* (Rutherford, NJ: Fairleigh Dickinson University Press, 1990), 66–76; and also C. W. E. Bigsby, *A Critical Introduction to Twentieth-Century American Drama*, i: *1900–1940* (Cambridge: Cambridge University Press, 1982), 1–35.

[24] See e.g. Deak, *Symbolist Theater*; Martin Puchner, *Stage Fright: Modernism, Anti-Theatricality and Drama* (Baltimore: Johns Hopkins University Press, 2002), 59–80; and Katharine Worth, *The Irish Drama of Europe from Yeats to Beckett* (London: Athlone Press, 1978).

the demise of a text-centered approach to theater'.[25] Another great revolution of
modern drama, along with the role of the audience, the styles of acting, and so on,
was the use of increasingly sophisticated notions of meta-theatre, often called 'play
within a play', thus breaking the fourth wall almost as soon as it had, so to speak, been
comfortably installed. The two go hand in hand, of course, and it is not hard to see
why. If you want to challenge your audience, to rouse its activist sentiments and make
it feel some discomfort, you start by acknowledging its presence. Meta-theatricality
develops from its Renaissance (and earlier) roots to take on new forms and purposes
in modernist theatre. The primary aim of meta-theatre is of course to disrupt the
audience's passivity as spectators and to implicate them in the action by addressing
them directly. Pirandello, O'Neill, Wilder, and Brecht are masters of meta-theatre.
They reveal the workings of the stage rather than disguising them and pretending the
actors and the audience are in 'real' rooms having real conversations. In the early
1920s, the first productions across Europe of Pirandello's *Six Characters in Search of
an Author* unsettled and thwarted audience expectations of the divide between the
stage and the spectators, even of how a play ought to open, let alone proceed, when
on entering the theatre they encountered a bare stage peopled by a few actors
desultorily chatting. Had the play already begun? If so, was this all there was to it?
Why were some of the actors sitting in the audience and suddenly coming forward
onto the stage? Pirandello's meta-theatre asks philosophical questions about the line
between reality and illusion. Contrast this with the meta-theatre of Brecht, developed
from this same period and until his death in 1956, which likewise aims to disrupt the
viewer but in order to rouse him or her to action. Brecht wants to get away from what
he calls the 'dramatic' theatre, or the 'culinary' experience of seeing a play, in which
the audience passively watches the action in a kind of intellectual and moral stupor.[26]
His Epic Theatre requires the actor to act in such a way that the audience will not
identify too much with him or her but think about the reasons behind the character's
predicament. From these examples it is clear that meta-theatre takes on both
aesthetic (Pirandello, O'Neill) and political (Brecht, Wilder, Auden) qualities.[27]

The history of modernism on stage is a history of sudden arrivals and radical
departures; of catastrophism rather than Darwinian gradualism. The plays of Samuel
Beckett might seem to come out of nowhere, as he is usually taught in theatre history
courses that emphasize what a shock it was when *Waiting for Godot* premiered in
1955. Yet as both Katharine Worth and David Bradby have shown, none of Beckett's
theatrical output, from *Eleuthéria* to *Godot* through to the shorter plays like *Not I* and
Play, would be conceivable without Maeterlinck, Craig, the Surrealists, and other

[25] Harding, *Contours*, 3.

[26] See *Brecht on Theatre: The Development of an Aesthetic*, ed. and trans. John Willett (New York:
Hill and Wang, 1957).

[27] One way in which meta-theatre enters modernist drama is in theories about the theatre. Wilde,
O'Neill, Craig, and Pirandello all wrote essays on the role of masking in drama; Appia committed his
design ideas and theories to paper; Granville-Barker revolutionized the modern staging of Shakespeare
through both his productions and his volumes of essays relating to them; *Brecht on Theatre* is still the
Brecht bible for anyone interested in epic theatre in theory and practice.

modernist predecessors in the theatre.[28] Incongruity, silence, fragmentation of struc-
ture and speech, contradictory meaning ('Let's go.' *They do not move*), desolation: all
of these seemingly radical innovations have deep roots in modernist theatrical
performance. Beckett's apparent moonscapes, the barren landscapes of the mind,
have much in common with the forsaken settings of Maeterlinck's marooned blind
figures who are waiting for something to arrive or to happen, without quite knowing
what. 'He makes no attempt to situate his characters—to give them roots in what
seems like recognizable reality,' writes Maya Slater of Maeterlinck, a description that
sounds uncannily like Beckett's dramas as well.[29] And again: 'The problems that
provide the intrigue of the plays are visibly human dilemmas, but stripped of their
contemporary trappings. . . . But the most striking emotion in Maeterlinck is an
unfocused sense of distress and unease, an inexplicable, nightmarish fear, which
links these dramas to the world of dreams.'[30] This could just as easily describe
Beckett's *Endgame*, *Not I*, *Play*, or *Catastrophe*, or so many of his other 'dramaticules'.
Modernist theatre practitioners from Edward Gordon Craig to Meyerhold seem to
want to get rid of or transform the human body into something that can be better
controlled, more machine-like—less human. Here we seem to have a profound case
of anti-theatricality, at least in the narrow sense of the mainstream theatre. Beckett's
Not I, in which the entire text of the play is spoken by a mouth, with a silent black-
clad 'auditor' mournfully lifting its arms at specific points throughout the play, might
seem to be the culmination of this attempt to get away from the traditional fore-
grounding of the actor. But is it anti-theatrical? As David Savran points out, Beckett
is 'so central to the modernist canon in part because he problematizes theatrical
presence in a way that both recapitulates and defamiliarizes the achievements of early
modernism. He is like Maeterlinck without all the fog and veils.'[31] The ability to
utilize and transform the anxiety of influence and the anti-theatrical strain that
characterize modernism in this hugely innovative and productive way marks out
Beckett's achievement—but you need a sense of the theatrical context for his work in
order to see this fully. In fact, as Worth and others have shown, much of what we
think of as modernism in the theatre comes from Irish drama: the works of Wilde,
Shaw, Yeats, Synge, O'Casey, Beckett, and others, and the theatres they established
such as the Abbey. By contrast, little innovation seems to have emerged from English
drama. Beckett is simply the tail end—or the culmination—of a strongly Irish–
European modernist theatre.

If textual primacy emerged as one stumbling block for modern theatre, another
was surely materiality: the sheer practical problem of the bodily presence of the
actor and the physical conditions of the stage. Symbolists and Expressionists sought
to get beyond materiality and corporeality into something far more abstract and

[28] Worth, *The Irish Drama of Europe from Yeats to Beckett*, and David Bradby, *Plays in Performance: Waiting for Godot* (Cambridge: Cambridge University Press, 2001).

[29] Maurice Maeterlinck, *Three Pre-Surrealist Plays*, ed. Maya Slater (Oxford: Oxford University Press, 1997), pp. x–xi.

[30] Ibid., p. xi.

[31] David Savran, 'The Haunted House of Modernity', *Modern Drama*, 43 (Winter 2000), 592.

indefinable, much more experiential and elusive, experimenting with accepted no-
tions of acting, dramatic text, staging and design, lighting and sound, movement
and voice. This closely relates modern theatre to a scientific paradigm—theatre as
laboratory, as a site of investigation, testing hypotheses, waiting for results and then
analysing them. Laboratories have participants but not audiences—at least, not until
the finished results are published for a readership. But theatrical experimentation
takes place before a live audience, and this development, which we take for granted as
central to our own contemporary theatre, originates in modernist drama. Tracing
and accentuating this notion of theatre as experiment, whether one lights on Adolphe
Appia's abtract lighting designs or Meyerhold's 'biomechanics', one sees the direct
link with contemporary science. 'Meyerhold', writes Edward Braun, 'presented bio-
mechanics as the theatrical equivalent of industrial time-and-motion study. He
compared it on the one hand to the experiments in the scientific organization
of labour by the American Frederick Winslow Taylor and his Russian follower
Gastev, and on the other to the theories of "reflexology" developed by the "objective
psychologist" William James and the Russians Bekhterev and Pavlov.'[32]
 Meyerhold writes:

In art our constant concern is the organization of raw material. Constructivism has forced the
artist to become both artist and engineer. Art should be based on scientific principles; the
entire creative act should be a conscious process. The art of the actor consists in organizing his
material: that is, in his capacity to utilize correctly his body's means of expression.[33]

It is striking to set this comment beside Edward Gordon Craig's earlier outright
rejection of the human actor for perpetuating the 'debased stage-realism' of contem-
porary theatre.[34] What a leap has been made from the conception of the actor in
the 1890s (the bemoaning of the body's physicality and the materiality of the stage
that dogged the Symbolists) to Craig's provocative dismissal of the actor as unneces-
sary, even dangerous, to the artistic process of theatre, and then Meyerhold's
(in the 1920s) radical reconceptualization of the actor's physicality as something
to be defamiliarized and stylized through systematic study and the scientifically
based exercises he called biomechanics.[35] There are myriad such reactions against
the grip of Stanislavsky and psychological realism. The actor's body as experimental
palimpsest is a central, defining attribute of the theatrical experience, and both
Craig and Meyerhold use analogies with science to show how far they are
challenging the idea of randomness and disorder associated with traditional
approaches to art.

[32] Edward Braun, *Meyerhold: A Revolution in Theatre* (Iowa City: University of Iowa Press, 1995), 172.
[33] Ibid. 173.
[34] Edward Gordon Craig, 'The Actor and the Übermarionette' (1907), repr. in Michael Huxley and
Noel Witts (eds), *The Twentieth-Century Performance Reader* (London: Routledge, 1996), 142–9.
[35] A good example of biomechanics can be seen in the production of Crommelynck's *The Magnificent
Cuckold* in Meyerhold's direction in 1921. See Braun, *Meyerhold*, 170–87, for discussion and illustrations.

The link with science, or the idea of acting as a science, underscores the interdisci-
plinarity of theatre in the modernist period. This is beginning to be acknowledged in
critical approaches to modernism and theatre. Toril Moi relates Ibsen to philosophy,
art history, and other fields, modelling the kind of cross-disciplinary work that
modernist historiography demands. Daniel Albright focuses on collaborations with-
in modernist art, painting, music, and theatre that show modernism as 'a trium-
phalist extension of the boundaries of the feasible in art'.[36] His definition of
modernism (which he acknowledges as just one of many) is 'the testing of the limits
of aesthetic construction',[37] an accurate description of what many of the avant-garde
theatrical productions of the modernist period were doing. Equally compelling is
Albright's brisk rejection of the notion that modernism was rather messy, random,
and accidental; quite to the contrary, as he puts it, there was 'a scrupulous choice of
artistic materials, and . . . hard work in arranging them. . . . The Modernists *intended*
Modernism—the movement did not come into existence randomly'.[38] Craig wrote in
1907 of 'that wilderness of weeds, the modern theatre'.[39] The tendency to see disorder
and chaos and mess in collaborative efforts (like *Ubu Roi*) as opposed to the
supposed neatness of single-artist endeavours (like Duchamp's urinal) is a critical
blind spot, and perhaps an unconscious bias and distrust of interdisciplinarity that is
increasingly being called into question.

One obstacle to a neat, tidy narrative of modernism in the theatre is the fact
that no single, satisfactory, agreed definition even exists of modernism. Martin
Puchner argues persuasively against erecting such a monolithic definition in his
book *Stage Fright*, endorsing the current plurality of modernisms. It is often useful
to divide modernism into periods, so that 'early modernism' encompasses the
1860s to the First World War, while 'high modernism' spans the First World War
to 1930, and Beckett dominates a period after that which we might call 'late
modernism'. But such neat divisions are always just critical tools whose usefulness
may at any time be questioned as new ways of thinking about the movement
emerge.

In addition to the problem of slippery terminology, one has to grapple with the
age-old 'anti-theatrical prejudice' first systematically identified by Jonas Barish and
now further examined by Puchner. Barish traced a bias against the theatre in Western
culture from its origins, peaking in the eighteenth century and continuing through to
the twentieth. Puchner argues that far from feeling defensive and protective of theatre
against so-called reactionary anti-theatricality, we should recognize it as one of the
hallmarks of modernist theatre: 'the attempt to undo or exorcise anti-theatricalism
obscures the fact that a suspicion of the theater plays a constitutive role in the period
of modernism, especially in modernist theatre and drama'.[40] Yet it also takes many

[36] Daniel Albright, *Untwisting the Serpent: Modernism in Music, Literature, and Other Arts*
(Chicago: University of Chicago Press, 2000), 31.
[37] Ibid. 29. [38] Ibid. 31.
[39] Craig, 'The Actor and the Übermarionette'. [40] Puchner, *Stage Fright*, 1.

forms. So you have on the one hand Ezra Pound denigrating the theatre as a 'gross' and 'coarse' art form,[41] a view that was shared by many modernists (novelists and poets), including D. H. Lawrence, who complained that 'our stage is all wrong, so boring in its personality'.[42] And on the other hand you have the wholehearted embrace and assimilation of anti-theatricality by playwrights like Beckett, Gertrude Stein, Brecht, and James Joyce—Joyce, author of the play *Exiles* and of the theatrical Circe chapter in *Ulysses*, which is the novel's longest chapter and which many critics view as its centre.[43]

Anti-theatricality is just one of numerous reasons why theatre has been marginalized as an art form central to modernism. Another is a bias against the ephemerality of the theatre, which leaves us with no object to study (much less agree on). What do we mean when we talk about a performance? Very often it is the memory of it, and thus unreliable because seen through a particular set of eyes, perhaps at a remove from the actual event, coloured by various biases, and so on. How do we get around this problem? As Jure Gantar notes in a discussion of the shortcomings of existing methods for analysing performance, 'even many of the recent theoretical perspectives still see accidentiality and unsteadiness of performance as the theatre's main weakness and not as its principal source of fascination'.[44] Gantar challenges us to reconceptualize the 'problem' of performance by thinking of its variation and ephemerality not as a problem but as, in fact, the distinguishing feature of the art form. Thus, the enterprise of reconstructing theatrical performance is not a drawback to the field but is 'catching the wind in a net', an elusive but rewarding process precisely because it emphasizes process and evidence over final knowable, text-based product.[45]

Finally, there is often a perception that theatre lags behind the other arts in the modernist period, essentially 'staging' modernism after it has been premiered in other genres like the novel, poetry, music, and the visual arts, and this can be related to a number of other factors. One is that the collaboration and consensus at the heart of any theatrical enterprise require sometimes conservative compromise in order to achieve a coherent and viable subject (although look at Dada and Surrealism). Another is the need to think of the box office, i.e. having to court an audience. And there is the 'reflecting model' often favoured in modern drama, with directors looking backwards to reinventing the classics rather than forward to new work. Thus, Jarry recycles *Macbeth* in *Ubu Roi*; Georg Fuchs at the Munich Art Theatre in the

[41] Ezra Pound and James Joyce, *Pound/Joyce: The Letters of Ezra Pound to James Joyce, with Pound's Essays on Joyce*, ed. Forrest Read (New York: New Directions, 1967), 46.
[42] Lawrence, quoted in Puchner, *State Fright*, 6.
[43] Puchner, *Stage Fright*, 81–100, and K. Shepherd-Barr, 'Reconsidering Joyce's *Exiles* in its Theatrical Context', *Theatre Research International*, 28/2 (July 2003), 169–80.
[44] Jure Gantar, 'Catching the Wind in a Net: The Shortcomings of Existing Methods for the Analysis of Performance', *Modern Drama*, 39 (1996), 538.
[45] The most thoroughgoing discussion of this issue can be found in Postlewait, *The Cambridge Introduction to Theatre Historiography*.

early 1900s wants a kind of theatre that 'would involve practicing artists and sculptors in the experimental staging of classical works';[46] and even Artaud and Brecht (despite Artaud's insistence on 'no more masterpieces') sometimes rework the classics of Western literature, even while they are also looking east to age-old theatrical forms from Balinese and Chinese theatre to inspire their innovations on stage, just as Yeats had looked to Japanese theatre. So while their styles of production may have been progressive, innovative, and radical, the subject matter wasn't. Yet these examples fail to take account of the innovations in form and in subject matter that were being made by women dramatists (such as Robins in plays like *Alan's Wife* and *Votes for Women!* and Glaspell in *Trifles*, *The Outside*, and *The Verge*), treating themes rarely seen on the stage such as infanticide, breast cancer, abortion, domestic abuse, and the search for an authentically female language, often in formally innovative ways; and likewise the pioneering productions of female directors in modernist theatre. This is one of the most exciting and important areas of recent scholarship within theatre history.[47]

These are the main reasons, then, why theatre has tended to fall away from the dominant narratives of modernism—those versions that are found in the numerous guides to and histories of the movement. Now is the time to ask: why do we care? Why do we *need* to recuperate theatre's place within this grand narrative? Certainly a big part of it is accuracy—most available histories of modernism simply don't tell us the full story of the role of theatre, and especially theatrical performance, in shaping the movement, even when they claim a totalizing authority. Also, there is quite a buzz of critical voices on this neglect of theatre, as even a glance at the literature will tell you. There is no doubt that we need to reclaim the term 'modernism' from its literary-critical currency. Finally, there is economics; modernism is a lucrative industry driven by institutional and educational and publishing norms that are all deeply interdependent. Changing how we understand modernism involves changing how we teach it and write about it.

Most definitions of modernism take a chronological, developmental approach, tracing the major currents in art and literature from Baudelaire to Beckett and giving a relentlessly historical and teleological feel (this led inevitably to that . . .). It might instead be more useful to take a key moment in the history of modernism, as Jean-Michel Rabaté does in his study of the year 1913, and provide a picture of what artistic events were happening at that moment and how those events across all the arts collectively constitute or illustrate a certain stage in modernism.[48] The year 1922 is often invoked as the quintessentially 'high modernist' moment. It saw the publication of Joyce's *Ulysses*, Eliot's *The Waste Land*, and Woolf's *Jacob's Room*. Look at

[46] Schumacher (ed.), *Naturalism and Symbolism in European Theatre*, 179.

[47] See e.g. Penny Farfan, *Women, Modernism and Performance* (Cambridge: Cambridge University Press, 2004), and Kelly (ed.), *Modern Drama by Women 1880s–1930s*.

[48] Jean-Michel Rabaté, *1913: The Cradle of Modernism* (Oxford: Blackwell, 2007).

what was happening in the theatre across Europe and America, both performances and texts (publications), such as:

- Crommelynck, *The Magnanimous Cuckold*, is produced by Meyerhold in Russia in constructivist and biomechanical style (this year Meyerhold coins the term 'biomechanics')
- Cocteau's *Antigone* is performed in Paris with sets by Picasso
- Bertolt Brecht, *Drums in the Night* and *Baal*
- Luigi Pirandello, *Six Characters in Search of an Author*, produced in London under Kommisarjevsky's direction
- Pirandello, *Henry IV*
- Eugene O'Neill, *The Hairy Ape*
- Antonin Artaud sees a group of Cambodian dancers at the Colonial Exhibition in Marseilles, which later influences his seminal vision of the theatre *The Theatre and Its Double*
- Arnolt Bronnen's *Vatermord* is performed (written 1915); it causes a sensation in Expressionist theatre
- Vakhtangov directs *Turandot* by Carlo Gozzi (originally 1762) at Third Studio of Moscow Art Theatre, with Cubist sets designed by I. Nivinsky. The design was 'a Meyerhold-like composition of platforms, gangways and galleries, and the action was made "contemporary" by such devices as that of having the King carry a tennis racquet in lieu of a scepter. Characters from the world of the *commedia dell'arte* like Pantalone and Truffaldino and Tartaglia were woven into the performance, and the actors appeared to improvise their costumes and props—one wrapped a towel about his head for a turban, another tied a scarf round his chin for a beard.'[49] The overall tone of the production was 'gay and light-hearted. The actors put on their costumes, and the stagehands set the scene, in full view of the audience. The music was played on combs and tissue-paper.'[50] It ran for more than 1,000 performances.

These are just a few of the performances happening all over Europe and America that might be cited, along with the 'usual suspects' like *The Waste Land* and *Ulysses*, as key events of modernism. What is striking is how international and collaborative they are, as well as how innovative in their staging and texts. It is worth the painstaking effort of piecing together the evidence to reconstruct the kinds of performances I've described above. Modernism in the theatre provides a multifaceted, kaleidoscopic picture of tumultuous theatricality striving beyond the bounds of the stage that is its platform.

[49] J. L. Styan, *Modern Drama in Theory and Practice* (Cambridge: Cambridge University Press, 1983), iii. 94.

[50] Ibid. 95.

CHAPTER 8

··

MODERNISTS AS CRITICS

··

MICHAEL VALDEZ MOSES

Poets are the unacknowledged legislators of the world.
(Percy Bysshe Shelley, 'A Defence of Poetry')

DURING the long reign of the New Criticism, the modernist lyric, long poem, novel, drama, and belletristic essay profitably preoccupied students of modernism almost to the exclusion of all other kinds of writing. However, a sweeping critical reassessment of literary modernism since the early 1990s has transformed the literary cartography of modernism. While the lyric and long poem (or poem sequence), modernist novel, avant-garde play, and literary essay still hold pride of place, a new, or at least a different, set of genres—the manifesto, autobiography, memoir, travel writing—have assumed important places within the modernist canon. Oddly, the ongoing reassessment of the generic contours of literary modernism continues to neglect a kind of writing of central concern to many of its leading authors: social and political criticism. This neglect seems all the more puzzling when one considers how prominently and abundantly works of social and political criticism figure in the works of such Anglophone writers as Yeats, Eliot, Pound, Lewis, Dos Passos, Warren, Tate, Hurston, Wright, Woolf, Lawrence, Shaw, Orwell, Huxley, West, and Wells, to say nothing of such Continental modernists as Mann, Hesse, Döblin, Canetti, Unamuno, Zamyatin, Bely, Gorky, Rolland, Céline, Sartre, D'Annunzio, Čapek, and Hamsun.

One possible reason for this relative neglect is the fact that modernist works of social and political criticism have assumed varied and peculiar shapes. Failing to conform to an easily definable and predictable set of literary conventions, modernist works of social and political criticism have appeared under numerous guises: editorials, book reviews,

radio talks, political speeches and pamphlets, academic lectures, anthropological field surveys, mystical and visionary speculations, travelogues, reportage, theatre and film criticism, cultural guides and primers, newspaper and journal articles, philosophical essays, theological arguments, private (and public) correspondence, memoirs, reminiscences and autobiographies, table talk, and interviews. Indeed, many of these writings are *sui generis*, unclassifiable works that fail to fit neatly or firmly into any of the (sub-)generic categories on which literary scholars and professional critics customarily rely. Nevertheless, one can't help but be struck by how central a place works of critical prose, and, most particularly, of social, political, and cultural criticism, occupy within the œuvre of many of the leading literary modernists.

For example, of the fourteen volumes that comprise the recent Scribner edition of Yeats's collected works, six consist of essays, reviews, introductions, speeches, and articles, the bulk of which are focused on cultural, political, and social subjects broadly conceived. A seventh volume consists of autobiographical reminiscences rife with Yeatsian commentary on political and cultural topics, while two others are made up of mystical writings (the two versions of *A Vision*) that Yeats himself compared to Oswald Spengler's overtly political-philosophical work *The Decline of the West*. Wyndham Lewis's works of social and cultural criticism include *The Art of Being Ruled, Time and Western Man, Paleface, Hitler, Left Wings Over Europe, Count Your Dead! They Are Alive, The Jews: Are They Human?, The Hitler Cult*, and *America and Cosmic Man* (and many more volumes of Lewis's non-fiction prose might easily be classed as social criticism). Given the prevalence of social criticism within modernist literature, surely it is time to take seriously the proposition that political and cultural criticism comprise a conspicuous and distinctive form of modernist writing, one not merely supplementary or ancillary to the main body of the modernist canon, but in fact one that occupies a primary, indeed essential, place in any representative account of literary modernism.

No doubt the relative neglect of modernist social criticism has historically been less a consequence of scholarly ignorance of or indifference to this important body of writing than it has been the predictable result of a professional desire to shield the study of modernist literature from the scandals and unwelcome controversies that scrutiny of these writings predictably elicits. For if modernist social and cultural criticism offers an embarrassment of riches for the political critic, social theorist, and historian of ideas, it provides a rich source of embarrassment for a professional and academic literary establishment that finds many of these writings politically inflammatory and socially unconscionable. The often stridently anti-liberal, anti-democratic, and racially insensitive nature of some of these works (to say nothing of their often politically incorrect views on matters of gender, sexuality, class, and religion) has proven a major obstacle to their sustained, serious, and judicious analysis, so much so that at the time of this writing, key works such as Eliot's *After Strange Gods*, Lewis's *The Art of Being Ruled, Paleface, Hitler*, and *The Hitler Cult*, Pound's *Jefferson and/or Mussolini*, and Wells's *Stalin–Wells Talk* (with commentary by G. B. Shaw) remain out of print and hard to obtain. In the 1980s and 1990s a long-overdue consideration of the allegedly 'apolitical' character of the

New Criticism helped cast much-needed light on a few of the major works of modernist political criticism. However, the seminal studies of Fredric Jameson, Michael North, Paul Peppis, Charles Ferrall, Terry Eagleton, Declan Kiberd, Seamus Deane, W. J. McCormack, and others have not led to a broader and sustained consideration of modernist social and cultural criticism as such. The 'problem' of Eliot's or Pound's reputed anti-Semitism, or of Yeats's, Lewis's, and Pound's alleged fascist sympathies, or of Woolf's questionable views on class and ethnic differences, have been much debated. But these critical controversies have not generated a more capacious, probing, and judicious examination of modernist political writings as a whole; they have instead merely provided a ready and easy way to treat the 'canonical' high modernist writers as the convenient whipping boys (and girls) for more fashionable literary movements and up-to-date critical paradigms.

Any rigorous consideration of modernist social criticism must begin with an appraisal of the historical and political context in which the modernists wrote. The first half of the twentieth century (especially the period from 1914 to 1945) has been aptly characterized as an apocalyptic epoch in modern Western civilization: a 'crisis of modernity'. Among the most visible manifestations of that crisis were the First World War (16 million military and civilian deaths, 21 million additional casualties), the Second World War (50 to 78 million military and civilian fatalities), the Great (worldwide) Depression that marked the period between the two wars, the holocausts and genocides that punctuated the first half of the twentieth century, the collapse of several major empires (the Russian, Austro-Hungarian, and Ottoman), and the complete reorganization of the political map of Europe, the Middle East, and Asia. Critics, philosophers, social theorists, and historians have frequently suggested that these epochal catastrophes were the outward symptoms of a profound and comprehensive crisis of Western culture. They have offered many different (and sometimes mutually exclusive) explanations for the crisis of modernity: the precipitous decline of organized religion; the sudden collapse of the metaphysical foundations of Western thought (nihilism); the rise of new and more lethal forms of technology and the dominance of instrumental reason; the rapid urbanization of everyday life and its accompanying social anomie; the dissolution of traditional cultural and ethical norms; the erosion of social hierarchies based upon racial, gender, and class differences; the growing fragmentation and instability of the Western psyche; the depredations of ascendant nationalist and declining imperialist politics; and the rise of the total state.

While Anglophone modernist writers touch upon almost all of these possible explanations for the modern apocalypse at one point or another in their non-fiction prose, their social criticism seems especially concerned with the twin crises of modern capitalism and liberal democracy. Focusing upon the writings of Ezra Pound, Wyndham Lewis, and T. S. Eliot, I shall argue that the 'extremist' elements within much Anglophone modernist criticism emerge as the consequence of a profound and pervasive sense that capitalism was a defective and unsustainable form of economic life and that liberal democracy was an anachronistic form of government either doomed to political extinction or no longer adequate to the

pressing social and cultural demands of the age. To be sure, not all of the modernists were anti-liberal and anti-democratic (though almost all were critical of the political and cultural consequences of capitalism). But even those, such as Virginia Woolf, who were willing to defend (a considerably modified form of) liberal democracy entertained grave doubts about its efficacy and viability in the new century.[1]

One of the earliest and most prolific contributors among the Anglo-American modernists to social criticism, Ezra Pound also proved one of the most important and controversial sceptics of liberal democracy and modern capitalism. An outspoken admirer of Mussolini and an enthusiastic supporter of Italian Fascism from the late 1920s through the end of the Second World War, Pound was also a sometime defender of American constitutionalism, Thomas Jefferson, John Adams, the American founders, private property, individualism, the preservation of a separation of the private and pubic spheres, and peace among nations. While such capacious enthusiasms will strike most contemporary commentators as evidence of Pound's unsystematic, idiosyncratic, and downright contradictory political opinions, Pound seemed to regard them as complementary elements within a unified social vision. To be sure, many of his early works of social commentary, 'Patria Mia' (1913), 'Provincialism the Enemy' (1917), and 'Probari Ratio' (1920), typify a distinctly American vein of political and belletristic criticism, one that defends the basic principles and objectives of the American founders and of American liberal democracy, while deploring the impoverished state of American arts and culture. But even in the 1930s, Pound was no less ardent in his defence of the Founding Fathers (with the exception of Hamilton) and of the principles of the republic, even as he had become a critic of its rapid and seemingly irremediable decline, a process of decay, he claimed, that had begun at the end of the American Civil War and that culminated in the corrupt administrations of Harding, Wilson, Coolidge, and Hoover.

By 1933, when he came to write *Jefferson and/or Mussolini: L'Idea Statale: Fascism As I Have Seen It*, Pound still harboured hopes (soon to be disappointed) that F.D.R. might prove to be a new Duce for America. At the same time he declared Mussolini to be a new Jefferson and Jefferson to be the Duce of the early American republic: an eminently practical and adaptable politician, a great man whose genius could not be constrained by an inflexible political ideology, a forceful, dynamic, visionary leader who exemplified the virtues of what legal scholars have since called a 'living constitution' (as opposed to the strict construction of its original meaning). Curiously, even as he embraced the 'totalitarian' ideals of Italian Fascism (a term that Pound explicitly uses in his *Guide to Kulchur*), Pound continued to insist in *Jefferson and/or Mussolini* that 'the best government is that which governs least',[2] and he seriously

[1] It is impossible in a brief chapter to provide a fully nuanced, detailed, and comprehensive account of modernist social criticism. An account that, for example, included a sustained and rigorous consideration of Yeats's, Woolf's, Lawrence's, Orwell's, or Dos Passos's social writings would complicate and substantially alter the characterization of modernist criticism offered here. And were the social criticism of Continental writers to be taken into account, the portrait offered of modernist criticism here would have to be altered and qualified even more radically.

[2] Ezra Pound, *Jefferson and/or Mussolini* (New York: Liveright, 1935), 15.

entertained the prospect that one day the fascist 'state could sit back and do nothing', 'which sounds again, like Jefferson'.[3] Pound maintained that Jefferson, Mussolini, and even Lenin were anti-statist and that all desired to limit severely and even to eliminate the political machinery of the state.[4] Happily, in Pound's view, individual liberties were alive and well in Mussolini's Italy: 'I feel freer here that I did in London and Paris,' he writes from Rapallo in 1933.[5]

If Pound's easy comparison of Jefferson, Mussolini, and Lenin—or of Roosevelt and Il Duce—sounds to us like so much political cant, it should be remembered that the sort of shocking conjunction to which Pound is given was a commonplace of American and European political rhetoric in the 1920s and early 1930s.[6] In any case, Pound was in earnest when he claimed that Mussolini's Fascist regime was a legitimate successor to the American political experiment: 'the heritage of Jefferson, Quincy Adams, old John Adams, Jackson, Van Buren is HERE, NOW *in the Italian peninsula* at the beginning of the fascist second decennio, not in Massachusetts or Delaware'.[7] I would argue that what to us seems Pound's wilful and unwarranted conflation of American republicanism and Italian Fascism was strongly motivated by what I am calling his monoscopic 'culturalist' politics, a characteristic feature of much modernist social criticism. That is, from his earliest political essays and journalistic pieces to his more substantive works of the 1930s, Pound judges the ultimate worth of a political regime, as of an economic system, according to whether it promotes culture, arts, and letters in the broad sense. For Pound, a good regime, just like a good economy, is by definition one that promotes the arts and patronizes the artist. The architectonic distinctions between one regime and another, for example the institutional and legal differences between a liberal democracy and an authoritarian or totalitarian government that modern political theorists are so concerned to parse, are submerged in Pound's political imagination: the truly important differences between one polity and another for him depend upon whether a government encourages and develops the arts and, even more importantly, whether it honours and supports the artist.

As early as 1913, in his essay 'Patria Mia', Pound lambastes the United States for its impoverished culture and its failure to support the arts.[8] He is particularly distressed by the fact that in contemporary America there exists no reliable source of patronage

[3] Ibid. p. viii. [4] Ibid. 70. [5] Ibid. 74.

[6] The German historian Wolfgang Schivelbush argues that it was common for American, Italian, and German intellectuals, politicians, and journalists in the 1930s to argue that Italian Fascism, German Nazism, and the American New Deal were complementary variants of one another, a claim made by their defenders as well as by their detractors. See Wolfgang Schivelbush, *Three New Deals: Reflections on Roosevelt's America, Mussolini's Italy, and Hitler's Germany, 1933–1939*, trans. Jefferson Chase (New York: Metropolitan, 2006).

[7] Pound, *Jefferson and/or Mussolini*, 12.

[8] Ezra Pound, 'Patria Mia', in *Selected Prose: 1909–1965*, ed. William Cookson (New York: New Directions, 1973), 109–11, 122, 128. The original version of the essay appeared as two articles, each in multiple instalments, in the *New Age* between September 1912 and June 1913.

for the artist, the man of genius.[9] For Pound, this is the inevitable consequence of an American political system that rests upon a capitalist economy. He insists that 'the sincere artist wants leisure for his work ... He does not obey or concede to the laws of commerce, to the laws of supply and demand.'[10] More than two decades later, in 'Murder by Capital', Pound expresses his 'blood lust' against the depredations done to art by capitalism, which, for him, is summed up in a single term: 'usury', the charging of interest that is the basis of the capitalist system.[11] Writing in the depths of a worldwide depression, Pound insists that the most serious economic problem he confronts is the high unemployment rate that has plagued him and his fellow artists for years:

The unemployment problem that I have been faced with, for a quarter of a century, is not or has not been the unemployment of nine million or five million, or whatever I might be supposed to contemplate as a problem for those in authority or those responsible ... it has been the problem of the unemployment of Gaudier-Brzeska, T. S. Eliot, Wyndham Lewis the painter, E. P. the present writer, and of twenty or thirty musicians, and fifty or more other makers in stone, in paint, in verbal composition.[12]

One can't help but be impressed by the sheer vanity of Pound's lament that the most serious economic problem of the age is the financial plight of himself and his friends qua artists. But in any case, Pound's brief on behalf of the arts and the artist is consonant with his praise of Mussolini and Fascist Italy. For according to Pound, Il Duce is 'an *artifex*': 'take him as anything save the artist and you get muddled with contradictions'.[13] Whether as the founder and maker of a new Italy, the sponsor of public works projects, or as the great friend and patron of the arts, Pound's Mussolini is the figure of the artist writ large; his material is the Italian state, people, and culture, and his genius is to have imposed a new form on all of them.[14] Repeatedly, Pound celebrates the renaissance in Italian culture and politics that Mussolini's Fascist rule has inaugurated: the building of new roads, the publication of new books, the flourishing of literature, the restoration of old buildings and ancient monuments. According to Pound, 'the fascist revolution was FOR the preservation of certain liberties and FOR the maintenance of a certain level of culture, certain standards of living ... [it was] a refusal to surrender a great slice of the cultural heritage'.[15] In a particularly disingenuous and self-serving passage, Pound claims that it is the 'great artists' who know how to live; it is they who 'are interested in the WORK being done and the work TO DO, and not in personal considerations,

[9] Pound, 'Patria Mia', in *Selected Prose: 1909–1965*, 126–7, 135, 139–40.

[10] Ibid. 139.

[11] Ezra Pound, 'Murder by Capital', in *Selected Prose*, 229. The article originally appeared in the *New Criterion* in July 1933.

[12] Ibid. 230.

[13] Pound, *Jefferson and/or Mussolini*, 34.

[14] Although he disparages Nietzsche in *Jefferson and/or Mussolini*, Pound's conception of the political leader as the artist with a genius for statecraft is surely indebted to his writings, as well as to Burckhardt's *The Civilization of the Renaissance in Italy*, and in particular the chapter 'The State as a Work of Art'.

[15] Pound, *Jefferson and/or Mussolini*, 127.

personal petty vanities and so on', and such 'impersonality', Pound concludes, is 'implicit in fascism, in the *idea statale*'.[16] Pound returns to this claim in his later work of 1938, *Guide to Kulchur*, in which he praises Mussolini for his recognition that his 'people need poetry'; the Italian dictator has 'told his people that poetry is a necessity *to the state*', which indicates a 'higher state of civilization in Rome than in London or Washington'.[17]

By the 1930s, Pound's enthusiasm for the American political system had been seriously eroded by his conviction that its liberal-democratic institutions had been thoroughly vitiated by an economic system dependent upon usury. The so-called free press had become merely the mouthpiece for vested financial interests, elected officials bought and paid for, mere instruments in a conspiracy run for the benefit of financiers and capitalists.[18] In theory, democracy run by clean and honest men could achieve the same level of civilization, the same 'Kraft durch Freude', as any dictatorship, but, unfortunately, for over a hundred years, democracies had lamentably failed to educate their peoples in the rudimentary necessities of democratic life.[19] Having left behind any hope for the rule of 'the best' (the original aim of Jefferson, Adams, and the Founding Fathers), America, like the rest of the so-called liberal-democratic West, had ceased to be capable of self-government. Borrowing a page from Wyndham Lewis's *The Art of Being Ruled* (1926), Pound insists that men must earn their freedom. The vast majority of them, remaining ignorant of fundamental economic and political truths, are unable 'to get along without being cowherded'.[20] The result is that representative democracy has become both a historical anachronism and a sham: 'parliaments as now run (Parliament, U.S. House of Representatives and Senate) are as obsolete as the Witenagemot'.[21] At least since 1865, elected officials in the American Congress have served not the public, but the 'gombeen men almost exclusively'.[22] Established to protect rights and freedoms of the people, democratic institutions have become the instruments of moneyed interests who routinely cheat the public. 'Liberalism is a running sore,' according to Pound; 'its surviving proponents are vile beyond printable descriptions. They have betrayed the "*Droits de l'homme*", they are more dastardly than Judas. . . . In our time the liberal has asked for almost no freedom save freedom to commit acts contrary to the general good.'[23]

It would be unfair to suggest that Pound simply favours the interests of the artist and culture over that of the public and the public good; nonetheless, he conveniently

[16] Ibid. 68.
[17] Ezra Pound, *Guide to Kulchur* (London: Peter Owen, 1978), 144, 249.
[18] Pound, *Jefferson and/or Mussolini*, 41–3, 94.
[19] Pound, *Guide to Kulchur*, 157–8. [20] Ibid. 244.
[21] Ibid. 173. Pound qualifies his condemnation of representative institutions by suggesting that greater transparency, guaranteed by the broadcast of parliamentary and congressional debates over the radio waves, might educate the people and restore the prospects for democratic self-government in America and Britain.
[22] Ibid. 174. [23] Ibid. 254.

maintains that what is good for the artist *is also* what is good for the community. And that something turns out, at least in the case of modern Italy, to be a leader who gets things done, a charismatic and authoritarian *artifex* unconstrained by liberal-democratic institutions and legal niceties, one with the taste, wisdom, and will to educate the public, revitalize the arts, plan the economy, redistribute credit (money), initiate public works, restore the monuments of antiquity, raise the level of culture, and, not incidentally, patronize and honour the artist as part of a rebirth of Roman civilization.[24] Pound implies that the artist of the new Fascist regime should also serve the public; he should help to educate his fellow citizens and mould their tastes. The *Guide to Kulchur* is just one of Pound's many concrete attempts to fulfil the duties of a public-spirited artist. Like his *ABC of Economics* (1933) and his *ABC of Reading* (1934), the *Guide to Kulchur* is meant to be Pound's direct intervention into the public sphere, a concrete effort to make citizens suited for the new regime.[25] The *Guide* thus consists of 'notes for a totalitarian treatise'; it is to be part of a pedagogic enterprise that Pound calls 'the New Learning or the New Paideuma'.[26] But unlike some of Pound's earlier pedagogic works, *Guide to Kulchur* is composed according to an 'ideogramic method' that 'consists of presenting one facet and then another until at some point one gets off the dead and desensitized surface of the reader's mind, onto a part that will register. . . . The newness of the angle being relative and the writer's aim, at least this writer's aim, being revelation.'[27] In sum, Pound structures the *Guide* less like a primer and more like one of his Vorticist poems or *The Cantos*. A kind of elaborate pastiche, the *Guide* does not adhere to strict chronology or follow a linear argument, but instead proceeds according to a kind of Cubist or associative logic. In the end, one can surely doubt the efficacy of Pound's new method, just as one can deplore its political objectives, but one needs nonetheless to credit him with the invention of a new and distinctively modernist form of social and political criticism.

If his modes and methods of social criticism were sometimes as idiosyncratic and his views no less objectionable to contemporary political sensibilities as Pound's, Wyndham Lewis was nonetheless a more erudite, rigorously analytical, and intellectually gifted student of political philosophy than was his fellow modernist. But whereas Pound only gradually found his way from a cranky individualism in the American grain to an increasingly strident embrace of 'radical' (Social Credit) economic theory and fascist political sympathies, Lewis was early on a rhetorically skilful critic of the capitalist system and Western liberal democracy. Offering what now seems a singularly dubious honour, Pound praised Lewis for having 'discovered Hitler' before the American poet discovered Mussolini.[28] *Hitler* appeared in print in

[24] See e.g. Pound's insistence that each city maintain a few musicians at public expense; ibid. 170–1.

[25] Pound actively sought to cooperate with Mussolini's government and even proposed to the Italian Ministry of Culture that he be given charge of the education of Allied prisoners held in German and Italian prisoner of war camps during the Second World War. See Tim Redman, *Ezra Pound and Italian Fascism* (Cambridge: Cambridge University Press, 2009), p. x.

[26] Pound, *Guide to Kulchur*, 27. [27] Ibid. 51. [28] Ibid. 134.

1931. It was one of the earliest and most sympathetic analyses of National Socialism to appear in English. Shortly after the outbreak of the Second World War, Lewis repudiated his favourable assessment of the Führer in *The Hitler Cult*, a wide-ranging critique of Nazism. But by then Lewis's political and intellectual reputation had suffered a near-fatal blow. Although he belatedly attempted to downplay his earlier enthusiasm for the German leader, it is demonstrable that his attraction to radical anti-liberal and anti-democratic politics was no mere momentary infatuation of the early 1930s. His most important and systematic work of political and social criticism, *The Art of Being Ruled*, had been published in 1926. While it did not command the kind of public attention Lewis thought it deserved, it set out in a forthright and uncompromising manner the author's scathing critique of liberal democracy and modern capitalism.

In *The Art of Being Ruled*, Lewis makes clear that his political sympathies lie with the anti-liberal and anti-democratic revolutionary movements of the age, the Soviet and (Italian) Fascist respectively:

I have already said that in the abstract I believe the sovietic system to be the best. . . . it looks to the East, which is spiritually so much finer than Europe, for inspiration. It springs ostensibly from a desire to alleviate the lot of the poor and outcast, and not merely to set up a cast-iron, militarist-looking state. And yet for anglo-saxon countries as they are constituted today some modified form of fascism would probably be best. The United States is, of course, in a unique position: and for the moment it is the only country in the world of which you can say it would not benefit by a revolution. And eventually, with its great potentialities, it may be able to evolve some novel form of government of its own.[29]

Lewis's enthusiasms for Soviet Russia, Fascist Italy, and 1920s America no doubt will strike many today as inconsistent. But Lewis was an early adherent of the thesis, later advanced by Hannah Arendt and F. A. Hayek, that the Soviet (Marxist) and Fascist (Italian) systems were variants of one another, Fascism being a refinement of Marxian socialism.[30] Lewis's otherwise unaccountable praise of America must likewise be understood in the context of his admiration for Henry Ford and the system of 'Fordism', a particular passion of Lenin's, who had tried to introduce it into Russia as a means to modernize the Soviet economy.[31] And while Lewis vacillates between his embrace of communism (or Leninism, as he more often terms it) and Fascism, he remains consistently opposed to democratic liberalism: 'I am not a communist; if anything I favour some form of *fascism* rather than communism. Nevertheless, when two principles are opposed, and one of them is english liberalism, in most cases I should find myself on the other side.'[32]

Lewis's opposition to liberal democracy in the mid-1920s is based upon his conviction that liberalism countenances a false view of human nature and that its

[29] Wyndham Lewis, *The Art of Being Ruled*, ed. Reed Way Dasenbrock (Santa Rosa, Calif.: Black Sparrow Press, 1989), 320–1.

[30] Ibid. 70.

[31] For Lewis's embrace of Fordism, see *The Art of Being Ruled*, 43, 139, 171–2.

[32] Ibid. 35.

political institutions are doomed to historical extinction. In Lewis's account, the
French Revolution and the Enlightenment promoted the unsustainable political
myth that the mass of men both desire to be and are capable of becoming free and
responsible individuals. Far from being a philosophy of freedom, modern liberalism
is paradoxically 'the first genuine philosophy of slaves that has ever been formu-
lated'.[33] According to Lewis, the great majority of men don't wish to be free, though
they sometimes want to pretend as if they are:

[Men] do not really know what they want . . . they do not, in their heart, desire 'freedom' or
anything of the sort. 'Freedom' postulates a relatively solitary life: and the majority of people
are extremely gregarious. A disciplined, well-policed, herd-life is what they most desire. . . .
That men should *think* they wish to be free, the origin of this grave and universal mistake, is
the (usually quite weak) primitive animal in them coming into his own for a moment. . . .
That is the saturnalian, libertarian, rebellious self that asserts itself for a moment. But if they
have to choose between what ultimately the suggestions of the 'free' self, and the far steadier,
stronger impulse of the gregarious, town-loving, mechanical self, would lead to, they invari-
ably choose the latter. . . . So inevitably they are not 'free' nor have any wish to be, in the lonely,
'independent,' wild, romantic, rousseauesque way. In short, the last thing they wish for is to be
free. They wish to pretend to be 'free' once a week, or once a month. To be free all the time
would be an appalling prospect for them.[34]

What the masses want is 'an absence of responsibility, an automatic and stereotyped
rhythm'; liberal ideology is then a delusion: 'all the libertarian cries of a century ago
were based upon unreal premises, and impulses that are not natural to, and cannot
be sustained by, the majority of men. Luxury and repose are what most men
undeniably desire.'[35] Lewis accordingly denies Goethe's claim that men wish to
grow, develop, think, and suffer for themselves. People generally (and women
especially) desire to live like children, ruled over by those who will take care of
them and relieve them of all responsibilities.[36] Nor is it the case that most human
beings wish to cultivate their own distinctive personalities. In fact the majority have
no individual 'personalities' to express; they are perfectly content to conform to a
social norm. Far from wishing to stand out, the great majority wish only to be social
types:

if so forced . . . to abandon some cliché, all men, whether white, yellow, or black, take the first
opportunity to get their *cliché* back, or to find another one. For in the mass people wish to be
automata: they wish to be *conventional*: they hate you teaching them or forcing them into
'freedom': they wish to be obedient, hard-working machines.[37]

Given Lewis's view of human nature, it is not hard to see why he finds a centrally
planned socialist economy so attractive. The marketplace fosters 'the small man',
the individual businessman, and Lewis objects to his 'small superiority, egotistic

[33] Lewis, *The Art of Being Ruled*, 132. [34] Ibid. 42.
[35] Ibid. 130. [36] Ibid. 44, 92, 130. [37] Ibid. 151.

"independence," smugness, assertiveness, and uselessness'.[38] The shopkeeper or small businessman performs no useful economic function, nor has he any right to prefer his petty interests over those who are below and above him in the social scale. His social climbing, his desire to improve his economic position, only makes the small man unhappy and discontented. Were he to have a fixed place within a stable social hierarchy, he would no longer feel that he has been unlucky in the lottery that is the marketplace.[39] In the end, Lewis has only contempt for the small businessman and independent economic agent, for it is the latter's obstinacy and competitiveness that stand in the way of the sweeping economic revolution Lewis envisions. In the same vein, Lewis finds the pretensions to personal 'taste' and individual desires among consumers risible. Their hunger for new fashions and novelty consumer goods is in no way an expression of their individual personalities. Anticipating the critique of mass culture later advanced by Adorno, Horkheimer, and the Frankfurt School, Lewis insists that the 'tastes' of the masses are malleable, the product of cunning advertisements and the manipulations of the big manufacturers and producers.[40]

Lewis's critique of liberal-democratic institutions follows similar lines. The general or sovereign will, the notion of 'what the people want', is a contradiction in terms. The masses don't know or particularly care what they want.[41] Lewis's critique follows easily from his claim that 80 per cent of the adult population are 'cretins' who irrationally wish to be treated as adults.[42] Democracy is an exercise in flattering the vanity of those incapable of and uninterested in ruling themselves; it is 'the greatest vanity of the greatest number'.[43] 'The vote of a free citizen is a farce: education and suggestion, the imposition of the will of the ruler through the press and other publicity channels, cancelling it.'[44] The people are plastic beings shaped and manipulated by governments, political elites, financiers, the press, and the vehicles of mass culture: radio, cinema, and theatre.[45] The First World War stands as the supreme example of such manipulation, demonstrating that the masses can even be persuaded to take up arms and slaughter each other by the millions.[46] Accordingly, Lewis enthusiastically celebrates the end of democracy: '"liberty" is dead', 'the parliamentary system', like representative government in general, has 'lost its meaning' and is 'finished'.[47] Lewis forecasts the inevitable triumph of centralized governments and planned economies, culminating, he thinks, in some kind of authoritarian world state that will synthesize the Soviet and Fascist models.[48] And for Lewis, this is a good thing. The masses will be happier and better looked after under an authoritarian and

[38] Ibid. 104. [39] Ibid. 141, 325. [40] Ibid. 97–9, 332, 362.
[41] Ibid. 80. [42] Ibid. 84–5. [43] Ibid. 216.
[44] Ibid. 106. [45] Ibid. 49, 52, 74. [46] Ibid. 82, 106.
[47] Ibid. 69–70, 130–1. [48] Ibid. 46, 53–4.

rigidly hierarchical system of government. The vast majority will be pleased *not* to have to rule themselves—this is 'the art of being ruled'. Liberated from adult responsibilities, the populace will be able to enjoy the luxury and repose guaranteed by a centrally planned economy, which will be more rational, more humane, and more efficient than the economic anarchy of capitalism.

But what of the few who must *do* the ruling? According to Lewis they are a naturally superior caste, an intellectual and creative elite who understand what it means to be free and who deserve their freedom. This ruling caste consists of two distinct sub-groups. The first actively desires to rule. They are therefore necessarily dependent upon the governed; they cannot realize their ambitions or demonstrate their virtues without the *material* of the people. This new type of ruler is a Machiavellian prince, a modern philosopher–king who must be 'forced to rule by force'.[49] These new Lenins and Mussolinis, though distinct from the second sub-group of elites, nonetheless resemble them, for they are 'like the good artist'.[50] Lewis's conception of the elite here converges with Pound's: for the second and more interesting group within his ruling caste consists of artists and creative intellectuals. It is these few 'creative minds' who turn out to be the focus of *The Art of Being Ruled*, and it is Lewis's concern for their protection and welfare that provides the motive force behind his *magnum opus* of social criticism.[51] Needless to say, this group must be adequately supported by the regime, for the creative intellectual is not, by definition, a vulgar capitalist. He does not concern himself with profiteering, and as a consequence he is all the more devoted to his intellectual and creative work, which provides the greatest benefit to the *polis*. As the 'greatest and most valuable of all "producers"' the creative artist and intellectual 'should be accommodated with conditions suitable to his maximum productivity. . . . He should be relieved of the futile competition in all sorts of minor fields, so that his purest faculties could be free for the major tasks of intelligent creation'.[52] Lewis insists that the creative intellectual and artist must not only be richly provided for and honoured by the regime, but he must also be left in perfect freedom, in no way interfered with by the regime. Such individual freedom is justified, Lewis thinks, because a member of the natural elite possesses the capacity and individual will to be free. He will in turn concern himself only with his creative work and leave the masses to their vulgar pleasures. Such a separate and unequal state of things, Lewis assures us, benefits the whole of society. Lewis thus turns out to be as avid a 'culturalist' critic of economic systems and political regimes as Pound. In Lewis's ideal polity, what is good for the modernist artist, who unhappily finds himself underpaid in the capitalist marketplace and underappreciated in a democratic age of mass culture, is ultimately good for everyone else.

If during the 1930s T. S. Eliot differed from Pound and Lewis by virtue of his scepticism towards totalitarian government, he was only slightly less critical than his fellow modernists of liberal democracy and the spirit of capitalism. In 1939, some

[49] Lewis, *The Art of Being Ruled*, 94. [50] Ibid. 93.
[51] Ibid. 86, 111, 127–8, 135, 220, 231, 373–5. [52] Ibid. 375.

dozen years after he became a British citizen and a member of the Church of England, Eliot offered his own brand of social criticism in *The Idea of a Christian Society*. Although he claims to be only secondarily concerned with a Christian critique of 'our present economic system', Eliot makes clear his moral and religious objections to the capitalist order:

The realization of a Christian society must lead us inevitably to face such problems as the hypertrophy of the motive of Profit into a social ideal, the distinction between the *use* of natural resources and their exploitation, the use of labour and its exploitation, the advantages unfairly accruing to the trader in contrast to the primary producer, the misdirection of the financial machine, the iniquity of usury, and other features of a commercialized society which must be scrutinized on Christian principles.[53]

Eliot mounts an attack on 'unlimited industrialism', which 'creates bodies of men and women—of all classes—detached from tradition, alienated from religion and susceptible to mass suggestion: in other words, a mob'.[54] His critique of capitalism differs in several interesting ways from that of Pound and Lewis. Most obviously, Eliot condemns the materialism of Western commercial society in specifically religious and ethical terms; capitalism is unchristian, it encourages the sin of 'Avarice'.[55] Additionally, by focusing on industrialism, rather than the ownership of the means of production or the distribution of Social Credit, Eliot implicitly criticizes all forms of economic life that make use of the modern factory system, including those of Fordist America, Fascist Italy, Nazi Germany, and Soviet Russia. Finally, Eliot anticipates a favoured contemporary form of anti-capitalist critique by anatomizing capitalism's destructive effects upon the environment: 'the exhaustion of natural resources', 'soil erosion', 'the exploitation of the earth'.[56]

Like his modernist counterparts, Eliot expresses little or no faith in liberal democracy. Writing just prior to the outbreak of the Second World War, at the lowest ebb of liberal political influence in more than a century, Eliot observes: 'the attitudes and beliefs of Liberalism are destined to disappear, are already disappearing'.[57] Eliot insists that the retreat of liberalism everywhere on the European scene is due in no small part to the fact that liberalism 'prepares the way for that which is its own negation'; its invites brutal, mechanized, and artificial forms of political control as a remedy for the chaos it creates.[58] In Eliot's view, the West is headed for some form of 'totalitarian democracy', a majoritarian tyranny that will extinguish the freedoms once championed by the old liberal order.[59] The weakness of liberalism, its

[53] T. S. Eliot, *The Idea of a Christian Society*, in *Christianity and Culture* (New York: Harcourt Brace, 1949), 26.
[54] Ibid. 17. See also 26, 48–51, 53, 76. [55] Ibid. 76.
[56] Ibid. 48–9; Luc Ferry has drawn our attention to the fact that 'environmentalism' was a key ideological component of German National Socialism in the 1930s. See Luc Ferry, 'Nazi Ecology', in *The New Ecological Order*, trans. Carol Volk (Chicago: University of Chicago Press, 1995), 91–107.
[57] T. S. Eliot, *The Idea of a Christian Society*, 14.
[58] Ibid. 12. [59] Ibid.

vulnerability to its totalitarian adversary, is due to the fact that liberal-democratic ideology is contentless; it lacks a substantive moral or spiritual aim. Liberalism claims to liberate the individual, but not for the sake of any higher or greater good. It grants man a purely negative form of freedom, a 'freedom from' constraints, but not a 'freedom for' any positive or substantive objective. Western (and specifically English) liberalism thus increasingly defines itself only in opposition to the totalitarianism of Russia and Germany. In itself it stands for nothing.[60] The spiritual emptiness that Eliot discerns at the heart of liberalism leads him to suggest that liberal democracy and totalitarianism are ultimately just two different if antagonistic forms of modern secularism, two manifestations of materialistic 'pagan' culture. For Eliot, the more fundamental distinction is thus not between a liberal-democratic and a totalitarian society, but between a pagan and a Christian culture.

Unlike Pound or Lewis, who generally have little truck with Christian polemics or organized religion, Eliot spends the greater part of his political treatise arguing in favour of a new revivified form of 'Christian Society', one 'directed by a Christian philosophy of life'.[61] Eliot's ideal Christian society is thus pointedly *not* animated by the spirit of capitalism or the materialistic ethos characteristic of both liberalism and totalitarianism.

And while personal and religious freedoms are not to be strictly circumscribed by law, Eliot insists that the coherence and integrity of such a society will depend upon a unity of Christian belief and religious practice guaranteed by tradition, custom, education, and social conformity. While Eliot is careful to specify that such a society will not require the coercion of its members by Church or state (which will remain separate institutions with direct and official relations), he nonetheless envisions a society in which political leaders will receive a Christian education and will feel obliged to conform to the Christian beliefs of the society as a whole. Religious observance among the masses, whom Eliot calls 'the Christian community of citizens', would be a matter of 'largely unconscious behavior', but an inner core of believers, 'the Community of Christians', an elite Coleridgian 'clerisy', gifted with 'intellectual and spiritual superiority', would lead a 'conscious Christian life on its highest level'.[62] If Eliot's ideal Christian society is not totalitarian, it is nonetheless deeply conformist. Uniformity of belief and practice does not depend upon outright force, but is the effect of disciplinary educational, social, and religious institutions and practices so pervasive and inescapable as to make coercion unnecessary.[63] Nor is Eliot's Christian society an individualist or democratic one. The Christian community provides both

[60] T. S. Eliot, *The Idea of a Christian Society*, 12, 15.
[61] Ibid. 30. Lewis occasionally offers a favourable assessment of the Roman Catholic Church in his social criticism. See e.g. *Men Without Art*, 220–3.
[62] Ibid. 23–8.
[63] While Eliot insists upon religious toleration as a necessary political principle in his Christian Society, he is not eager to make this regime particularly hospitable for non-believers. Eliot seems especially unwelcoming towards secular and cosmopolitan Jews who are not bound to the land, its people, or its religious traditions. For this latter point, see T. S. Eliot, *After Strange Gods: A Primer of Modern Heresy* (New York: Harcourt Brace, 1934), 20.

the matrix of and the horizon for its members. The state and the Church are hierarchical organizations that work in tandem in order to preserve the faith, traditions, laws, and customs of Christian society. Eliot seems unperturbed by the charge that his ideal regime might prove uncongenial to democrats. In his view, 'democracy' 'does not contain enough positive content to stand alone' against its political adversaries. 'If you will not have God', Eliot insists, 'you should pay your respects to Hitler or Stalin.'[64]

With the Allied victory over the Axis powers in the Second World War assured, the inevitable doom of Western liberal democracies seemed less certain in the immediate post-war era. To be sure, the Western liberal democracies were soon engaged in a cold war against a totalitarian superpower, but the prospects in the late 1940s for the survival and even resurgence of democratic liberalism appeared more promising than they had for several decades. In the wake of the destruction of Nazi Germany and Fascist Italy, even a cultural pessimist like Eliot began to offer a somewhat less apocalyptic view of the fate of liberal democracy in *Notes Towards the Definition of Culture*, composed between 1945 and 1946, and published in its final form in 1948. To be sure, Eliot remains deeply suspicious of egalitarian politics, mass culture, and the commercial ethos of Western, and most especially plutocratic American society. He is more insistent than ever that the only possible basis for culture is religion: 'no culture can appear except in relation to a religion'.[65] But *Notes* also demonstrates a new willingness on Eliot's part to praise liberal individualism and to acknowledge the virtues of democracy.[66] More suggestively still, Eliot's post-war social criticism sounds a new theme, though one much in evidence in the pre-war works of Pound and Lewis: the thesis that culture, most particularly high culture, depends for its flourishing upon the efforts of privileged elites.

Eliot maintains that the post-war period is one of precipitous cultural decline for Western civilization. The causes of this decay are many, but one of the main culprits is a secular democratic ethos that promotes the homogenization, standardization, and vulgarization of culture. Wary of political demagogues and central planners who might attempt to engineer a cultural renaissance, Eliot insists that a rebirth of 'our' culture cannot be obtained 'by deliberate organization'.[67] Culture cannot be imposed by an absolute central authority, whether political or ecclesiastical: 'the improvement and transmission of culture can never be the direct object of any of our practical activities'.[68] Eliot seems to have broken decisively here with the authoritarian premisses and grandiose projects that characterized much modernist social criticism in the 1920s and 1930s. He seems tantalizingly close to embracing a conception of culture as a kind of Hayekian 'spontaneous order' that grows and develops on its own, yet he cannot quite entirely forgo the cultural pretensions that fired the

[64] Eliot, *The Idea of a Christian Society*, 50.
[65] T. S. Eliot, *Notes Towards the Definition of Culture*, in *Christianity and Culture*, 100.
[66] Ibid. 142, 175. [67] Ibid. 92. [68] Ibid. 139.

modernist imagination before the war. For if we cannot fabricate culture out of whole cloth, Eliot suggests we can still 'will the means which are favorable' to it.[69] To be sure, these means are not the ones routinely wielded by a Führer, a Duce, or a Stalin (the 'Great Friend of Art'), or for that matter, by any well-meaning minister of culture. They are rather a set of conditions under which culture *may* arise: these preconditions are an 'organic' structure, a variety of local geographical settings, and a delicate balance between unity and diversity in religion. Eliot seems to have taken a page from Burke's political writings, for he now understands that culture depends upon the conservation and cultivation of organicism, localism, and moderate religious pluralism. If the post-war Eliot displays a more moderately conservative (as opposed to a radical or reactionary) sensibility, his lingering attachment to the Olympian cultural ambitions of high modernist social criticism shows through in his repeated insistence that the birth, growth, and transmission of culture requires the existence of 'elites'.[70]

Eliot's 'elites of the future' are to replace the classes of the past; they are not to be a rigidly defined caste. But they still sound suspiciously like the very same folks who were to play a leading role as the creators, arbiters, and purveyors of culture in the visionary social theories of Pound and Lewis. Eliot's elites are 'the ablest artists and architects' who 'rise to the top, influence taste, and execute the important public commissions'; they are 'the ablest minds' to 'find expression in speculative thought'.[71] For all of his horror of the absolutist and totalitarian menace, Eliot is no less eager after the war to offer 'a plea on behalf of a form of society in which the aristocracy should have a peculiar and essential function'; the elites, a natural aristocracy whose nucleus will be drawn from the dominant class, will in Eliot's utopian future represent 'a more conscious culture and a greater specialization of culture'.[72] Eliot's new regime will be culturally diverse and politically decentralized, but it will also be socially stratified, religiously based, and within each geographical locality, conservative and traditionalist.

If modernist social criticism is often marred by political extremism, and characterized by a radical impatience with and hostility towards liberalism and democracy, it is not owing to a lack of cultural refinement or aesthetic education on the part of its leading representatives. The antagonism that Pound, Lewis, and Eliot exhibited towards liberal democracy in the 1920s and 1930s, much like their rejection of market economies and commercial society, originated in a romantic conception of art as the highest and most exalted human calling. They unabashedly conceived of the artist and the creative intellectual as the naturally gifted and inspired leaders of a higher culture upon which a revolutionary political order would be founded. 'Culturalists' to the last, they judged political and social life by a standard established by art itself.

[69] T. S. Eliot, *Notes Towards the Definition of Culture*, in *Christianity and Culture*, 186.
[70] Ibid. 108. [71] Ibid. 118. [72] Ibid. 121, 114–15.

Culture was not to be subordinate to or a minor dominion within politics. It was to be the *raison d'être* of political life. What was right for art and the artist was by definition the right kind of politics. The high modernist credo might well have been not 'l'art pour l'art', but rather, 'politics for art's sake'. At long last, the poets were to be the *acknowledged* legislators of the world.

CHAPTER 9

···

GENDERING THE MODERNIST TEXT

···

DEBORAH LONGWORTH

Some people think that women are the cause of modernism, whatever that is.

(*New York Evening Sun*, 13 February 1917)

'No age can ever have been as stridently sex-conscious as our own,' Virginia Woolf muses in *A Room of One's Own* (1929), as she contemplates the long list of books catalogued under 'Woman' in the library at the British Museum:

The Suffrage campaign was no doubt to blame. It must have aroused in men an extraordinary desire for self-assertion; it must have made them lay an emphasis on their own sex and its characteristics which they would not have troubled to think about had they not been challenged. And when one is challenged, even by a few women in black bonnets, one retaliates, if one has never been challenged before, rather excessively.[1]

A Room of One's Own was published in 1929, less than a year after women in Britain finally achieved equal voting rights with men.[2] Woolf's adoption of an ironic, deliberately whimsical tone is a common strategy in her essays, but her suggestion of a causal connection between the rise of the suffrage movement and a contemporaneous outpouring of taxonomies of the female sex by male writers is not entirely tongue in cheek. 'Life for both sexes', Woolf observes,

[1] Virginia Woolf, *A Room of One's Own/Three Guineas*, ed. Morag Shiach (Oxford: Oxford University Press, 1992), 129.

[2] The Representation of the People Act of February 1918 gave the vote to women over 30 if either they or their husbands were in possession of or renting property. It was not until July 1928 that all women over the age of 21 were granted the right to vote. See Elizabeth Crawford, *The Woman's Suffrage Movement: A Reference Guide 1866–1928* (London: University College London Press, 1999).

is arduous, difficult, a perpetual struggle. It calls for gigantic courage and strength. More than anything, perhaps, creatures of illusion as we are, it calls for confidence in oneself. . . . Hence the enormous importance to a patriarch who has to conquer, who has to rule, of feeling that great numbers of people, half the human race indeed, are by nature inferior to himself. It must indeed be one of the chief sources of his power.[3]

Men have insisted on women's inferiority, Woolf argues, 'for if they were not inferior, they would cease to enlarge'.[4] 'That serves to explain in part the necessity that women so often are to men,' she concludes. 'And it serves to explain how restless they are under her criticism.'[5] Recalling, for example, that a male acquaintance, normally the 'most humane, most modest of men, had thrown down a book by the novelist Rebecca West, declaring her to be an 'arrant feminist!', Woolf decides that his enraged response 'was a protest against some infringement of his power to believe in himself'.[6] With his sense of superior identity under threat from women's demand for equality, man responds with a violent reassertion of masculinity.

The only contemporary author to be mentioned by name in *A Room of One's Own*, Rebecca West was a writer of impassioned pieces on feminism and politics for *The Freewoman* and the socialist weekly *The Clarion*, as well as novels and stories that focused on gender dualism and antagonism between the sexes. 'I believe in the sex-war,' she had declared in her essay 'On a Form of Nagging', published in the feminist weekly *Time and Tide* in 1925. 'I am . . . anti-man.'[7] Woolf may have thought West 'a cross between a charwoman and a gypsy',[8] but she admired her uncompromising feminist stance, and her account in *A Room of One's Own* of man's need for female inferiority to act as a standard against which he can affirm his own superiority strikingly echoes West's earlier polemic in 'Nagging'. 'Man, baffled and fatigued by his struggle to establish and perpetuate human life in the universe,' West writes here, 'becomes afraid of judging his progress by the standard of approach to the absolute good. He prefers a relative standard. He wants to feel that however badly he is doing someone else is doing worse. As the only person with whom man can compare himself is woman, it is desirable that she should do worse.'[9]

The stalemate of the sex war as played out in contemporary gender relationships was the subject of West's first published short story, 'Indissoluble Matrimony', which appeared perhaps somewhat surprisingly in *Blast*, the Vorticist journal run by the self-consciously virile but far from pro-feminist Wyndham Lewis, in 1914.[10] A fictional

[3] Woolf, *A Room of One's Own*, 44–5.
[4] Ibid. 46. [5] Ibid. [6] Ibid. 45.
[7] Rebecca West, 'On a Form of Nagging', *Time and Tide* (31 Oct. 1924), 1052.
[8] Stefan Collini, *Common Reading: Critics, Historians, Publics* (Oxford: Oxford University Press, 2008), 56.
[9] West, 'On a Form of Nagging', 1052–3.
[10] Rebecca West, 'Indissoluble Matrimony', *Blast*, 1 (20 June 1914), 98–117; repr. in *The Young Rebecca: Writings of Rebecca West 1911–17*, ed. Jane Marcus (Bloomington: Indiana University Press, 1982), 267–89.

treatment of West's theory of the weak man's need to denigrate woman by insisting on her inferiority to himself, it depicts one evening in the marriage between George Silverton, a rather weedy solicitor's clerk with a psychotic 'disgust for women', and his wife, Evadne, who, 'after reading enormously of economics . . . had begun to write for the Socialist press and to speak successfully at meetings'.[11] Evadne's public triumphs, along with her calm self-preoccupation, constant air of confident 'exaltation', and face 'heavy with intellect', arouse resentment and hatred in her husband, who refers to her with eroticized loathing as 'Negro', 'Oriental', a 'depraved, over-sexed creature'.[12] Narrated through the increasingly hysterical interior monologue of Silverton, the story upturns standardized gender stereotypes, revealing through his frenzied preoccupation with what he regards as the monstrosity of his wife's strength and pulsing energy his own self-perception as 'a poor thing with a habit of failure'.[13] Unable to compete with her physically or intellectually, offended by her calm independence, and consumed with self-loathing at his desire for her sensual physicality, he resorts to wild accusations of her sexual infidelity. His crazed insistence eventually leads to a primitive battle to the death on the heathland beyond their house, where they fall together into the swirling waters of a mill-race. Believing that he has finally succeeded in drowning Evadne, Silverton returns home to perform what he fantasizes will be a glorious suicide, only to find her already returned and in deep, contented sleep, her wet clothes thrown onto a nearby chair. Even in his final, desperate attempt at murder–suicide she thwarts him, having performed her nightly ritual of turning off the gas with which he intends to suffocate them both, and he ultimately collapses in defeat: 'He had thought he had had what every man most desires: one night of power over a woman for the business of murder or love. But it was a lie.'[14] Beaten, he gets into bed, to be encircled by Evadne's strong and controlling arms. Neither in murder, nor in love, is he the one in power.

With hindsight the publication of a story by the outspokenly feminist West in *Blast* might seem to sit somewhat uncomfortably with subsequent paradigmatic taxonomies of the origins of Formalist literary modernism, in which the launch of *Blast* is identified as one of a series of formative moments by its all but entirely male makers.[15] The effect of Silverton's unreliable narration, however, ensures that 'Indissoluble Matrimony' echoes key markers of the Vorticist aesthetic at the same time as it undercuts it; the depiction of an essential division of the sexes, bourgeois male impotence, and a Nietzschean power struggle to the death between man and woman, for example, cohere with Lewis's critique of Western society, yet are only an expression of Silverton's irrational crisis of masculinity. Indeed, from the perspective of West's feminism, moreover, the fact that Evadne's vitality appears to feed off her

[11] Rebecca West, 'Indissoluble Matrimony', *Blast*, 1 (20 June 1914), 271.
[12] Ibid. 268, 271, 272. [13] Ibid. 288. [14] Ibid.
[15] See Hugh Kenner, *The Pound Era* (Berkeley: University of California Press, 1971); Michael Levenson, *A Genealogy of Modernism: A Study of English Literary Doctrine 1908–1922* (Cambridge: Cambridge University Press, 1984); Stan Smith, *The Origins of Modernism: Eliot, Pound, Yeats and the Rhetorics of Renewal* (Hemel Hempstead: Harvester Wheatsheaf, 1994).

husband's weakness overturns what both she and Woolf identify as man's long use of woman as the inferior instrument against which to assert his own strength.

I begin this essay with a brief outline of Woolf's and West's discussion of the 'sex war', because it offers an example of modernist gender debate as it was being articulated in the 1910s and 1920s, but also prefigures one of the key narratives of the 'gender of modernism' within subsequent modernist studies. Echoing Woolf and West in their now classic three-volume study *No Man's Land: The Place of the Woman Writer in the Twentieth Century* (1988), Sandra Gilbert and Susan Gubar not only returned critical attention to the fact that modernism was concomitant with 'an ongoing battle of the sexes . . . set in motion by the late nineteenth-century rise of feminism and the fall of Victorian concepts of "femininity"', but also declared this battle to be fundamental to the mode and manner of its emergence among the high European avant-garde.[16] The turn of the century was certainly a period of widespread gender anxiety, marked by an urgent engagement with definitions of masculinity and femininity, as the hitherto accepted dominance of the Western male subject was beset by the challenges of organized feminism, a decadent counter-masculinity, the perceived feminization of modernity and mass culture, and the change in women's social and economic roles during the First World War. As both male and female writers 'engendered words and works which continually sought to come to terms with, and find terms for' this destabilizing of masculine and feminine stereotypes, Gilbert and Gubar claim, the problem of gender 'became not just a theme in modern writing but a motive for modernism'.[17]

Gilbert and Gubar have been heavily critiqued for what some have regarded as the 'high feminist' essentialism of their critical position, assuming a common experience and cause among women that disregards specificities of historical and cultural difference. Yet their argument that the gender politics of modernism contributed to the shaping of modernist texts and aesthetics nevertheless does call attention to the significance of gender within the origins of modernism, recovering the preoccupation with femininity and the 'feminine', and what were indeed very *conscious* assertions of modernist masculinity, that so pervaded the aesthetic challenges, literary manifestos, and broader historical milieu of the period. The 1940s to 1970s witnessed the construction of a canonical teleology of literary modernism by the critical academy that, as Bonnie Kime Scott has famously charged, was 'unconsciously gendered masculine'; one in which male writers were selectively quoted, women writers largely elided, and the gendered discourse of modernism all but written out of early twentieth-century literary history.[18] Feminist literary critics from the 1980s

[16] Sandra Gilbert and Susan Gubar, *No Man's Land: The Place of the Woman Writer in the Twentieth Century*, 3 vols (New Haven: Yale University Press, 1988–94), i: *The War of the Words*, 156. See also ii: *Sexchanges* and iii: *Letters from the Front*.

[17] Ibid. i. 156.

[18] Bonnie Kime Scott (ed.), *The Gender of Modernism: A Critical Anthology* (Bloomington: Indiana University Press, 1990), 2.

sought to recover the work of 'forgotten' women writers (a strategy that led to the rediscovery of writers who had enjoyed significant reputations within the modernist period, such as Djuna Barnes, H.D., Mina Loy, Katherine Mansfield, Dorothy Richardson, May Sinclair, Jean Rhys), and to reclaim for a revisionary modernist canon those who had retained a degree of personal notoriety while being denied artistic importance (such as Edith Sitwell and Gertrude Stein).

As modernist studies has evolved across the turn of a new century, the initial recuperative focus of feminist modernist studies has shifted in accordance with a revisionary cultural materialism to an examination of the polymorphous gender politics of the period, and in accordance with theoretical developments, to an awareness of the *instability* of gender as the foundation of concepts of identity and difference. 'In history, across cultures, and in the lifetime development of the individual', Scott declared in her influential anthology *The Gender of Modernism* (1990), 'there are variations in what it means to be masculine, or feminine, in the availability of identifications such as asexual and androgynous, and in the social implications of lesbian, homosexual, and heterosexual orientations.'[19] Contemporary intersections between modernist studies and gender–sexuality studies have broadened the terms of debate to an extent that makes it impossible to do the topic justice in a single chapter; the reader is thus also directed to the complementary analyses of different aspects of *sexual*-textual modernism dealt with elsewhere in this volume (see Chapters 11 and 12).

Here I focus on the differing strategic appropriation of the concepts of masculinity and femininity within the development of early twentieth-century modernist aesthetics and formal literary experimentation: from the overtly masculinist and unapologetically misogynist artistic manifestos of pre-war literary avant-gardism, to the preoccupation with 'engendered words' and the potential of distinctively 'feminine' forms of prose and verse technique. An examination of the gendered politics and poetics of the modernist period demonstrates not only the significance of concepts of masculinity and femininity for key debates about modernity, authorship, aesthetics, and formal style, but also the contested nature of gender discourse as it circulated within the period, across different groups and genres, and between both male and female writers. Even a brief survey reveals significant divergences of aesthetic and ideological opinion, as well as often fierce rivalry, among leading women writers, which belies any idealized notion of a mutually supportive collectivity of modernist women. Modernism's relationship with gender has never been simple, nor based on any straightforward binary understanding of masculine or feminine. It is complex, overdetermined, and ever fertile, as articulated in the gendered focus and form of modernist writing, and continually reflected in literary criticism's own gendered constructions and reconstructions of modernist texts, modernist culture, and modernist aesthetics.

[19] Scott (ed.), *The Gender of Modernism: A Critical Anthology*, 2.

FREEWOMEN, EGOISTS, AND
THE AVANT-GARDE

The rebel art scene of London in the years leading up to the First World War was a self-consciously masculine and heterosexist affair, pitting itself against what it regarded as the degenerate effeminacy of nineteenth-century values, and their continuing influence in the twentieth. In March 1910 Filippo Tommaso Marinetti arrived at the Lyceum Club for Women to proclaim 'The Founding and Manifesto of Futurism': 'We will glorify war—the world's only hygiene, militarism, patriotism, the destructive gesture of freedom-bringers, beautiful ideas worth dying for, and scorn for women.'[20] The emergent English avant-garde was energized by Marinetti's aggressive approach. Although it was soon to reject Futurism's nationalist passion in order to assert its own artistic programme, it was equally anti-feminine, pursuing political and aesthetic revolution through a rhetoric grounded in a struggle between the polarities of masculine and feminine identity; the former associated with the vigour and dynamism of the machine, the latter with nature, chaos, and the sentimental. Critic, philosopher, and poet T. E. Hulme, for example, renowned for his hyper-masculine presence and traditional views about women, called for a modern poetry of 'virile thought' to replace the degenerate effeminacy of Romantic aesthetics, a position echoed by the one-time Vorticist C. R. W. Nevinson in his breakaway Anglo-Futurist manifesto (written with Marinetti) for 'an English Art that is strong, virile and anti-sentimental.'[21] Wyndham Lewis, while quick to disown Nevinson's manifesto and to distinguish himself from the Futurist programme, nevertheless also conceived Vorticism as an art of vigorous, kinetic forces, counter to the 'jellyfish diffuseness' of feminine subjectivism he attacked in his novel *Tarr* (1918), and would later critique in his studies on post-war modernism *The Art of Being Ruled* (1926), *Time and Western Man* (1927), and *Men Without Art* (1934).[22] Perhaps the most overt expression of sexualized rhetoric by this heterosexual masculine avant-gardism was the postscript Ezra Pound wrote to his translation of Rémy de Gourmont's *The Natural Philosophy of Love* in 1921, in which he speaks of 'creative thought' as an 'act of fecundation, like the male cast of the human seed', and the creative artist as 'the phallus spermatozoid charging head-on, the female chaos'.[23] 'Even oneself has felt it', he asserts, 'driving any new idea into the great passive vulva of London.'[24] London in the 1910s, for Pound, Hulme, Lewis, Marinetti, and their fellow Vorticists and

[20] F. T. Marinetti, 'The Founding and Manifesto of Futurism', in Mary Ann Caws (ed.), *Manifesto: A Century of Isms* (Lincoln: University of Nebraska Press, 2001), 187.

[21] T. E. Hulme, 'A Lecture on Modern Poetry', in *The Collected Writings of T. E. Hulme*, ed. Karen Csengeri (Oxford: Clarendon Press, 1994), 51; F. T. Marinetti and C. R. W. Nevinson, 'English Vital Art', *The Observer*, 7 June 1914, repr. in Nevinson, *Paint and Prejudice* (London: Harcourt Brace, 1938), 80.

[22] Wyndham Lewis, *Tarr: The 1918 Version*, ed. Paul O'Keeffe (Santa Rosa, Calif.: Black Sparrow Press, 1990), 314.

[23] Ezra Pound, 'Postscript', repr. in *Pavannes and Divagations* (New York: New Directions, 1958), 204.

[24] Ibid.

Futurists, became the locus of virile experimentation, paradoxically symbolizing at once the bourgeois feminine mass, and the vortex of force from which the elite male avant-garde artist was to effect artistic and political transformation.

Despite the masculine stance and often misogynistic rhetoric of both Futurism and Vorticism, Marinetti, Lewis, and Pound were far more ambivalent in their actual interactions with modern women and women artists. While one of the declarations of the 'Manifesto of Futurism' was to 'fight . . . feminism', Marinetti, for example, was willing to concede two years later that if women had been exposed for generations to the same physical and intellectual experiences as men, then 'it would perhaps be legitimate to speak of the equality of the sexes'.[25] His real ire was directed at what he called 'the Fatal Woman of cardboard', defined in his 1911 essay 'Against *Amore* and Parliamentarianism' as 'woman conceived as the sole ideal, the divine reservoir of *Amore*, the woman-poison, woman the tragic trinket, the fragile woman, obsessing and fatal'.[26] Repudiating feminism, Marinetti's determination to destroy the late nineteenth-century decadent or Symbolist fascination with *Amore* that he believed was hindering man's natural virility nonetheless drew him into allegiance with a certain group of women who were equally energetic in their denunciation of nineteenth-century female stereotypes, and more than willing to protest their views through violent action. '[O]ur best allies are the suffragettes', the Futurist leader declared in 'Against *Amore* and Parliamentarianism', 'because the more rights and powers they win for woman, the more will she be deprived of *Amore*, and by so much will she cease to be a magnet for sentimental passion or lust.'[27]

British suffragettes had made up a significant number of Marinetti's Lyceum Club audience in 1910, and in March 1912 he joined the Women's Social and Political Union (WSPU) in a window-smashing protest rally in central London. Later the same day, he recalled, he was lecturing in a building that the suffragettes had taken over, 'gesturing out of a miniature painting the aesthetic of the machine plastic dynamism and idolatry of things modern the importance of flying in literature and art to the more attentive of the 1000 women there'.[28] While Marinetti's tone is condescending as he describes the women listening to his talk on modern art, the proclamations of militant suffragism bore remarkable similarities to the language and import of the Futurist manifestos. Moreover, the action perpetrated by the WSPU—hunger strikes, window smashing, arson attacks, and art vandalism—not only cohered with Futurist rhetoric about destroying the past, but put it forcibly into practice. 'The bad and the old have to be destroyed to make way for the good and new,' Christabel Pankhurst announced in *The Suffragette* in May 1913, describing the objectives of the WSPU as 'a great blasting away of ugly things'.[29]

[25] F. T. Marinetti, 'Against *Amore* and Parliamentarianism', in Bonnie Kime Scott (ed.), *Gender in Modernism: New Geographies, Complex Intersections* (Urbana: University of Illinois Press, 2007), 81.
[26] Ibid. [27] Ibid.
[28] F. T. Marinetti, 'Suffragettes and the Indian Docks' (1912); quoted in Janet Lyon, *Manifestoes: Provocations of the Modern* (Ithaca, NY: Cornell University Press, 1999), 101.
[29] Christabel Pankhurst, 'What Militancy Means', *The Suffragette*, 2 (May 1913), 492.

The London Vorticists also recognized the sympathies between the aggressive propaganda strategies of the more radical wing of the suffragette movement and their own polemic of energetic destruction, with the art-slashers 'Lillie Lenton' and 'Freider Graham' drawing a salute from Wyndham Lewis in being ranked among the 'Blessed' in *Blast*:

> MAIS SOYEZ BONNES FILLES!
> NOUS VOUS AIMONS!
> WE ADMIRE YOUR ENERGY. YOU AND ARTISTS
> ARE THE ONLY THINGS (YOU DON'T MIND
> BEING CALLED THINGS?) LEFT IN ENGLAND
> WITH A LITTLE LIFE IN THEM.[30]

Like Marinetti drawing an alliance between radical suffragism and avant-garde aesthetics, Lewis qualified his praise with a reassertion of the authority of the masculine artist, endorsing women's right to the vote at the same time as denying them aesthetic sensibility. 'TO SUFFRAGETTES', he declares in *Blast*, 'A WORD OF ADVICE':

> IN DESTRUCTION AS IN OTHER THINGS,
> stick to what you understand.
> WE MAKE YOU A PRESENT OF OUR VOTES.
> ONLY LEAVE WORKS OF ART ALONE.
> YOU MIGHT SOME DAY DESTROY A
> GOOD PICTURE BY ACCIDENT.
> THEN!—[31]

Vorticism, from this assertion, would seem to be far less aggressively enthusiastic about the actual rather than metaphoric destruction of art than its broader 'blasting' implies. Lewis's patronizing tone also serves to re-establish a hierarchy of the male artist over the female suffragette; women might be worthy of the right to vote, Lewis implies, but have little capacity for artistic judgement. Rowena Fowler argues that this might be taken as evidence of a 'proto-feminist' attack on images of male authority.[32] Her claim may be overstated. As Aaron Jaffe notes of the subsequent statements by women who slashed artworks, 'none explicitly verbalized either the subjects of the paintings or the paintings themselves as *deserving* of execration'.[33] But it is certainly possible that the suffragettes targeted artworks and institutions (the Royal Academy, the National Gallery, and the National Portrait Gallery) that they

[30] Wyndham Lewis, *Blast 1* (London: Thames & Hudson, 2009), 151.

[31] Ibid. Lillian Lenton committed a series of arson attacks between 1913 and 1914, and was suspected of setting fire to the Kew Gardens tea pavilion on 20 February 1913, for which she was sentenced to time in Holloway Prison. She was released after going on hunger strike and contracting pleurisy from being forcibly fed. Freda Graham slashed five paintings at the National Gallery on 22 May 1914, and received a six-month sentence, although she was released on 5 June after suffering force-feeding.

[32] Rowena Fowler, 'Why Did Suffragettes Attack Works of Art?', *Journal of Women's History*, 2/3 (1991), 124.

[33] Aaron Jaffe, *Modernism and the Culture of Celebrity* (Cambridge: Cambridge University Press, 2005), 191.

associated with a patriarchal status quo. The aim of both Marinetti's and Lewis's association of avant-gardism with radical suffragism is ultimately the same; to tap the feminine destructive energy of the suffragettes by the masculine creative energy of the avant-garde, at the same time as maintaining an intellectual and hierarchical detachment from it.

If Marinetti's support of the suffragettes was somewhat backhanded—he celebrated their will to destructive action but scorned its purpose, 'their infantile enthusiasm for the miserable, ridiculous right to vote'—many vanguard feminists were similarly critical of parliamentary structures and disagreed with the limits of the Pankhursts' brand of suffragism.[34] As Lucy Delap has demonstrated, the term 'feminism' in both Britain and the United States at the turn of the century connoted a radical perspective, distinct from and often overtly critical of suffragism, and aligned more with the individualist tendencies of avant-garde aesthetics.[35] Indeed, in America the National Association Opposed to Women's Suffrage made an explicit connection between the two when it stated that feminism was 'a movement born of a cubist and futurist age of extremes'.[36] For 'avant-garde' feminists, among them writers and artists working on the margins of the Futurist and Vorticist avant-gardes, the project of female emancipation was as much conceptual, metaphysical, and aesthetic as it was social and political.

Marinetti's Futurism had a significant following among the female literary vanguard, and both Poundian Imagism and Vorticism included women among their ranks, belying the myths of masculine avant-garde self-formation that have subsequently dominated canonical narratives of all three movements. Genealogies of the pre-war English avant-garde, for example, have until recently tended to silence the role of the artists Kate Lechmere, Jessica Dismorr, Helen Saunders, and Dorothy Shakespear in the emergence of Vorticism: Lechmere setting up the Rebel Arts Centre as a centre, school, and showcase for Vorticist art in 1914, while Dismorr and Saunders acted as signatories to the 'Manifesto' in *Blast* in 1914, and Dismorr, Saunders, and Shakespear all contributed to *Blast* 2 in 1915. Lechmere's account of the Saturday afternoon soirées at the Rebel Arts Centre, where she was left to act as social hostess 'because Lewis insisted that the organising of tea-parties was a job for women, not artists', nevertheless suggests that she perceived a similar distinction being made between passive feminine instinct and creative masculine energy by the male writers and artists in whose circle she moved to that which they maintained with the suffragettes.[37] Women might support the project of avant-garde art, and be romantically entangled with its leaders, but they were not

[34] Jaffe, *Modernism and the Culture of Celebrity*, 191.
[35] Lucy Delap, *The Feminist Avant-Garde: Transatlantic Encounters of the Early Twentieth Century* (Cambridge: Cambridge University Press, 2007). See also Nancy Cott, *The Grounding of Modern Feminism* (New Haven: Yale University Press, 1987).
[36] Delap, *The Feminist Avant-Garde*, 2.
[37] Richard Cork, *Vorticism and Abstract Art in the First Machine Age* (Berkeley: University of California Press, 1976), 148. See also Jane Beckett and Deborah Cherry, 'Modern Women, Modern Spaces: Women, Metropolitan Culture and Vorticism', in Katy Deepwell (ed.), *Women Artists and Modernism* (Manchester: Manchester University Press, 1998), 36–54.

themselves truly avant-garde artists. As Ezra Pound declared in a review of the artist Nina Hamnett in 1918: 'Not wildly anti-feminist we are yet to be convinced that any women ever invented anything in the arts.'[38]

Perhaps surprisingly, it was Futurism that produced an identifiable pro-feminist discourse on its own account, notably in the early writings of the writer and dancer Valentine de Saint-Point and the poet Mina Loy. Both drew upon the Futurist celebration of virile modernity, and its rejection of sentimental, domesticated femininity, while rewriting its misogynistic rhetoric into an ideal of strong, sexual womanhood. The Futurist revolution should not be without women, Saint-Point declared in her 'Manifesto of Futurist Women', and 'instead of scorning her, we should address her'.[39] Observing that men and women 'are all equal', and that in contemporary society 'They all merit the same scorn,' she outlines a view of humanity that is essentially androgynous.[40] The strongest and most successful periods of human history, she argues, have been those in which men and women each possessed a balance of both masculine and feminine attributes. These eras have produced the superman, 'the prodigious expression of a race and an epoch only because he is composed at once of feminine and masculine elements'.[41] Similarly, they are the periods in which women have exhibited an element of masculine strength: as 'Furies, Amazons, Semiramis, Joans of Arc, Jeanne Hachettes, Judith and Charlotte Cordays, Cleopatras and Messalinas'.[42] As for the present moment, however, she agrees with Marinetti that it has become dominated by the feminine principle in both sexes. Women's wild instinct has been tamed, and in her culturally induced weakness she has become an enervating force, sapping the potential strength of modern life: 'octopuses of the hearth, whose tentacles exhaust men's blood and make children anemic'.[43] *'What is most lacking in women as in men is virility,'* she asserts, and 'That is why Futurism, even with all its exaggerations, is right,' for 'To restore some virility to our races so benumbed in femininity, we have to train them in virility even to the point of brute animality.'[44] An embrace of Futurism will restore women's natural will to violence and lust. 'But no feminism,' she warns. 'Feminism is a political error. Feminism is a cerebral error of woman, an error that her instinct will recognize. *We must not give woman any of the rights claimed by feminists.*[45] What Saint-Point objects to in organized feminism is, in part, like Marinetti, the suffragist focus on gaining equality with men in a state political structure that both deem feeble and irrelevant. But it is also, and for Saint-Point more significantly, the *intellectual* drive of feminism, which she regards as counter to women's primordial role as either 'egoistic and

[38] B. H. Dias [Ezra Pound], 'Art Notes', *New Age* (1 Aug. 1918), 223.
[39] Valentine de Saint-Point, 'Manifesto of Futurist Women (Response to F. T. Marinetti), 1912', in Caws (ed.), *Manifesto*, 215.
[40] Ibid. 213. [41] Ibid. [42] Ibid. 214.
[43] Ibid. [44] Ibid. [45] Ibid. 215.

ferocious mother' or virile lover.[46] Saint-Point's 'Futurist Woman' is an Amazonian superwoman: combative rather than domestic, destructive rather than nurturing, and sensual rather than sentimental.

Where Saint-Point somewhat contradictorily posits an androgynous equality of men and women, Mina Loy's 'Feminist Manifesto', written in 1914 although unpublished during her lifetime, defends their absolute difference, urging women to

> ... be Brave & deny at the outset—that pathetic clap-trap war-cry, Woman is the equal of man—
> for
> She is NOT![47]

Loy described her manifesto as 'a rough draught beginning of an absolute resubstantiation of the feminist question'.[48] Directed at the contemporary suffragist, and written with archetypal Futurist idiom and emphatic typography, Loy opens with the complaint that 'The feminist movement as at present instituted is Inadequate':

> Women if you want to realise yourselves ...
> There is no half-measure—NO scratching on the surface of the rubbish heap of tradition, will bring about Reform, the only method is Absolute Demolition.[49]

Eschewing educational opportunity and political equality as the principal objects of feminism, she demands instead the complete overturn of the economic basis of marriage, and the parasitic state of wife and motherhood it entails. Loy agrees with both Marinetti and Saint-Point about the degenerative effect on men and women caused by the cultural acceptance of man's role as the worshipper and protector of women—in which man 'is no longer masculine' and woman 'not yet Feminine'—and like Saint-Point counters the cultural inferiority of women by situating female power within an essentialist view of the sexual and fecund female body.[50] Yet while Saint-Point believes that women have a natural function as either mothers or lovers, and should embrace these roles with Amazonian heroic strength, Loy regards the division of women's maternal and sexual identity to be in itself culturally defined, and a means of subjugating women through a moralization of gender roles. Her call for reform through demolition is not only metaphorical, directed at a sweeping away of nineteenth-century Romanticism, but also physical, advocating 'the unconditional surgical destruction of virginity throughout the female population at the age of puberty' as the only way to overcome the economic bargaining tool of sexual innocence by which the value of women is judged within society.[51] 'To obtain results

[46] de Saint-Point, 'Manifesto of Futurist Women', 216.
[47] Mina Loy, 'Feminist Manifesto', in Caws (ed.), *Manifesto*, 611.
[48] Quoted in Mina Loy, *The Last Lunar Baedeker*, ed. Roger Conover (Highland, NC: Jargon Society, 1982), 327.
[49] Loy, 'Feminist Manifesto', 611. [50] Ibid. [51] Ibid. 612.

you must make sacrifices,' Loy declares, '& the first & greatest sacrifice you have to make is of your "virtue".'[52]

Vanguard feminists in Britain were equally questioning of what they regarded as the limited or naive aims of collective feminism or suffragism, if less enthusiastic to embrace quite such a violently revolutionary discourse for its critique. Perhaps the paradigmatic instance of the complex interdependence that could arise between radical anti-bourgeois feminism and masculine modernism is to be found in the history and philosophy behind the evolution of the radical feminist weekly *The Freewoman* (1911–12) and its successor the *New Freewoman* (1913) into the 'little magazine' that would become one of the primary vehicles of emergent Anglo-American literary modernism, *The Egoist* (1914–19). Launched in London by Dora Marsden and Mary Gawthorpe (members of the WSPU who had grown disillusioned with the Pankhurst brand of militant suffragism), but with both British and American contributors and an Anglo-American readership, *The Freewoman* was critical of the concentration of the suffrage upon political enfranchisement. Instead it spoke for the broader social, cultural, and intellectual emancipation of women, its articles also frankly discussing sexuality and sexual disease, advocating free love, critiquing the institution of marriage, and highlighting the economic inequalities of motherhood. As such it provided a space for vanguard feminism, Marsden declaring in its opening number in November 1911 that 'feminism is the whole issue, political enfranchisement a branch issue and the methods, militant or otherwise, are merely accidentals'.[53]

The Freewoman lasted less than a year before suffering the economic problems of other 'little magazines', and with the loss of its patron Charles Greville, as well as W. H. Smith's decision to cease presenting a paper so mired in controversy on its newsstands, was soon forced to fold. With one of *The Freewoman*'s wealthier subscribers, Harriet Shaw Weaver, providing financial support, Marsden relaunched the journal the following year as the *New Freewoman: An Individualist Review*. The subtitle was significant, articulating Marsden's increasing shift in concern from organized feminism to radical individualism. '*The New Freewoman* is not for the advancement of women, but for the empowering of individuals—men and women,' she declared in an editorial essay in July 1913; 'it is not to set women free but to demonstrate the fact that "freeing" is the individual's affair.'[54] Including writings on feminism, socialism, anarchism, Nietzschean thought, and radical aesthetics, Rebecca West, whom Marsden had made assistant editor, recalled its content as consisting of 'the revolt of women, philosophic anarchism, and a general whip-round for ideas which would reform simultaneously life and art'.[55] West encouraged a more 'literary side' to the journal, and invited Ezra Pound to contribute.[56] Ultimately it was Marsden's individualist

[52] Ibid.

[53] Dora Marsden, 'Bondwomen', *The Freewoman* (23 Nov. 1911), 3.

[54] Dora Marsden, 'Views and Comments', *New Freewoman* (1 July 1913), 24.

[55] Rebecca West, quoted in George Bornstein (ed.), *Representing Modernist Texts: Editing as Interpretation* (Ann Arbor: University of Michigan Press, 1991), 74.

[56] Quoted in Bonnie Kime Scott, *Refiguring Modernism*, i: *The Women of 1928* (Bloomington: Indiana University Press, 1995), 44.

philosophy, combined with, under Pound's literary editorship, a more prescribed aesthetic agenda, that came to dominate the tone and focus of the paper. Eventually, in December, Pound, Richard Aldington, and three other male contributors wrote to Marsden calling for the paper to be renamed in such a way as to avoid any suggestion of particularly suffragist or feminist allegiance: 'We, the undersigned men of letters', it began, 'venture to suggest to you that the present title of the paper causes it to be confounded with organs devoted solely to the advocacy of an unimportant reform in an obsolete political institution'.[57] Recommending that Marsden 'consider the advisability of adopting another title', Pound et al. emphasized that it should be one that would clearly define the paper 'as an organ of individuals of both sexes and of the individualist principle in every department of life'.[58]

Feminist modernist studies has been quick to read the emergence of *The Egoist* as something of a conspiracy on the part of Pound to purge Imagist modernism of its uneasy association with early feminism. K. K. Ruthven, for example, identifies the renaming of the *New Freewoman* as the 'paradigmatic instance of the subordination of women by a male-dominated modernism'.[59] Letters to Harriet Shaw Weaver certainly suggest that Marsden *was* suspicious of Pound's increasingly proprietorial bearing towards the journal, and Weaver herself, recalling the history of the journal, commented upon 'The new masculine element which had allied itself with the paper' and 'before long raised objections to the title'.[60] Yet this is to downplay the fact that Marsden herself also *agreed* with Pound in thinking suffragism politically obsolete and metaphysically unimportant, that her individualism bore obvious parallels with Pound's definition of Imagism in individualist terms and of Vorticism as 'a movement of individuals, for the protection of individuality', and that the word 'egoist' appeared frequently in her editorials.[61] The title of the *New Freewoman*, it could be argued, was already anomalous with her philosophy of individual em-powerment through self-realization regardless of gender.[62] 'Woman? Is there such a thing even as *a* woman sensed from the inside?', she had demanded in the *New Freewoman* in 1913, 'Never in the course of a long life have we felt "There, I felt that as a woman." Always things have been felt as individual and unique, as much related to other women as to other men'.[63] Rachel Blau DuPlessis suggests that Marsden was too quick to assume that the feminist battle had been won and to cast aside *The Freewoman* and the *New Freewoman*'s focus on broad female emancipation for a more gender-neutral egoism.[64] Of course, although detaching the journal from its

[57] Dora Marsden, 'Views and Comments', *New Freewoman* (15 Dec. 1913), 244.

[58] Ibid.

[59] K. K. Ruthven, 'Ezra's Appropriations', *Times Literary Supplement*, 20–6 Nov. 1987, 1278.

[60] Harriet Shaw Weaver, MS, n.d., Harriet Shaw Weaver Papers, British Library.

[61] 'Edward Wadsworth, Vorticist', *The Egoist*, 1 (15 Aug. 1914), 306.

[62] For Marsden's complicity in the change of name, see Robert von Hallberg, 'Libertarian Imagism', *Modernism/Modernity*, 2/2 (1995), 63–79, and Bruce Clarke, *Dora Marsden and Early Modernism* (Ann Arbor: University of Michigan Press, 1996).

[63] Dora Marsden, 'Views and Comments', *New Freewoman* (1 July 1913), 24.

[64] Rachel Blau DuPlessis, *The Pink Guitar: Writing as Feminist Practice* (London: Routledge, 1990), 44.

overtly feminist origins, the increasing emphasis on 'the individualist principle' in the *New Freewoman* and *The Egoist* also, in no small part, served to defuse the more overt 'masculinist' rhetoric of the pre-war avant-garde.

Dissenting from the ideals of organized feminism, and highlighting the overlap of the egoism of both the pre-war English avant-garde and vanguard feminism, Marsden confounds any easy narrative of dichotomous gender wars in the modernist period.[65] Yet the debate over feminist egoism also demonstrates the ambiguity of gender associations as they circulated within modernist aesthetics. The capturing of the experience of woman as sensed from the inside, for example, was exactly the project upon which the novelist Dorothy Richardson, whose own idiosyncratic feminism was accompanied by a staunch egoism equal to that of Marsden's own, was simultaneously embarking. Richardson's thirteen-book novel *Pilgrimage* (1915–67) continued the psychological turn of avant-garde feminism—away from the suffrage concern with social and political rights and towards the self-realization of individual consciousness—into fiction. Yet Richardson firmly believed in the absolute difference of male and female consciousness, as she outlined in a review article, 'The Reality of Feminism', in 1917, contrasting the classificatory, formulaic tendency of the male mind with what she considered to be the integrated, synthetic quality of female consciousness. 'Men tend to fix life, to fix aspects,' she writes. 'They create metaphysical systems, religions, arts, and sciences. Woman is metaphysical, religious, an artist and scientist in life.'[66] Egoism, moreover, for Richardson, is a specifically *female* attribute. '[T]he essential characteristic of women is egoism,' she declared in a later essay, 'Woman and the Future', published in *Vogue* in 1924. She distinguishes this trait from 'male selfishness' and defines it instead as a woman's mode of existing 'all her life in the deep current of eternity, an individual, self-centered'.[67] In her attempt to portray the complete self-centredness in this manner of her autobiographical protagonist in *Pilgrimage*, Miriam Henderson, Richardson presents an internal consciousness that is at once individual, unique, *and* distinctively female; a metaphysical, feminist, and formal assertion of female egoistic individualism. In so doing, as we shall see, she pushes the issue of gender into the *textual*, or formal and stylistic, politics of modernism. Aiming to produce what she described as 'a feminine equivalent to the [then] current masculine realism', Richardson forged for her purpose a mode of writing which May Sinclair would later coin 'stream of consciousness', and Virginia Woolf would describe as 'the psychological sentence of the feminine gender'.[68]

[65] For further discussion of the gendered aspects of modernist egoism, see Jean-Michel Rabaté, *James Joyce and the Politics of Egoism* (Cambridge: Cambridge University Press, 2001), and 'Gender and Modernism: *The Freewoman* (1911–1912), *The New Freewoman* (1913) and *The Egoist* (1914–19)', in Peter Brooker and Andrew Thacker (eds), *The Oxford Critical and Cultural History of Modernist Magazines*, i: *Britain and Ireland 1880–1955* (Oxford: Oxford University Press, 209), 269–89.

[66] Dorothy Richardson, 'The Reality of Feminism', in Scott (ed.), *The Gender of Modernism*, 404.

[67] Dorothy Richardson, 'Woman and the Future', in Scott (ed.), *The Gender of Modernism*, 412, 413.

[68] May Sinclair, 'The Novels of Dorothy Richardson', in Scott (ed.), *The Gender of Modernism*, 442; Virginia Woolf, 'Romance and the Heart', in *A Woman's Essays*, ed. Rachel Bowlby (London: Penguin, 1992), 51.

FEMININE SENTENCES

The first decades of the twentieth century witnessed a vigorous and widespread debate over the gendered characteristics of writing. One of Virginia Woolf's first contributions for the *Times Literary Supplement* (*TLS*) was a review of W. L. Courtney's *The Feminine Note in Fiction* (1904). Hoping for a study that would explore the work of the woman writer and identify 'which of her characteristics are essentially feminine and why, and what is their significance', Woolf notes 'with disappointment, though not with surprise', that the author 'has done nothing of the kind'.[69] Is it 'not too soon after all to criticise the "feminine note" in anything?', she demands, and 'will not the adequate critic of women be a woman?'[70] In a later review, of R. Brimley Johnson's *The Woman Novelists* (1918), Woolf was willing to concede that perhaps a male critic *could* sometimes be an adequate commentator on women's writing, and that Johnson, avoiding the usual prejudices of one sex towards the other, had said some very interesting things about 'the peculiar qualities of the literature that is written by women'.[71] Woolf calls attention to the social and ideological conditions that influence those qualities, but ultimately seems to agree with Johnson's argument that the form and focus of women's fiction is distinct from that of men, noting the significance of 'the difference between the man's and the woman's view of what constitutes the importance of any subject', from which 'spring not only marked differences of plot and incident, but infinite differences in selection, method and style'.[72] The question of the *difference* of women's writing, whether that difference is inevitable or culturally imposed or formed, and whether it might be transcended in an ideal of genderless or androgynous writing, is one with which many of the women novelists and poets considered in this chapter struggled, and out of which they significantly shaped the modernist text.

The conviction that hitherto the relation of women and writing had largely been determined 'by conditions that have nothing whatever to do with art', and the consequent claim that 'a woman must have money and a room of her own if she is to write fiction', were two of the key arguments that Virginia Woolf impressed upon the audience of her lectures entitled 'Women and Fiction', delivered at Girton College, Cambridge, in 1928, and later developed into the longer *A Room of One's Own* (1929). 'I learned for the first time, and with surprise, that the problems of "a woman writer" were supposed to be different from the problems of a man who writes,' the poet Kathleen Raine recalled; 'that the problem is not one of writing but of living in such a way as to be able to write. *A Room of One's Own* made claims on life far beyond mine: a room and a small unearned income were, to me, luxuries

[69] Virginia Woolf, 'The Feminine Note in Fiction', in *Selected Essays*, ed. David Bradshaw (Oxford: Oxford University Press, 2008), 127.
[70] Ibid.
[71] Virginia Woolf, 'Women Novelists', in *Selected Essays*, 129.
[72] Ibid. 131.

unimaginable.'[73] While Raine highlights the material element of Woolf's argument, she overlooks the ideological and artistic subtleties of the latter's comments on the potential focus, technique, and values of modern women's writing. The preoccupation and challenge of *A Room of One's Own* was in fact very much to do with *the problem of writing*.[74] Woolf sees the room of one's own not as an end in itself, but rather as something of a metaphor for the blank page, of which the woman writer was finally in free possession, but was now faced with filling. Her concern was the emancipation of the female voice, a struggle far greater, she implied, than the achievement of votes for women. As she wrote in her essay 'Professions for Women', the new freedoms afforded by the room of one's own were only a beginning. '[T]he room is your own but it is still bare,' she warned:

It has to be furnished; it has to be decorated; it has to be shared. How are you going to furnish it, how are you going to decorate it? With whom are you going to share it, and upon what terms? These, I think, are questions of the utmost importance and interest. For the first time in history you are able to ask them; for the first time you are able to decide for yourselves what the answers should be.[75]

Woolf herself had struggled with these questions for over a decade. In an early essay, 'Men and Women', published in the *TLS* in 1920, she had commented that although 'the woman of the middle class has now some leisure, some education, and some liberty to investigate the world in which she lives, it will not be in this generation or in the next that she will have adjusted her position or given a clear account of her powers'.[76] Women may have gained equality with men on certain social and political terms, but the pervasive influence of established gendered ideology remained. Quoting the words of Bathsheba Everdene in Thomas Hardy's *Far From the Madding Crowd*—'I have the feelings of a woman, but I have only the language of men'— Woolf observed: 'From that dilemma arise infinite confusions and complications. Energy has been liberated, but into what forms is it to flow? To try the accepted forms, to discard the unfit, to create others which are more fitting, is a task that must be accomplished before there is freedom or achievement.'[77]

Richard Johnson's new book of the same year, *Some Contemporary Novelists*, argued that there was indeed an identifiable new character to women's writing, in focus, method, and style. 'The new woman, the feminine novelist of the twentieth century, has abandoned the old realism,' Johnson argued, her aim being instead 'to photograph (though as an artist) the soul: to express thought and feeling in words. Whence arise a new form of construction, and almost a new style.'[78] Johnson's

[73] Kathleen Raine, 'Virginia Woolf at Girton', in John Henry Stape (ed.), *Virginia Woolf: Interviews and Recollections* (Iowa City: University of Iowa Press, 1995), 16.

[74] Woolf, *A Room of One's Own*, 4.

[75] Virginia Woolf, 'Professions for Women', in *Selected Essays*, 144.

[76] Virginia Woolf, 'Men and Women', in *A Woman's Essays*, 20.

[77] Ibid.

[78] R. Brimley Johnson, *Some Contemporary Novelists: Women* (London: Leonard Parsons, 1920), pp. xiv, xvii. Johnson devoted chapters to fourteen writers: May Sinclair, Eleanor Mordaunt, Rose Macaulay, Sheila Kaye-Smith, Ethel Sidgwick, Amber Reeves, Viola Meynell, Dorothy Richardson, Virginia Woolf, Stella Benson, E. M. Delafield, Clemence Dane, Mary Fulton, and Hope Mirrlees.

argument was drawn predominantly from the example of Richardson, the 'most extreme and consistent in her determination towards individuality' and in style and method 'the most original of all our novelists', yet his analysis was prescient. Moreover, in his suggestion that the modern woman writer, in her search for 'that Reality which is behind the material, the things that matter, spiritual things . . . finds man an outsider, wilfully blind, purposefully indifferent', and his recognition that her protagonists, being 'comparatively indifferent to actual things and events, tend to egoism', he articulated not only a new literary form of feminine realism, but also at its heart a specifically female egoism.[79] Richardson's *Pilgrimage* series was the paradigmatic example. Five books had by this time appeared—*Pointed Roofs* (1915), *Backwater* (1916), *Honeycomb* (1917), *The Tunnel* (1919), and *Interim* (serialized in the *Little Review* 1919–20)—through which Richardson's readers had followed Miriam Henderson as she embarked upon an independent if impoverished life as a student teacher, a governess, and finally a dental secretary in London, experiencing the trauma along the way of family bankruptcy and her mother's suicide. Yet the plot of the novels was ultimately incidental to its method, in which all of the narrative is focused entirely within Miriam's perceiving consciousness. 'The material that moved me to write would not fit the framework of any novel I had experienced,' Richardson later said of her development of this new style. 'Monstrously, when I began, I felt only that all masculine novels to date, despite their various fascinations, were somehow irrelevant, & the feminine ones far too much influenced by masculine traditions.'[80] What she set out to do in *Pilgrimage*, she declared in her retrospective 'Foreword' to the collected edition of the novel in 1938, was to write a novel that would present 'a feminine equivalent of the current masculine realism'.[81]

One of the few early reviewers to recognize what Richardson was attempting to do in *Pilgrimage* was May Sinclair, in her essay 'The Novels of Dorothy Richardson', published in *The Egoist* in 1918. Noting the perplexity with which readers responded to a novel in which we are given little idea of the protagonist's appearance, age, or background until at least a quarter of the way in, Sinclair explained that Richardson had evolved an extreme version of free indirect narrative technique in which

she must not interfere; she must not analyse or comment or explain. . . . she must not tell a story or handle a situation or set a scene; she must avoid drama as she avoids narration. . . . She must not be the wise, all-knowing author. She must be Miriam Henderson. She must not know or divine anything that Miriam does not know or divine; she must not see anything that Miriam does not know or see.[82]

It was this positioning of the narrative entirely and unceasingly within the 'first hand, intimate and intense reality' of Miriam's mind, Sinclair argued, in identifying herself completely with 'Miriam's stream of consciousness', that Richardson 'produces her

[79] Johnson, *Some Contemporary Novelists: Women*, pp. xxiii, 133, xv, xix.
[80] Dorothy Richardson, *Journey to Paradise: Short Stories and Autobiographical Sketches*, ed. Trudi Tate (London: Virago, 1989), 139.
[81] Dorothy Richardson, 'Foreword', in *Pilgrimage*, 4 vols (London: Virago, 1979), i. 9.
[82] May Sinclair, 'The Novels of Dorothy Richardson', in Scott (ed.), *The Gender of Modernism*, 443.

effect ... of getting closer to reality than any of our novelists who are trying so desperately to get close'.[83] Yet it also accounted for the lack of external information given to the reader; Miriam is not going to describe her surroundings or explain the context of her actions *to herself.* Virginia Woolf, for example, agreeing with Sinclair in her review of *The Tunnel* the following year that 'Miss Richardson gets so far as to achieve a sense of reality far greater than that produced by the ordinary means,' similarly observed that

The reader is not provided with a story; he is invited to embed himself in Miriam Henderson's consciousness, to register one after another, and one on top of another, words, cries, shouts, notes of a violin, fragments of lectures, to follow these impressions as they flicker through Miriam's mind, waking incongruously other thoughts, and plaiting incessantly the many-coloured and innumerable threads of life.[84]

As Richardson stated in 1923, 'Information there must be, but the moment it's given directly as information, the sense of immediate experience is gone.'[85]

One of the problems that arises out of early comments on such 'feminine realism' or 'feminine impressionism', however, is quite what it is that genders this writing as distinctively female. Richardson writes in typically long sentences, often with little punctuation, or broken only by ellipses to register changes in stimuli or a shift in thought. But while this perhaps provides a realistic illusion of the workings of consciousness, what registers it as gendered? It is a question Woolf overtly raised in her review of Richardson's *Revolving Lights* in 1923. Stating that Richardson 'has invented, or, if she has not invented, developed and applied to her own uses, a sentence which we might call the psychological sentence of the feminine gender', she defines this sentence as

of a more elastic fibre than the old, capable of stretching to the extreme, of suspending the frailest particles, of enveloping the vaguest shapes. Other writers of the opposite sex have used sentences of this description and stretched them to the extreme. But there is a difference. Miss Richardson has fashioned her sentence consciously, in order that it may descend to the depths and investigate the crannies of Miriam Henderson's consciousness. It is a woman's sentence, but only in the sense that it is used to describe a woman's mind by a writer who is neither proud nor afraid of anything that she may discover in the psychology of her own sex.[86]

This is a long and loaded passage, in which Woolf reflects upon the concept of a style and form of literary expression specific to women with critical nuance but also considerable ambiguity. At first she proposes to identify a literary form or style that is indeed *itself* gendered—the 'psychological sentence of the feminine gender'— and possesses certain characteristics that define it as so, presumably by contrast with a set of more conventional novelistic strategies that are deemed 'masculine'. This

[83] Ibid. 446, 444.
[84] Virginia Woolf, 'The Tunnel', in *A Woman's Essays*, 16.
[85] Dorothy Richardson, *Windows on Modernism: Selected Letters of Dorothy Richardson*, ed. Gloria Glikin Fromm (Athens: University of Georgia Press, 1995), 68.
[86] Woolf, 'Romance and the Heart', 51.

form is not exclusive to the woman writer, however, and Woolf notes that several male writers have written sentences of just this kind. Here she almost certainly has James Joyce's *Ulysses* (1922) in mind, in which the closing 'stream of consciousness' of Molly Bloom runs to 'the extreme' of 24,000 words in eight barely punctuated sentences. Nor does it always seem to have to represent the female consciousness, as she goes on to distinguish Richardson's 'feminine sentence' from those of male writers because it *does* concentrate on a woman's mind. By the 'psychological sentence of the feminine gender', then, Woolf does seem to mean, more generally, the formal method of focusing narrative through a character's 'stream of consciousness'. Yet she also clearly wishes to distinguish this from something else, which she describes as 'a woman's sentence', and which seemingly *is* focused on 'a woman's mind' and written by a woman writer, with the intention of presenting female psychology as truthfully and realistically as possible.

The question remains, however, where does this leave Molly Bloom's narrative at the end of *Ulysses*, in which Joyce certainly fashions a sentence intended to descend to the depths and crannies of a woman's mind? For all the formal characteristics of the 'feminine sentence', Molly Bloom and Miriam Henderson are profoundly dissimilar as examples of female streams of consciousness; the former instinctive and physical, the latter self-conscious and hypersensitive. The 'Penelope' section of *Ulysses* is offered as the narrative of archetypal, eternal 'Woman', identified with nature and the earth. In writing Molly's narrative, Joyce was recycling, albeit also exposing and satirizing, normative cultural constructions of womanliness and female consciousness. Miriam is supremely individualist, Richardson's primary objective the faithful representation of her individual female consciousness. It is also worth remembering Richardson's belief in the absolute distinction of the male and female consciousness; the former systematic, the latter synthetic, the former focused on *doing*, the latter on *being*. As Woolf had quoted in her review of *The Tunnel*, Miriam Henderson complains forcefully that 'if books were written like that, sitting down and doing it cleverly, and knowing just what you were doing, and just how someone else had done it, there was something wrong, some *mannish* cleverness that was only half right. To write books knowing all about style would be to become like a man.'[87] Miriam is thinking of Henry James's free indirect method in *The Ambassadors* (1903) in this passage, but Richardson writing in 1931 might also have had Joyce in mind, both being writers whose psychological method she admired, but whose blatant delight in their own technical ability was for Richardson typically 'male'. In one of the many self-reflexive references to *Ulysses* in *Finnegans Wake*, Joyce reminds the reader that Molly's monologue is the work of a male hand, 'the penelopean patience of its last paraphe', with its representation of the 'vaulting feminine libido of those interbranching ogham sex upandinsweeps sternly controlled and easily repersuaded by the uniform matteroffactness of a meandering male fist'.[88] Richardson quoted exactly this 'meandering male fist' when she reviewed *Finnegans Wake* in 1939, noting the

[87] Richardson, *Pilgrimage*, ii. 131.
[88] James Joyce, *Finnegans Wake*, ed. John Bishop (London: Penguin, 1999), 123.

skill of Joyce's 'long, lyrically wailing, feminine monologue', but writing that Joyce's prose would always remain 'a signed self-portrait', bearing 'its author's [male] signature not only across each sentence, but upon almost every word'.[89]

In contrast to novelists such as Woolf, Richardson, and Sinclair, who forcefully asserted the possibilities of a female, feminine, or woman's prose, modernist female poets, among them H.D., Edith Sitwell, and Gertrude Stein, made a conscious effort to separate themselves from definitions of 'feminine' poetry, even as they strove to develop verse on their own terms as female poets. Unlike in the novel, where there is no feminine suffix to distinguish the female from the male novelist, the gendered marker of the noun 'poetess' had long served to judge women's poetry according to conventional feminine qualities. Indeed, in the same year as Richard Brimley Johnson was enthusiastically identifying the 'new realism' of modern women's writing, an article in the *TLS* entitled 'The Poetry of Women' was bemoaning the negative consequences of female emancipation and egoistic feminism on the genre of the novel, declaring that 'The ideal of self-expression, which has supplanted self-sacrifice as the aim of the modern woman, has probably brought with it as many abuses as it has banished.'[90] It is with transparent relief that the author reflects upon the inviolability of poetic form, which he deems safe from such insidious influence, commenting that 'though we allow the novel to be abused in the interests of sex propaganda, lyrical poetry, by the very strict limits of its constitution, will permit no such transgression'.[91] This was not to suggest that women should not write poetry. Indeed the essay, a review of three contemporary female poets, went on to commend the 'delicate echoing of nature's lyrical moments' by which he deemed 'these writers obtain their happiest effects', commenting with patronizing enthusiasm that 'Woman accepts the language of children and birds and trees, because she is of nature's household.'[92] When the Georgian poetry impresario J. C. Squire filled his 1921 *Anthology of Women's Verse* with just this sort of women's lyric poetry, it drew from Rebecca West the urgent command that 'feminist societies should buy up all copies of this book and suppress them'.[93]

A more positive review of Squire's anthology in the *TLS* expressed widespread critical opinion in its comment that 'sincere women's poetry will have the warmth, the wholeness, the grace, the allurement, the tenderness, or the mockery of the feminine mind'.[94] One female poet who made little claim to grace, allurement, or tenderness, but certainly possessed a strong taste for sharp-tongued mockery, was Edith Sitwell. The gendered aspects of Sitwell's avant-gardism received almost no recognition in her lifetime, and earned little more from late twentieth-century

[89] Dorothy Richardson, 'Adventure for Readers', in Scott (ed.), *The Gender of Modernism*, 429, 426.
[90] 'The Poetry of Women', *Times Literary Supplement*, 9 Dec. 1920, 810. For a full account of gender and the feminine in Anglo-American modern poetry, see Jane Dowson, *Women, Modernism and British Poetry, 1910–1939: Resisting Femininity* (Aldershot: Ashgate, 2002).
[91] 'The Poetry of Women'. [92] Ibid.
[93] Rebecca West, 'Women Poets', *The Bookman* (May 1921), 92–3.
[94] 'Poetesses', *Times Literary Supplement*, 24 Nov. 1921, 267.

feminist modernist studies. The tendency to group her together with her brothers Osbert and Sacheverell in the triumvirate of 'Sitwellism' has obscured the professional links and committed friendships that she held with other women, and her own early attempts at writing a new female poetry. 'Damn them,—oh damn them!', she cried in exasperation, when her collection *Clowns' Houses* (1918) was criticized in a review in the *New Statesman* for its 'trivial' subject matter: 'They grumble because they say women will try to write like men and can't—then if a woman tries to invent a female poetry, and uses every feminine characteristic for the making of it, she is called trivial. It has made me furious, not because it is myself, but because it is unjust.'[95] What Sitwell highlights here is the gendered double standard of critical rhetoric that at once defines and denigrates women's poetry on the basis of standards of polite femininity rather than art. At the same time she did not believe that women could or should write like men. 'Women poets will do best if they realise that male technique is not for them,' she wrote in 'Some Observations on Women's Poetry' for *Vogue* in 1925; and in an essay for the Anglo-French avant-garde journal *Échanges* in 1930, she complained of 'the present harmful mania for uniformity—in an age when women try to abolish the difference between their aspects and aims and those of men'.[96] Much of Sitwell's own subsequent poetry, like her cultivated public image, would develop a carefully impersonal, rhythmic experimental technique, although she continued to comment frequently and forcefully on the problem of gender and gendered form in poetry. 'Women's poetry', she summarized to the critic Maurice Bowra in 1944:

is simply awful—incompetent, floppy, whining, arch, trivial, self-pitying,—and any woman learning to write, if she is going to be any good at all, would, until she had made a technique for herself (and one has to forge it for oneself, there is no help to be got) write in as hard and glittering a manner as possible, and with as strange images as possible—strange, but believed in. Anything to avoid the ghastly wallowing.[97]

Seeking to distinguish herself from the nineteenth-century lady poetess, the modern female poet, Sitwell implied, had no more of a female literary tradition to support her than the female novelist. Instead of a positive reworking of feminine subjectivism, however, of the kind that Richardson pursued in the novel, Sitwell advocated a style of poetry for women that was impersonal, anti-sentimental, and largely androgynous.

It is with the possibility of an androgynous creative mind that would transcend the boundaries of sexual and gender difference that I close this essay. If the gendered sentence exists, might it also be possible to conceive of a non-gendered sentence?

[95] Edith Sitwell, letter to Robert Nichols, 26 Dec. 1918, Harry Ransom Center, Austin, Texas, Edith Sitwell Archive.
[96] Edith Sitwell, 'Some Observations on Women's Poetry', *Vogue* (Mar. 1925), quoted in *Edith Sitwell: Fire of the Mind*, ed. Elizabeth Salter and Allanah Harper (London: Michael Joseph, 1976), 189; Edith Sitwell, 'Modernist Poets', *Echanges*, 2 (1930), 80.
[97] Edith Sitwell, letter to Maurice Bowra, 24 Jan. 1944, Harry Ransom Center, Austin, Texas, Edith Sitwell Archive.

Might the ideal creative mind be androgynous, a mind through which both men and women could write without the burdening consciousness of their sex? These are the questions that Woolf poses at the close of her discussion of women and fiction in *A Room of One's Own*. 'Perhaps a mind that is purely masculine cannot create, any more than a mind that is purely feminine,' she posits. 'It is fatal to be a man or woman pure and simple; one must be woman-manly or man-womanly....Some collaboration has to take place between the woman and the man before the art of creation can be accomplished.'[98] Woolf's concept of the androgynous literary mind, while celebrated as an imaginative resistance of social and linguistic gender oppositions by some feminist critics, has troubled others who construe it as a strategy for evading her social and historical identity and experience as a real woman, escaping instead into the detachment of an impersonal aestheticism.[99] For these readers, her statement that 'It is fatal for a woman to lay the least stress on any grievance; to plead even with justice any cause; in any way to speak consciously as a woman,' is a refusal of solidarity with the very tradition of women's writing that she claims to promote.[100] Woolf argued that a writer should avoid intentionally thinking of their sex when they wrote, but this was not to say that their writing would not *reveal* their sex. For Woolf, it is exactly when a woman writer is not preoccupied with the limits or effects of her gender that she will write most naturally her own female prose, and that her text, in effect, is truly gendered. Yet this aim, she makes clear throughout her reflections on the gender of writing, was for the modern woman author an ongoing project. Speaking *as a woman*, she told the audience of her lecture 'Professions for Women' in 1931, 'telling the truth about my own experiences as a body' was something she did not think she or any other writer had yet achieved.[101]

[98] Woolf, *A Room of One's Own*, 128.
[99] See Carolyn Heilbrun, *Towards a Recognition of Androgyny* (New York: Knopf, 1973); Toril Moi, *Sexual/Textual Politics: Feminist Literary Theory* (London: Methuen, 1985); and Elaine Showalter, *A Literature of Their Own: British Women Novelists from Brontë to Lessing* (London: Virago, 1977).
[100] Woolf, *A Room of One's Own*, 136.
[101] Woolf, 'Professions for Women', in *Selected Essays*, 144.

C H A P T E R 1 0

..

CLASS POSITIONS

..

ANDRZEJ GĄSIOREK

In an essay written in early 1914, Ezra Pound asserted that the 'artist has at last been aroused to the fact that the war between him and the world is a war without truce' and that 'his only remedy is slaughter'. Vituperating against existing social conditions, he announced that artists were 'about to take control' and informed the public that it would 'do well to resent these "new" kinds of art', not least because the avant-garde artist 'has no intention of trying to rule by general franchise'.[1] In May 1918, seven months after the October Revolution, Alexandr Rodchenko addressed a manifesto to all 'who have come to life, to all living humankind', urging them to demolish 'everything outmoded, everything that's in the way, everything dying, everything superfluous, everything enslaving, everything oppressing us'.[2] Pound and Rodchenko desired radical change, but whereas Pound saw modern artists as vanguard figures whose hostility to a moribund social system pitted them against any possible audience (apart from fellow artists) they might have, Rodchenko saw modern artists as integral to an organized struggle against injustice. For Rodchenko, art needed to appeal to the people for whom it was made and to encourage them to become creative. This entailed a *fusion* of art and life: 'LIFE, a conscious and organized life, capable of SEEING and CONSTRUCTING, is contemporary art. A PERSON who organizes his life, work, and himself is a CONTEMPORARY ARTIST.'[3]

Pound's and Rodchenko's views tell us a lot about the possible positions that could be adopted by modernists vis-à-vis the question of art's function in the modern world. These included defences of artists' superiority to society and justifications of

[1] Ezra Pound, 'The New Sculpture', *The Egoist*, 4/1 (16 Feb. 1914), 68.
[2] Alexander Rodchenko, *Experiments for the Future: Diaries, Essays, Letters, and Other Writings*, ed. Alexander N. Lavrentiev, trans. Jamey Gambrell (New York: Museum of Modern Art, 2005), 82.
[3] Ibid. 142.

the value-conferring power of their work, arguments in favour of art's isolation from politics on the grounds that it depended on its freedom from non-aesthetic concerns, and counter-claims to the effect that only by means of a radically new art could a decadent social order be redeemed. Within these perspectives there nestled a number of further distinctions and disagreements. To take just one example, among those who viewed modern art as offering hope for social change one finds artists who sought answers in various religions, socio-economic theories, political programmes, and philosophical systems. Every one of these currents of thought, in turn, had a complex, overdetermined aetiology; modernists were influenced by intersecting— and at times mutually incompatible—intellectual traditions. We should also note that the different attitudes to the role of the artist revealed by Pound and Rodchenko highlight the importance of the historical and institutional conditions within which such attitudes were forged. An artist's or writer's characteristic pattern of thinking may not be determined in any simple sense by their milieu, but the conditions under which they develop, create, share, promote, and sell their work play a major part in establishing how their thinking is publicly articulated. The differences between Pound and Rodchenko are matters of personal conviction but also indicators of the artistic and institutional possibilities available to them.

Social and cultural conditions in the first four decades of the twentieth century varied from country to country, from city to city, and from decade to decade. Any account of modernism's relationship to issues of class must emphasize this from the outset if it hopes to comment on the diverse range of work produced by modernists working in, say, the Soviet Union, Weimar Germany, France, and England, the countries to be discussed in this chapter.

MODERNISM IN ENGLAND BEFORE THE FIRST WORLD WAR

In England, the period just before the First World War witnessed the emergence of writers who were seeking to break new literary ground, such as T. E. Hulme, D. H. Lawrence, Wyndham Lewis, and Ezra Pound. These were the years of the Poets' Club and the subsequent development of Imagism; the Post-Impressionist exhibition of 1910; the rejection of realist styles of writing; the establishment of cultural journals and 'little magazines' such as the *New Age*, the *English Review*, the *New Freewoman* (which became *The Egoist*), *Rhythm*, and the *Blue Review*; and the galvanizing visits of the Italian Futurist F. T. Marinetti, which were to influence an avant-garde that was coalescing around Lewis and that would culminate in Vorticism.

It has been suggested that this modernist ferment was motivated by fears about the impact on culture and society of the increasingly literate lower-middle and working

classes. Modernists, it is argued, were anxious about the encroachments of these classes onto the preserve of 'high' art and were hostile to the 'mass' culture associated with them. The popular novelist J. B. Priestley observed that for modernists contemplating these social changes it appeared that 'real literature . . . could only be found to exist on the outer and advancing edge'; he considered that this attitude resulted in a defensive response to the sense of menace modernists felt in the face of 'mass communications, mass writing and reading, mass standards, mass values'.[4] Other critics have claimed that modernism set out to *exclude* the lower-middle and working classes from 'high' culture by producing art that was inaccessible.[5] Such claims are vulnerable to several objections: they are selective in their choice of examples and ignore the counter-evidence; they fail to see the ways in which disparate writers, groups, and movements were interwoven, despite the disagreements that also divided them on various questions; they rely on an untenable opposition between 'art' and 'commerce', and thereby treat a complex cultural field as a homogeneous entity.[6]

Anglo-American modernists were guilty of appalling snobberies. They were anxious about what they saw as an ongoing process of cultural fragmentation, the levelling down of standards that they associated with the spread of democracy, the negative effects of 'mass' reading habits, and the evacuation of subjectivity threatened by modernity's rationalizing logics. But in the years just before the First World War there was a sense among many modernists that radical social change was possible and that the new arts could play a role in helping to bring it about. Much of the rhetoric directed by figures like Pound against a supposedly ignorant public was aimed less at the lower-middle and working classes than at the bourgeois and upper-class adherents of 'culture', whose fixed ideas about the arts threatened to hold back modernism's innovations. Other writers followed the line of thought—which ran from Gautier and Baudelaire through to the Aesthetes and Decadents—that resisted the bourgeois preoccupation with morality. Joyce's 'The Day of the Rabblement' (1901) lambasted 'the rabblement, placid and intensely moral', who thought of themselves as 'the trustees of every intellectual and poetic treasure'.[7] Such sentiments were widely shared. The desire to shatter the cultural power of the bourgeoisie, which would later become a cliché, was at the time seen as the needful first step to artistic renovation.

Ideas about the form that renovation might take varied widely. Orage promoted Guild Socialism in the *New Age*; Ford and Marwood defended a national minimum wage in the *English Review*; Huntly Carter and Dora Marsden called for the spirit of 'Soul' to counter the sterility of the intellect in the *New Freewoman*; Rebecca West

[4] J. B. Priestley, *Literature and Western Man* (Harmondsworth: Penguin, 1969), 325, 337.

[5] See John Carey, *The Intellectuals and the Masses: Pride and Prejudice Among the Literary Intelligentsia, 1880–1939* (London: Faber and Faber, 1992), chs 1, 2, and Jonathan Rose, *The Intellectual Life of the British Working Classes* (New Haven: Yale University Press, 2001), chs 12, 13.

[6] See Peter Keating, *The Haunted Study: A Social History of the English Novel, 1875–1914* (London: Fontana, 1991), and Peter D. McDonald, *British Literary Culture and Publishing Practice, 1880–1914* (Cambridge: Cambridge University Press, 1997).

[7] James Joyce, *The Critical Writings*, ed. Ellsworth Mason and Richard Ellmann (New York: Viking Press, 1968), 70.

wrote articles about women's suffrage in the *New Freewoman* and the socialist *Clarion*; Stirnerite and Nietzschean ideas about individualism were influential in the pages of *The Egoist*; Hulme elaborated a 'tory philosophy' that drew on anarchist thought, Sorelian syndicalism, and the Action Française; Lawrence articulated an 'organic' critique of industrialization; Lewis and Pound rejected painterly academicism and poetic verbosity in *Blast*, a multivalent text that refused reified class positions in favour of an appeal to the artistic instincts of all. Few of those mentioned here were socialists (Orage and West are the exceptions), but all were driven by the belief that British society needed to be transformed, and various not always compatible strains of thought—egoist, anarchist, syndicalist, spiritualist, Theosophical, nihilist—intersected in and across their respective writings and paintings.

This was a period characterized by manifestos, debates, and squabbles, all of which were fundamental to modernists' need to define their positions and to differentiate them from those of rivals. These positions were before the war commonly (though not always) couched in *aesthetic* rather than *political* terms. That is to say, the new arts were seen as heralding change; if they could but gain a foothold in cultural life they would inaugurate a thoroughgoing *Umwertung der Werte*. But other voices, typically those of an older generation, were more pessimistic. H. G. Wells was in *Tono-Bungay* (1909) obsessed with images of decrepitude, figuring the nation as a decaying body slowly being eaten up by cancerous growths. In such novels as *The Secret Agent* (1907) and *Under Western Eyes* (1911), Joseph Conrad produced an ironic account of anarchists and revolutionaries. Conrad's work offered a bleak indictment not just of revolutionary thought and action but also of a social system predicated on the illusory stability of a meaningless legal code. The naturalist nightmare that is *The Secret Agent* takes much of its tone from Ford's *The Soul of London* (1905), which saw the capital in terms of an internecine but indecipherable class struggle. And despite Conrad's dismissal of the anarchists as criminals whose actions could not stand up to scrutiny, the novel not only disclosed the potency of the anarchists' belief that a 'cannibalistic' economy was feeding 'on the quivering flesh and the warm blood of the people' but also showed that their contempt for 'the great edifice of legal conceptions sheltering the atrocious injustice of society' was perfectly comprehensible.[8]

Ford's 'toryism' was different from Conrad's reactionary politics, inflected as it was by the radicalist antecedents he derived from Pre-Raphaelitism and the Young England movement, which led him to emphasize the parallels between toryism and socialism. In *The Good Soldier* (1915), Ford exposed the psychological implications of the sham society anatomized by Wells in *Tono-Bungay*. The difficulty of seeing through apparently convincing social appearances is a key preoccupation of *The Good Soldier*; it peels away the landed gentry's protective camouflage in order to suggest that the Ashburnhams are 'screaming hysterics' whose seemingly perfect lives mask intolerable private pain. The novel's exposure of the repression required to maintain the image of perfection is part of its wider anxiety about social standardization and the extirpation of

[8] Joseph Conrad, *The Secret Agent: A Simple Tale* (Harmondsworth: Penguin, 1975), 50, 72–3.

individualism. If the Ashburnhams are a sham, then the Bayhams, who supersede them, represent a deadening normality that imposes uniformity on society, while those individuals who might conceivably be able to reinvigorate it are crushed. *The Good Soldier* suggests that the landed gentry are incapable of resisting the rise of the middle classes. Although it sees through the too perfect appearances of the upper classes, it is nonetheless deeply hostile to the creeping embourgeoisement it identifies as a prevalent feature of modern life.

The most impassioned attempt to shatter existing conceptions of social life occurs in Lawrence's work. The social standardization feared in *The Good Soldier* is in such novels as *The Rainbow* (1915) and *Women in Love* (1920) seen in terms of systemic industrial–technological mechanization. In a dark vision of complete automation, individuals exist merely to serve as interchangeable workers and, in a chilling touch, come to accept and even to desire their subjugation. Ford had already been concerned with modernity's drive to rationalize in *The Soul of London*, though he was mainly concerned with its consequences for subjectivity and the public sphere; suggesting that social reformers were principally concerned with gains in efficiency, he argued that this 'inevitably' damaged 'our human consciousness' and 'our civic interests'.[9] Lawrence's obsession with this issue focused on the first of these concerns: it wasn't threats to the public sphere that troubled him, but the danger to individual identity. In *The Rainbow*, Ursula Brangwen's response to the coal-mine, 'the great machine which has taken us all captives', makes Lawrence's point: 'If she could destroy the colliery, and make all the men of Wiggiston out of work, she would do it. Let them starve and grub in the earth for roots, rather than serve such a Moloch as this.'[10]

This deeply felt rage against materialism and mechanization led Lawrence to espouse ideals that sought to fuse external social change with an internal transformation of the self. These ideals manifested themselves most clearly in his abortive attempts to link up with Bertrand Russell in the first year of the First World War; the two men were to preach a supposedly shared social philosophy that quickly revealed itself to be the source of major existential and political disagreements. Lawrence's initial thinking at this time was religious in its basic assumptions, but he soon began to distance himself from his earlier spiritual language and to argue in favour of an elected aristocracy, which would allow working men limited control over their immediate environment (but not over the state), but would displace women from public life, leaving them in charge of domestic matters.[11] Mistrust of the lower classes, coupled with a biological view of sexual relations, were key features of Lawrence's thought from *The Rainbow* onwards. Lawrence tended to divide people into two classes, a natural 'aristocracy' and a plebeian 'mass', and his politics were resolutely individualist. He consistently emphasized the importance of an inward realization of the self through which 'each man' would grasp 'that he must single

[9] Ford Madox Ford, *The Soul of London* (London: Alston Rivers, 1905), 96.
[10] D. H. Lawrence, *The Rainbow* (Harmondsworth: Penguin, 1979), 350.
[11] For differences between Lawrence and Russell, see Ray Monk, *Bertrand Russell: The Spirit of Solitude* (London: Vintage, 1997), 403–30.

himself out, nor remain any longer embedded in the matrix of his nation, or community, or class'.[12]

Similar ideas about the political need for a natural aristocracy are discernible in T. E. Hulme's pre-war writing. Hulme's attitudes to class are interesting; his thinking drew on numerous intellectual traditions and underwent many changes, and these aspects of his thought disclose early modernism's evolving, labile nature. Hulme is best known for his Imagism, his 'classicism', his toryism, and his anti-humanism. But he was a voracious reader who drew at different moments in his short life on figures as diverse as Riegl, Worringer, Bergson, Sorel, Lasserre, and Proudhon. His thinking underwent a number of changes and is hard to categorize. During his 'tory' and 'classicist' phase he believed in an 'absolutely fixed' human nature, and he mocked reformist schemes which hoped to transform that nature.[13] If Hulme's assaults on socialist 'romanticism' seem to caricature the positions he is attacking, consider these Bergson-inflected words of Orage's: 'The world for the Socialist is an everlasting becoming, a perpetual process of generation and regeneration, a continual mounting of life up the ladder of becoming. Hence it follows that the Socialist has illimitable vistas for the future of man.'[14] Sentiments of this kind incensed Hulme, but during the First World War his interest in anarchism complicated his toryism. He argued that 'the right theory of society is to be found in Proudhon, and *not* in the *reactionaries*' and that this theory would result in 'a different conception of democracy', a line of thinking that was also developed by Lewis in the post-war period. In his late writings Hulme aligned Proudhon with Sorel in order to connect the classical spirit with class struggle: 'No theory that is not fully moved by the conception of justice asserting the equality of men, and which cannot offer something to all men, deserves or is likely to have any future.'[15]

After the war the energy and hope visible in the ferment of ideas and writings and artistic productions of the pre-war years seemed to have come to nothing, although this wasn't always immediately apparent. Lewis, for example, was initially optimistic that the Vorticist project could be continued (see the important pamphlet *The Caliph's Design*, 1919), while Joyce thought that the war had not significantly affected his work. But other writers, such as Ford and Lawrence, were badly affected by the war. There were also troubling connections between pre-war rhetoric and the reality of armed conflict, a historical irony with which Lewis would be much preoccupied in the 1920s. Pound concluded in *Hugh Selwyn Mauberley* (1920) that European civilization had proved to be a 'botched' affair. But elsewhere, for example in the Soviet Union, in Germany, and—among the Surrealists, especially—in France, different responses to war and revolution manifested themselves, and it is to these that I now turn.

[12] D. H. Lawrence, *Study of Thomas Hardy and Other Essays*, ed. Bruce Steele (Cambridge: Cambridge University Press, 2002), 39.

[13] T. E. Hulme, *The Collected Writings of T. E. Hulme*, ed. Karen Csengeri (Oxford: Clarendon Press, 1994), 240–1.

[14] A. R. Orage, 'Towards Socialism', *New Age*, 3 (1907), 361.

[15] Hulme, *Collected Writings*, 365, 409, 251.

EXPERIMENTS FOR THE FUTURE: THE
EARLY YEARS OF THE SOVIET UNION

A 1922 *Veshch* editorial by El Lissitzky and Ilya Ehrenburg spoke of 'seven years of separate existence' in Russia and western Europe. This questionable claim ignored various interactions between Russian and European artists, writers, film-makers, dramatists, and theatre directors before the Russian Revolution of 1917, but it revealed a sense of isolation, which was doubtless exacerbated by the Russian avant-garde's awareness that in 1918 various western states had sided with the White faction during the civil war (1917–23).[16] During this turbulent period, when the political outcome of the 1917 Revolution was uncertain, many Futurists—most famously, Vladimir Mayakovsky—chose to serve the revolutionary cause through their art. But the most significant contribution was made by the Constructivists, who sought to transform the entire basis, function, and dissemination of art through a modernized aesthetic practice orientated towards the renewal of everyday existence.

There were differences of opinion over how best to support working-class interests and over the role that art should play in the communist state. Among the movements that emerged after 1917, Kuznitsa (the Smithy), Futurism, Proletkult, the Serapion Brothers, and Constructivism were among the most important. These groups have often been seen as rivals, but, as in pre-war Britain, there were various personal and professional connections between them.[17] As Commissar of Enlightenment in the years 1917–29, Anatoly Lunacharsky developed the idea of a Proletkult, for which the major theorist was Alexander Bogdanov. Proletkult aimed to forge a proletarian culture, though there was little agreement over what this meant. Some argued that this new art could only emerge from established bourgeois traditions, which would be developed by the proletariat, whereas more radically minded intellectuals rejected the past altogether.[18] In addition, most of those who were associated with Proletkult were hostile to Futurism's anarchic spirit, its individualism, and its incomprehensibility to the working classes.[19]

These debates were never just theoretical matters. They had real consequences, given the power of state-led cultural policy, as Proletkult discovered when it was labelled 'petit-bourgeois' by *Pravda* in 1920, and as other avant-gardists would also learn with the hardening of Soviet ideology from the late 1920s onwards. Mayakovsky is a case in point. In 1918 he declared: 'There is no such thing as a supraclass art. The new art is being created by the proletariat, and only we, the Futurists, are in

[16] El Lissitzky and Ilya Ehrenburg, 'The Blockade of Russia Is Coming to an End' (1922), in Stephen Bann (ed.), *The Tradition of Constructivism* (New York: Da Capo, 1974), 53–7.

[17] See Susan Compton, *Russian Avant-Garde Books, 1917–34* (London: British Library, 1992), 45–9.

[18] See Lynn Mally, *Culture of the Future: The Proletkult Movement in Revolutionary Russia* (Berkeley: University of California Press, 1992), pp. xvi–xvii, and Edward J. Brown, *The Proletarian Episode in Russian Literature 1928–1932* (New York: Columbia University Press, 1953), 6–10.

[19] See Mally, *Culture of the Future*, 144–6.

step with it.'[20] This was an attempt to align Futurism with the working class and to trump other movements. Mayakovsky created a distinctive personal voice, which combined great linguistic originality with a positive regard for popular culture. Much of his writing was propagandistic, though he aimed at a style that could simultaneously express political longing and imagine the conditions in which it might be realized, as in poems like 'Order No. 2 to the Army of the Arts' (1921), which ends:

> Comrades,
> give us a new form of art—
> an art
> that will pull the republic out of the mud.[21]

Mayakovsky's controversial play *Mystery-Bouffe*, in contrast, which was staged by Meyerhold and designed by Malevich, was an example of straightforward propaganda. A modernistic updating of the morality play, it posited the division of humanity into the 'clean' (the bourgeoisie) and the 'unclean' (the proletariat) after an apocalyptic flood, and it concluded with a rhapsodic vision of unity between people, machines, and tools. The machines explain that they have been enslaved by capitalists but will now shine for the workers 'in the darkest night' in order to 'make the world spin like a merry-go-round'. An engineer offers a paean to labour, proclaiming:

> If this is the work of our own hands,
> what door will not open before us?
> We are the architects of earths,
> the decorators
> of planets. We're miracle-makers.

By the end of the play the world has been turned into 'one great Commune | it's ringed round by the working class'.[22]

The play was attacked on all sides and has usually been considered a failure. But the nature of the attacks varied, ranging from charges of obscurity to accusations that its utopian vision was politically unfocused.[23] Trotsky's *Literature and Revolution* (1924) is relevant here because it took a different line in its critique of Futurism, one that centred on its *class* implications. Futurism, Trotsky argued, offered only a *literary* rebellion and, to compound the problem, rebelled solely against the literature of the past. This form of revolt was meaningless in relation to the proletariat: the working classes were not in thrall to a bourgeois culture from which they had always been excluded, and the creation of culture was in any case not their primary objective, which was, rather, social and political revolution. In a catchy formulation, Trotsky

[20] Cited in Victor Erlich, *Modernism and Revolution: Russian Literature in Transition* (Cambridge, Mass.: Harvard University Press, 1994), 47.

[21] Vladimir Mayakovsky, *The Bedbug and Selected Poetry*, ed. Patricia Blake, trans. Max Hayward and George Reavey (Bloomington: Indiana University Press, 1960), 149.

[22] Vladimir Mayakovsky, *The Complete Plays of Vladimir Mayakovsky*, ed. Robert Payne (New York: Simon & Schuster, 1971), 133, 136–7, 138.

[23] See Vsevolod Meyerhold, *Meyerhold on Theatre*, ed. and trans. Edward Braun (London: Methuen, 1998), 160–6; Erlich, *Modernism and Revolution*, 50–5.

wrote that whereas the Futurist 'is a revolutionary innovator of form', the Commu-
nist 'is a political revolutionist'. In addition, he dismissed the possibility of a
proletarian culture on theoretical grounds. Any notion of working-class cultural
'authenticity' was a fantasy, since such a concept could only have meaning once the
revolution's aims had been fulfilled, after which point there would no longer *be* a
proletariat in the old sense. When a new communist culture emerged, it would 'be
not an aristocratic one for a privileged minority, but a mass culture, a universal and
popular one'.[24]

Trotsky's objections to Futurism and to defences of a so-called 'proletarian' culture
were theoretical. The terms he deployed—mass, universal, popular—were vague. For
those associated with Constructivism the creation of a *specific* culture that could
serve the revolutionary cause in the here and now was dependent on avant-garde
activism. Constructivism negated aesthetic idealism in favour of a utilitarian art
orientated to the transformation of everyday life. Whatever the differences among
figures such as El Lissitzky, Rodchenko, Stepanova, Gan, and Tatlin, they welcomed
industrial processes in an attempt to inaugurate productivist practices that would
overcome the separation of art from life through a collective reinvention of social
existence. This programme entailed the destruction of 'bourgeois' contemplative
ideas about art in favour of a radically different creative and constructive view of
art-in-practice. Central to this approach was the making of useful objects, the
redesigning of cities, and the interpenetration of art and life through film, photogra-
phy, theatre, magazines, and posters. Constructivists sought to *fuse* art with politics,
to combine it with lived experience. They wanted not so much to harness art to an
exterior political cause as to connect it to the technologies by which everyday life was
being remade. Hence Gan's demand for an 'EMERGENT CULTURE | OF LABOR
AND INTELLECT' that would express itself by 'INTELLECTUAL–MATERIAL
PRODUCTION', and also Rodchenko's paean:

> TECHNOLOGY
> We—are your first fighting and punitive force . . .
> WE—ARE THE BEGINNING
> OUR WORK IS TODAY:
> A mug
> A floor brush
> Boots
> A catalogue.[25]

Constructivism's *productivist* ethos aimed to intensify the activity of reader and/or
spectator. The theatre director Meyerhold, for example, drew on Frederick Winslow
Taylor's ideas about mechanization to develop his theory of biomechanical acting,
through which he hoped to establish a new relationship with the audience, who
would become co-creators of the dramatic spectacle. He wrote: 'We must reconstruct

[24] Leon Trotsky, *Literature and Revolution* (New York: Russell and Russell, 1957), 130, 192–3.
[25] Cited in Bann, *The Tradition of Constructivism*, 37; Rodchenko, *Experiments for the Future*, 144.

the theatre in such a way that the spectator is presented not with unadorned facts but with a revolutionary form through which he can absorb powerful revolutionary content, dazzling in its variety and its complexity.' For Meyerhold, this approach was similar to Eisenstein's theory of montage; Eisenstein's 'attractions', he argued, functioned like his own *mise-en-scène* to stimulate the observer's imagination. By reconceiving the relationship between work and audience he sought to bring about a reciprocal creative modality: 'A new world is created, quite separate from the fragments of life from which the film is composed.'[26] Eisenstein, in turn, argued that the juxtapositions of montage meant that ideas about form and content had to be revised: '*Revolutionary form is the product of correctly ascertained technical methods for the concretisation of a new attitude and approach to objects and phenomena—of a* new class ideology—of the true renewal not just of the *social significance but also of the material–technical essence of cinema*, disclosed in what we call "our content."' For Eisenstein this new modality was propagandistic: the cinematic and theatrical work was conceived as 'a *tractor ploughing over the audience's psyche in a particular class context*', and in films such as *Strike* (1924), *Battleship Potemkin* (1925), and *October* (1927) he sought to enact this vision.[27] For Eisenstein, Soviet film not only had to situate itself in a determinate social conjuncture (thus addressing the issue of class) but also had to challenge the audience's political beliefs in order to transform them.

Meyerhold, Eisenstein, and Rodchenko were developing an avant-gardism that was to serve the interests of the proletariat under the new political order. El Lissitzky wrote that architecture was 'poised on the threshold of the future' and would 'participate in the full realization of the new world', a sentiment echoed in Mayakovsky's poem 'Brooklyn Bridge':

> I am proud
> of just this
> mile of steel;
> upon it,
> my visions come to life, erect—
> here's a fight
> for construction
> instead of style
> an austere disposition
> of bolts
> and steel.[28]

These resounding lines concealed Mayakovsky's newly ambivalent feelings about mechanized modernity, the result of his 1925 tour of America.[29] Disillusionment with the political direction of the Soviet Union and its control of the arts was already

[26] Meyerhold, *Meyerhold on Theatre*, 273, 318–19.

[27] Richard Taylor (ed.), *The Eisenstein Reader*, trans. Richard Taylor and William Powell (London: BFI, 1998), 95, 55, 56.

[28] El Lissitzky, *Russia: An Architecture for World Revolution*, trans. Eric Dluhosch (London: Lund Humphries, 1970), 27; Mayakovsky, *The Bedbug and Selected Poetry*, 177.

[29] See Mayakovsky, *The Bedbug and Selected Poetry*, 34.

beginning to show itself, though the horrific treatment of 'formalists' and 'decadents', especially after 1936—censorship, enforced exile, imprisonment, torture, and murder—was yet to come. Stephen Bann observes that Constructivist avant-gardism exemplified 'the paradox of creating models for a society that clearly did not exist', and it gradually became apparent that such models would not be tolerated.[30] The 'moment' in which it had been possible to juxtapose a formally radical art with a political commitment to the working class quickly passed, to be replaced by socialist realism and the demands of orthodoxy.

This brief discussion of the avant-gardes in the Soviet Union of the 1920s reveals two things very clearly: firstly, that views about how the arts might advance the cause of revolutionary politics varied widely and gave rise to passionate ideological–theoretical debates; secondly, that these debates didn't exist in a rarefied aesthetic realm but were bound into particular communities, conditions of work, and policy decisions. Avant-gardists were aware of the pressures that could be exerted on them if their work deviated from whatever ideological canons were in the ascendancy at any given time. There was no systematic 'line' just after the revolution, but the question of what was to be regarded as 'progressive' was incessantly debated. The charge of 'formalism', which would become such a weapon in the censor's armoury, covered a multitude of alleged 'aberrations', but it originally derived from a serious concern with art's social and political purpose. Avant-garde experimentalism, which could be accused of being incomprehensible to the proletariat, tainted by 'bourgeois' attitudes, and subjectivist, was forced from the outset to defend its political usefulness. Vyacheslav Zavalishin thus suggests that the 'Party favored conservatism, and for good reason—modern art was unintelligible to the masses and had little propaganda value'.[31]

SURREALISM, EPIC THEATRE, COMMITMENT

Given this background, it's not surprising that otherwise markedly different writers such as André Breton and Bertolt Brecht ran into problems with communist critics when they made political claims for their experiments—Surrealism and epic theatre, respectively—because by the 1920s there was already a history of scepticism about the link between avant-gardism and leftist politics. Surrealism grew out of Dada, with which it shared a contempt for bourgeois values, horror at the carnage of the First World War, disgust with the social order that allowed the war to happen, and impatience with all arts that carried on as though recent historical events were an interregnum that would pass, rather than proof that pre-war Europe had been irremediably corrupt and needed to be swept away. Surrealism aimed to free literature from the Symbolist legacy and to

[30] Bann, *The Tradition of Constructivism*, p. xxiii.
[31] Vyacheslav Zavalishin, *Early Soviet Writers* (New York: Praeger, 1958), 230.

unleash the liberatory potential of the unconscious mind, principally by way of the dream. The emphasis initially fell on the transvaluation of aesthetic, ethical, and social norms through the heterodox power of the irrational mind. This transvaluation was to reintegrate the broken halves of the human psyche by inventing new forms of artistic expression, and in the early years of Surrealism the stress was far more on reactivating the individual mind than on transforming the body politic.[32] But by 1925 Breton had concluded that automatic writing, the lyricism of dreams, nihilist humour, and urban *flânerie* could not really engage with the economic injustices of capitalism. Bretonian Surrealism turned to politics with the aim of melding a belief in psychic liberation with a commitment to class struggle.

The numerous problems that ensued have been amply documented: disagreements, schisms, broken friendships, changes of direction, and excommunications. If it now seems obvious that Surrealism and communism would inevitably clash, it didn't appear that way at the time. Although some Surrealists, for example Pierre Naville, questioned the viability of the movement's turn to politics, for Breton and Aragon the two paths to liberation could be conceived as complementary, as different but equally necessary aspects of revolutionary change. In practice, the French Communist Party saw little of value in Surrealist work, much of which could seem as though it was little more than a form of anarchic provocation. Breton, in turn, became frustrated at the Party's literal-mindedness, its inability to see that Surrealism's contribution to the class struggle was not intended to be *directly* useful, and its demand for justifications of Surrealist interventions. Despite Breton's desire to place the movement *au service de la Révolution*, communism's gatekeepers remained unconvinced that it was of much use to revolutionary politics. Its individualism, its experimentalism, and its loyalty to artistic imperatives were seen to undermine its political credentials.

Nowhere was this brought out more clearly than in the 'Aragon affair'. Having participated in the Second International Congress of Revolutionary Writers in Kharkov (1930), Aragon went back to France a committed communist who wanted Surrealism to accept dialectical materialism as 'the sole revolutionary philosophy' and the 'actual practice of the Third International as the only revolutionary action'. His poem *Front Rouge* (1931), which exalted 'the violent domination of the Proletariat over the bourgeoisie', also extolled the Communist Party, the Red Army, and the Five-Year Plan. Breton supported Aragon's right to produce such a poem, though he thought its heightened rhetoric and aggressive particularism disclosed a 'poetically regressive' romanticism. In contrast to the approach taken by *Front Rouge*, Breton defended Surrealism's use of 'indirect language' and argued that 'professional revolutionaries' and 'revolutionary intellectuals' formed distinct groups, each of which had a valuable role to play in the creation of a proletarian culture.[33] But Surrealism's indirect means were quite precisely what was *not* wanted at a time when the

[32] See André Breton, *Conversations: The Autobiography of Surrealism*, trans. Mark Polizzotti (New York: Marlowe, 1993), 20, 25, 81.

[33] Cited in Maurice Nadeau, *The History of Surrealism*, trans. Richard Howard (London: Jonathan Cape, 1968), 176, 290, 303, 300, 302.

orthodoxy of socialist realism was being established. That its literary experiments might contain an emancipatory potential, even if this were not directly translatable into political action (Naville's principal charge against Surrealism), was a possibility that could scarcely be countenanced by most communists.[34]

Reflecting on Surrealism's history, Breton suggested that although it had mainly been preoccupied with inner states of mind rather than with external political change, he had struggled to avoid a confrontation with the Communist Party because he had believed that Marxism 'bore the greatest hope for the liberation of oppressed classes and people'. But he was intransigent in his conviction that the arts should not be forced into a political straitjacket, insisting that each individual must be granted 'the right to pursue his investigations in the domain which is his own' or else he 'will be lost to himself and to the revolution'.[35] But although Breton was appalled at social injustice, he was never fully persuaded that capitalism was the source of human misery. The tension in his position becomes clear when we take into account his view that 'the world's real torment lies in *the human condition*, even more than in *the social condition* of individuals', and that 'this social condition, which was totally arbitrary and iniquitous ... acted as a screen between man and his true problems—a screen that we therefore needed first and foremost to pierce'.[36] This line of thought suggests that Breton would never have found it easy to subordinate Surrealism to any programmatic political line, whatever his sympathies with its overall stance. It also helps to explain why, having broken with the Communist Party in 1935, Breton aligned himself with Trotsky, whom he met in 1938 and with whom he co-wrote the manifesto 'For an Independent Revolutionary Art'. The key to this manifesto was its juxtaposition of the words 'independent' and 'revolutionary'.[37]

Brecht's conception of epic theatre was marked by none of Breton's ambivalence about explicitly political writing, although in moments of self-doubt he could imagine himself being 'interrogated by a tribunal' to which he would be forced to admit that he 'think[s] too much about artistic problems ... about what is good for the theatre, to be completely in earnest'. But he maintained that in response to such interrogation he would 'add something still more important: namely, that [his] attitude is *permissible*'.[38] Brecht's epic theatre was a rigorously materialist form of drama that sought to lay bare the economic inequities and social injustice of the capitalist order. By turning against German Expressionism (in the parodic early play *Baal*), Brecht drew on a dramatic lineage that went back to Piscator and Meyerhold,

[34] Walter Benjamin, in contrast, was extraordinarily perceptive about Surrealism. See 'Surrealism: The Last Snapshot of the European Intelligentsia', in Walter Benjamin, *Selected Writings*, ii: *1927–1934*, ed. Michael W. Jennings, Howard Eiland, and Gary Smith, trans. Rodney Livingstone (Cambridge, Mass.: Belknap Press, 1999), 207–21.

[35] Nadeau, *The History of Surrealism*, 302.

[36] Breton, *Conversations*, 104, 97.

[37] Breton claimed that his interest in Trotsky went back to 1925, and that reading Trotsky 'marked the first step, and a decisive one ... toward a better understanding of the ideas and ideals that had triggered the Russian Revolution' (Breton, *Conversations*, 92).

[38] See Walter Benjamin, 'Conversations with Brecht', in *Understanding Brecht*, trans. Anna Bostock (London: New Left Books, 1977), 106–7.

two directors who had already experimented with multi-media stagings of politically motivated works. As early as 1905 Meyerhold had developed a non-naturalist *stylized* theatre in which actors represented behaviour in an estranged manner, with the aim of blocking an empathic audience response. Brecht took this further because his entire approach to drama was motivated by a desire to bring about praxis in the world outside the theatre. The *Verfremdungseffekt* was one aspect of this approach, as was the Meyerholdian emphasis on a *thinking* audience, but the key point was Brecht's *re*-presentation of society as an arbitrary construct. There was a correlation between epic drama's formal artifice and its critique of capitalism because, as Benjamin observed, epic theatre 'proposes to treat elements of reality as if they were elements of an experimental set-up'.[39] Brecht attacked the *Gesamtkunstwerk* on the grounds that it aimed to hypnotize the audience. He argued that all elements of the work (music, text, acting, staging) should be separated out from each other so that spectators could be active participants rather than passive consumers of what he referred to as 'culinary' entertainment. His model of 'the didactic' sought 'to develop the means of pleasure into an object of instruction, and to convert certain institutions from places of entertainment into organs of mass communication'. Epic theatre was to be popular—aimed at the working classes—and its techniques were to instantiate a new 'realism' that was 'broad and political, free from aesthetic restrictions and independent of convention'.[40]

Brechtian drama demanded a new type of audience and sought to alter the socio-economic basis of cultural institutions such as the theatre (and, by implication, other institutions as well). An ideal of transformation lay at the heart of this project, but shifting the audience's attitude to the dramatic spectacle was only a first step on the path of wider political change through praxis. Crucially, Brecht grasped, as did Benjamin, that this ideal could not be realized if the institutional structures of theatre (the 'apparatus') remained untouched—in other words, if the 'radicalism' of his drama was confined to the stage. Thus, in his notes to the opera *Mahagonny*, Brecht insisted that it wasn't enough to criticize society at the level of *representation*—the *apparatus* through which the critique was articulated needed to be attacked as well. Admitting that *Mahagonny* was trapped in this problematic, he warned that theatrical innovation was pointless unless it addressed itself to the question of its role *within* the system it was trying to oppose.[41] *Mahagonny* was perhaps 'as culinary as ever', Brecht suggested, but he maintained that at least it 'brings the culinary principle under discussion, it attacks the society that needs operas of such a sort; it still perches happily on the old bough, perhaps, but at least it has started . . . to saw it through'.[42] Benjamin was to develop these issues further in his devastating critique of a leftist 'consumption' of misery that was severed from political action. Citing Aragon, he

[39] Benjamin, *Understanding Brecht*, 99.
[40] Bertolt Brecht, *Brecht on Theatre: The Development of an Aesthetic*, trans. John Willett (London: Methuen, 1964), 42, 109.
[41] Ibid. 35. [42] Ibid. 41.

argued that class betrayal 'consists in an attitude which transforms [the writer] from a supplier of the production apparatus, into an engineer who sees his task in adapting that apparatus to the ends of the proletarian revolution'.[43]

Brecht's enterprise was orientated towards productivity in two senses: the creation of individual theatrical experiments, and the wider development of a political pedagogics that would contribute to the revolutionary struggle. Like Breton, however, he faced criticisms of his approach that questioned its political worth. His most powerful critic was the Hungarian Marxist Georg Lukács. For Lukács, Brecht's epic theatre dealt inadequately with the contradictions of capitalism because its modernist techniques provided no means for grasping the totality of the historical process. Epic theatre was 'formalist': weakened by its lack of 'realism', it was unable to embody the actual relationship of human beings to the social order and was incapable of indicating how contemporary contradictions might be overcome. Lukács's critique of Brecht was inseparable from his wider critique of modernism, which derived from his positive evaluation of the nineteenth-century realist novel. Brecht's response was to argue that 'realism' could not be conceived as an unalterable set of techniques but needed to be seen as a stance vis-à-vis the world that had to adapt in response to an ever-changing social life. Within Brecht's defence of realism, the committed writer could learn from and draw on techniques developed by modernist writers, provided these were not seen as adequate in themselves.

This was a 'conventionalist' defence in the sense that, for Brecht, Lukács mistakenly conflated nineteenth-century realism with epistemological realism per se; in Lukács's thought modernist or avant-garde departures from that *particular* realist tradition were read as failures of representation, whereas for Brecht modes of representation needed to evolve if they were to engage with an unfolding social reality. Brecht thus argued that the 'realism' of epic theatre was not to be conceived in a *reflectionist* (mimetic) sense but rather in a *productivist* manner that sought to uncover the truth of social relations under capitalism:

> *Realist* means: laying bare society's causal network
> showing up the dominant viewpoint as the viewpoint of the dominators
> writing from the standpoint of the class which has prepared the broadest solutions for the
> most pressing problems afflicting human society
> emphasizing the dynamics of development
> concrete and so as to encourage abstraction.[44]

Brecht's emphasis on 'abstraction' in this context reveals that he had moved away from an aesthetics based on *Einfühlung* (empathy, feeling) and towards a form of dramatic presentation that distanced spectators in order to make them *reflect* rather than *feel*. He wanted to get away from the viewpoint of a central protagonist (*Mittelpunktsindividuum*) on the grounds that 'the world itself is insufficiently reproduced, if it appears only in the mirror of the feelings and contemplations of

[43] Benjamin, *Understanding Brecht*, 96–7, 102. See also 'Left-Wing Melancholy', in Benjamin, *Selected Writings*, ii. 423–7.
[44] Brecht, *Brecht on Theatre*, 109.

the hero'.[45] For Lukács, in contrast, modernism disclosed an abnormal, morbid, and decadent attitude, which isolated writers from the social dialectic and prevented them from seeing in it the seeds of an alternative future. Modernism's inability to grasp the inner nature of the social dialectic was exemplified by its fragmented forms, which not only disclosed the collapse of realism's totalizing ambitions but also revealed its subjectivism—the sign of its loss of faith in artistic objectivity, which for Lukács was the prerequisite of a politically viable aesthetic.[46]

CLASSES, ELITES, AND MINORITY CULTURE

Lukács's arguments were much contested (not least by Brecht, though he didn't publish them in his own lifetime). Nonetheless, despite their limitations—specifically their reliance on nineteenth-century realism as a locus of aesthetic–political value—they offered a powerful (and influential) critique of modernism's weaknesses. In less theoretically supple hands, these kinds of criticism could be crude and simplistic. In 1930s Britain, Marxist critics such as Christopher Caudwell, Ralph Fox, and Alick West offered similar arguments (Joyce was the usual whipping boy) and, like Lukács, offered some version of realism as the alternative to modernist psychologism and bourgeois idealism. Although they differed from each other on key points, Caudwell, Fox, and West all argued in favour of a return to a socially embedded realism that eschewed the subjectivist and fragmented narrative modes associated with modernism in favour of 'objective' representations of human relations. West believed that the proletarian attitude to life was conducive to 'the creation of good literature' because the working classes were closely in touch with economic realities, while Fox urged the contemporary novelist to create 'the typical man, the hero of our times, and in this way to become, as Stalin has phrased it, "an engineer of the human soul"'.[47] Alec Brown went as far as to assert that 'LITERARY ENGLISH FROM CAXTON TO US IS AN ARTIFICIAL JARGON OF THE RULING CLASS,' but this kind of thinking was much contested in the 1930s by such writers as William Empson, Lewis Grassic Gibbon, George Orwell, and Edgell Rickword. Empson's subtle reflections on the relationship between pastoral and proletarian writing led him to question the viability of 'a rigid proletarian aesthetic'; Grassic Gibbon dismissed Brownian rhetoric as 'bolshevik blah' and insisted that 'Capitalist literature, whether we like it or not, is not in decay'; Orwell attacked communist critics for

[45] Brecht, cited in H. Gustav Klaus, 'Socialist Fiction in the 1930s: Some Preliminary Observations', in John Lucas (ed.), *The 1930s: A Challenge to Orthodoxy* (Hassocks: Harvester, 1978), 21.

[46] See Georg Lukács, *Writer and Critic*, ed. and trans. Arthur Kahn (London: Merlin, 1978), 25–60, 103–9, and 'On Bertolt Brecht', *New Left Review*, 110 (July–Aug. 1978), 88–92.

[47] Alick West, *Crisis and Criticism* (London: Lawrence & Wishart, 1937), 181; Ralph Fox, *The Novel and the People* (London: Cobbett, 1944), 101.

failing to distinguish political beliefs from aesthetic standards and for judging literature on ideological grounds; Rickword emphasized modernism's achievements and acknowledged the limitations of much working-class writing.[48]

Marxist and socialist criticisms of modernism were commonly expressed during the inter-war years, and they often went hand in hand with denunciations of 'popular' literature. It was argued that in both cases—commercially motivated 'popular' writing *and* a supposedly more serious 'highbrow' writing—the notion of literature as a repository of value was being debased. Such criticisms were not restricted to the left, however. Various writers and critics (for example, Rickword, Lewis, Orwell, and the Leavises) were hostile to what they saw as a new phase in the commercialization of literature because they feared that this was leading to its complete subordination to the values of the marketplace. Where these arguments differed, obviously, was over the question of what constituted literary value. Leftist critics tended to see 'popular' writing as an escapist (and ideologically manipulative) mode that distracted its readers from the reality of an unjust capitalist social order, whereas conservatively inclined critics tended to see in it a lowering of cultural standards that they associated with democracy's levelling tendencies.

These readings of the situation produced three major responses: arguments in favour of the politicization of literature and its necessary engagement with social problems—a line of thought that ran from the *Calendar of Modern Letters* to *Left Review* and the *London Aphrodite*; arguments that emphasized literature's moral and social dimension rather than its political role, most obviously in F. R. Leavis's critical journal *Scrutiny*, by way of I. A. Richards's *Principles of Literary Criticism* (1924); arguments defending literature's autonomy on the grounds that its harnessing to political ends betrayed its capacity for disinterested crystallizations of contemporary social life. But writers' responses to issues that coalesced around questions of class didn't fit neatly into predetermined categories. Attacks on 'mass' society and democracy, for example, were common in the work of numerous modernists, but they were highly differentiated and, an equally important point, they varied not just from writer to writer but also *within* a given writer's own developing thought. Nor was it the case that writers who were sometimes hostile to 'mass' society necessarily believed that their work should only address a select audience. The claim that modernism actively sought to exclude the working classes or the lower middle-class 'clerks' is a problematic one. Although many modernists were disdainful of the petit bourgeoisie (as indeed were most Marxists) and uninterested in the proletariat, they did not address their work to any particular social class *as such*. If they weren't generally supporters of political revolution on behalf of the working class, then they can hardly be said to have been supporters of the bourgeoisie or the aristocracy. If anything, modernists of this

[48] For Brown's claim and Grassic Gibbon's rebuttal, see David Margolies (ed.), *Writing the Revolution: Cultural Criticism from Left Review* (London: Pluto Press, 1998), 28, 38; for Empson, see 'Proletarian Literature', in William Empson, *Some Versions of Pastoral* (Harmondsworth: Penguin, 1966), 9–26; for Orwell, see George Orwell, *Essays*, ed. John Carey (New York: Knopf, 2002), 63–6; for Rickword, see Edgell Rickword, *Literature in Society: Essays and Opinions*, ii: *1931–1978*, ed. Alan Young (Manchester: Carcanet, 1978), 56–60, 93–104.

type (Eliot, Lawrence, Lewis, Pound) believed in the possibility of creating an intel-
lectual and artistic elite that could set the pattern for a society of the future.

Among those who were sympathetic to the plight of the working classes—even if
they didn't go so far as to espouse revolutionary politics—the difficulty of entering
into working-class experience or of engaging with their predicament became as much
a subject of their writing as any attempt to represent that experience. Along with
Lawrence, James Hanley is one of the few writers from a working-class background
who can be aligned with modernism, but most working-class writers adopted realist
modes. Woolf signalled her unease about this class gap in 'Memories of a Working
Women's Guild' (1930). Despite her fellow feeling for working women, she admitted,
her knowledge of their lives was theoretical. If 'every reform they demand was
granted this very instant it would not touch one hair of my comfortable capitalistic
head'.[49] Her subsequent evocation of an uneasy 'aesthetic sympathy', which has no
connection with her actual feelings, is itself subjected to critique in *The Years* (1937)
through a character's sense of alienation from a moneyed world that is out of touch
with the realities of the class system. Where in this privileged domain, he asks, 'are
the Sweeps and the Sewer-men, the Seamstresses and the Stevedores'; he concludes
that in drawing-room discussions about social reform 'there's not an idea, not a
phrase that would feed a sparrow . . . there's a gap, a dislocation, between the word
and the reality'.[50] *A Room of One's Own* (1928) and *Three Guineas* (1938) turn this
concern into accounts of the relationship between class and gender in patriarchal
societies. A key aim, formally enacted through the meandering style of *A Room*, is to
challenge the linear certainties of patriarchal assumptions, and thereby to call exist-
ing hierarchies of value into question. Offering a materialist analysis of class and
gender, *A Room* and *Three Guineas* insist that the 'right' to intellectual and artistic
freedom is an abstract concept unless it is predicated on a minimal material basis.[51]

Lawrence was acutely aware of these issues. His most powerful writing evoked class
and gender conflicts, specifically the desperate need for characters to break free from
a paralysing social system, with an unmatched precision. But in his later work
Lawrence's anti-democratic tendencies came to the fore. He railed against a 'mistaken
democracy' and sought to restrict knowledge to a 'sacred few'. Defending his con-
ception of a cultivated minority, an intellectual, semi-hieratic aristocracy, he argued
that society needed a 'higher, responsible, conscious class' and that the lower classes
should be kept in a state of pre-conscious ignorance: '*The great mass of humanity
should never learn to read and write—never.*'[52] Lewis, who was no less critical of
democracy, attacked it for different reasons and from a different standpoint. His
main concern was with democracy's inability to withstand the power of big business,
its fragmentation of the body politic, and its susceptibility to the influence of the
media; his works of cultural and philosophical criticism sought to uncover what he

[49] Virginia Woolf, 'Memories of a Working Women's Guild', in *Selected Essays*, ed. David Bradshaw
(Oxford: Oxford University Press, 2008), 146–59, 148.
[50] Virginia Woolf, *The Years*, ed. Jeri Johnson (Harmondsworth: Penguin, 1998), 296.
[51] Woolf, *A Room of One's Own*, 41, 106.
[52] D. H. Lawrence, *Fantasia of the Unconscious and Psychoanalysis and the Unconscious*
(Harmondsworth: Penguin, 1974), 11, 88, 77, 87.

considered the *real* forces at work in social life and to communicate these to as wide an audience as possible. Much of Lewis's work in the 1920s and 1930s was a satiric assault on the destruction of agency he saw in various forms of 'type' life that left the individual a laughing dummy (the caricatural figures he mocked as 'Tyros'), a trained behaviourist machine (*Snooty Baronet*), or a programmed mouthpiece for ideology (*The Revenge for Love*). Lewis also believed in intellectual aristocracies, and he was attracted to both fascist and communist politics. By the late 1930s, however, he had rejected all doctrines that favoured political centralization, had retracted his support for Hitler in 1931, and was arguing in favour of the ideals of anti-nationalist federalism and social democracy.[53]

Numerous Anglo-American modernists were drawn to the idea of intellectual and/ or artistic aristocracies, which they saw as the only means available to them for the defence of 'culture'. Yeats's late thinking, in *On the Boiler* (1938), for example, chimed with Ortega y Gasset's conviction that the revolt of the masses was equivalent to a barbaric invasion, a feeling that was at certain moments in his career also shared by T. S. Eliot.[54] There is 'no doubt', Eliot wrote in *Notes Towards the Definition of Culture* (1948), 'that in our headlong rush to educate everybody, we are lowering our standards, and more and more abandoning the study of those subjects by which the essentials of our culture . . . are transmitted; destroying our ancient edifices to make ready the ground upon which the barbarian nomads of the future will encamp in their mechanised caravans'.[55] Eliot was desperately anxious about social disintegration, and his account of elites, which depended on a hierarchical conception of communal life, sought to explain how national cohesion might be maintained. Elites are not classes, of course, but groups who have a particular place in a given social order and a specific role to play in it. For Eliot, the theory of elites offered a way of combating the deleterious consequences of the classless society he thought was gradually coming into being after the Second World War. Elites were specialized groups with particular aptitudes who were given the task of protecting and promoting socially necessary pursuits (science, philosophy, the arts, politics, etc.) for the greater public good.

Drawing on Karl Mannheim's work, Eliot observed that theorists of future classless societies envisaged elites *replacing* classes, and, although he was broadly in favour of the cultural specialization thereby implied, he feared that an unintended consequence of any social reorganization on such lines would result in the atomization of human relations and the dissolution of 'organic' bonds. Eliot's overriding concern was to defend a society that would be vertically structured but interlinked in all its parts, and he thus wrote in support of a mixed society in which both classes and elites had a part to play. According to Eliot's 'view of culture, the whole of the population *should* "take an active part in cultural activities"—not all in the same activities or on the same level', since in 'a vigorous society there will be present both class and élite,

[53] See Wyndham Lewis, *The Art of Being Ruled*, ed. Reed Way Dasenbrock (Santa Rosa, Calif.: Black Sparrow Press, 1989), *The Hitler Cult* (London: Dent, 1939), and *Anglosaxony: A League That Works* (Toronto: Ryerson, 1941).

[54] See José Ortega y Gasset, *The Revolt of the Masses* (New York: Norton, 1964), 53.

[55] T. S. Eliot, *Notes Towards the Definition of Culture* (London: Faber and Faber, 1972), 108.

with some overlapping and constant interaction between them'.[56] A minority culture was needed to set the tone for the other levels of culture, while at the same time protecting itself from them: 'it is an essential condition of the preservation of the quality of the culture of the minority, that it should continue to be a minority culture'. As in the Leavises' work and in the thinking of Lawrence, Pound, and Yeats, Eliot maintained that minority culture could serve as a bulwark against the degeneracy of the age through a two-stage process: firstly, by maintaining certain aesthetic values (a keeping alive of the sacred flame), and secondly, by transmitting them to wider society, once this society was ready for them. Eliot upheld the value of 'an aristocracy' with the 'peculiar and essential function' of being the standard-bearer for culture itself, an idea that can be traced to Arnold and Coleridge.[57]

Eliot's post-war position might be described as a cautiously defensive one. A more ambitious attempt to imagine how a minority culture could transform society can be seen in Pound's work. Committed to the task of revolutionizing poetry from the 1910s onwards, Pound embarked on a path that would eventually entail a fundamental economic and political revolution. His desire to make literature count in some real way informed *The Cantos*, as well as being visible in his articles, his propaganda broadcasts, and his identification of Fascist Italy as the locus for a new *risorgimento*. The value-creating authority of the avant-garde artist was now to be supplemented by, perhaps embodied in, the Fascist dictator. The seeds of this desire to express ideas through acts possibly lay in his reading of de Gourmont and Lenin, out of which he developed the concept of words-in-action, a way of thinking about praxis that could in principle have had either a socialist or fascist valence.[58]

Pound's ideas about praxis cannot easily be described or dismissed. By trying to imagine how writers who saw themselves as an advance guard could intervene in the political process, he endeavoured to shape history in and through the category of the aesthetic. When Roger Griffin suggests that Fascism in the inter-war years provided a way 'not of impotently watching history unfold, but of actually "making history"' and that it sought to 'create a new culture in a total act of creation, of *poiesis*', one could substitute the word 'communism' for that of 'Fascism'.[59] As we have seen, Pound's pre-war hope that the artist was about to take control of a moribund society and then transform it was shared by the communist Rodchenko and his fellow Constructivists, who *did*, for a time, participate in such a utopian project. (Here, we might also cite Benjamin's 'Theses' and his invocation of a messianic *Jetztzeit* pregnant with emancipatory possibilities—a 'time filled by the presence of the now'—in this context.[60])

[56] Ibid., *Notes Towards the Definition of Culture*, 38, 44.

[57] Ibid. 108, 48, 107.

[58] For Pound and de Gourmont, see Richard Sieburth, *Instigations: Ezra Pound and Rémy de Gourmont* (Cambridge, Mass.: Harvard University Press, 1978), 139–40; for Pound and Lenin, see Tim Redman, *Ezra Pound and Italian Fascism* (Cambridge: Cambridge University Press, 1991), 74, 98, 119–21.

[59] Roger Griffin, *Modernism and Fascism: The Sense of a Beginning Under Mussolini and Hitler* (London: Palgrave Macmillan, 2007), 4.

[60] Walter Benjamin, 'Theses on the Philosophy of History', in *Illuminations*, ed. Hannah Arendt, trans. Harry Zohn (New York: Schocken Books, 1978), 261.

CONCLUDING REMARKS

Modernist writers, designers, and artists took up a number of positions on questions of class and politics. These depended on personal convictions, and also on determinate social, cultural, institutional, and political contexts. Anglo-American modernists such as Eliot, Ford, Hulme, Lawrence, Lewis, Pound, Yeats, and Woolf were working in a very different kind of social situation from Russian avant-gardists after the October Revolution, radical dramatists such as Brecht in Weimar Germany, or Surrealists in post-war France. The various attitudes to issues of class taken up by these figures also changed over time; in none of these cases can we speak of fixed positions. Whether we take a cross-sectional, geographically spread-out synchronic view of the work discussed in this chapter or a chronological, nationally focused diachronic view of any given modernist (or group of modernists), what we find everywhere is diversity, movement, and change. As we have seen, even among those who were committed to the politicization of art, possible positions ranged from communism to Fascism and included anarchist, egoist, tory, socialist, and syndicalist strands. Among those who believed the arts should not be partisan at all, but should defend the autonomy of the aesthetic, there was an equal diversity of views, which ranged from utter indifference to social problems to the belief that the arts could only engage meaningfully with such problems if they were free to follow whatever path they chose.

Modernist attempts to harness the aesthetic to political ends involved debates about the viability of doing so, and also about the accessibility of experimental modes to readers and audiences. These concerns are particularly evident in the early years of the Soviet Union, in Brecht's drama and in his theoretical reflections on that drama, and in Bretonian Surrealism in its communist phase. In the Anglo-American context, leftist modernism is more rarely seen (though anarchist, socialist, and syndicalist ideas are woven into the work of its key figures), while 'reactionary' defences of artistic and intellectual minorities are commonly articulated. But even here the issues are complex. For if some Anglo-American modernists thought that elites of some kind should have a guiding social role, this wasn't necessarily because they wanted to exclude any particular class. (They were, in fact, hostile to *all* classes, albeit in different ways and for different reasons.) It was as much because they believed that avant-garde art was *always* ahead of the understanding of the majority, of whatever class, and that it could only appeal to a small audience of initiates, at least until others caught up.[61] It is here that the idea of a separate group of enlightened and vanguardist figures—a cadre or an elite, but not a *class*, since it could include individuals from all backgrounds—a modernist updating of the Arnoldian belief in supra-class 'aliens' or the Coleridgian defence of a guiding 'clerisy', came to the fore. In the end, there can be no totalizing account of modernism's engagement with class issues because this engagement took diverse forms and because there are so many subterranean links between lines of thought and modes of practice that are otherwise dissimilar.

[61] See e.g. Ortega y Gasset, *The Dehumanization of Art and Other Essays on Art, Culture, and Literature,* trans. Helene Weyl (Princeton: Princeton University Press, 1972), 12.

CHAPTER 11

··

QUEER
MODERNISM

··

ROBERT L. CASERIO

A HOMOSEXUAL–HETEROSEXUAL DIVIDE,
OR, A QUEER ALLIANCE?

··

How might one best tell the story of the prominence that same-sex eros acquires in modernism? The most established narrative is not wholly trustworthy. It insists that, from the 1880s on, medicine and jurisprudence newly construct 'the homosexual' by assigning him or her an identity or category that contrasts with another newly formulated one: 'the heterosexual'. The contrast, this story says, reifying both identities, creates paranoid antagonism between them. Because of the reification, the homosexual is victimized. Evidences of the victimization include Oscar Wilde's imprisonment in 1895 under recent laws prohibiting sex between men; suppression of Havelock Ellis's study *Sexual Inversion* in 1898; E. M. Forster's self-suppression of *Maurice* (1913), a novel which pictures a happy union between a middle-class man and a working-class man; the 1916 hanging of Irish rebel Roger Casement, whose gay sex diaries were used to secure his execution for treason; confiscation of A. T. Fitzroy's *Despised and Rejected* (1918), a First World War novel about a friendship between a lesbian and a gay conscientious objector; and prosecution of Radclyffe Hall's *The Well of Loneliness* (1928), in which the lesbian heroine yearns for public acceptance. In fictions by homosexual writers, according to this narrative, homosexuality never comes to good because of the writers' punitive internalization of the new homosexual–heterosexual divide. Hence Wilde undoes Dorian Gray, as if

to condemn Dorian's links with homoeroticism; and projects his own eros onto his Salome, who, kissing the mouth of the saint she has killed, understands that 'love hath a bitter taste'.

The persecutions encapsulate enduring hatred. Yet even Wilde's Salome discounts what she suffers for her deviance: 'They say that love hath a bitter taste . . . But what of that? What of that? I have kissed thy mouth, Jokanaan.'[1] Salome's finale is shocking in part because she discounts victimization by both eros and repression. Wilde's purport concerning eros is twofold: Salome's and Dorian's bitter fates are counter-balanced by Jack 'Ernest' Worthing's invincible desire in *The Importance of Being Earnest*. That play recognizes desire as victoriously deviant and non-functional, in contrast to what regulators of eros might claim. The non-functional aspect—queer love—conforms reality to itself, leaving no bitter taste.

Not that same-sex love should be more exempt from Aphrodite's malice than any other love. Tragic fatality is assigned by nineteenth-century naturalist fiction, which is a seedbed of modernism, to all sexuality. The Brazilian novel *Bom-Crioulo* (1895) by Adolfo Caminha explicitly represents a black seaman's love for a white cabin boy, who becomes the sailor's partner but then betrays him with a white Portuguese woman. She and the sailor, despite their contrasts, are two sides of the same coin. What Caminha's novel defeats is not homosexual love, but evasion of the humbling reality of eros, queer no matter what its variety.

But neither phobia nor naturalism suffice as explanations of homosexuality in modernism. The dignity that John Addington Symonds gives it in his 'The Dant-esque and Platonic Ideals of Love' (1890) and in his biography of Michelangelo (1893) was not censored. Samuel Butler's *Shakespeare's Sonnets Reconsidered* (1899), arguing that Shakespeare surrendered to a rent boy, compassionates the poet. Edward Carpenter, one of the founders of English socialism, associates heroic cultural icons with same-sex eros. He declares that opposite-sex love is culturally constructed as 'normal' because it abets capitalist ownership and middle-class property. Therefore opposite-sex love can only be considered as a phase of arrested development in human progress. *Love's Coming-of-Age*, Carpenter's manifesto, was widely translated between 1897 and 1911 and saw fourteen editions in Germany. Meanwhile, Wilde's figure produces in England an unbroken chain of queer writing. As if to follow through on Wilde's deathbed conversion to Catholicism, Frederick Rolfe in *Hadrian the Seventh* (1904) imagines a chaste but homoerotic Pope, who arranges a male–male marriage between one of his chamberlains and a failed candidate for the priesthood. Ronald Firbank, whose fiction dates from 1905, resurrects Wilde in his art. Firbank's novels contain obvious representations of same-sex love, but were not prosecuted. Neither was Virginia Woolf's representation of transgendered bodies and queer desire in *Orlando* (1928).

Exclusive attention to puritanical English culture, without notice of the greater sexual honesty of Europe, Latin America, and Russia, wrongly supports focus on

[1] Oscar Wilde, 'Salome', in *The Complete Works*, ed. J. B. Foreman (London: Collins, 1990), 552–75.

queer victimization. André Gide's *The Immoralist* (1902), inspired by Wilde, also echoes Carpenter: Gide's immoralist overcomes arrested development as he lets go of his property (identifying with those who steal from him) and enacts bisexual desire. The immoralist's queer love mixes pleasure and pain; but that is not to say that a fully earned queer happiness has no place in modernist fiction. The Russian novel *Wings* (1906) by Mikhail Kuzmin is a collage of moments in the experience of a young man who gradually realizes his love for an older man, with whom he achieves a happy ending. Typically modernist in its departure from conventional narrative form, *Wings* pairs its formal experiment with its protagonist's experiment in unregulated eros.

Writings that affirm queer love's coming of age in modernism suggest a new historical (and literary-historical) narrative that would make more of brave initiative. It would also make less of the homosexual–heterosexual divide. Practitioners of same-sex love are not the only modernists who want to liberate eros from regulation. The current use of the term 'queer' in academic culture challenges the homosexual–heterosexual (or straight–gay) contrast. The storytelling this chapter adopts is in line with this challenge. 'Queer theory' questions common assumptions about human sexuality, especially if that is thought to be definitively anchored in social, historical, legal, or medical 'certainty'. The term 'queer' perplexes certainty. The modernist construction of homosexuality evolves from an alliance of plural erotic dispositions that are united in antagonism to opposite-sex love, bourgeois marriage, and family. To emphasize homosexuality as a product of medical and juridical innovations is to overlook the alliance. It also overlooks modernist homosexuality's derivation from ideologies that characterize queer persons as standard bearers of culture and as paragons of democratic citizenship.

Eve Sedgwick's work is one origin of the established storytelling that this chapter questions and supplements. Sedgwick claims that our understanding of homosexuality unfortunately has not advanced beyond modernism's. Identifying modernism and queer love with their representation in the novels of Marcel Proust, Sedgwick writes:

Most moderately to well-educated Western people in this century seem to share a similar understanding of homosexual definition ... close to what Proust's probably was, what for that matter mine is and probably yours ... it is organized around a radical and irreducible incoherence. It holds the minoritizing view that there is a distinct population of persons who 'really are' gay; at the same time, it holds the universalizing views that sexual desire is an unpredictably powerful solvent of stable identities; that ... heterosexual persons and object choices are strongly marked by same-sex influences and desires, and vice versa; and that at least male heterosexual identity and ... culture may require for their maintenance the scapegoating ... of ... same-sex male desire.[2]

Sedgwick insists that contradictions have 'presided over all the thought on the subject' and amount to an 'indisseverable girdle of incongruities' in the face of which the only 'promising project' would be 'study of the incoherent dispensation

[2] Eve Kosofsky Sedgwick, *Epistemology of the Closet* (Berkeley: University of California Press, 1990), 85.

itself', which, she adds, presides over 'the most generative and the most murderous plots of our culture'.[3]

How are Sedgwick's claims to be assessed after a scholarly generation of commentary on 'the incoherent dispensation'? Her assertion about modernist incoherence is open to contest. Freud, an exemplary modernist, argues that there are persons who 'really are' gay, and also that sexual desire powerfully dissolves stable identities—male and female, as well as heterosexual and homosexual—because eros obscures, as well as multiplies, objects of longing. His argument does not indicate incoherence but results from his strenuous pursuit of systematic knowledge. Freud finds that eros in all of its guises is a riddling phenomenon, as well as a problem for investigation: 'The exclusive sexual interest felt by men for women is also a problem that needs elucidating and is not a self-evident fact.'[4] What maintains the riddle is that in human life 'the sexual instinct is independent of its object.'[5] Human sexuality is not tied to reproductive need or purpose. 'The requirement, demonstrated in prohibitions [against "extra-genital satisfactions" and object choices other than "the opposite sex"], that there be a single kind of sexual life for everyone, disregards the dissimilarities, whether innate or acquired, in the sexual constitution of human beings.'[6]

Freud's rediscovery of our sexual constitution attempts to move his audience past punitive aggressions that inhere in cultural prohibitions. Accordingly, insisting on the independence of desire from regulated object-choices, in his studies of Leonardo da Vinci and Michelangelo Freud heroicizes, rather than scapegoats, homosexual impulse. Leonardo, whom Freud sees as a proto-modernist rebel, so magnetizes Freud that Freud admits his theorizing about Leonardo might be mistaken because he has 'succumbed to the attraction of this great and mysterious man'.[7] Wanting to equate himself and his bold science with the Renaissance figure, Freud permits his seduction by another male. And he allies himself with extra-genital satisfactions. For Freud makes himself synonymous with a male who, according to Freud, exchanged sucking at his mother's breast for the fantasy of taking a penis into his mouth. Identification with Leonardo 'queers' Freud, and homoeroticizes his research. In the process, admittedly, Freud consolidates the artist's sexual identity. But in choosing Leonardo as his 'mate', Freud also exemplifies the arbitrary limits of sexual categorization and conduct as they apply to himself as well as to Leonardo.

Freud is a queer theorist and a queer modernist, alongside Oscar Wilde. That Freud and Wilde have similar perspectives is part of the queerness. In the modernist era a remarkably coherent agreement—indifferent, one should note, to 'minority' and 'majority' categorizations and values—arises among persons whose desires are

[3] Sedgwick, *Epistemology of the Closet*, 90.
[4] Sigmund Freud, *Three Essays on the Theory of Sexuality*, ed. and trans. James Strachey (New York: HarperCollins, 1975), 12.
[5] Ibid. 14.
[6] Sigmund Freud, *Civilization and its Discontents*, ed. and trans. James Strachey (New York: Norton, 1961), 60.
[7] Sigmund Freud, *Leonardo da Vinci and a Memory of His Childhood*, ed. James Strachey, trans. Alan Tyson (New York: Norton, 1964), 84.

diverse but who are uniformly opposed to 'a single kind of sexual life for everyone'. In this coalition a liberating ethos that derives from Henrik Ibsen becomes an essential motive. The influence of Ibsen's modernist dramas on the demise of conventions governing morality, especially in regard to sexual relations and gendered identities, is summarized by George Bernard Shaw. His remarks on the enormous difficulty of performing Ibsen highlights what Ibsen and modernism mean. 'The whole point of an Ibsen play', Shaw writes, 'lies in the exposure of the very conventions upon which are based those by which the actor is ridden.'[8] Even in the presence of Ibsen's text, pre-established conventions of performance (and of producible scripts) leave the actor clueless. But it is not only the stage actor who is disorientated. Ibsen's plays confound their audiences because his characters do not conform to the conventions by which audiences are ridden. Ibsen's scripts, exceeding the current repertory of social roles and performances, belong to a future in which action and acting, offstage as well as on, will be entirely new. The novelty, Shaw concludes (adapting words of the proto-modernist Richard Wagner), will come to birth only when '"the mechanism"' that conventionally scripts 'this or that Religion, Nationality, or State' is revolutionized.[9]

Homosexuality as we know it arrives at the centre of modernism's revolutionary challenge to cultural repertories. This challenge is so comprehensive that modernism seeks to break with religion, nationality, and the state. A queer force, an ally in a wilful derangement of established order, homosexuality shows itself, especially in the literary field, in writers whose biographies do not include same-sex love, but whose imaginations engage it. The novelist Dorothy Richardson is both a feminist and a critic of the suffrage battle, a socialist and an anti-socialist. These are contradictory positions that subvert recognizable scripts. Miriam Henderson, the heroine of Richardson's *Pilgrimage*, is a similar subversive. So is the novel in which she appears. *Pilgrimage* is a modernist work because of its experimental form: it combines a thirteen-volume length with an overall avoidance of actions and events. A crucial experience for Miriam, at the height of her participation in the suffrage struggle, is her falling in love with another woman, Amabel, who reciprocates this love. Miriam's erotic nature, because it is exceedingly queer, does not stay attached to Amabel, who is a conventional role-player after all. Nevertheless, Richardson makes homosexual impulse a key way station in Miriam's search for a radically alternative life.

Joseph Conrad's biography does not document any same-sex love. Yet it has been difficult for queer theory to overlook the evocation of eros in Conrad's 'The Secret Sharer' (1909), in which a young ship-captain finds himself tenderly harbouring a seaman on the run from the law. The captain's intensely illicit relationship invites 'queer' reading, not because homosexual feeling is buried in the tale, but because Conrad's captain wears his heart on his sleeve. To be sure, no overt sexual act appears in the text; this is plausibly a sign of Conrad's wanting to strip male intimacy of sex. Yet it is also possible to argue that sexuality locates us 'beyond and outside . . . all

[8] George Bernard Shaw, *The Quintessence of Ibsenism* (New York: Dover, 1994), 72.
[9] Ibid. 84.

signification, all representation'.[10] The queerness of eros, its anonymous disorientat-
ing power, is better represented, rather than better repressed, by evocations of a love
that is not responsible to naming or definition.

James Joyce is the most prominent queer modernist. Polymorphous eros pervades
his work. *Finnegans Wake* (1924–39), a family drama, pivots on multiple primal
scenes of sexual desire. In one of Freud's cases the primal scene is an infant's
observation of his parents' sexual intercourse. The infant's observation creates
conflicting yearnings: to be like his father, penetrating his mother; to be like his
mother, penetrated by his father. In the *Wake* one primal scene is purely homosexual:
the place of Freud's observing infant is assigned to twin brothers who see their
father's nakedness, and who desire sexual congress with him. If only because it is
hard to tell apart desire and action in the *Wake*, one can say that the congress is
realized, and with the father's participation. The result of such transgression, ex-
pressed as a same-sex 'cremation', is what the text calls 'the abnihilisation of the
etym'—an atomic explosion of the nuclear family, and of its regulation by male–
female pairings and reproductive ends.[11] The *Wake*'s very prose depends on Joyce's
detonation of English and of multiple other languages as well. Joyce builds a new
language on the basis of the fragments of the old. The *Wake*—another refusal of
Shaw's (and Wagner's) trinity of established authority—extends queer modernism to
the brink of the Second World War.

QUEER MODERNISM'S ATTACK ON MARRIAGE

Homosexuality takes on definition within a queer modernist coalition that seeks to
subvert the institution of marriage and the family. A result of Ibsen and Wilde's
influence, a revolutionary theatre fosters the subversion. Shaw's Preface to his play
Getting Married (1908) argues that marriage is 'a curious mixture of sex slavery, early
Christian sex abhorrence, and later Christian sex sanctification'; it is a 'political
contrivance', not a 'sacred ethical obligation'.[12] Proclaiming that 'every human being
has a right to sexual experience', Shaw does not discriminate among experiences.[13]
The play exalts the character of its principal married woman because she does not
devote herself to monogamy. Harley Granville-Barker's experimental play *Anatol*
(1911) adapts a work by Viennese modernist Arthur Schnitzler (who influenced
Freud). Anatol thinks he should be married, if only as a solution to his promiscuity.

[10] Cesare Casarino, *Modernity at Sea: Melville, Marx, Conrad in Crisis* (Minneapolis: University of Minnesota Press, 2002), 220–1.

[11] James Joyce, *Finnegans Wake* (Harmondsworth: Penguin, 1980), 350, 353.

[12] George Bernard Shaw, *Getting Married* and *Press Cuttings* (Harmondsworth: Penguin, 1986), 95, 37.

[13] Ibid. 78.

But the play suggests that there can be no such outcome. Anatol learns that 'it's always somebody else one gets married to', rather than the person one most wants.[14]

A second generation of modernists continues to promote the right to sexual experience without legitimization by marriage. In Firbank's play *The Princess Zoubaroff* (1920) opposite-sex couples are sick of being wedded. The princess, married six times by the age of 35, is founding a lesbian convent in Florence. She collects her postulants, who include Enid, a bride of one week; within a few moments of meeting, Enid ecstatically nestles her face in the princess's skirt. The play includes a children's birthday party for an infant whose father has run off with another man. The children charm, but the marital structure that governs their production is deadening, especially in comparison with same-sex attractions. A male couple, based on Wilde and Alfred Douglas, exuberantly reunite with a manservant to whom they have made love on some previous encounter. Despite the bawdy sound of the stage events, Firbank's elliptical and abstracted dialogue—whose artifice is characteristically modernist— envelops the female and male pairings and groupings in an aura that is both carnal and ethereal. A retreat into a same-sex erotic cloister, even into a closet in the sense that Sedgwick gives it, is a superior life compared to 'normal' social and sexual existence.

D. H. Lawrence's *Women in Love* (1920) is a queer protest against dividing same-sex love from its opposite. One of its protagonists, Rupert Birkin, calls marriage 'the most repulsive thing on earth' and insists that human 'tightness . . . meanness . . . and insufficiency' result when 'the relation between man and woman is made the supreme and exclusive relationship'. Birkin believes that 'the love-and-marriage ideal' must make way for an 'additional perfect relationship between man and man . . . You've got to get rid of the exclusiveness of married love. And you've got to admit the unadmitted love of man for man.'[15] Birkin proposes that additional perfect relationship to his friend Gerald Crich. Is the proposal homosexual? Biographers insist on Lawrence's castigations of homosexuality, tying them to Lawrence's novella *The Fox* (1923), wherein a First World War veteran destroys a lesbian couple's happy ménage. But Lawrence the man is tighter and meaner than his fiction. If Lawrence does not indicate that the alliance between Birkin and Crich will be genitally orgasmic, he nevertheless includes a chapter, preceding Birkin's male– male marriage proposal, in which Birkin and Crich wrestle naked. The wrestling makes genital focus appear a limited aspect of intercourse. 'The wrestling had some deep meaning to them—an unfinished meaning'; Birkin insists, and Crich agrees, that 'we should be more or less physically intimate too—it is more whole'.[16] The tragedy of *Women in Love* is that the men are not equally in love with each other; the conventional Crich refuses Birkin's proposal. Birkin is left with the woman he loves, but he feels incomplete without a male partner.

J. R. Ackerley's play *The Prisoners of War*, produced in 1925, equates homosexual and heterosexual sorrows, but it offsets tragedy with a happy queer coupling. The

[14] Arthur Schnitzler, *Anatol*, trans. Granville Barker (New York: Mitchell Kennerley, 1911), 109.

[15] D. H. Lawrence, *Women in Love* (New York: Modern Library, 1950), 402–3.

[16] Ibid. 310.

prisoners awaiting repatriation include Captain Jim Conrad, a novelist. (Ackerley, combining the real novelist's name with Conrad's *Lord Jim*, seems to have noted the queerness of 'The Secret Sharer'.) Ackerley's Conrad longs for another prisoner, Grayle. But Conrad cannot express his confined eros. At war with himself, he is driven to assault Grayle, then falls into melancholic isolation. The play is not a tragedy of psychological–medical victimization, however. It includes a 'normally' married male prisoner, another exemplar of the straight–gay alliance of the period. It is this character who tries to make Conrad accept his desire for Grayle. Surprisingly, if we expect a drama about male–male love to end in homosexual self-destruction, Ackerley's play ends with heterosexual suicide. The married man kills himself on hearing that his wife has died. Meanwhile, another male pair counterpoints Conrad's alienation and the married man's grief. The happy couple, holding hands on stage, and even simulating sexual ecstasy by playacting an aeroplane flight (one man seated closely behind the other), plan a post-war life together in Canada.

Noel Coward's *Design for Living* (1933) shows that the Ibsenite revolution remains vital into the 1930s. Coward's Otto, Leo, and Gilda constitute a ménage—originally a pairing of the men, which is then broken up by Gilda's initiation of an affair with Otto. When Gilda sleeps with Leo, Otto walks out, as much because of his possessiveness towards Leo as his jealousy about Gilda. In time Gilda, unable to tolerate her desire for both men, leaves them, and marries someone else. But Otto and Leo can't live without each other, or without Gilda. And she can't live without them. The trio decide to break up Gilda's marriage, and to reunite, in the absence of any social design that might regulate their queer practice. Gilda's husband calls it a 'disgusting three-sided erotic hotch-potch'.[17] But queer modernism appears not to have a bitter taste for Coward's opposite-sex/same-sex lovers, or for Coward's audiences.

CITIZEN QUEER

Queer modernism promotes the idea that liberation of same-sex eros is an ultimate realization of democracy. The revolt against marriage is, after all, a political impulse, anti-patriarchal and anti-dictatorial. In the struggle to liberate eros from the dictatorship of marriage, the liberation of women and the liberation of homosexuality become vanguard political callings. To be sure, to single out homosexuals as dedicated beasts of democratic burden is to potentiate a hardening of distinct erotic identities that is at odds with queer inspiration. Nevertheless, it is the ideology of democracy—not only of punitive jurisprudence or medicine—that aids the construction of the citizen queer. Blurring the straight–gay divide also plays its role. One builder of a queer political vocation is Walt Whitman. His egalitarian ethos (and his

[17] Noel Coward, *Play Parade* (Garden City, NY: Garden City Publishing, 1933), 110.

proto-modernist aesthetic) confounds attempts to fix genders and object choices, leading turn-of-the-century modernists to characterize homosexuals as ideal members of any republic.

Symonds's work, begun in the 1870s, argues that ancient Greece recognized 'sexual inversion' as a spur to education, military valour, and citizenship. In the modern world same-sex love can have the same function because, Symonds proposes, if it is accepted instead of criminalized, it can cross—and erase—class, gender, national, and racial boundaries, thereby fulfilling egalitarian progress. The model for it, Symonds argues, is Whitman, who 'recognizes among the sacred emotions and social virtues, destined to regenerate political life and to cement nations, an intense, jealous, throbbing, sensitive, expectant love of man for man . . . a love that finds honest delight in hand-touch, meeting lips, hours of privacy, close personal contact'.[18] Carpenter enlarges on Symonds's ideas. The human sexual constitution is as pluralist for Carpenter as for Freud. But Carpenter also believes that homosexual men and women are especially fitted for evolutionary advancements of civilization. In primitive societies 'intermediate types'—priests, priestesses, medicine men, witches, artists, heroic male and female warriors—transcended ordinarily gendered expectations when they loved their own sex and did not merely breed. Because their differing desires abstracted them from convention, their thought became divination, originating religion as well as profane cultural achievement. They also conduced to gender enfranchisements and still do so. Homosexual temperaments in ancient Sparta, Carpenter proposes, favoured 'freedom and self-dependence and political activity of women. In present-day life, it is the [homosexual] classes of men . . . who chiefly support the modern woman's movement'.[19]

The alliance of same-sex love with egalitarian possibility dominates the imaginations of queer modernists. Rolfe's Pope Hadrian—whom Carpenter would have designated 'the intermediate as priest'—opposes the British Liberal and Labour parties because he thinks they are self-promoting capitalists in sheep's clothing. In contrast, Hadrian is to be understood as genuinely radical because Rolfe imagines him, the tender pastor of a same-sex couple, as an anarchist within the Church. In the anarchist spirit Hadrian sells off the entire Vatican collection of antiquities and art in order to transform Italy into a progressive, secularly administered, modern social welfare state.

Wilde in 'The Soul of Man Under Socialism' (1890) had formulated a queer anarchist spirit by annealing anarchist individualism and socialism. Firbank develops Wilde's paradoxical blend by assigning eros a further egalitarian thrust: queer love undermines imperialism. In Firbank's novel *The Flower Beneath the Foot* (1924) the imaginary kingdom of Pisuerga accepts, for profit's sake, subjection to Great Britain. Before submitting to de facto imperialism, Pisuerga has been a happily multicultural country, mingling Christian and Muslim elements, and tolerating intimacies that overleap class and ethnic barriers. Lesbianism is a routine part of its court amours (and a former prime minister lives on a Pisuergan island with a choirboy lover). The British takeover

[18] John Addington Symonds, *Male Love* (New York: Pagan Press, 1983), 101.
[19] Edward Carpenter, *Intermediate Types Among Primitive Folk* (New York: Arno Press, 1975), 111.

treads this freer life under foot. But Firbank imagines a group of young North African gay males, migrant workers in a Pisuergan flower shop, who are partly the trodden flowers of the novel's title and partly exponents of a liberty that is superior to the economic and state structure that they adorn. That the flower shop workers turn nature into decorative artifice pairs them with Firbank the artist–novelist, whose own combination of modernist artifice and homosexuality makes him another rootless migrant. It is a saving rootlessness, however, because it expresses a potential for a democratizing, anti-imperialist, and cosmopolitan queer citizenship.

The progressive political potential of queer sexuality inspires Lytton Strachey. Allied with Carpenter and Freud, Strachey sees world-historical figures anew in the light of 'intermediacy'. In *Elizabeth and Essex* (1928) Queen Elizabeth I is a proto-feminist, evading gender identities ('all steel one moment and all flutters the next'[20]). Essex stands for patriarchal manhood, a rigid contrast between what is male and female. When Elizabeth beheads him, 'manhood was overthrown at last',[21] and modernity and modernism come into view. One agent of the overthrow is Strachey's queer Francis Bacon (whose mother complains about expenses Bacon incurs on behalf of male bedfellows). Bacon complements the queen: their 'two most peculiar minds' are nicely matched.[22] Their peculiarity, derived from their deviation, is also their strength. Strachey's Elizabeth and Bacon forecast a politics of sex and gender that belongs to post-war government and citizenship.

T. E. Lawrence, soldier, political agent, political intermediate as well as sexual intermediate, appears to step into history out of the pages of Symonds, Carpenter, Freud, Rolfe, Firbank, and Strachey. He arrives when what needs democratization is not only the nation but the globe. Lawrence in the First World War undertook to organize a revolt of Arab territories against Turkish imperialism, for the sake of Arab autonomy. In fact, as Lawrence painfully learned, he was helping Arabs to exchange a Turkish imperialist yoke for a British one. Nevertheless, the struggle for liberation which he stimulated started a century of anti-imperialist resistance in the Middle East. Lawrence's 1926 memoir of the revolt involves homosexuality with dedication to anti-imperialist aims. It asserts that 'the need to fight for an ideal'—freedom— became a 'merciless taskmaster' that 'drained' those it possessed of 'morality, of volition, of responsibility'.[23] Lawrence's understanding of ideal liberty (even as a paradoxical form of possessed enslavement) couples liberation with male–male love. Such eros, Lawrence says, was 'a sensual co-efficient of the mental passion which was welding our souls and spirits in one flaming effort'.[24] When Lawrence consents to Emir Feisal's request that he adopt Arab dress as a substitute for a military uniform, a servant fits Lawrence with 'splendid white silk and gold-embroidered wedding garments which had been sent to Feisal lately (was it a hint?)'.[25] The parenthesis

[20] Lytton Strachey, *Elizabeth and Essex* (San Diego: Harcourt Brace Jovanovich, 1956), 271.
[21] Ibid. 263. [22] Ibid. 222.
[23] T. E. Lawrence, *Seven Pillars of Wisdom* (New York: Doubleday, 1935), 29.
[24] Ibid. 30. [25] Ibid. 126.

reads in a double way, especially in light of 'sensual co-efficients'. Later in the struggle, when Lawrence is captured by Turks and brutally beaten as part of a sexual violation (to which he responds erotically), Lawrence describes the event in terms of 'tactical deductions' he has devised for the revolt.[26] The tactics strikingly mark a confluence of anti-imperialism and queer eros. Lawrence eschews activist engagement for 'a war of detachment' and for what he mysteriously calls 'the pathic, almost the ethical'.[27] 'Pathic' is a traditional term for a passive partner in homosexual intercourse.

Christopher Isherwood exemplifies another variant of homosexuality's egalitarian calling. In Isherwood's novel *The World in the Evening* (1954) an American serviceman in the Second World War remarks: 'Compared with this business of being queer, and the laws against us, and the way we're pushed around even in peacetime—this war hardly seems to concern me at all.'[28] What matters more is militancy on behalf of gay rights. But Isherwood's memoir *Christopher and His Kind* (1976), about Isherwood's life in 1929–39, revises the call to militancy. As war approaches, Isherwood tries to rescue his lover Heinz from German citizenship, which will force Heinz into the military—or into a concentration camp for 'degenerates'. The rescue attempt fails, in part because a gay immigration officer, who perceives that Isherwood and Heinz are lovers, rejects Heinz's attempt to enter England, on the basis of English laws against same-sex eros. The officer honours his national allegiance more than his fellow homosexuals, whom he is willing to sacrifice to the same criminalization of queer love that ruined Wilde. Isherwood takes this as an object lesson: modern democratic citizenship exists by invidiously defining itself against those it excludes, reproducing imperialism and variants of fascism within itself. It notoriously excludes 'kinds' whom it finds not religiously, racially, ethnically, or sexually acceptable.

In the face of modern democracy's self-contradictions, Isherwood decides 'never [to] deny the rights of his tribe, [and] never . . . [to] sacrific[e] himself to . . . the Greatest Good of the Greatest Number'.[29] He decides also, when Heinz is drafted, that he cannot kill Germans, for they would include others as guiltless of fascism as Heinz, and it would not be acceptable to kill the innocent, no matter what circumstances obtain. Nationalism is part of the problem. In the wake of queer modernism, citizenship for Isherwood comports best with cosmopolitan exile. The citizen queer can belong to no modern country because his experience exceeds the scripts that define public life and that remain attached to aggression rather than peace.

Moreover, the queer 'kind' resist the fixed identity that goes along not just with citizenship and sexual norms but also with selfhood. The narrative of *Christopher and His Kind* breaks with self in a way that renews modernism's experimentalism; it repeats, for example, Dorothy Richardson's fracturing of her narrator's identity in *Pilgrimage*. The motive for such a break-up are multiple identities that time produces

[26] Ibid. 195. [27] Ibid. 194–5.
[28] Christopher Isherwood, *The World in the Evening* (New York: Farrar, Straus, Giroux, 1988), 281.
[29] Christopher Isherwood, *Christopher and His Kind* (New York: Farrar, Straus, Giroux, 1976), 335.

in any subject. Isherwood in 1976 is and is not the 'Christopher' of 1929–39. The fact that 'Christopher' is a novelist complicates matters. For 'Christopher' has invented additional identities for himself in his books, and has done the same for persons he knew in his past. The resulting multiplication of selves is a characteristically queer modernist unsettling of certainty.

BEYOND POLITICAL VOCATION

Sexual liberation in the years between world wars in the twentieth century vindicates the queer assault on marriage—even if the marital institution lamely continues thereafter. But under the pressure of wartime and post-war disillusionment, the democratic vocation of queer eros begins to look implausible if only because democratic vistas dwindle to the status of a dogmatic script of the kind that modernism is bound to undermine. Liberal democracy's compromises—its openness to jingoism and fascism; its betrayal by capitalism, imperialism, socialism, and communism alike; its refusal to decriminalize queer desire—argue a need for queer eros to retreat from political mega-narratives that run the world. Why drag the queer human sexual constitution backwards by delimiting it in terms of already spoiled modes of social and political life? Or by submitting it to a heroic narrative (such as Carpenter's story of the intermediate redeemer of democratic civilization) when modernism characteristically subverts such narrative?

These questions do not signal the end of queer modernism, however. They issue from an antinomian impulse that it sets loose. After the assault on marriage, queer antinomianism expresses itself as a general aggression against norms, even those associated with democratic dogma. The dogma becomes unproductive when components of queer alliances come apart, insisting on their separate identities and politics. Examples of such insistence, whereby political claims bode ill for queerness, emerge from the Harlem Renaissance in Wallace Thurman's *Infants of the Spring* (1932) and from an Anglo-Indian context in J. R. Ackerley's *Hindoo Holiday* (1932). In Thurman's novel a black writer, Raymond, and a white intellectual, Stephen, become intimates. Raymond wants his friendship with Stephen to transcend racial and sexual politics because he thinks that life must not be defined according to ideological crusades. Thurman underwrites Raymond's desire for transcendence by doubling it in a black painter who admits to bisexuality, and who, when asked if he prefers sex with women or men, answers: 'After all there are no sexes, only sex majorities, and the primary function of the sex act is enjoyment . . . I enjoyed one experience as much as the other.'[30] Unfortunately, the pressure to cast eros into roles that invite knee-jerk social or political performance destroys the friendship between Raymond and

[30] Wallace Thurman, *Infants of the Spring* (Boston: Northeastern University Press, 1992), 44.

Stephen, as well as the bisexual painter, who commits suicide. His action, suggesting a reactionary will to identify with Wilde as a victimized queer, plays into a separatist narrative about eros that Raymond wants to avoid. But in order to avoid it, Raymond must become, he says, not 'a social creature in the accepted sense of the word'.[31] It is in the realm of 'social creatures', where pre-existing political visions regulate racial and erotic behaviour, that love between Raymond and Stephen is undone.

Hindoo Holiday also expresses—in the light of queer eros—an unease with political frameworks. The book records Ackerley's employment in India in 1923 as a private secretary to a queer maharajah. The relations of ruler and secretary are interwoven with jealousies about each other's boyfriends, and are complicated by cultural differences that each is shaped by but also wants to escape from. But in describing his passage to India, Ackerley exhibits a peculiarly withdrawn relation to its political dimensions. When he describes romantic success with Hindu males (one of whom allows Ackerley to kiss him on the mouth, despite religious taboos), Ackerley's delicately modulated account wards off any considerations that are not personally immediate. His motive might lie in a portion of his text—a memory of being under fire in France in 1917 that has nothing to do with eros—that he omitted from the book's first edition. Ackerley remembers coming upon a wounded German soldier desperately signalling for first aid; before Ackerley can respond, his orderly rushes forward, shoots the man dead, robs him, and vaunts his act. The memory seems to express a horror Ackerley feels for all action justifiable by, or referable to, political principles. Invoking them appears to entail inevitable deadly enmity, which is why Ackerley keeps them distant.

Queer modernism's swerve from political engagement proposes same-sex love as a measure of the inadequacy of all political models whereby the contemporary world is ordered; it simultaneously suggests that social being and queer eros are inevitable antagonists. The queer side of the antagonism, and not the social one, comes to be favoured.

Willa Cather's *The Professor's House* (1925), a novel about male–male love by an author who resented attempts to categorize her love of women, exemplifies the anti-political, antisocial swerve. The professor is a distinguished historian who has loved, and has lost to the world war, Tom Outland, his quondam research assistant who had become entangled in implicitly bisexual ways with the professor's wife and daughters as well as with the professor. The professor regards Outland as the 'second infatuation'[32] of his life, his wife being the first; and he sleeps under a blanket that belongs to lost Tom. 'Nothing could part me from that blanket,' he says; to which one of his daughters responds: 'He wouldn't have given it to anybody but you. It was like his skin.'[33] The older man's sleeping with the skin of the younger expresses a secret relationship with Tom, one that is unresponsive to definition. Accordingly, the professor refuses to have his history with Outland 'translated into the vulgar

[31] Ibid. 193.
[32] Willa Cather, *The Professor's House* (New York: Vintage, 1953), 49.
[33] Ibid. 130.

tongue'.[34] 'Your bond with [Tom] was social,' the professor tells his daughter—whom Outland had proposed to marry—'and it follows the laws of society, and they are based on property. Mine wasn't, and there was no material clause in it.'[35] 'The vulgar tongue' would betray what the professor feels is intensely hermetic: an antisocial or asocial relation. By pitting queer longing against opposite-sex marriage and family—Cather too is in the anti-marriage alliance—the novel suggests a desperate need to get beyond a proper, propertied order. It would seem, then, to point to a socialist or communist political model or narrative as a way forward. Yet it does not, as if such alternatives would only entrap it in another vulgar tongue. To increase her novel's distance from regulatory language, Cather employs a typically modernist, disjunctive, and disorientating narrative structure to tell the professor's queer story.

A theory of how queer eros withdraws from politics in the inter-war period is discoverable in an unlikely 'straight' source: modernist arch-satirist Wyndham Lewis. Lewis is unjustly regarded as homophobic and misogynist. Certainly he believes that the high profile of homosexuality in modernism results from nefarious developments. In *The Art of Being Ruled* (1926) he criticizes 'women' and 'homosexuals' for grouping themselves under classificatory labels. But that is because he believes classification makes it easier for power to rule them. And Lewis finds that, although feminism and queer eros undo male patriarchy, patriarchy is being reconstructed as a 'gigantically luxorious patriarchate [that] democracy and monster industry together have invented.'[36] But being himself against patriarchy, Lewis leagues with all who subvert it. *The Art of Being Ruled* attempts to instruct his allies about their co-optation far more than it aims to devalue them. Indeed, Lewis does not devalue them. For he locates in all who are governed—the mass of humankind—a creative capacity for withdrawal from action, especially political action, which Lewis judges to be inextricable from oppression and violence. It is better for 'the people' to have a spectator's role in relation to governmental action than to participate in it. The spectator's role is 'godlike', because detachment, and passivity, are 'privileges' and afford 'greater mental satisfactions' than activist engagement.[37]

Lewis identifies his own art with such detachment—and with his version of queer Shakespeare in his study of the dramatist *The Lion and the Fox* (1927). Shakespeare's same-sex eros, Lewis declares, feminizes him. That alienates him from what Lewis calls the 'agent-principle' of the Renaissance—a brutely masculinist idol of agency at the root of Renaissance imperialism and abuse of power.[38] Shakespeare admires great examples of the agent-principle that he himself invents for the stage; nevertheless, Lewis hypothesizes, Shakespeare's spectatorial detachment incites his tragedies, in which Shakespeare prefers to celebrate the Hamlet-like loss of male powers of action and rule.

[34] Cather, *The Professor's House*, 62.
[35] Ibid. 63.
[36] Wyndham Lewis, *The Art of Being Ruled*, ed. Reed Way Dasenbrock (Santa Rosa, Calif.: Black Sparrow Press, 1989), 181.
[37] Ibid. 302.
[38] Wyndham Lewis, *The Lion and the Fox* (New York: Harper and Brothers, n.d.), pt 4, *passim*.

Djuna Barnes's modernism is unafraid to exchange political action for passion and passivity. Barnes's Dame Musset, the heroine of *Ladies Almanack* (1928), thinks of the 1880s and 1890s as a more exciting time because lesbianism then was not the fashionably political thing it has become. When Musset encounters younger women who are activists on behalf of gay marriage and gay parenting, she finds them tediously opposed to the risks of promiscuity. 'Love of Woman for Woman should increase Terror' not consort with legalization.[39] After Musset dies, her tongue withstands cremation, and performs cunnilingus. Barnes thereby suggests eros's undying defiance of ordinary articulations, including political terms. Experimenting with language, *Ladies Almanack* forges an artificial modernist style out of Jacobean components, to facilitate a reader's detached distance from its subjects. Barnes's *Nightwood* (1936), which continues her modernist resistance to straightforward speech and meaning, represents the bitter taste of love between two women, but it assigns one of the women to a transvestite gay counsellor. He recalls Lewis's Shakespeare. His detachment and passivity are intended as a lesson for his unhappy patient, who wrongly wants to master and to govern the woman she desires.

'The tragedy of the spirit when it's not content to understand but wishes to govern'[40] is illustrated by another queer text from 1936: the pragmatist philosopher George Santayana's *The Last Puritan*. The puritanism of Santayana's protagonist, Oliver Alden, inheres in his will to rule. Oliver wants to command eros—especially his own queer kind. He falls in love with his father's beloved, a sailor nicknamed Lord Jim (Conrad's availability to queer imaginations endures), but Oliver won't recognize his passion; nor does he allow himself to recognize his ensuing desire for his glamorous cousin Mario. Mario, the narrator says, 'was what men of the world had always been, brilliant slaves of their circumstances'.[41] Because Oliver insists that he will dominate circumstance, he is foredoomed. Santayana applauds Mario, and unregulated desire: each exemplifies acceptance of what comes. The acceptance, a deferment of action and heroism, seems to Santayana a better adventure than any political possibility.

Scepticism about politics and distance from 'the vulgar tongue' propel queer modernism towards the twenty-first century. Hart Crane's *The Bridge* (1930) is an American nation-centred epic, yet its opaque language is at odds with public utterance. Its speaker appears to address his poem when he exclaims 'Only in darkness is thy shadow clear.'[42] Queer eros prefers obscurity to normative meaning. And even as Crane celebrates the sublime epic of American technology, he also celebrates its crashing failures. Crane redirects *vita activa* towards a pathic undergoing of action. Summoning Whitman as a pathic double, Crane inverts the heroic agency with which the earlier poet was invested by Symonds and Carpenter. European and Latin American writing furnish similar derangements of expected

[39] Djuna Barnes, *Ladies Almanack* (Elmwood, Ill.: Dalkey Archive Press, 1992), 20.
[40] George Santayana, *The Last Puritan* (New York: Charles Scribner's Sons, 1936), 10.
[41] Ibid. 509.
[42] Hart Crane, *The Complete Poems* (Garden City, NY: Doubleday, 1966), 46.

associations. In Spain, Federico García Lorca's last play, *The Public* (1936), is a phantasmagoria that dissolves boundaries—between illusion and reality, between genders, between 'homo' and 'heter'—to illustrate that 'love is pure chance'.[43] Accordingly, what is expected of love and what is expected of drama's responsibilities to 'the public' must be dissolved. In Cuba, José Lezama Lima's novel *Paradiso* (1968) includes explorations of eros that require a 'perversion' of language. For they meditate queer anal eroticism, which the novel associates with the Egyptian god Anubis, divinity of same-sex love 'who wants to guide where there are no paths', and whom the Greeks 'never lose sight of . . . in all his . . . sexual transformations'.[44] The pathway of Anubis' metamorphoses is 'the mysterious labyrinth' of analogies that underlies cognition and art. Guidance through such labyrinths depends upon 'anastrophe', an inversion or unusual ordering of words or clauses that 'recalls the anality' of the god.[45] Lezama's anastrophic art includes an inversion of the superior value assigned to action in comparison with passive suffering.

Castro's Cuba, a state machine promising an ultimate realization of democratic dogma, resists the anastrophes of both queer eros and revolutionary straight–gay alliances. Perhaps consequently, the Cuban novelist Reinaldo Arenas refuses to instrumentalize homosexuality for politics. Intransigently dissenting from state power and group identity, Arenas apparently accepts the state's designation of him as 'antisocial'.[46] The epithet can be related to Arenas's declaration that 'The beauty of a sexual relationship lies in the spontaneity of the conquest and in its secrecy'.[47] Inspired by Lezama's anastrophe and in line with secrecy, Arenas's fiction reasserts a modernist undoing of narrative that replaces it with lyric utterance. The lyricism withdraws from publicity into secret labyrinths of feeling, 'a territory that escapes the control of the political police'.[48] Having suffered years of imprisonment in Cuba for being queer, Arenas ultimately escapes to New York. But he does not rejoice in American capitalism or its democratic mask. He becomes an exile, with 'no place anywhere'; 'nor do I want to be included under any opportunistic or political label'.[49]

A contrastive case to that of Arenas seems to present itself in *Prisoner of Love* (1986), the last work of the French modernist Jean Genet. Genet's novels from the 1940s celebrate gay outlawry, but *Prisoner of Love* recounts another queer alliance: Genet's association with Palestinian guerrillas at war with Jordan, Israel, and Syria; and with Black Panthers in the US. Writing sympathetically about those groups, Genet affirms a commonly shared desire to project self-images that will inspire an egalitarian future. Nevertheless, Genet represents his models of revolt warily. Despite his feeling for the future, his book is anti-teleological and anastrophic: it is without

[43] Federico García Lorca, *The Public and Play Without a Title*, trans. Carlos Bauer (New York: New Directions, 1983), 43.

[44] José Lezama Lima, *Paradiso*, trans. Gregory Rabassa (Austin: University of Texas Press, 1988), 352, 353.

[45] Ibid. 354.

[46] Reinaldo Arenas, *Before Night Falls*, trans. Dolores M. Koch (New York: Viking, 1993), 278.

[47] Ibid. 179. [48] Ibid. 87. [49] Ibid. 293, 301.

an identifiable beginning, middle, or end. And it amounts to no manifesto of a political position. Genet, a permanent exile (in image, at least), seeks to avoid 'the allurements of rebellions whose apparent poetry conceals invisible appeals to conformity'.[50] Surprisingly, Genet subordinates his queer modernism to spectatorship. 'The various hazards that have allowed me to survive in the world don't allow me to change it, so all I shall do is observe, decipher and describe it.'[51] This does not mean that Genet's descriptions are not partisan. Even so, Genet perplexes activism. To be a prisoner of love—of whatever kind eros imposes—is to suffer constraint. The vocation of Carpenteresque queer leadership is submerged, even reversed. Arenas and Genet have opposite political leanings, but they end up on the same detached side.

The queer modernist writing that evades political formulas makes no appearance in Sedgwick's critical writing. *Epistemology of the Closet* intends to enhance liberation, although in Sedgwick homosexuality is an object of liberation, not its agent. But queer theory after Sedgwick is decidedly in tune with queer modernism's deviance from its original political mission. Tim Dean moves away from interest in queer identity inasmuch as it is assumed to aim at 'individual liberty and autonomous agency'.[52] The assumption, assigning superiority to autonomy, creates a 'hierarchy of political seriousness' that might 'betoken heterosexist logic'[53] or return eros to the mechanisms it was modernism's purpose to revolutionize. Following Freud's heir Jacques Lacan, Dean reminds us that all sexual desire is unconscious. The unconscious is the root of desire's unaccountable character. Desire does not synchronize with reproductive function, and is 'incompletely assimilable to the ego...hence inimical to the person, fundamentally impersonal'.[54] In its fundamental impersonality, eros is at odds with the intelligible social matrix in which individuals establish bounded identity. As many queer modernists claim, and as Dean's argument confirms, queer eros is antisocial. Inimical to the puritanism that is government, it can't be harnessed to political use. While this might seem to be a bleak view, it is not. Dean emphasizes eros as an unruly but eternal excess of drive or impulse (and not as an eternal lack). In relation to this excess the ego—'the self-governing agent who is master of his world because master of himself'[55]—is undone. Surrender to the undoing suggests a radical alternative to public aims.

A related theory about the distance of queer eros from the body politic is Lee Edelman's. Edelman argues that 'the queer, in the order of the social, is called forth to figure...the negativity opposed to every form of social viability'.[56] Politics is a supreme instance of viable form; the production of children for the sake of the

[50] Jean Genet, *Prisoner of Love*, trans. Barbara Bray (Hanover, NH: Wesleyan University Press, 1992), 293.

[51] Ibid. 205.

[52] Tim Dean, *Beyond Sexuality* (Chicago: University of Chicago Press, 2000), 224.

[53] Ibid. 225. [54] Ibid. 238. [55] Ibid. 241.

[56] Lee Edelman, *No Future: Queer Theory and the Death Drive* (Durham, NC: Duke University Press, 2004), 9.

future, with its opposite-sex reproductive matrix, undergirds politics. But for Edel-
man 'the only queerness that queer sexualities could ever hope to signify would
spring from their determined opposition to this underlying structure of the polit-
ical'.[57] The opposition also would insist, Edelman explains, that desire resists intelli-
gibility. Queer modernism's disorientation of sense—as in its experiments with
narrative and language—instances the queerness that Edelman defines as 'unregen-
erate, and unregenerating, sexuality'.[58]

 If the recent queer theorists are right—and the queer modernist texts I have
traversed in this section strongly support them—queer eros throws into suspense
our understanding of what is 'social'. But the suspense, Dean suggests, might be
temporary: an interval from which new forms of relationship can emerge. Ibsen's
scripts suspended their audiences' understanding of social being; but one result was
queer modernism. The idea of such suspense can be linked to the creatively passive
pleasures and 'greater mental satisfactions' of aesthetic spectatorship. Indeed, aes-
thetic experience, according to Dean, is *the* entryway to new forms of relatedness
(although in Dean's argument aesthetics requires submission of mental satisfactions
to eros). Art shows us what eros perceives beyond social order, hence 'beyond
sexuality'. Art is not a sublimation of eros, however. Art, Dean argues, immediately
manifests the queer character of eros.

 Our understanding of 'homosexual definition', Sedgwick thinks, is close to what
Marcel Proust's 'probably was'. How might we understand that definition, given the
present chapter's story of queer modernism, and given Dean's and Edelman's recent
work? The thread of modernism that subverts agency in light of same-sex eros shows
itself in Proust as an object of representation and a model for aesthetics. In *Cities of
the Plain* (English version, 1927) Proust's narrator discovers multiple homosexual
liaisons among persons—including his beloved Albertine—whose eros he had not
known. It is thanks to his captivity by Albertine that he undergoes revelations of the
strangeness of all desire. Moreover, queer eros makes him a prisoner of love because
he cannot compete with queer rivals according to habits of government that his
conventional sexual orientation would seem to license. Unable to rule Albertine,
Proust's narrator undergoes a revelatory arrest of will: the involuntary medium of the
famous Proustian moment of vision whereby an aspect of the past is revived, and
time is overcome. Curiously, given the dedication of Proust's fiction to society, the
involuntary state, in which a finer and timeless knowledge of experience rises into
view, depends on a withdrawal from social life. Robert de Saint-Loup, for example, in
refusing to participate in the Verdurin circle, persuasively insists that to belong to a
social world is deadening. The final pages of *Cities of the Plain* lament the destruction
by social reality of visions that are involuntary: visions that creatively detach one
from what is commonly, coarsely, taken to be real.

[57] Edelman, *No Future: Queer Theory and the Death Drive*, 13.
[58] Ibid. 47.

Instead of making the social world new, the Proustian narrator (and the Proustian aesthetic) sees the social world anew, in a moment of passivity. Would such vision not be a prerequisite for taking subsequent deliberate action on behalf of innovation? And does the Proustian narrator's withdrawn and passive vision not inwardly level the world's hierarchies (the social and moral ones that dominate eros), as a promise of external egalitarianism? Affirmative answers to both questions are possible. Proust's queer modernism, predicting later queer works to come, retreats from the heroism of action that Symonds and Carpenter and their allies idealize. Nevertheless, it perhaps restores the goals of the earlier ideal in a different form.

CHAPTER 12

...

LESBIAN SEXUALITY IN THE STORY OF MODERNISM

...

JOANNE WINNING

WHAT might it mean to talk about the story of sexuality in modernism? In what ways is it necessary to acknowledge, to quote Karla Jay, that 'there are many modernisms' and to redress the imbalance in which 'what is missing from traditional literary explorations of modernism is a recognition of the important role lesbians had in formulating it'?[1] The aim of this chapter is to consider some of the key issues that arise in the study of sexuality within modernism, and some of the ways in which modernist critics have responded to these. The central difficulty of undertaking analysis of the issue of sexual identity within modernism is that it requires working across different discursive and disciplinary boundaries. The analysis of sexual identity requires an understanding of sociocultural and affective issues and frames while the analysis of the cultural forms of modernism involves the skills of literary and critical reading, as well as the consideration of cultural context. In this sense, multiple interpretative angles can, and must, be taken on the issue of sexuality within modernism.

As an introduction to such analysis I want to consider the example of a little-known modernist literary artefact, *The Contact Collection of Contemporary Writers*,

[1] Karla Jay, 'Lesbian Modernism: (Trans)Forming the (C)Anon', in George E. Haggerty and Bonnie Zimmerman (eds), *Professions of Desire: Lesbian and Gay Studies in Literature* (New York: Modern Language Association of America, 1995), 72–3.

published by Robert McAlmon's Contact Press, in Paris in 1925.[2] While it may read like a 'roll of honour' from the modernist network and have been of some interest on the Paris scene in 1925, the *Collection* is the kind of small cultural object which falls through the net of later critical and cultural attention, lost under the sheer weight of the material remains of the modernist period: books, magazines, letters, diaries, notebooks, photographs, and works of criticism. Perhaps the greatest significance of the volume is clear when it is viewed as a kind of symbolic artefact in the stories that get told about modernist culture and production and the way in which sexual identity has been occluded in these, both because dominant high modernism would seem to repudiate lesbian sexuality on account of what Shari Benstock calls its 'fear of contamination', and also because of the failure of late twentieth-century modernist criticism to take sexual politics into account.[3]

On its verso frontispiece, the *Collection* gives its List of Contributors as a statement of its credentials in the cultural production of modernism. It lists extracts of works in progress by twenty modernist practitioners. Several of these extracts went on to become parts of familiar, iconic modernist texts, such as James Joyce's *Finnegans Wake* and Dorothy Richardson's *Pilgrimage*. There are stories and writing samples by writers which have come to figure centrally in the story of modernism told, and more latterly revised, by later twentieth-century critics: Djuna Barnes, Bryher, Mary Butts, Ford Madox Ford, Ernest Hemingway, H.D., James Joyce, Mina Loy, Ezra Pound, Dorothy Richardson, May Sinclair, Gertrude Stein, and William Carlos Williams. There are also contributions by lesser-known writers, or surprising inclusions from figures who are known best in other fields of early twentieth-century cultural, literary, and aesthetic discourse: Norman Douglas, Havelock Ellis, Marsden Hartley, John Herrman, Wallace Gould, Robert McAlmon, and Edith Sitwell.

One of the first ways in which one might think about sexuality in modernism is in the very fact of the *Collection*'s existence and its cultural production. The roll-call of names in the *Collection* speaks of the large and complex network of practitioners and lines of connection and influence, some of which are structured through sexual identity. One example of this is the central relationship behind the publication in the marriage of convenience between Robert McAlmon and Bryher, key modernist writer and patron. It was Bryher's private income that bankrolled McAlmon's Contact Press, and her extensive relationships with writers and artists that helped McAlmon produce his list of contributors. One example of this is the inclusion of Havelock Ellis's 'A Note on Conrad'. Ellis was extremely important to Bryher, in both personal and intellectual terms, and his inclusion in the *Collection*, with this short piece of criticism, will have been orchestrated by Bryher, who considered him one of the central thinkers of the period. Bryher's own account of gender identity in her

[2] See Robert McAlman (ed.), *Contact Collection of Contemporary Writers* (Paris: Three Mountains Press, 1925).

[3] See Shari Benstock, 'Expatriate Sapphic Modernism: Entering Literary History', in Karla Jay and Joanne Glasgow (eds), *Lesbian Texts and Contexts: Radical Revisions* (London: Onlywomen Press, 1990), 186; Mary E. Galvin, *Queer Poetics: Five Modernist Writers* (Westport, Conn.: Praeger, 1999), 5.

autobiographical fiction must be read for its sexological inflection, as well as its attempt to make an intervention within the cultural discourses on lesbian subjectivity. Moreover, the figure of Ellis points to the need for an analysis of cultural discourse and context since Ellis provides one of the central discursive contexts for lesbian modernism through his sexological writings on inversion. Indeed, any nuanced examination of sexuality and modernism must examine sociocultural context and discourse if it is fully to comprehend the terms of lesbian modernism.[4]

Modernist texts, as discursive forms, inscribe themes and representations of dissident sexual desire and identity. In the *Collection*, as in the many and varied examples of lesbian modernist textuality, critical readings of these themes and representations must undertake the kind of sensitive reading which looks to the in-between spaces to determine meaning. Lesbian sexuality articulates itself most fully here in texts by Djuna Barnes, Dorothy Richardson, and Gertrude Stein. In Barnes's story 'A Little Girl Tells a Story to a Lady', the themes of childhood and reproduction are unsettlingly interwoven with sexual desire between the women and while lesbian sexuality is never directly expressed, its trace haunts the story.[5] In Dorothy Richardson's 'Work in Progress', an extract that was to be included in *The Trap*, the eighth novel in her thirteen-novel series *Pilgrimage*, the central protagonist, Miriam Henderson, meets and begins to share digs with a young woman who is engaged in promoting the socialist beliefs of the Lycurgans (Richardson's fictional name for the Fabians). Miriam attempts to draw Miss Holland into a closer, more intimate friendship by taking her for a late-night coffee to Donizetti's, the Italian café that has come to symbolize her social and intellectual autonomy. Yet Miss Holland is horrified by the lateness of the hour and the heterogeneity of the patrons—'all sorts of queer people', as Miriam describes them.[6] As in the rest of *Pilgrimage*, the extract articulates lesbian subjectivity in its representation of Miriam's complex gender identity and identifications. In the feelings of rejection she experiences at Miss Holland's refusal to engage, she comforts herself by taking on a male role, as she often does throughout *Pilgrimage*: 'Like a husband's life the life he goes off into in the morning and can lose himself in, no matter what may be going on at home.'[7] Miriam retreats from her brief 'flirtation' with Miss Holland, describing it again in heterosexual terms: 'By the time they reached home she felt free from all interest in Miss Holland and saw their contract as it had first appeared, a marriage of convenience.'[8]

[4] As I will show, the terms to describe the phenomenon of lesbian sexuality within modernism are varied. I adopt the term 'Lesbian modernism' in this chapter, with 'Lesbian' capitalized, except where other critics use other terms or 'lesbian' in lower case. See also my *The Pilgrimage of Dorothy Richardson* (Madison: University of Wisconsin Press, 2000) and *Lesbian Modernism: A Cultural Study* (forthcoming).

[5] Its inclusion in Robert McAlmon (ed.), *Contact Collection of Contemporary Writers*, was the first publication of the story. It was later revised and published in the 1962 collection *Spillway* under the title 'Cassation'. See Djuna Barnes, *Spillway* (London: Faber and Faber, 1962), 20–30.

[6] Dorothy Richardson, 'Work in Progress', in McAlmon (ed.), *Contact Collection of Contemporary Writers*, 218.

[7] Ibid. 220. [8] Ibid. 220–1.

When they return to their shared room, with their beds separated only by the makeshift divider of a curtain, Miriam looks 'forward to getting into bed in the new surroundings, recapturing singleness'.[9] As with so many modernist texts, the reading of sexuality requires attention to both content and form. The third example, Gertrude Stein's 'Two Women', is representative of her ongoing experimental reformations of linguistic and syntactic structures. In this story the sense of lesbian relationship and affective bonds between women is rendered through the practice of repetition:

> When they were together they said to each other that they were together and that each one of them was being living then and was going on then being living. When they were together they called each other sister. When they were together they knew they were together. When they were together, they were together and they were not changing then, they were together then.[10]

Notably, the story weaves together notions of living and loving to produce a narrative of relationship, proving Stein to be, as Shari Benstock puts it, 'a theoretician of the domestic'.[11]

Emotional bonds, domesticity, and the range of lived relationships are of course also central aspects in the analysis of sexuality. The use of biographical material within literary-critical work is somewhat contentious; nevertheless, it is impossible to explore sexuality within the modernist period without making some attempt to understand the personal circumstances of each practitioner. How to interpret these circumstances without anachronism or projection will be discussed later in this chapter, but the *Collection* demonstrates what can be gained by exploring biographical detail. Biographical hints and traces appear, for example, in the dedications some writers include. Thus, Djuna Barnes's story is dedicated to 'T.W.', who we know from letters and memoirs and indeed Barnes's key text *Nightwood* to be Barnes's lover, the silverpoint artist Thelma Wood. H.D.'s extract 'Hedylus' is dedicated to 'Perdita', the daughter she conceived with the Scottish composer Cecil Gray, but whose upbringing she undertook with her lover and companion Bryher. Also, in general, any critic coming to analyse themes of sexuality in modernist texts must on some level engage with biographical evidence because so many of the lesbian modernists use their own life material as the central frameworks for their literary experiments. In the *Collection*, Bryher's extract 'South' is from the unpublished novel *South*, which was the fourth title in the series of autobiographical novels beginning with *Development* in 1920, and continued in *Two Selves* (1923) and *West* (1925).[12] These novels detail the coming to identity and writing of the young woman Nancy, the fictional Bryher. *Two Selves* ends with Nancy's meeting an American poet, Helga Doorn, in Cornwall. In terms of the autobiographical narrative, the extract from 'South' describes the

[9] Ibid. 221.

[10] Gertrude Stein, 'Two Women', in McAlmon (ed.), *Contact Collection of Contemporary Writers*, 303.

[11] Benstock, 'Expatriate Sapphic Modernism', 194.

[12] Fragments of the novel *South* survive in the Bryher Papers, Beinecke Rare Book and Manuscript Library, Yale University. See Winifred Bryher, *Development: A Novel* (London: Constable, 1920), *Two Selves* (Paris: Contact, 1923), and *West* (London: Jonathan Cape, 1925).

journey to Greece that Bryher, H.D., and Havelock Ellis took together in 1920. Ellis appears in the story as the fictional Dr Athelstan Harris, an example of how crucial it is to understand the story of sexuality within modernism if we are to comprehend its complex cultural production. Ellis features as both figures in Bryher's autobiographical narrative, but also appears in the *Collection* as himself, in his commentary on Conrad, where his name is synonymous with some of the key intellectual discourses about gender and sexuality in the modernist period.

THE BEGINNINGS OF THE PROJECT

How have literary scholars come to analyse sexuality within modernism? As frequently noted, the precipitating event that caused the cultural turn in modernist critical studies was the growing recognition, in radical recuperative work undertaken by feminist modernist scholars, of the radical centrality of gender to modernism. In 1986 and 1987 two books by feminist scholars were published which were to generate a landslide of new critical interest in the form and detail of modernism: Shari Benstock's *Women of the Left Bank: Paris, 1900–1940*, and Gillian Hanscombe and Virginia Smyers's *Writing for Their Lives: The Modernist Women, 1910–1940*. These texts introduced the substantial cast of women involved as cultural and artistic practitioners in modernism and the avant-garde. Taking these women and their works into account required a radical reassessment of the model of modernism that had prevailed in literary and critical studies through the latter half of the twentieth century. The fullness of the modernist period was recognized by Bonnie Kime Scott in 1990 in her introduction to *The Gender of Modernism*: 'Modernism as we were taught it at mid-century was perhaps halfway to truth.'[13] Much of the blame for this, Scott implies, was because 'it was unconsciously gendered masculine'. The project of opening up the study of modernism to include questions about the impact of difference—sex, race, class, and sexuality—on its shape and production has changed the nature of modernist criticism. As Douglas Mao and Rebecca L. Walkowitz describe this change, the 'new modernist studies . . . encompass at least two significant enterprises: one that reconsiders the definitions, locations, and producers of "modernism" and another that applies new approaches and methodologies to "modernist" works'.[14]

The early work of Hanscombe and Smyers, and Benstock, mapped out some of the central issues inherent in the project. First and foremost the task was to recuperate

[13] Bonnie Kime Scott, 'Introduction', in Scott (ed.), *The Gender of Modernism: A Critical Anthology* (Bloomington: Indiana University Press, 1990), 2.
[14] Douglas Mao and Rebecca L. Walkowitz, 'Introduction: Modernisms Bad and New', in Mao and Walkowitz (eds), *Bad Modernisms* (Durham, NC: Duke University Press, 2006), 1.

'lost' names. Hanscombe and Smyers's roll-call included the aesthetic 'practitioners' (H.D., Bryher, Dorothy Richardson, Amy Lowell, Gertrude Stein, Djuna Barnes, Thelma Wood, Mary Butts, Mina Loy, Marianne Moore) and the 'facilitators' (Harriet Moore, Harriet Shaw Weaver, Dora Marsden, Margaret Anderson, Jane Heap, Sylvia Beach, and Adrienne Monnier).[15] Hanscombe and Smyers were quick to see the importance of personal connections and the connectedness of these women to forms of cultural production. Female modernism, they argue, functioned through a network: 'They all seemed to write to each other, or about each other. They introduced one to the other. They sometimes fell in love with each other or with each other's partners. They were all either writing, or publishing what the others were writing, because they believed in each other's work.'[16] Smyers characterizes this network as one in which the women made uniquely non-normative sexual choices: 'none of them seemed to live conventionally: some were lesbian, some were bisexual, some promiscuous, some seemingly asexual'.[17] Looking at this complex, compelling network which underpins modernist production across London, Paris, Berlin, and New York, Hanscombe argues for 'what appears to be a clear connection between literary endeavour and the shunning of conventionally heterosexual lives. . . . The lesbian alternative chosen by many of them is seen to have direct bearing either on their conditions of work, or on the contents of what they wrote, or both.'[18] Moreover, she argues, one of the fundamental features of their modernist aesthetics was the 'breaking down of boundaries between "art" and "life"'.[19] As Hanscombe describes the imbrication of autobiographical material and aesthetic endeavour, 'these women lived-what-they-wrote or wrote what they lived'.[20]

In its ostensibly narrower geographical focus on Paris, Shari Benstock's *Women of the Left Bank: Paris, 1900–1940* introduced other key figures in addition to those recuperated by Hanscombe and Smyers—such as Natalie Barney, Renée Vivien, Kay Boyle, Nancy Cunard, Janet Flanner, Solita Solano, and Caresse Crosby. Benstock describes the 'tale of

[15] As more recent critical analysis demonstrates, such a clear distinction between 'practice' and 'facilitation' is problematic. This is not just to dispute the long-standing construction of these facilitators as 'midwives' (a metaphor actually first used by the bookseller Sylvia Beach, but taken up by later literary critics as some kind of fact), but to point out that many facilitators were actually also practitioners—for instance, Adrienne Monnier, who, in addition to providing cultural space and an organ of dissemination in her bookshop La Maison des Amis des Livres, was also writing experimental fiction under the pseudonym 'Sollier'. This is also to argue for a more complex model of cultural production in which, following Pierre Bourdieu, we start to understand practices such as editing, publishing, and patronage as contributing content and meaning in the field of cultural production. See Pierre Bourdieu, *The Field of Cultural Production: Essays on Art and Literature*, ed. Randal Johnson, trans. Richard Nice (Cambridge: Polity Press, 1993). For further discussion of women and the cultural production of modernism, see Bridget Elliott and Jo-Ann Wallace, *Women Artists and Writers: Modernist (Im)Positionings* (London: Routledge, 1994), and my *Lesbian Modernism: A Cultural Study* (forthcoming).

[16] Virginia L. Smyers, 'Preface' to Gillian Hanscombe and Virginia L. Smyers (eds), *Writing for Their Lives: The Modernist Women, 1910–1940* (London: Women's Press, 1987), p. xvii.

[17] Ibid. [18] Ibid., p. xv.

[19] Ibid., p. xiv. [20] Ibid., p. xv.

difference' of female modernism as a story that inscribes 'the underside of the cultural canvas' and represents 'a countersignature to the published Modernist manifestos and calls to the cultural revolution'.[21] Her argument, which is taken up by later critics, as I will show, is that there was a profound and indelible link between lesbian sexuality and aesthetic experimentation. She situates lesbian sexuality as the radical impetus that prompts modernist endeavour and identifies it as a kind of unifying principle within the networks of production. It is sexual dissidence, Benstock argues, that underpins the Parisian networks, the 'powerful communities of women artists', which were established by either lesbians, or heterosexual women who lived outside normative heterosexual paradigms.[22] Benstock's full and detailed archival work on these 'communities' was later supplemented by the extensive visual materials presented in Andrea Weiss's *Paris Was a Woman: Portraits from the Left Bank* and in the release of Greta Schiller's documentary based on the same materials in 1995.[23] Such recuperative work helped to flesh out the research area, and by the mid-1990s critical work on the definition of the relationship between sexuality and modernism was well under way.

COMING TO TERMS: LESBIAN, SAPPHIC, QUEER

Reviewing the books by Hanscombe and Smyers and Benstock shortly after their publication, Makiko Minow considered the lives and materials opened up by these recuperative surveys and noted the 'real incentive' for scholars and readers to 'immerse themselves in what we may have to learn to call "lesbian modernism"'.[24] Minow's coinage of the term 'lesbian modernism' speaks of the contemporary milieu of the late 1980s. Discovering the sizeable presence of what looks, at least to late twentieth-century, post-Second Wave eyes, like lesbian sexuality in the lives and works of modernism, what other term might a critic use to describe either sexual identity or cultural production? Yet Minow's coinage in 1989 demonstrates the fact that terminology is a complicated matter. Despite the undeniable presence of lesbianism in the circles and canons of literary modernism, to talk in terms of 'lesbian modernism' is immediately to encounter difficulties of definition. As Susan Stanford Friedman argues:

Definitions mean to fence in, to fix, and to stabilize. But they often end up being fluid, in a de-stabilized state of on-going formation, deformation, and reformation that serves the changing

[21] Shari Benstock, *Women of the Left Bank: Paris, 1900–1940* (London: Virago, 1987), p. xii.

[22] Ibid.

[23] See Andrea Weiss, *Paris Was a Woman: Portraits from the Left Bank* (London: Pandora, 1995) and *Paris Was a Woman*, dir. Greta Schiller (UK/US, 1995).

[24] Makiko Minow, 'Versions of Female Modernism', *News From Nowhere: The Politics of Modernism*, 7 (Winter 1989), 65.

needs of the moment. They reflect the standpoint of their makers. They emerge out of the spatio/temporal context of their production. . . . They change dramatically over time and through space.[25]

Certainly we require definitions. Yet, as Friedman rightly points out, definitions continue to fail to name a static object. Perhaps more importantly, what a definition excludes is at least as important as what it contains. What might we mean, then, by 'lesbian modernism'? Undoubtedly, we are attempting to articulate an identifiable cultural phenomenon—the ways in which women who, in their own moment, identified as lesbian, or whom we might now, in our contemporary context, identify as lesbian; who lived within, exhibited, and contributed to the definition of being modern within the amorphous temporal period cultural theorists have come to coin 'modernity' and produced the specific aesthetic objects we have come to call modernist. Yet, even as we introduce this term, 'lesbian modernism', we are immediately confounded by a resistance to the process of definition. What *is* a lesbian? (I will return to this complex question in due course.) And following on from this perhaps unanswerable question, how might we form both noun and also adjective out of that primary definition, so that we can start to identify behaviours, identification, and indeed made objects as 'lesbian'?

One of the fundamental problems which any critical analysis of sexuality in modernism encounters is the question of how to describe sexual identity, how to ascertain the way in which these subjects conceived of their own sexuality. Such a difficulty might be evidenced in the following three contrasting modernist examples. In 1923 Virginia Woolf recorded her first, giddy meeting with Vita Sackville-West and noted: 'She is a pronounced Sapphist & may, thinks Ethel Sands, have an eye on me, old though I am. Nature might have sharpened her faculties.'[26] Woolf's use of the term 'Sapphist' to describe Sackville-West, invoking as it does the historical precedent of the Greek poet Sappho, sits in direct contrast with the terminology we find used by Djuna Barnes. In 1935, in the midst of the editing of *Nightwood*, with its narrative of sexual desire between women, Djuna Barnes's friend and partner in crime Emily Coleman asks her frankly if she thinks she really is a lesbian. In a typically mordant reply Barnes notes: 'I might be anything. If a horse loved me, I might be that.'[27] While Coleman grasps at the term 'lesbian', Barnes actively repudiates it. Nevertheless, as her literary texts and personal materials make clear, the sexual and emotional relationship that occupied the heart of her life and aesthetic is with Thelma Wood. A third example demonstrates the way in which descriptions of sexual identity cannot be so neatly separated from gender identity. Describing her discussion with Havelock Ellis on the subject of her identity, Bryher writes:

[25] Susan Stanford Friedman, 'Definitional Excursions: The Meanings of Modern/Modernity/Modernism', *Modernism/Modernity*, 8/3 (Sept. 2001), 497.

[26] Virginia Woolf, diary, Monday, 19 Feb. 1923, in *The Diary of Virginia Woolf*, ii: *1920–1924*, ed. Anne Olivier Bell (Harmondsworth: Penguin, 1981), 235.

[27] Djuna Barnes, letter to Emily Coleman, 27 Oct. 1935, Djuna Barnes Papers, Special Collections, University of Maryland Libraries.

We got on to the question of whether I was a boy sort of escaped into the wrong body and he says it is a disputed subject but quite possible and showed me a book about it. . . . We agreed it was most unfair for it to happen but apparently I am quite justified in pleading I ought to be a boy—I am just a girl by accident.[28]

What must be teased out, in the case of Bryher and indeed other women, is the extent to which gender dysphoria might actually be the articulation of same-sex desire, and vice versa.

In her book *Queer Poetics: Five Modernist Writers*, Mary E. Galvin notes the need for a 'subtle rubric' when coming to define sexual identity.[29] Yet how is such a rubric to be created without lapsing into anachronism? Even where terms of identity appear to exist within the modernist period, how can we be sure of their cultural meaning? As Anne Hermann notes of Virginia Woolf's use of the term 'queer', 'Queer, for Woolf in 1921, doesn't yet mean gay.'[30] In her book *H.D. and Sapphic Modernism*, Diana Collecott quickly comes to the central problem with such terms, not least because her theoretical vocabulary is drawn from late twentieth-century critical theory. Collecott argues that the posing of the question 'was Sappho lesbian?' (and, for that matter, was H.D.?) is complicated by our reliance on 'current categories of gender and sexuality'.[31] Collecott writes that she will, of necessity, still use these categories, despite the danger of anachronism, in order to ask the most pressing question of 'what both a bisexual and a lesbian *eros* might mean for H.D.'s writing'.[32] Collecott's licence to attempt such an analysis is predicated on the existence of a discourse about lesbian desire and subjectivity among some of the major female modernist practitioners, despite the fact that 'biographers and cultural historians' of the first half of the twentieth century have been 'reluctant' to recognize either this subcultural knowledge or its vocabulary.[33] As Collecott notes, '"Saph" was slang for lesbian among H.D.'s correspondents' and 'Virginia Woolf referred in private to writing about "Sapphism" but feared being "hinted at for a Sapphist" by the world at large.'[34]

Following Benstock, Erin G. Carlston describes the way in which 'women writers of the period—many of whom could be considered lesbian or bisexual, in contemporary terms, if not always in their own—were excluded from a "male modernism" that was inherently reactionary and misogynist, and constituted an entirely different literary movement: Sapphic modernism'.[35] After staking the claim for Sapphic modernism's separateness from high modernism, Carlston considers the instability of its contents. She argues that 'Sapphic modernism', as well as 'intellectual fascism',

[28] Bryher, letter to H.D., 20 Mar. 1919; cited in Maggie Magee and Diane C. Miller, *Lesbian Lives: Psychoanalytic Narratives Old and New* (New York: Analytic Press, 1996), 5.
[29] Galvin, *Queer Poetics*, 2.
[30] Anne Hermann, *Queering the Moderns: Poses/Portraits/Performances* (New York: Palgrave, 2000), 2.
[31] Diana Collecott, *H.D. and Sapphic Modernism, 1910–1950* (Cambridge: Cambridge University Press, 1999), 3.
[32] Ibid. [33] Ibid. 4. [34] Ibid.
[35] Erin G. Carlston, *Thinking Fascism: Sapphic Modernism and Fascist Modernity* (Stanford, Calif.: Stanford University Press, 1998), 2.

are 'highly contested terms'.[36] For this reason, she notes that her 'definitions are, intentionally, provisional, adapted for the purposes of the current work'.[37] Her use of the term 'Sapphic' therefore comes with a proviso, the desire to 'call into question some of the assumptions about sexuality and gender that may seem explicit in its usage'.[38] Like Collecott, Carlston is aware of the dangers of anachronism, refusing to deploy a 'transparent relation between biography and literary production' in which late twentieth-century forms of lesbian identity are applied to 'the sexual cultures of the early twentieth century'.[39] One of the recurring issues in the theorization of the relationship between sexual identity and cultural practice is the problem of constructing a master narrative in which the specificities of each woman's sexual identity and literary experiments are subsumed within a monolithic description. Carlston notes that her chosen subjects—Djuna Barnes, Marguerite Yourcenar, and Virginia Woolf—are only 'tangentially related' to the 'lesbian community in Paris that self-consciously modelled itself on Sappho's circle'.[40] In addition, their 'lives and works do not otherwise lend themselves to any easy definition of lesbianism or bisexuality, or of lesbian writing'.[41] Nevertheless, 'all three experienced (homo) sexuality as an aesthetic problematic and political *enjeu*, as well as a private problem or pleasure'.[42] Carlston sets out to fashion her own definition of sexual identity: 'In my readings, it is in the writer's attentiveness to these "moments of rupture" that her Sapphism manifests itself'; 'Sapphism will, then, be taken to express itself not as an organized identity or as a *mise-en-texte* of biography, but as a hypersensitivity to sexuality in, and as, the aesthetic and the political.'[43]

In her book *Sapphic Primitivism*, Robyn Hackett builds 'upon the work of scholars who have provoked scepticism about naturalized sexual identity categories'.[44] Hackett identifies the early twentieth century as the period in which the cultural work to naturalize the categories of sexual identities was being undertaken. Conversely, she notes that 'the most substantial innovation of late twentieth-century sexuality studies' was the articulation, in theoretical terms, of the fact that both homosexuality and heterosexuality are 'historically rather than naturally produced'.[45] She continues that while the categories of 'the homosexual' and 'the lesbian' have been constructed in what she terms 'the civil-rights era' within 'medical, legal, political and social discourse', in fact 'as human types, they have not existed in all times and all places'.[46]

[36] Ibid. 6. [37] Ibid. [38] Ibid. [39] Ibid.
[40] Ibid. [41] Ibid. [42] Ibid. [43] Ibid.
[44] Robyn Hackett, *Sapphic Primitivism: Productions of Race, Class, and Sexuality in Key Works of Modern Fiction* (New Brunswick, NJ: Rutgers University Press, 2004), 1.
[45] Ibid. [46] Ibid.

In her analysis of the works of Olive Schreiner, Virginia Woolf, Sylvia Townsend Warner, and Willa Cather, Hackett notes that she will use the term 'lesbian', despite the fact that 'it sometimes feels impossible to do so in the light of discursive theories of homosexuality'.[47] She recognizes that the phrase 'erotics between women' may be more accurate but argues that it is 'too clunky to be practical for consistent use'.[48] She also considers the phrase 'female sexual autonomy' useful, but rejects it for the way it occludes 'homosexual relations'.[49]

For Gay Wachman, in her book *Lesbian Empire: Radical Cross-Writing in the Twenties*, the terms of sexual identity cannot be separated from class. She uses the term 'lesbian' because she finds it carries less cultural loading than 'Sapphist': 'I use the words *lesbian* and *lesbianism* when I need umbrella terms; I prefer them to *sapphist* and *sapphism* because of the class implications of the latter: knowledge of Latin and Greek was a privilege of upper-middle class men and a basic component of the systems of exclusion that constituted empire.'[50] The term 'lesbian' offers Wachman 'an inclusive transhistorical term that can include both gender identification and sexual preference'.[51] Wachman's explication of her use of terminology is important, since it situates her own critical vocabulary in her contemporary moment. Terminology in the modernist period, she notes, is multitudinous; 'modernist lesbians themselves have used *lesbian*, *sapphist*, and *invert*.[52] The criteria Wachman uses for describing a writer as a 'lesbian modernist' is applied to those who, despite living 'deep in the closet', all 'foreground lesbian, gay, or other forbidden desire in their writing'. She notes too, using contemporary notions of identificatory practice within sexual identity, that 'all of them, except for Evadne Price, have been identified as lesbian or bisexual at some point in their lives'.[53]

DEFINING MODERNISM

As this range of critical engagements suggests, terms to describe dissident or same-sex desire and its representations, or its structural roles, within modernism are varied. Since the 1990s, critics have deployed three main critical terms to describe the imbrication of sexuality within modernism: 'Sapphic modernism', 'lesbian modernism', and 'queer modernism'. The use of such terms to describe the relationship

[47] Hackett, *Sapphic Primitivism: Productions of Race, Class, and Sexuality in Key Works of Modern Fiction*, 1.
[48] Ibid. [49] Ibid. 2.
[50] Gay Wachman, *Lesbian Empire: Radical Cross-Writing in the Twenties* (New Brunswick, NJ: Rutgers University Press, 2001), 5.
[51] Ibid. [52] Ibid. [53] Ibid. 6.

between sexuality and modernism occurs in the context of the new modernist critical studies in which definitions of modernism have multiplied in such a way that it is now far more accurate to talk in terms of the *modernisms* of the early twentieth century than *modernism* as monolithic movement. The most innovative and productive work produced in modernist studies over the past two decades has forced us to reconfigure our understandings of the parameters of the modernist period and its aesthetic forms. These reconfigurations have placed the literary and aesthetic movements of modernism back into their cultural and social contexts as a way of more closely reading the stimuli and impulses behind this great period of experimentation. In this sense, context, we might say, is all. As Gabriele Schwab has argued, 'Changing literary form is not merely an aesthetic game played by writers concerned with innovation and originality or haunted by anxiety of influence. Rather, it is primarily a response to pressures or challenges arising from different "environments"—such as other literary or discursive forms, cultural formations, psychological needs, social changes, or political concerns.'[54] Conceiving of modernism as a reaction against and to the environments of the early twentieth century has allowed discussion of 'difference'—be it of gender, class, race, or sexuality—to become central in our new understandings of the modernist period. We work now in a wide field of study that includes, in addition to the work on sexuality, female modernism, black modernism, transnational modernism, and Jewish modernism, among others.

In this burgeoning critical space, the project to map and define the reciprocal relationship between lesbian sexuality and the range of literary and aesthetic modernisms requires a redefinition of modernism itself. Plotting the terms of these women's literary experiments means beginning to rewrite the modernist canon, and even, perhaps, in the wake of postmodernism, to do away with the notion of that canon altogether. In many instances it means rethinking the classic terms of textual practice, preoccupation, and content that have been held traditionally to be modernist. If, following Schwab, we talk of 'psychological need' as one of the preconditions of modernism, we can see how, in the fractured pluralist spaces of the modernist text, lesbian subjectivity is offered a unique space for representation. In this sense, lesbian modernists use the structures of the modernist text to inscribe forms of lesbian subjectivity in order to concretize these against cultural and social erasure. The notion that subjectivity, or a concretized sense of the self, might be created in and through the modernist text reads *against* the grain of our traditional understandings of the modernist constructions of subjectivity and the innate fragmentations of the human self. Rather than negating the existence of or the importance of a notion of lesbian modernism, this suggests how central it must be to a new critical vocabulary of the modernist period. Yet, as Shari Benstock wrote in the 1990s, feminist criticism had failed to come to 'definitional terms with modernism as an aesthetic–cultural–historical concept'.[55] Moreover, she noted how 'we have posed the

[54] Gabriele Schwab, *Subjects Without Selves: Transitional Texts in Modern Fiction* (Cambridge, Mass.: Harvard University Press, 1994), 16.
[55] Benstock, 'Expatriate Sapphic Modernism', 184.

question "was there a modernism for women?" without asking "What was modernism?"' Benstock argues that 'the attempt to define Sapphic modernism cannot elude these earlier questions'. The redefinition of modernism itself, then, becomes a central task in critical work on sexuality and modernism. Moreover, this work is not to be undertaken as a tokenistic enterprise, since its impact is upon our understandings of modernism as a whole. As Robyn Hackett argues, 'Sapphic modernism is not a lesser subset of literary modernism. Rather it is central to the birth of modernism as a movement, and hence needs to be central to our understanding of modernism.'[56]

One of the first revisions to be made is the argument that, contra traditional notions of modernism as an art which eschews the personal, sexual identity is in fact central to the modernist impulse. As Shari Benstock argued, 'In highly conscious forms of writing, such as modernism claimed to be, linguistic structures trace and erase the psychosexual contours in a single gesture.'[57] For Colleen Lamos, modernism is actually structured by its identifications with, or reactions to, sexual desire. She argues that 'Homophobia and homophilia are equally constitutive of Anglo-American modernist literature, a literature that is charged by the split between same- and other-sex love, energized and riven by the homo/hetero binary division.'[58] Lamos continues that one cannot discern separate 'homosexual' and 'heterosexual' modernisms, but rather 'a single literary corpus that is torn in various ways by the scission between these (supposedly) incongruent longings'.[59] Mary E. Galvin argues that difference—in this case of sexual identity—has a causative relationship with literary experimentation: 'Just as a variety of sexualities are possible in the realm of the nonheterosexual, so our writers have developed a variety of poetics to articulate our hard-won "differences."'[60] When it comes to looking at her five chosen subjects (Emily Dickinson, Amy Lowell, Gertrude Stein, Mina Loy, and Djuna Barnes), Galvin argues that her 'basic assumption . . . is that the mind which can imagine other sexual orientations and gender identities can and must also imagine new ways of writing'.[61] H.D., she argues, is 'motivated by the need to open up social/intellectual/psychic space for queer existence', seeking in the 'new freedom of modernism' a means to 'piece together the significance of her personal experiences through the techniques of imagism'.[62] Similarly, Stein's technique of using the 'continuous present', in which she deconstructs existing syntactical structures in order to reconstruct linguistic form, is 'an alternative means of conceptualizing personal identity'.[63] Galvin sees this practice as coterminous with Stein's 'need to speak of/from her lesbian consciousness'.[64]

[56] Hackett, *Sapphic Primitivism*, 13.
[57] Benstock, 'Expatriate Sapphic Modernism', 188–9.
[58] Colleen Lamos, 'Queer Conjunctions in Modernism', in Bonnie Kime Scott (ed.), *Gender in Modernism: New Geographies, Complex Intersections* (Urbana: University of Illinois Press, 2007), 336.
[59] Ibid. [60] Galvin, *Queer Poetics*, 6. [61] Ibid.
[62] Ibid. 9. [63] Ibid. 8. [64] Ibid.

Jaime Hovey, in her book *A Thousand Words*, argues that the issue of sexuality within modernism has been occluded by a particular model of modernism, advanced both within the period and by later critics, in which the credo of impersonality and 'artistic sublimation' is promoted. This mindset has led to 'the ascendancy in the decades after the Second World War of certain strains of modernist writing and modernist interpretation—Irving Babbitt's hypermasculine aesthetics, Ezra Pound's vilification of Imagism's feminine and lesbian poetics, T. S. Eliot's insistence on artistic impersonality—as official versions of modernism'.[65] Such a critical predominance has 'helped marginalize the queerer modernisms of the effete Oscar Wilde, the lesbian Imagist Amy Lowell, the queer apologist Radclyffe Hall, and the sexually reticent Eliot himself'.[66] Hovey's argument demonstrates the way in which the very terms of modernist experimentation are called into question when the discussion of sexuality enters the frame. Her inclusion of writers such as Wilde and Hall would seem to test the frame of modernist canonicity. This, indeed, is a recurring theme within major critical works on sexuality and modernism.

In her book *Lesbian Empire*, Gay Wachman attends to those lesbian modernists she sees as engaging in 'cross-writing'. She creates this term to describe the process in which a writer 'transposes the otherwise unrepresentable lives of invisible or silenced or simply closeted lesbians into narratives about gay men'.[67] She locates this literary practice particularly in the historical novels of Marguerite Yourcenar, Mary Renault, and Bryher, arguing that 'when they set their novels in a time and place, such as ancient Greece, that tolerates homosexuality, they use that freer environment to celebrate homosexual romance'.[68] Wachman is clear that her interests lie neither with '"high modernist" writing' nor with 'the literature of exile' that is conceived as a key modernist trope. Wachman broadens the conception of modernism to include non-experimental work; alongside the 'traditional' figure of Woolf, Wachman's subjects include Sylvia Townsend Warner, Radclyffe Hall, Clemence Dane, Rose Allatini, and Evadne Price. Similarly, Robyn Hackett brings two writers previously not considered modernist, Olive Schreiner and Willa Cather, into her study.

The inclusion of writers whose literary practice had not been traditionally interpreted as modernist of necessity means that modernist practice itself comes under scrutiny. Even where critics are not drawing 'new' figures into the discussion, they often locate seemingly 'non-modernist' practice in established modernists. For example, in her discussion of Djuna Barnes's early work *The Book of Repulsive Women*, Galvin argues that 'Barnes utilized a strategy of disruptively inhabiting formal metre and rhyme to undermine formal boundaries and expectations, thereby clearing a space for multiplicitous, nonheterocentric thinking.'[69] While such a practice may sound typically modernist, Galvin also notes that, 'In these poems, as well as

[65] Jaime Hovey, *A Thousand Words: Portraiture, Style, and Queer Modernism* (Columbus: Ohio State University Press, 2006), 3.

[66] Ibid. 6. [67] Wachman, *Lesbian Empire*, 1.

[68] Ibid. [69] Galvin, *Queer Poetics*, 8–9.

all her subsequent works, Barnes also developed a technique of reappropriating "archaic" language styles and forms by which she could write lesbianism into literary existence.[70] Here, then, traditional modernist practice sits alongside other techniques that would be considered alien to high modernism. It is sexuality, for Galvin, which prompts Barnes to broaden her experiment.

If the definitions of who and what is a modernist practitioner are tested by this study, so too is the question of the temporal period of modernism. Galvin argues that Emily Dickinson is 'a sexually deviant precursor to the modernists'.[71] She finds in Dickinson's 'poetic innovations', which she lists as the disruption of syntax, formal metre, and rhyme, as well as her use of 'hymn', the transformation of 'the duplicity of language from a medium of coding and disguise into a technique for questioning and undermining the certainty of all boundaries, all categorical distinctions'.[72] It is these techniques, she argues, which provide 'the poetic groundwork for the modernists'.[73] In her early account of lesbian modernism, Karla Jay argues that perhaps it might be defined by the fact that it is not, at least at face value, actually modernist at all:

> The most daring possibility of lesbian modernism is that it exists right under the collective nose of patriarchy. Perhaps it is not always encoded in hermetic language or stylistic theatrics. Instead, it boldly poses in conventional clothes. *It denies its modernism.* It wears the style and other trappings of the traditional novel in order to undermine its very conventions. It is a literary transvestite, a saucy trompe l'œil.[74]

Other critics find major defining themes, characterizing modernism as being issue-led. In her comparative analysis of the work of Woolf and Stein, Corinne E. Blackmer, for example, argues that 'for Woolf and Stein, lesbian modernism signifies a historical break with the nineteenth-century ideology of separate spheres'.[75] In this rejection of the gendered divide between public and private realms, Woolf and Stein created lesbian modernist narratives in which 'the lesbian enters the public domain as an autonomous, artistically creative, self-directed being whose conscious desire for women contradicts dominant assumptions regarding women's innate sexual passivity'.[76] The deeper implications of this figure are that 'more radically, her very existence implies the eventual elimination of gender as a significant force in cultural and social relations'.[77] Thus, for Blackmer, lesbian modernism is typified by its assault upon and repudiation of the traditional, patriarchal ideology of gender.

For Erin G. Carlston, the key linkage is with fascism. She undertakes the examination of Sapphic modernism in relation to the political context of fascism within the

[70] Galvin, *Queer Poetics*, 8–9. [71] Ibid. 7.
[72] Ibid. [73] Ibid.
[74] Jay, 'Lesbian Modernism', 79.
[75] Corinne E. Blackmer, 'Lesbian Modernism in the Shorter Fiction of Virginia Woolf and Gertrude Stein', in Eileen Barrett and Patricia Cramer (eds), *Virginia Woolf: Lesbian Readings* (New York: New York University Press, 1997), 79.
[76] Ibid. [77] Ibid.

modernist period. She situates her study 'between two important revisionist projects that have developed since the 1970s and that are still very much under way: feminist re-readings of modernism on the one hand, and studies of fascist culture on the other'.[78] In another direction, Robyn Hackett deduces a formative link between expressions of lesbian subjectivity and the primitivist impulses with which modernism is commonly associated. As such she develops the term 'Sapphic primitivism', which describes 'a mode of writing in which figurations of blackness and working-class culture appear as constitutive elements of white-authored fictional representations of female sexual autonomy including homoerotics'.[79] Hackett aims to work on the complex intersections between race, class, and sexuality, as these are articulated, embraced, and repudiated in the works of her chosen writers. 'Schreiner, Woolf, Warner, and Cather, and their texts', she argues, 'sometimes reflect the racism and/or homophobia of many people of their eras and locations.'[80] Heavily influenced by Toni Morrison's nuanced and perceptive analysis of the symbols of 'whiteness' and 'blackness' within American literature, and the cultural discourses it surreptitiously inscribes, Hackett sets out to interrogate 'lesbianism and whiteness', finding in the racialized metaphors and symbolic structures of her chosen texts a displacement of sexual dissidence onto racial otherness.[81] Thus, for instance, Hackett notes the way in which Woolf's drafts of her classic modernist novel *The Waves* write out the theme of lesbian desire while simultaneously writing in a set of racialized symbols, so that in the final published draft, 'when other characters talk about sex, Rhoda talks about Africa, India, Turks, dark pools, tigers, or ships that cross oceans'.[82] The primitivist turn within modernism has attracted critical attention for much of the later twentieth century, yet here, Hackett seeks to theorize it in more politicized terms.

INVESTMENTS IN THE CRITICAL PROCESS

Hackett's politically motivated intention, which is shared by other critics and theorists of sexuality and modernism, marks one of the most fundamental differences between this work and traditional accounts and analyses of modernism, in which modernism, and in turn critical responses to it, are seen as a movement guided by the principle 'l'art pour l'art'. Such a political emphasis means that the critic him/herself is an active, situated subject in the process of investigation for whom questions of intellectual, political, and affective investments become important. For instance,

[78] Carlston, *Thinking Fascism*, 1.
[79] Hackett, *Sapphic Primitivism*, 3.
[80] Ibid.
[81] See Toni Morrison, *Playing in the Dark: Whiteness and the Literary Imagination* (New York: Vintage, 1993).
[82] Hackett, *Sapphic Primitivism*, 5.

Mary E. Galvin acknowledges that her initial interest in the lesbian modernists arose out of her identification with them and her need to find historical antecedents for her own sexual identity:

In my own journey of re-envisioning and renaming lesbian sexuality and consciousness, I have often been drawn back to the period of the modernists. While I was learning the 'straight', mostly male, modernist tradition in college and also learning, somewhat haphazardly, of the women writing then, I was struck by how many were lesbian, bisexual, or nonheterocentric in their lives.[83]

The body of criticism that has grown up out of the eventual recognition and recuperation of sexual dissidence within modernism has had to acknowledge its own contemporariness, its situatedness within its own cultural moment. In aiming to produce careful, historically sensitive readings of the ways in which sexuality is central to the story of modernism, such critical interventions draw modernism into our period, and demonstrate the continuity between early twentieth-century sexualities and our own.

[83] Hackett, *Sapphic Primitivism*, 5.

CHAPTER 13

··

HARLEM
MODERNISMS

··

JONATHAN W. GRAY

I do not deny that a Negro in a log cabin is more picturesque than a Negro
in a Harlem flat, but the Negro in the Harlem flat is here, and he is part of a
group . . . whose ideals are becoming increasingly more vital than those of
the traditionally artistic group, even if its members are less picturesque.

(James Weldon Johnson, *The Book of American Negro Poetry*)

BEFORE one can begin to think (again) about the relationship between the Harlem
Renaissance and modernism, one must come to grips with how Harlem became
modern. This question is intertwined with a larger one: how black Americans
attained what might be called a modern sensibility. Firstly, if the literary modernism
that produced Eliot, Stevens, and Pound can be understood as deriving in part from
their discomfort with (or their embrace of) a newly mutable society, a society that
was 'exploitative . . . too industrial [and] changing too quickly', then any assessment
of black modernism along these lines will quickly prove insufficient.[1] It is more
accurate to claim that black America's modernity emerged as a reaction to the brutal
exploitation black Americans endured in the South after the civil war. Black Amer-
icans wanted access to the industrial jobs that promised a significantly better
standard of living than the agricultural or domestic jobs most held at the turn of
the century. The desire to escape Southern mistreatment and/or enter into the newly
emerging manufacturing market produced an uncritical embrace of the industrial-
ization heralded by the rise of Fordist production in the North and Midwest, and the

[1] C. Barry Chabot, *Writers for the Nation* (Tuscaloosa: University of Alabama Press, 1997), 2.

social changes that accompanied this transformation. Black Americans, from this perspective, are modern by circumstance and inclination if not by social standing and education.

This view is complicated by the fact that there were also black Americans who possessed the more typical modern outlook produced by university education and cosmopolitan experience. Chief among this small but influential cohort were Alain LeRoy Locke and James Weldon Johnson, the two men perhaps most responsible (along with Jessie Fauset and Charles Johnson) for assembling and disseminating the representative literary voices of the Harlem Renaissance. Yet in critical investigations of the Harlem Renaissance, Locke usually has pride of place over Johnson, thanks primarily to Locke's anthology *The New Negro* (1925). This is curious, since the first edition of Johnson's anthology *The Book of American Negro Poetry* (1922)—the first modern anthology of African American literature—pre-dates Locke's effort by four years and offers a more varied collection of black voices, making it just as important as Locke's text for tracing the emergence of modernist voices in black art. It is a testament to Locke's ability to market his vision of the Harlem Renaissance and his notion of cultural pluralism that *The New Negro* continues to be regarded as the pre-eminent text of the period despite the compromised nature of Locke's text.

But before any consideration of the philosophical differences that informed Locke's and Johnson's editorial decisions can begin, we must return to the question of black modernity. Louis Menand offers a particularly useful definition of modernity as 'the condition a society reaches when life is no longer conceived as cyclical ... In modern societies ... the ends of life are not thought to be given; they are thought to be discovered or created.'[2] If Menand's notion is correct, it is easy to understand how the conceptions of black Americans, even those who lived outside the South, at the turn of the twentieth century could be understood as modern. Indeed black existence since the end of the civil war might be understood as centred upon the desire to discover or create a new way of being that might separate them once and for all from the servile existence endured by their forebears. Black Americans' embrace of the changes in social and economic patterns occasioned by the shift to modern manufacturing—born of their desire to escape a stratified past—produced a relationship to modernity that was very different from the notions articulated by Duchamp or Pound.

This embrace of uncertainty and change can be seen in the circumstances surrounding the foundation of Harlem as the capital of black America. Nothing could have seemed more unlikely at the turn of the century than a fashionable neighbourhood on the island of Manhattan, a neighbourhood that contained vital commercial corridors along Lenox, Broadway, and 125th Street, falling under the control of black Americans. Indeed, as James DeJongh notes, 'the idea of Negroes occupying the new, upscale area seemed bizarre and outlandish to many [white] residents and property owners' in Harlem until it happened.[3] One cannot fault white New Yorkers for this

[2] Louis Menand, *The Metaphysical Club* (New York: Farrar, Straus, Giroux, 2001), 399.
[3] James DeJongh, *Vicious Modernism* (New York: Cambridge University Press, 1990), 5.

attitude, especially given that the transformation of Harlem began in 1905, just after a historical period described by Rayford Logan as the 'nadir' of race relations in the United States.[4] This was not, one would think, the ideal time to create a vibrant black community, but this is indeed exactly what happened.

The circumstances that resulted in black Americans' reflexive embrace of the new and contingent grew out of their experiences during the nadir. Most scholars agree that the infamous Compromise of 1877, when Republicans agreed to withdraw the Northern troops who were protecting black Americans' newly won civil rights in the South in order to elect Rutherford B. Hayes president, simultaneously ended Reconstruction and marked the beginning of the nadir. Logan identifies a series of broken promises that follow the Compromise, the Supreme Court's 1896 decision in *Plessy* v. *Ferguson* that formally re-established segregation throughout the South being chief among these.[5] The Great Migration from the South to manufacturing centres in the North like New York, Chicago, and Detroit demonstrates black Americans' desperate adoption of modern possibility as a response to these serial betrayals. Of course, Southern blacks who made their way north in search of employment were uncertain of what was awaiting them, but they found in Harlem a neighbourhood ready to receive them, a community that seemed to symbolize the kind of social mobility and progress possible in the North.

Harlem existed as a black Mecca owing to the efforts of a small group of men working to improve the status of the black community in New York City by exploiting economic uncertainty. Philip A. Payton, the putative 'Father of Colored Harlem', exploited a local real estate bubble in order to transform Harlem from white to black.[6] The city of New York announced that it was extending the Lenox Avenue subway line north of Central Park, and this triggered a wave of real estate development that transformed Harlem from a sleepy neighbourhood to an exciting frontier in New York City real estate. Investors bought property and built apartment buildings in anticipation of an influx of new residents. When the Lenox Avenue extension took longer to complete than estimated, Harlem was left replete with new luxury apartment buildings with no tenants to occupy them. As James Weldon Johnson reported in his history of Harlem contained in *The New Negro*, 'Harlem had been overbuilt with large, new-law apartment houses . . . and landlords were finding difficulty in keeping houses on the east side of the section filled' owing in part to a lack of access to public transportation.[7] Payton, a young African American real estate speculator, recognized the opportunity presented by these empty rooms and

[4] Logan coins this term in *The Negro in American Life and Thought: The Nadir, 1877–1901* (New York: Dial Press, 1954).

[5] Logan's discussion of how literary magazines like *Harpers* and *The Atlantic* portrayed black Americans during the nadir is especially useful. See *The Betrayal of the Negro: From Rutherford B. Hayes to Woodrow Wilson* (New York: Da Capo Press, 1997), 242–62.

[6] Gilbert Osofsky, *Harlem: The Making of a Ghetto*, 2nd edn (Chicago: Ivan R. Dee, 1996), 95.

[7] James Weldon Johnson, 'Harlem: The Culture Capital', in Alain Locke (ed.), *The New Negro: An Interpretation* (New York: Touchstone, 1997), 303.

convinced the landlords that filling their empty apartments with black tenants with steady manufacturing jobs was a better prospect than keeping them vacant.

Payton was providing a service for black New Yorkers by opening a closed neighbourhood. Prior to his excursion to Harlem most blacks lived either in the tenements of San Juan Hill in 53rd–68th streets on Manhattan's West Side (most of the tenements in this area were demolished in the 1950s by Robert Moses to make way for Lincoln Center) or in an area then called the Tenderloin—a neighbourhood Johnson was intimately familiar with. The Tenderloin stretched, as Robert Dowling notes, 'from Fifth Avenue across to Seventh and from Forty-second Street down to Twenty-fourth'. The Tenderloin was 'legendary for its proliferation of dance halls, brothels, cabarets, and gambling clubs.... Southern Black migrants congregated there, and unavoidable feelings of homesickness and disorientation were accompanied by radical, and often disastrous, moral and psychological changes.'[8] So, although the Tenderloin welcomed African Americans from the South, the area was a notorious slum unsuitable to the creation of a flourishing black community. (It was, however, somewhat similar to the neighbourhoods in Boston and later in London that would so trouble and transfix T. S. Eliot.) Still, blacks were permitted to own saloons and other businesses in the Tenderloin, and they were happy to sell at a profit and purchase property in Harlem once Payton provided a way.

While there were stable middle-class black neighbourhoods in Jamaica, Queens, and Bedford-Stuyvesant in Brooklyn, Payton recognized that access to a neighbourhood on the island of Manhattan was desirable, and formed the Afro-American Realty Company, 'a Negro corporation organized for the purpose of buying and leasing houses for occupancy by colored people'. This unprecedented step led to a competition with white residents of Harlem, who fought to keep blacks from the better addresses in the neighbourhood. Inspired by the opportunity to establish control of a Manhattan neighbourhood, Payton, partnered with 'J. C. Thomas, bought two five-story apartments, dispossessed the white tenants and put in colored'. J. B. Nail, the proprietor of a popular saloon in the Tenderloin and Johnson's future father-in-law, 'bought a row of five apartments and did the same thing'. Most importantly, black civic associations began to shift from their earlier locations to Harlem. Nothing symbolized this change more than when St Philip's, a black church, 'bought a row of thirteen apartment houses on One Hundred and Thirty-fifth Street, running from Seventh Ave almost to Lenox'.[9]

Owing to the efforts of Payton and his associates, Harlem became something almost unheard of: a modern black neighbourhood founded on speculation and good fortune. It represented a vast improvement on the kind of urban life possible for blacks in San Juan Hill and the Tenderloin. If, by 1935, Harlem was little more than a slum, it is important to remember that it did not begin that way, that it initially

[8] Robert Dowling, 'A Marginal Man in Black Bohemia: James Weldon Johnson in the New York Tenderloin', in Barbara McCaskill and Caroline Gebhard (eds.), *Post Bellum, Pre Harlem* (New York: New York University Press, 2006), 117.

[9] Johnson, 'Harlem: The Culture Capital', 304.

contained 'the finest housing Negroes had been permitted to live in'.[10] As Tim Youngs states in Chapter 15 in this volume, 'Modernism is built on travel,' and it was the migration of black workers and artists alike from the South, the lower Midwest (Aaron Douglas and Langston Hughes, respectively the most prominent painter and poet of the Harlem Renaissance, both grew up in Kansas), and even the Caribbean to Harlem that marked the district and its inhabitants as thoroughly modern. In this way Harlem was, as Locke would have it, 'a race capital....[a] cente[r] of folk-expression and self-determination'.[11] Harlem, then, began emerging as a simultaneously modern and black space in the late 1900s and was firmly entrenched as such by the conclusion of the First World War, when the decorated veterans from the all-black 369th Regiment of the New York National Guard (another sign of black modernity emerging from the uncertainty of war) marched up Fifth Avenue to the proud community ready to welcome them home.[12] Yet even as Harlem emerged in the black consciousness as the figurative metropole of black America, the shape and contour of the art emerging from the quarter was largely inchoate until Johnson, and then Locke, articulated their visions of how exactly literary art related to Harlem and thus to the larger black community.

DEMOCRACY AND ART

Both Johnson's *Book of American Negro Poetry* and Locke's *The New Negro* elide certain voices in their attempt to craft a literary canon suitable for widespread black and white consumption. These elisions establish the boundaries of black American modernity. Although each anthology makes overt gestures towards an authentic representation of the black American artistic community, the politics of canon formation were never far from the thoughts of either editor. Both men were, in their respective anthologies, attempting to finesse 'the important post-war ideological fight between advocates of black nationalism, socialism, and American capitalism who in different ways struggled to position themselves as leaders of working class black Americans'.[13] Johnson and Locke sought specifically to displace the followers of the black nationalist Marcus Garvey and of those—like the followers of A. Phillip Randolph and Chandler Owen—aligned with socialist organizations. Taking their

[10] Ibid.
[11] Locke (ed.), *The New Negro*, 7.
[12] David Levering Lewis, *When Harlem Was in Vogue* (New York: Penguin, 1997), 4. Lewis suggests that the march of the 369th marks a beginning of the Harlem Renaissance. I have been trying to demonstrate here that Harlem's emergence as the Mecca of black modernity cannot be identified so precisely.
[13] Anthony Dawahare, 'The Specter of Radicalism in Alain Locke's *The New Negro*', in Bill V. Mullen and James Smethurst (eds), *Left of the Color Line: Race Radicalism and Twentieth-Century Literature of the United States* (Chapel Hill: University of North Carolina Press), 68.

cue from W. E. B. DuBois as much as from mainstream American political discourse, both Johnson and Locke opposed Garvey's version of black nationalism since it advocated withdrawing from the United States and returning to Africa.[14] Johnson and Locke also shunned the uncertainty inherent in organizing towards a socialist revolution, not out of an attitude of political quietism but out of an unshakeable confidence in the possibilities for black achievement within the American capitalistic paradigm.[15] These men wanted black Americans to have a genuine opportunity to compete within the American system before they would entertain any thought of leaving the United States or abandoning its economic system. It is not surprising, given their singular accomplishments prior to editing their anthologies, that Johnson and Locke felt entitled to intervene in this contest of representation and to legitimize particular claims while silencing others, nor is it surprising that both would articulate the reconciliation of autonomous black identity and American nationalism as the 'natural' position of modern black Americans.

Johnson's life is marked by capacious optimism and remarkably diverse achievement. Raised in a middle-class household in Jacksonville, Florida, he rose to heights unprecedented for a black American in several fields. After graduating from Atlanta University (one of the many colleges and universities founded to educate the descendants of slaves in the wake of the civil war) in 1894 Johnson worked as a high school principal in his home town, where he also operated a newspaper and practised law. In 1902, after summering in New York the previous two years, he moved to the Tenderloin, where he collaborated with his brother Rosamond and Bob Cole, 'forming a team that published a number of hit songs for Broadway shows and reviews'.[16] While in New York, Johnson studied literature at Columbia University with Brander Matthews and served as president of the city's Colored Republican Club.[17] In 1906 the Roosevelt administration appointed Johnson 'to a consular post in Venezuela, and later to one in Nicaragua'.[18] Johnson returned to New York after the election of Woodrow Wilson in 1912, eventually becoming executive secretary of the National Association for the Advancement of Colored People (NAACP) in 1916. Johnson's life was a testament to the potential for black Americans to create new

[14] See Michelle Ann Stephens, *Black Empire: The Masculine Global Imaginary of Caribbean Intellectuals in the United States, 1914–1962* (Durham NC: Duke University Press, 2005), for an insightful analysis of how expatriates like Garvey and Cyril Briggs sought to articulate a vision of an international black community that had as much to do with the political realities in their former colonies as those in the United States.

[15] It is unsurprising that Johnson, who worked as a diplomat and actively helped put down an uprising in Venezuela, would be cool towards socialism. See William E. Gibbs, 'James Weldon Johnson: A Black Perspective on "Big Stick" Diplomacy', *Diplomatic History*, 8/4 (1984), 329–47, for a full account of Johnson's role in an American imperial adventure.

[16] Dickson D. Bruce, Jr, *Black American Writing from the Nadir* (Baton Rouge: Louisiana State University Press, 1989), 231.

[17] See Tess Chakkalakal, ' "Making a Collection": James Weldon Johnson and the Mission of African American Literature', *South Atlantic Quarterly*, 104/3 (2005), 528–34, for more on the relationship between Johnson and Matthews.

[18] Bruce, *Black American Writing*, 232.

possibilities out of the chaos of modern life. He shaped his anthology to reflect the resiliency of the black community in the face of violence, contempt, and indifference.

Locke's achievements were, if less varied than Johnson's, just as impressive. The product of middle-class parents in Philadelphia, Locke, who graduated *magna cum laude* from Harvard, was the first black Rhodes scholar. While at Oxford he was denied entrance into five Oxford colleges, an experience that highlighted the pertinence of racial prejudice even at the highest reaches of society. After studying at Oxford and the University of Berlin from 1907 to 1911, he took a position at Howard University, where he taught until 1925 (when he was fired for demanding pay equal to that of white professors) and again from 1928 (when the first black president of Howard brought him back to campus) until he retired in 1953. After completing his dissertation in 1918, Locke became a prominent member of the black intelligentsia, submitting articles and reviews to a number of leading periodicals, principally *Opportunity*, which brought him to the attention of important patrons like Charles S. Johnson and Charlotte Osgood Mason.[19] Like Johnson, the heights to which Locke had risen made him disinclined to support either socialism or a parochial nationalism that posited a separate destiny for black Americans outside of the United States.

Both men perceived their anthologizing as a means to expand the realm of the possible for black Americans by exposing their artistic achievements to the rest of society. Johnson equated his efforts in *The Book of American Negro Poetry* with his work for the NAACP when he proclaimed, in his masterful Preface to the volume, that 'the production of literature by the colored people in this country ... is a matter which has a direct bearing on the most vital of American problems', representative democracy.[20] Johnson maintained this because he held that 'The status of the Negro in the United States is more a question of national mental attitude toward the race than of actual conditions. And nothing will do more to change that mental attitude and raise his status than a demonstration of intellectual parity by the Negro through the production of literature and art.'[21]

If, according to Johnson, whites could reduce their hostility to black achievement by consuming black art, then talented and cosmopolitan black Americans could simultaneously strengthen the nation and the black community by producing art worthy of acclaim. Of course, this claim seems to ignore the deplorable conditions that the majority of black Americans endured throughout the South, privation that Johnson—who worked as a country teacher in rural Georgia while an undergraduate at Atlanta University—had experienced first hand. It seems clear, given the increased radicalism that swept through the black community at the close of the First World War and the violent response from white communities in the North and South, that

[19] *The Philosophy of Alain Locke: Harlem Renaissance and Beyond*, ed. Leonard Harris (Philadelphia: Temple University Press, 1989), 3–6.
[20] James Weldon Johnson, *The Book of American Negro Poetry* (New York: Harcourt Brace Jovanovich, 1959), 9.
[21] Ibid.

Johnson's claim is meant to minimize the efficacy of a class-based or a black nationalist analysis of racial violence.[22]

In light of the utopian trust in the possibility for reform Johnson articulates in his Preface, it is important to note that he worked in the trenches to achieve this reform in his role as executive secretary of the NAACP. Indeed, Johnson directly experienced the realities of racial violence. He investigated a high-profile lynching in Memphis in 1917 for the NAACP, and this experience—though deeply troubling—produced an insight that would guide his understanding of the path to a free and modern life for black Americans and shape the production of *The Book of American Negro Poetry*. Johnson realized during his inquiry in Memphis that 'in large measure the race question involves the saving of black America's body and white America's soul'.[23] Johnson would work against lynching throughout his tenure as executive secretary, most notably by lobbying Congress to support the 1921 Dyer Bill—an anti-lynching law that would eventually be defeated by Southern legislators. If Johnson's efforts in support of the Dyer Bill were meant to protect black America's body, *The Book of American Negro Poetry*—which Johnson was compiling in his spare time as he worked to shepherd the Dyer Bill to a vote—would enrich white America's soul.

The tensions of this approach are palpable in the Preface, where Johnson proclaimed that 'no people that has produced great literature and art has ever been *looked upon* by the world as distinctly inferior'.[24] Johnson contrasts the ritual avoidance of responsibility that lynching demands of its white participants with the hope that making the fullness of black American culture visible will make the ritual obsolete. Johnson's optimistic invocation of visibility here reverses the ambivalent ending to his 1912 novel *Autobiography of an Ex-Colored Man*, where the unnamed protagonist fades into the American mainstream in order to escape the limitations of race. Anticipating Ralph Ellison in interesting ways, invisibility empowers individual self-determination in Johnson's novel, while Johnson's anthology insists that increased visibility will be the salvation of the decidedly non-fictional black American masses.[25]

Alain Locke made similar, if less overtly political, claims four years later in the introduction to *The New Negro* when he characterized the 'Old Negro . . . [as] a stock figure perpetuated as an historical fiction partly in innocent sentimentalism, partly in deliberate reactionism'.[26] Locke calls for the rejection of this clichéd formulation and

[22] Lee Williams, *Post-War Riots in America: 1919 and 1946* (Lewiston, NY: Edwin Mellen, 1991), 40. In fact, Johnson in his role as executive secretary of the NAACP had presented a report to Congress on race riots in Chicago and Washington DC in 1919. That he does not explicitly mention these experiences indicates the lengths to which Johnson and others considered such critiques *verboten*.

[23] James Weldon Johnson, *Along This Way: The Autobiography of James Weldon Johnson* (New York: Penguin, 1990), 318.

[24] Johnson, *Book of American Negro Poetry*, 9; my emphasis.

[25] For a consideration of the connections between Johnson's and Ellison's use of the trope of visibility in their writing, see Kenneth W. Warren's discussion 'Ralph Ellison and the Cultural Turn in Black Politics', in his *So Black and Blue: Ralph Ellison and the Occasion of Criticism* (Chicago: University of Chicago Press, 2003), 25–41.

[26] Locke (ed.), *The New Negro*, 3.

'that the Negro of to-day be seen through other than the dusty spectacles of past controversies'.[27] Note Locke's subtle emphasis on visibility and his rejection of a sustained critique of the material conditions of the past. Locke's New Negro, newly arrived in industrial cities, has by 'the very process of being transplanted... becom[e] transformed'[28] into a modern subject that demands re-evaluation. This transformation does more than reshape the previously stunted black community. Since 'Democracy itself is obstructed and stagnated to the extent that any of its channels are closed,' freeing Black Americans from discrimination strengthens the fabric of American society.[29] Locke evades mention of the violence and absence of opportunity that produced the Great Migration by declaring black Americans' escape from the South 'a deliberate flight not only from countryside to city, but from medieval America to modern'.[30] Even more explicitly than Johnson, Locke identifies a black American desire for modernity as the catalyst in the transformation that began after 1905 and accelerated after the onset of the First World War.

Locke's and Johnson's decision to neutralize voices in the black community that might contest their assertions about the relationship between art and democracy meant that both editors were careful about the authors they selected for their anthologies. Of course, not all black artists and intellectuals during the post-First World War period were patriotically seeking to perfect the Union, and so Johnson and Locke simply ignored the poets who published primarily in publications like Garvey's *Negro World* and Chandler Owen and A. Phillip Randolph's *Messenger*.[31] Johnson's text had by its very nature to be more inclusive because he intended his anthology to trace the evolution of an important literary genre; Locke could exercise greater control in part because he sought to define an important cultural moment. Still, Johnson included a handful of poems (including some of his own) that white readers might have found troubling, if not incendiary. The inclusion of these voices allowed Johnson's text to yield a more complete picture of the competing ideals that produced black American modernity, but Johnson self-consciously framed this picture to make the demands of the black community palatable to the white elites and black masses alike. While the formal differences of the two collections—Locke's text includes poems, short stories, musical lyrics, historical and critical essays, and reportage—makes a straightforward comparison of these texts difficult, comparing the kinds of poets and poems collected in *The Book of American Negro Poetry* with those contained in *The New Negro* makes the differences in output, if not intent,

[27] Ibid. 5. [28] Ibid. 2.
[29] Ibid. 6. [30] Ibid.
[31] A systemic re-evaluation of these voices is long overdue. Venitra Patton and Maureen Honey (eds), *Double Take: A Revisionist Harlem Renaissance Anthology* (New Brunswick, NJ: Rutgers University Press, 2001), attempts to place the authors excluded by Johnson and Locke into dialogue with canonical Harlem Renaissance authors, allowing students and scholars to approximate the kinds of debates that were *au courant* in Harlem during the period.

clear. This is especially the case when one remembers that Johnson's text served as a model for Locke to emulate.

THE 'FIRST NEGRO REVOLUTIONARY POETS'?

The first edition of *The Book of American Negro Poetry* included contributions from thirty-one poets, including Johnson himself. There are no scholarly notes in this text, as there are in the second edition, published in 1931. Several of the poets included in the volume, from William Stanley Braithwaite to Alice Dunbar Nelson, had little to say about issues of race and democracy, and because of its timing, the first edition does not include many of the writers who would come to be synonymous with the Harlem Renaissance—poets like Langston Hughes, Countee Cullen, Arna Bontemps, Helene Johnson, Gwendolyn Bennett, and Sterling Brown. Still, despite coming too early to include these worthies, Johnson's collection assembled enough figures, including Paul Laurence Dunbar, Fenton Johnson, Georgia Douglas Johnson, and Claude McKay, to give his audience a sense of the progress of black writing. Surprisingly, the writer with the most poems in the collection was not Johnson's good friend Dunbar—although he was the best-known black American poet by far in 1922, Johnson only includes eight of Dunbar's poems—but a relative newcomer, the Jamaican Claude McKay, with twelve. Dunbar, of course, was a dialect poet whose expression ran the risk of reinforcing rather than challenging notions of black intellectual inferiority. In this way, giving McKay the most space and allowing his voice to serve as counterpoint to the other more conservative poets gave an artistic tradition that was neither unified nor coherent an air of progression.

There are 106 poems in the first edition of *The Book of American Negro Poetry*, and only a handful engaged with issues of racial violence and American democracy: James David Corrothers's 'At the Closed Gate of Justice' and 'In the Matter of Two Men', Fenton Johnson's 'Tired', James Weldon Johnson's 'Brothers' and 'The White Witch', and Claude McKay's 'The Lynching', 'If We Must Die', and 'To the White Fiends'. Yet even these poems, which decry America's racial injustice, do not call into question black people's allegiance to American democracy. Indeed most of these poems portray black Americans as the US citizens that best embody the patience and willingness to work for reform that strengthens democratic societies. Fenton Johnson's 'Tired' and Claude McKay's 'The Lynching' and 'To the White Fiends' are perhaps the most challenging poems in the first edition, but none suggests a militancy which might disrupt the status quo.

James Weldon Johnson described Fenton Johnson in the scholarly notes to the second edition as 'one of the first Negro revolutionary poets'. According to Johnson, Fenton Johnson's poetry tried to

voic[e] the disillusionment and bitterness of feeling the Negro races was then experiencing. In some of this poetry he went further than protests against wrongs or the moral challenges that the wronged can always fling against the wrongdoer; he sounded a note of fatalistic despair. It was his poetry written in this key that brought him recognition . . . Doubtless its effect was in some degree due to the fact that it was an idea so foreign to any philosophy of life the Negro in America had ever preached or practiced.[32]

This is a curious qualification. If Fenton Johnson's poetry expressed an idea that was 'foreign to any philosophy of life the Negro in America had ever preached or practiced', then James Weldon Johnson should not have included those poems in his collection. If this was not the case, then something in 'Tired', the only one of Fenton Johnson's protest poems included in *The Book of American Negro Poetry*, should, one presumes, reveal the revolutionary zeal that was then at work within the black community. Yet, as we can see below, this is not the case.

Tired
I am tired of work; I am tired of building up somebody else's civilization.
Let us take a rest, M'lissy Jane.
I will go down to the Last Chance Saloon, drink a gallon or two of gin, shoot a game or two of
 dice and sleep the rest of the night on one of Mike's barrels.
You will let the old shanty go to rot, the white people's clothes turn to dust, and the Cavalry
 Baptist Church sink to the bottomless pit.
You will spend your days forgetting you married me and your nights hunting the warm gin
 Mike serves the ladies in the rear of the Last Chance Saloon.
Throw the children in the river; civilization has given us too many. It is better to die than it is
 to grow up and find out that you are colored.
Pluck the stars out of the heavens. The stars mark our destiny. The stars mark my destiny.
I am tired of civilization.[33]

Perhaps the most alarming note here is the speaker of the poem's rejection of modern possibility. The speaker has clearly lost faith in the mantra of black achievement preached by leaders like Garvey and Du Bois. As a result he is more than ready to abandon the Protestant work ethic and escape the privations of the civilization that supposes him less than human. There is a plaintive quality to this poem but almost no revolutionary fervour. Instead it suggests a possible collapse of American civilization, but one due to the passive withdrawal of black Americans' labour rather than any anarchic action. The withholding of labour results not from a carefully thought out socialist agenda, but arises out of the despair resulting from dealing with endemic racism. Indeed, the speaker seeks to escape the closed destiny that America seems to offer its blacks, not by returning to Africa or by pursuing unprecedented academic achievement, but by drowning himself in alcohol. The fatalistic despair that James Weldon Johnson notes in his Preface is easy to identify, but the strains of rebellion are more difficult to detect.

[32] Johnson, *Book of American Negro Poetry*, 140.
[33] Ibid. 144–5.

The same cannot be said for Claude McKay, the poet who represents the future in Johnson's text. Johnson's 1931 notes inform the reader that McKay 'came to New York [in 1915], arriving in that city at just about the time that Harlem was beginning to assume form as the Negro world metropolis'.[34] McKay's timing is such that he is able to witness the evolution of Harlem as the United States' involvement in the First World War brought improving economic conditions to the black community. McKay's poetic voice is as strident as his preferred poetic form, the sonnet, was unusual, and Johnson's introductory notes identify McKay as perhaps the most important black poet of the post-war era for that reason:

McKay belongs to the post-war group and was its most powerful voice. He was pre-eminently the poet of rebellion. More effectively than any other poet of that period he voiced the feelings and reactions that the Negro in America was then experiencing. . . . This is masculine poetry, strong and direct, the sort of poetry that stirs the pulse, that quickens to action.

Johnson foregrounds McKay's militancy by including three of his most strident protest sonnets, 'The Lynching', 'If We Must Die', and 'To the White Fiends'. These poems are, upon closer inspection, less revolutionary than Johnson suggests.

McKay's 'If We Must Die' is, along with Langston Hughes's 'The Negro Speaks of Rivers', perhaps the most famous poem of the Harlem Renaissance. The sonnet, though effective at summoning the sense of injustice and defiance at being subject to an unjust and capricious attack, contains enough racial ambiguity (the speaker is never identified by race, meaning you would have to know McKay's background to understand whose actions he is denouncing) to have been read by Winston Churchill during one of his radio addresses during the Blitz. 'The Lynching' cleverly suggests that committing acts of racial violence deforms the community it is supposed to protect, but in this regard remains a poem meant to inspire reform in the white community not revolt in the black. 'To the White Fiends' is initially a rebellious poem, in which the speaker declares himself able to 'shoot down ten of you for every one | Of my black brothers murdered, burnt by you'. Yet even as the octet gathers this energy, the sestet works to contain it. After the turn the speaker declares himself simply

> a light
> [sent by God] to burn on the benighted earth
> Thy dusky face O set among the white
> For thee to prove thyself of highest worth.

Thus, McKay figures turning to black spirituality and belief in progress and not retributive violence as the proper response to unprovoked racial violence. These sonnets, while demanding an eventual end to black oppression, defer the moment when white Americans might have to face their sins.

Still if McKay's sonnets fail to map out a revolutionary programme, their rhetorical brilliance must not be overlooked. Indeed, as James Keller notes, precisely because McKay 'chose to contain his politically volatile subject matter within a verse

form that signifies the aristocratic European literary tradition . . . the ideological contradiction manifest in the practice of joining tradition and dissent is functional, [and] through this poetic compromise McKay was attempting to create a space in which to challenge white America's claim to cultural superiority'.[35]

Johnson sought to occupy the space McKay creates with his (less than) revolutionary poems, for it was within this space that the souls of white folks might be transformed by black art. Johnson tentatively sought to evoke the spectre of black revolution to create the rhetorical space for interracial reconciliation; Locke's goals in *The New Negro* were far more modest. Locke spent almost his entire career at Howard University, but in 1925, when he edited the Harlem issue of the *Survey Graphic*, which served as a precursor to *The New Negro*, his academic career was in doubt. That autumn, while he was overseeing the transformation of the magazine issue into a manuscript, he was outside of the academy for the first and only time in his career. Perhaps this is why, in compiling *The New Negro*, Locke was even more cautious than Johnson four years earlier, despite the markedly greater interest in the artistic achievements of black Americans demonstrated by the success of the Harlem issue of *Survey Graphic*. Despite a more favourable environment, Locke limited discussions of the political to prescriptive essays that effectively concealed those currents from view. Nowhere was this plainer than in Locke's treatment of McKay.

Locke chose William Stanley Braithwaite to write 'The Negro in American Literature', the essay that placed the emerging writers of the Harlem Renaissance, including McKay, in the context of the larger American literary tradition, specifically in relation to writing that addressed race. Braithwaite was an astute choice for this assignment as he was perhaps the most accomplished black literary critic of the 1920s, but he was also, as James Weldon Johnson notes, 'so detached from race that for many years he had been a figure in the American literary world before it was known generally that he is a man of color'.[36] Given Braithwaite's perspective it is unsurprising that, although he considered McKay 'the poet who leads his generation', he cautions against the racial politics expressed in McKay's protest poems. Braithwaite complained that

[McKay's] work is caught between the currents of the poetry of protest and the poetry of expression; he is in turn the violent and strident propagandist using his poetic gifts to clothe arrogant and defiant thoughts . . . When the mood of *Spring in New Hampshire* or the sonnet *The Harlem Dancer* possesses him, he is full of that spirit and power of beauty that flowers above any and all men's harming. How different in spite of the admirable spirit of courage and defiance, are his poems of which the sonnet *If We Must Die* is a typical example.[37]

Braithwaite clearly favours poetry that does not dwell on issues of race but instead aspires to make a sterile universal appeal to beauty. Despite the fact that, as Locke maintained, the black American has been 'a stock figure perpetuated as an historical

[35] James R. Keller, ' "A Chafing Savage, Down the Decent Street": The Politics of Compromise in Claude McKay's Protest Sonnets', *African American Review*, 28/3 (1994), 448.

[36] Johnson, *Book of American Negro Poetry*, 99.

[37] William Stanley Braithwaite, 'The Negro in American Literature', in Locke (ed.), *The New Negro*, 40.

fiction...in deliberate reactionism',[38] Braithwaite suggested that the black artist must not meet such distortions in kind, but must instead look forward to the moment when the need to address racial injustice would no longer be necessary.

Still, despite his qualifications, Braithwaite declared McKay to be one of the exemplary writers of the Harlem Renaissance and identified 'If We Must Die' as one of his more notable pieces. Despite Braithwaite's acknowledgement, Locke omitted the poem—and all of his other protest sonnets—from *The New Negro*. In place of these pieces he included 'The White House', a poem that castigates presidential indifference to racial injustice. This poem is neither as strident nor as polished as McKay's sonnets, and the effect is to reinforce the notion advanced by Braithwaite that when artists protest they do so at the cost of their art. To further muddy things, Locke changed the title of the poem to 'White Houses' diffusing the focus of the poem from a direct address to the political leader of the nation to a vague critique of the broader white community. As Arnold Rampersad notes, this unasked for editorial change incensed McKay.[39] It is perhaps unsurprising that McKay would abandon Harlem for Europe in 1922, journeying to Moscow before settling in Paris, even as Johnson and Locke were struggling to articulate a Janus-faced black modernism compatible with black and white Americans alike.

To note the lengths to which both Johnson and Locke went to minimize dissent while articulating black modernisms should not denigrate their effort. Indeed, it was in their struggle to create a coherent and politically acceptable black canon that Johnson and Locke themselves exemplify black modernism. Each sought to codify their understanding of what modernism meant for their community while attending to more weighty matters. In this they resemble no one more than Ezra Pound, another chauvinistic and ambitious American artist, who sought to shape artistic expectations, although Pound certainly felt no need to bow to any liberal consensus. And yet, as Barbara Foley notes, 'it detracts nothing from Locke's project—indeed, it only enhances the project's historical and ideological importance—to note the extent to which its limitations were to a significant degree the limitations of the current leftist thinking that substantially influenced his work.'[40] Johnson and Locke produced two literary projects that, despite their ideological limitations, created a black canon while simultaneously producing introductory statements that convincingly, if not comprehensively, explained the black American embrace of modernity without risking the anger of white Americans, whose souls Locke and Johnson were trying to redeem.

[38] Locke (ed.), *The New Negro*, 1.
[39] Arnold Rampersad, 'Introduction', in Locke (ed.), *The New Negro*, pp. xxi–xxii.
[40] Barbara Foley, *Spectres of 1919: Class and Nation in the Making of the New Negro* (Urbana: University of Illinois Press, 2003), 205.

CHAPTER 14

..

COLONIAL
ENCOUNTERS

..

LAURA DOYLE

THE beginnings of modernism might well be traced to colonial encounters that long pre-date modernism itself. That is, the fundamental conditions for at least Anglo-European modernism as it developed in Britain, Ireland, continental Europe, and the Americas might have been created centuries earlier, in the face-to-face meetings of Anglo-Europeans and peoples of other lands, which often began as trading relations but soon became situations of domination and struggle. Reading Anglophone modernism in this light allows us to consider colonial encounters in modernism in fresh terms, and in a richer historical dimension: not only as part of the drama represented in modernist texts, but also as the back story to diverse modernisms' emergence, which in turn explains the close relation between modernist and post-colonial literature, or the historical and symbolic 'encounter' between them in Anglophone literary history.

Modernist experimentation has often been interpreted as a response to the First World War, its traumatic effects precipitating the fractured forms and 'wasteland' imaginary of American and Anglo-European modernisms. This chapter highlights a broader background for this link between war and literary experimentation: the increasing proliferation and visibility of global war and anti-colonial insurgency. Throughout the nineteenth century and among several empires around the world, dozens of deadly battles were fought by both colonizers and colonized and experienced by them together, yet from radically different perspectives. At the same time, technologies of circulation—including radio, telegraph, photography, and new forms of print, as well as increasingly rapid and far-reaching networks of transportation—brought the violence and uneven material conditions of the globe into closer view for many who would otherwise have known only their own corner of the world.

This chapter suggests that these developments create a global orientation and 'nervous condition' shared by modernist and post-colonial writers, although in different degrees and with different stakes. It is these conditions that prompt their reconfigurations of space, time, and intersubjectivity, a common project which can be signalled in the term 'geomodernism'.[1] Treating both canonical Anglo-European and post-colonial writers as geomodernists, we better appreciate the differences and similarities in their manipulations of perspective and temporality, by which they capture the discrepant and deadly effects of this global condition. This chapter supplements my discussion elsewhere of female geomodernists in these terms.[2]

The historical and geopolitical approach introduced here aims to move beyond the 'borrowing' model, in which canonical Anglo-European modernists innovate and post-colonial writers subsequently borrow or revise these innovations. Even some recent efforts to adjust this paradigm seem to slip back into it. Tim Woods, for instance, suggestively argues that 'Modernism acted as a mirror held up to colonialism,' yet he then falls into a familiar formulation in explaining that 'European artists looked to Africa for borrowings to revitalize what was perceived to be a flagging and insipid Western *aesthetic*, African writers borrowed from European modernism for the purposes of promoting a racial politics of counter-colonialism.' Woods concludes that 'Hence, modernism and modernity opened resistance spaces for a great variety of Africans.'[3] Here, not only aesthetic innovation but also resistance itself originates with Europeans.

Yet this chapter proposes that, on the contrary, in light of the history of anti-colonial insurgency, we might reverse or at least complicate this claim and say that Africans also modelled the energy of resistance for Europeans—not only by involuntarily lending them an exotic aesthetic but by actively battling and organizing against the realities of Anglo-European colonialism to which many Anglo-Europeans would otherwise have turned a blind eye. If 'resistant spaces' are opened by modernism, these derive at least in part from a resistant pressure placed on Anglo-European writers from without, a pressure intended to counteract the aggressive practices of multiple empires.

To understand fully these exchanges among artists, it is necessary first to revisit key conditions of nineteenth- and early twentieth-century history, in the process adjusting our accounts of empire in this period. Doing so, we can better respond to

[1] Laura Winkiel and I introduced this term in *Geomodernisms: Race, Modernism, Modernity* (Bloomington: Indiana University Press, 2005).

[2] See Laura Doyle, 'Geomodernism, Postcoloniality, and Women's Writing', in Maren Linett (ed.), *The Cambridge Companion to Modernist Women Writers* (Cambridge: Cambridge University Press, 2010).

[3] See Tim Woods, 'Memory, Geography, Identity: African Writing and Modernity', in Peter Brooker and Andrew Thacker (eds.), *Geographies of Modernism: Literatures, Cultures, Spaces* (London: Taylor & Francis, 2005), 128. For studies that, in contrast, begin to consider a lateral rather than lineal, or 'inheritance', kinship among Anglo-European modernists and post-colonial writers, see Simon Gikandi, *Maps of Englishness: Writing Identity in the Culture of Colonialism* (New York: Columbia University, 1996); Jahan Ramazani, *The Hybrid Muse: Postcolonial Poetry in English* (Chicago: University of Chicago Press, 2001; and Mary Lou Emery, *Modernism, the Visual, and Caribbean Culture* (Cambridge: Cambridge University Press, 2007).

Andreas Huyssen's call in his essay 'Geographies of Modernism in a Global World' for a more broadly oriented modernist studies.[4] We can likewise more effectively reframe the geomodernists' startling visions, including their techniques for rendering such a world and their troubled mutual awareness of each other in it.

Warring Global Empires

Although British historians have often characterized the nineteenth century as the era of 'Pax Britannica' in which the empire was consolidated and the 'great nations' rarely entered battle, a closer look reveals otherwise. Likewise, US historians emphasize its policy of isolationism until the Second World War, eliding its interventions in South American and Caribbean politics as well as in the Pacific world and Africa. At the same time, and perhaps most importantly, English-language portraits of nineteenth-century history tend to erase the presence of other world empires, such as Russia and China. All of these tendencies limit our understanding of geomodernist literature.

We can begin to address this problem in our accounts of world literature (in any period, in fact) when, as I've argued elsewhere, we look past the standard narrative of successive empires—in which a new one arises from the ashes of the old, decadent one—and instead take notice of the fact that in any one period there are several, vying world empires.[5] In the case of Anglophone geomodernisms, both canonical and post-colonial, we are blocked by one such narrative that persists even in our most pointedly post-colonial scholarship: the story of how, by the nineteenth century, Anglo-European empires established 'unchallenged dominance' on the world stage. We find this account, for instance, in the current English-language Wikipedia entries on the nineteenth century, which reflect one of the dominant scholarly perspectives as well as a popular consensus. Under the general heading 'The Nineteenth Century', following a brief mention of the 'collapse' of other empires, readers learn that 'After the Napoleonic Wars, the British Empire became the world's leading power, controlling one quarter of the world's population and one third of the land area.'[6] Likewise, under 'British Empire', we read that after 1815 'Britain enjoyed a century of effectively unchallenged dominance, and expanded its imperial holdings across the globe.'[7] Certainly the powerful British empire expanded in the nineteenth century,

[4] Andreas Huyssen, 'Geographies of Modernism in a Global World', in Peter Brooker and Andrew Thacker (eds), *Geographies of Modernism: Literatures, Cultures, Spaces* (London: Routledge, 2005), 15.
[5] See Laura Doyle, 'Notes Toward a Dialectical Method: Modernities, Modernisms, and the Crossings of Empire', *Literature Compass* 6 (March 2010): 1–19.
[6] Wikipedia, 'The Nineteenth Century', <http://en.wikipedia.org/wiki/19th_century>, 1. In the next sentence, this entry reports that Britain 'enforced a Pax Britannica, encouraged trade, and battled rampant piracy'. The phrasing 'enforced ... Pax' gives a hint of what's elided here.
[7] Wikipedia, 'British Empire', <http://en.wikipedia.org/wiki/British_Empire>, 1.

but it was hardly 'unchallenged'. Rather, it continually parried and manoeuvred, gained ground and lost ground, in a world of several competitive empires.

A few pages into the article on the British empire, a brief qualifying clause gives us a glimpse of this fact: 'Victory over Napoleon left Britain without any serious international rival, other than Russia in central Asia.'[8] In the next section, subtitled 'Rivalry with Russia', the fuller history is allowed into view—contradicting the article's original thesis. Here we read that 'during the 19th century Britain and Russia vied to fill the power vacuums that had been left by declining Ottoman, Persian, and Qing Chinese empires'.[9] Acknowledging the history of pitched and fairly even battles between the British and the Russians, this sentence meanwhile, with a flick of the wrist, erases the considerable parts eventually played by Germans, Prussians, and Austro-Hungarians in this contest. It furthermore whitewashes the process whereby all of these empires, in a shifting history of alliance and rivalry, actively sought to weaken the trade dominance of the Qing empire and to push back the borders of the Ottoman empire. Instead of merely filling a 'vacuum' left by the decadence of inevitably decaying empires, these several empires reached into Ottoman and Qing territories via nearly constant diplomatic pressure, manipulation of alliances, military conscription, and bloody battle. Then, too, the assertion that 'victory over Napoleon left Britain without any serious international rival' implies that the British alone defeated Napoleonic France, overlooking the crucial Russian defeat of the French in 1812, which crushed Napoleon's 'Grand Armée' and significantly enabled the British triumph.

The narrative of unchallenged British dominance still shapes Anglophone literary scholars' accounts of the nineteenth century and in turn distorts our sense of the context for geomodernisms. When we look beyond the model of 'the' Anglo-European core with 'its' circle of peripheries and semi-peripheries, we see that the nineteenth-century globe was shaped by far-flung multiple empires and multiple cores, all vying over multiple 'peripheries'. This perspective in turn brings into the foreground the many inter-imperial and anti-imperial battles of the nineteenth century, fought with increasingly deadly weapons and ever more quickly mobilized troops. In fact, in the nineteenth century the British were relative newcomers to the pursuit of empire in Asia (other than India), the Pacific, and Africa, and they actively pursued a place for themselves in these regions. In the second half of the century alone, Britain engaged in half a dozen expansionist wars in the East and the South, including the Crimean War (1853–6), the decade-long Anglo-Maori War (1860–72), the Second Anglo-Afghan War (1878–80), the Zulu War (1878–81), the First Anglo-Boer War (1881), the Third Anglo-Burmese War (1885), and the Second Anglo-Boer War (1899–1901). Meanwhile, of course, Britain repeatedly deployed troops to squelch uprisings throughout their colonial territories—of which the Sepoy Rebellion in India (1857) and the Morant Bay Rebellion in Jamaica (1865) were only the most severe. In short, constant warring was required to maintain and expand the

[8] Wikipedia, 'British Empire', <http://en.wikipedia.org/wiki/British_Empire>, 9.
[9] Ibid. 10.

empire. Far from being a settled world order blessed by a Pax Britannica, the shifting alliances and battles of the nineteenth century among the Russians, Chinese, Turks, French, Prussians, Germans, British, and eventually the Japanese meant that the British and many others were in battle for as many years as they were at peace during the second half of the nineteenth century, often at multiple battle sites.

In roughly the last quarter of the nineteenth century, the intensification of battle and competition was propelled by a range of events, including the defeat of France in the Franco-Prussian War, the emergence of Japan, the US, and Germany as industrializing world powers and territory seekers, and the Long Depression of 1873–96. Set off initially by the collapse of the Vienna Stock Exchange in 1873, the Long Depression developed into a catastrophic worldwide deflation, causing starvation, unemployment, and bankruptcies in every empire. In turn, this depression motivated all of the empires to seize and secure new territories for additional markets and cheap labour, especially in Asia, Africa, and the Pacific. Marxist economists have justifiably considered the Long Depression an early turning point in the shift from industrial to finance capitalism; yet it is also important to note that it was both precipitated by imperial agents (for instance, in so far as Napoleon's war with Prussia and the Germans precipitated it) and in turn catalysed fresh imperial aggression as well as new imperial finance strategies. Much attention has been given to the 'scramble for Africa' at the end of the nineteenth century; but in this period there was simultaneously a 'scramble' for Asia—including a scramble *in* Asia, for Russia and Japan vied with each other and several Western empires (including eventually the US) for dominance over Chinese port areas and strategic Pacific islands.

Constant involvement in these wars in Africa and Asia required the movement towards conscription and the increased financing of mobilization plans in Britain and Europe. Accordingly, it also fostered the bellicose imaginary that Patrick Brantlinger in *Rule of Darkness* and Cecil DeGrotte Eby in *The Road to Armageddon* have tracked in later nineteenth-century British literature and popular culture. In the Anglo-Boer Wars new ruthless tactics entered more openly into the realm of possibility and the public consciousness, including the British creation of concentration camps and the murder of civilians through the authorized burning of crops and villages. At the same time, these expansionist wars arose amid and in dialectical relation with the class struggles of the nineteenth century (as so clearly exemplified by the Paris Commune of 1871, a working-class uprising precipitated by the Prussian and German defeat of France), and these class uprisings were another problem that imperial conscription helped to 'solve'.

At the same time, in another part of the globe, South American territories actively battled for independence from Spain (1814–26), and thereafter engaged in trade wars among themselves (including those between Chile, Peru, and Bolivia in the 1880s), in the process often violently suppressing indigenous claims to rights or lands. To the north, Anglo-Americans pursued 'Indian removal' policies, devoting large military budgets and many troops to battles with indigenous peoples, and later to the Mexican War. This westward expansion helped to precipitate the bloody US Civil War (by raising questions about whether new states would allow slavery) even as it

ultimately led to the invasion and annexation of the Philippines at the end of the nineteenth century. At century's end, US military involvement in Cuba's independence struggles likewise fostered strategic US expansion of their sphere of influence under the cover of alliance and support for liberation.

This intensely embattled world was also becoming a more visible, tightly interconnected world. The world's several expanding empires invested prodigiously in infrastructure, including in railroads, canals, shipways, radio, photography, and telegraph cables, all of which dramatically increased the movement not only of goods and armies but also of news and information. Readers on one side of the world learned with startling speed about war, disaster, and destruction on the other side. Nor did one need to be literate to share in this new global order: for now the battle front was represented in photographs, such as in the Crimean War, one of the first wars to be thus relayed to civilian eyes. It seems fair to speculate that anyone who saw or read the newspapers would have a sense of world turbulence, of violent invasions, rebellions, and reprisals.

Yet these new vehicles for what Fredric Jameson and others have characterized as a new global 'simultaneity' were double-edged swords, for the same technologies of communication and travel that served empire eventually also enabled international awareness, organizing, and protest. As aggressive imperialist war became ever more rapidly mobilized, so did resistance and solidarity movements (a trend increasingly evident after the Haitian Revolution).[10] Recent histories of anti-colonial and anti-slavery insurgence in the Americas, India, Africa, China, and Russia establish clearly that empires faced resistance wherever they travelled.

By the early twentieth century, fostered by improvements in travel and communication, independence movements in Ireland, Africa, India, and the West Indies collaborated, debated, formed coalitions, exchanged newspapers, and took inspiration from each other, as has been recently studied by scholars such as Priyamvada Gopal and Elleke Boehmer. These activists built political networks that eventually hosted communist international congresses and pan-national or pan-ethnic congresses, including the Pan-African Congresses held in Europe between 1919 and 1945. (And we should note here, too, that the rebellions of serfs in the Russian empire, for instance, spread in some ways as a form of anti-colonial rebellion, in so far as the labourers hailed from territories that had been invaded and annexed by Russia.) In part prompted by these subaltern groups (rather than, as is often assumed, the other way round), Anglo-European ex-colonial administrators such as Virginia Woolf's husband, Leonard Woolf, wrote critiques of what Woolf called economic imperialism, and writers such as Mark Twain helped to organize the US Anti-Imperialist League and the public challenges to annexation of the Philippines.

[10] This 'back edge' of empire's technologies had already begun to take effect by the end of the eighteenth century, so that, for instance, the eventual leaders of the 1798 Irish rebellion found inspiration as they read the pamphlets and newspapers or heard first-hand accounts of revolutionary events in Haiti and France within weeks of their occurrence. They soon successfully sought them out as allies.

Under these conditions, as Frantz Fanon later remarked, 'In spite of all that colonialism can do, its frontiers remain open to new ideas and echoes from the world outside. It discovers that violence is in the atmosphere, that it here and there bursts out, and here and there sweeps away the colonial regime.'[11] From the other side of one such empire, Virginia Woolf similarly observed that each person in London was 'linked to his fellows by wires which pass overhead, by waves of sound which pour through the roof and speak aloud to him of battles and murders and strikes and revolutions all over the world'.[12] And Édouard Glissant reiterated the point: 'Today we hear the blast from Matouba, but also the volley of shots fired at Moncada' and thus does 'history come to life with stunning unexpectedness'.[13]

Such conditions themselves came into being with 'stunning unexpectedness' at the turn into the twentieth century. Global circuits of travel and communication carried contraband weapons, political activists or revolutionaries, and tremors of fear even as they also transmitted commodities, merchants, governors, soldiers, and penniless labourers. By the end of the nineteenth century, world consciousness was shaped, I suggest, by this charged awareness of both aggressive imperial expansion and anti-imperial resistance. This situation variously inspired and provoked avant-garde literary and artistic movements around the world—in Cuba, Russia, and Egypt as well as in Japan, the US, and Britain—which were often closely or loosely mingled with political movements of all stripes, as documented in recent studies of global modernisms.[14] This is the world in which modernism meets post-colonial literature, deconstructing (whether mournfully or critically) the centric perspectives of the imperial metropoles.

WHEN THERE IS HERE:
POST/COLONIAL RETURNS

This emergent condition and geopolitical consciousness might be characterized as an apprehensive *post/coloniality* of vision, or in other words a sense of the post-colonial *possibility* on the horizon—often long before decolonization proper was under way.

[11] Frantz Fanon, *The Wretched of the Earth*, trans. Constance Farrington (New York: Grove Press, 1963), 70.

[12] Virginia Woolf, 'Narrow Bridge of Art', in *Collected Essays of Virginia Woolf* (New York: Harcourt, Brace & World, 1966), 222.

[13] Édouard Glissant, 'The Quarrel with History', in *Caribbean Discourse: Selected Essays*, trans. J. Michael Dash (Charlottesville: University Press of Virginia, 1989), 63.

[14] See especially two new collections: Mary Ann Gillies, Helen Sword, and Steven Yao (eds), *Pacific Rim Modernisms* (Toronto: University of Toronto Press, 2010), and Mark Wollaeger (ed.), *The Oxford Handbook of Global Modernisms* (New York: Oxford University Press, forthcoming). Also see selected essays in Brooker and Thacker (eds), *Geographies of Modernism*, and Doyle and Winkiel (eds), *Geomodernisms*.

The slash between 'post' and 'colonial' in this spelling signifies the not yet realized but apprehended or anticipated possibility of a time after colonialism.[15] It is a 'slashed' condition in that it forces persons to live astride two incommensurable orders, feeling the world's 'unevenness' and friction, and to live between two temporalities as well, in so far as any orientation towards a post-colonial future aggravates and inflects, but does not erase, the colonial 'now'. This slash is a function, we might say, of the slash in what Walter Mignolo and Artuor Escobar call the modern/colonial structure of the geopolitical world: in their formulation, the slash marks the unequal distribution of labour and profit as well as physical comfort and security through all regions of the world. 'Over there' comes to differ radically from 'over here', separated by a barbed divide. Yet as activists protest, insurgents attack, and newspapers record these events, a post/colonial vision increasingly looms or beckons from 'over there', turning alterity into an interiorized sensitivity that links world subjects even as it signals the divisions between them.

Geomodernists dramatize this intersubjective, geopolitical condition by reworking narrative form in two key ways. They splice together multiple, discrepant perspectives; and they shift wrenchingly between past, present, and future. Canonical Anglo-European modernist fiction has, of course, often been discussed in terms of such formal innovations. Yet when we recall that the fractured condition expressed in Anglo-European texts was already and increasingly lived by the colonized, and indeed had been forced into view by their resistance, we might be led to think of Anglo-Europeans not so much as the 'pioneers' of such modernist forms but rather as the folks who had prior and superior access to the means of production with which to represent this modern/colonial condition. If Caribbean artists such as Kamau Brathwaite admired T. S. Eliot,[16] and Chinua Achebe's titles allude to the poetry of W. B. Yeats, this may be so because these 'Third World' writers mean to signal the way that 'their own' history lies at the back of canonically modernist aesthetics.

[15] Here I am riffing on Nelson Maldonado-Torres's notion of 'coloniality' in his essay 'On the Coloniality of Being'. He distinguishes between colonialism as institution and coloniality as a state of being: 'Colonialism denotes a political and economic relation in which the sovereignty of a nation or a people rests on the power of another nation, which makes such nation an empire. Coloniality, instead, refers to long-standing patterns of power that emerged as a result of colonialism, but that define culture, labor, intersubjective relations, and knowledge production well beyond the strict limits of colonial administrations. Thus, coloniality survives colonialism.' Conversely, I suggest, anti-coloniality or post-colonial consciousness *precedes* the founding of a post-colonial state; this consciousness prepares the strained 'patterns of power' within those states, including in the realms of culture, labour, intersubjective relations, knowledge production—and, we should add, in the fact of battle. See Nelson Maldonado-Torres, 'On the Coloniality of Being: Contributions to the Development of a Concept', *Cultural Studies*, 21/2–3 (Mar.–May 2007), 240–70.

[16] Describing the recordings of Eliot that so impressed him and other Caribbean writers of the 1930s and 1940s, Brathwaite explains that what 'turned us on' was Eliot's 'dry, deadpan delivery, the "riddims" of St. Louis', which resonated with 'the dislocations of Bird, Dizzy, and Klook' (Edward Kamau Brathwaite, *Roots* (Ann Arbor: University of Michigan Press, 1993), 286). Simon Gikandi connects this sense of dislocation to the 'crisis of late colonialism', which, he says, was also 'the crisis denoted by modernism' (*Maps of Englishness*, 158). My own point expands on Gikandi's to highlight the longer history of dislocation and war that encompassed both Eliot and Caribbean writers.

In this and the next two sections, this chapter aims to show how the experiments in perspective and time undertaken by canonical Anglo-European geomodernists partially register a condition that post-colonial or 'minority' geomodernists bring into fuller view. This and the next section focus on the form of multi-perspectival narration that I call 'horizon reversal', which captures a specifically post/colonial consciousness by juxtaposing the discrepancies of here and there, us and them, war zone and safe zone, poor and rich. I begin here with post-colonial novels because doing so in turn makes more legible the incipient form of horizon reversal in the canonical Anglophone modernist novels discussed in the next section.

In Caryl Phillips's 1988 novel *A Distant Shore*, we alternate between the perspectives of Dorothy, an older white Englishwoman, and Gabriel (known as Solomon in England), a younger black man fleeing the violence in his unnamed homeland in Africa. Their lives converge when he is hired as nightwatchman in Dorothy's suburban development. Both Dorothy and Gabriel are radically alone, having lost all family; both are looking for peace after emotional trauma. Just as they begin tentatively to explore a friendship, Gabriel is killed by racist thugs, an event which breaks Dorothy's tenuous hold on everyday life and leaves her heavily sedated in a therapeutic hospital. Gabriel's experiences of war and terrible violence in his troubled post-colonial country contrast sharply with Dorothy's quieter emotional isolation after her husband leaves and her sister dies. Phillips heightens this contrast by revealing to us, in alternating flashbacks of their past lives, how much they don't know about each other. Readers experience jarring shifts between scenes in which Gabriel sees his mother raped or nearly kills a friend for money, and scenes in which Dorothy waits in the rain at a bus stop or pathetically stalks a colleague she would like to date.

These reversals and contrasts capture the difference between here and there, between Dorothy and Gabriel, rendering the halting progress and the sudden end of their friendship as the result of a post/colonial legacy in which they hail from 'worlds apart' across the divide of something called 'race'. While the novel allows readers to straddle the worlds of Gabriel and Dorothy, it also impresses us with the paradoxical fact that what they most share is their isolation from each other as well as from their socially stifled communities.

An array of post-colonial and minority novels adopt a comparable structure of horizon reversal to capture the transnational cross-currents and conflicts arising from post/colonial histories. African Atlantic writers Nella Larsen and Claude McKay developed early uses of this structure of reversal. In *Quicksand*, Larsen's character Helga Crane travels between city and country and back and forth across the Atlantic only to find that she nowhere escapes the racial logic of the modern/colonial divide. In *Banjo* and *Home to Harlem*, McKay moves us between the United States, the Caribbean, and France to capture complex diasporic relations among Afro-French, Afro-Americans, Afro-Caribbeans, and other diasporic communities against a backdrop of policing whites.

Recent authors have more fully elaborated on this form. In Andrea Levy's *Small Island* (2004), we travel between Jamaica and England and among the perspectives of four characters—two of them black Jamaican and two white British—whose lives,

loves, and losses intersect before, during, and after the Second World War. In Monica Ali's *Brick Lane* (2003), we follow the lives of two sisters, the one who stays in Bangladesh and yet wanders from husband to husband, and the other, whose marriage takes her to London and into a modern life that is hemmed in, however, by both anti-Muslim racism and gendered alienation. Kiran Desai's *The Inheritance of Loss* (2006) likewise carries us between two 'worlds' or locations, in this case the mountains of northern India and New York City. In *Woman Hollering Creek* and *Interpreter of Maladies*, Sandra Cisneros and Jhumpa Lahiri, respectively, use the short-story collection to create this effect: as readers proceed from one story to another, we also shuttle back and forth across national borders and, like the characters, must labour to reconcile divergent yet interdependent social worlds.

These post-colonial and minority texts are all practising what has traditionally been called multi-perspective narration and has typically been deemed modernist. Yet approaching these texts from within the geopolitical history sketched above allows us to indicate their embedded attention to the structure of modernity/coloniality and to highlight this structure in the term 'horizon reversal'. In all of them, we travel between locales to see the story from its 'other side'. As characters migrate and points of view shift, 'her' becomes 'me', and 'over there' becomes 'here'—dramatizing all at once the incommensurability, the tragic complementarity, and the potential collapse or exchangeability of these locales. In many of these novels, while the characters of one world assume that conditions are safer and better in the other, the technique of horizon reversal highlights the discrepancy between idea and reality, and the unexpected differences between here and there, in which the modern/colonial divide sometimes operates to ironic effect—even as the novels ultimately make manifest the common 'inheritance of loss' in both worlds. Such a structure displays the historical development noted by John Berger (and providing the epigraph for *The God of Small Things*): 'Never again will a single story be told as though it's the only one.'

Yet while setting up contrasts, these novels also track the economic circuits and warring matrix through which the characters travel to encounter each other. Indeed, many such post-colonial novels include insurrectionary war as a setting or catalyst for their stories—from such classics as Alejo Carpentier's *The Kingdom of This World*, Gabriel García Marquez's *One Hundred Years of Solitude*, Michelle Cliff's *No Telephone to Heaven*, and Anita Desai's *Clear Light of Day* to more recent works by Kiran Desai, Caryl Phillips, and Zakes Mda. Violent political insurrection propels their protagonists from here to there, across imperial as well as national or racial borders. The texts depict the trauma of war's physical and psychic violence while they also make felt a different yet linked kind of trauma: the shock of witnessing the world's radical inequalities in physical comfort, security, and mobility. They reveal in turn how this deeply discrepant structure of physical experience creates a nearly uncrossable emotional divide between the self and others, or between enfranchised and disfranchised subjectivities. The narratives track the characters' failed attempts to cross or combine worlds, while signalling, through horizon reversals, the need to acknowledge the unsustainability of this uneven, global, and violent post/colonial state of things.

Most importantly, these post/colonial geomodernists create not just the other half of the world but its full horizon. Their fictions are not supplemental but dialectical. They do not simply tell the story only from the 'native' or subaltern side. They tell the story as experienced on many sides, reflecting the authors' determination to encompass a multidimensional history. Often these 'sides' meet within a single character, who in effect becomes a carrier of slashed post/coloniality, bringing that condition into all future encounters—such as Sari in Desai's *The Inheritance of Loss* or Kabnis in Toomer's *Cane*. In this sense, the structure of horizon reversal captures not only a geopolitical world order but also an onto-social and emotional condition.

SOMETHING BEYOND HERE: INTIMATIONS OF POST/COLONIALITY

Reading this feature of horizon reversal as a grappling with the colonial/modern order, and noting its expressions of an active, embattled post/coloniality of vision, we are able to read canonical Anglo-modernism with new eyes. On the one hand, we can see just how much of the 'over there' canonical Anglo texts leave out; yet, on the other hand, we see more clearly how they are nonetheless structured by the pressure and presence of that other locale and its intersubjective intimations of post/coloniality. Without launching a full practice of horizon reversal, canonical modernists often fleetingly register the 'distant shore' at the 'periphery' of an imperial centre. Much of Virginia Woolf's fiction is organized implicitly around this distant shore, as hinted in Lily Briscoe's reflection in *To the Lighthouse* that 'so much depends upon distance'.[17]

Woolf attempts to cross this distance in her first novel, *The Voyage Out* (1915), and in effect tells a tale of the difficulty of doing so. She opens her novel with a 'look back' at England that recalls the beginning of Marlowe's tale in *Heart of Darkness*: as her white English heroine Rachel departs from London on a ship to South America, she suddenly sees England as 'a very small island . . . a shrinking island'. Once in South America, Rachel takes a trip upriver in which she simultaneously falls in love with a young Englishman and encounters, in native village women, 'the motionless inexpressive gaze of those removed from each other far, far beyond the plunge of speech' so that Rachel and her lover suddenly feel 'very cold and melancholy'.[18] Shortly thereafter Rachel is struck by the fever from 'over there' that finally kills her and scatters the expatriate community.

Woolf and Conrad begin from the same premiss, surprising to many of their contemporaries: that this island and empire might legitimately be narrated from

[17] Virginia Woolf, *To the Lighthouse* (New York: Harcourt, Brace, 1927), 191.
[18] Virginia Woolf, *The Voyage Out* (New York: Harcourt, 1920), 32, 284–5.

outside. Like many other Anglo-European authors (and in Conrad's case complicated by his Polish origins), they thereafter erase the subjectivities of the peoples in the Congo or South America, overwriting them with the subjectivities of the English adventurers who enter their lands. Yet in so far as they create their fictions from this outside perspective, they place their readers in a world where, however fleetingly, England is *seen and made from outside.*[19] That is, they set a dialectical positioning in motion—however their complete texts then work to contain that effect. And after all they cannot contain it altogether. The alienated or violent realities of those colonial locales put into defensive motion the troubled or horrified consciousnesses of Rachel Vinrace, Marlowe, and Kurtz. Post/coloniality registers its dialectic-igniting presence in their novels.

In the case of Woolf, we might say that after *The Voyage Out*, she takes herself back home to narrate the metropole world as it is haunted by such realities and to show her white British characters' absorbing the violence of imperialism. In *Jacob's Room* and *To the Lighthouse* this violence circulates through the warring imaginations of fathers and mothers even as it kills their sons at the battlefront. In *Mrs Dalloway*, it comes home to London via the suicides of war veterans such as Septimus Smith and the colonial administrators like Peter Walsh who surreptitiously fondle their pocket knives. In *The Waves*, six characters pivot around the 'barbarian', imperialist presence of Percival, whose death takes place 'over there' in India yet nonetheless unsettles the unity of a London circle of friends. Even as they relish the skyline, so to speak, of an imperial horizon, Woolf's characters feel the tremors of a post/colonial struggle elsewhere. Like her character Clarissa Dalloway, Woolf apparently sensed that her London milieu was shaped by 'spectres who stand astride us and suck up half our life-blood, dominators and tyrants', infecting her, too, with 'this hatred' that makes her own 'home rock, quiver, and bend as if indeed there were a monster grubbing at the roots'.[20] Woolf explicitly traces the presence of tyranny at home to tyranny abroad through her portrait of the psychologist Dr Bradshaw, who wishes to put the suicidal Septimus in an institution and whom Woolf casts as a man who 'feasts on the wills of the weakly, loving to impress, to impose' and whose imperial counterparts are 'even now engaged—in the heat and sands of India, the mud and swamp of Africa, the purlieus of London'.[21]

We might even ask whether Woolf's ground-breaking novelistic form and sense of political irony emerge at least partly from her sense of what's happening 'over there'. In other words, might her novels' quicksilver movement from one point of view to another evince the anxious pressure of this post/colonial world—where, in Glissant's phrase, 'history come[s] to life with stunning unexpectedness'? Woolf was acutely aware, as we saw, of the 'battles and murders and strikes and revolutions all over the

[19] Conrad's Polish origin and his movement between Russian and Anglo-European empires undoubtedly played a role in his outsider's orientation, while Woolf's can be attributed in part to her experience as a daughter of the educated class whose gender and sexuality excluded her from many of that class's privileges, as she indicates in *Three Guineas*.
[20] Virginia Woolf, *Mrs Dalloway* (New York: Harcourt, Brace, 1925), 12.
[21] Ibid. 100.

world', and of the time-and-space-collapsing technology that conveyed them to her. Might the continual horizon reversals of her novels capture this bewildering global circuitry? Her narration literally collides conflicting perspectives, as when, for example, the colonial administrator Peter and the war veteran Septimus bump against each other in the park, so that readers feel the discrepancy between Septimus's vision of Peter Walsh as a 'dead man in a grey suit' and Peter's shallow view of Septimus and his desperate wife merely as 'lovers squabbling'.[22] Although focusing only on white British characters, Woolf seems thus to have dramatized her own involvement and immersion in a violent milieu of post/coloniality.

Perhaps more surprisingly, the framework of post/coloniality calls us to reinterpret texts that at first glance seem far removed from its legacies, such as Ernest Hemingway's 1925 collection of stories *In Our Time*. After the collection opens with two harrowing war vignettes (from the First World War and the Graeco-Turkish War), the third piece swerves to a very different scene in 'Indian Camp'. Set in the US Midwest, it follows a white Midwestern boy who accompanies his father 'over there' across the river, to an Indian reservation, where the father, a doctor, performs a Caesarean section on a 'squaw' woman giving birth, during which her husband slits his own throat in agony over her suffering, which in turn deeply disturbs the boy. This highly symbolic encounter can be read allegorically as a microcosm of the colonial turning point in American history, in which a white man's intention to 'save' an Indian (laudable, as Hemingway casts it) results in a trauma that thereafter, it is implied, haunts the boy, whom we can read as a figure of the young white nation. The next story tellingly features a stand-off between the father and two Indian men over ownership of lumber. Hemingway then implicitly positions these Indian–white encounters as historically symbolic points of origin for a future of American and European war: the collection thereafter alternates between war vignettes and stories of Americans abroad or home from abroad after the war, experiencing failures of intimacy or communication either among uprooted white Americans or between them and 'foreign' others.

Hemingway's post-war world of rambling expatriates and displaced souls only fleetingly hints at the post/colonial origins of his characters' fractured world, but his flat-toned, wry portraits resonate with novels by his near contemporary Jean Rhys, who more directly includes this historical post/coloniality. Rhys's early novels include Caribbean characters as well as others who are dislocated by a warring world, while her later novel *Wide Sargasso Sea* more fully practises horizon reversal as it imagines the back story of Bertha, the Creole madwoman in the attic in Charlotte Brontë's novel *Jane Eyre*. Set just after emancipation in a still-tense and unstable nineteenth-century Jamaica, the novel experiments with reversals of perspective in a way that later post-colonial writers would master. Rhys places us on both sides of the Atlantic, with characters looking back at the other island, and switching us dizzily between the consciousnesses of Antoinette (later called Bertha), Rochester, the black servant

[22] Ibid. 70–1.

Christophine (via her dialogue), and ultimately the English servant Grace Poole. The powerful, dissenting presence of Christophine plays a crucial, if disturbingly unclear, role in the breakdown of relations between Antoinette and Rochester. She thus comes to represent the hidden post/colonial world that later threatens the romance of Rochester and Jane Eyre, and, it is implied, troubles the appearance of settled order in Brontë's England.

E. M. Forster's *A Passage to India* is one of the only early twentieth-century British texts located in a colonial setting and attempting to represent the interior viewpoint of 'the other'. (James Joyce's *Ulysses* presents a more complex instance.[23]) Its drama begins with the arrival of Adela and Mrs. Moore in India, as seen from the point of view of Aziz, a Muslim Indian. Thereafter, the novel traces the ways that English presumptions brought from 'there' overlook or clash with Indian practices and beliefs 'here'—a problem that culminates in the rape accusation lodged by the family of Adela against Aziz. As Jenny Sharpe establishes in *Allegories of Empire*, Forster's narrative of this conflict, which provokes a spurious trial and street riots, replays the violent drama of the 1857 Sepoy Rebellion (including cries of rape); and it does so amid renewed anti-colonial agitation among Indians in the early twentieth century.[24]

Forster, thus, on one hand, expresses a sympathetic post/colonial consciousness; yet, on the other hand, like Woolf, he reveals an apprehensive ambivalence about its possibilities, and he softens its threat by exoticizing India as a land of unfathomable mysteries. The narrator laments, for example, that 'generations of invaders . . . have tried [to take hold of India]' but they have 'remained in exile' in that land mainly because—although India calls ' "Come" through her hundred mouths'—'She is not a promise, only an appeal.'[25] Accordingly, all of the Anglo characters in the novel hear a seductive message in India that they cannot comprehend, as with Adele and Mrs. Moore mesmerized by mysterious echoes in the Marabar Caves. In retrospect, such a pattern manifests Forster's own incomprehension of the political resistances and energies surrounding him in India. Yet these forces nonetheless prompted him to set his novel 'over there'—and led him to close it with a melancholy farewell between Aziz and his British friend Fielding. Through such reversals, canonical geomodernist narratives simultaneously gesture towards the post/colonial or post/slavery surround and convey their discomfort in the face of it. The plural and fractured forms of their fiction are precipitated, they hint, by these non-white gazes, subjectivities, and forms of resistance.

[23] James Joyce's *Ulysses* is, of course, also set in a colony and also tracks the interior of the other, but, like Irish texts generally, it occupies a highly complex position within the post/colonial scheme. In Irish history there is not only the Anglo-Irish.

Catholic Irish fissure dividing Ireland from within, but also the fact that the Irish (exactly as a result of being colonized) served in England's colonial project in India and Africa. Then, too, as Joyce reveals, Irish Jews and Irish women exist as subaltern or silenced subjects within Ireland. It may be that one could read the reversals between the viewpoints of Stephen and Bloom within Ireland as Joyce's indirect rendering of this colonialism-within-colonialism, which he then further unsettles by closing with the binary-exploding voice of Molly Bloom.

[24] Jenny Sharpe, *Allegories of Empire: The Figure of Woman in the Colonial Text* (Minneapolis: University of Minnesota, 1993); see ch. 5.

[25] E. M. Forster, *A Passage to India* (New York: Harcourt, Brace & World, 1952), 86.

As suggested above, post-colonial novelists take this incipient practice of horizon reversal to its radical conclusion. They divulge the full landscape glimpsed in these edgy canonical novels. They tear readers away from material security and set us down amid homelessness, hunger, and battle, rather than merely gesturing towards these. They unveil more completely the friendless exile awaiting those who travel across the modern/colonial divide, situating us inside the emotional unhinging of those who straddle these worlds. Strangely, by following the destructive force of the colonial/ modern world system as it migrates in the bodies of displaced characters and affects each and every encounter, they begin to build another matrix. They represent a co-produced existence.

They also represent a *historical* coexistence, or co-production of history. As the next and final section suggests, geomodernist writers of all kinds counter our habitual evasions and forgettings, wrenching readers into a heightened experience of the post/colonial temporality that is all of ours, whoever we are.

WHEN THEN IS NOW

When a post/colonial 'there' arrives 'here', past and future gather unsettlingly in the present, sometimes in a perpetually repeating, perpetually remade, and always at risk present. Thus does the protagonist of Rashid al-Daif's novella *Passage to Dusk* lose his arm from a shrapnel blast during the Lebanese Civil War—again and again in the text's rendering, as the first-person narrator hovers on the edge of death and endlessly revisits the scene and its aftermath. According to Ken Seigneurie, several Lebanese authors practise this 'iterative' narration in their attempt to capture the state of 'ongoing war' in the region.[26] I would add that this iterative technique appears in a wide range of post-colonial fiction. In Arundhati Roy's *The God of Small Things*, for instance, we repeatedly approach and repeatedly step back from the moment of the English girl Sophie Mol's arrival and death in India, a crisis coupled with the murder of Velutha, each time experiencing these events from another angle and within a different time-frame.[27]

Critics have noted similar manipulations of time in American and Anglo-European modernists such as Faulkner, Proust, Woolf, and Joyce, and have tended to characterize this practice as their subordination of 'clock time' to 'subjective time', with its currents

[26] See Ken Seigneurie, 'Ongoing War and Arab Humanism', in Doyle and Winkiel (eds), *Geomodernisms*, 96–113, esp. pp. 102–3.

[27] The novel's looping temporal structure, wherein we move forward up to a penultimate moment before these crises and then circle back in time to approach them again from another perspective, has led readers to compare Roy's method to Faulkner's, although Roy had not read Faulkner when she wrote the novel and she discounts this comparison. This looping movement, however, may be understood as their separate attempts to capture the geopolitical history such authors necessarily share.

of memory, which has in turn been considered as part of modernism's turn away from history and realism towards interiority and aestheticism. Yet recent work on the political dimensions of modernist writing allows us to see that all of these authors—Anglo-European and post-colonial both—attempt to represent the subjectivity of history, as it is lived in time. In particular, I would suggest, they invite readers to reflect on the determining forces of history, and on the possibility of redirecting them. I shall trace three twists in geomodernist writers' representations of temporality, by which they challenge hegemonic narratives of time and history.

First, these texts expose the fact of colonial overdetermination. That is, repetitions, returns, and flashbacks in these novels not only depict an involuntary return to a traumatic legacy (although they do powerfully capture this emotional process). Their looping movements also create the sensation that certain events have 'already happened' in so far as they are decreed by a social logic or ideology. Lives are propelled by the locomotive of colonial, racist, and sexist world history, so that in *Light in August* Faulkner's Joe Christmas is fated to murder Joanna Burden, and Roy's Veluthi, the 'untouchable', is fated to be murdered for loving Ammu. In these narratives, the future seems to be always already created, a fate towards which everyone is involuntarily moving, or being moved.

Caryl Phillips's *A Distant Shore* is structured to achieve a similar effect: its very first section records the novel's culminating, violent event—the murder of Gabriel—and subsequent sections circle back in time to reapproach the murder from both his own and Dorothy's consciousnesses. Phillips immerses us in a history that the characters are living as open-ended, but the outcome of which already haunts the readers. In a variation on this method, Toni Morrison's *Beloved* repeatedly alludes to but defers the full telling of Sethe's murder of her daughter. Readers thus must live through a set of experiences that might have ended otherwise, simultaneously feeling hope for other outcomes and knowing better, letting hope propel our responses and girding ourselves for the 'inevitable' outcome.

In *The God of Small Things*, Roy's narrator reflects on this legacy of overdetermination. When Ammu's children Rahel and Esthappen watch from their hiding place as the police club Velutha nearly to death, the narrator refers to the police as 'history's henchmen' and remarks that 'There was nothing accidental about what happened that morning. Nothing *incidental*. It was no stray mugging or personal settling of scores. This was an era imprinting itself on those who lived in it. History in live performance.'[28] The very structure of the narrative embodies the historical rehearsals by which this 'performance' was long ago prepared.

Yet, secondly, many such authors also foreground an anti-colonial counter-history, which is coupled with colonialism's determinations. Michelle Cliff's *No Telephone to Heaven* powerfully portrays this dialectical axis of struggle. Set during the violent upheaval of the 1970s in Jamaica, the scene that the novel opens with and returns to is that of an old truck lumbering steeply uphill on a muddy, broken road, hauling guns

[28] Arundhati Roy, *The God of Small Things* (New York: Harper Perennial, 1998), 293.

and people in khakis to the site (although we don't know it yet) of their insurrectionary attack. Within each chapter, after this opening moment, we fall back in time to learn about the past lives of those on the truck, their efforts to stop wandering and to find a stable home, and then we return in the next chapter to the journey towards insurrection. Cliff is recording the 'other' side of history: counter-imperialism. Although this looping structure with its struggling movement uphill ends, like so many geomodernist and post/colonial novels, in death and loss (here, the murder of Clare and other guerrillas and the debasement of Christopher), the action to which we continually return is a movement to defeat the determinations of imperial history.

Recasting history's progress as history's questions, breaks, and lost opportunities, Cliff joins other geomodernists who combine their looping narration with narratives of insurrectionary war, as mentioned above. These authors establish that this, too—this uphill work of resistance—is a driving, returning, world-historical force, undertaken by characters who fearfully, yet persistently, revive that resistance, even sometimes against their own wishes, against their dreams of another life. Thus, this counter-history, too, keeps arriving within this looping structure that holds the future hostage to a colonial past. And so geomodernists render this double helix of history particularly legibly.

At the same time, there is a third dimension of this temporal helix. Something else happens within this looping structure. To the extent that these texts are always stepping back from the overdetermined moments of crisis, they give us an opening in which to imagine that the crises might not (have) happen(ed). They offer us a consciousness of post/coloniality that might change the direction of history. In *A Distant Shore*, Phillips ends three of his novel's five sections with just this kind of anticipatory moment, in which either Gabriel or Dorothy senses the possibility of kindness, of finding in the other a person to whom they can tell their lonely story. Likewise, within such pauses or gaps in *The God of Small Things*, Rahel, Esthappen, and Sophie Mol become friends, despite the twins' prejudice against Sophie and their early pact to exclude her from their world. In this way, geomodernism's looping motions make felt the potential for divergence from ideology's determinations, challenged not only by armed insurgence but also by mere contingency and by unexpected intimacy or generosity.

Some geomodernist novels cast these possibilities as a magical, ancestral, or spiritual dimension of their worlds—that which escapes an imperialist, profit-accruing, strictly forward-moving modernity. Novels such as Alejo Carpentier's *The Kingdom of This World*, Bessie Head's *A Question of Power*, Chinua Achebe's *Things Fall Apart*, Zakes Mda's *The Heart of Redness*, and (in passing moments) Ayi Kwei Armah's *The Beautyful Ones Are Not Yet Born* conjure this kind of wholly other, more magical or surreal temporality. Often they leave readers to draw their own conclusions about whether this dimension is a figment of the traumatized psyche which *must* project an alternative reality in order to survive, or whether it is indeed the truer reality, the unacknowledged, sustaining realm in which the horizon is a bracing circle rather than a 'distant shore' to which one is exiled and forever lost.

However we understand their magic, and however we interpret the authors' attitudes towards it, these narratives enact a desire to step back from a world in which the fatedness of violent coercion is so tightly coupled with the fatedness of violent resistance. By foreshadowing the event—the violence—and then whisking us backward (or sideways) into a better moment and an alternative current of interactions, they gesture towards a path not determined and a future that is neither post nor colonial, in which the meanings of those words suddenly dissolve within an alternative language, like the one Rahel and Esthappen create together that is incomprehensible to adults. Or they leave us swept up—and away—by ancestral, magical visions, as with Ti Noël at the end of Carpentier's *Kingdom of This World*. They create the sense and the vision of another kind of history.

All manner of colonial encounters thus stand at the centre of modernism, a phenomenon reframed here as a wider field of geomodernism that spans the twentieth and twenty-first centuries. White and post-colonial writers in effect speak to each other via these reconfigurations of time and space, variously expressing the troubled condition of post/coloniality, which both precedes and lingers within post-colonial states. While many of these authors have influenced each other, to reduce the relations among them to a borrowing by post-colonial authors from modernist authors overlooks their co-rootedness in this global world. Instead, working from opposite directions along the post/colonial continuum of modern history, Anglo-European and post-colonial geomodernists together rework our fundamental modes of orientation within time and space. They situate us within the fracture that opened when those long-ago colonial encounters turned towards domination, slavery, and expropriation, and created a deeply oppositional and uneven relation between here and there. Post-colonial authors have drawn more fully into the open the material violence and psychic dislocations that canonical modernists symbolically encoded in their fragmented texts.

Taken together, and perhaps read together in literature classrooms, these diverse texts force us to feel our caughtness within the destructive momentum of this history. At the same time, they invite us to seize the possibilities within a present and a future that are not yet wholly determined.

...

TRAVELLING MODERNISTS

...

TIM YOUNGS

Comes over one an absolute necessity to move.

(D. H. Lawrence, *Sea and Sardinia*)

MODERNISM is built on travel. Its ideas and aesthetics crossed cultures. Physically, as Alan Bullock reminds us, modernism was a consequence of the overlapping of the 'great industrial expansion' of the 1870s onwards with the urbanization and techno-logical revolution that produced in the 1890s and 1900s 'a series of key developments that remain the foundation of the technology of the twentieth . . . century'. Bullock's list of these developments includes innovations that directly affected travel: 'the internal combustion engine, the diesel engine and the steam turbine; electricity, oil and petroleum as the new sources of power; the automobile, the motor bus'.[1] They introduce what Wyndham Lewis, in his travelogue of North Africa, called 'the Petrol Age'.[2]

These advances in the technology of transport contributed to an intensity and mechanization of movement that characterizes the modern age. Increased tourism

The epigraph reads in full: 'Comes over one an absolute necessity to move. And what is more, to move in some particular direction. A double necessity, then: to get on the move, and to know whither' (*Sea and Sardinia* (London: Heinemann, 1950), 7).

[1] Alan Bullock, 'The Double Image', in Malcolm Bradbury and James MacFarlane (eds), *Modernism: A Guide to European Literature, 1890–1930* (Harmondsworth: Penguin, 1976), 59.

[2] Wyndham Lewis, *Filibusters in Barbary* (London: Grayson and Grayson, 1932), 115. I am grateful to Nathan Waddell for first urging me, years ago, to read both *Filibusters in Barbary* and E. E. Cummings's *Eimi*, discussed below.

(by ship and train, but also by the newer modes of motor car and plane[3]); journeys to wars—to fight them and to report on them;[4] political missions and delegations; artistic visits and exchanges; travels to and from colonies; and exile (both voluntary and forced), are among the types of travel that made up modernist mobilities and stimulated many of its notable travel books. This is especially true of the 1920s and 1930s, the decades associated with the height of modernism, and the ones that are focused on in this chapter.

Journeys, both actual and imagined, were a preoccupation of the literature of the period. Paul Fussell observes that 'To canvass merely the titles of works between the wars is to sense their permeation by the "travel" spirit';[5] Samuel Hynes nominates travel as 'the most insistent of 'thirties metaphors;[6] and Philip Dodd writes that 'The travel book, whose claim to be the most important literary form of the 1930s has been consolidated by recent criticism, would appear to be the most appropriate form for writers restless with inherited beliefs, and eager to "explore" and "discover" new allegiances.'[7]

The intellectual and aesthetic milieu also stimulated new ways of perceiving and representing travel. Stan Smith has noted that 'The 1920s and '30s were a boom time for travel writing in a specifically Modernist mode.'[8] This was also the era in which travel writing was increasingly the result of travel 'undertaken specifically for the sake of writing about it.'[9] Graham Greene secured an advance from his publisher, William Heinemann, to travel to Liberia in 1934, spent his money on the trip, and then struggled to turn the experience into an engaging narrative. Paul Fussell summarizes the solution that Greene found:

The way out was to conceive the journey as a metaphor for something else. 'The account of a . . . slow foot-sore journey into an interior virtually unknown—was only of interest if it paralleled another journey. . . .' Thus, he says, 'I rashly proposed to make memory the very subject of this book,' specifically, memory of the complicated delights of fear in infancy.[10]

[3] Wyndham Lewis comments, 'For the first time in the Earth's history we have to take into count a new territory—namely the upper atmosphere,' and writes excitedly of these 'nomads' of the air (*Filibusters in Barbary*, 224, 5). See also Sidonie Smith, *Moving Lives: Twentieth-Century Women's Travel Writing* (Minneapolis: University of Minnesota Press, 2001), ch. 3: 'In the Air: Aerial Gender and the Familiarity of Flight'.

[4] Schweizer notes that 'Waugh, Greene, Orwell, [Peter] Fleming, Auden, Isherwood, and others all became "war correspondents" at one time or another' (Bernard Schweizer, *Radicals on the Road: The Politics of English Travel Writing in the 1930s* (Charlottesville: University of Virginia Press, 2001), 106). To these we might add names such as the Americans Stephen Crane, Martha Gellhorn, and Ernest Hemingway, but my focus in this chapter, like Schweizer's in his book, is on British travellers.

[5] Paul Fussell, *Abroad: British Literary Traveling Between the Wars* (New York: Oxford University Press, 1980), 53.

[6] Samuel Hynes, *The Auden Generation: Literature and Politics in England in the 1930s* (London: Pimlico, 1992), 229.

[7] Philip Dodd, 'The Views of Travellers: Travel Writing in the 1930s', *Prose Studies*, 5/1 (1982), 128.

[8] Stan Smith, 'Burbank with a Baedeker: Modernism's Grand Tours', *Studies in Travel Writing*, 8/1 (2004), 2.

[9] Helen Carr, 'Modernism and Travel (1880–1940)', in Peter Hulme and Tim Youngs (eds), *The Cambridge Companion to Travel Writing* (Cambridge: Cambridge University Press, 2002), 74.

[10] Fussell, *Abroad*, 67.

Greene's treatment of that theme saw him mapping his childhood fears and excitement onto the interior of Africa, finding there a vitality that civilization had repressed in Europe:

Freud has made us conscious as we have never been before of those ancestral threads which still exist in our unconscious minds to lead us back. The need, of course, has always been felt, to go back and begin again. Mungo Park, Livingstone, Stanley, Rimbaud, Conrad represented only another method to Freud's, a more costly, less easy method calling for physical as well as mental strength.[11]

Despite its proliferation during this period, the travel writing of these decades has received remarkably little attention compared to other forms of literature.[12] When critics have discussed it, they have tended to dismiss it as inferior to its authors' more respectable literary output or to judge it of interest principally for its illumination of those worthier and more serious works.[13] Even the role of journeys in texts that have now assumed canonical status is under-examined.[14]

Many prominent modernists produced travel texts. A far from complete list would include W. H. Auden, E. E. Cummings, D. H. Lawrence, Wyndham Lewis, Katherine Mansfield, John Dos Passos, John Steinbeck, Evelyn Waugh, Rebecca West, and Edith Wharton. Besides recounting their own journeys in their travel books and essays, they explored the significance of journeys in their fiction, poetry, and drama also. 'The way to imitate an early Auden poem is to get as many frontiers into it as possible,' observes one critic.[15] Virginia Woolf, whose first novel was *The Voyage Out* (1915), underlined the porosity of literary genres when she wrote that 'books have a way of influencing each other' and that 'Fiction will be much the better for standing cheek by jowl with poetry and philosophy';[16] she meant with travel writing too, since she asks her female readers to 'write books of travel and adventure, and research and scholarship, and history and biography and criticism and philosophy and science. By doing so you will certainly profit the art of fiction.'[17]

[11] Graham Greene, *Journey Without Maps* (London: Pan Books, 1957), 252.
[12] For example, Michael Levenson (ed.), *The Cambridge Companion to Modernism* (Cambridge: Cambridge University Press, 1999), includes essays on the novel, poetry, drama, visual arts, and film but not on travel writing. Travel texts are also absent from the works listed in its Chronology. The section on genres in Pericles Lewis, *The Cambridge Introduction to Modernism* (Cambridge: Cambridge University Press, 2007), consists of chapters on poetry, prose fiction, and drama. Malcolm Bradbury and James MacFarlane (eds), *Modernism: A Guide to European Literature 1890–1930* (Harmondsworth: Penguin, 1976), has as the second of its two parts three chapters on genres: 'The Lyric Poetry of Modernism', 'The Modernist Novel', and 'Modernist Drama'.
[13] For a discussion of how the reputation of W. H. Auden's travel books has suffered from this approach, see Tim Youngs, 'Auden's Travel Writings', in Stan Smith (ed.), *The Cambridge Companion to W. H. Auden* (Cambridge: Cambridge University Press, 2004), 68–81.
[14] Paul Fussell rightly advises that 'to read such modern masterpieces as *The Waste Land*, *Ulysses*, and *A Draft of XVI Cantos*, all from the early or mid-1920s, with a renewed awareness of their "period" travel dimension is perhaps to re-attach some meaning to them which has been largely adrift since their time' (Fussell, *Abroad*, 52).
[15] Ibid. 32.
[16] Virginia Woolf, *A Room of One's Own* (Harmondsworth: Penguin, 1945), 90.
[17] Ibid.

Besides travel, but related to it, a useful way of regarding the modernist years, and certainly one that furthers our understanding of travel writing of the period, is to see them as characterized by the crossing or dissolution of boundaries. Such a view would encompass the threat to and violation of national borders, especially in Europe; the merging of the internal and external under the influence of Freud; the conflicting views of the relationship between the individual and the state; and the combination of perspectives in avant-garde visual art, notably, but by no means solely, in Cubism. These types of juxtapositions and boundary collapse encompass the political, psychological, and aesthetic, those aspects that are commonly classed as the defining contexts of modernism.[18]

Paul Fussell writes of the Congress of Paris in 1919 that 'numerous experts redrew the European frontiers to reward victors and humiliate losers, and for the next twenty years Europe became frontier-obsessed and, like Auden, map-mad'. Fussell's breathless list conveys the range and pace of geographical instability:

As a result of the treaties not just of Versailles but of Neuilly, St. Germain, Trianon, and Sèvres, dramatic alterations were worked on the borders of Germany, France, Belgium, Italy, Austria, Denmark, Greece, and the former Ottoman Empire. The frontiers of Lithuania, Poland, Hungary, Romania, Yugoslavia, and Czechoslovakia were defined or re-defined. 'Fiume' and 'Danzig' were equipped with their own small frontiers in their new capacity as free cities or states.[19]

European powers had themselves carved up Africa in the previous century in a process formalized at the Congress of Berlin in 1884. In a travel book on Abyssinia, Evelyn Waugh is scathing of what followed: 'the avarice, treachery, hypocrisy and brutality of the partition are now a commonplace which needs no particulariza-tion'.[20] Against this needs to be set Waugh's comment that 'However sordid the motives and however gross the means by which the white races established—and are still establishing—themselves in Africa, the result has been, in the main, beneficial.' Applying a logic whose contortions illustrate the mixed and confused attitudes towards imperialism, colonialism, and 'race' displayed by many in the inter-war years, Waugh asserts that 'The significance of the Congo atrocities is not so much that they were committed as that they were exposed and suppressed; there is a conscience in Europe which, when informed and aroused, is more powerful than any vested interest.'[21]

The subject of Waugh's book was the Italian invasion of Abyssinia (1935–6), one of several conflicts of the decade to generate numerous travel narratives. The Spanish Civil War (1936–9) spawned, among many other notable works, George Orwell's *Homage to Catalonia* (1938) and W. H. Auden's 'Spain' (1937), which latter Stan Smith

[18] For example, Pericles Lewis groups critical transformations into 'three major categories: the literary and artistic (crisis of representation); the socio-political (crisis of liberalism); and the philosophical and scientific (crisis of reason)' (Lewis, *The Cambridge Introduction to Modernism*, 3).

[19] Fussell, *Abroad*, 33.

[20] Evelyn Waugh, *Waugh in Abyssinia* (London: Penguin, 1986), 11.

[21] Ibid. 25.

describes as, in a sense, 'the most representatively symbolic piece of travel writing of the whole era'.[22] Auden and Isherwood's *Journey to a War* (1937) covers the Japanese aggression against China. The American Agnes Smedley's *China Fights Back* (1938) recorded the progress of the Eighth Route Army and her identification with it and with the communist cause. Left-leaning intellectuals processed to Soviet Russia and generally became disillusioned by what they discovered. Reminders of hostilities found their way into accounts apparently remote from the battle zones. In his travel book of Mexico, *The Lawless Roads* (1939), Graham Greene's neighbours in the Hotel Español in Las Casas listen to the radio, following news of Franco's military advances in Spain; and on a German ship sailing from Veracruz to Lisbon, Greene finds more than two dozen Spanish volunteers on their way to fight for the fascists.[23] Auden briefly meets Goering's brother in Iceland, a country which, Auden tells us, the Nazis believed to be 'the cradle of the Germanic culture'.[24] While there, Auden learns of the Spanish Civil War.

Connections between national and artistic shape have been discerned by Fussell in his pioneering study of inter-war travel writing:

Fragmenting and dividing anew and parcelling-out and shifting around and repositioning—these are the actions implicit in the re-drafting of frontiers. All these actions...imply an awareness of reality as disjointed, dissociated, fractured. These actions of dividing anew and shifting around provide the method of collage in painting, and in writing they provide the method we recognize as conspicuously 'modern,' the method of anomalous juxtaposition.[25]

The links between the political and the aesthetic described here by Fussell have been identified by many scholars of modernism, as have the borrowing of techniques across art forms. John Lucas, for example, writes that 'Fragmentariness seems indeed to be the condition of art in the 1920s. Dada, Imagism, stream of consciousness, the shifting momentariness of cabaret acts, of cinema montage: these all testify to art as collage. Fragmentariness is mimetic, expressive of, and/or a critical response to a world gone smash.'[26]

Lucas's study of radicalism and the 1920s includes no travel texts, yet readers of Auden and MacNeice's *Letters from Iceland* (published the following decade) are told near the start of that book, 'It is a collage that you're going to read.'[27] Auden and MacNeice are deliberate and knowing in their use of different forms, employing in their collage verse, letters,

photographs,
Some out of focus, some with wrong exposures,
Press cuttings, gossip, maps, statistics, graphs.[28]

[22] Smith, 'Burbank with a Baedeker', 6.
[23] Graham Greene, *The Lawless Roads* (London: Penguin, 1947); see 194–5, 246–7.
[24] W. H. Auden and Louis MacNeice, *Letters from Iceland* (London: Faber and Faber, 1937), 119.
[25] Fussell, *Abroad*, 36.
[26] John Lucas, *The Radical Twenties* (Nottingham: Five Leaves Press, 1997), 177.
[27] Auden and MacNeice, *Letters from Iceland*, 21.
[28] Ibid.

It is, as Stan Smith acknowledges, a book that 'plays deliberative games with the travelogue format'.[29] It is not alone in the period in doing that. Glen MacLeod's reminder that 'Modernist writers often patterned their literary experiments on parallels drawn from the visual arts'[30] applies to authors of travel books too. So do the remarks in one guide that 'modernism called attention to the medium of the literary or artistic work, defined itself in contrast to convention, and radically altered the means of representation'.[31]

The contexts and types of journey undertaken during the modernist years and mentioned above affected the form and themes of travel texts. Together they contribute to the production of travel writing whose innovations have rarely been matched in subsequent examples of the genre. Much modernist travel writing is self-conscious about its own conventions. It experiments with point of view, invites critical attention to its narrator, examines the relationship between observer and observed, questions the location and use of power, parodies its progenitors, and wonders about its own function. All of these features have the potential to undermine the authority of the traveller and of the travel book. The potential is not always realized, but it is present, and by being present goes some way to fulfilling it.

Modernist travel books experimented, then, with combinations of forms, the fragmentation of narrative, and game playing with personae. Bernard Schweizer reports of Rebecca West's travelogue of Yugoslavia (1941) that 'It has frequently been held against *Black Lamb and Grey Falcon* that the book suffers from fragmentation and rampant digressiveness.'[32] Similar charges have been levelled against *Letters from Iceland*, perhaps encouraged by its authors' self-mocking and unhelpful put-downs of it as an opportunistic ragbag and a hotchpotch.[33] In *Eimi*, his account of a visit to Soviet Russia, E. E. Cummings breaks up the narrative even at word level. An example of this shows both the process and the effect: 'vio (screa)lent(ming)ly'.[34] In approximation of his hosts' pronunciation of his name, Cummings represents himself in the third person as 'Kem-min-kz', and modifies this to 'Kself'.[35] The device helps readers see what is normally occluded: that the 'I' in travel writing is a construction; that the writer becomes someone else in the text.

When critics testify to the influence of visual arts on prose, they generally seem to exclude travel writing from their discussions of both fiction and non-fiction. Yet the affinities were apparent to some contemporary readers. Mara Kalnins refers to Carl Van Doren's review of D. H. Lawrence's *Sea and Sardinia* in *The Nation* on 4 January 1922, in which he praised the writing's visual quality, compared its narrative to a film,

[29] Smith, 'Burbank with a Baedeker', 6.
[30] Glen MacLeod, 'The Visual Arts', in Levenson (ed.), *The Cambridge Companion to Modernism*, 194.
[31] Lewis, *The Cambridge Introduction to Modernism*, 3.
[32] Schweizer, *Radicals on the Road*, 82.
[33] See Youngs, 'Auden's Travel Writings', 71.
[34] E. E. Cummings, *Eimi* (New York: Covici, Friede, 1933), 137.
[35] Ibid. 89, 289.

and referred to Lawrence as an Imagist.[36] Many of the modernists who wrote travel books also painted or drew. This is true of Lawrence, Cummings, Lewis, and several others. Their awareness and practice of visual experimentation (including in film) is evident in their travel writing. In his politically conservative but linguistically inventive *Eimi*, Cummings admires some works by Matisse:

5 gradually distorted heres (flat upon a flatgreen aslope insolently that ; or against crudely blue skyflattest this ; or andishly among both's neither)splurge ; opposite, swiftly reproportioned, if of no world, creatures lymphatically pauseflowing (what neverdancers always-dancing!) reel, droopingly are precise of rhythm perpetually selfinventing the constituents . . .[37]

Ernest Hemingway testifies more straightforwardly to the influence of Impressionist painters on his own prose style. Remembering his near-daily visits to the Musée du Luxembourg to see the works of Cézanne, Monet, and Manet, and the other Impressionists whose paintings he had first seen in the Art Institute at Chicago, he writes, 'I was learning something from the painting of Cézanne that made writing simple true sentences far from enough to make the stories have the dimensions that I was trying to put in them. I was learning very much from him but I was not articulate enough to explain it to anyone.'[38]

Unsurprisingly, one of the parallels between visual and literary techniques apparent in modernist travel writing is the concern with perspective. In some cases there is a recognition of the existence of different and multiple points of view, as indicated in Hemingway's remark that 'There is never any ending to Paris and the memory of each person who has lived in it differs from that of any other.'[39] Understanding that there are different points of view helps reduce the dominance of any one of them. In other cases audiences are made aware of their own ways of looking, as in the photograph in Auden and Isherwood's *Journey to a War* that is captioned 'Enemy Planes Overhead' but which shows not the planes but two men in a trench looking to the sky.[40]

Not all travel books of the period exposed their own workings or undercut their own authority. But a significant number did. In them, what is seen and how that is reduced to paper form part of the subject. Here is the opening of Lawrence's *Mornings in Mexico* (1927):

One says Mexico: one means, after all, one little town away South in the Republic: and in this little town, one rather crumbly adobe house built around two sides of a garden *patio*: and of this house, one spot on the deep, shady verandah facing inwards to the trees, where there are

[36] See Mara Kalnins, 'Introduction', in D. H. Lawrence, *Sea and Sardinia*, ed. Mara Kalnins (Cambridge: Cambridge University Press, 1997), pp. xxxiii–xxxiv. Kalnins points out that among the titles Lawrence originally had in mind for the book was *Sardinian Films*. See Kalnins also for a detailed account of the book's composition, publication, and reception.

[37] Cummings, *Eimi*, 185.

[38] Ernest Hemingway, *A Moveable Feast* (London: Arrow Books, 2004), 8.

[39] Ibid. 126.

[40] W. H. Auden and Christopher Isherwood, *Journey to a War* (New York: Random House, 1939); see 'Picture Commentary'.

an onyx table and three rocking-chairs and one little wooden chair, a pot with carnations, and a person with a pen. We talk so grandly, in capital letters, about Morning in Mexico. All it amounts to is one little individual looking at a bit of sky and trees, then looking down at the page of his exercise book.[41]

It is a shame, Lawrence goes on, that when we come across books whose titles suggest a survey of a whole country, or even of a continent, we do not 'immediately visualise a thin or a fat person, in a chair or in bed, dictating to a bob-haired stenographer or making little marks on paper with a fountain pen'.[42] In directing our eye from the larger picture to the individual writer, from object to subject, Lawrence is making his readers notice not only the country being described, as is customary, but also the person who is providing the description, which is not. We become more conscious of the gap between the general scene and the lone figure who presents it to us, and therefore of the process of imaginative enlargement and reduction. Lawrence implies that travellers' accounts are incomplete and inadequate. He was not alone among his contemporaries in doing so. In *A Moveable Feast* Hemingway keenly distinguishes his deep knowledge of Paris from the cursory observation of short-term visitors, even literary ones: 'Travel writers wrote about the men fishing in the Seine as though they were crazy and never caught anything; but it was serious and productive fishing.'[43] Evelyn Waugh mocks Britain's ignorance of Abyssinia after the Italian invasion of that country and ridicules the use to which travel writing is put:

But Abyssinia was News. Everyone with any claims to African experience was cashing in. Travel books whose first editions had long since been remaindered were being reissued in startling wrappers....The journal of a woman traveller in Upper Egypt was advertised as giving information on the Abyssinian problem. Files were being searched for photographs of any inhospitable-looking people—Patagonian Indians, Borneo head-hunters, Australian aborigines—which could be reproduced to illustrate Abyssinian culture.[44]

These passages from Waugh, Hemingway, and Lawrence—and there are many like them in the works of their contemporaries—display the workings of travel writing. Making these more visible invites a questioning of them. Lawrence's directing our gaze to the individual who writes encourages reflection on representation and on how the external world is condensed. In a decade that was 'notoriously self-conscious',[45] it is fitting that Lawrence should start his travel book with a recognition of the superficiality or partiality of any one way of looking. His method here, a painterly and cinematic one, is in keeping with the concerns outlined by Pericles Lewis, though Lewis's focus is not on travel writers: 'The modernists were not necessarily seeking an art without any conventions, but rather an art that examined its own conventionality, that put the conventions of art on display, an art that put art itself in question.'[46]

[41] D. H. Lawrence, *Mornings in Mexico* (London: Martin Secker, 1927), 9.
[42] Ibid.
[43] Hemingway, *A Moveable Feast*, 25.
[44] Waugh, *Waugh in Abyssinia*, 40.
[45] Lucas, *The Radical Twenties*, 7.
[46] Lewis, *The Cambridge Introduction to Modernism*, 6.

Similar questions of representation to those raised by Lawrence, and also occasioned by a visit to Mexico, are posed by Graham Greene, a little over a decade later, in *The Lawless Roads*.[47] In his prefatory note to that work, Greene claims that 'This is the personal impression of a small part of Mexico at a particular time, the spring of 1938.'[48] In the body of the book itself he contemplates the task that faces writers such as himself: 'How to describe a city? Even for an old inhabitant it is impossible: one can present only a simplified plan, taking a house here, a park there as symbols of the whole.'[49]

As well as commenting on the problems of representing a place, Greene shows his awareness that superficial observations may lead to erroneous conclusions: 'That is the danger of the quick tour, you miscalculate on the evidence of three giggling girls and a single Mass, and malign the devotion of thousands.' And he goes on, 'And again if only I'd known it, I was taking the tourist view—on the strength of one prosperous town on the highway, on the strength of a happy mood, I was ready to think of Mexico in terms of quiet and gentleness and devotion.'[50] This latter statement combines a confession of mistaken generalization with a conservative urge to distinguish himself, as a traveller, from the tourist. As has often been remarked of travellers from the mid-nineteenth century onwards, the desire to make this distinction is a nostalgic one that has class connotations, born of disdain for the commercial and for the masses. It aims to preserve the individuality of the traveller against the tourist hordes and to mark the superior cultural tastes of the former. Thus, as soon as Greene invites readers to question the processes of perception and representation in potentially radical ways, he qualifies that radicalism with a reactionary impulse to present the tourist view as superficial and determined by light emotion.

While Greene's admissions of his own fallibility occur early on in his book, they are succeeded by a series of statements on Mexico as a 'hating and hateful country', a 'country of disappointment and despair', with tasteless, repellent food; on Indian women with 'hideous' faces, Mexicans' 'horribly immature' cheerfulness with 'no sense of human responsibility', and—he quotes Lawrence with approval—a capital city in which, like the country at large, 'The Spanish-Mexican population just rots on top of the black savage mass.'[51] Greene admits some possible causes of his antipathy towards Mexico, but these do not prevent him from including supposedly authoritative remarks on the country. He could have omitted, but does not, the 'random thoughts' he jotted down when bored, on 'How one begins to hate these people' and on how 'If Spain is like this, I can understand the temptation to massacre.'[52] Thus, the caveats nearer the beginning of the book are replaced by confident assertions of the general unattractiveness of Mexican people and society.

[47] Greene may not normally be thought of as a modernist author but I believe his use of Freudian ideas about the unconscious to structure a parallel, interior journey in *Journey Without Maps* and his self-consciousness about perspective and narrative in *The Lawless Roads* justify the brief attention to him here.

[48] Greene, *Lawless Roads*, 5. [49] Ibid. 69. [50] Ibid. 41, 42.

[51] Ibid. 144, 236, 204, 182, 99. [52] Ibid. 227.

In his Author's Note and in his Note to the Second Edition, Greene appears to excuse himself. In the former he remarks that time has proved him wrong in at least one respect: the religious apathy he recounted in Tabasco was more apparent than real; and in the latter, written eight years after the book's first publication, he comments: 'it may seem now that the author dwells too much on the religious situation, which may have changed, at the expense of other more permanent sides of Mexican life. His excuse must be that he was commissioned to write a book on the religious situation, not on folk lore or architecture or the paintings of Riviere.'[53]

Greene's motivation lay in his opposition to what he saw as socialist persecution of the Catholic Church, but his negativity about Mexico means that while he highlights the problems of observing and writing, the emphasis is more on the hateful country that he claims to have found. That imbalance serves as a reminder that although the formal innovations of the travel books discussed in this chapter do heighten awareness of textual artifice and invite questions about power, they often offer little change from their nineteenth-century precursors in their judgements on other cultures.[54]

Modernist attitudes towards 'race' were ambivalent, as is illustrated by primitivism. So, too, were those towards technology, and for a similar reason: the displacement of the pre-industrial by the arrival of the new. Celebration of the modern was mixed with regret over the disappearance of the traditional. The latter is dealt with in a characteristically unsentimental manner by Evelyn Waugh, who advises that 'Those who are inclined to lament the passing of a low but individual culture should remember that it was already marked down for destruction.'[55]

Travel writing of earlier periods had articulated concerns about the impact of urbanization, new technology, and communications on landscape and lifeways. The 1920s and 1930s saw a concentrated reflection on these issues. Often modernity is embraced. One of the wittiest and most quoted examples is Auden's expression of his preference for industrial landscape: 'Clearer than Scafell Pike, my heart has stamped on | The view from Birmingham to Wolverhampton.' And: 'Tramlines and slagheaps, pieces of machinery, | That was, and still is, my ideal scenery.'[56] Sometimes modernity finds favour where one might least expect it. D. H. Lawrence, whose travels 'were energised by a passionate quasi-primitivist quest',[57] wrote admiringly of the 'splendid' automobiles in Italy, whose roads 'always impress me', particularly where they run 'with curious ease' over the 'most precipitous regions', and declared: 'I think it is marvellous how the Italians have penetrated all their inaccessible regions . . . with great high-roads: and how along these high-roads the omnibuses now keep up a perfect communication.'[58] He asserts that the peasants themselves wish for an end to their isolation and welcome the new mobility. On the other hand, noting that the

[53] Greene, *Lawless Roads*, 5.
[54] By contrast, see Peter Nicholls's discussion of African American modernism, in Nicholls, *Modernisms: A Literary Guide*, 2nd edn (Basingstoke: Palgrave Macmillan, 2009), ch. 10.
[55] Waugh, *Waugh in Abyssinia*, 50.
[56] Auden and MacNeice, *Letters from Iceland*, 51.
[57] Carr, 'Modernism and Travel', 83.
[58] Lawrence, *Sea and Sardinia* (1950), 176.

'permanent way of almost every railway is falling into disrepair; the roads are shocking', he wonders: 'Is our marvellous mechanical era going to have so short a bloom? Is the marvellous openness, the opened-out wonder of the land going to collapse quite soon, and the remote places lapse back into inaccessibility again? Who knows! I rather hope so.'[59]

This contradiction in Lawrence's position clearly reflects the ambivalence of the age: the recognition of the need for and the achievements of progress but also the regret for places that lose their character.[60] Those attitudes were sharply intensified by the First World War, a mechanized conflict that was, in the words of John Lucas, 'a confirmation of modernity. It was a machine war and men were fed to the machines.'[61] The paradoxical outlook on technology and 'race' is probably nowhere more apparent than in Waugh's remark that 'A main road in England is a foul and destructive thing, carrying the ravages of barbarism into a civilized land—noise, smell, abominable architecture and inglorious dangers. Here in Africa it brings order and fertility.'[62]

The sensibility more conventionally associated with Lawrence—the preference for worlds whose spirituality is more vital than the soullessness of modern industrialism—is expressed in *Mornings in Mexico*. There his delight at freedom from motorized transport is more than a description of how things are in Mexico (just as travel accounts are often oblique commentaries on the traveller's home country); it is a rejection of the dependence on it that has afflicted his home country, and it is consequently a way of connecting to his childhood there: 'thank God, in Mexico at least one can't set off in the "machine." It is a question of a meagre horse and a wooden saddle; or a donkey; or what we called, as children, "Shanks' pony"—the shanks referring discourteously to one's own legs.'[63]

To his relief, Lawrence finds in Mexico the freedom from technology that he remembers from his childhood. Of the countryside around Eastwood, where he grew up, he was to write: 'To me, as a child and a young man, it was still the old England of the forest and agricultural past; *there were no motor-cars*, the mines were, in a sense, an accident in the landscape, and Robin Hood and his merry men were not very far away.'[64]

The desire to escape an industrialized, stale, and corrupt world is evident in other modernist writers. Wyndham Lewis writes at the beginning of his travel book of southern Morocco:

The sedentary habits of six years of work had begun, I confess, to weary me. Then the atmosphere of our dying European society is to me profoundly depressing. Some relief is

[59] Ibid. 116.

[60] 'The years between 1880 and 1940 are perhaps best seen as the beginning of the era of globalisation' (Carr, 'Modernism and Travel', 73).

[61] Lucas, *The Radical Twenties*, 13.

[62] Waugh, *Waugh in Abyssinia*, 163.

[63] Lawrence, *Mornings in Mexico*, 27.

[64] D. H. Lawrence, 'Nottingham and the Mining Country' (1929), in *Selected Essays* (London: Penguin, 1950), 114; my emphasis.

necessary from the daily spectacle of those expiring Lions and Eagles, who obviously will never recover from the death-blows they dealt each other (foolish beasts and birds) from 1914–1918 . . .

Perhaps nothing short of the greatest desert in the world, or its proximity, would answer the case.[65]

Lewis's narrative goes on to exhibit the disdain for tourism that is characteristic of much modernism and that we have seen in Greene. His intention to plan a route that would avoid 'the stupefying squalor of anglo-american tourism about one, poisoning the wells and casting its baedekered blight' is typical of the growing feeling during the inter-war years that tourism is making travel less authentic and less personal.[66] Like Lawrence, Lewis seeks in foreign places a direct experience of nature that cannot easily be found in industrial England. Thus, when he visits Oran, 'a stereotyped French city', he asks whether it is not enough that the people who live there (the Berbers) are as they have always been and he despairs that 'Our Machine Age civilization has pushed its obscene way into the heart of their country.'[67]

For Lewis, as for Lawrence, the sense of artificiality extends to political arrangements also: socialism (in Lawrence's writings) and democracy (in Lewis's) interfere with and corrupt the natural order of things. Thus, Lewis writes that

in England we exist so much in the midst of the reverse of all that is satisfyingly life-size, naked and simple, so much in fact in contact with what is undersized and so *everymanishly* mean (far too *menschlich*, in the German of Nietzsche) that one might cease to believe in its existence if one did not go and resume contact with natural things from time to time, to forget how men have dwarfed it to their own stature, especially under the guidance of the Democratic Idea.[68]

Here Lewis is answering his own question of why he is about to undertake the journey rather than imagine it. The other answer he gives is that he is restless by nature. The question itself is one that relates to the reading of travel writing; to the difference between the author's experiences and the reader's imaginative perception of them.

Lewis's observations rest on the degree to which his experience of a place corresponds with his former image of it. He tells us that because 'I always desire the fullest information regarding any habitation or work of man, strange to me, which I propose to approach and interrogate . . . before I set foot in Maghreb I knew more about the inhabitants of, say, the hinterland of Tetouan than they know themselves—though I never have been to Tetouan.'[69] Later in the narrative Lewis

[65] Lewis, *Filibusters in Barbary*, pp. vii–viii.

[66] Ibid., p. viii. Of Baron Baedeker, Aldous Huxley growls, 'how I have hated him for his lack of discrimination!' He regrets that from Baedeker 'There is no escape; one must travel in his company—at any rate on a first journey. It is only after having scrupulously done what Badeker [*sic*] commands, after having discovered the Baron's lapses in taste, his artistic prejudices and antiquarian snobberies, that the tourist can compile that tourist guide which is the only guide for him. If he had but possessed it on his first tour!' (Aldous Huxley, *Along the Road: Notes and Essays of a Tourist* (London: Chatto & Windus, 1925), 37, 38–9).

[67] Lewis, *Filibusters in Barbary*, 23, 24.

[68] Ibid. 8. [69] Ibid. 3.

refers to the difference between one's prior views of a country and one's experience of it in a manner not dissimilar to that in which post-colonial theorists have returned to the matter more recently. He asks: 'In visiting a country for the first time, your head is stuffed with preconceived anticipatory pictures, is that not so?' When we make that visit, there is a 'confrontation' between those anticipatory pictures and what we see. 'The two towns, that of fancy and that of fact, will without your noticing it slowly begin fighting. At once there are certain fundamental things, which, usually unexpectedly, you discover, one after another.'[70]

This has happened to him at Oran in particular. But if this statement exposes the limitations and inaccuracies of ideas held by people who have not (yet) travelled to the countries about which they have impressions, Lewis is nevertheless privileging the observations he made in North Africa and thereby claiming some authority as a result of his travels. And, of course, such demonstrations of self-awareness do not preclude the perpetuation of racial stereotypes. Surveying the Japanese sailors at the port of Marseilles, Lewis suggests that they 'in every respect looked like the merest children'; that they 'were authentic Peter Pans'.[71] He will not allow them to grow up.

The effect may be the same in seemingly more positive accounts of other cultures. Regarding the 'primitive' as a necessary counterpoint to the modern means that Greene in Liberia and Lawrence in Mexico do not want the people there to grow up if to do so is to have them enter industrial society with its materialism and its repressiveness. Lawrence contrasts Mexican and American Indian conceptions of time with those of white people. Whereas 'to a Mexican, and an Indian, time is a vague, foggy reality' and consists only of 'en la mañana, en la tarde, en la noche: in the morning, in the afternoon, in the night', 'the white man has a horrible, truly horrible, monkey-like passion for invisible exactitudes'.[72] And the same with money and with distance. But the Mexican has to serve the 'great white monkey' in order to survive. 'He has to learn the tricks of the white monkey-show: time of the day, coin of money, machines that start at a second, work that is meaningless and yet is paid for with exactitude, in exact coin.'[73]

Lawrence's juxtaposition of the primitive and the modern, the pre-industrial and the mechanical, is clearly seen in his account of the Hopi snake dance in Arizona. Three thousand people, including tourists, whose motor cars drive thirty miles across the desert, travel to witness it. The dance involves men holding live rattlesnakes in their mouths. Lawrence's destination, as is frequently the case with travellers, affords the opportunity for critical comments on his departure point. He contrasts with the snake dance the relatively easy scientific conquest of natural forces that 'we' have won and concludes it has been only a partial victory: 'To us, heaven switches on daylight, or turns on the shower-bath. We little gods are gods of the machine only. It is our highest. Our cosmos is a great engine. And we die of ennui.'[74]

The philosophical use he makes of 'the Indian' ends up fitting Stan Smith's observation that all modernist writers, in both their literal and symbolic travelling,

[70] Ibid. 26. [71] Ibid. 6, 7. [72] Lawrence, *Mornings in Mexico*, 58–9.
[73] Ibid. 61. [74] Ibid. 146.

are 'dropping in on alien cultures, like any tourist, and picking up whatever items suit their purpose from the cultural bazaars'.[75]

Just as John Lucas has cautioned that in regarding the 1920s 'it is possible to overdo the idea of fragmentariness',[76] so it is possible to overdo the idea of fragmented, self-conscious, self-questioning modernist travel books. In *Sea and Sardinia*, for instance, Lawrence's view of the Italians' grudge against the English as a legitimate one because 'We . . . have taken upon ourselves for so long the rôle of leading nation' and 'in the war, or after the war, we have led them into a real old swinery' is accompanied by his insistence that 'I am a single human being, an individual, not a mere national unit, a mere chip of l'Inghilterra or la Germania. . . . I am myself.'[77] The strength of that insistence testifies to the degree to which Lawrence felt his individuality threatened and indicates that modernist travel books, if fragmentary, are constitutive too.[78] If this function of self-establishment continues, as in earlier periods, to be performed against other territories and peoples, its workings are generally more visible than before and throw some light on the processes of modern subjectivity within and outside texts.

This chapter has discussed a few examples that make up only a small proportion of the travel writing produced during the modernist period. Many people wrote about their travels differently or travelled without writing about them. Nevertheless, the narratives discussed here do share with one another, and with other art of the period, a serious and, to this date, under-examined concern with perspective and form. In their formal inventiveness, their exposure of and experimentation with generic conventions, they reveal their authors to be searching within travel texts for a suitable means of expressing identity in the modern world.

[75] Smith, 'Burbank with a Baedeker', 13.
[76] Lucas, *The Radical Twenties*, 178.
[77] Lawrence, *Sea and Sardinia* (1950), 288.
[78] Helen Carr observes that increasingly in the twentieth century travel writing became 'a more subjective form, more memoir than manual' (Carr, 'Modernism and Travel', 74).

PART III

CONTEXTS AND CONDITIONS

CHAPTER 16

..

THE MACHINE AGE

..

NICHOLAS DALY

MODERNISM is not the literature of technology, but one in a longer series of
literatures of technology. Romanticism was, among other things, a response to the
transformation of the lived environment wrought by industrialization; and the
literature of the Victorian period, from the 'industrial novels' of the 1840s and
1850s to the late Victorian fantasies of Wells and Stoker, continued to offer narratives
of human–machine encounters. The flourishing of modernism might then be seen to
correspond to what is termed the second industrial revolution. If the first industrial
age was driven by coal, iron, and steam, the second, beginning in the 1880s, was
ushered in by the internal combustion engine, the harnessing of electricity, new
technologies of sound and image, and the utilization of radioactive materials, with
the X-rays of Röntgen at one end, and the devastation of Hiroshima and Nagasaki at
the other. At roughly the same time a revolution took place in production and in
information management: these were the years of Taylorization and Fordism, and the
appearance of an increasingly sophisticated office culture. The cultural artefacts that
appeared alongside these material and immaterial revolutions were marked by these
changes, and also shaped responses to them. This historicization has a number of
weak points, in so far as the visual modernism of Manet and Whistler, for example,
appeared in the 1860s. Nor does such a tidy narrative help us to categorize those
writers of the *fin de siècle* who seem as distant from the high modernist world of
Woolf as that of Dickens: H. G. Wells's self-conscious *Bildungsroman, Tono-Bungay*
(1909), for example, with its radioactive quap, and almost Futurist idealization of
flight and speed, appears at this moment as more of a modernist text than a late
Victorian fantasy, but this modernism is clearly not that of Joyce, Woolf, and Eliot.

But bracketing such problem cases, if we begin by narrowing our focus to the
modernism of the 1920s, we can very clearly see that it was shaped by the second
industrial revolution. If we consider *Ulysses* (1922), *Mrs Dalloway* (1925), and *The*

Waste Land (1922), it is clear that we are dealing not just with texts that depict the technologically transformed city, but also with texts that have absorbed technology at the level of form, as such movements as Futurism and Vorticism had done in the visual arts.[1] *Ulysses*, as a historical novel, registers the technologies of 1904—its newspaper presses, its photography, its electric trams—but it has also introjected technology as style: Homeric parallels may provide some of the superstructure, but we also encounter the syntactic economy of the telegraph or the montage and point-of-view techniques of the cinema. (Some years later, such techniques were to be given a much more explicit place in John Dos Passos's monumental *USA* trilogy (1930–6), with its cut-up format and its explicitly labelled 'camera-eye' sections.) The Homeric elements are not to be bypassed, of course: indeed, such dialectical interlardings of the mythic and the high-tech might even be thought of as the defining characteristic of at least one kind of modernism. *Mrs Dalloway* echoes *Ulysses* in taking us through one day in the modern metropolis, and it is also marked by the presence of technology as content, most obviously the commercial magic of the sky-writing aeroplane that spells out the name of some popular commodity; in doing so it displaces the attention of the crowd from an older system of values, represented by the prestige of the passengers of the motor car. But Woolf also uses technology in more subtle ways: Septimus Smith is a victim of shell shock, a form of psychological damage characteristic of industrial warfare. The novel shows that his freely associative thoughts, in which the war years and the present intermingle to horrifying effect, are only a more extreme version of the stream of consciousness of Mrs Dalloway herself, for whom the past is often vividly present. Yet here too the mythic and the modern collide: the old woman singing a garbled version of Strauss's *Allerseelen* is at once some kind of earth mother and part of the flotsam of urban life, a drunk hanging around a tube station—in Woolf, the London Underground takes us very quickly to chthonic destinations.

Eliot's *The Waste Land* is another heady 1920s cocktail of mythic past and urban modernity, but it seems to represent a far less positive image of that present. Its dreary city, inhabited by young men, carbuncular, neurasthenic women, and the dead, offers a vision of the modern metropolis that arguably becomes far more influential than the more optimistic visions of Joyce and Woolf. This is the city as accursed place, a metropolis drained of meaning, though full of signs, a city that has its analogue in popular modernism as the city of film noir, which is corrupt through and through. Technology appears here as an index of inorganicism: the mechanical occupation of the typist, home at tea-time to her tinned repast, is clearly meant to be somehow consonant with the mechanical and joyless sex she endures. As with Woolf's London, the effects of industrial warfare are everywhere: the war dead walk the streets, and nerves are bad, but here there is no buzzing life force, no larking or plunging to counterbalance the sense of apocalypse—it is all Septimus, and no Mrs Dalloway. Again, technology marks the style as well as the content. Eliot's poem

[1] On the impact of technology on high modernist form, see e.g. Sara Danius, *The Senses of Modernism: Technology, Perception, and Aesthetics* (Ithaca, NY: Cornell University Press, 2002).

is, if anything, even more a work of montage: Tiresias is thrown into the mix with Madame Sosostris; the sombre rhythms of Webster jar with those of the music hall.

Eliot's hostility to modernity, and his anti-modern espousal of ritual and religion, was an idiosyncratic response, but it should remind us that there is a rich seam of modernist anti-modernity. Ernest Hemingway's work, for example, tends to avoid the city altogether, his protagonists pursuing some kind of escape from the complexities of industrial life in unevenly modernized parts of the earth, from rural America ('Big Two-Hearted River') and Spain (*The Sun Also Rises*) to the African plains ('The Short, Happy Life of Francis Macomber'). In his fiction, hunting and fishing offer the prospect of some more real engagement with the world to those who have returned scarred, physically or otherwise, from the First World War. But as Fredric Jameson argues in *Marxism and Form*, such settings also offer the prospect of a certain type of sentence, a sentence shorn of too much modern clutter and urban complexity.[2] At its most extreme it is easily parodied—guns, fishing rods, and places are simply 'good'— but this is a literature with serious philosophical ambitions: it wants to get closer to things by shedding any prosiness. In such modernist anti-modernity there are continuities with Romantic and Victorian responses to industrial society, as well as innovations. Eliot's eventual embrace of a form of High Church ritualism recalls the Oxford Movement, but also the medievalism of the Pre-Raphaelites. Hemingway's eschewal of urban life for the less industrialized parts of the world bears a family resemblance, at an international level, to the adoption of the Lake District by Wordsworth.

D. H. Lawrence is perhaps the most obvious candidate for the title of belated Romantic. His work combines a hearty dislike for Midlands industry with a faith in the residual power of the natural world. Lawrence also sought out the non-modern in remote places—for example, in *The Plumed Serpent* (1926)—but in his work the escape from modernity took an idiosyncratic turn. In such works as *Women in Love* (1920) and *Lady Chatterley's Lover* (1928), it appears as a journey not in space but into sexual intimacy. If in Hemingway sexual relationships bring back in the complexity that his protagonists (e.g. Jake in *The Sun Also Rises*) are trying to flee, in Lawrence, sexuality becomes a nature reserve in which a more fundamental, or more primitive, humanity survives. As with Woolf, Eliot, and Hemingway, the First World War casts a long shadow in his work, and industrialism is linked to industrialized killing. Private life, in particular the sphere of intimacy, is fetishized, while the public sphere, and with it the world of work, is drained of any life-giving value. (This may seem, of course, less a Romantic solution to the ills of industrial modernity than a Victorian one.) If Lawrence's work has lost some of its critical prestige, this is in part because his enshrining of the sexual sphere as a zone of salvation seems to go hand in hand with a vision of sexual liberation that is in the end quite conservative: men must be real men and women must be real women in ways that seem nostalgic rather than revolutionary.

[2] Fredric Jameson, *Marxism and Form* (Princeton: Princeton University Press, 1971).

The anti-industrial agenda is given explicit voice in *Lady Chatterley's Lover* by Mellors, the soldier-turned-gamekeeper who gives Constance Chatterley a crash course in proper sexuality: 'I'd wipe the machines off the face of the earth again, and end the industrial epoch absolutely, like a black mistake.'[3] The novel's foil to the virile but tender Mellors is Constance's husband, Clifford, who is living proof of the destruction wrought by industrial modernity. Broken by industrial warfare, he has now become dependent on machines. Shipped back from Flanders 'more or less in bits', he is reassembled by the doctors, and now can drive around his garden in 'a bath-chair with a small motor attachment', but he cannot have children, and his face has 'the slight vacancy of a cripple'.[4] (He is a much more extreme version of Hemingway's Jake, in *The Sun Also Rises*, another man emasculated by war.) It is not just the men who have been damaged by modernity, though, and Mellors's mission is to clear away the funny ideas that Constance has picked up while living in modern, free-living student circles in Germany before the war, as evidenced in the following piece of free indirect discourse:

A woman could take a man without really giving herself away . . . she could use this sex thing to have power over him. For she only had to hold herself back in sexual intercourse, and let him finish and expend himself without herself coming to the crisis: and then she could prolong the connexion and achieve her orgasm and her crisis while he was merely her tool.[5]

Under Mellors's tutelage, she learns a more yielding style of sexuality, more in keeping with, one assumes, Lawrence's view of the natural order. It is hard not to laugh at some of the more bizarre aspects of the novel's programme for the reassertion of natural gender divisions, as with Mellors's wistful utopian account of a sort of sexual colour-coding:

An' I'd get my men to wear different clothes: appen close red trousers, bright red, an' little short white jackets. Why, if men had red, fine legs, that alone would change them in a month. They'd begin to be men again, to be men! An' the women could dress as they liked. Because if once the men walked with legs close bright scarlet, and buttocks nice and showing scarlet under a little white jacket: then the women 'ud begin to be women. It's because th' men AREN'T men, that th' women have to be.[6]

An end to industrialism, and tight red trousers for the men: this must be one of the more curious utopian visions to have been shaped by the second industrial revolution. And yet, Lawrence's primitivism has numerous parallels, not least in popular culture. Cognate fantasies of back-to-basics sexuality presumably underwrote the appeal of the Irish author Henry de Vere Stacpoole's romantic Robinsonade *The Blue Lagoon* (1908); and the millions who read the Tarzan stories of Edgar Rice Burroughs, beginning with *Tarzan of the Apes* (1912), and who avidly watched its innumerable feature film and serial adaptations, must at least in part have been drawn by a similar

[3] D. H. Lawrence, *Lady Chatterley's Lover* (Harmondsworth: Penguin, 1984), 230.
[4] Ibid. 5, 6. [5] Ibid. 8. [6] Ibid. 229.

dream of men being men, and women women, shorn of the cumbersome trap-pings—including clothes—of modernity. If there were modernists, high and popular alike, who readily embraced machine culture and the promise of modernization, it is important to bear in mind that a significant quantity of the literature of technology took such pastoralist and primitivist form. Nor was this exclusively true of literature. Any history of the visual arts in relation to the second industrial age will be drawn to such movements as Futurism and Vorticism, movements that explicitly oriented themselves with respect to the modern. But a great deal of the artistic production of these same years espoused the pastoral (as in much Impressionist-influenced and Post-Impressionist work), or embraced the primitive (for example, in the work of Picasso, Braque, and Brancusi).

ICONIC MACHINES

If we step back from the responses of particular authors, we can discern that various key new technologies appear again and again in modernism. The mass transport of the railway was the iconic transport technology of the nineteenth century, while in the twentieth century that role was played by the motor car, which offered indus-trialized transport to the individual. For the Futurists the car was intimately asso-ciated with their vision of the possibilities of modern art. In F. T. Marinetti's prelude to the 1909 *Manifesto*, it was the famished roar of automobiles that lured him and his friends onto the streets, and the car itself provided an ideal image of the beauty of power and speed. As Marinetti famously announced: 'A racing automobile whose hood is adorned with great pipes like serpents of explosive breath . . . a roaring car that seems to ride on grapeshot, is more beautiful than the *Victory of Samothrace*.'[7] Vorticism, by contrast, is not usually seen to enjoy the same love affair with the combustion engine, though there are some exceptions, such as Claude Flight's Vorticist-influenced work *Paris Omnibus* (1923), in which the abstraction and use of clean geometric lines espoused by Wyndham Lewis and his circle is combined with a Futurist investment in movement. (Flight is a significant figure in the transmission of Futurist ideas about the representation of modernity through his teaching of linocut printing at the Grosvenor School of Modern Art, where his pupils included Sybil Andrews and Cyril Power.) The automobile appears as an icon of modernity across a wide range of twentieth-century literary production, from Rudyard Kipling to E. M. Forster, and from Fitzgerald to the belated modernism of J. G. Ballard. Kipling was an early convert, and cars featured in his work from *Traffics and*

[7] Filippo Tommaso Marinetti, 'The Founding and Manifesto of Futurism' (1909), in Vassiliki Kolocotroni, Jane Goldman, and Olga Taxidou (eds), *Modernism: An Anthology of Sources and Documents* (Edinburgh: Edinburgh University Press, 1998), 251.

Discoveries (1904) onwards. Like some other early literary evocations of motoring, Kipling's representations of the car linked it to new freedoms, but also to the seemingly endless vistas of space offered by the ideologies of empire. The Futurists, of course, with their vision of the hygienic force of war, and their enthusiasm for Italy's imperial ambitions, were not so very different in this respect.

If the car could represent the spirit of modern times, the car accident provided a convenient figure for recklessness (as in *The Great Gatsby*, 1925), and a nice shorthand for the revenge of the fates on those who live fast, as with Iris March in Michael Arlen's 1924 bestseller *The Green Hat* and Agatha Runcible in Evelyn Waugh's *Vile Bodies* (1930). Indeed, it can be argued that Waugh's novel, in which cars and aeroplanes in the end only produce illness, is a direct parody of the machine-worship of Marinetti, who makes a cameo appearance as Marino, an Italian race car driver, who is described as 'a real artist'.[8] More generally, cars could be used to represent the systemic failures of modernity, as with Louis MacNeice's 'Birmingham' (1933), where they appear as part of a decidedly hellish cityscape:

> Smoke from the train-gulf hid by hoardings blunders upward, the brakes of cars
> Pipe as the policeman pivoting round raises his flat hand, bars
> With his figure of a monolith Pharaoh the queue of fidgety machines
> (Chromium dogs on the bonnet, faces behind the triplex screens).
> Behind him the streets run away between the proud glass of shops,
> Cubical scent-bottles artificial legs arctic foxes and electric mops.[9]

Here there is no sense of the car as vehicle of spatial or existential freedom. Instead we have a glimpse of one of the twentieth century's recurring images of the failure of modern utopia—the traffic jam.

Automobiles were even more pervasive in other twentieth-century media, especially in the popular modernism of the cinema. Film's intimate relationship to the car was established very early on in the comedies of Mack Sennett, but its subsequent roles were diverse, from gangster movies to romantic comedy, to horror. The internal combustion engine even generated its own genre, the road movie, which used the chronotope of the car journey (or motorbike, or bus journey) as its structuring device. Most road movies fall into the category of the popular, but there are a few belated high modernist exceptions, such as Wim Wenders's *Kings of the Road* (1976). The traffic jam also appears as a signifier of dystopia in films as different as Jean-Luc Godard's *Weekend* (1967) and Joel Schumacher's *Falling Down* (1993).

There is a good deal to be said about the poetics of car space as it developed on screen: the romantic or even sexual intimacy of the back seat (or front seat in older models, before the advent of the individual 'bucket seat', as we see in some of the scenes between Humphrey Bogart and Lauren Bacall in *The Big Sleep*, 1946); the authority of the driver's seat; the windscreen as window on the world. As Sean

[8] See Brooke Allen, 'Vile Bodies: A Futurist Fantasy', *Twentieth-Century Literature*, 40/3 (Autumn 2004), 318–28.
[9] *The Collected Poems of Louis MacNeice*, ed. E. R. Dodds (London: Faber, 1966), 17.

O'Connell has shown, historically the car emerged as a strongly gendered space, one in which men drove and women (and children) were passengers.[10] Films tended not only to draw on but also to reinforce such views, though at times they played with them in interesting ways: the aftermath of the Second World War saw a number of such car scenes. One thinks of *The Big Sleep*, where a female taxi-driver (Joy Barlow) chats Marlowe up and gives him her number while he sits in the back, or *The Blue Dahlia* (1946), in which Veronica Lake picks up the hunted Alan Ladd. In Ballard's late modernist *Crash* (1973), the intimate place the car has found in our dreams and waking fantasies is explored in explicit detail, as is the nature of the machine-transformed cinema star.

The car was not the only iconic transport technology of the twentieth century, of course. It had a serious rival in the aeroplane, and it is significant that when plane and car vie for the attention of the London crowd in *Mrs Dalloway* the plane wins. Where the car connoted individualism and the dizzying speed of modernity, the plane was a natural symbol of transcendence, of the final conquest of time, space, and the leaden weight of gravity itself. In *Mrs Dalloway*, of course, that idea of transcendence is qualified: the plane is being used to produce sky-written advertising for toffee—Pegasus is very much in harness, and the heavens themselves become a commercial hoarding. Planes are nowhere to be seen in *A Portrait of the Artist as a Young Man* (1914–15), or in *Ulysses*, but Stephen's surname, Dedalus, is overdetermined, not only by Greek myth, but by the literal flight that was becoming an everyday reality, particularly in France, while Joyce was writing those novels. The pioneering powered flight of the Wright brothers had occurred on 17 December 1903 at Kitty Hawk on the North Carolina coast, but by the end of the decade it was Paris that had established itself as the capital of aviation. Wilbur Wright's flights at Hanaudières and elsewhere in France had galvanized French aviators, and by 1909 a generation of French pilots had become household names: Henry Farman, Alberto Santos-Dumont (born in Brazil, but based in Paris), Hubert Latham, and Louis Blériot.[11] Foremost among these was Blériot, who became a national hero in France, as well as an international figure, when he flew his monoplane across the English Channel in 1909. Henceforth, long-distance flights over water, with all their mythic echoes of Icarus and Daedalus, would occupy a special place in the imagination of flight.[12] The pilot as hero (and by the 1920s, heroine) was a natural figure of transcendence, flying by the nets of gravity itself: it is almost impossible to imagine that Joyce was immune to these developments.

Planes were still a comparative novelty during the composition of *Portrait*, but by the time *Ulysses* was published, the forced technological acceleration of the First World War had made them a familiar feature of modern life, and they appealed to the

[10] Sean O'Connell, *The Car in British Society: Class, Gender and Motoring, 1896–1939* (Manchester: Manchester University Press, 1998).

[11] For a detailed account, see Robert Wohl, *A Passion for Wings: Aviation and the Western Imagination, 1908–1918* (New Haven: Yale University Press, 1994).

[12] Ibid. 66.

poet as much as to the novelist. It is possible to trace a sub-genre of aviation poetry that explores a cluster of ideas about flight, transcendence, and death. In Katharine Tynan's 'For an Airman' (1917) new content sits uneasily with the traditional poetic diction:

> Having found wings, he tossed, light as a feather,
> Airy as thistledown, 'twixt earth and sky.
> Oh, but the dark earth held his soul in tether!
> Could he come back who knew what 'twas to fly?[13]

Ultimately, in death, the airman '[Shakes] himself free of bonds that irked him daily'. That those who learn to fly might come to set less store by earthly things is likewise suggested in a better-known poem, Yeats's 'An Irish Airman Foresees His Death' (1919). (As Bernhard Rieger has shown, this idea of the heroic nature of a pilot's death survived the war years, and in Germany was denoted by the term *Fliegertod*.[14]) Not altogether unlike Joyce's hero, the poem's airman (Robert Gregory, son of Lady Gregory, elsewhere mourned by Yeats as a Renaissance man, 'our Sidney') is driven 'to this tumult in the clouds' not by patriotism or by hatred of the enemy, but by 'a lonely impulse of delight'.[15] Poetic flight and actual flight merge in the poem's evocation of the pilot's vision of life in balance with death; the air as medium is linked to the 'waste of breath' that the years to come seem to be, but also to poetic inspiration, and to the poet's lonely voice.

Such idealism was not, however, the only note in aviation poetry. Consider, by way of contrast, the materiality of John Rodker's striking poem 'War Museum—Royal College of Surgeons' (1929), which describes the leftovers of war, preserved in formaldehyde:

> This is the airman's heart.
> He fell five hundred feet
> and the impetus snapped the hurtling heart
> from its two frail tubes.[16]

A similar orientation towards material realities marks W. H. Auden's 'The Airman's Alphabet', which alternates between irony and poignancy in its telegraphic listing of a pilot's environment, in which C is for Cockpit, D is for Dashboard, and so on. But new wine did not always appear in new bottles, and experimental modernist form did not have the field to itself. Even during the Second World War, high-tech air combat could be combined with more conventional sentiments and more conventional poetic diction and metre. The pilot in Sir Charles Roberts's 1940 poem 'Epitaph for a Young Airman (Shot Down over the Channel)'

[13] Katharine Tynan, *Late Songs* (London: Sidgwick & Jackson, 1917), 29.
[14] Bernhard Rieger, *Technology and the Culture of Modernity in Britain and Germany, 1890–1945* (Cambridge: Cambridge University Press, 2005), 130.
[15] *Yeats's Poems*, ed. A. Norman Jeffares (London: Gill and Macmillan, 1989), 237.
[16] *John Rodker: Poems & Adolphe 1920*, ed. Andrew Crozier (Manchester: Carcanet, 1996), 125.

> Would scale the heights of air too thin
> For toil of labouring breath,
> Alone to front the foe and fling
> His dare to flaming death.[17]

Except for the fact that it describes air warfare, this could have been written in 1840 rather than 1940.

If airmen became on occasion attractive subjects of lyric poetry, they loomed much larger in the popular visual culture of the period, not least because film and flying grew up together. Moving pictures and flight were both capable of the conquest of time and space, and by the 1920s the two technologies were combined to real effect. In 1927 the first Academy Award for best picture went to the First World War film *Wings*, directed by former Lafayette Flying Corps pilot William Wellman. Made for the then enormous figure of $2 million, the film used footage of air battles to spectacular effect. Clara Bow, its heroine, had already become an icon of modernity in various flapper roles; in this film she is cast to type as a tomboyish girl next door who joins the Army Motor Corps to be closer to the man she loves. (The same year would see her become the original 'It' girl, when she appeared in the romantic comedy of that name.) The success of *Wings* may in part be attributed to the air mania that swept the United States in 1927, which was also the year of Charles Lindbergh's solo transatlantic flight: the pilot as hero had well and truly arrived. *Wings* was not, of course, the first film to make use of the spectacular potential of flight. It had been preceded by such films as Hepworth's short feature *The Jewel Thieves Outwitted* (1913), featuring a Bristol Boxkite, and such stunt pictures as *The Great Air Robbery* (1919), featuring stunt pilot Ormer Locklear, and *The Sky Raider* (1925), which starred French First World War ace Charles Nungesser, who promoted the film by performing at 'barnstorming' exhibitions across the country. However, *Wings* was the first big-budget film really to develop the possibilities of the airborne camera. It was followed by many others, including Howard Hughes's lavishly made *Hell's Angels* (1930) and Victor Fleming's *Test Pilot* (1938), but also by such low-budget serials as *The Mysterious Airman* (1928) and by melodramas such as *The Sky Hawk* (1929), in which John Garrick plays a crippled and disgraced British airman who redeems himself by fighting Zeppelins over London.

The popular modernism of the United States readily embraced the aeroplane, but it was in Italy that flight, and the figure of the pilot, most emphatically became part of national political consciousness. The first key figure in this curious linkage of national politics and flight was the poet, novelist, and political provocateur Gabriele D'Annunzio. His aviation novel *Forse che sì forse che no* (1910) appeared before the First World War, as did his first statements exalting aviation as a sublime and heroic activity. But it was during the war that D'Annunzio really established the nexus between what he saw as the daring Italian spirit and the air in a national mission to go

[17] *Collected Poems of Sir Charles G. D. Roberts: A Critical Edition*, ed. Desmond Pacey (Wolfville, NSW: Wombat Press, 1985), 342.

higher and further. Although he could not himself fly, he embarked as lead passenger on a series of well-publicized raids upon Austrian territory, including a 1,000 kilometre flight to Vienna, where he and his squadron dropped not bombs but propaganda leaflets. After the war actual and rhetorical flights continued, as he exhorted Italian aviators to turn on Italy's liberal government and to turn away from the degeneracy of the West, which he characterized as 'an immense Jewish bank in the service of a merciless transatlantic plutocracy'.[18] Here we see how the rhetoric of transcendence of the material could easily combine with other, less abstract and less attractive ideologemes—one thinks of the subsequent glamour of mountain climbing under the National Socialists, and Lindbergh's belief in racial destiny.

Mussolini built on the symbolic connections forged by D'Annunzio. He learnt to fly, and he made use of aeroplanes to make dramatic arrivals for political speeches. But he also harnessed the spectacular power of large-scale formation flying to advertise Italy as a thrusting, ambitious nation, a country that was alive to the transformative power and the speed and energy of modernity, as Wohl has shown. In 1923 he had 263 planes fly over Rome to commemorate his march on that city. In 1926 he appointed Italo Balbo as under-secretary of aviation, and under the latter's leadership the Italian air force adopted the Fascist emblem and salute, and indeed came themselves to emblematize the power of Fascism. Mussolini gave him veritable carte blanche to mount a series of dramatic 'cruises', in which air force seaplanes flew en masse and in formation to various parts of the globe, bringing the message, and the iconography, of Fascism to a world that was far from indifferent to it. The most dramatic of these multi-stage cruises were flights from Rome to Rio de Janeiro in 1930 (involving a transatlantic flight from the west coast of Africa); and from Rome to New York via Chicago in 1933. Wherever they appeared, the crowds gathered: hundreds of thousands filled the beach at Rio to greet the seaplanes; in Chicago 100,000 people came to see them land on Lake Michigan; in New York they were given a ticker-tape parade. Of course, very few people, relatively speaking, would actually see the flights, but the newspaper reports, newsreels, chromolithographic posters, and souvenirs would involve millions more in these aerial adventures. The posters, and the Exposition of Italian Aeronautics that followed in 1934, used striking modernist designs that made Italian planes and airmen look like the future itself. And like his high modernist contemporaries, Balbo saw the possibilities of combining cutting-edge modernity and myth. For the South American flight he chose for his squadron motto a line from Dante's *Song of Ulysses*: 'And I embarked upon the open sea.'[19]

I have suggested that there was a special affinity between the iconic transport technologies of the twentieth century and another new technology, the last great machine of the nineteenth century, the cinema. The cinema is a rather different technology from its siblings; it is a technology of representation, and thus capable of producing self-conscious meditations on its own status as a technology. This was true as early as 1904, as we see in *The Countryman's First Sight of the Cinematograph*, or in the

[18] Wohl, *A Passion for Wings*, 59. [19] Ibid. 74.

films of George Méliès, which frequently dwell on the magical transformations made possible by the motion picture camera. By the 1920s film had its own theoreticians—in Russia such figures as Dziga Vertov, Lev Kuleshov, and Sergei Eisenstein—who were keen to employ modernist shock techniques. The most famous of these, Eisenstein, put his theory of montage to work in such films as *Strike* (1924), *Battleship Potemkin* (1925), and *October* (1927). Eisenstein's montage is quite different from the style of continuity editing that evolved in Hollywood, and which seeks to interpellate the viewer into the action by keeping him or her always carefully orientated with respect to the on-screen action. In Eisenstein's practice such continuities are regularly broken, and we are reminded of the pro-filmic nature of the action through, for example, rhythmic editing, in which emotional effects can be achieved at the same time as distancing from the actual 'story'. For cultural commentators, film sometimes represented a dangerous technology, because of its ability to hold crowds spellbound, while also blurring the line between fact and fiction.[20] It did not help that the most basic effect of moving pictures—the effect of motion created through the projection of a series of still images—remained something of a mystery, given the limited explanatory power of such concepts as the persistence of vision. Some of the hostility to the new technology had less to do with its mysteries, and rather more to do with its audience, since from early on it was associated not just with mass culture, but with the masses themselves. Some key figures took a different view. James Joyce, for example, attempted to bring Italian super-films to Dublin through the Volta Cinema, and Shaw described himself as a movie fan.[21] There is another facet to the relationship between modernism and the cinema, of course. Under the aegis of the *auteur* theory that grew out of the work of André Bazin, a form of high modernism survived in film criticism (and to some extent practice) long after the Second World War.

SURVIVALS

Not all of the iconic technologies of the twentieth century were new. As Rieger has shown, the transatlantic passenger ship also came to emblematize a certain version of modern life: the technology-driven 'floating palace'.[22] Where the car connoted

[20] Rieger, *Technology and the Culture of Modernity*, 86–115.

[21] On the attitudes of Shaw, Woolf, Waugh, and others, see D. L. LeMahieu, *A Culture for Democracy: Mass Communication and the Cultivated Mind in Britain Between the Wars* (Oxford: Clarendon Press, 1988), 113–16. On film and the avant-garde, in particular in relation to the advent of sound, see Tim Armstrong, *Modernism, Technology and the Body: A Cultural Study* (Cambridge: Cambridge University Press, 1998), 226–34; on modernism and film, see Laura Marcus, *The Tenth Muse: Writing About Cinema in the Modernist Period* (Oxford: Oxford University Press, 2007), and David Trotter, *Cinema and Modernism* (Oxford: Blackwell, 2007).

[22] Rieger, *Technology and the Culture of Modernity*, 158–92.

individual freedom, and the plane offered transcendence, the ocean liner came to stand for the combination of technology and luxury. Indeed, the vision of opulence on the high seas that was sold to the public was marketed so effectively that we still think of ships of the Cunard line as offering a benchmark for stylish living. By the 1930s the version of modernity that they offered also encompassed modernist design, and the owners of the *Queen Mary* deliberately set out to capture the up-to-the-minute appeal of Art Deco while steering away from anything too avant-garde. (The lithographic advertising posters for transatlantic travel in this period were sometimes more daring than the ships themselves in their embrace of modernist aesthetics.)

To market ocean travel as the last word in modern comfort meant repressing other associations, not just emigration and seasickness, but nautical disasters. The major event to be repressed was of course the sinking of the White Star line's *Titanic* in 1912. Indeed, it is scarcely an exaggeration to say that the sinking of the *Titanic* came to represent the most powerful image of technological disaster for the rest of the century. From being the embodiment of the industrial sublime, overnight it came to represent the limits of human agency, the end of hubris, and the residual maleficent power of natural forces. Early responses saw the disaster as the appropriate end of excessive human ambition, as in T. W. H. Crosland's 'Titanic', published in 1917: 'O towers of steel and masts that gored the moon | On you we blazoned our pomp and lust and pelf.' Thomas Hardy's 'The Convergence of the Twain' interprets the disaster in similar light:

> In a solitude of the sea
> Deep from human vanity
> And the Pride of Life that planned her, stilly couches she.

If this is a rather predictable note to strike, the poem goes on to sketch a more chilling idea, that a baleful destiny forged ship and iceberg together, with a view to their eventual collision:

> Well: while was fashioning
> This creature of cleaving wing,
> The Immanent Will that stirs and urges everything
>
> Prepared a sinister mate
> For her—so gaily great—
> A Shape of Ice, for the time far and dissociate.
>
> And as the smart ship grew
> In stature, grace, and hue,
> In shadowy silent distance grew the Iceberg too.[23]

Its iconicity was extensively revived and reworked throughout the century in such films as *Saved from the Titanic* (1912), *Nacht und Eis* (1912), *Atlantic* (1929), *A Night to Remember* (1958), and James Cameron's postmodern *Titanic* (1997), and indirectly in, say, *The Poseidon Adventure* (1972; based on a novel by Paul Gallico). In later years it would be joined by other images of massive techno-catastrophe, such as the

[23] *Poems by Thomas Hardy*, ed. Trevor Johnson (London: Folio Society, 1979), 249–50.

Hindenburg engulfed in flames, as well as by images of deliberate destruction designed to shock and awe: Hiroshima and Nagasaki, Dresden, the World Trade Center. But the fact that it has never altogether lost its original power suggests that the *Titanic* holds us because it is linked to a period when technology was credited with extraordinary power to transform the world for good. It is that sense of optimism crushed that gives the *Titanic* its aura.

Another nineteenth-century machine that continued to enjoy iconic power was the train. While the 'railway rescues' of such Victorian melodramas as Augustin Daly's *Under the Gaslight* (1868) were now more likely to evoke laughter than suspense when they were occasionally staged, the same scenarios became vividly effective again when transferred to the screen. Thus, dramatic railway action fills such popular serials as *The Perils of Pauline* (1914), with Pearl White, and *A Lass of the Lumberlands* (1916), starring Helen Holmes. The railway was more than just a source of spectacle, though. As Lynne Kirby has shown, railway films also allowed the new technology of the cinema to contemplate its own transformative power in a displaced form.[24]

In the galleries, the train lingered as an icon of modern life, as in the work of the British Futurist Christopher Nevinson. Though he is, perhaps, better known for his abstract representations of the industrial warfare of 1914–18 (*Bursting Shell*, 1915; *La Mitrailleuse*, 1915), Nevinson displayed a range of attitudes to the machine, from his bustling *Departure of the Train de Luxe* (1913, now lost)—which might be seen as a radical reworking of such famous Victorian railway paintings as William Frith's *The Railway Station* (1862) and George Earle's *Going North, King's Cross* (1893)—to his sombre vision of New York, *The Soul of the Soulless City* (1920), in which the railway line leads us into the heart of an oppressive concrete forest. Somewhat ironically, in light of the bleak perspective of the latter, he also produced pastoral images that were used in chromolithographic posters for the Underground Electric Railways Company, such as *Home Counties; No. 4, Kent* (1924), and to advertise excursions by motorbus (*Picnics*, 1921).

Trains were still of use to the novelist, too, allowing for close as well as brief encounters, in an age when the Pullman car had not yet displaced the compartment in many countries. Cross-class encounters, a staple of the Victorian imaginary, could still be placed on trains, as we see in Ford Madox Ford's *The Good Soldier* (1915), where the compromising episode that forces the Ashburnhams to go abroad is Edward's ambiguous encounter in a third-class compartment with a young working-class woman, interpreted by her as a sexual assault (given the novel's unreliable narrator, we are never sure whether or not she is correct). The chronotope of the railway is put to rather different use in Lawrence's *Women in Love*, where a railway journey to London allows the two male protagonists, Gerald Crich and Rupert Birkin, to have a long discussion about the state of the modern world (it is, unsurprisingly, 'completely bad' according to Lawrence's spokesperson in the novel).

[24] Lynne Kirby, *Parallel Tracks: The Railroad and Silent Cinema* (Exeter: University of Exeter Press, 1997).

Elsewhere Lawrence imagines the railway journey more hopefully, as an occasion of erotic potentiality, as with the melding of beloved and background in 'Kisses in the Train':

> I saw the midlands
> Revolve through her hair;
> The fields of autumn
> Stretching bare,
> And sheep on the pasture
> Tossed back in a scare.[25]

As Andrew Thacker has shown, the viewless trains of the London Underground appear as highly charged spaces in the work of the Imagist poets. In a series of Imagist poems from the 1910s travel by Tube is represented as emblematic of modern urban life, a confined space in which the individual artist–traveller experiences urban alienation and the reduction of the self in a distilled form. In such poems as Richard Aldington's 'In the Tube' (1915) and F. S. Flint's 'Tube' (1920), modern urban experience is condensed into the moment when the poet encounters the dead eyes or hostile gaze of his fellow commuters:

> A row of eyes,
> Eyes of greed, of pitiful blankness, of plethoric complacency,
> Immobile,
> Gaze, stare at one point,
> At my eyes.[26]

When the anonymous Tube experience leads to momentary sexual reverie, as in Flint's 'Accident' (1915), even this turns to ashes. Somewhat paradoxically, Imagist technique, with its fetishization of the visual, comes to act as a way of containing such a bleak and disorientating experience of metropolitan life.

Sometimes the technologies that literature incorporates are on a very small scale: gadgets rather than juggernauts of the industrial sublime. Such an item is the orange-juicer described by Nick Carraway in chapter 3 of *The Great Gatsby*, which is able to extract the juice of two hundred oranges in half an hour, with two hundred presses of a little button. Where the juicer is a metonym of magic, a sign of the Arabian Nights aspect of Gatsby's mansion, the gadgets of modernity are just as often used to signify a more Eliotic urban modernity, full of stuff, but empty of meaning. This, one assumes, is the point of the electric mops that join the cubical scent bottles, artificial legs, and arctic foxes in the shop windows of Louis MacNeice's 'Birmingham', to which I have already referred.

From the early 1900s, the domestic interior was transformed by such new technologies of convenience as the vacuum cleaner, which took at least some of the

[25] From *Rhyming Poems* (1928), in D. H. Lawrence, *The Complete Poems of D. H. Lawrence*, ed. Vivian de Sola Pinto and Warren Roberts (Harmondsworth: Penguin, 1977), 120.

[26] Richard Aldington, 'In the Tube', cited in Andrew Thacker, *Moving Through Modernity: Space and Geography in Modernism* (Manchester: Manchester University Press, 2003), 93.

drudgery out of housework for those who could not afford servants, and reduced the need for servants among those who could. At another level, the very nature of interior space was transformed by those sound technologies that brought other voices into the home: the wireless, the telephone, and the gramophone (the latter two had been around for quite some time, but they became available to the masses in the early twentieth century). The wireless, or radio, created a new genre, the radio play (the earliest example in Britain was probably Richard Hughes's *A Comedy of Danger*, broadcast by the BBC on 15 January 1924). Several modernists wrote for radio, either because they needed the money, or because they were attracted by the possibilities of the medium itself, like Döblin, who rewrote *Berlin Alexanderplatz* for the radio as *The Story of Franz Biberkopf*.[27] Döblin had some reservations about radio's ability to provide anything but a private experience, in contrast to the collective experience of the theatre, but he also realized that the radio (and the telephone) meant that 'every apartment is blown apart, nobody lives alone anymore under his roof and within his four walls'.[28] Louis MacNeice, Tyrone Guthrie, Harold Pinter, and Samuel Beckett are among the many writers who wrote significant drama for radio; and others, such as Elizabeth Bowen, wrote stories for radio broadcast.[29] The gramophone and the telephone also marked literary production. The latter obviously created new possibilities for dialogue, but all three sound technologies in turn suggested ways in which voice could be disembodied and made pure sound, an autonomous element outside of its use in characterization or the conveyance of narrative information. This was also, of course, to preserve the voice from the natural shocks that flesh is heir to: to be recorded, as to be filmed, is to be immortal, something Conrad seems already to have grasped in *Heart of Darkness*.[30] Nor was the experience of voice the only significant aspect of these technologies. All three made it possible for the non-musician for the first time to experience music in solitude (the gramophone and radio, obviously, but even the telephone was used for 'telephone concerts' in its early years).

An account, such as this one, which has tracked the representation of individual technologies, has its blind spots. It is difficult, for example, on such a model to do justice to Vorticism, conceived as a riposte to Cubism and (especially) Futurism, and arguably Britain's major contribution to the early twentieth-century 'isms'. While the name itself is attributed to Ezra Pound, the key figure behind the movement was Wyndham Lewis. Launched on the world with the publication of the magazine *Blast* in July 1914, and a Vorticist Exhibition at the Doré Gallery in London in June 1915, the wider circle included David Bomberg, Jessica Dismorr, Jacob Epstein, Henri Gaudier-Brzeska, Helen Saunders, and Edward Wadsworth. Like the Futurists, the

[27] For an overview of modernism's relationship to radio, see Todd Avery, *Radio Modernism: Literature, Ethics, and the BBC, 1922–1938* (Aldershot: Ashgate, 2006).

[28] See Peter Jelavich, *Berlin Alexanderplatz: Radio, Film, and the Death of Weimar Culture* (Berkeley: University of California Press, 2006), 86.

[29] See e.g. John Drakakis (ed.), *British Radio Drama* (Cambridge: Cambridge University Press, 1981).

[30] Ivan Kreilkamp, 'A Voice Without a Body: The Phonographic Logic of *Heart of Darkness*', *Victorian Studies*, 40/2 (1997), 211–44.

Vorticists sought to free art and society from the dead hand of the past: 'Blast years 1837 to 1900' proclaimed the magazine, which hammered home its point through the use of a distinctive new typography. Unlike the Futurists, the Vorticists largely eschewed the direct representation of new technologies, though their work is every-where informed by the awareness of the industrialization of everyday life. Geometric abstraction characterizes much of Lewis's work from this period (for example, in *Planners: Happy Day*, 1912–13, and *The Crowd*, 1915); cityscapes are evoked through gridded shapes; human bodies are represented as angular geometrized forms; the flowing organic forms of Art Nouveau and Jugendstil are emphatically rejected for a more hard-edged vision that anticipates Constructivism and the later tendencies of Bauhaus. As a movement, Vorticism did not survive the war, but its influence on post-war British fine art and design was significant.

Ezra Pound, who may have given the Vorticists their name, was also a leading Imagist, whose 1913 manifesto proclaimed 'No Unnecessary Word'. As Hugh Kenner has shown, this thesis reveals another way in which twentieth-century modernism shows the pressure of the machine age without necessarily representing machines.[31] For Pound and T. E. Hulme, among others, the task of the modern writer would be to assemble a text that resembled a machine in terms of precision and economy of movement; a good writer would scrupulously pare away the inessential—a task Pound would famously perform for T. S. Eliot as well as for himself. (We might assume that this precision-tool vision of writing was brought into sharper focus by a specific machine that I have scarcely mentioned, the typewriter, which from the 1870s onwards fundamentally changed the relationship between the writer and the written word: the typewritten manuscript is something very different from its handwritten predecessor, and not just because of its neatness—it is not a manuscript at all in the original sense of that word.)

While I have dwelt here on the impact of particular technologies, it is perhaps this more general drive to purge the literary, visual, or auditory artefact of excess, to make it function like an efficient machine, that is in the end the most profound mark left by the machine age on modernism. We find its traces in the visual arts in a variety of shapes, but especially in the tendency to abstraction. Clive Bell's idea of 'significant form', which he first promulgated in 1913, provides one well-known rationale for this purification. For Bell, it is the combination in particular ways of lines and colours that stirs our 'aesthetic emotions'. Thus, a major Victorian genre painting like William Powell Frith's *The Railway Station* (1862) 'is not a work of art; it is an interesting and amusing document. In it line and colour are used to recount anecdotes, suggest ideas, and indicate the manners and customs of an age; they are not used to provoke aesthetic emotion.'[32] Victorian paintings, anecdotal and full of historical detail—like Victorian novels, those 'loose, baggy monsters', as Henry James termed them—these too had been shaped by a machine age, but for most modernists they had not absorbed the right lessons from it. From a modernist perspective, the Victorian artist

[31] Hugh Kenner, *The Mechanic Muse* (New York: Oxford University Press, 1987), 37–59.
[32] Cited in David E. Cooper (ed.), *Aesthetics: The Classic Readings* (London: Blackwell, 1997), 184.

THE MACHINE AGE 299

had allowed narrative to take over. Victorian novelists were so indifferent to the purity of form that they even allowed illustrations into their works. What would be needed to 'blast years 1837 to 1900', as the Vorticists put it, was a formalist turn, an investment in the specific properties of the word on the page, or line and colour on canvas. In its purity of purpose the artefact should be like a machine, but it did not have to represent one, a point repeatedly made by Hulme and Lewis in their respective theorizations of the new art.

In the visual arts, a machine aesthetic of formalism and abstraction thrived, and continued to enjoy enormous prestige long after the Second World War, not least thanks to the efforts of Clement Greenberg, who pitted the abstraction of high modernism against the kitsch of commercial culture. But such an austere vision did not appeal to all. Moreover, in other cultural forms abstraction can be difficult if not impossible: in the novel, for example, narrative and historical detail always find their way in. In this light we might note that Joyce's *Ulysses*, arguably the most ambitious modernist novel of the 1920s, is more capacious than any loose and baggy Victorian novel. If it is a textual machine, it is one from the imagination of William Heath Robinson rather than a streamlined Art Deco creation. Nonetheless, we can trace the lingering effects of the machine aesthetic in literature and drama too. It would be Joyce's fellow countryman Samuel Beckett who would most thoroughly pursue a late modernist machinic vision of text and character alike in the years after the Second World War.

..

MODERNISM IN THE AGE OF MASS CULTURE AND CONSUMPTION

..

JOHN XIROS COOPER

I F you want to begin to explore the relationships among modernism, mass culture, and consumption, start by putting down this book and taking a walk through your town or city. Look at the buildings, posters, billboards, and shop signage, look at the interiors of rooms, furniture design, lighting design, the design of people's clothes, their haircuts, and the way language circulates in social space. What you see around you is so thoroughly infused with modernist ideas, styles, and themes that it has become difficult for us today to remember that at one time modernism was a willingly marginal, often aggressively counter-cultural, and avant-garde movement among tiny groups of artists and hangers-on in the major metropolises of the Western world. Tamara de Lempicka, a painter in Paris in the 1920s, put it well: 'I live life in the margins of society, and the rules of normal society don't apply to those who live on the fringe.'[1]

Even though these small modernist communities defined themselves as the cultural antagonists, even enemies, of the emerging mass societies of the West, in a matter of a few decades 'normal society' had thoroughly embraced the new art and its associated sensibilities. Art, literature, design, music, dance, and many innovative

[1] Tamara de Lempicka, <http://www.paloma.ca/lempicka.html>.

forms of living practised in these small bohemian communities came to represent new sociocultural standards for the whole of society. An elitist culture deliberately positioning itself on the margins of mass society found itself within one or two generations as the mass culture of that society. And nowhere is that more in evidence than in our everyday lives, from the reproduction of Cubist paintings on T-shirts to the atonal soundtrack of any popular horror film. The present contours of our lives in both their material and subjective aspects at one time represented a revolutionary reimagining of visual culture, language, social space, and individual identities. What put our great-grandparents and grandparents in a lather, we now expect as a matter of course. But, and this is perhaps the key point, without the shock value. Modernism has conquered society but, paradoxically, without ever setting out to do so. It did not *cause* these cultural changes. Modernist forms of art and life arose as material and psychological embodiments of the experience of modernity in a world undergoing market-driven modernization.

Modernism did not set out to colonize the culture of mass society. The first modernist painters, writers, dancers, and musicians thought they were emancipating art and themselves from the bonds imposed on it by a sclerotic culture inherited from the past, from traditions that, at a minimum, needed renewing or, perhaps preferably for the Italian Futurists, complete demolition. They saw their efforts as partly a programme of resistance to a moribund past and partly an exhilarating reinvention of the present. Like all bohemians, they took pleasure in being outsiders and in delivering satirical smacks at the middle-class philistinism they saw all around them. Ezra Pound, for one, seemed to believe in the intellectual and cultural superiority of the modernist avant-garde as an article of faith. Indeed, he thought that there were no more than about five hundred people in the world who could understand his work.[2] The initial public reaction to such difficult and exemplary modernist works as Pound's *Cantos*, T. S. Eliot's *The Waste Land*, James Joyce's *Ulysses*, and Virginia Woolf's novels of the 1920s seemed to underline Pound's point. Yet within a matter of a few years, many of these works were circulated to large numbers of customers and had become cultural symbols of the new sensibility. Even the Bloomsbury group by the turn of the millennium had gained currency as a 'brand', if popular culture is anything to go by. Certainly the convergence of the Bloomsbury ethos with the patterns of life and relationship today can be glimpsed in the extraordinary general success of the film *The Hours* in 2002. This success even extends into the domain of those who in the past might have been thought of as irredeemably philistine. Who could have guessed, when *Mrs Dalloway* went to press in 1925, or even thirty years ago, that Septimus Smith's suicide by impalement on a rusty spike and Clarissa's reflections on the fall of the body and the 'suffocation of blackness'[3] could provide contemporary popular culture with a marketable psychological style, supplemented by interior decoration, flower arrangement, and good books? One key moment in

[2] Ezra Pound, *The Selected Letters of Ezra Pound, 1907–1941*, ed. D. D. Paige (New York: New Directions, 1971), 37.

[3] Virginia Woolf, *Mrs Dalloway* (Harmondsworth: Penguin, 1968), 202.

this transition occurred when Joyce's *Ulysses*, published in 1922 in a very limited edition by two enterprising Paris booksellers, Sylvia Beach and Adrienne Monnier, and circulated to a small subscribers' list, was taken up by Random House, the large New York publishing firm, and produced as a trade publication in 1934. In a mere twelve years, modernism, in the form of Joyce's novel at least, had arrived in the mainstream.

In the process of changing the forms of art, in all the artistic disciplines, the modernists also reinvented for themselves the patterns of social and personal life into which they had been born. This may not have been done as consciously as their artistic projects, but it was as powerfully determinative of the future as was the concurrent revolutionizing of the arts. The bohemian communities into which they migrated provided a new kind of social space for 'experiments in living'[4] that by century's end would define many of the principal forms of communal life in the West. From Montmartre in Paris to New York's Greenwich Village, from London's Bloomsbury and Soho to Florence's Oltrarno district, small enclaves of artists, writers, and musicians broke free of the traditional restraints that had regulated behaviour and personal relationships in the nineteenth century. Experiments in new forms of relationship were aided by the rise of the discipline of psychology and especially by the influence of the theories of Sigmund Freud. His forceful arguments that the healthy expression of desire helped to defeat the culture of inhibition transformed personal relations. Sexual behaviour in particular underwent a profound liberation in these small communities. Not only did sexual relations between men and women change, but all forms of sexuality were affected, including same-sex interactions and gender mobility. The fiction of the period charted the amplitude of the change, from D. H. Lawrence's *Women in Love* (1920) to Radclyffe Hall's *The Well of Loneliness* (1928) or from Wyndham Lewis's frantic satire *Tarr* (1918) to Molly Bloom's gush of assent at the end of *Ulysses*. In the course of the century, this greater openness and frankness spread from the bohemian fringes of society to society at large.[5] The so-called 'sexual revolution' of the 1960s marked the tipping point in this evolution. The new focus was not on maintaining traditional stable domestic structures at all costs, but on opening new possibilities of individual experience and the satisfaction of personal desires. This could not be accomplished simply by changing personal relationships. It was necessary to dissolve older social bonds as well. Thus, running parallel to transformed personal relations, other changes came into play in the making of new forms of sociality, changes to family structure, traditional social solidarities, and communal loyalties. But it was in the art of the modernists that the experience of modernity first became visible.

Their principal focus was on the making and the remaking of art, and, as a result, they concentrated their thinking about art on a variety of ideas which had as their

[4] Virginia Nicholson, *Among the Bohemians: Experiments in Living, 1900–1939* (Harmondsworth: Penguin, 2002).

[5] Anthony Giddens, *Modernity and Self-Identity: Self and Society in the Late Modern Age* (Stanford, Calif.: Stanford University Press, 1991), 88–98.

fundamental principle a simple starting point but one with complicated conse-
quences. They began with the idea that art should not serve any social, political, or
religious purpose or obligation beyond being true to itself as a pursuit with its own
means and its own ends. In short, they began with the now familiar idea of the
autonomy of art. The philosophical foundations of aesthetic autonomy lay in the late
eighteenth century in the work of the German philosopher Immanuel Kant. In his
Critique of Judgement (1790), Kant elaborated a theory of aesthetic autonomy that
rested on two fundamental principles. Firstly, art constitutes a 'second nature'[6] over
and above the nature common to us all. Kant does not mean that art occupies an
ideal or other-worldly space, but that art draws on the 'material supplied to it by
actual nature' and transforms it. Secondly, the art-activity and its products are not
directed to a specific purpose.[7] They are not entirely *purposeless* in the bad sense of
the word, but they do not serve utilitarian or didactic ends. The less entangled in a
world of interests, the more fully does art embody its essential character. These
doctrines of separation and disinterestedness set down the philosophical warrants
for the slow evolution of the arts in the nineteenth century.

In Great Britain, the art critic and philosopher Walter Pater expanded on these
ideas in his book *The Renaissance* (1873), on the painting and poetry of Italy during
the fifteenth and sixteenth centuries. Here he argued that 'All art constantly aspires to
the condition of music,'[8] which is to say, to a condition of pure expression and,
hence, of pure aesthetic experience without being directed to any end beyond itself.
In his Conclusion, Pater sketched an influential theory of aesthetic appreciation and
what some took to be a programme for how to live one's life. Emphasis was placed on
experience for its own sake and not on experience as a means to the attainment of
other goals, such as moral improvement, riches, or social approval. 'Not the fruit of
experience', he wrote, 'but experience itself is the end.'[9] Art proposes to give nothing
beyond moments of the 'highest quality' of our experience 'and simply for those
moments' sake'.[10] The concept of aesthetic epiphany was not new with Pater; it occurs
first in the work of the Romantic poets, three-quarters of a century before Pater
wrote. Wordsworth's 'spots of time' in *The Prelude* (unpublished in his lifetime) and
Coleridge's speculations on the Imagination in the *Biographia Literaria* (1817) are
important precursors. But with Pater the idea took hold in a new way, not just as a
way of explaining certain literary or artistic phenomena, but as the starting point of a
new way of life.

The emphasis on the moment of vision had its roots, as suggested just above, in an
earlier cultural situation. The Romantic writers embraced the 'sublime' as a peak
cognitive experience. The word 'sublime' is derived from the Latin meaning 'lofty,

[6] Immanuel Kant, *The Critique of Judgement*, trans. James Creed Meredith (Oxford: Clarendon Press,
1969), 176.
[7] Ibid. 42–4.
[8] Walter Pater, *The Renaissance: Studies in Art and Poetry*, introd. Kenneth Clark (London: Collins,
1961), 129.
[9] Ibid. 222. [10] Ibid. 224.

elevated, something on high', a concept that passed to the Romans from a Greek source thought to have been authored by Longinus in the third century CE. The concept has a long and distinguished history from antiquity to the late eighteenth century. The original concept was tied to the generic and stylistic practices of older literary traditions. The sublime had its roots in the ancient doctrine of the three levels of style—high, middle, low—each embodied in particular genres and forms. With the Romantics sublimity undergoes a profound sea-change. As the old generic and formal tradition began to unravel among the Romantic poets in particular, the concept shifted from being an issue of style and form to being one of experience. Edmund Burke's treatise on aesthetics was the key text in the British context. In *A Philosophical Enquiry into the Origins of Our Ideas of the Sublime and the Beautiful* (1757), Burke drew attention away from the sublime as an aspect of the style of the art object and more emphatically towards the affective experience of the consumer. In this highly influential work, Burke, along with Kant in both his *Critical Observations on the Feeling of the Beautiful and Sublime* (1784) and his *Critique of Judgement* (1790), redefined the sublime as a kind of exalted pleasure, thus shifting the discussion of aesthetics from an emphasis on the making of art and what the writer or artist needs to do to produce a pleasurable affect to what happens to the consumer's inward experience in the reception of great art.

This shift in aesthetic thought corresponded to a new focus in the eighteenth century on the private experience of the person in general. It is perhaps related to the fundamental changes in experience brought about by industrialization. The industrial model not only changed economic life but had important social and psychological consequences. At bottom, changes in how work was organized, how objects for use were made and distributed, how the family unit participated in the labouring process, led to changed social and cultural patterns of life. As the developing societies in the West moved from crafts-oriented forms of manufacture in the nineteenth century to factory production, and then from there, in the early decades of the twentieth century, to new forms of mechanized manufacture—the assembly line, for example—mechanization and the rationalization of the work process became the dominant structural model for production. This had important economic consequences, the most important of which was the explosive expansion of capacity and hence of trade, exchange, and consumption.

But the impact was not limited to the economic sphere alone. There were important psychological and cultural consequences as well. There are too many of these to treat briefly here, but one is of paramount importance. The factory mode of production, and its later refinement in the assembly line, is predicated on the idea that the work process can be broken down into smaller units of activity that can be automated. The entire range of knowledge that goes into making something from beginning to end, including inventing the tools necessary to carry it off, begins to fragment into modules of expert technical know-how. These in turn, in the new assembly-line model, lead to further divisions of labour into discrete actions that one worker or one machine can repeat over and over again. The made object as the final product of a single person's engagement with its making from beginning to end

passed into marginal activities, such as the manufacture of certain luxury goods serving smaller and smaller groups of consumers, usually at the high end of the income scale, as for example in the Arts and Crafts movement we associate in England with the name of William Morris in the late nineteenth century and its later embodiment in the Omega Workshops set up by Roger Fry just before the First World War. Or it passed into the domain of hobbies and recreational pastimes. Meanwhile, mass production roared on, supplying the mass of consumers with manufactured products for which no single human being was responsible. Indeed, the business entities, companies, and corporations which were responsible for the manufacture of these consumables moved very quickly to make themselves legally invisible by reducing their own legal liabilities through the mechanism of the limited company and other juridical dexterities. In the process the human person, too, descended into the domain of legal fictions. With the passing of *Homo faber*, man the maker, the experience of human wholeness in the act of making things now passed to the act of consumption. And it is in the act of consumption, *Homo emptor*, man the consumer, that the shift in aesthetic philosophy discussed above had its most involved consequences.

These changes did not proceed without comment in the nineteenth century. Against the dematerialization of the whole person a rearguard action was fought by a whole series of Victorian thinkers: Morris, of course, but also Thomas Carlyle and John Ruskin. Ruskin spoke eloquently about the division of labour as the original sin of industrialism:

We have much studied and much perfected, of late, the great civilized invention of the division of labour; only we have given it a false name. It is not, truly speaking, the labour that is divided; but the men:—Divided into mere segments of men—broken into small fragments and crumbs of life. . . . You are put to stern choice in this matter. You must either make a tool of the creature, or a man of him. You cannot make both.[11]

Ruskin, along with many of his contemporaries, saw this in moral terms; it is 'degradation', he writes, to turn a human being into 'a machine'. Work has become 'degrading' and renders workers 'less than men'.[12] The great manufacturing centres produce everything except whole human beings. Cotton, steel, sugar, pottery, cascade from the smoke-belching works yards, 'but to brighten, to strengthen, to refine or to form a single living spirit'[13] is nowhere taken into account. The Romantics had already surveyed the waste land Ruskin detested, William Blake most vigorously. The antidote to this state of affairs for the small minority who could see the devastation lay in the direction of art and especially in the new affective form theorized by Burke, Kant, and others. What was not clear at that time was how the new aesthetics would one day provide consumption with its *raison d'être*. If pleasure and the heightening of

[11] John Ruskin, *The Nature of Gothic: A Chapter from the Stones of Venice* (London: George Allen, 1899), 163.
[12] Ibid. 165. [13] Ibid.

experience was the goal in a new kind of art, it was not long before its lofty affects settled in their more prosaic disguises in the everyday experience of consumption.

Modernism descends from the culture of resistance to industrial civilization in the nineteenth century. If the human being is reduced to being little more than an appendage of the machine in the production process, how is the human essence to be preserved? The answer lies in the links among a number of ideas, the idea of the autonomy of art, the new focus on experience as an end in itself, the value placed on moments of visionary delight, and the objects of consumption as occasions for feeling and emotion. Finally, the philosopher William James added one more element that was very influential in the making of modernism. In his essay 'Does "Consciousness" Exist?' (1904), James argued that consciousness, the metaphysical substance of our subjectivity, does not in fact exist as a thing, as, say, a spirit or soul are said to exist as analysable entities in older philosophical systems. In fact, he went on to write that consciousness is a function of certain experiential relations; it is more like a process than a finished product. Thus, philosophers who in the past sought to ascertain the consciousness-substance, whatever its constituent elements might be, were mistaken. Consciousness is an always unfinished potentiality, a set of changing relationships that were never completed in and of themselves, but ended only with the death of the body of the individual subject.[14] Such a conception of inwardness or subjectivity opened possibilities both for the making of works of art and for the constitution and maintenance of personal identity. For one thing, in this new context, attention shifts to the work of art as a process rather than as a finished product. The poet's reflections during the process of composition, for example, become incorporated as poetic material, as in Ezra Pound's *Cantos*. The work's boundaries cannot be fixed generically and the traditional notion of a single narrative presence in the work disappears in a welter of voices, stark images, fragments, and quotations. Such is T. S. Eliot's *The Waste Land* (1922). James's ideas also make it a little more difficult to argue for the imperturbability of the sovereign self. Perhaps making and maintaining a self is as much a work in progress as the modernist work of art. But before we explore the matter of the consuming self as the new location for wholeness in modernity, we need to return for a moment to a Kantian theme.

The idea of aesthetic autonomy had a number of iterations in modernism. The critic Mary Gluck has suggested that three are particularly important when we consider the relationship between modernism and mass society. Modernists saw themselves in an adversarial relation to modern society, their task being 'to affirm values, perceptions, or intuitions . . . excluded from social and political modernity'.[15] They also constituted a social space within which 'the non-utilitarian values of aesthetic production'[16] could be protected from the corrosive action of the

[14] William James, 'Does "Consciousness" Exist?', *Journal of Philosophy, Psychology, and Scientific Methods*, 1 (1904), 477–91; repr. in William James, *Essays in Radical Empiricism and a Pluralistic Universe* (New York: Longmans, Green, 1943), 1–38.

[15] Mary Gluck, *Popular Bohemia: Modernism and Urban Culture in Nineteenth-Century Paris* (Cambridge, Mass.: Harvard University Press, 2005), 4.

[16] Ibid. 5.

commercial marketplace. The concept of aesthetic autonomy discovers a kind of institutional legitimacy in the modernist approach to artistic creation. It was, in the words of the French social theorist Pierre Bourdieu, 'a world apart, subject to its own laws'.[17] More radically still, modernists sometimes interpreted aesthetic autonomy to mean withdrawal into an extreme subjectivity, a private world that not only opposes the social reality of the masses, but renounces it as the domain of illusion and hallucination. What is real, as Pater argued, is the interior; and detachment distinguishes both the practice of great art and the operation of the psyche. The external world is full of sound and fury signifying nothing important or lasting.

Each of these iterations does not so much separate modernism and the modernists from mass society as identify the factors that later in the twentieth century, in a curiously paradoxical way, mark modernism's link to the society of mass consumption, not its difference. Before testing such an assertion, we need to think about how the dynamic of consumption in the new conditions of market-driven modernization alters communal bonds and personal identity. The process involves both history and sociology. Without a doubt the most important socio-historical process of the last two hundred years has been modernization, especially in the forms it takes under the conditions of the capitalist market. Societies entering modern times rapidly untie traditional social, political, and personal bonds and make possible new kinds of sociality. Lawrence Friedman in *The Horizontal Society* (1999) has described these changes in spatio-directional terms. He argues that the principal social form in traditional societies is vertical in the sense that most social and political relationships are hierarchical, deep-seated, and based on either kinship loyalties or oaths of fealty. In post-traditional societies, relationships are horizontal in the sense that other kinds of relationship trump inherited arrangements. Ties of friendship, common interests, and alterable connections are based on the continuously renewed promise of mutual advantage rather than the immemorial bonds of blood or vassalage. The pull of family or clan weakens and is replaced by new loyalties and new communities of interest; fluidity supersedes stasis.[18] For Friedman, this horizontalizing tendency marks the primary social transformation of our time, but he hasn't recognized that the modernist bohemias of the early twentieth century were the first such horizontal groupings in the developing world.

Modernization encompasses a number of sub-processes that affect both the individual qua individual and the individual's relation to the collective. They are well known: secularization, the ideologies of individualism and egalitarianism, the increase of leisure time and access to commodities, democratization, and the redefining of the human subject in psychological terms. Old patterns of life and inherited identities begin to disappear, and the person, as uniquely inner-directed, hungry for experience, and alienated from others, enters history as the kind of human subject a society of consumption needs in order to flourish. In an age

[17] Pierre Bourdieu, *The Rules of Art: Genesis and Structure of the Literary Field*, trans. Susan Emanuel (Stanford, Calif.: Stanford University Press, 1995), 48.

[18] Lawrence M. Friedman, *The Horizontal Society* (New Haven: Yale University Press, 1999), 240–4.

when traditional identities lose ground by the weakening of a range of prior en-
tanglements—namely, inherited communal bonds, the taut ties of family, and
traditional roles—the constitution of a new kind of social space provides the bridge
to new forms of identity. It is artists who are the first in the early twentieth century to
take advantage of these social changes. They were the first to realize in practice the
new freedom available in a society in which tradition plays less and less of a role in
determining both artistic practice and one's place. The freedom to redefine oneself is
not restricted to artists; it is eventually available to all. But where artists continuously
create and re-create their own reality through the activity of making art, the popula-
tion at large may need other forms of engagement to begin to live through the
consequences of a new socio-cultural freedom. In this latter respect, as Walter
Benjamin suggested in his *Arcades Project*, consumption takes on a powerful role in
making social and psychological life.[19]

Consumption has always been part of the social and economic history of the
human species, but it has most often been part of the necessary activity for the
production and reproduction of material life. Consumption as a way of organizing
who you are and projecting your social position was restricted in pre-modern times
to the upper reaches of the social and political hierarchy. Aristocracies, freed from the
daily grind of survival, had the leisure and the means to consume in order to lay
claim to such intangibles as status and social position or to adorn or justify their
monopoly of power. These were not primarily exercises in the making of an identity;
nobles were as steadfastly defined by tradition as their serfs. In post-traditional
society, however, consumption takes on a whole new role. It now becomes constitu-
tive of the person rather than functioning as a secondary marking system that
positions the given self in an entrenched hierarchy. And in this new social space
the commodity takes on a new importance as a signifying agent. It becomes the
primary vocabulary in a new language of consumption. With modernization and the
arrival of mass production, commoditization expands into every area of life. Cer-
tainly, consumption to some extent still involves the real activity of survival, but this
task recedes as consumption expands to give shape and value to the psychological
and emotional reality of the person. The mass consumer, now occupying an inter-
iorized reality, acquires consumer objects no longer simply for their usefulness, but
more often now for the *experience* they deliver. The quality and intensity of those
experiences mark the value of the commodity, not in terms of its usefulness, nor even
its value as coin of exchange, but for something else, something positively intangible.
It's as if the throbbing excitement one feels in driving a flashy car very fast defines a
whole new scale of measuring value. Neither use-value, nor exchange-value, but the
pleasure-value of the thing. From these intense pleasure-values, the consumer builds
up bit by bit an identity that is part theatre, part psychopathology. That this
construction is at heart an imaginary artefact does not undermine its powerful
hold over the self. Nor does the mutually reinforcing presence of others who are

[19] Walter Benjamin, *The Arcades Project*, trans. Howard Eiland and Kevin McLaughlin (Cambridge,
Mass.: Belknap Press, 1999), 854.

involved in the same process of self-fabrication. When we no longer recognize each other's kinship and/or clan affiliations, we begin to recognize instead patterns of consumption and the behaviours they kindle as the determining instances of identity. We no longer 'know' a person because we know what village he or she comes from, we 'know' them because of how low on their hips they wear their Sonia Rykiel jeans.

In the phenomenon of mass consumption, we see how in the aesthetic theory of Burke, 'experience' as the aim of the fully conscious life, modernist art, and capitalist modernization flow into each other to help shape modern life. These several forces free consumption of its older, even ancient, necessities. The labour of accumulating things necessary to maintain life materially gives way to a new regime, the consumption of things as symbols and signs, as marking instances of identity. If there is a 'real' person at the centre of this network of significatory objects, behaviours, formulaic expressions, and theatrical effects, he or she is very well hidden from view. Consumables construe character. They are involved continuously in a new kind of labour, what the noted sociologist of human interaction Erving Goffman has called the 'presentation of self in everyday life'. The so-called 'real' person theorized by the various classical, Renaissance, or liberal humanisms may very well be there, but what characterizes modernity as we know it is the 'real' person's increasing absence from the social world to be replaced by the self-fabricating persona. Indeed, in the post-traditional world the more 'real' one is in everyday life, the more pathological one seems. Under these conditions, a traditional humanist like Walter Pater, not surprisingly, calls attention to experience as the aim of a fully conscious life. This inspiring affirmation of what gives substance to the self takes on a more plaintive note when it is seen as a rearguard action, a way of defending the idea of 'real' person who now seems to have vanished in a forest of signs and symbols. The hunger for experience in modernity, namely finding a way to be real, becomes the most arduous and nerve-racking of tasks. And if we listen to modernists like Samuel Beckett, it may even be fruitless.

T. S. Eliot's poem 'The Love Song of J. Alfred Prufrock' (1915) portrays rather well the dilemmas faced by the self on this emerging psychosocial terrain. The dramatic monologue form provides an apt vehicle for the exploration of this theme. The persona of J. Alfred Prufrock is beset with doubt both about the status of the external world and, more searingly, about his own reality. What is he exactly? A fully conscious human being or something else: an anaesthetized body lying on a table, or, simply, a tailor's dummy in 'morning coat . . . collar mounting firmly to the chin' with a 'necktie rich and modest, but asserted by a simple pin'?[20] The language of the poem points directly to the issue of the self lost in a swirling fog of meanings which the persona cannot understand. Anxiety suffuses the poem through its modal tics, from 'Do I dare . . .'[21] to 'Shall I say . . . ?'[22] and on to 'Shall I part my hair behind?'[23] And what will any of these chosen behaviours mean? The Prufrock persona, unable to

[20] T. S. Eliot, *Collected Poems, 1909–1962* (London: Faber and Faber, 1989), 14.
[21] Ibid. [22] Ibid. 15. [23] Ibid. 17.

find the interpretative calculus that will position him more securely in the social world, settles finally on the question of what or who he is: Lazarus, lover, Hamlet, Fool, are all possibilities, but all in the end fall away, as he is left finally contemplating his trousers on the seashore.[24] At the end of his tether ('I grow old . . . I grow old'), he receives a glimpse of a ravishing vision of 'mermaids singing', an allusion to the lyric effusiveness of John Donne's 'Goe and catch a falling star'. The moment of aesthetic bliss is real, but he feels entirely cut off from it: 'I do not think that they will sing to me.'[25] There is a world of stability and value out there somewhere expressed in terms of lyric intensity and aesthetic vision, but the persona, lost in an all too familiar world of shifting meanings and codes, can only experience its absence.

Eliot's immediate influences in writing such a poem were late nineteenth-century French poets, like Charles Baudelaire and Jules Laforgue, who were some of the first artists to understand the new situation of the human subject in modern times.[26] Baudelaire, in fact, in his essay on modern times, had brought to vivid light the kind of distress from which Eliot's Prufrock suffers, but had reversed the polarities by seeing it not as distress but as a new kind of heroism. Art stands over and beyond the contours of a social world, a world shaped by consumption as a variable and evanescent system of signs. The tragedy for Baudelaire and for Eliot lies in the seemingly unbridgeable gap between the redemptive aesthetic moment and the abject human subject.

Eliot's *The Waste Land* expands on this predicament more comprehensively. This notoriously difficult poem puzzled and angered many of its early readers, but it did offer in its themes and formal pyrotechnics a blistering diagnosis of the quandary of being a person in a shifting world. Where Prufrock stands (actually, 'drowns' is the word Eliot uses in the poem) in a social world that will not stay still long enough to be made sense of, the speaker in *The Waste Land* is almost impossible to locate as a presence. Prufrock is a name that defines a possible zone of consciousness,[27] but the speaker in the later poem has almost entirely vanished from view and we only discover a possible persona in one of the poem's footnotes in the curious figure of Tiresias,[28] victim or, if you will, plaything of the gods in Greek mythology. 'Tiresias,' Eliot writes, 'although a mere spectator and not indeed a "character", is yet the most important personage in the poem, uniting all the rest.'[29] Yet Tiresias hardly figures in the poem at all, except for one short episode in 'The Fire Sermon' section. So what Eliot means by this gloss is not immediately evident. Tiresias barely exists as a recognizable human subject. He is, of course, a mythological abstraction and for all intents and purposes an empty space in terms of the contemporary world evoked by the poem. It is almost as if (were we to believe Eliot's footnote) all the voices, figures,

[24] Eliot, *Collected Poems, 1909–1962*, 14.
[25] Ibid.
[26] Charles Baudelaire, 'The Painter of Modern Life', in *Baudelaire: Selected Writings on Art and Literature*, trans. P. E. Charvet (New York: Viking Press, 1972), 395–422.
[27] Hugh Kenner, *The Invisible Poet: T. S. Eliot* (London: Methuen, 1966), 17.
[28] Eliot, *Collected Poems*, 71.
[29] Ibid. 82.

images, and episodes in the poem constitute spectres that congregate phantasmally around an absence.

One might argue, as a result, that the poem has no centre to speak of, yet is still able to pull into its orbit an assemblage of images, quotations, allusions, dialogues, literary references, and fragmentary forms that produce something like the overall effect of a literary work. This is very much like the modern consumer who accumulates things to convey the appearance of a person but is no person at all. If the new model person in modernity can be said to identify a site where clothes, gestures, clichés of speech, and mediated feeling provide an opportunity for an identity to happen, then we might be justified in thinking that an aggregation of poetic effects does not constitute a poem as such but identifies a place where we can expect a poem to happen. Eliot will persist in exploring the implications of this dilemma until his embrace of Christianity in 1927.

Fragmentary poetic forms, abstraction in the visual arts, fast-cutting montage techniques in film, the breakdown of traditional tonality in music in the era of dodecaphonic serialism, and the hard, gemlike flame of aesthetic epiphany defined the avant-garde culture of the early twentieth century. What was not noticed in those early days of modernism across the arts was how well these approaches harmonized with the unbounded, ruptured, non-linear nature of capitalist modernization. At its very core burned the intoxicating rapture of consumption. By the 1930s the more prescient artists and thinkers had already begun to make the connection, and none more tellingly than the great Anglo-American social theorist and film clown Charlie Chaplin. Like Walter Benjamin in his *Arcades* drafts, Chaplin completes the picture of modernity by bringing into view the importance of consumption as the necessary complement of production for any larger understanding of capitalist mass society. The episode of the department store (in *Modern Times*, 1936) where Charlie is employed for a single madcap night shift as a security guard makes this perfectly clear. Once on the inside, Charlie brings Paulette Goddard, the gamine, into the store and they cavort among the fur coats, the bedroom suites, and other goods. Charlie dutifully tries to do his job, but ends up drunk when he and a gang of blundering thieves begin tasting the wines and spirits in the store's liquor boutique. Charlie's intoxication neatly symbolizes the wonderland of consumption by which capitalism rounds off the hard labour of production. He sleeps it off submerged on a display table full of women's clothes. This episode in the store is also the occasion for one of Chaplin's most inspired comic routines. He roller-skates blindfolded on a mezzanine floor that has had its restraining guardrails removed during renovations. His blind swoops and swerves, inches from the unguarded edges, reinforce the vertiginous delirium induced by consumption freed from the chore of satisfying actual needs.

Perhaps the word 'delirium' most aptly describes the condition into which the human subject slips in a reality increasingly defined by consumption where objects and products are acquired not for how they satisfy the necessities of life but as modes of communication. The Russian American novelist Vladimir Nabokov diagnosed a form of this condition in his 1948 short story 'Signs and Symbols'. The nameless central character is a 'young man' clearly suffering from severe mental imbalance.

He is described in the story's second sentence as having 'no desires',[30] in other words as having no substantial centre. '[O]bjects' beset him and define the 'reality' in which he lives. But it is not the objects as such, the objects in all their solidity and materiality as objects, that might or might not satisfy real needs. They are, instead, signifying events, 'either hives of evil' vibrating with malign intentions that only he can perceive, or 'gross comforts for which no use [can] be found in his abstract world'.

A life full of delusions sums up the young man's life. Everything around him 'is a veiled reference to his personality and existence'.[31] The resemblance to Prufrock's anxious musings in Eliot's poem, though not exact, is suggestive nonetheless. Clouds, the 'staring sky', the alphabet, 'darkly gesticulating trees', pebbles, stains, and sun flecks communicate 'incredibly detailed information regarding him'. Nabokov comments: 'Everything is a cipher and of everything he is the theme.' Even the young man's suicide attempt has an abstract, metaphysical origin. He did not want so much to end his life as 'to tear a hole' in the world 'and escape' a world entirely circumscribed by signs and symbols. Strictly speaking, the story is not about consumption, or at least Nabokov does not point us in that direction. Indeed, the story may be deeply philosophical, a kind of allegory about the conflict between ontological and epistemological perspectives, the tension, more simply, between being and knowing. But the young man's condition ('This thing, that hath a code and not a core'[32]) mirrors the situation of the individual in societies of consumption. Of course, it is an exaggeration to suggest that the average consumer suffers from dementia, or, to put it another way, a dementia this severe. But the point of the tale is clear enough. There is something pathological in a culture in which things exist only as signalling systems, where the consumption of jewellery or other personal adornments, for example, goes far beyond the desire to relish beautiful things simply for their own sake or to mark one's status in some traditional hierarchy but becomes, instead, a subtle (or not so subtle) coding mechanism for establishing your identity. In 1912 Ezra Pound was already registering the condition that would become more familiar and, thus, more normal later in the century: in his 'Portrait d'une femme' he would say about the identity of his sitter,

> No! There is nothing! In the whole and all,
> Nothing that's quite your own.
> Yet this is you.[33]

Nothing 'quite your own' implies that although there are things attaching to the persona, none identifies her being. The paradox of there being nothing at the core of a person surrounded by things, and yet this still constituting a form of social being, a persona so to speak, singles out the dilemma of the self in consumer society.

[30] Vladimir Nabokov, 'Signs and Symbols', in *The Portable Nabokov*, ed. Page Stegner (New York: Viking Press, 1976), 172.

[31] Ibid. 174.

[32] Ezra Pound, 'An Object', *Collected Shorter Poems* (London: Faber and Faber, 1961), 76.

[33] Ibid. 74.

The modernist impulse in the arts began as resistance to this state of affairs. For Baudelaire the goal of the modern artist assumes the character of a heroic quest. The modern artist 'is looking for that indefinable something we may be allowed to call "modernity", for want of a better term to express the idea in question. The aim for him is to extract from fashion the poetry that resides in its historical envelope, to distil the eternal from the transitory.'[34] To distil the eternal from the transitory. This is the goal of much early modernist aesthetics. In Eliot's *The Waste Land*, the moment of visionary experience, 'Looking into the heart of light',[35] promises to redeem a time dissolved by what is fleeting and unstable. One might consider it as a way of filling up the space left by the death, or at least the disappearance as an active presence in everyday life, of God. Or take Ezra Pound's radiant 'olive tree blown white in the wind',[36] which works to emancipate the luminous moment from the darkness of the surrounding 'enormous tragedy'. And in fiction the use of aesthetic epiphany by Joyce in *Ulysses* and Virginia Woolf in her novels of the 1920s attempts to accomplish the same thing. In a modernity in which the capitalist ethos questions, derides, and erodes values inherited from the past and the social and cultural traditions that sustained them, the aesthetic experience takes on a new importance. It becomes the quintessential barrier against not only the encroaching philistinism of a commercial civilization, but the disintegrative effects of an increasingly more virile market capitalism. And precisely at that point we find a poignant historical irony.

In an ironic reversal of fortunes, the moment of aesthetic bliss, the modernist renewal of the Romantic sublime, rather than defending the incomparable aesthetic experience as an inviolable moment in a life beset by the bustle of exchange, becomes the most potent marketing technique in the arsenal of the very commercial ethos it was meant to resist. Commodities do not simply serve material needs; they become occasions for peak experiences of all kinds to happen. The allure of Pater's 'quickened, multiplied consciousness'[37] as the supreme cognitive good is not lost on later generations of canny moderns, no longer 'modernists', if we limit that term to the writers and artists of the early twentieth century, but those who, like all of us, the masses in short, are now at home in modernity. Objects for purchase as diverse as cars, frilly camisoles, pints of beer, hair products, and football games promise to deliver experiences that thrum with excitement, arouse us emotionally, and yield intense pleasures.[38] We learn to live for those moments as relief from the humdrum routines of work, leisure, sleep. We do this again and again even though these 'moments' have become a wan pastiche of the kind of numinous experiences that dot Clarissa Dalloway's or Peter Walsh's day in Virginia Woolf's *Mrs Dalloway*, when the characters are 'taken by surprise with moments of extraordinary exaltation'.[39]

[34] Baudelaire, 'The Painter of Modern Life', 403.
[35] Eliot, *Collected Poems*, 64.
[36] Ezra Pound, *The Cantos* (New York: New Directions, 1995), 445.
[37] Pater, *The Renaissance*, 224.
[38] See John Xiros Cooper, *Modernism and the Culture of Market Society* (Cambridge: Cambridge University Press, 2004).
[39] Woolf, *Mrs Dalloway*, 64.

It is important to remember that modernism did not cause this state of affairs to happen. Artists like Woolf, Joyce, Eliot, H.D., and others believed they were, in the words of Lucy McDiarmid, 'saving civilization' from crass philistinism.[40] Yet some of the values and aesthetic strategies they championed as resistance to mass society and commercial civilization underwent ironic reversals of valency. They ended up providing the cultural scaffolding for the very civilization they believed they were resisting. This was not because mass society appropriated modernism as just one more fashion among many others to choose from. Modernism constitutes the fundamental cultural reality of post-traditional societies that have escaped from their older social, political, and economic arrangements. It is in fact the default setting, so to speak, of societies unmoored from tradition. In the twentieth century,[41] market-driven capitalism, an economic system that Joseph Schumpeter believed could only prosper in what he called 'the perennial gale of creative destruction', powered this transformation. Modernism, too, functions in a whirlwind of constant change, in an environment of continuous mobility, undoing the cultural past not by what we might call destructive destruction, that is, its complete annulment, but by, to use Schumpeter's term, creative destruction, an active forgetting of the past by its relentless renovation and updating, what Ezra Pound was referring to in the 1930s by his call to 'make it new'. This programme of relentless change corresponds with the underlying action of capitalism and the consumer flows which are its lifeblood and its *raison d'être*. Mass society constitutes the ideal medium for the open circulation of commodities, ideas, experiences, and the culture of change and innovation which they stimulate. Modernism is one of those flows even though its protagonists in the early part of the twentieth century believed they were pursuing another course. Only when modernist aesthetic sensibility came to dominate the cultures of advanced market societies did the connections among modernism, mass culture, and consumption come fully into view.

[40] Lucy McDiarmid, *Saving Civilization: Yeats, Eliot, and Auden Between the Wars* (Cambridge: Cambridge University Press, 1984).

[41] Joseph Schumpeter, *Capitalism, Socialism and Democracy* (New York: Harper, 1975), 84.

CHAPTER 18

PUBLICATION, PATRONAGE, CENSORSHIP

LITERARY PRODUCTION AND THE FORTUNES OF MODERNIST VALUE

AARON JAFFE

Fortune . . . shows her power where no measures have been taken to resist her.

(Niccolò Machiavelli, *The Prince*)

Why read X? and X?
But I'm X, too . . .
(Bob Perelman, 'Iflife'[1])

BALANCING THE BOOKS

WHEN the *Titanic* sank on 14 April 1912, it contained at least one missing item from the Joseph Conrad checklist, a holograph manuscript of 'Karain, a Memory'. While the manuscript was lost at sea, the story wasn't. It had, after all, been already

[1] I am grateful to Alan Golding for quoting this to me.

published, multiple times in fact: first in *Blackwood's Magazine* in 1897, then later the same year in the *Living Age*, then collected in the book *Tales of Unrest* in 1898.[2] In this sense, the original no longer mattered.

The Conrad manuscript that went down with the famously sinkable unsinkable ship was on its way to one of the great patrons of modernism, John Quinn, a wealthy American lawyer, who promised the author the then substantial sum of £40 for 'Karain' and another tale, sent under separate cover.[3] Ten days after the event the author wrote to his literary agent, J. B. Pinker, lamenting the two losses, the ship and the income represented by his manuscript: 'This affair . . . has upset me', he writes, 'on general grounds, but also personally. . . .I depended on that sum, but only registered [the parcel] without insuring so as to avoid the trouble of getting the consular certificate.'[4] Given that £40 amounts to £15,564 in 2008-adjusted money, it should not surprise us that Conrad felt the loss in sharply pecuniary terms.[5] Tellingly, his response links the two losses—the ship, with all its souls, and the manuscript—by immediate reference to the inadequacies of indemnity, a concept that simultaneously means protection against potential loss, legal exemption from liability for loss, and the sum paid in its compensation for loss. Conrad's uneasiness may come less from the feeling of having lost something singular from his bibliographic past and irreplaceable for his archival future than from his sudden awareness of the connection between the precariousness of his current literary fortunes and the hazards of transatlantic commercial transport, a world he had seemingly left behind upon becoming a full-time author.

The incident also reveals that figures like Quinn—modernism's benefactors—were not as altruistic as they are sometimes portrayed. Modernist literary materials that fell into their hands are often described decorously in correspondences as gifts, but here the terms are decidedly transactional: collect-on-delivery, as it were. Conrad had long relied on sales of his manuscripts and typescripts to Quinn to tide himself over between writing projects great and small.[6] In the letter to Pinker, there is no discussion of Quinn and Conrad sharing the loss, for example, or, as one might expect (if patronage were truly a form of modernist indemnity), of Quinn making good on the lost funds. Indeed, Conrad immediately sets out to recover the deficit, asking his agent to sell a prospective essay on the maritime disaster to the *English Review* for £30 ('or such sum as you think I may ask for'): 'A personal sort of pronouncement, thoughts, reminiscences and reflec[t]ions inspired by the event with a suggestion or two. Something quite fit for the [English] Review which cannot let such a tragedy pass unnoticed.'[7] The rhetoric of salesmanship is unmistakable, as

[2] See Conrad First, The Joseph Conrad Periodical Archive, <http://www.conradfirst.net/index/volumes>.

[3] See John Stape, *The Several Lives of Joseph Conrad* (New York: Random House, 2007), 184–5.

[4] Letter to J. B. Pinker, 22 Apr. 1912, in *The Collected Letters of Joseph Conrad*, ed. Frederick R. Karl and Laurence Davies, v (Cambridge: Cambridge University Press, 1996), 55.

[5] The conversion comes from <http://www.measuringworth.com/ppoweruk>.

[6] Stape, *The Several Lives of Joseph Conrad*, 182.

[7] Ibid. 56.

is the calculation, as Conrad biographer John Stape observes, that a 'brief foray into topical journalism' could replace the funds expected from Quinn.[8]

'Some Reflections on the Loss of the *Titanic*', which appeared in the *English Review* in May, is thus something of a case study in the object lessons of exchange value and public circulation for the modernist author. Before any sober observations about mercantile seamanship are proffered, Conrad pronounces an unmistakable unease about the role of print culture in the episode: 'It is with a certain bitterness that one must admit that the late S.S. Titanic had a "good press".'[9] With newspapers spread out over his desk ('the white spaces and the big lettering of the headlines have an incongruous festive air to my eyes'), he reflects on the role that cultural production played in staging 'the real tragedy . . . of all these people who to the last moment put their trust in mere bigness, in the reckless affirmations of commercial men and mere technicians and in the irresponsible paragraphs of newspapers booming these ships!'[10] In effect, the reality-dilating effects of publicity are taken to task in an inversion of the obscene inquest about the *Patna* in *Lord Jim* on the fatuity of facts and the actuality of impressions. Conrad implicates the magnitude of the disaster in the business of bigness—publicity and hype—that overwhelms the lessons of sensible seamanship, transforming a steamship into 'a sort of marine Ritz, proclaimed unsinkable and sent adrift with its casual population upon the sea, without enough boats, without enough seamen . . . but with a Parisian café and four hundred of poor devils of waiters'.[11] If the *Titanic* continues to get 'good press' even after its wreckage, notwithstanding the singular loss of an actual ship with over 1,500 'piteous' souls, then this ethical grey zone also extends to at least one item of lost Conradiana, a loss which Conrad has the tact to self-censor from his public reflections but which remains crucial to any understanding of this literary affair. The lost manuscript, representing a means of keeping the author's household economics afloat, is now replaced by a particular publishing opportunity, promising a beneficial raft of publicity for the world's foremost sailor-turned-novelist, whose literary livelihood is now more than ever hand to mouth.

This chapter concerns the material conditions of literary modernism. That is, it concerns how literary materials—books, stories, poems, essays, articles, reviews, manifestos—got from the modernist author into the world. How did modernist texts get published? How did modernism reflect, resist, and make use of historical changes in a transatlantic, transnational system of literary publication and publicity in its time? Who were its patrons and how did their patronage work for modernism's gain? Did the forms of censorship modernists faced from the state and less formal censors in fact impede the circulation of their texts or assist it? What is the relation between modernism and the emergent cultures of publicity in the early twentieth

[8] Ibid. 185.
[9] Joseph Conrad, 'Some Reflections on the Loss of the *Titanic*', in *The Portable Conrad*, ed. Michael Gorra (New York: Penguin, 2007), 635.
[10] Ibid. 636. [11] Ibid. 645.

century, a period when advertising, public relations, celebrity, and consumer cultures and subcultures were all in rapid ascendancy? Rather than the upstream work leading to literary creation, then, this chapter concerns downstream efforts in placing that text, putting it in circulation, setting it apart from other materials, getting it into the hands of the right cultural handlers, who were sympathetic, discerning, influential, or puzzled enough to nudge it along in promotional terms. Consequently, it is less interested in the scene of the individual modernist before his or her muse, notepaper, typewriter, stenographer, or secretary than it is in modernism's many economic strategies, benefactors, agents, cottage industries, and pocket industrial revolutions.

In 1913, the year after the *Titanic* sank, Conrad published *Chance*, and his fortunes changed for ever. Massive American sales made the difference. This overseas market was secured by the exertions of his literary agent, Pinker, enabled by his understanding of favourable changes in international copyright laws, and stoked by a serialized tie-in that ran some months before in the *New York Herald*, a newspaper with a vast circulation that Conrad had approached with his *Titanic* essay in the previous year. For comparison, here are some of the other books published in the English and American book markets around this time: *Laddie, Child of the Storm, The Desire of His Life, Heart of the Hills, The Amateur Gentleman, The Woman Thou Gavest Me, Pollyanna, The Valiants of Virginia, The Fortunate Youth, Diane of the Green Van, The Devil's Garden,* and *The Prince of Graustark.* Here are some other texts that also appeared, albeit to less notice: *Sons and Lovers, Tender Buttons, Blast, Dubliners, A Portrait of the Artist as a Young Man, 'The Love Song of J. Alfred Prufrock,' The Voyage Out, The Good Soldier,* and *The Autobiography of an Ex-Colored Man.* The difference between these two lists is that the first, which is filled with now unfamiliar-sounding titles, includes only best-sellers, whereas none on the second—the roll-call of modernist all-stars—came close to this status.[12] One of the enduring enigmas of modernist studies is how—how specifically and materially, without reference to any mystical test of time or other supernatural agencies—these modernist titles outpaced their competitors in fame and fortune, leaving them all but in the dustbin of literary history.

One way to begin approaching the enigma of modernism's own material culture is to ask who actually read modernism in its own time.[13] This question—who actually reads modernism?—begs not only a familiar question of modernist interpretation (who gets this stuff anyway?) but also another key concern about its logistics and economics: how did they get it? What kind of literary marketplace helped bring to

[12] On the best-seller, see Clive Bloom, *Bestsellers: Popular Fiction Since 1900* (New York: Palgrave, 2002), 1–28.

[13] Ungenerous as it sounds, this preliminary question characterizes one of the most interesting directions of modernist scholarship, which should be dated to the mid-1990s. The appearance of Lawrence Rainey's *Institutions of Modernism: Literary Elites and Public Culture* (New Haven: Yale University Press, 1998) is a good watermark. Generally speaking, this development can be described as a turn towards material culture in modernist studies, the broad strokes of which owe something to the 'new historicist' turn in literary studies to context and the archive, the reception of the work of the French sociologist Pierre Bourdieu, and interest in new, more theoretically attuned forms of bibliographical studies and book history.

light such demanding and difficult texts as *The Making of Americans, Lord Jim, Mrs Dalloway, Cane, The Waste Land, Ulysses, The Cantos, Paterson,* and *At Swim-Two-Birds*? Inquiry in this vein often turns on an elastic vocabulary of economic metaphors: capital, money, investment, prices, inflation. 'Who paid for modernism?' is the order of the day, as Joyce Wexler puts it in the title of her 1997 book, as if incredulously checking James Joyce's bar tab.[14] To Wexler's question, literary critics and scholars of modernism have added other pecuniary concerns. What did modernism cost? Was it worth the price? Significantly, by taking hidden expenditures, concealed patrons, secret benefactors as a given, they presume for modernism not readers per se but debts.

Like the profligate child with some pedigree but uncertain inheritance, modernism is trailed paradigmatically at every turn by its red ink. The plain fact is that many individual modernist authors could not cover their expenses on publication sales alone. All the same, they paid the bills in other ways. Some were independently wealthy (Henry James, Virginia Woolf, Gertrude Stein, Nancy Cunard) or had wealthy spouses (Ezra Pound) or lovers (H.D.) or friends (James Joyce). Some toiled in reviewing or journalism or editing or screenwriting or academia. Some kept their day jobs (T. S. Eliot, Wallace Stevens, William Carlos Williams). Stories and novels and even poems and manuscripts were sometimes sold; royalties, residuals, and stage and film rights sometimes crawled in; funds and fellowships were sometimes secured. And there was that old standby, living on the cheap somewhere, until pay dirt came (and then occasionally living in debt thereafter). Modernist memoirs by Sylvia Beach, Margaret Anderson, Caresse Crosby, and many others tell an all too familiar biographical story of modernism as an ill-starred business venture: modernism as a heroic risk position for undervalued authors before a hostile marketplace for their goods. Ironically, there is a certain long-standing undertone of outraged virtue in rendering scholarly accounts of the great modernist individuals who sold things very few ordinary people seem to want.

Down to brass tacks, then. The start-up money that put modernist texts into the world came from the modernists themselves; patrons and investors; periodicals and the subscriptions, advertising funds, and silent benefactors underwriting them; and the capital held by publishing houses. Still, it should be remembered, countless texts (modernist and non-modernist alike) went into print without any success at all. Indeed, this is the norm Franco Moretti describes as 'the slaughterhouse of literature': 'The majority of books disappear forever—and "majority" actually misses the point: if we set today's canon of nineteenth-century British novels at two hundred titles (which is a very high figure), they would still be only .05 percent of all published novels.'[15] Another way of saying this is that—compared with other endeavours, putting someone on the moon, for instance—literary production in an age of industrialized publication is both cheap and risky: it sustains the initial appearance

[14] Joyce Piell Wexler, *Who Paid for Modernism? Art, Money, and the Fiction of Conrad, Joyce, and Lawrence* (Fayetteville: University of Arkansas Press, 1997).

[15] Franco Moretti, 'The Slaughterhouse of Literature', *Modern Language Quarterly*, 61/1 (2000), 207.

of reams and reams of failed material destined for oblivion. Printing modernist texts is not particularly capital-intensive; the modernist enigma is why anything at all stands out from the great heap. In *The First Men in the Moon* (1901), H. G. Wells makes the point that literary renown may be harder to achieve than getting to the moon. Benton, the failed businessman and would-be playwright, shelves his furtive literary career to help market an anti-gravity commodity, Cavorite, because it simply has better long-term prospects: 'I saw in [Cavorite] my redemption as a business-man. I saw a parent company, and daughter companies, applications to right of us, applications to left, rings and trusts, privileges and concessions spreading and spreading, until one vast, stupendous Cavorite Company ran and ruled the world.'[16]

Rather than conflating the spendthrift ways of certain individual modernists with the aggregate material strategies of modernism as an institutionalized, discursive whole—as a durable cultural disposition, as Bourdieu might put it—it might be more useful to examine how modernist value got produced. It goes a long way towards pushing modernism from red to black in the bookkeeping ledger to register all the ways it functioned as a smart investment, with potential for prodigious gain, for example, for collectors of modernist manuscripts like Quinn. When Quinn auctioned his Conrad collection in 1923 for a substantial mark-up ('231 works by Conrad, for which Quinn paid $10,000, achieved astonishing prices and sold for $111,000'; i.e. $1.4 million in 2008), it was quite clear to the none-too-pleased author that some extreme profit-taking was going on.[17] Or, for that matter, we can take measure of modernism's gain by examining the expanding cultural power of its legal heirs, such as Valerie Eliot, T. S. Eliot's second wife, who sits on the board of Faber and Faber, a firm the fortunes of which rest on Andrew Lloyd Webber's adaptation of her husband's *Old Possum's Book of Practical Cats*; or Stephen Joyce, James's grandson, who administers his grandfather's body of work.[18] Despite relatively inauspicious beginnings, it is axiomatic that modernism became what it was—outpacing the best-sellers over the long term—because it produced, stored, and increased cultural value.

Jonathan Rose has suggested that modernism not only had its own business model but was also, above all else, a business model. If inquiry in this vein seems a bit jarring, it may be because one of modernism's own favourite legends, a legend enshrined by a generation of modernist scholars-cum-hierophants, is that its cultural objects and their makers are aloof from or outright hostile to the exigencies of the market. As Kevin J. H. Dettmar and Stephen Watt write:

To borrow a phrase from Walter Benjamin, in [this] secular or 'negative theology' . . . any suggestion that modernist art is not pure is read as a 'concept that belittles.' This is so because, following Benjamin's argument, a concept that shatters the aura of authenticity also brings the

[16] H. G. Wells, *The First Men in the Moon* (New York: Penguin, 2005), 17.

[17] Jeffrey Meyers, *Joseph Conrad: A Biography* (New York: Charles Scribner's Sons, 1991), 352–3.

[18] On this arrangement between Valerie Eliot and Andrew Lloyd Webber, see John Mullan, 'Style Council', *The Guardian*, 25 Sept. 2004. On Stephen Joyce, see D. T. Max, 'The Injustice Collector', *New Yorker* (19 June 2006), 34–43.

unique and distant into the realm of the transitory and the commensurate—into the world of the commodity and its nearly limitless reproducibility.[19]

Yet the bibliographic record and even the contents of the literary texts themselves register considerable complicity and ambivalence about worldly matters of supply and demand. In *Lady Chatterley's Lover*, for example, D. H. Lawrence has Clifford Chatterley railing against the 'bitch goddess Success': 'He realized now that the bitch-goddess of Success had two main appetites: one for flattery, adulation, stroking and tickling such as writers and artists gave her; but the other a grimmer appetite for meat and bones.'[20] Of course, the odious Clifford (with his 'blind, imperious instinct to be known') can hardly be considered an exemplar of a modernist keeping good faith with the marketplace, but the episode does show that Lawrence was more than aware of an economic continuum in which both coal and books can be figured as transitory and commensurate. Figures like Lawrence or Pound were more than mere haters of mass culture and commercialism; they proposed powerful alternative theories of cultural production, as Edward P. Comentale has argued.[21] The practical terms of these alternative economics may be best ascertained by considering the ways in which the modes and means of literary production and their relentless forms of self-promotion were not incidental to the literary artefact but constitutive of it.

Rose pursues this angle with a cynicism suitably flinty-eyed for motive. In his view, modernism is not only deeply invested in its own material conditions but also counts the production of its proper material conditions as its most profound investment. One of the book historian's first premises is to 'recognize that books are bought and sold. Marxists may call that "commodification," but book historians usually add to that critique with a Seinfeldian shrug: "Not that there's anything wrong with that." They accept that books are business.'[22] Still, Rose's Seinfeldian impulse may none-theless recall dim memories of false consciousness. The point made by literary critics, Marxist or otherwise, is that commodities are not one and the same with the work or the matter that goes into them. When *The Waste Land* plays the role of a commodity, something strange has happened to it. In this sense, commodification is a big deal for anyone who senses a fundamental non-equivalence between a literary object's exchange value—which brings commodification's hazards, namely rationalization, fetishism, and reification (thinking of Adorno)—and its meaning.[23] Nor did the modernist follow a simple cash grab for book receipts. He or she often seemed to prefer book reviews and press clippings to the cash nexus. Modernism's culture of

[19] Kevin J. H. Dettmar and Stephen M. Watt (eds), *Marketing Modernisms: Self-Promotion, Canonization, Rereading* (Ann Arbor: University of Michigan Press, 1996), 2.

[20] D. H. Lawrence, *Lady Chatterley's Lover* (London: Penguin, 1994), 111.

[21] Edward P. Comentale, *Modernism, Cultural Production, and the British Avant-Garde* (Cambridge: Cambridge University Press, 2004).

[22] Jonathan Rose, 'Lady Chatterley's Broker: Banking on Modernism', *Common Review*, 6/3 (Nov. 2008), 13.

[23] For Adorno's account of 'mediation', see Theodor W. Adorno, 'Fetish Character in Music and Regression of Listening', in Andrew Arato and Eike Gebhardt (eds), *The Essential Frankfurt School Reader* (New York: Continuum, 1997), 270–99.

value is more about hoarding and collecting value for its agents, intermediaries, and middle management than about selling books for publishers or authors.

Put another way, the question, *pace* Rose, is this: is modernist literary production primarily about the production of material culture?[24] Certainly, modernism results in an astounding amount of output, the range of which may be counted as one of its strategic strengths, but the production of modernist literary culture is less about the production of books (buying or selling literary goods on the open market) than it is about creating an alternative small world (a space, a scene, and a reality) for the production of literary value. The most theoretically developed version of this claim comes, perhaps, from Bourdieu, who calls this small world the 'restricted' field of cultural production, or 'the economic world reversed'. The idea, in effect, amounts to the notion that, unlike unrestricted, large-scale economic conditions, the circumstances in modernism are different. When a system of value is primarily symbolic, as in literary modernism, sales figures are beside the point. It's about the sequestration of symbolic value by agents capable of conferring legitimacy: 'cultural intermediaries', in Bourdieu's phrase.[25] Publishing, patronage, censorship, and—the term implied by all three of these words—publicity represent an order of operations for the creation of a small world for value that must be kept spinning. This is not business as usual or business per se, but rather a plan for keeping busy.

TARZAN VERSUS DEDALUS

One of the chief difficulties of analysing the small world of modernism is the struggle to find representative examples. Every specific datum comes up for consideration *par excellence* rather than *par exemple*. The fortune of *Ulysses* is always a token of publication, patronage, and censorship but is never quite typical. Let us posit, then, two different, coexisting models of literary production in the modernist period for the restricted and the unrestricted fields, calling one the Tarzan model and the other the Dedalus model. The Tarzan and Dedalus models, then, are not meant to evoke specific characters, nor are they meant to evoke specific books. Recalling Clifford Chatterley's formula, both model different illustrative recipes for satisfying the two chief cravings in literary life: for 'flattery, adulation, stroking and tickling', as well as for 'meat and bones'. Tarzan and Dedalus promise, in other words, two different roads towards these ends: the Tarzan model, measured in the acceleration

[24] There were, of course, in a banal sense, many modernist non-books: poems, plays, essays, manifestos, and other kinds of written, material culture. Quite rightly, Rose, like other book historians, is not particularly pedantic about what he means by 'book'.

[25] Pierre Bourdieu, *The Field of Cultural Production: Essays on Art and Literature*, ed. Randal Johnson, trans. Richard Nice (New York: Columbia University Press, 1993), 127.

of book business, and the Dedalus model, measured in the expansion of a literary culture. Taking a page from Mark Twain, the Tarzan model travels halfway around the world, while the Dedalus model is still fastening its pinions.

The Tarzan model, in other words, has a trajectory, but the Dedalus model has a calling.[26] In the Tarzan model, the author, a one-time magazine editor, publishes a story in a mass distribution periodical. In serial form, it becomes a rapid hit. Success is gauged not only by enthusiastic letters from readers but also in sold-out newsstand copies and in discernible increases in subscription requests. Circulation extends to the hundreds of thousands. The magazine's editors request a follow-up, a sequel with a more satisfactory ending, but this time the editors are outbid by a rival. Meanwhile, a quick book deal is secured on better terms than the first with a forgettable publishing house, and, with minimal editing, the instalments are bundled and packaged as a novel. Other versions rapidly follow, packaged in various formats for different target demographics: a version with a press known for cheap popular editions; a children's edition with more illustrations; versions for other English-language markets; and, within six years, translations, multiple sequels, newspaper comic strips, stage and screen adaptations, cardboard giveaways, and sundry product tie-ins. Commodification here means a clear path to rapid serial ubiquity: as the literary commodity takes flight, one could be easily forgiven for forgetting that there was ever an original to get one's hands on.[27]

The Tarzan model could just as readily be described as the Sherlock Holmes or the Pimpernel model; or, for that matter, considering its roots in mid-nineteenth-century changes in the publishing industry, as the Dorritt or d'Artagnan model. The rapidly serialized literary property, quickly mobilized on a vast scale briskly leaving the initial textual armature behind, may be counted, along with the cheap penny novels of the 1840s, the dime westerns of the 1870s, and the pulps and slicks of the new century, as a legacy of mid-nineteenth-century literary modernity. By the twentieth century, a publishing system based on modern production efficiencies had been in place for over fifty years. Cheap paper, mechanized printing, inexpensive prices, tie-ins with newspapers and weeklies, lending libraries, seriality, and ubiquity enabled a boom and then a glut, allowing more authors to live more precariously than ever before and equally significantly allowing more published goods to reach more buyers than ever before in history. In a certain sense, this model is suited to a modernity that wants things fast, cheap, and out of control.

The Dedalus model begins, at least superficially, much like the Tarzan model: a novel is serialized in a periodical, and serialization, once again, is part of the larger publication destiny, the prologue to subsequent book publication. Yet it is here that the surface similarities break down. In the Dedalus model, the periodical itself is

[26] I thank Ed Comentale for a careful reading of this chapter and for helping me recognize this connection in particular.
[27] In this chapter, I employ an expanded sense of the word 'serial' to include serial novels as well as other forms of literary seriality; this is developed at more length in my 'Orlando Pimpernel', in Jonathan Goldman and Aaron Jaffe (eds), *Modernist Star Maps* (Aldershot: Ashgate, forthcoming). Thanks to Susan M. Griffin for reading this chapter and asking me to clarify this point.

actually a so-called 'little magazine', a journal with negligible circulation, decidedly difficult to obtain. Verloc's newsagent shop in Conrad's *The Secret Agent* (1907) is not far from the mark:

The window contained photographs of more or less undressed dancing girls; nondescript packages in wrappers like patent medicines; closed yellow paper envelopes, very flimsy, and marked two and six in heavy black figures; a few numbers of ancient French comic publications hung across a string as if to dry; a dingy blue china bowl, a casket of black wood, bottles of marking ink, and rubber stamps; a few books with titles hinting at impropriety; a few apparently old copies of obscure newspapers, badly printed, with titles like *The Torch, The Gong*—rousing titles. And the two gas-jets inside the panes were always turned low, either for economy's sake or for the sake of the customers.[28]

Smuggled over borders, secreted in 'little magazines' with rousing titles to quirky book marts, the Dedalus model is furtively carried home in brown paper wrappers. Circulation numbers are on an order of magnitude of a few hundred, so if you get your hands on one, it is more likely to be a review copy than anything else. As a matter of contrast, review copies in the Tarzan model are so scarce they are kept under glass cases in research collections. For Dedalus, reviewers—or, indeed, scouting agents for book publishers—may be the targets anyway. In the Tarzan model, sales lead to sales. Here, serialization is a venture with the express purpose of garnering attention from a single audience member, a book publisher with a 'literary' list who might be willing to take a risk, who might view the book as a loss leader, a prestige or publicity getter, a contribution to literary posterity, a salvo against restrictive standards of taste, or the cornerstone of a legal case.

If the Tarzan model works unconsciously of its critical response, the Dedalus model fully embraces it. Yet the embrace happens chiefly under the cover of ambivalence. It is less that this book's career depends on a favourable reception by a critical establishment and more that its fortunes depend on the book's ability to keep this establishment busy or indeed expand its reach. Having taken the better part of a decade to compose—surviving multiple hazards, languishing in one bureaucratic cul-de-sac or other of literary administration—the dilatory aspect of the publication process is perhaps itself the book's most defining feature. If publishers' readers of the manuscript, themselves noted critics (Henry James's 'little writers') recommend rejection or even suppression, fearing aesthetic competition, libel, obscenity, or their own non-comprehension, these responses can be blandished by the text's boosters as a promotional badge of honour. They didn't so much delay the appearance of the work as prolong its exposure to the relevant middle managers.

'How many people read the literary object?' may be the wrong question for the Dedalus model, if more professors specialize in modernism today than subscribed to the 'little magazine' that published modernism to begin with. How did it or its authors get known, then? Lawrence Rainey observes that the editors of *The Dial* who first published and indeed awarded the Dial Prize to *The Waste Land* did so without

[28] Joseph Conrad, *The Secret Agent: A Simple Tale* (Ware: Wordsworth, 1997), 13.

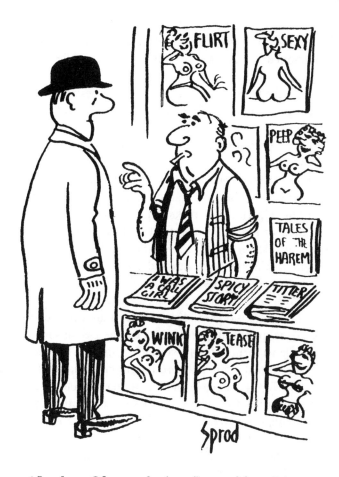

'*Lady Chatterley's Lover*'? Listen,
*mate, if that's the book that's so pure and
decent it's even fit for schoolgirls to read
then we don't stock it.*"

Fig. 18.1 George Sprod, Cartoon on the *Lady Chatterley's
Lover* trial, *Punch* (9 November 1960)

any close consideration of the poem.[29] We must look to such scenes if we are to
understand the productive powers in the small world upon which the Dedalus model
depends. The broker of the deal, Gilbert Seldes, was a notable agent of cultural
arbitrage, charged by the editors to do the reading and evaluating for them. Indeed,
Ezra Pound, who also played a role in this negotiation, was himself a pioneer and a

[29] See Rainey, *Institutions of Modernism*, 106.

master of this kind of work. The fact that *The Dial* was not besotted with Eliotic aesthetics is beside the point, for that activity was delegated to Seldes, Pound, and others, who functioned, in essence, as modernism's middle managers. As Alan Golding has argued, noting a system of synergistic literary networking shared by the relatively well-heeled *Dial* and more avant-garde, shoestring outfits like the *Little Review*: 'the shaping of taste by modernist magazines is a collective project, not a matter of . . . atomized influence'.[30]

'Most of the enduring literature of our time has had its origins in the critical journal of unpopular standards,' wrote Allen Tate.[31] There has been a flowering of research on these venues in the last ten years, casting new light on a vibrant, albeit tendentious and slow-moving, field of publishing traffic: 'an odd and absorbing concourse' for shifting and shuttling 'experimental works or radical opinions of untried, unpopular or under-represented writers'.[32] For the most part, titles like the *Little Review*, *The Egoist*, *Others*, *Broom*, the *Seven Arts*, *Poetry and Drama*, and *The Torch* were short-lived ventures, but they supplied rough-and-ready access points for a variety of encounters with heteroclite literary goods. What's more, they comprised a complex constellation of literary institutions of prestige that gave modernist work a small but influential basis of operations on both sides of the Atlantic. Isolated and atomized, a typical 'little magazine', publishing its excerpts for the Dedalus model, hardly seems to speak for more than a form of hobbyist modernism, yet, in practice, the aggregation of these venues formed a mutually productive network for all involved.

The advent of the Tarzan model created a steeper incline for the entrant in the unrestricted literary market, the unknown or lesser-known individual author trying to earn a regular living through literary publishing, a fact a transitional writer like Conrad knew all too well. In a sense, as Mark Morrisson writes, following the work of Peter Keating, the surge in idiosyncratic small publishing strategies also signals the collapse of stable means of income for new literary authors: 'changes in the institutions of book publication paradoxically both made cheap books more widely available to the reading public and ensured that a new or experimental author, especially a poet, could not make a living or reach wide audiences through book publication alone'.[33] Newer, medium-circulation magazines such as *Vogue*, the *Smart Set*, *Vanity Fair*, the *New Yorker*, the *Saturday Evening Post*, the *American Mercury*, and *Esquire* played a key transitional role in consolidating modernist value, putting its affective capacities for 'flattery, adulation, stroking and tickling' at the services of 'grimmer appetites' eager for notes of cosmopolitan style, fashion, and sophistication.

[30] Alan Golding, '*The Dial*, the *Little Review*, and the Dialogues of Modernism', in Suzanne W. Churchill and Adam McKible (eds), *Little Magazines and Modernism: New Approaches* (Aldershot: Ashgate, 2007), 68.

[31] Quoted in Russell Fraser, *A Mingled Yarn: A Life of R. P. Blackmur* (New York: Harcourt Brace Jovanovich, 1981), 40.

[32] Suzanne W. Churchill and Adam McKible, 'Introduction', in Churchill and McKible (eds), *Little Magazines and Modernism*, 5–6.

[33] Mark S. Morrisson, *The Public Face of Modernism: Little Magazines, Audiences, and Reception, 1905–1920* (Madison: University of Wisconsin Press, 2001), 11.

Faye Hammill argues persuasively that a medium-circulation magazine like *Vanity Fair*, by putting modernist names alongside other signifiers of elite distinction, sophistication, and glamour, provided 'a middle space, located between the author-centered production model of the avant-garde magazines and the market-driven arena of the daily papers and mass-circulation weeklies'.[34] The role of these magazines as well as daily papers and mass-circulation weeklies in providing a gateway to the culture of celebrity—a cosmopolitan system of value in which a glancing mention on the gossip pages promised the modernist an unprecedented degree of exposure—should not be overlooked.

Harold Monro—a poet, a little-magazine editor, a small-bookshop owner, an anthologist, and a book publisher—saw the possibilities for an unhurried roll-out across the wide publication and publicity spectrum:

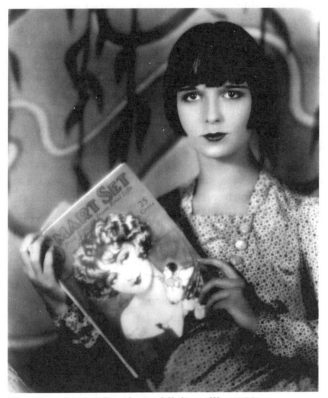

Fig. 18.2 Louise Brooks, publicity still, 1920s

[34] Faye Hammill, 'Between the Covers: Modernism, Celebrity and Sophistication in *Vanity Fair*, 1914–1936', in Goldman and Jaffe (eds), *Modernist Star Maps*.

our present hope [for the future of poetry] lies rather in circulation than innovation. We desire to see a public created that may read verse as it now reads its newspapers . . . [Books of poetry] are meant to be sold anywhere and everywhere, carried in the pocket, read at any spare moment, left in the train, committed to memory and passed on . . . [35]

Monro's vision never materialized in quite this form, but the disposable publication forms that he coveted were not irrelevant to the Dedalus model.[36] In effect, a bookstore perhaps only slightly more respectable than the newsagents in Conrad's *The Secret Agent*—Monro's own Poetry Bookshop, Shakespeare and Company, Dickson & Blackmur, Albert and Charles Boni's Washington Square Book Shop, or Gotham Bookmart—is ground zero for the Dedalus model. Here, shifting an issue of any disposable, ubiquitous periodical, whether newsprint, slapdash 'little magazine', literary review, slick or sophisticated magazine, enables the expansion of unusual shelf stock or odd subscription schemes in more lasting, durable objects, first editions, and books-in-print. Even if modernist studies has yet to appraise the significance of this particular archive to the extent it has the 'little magazine' field, it necessarily presents a wide spectrum of outlets, contact zones rife with unexpected, interpretatively rich links between authors, booksellers, publishers, agents, publicists, and readers.

The twentieth century begins with conditions of overproduction in the markets for literary goods and elsewhere. The Dedalus model provides an image of under-production as a negative, dialectical response to these conditions. Rainey proposes for modernism 'a tripartite publication program: journal, limited edition, and public or commercial edition', putting a lot of emphasis on the importance of the second term, the exquisite limited editions which effectively made every reader a patron of the modernist author.[37] The insulation of modernism in collecting culture these editions enabled is telling as a kind of indemnity against market risk. For all the rarefied, small houses willing to preserve authorial privilege at all costs—presses such as The Hours, Black Sun, Cuala, Hogarth, The Egoist; boutique operations recalling an Arts and Crafts ethos of the prior century—there were many more publicity-savvy firms, new and old, that kept modern literary lists significantly invested in modernist trends. The rise of the most famous publishers of modernist texts, with their attendant links to emergent advertising and publicity techniques, also testifies to a transition in consumer culture that enabled modernist risks and rewards for firms like Huebsch, Knopf, Boni and Liveright, Charles Scribner's Sons, Harcourt Brace, Random House, Viking, and New Directions in the US, and Elkin Mathews, John Lane, Bodley Head, J. M. Dent, Heinemann, Chatto & Windus, Faber and Faber, Methuen, Secker and Warburg, and Penguin in Britain. Dent's Everyman Library was

[35] Harold Monro, 'Broadsides and Chap-Books', *Poetry and Drama*, 1/3 (Sept. 1913), 265.

[36] Poetry anthologies were perhaps the most direct corollary (see my *Modernism and the Culture of Celebrity* (Cambridge: Cambridge University Press, 2005), ch. 4), but here I would simply underscore a strategy that makes room for a deliberate, diversified, and heteroclite product.

[37] In addition to Rainey, see also Megan Benton, *Beauty and the Book: Fine Editions and Cultural Distinction in America* (New Haven: Yale University Press, 2000).

one such scheme, as was the Modern Library that Bennett Cerf bought from Boni and Liveright for Random House. Boni and Liveright's fortunes—fortunes used to publish and promote Jean Toomer's *Cane*, for instance—were made by packaging miniature volumes of Shakespeare in Whitman's chocolates.[38] Two professional developments are germane to any consideration of this developing aspect of literary production in an age of literary oversupply and obsolescence: firstly, the rise of the literary publicist—figures like Edward Bernays—who knew how to help literary publishers survive leveraging one kind of book on others; secondly, the rise of the literary agent—figures like Pinker—who knew how to negotiate these anxious conditions for authors.[39] It misses the mark to describe the increasing complexity of this modernist cultural field simply as the triumph of one business strategy over others, but it is not wrong to observe that modernism had its business strategies (even at its origins, when they were ad hoc and DIY), strategies productive of short-lived literary ventures in the short term and of cultural middle management in the long run. In the Dedalus model, manuscripts shuttle through various publishing houses; tracking the failed negotiations is a necessary subject for the new modernist studies.

CONTRABAND

Evelyn Waugh's *Vile Bodies* (1930) contains a brief but crucial scene that makes modernist value commensurate with contraband. Early in the novel, the protagonist Adam Fenwick-Symes is returning to London from a spell in Paris composing his autobiographical novel. After a rough Channel crossing, the manuscript is summarily confiscated by bullying customs officials, who have quite obviously not read the book. Indeed, like the agents of modernist publication, the agents of censorship do not require literary study as necessary precondition. After almost a century of famously repressed literature—*Madame Bovary*, *Les Fleurs du mal*, the Oscar Wilde trials, *The Rainbow*, *Ulysses*, *The Well of Loneliness*,—the relevant information is widely known: 'One by one he took the books out and piled them on the counter. A copy of Dante's *Purgatorio* excited especial disgust. '"French, eh?" he said. "I guessed as much, and pretty dirty, too I shouldn't wonder. Now just wait while I look up these here *books*"—how he said it!—"in my list. Particularly against books the Home Secretary is." '[40] The manuscript has two problems: firstly, it comes from France; secondly, it has the whiff of other books with prominently displayed authors.

[38] See James C. Davis, *Commerce in Color: Race, Consumer Culture, and American Literature, 1893–1933* (Ann Arbor: University of Michigan Press, 2007), 186.

[39] See Mary Ann Gillies, *The Professional Literary Agent in Britain, 1880–1920* (Toronto: Toronto University Press, 2007).

[40] Evelyn Waugh, *Vile Bodies* (New York: Back Bay, 1999), 23.

On such seemingly philistine suspicions, Fenwick-Symes is taken to the dreaded inner office ('the walls of which were lined with contraband pornography and strange instruments') for what promises to be a more thorough examination:

> With the help of a printed list, which began 'Aristotle, Works of (Illustrated),' they went through Adam's books, laboriously, one at a time, spelling out the titles ...
> 'You can take these books on architecture and the dictionary, and I don't mind stretching a point for once and letting you have the history books too. But this book on Economics comes under Subversive Propaganda. That you leaves behind. And this here Purgatorio doesn't look right to me, so that stays behinds, pending inquiries. But as for this autobiography, that's downright dirt, and we burns that straight away, see.'[41]

The problem of literature and censorship has everything to do with this imagined list and its alphabetized titles. The impression is that the list is long, but how long could it be? One constraint is that it requires any book on it to have achieved a certain degree of fame; it must have been successfully published before it can be subjected to post-production suppression. The unpublished work—the one that never gets past the sundry informal gatekeepers with various reasons not to publish it—needs to be censored. The second lesson concerns the power of the state, conveyed here by the reference to the home secretary, who restricts the flow of information in the name of shielding the public from the dangers of indecency and subversion. Tellingly, the scene where the book becomes contraband is left to a sub-functionary acting at his own discretion at the maritime border of the state. The interface, embodied by the philistine customs agent, concerns repressive and ideological state power. This particular occasion, after all, is one of prior restraint, for Fenwick-Symes's unpublished manuscript can't yet be on any home secretary's list of censored titles. Many of the agents of literary repression were informal—publishers acting from fear of libel, for instance—or semi-official and non-governmental entities obstructing postal circulation or market access, particularly in the United States, with the Watch and Ward Society in Boston or the New York Society for the Suppression of Vice. At the very border of the nation-state, a text marked as potential contraband internalizes a phenomenological border between the state (provincial, decent, London, Boston) and modernism (cosmopolitan, out there, Paris). This scene paradigmatically, however perversely, functions as an event for the presentation of (alternative) value. 'A classic is a dirty book somebody is trying to get by me,' as one customs agent put it.[42]

Modernist censorship, as Adam Parkes, Allison Pease, and Elisabeth Ladenson have all argued, is frequently about sex: either about containing representations of unruly (sexed, female, working-class, homosexual) bodies or about making such bodies fit objects for mass cultural consumption and management.[43] Yet there are specific differences in the forms of legal and pseudo-legal jeopardy encountered at

[41] Waugh, *Vile Bodies*, 24–5.
[42] Loren Glass, 'Redeeming Value: Obscenity and Anglo-American Modernism', *Critical Inquiry*, 32/2 (Winter 2006), 345.
[43] Adam Parkes, *Modernism and the Theater of Censorship* (New York: Oxford University Press, 1996); Allison Pease, *Modernism, Mass Culture, and the Aesthetics of Obscenity* (Cambridge: Cambridge University Press, 2000); Elizbeth Ladenson, *Dirt for Art's Sake: Books on Trial from Madam Bovary to Lolita* (Ithaca, NY: Cornell University Press, 2007).

the censorial threshold, and sometimes they are not just about the logic of pornography. The potential for blasphemy, insult to the monarch, promotion of social vice through profane language, libel, plagiarism, or political sedition, for instance, all court the censor, too. Each story of censorship has its particulars: the blotted-out name of Rupert Brooke in *Blast*; the scandalous word 'bloody' in John Masefield's *Everlasting Mercy*; H. L. Mencken's flaunted copy of the *Smart Set* in Boston; the words 'fucking', 'cocksucker', and 'shit' on Maxwell Perkins's editorial to-do list, scheduled for purging from *A Farewell to Arms*;[44] the transformation of a book called *The Nigger of the 'Narcissus': A Tale of the Sea* into *The Children of the Sea: A Tale of the Forecastle* for the American market. From a different angle—made visible by the work of the British Ministry of Information in the First World War—the question of literary censorship and modernism is foremost about the wavering legitimacy of restricting and restricted information in political modernity. This aspect of the matter is particularly interesting for modernist studies, for the status of restricted information in the unrestricted field of cultural production provides a suggestive homology for modernism itself.

The relevant lesson for the modernist as a would-be purveyor of contraband in these circumstances is publicity. Tellingly, following his maritime disaster, Fenwick-Symes goes on to seek his fortunes in the manufacture of publicity as a tabloid gossip columnist. Pease writes that pornography, or, more significantly, discourse about the pornographic, is 'one of late-Victorian and Edwardian Britain's most overlooked cultural products'.[45] Like modernism, it emerges from familiar anxieties about mass cultural plenitude: 'For the high-cultural reading public, the problem of increased literacy manifested itself in a new, self-spawning mass culture that began to proliferate in the form of newspapers, magazines, and penny fiction. Articles decrying the rise in frivolous reading materials created by and for the literate working classes were published repeatedly throughout the later years of the century.'[46] Pease reads pornography as another avenue of high-art co-optation, with a specific ideological objective of social control. Furthermore, as Celia Marshik has convincingly argued, these efforts themselves point to an eroded state monopoly on the flow of information. The interests, motives, and surprising consequences of information restraint emanated from not one but multiple sites of dispersed sovereign power: Parliament, the courts, the Post Office, the press, the Salvation Army, and elsewhere. In this context, Marshik argues, 'censorship was repressive [but] also had productive effects. Individual texts were enhanced as a result of the threat of censorship, and this threat enabled writers to construct public personae—such as that of martyr (as in the case of Dante Gabriel Rossetti) or *enfant terrible* (as in the case of Joyce)—that exercise a strong hold on the imaginations of readers even today.'[47] Ladenson avers that

[44] For this last incident, see Loren Glass, '#$% ^&*!?: Modernism and Dirty Words', *Modernism/Modernity*, 14/2 (2007), 209. In a series of articles on modernism and obscenity, Glass has modelled a method for an integrated critical discussion of obscenity, legal history, and publication history.

[45] Pease, *Modernism, Mass Culture, and the Aesthetics of Obscenity*, p. xiii.

[46] Ibid. 44.

[47] Celia Marshik, *British Modernism and Censorship* (Cambridge: Cambridge University Press, 2006), 4.

censorship history—various legal proceedings and attendant controversies alongside fraught publication histories and literary publicity campaigns—becomes bound up with such famously censored books as *Madame Bovary, Fleurs du mal, Ulysses, The Well of Loneliness,* and *Lady Chatterley's Lover.* Censorship—and perhaps more vitally, a work's capacity to solicit and then withstand charges of indecency or obscenity—is often a key ingredient in a classic work's subsequent dissemination, its interpretation, and, in many cases, its very materiality as it becomes a perennial survivor of Moretti's slaughterhouse. Legal histories stick to these texts like lamprey fish. Flaubert, for example, anticipated this much when he hired a private stenographer to record the trial of *Madame Bovary* and included the transcripts in the published volume. A work with a censorship history continues to add an interpretative frisson for present-day readers who supplement their scene of reading with a requisite if largely implicit rereading of the bad interpretative choices of the past's literary litigators. Ladenson's question—what transmogrifies literary trash into contraband with viable literary value?—is not terribly different from the general question facing any literary production in modernity.

Conrad was acutely aware of the conditions of literary overproduction and consequent strategies of restraint and control in managing the field of literary production and publicity. Moreover, his fiction frequently reflects on these matters, mediating the dynamic circulation of goods and the circulation of literary reputation in fictional form. The problem of patronage, for example, is acute in stories like 'The Anarchist', which very explicitly critiques the bogus *noblesse oblige* of patronage through a Hegelian master–bondsman fable. As Shafquat Towheed has recently noted, Conrad's fiction is often prepossessed by literary production, distribution, and reception: 'Scholars choosing to interpret Conrad's novels as symbolic musings on authorship are underestimating his own awareness of these issues and the extent his fiction was shaped by the rapidly changing legislative climate' vis-à-vis authors' rights.[48] One clue to the centrality of these concerns to Conrad's output is in his famous author's note to *Tales of Unrest* concerning 'The Outpost of Progress', in which he describes the story as 'the lightest part of the loot [he] carried off from Central Africa'.[49]

Another part of this loot, *Heart of Darkness,* can be read as a modernist literary publication fable, a tale of undersupply. Forget the rivets—the small, indispensable things of modernity, for want of which the entire enterprise grinds to a halt—Africa has no books. Africa is, in Marlow's account, a place nearly devoid of print culture and therefore with virtually no circulating information. When Marlow stumbles on a single book, 'AN INQUIRY INTO SOME POINTS OF SEAMANSHIP, by a man Towser, Towson—some such name', plucked from near 'a heap of rubbish reposed in a dark corner', he calls it 'an extraordinary find':

[48] Shafquat Towheed, 'Geneva vs. St. Petersburg: Two Concepts of Literary Property and the Material Lives of Books in *Under Western Eyes*', *Book History,* 10 (2007), 171.

[49] Joseph Conrad, *Tales of Unrest* (New York: Doubleday, Page, 1924), p. xi.

I handled this amazing antiquity with the greatest possible tenderness, lest it should dissolve in my hands. Within, [the author] was inquiring earnestly into the breaking strain of ships' chains and tackle, and other such matters. . . . At the first glance you could see there a singleness of intention, an honest concern for the right way of going to work, which made these humble pages, thought out so many years ago, luminous with another than a professional light. . . . Such a book being there was wonderful enough; but still more astounding were the notes pencilled in the margin, and plainly referring to the text. I couldn't believe my eyes! They were in cipher! Yes, it looked like cipher. Fancy a man lugging with him a book of that description into this nowhere and studying it—and making notes—in cipher at that! It was an extravagant mystery.[50]

Marlow is astounded to discover not a modernist book per se but a thing that is a literary artefact of modernity nonetheless, evidence of an attempt to sort useful information from useless noise. Here, Marlow is another improbable modernist reader looking for something different to read, except Conrad has created a fictional world in which something different to read is also something to read at all. It is a scene of reading in a forensic sense, a reader reconstructing an imaginary scene of another reader before a book. In the anonymous, sedulous reader—the ciphering note-taker—he has found a secret sharer. The improbability of this encounter tells us where we are, as does Marlow's certainty that Kurtz, for all his own extravagant mystery, would appreciate it, too.

Even as print culture cannot penetrate to the inner station, Kurtz's reputation—indeed, his name—seems to radiate outward. If nothing else, the achievement in extracting commodities and reputations where no other European agent could adds to his charisma and makes his name an object of desire. What is odd here is the sense that Kurtz's name is already known outside, a magical association with modernity's sovereign power that suggests a kind of improbable, esoteric conspiracy that stretches back to Belgium. Yet for much of the novella, the point is precisely that Marlow doesn't know who Kurtz is ('"Tell me, pray," said I, "who is this Mr. Kurtz?"').[51] How could he, after all, without a functioning system of communication from the inner station to the outer world. In the end, this reading is confirmed by the second instance of print culture in the novella, another contraband esoteric manuscript at the threshold of modernist value, Kurtz's odious report to the International Society for the Suppression of Savage Customs.

When we finally get to the repellent heart of darkness, we are faced not with 'The horror! The horror!' (or, even 'Mistah Kurtz, he dead') but with a representation of Kurtz as Flaubert ('savage customs, c'est moi') and Marlow as the book detective and literary middleman, pondering the fortunes of a holograph manuscript:

the International Society for the Suppression of Savage Customs had intrusted him [Kurtz] with the making of a report. . . . And he had written it too. I've seen it. I've read it. It was eloquent, vibrating with eloquence. . . . Seventeen pages of close writing he had found time for! . . . it was a beautiful piece of writing. . . . There were no practical hints to interrupt the

[50] Joseph Conrad, *Heart of Darkness*, in *The Portable Conrad*, 317. [51] Ibid. 302.

magic current of phrases, unless a kind of note . . . may be regarded as the exposition of a method. It was very simple . . . 'Exterminate all the brutes!' The curious part was that he had apparently forgotten all about that valuable postscriptum, because, later on, when he in a sense came to himself, he repeatedly entreated me to take good care of 'my pamphlet' (he called it), as it was sure to have in the future a good influence upon his career.[52]

One of the most difficult aspects of Conrad's novella is coming to terms with Marlow's irresistible need to flatter, adulate, stroke, and tickle this indecent document of barbarism—not least in this scene, when a reader would be forgiven for assenting to its suppression.

Thinking of the fables of modernist print culture in *Heart of Darkness*—and also of the episode of the *Titanic* and Conrad's manuscript—it is instructive to consider one additional occulted modernist production story. Conrad tells the story of his first novel (*Almayer's Folly*, 1895) in *A Personal Record* (1912). It was 'a much delayed book', he observes, which was 'begun in idleness—a holiday task', as if, as John Batchelor notes, he were swept up by a bout of 'creative irresponsibility'.[53] Strictly speaking, *Almayer's Folly* was begun in 1889 while Conrad was between commissions, renting a flat in London. Yet the pride of place in 1912 is given not to the story of the novel's composition but rather, as in *Heart of Darkness*, to a subsequent, seemingly more fantastic scene: its first consumption as a manuscript. After beginning *Almayer's Folly* in 1889, Conrad went back to his non-literary, maritime career. In fact, in this period he accepted the fiasco of a riverboat commission on the Congo that became the basis for his most famous work. As he carried his own manuscript over land and sea, 'as if it were a talisman or a treasure', from station to station—Africa, Australia, the Ukraine, Belgium, Switzerland, France—risking its loss at every border crossing, its nearly slipping from his pocket into a river, its misplacement with a bundle in a Berlin *Bahnhof*—one gets a distinct impression of the Dedalus model: the hazards and improbabilities faced by would-be modernists with no obvious readers.[54] Then, while working as first mate on board the *Torrens* at the end of 1892, Conrad found a reader at last: 'It would be on my part the greatest ingratitude ever to forget the sallow, sunken face and the deep-set, dark eyes of the young Cambridge man . . . who was the first reader of *Almayer's Folly*—the very first reader I ever had.'[55] Here is one of Conrad's inscriptions in the very book he eventually published, scrawled much later, in an unsteady hand: 'My first book. My best remembered sensation about it is the perpetual surprise that I should be able to do it at all. Began in the spring of the year 1889. Finished in 1894. Joseph Conrad.'[56] The dates 1889–94 make all the difference, as Pound would write about another book by another author. As it happens, Quinn eventually acquired the *Almayer's Folly* manuscript too. It was auctioned with the rest of his collection in 1923.

[52] Conrad, *Heart of Darkness*, 331.
[53] Joseph Conrad, *A Personal Record* (Marlboro, Vt: Marlboro Press, 1982), 114; John Batchelor, *The Life of Joseph Conrad* (Oxford: Blackwell, 1994), 42.
[54] Conrad, *A Personal Record*, 33.
[55] Ibid. 36; see Stape, *The Several Lives of Joseph Conrad*, 70–1.
[56] Repr. in Norman Sherry, *Conrad* (London: Thames & Hudson, 1998), 99.

CHAPTER 19

MODERNISM IN MAGAZINES

SUZANNE W. CHURCHILL
AND ADAM MCKIBLE

> In our studies of modernism, we tend, perhaps rightly, to privilege the little
> magazines, but we cannot adequately understand even them without an
> understanding of the mass magazines and those [Ezra] Pound called 'the
> elder magazines', against which they situated themselves.
>
> (Robert Scholes, 'Afterword'[1])

'LITTLE magazines' have received the lion's share of the credit for instigating modern-
ism, much of it deserved: 'They are intrinsically connected with the idea of the avant-
garde, so much so that they may almost be said to constitute it,' argues David Perkins.[2]
Little magazines have also been opposed, by definition, to mass commercial magazines:
'A little magazine is a magazine designed to print artistic work which for reasons of
commercial expediency is not acceptable to the money-minded periodicals or presses,'
write Frederick Hoffman et al. in what remains the definitive study, *The Little Magazine:
A History and a Bibliography*.[3] But, as Robert Scholes argues, we cannot understand little
magazines if we do not study the larger, more commercial magazines that emerged in

[1] Robert Scholes, 'Afterword: Small Magazines, Large Ones, and Those In-Between', in Suzanne
W. Churchill and Adam McKible (eds), *Little Magazines and Modernism: New Approaches* (Aldershot:
Ashgate, 2007), 217–18.

[2] David Perkins, *A History of Modern Poetry: From the 1890s to the High Modernist Mode* (Cambridge,
Mass.: Belknap Press, 1976), 324.

[3] Frederick J. Hoffman, Charles Allen, and Carolyn F. Ulrich (eds), *The Little Magazine: A History and
a Bibliography* (Princeton: Princeton University Press, 1946), 2.

the same era. Moreover, we cannot fully understand modernism unless we recognize that magazines of all types and sizes—not just the 'littles'—were instrumental to the development and circulation of modernist ideas and aesthetics.

The much-vaunted 'little-magazine renaissance' that began on or about 1910 with the appearance of *The Crisis* and *The Masses* was actually part of a much larger boom in magazine production. The number of magazines in the US grew from 400 in the 1860s to 3,500 by 1900, and in Great Britain the numbers were even more impressive: 172 daily newspapers at the turn of the century, and more than 50,000 periodicals in 1922. Among these, more than 600 could be classified as little magazines.[4] A number of technological developments sparked this magazine boom. The ability to make paper from cheap wood pulp rather than rags and the invention of mechanized Linotype printers reduced costs considerably.[5] Outmoded hand presses, discarded by commercial publishers, could be acquired inexpensively by little magazine editors: Man Ray, for example, got an old one from a print shop so that he and Alfred Kreymborg could launch *The Globe*.[6] The development of the half-tone process in the early 1890s replaced the more expensive and labour-intensive method of wood engraving, making it possible to reproduce images quickly, cheaply, and accurately.[7] The reduced costs of printing were translated into lower cover prices for illustrated magazines, which made them more affordable to a much wider range of incomes.

The rise of the advertising industry also fuelled the boom in commercial magazine production. As Theodore Peterson explains, nineteenth-century magazine publishers in America generally avoided advertisements, believing that it 'lowered the standing of their publications', but by the 1860s, 'quality' magazines such as *Century, Youth's Companion*, and *Atlantic Monthly* began running advertisements.[8] Advertising increased magazine revenues, which financed bigger, glossier issues with larger, flashier images. Newsstand and subscription prices could be lowered below the costs of production, which increased circulations exponentially. But, as Scholes observes, the dependence on advertising made it difficult for new and unproven writers to get published, since editors were less likely to take chances on contributors who lacked the name recognition to generate sales. Rejected by commercial magazines, struggling writers and artists were driven to publish their own magazines. Thus, the proliferation of little magazines was a corollary to the successful commercialization of the 'larges', or, as Scholes puts it, 'What we call avant-gardism became part of the cultural mixture that was modernity.'[9] The little magazine renaissance and the commercial magazine boom were

[4] Susan Belasco and Linck Johnson, 'Introduction', in Belasco and Johnson (eds), *The Bedford Anthology of American Literature*, ii (Boston: Bedford/St Martin's Press, 2008), 25; Ann Ardis and Patrick Collier, 'Introduction', in Ardis and Collier (eds), *Transatlantic Print Culture, 1880–1940: Emerging Media, Emerging Modernisms* (New York: Palgrave MacMillan, 2009), 1; Hoffman et al. (eds), *The Little Magazine*, 2.

[5] David Reed, *The Popular Magazine in Britain and the United States, 1880–1960* (Toronto: University of Toronto Press, 1997), 27–8, 43.

[6] Alfred Kreymborg, *Troubadour: An Autobiography* (New York: Sagamore Press, 1957), 155.

[7] Theodore Peterson, *Magazines in the Twentieth Century* (Urbana: University of Illinois Press, 1964), 7.

[8] Ibid. 21–2. [9] Scholes, 'Afterword', 219.

both sparked by the same developments in technology and advertising, as well as by rising literacy rates, shifts in labour and manufacturing practices, improvements in transportation, and reductions in postage rates.

Modernism and little magazines not only emerged from the same socio-economic conditions and technological developments that produced mass culture and popular magazines; many modernists were also 'deeply complicitous' in the commercial marketplace.[10] Djuna Barnes wrote fiction for the pulps, William Faulkner published short stories in the *Saturday Evening Post*, and highbrow fashion magazines vaulted some modernists to celebrity status: *Vogue* added T. S. Eliot to its 'Hall of Fame' in 1924, paid homage to Pablo Picasso the same year, and featured an essay by Virginia Woolf in 1926. 'Quality' magazines such as *Scribner's*, the *New Statesman*, and the *Times Literary Supplement* cultivated an intellectual audience for avant-garde art and writing, while popular newspapers and periodicals seized upon modernist innovations as sensational material for gossip and amusement. Advertisers and product designers adopted modernist aesthetics to sell their goods, and, in turn, little magazines solicited advertisements and appropriated promotional tactics from the commercial sector to sell their ideas: *Blast* borrowed its bold print from mass advertising, and the *Little Review* joined the popular 'cult of youth'. The so-called 'great divide' between modernism and mass culture, theorized by Andreas Huyssen, shrinks considerably when we examine modernism in the context of magazines.[11] Modernism was published, parodied, and promoted in a wide range of periodicals, from the little magazines that championed the movement, to the mass-market magazines that were purportedly the antithesis of modernist novelty and experimentation.

Although modernism circulated in commercial markets, it should not be considered synonymous with mass culture. Indeed, to highlight the collusion between modernist and commercial periodicals risks simplifying the complex array of motivations, interests, and relations that distinguished various magazines and their constituencies. As our investigation will show, modernism was identified by a common set of markers in a wide range of magazines, yet it was inflected differently in each, depending on each magazine's position in the public sphere. To understand the story of modernism in magazines—its common markers and divergent inflections—we will examine several stories published in those magazines to see how they

[10] Kevin J. H. Dettmar and Stephen Watt, 'Introduction: Marketing Modernisms', in Dettmar and Watt (eds), *Marketing Modernisms: Self-Promotion, Canonization, Rereading* (Ann Arbor: University of Michigan Press, 1996), 6. For further discussion of interactions between modernism, the public sphere, and the commercial marketplace, particularly those cited in this paragraph, see David Earle, *Re-covering Modernism: Pulp, Paperbacks, and the Prejudice of Form* (Aldershot: Ashgate, 2009); Aaron Jaffe, *Modernism and the Culture of Celebrity* (Cambridge: Cambridge University Press, 2005); Ann Ardis, *Modernism and Cultural Conflict: 1880–1922* (Cambridge: Cambridge University Press, 2002); Karen Leick, 'Popular Modernism: Little Magazines and the American Daily Press', *PMLA* 123/1 (Jan. 2008), 125–55; Patrick Collier, *Modernism on Fleet Street* (Aldershot: Ashgate, 2006); Mark Morrisson, *The Public Face of Modernism: Little Magazines, Audiences, and Reception, 1905–1920* (Madison: University of Wisconsin Press, 2001).

[11] Andreas Huyssen, *After the Great Divide: Modernism, Mass Culture, Postmodernism* (Bloomington: Indiana University Press, 1986).

represent modernism. The story of modernism in magazines can perhaps best be understood not as a single narrative of complicity or collusion, but as an amalgamation of shifting, overlapping, and competing narratives about what it means to be modern.

THE LITTLE REVIEW
(MARCH 1914–MAY 1929)

We begin with what, in both its title and its motto, 'Making no compromise with the public taste', might be deemed the quintessential modernist little magazine, *The Little Review*. Its founding editor, Margaret Anderson, embodied the conjunction of the 'new woman' and the modernist periodical; she participated directly in the development of modernist practices and sensibilities, and her magazine championed modernism's mythic lone geniuses. Anderson originally published *The Little Review* in Chicago, intending to fill it with 'the best conversation the world has to offer'.[12] The magazine would migrate to New York in 1917, where it would evolve into one of the most influential organs of avant-garde modernism. In 1914, however, Anderson was generally more interested in promoting innovative ideas about the individual than in supporting modernist aesthetics. The November 1914 issue of *The Little Review*, from which we draw our first story, has only a few examples of what would now be recognized as canonical high modernism: Ezra Pound receives several paragraphs of notice; Gertrude Stein's *Tender Buttons* (1914) is reviewed; and one of F. T. Marinetti's manifestos is published. Friedrich Nietzsche and Emma Goldman figure more prominently, along with the presentation and discussion of free verse. The single thread linking the wide-ranging conversation in the magazine is the creation of a modernist sense of self, an identity dramatized in Lawrence Langner's one-act play, 'Wedded: A Social Comedy', which provides a paradigmatic story of modern self-discovery and assertion. At ten pages the largest single contribution to the November 1914 issue, Langer's play presents the modern young woman, one who thinks for herself, challenges conventional morality and sexual mores, and advocates birth control—in other words, she is a *Little Review* modernist in the making.

 The curtain rises on a working-class parlour in Brooklyn, decorated for a wedding. The scene is a decidedly Victorian hangover: 'There is a profusion of pictures, ornaments, and miscellaneous furniture.'[13] On the sofa is the body of the groom, who died just before the service was to begin. We soon discover that our modern, free-loving heroine, Janet Ransome, is already pregnant with Bob's child. Most of

[12] Margaret C. Anderson, *My Thirty Years' War: An Autobiography* (Westport, Conn.: Greenwood Press, 1971), 35.
 [13] Lawrence Langner, 'Wedded: A Social Comedy', *The Little Review*, 1/8 (Nov. 1914), 8.

Langner's play is concerned with whether the Revd Tanner, who was to preside over the ceremony, will fill out the marriage register so it appears that Janet and Bob exchanged vows before he died. Tanner, who decries Janet's premarital sex as 'what we have to expect of the younger generation',[14] initially resists falsifying the register, but Mrs Ransome begs him to save her family's respectability. Meanwhile, Janet refuses the Reverend's help. She explains bitterly that she and Bob delayed their marriage until he could support a family, but he had been unable to earn a decent wage, and they could no longer resist their desires: 'We did wait. Isn't three years long enough? D'ye think we was made of stone? . . . I only wish to God we hadn't waited at all, instead of wastin' all them years. . . . I wanted him to love me, an' I ain't ashamed of it, neither.'[15]

When Mrs. Ransome protests that she raised her daughter 'to be innercent about things', Janet faults her mother and society at large for keeping her ignorant about birth control. Shocked, Tanner claims that 'there is nothing worse than trying to interfere with the workings of nature, or—if I may say so—of God'.[16] Articulating the early *Little Review*'s position on both sexual liberty and class consciousness, Janet points out that 'the rich people' must have knowledge of and access to birth control, 'because they never have more'n two or three children in a family; but you've only got to walk on the next block—where it's all tenements—to see ten and twelve in every family, because workin' people don't know any better'.[17] Although Janet's speech is unschooled, even Tanner must acknowledge that she's 'an intelligent girl' with 'most extraordinary views'.[18]

Despite Janet's principled opposition to Tanner's religiosity and to her mother's Victorian propriety, Mrs Ransome ultimately convinces her to appease the minister so he will alter the register. 'Unwillingly feigning remorse',[19] Janet capitulates by apologizing to Tanner and bowing to his hypocritical demands. Yet her defiant spirit remains unbroken, and the play concludes with her throwing the prayer book at the bric-à-brac: 'She flings the prayer-book at the other end of the room, smashing some of the ornaments on the mantle-shelf, and throws herself upon the side of the couch, sobbing wildly.'[20] The play figures Janet's defeat as a minor tragedy; her heroism stems from her clear-eyed understanding of the compromise she is making with a false value system. As a young female embodiment of Nietzschean philosophy, Janet exposes religious hypocrisy and smashes the ornaments of the past in order to pave the way for an honest, plain-spoken, free-loving, and free-thinking new age.

Indeed, Janet Ransome is not the only representative of Nietzschean radicalism in the November 1914 *Little Review*, the issue containing Langner's play: Nietzsche is invoked repeatedly, both in person and in the form of female representatives, to promote the magazine's own modernist ideals. George Soule, a regular early contributor, typifies the *Little Review*'s characterization of Nietzsche by asserting that his 'value, his quality, consist not in the fact that he said this or that, but that life in him

[14] Ibid. 12. [15] Ibid. 15. [16] Ibid. 16. [17] Ibid.
[18] Ibid. [19] Ibid. 18. [20] Ibid.

was strong and beautiful. This is true of all prophets . . .'.[21] Anderson makes similar claims about Emma Goldman in 'The Immutable'. Although she does not name Nietzsche, she clearly draws on his example when she describes Goldman's anarchism as a manifestation of her personality rather than as a consciously articulated politics:

her Anarchism is a metaphysical hodge-podge, the outburst of an artistic rather than a scientific temperament. And so [her critics] all miss the real issue, namely, that the chief business of the prophet is to usher in those times which often appear in direct opposition to scientific prediction, and—this above all!—that life in her has a great grandeur.[22]

Whenever he is invoked by name or by allusion, Nietzsche represents the ideal of the solitary heroic genius, a 'prophet' who stands in 'great grandeur' above his contemporaries—a role that would eventually become synonymous with many of the creators of canonical high modernism. Yet what is striking about the female embodiments of Nietzschean ideals in the November 1914 *Little Review* is that when this spiritual father of modernism appears in female form, his heroic isolation combines with maternal compassion, seemingly without contradiction. Thus, when Anderson provides evidence of Goldman's greatness, she praises 'that imperative gift of motherhood which is hers and which spends itself with such utter prodigality upon those who come to her for inspiration', yet a sentence later depicts the same maternal icon as 'a mountain-top figure, calm, vast, dynamic, awful in its loneliness, exalted in its tragedy'.[23]

The tragedy of the modern woman, as embodied by both Goldman and our ill-fated heroine Janet Ransome, proves not to be her awful loneliness, but her inexorable social bonds. Even though she heroically proclaims her personal truths and is alienated from society as a consequence, she remains enmeshed in a social matrix of mothers, fathers, husbands, children, and clergymen. Ultimately, what forces Janet to capitulate to the demands of Tanner and her mother is not the fear of public disgrace, but Janet's love for her unborn child ('D'ye want them to make *its* life a misery?') and for her deceased husband ('D'ye want your boy—Bob's boy—to be hatin' his own father?'[24]). Janet, with her untutored speech and 'extraordinary views'; Goldman with her foreign, Jewish name and personal notoriety; and Anderson herself, with her courage to publish their unorthodox stories: each epitomizes the modern, self-fashioning woman found throughout the pages of the early *Little Review*. In her various guises, this modern woman, more than Nietzsche alone, represents modernism in the *Little Review*. She is a producer of modernism—a free-thinking, free-loving woman who is enlivened by her maternal creative powers and by her courageous intellectual iconoclasm.

Perhaps not coincidentally, the same issue that tells Janet Ransome's story also prints a hostile letter from a 'Rev. A.D.R., Chicago':

I earnestly request you to discontinue sending your impertinent publication to my daughter who had the folly of undiscriminating youth to fall in the diabolical snare by joining the ungodly family of your subscribers. As for you, haughty young woman, may the Lord have

[21] George Soule, 'Zarathustra vs. Rheims', *Little Review*, 1/8 (Nov. 1914), 4.
[22] Margaret Anderson, 'The Immutable', *Little Review*, 1/8 (Nov. 1914), 20.
[23] Ibid. 19. [24] Langner, 'Wedded', 17.

mercy on your soul! Have you thought of the tremendous evil that your organ brings to American homes, breaking family ties, killing respect for authorities, sowing venomous seeds of Antichrist–Nietzsche–Foster, lauding such villains as Wilde and Verlaine, crowning with laurels that blood-thirsty daughter of Babylon, and committing similar atrocities? God hear my prayer and turn your wicked heart to repentance.[25]

There is the tantalizing (but unverifiable) possibility that this letter is a forgery designed by Anderson to highlight the magazine's own identity politics, especially since the Reverend's screed is followed by letters from 'A. Faun, Paris' and 'A Proletarian'. But it would not be surprising to learn that the Reverend's letter was no forgery at all, because the anxieties he articulates about modernism's pernicious effects on women would become staples of such large-circulation magazines as *The Saturday Evening Post*. In fact, his anxious conflation of modernism, young women, and the little magazines they read offers a fairly accurate crystallization of the fears and fantasies that would come to characterize modernism in mainstream American media.

THE SATURDAY EVENING POST
(4 AUGUST 1821–8 FEBRUARY 1969)

Between 1899 and 1937, under the editorship of George Horace Lorimer, the *Saturday Evening Post* grew to be one of the most popular magazines in America, boasting a circulation of 2.25 million and advertising revenues of more than $28 million.[26] Corrine Lowe highlights the *Post*'s market and cultural dominance, as well as its tendentious engagement with modernism, in her 3 May 1919 short story 'Alice Through the Working Class'. The heroine of Lowe's story is a paradigmatic character in the magazine: stylish, articulate, and urbane, the typical young woman featured in the *Post* is an avid participant in American youth culture; she flirts dangerously (if naively) with aliens, seditionists, and aesthetes; and if she is literary, she reads and contributes to little magazines. But the *Post*'s young woman also possesses a foundation of common sense, harbours traditional values, and inevitably falls in love with the proper man. In the *Saturday Evening Post*, the reformed, domesticated flapper is an object of endless fear and fascination, but the moral of her story is always the same: she must be restored to her senses and cured of her mania for modernism. In the process, she must re-embrace traditional values yet remain a full participant in the commercial culture of modernity. In a typical *Post* story, decadent, bohemian modernism is opposed to a productive modern lifestyle, yet, as we see in 'Alice

[25] 'Rev. A.D.R., Chicago', letter, *Little Review*, 1/8 (Nov. 1914), 69.
[26] Peterson, *Magazines in the Twentieth Century*, 12.

Through the Working Class', a youthful flirtation with modernism is often a neces-
sary precursor to a mature commitment to modern, middle-class values.

Born in Duluth, Minnesota, Lowe's protagonist Alice Sunderland is a pure product
of the American heartland, yet she is susceptible to European influences: she admires
art, especially 'Michelangelo's David and other cultured carbon prints'; reads 'the
best books'; and comes to see unfortunate 'discrepancies between papa... and the
most sensitive of Mr. Henry James's heroes'.[27] Her drama begins when she finds
herself at the very centre of modernist experimentation, among the bohemians of
New York's Greenwich Village. Alice Sunderland is, to a great extent, a Midwestern
middle-class version of Langner's East Coast working-class heroine in 'Wedded:
A Social Comedy', but Alice's inevitable recuperation into traditional womanhood
is figured as an actual comedy (leading to marriage), rather than an ironic social
comedy (leading to feigned acquiescence and a false marriage). Alice is the very
image of youthful individualism seduced by modernism, and she is particularly
susceptible to the allure of modernist little magazines. At 18 she becomes 'afflicted
by the literary temperament which generally goes with an absence of literary pro-
duction. By and by, however, she did come down with literature.'[28] Before long, she
comes across The Squall:

This magazine was got out in an attic in New York, and the artist who did its covers always
went in for ladies and gentlemen with knock-kneed eyes. The cartoonist who drew the double
pages inside was equally prejudiced. To him a man with a bank account was always evil and
draped in watch chains, and the workingman was invariably virtuous.... As for the literature
itself, both articles and verse gave a thorough grounding in the three R's: Russian, Red and
Radical. To most folks The Squall would have sounded like intellectual colic. To Miss Alice,
however, it was a first revelation of the wide outlook. Almost at once the inevitable happened.
She began sending in vers libre to The Squall.[29]

Alice's first attempts at free verse are rejected by this little magazine, but once she
jettisons 'the old theory that words should make sense' her poetry is accepted for
publication—which in turn prompts an appreciative letter from society woman and
Squall benefactor Mrs Dudley Searles Bennington: 'Your full-skinned sad prose
ecstasy has filled me with terror. Each word of yours is a worm to crawl out and
feed upon every damp, slimy thing in the soul's rank comfort. Worms—more
worms—dainty, wriggling, omnivorous!'[30] Obliging Mrs Bennington, 'Miss Alice
continued the worm service' by publishing more free verse in The Squall:

[27] Corrine Lowe, 'Alice Through the Working Class', Saturday Evening Post (3 May 1919), 18.
[28] Ibid.
[29] Ibid. The Squall's cartoonist is probably a parody of Art Young, who contributed to politically
radical little magazines such as The Masses and Liberator, but The Squall's interest in vers libre aligns it
with avant-garde magazines such as the Little Review. Lowe is conflating a spectrum of 'little magazines'
into one parodic, paradigmatic periodical.
[30] Lowe, 'Alice Through the Working Class', 18–19.

When I feel the touch of you, your arm curving about me,
I feel pampered and spoiled like the dainty moon that must have a pillow of sky;
And then I ask myself, Who am I that I should have the touch of your arm?
Hush. Now I know. It is to ease myself of the wolfish X-ray that prowls between you and me,
And will soon tear away this poor lunar upholstery.[31]

Despite the flagrantly sexual nature of her poetry, the story makes it clear that Alice is in fact innocent, pure, and 'really a nice little thing who was only trying to be fashionable'.[32] The fashion in this case—one shared by Mrs Bennington—apparently is an interest in the latest style in free verse, practised by poets such as Mina Loy, a prominent figure in modernist little magazines whose 1917 'Songs to Joannes' begins famously with 'Pig Cupid his rosy snout | Rooting erotic garbage'.[33] Alice, who is 20 years old during the main action of the story, is therefore a perfect example of the young modern woman, and *The Squall*, a little magazine staffed by New York intelligentsia, is an ideal synecdoche for modernism itself.

Mrs Bennington convinces Alice to move to New York and promises to help her obtain a position at a commercial 'woman's page', and Alice soon finds herself among the motley assortment of effete (and often effeminate) 'Bolshevictorians' associated with *The Squall*. The humorous 'Bolshevictorian' moniker typifies the *Post*'s conflation of political radicalism and decadent aestheticism with modernism. Alice falls prey to the bored upper-class marriage games of the Bolshevictorians' wealthy benefactors, the Benningtons. Mr Bennington is a cynical and essentially harmless rake who plays at seducing Alice in order to expose the foolishness of his wife's faddishness. As the story climaxes and the parlour radicals are revealed as cowards and phoneys, Mrs Bennington's dog Trotzky arrives. Her husband declares:

Ah, poor dog . . . do you know that your day is over? Do you know that to-morrow you will be living downstairs with Swami, the goldfish, and his wife, Subconscious, and that you won't be getting any more attention than Freud, the Persian kitten? The Bolshevist fad is over now . . . just like the Swami Fad and the Freudian fad [are] over.[34]

As the story ends, Alice and her hero, a fellow middle-class Midwesterner, flee the dangerous frivolities of Greenwich Village's faddish modernists and bored aristocrats by taking a bus up Fifth Avenue. She professes her enduring love for him, because he looks just like Michelangelo's David, and he confesses his attraction to her because 'you look exactly like a picture on an insurance calendar—one that I fell in love with when I was sixteen and have kept on my desk at home ever since'.[35]

As expected in a *Saturday Evening Post* story, Lowe's heroine is successfully cured of her bohemian afflictions, and the modern young woman lives happily ever after, 'insured' of a happy life because of her conformity to bourgeois values and tastes. Yet a troubling worry remains because, paradoxically, she probably contracted her case of

[31] Ibid. 19. [32] Ibid.
[33] Mina Loy, 'Songs to Joannes', *Others*, 3/6 (Apr. 1917), 3.
[34] Lowe, 'Alice Through the Working Class', 127.
[35] Ibid.

modernism through repeated contact with the consumer culture advertised everywhere in the pages of the *Post*. The upstanding capitalist goods and services advertised in the *Post* are the supposed antithesis of the 'Bolshevictorian' and bohemian leanings of modernism, yet the slogans of mass advertising ('new and improved') and modernism ('make it new') bear an uncanny resemblance to one another. Moreover, the liberation and progress promised by the technologies of modernity, particularly for women, dovetailed dangerously with the freedoms and advances advocated by the politically radical modernists. A female reader of the 3 May 1919 issue of the *Post* would have been sorely tempted by the advertisements to curtail her housework—by heating a can of Campbell's soup on her Hotpoint range in her Hoosier kitchen—so she could don her Ipswich hosiery and step out in the world. A good number of these advertisements highlight women's increasing emancipation through advances in technology and science, and many promise to liberate women from the oft-repeated word 'drudgery'. The magazine's female readership learned to value efficiency, and they clearly yearned to be free of domestic labour. These lessons were at odds with the magazine's editorial content, however, which urged its readers to embrace traditional gender roles. Commenting on the magazine's contradictory messages to women, Jan Cohn observes, 'with regard to modern girls, there was simply bewilderment'.[36]

Thus, the young women of the *Saturday Evening Post* represent a proliferation of contradictions and anxieties surrounding modernism and modernity in the magazine. Liberated by twentieth-century technology, tempted by modernist aesthetics and political radicalism, but wedded to common sense and nineteenth-century morality, the young women of the *Saturday Evening Post* flirt with the boundaries of culture and propriety, only to be drawn back into the traditional spheres of domesticity and femininity they secretly crave. With innocence regained again and again, the women of the *Saturday Evening Post* promise to become the wives and mothers of real Americans, who will, miraculously, make the world more modern—through technology, science, and business—without becoming modernist themselves. Thus, Alice Sunderland's New York escapade works to resolve a deeply embedded set of contradictions in the *Post*: namely, the story narrates the way young American women must navigate the dangerous precipice between modernist licence and modern liberation, and learn to distinguish between the 'bad' modernism that leads to moral dissolution and the 'good' modernization that strengthens and preserves traditional gender and family norms. These contradictions are forever at play in the *Saturday Evening Post*, which was a prominent engine driving American modernization—the very same modernization that threatened to undermine the magazine's ideologically conservative construction of gender roles and family responsibilities. The magazine advocated industrial efficiency and the continued rise

[36] Jan Cohn, *Creating America: George Horace Lorimer and the Saturday Evening Post* (Pittsburgh: University of Pittsburgh Press, 1989), 140. See also Morrisson, *The Public Face of Modernism*, on how magazines both little and large engaged in the maintenance of a 'carefully drawn but ever-shifting line . . . between a healthy interest in consumption and fashionable self-presentation, and morally dangerous sexual abandon' (p. 164).

of mass production, while also deploring the rapid transformation of the traditional family and the extraordinary influx of immigrant workers demanded by these changes; it promoted the new products and labour-saving devices that would free women's time and lives, while expecting those same women to stay firmly bound to their scientifically nourished families in their drudgery-free homes; and the *Post* advertised new forms of mass cultural entertainment—especially radio, film, and phonographs—while demanding that these same consumers steer clear of other innovative cultural forms, particularly the array of texts and practices associated with modernism. Championing modernization but demonizing modernism, the *Saturday Evening Post* had an ambivalent, fearful response to the modernity that encompassed both. The *Post* thus deployed its fiction to shore up the illusive distinction between the wholesome and durable new products of mass consumer culture and the decadent and fashionable innovations of modernism.

'Alice Through the Working Class' is notable not only because the story illustrates the *Post*'s conflicted response to modernism, but also because it offers us a mass-circulation American magazine's depiction of little magazines. In fact, Lowe's story echoes some of the key concerns raised in the lead essay for the 3 May issue, Harry Leon Wilson's 'Naughty Boys!' According to Wilson, all children (because they are disobedient, lazy, and cowardly) are essentially Bolsheviks—and all Bolsheviks are merely children in adult bodies. Dismissively mocking 'dear Nietzsche', Wilson imagines greater success for his childhood radicalism if he had only taken up the printing press instead of the peashooter:

I didn't know it then, but what I should have done was to start one of those radical little papers, something called The New Dawn or Liberty or The Toiling Masses. . . . I don't know why I didn't think of that radical paper to incite those masses of the younger set to do the things I was afraid myself to do.[37]

Wilson ultimately turns his scorn towards 'our learned native Bolshevist . . . those forward-thinking idealists who gather about the samovar and the gas log and talk about the big, the vital things, and try to jazz up the body politic on tea and cigarettes. . . . Vicious they are after the third beaker of oolong!'[38] These native radicals are, of course, the same faddish 'Bolshevictorians' who contribute to *The Squall* in Lowe's story. According to Wilson, the best remedy for America's parlour radicals—those naughty boys!—is a good spanking.[39]

Towards the end of his essay, Wilson describes various intellectual types, many of whom are reprised in Lowe's story. In a section titled 'More Squirrels Than Masses', Wilson repeats 'masses' so often that he is clearly caricaturing *The Masses*, the little magazine that had famously gone on trial a year earlier. In particular, Wilson spoofs Max Eastman and John Reed, two highly visible emblems of little-magazine culture in general. Taking aim at Eastman, Wilson writes:

[37] Harry Leon Wilson, 'Naughty Boys!', *Saturday Evening Post* (3 May 1919), 3, 4.
[38] Ibid. 42. [39] Ibid.

Then we have those literary geishas who write in safe seclusion and take a chance on what happens after it is printed. There is that superstylish Bolshevist, with a safety-first catch, who the other day told a jury he hadn't meant it that way at all.... He is a handsome wretch, who can talk about the causal plexus of the all, and write poetry, and do other literary tatting if he wants to.[40]

The implications of Wilson's characterization of male little-magazine contributors as 'literary geishas' who do 'literary tatting' are unmistakable. The radicals and modernists who write for these publications are little more than idle, effeminate poseurs who are corrupted by foreign influences and have neither common sense, courage, nor a work ethic. Their weakened masculinity encourages otherwise sensible young women to fall prey to all the temptations of the modern world. In Wilson's formulation, radical and modernist writing is merely tatting—the decorative lacework of feminized men who ensnare unwitting young women like Alice Sunderland of Duluth.

 Although the *Post*'s anxious mockery of modernism differs markedly from the *Little Review*'s earnest celebration of it, the markers of modernism are remarkably similar: little magazines, free verse, birth control, free love, and forays outside gender boundaries (whether in the form of intellectual women or effeminate men), as well as radical thinkers (Nietzsche, Freud, Goldman, Eastman, Stein) and novel theories (socialism, anarchism, feminism, psychoanalysis). No matter which stars form a particular constellation of modernism, however, the central figure limned out is a young, modern woman—the mother of modernism in the *Little Review*, or its potential conquest in the *Saturday Evening Post*.

THE NEW YORKER (21 FEBRUARY 1925–PRESENT)

The New Yorker tells yet another story of modernism, which, in the 7 May 1927 issue, takes the form of a parody. The chief target is Gertrude Stein—the intellectual woman who serves not only as an emblem of modernism, but also as a counterpoint to the smart, sporty woman who embodies the *New Yorker* point of view. Founded in the mid-twenties, the *New Yorker* was (and remains) a mid-sized magazine geared towards the upwardly mobile middle class—particularly the fashionable, cosmopolitan set. From the outset, the magazine sought to position itself in the middle of things by focusing on Manhattan, the centre of modern art and culture in America. Founding editor Harold Ross set the tone in his prospectus:

The New Yorker will be a reflection in word and picture of metropolitan life.... Its general tenor will be one of gaiety, wit and satire, but it will be more than a jester. It will not be what is

[40] Wilson, 'Naughty Boys!', 45.

commonly called highbrow or radical. It will be what is commonly called sophisticated, in that it will assume a reasonable degree of enlightenment on the part of its readers. It will hate bunk.[41]

First issued in 1925 with a print run of 15,000 copies, the *New Yorker* reached a circulation of 125,000 by the 1930s—a figure that falls between the *Little Review*'s circulation of 2,000–3,000 and the *Saturday Evening Post*'s peak of 1.25 million.[42] Less intellectual than the *Little Review* and less 'commonsense' than the *Post*, the *New Yorker* fell 'smartly' in between. This delicate balance—neither here nor there, but always in the know—became the signature of the magazine in its early years, as it sought to locate its readers at the centre of urban culture, while retaining an ironic distance from its various constituencies, including the radical set known as the modernists. Modernism, like any other metropolitan phenomenon, fell within the *New Yorker*'s ken, but was not taken too seriously.

Modernism is explicitly invoked in the 7 May 1927 *New Yorker* through Gertrude Stein and little magazines. Stein first gets mentioned in the *Talk of the Town* under the topic 'Erratum', where her name serves as a synecdoche for incomprehensible babble. The editor of the *Evening Post*, whose own paper misreported his social itinerary, 'might perhaps take comfort in the story of Miss Gertrude Stein's contribution, "An Elucidation", in the Paris magazine *transition*. This was so balled up that an elucidation of "An Elucidation" had to be printed separately later.'[43] Stein reappears later, along with James Joyce and baseball legend Ty Cobb, under the headline 'More Authors Cover the Snyder Trial', a hilarious parody by James Thurber.[44] The parody yokes high modernism and popular sports with the top tabloid story of the day: the murder trial of Ruth Snyder. The titillating details of the sordid tale are recounted earlier in the same issue, in a lengthy article by the 'Reporter At Large', entitled 'Clytemnestra: Long Island Style': Ruth Snyder and her lover, Judd Gray, 'slugged' Albert Snyder 'while he was sleeping on his good ear'; when questioned by police, they promptly 'squealed on' each other, thereby killing 'their chance of figuring as one of the great pairs of lovers in history, despite the encomiums which each defendant's counsel bestowed on the other defendant's irresistible sex appeal'.[45] In Thurber's lampoon, the racy tale sounds like a muddled 'Dick and Jane' primer, and Stein comes across as self-centred and egotistical:

[41] Harold Ross, 1924 prospectus, quoted by Ben Yagoda, *About Town: The New Yorker and the World It Made* (New York: Scribner, 2000), 38.

[42] For *New Yorker* circulation figures, see Lyman B. Hagen, 'The *New Yorker*', in Edward Chielens (ed.), *American Literary Magazines: The Twentieth Century* (Westport, Conn.: Greenwood Press, 1992), 215; for the *Little Review*, see Morrisson, *The Public Face of Modernism*, 149; for the *Post*, see Reed, *The Popular Magazine in Britain and the United States*, 105.

[43] 'Erratum', *New Yorker*, 3/12 (7 May 1927), 14.

[44] As Karen Leick argues, the lampoon suggests 'that if Joyce or Stein were to report on this sensationalism trial, each would write in the sensational highly publicized style that Americans knew so well' ('Popular Modernism', 133). Readers of the *New Yorker* would be especially familiar with the modernist sensationalism, given that, in the previous month's 'Paris Letter', Janet Flanner had quoted from Joyce's 'Work in Progress' (what would become *Finnegans Wake*) in the first issue of *transition* (Apr. 1927), 133.

[45] Elmer Davis, 'Clytemnestra: Long Island Style', *New Yorker*, 3/12 (7 May 1927), 33–4.

I
WHO DID WE DID DID WE WE DID, SAYS MISS STEIN!
This is a trial. This is quite a trial. I am on trial. They are on trial. Who is on trial?
I can tell you how it is. I can tell you have told you will tell you how it is.
There is a man. There is a woman. There is not a man. There would have been a man. There was a man. There were two men. There is one man. There is a woman where is a woman is a man.
He says he did. He says he did not. She says she did. She says she did not. She says he did. He says she did. She says they did. He says they did. He says they did not. She says they did not. I'll say they did.[46]

Nailing the repetitive style Stein developed in early writings, Thurber wittily implies that her prose is a trial to read. His heavy use of the pronoun 'I', however, is a less accurate hit. Stein rarely uses the pronoun 'I' in her notorious 1914 collection *Tender Buttons*, though she does use it occasionally in *The Making of the Americans*, which was serialized in *transatlantic review* in 1924 and may have been fresher in Thurber's mind. Thurber exaggerates Stein's use of 'I' in an effort to distance the *New Yorker's* sophisticated 'smartness' from the modernists' solipsistic Intelligence (implicitly spelled with a capital 'I').

The modern, urban young woman who embodies the *New Yorker* sensibility does not play a role within the *New Yorker's* parody of modernism. She remains outside and above the action, a reader who is presumed to be as familiar with the modernist intelligentsia as she is with baseball heroes and tabloid headliners. With her casual yet sophisticated style, the *New Yorker* modern woman hovers between and above the extremes of the modernist sphinx (represented by Gertrude Stein) and the tabloid dame (represented by Ruth Snyder). She is a consumer of all things modern and urbane—highbrow, popular, and lowbrow—but is wedded to none. (Her preferred form, after all, is the parody, not the comedy ending in marriage.) Rather than being cast as the heroine of an ironic modernist drama, a popular romantic comedy, or a sordid tabloid tale, she stars in advertisements for fashionable clothes, automobiles, and French perfumes. On page 1, she appears dressed in 'Paquin's white taffeta frock that swirls asymmetrically to 1927 Summer smartness'. The advertisement depicts a scene worthy of *The Great Gatsby* (1925): a fashionable flapper with bobbed hair stands in front of an open-air deck, where elegant waiters serve diners, and couples dance under the stars. Smartness, the advertisement suggests, is as much a look as a sensibility, a jaunty pose, rather than a serious position. If one looks smart, one must be intelligent—but it's more important to sport a smart look than to spout intelligent thoughts. Smartness, for the *New Yorker*, is a perfect performance that appears casual and effortless. It is thus distinct from modernist intelligence, which demands effort and requires serious intellectual and emotional engagement.

Given that the *New Yorker* woman is a consumer of modernism, it comes as no surprise that modernism is most readily assimilated in the 7 May 1927 issue in its

[46] J.G.T. [James Thurber], 'More Authors Cover the Snyder Trial', *New Yorker*, 3/12 (7 May 1927), 69.

advertising aesthetics. An advertisement for Ben Lewis's shoe store, for example, features a hand-drawn Cubist design with the stylized signature of an artist named ZERO, and the lead item in the 'This and That' column also attests the confluence of high art and commercial culture: 'To illustrate the influence of art, modern, classic and primitive, on the industries of today, R. H. Macy is having an exhibition all this week known, quite appropriately, as the Art in Trade Exhibition.'[47] M.P.'s column 'The Art Galleries' underscores the cultural significance of Macy's show and also recommends the sixth annual advertising art exhibition at the Art Center. The column concludes with a wry comment about the convergence of art and commerce: 'we note of late a healthy sign of shops and stores displaying art in their street windows . . . It is a fine step in the right direction and leads to our ultimate happiness—the day when you can buy Braque pears at Hicks and lesser plums and peaches at Reeves.'[48] Used to sell commodities in the *New Yorker*, modernist art has itself become a commodity, its aesthetics integrated into the latest designs of luxury goods. Thus, Nicholas Trott praises the new sport sedan from the Franklin car company on the grounds that the designer 'accepts the fact that the square-angled chassis frame and the essentially cubical body are the base of car construction. As a result, his bodies are a study in cubism conservatively applied.'[49]

The smart, modern woman of the *New Yorker* is familiar with Stein and little magazines, but does not subscribe to them. She attends baseball games, dressed in the latest sportswear. She goes to the galleries to see the new art and stops at Macy's along the way. In the pages of the *New Yorker*, modernism materializes neither as an ascendant individualism that must be championed, nor as an assault on traditional values in need of defence and salvation, but as a form of entertainment, as well as a product and an aesthetic that can be purchased and appropriated to serve the needs of the smart socialite.[50]

CONCLUSIONS

The *Little Review*, *Saturday Evening Post*, and *New Yorker* tell different stories of modernism, using the disparate forms of one-act play, short story, and parody. Through these stories, as well as through their rich stores of linguistic and bibliographic codes, each magazine positioned itself differently in relation to modernism

[47] K.J., 'Art at Macy's—Dime Novel', *New Yorker*, 3/12 (7 May 1927), 63.

[48] M.P., 'The Art Galleries: A Little Bit of Philosophy While the Editor's Back Turned to Us', *New Yorker*, 3/12 (7 May 1927), 79.

[49] Nicholas Trott, 'Open Air Complex . . . Perilous Town Car', *New Yorker*, 3/12 (7 May 1927), 81.

[50] Thanks to Eric LaForest, Davidson College 2006, for drawing attention to modernism's amusing presence in the *New Yorker*.

and the masses.[51] Championing modernism, the *Little Review* aggressively challenged conventional morality and mass culture. The *Saturday Evening Post*, in contrast, fed the public a homogeneous diet of common-sense wisdom, which included frequent warnings about the dangers of modernism to the public health. Poised between these two extremes, the *New Yorker* assumed a stance of familiarity with both modernists and the masses, while also projecting itself as too suave and sophisticated to be riled by either.

These three American magazines are by no means representative of the wide range of mass-market magazines, popular digests, quality monthlies, pulp fiction rags, political journals, university-affiliated literary magazines, and special interest publications of the era—or of the many nations, cultures, and constituencies that produced them. Nevertheless, these stories provide significant evidence of a complex, mutually constitutive relationship between modernism and mass culture. Published in 1914, 1919, and 1927, and presented here in chronological order, the stories also suggest a narrative arc for the development of modernism in America: from modernism's first formulations by the high-minded, self-fashioning radicals of the *Little Review*, who were experimenting as much with life as with art; to its big break on the public stage, where it was greeted with great consternation as an alien invasion by the *Saturday Evening Post*; to its appropriation as a familiar and fashionable commodity, with brand-name celebrities and easily parodied forms in the *New Yorker*. But this is only one possible overarching narrative of modernism in magazines. Had we examined stories from other periodicals or geographical areas, we might have come across entirely different perspectives that plot out widely divergent narrative arcs. Or not, because what is most surprising about the three stories discussed here, drawn almost at random from three very different types of magazine, is the common ground between them.[52]

Despite differences in genre, tone, and perspective, the stories of modernism recounted in the *Little Review*, the *Saturday Evening Post*, and the *New Yorker* bear two important similarities. Firstly, in these journals, modernism is identified through little magazines. Political ideas, lifestyle choices, and aesthetic practices are recognized as modernist to the extent that they are affiliated with and endorsed by little magazines. Characters are also modernist to the extent that they affiliate with, contribute to, and read the 'littles'—where verse is free, sexuality is liberated, and tradition, morality, and behaviour are refreshingly, terrifyingly, or laughingly challenged. For modernists, as well as for their commercial counterparts, the little magazine served as a synecdoche for an entire artistic, social, and political phenomenon. Secondly, in the magazines we examined, the modern woman is a recurring, emblematic figure for modernism, whether as its producer, potential conquest, or

[51] See Jerome McGann, *The Textual Condition* (Princeton: Princeton University Press, 1991), and George Bornstein, *Material Modernism: The Politics of the Page* (Cambridge: Cambridge University Press, 2001), for theorization of linguistic and bibliographic codes.

[52] For some European modernists, twentieth-century America—especially New York City—had iconic status as the exemplary culture of advanced modernity. If Europeans looked to America for markers of modernism, they may well have found themselves riveted by the same preoccupations.

consumer. Each magazine defines its identity through a different type of modern woman—the free-thinking anarchist of the *Little Review*, the domesticated flapper of the *Saturday Evening Post*, or the smart socialite of the *New Yorker*. Although this female icon may have a male mate who also responds to modernism, the modern woman is the focal point for gauging this phenomenon, perhaps because she, like modernism itself, was a new and disruptive phenomenon in the early decades of the twentieth century.

Whereas men had enjoyed power and freedom in the public sphere for centuries, the modern woman had only recently become a visible, vocal presence there.[53] Indeed, the rise of modernism and mass culture converged with dramatic changes in women's experiences. A middle-class American woman in 1850 might have lived on a farm, where daylight hours were devoted to domestic labour and management; reading—if she had the time and material—would be done in the evening by fire or candlelight. By 1920 a middle-class American woman was more likely to be living in a city apartment with a telephone, electric lights, running water, an oven, ready-made clothes, and perhaps even a washing machine. For anything she lacked, she could take an elevator downstairs, get in a car, trolley, or subway, and go to a department store, where she could purchase what she needed—along with the latest issue of *Ladies' Home Journal*. Modern conveniences gave millions of women greater leisure time, mobility, access to reading materials, and buying power. Recognizing women's central role in relation to magazines, manufacturing, and modernity, Cyrus Curtis, the innovative publishing magnate, declared:

Do you know why we publish the Ladies' Home Journal? . . . The editor thinks it is for the benefit of American women. That is an illusion, but a very proper one for him to have. But I will tell you; the real reason, the publisher's reason, is to give you people who manufacture things that American women want and buy a chance to tell them about your products.'[54]

Because of her increasing autonomy, the modern woman became a testing ground for all things new and dangerous. The magazine stories examined here illustrate an array of responses to her increasingly prominent presence in the public sphere and her new-found power and mobility in the commercial marketplace. The *Little Review* champions women's emergence out of the private, domestic sphere into the public world of publishing (even as it recognizes the social forces that constrain her); the *Post* condemns her movements into the public sphere, flashing the crisis of a dissolved domestic sphere before its readers' eyes, only to resolve that crisis by returning the modern woman to her rightful place in the American middle-class

[53] Jürgen Habermas argues that the public sphere was corrupted in the nineteenth and twentieth centuries by the rise of mass commercial culture. But what Habermas sees as the decline of the public sphere can also be viewed as its democratization: as more recent historians and theorists have shown, the mass commercial marketplace constituted a much larger and more inclusive public arena, more open to the working classes and women (Morrisson, *The Public Face of Modernism*, 7–9). If the advertisements in *The Post* and the *New Yorker*, which touted everything from washing machines to fine furs, are any index of the workings of the commercial public sphere, it was especially welcoming of women, who represented a rich market for new household goods and luxury products.

[54] Quoted by Reed, *The Popular Magazine in Britain and the United States*, 18.

home; and the *New Yorker* burlesques the modern public woman, embracing her as a form of entertainment but refusing to take her too seriously.[55] Although the rise of modernism in magazines cannot be reduced to a simple formula (i.e. that modernization led to the modernist woman), it is clear that in American periodical culture the young urban woman is emblematic of modernity—and when she has a little magazine in her hands, she is an iconic figure of the forms of behaviour and aesthetics that we call 'modernism'. Additionally, this modern woman represents the ideal consumer of mass culture, one who embodies the newness, youth, and individualism valorized both in the commercial drive to make 'new and improved' products and in the modernist drive to 'make it new'.[56] Modernism and little magazines were not only products of the same culture of modernity that generated mass culture, mass advertising, and mass-market magazines, but also banked on the same ideals of youth, individualism, and self-improvement, and modelled these ideas in the form of a young modern woman.

The story of modernism in magazines is a tale of complex entanglements between high art and intellectual thought, mass culture, and the commercial marketplace. This story supplants the myth of the lone, alienated artist battling against the cloddish bourgeois, and recasts the modernist as a person (or collective) engaged in a broader and variegated effort to use modern print culture to transform individual consciousness and shared social ideals. Mark Morrison's study of little magazines evinces 'optimism about the power of mass market technologies and institutions to transform and rejuvenate contemporary culture', and modernists shared this sense of unprecedented opportunity with their commercial counterparts, who likewise sought to exploit the power of new print technologies and burgeoning audiences.[57] Studying magazines of all sizes allows us to see modernism as part and parcel of modernity—an artistic and social phenomenon shaped by and within a rapidly expanding, increasingly commercial public sphere. By reading modernism in magazines, we can picture Janet Ransome as a Nietzschean hero, Max Eastman as a Bolshevictorian literary geisha, and Gertrude Stein as the Cubist parody of a Long Island moll.

[55] Thanks to Ethan Jaffee, Davidson College 2009, for this formulation.

[56] See Morrisson, *The Public Face of Modernism*, 133–66, for a detailed discussion of modernism's participation in the commercial 'cult of youth'.

[57] Ibid. 6.

PRIMITIVISM

MODERNISM AS ANTHROPOLOGY

MICHAEL BELL

This thing of darkness I acknowledge mine.
(William Shakespeare, *The Tempest*, V. i. 130)

PRIMITIVISM, as the nostalgia for a pre-civilized condition, is an ancient motif. It must be almost as old as the capacity for civilized self-reflection for which 'primitive' is a necessary term. And by the same token it is always a projected attribution dependent on the viewpoint of the civilized. For no life condition can be primitive in itself, and the word must be understood within implicit quotation marks. It follows from this, too, that primitivist expression, especially within the arts, is likely to reflect most significantly not on the supposedly primitive life forms which are invoked so much as on the condition of mind and feeling from which the primitivist impulse arises. The tradition of pastoral organizes such a recognition into an aesthetic convention, but within the culture at large there will be more literal conceptions, and misconceptions, of the primitive 'other' which are not so securely contained aesthetically. Primitivism, therefore, is always likely to reflect underlying cultural formations and, although there has been a recognizable continuity in perceptions of the primitive through different historical phases of European and Anglophone culture, the early twentieth century was a distinctive and transitional period partly because of the gradual establishment of anthropology as an intellectual discipline. Anthropology, as the study of tribal peoples which had been developing apace since the eighteenth-century Enlightenment, indeed as an important aspect of

the Enlightenment's own self-definition, now began to shift its value to become a crucial means for a newly radical critique of Enlightenment itself.

But such large shifts do not occur quickly, or uniformly, across a culture, and along with its complex range of manifestations when looked at collectively, a significant aspect of the primitivist motif in the literature of the period is its Janus-faced ambivalence at almost all times. The word itself encompasses two opposite evaluations. The 'primitive' can be what is unspoiled, a pure origin, or it can be the crude and undeveloped. Moreover, whereas both of these meanings generally assume a confidently civilized viewpoint, whenever the primitive appears as a threat it may be seen as the barbaric; as that which follows and destroys a civilization. Furthermore, along with these ambivalent meanings, primitivism is not simply bound by temporality. It may have not just a backward vista, whether nostalgic or condescending, but a forward and utopian one.

Because primitivism covers in the abstract such a wide and elusive range of possibilities, the example of D. H. Lawrence will be used as a continuing comparative thread. I have indicated elsewhere that Lawrence was the most substantial modern primitivist, and precisely because of that, he was also the most penetrating critic of the primitivist impulse as a peculiarly modern form of sentimentality.[1] And yet, for all this, he was himself also capable of being ensnared in its inauthenticities. To see all these possibilities within one writer helps to warn against single, all-encompassing definitions and brings out the internal relations between different aspects and modes of modern primitivism. But before exploring some specific writers, it is important to make some general observations.

MODERNIST CONSTRUCTIONS OF THE 'PRIMITIVE'

Despite its scholarly and scientific claims, the anthropology available to the generation of Conrad, Eliot, Joyce, Lawrence, Pound, and Yeats was still pre-scientific and based on premises that would be dismissed by the later discipline of social anthropology. Most importantly, there was assumed to be a universal primitive mind, which could still be encountered among tribal peoples around the world, and which represented a stage in cultural evolution through which modern Western man had once passed. Lucien Lévy-Bruhl's *Primitive Mentality* (translated in 1923), originally published in 1922, the year of *The Waste Land* and *Ulysses*, is a classic instance. Clearly, these assumptions served to maintain the rationale of colonialism as a dutiful stewardship of less developed peoples. But this was also the period in which such Victorian assumptions, notably documented by George Stocking, were being questioned. From the turn of the century until his death in 1912, Andrew Lang had already

[1] Michael Bell, *D. H. Lawrence: Language and Being* (Cambridge: Cambridge University Press, 1992).

questioned the intellectual premises of Frazer, whose influential study *The Golden Bough* was growing throughout the period from 1890 up to its summative version of 1922. More significantly, Bronisław Malinowski laid important foundations for later anthropological practice through the field work that was to result in his *Argonauts of the South Pacific* (1922). In contrast to 'armchair' scholars, like Edward B. Tyler and Sir James Frazer, who developed extensive theories from library resources, he insisted on the necessity for direct observation from within the culture, however problematic and elusive that criterion was to prove in practice.

There is, therefore, a continuous critical judgement required by readers of the literature based on, or making use of, this now discredited mode of anthropological thinking. At one extreme, such literature may be dismissed as not only misled, but politically pernicious; and the more so since some of these questionable assumptions continue, as Marianna Torgovnick has emphasized, to underlie popular beliefs and attitudes down to the present day.[2] Yet a false science no more governs the value of the literary imagination than the humours theory of Chaucer and the cosmology of Shakespeare determine the value of their imaginative worlds. More important is the complex of attitudes out of which these beliefs were created. A widespread belief which is not true is for that very reason the more culturally revealing, and modern primitivism is as much a means of cultural self-critique as of ideological self-deception. Indeed, our later critical standpoints are themselves largely derived from this period's self-reflection, its imaginative questioning of its own assumptions. In its positive aspect, the idea of primitive man in this period represented a significant image of human wholeness, a counter-image to the felt alienation of modernity. In short, it is precisely because the belief in the lost mythopoeic unity of an archaic world may be in itself one of the most powerful myths of the period that the literature based on it needs to be approached with a critically alert and historically informed response.

In effect, modern primitivism was one of the means by which this literary generation explored the limits and tested the premises of Enlightenment. A significant form in which the spirit of Enlightenment still governed much modernist writing, albeit ambivalently, was its universalism. For example, the belief in the advanced evolutionary state of white Europeans, however damaging in some respects, rested on an assumed unity of mankind which was part of an otherwise progressive outlook. In this respect, a powerful new current in the understanding of man was the Freudian theory of the unconscious which was itself universalistic, drawing on archaic mythic motifs, such as Oedipus and Elektra, to define universal psychic experiences. Freud was immensely interested in contemporary anthropological study of 'primitive' man as a means of insight into hidden layers of the psyche. He collected tribal objects, and drew on terms such as 'totem', 'taboo', and 'fetish' for his explanations of psychic phenomena. Freud's notion of the unconscious gave discursive articulation and support to a more generalized perception that primitive man lurked, as a permanent

[2] Marianna Torgovnick, *Gone Primitive: Savage Intellects, Modern Lives* (Chicago: University of Chicago Press, 1990).

danger, within the civilized self. For as Freud made clear in his late work *Civilization and its Discontents* (1930), the achievement of civilization is based on the suppression and sublimation of instinctual life. It is a tragic conception in line with the rationalist strain of Enlightenment.[3]

At this point it is necessary to note that a larger culture war of the period was partly defined through opposed notions of classic and romantic. Some of the modernist generation, such as Eliot, Joyce, and Pound, saw themselves as affirming a classical spirit against the supposed subjectivity and undisciplined emotionalism of the romantic heritage, while others, such as Lawrence and Yeats, positively acknowledged their romantic descent. For them, it was rather truth of feeling which guided both the good life and the creation of form. But, in truth, even the classical wing of modernism was itself part of this generation's internal reworking of romantic insights, just as romanticism in turn was an internal self-balancing of the Enlightenment. The antireligious and rationalist thrust of the Enlightenment, especially in France, had given rise, most notably in England and Germany, to a corrective emphasis on the importance of feeling along with the immanent divinity of nature, the 'natural supernaturalism' defined by M. H. Abrams.[4] And given recent interest in the gender of modernism, it is worth noting that the eighteenth-century 'man of feeling', who was a precursor to romantic sensibility, had been highly feminized, and therefore marginal. These gender implications continue into modernism in so far as the struggle for authority on both sides of the modernist generation was often perceived as a masculine value, whether this was through the formal discipline of Joyce or the emotional self-discovery of Lawrence.

In broad accordance with classic and romantic allegiances, there were two opposed responses to 'the primitive within'. These responses were so opposed in their temperamental premises as to be mutually incommunicable even though each believed the other to be transparently misguided. For the 'Freudian' conception was significantly countered by what could be called the 'Nietzschean', or 'Lawrencean', view. On this account, instinctual life is not intrinsically dangerous and therefore requiring repression; rather, it becomes dangerous because it is repressed. Friedrich Nietzsche affirmed this in *The Gay Science*, while in Lawrence's *Women in Love* (1920) Gerald Crich and Rupert Birkin argue, rather fruitlessly, over the merits of these opposed conceptions.[5] Gerald argues that if we all acted spontaneously on our instincts we would all be killing each other; Birkin counters that this belief is merely a sign of Gerald's own murderously repressed condition, although he acknowledges that to act with true spontaneity would indeed be a rare and difficult achievement. From this point of view, pre-modern tribal cultures represented for Lawrence not that which must be disciplined and developed, but

[3] Sigmund Freud, *Civilization and its Discontents* (London: Hogarth Press, 1930).

[4] M. H. Abrams, *The Mirror and the Lamp* (Oxford: Oxford University Press, 1953).

[5] Friedrich Nietzsche, *The Gay Science*, trans. Walter Kaufmann (New York: Random House, 1974), 236; D. H. Lawrence, *Women in Love*, ed. David Farmer, John Worthen, and Lindeth Vasey (Cambridge: Cambridge University Press, 1987), 32–3.

a unique living clue to the instinctual self from which modern man is so estranged that he cannot even recognize what he has lost.

All the writers mentioned so far were aware of Nietzsche, whose *The Birth of Tragedy Out of the Spirit of Music* (1872) had already effected a complex reformulation of the classical spirit in relation to the primitive. J. J. Winckelmann's ideal of classical serenity, the 'noble simplicity and quiet grandeur' espoused by Goethe, was given an opposite meaning in Nietzsche. For him, the spirit of lucidity and order associated with the god Apollo, and expressed in ancient Greek art, did not express the given reality of Greek life but was precisely the artistic dream the Greeks needed to project in order to counter the power of the god Dionysos, the god of wine, orgy, and social destruction, to whom they would otherwise have been too close. For Nietzsche, the Dionysian orgies were a ritually contained form through which ancient peoples in the early stages of civilized evolution were able to maintain a connection with, indeed a periodic immersion in, the primal energies of life. So Nietzsche, too, had a tragic conception of life, but this was tragedy as affirmation of instinctual energy despite the pains and costs.

For Nietzsche, however, the history of Greek tragedy represented a gradual process of overcoming this primitive power, and then finally a complete loss of connection with it. In Nietzsche's radical critique, post-Socratic Enlightenment, in effect the whole of Western culture, had an inbuilt tendency to decadence for which modernity was the final phase. Importantly, however, he recognized that the Dionysian power was not only destructive but impossible to experience without the mediation of the Apollonian spirit of art. For the pure Dionysian would destroy the individuality and consciousness on which the experience, as experience, would depend. So the great achievement of the Greeks, in his view, was to turn this experience from a primitive, and destructively literal, ritual into an aesthetic experience gradually removed to the separate realm of the theatrical stage. Similarly, the aesthetic was the most likely mode through which the Dionysian power could still be recovered, even in modernity. For the younger Nietzsche, the musical drama of Wagner seemed for a while to be precisely such an art.

Likewise, it is vitally important where modern primitivism is concerned to note the difference between literalistic conceptions, whether nostalgic or repressive, and conceptions which are crucially defined by aesthetic mediation. In the 'Fetish' chapter of *Women in Love*, for example, Gerald and Birkin react differently to an African statuette of the kind that greatly influenced visual artists of the period.[6] Where Gerald finds it repulsive, Birkin sees it as the expression of an alternative human development with an intimate meaning for the world around him. He does not wish literally to espouse, nor does he recommend espousing, this other form of life, but the statuette, with the concentration peculiar to a work of art, provides a powerful formulation of psychic possibilities he feels to be lacking in his own mode of life. The same applies for a writer of the opposed ideological standpoint. Thomas

[6] Lawrence, *Women in Love*, 77–81.

Mann's fifty-year career was a sustained agonistic struggle with Nietzsche from within a 'Freudian' conception. Hans Castorp, in Mann's *The Magic Mountain* (1924), is able to experience the romantic, Dionysian longing, now identified as the Freudian death wish, expressed in pieces of music by Schubert and Verdi. Yet he does not, like many of his contemporaries, succumb to its power. Through an aesthetic experience, his life can acquire the necessary gravitas of this knowledge without his literal yielding to the destructive impulse.

As John B. Vickery has shown, Nietzsche's new appreciation of the primitive under the sign of Dionysos was echoed in the generational reaction of modernist writers to *The Golden Bough*.[7] Frazer's work was a monument of late Victorian anthropology in the mode of agnosticism. In a universalistic spirit once again, it analysed a great variety of folk customs around Europe and the Middle East as the survivals of ancient seasonal rituals promoting fertility. It looks back on that early stage of culture as a period of superstition which scientific enlightenment has overcome. And although any statement of its implication for religious belief had to be handled with ironical finesse, the implication for Christianity was clear enough: Christ was yet another of the seasonal gods whose destruction in the springtime led within three days to a renewal of life. As Vickery points out, however, the modernist generation were engaged less by the agnostic condescension of Frazer's enlightened argument and more by the cultural wealth, and the poetic pregnancy, of the archaic life forms he had assembled. Ludwig Wittgenstein, in his brief remarks on *The Golden Bough*, written in the 1930s, makes the point in a philosophical way that involves of necessity a personal and cultural critique of Frazer. Frazer's assumption of superiority blinds him to the possible meaning of his own material because it leads him to think of magic as a 'mistake'. Wittgenstein does not claim to know the 'true' meaning of it either, but he sees that man is a 'ceremonious' animal and that modern man is no less ritualistic, and properly so, than were these remote ancestors.[8]

Wittgenstein shared with his modernist contemporaries here a recognition that man, as a linguistic animal, creates worlds which may be incommensurable and therefore not open to judgement from another world-view, nor indeed from some universal viewpoint of reason for in this context that very criterion begins to shimmer. It is the dawning consciousness of living not in a world but in a world-view that Martin Heidegger, another radical critic of Enlightenment, was later to suggest as a defining feature of modernity. Modern man learns to understand the world picture of the classical period, and of the Middle Ages, yet neither of these had a consciousness of inhabiting a world-view. Only modern man, through his aware-ness of historical relativity, acquires such a double consciousness of the 'world' he himself inhabits. Heidegger saw anthropology, for that reason, as the defining modern discipline: the discipline that throws man himself into question both as an

[7] John B. Vickery, *The Literary Impact of the Golden Bough* (Princeton: Princeton University Press, 1973).
[8] Ludwig Wittgenstein, *Remarks on Frazer's Golden Bough*, ed. Rush Rhees, trans. A. C. Miles (Hereford: Brynmill Press, 1979), 1e, 7e.

entity in himself and as a standpoint for inquiry.[9] Just as importantly, however, the same awareness then begins to inform modern man's relation to other contemporary cultures, as can be seen in a number of literary texts.

Primitivism in the Literary Imagination

It is evident by now that the literary imagination could hold primitivist materials or motifs in a variety of interpretative frameworks, sometimes even simultaneously, and indeed this is how it was able to throw those very frameworks into question. Joseph Conrad's *Heart of Darkness* (1899), with its multiple narrative frames, is a classic instance. Conrad's novella bases itself on the Victorian and 'Freudian' conceptions as already defined. Modern Africa embodies the primitive condition that Britain had once represented when colonized by the Romans. And in so far as that primitive state still exists secretly or potentially within the civilized self, Marlow's journey up the river is a journey into the psyche.

In its ideological framing the work partakes of contemporary racist and colonial culture, as Chinua Achebe has claimed, but Conrad subverts these understandings from within.[10] According to a widespread and long-standing European belief, which has itself since been challenged as largely mythical, the African crew in the story are believed to be cannibals and yet, as provisions grow short, they do not attack Marlow or his white passengers. They exercise 'restraint' in striking contrast to almost all the white Europeans encountered in Marlow's narrative, and restraint is the essence of morality in the 'Freudian' conception. Meanwhile, the Europeans have abused the pedagogical and protective role that would be the only justification for their presence in Africa. In this respect, Conrad's novella is squarely in the tradition of Montaigne's essay 'Of the Cannibals', in which he remarks, after praising their 'restraint', that 'We may well call them barbarous in regard of reason's rules, but not in respect of us that exceed them in all kinds of barbarism.'[11] In Conrad, however, the European barbarism does not just exceed that of the Africans, it arises precisely from the internal nature of the supposed civilization. That is a crucial recognition and although the moral horror that Conrad depicts in the story does not dismantle his ideological framework, and indeed it depends on that for its presentation, it nonetheless shames that framework and is a significant step in the decolonization of the European mind. Of course, as Achebe himself witnesses, the decolonization of the colonized mind is

[9] Martin Heidegger, 'The Age of the World Picture', in *The Question Concerning Technology and Other Essays*, trans. William Lovitt (New York: Harper and Row, 1977), 133.

[10] Chinua Achebe, *Hopes and Impediments: Selected Essays 1965–1987* (London: Heinemann, 1988), 1–13.

[11] Michel de Montaigne, *Selected Essays of Montaigne*, ed. Walter Kaiser, trans. John Florio (Boston: Houghton Mifflin, 1964), 76.

another story which would eventually require another literature beyond the scope of European modernists.

Conrad's implicit analysis of the colonial mind is effectively extended and deepened by an episode in Lawrence's *The Rainbow* (1915). The principal character, Ursula Brangwen, has a protracted affair with her cousin Anton Skrebensky, during which he does military service in Africa. Although she has by now realized that he is a hollow man, and not a suitable soul-mate for her, she is momentarily moved when he speaks to her of Africa and its 'darkness'.[12] In the context of the novel, it is clear that his own emotional repression, which is the reason she rejects him, is also the source of his fascination with Africa. He is both fascinated and repelled: fascinated because the 'primitive' life he encounters there is his own repressed self, and repelled because he cannot acknowledge it as his own. The 'Africa' in question is entirely an Africa within. Ursula is momentarily moved because he comes so close to revealing himself, and she is also briefly infected by his primitivist exoticizing, but he gains no insight into his own condition and goes off to colonial service in India.

In this episode, Lawrence encapsulates the essential insight of later post-colonial critique, the exotic construction of the 'other' as primitive, and he does it so effectively partly because this is not a novel 'about' colonialism. It is set almost entirely in the English Midlands and is concerned with the inner condition of its modern European characters as understood within their own myths of origin, biblical, Darwinian, and anthropological. His insight into the colonial relation is a by-product of a larger analysis of modernity in which the narrative language subtly places the religious and scientific conceptions of human origins, the scandalous rivals of the Victorian era, within an anthropologically informed vision of a possible mythopoeic relation of man to nature and to himself. I have explicated elsewhere how, in the multilayered psychology of the characters, the three historical generations of the Brangwen family simultaneously represent the much longer time-span of three stages in human evolution expounded by a number of anthropological thinkers: the mythic, the religious, and the scientific or modern.[13] The significance of this larger evolutionary context is that it enables Lawrence to define as a more than merely personal matter the thwarted, nostalgic projection of a lost or repressed self in Skrebensky. Quite unwittingly and impersonally, Skrebensky represents modern primitivism in its aspect as symptom.

The case of *The Rainbow* suggests another significant distinction I have developed elsewhere: that between a 'conscious primitivism' and a 'primitive consciousness'.[14] Much contemporary anthropology suggested that early man had a sympathetic, magical relation to nature which was incompatible with a scientific world-view. Ernst Cassirer, in his three-volume *Philosophy of Symbolic Forms* (originally published 1923, 1925, 1929), drew on this anthropological literature to define, in terms of

[12] D. H. Lawrence, *The Rainbow*, ed. Mark Kinkead-Weekes (Cambridge: Cambridge University Press, 1989), 413.

[13] Bell, *D. H. Lawrence*, 76–92.

[14] Michael Bell, *Primitivism* (London: Methuen, 1972).

Kantian world construction, the tragic incompatibility between the archaic and modern world-views. A world of magical and ritual efficacy had its own sense of time, and its own way of relating to significant objects in the world; a relation of identification or natural piety rather than instrumental use value. It is difficult to disentangle in this anthropological conception the elements of objective observation and romantic theorizing. But so far as literature is concerned, the distinction is not necessarily crucial if the author can present a persuasive embodiment of a given sensibility inhabiting a world. It may even be that the best presentation of a 'primitive' sensibility or mode of consciousness would have no archaic setting or mythic motif; no overt signature, whether exotic or scientific, of the primitive. Some of the most characteristic and uncanny moments in Wordsworth's poetry, for example, would exemplify this, as does much of the narrative language of *The Rainbow*. Indeed, the strength of *The Rainbow* is that it draws primarily on a Wordsworthian poetic heritage and is not made excessively self-conscious by an inflection into anthropological theory. This reflects the fact that, for Lawrence, such theory mainly confirmed what he had already intuited or surmised.

On the other hand, just as it is possible to express primitive consciousness without an ostensibly primitive subject matter, so it is possible to represent primitive material without a truly primitive consciousness. The classic modernist example of this would be Eliot's *The Waste Land* (1922), in which the title signals its structural allusion to the myth of the Fisher King as interpreted by Jessie L. Weston's *From Ritual to Romance* (1920). Weston had argued that medieval Arthurian romance was derived from primitive myths concerning fertility rituals. She was influenced by the Cambridge school of anthropology arising from Frazer which had evinced from the outset strong literary associations. Frazer's title is itself a reference to the golden bough which Virgil's hero Aeneas has to take into the underworld in *Aeneid* 6. His whole study could be taken as a gigantic footnote to a line of Virgil. Eliot uses the fertility myth as the implicit background commentary on the modern condition, although the power of the poem lies largely in the fractured, distorting, and grotesque lens through which this is dimly perceived by the modern sensibility. Eliot, therefore, exemplifies Vickery's observation that the modernists reclaimed Frazer's primitive material as a criterion to hold against the modern condition, but he nonetheless shares Frazer's bookish medium of reflection. Eliot's poem, as borne out by his œuvre overall, is a spiritual quest in which allusions to primitive forms are rather symbolic and distanced. Indeed, for many readers, there is an emotional contradiction at the heart of the poem in so far as its now classic images of sterile modern sexuality seem rather to reflect an underlying discomfort with sexuality as such. The house agent's clerk and the typist are as much expressions of social condescension and distaste. Yet the intensity and concentration of the poem have stamped an indelible image on its age, its vision of modernity has often been treated as a premiss rather than a particular sociocultural projection, and Eliot's essentially oblique, allegorical use of the primitive allusions is a key element in the imaginative authority it has exercised.

Eliot's case is a reminder, therefore, that the creative premises and processes as perceived by the author do not necessarily reflect the artistic outcome, so that the

distinction between a sympathetic creation of primitive consciousness and conscious use of primitivist motifs may not be apparent to the writer. William Golding's two early novels *Lord of the Flies* (1954) and *The Inheritors* (1955) are perhaps cases in point. Golding's first novel is a post-war fable of regression to the primitive seen within the 'Freudian' model of a collapse of civilized restraint. It is deftly told for its purpose, although it is doubtful whether its tendentious psychological premiss would be fully persuasive if its interest lay more purely at a level of psychological realism. Its true focus lies at the level of cultural formations as it seeks to challenge popular heroic models of boy's literature such as R. M. Ballantyne's *The Coral Island* (1857). In the first version, which was radically changed at the publisher's suggestion, there was a long opening section recounting the plane crash by which the boys arrive on the island. The motive for cutting this may have been dramatic economy, a desire to cut to the chase, but it has the effect of removing a certain realistic context and placing the boys in a more mysterious imaginative, as well as physical, environment. In other words, we may doubt quite how much Golding himself recognized what he was doing here, but the effect is achieved. Similarly, *The Inheritors* had its origin in a response to the optimistically progressive narrative of H. G. Wells's *Outline of History* (1920). On the literal face of it, Golding's second novel attempts to convey the mind and sensibility of a group of Neanderthals in the process of being supplanted by a more aggressive breed, the ancestors of modern man. Once again, Golding may have had a more anthropologically literalistic conception in the writing, but the story is told with an art that rather maintains concentration on the fable of a lost innocence. For no one knows what a Neanderthal consciousness would be like, and any more thoroughgoing, realistic attempt to re-create such a world would probably present damaging problems for the narrative. The artistic tact of the book, therefore, is precisely to avoid this, to suggest rather a primary contrast of the innocent and ruthless in terms which make sense to readers. As it happens, Golding's two novels present opposite conceptions of the primitive, the barbaric, and the benign, but in each case it functions as an ideological motif within a civilized self-reflection; a conscious use of the primitive idea without invoking a truly primitive consciousness.

Yet if Golding's primitive motif is artistically contained, conscious primitivism has its dangers, both politically and artistically. In the 1920s, when he was already in many respects isolated from a mainstream readership, Lawrence was invited to settle in the native American country of the American south-west, where he was initially suspicious of the modern white interest in the native Americans, which he saw as a sentimental indulgence. Yet he also increasingly felt there was something important in this fascination, that the native American mode of life and being could give some clue for his own quest for the full life, and he went on to visit Mexico just as the post-revolutionary government was seeking to build a new society and to acknowledge, if not recover, the native heritage of the Mexican people. Diego Rivera had just painted indigenist murals in the Ministry of Education and the anthropologist Manuel Gamio was recovering knowledge of pre-Columbian culture. Lawrence viewed these developments with some sympathy, but he saw them as fatally flawed in so far as they were manifestations of modern political and artistic will. Accordingly, in

The Plumed Serpent (1926), a novel which he for some years thought would be his most important work, he speculated about a more profound and organic transformation of modernity through a revival of the ancient pre-Christian religious sensibility of Mexico. He imagined a Mexican anthropologist, Ramón Carrasco, leading a revival of the old religion.

The novel, despite many brilliant passages and elements, is generally, and I think rightly, regarded as a failure. There are several dimensions to this, including Lawrence's reactive assertion of male dominance in the sexual relation which Torgovnick emphasizes as a widespread motif in modern primitivism. But the root cause of the novel's imaginative failure is the overt anthropological self-consciousness in its attempts to present the ancient religious sensibility. By a strange irony, the suggestion of natural religion which had been presented dramatically but subliminally in the language of *The Rainbow* has now become a conscious project constructed in a discourse whose explicitness denies its intended meaning. Even as it notionally affirms the pre-conscious character of a pre-modern sensibility, its discourse is too often that of conceptual and self-conscious modernity. Far from being the culmination of the Lawrencean vision, therefore, it is an unwitting parody of his true genius, his romantic critique of modernity. It is an exemplary lesson in how close for modern primitivism the authentic is to the inauthentic. Nietzsche's disenchantment with Wagner was premonitory in this respect. When he came to 'see through' Wagner, he saw him not just as an artistic failure but as a mesmerically seductive mountebank. For a while Lawrence cast a comparable spell on himself.

POLITICS, POWER, AND MYTH

The rhetorical weakness of *The Plumed Serpent*, along with a strained mixture of literalism and utopianism, constantly blurs its effect and has led to understandable misreadings. Lawrence imagines an essentially religious revival led by a charismatic figure, but at some point this will have to find a political expression as the whole society adopts the new, or rather a version of the ancient, religious life form. Casual readers of Lawrence have seen this as fascism, whether literary or literal in its intention, and as revealing the true tendency of his œuvre. The latter claim is surely wrong and, in fact, by two years after the book's publication, Lawrence had rejected the 'leadership' notion, travelled to Italy, and turned his attention to another ancient culture, the Etruscans, whom he praised for all the qualities that distinguished them from their conquerors, the ancient Romans, who were the explicit model for Mussolini's Fascist Party, now already in power. *Etruscan Places* (1932) is equally primitivist, but it is an explicitly anti-fascist book. One might say that Lawrence was truly interested in ancient religious consciousness and only superficially in politics, whereas fascists were truly interested in political power and had only a pretended interest in

religion. But there is clearly an important larger theme here about the relations between primitivism in politics and in literature.

A number of writers in the period had expressed values consonant with fascist ideology and in some cases, such as Ezra Pound, there is an evident continuity between literature and politics. But other cases are more elusive and, rather than being seen simply as the literary wing of fascism, they might be taken as giving expression in aesthetic form to contemporary analyses and anxieties which need to be understood if fascism itself is to be properly comprehended. Modernist speculations about power are a particularly troubling case in point. Lawrence's utopian vision of the end of the Christian era in Mexico leading to the return of more ancient and sanguinary gods has an echo in W. B. Yeats's historical speculations in *A Vision* (1926, revised 1937). Yeats imagined a series of historical cycles in which the permanent possibilities of human experience are recycled in opposite, complementary cultures. Hence the idealistic Christian culture of love and benevolence was preceded by the Graeco-Roman era of blood and power, their two different annunciations being imaged respectively as a virgin impregnated *intacta* by a dove and a woman raped by a swan. So in 'The Second Coming' Yeats's speaker anticipates the advent of the world that is to succeed the Christian one as a 'rough beast | Its hour come round at last'.[15]

Both Lawrence and Yeats saw an embarrassment about power in their culture. Not, that is to say, embarrassment about exercising it, but about acknowledging it. They shared Nietzsche's view that the Christian ideal of love was not simply a spiritual leavening of worldly behaviour, but a disabling form of bad faith in the exercise of power. Likewise, certain conceptions of sexual love are unacknowledged forms of power. Once again, Nietzsche's 'will to power' is the model behind these modernist speculations. For him, the will to power is not so much the primitive origin of life at some remote time in the past as the primordial basis of all life now, however highly developed. Nietzsche's organic notion of power here was explicitly very different from the bullying exercise of political or military power, which he regarded as a compensatory symptom of weakness. Yet he was frequently to be taken up in this fascist spirit and, as he was well aware, his thought was dangerous in the wrong hands or in weak heads. His thought was essentially a matter of mobile, diagnostic, corrective insights rather than a programme of action, or even a positive description of the world. The conservative modernists were similarly elusive, and the mutual porousness of philosophy, literature, and politics in their preoccupation with power has to be a constant theme for critical assessment. After all, however utopian their speculations may have been, they all sought an impact upon the world through the medium of their art.

Just as primitivism has a different meaning in politics, so it may have a different life in other artistic media. The successive cults of Oceania and then of Africa in the late nineteenth and early twentieth centuries affected all of the arts but, as has just

[15] W. B. Yeats, *Collected Poems* (London: Macmillan, 1950), 211.

been suggested, it may be that the verbal art of literature finds it hardest to contain such material within aesthetic bounds. Language inevitably affirms, questions, and makes meanings. Painting and sculpture, by contrast, are open to significantly different formal possibilities. While Lawrence's own symbolic geography of the psyche is inscribed in the narrative imagery of *Women in Love*, and extends between the impossible extremes of the 'Nordic' and the 'African', there are also African sculptured objects within the narrative, and Loerke, the type case for a modern artist, is an enthusiast of primitive art. Loerke is, in the first instance, a more developed, sophisticated and self-conscious version of Skrebensky's naive fascination with Africa. His artistic taste is a sophisticated indulgence in the exotic. At the same time, he has technical and expressive power as well as a dark modern experience in his childhood formation. In this regard, he points to the new use of tribal art that occurred in the early twentieth century. As Robert Goldwater has indicated in detail, the nineteenth-century interest in primitive objects had been predominantly ethnographic.[16] But paralleling the modernist writers' reversal of Frazer, modern painters and sculptors began, over the course of a decade or so at the beginning of the century, to see primitive expression with a new appreciation. The 'simple' forms, and the absence of accurate representation, in tribal objects were not signs of incompetence but evidence of a highly developed aesthetic sense. As contemporary art began to reject the representational in favour of various forms of abstraction, such as analytic Cubism, so primitive art became exemplary. Hence, whereas Paul Gauguin, the major primitivist among late nineteenth-century European artists, sought to depict, in a deliberately naive form, the alternative mode of life he had found in Tahiti, Picasso's modernist use of African masks in *Les Demoiselles d'Avignon* (1907) has a more mixed effect. Although his allusions undoubtedly invoke an exotic darkness, they also explore formal possibilities, intense simplifications, which would be crucial to avant-garde art.

This points to a more general paradox of modernist primitivism: that the primitive and the avant-garde can be combined. Joyce's *Ulysses* is a case in which the use of myth in the form of the Homeric parallel at once invokes an archaic template for the modern action and puts it to an ostentatiously avant-garde use. The crucial but slippery term here is 'myth', which in the modernist context affirms both continuity with, and distance from, the primitive. Although the theorizing of myth came largely from anthropology, its use as a central category by modernist writers lent it an ambiguous relation to the primitive. As has been suggested earlier, an important recognition eventually enforced by anthropology is that man is inescapably a mythopoeic animal. Hence, the confident epistemological standpoint of the scientific eye which looks on primitive man eventually sees a mirror reflecting the arbitrariness, or ungroundability, of its own world-view. Myth can then be a sign of this specifically modern recognition with no regressive or nostalgic implication.

[16] Robert Goldwater, *Primitivism in Modern Art* (1938; rev. edn, London: Vintage, 1967).

Joyce's *Ulysses*, for example, is a comedy of man's creation of meaning, each episode foregrounding a different mode of 'world' formation, such as history, science, religion, or literature. Man, that is to say, does not bring existence into being, but creates it as world, as meaning. This is a specifically modern awareness, cognate with the 'linguistic turn' that occurred over the nineteenth and early twentieth centuries. Joyce's modernism both celebrates and satirizes man as the linguistic animal and creates an artistic, psychological unity out of the incommensurable discourses progressively assembled in the individual episodes. He does not so much return to the archaic myth as create an ostentatiously modern equivalent through overtly aesthetic means. The aesthetic is the modern equivalent of myth, and to affirm the relevant significance, all that is required is the mythic sign. The avant-garde and aesthetic spirit of Joyce's Homeric parallel was caught by T. S. Eliot in his review of *Ulysses*, where he saw Joyce's use of the 'mythic method' as comparable to Einstein's contribution to modern physics since it was a procedure that could be used by other literary artists as 'a step towards making the modern world possible for art'.[17] The phrasing here is very exact, or revealing. No one seeking to re-create a mythopoeic sensibility from the inside would speak in this external, instrumental way of 'using' the 'mythic method'. As has been seen, Eliot himself was no primitivist but wished rather to assimilate the primitive into the forms of civilization, so that poetry is at once the most primitive and the most civilized activity.[18] A comparable claim underlies Robert Graves's conception of poetry as set out in *The White Goddess* (1948, enlarged 1966). For Graves, all poetry originates in an address to the Goddess of Love, yet it delights in elaborate formal play.

Eliot was a great influence not just as a poet but in forming an understanding of literature more generally in the modern academy. It is worth noting, therefore, that the primitive, as the primordial, can be invoked as a form of authority to be exercised even more effectively perhaps by critics than by imaginative authors. The mutually influential relations of literature and anthropology, especially in the Cambridge school, provided ways of reading literature which suggested that its most profound level of significance was as a form of myth. Maud Bodkin's *Archetypal Patterns in Poetry* (1934) is a later product of this tradition. There is no doubt that this was an appropriate lesson to learn from modernist literature, but the recognition is likely to change its nature when it is appropriated by the academy. Bodkin's study already shows signs of becoming a method, and Marc Manganaro has traced the line that leads from Frazer through Eliot to Northrop Frye and Joseph Campbell.[19] The use of myth in modern literature gave rise to a mid-century academic school of myth criticism. As with most specialized approaches this produced useful insights, and Frye, its most notable example and promoter, was a widely read, perceptive reader. But in works like *The Anatomy of Criticism* (1957) he also sought to develop a

[17] T. S. Eliot, '*Ulysses*, Order and Myth', *The Dial*, 75 (1923), 483.

[18] T. S. Eliot, 'Tarr', *The Egoist*, 5/8 (Sept. 1918), 106.

[19] Marc Manganaro, *Myth, Rhetoric and the Voice of Authority: A Critique of Frazer, Eliot, Frye and Campbell* (Princeton: Princeton University Press, 1990).

systematically authoritative system ultimately underwriting a religious conception. Irrespective of ideological tendency, any mode of reading that becomes a 'method', or an 'approach', is likely to dwindle into cliché; elucidating mythic allusion became for a while the blank cheque for claims of critical profundity seemingly underwritten by both anthropological authority and the example of the great modern writers.

In conclusion, what needs most to be emphasized is that modern primitivism is highly varied in its literary modalities as well as in its political or psychological implications. There is clearly no single school of 'primitivists' in the programmatic way that we can think of the Futurists, or even the reconstructive way in which we can assemble the romantics. There are, however, a number of literary distinctions and historical cultural formations through which particular primitivist manifestations of the period may usefully be understood, and in this regard a critical understanding of contemporary anthropological conceptions is clearly crucial.

C H A P T E R 21

QUESTIONS OF HISTORY

DANIEL MOORE

MODERNISM CONTRA HISTORY

PAUL DE MAN's assertion in *Blindness and Insight* that 'of all the possible antonyms of modernity . . . none is more fruitful than history' seems neatly to describe the difficulty of reconciling the manifestations of sociocultural, scientific, and political modernity with the historical realm in the early twentieth century.[1] The First World War (and the polarization of political ideas that followed it), mass consumerism, continued urbanization, technological and scientific advances, universal suffrage—none had antecedents in the past, and aside from the academic study of history, it was not entirely clear how an understanding of the past would in any way ease the passage or aid progress through those times of monumental change. This difficulty of making sense of the past (and one's relationship to it) necessarily found its way into the realm of artistic representation. If Stephen Bann is correct to draw attention to the 'historical-mindedness' of the nineteenth century (that is, the pervasiveness of historical objects, metaphors, and discourse in the cultural and artistic sphere during that period), we might well consider its opposite a suitable label for the art and culture of the early twentieth century.[2] Peter Mandler has characterized the years around the beginning of the twentieth century as a period

[1] Paul de Man, *Blindness and Insight: Essays in the Rhetoric of Contemporary Criticism* (Minnesota: University of Minnesota Press, 1983), 112.
[2] Stephen Bann, *Romanticism and the Rise of History* (New York: Twayne, 1995), p. xi.

that saw the 'drifting away' of modern Western culture from history.[3] Indeed, many of the artistic movements of the early twentieth century actively sought an epistemological basis for their aesthetic that explicitly negated the past and its influence. This is, of course, not a new idea—the dominant critical response to modernist art and literature is to call it an aesthetics of rupture, of a break with the past and a desire to cast off the historical 'weight' with which it felt burdened. The development of new styles, a current of formal inventiveness, and a willingness to represent ideas and concepts previously inexpressible in art are all readily explained by this model of rupture or break.

Finding proof for this break with the past in the canon of literary modernism is not a difficult exercise. The aesthetic response to modernity offered by Filippo Tommaso Marinetti and the Italian Futurists is clear in its attitude to 'historical-mindedness'; if their new-found aesthetic was one of dynamism, speed, and light, it made no attempt to hide its contempt for a life and an art founded on the alternative principle of tradition. M. M. Bakhtin and P. N. Medvedev suggest that Futurism's rejection of all things historical contains within it an 'extreme modernism and radical negation of the past', and it is easy to see this rejection in the polemical manifesto in which Marinetti announced Futurism's arrival.[4] Marinetti's 'Founding and Manifesto of Futurism' (1909) declared open season on history. He begins by castigating the 'smelly gangrene of professors, archaeologists, ciceroni and antiquarians. For too long has Italy been a dealer in second-hand clothes. We mean to free her from the numberless museums that cover her like so many graveyards.' The manifesto continues:

Museums: cemeteries!...Identical, surely, in the sinister promiscuity of so many bodies unknown to one another. Museums: public dormitories where one lies forever beside hated or unknown beings. Museums: absurd abattoirs of painters and sculptors ferociously slaughtering each other with colour-blows and line-blows, the length of the fought-over walls!...

Do you, then, wish to waste all your best powers in this eternal and futile worship of the past, from which you emerge fatally exhausted, shrunken, beaten down?[5]

Bound up in the Futurist programme is both a refusal to live within the confines of the past and a rejection of an artistic tradition in favour of the vitality of a new aesthetic. The shackles of the past are cast off, and its easy comforts discarded, in favour of a brutalizing art system that pays no heed to the conventions of history, nor indeed of the social contract: 'We will glorify war,' Marinetti claims—'the world's only hygiene.'[6] It is not just the desire to create a new art outside of the traditions and styles of old that is important for our purposes here. The utter annihilation of the material past to which Futurism gestures is not only an aesthetic strategy but also a

[3] Peter Mandler, *History and National Life* (London: Profile Books, 2002), 47.
[4] M. M. Bakhtin and P. N. Medvedev, *The Formal Method in Literary Scholarship: A Critical Introduction to Sociological Poetics* (Cambridge, Mass.: Harvard University Press, 1985), 171.
[5] F. T. Marinetti, *Le Figaro*, 20 Feb. 1909. The manifesto appears as 'The Founding and Manifesto of Futurism' in Umbro Apollonio (ed.) *Futurist Manifestos (Documents of 20th Century Art)*, trans. Robert Brain, R. W. Flint, J. C. Higgitt, and Caroline Tisdall (New York: Viking Press, 1973), 19–24: 22.
[6] Ibid, 23.

political one. If the past is to serve any life-affirming purpose in the present, Marinetti's polemic suggests, we can laugh at and draw energy from its cremation. Marinetti's insistence that it is the veneration of the past (which manifests itself in the antiquarian love of the old art object) which is most damaging to the modern mind is repeated again and again in modernist writing. We can read the Vorticist 'Blasting' of Victoriana as the same rejection of stagnation:

> BLAST
>
> years 1837–1900
> Curse abysmal inexcusable middle-class (also Aristocracy and Proletariat).
>
> BLAST pasty shadow cast by gigantic BOEHM . . .
>
> WRING THE NECK OF all sick inventions born in that progressive white wake.[7]

Wyndham Lewis, more clearly than Marinetti, centres his attack on the Victorians, and his rather scattered targets are rationalism, provincialism, Romanticism, and Darwinian evolution (among others)—all manifestations of Victorianism, as Lewis conceives it. For Marinetti and Lewis, in spite of their differences, the nineteenth-century world-view was dead, and 'historical-mindedness' had to be done away with. On the eve of war, Lewis was to go even further in his rejection of history: 'Europe today dislikes history,' he observed. 'It is not one of her subjects. The past is a murderous drug whose use should be forbidden. We have got clean out of history. We are not today living in history.'[8]

This extreme rejection of the antiquarian love of the past has its roots in Nietzsche's essay 'The Use and Abuse of History for Life', published in the second part of his *Untimely Meditations* in 1874. In that early work, he outlined three different 'attitudes' to the study of the past—the monumental, the antiquarian, and the critical. This was, in essence, the first modern attempt at substantial historiography. For Nietzsche, the actual processes involved in writing history (fact-gathering, narrative construction, and so on) are ultimately shaped by the *attitude* to the past adopted by the historian, and the historian's age more generally. History, he asserts, 'is the work of the dramatist: to think one thing with another, and weave the elements into a single whole, with the presumption that the unity of plan must be put into the objects if it is not already there'.[9] The monumental attitude to the past is perhaps most acutely nineteenth-century in its scope. For Nietzsche, this type of historical attitude 'is necessary above all to the man of action and power who fights a great fight and needs examples, teachers, and comforters; he cannot find them among his contemporaries'.[10] But it is his conception of the 'antiquarian' attitude to the study of the past that has the most demonstrable line of connection with those later critiques of the worship of the historical found in Futurism and

[7] Wyndham Lewis, *Blast: Review of the Great English Vortex*, 1 (Santa Barbara, Calif.: Black Sparrow Press, 1981), 18.

[8] Wyndham Lewis, 'A Later Arm Than Barbarity', *Outlook*, 5 (Sept. 1914), 299.

[9] Friedrich Nietzsche, *The Use and Abuse of History for Life*, trans. Adrian Collins (Indianapolis: Bobbs-Merrill, 1957), 37–8.

[10] Ibid. 16.

Vorticism. Nietzsche argues that 'antiquarian history knows only how to *preserve* life, not how to generate it . . . antiquarian history hinders the powerful willing of new things; it cripples the active man, who always, as an active person, will and must set aside reverence'.[11] The stifling worship of the dust of the past can lead only towards torpidity and inaction in the present, and it is this that the Futurists and Vorticists warn against. This Nietzschean arc is an important one in our understanding of the philosophy of history in the long twentieth century, and it offers us one clear trajectory in modernist thought, one that pulls squarely against the retreat into the past for aesthetic, social, and political comfort.[12] In fact, both Futurism and Vorticism imply that the man who no longer lives in history or is focused on his past can develop an individual will and dynamism that exceeds the possibilities afforded him in previous ages. Lewis declares, in *Blast*, a belief that there is 'no perfectibility except our own', which is achieved through an 'art of Individuals'. Marinetti's 'Renaissance man' in the 'Founding and Manifesto of Futurism' seeks to 'break down the gates of life to test the bolts and the padlocks!' through 'violent assault on the forces of the unknown, to force them to bow before man'.[13] It is not difficult to see some manifestation of Nietzsche's *Übermensch* coded into this new expression of humanity, and both movements suggest that the advancement of man into a more powerful, rational, controlled state is going to be achieved through an exploration of the world in an art that casts off the shackles of the past entirely.[14]

It is all too easy to leave it here, and many have. Modernism is, in this sense, a narrow aesthetic rejection of history and the study of the past, obsessed with form, centripetal, subjective, and without any impetus towards engaging with the wider sociocultural realm. There is, without a doubt, some truth in this argument, and many modernist movements (including the two with which I have opened) were much more coherent in the agendas of formal experimentation they laid down for themselves than in achieving any social or political goal. I would suggest, however, that a number of less extreme positions exist within the canon of modernist writing, and it is towards these I want to gesture here. I want to show some of the ways in which history and historiography permeate modernist thought, and how thinking and writing about the past afforded modernism a way of defining its attitudes and critical apparatuses. Moreover, I want to show that it is useful to think of modernism as a product of the same epistemological concerns that infected the discipline of history during the later nineteenth and early twentieth centuries, which centred on the possibility of achieving objective knowledge of the past, the relationship between

[11] Ibid. 42.
[12] For an analysis of Nietzsche's role in the development of a modernist aesthetic, see Kathryne V. Lindberg, *Reading Pound Reading: Modernism After Nietzsche* (New York: Oxford University Press, 1987); Robert Gooding-Williams, *Nietzsche's Dionysian Modernism* (Stanford, Calif.: Stanford University Press, 1999); and Peter Zusi, 'Towards a Genealogy of Modernism: Herder, Nietzsche, History', *Modern Language Quarterly*, 67/4 (2006), 505–25.
[13] Lewis, *Blast*, 1. 9.
[14] Nietzsche's conception of the *Übermensch* ('superman', or 'overman') is first expressed in *Thus Spoke Zarathustra* (1883).

historians and their materials, and the often different claims about historical 'truth' made in the developing fields of archaeology and anthropology. I want, therefore, to offer a survey more than anything else, because all of these competing interests in historiography and the philosophy of history are not necessarily congruent, nor even compatible with each other. What these differing approaches are testament to, however, is a sustained interest in history and historiography, neither of which were ever very far from the heart of the modernist enterprise.

'HISTORY IS A NIGHTMARE FROM WHICH I AM TRYING TO AWAKE'

Reader after reader has explored precisely what it is that Stephen Dedalus wishes to escape from.[15] Certainly it is a desire to flee a suffocating Irish collective consciousness and a tradition of thinking that colours every thought with a political or religious hue: the narrow-minded, Unionist, anti-Semitic model of history constructed by the headmaster Mr Deasy holds little value as a way of making sense of the world for Stephen. But perhaps he abhors something less specific than the mobilization of the political and religious energies of the past to influence the direction of the present. It may be that he is running away from the entire narrative frame of historical knowledge, and that it is the imposition of a divine order on the events of the past, which imbues them with a teleological dimension, that most disturbs him:

—The ways of the Creator are not our ways, Mr Deasy said. All human history moves towards one great goal, the manifestation of God.
 Stephen jerked his thumb towards the window, saying:
 —That is God.
 Hooray! Ay! Whrrwhee!
 —What? Mr Deasy asked.
 —A shout in the street, Stephen answered, shrugging his shoulders.[16]

It is Deasy's all too easy conflation of history with God's will that elicits this knee-jerk reaction from Stephen, and the rest of Joyce's novel is alive to the dangers of such totalizing models of history. Indeed, it develops ways to disrupt such models. Robert Spoo argues for a reading of Joyce's work that encompasses the theoretical and philosophical implications of the study of history.[17] Spoo persuasively suggests that

[15] James Joyce, *Ulysses* (London: Penguin, 1992), 42.
[16] Ibid. 40.
[17] Robert Spoo, *James Joyce and the Language of History: Dedalus's Nightmare* (New York: Oxford University Press, 1995).

a text like *Ulysses* is best read against 'the context of European intellectual history—primarily nineteenth-century historical and aesthetic theory', and he seeks to explore Joyce's 'modernist response to that context'.[18] It is, after all, not a particular event or events that Stephen is trying to run away from; it is History itself. The word has a double content: it refers both to the action of the past and to the study and representation of that action in the present. We suspect that both are the stuff of nightmare for Stephen. The practices of academic history in the nineteenth and early twentieth centuries involved the kind of meaning-making that Stephen and Joyce found difficult to reconcile with their understanding of the world. Deasy seems to represent the consummate nineteenth-century historian: plodding, totalizing, and entirely driven by notions of progress and teleology. Indeed, the dominating trend of nineteenth-century historicism was a move away from quaint antiquarianism and the 'literary' nature of historical narratives towards a positivist and empiricist interpretation of the past, reliant on transparent analysis of documentary sources. The organizing principles behind the ordering of the 'facts' of history were invariably progressive and developmental, and those sections of the past that did not fit these principles were othered, ignored, and silenced. The philosopher–historian T. H. Green, introducing an edition of Hume's *Treatise of Human Nature* in 1874, paraphrased this kind of historiographic thinking:

There is a view of the history of mankind, by this time familiarised to Englishmen, which detaches from the chaos of events a connected series of ruling actions and beliefs—the achievement of great men and epochs, and assigns to these in a special sense the term 'historical'. According to this theory—which indeed, if there is to be a theory of History at all, alone gives the needful simplification—the mass of nations must be regarded as left in swamps of human development . . . It would seem that the historian need not trouble himself with them, except so far as relation to them determines the activity of the progressive nations.[19]

The collocation in this view of divine providence, Hegelian progressivism, and national pride demonstrates just how bound up these issues were in the historical thought of the period. Historical study, for its high Victorian exponents, was largely based on justifying imperial, moral, and political decisions. The purpose of history was an understanding of the diachronic progress of civilization, always figured in a rhetoric of moral rectitude. The historian J. A. Froude notes that it was

In the struggle, ever failing, yet ever renewed, to carry truth and justice into the administration of human society; in the establishment of states and in the overthrow of tyrannies; in the rise and fall of creeds; in the world of ideas; in the character and deeds of the great actors in the drama of life; where good and evil fight out their everlasting battle, now ranged in opposite camps, now and more often in the heart, both of them, of each living man—that the true human interest of history resides.[20]

[18] Ibid. 9.

[19] T. H. Green, *Works of Thomas Hill Green*, i (London: Longmans, Green, 1885), 1.

[20] Quoted in Waldo Hilary Dunn, *James Anthony Froudei*, 2 vols (Oxford: Oxford University Press, 1961–3), i. 37.

Abstract principles of good and evil, right and wrong, progress and chaos, are stencilled over past human action in order to make better sense of it. This is a brutal, imperialist historiographic methodology, crushing other national pasts either by defeat on the battlefield, or by elision on the page. What Stephen Dedalus finds so nightmarish in Mr Deasy's historical analysis is the same totalizing compulsion.

It is interesting that Stephen's desire to escape the weight of human history is coded in the language of dream. The burden of the events of his life, and indeed of those before it even began, become othered as the stuff of nightmare, sent down several orders of consciousness only to return, horrifically, to irrupt into the present. Nightmares end, of course. We return to reality on waking. But the perpetual unwanted dream of history and the long-awaited awakening into consciousness is a repeated image elsewhere. Walter Benjamin uses exactly the same linguistic construction to explain the historicist impulses of the nineteenth century in *The Arcades Project*. It is precisely the security that those teleological master narratives afforded that made them so appealing, and Benjamin is keen to explore what happens when the dreamer is woken:

It is not only that the forms of appearance taken by the dream collective in the nineteenth century cannot be thought away; and not only that these forms characterize this collective much more decisively than any other—they are also, rightly interpreted, of the highest practical import, for they allow us to recognize the sea on which we navigate and the shore from which we push off. It is here, therefore, that the 'critique' of the nineteenth century—to say it in one word—ought to begin. The critique not of its mechanism and cult of machinery but of its narcotic historicism, its passion for masks...[21]

We shall return to this description of the 'narcotic historicism' of the nineteenth century later on, but for Benjamin, here, the façades of teleological history are cracked. The 'critique' he offers of nineteenth-century historicism is directed towards its appearances and 'masks'—towards, in other words, the recurring signifier, the endless pursuit of some real historical understanding when the narratives of nineteenth-century history actively circumvent it. In this sense, Stephen's desire is to awake into authenticity, to escape the nightmarish world of endless signifiers and masks to gain some hold on real life through an understanding of his past and the history of Ireland.

In a different way, Gustav von Aschenbach, Thomas Mann's doomed protagonist in *Death in Venice* (1912), enacts the same Dedalian flight. He is almost compelled to escape the same maddening twin loads of productivity and history, and he rationalizes his trip to Venice in conscious opposition to the concerns that have dominated his life. But his repressed impulse is differently figured. For Aschenbach, the escape turns out to be *into* history rather than away from it. He visits Venice to flee tradition, academia, and *logos*, seeking solace in a more concrete, physical, tactile history. In Mann's biographical sketch of Aschenbach, it is clear that a life spent amassing

[21] Walter Benjamin, *The Arcades Project*, trans. Howard Eiland and Kevin McLaughlin (Cambridge, Mass.: Belknap Press, 2002), 391.

historical knowledge only leads to that same kind of inertia that Nietzsche outlined in 'The Use and Abuse of History'. Aschenbach feels, all too keenly, the weight of his own history and the history of his nation on his shoulders.

We can surely read Dedalus's and Aschenbach's desire to run away as a kind of anxiety of influence, a fear of living and producing in the midst of a cloistering, debilitating, ever-present past. Both men are also writers, whose escape is intimately bound up with the need to dip into some purer realm of experience in order to put fresh paint on the brush. This constant tension in both characters between past and present, and of the seemingly impossible task of uniting them in any useful sense, dominates their consciousness. If Marinetti and Lewis could decide that history was, in fact, bunk and that art must escape its own traditions in order to be vital, dynamic, and useful in the present, Joyce and Mann suggest that the more sensitive artist wants to effect a reconciliation with his personal, national, and artistic pasts, but simply does not know how to do this. Not long after his tête-à-tête with Deasy, when Stephen strolls along Sandymount Strand, his thoughts are filled with his own past and with the history of mankind. Trying to make sense of his place in the world, he enacts a kind of mental history filled with dreams, allusions, memories, and fragments. Indeed, we could read his half-joking imagined attempt to speak to Adam and Eve in the Garden of Eden through an endless succession of umbilical cords as the antithesis of Deasy's historicism. It is a personal history, one that lends an authenticity to Stephen's existence in a way that the traditional national narratives do not.[22] It also involves a cacophony of voices, with Stephen channelling his speech through generations of individuals on the way back to Adam. Likewise, Aschenbach's own feelings of decentredness and longing for authenticity are quelled not by his historical research but by the tangible history of Venice. It is that (often visceral) connection he makes with Venice that affords him the briefest glimpse of a life misspent; it is in Venice, amid heat, death, and ruin, that he begins to discover himself. These personal psychological connections with history provide both characters with a more genuine feeling for history and their place in it than the progressive teleology of a more universal history can give them. The latter seems only to be felt as a 'weight'.

Both Dedalus and Aschenbach are ultimately frustrated in their attempts to make better sense of their own pasts and their place in the wider narratives of history, but they both seek some kind of artistic and personal holistic union with the past. T. S. Eliot referred to the same kind of union between the artist and his past in 'Tradition and the Individual Talent'. 'Tradition', writes Eliot, 'involves, in the first place, the historical sense' and in turn 'a perception, not only of the pastness of the past, but of its presence.' Famously he goes on:

the historical sense compels a man to write not merely with his own generation in his bones, but with a feeling that the whole of the literature of Europe from Homer and within it the whole of the literature of his own country has a simultaneous existence and composes a simultaneous order. This historical sense, which is a sense of the timeless as well as of the

[22] Joyce, *Ulysses*, 46.

temporal and of the timeless and of the temporal together, is what makes a writer traditional. And it is at the same time what makes a writer most acutely conscious of his place in time, of his contemporaneity.[23]

The corporeal metaphor that Eliot uses, of writing with history in one's bones, is an apt one. It emphasizes the organic nature of the connection the artist needs to make with the past in order for him to become 'traditional'. Eliot's conception of 'tradition' goes a long way towards marking out the arts as the only legitimate medium in which to explore the limits of historical representation. It is only in the literary realm that the writer can unite the 'temporal' and the 'timeless' worlds, achieving a synergistic simultaneity that would be impossible in narrative, academic history. It is, perhaps, this 'simultaneous order' that both Dedalus and Aschenbach seek—a way of making sense of the past and, consequently, of the present.

The 'timeless' aspect of history—that is, the existence of structures and patterns beyond the events of the real world—interested Eliot immensely. He explored it in *The Waste Land*, and was keen to theorize it more fully in his critical writing. Indeed, Eliot recognized in Joyce's technique a manipulation of the past that didn't seek to drive home some national or political aim but tried to control and order the past. In '*Ulysses*, Order and Myth' Eliot argued that, 'In using the myth, in manipulating a continuous parallel between contemporaneity and antiquity, Mr Joyce is pursuing a method which others must pursue after him. . . . It is simply a way of controlling, of ordering, of giving a shape and a significance to the immense panorama of futility and anarchy which is contemporary history.'[24] The implication for Eliot was that, 'Instead of narrative method, we may now use the mythical method,' and this, he believed, was 'a step towards making the modern world possible for art'.[25]

Clearly, the 'mythical method' is a powerful historiographical tool. A number of other works deal with Eliot's historicism very competently, but it is worth exploring the historicist potentiality of myth as Eliot understood it.[26] A lot of Eliot's ideas about history came from F. H. Bradley, the nineteenth-century philosopher who formed the basis of Eliot's doctoral dissertation, and Bradley is certainly present in Eliot's conception of the 'mythic method'. In *The Presuppositions of Critical History* (1874), Bradley argued that the 'object of our endeavour is to breathe the life of the present into the death of the past' and that 'the past varies with the present, and can never do otherwise, since it is always the present upon which it rests'.[27] Bradley suggested that the 'critical' historian can make sense of the past only by creating a 'system' to control the 'facts' of

[23] T. S. Eliot, 'Tradition and the Individual Talent', in *Selected Essays* (London: Faber and Faber, 1999), 14.
[24] T. S. Eliot, '*Ulysses*, Order and Myth', *The Dial*, 75 (Nov. 1923), 483.
[25] Ibid.
[26] Eliot's historicism and historiographical awareness are explored in Ronald Bush, *T. S. Eliot: The Modernist in History* (Cambridge: Cambridge University Press, 1991); James Longenbach, *Modernist Poetics of History: Pound, Eliot, and a Sense of the Past* (Princeton: Princeton University Press, 1987); and Jewel Spears Brooker, *Mastery and Escape: T. S. Eliot and the Dialectic of Modernism* (Boston: University of Massachusetts Press, 1994).
[27] F. H. Bradley, *The Presuppositions of Critical History* (Oxford: James Parker, 1874), 32.

history.[28] One must, in other words, have some organizing principle through which to peer into the murky recesses of history; what can be gained is not complete knowledge (in the totalizing sense) but a satisfactory *interpretation*. As Eliot states definitively, ideas about the past 'do not qualify a real past or future, for there is no real past or future for them to qualify . . . Ideas of the past are true, not by a correspondence with a real past, but by their coherence with each other and ultimately with the present moment.'[29] This does not force historical study into a solipsistic relativism, where every interpretative attempt makes as much sense as any other. Eliot suggests, rather, that the past no longer exists and is, anyway, too ungainly and contradictory to make any sense if the historian lacks a critical apparatus. He must be in possession of a 'system' that makes sense of 'the immense panorama'. For Eliot, this was clearly not the same as the teleological, progressive rationales constructed in the long nineteenth century; it was organic, temporary, and dependent not on immutable principles but on personal interpretation. What he saw Joyce and Yeats doing was making sense of that panorama by systematizing history. The 'mythical method' was a refiguring tool, a key to giving order and structure to the random and to unlocking meaning in the past.

A number of other modernist thinkers became attracted to those (largely non-Western) traditions which leant more heavily on mythic pattern rather than teleology to explain history, and this manifested itself in a number of different approaches to understanding the events of the past. Cyclical conceptions of the past, for instance, were enormously attractive to a number of writers, including T. E. Hulme and W. B. Yeats. Louise Blakeney Williams's work on cyclical modes of history charts the rise of this kind of structuring device in the early part of the twentieth century.[30] Arguing against 'some observers [who] may judge the Modernists' critical writings and their uses of history as superficial and naïve', Williams suggests that it was precisely in that modernist moment that 'the idea of progress died and a different concept of history was born'.[31] Careful to note the importance of contemporary political anxieties, imperial policies, and concerns over the role of art in social life in the uptake of historical ideas, Williams follows the development of a new, vitalist engagement with history that was filled to some degree with hope, in the face of the failure of the grand narratives of progress with the onset of war.

Cyclical views of history were, of course, not new to the early twentieth century. Giambattista Vico's conception of the development of civilizations through cycles came in the eighteenth century, and was hugely influential for a number of modernist writers.[32] Vico's interpretation of the history of civilization in his *New Sceince* (1725)

[28] Ibid. 15.

[29] T. S. Eliot, *Knowledge and Experience in the Philosophy of F. H. Bradley* (New York: Farrar and Straus, 1964), 54.

[30] Louise Blakeney Williams, *Modernism and the Ideology of History* (Cambridge: Cambridge University Press, 2002).

[31] Ibid. 3, 2.

[32] Lots has been written on Vico's importance to modernist historical epistemology; see e.g. Joseph Mali, *The Rehabilitation of Myth: Vico's 'New Science'* (New York: Cambridge University Press, 1992), and Cecelia Miller, *Giambattista Vico: Imagination and Historical Knowledge* (New York: St Martin's Press, 1993).

suggests that there is an underlying uniformity in human nature across history that can serve as an explanatory principle for historical process. The commonality of man gives rise to a series of stages of development of commerce, law, and politics: human beings, faced with recurring societal challenges, essentially produce the same kinds of response over time. His was a static historical model, implying that man has certain immutable characteristics that cannot be transcended, and thus historical study became focused on the detection of these larger-scale principles in operation. It was the incompatibility of Victorian historicism with modern life that drew T. E. Hulme to this kind of a cyclical history. He criticized the 'metaphorical notion of automatic progress . . . you get in Hegel and Fourier' as being indistinguishable from 'the religious belief in absolute progress'.[33] And the source of this teleological narrative frame lay back in the nineteenth century. 'One is handicapped', he claimed, 'by being educated in Whig histories. It takes strenuous efforts to get rid of the pernicious notion implanted in one by Macaulay.'[34] Seeking alternatives to this kind of storytelling, Hulme found himself attracted to the larger-scale mythic patterns offered in a work like Sir Flinders Petrie's *The Revolutions of Civilization* (1911). 'Dr. Petrie gives an emphatic negative,' he argued, in answer to the question whether 'the progress and civilization of humanity have been slowly and steadily increasing'. Petrie was able to 'trace the rise, growth and decay of fourteen civilizations of equal length with the classical one', and Hulme's conclusion was that 'civilization is a recurrent phenomena [*sic*], and not an ever-sweeping onward movement'.[35] For Hulme, implicitly seeking confirmation of humankind's unchanging, non-progressive existence, this was a double boon. Firstly, the knowledge that humankind, although progressive in a technological sense, was essentially driven by the same social and political needs throughout its entire history allied itself with other areas of his reading. He opposed a model of Darwinian evolution (with all its progressive adjuncts) with Hugo de Vries's 'mutation theory', which he felt undermined Darwin. 'It supposes', he argued, 'that each new species came into existence in one big variation, as a kind of "sport", and, that once constituted, a species remains absolutely constant . . . there would then be no hope at all of progress for man.'[36] Secondly, and more importantly, this theory provided him with a way of formulating two polar, interpretative paradigms for understanding the world, one essentially 'romantic'—that is, that man is always 'becoming', and that his history reflects his gradual perfection—and one 'classicist'—that man is not progressing in any abstract sense, that he is bound by insurmountable physical, mental, and social limitations. The classical model was appealing because it fostered permanence and stability in an age of chaos, and

[33] T. E. Hulme, 'A Tory Philosophy', in *The Collected Writings of T. E. Hulme*, ed. Karen Csengeri (Oxford: Clarendon Press, 1994), 237.

[34] T. E. Hulme, 'A Note on the Art of Political Conversion', in *Collected Writings*, 212.

[35] Thomas Grattan [T. E. Hulme], 'On Progress and Democracy', in *Collected Writings*, 224.

[36] Hulme, 'A Tory Philosophy', in *Collected Writings*, 242–3.

Hulme favoured that 'system' in his seminal essay 'Romanticism and Classicism' (1911–12).

The move away from the 'romantic' notion of progress to a sphere of eternal cycles was attractive, too, to W. B. Yeats. Yeats developed his own schema for history over the course of the 1920s, and the need to develop some overarching system for the historical realm filled the last decades of his life. *A Vision*, which was published in 1925 and revised in 1937, was the result of this need. Yeats explained that 'the fundamental system' of *A Vision* describes a 'Great Wheel' of history, which made use of mythical concepts to explain the movements in human civilization over the course of thousands of years.[37] In essence, dichotomous and incompatible principles (discord and concord, war and love, subjectivity and objectivity) cyclically alternate with one another, one gaining potency at the expense of the other until they meet and the opposing movement begins. The 'Great Wheel' consisted of twenty-eight phases, a smaller wheel composing two groups of three phases, and each phase itself was a single, smaller wheel in itself. The 'Great Wheel' took about two thousand years to complete its cycle and reached its zenith (as far as artistic production and social unity are concerned) around phase fifteen. Yeats said he wrote *A Vision* at the end of phase twenty-two, and that civilization was sliding towards a new organizing principle after cataclysmic social upheaval. But it would be a mistake to call this system in any way pessimistic. The beginning of each mini-cycle (on the scale of mere decades) coincided with a newly organized control and order that the previous one lost, and the cycle never has a definite end-point: these cycles continue infinitesimally, never achieving perfection, but never reaching utter annihilation either. This form of the 'mythic method' clearly nudged history away from science towards magic and ritual, and it is easy to see why this kind of view of the past held an attraction for a generation besieged by the events and politics of a period that seemed to have no antecedent in history. It is a recuperative model, one which promises renewal after degeneration, rebirth after death. To some degree, it also transfers historical agency from the actions of the individual to some wider concept of Zeitgeist. If tragic things happen, despotic regimes take shape, and mankind should lose its way, then the wheel will turn again. The mythic structures that modernist writers explored were not simply escapist flights of fancy, but rather were recuperative strategies, aimed at a more holistic interpretation of history.

SAXA LOQUUNTUR

The mythic, personal, and artistic structuring of the past we have seen thus far was perhaps the most abstract of all the explorations in the philosophy of history made by

[37] W. B. Yeats, *A Vision* (New York: Macmillan, 1937; repr. 1966), 68.

modernist writing. If Yeats, Eliot, and Joyce contemplated the use and purpose of the historical realm at the spiritual, mythical, and ontological end of the spectrum, then several other writers were interested in the possibilities that more tangible physical histories could afford. Many of the innovative cultural-historical works that arose out of modernity's vexed relationship with history and historical study often concerned themselves with material history, as a problematic topic that could expose the faults in the grand historical narratives of the nineteenth century. Sigmund Freud's forays into cultural history, especially in *Civilization and its Discontents* (1930) and *Moses and Monotheism* (1939), used archaeology and material history metaphorically to reflect on the human act of interpreting the past. In essence, Freud equates the historical and psychical processes of cognition by suggesting that the act of recovery (of the past, of memory) is an excavating process. He uses this precise notion in 'The Aetiology of Hysteria' (1896). Suggesting that an anthropologist could go about understanding the culture of some 'semi-barbaric people' by attempting conversation, he proposes an alternative approach that might be more valuable: 'he may start upon the ruins, clear away the rubbish, and, beginning from the visible remains, uncover what is buried . . . [the artefacts] yielding undreamed-of information about the events of the remote past . . . *Saxa loquuntur* [the stones speak]'.[38]

The stones literally do speak, or are made to speak by careful and sensitive prodding. Excavation, be it physical or psychological, opens up a new arena for the exploration of unwritten, incomplete, and temporary histories. And for a number of modernist writers, Freud's deep connection between the personal, psychological realm and the objects that excavation and archaeology conjured forth provided a useful strategy for thinking about the past in a new way. Objects from history have always captured our attention; we are transfixed by both their aesthetic conventions and their 'pastness'. They were almost certainly created in periods of history that share little with ours—at both a technological and stylistic level, and at a broader sociological one too. And yet they exist. While the written documents that have found their way to us in the present were created with the intention of being kept as records, the dug-up object has no such pre-existing historicity: it arrives in the present accidentally, its only distinguishing feature being its fortuitousness at being found. Making sense of it involves a different kind of historical methodology, consisting of a blend of aesthetic receptivity and imaginative free association.

Archaeology shares some affinities with a small group of other disciplines, especially with clinical psychology and anthropology, as fields of study properly carved out in modernity. Each of these disciplines shares a common epistemology, founded on what Fredric Jameson might call 'depth models'.[39] 'Archaeology was born of

[38] Sigmund Freud, 'An Aetiology of Hysteria', in *The Standard Edition of the Complete Psychological Works of Sigmund Freud*, ed. and trans. James Strachey, 24 vols (London: Hogarth Press, 1943–74), iii. 192.

[39] Fredric Jameson, 'Postmodernism, or, The Cultural Logic of Late Capitalism', *New Left Review*, 146 (1984), 62. Jameson suggests that the differences between surface and depth models mark out modernity's epistemology. He cites the relationship between essence and appearance in Marxist thought and between superficial reading and deep meaning in modern hermeneutics as examples of surface–depth paradigms.

modernity,' according to Gavin Lucas. 'Indeed, it helped shape it.'[40] A science founded almost wholly on empirical study and materialist methodologies, the cult of the archaeological flourished during the late nineteenth century and the early years of the twentieth. It appealed to both the advancers of the new science of history and those who thought it could provide a parallel story of the past to history-writing proper. Ruled over by the new inventions that helped material out of the ground and into the museums, 'amateur and professional archaeologists were committed to a futurology that . . . elevated objects outside of space and time into a realm of trans-cultural and transhistorical beauty'.[41] The processes of excavation and archaeology were also powerful tropes in the early twentieth century for other reasons. As Lucas suggests, the 'uncontained historicity' of the objects being exhumed, coupled with the depth of their 'pastness', means that they are not readily securable in terms of their signification: 'Prehistory was not just a new past, it was also a lost past—lost to traditional forms of memory, whether written or spoken'; it was 'about the onto-logical priority of material culture before text'.[42]

For Lucas, then, archaeology highlighted one of modernity's key contradictions: 'the need to understand the past without relying on it as a source of authority. Archaeology resolved this contradiction, on the one hand, by creating a *new* or different kind of past from that laid down by tradition: prehistory; and, on the other, by creating a *new* way of understanding the past: the study of material culture.'[43]

More importantly for our purposes here, however, the archaeological object provides a way of criticizing those narrative, teleological histories that struggle in vain to make sense of it. The meeting of the dug-up object and the narratives that try to make sense of it is a moment when some of the inadequacies of the modes of nineteenth-century historicism are most readily demonstrable. Vernon Lee under-stood that when she stood looking at artefacts just exhumed at an archaeological dig in Rome. She saw 'patterned sheets of the various strata of excavation; bits of crock, stone, tile, iron, little earthenware spoons for putting sacrificial salt in the fire, even what looked like a set of false teeth . . . Time represented thus in space.'[44] The 'shock of the old' clearly had an impact on her historical sense, showing how 'the past is only a creation of the present', that things were 'not really of this earth, not really laid bare by the spade, but existing in realms of fantastic speculation, shaped by argument, faultlessly cast in logical moulds'.[45]

The juxtaposition of various historical artefacts (this time in a museum) also concerned D. H. Lawrence. The collection of Etruscan remains within the museum collections that Lawrence visits destroys the organic relationship of the art object to

[40] Gavin Lucas, 'Modern Disturbances: On the Ambiguities of Archaeology', *Modernism/Modernity*, 11/1 (2004), 109.
[41] Jeffrey Schnapp, Michael Shanks, and Matthew Tiews, 'Archaeologies of the Modern', *Modernism/Modernity*, 11/1 (2004), 4.
[42] Lucas, 'Modern Disturbances', 110–11. [43] Ibid. 112.
[44] Vernon Lee, *The Spirit of Rome* (London: Bodley Head, 1906), 141. [45] Ibid. 142.

the historical milieu to which it is tied. And this offended both Lawrence's *historical* sense (by disrupting any access to a real past in the act of collection and collation) and his *historiographical* sense (by the appropriation of those art objects into narratives about the development of human art and culture): 'Museums, museums, museums, object-lessons rigged out to illustrate the unsound theories of archaeologists, crazy attempts to co-ordinate and get into a fixed order that which has no fixed order and will not be coordinated! It is sickening . . . Why can't incompatible things be left incompatible?'[46]

The organic remains of history, *in situ*, are for Lawrence the only interesting and productive elements of the past. His distress at finding that some of the relics at Tarquinia have been sent to Florence and beyond is palpable: 'It is all very well to say, the public can then see the things. The public is a hundred-headed ass, and can see nothing. A few intelligent individuals do wander through the splendid Etruscan museum in Florence, struggling with the abstraction of many fascinating things from all parts of Etruria confusing the sensitive soul.'[47]

Again, we come around to the same notions of authenticity. Lawrence and Lee suggest that the only unmediated access we can have to the past is through the archaeological realm, and that seeing the past in its unadulterated form affords insights that the 'narrative method' (to adapt Eliot's term) obliterates. This kind of history, again, emphasizes the personal connection to the past. It is the interpretative efforts of the individual, based on intuition, emotion, and aesthetic receptivity, upon which historical analysis is grounded. In one sense, this is a return to Nietzsche's 'antiquarian' attitude to history: the adoration of the old does often slip into a kind of fetishization of the past. But in no way are Lee and Lawrence satisfied with this purely aesthetic response. They both hint at some other realm of historical knowledge that is lost in the act of narration or framing, and both suggest that it is in this realm that the most fruitful historical analysis can take place. Neither really offers any sustained methodology for making the most of this realm. It was Walter Benjamin who began to theorize this kind of historical inquiry more fully.

'HISTORY DECAYS INTO IMAGES, NOT INTO STORIES'[48]

Benjamin was interested in the same 'shock of the old' as Lee and Lawrence, and he explored the materiality of the past in some similar ways. He figured his own work in

[46] D. H. Lawrence, *Sketches of Etruscan Places and Other Italian Essays*, ed. Simonetta de Filippis (Cambridge: Cambridge University Press, 1992), 171.
[47] Ibid. 34.
[48] Benjamin, *The Arcades Project*, 476.

The Arcades Project as a kind of excavation, reclaiming written, visual, and material fragments from the rubble of the past and organizing them in a kind of tapestry, from which his ideas about bourgeois capitalism, progress, and history would spring forth. Again, his methodology was essentially recuperative. It was only in finding the forgotten and erased and seeing in it some connecting thread between the past and present that any kind of 'value' could be gained from the historical process. This was the key. The only point of historical work was to achieve this kind of symbiotic relationship with the past.

In a 1937 essay, Benjamin opposed 'historicism' with 'historical materialism', a term he appropriated from Friedrich Engels. If nineteenth-century historicism celebrated continuity and epic (akin, one supposes, to Nietzsche's 'monumental' attitude to the past), then the historical materialist

Must abandon the epic element in history. For him, history becomes the object of a construct whose locus is not empty time but rather the specific epoch, the specific life, the specific work. The historical materialist blasts the epoch out of its reified 'historical continuity' . . . Historicism presents the eternal image of the past, whereas historical materialism presents a given experience with the past . . . To put to work an experience with history—a history that is originary for every present—is the task of historical materialism.[49]

There is a lot to tease out here. Clearly, the Marxist frame of reference suggests that Benjamin's critique of historicism was part of a wider analysis of capitalist modes of knowledge, and his wider agenda was to begin to deconstruct those grand narratives that drive the capitalist engine. But what is most important for us here is Benjamin's conception of the presence of the past. His historical field does not lie securely in some other, past dimension; it surrounds us, awaiting signification in the present. The elements that make up that field are constantly made new by the historical materialist, who drags them from the past in order better to understand the present. This is a kind of vitalist reversal of Nietzsche's 'antiquarian' attitude; it is not the 'pastness' of the historical object that is venerated, but its 'presentness'. Benjamin's rhetoric is filled with metaphors of historical 'shock': explosions, blasts, and demolitions. It is an historical methodology that seeks to recharge the study of history by destroying its existing modes to facilitate new connections with the past.

The place where this connection between the past and the historian occurs is at the site of the 'dialectical image'. The notion of a history founded on 'images' rather than 'stories' is central to Benjamin's historical philosophy. He explains the structure of the dialectical image in *The Arcades Project*:

These images are to be thought of entirely apart from the categories of the 'human sciences' . . . for the historical index of the images not only says that they belong to a particular time; it says, above all, that they attain to legibility only at a particular time . . . It is not that what is past casts its light on what is present, or what is present its light on what is past; rather,

[49] Walter Benjamin, 'Eduard Fuchs, Collector and Historian', in *Selected Writings*, iii, ed. Howard Eiland and Michael W. Jennings (Cambridge, Mass: Belknap Press, 2002), 262.

image is that wherein what has been comes together in a flash with the now to form a constellation. In other words: image is dialectics at a standstill.[50]

The image, then, is the site of a raw historical power, and by bringing the image into 'constellation' with the present, a kind of explosive suddenly emergent historical epiphany is achieved. Of course, historical narratives still exist, but for a peek under the façade of a 'narcotic historicism', we must 'blast' the image out of the narrative frame that encloses it. Vanessa R. Schwartz suggests that Benjamin's study of the Paris arcades opened up 'not simply a history of changes and transformations in the materials and experiences of the visual but also an alternative way to think about historical categories and methods'.[51] If this is the case, then Benjamin's historiographical apparatus is revolutionary because it shows us that images and fragments simply cannot be made to fit any narrative historicism. If history does, indeed, break down into images, and those images carry a latent power in their 'dialectical' existence, then they present us with an entirely new historical epistemology, one where we don't need narrative structures to make sense of the past for us because, in the study of these 'images', the past and present 'flash' together in 'constellation'.

But what of the moving image? Benjamin mused on the historiographical possibilities cinema and film presented as early as 1935, suggesting that the discontinuity between still and moving images was a site of further exploration, but he didn't ever really offer a complete theorization of the moving image.[52] Virginia Woolf, too, realized that cinema and film, as a representational device, could offer access to a different order of knowledge: 'The most fantastic contrasts could be flashed before us with a speed which the writer can only toil after in vain ... No fantasy could be too far-fetched or insubstantial. The past could be unrolled ... While all the other arts were born naked, this, the youngest, has been born fully-clothed. It can say everything before it has anything to say.'[53] This almost unconscious element of filmic representation, the ability to speedily flash images in front of us bare of any narrative content, is why film is so exciting—and so dangerous. It can sway audiences with pathos, pomp, and pageantry, and persuade without logic. Siegfried Kracauer realized the power that film had both to represent and to make history. Kracauer's body of work is perhaps (along with Theodor Adorno's) the first true contemporary theorization of modernity. His final book, *History: The Last Things Before the Last* (1969), edited and published three years after his death, brought his interest in film together with his interest in history and historiography. In it, he espoused the view that history was in fact at the centre of his entire œuvre after all: 'I realised in a flash the many existing parallels between history and the photographic media, historical reality and camera-reality. Lately I came across my piece on "Photography" and was

[50] Benjamin, *The Arcades Project*, 462–3.
[51] Vanessa R. Schwartz, 'Walter Benjamin for Historians', *American Historical Review*, 106 (2001), 1723.
[52] Walter Benjamin, 'The Formula in Which the Dialectical Structure of Film Finds Expression', in *Selected Writings*, iii. 94–6.
[53] Virginia Woolf, 'The Cinema', in *The Crowded Dance of Modern Life*, ed. Rachel Bowlby (London: Penguin, 1993), 57.

completely amazed at noticing I had compared historicism and photography already in this article of the 'twenties.'[54]

Like photography, Kracauer observed, 'history marks a bent of the mind and defines a region of reality which despite all that has been written about [it], is still largely *terra incognita*.'[55] If we read some of his earlier work through the historicist lens he suggests had always been there, then his studies of film can be seen as a kind of extension of Benjamin's studies of the image. Kracauer's *From Caligari to Hitler: A Psychological History of the German Film* (1947) argued that German film bound history, myth-making, and documentary together. Film not only represented but also engaged in a social praxis that saw a democratic Germany move towards National Socialism.

Cinema, that perfect representational mediator of modernity, is united with history: the two, for Kracauer, are symbiotic. The developments in filmic technique by German directors, set designers, and camera operators simply could not have come about if the social situation in Weimar Germany hadn't demanded new representational techniques to capture the true conditions of modernity. A film like Robert Wiene's *The Cabinet of Dr. Caligari* (1919) contains, for Kracauer, a nascent social angst only expressible in the distorted, grotesque shapes of the Expressionist sets. Equally, a mass movement like National Socialism could only fully attain its political goals if it could authorize itself, and films like Leni Riefenstahl's *Triumph of the Will* (1935) or *Olympia* (1938) went some way towards fulfilling this need. *Triumph of the Will* opens with a long scene figuring Hitler's descent into Nuremberg in an aeroplane in terms of a mythic historical lineage extending from Norse and Aryan mythology. Wagner's *Die Meistersinger von Nürnberg* plays loudly in the background, slowly transforming into the *Horst-Wessel-Lied*, the anthem of the Nazi Party. Riefenstahl transposes the present onto the (mythic) past, and in doing so achieves a sort of analogue to Benjamin's dialectical image. By bringing into 'constellation' the past and present, the film imbues a 'flash' of meaning into the historical realm. The mythic, Aryan past only achieves signification in its final fulfilment: the Third Reich. The pomp of the rally itself builds slowly to a climax when Hitler walks through the huge crowd, Wagner's *Götterdämmerung* providing again a mythic–historical nexus for the action and situating the National Socialists in an already formulated mythic pattern of struggle and mastery. Film— in Kracauer's reading—becomes a new kind of historiographical device, an extension of the latent historical content of the Benjaminian image. It is capable of forging links with the past that are not dependent on narrative or story, but that offer an equally (if not more) powerful framing device for interpreting the past in the present.

[54] Siegfried Kracauer, *History: The Last Things Before the Last* (New York: Oxford University Press, 1969), 3–4.
[55] Ibid. 4.

CODA

..

It has, perhaps, been the result of an increased sensitivity towards historical thinking, developed over the course of the last few decades, that we can more fully explore the range and scope of the modernist exploration of history and historiography. Engaging with the philosophy of history in a number of important ways, modernist writing and theorizing blew away the cobwebs of nineteenth-century historicism. What many of the historical philosophies explored here demonstrate is that if a narrow academic history can make claims to be a scientific discipline, then there are many valid historical methodologies that cannot be reconciled to this notion. In theorizing the connections between history and myth, history and personal experience, history and psychoanalysis, and history and image, these engagements with the past fuse historical understanding with individual life, making better use of the past in the present. Knowing the events of a static past, *wie es eigentlich gewesen*,[56] with the main aim of drawing didactic lessons from it was exactly the 'attitude' to the past (to borrow Nietzsche's terminology) that modernism sought to avoid. Being able to interrogate that past by examining its gaps, contradictions, and silences; holding imaginary dialogue with its actors; examining its detritus; glaring at its images; digging up its sacredness and peering deep into its psyche were, as historical methodologies go, much more satisfying and, perhaps, life-affirming. The approaches I have explored here not only were emergent innovative approaches to seize hold of history more closely, but were, for many writers, recuperative processes that allowed one to personalize the past, and make sense of it that way. For Bernard Berenson, one of the leading art critics in the early twentieth century:

[History] should not be a mere chronicle, mere data, mere *res gestae*, mere events as events, no matter what their nature or purpose. Nor yet should history be exploited and abused as cabalistic lore whence to extract justification for the absurdities and passions of the hour. [Rather] it must be life-enhancing, life expanding, life-intensifying... History should lead us to recapture the past at those points that we most gladly recall and enjoy, discovering life [as] a universe of magic, mystery, and unlimited possibilities.[57]

This was Nietzsche's message, too. History, if it was not to be a burden to us, and if it was not to distract us from the concerns of the present, had to serve us and not us it. It is clear, from the different artistic approaches to understanding the past used by the writers and thinkers explored here, that out of modernity's fractured, hesitant, and mistrustful relationship with history came a blossoming of fresh attitudes to the

[56] A phrase used by the German historian Leopold von Ranke (1795–1886) in his *Geschichte der romanischen und germanischen Völker von 1494 bis 1514* ('History of the Latin and Teutonic Nations from 1494 to 1514'; 1824). Ranke's historicist ideal was knowing the past *wie es eigentlich gewesen*—'as it essentially was'.
[57] Bernard Berenson, *Aesthetics and History* (London: Constable, 1950), 229.

study of the past. Questions of history were, in short, somewhere near the forefront of the modernist enterprise. What is needed is a more fine-grained account of modernism's mediation of the past. We may be ready, as we pass through post-modernism's challenges to the discipline of history armed with a new set of herme-neutic techniques, to undertake a more complete re-evaluation of modernist historical and historiographic complexity.

C H A P T E R 2 2

MODERNISM AND PHILOSOPHY

PETER OSBORNE

> New or not new: that's the question which is asked of a work from both the
> highest and the lowest points of view. From the point of view of history,
> and of curiosity.
>
> (Friedrich Schlegel, 'Athenaeum Fragment' 45)

MODERNISM is a philosophical concept, but it has rarely been treated as such. Instead
of digging down through the mantle of its multifarious instances to its conceptual
core, and working back up to philosophical interpretations of its varieties, philoso-
phers have generally contented themselves with applications to the disciplinary field
of philosophy of conventional usages forged elsewhere. Thus, among the best recent
philosophical accounts of modernism in English, we find one that extends the
concept to philosophy by analogy with its use in art criticism,[1] one that restricts it
to the philosophical aspect of modernist art,[2] and a third that, despite its title,
neglects to analyse the concept directly at all, treating it as effectively synonymous
with 'modernity'.[3] The conjunction of 'modernism' with 'philosophy' thus demands
not so much the critical summation of a literature as, firstly, the construction of

[1] Stephen Melville, 'On Modernism', in *Philosophy Beside Itself: On Deconstruction and Modernism*
(Minneapolis: University of Minnesota Press, 1996), 3–33.

[2] J. M. Bernstein, 'Modernism as Philosophy: Stanley Cavell, Antonio Caro, and Chantal Akerman', in
Against Voluptuous Bodies: Late Modernism and the Meaning of Painting (Stanford, Calif.: Stanford
University Press, 2006), 78–116. See also J. M. Bernstein, 'Modernism as Aesthetics and Art History', in
James Elkins (ed.), *Art History Versus Aesthetics* (New York: Routledge, 2006), 241–68.

[3] Robert Pippin, *Modernism as a Philosophical Problem: On the Dissatisfactions of European High
Culture* (Oxford: Blackwell, 1991; 2nd edn, 1999).

modernism as a philosophical concept. Only then can the question of its significance for the philosophical field itself be intelligibly pursued. Such a construction is best grounded, not in philosophers' occasional and inconsistent uses of the term, but in the conceptual aspects of its broader semantic history.[4]

MODERNISM AS A PHILOSOPHICAL CONCEPT 1: HISTORICAL SEMANTICS

Two things should be borne in mind at the outset. Firstly, the core meaning of modernism derives from its place, as an 'ism', within the historically evolving set of terms of which 'modern', 'modernity', and 'modernization' are the main related elements. Secondly, these are all, foremost, *temporal* concepts, which, over the last two hundred years, have come to acquire their deepest meanings as categories within the *philosophy of history*.[5]

The English 'modern', meaning most simply 'of today' and by extension 'recent', may appear philosophically innocent. However, within the Western tradition, since at least the late fifth century, this 'today' of the modern (*modernus*) has carried with it a set of conceptual connotations acquired from its place within a present-centred, phenomenological temporality of present–past–future (today–yesterday–tomorrow) overlaid upon a linear, Christian form of historical time. Augustine's conception of the 'time of the soul' as a threefold present is the explicit philosophical anticipation of this conjunction.[6] Within such a linear consciousness of time (which supplanted the previously prevailing cyclical temporality), the present acquired the connotation of an irreversible break with the past. The 'today' of the modern thus henceforth marked a sense of the present as new (*novus*). More specifically, it came to be used to pick out from within the present those things that are most markedly different from the past in such a way as to generate expectations about the future, making them, by

[4] See Reinhart Koselleck, *Futures Past: On the Semantics of Historical Time* (1979), trans. Keith Tribe (Cambridge, Mass.: MIT Press, 1985); *The Practice of Conceptual History: Timing History, Spacing Concepts*, trans. Todd Samuel Presner et al. (Stanford, Calif.: Stanford University Press, 2002).

[5] Peter Osborne, *The Politics of Time: Modernity and the Avant-Garde* (London: Verso, 1995), chs 1 and 2; Paul Ricœur, *Memory, History, Forgetting*, trans. Kathleen Blamey and David Pellauer (Chicago: University of Chicago Press, 2004), pt 3, ch. 1, pp. 293–342. The following few pages extend the argument of *The Politics of Time*—from modernity to modernism—in line with the opening section of Peter Osborne, 'Modernisms and Mediations', in Francis Halsall, Julia Jansen, and Tony O'Connor (eds), *Rediscovering Aesthetics: Transdisciplinary Voices in Art History, Philosophy and Art Practices* (Stanford, Calif.: Stanford University Press, 2008), 163–77.

[6] Augustine, *Confessions* (398), trans. R. F. Pine-Coffin (Harmondsworth: Penguin, 1961), bk 11. For an account of Augustinian time as the crucible of 'modern thought', see Éric Alliez, *Capital Times: Tales From the Conquest of Time* (1991), trans. Georges Van Den Abbeele (Minneapolis: University of Minnesota Press, 1996), ch. 3: 'The Time of *Novitas*: Saint Augustine', 77–137.

the end of the eighteenth century, constitutive of the historical meaning and value of the present, or what we would now call 'the historical present'.

As such, the modern denotes a temporal structure of negation (negation of the past within the present by the new), which, in splitting the present from within (into the 'old' and the 'new'), makes 'modern' an inherently subjective, value-laden, and critical term. 'Modern' has no fixed, objective referent, 'only a subject, of which it is full'.[7] This subject of the utterance of the modern enacts a 'critique of the present' in its broad, threefold sense. Furthermore, in the modern, the new within the present does not merely demand more attention and value than what is not new; increasingly, it came to negate the latter's claim to be part of the 'living' present itself. Here, temporal negation is an antiquation, a *making* old (hence 'past' and no longer 'living') of the not-new within the present, through an act of disjunction or dissociation. This is the subjective conceptual basis of modernization theory. 'Modern' is thus an agonistic, conflict-generating term, as is evident in the opposition between the Ancients and the Moderns through which it first acquired an epochal, periodizing significance in twelfth-century Europe. It was not until much later, however, during the eighteenth century, that intensifying social and psychic investments in the temporality of the modern as the new gave rise to the concept of modernity— connoting a break not merely with the old, but with the temporality of tradition itself (in which the new appears, but only weakly, as an aspect of the differential repetition of the old). This was registered, paradigmatically, in the German coinage *Neuzeit* (literally, new time): the *self-transcending* temporality of an investment in the new that opposes itself to tradition in general.[8] This is a consciousness of time that is simultaneously and paradoxically *constitutive* of history as development and *de-*historicizing, in its absolutization of the present as the time of the production of the new.

The English 'modernism'—denoting a collective belief in and sympathy for the modern or the new—pre-dates the intensified sense of the present as modern associated with the concept of modernity,[9] but both its generalized form and its growing importance from the latter part of the nineteenth century rest upon it. Indeed, in its full, generalized sense, the concept of modernism first appears in Baudelaire's work in his affirmative attitude towards the phenomenological sense of *modernité* as a quality of experience that he was himself the first to articulate. The late eighteenth-century *Neuzeit* (a new time for a new world) and Baudelaire's mid-nineteenth-century coinage of *modernité* (the 'main characteristics' of which are 'the ephemeral, the fugitive, the contingent'[10]) are the two main semantic streams

[7] Henri Meschonnic, 'Modernity, Modernity', *New Literary History*, 23 (1992), 419.

[8] Koselleck, '"Neuzeit": Remarks on the Semantics of the Modern Concepts of Movement', in *Futures Past*, 231–66.

[9] In its early eighteenth-century usage, the term was restricted to linguistic change—'a modernism' being 'a usage, expression or peculiarity of style characteristic of recent times' (*The Shorter Oxford English Dictionary* (Oxford: Oxford University Press, 1973)).

[10] Charles Baudelaire, 'The Painter of Modern Life', in *The Painter of Modern Life and Other Essays*, ed. and trans. Jonathan Mayne (London: Phaidon Press, 1964), 13.

that fed the growing—indeed irresistible—power of the concept of modernity in the nineteenth century. The concept of modernism *condenses, intensifies*, and, most crucially, *affirms* this dual historical and phenomenological 'modernity'. In its most general conceptual meaning, modernism is a *collective affirmation of the modern as such*. This is not merely an affirmation of 'modern ways', at some particular time (which was the sense in which Luther used the Latin term *modernista*, for example), but an affirmation of the *temporality* of the modern: an affirmation of a specific temporal negation, *the time-determination of the new*.[11]

In Baudelaire's famous usage, *modernité* denotes not merely the quality of being modern or new, but the essential *transitoriness* that this quality had by then acquired, as a result of its intensification and generalization as a lived experience of time; and hence its aesthetic purity as a *feeling of time*. This form of experience had as its condition not just an extraordinary acceleration in the rhythms of social change— urbanization, industrialization, revolution—but their condensation and formaliza- tion in the metropolitan cultural logic of fashion. Indeed, it has been the increasing importance of fashion to capitalist production—in stimulating both innovation and consumption—that has subsequently led to the identification of modernity as capitalism's paradigmatic cultural form.[12] It is the commonality of these structures of experience across capitalist societies, which are otherwise culturally heteroge- neous, that makes their affirmation—modernism—so powerful a medium of cultur- al translation and exchange.[13] Baudelaire's use of the term *modernité* registers not merely the intensification of the experience of change but, equally importantly, his sense of the need to conquer it, to appropriate it subjectively, firstly, by submitting oneself to it (and hence, paradoxically finding a form of 'non-selfhood', *non-moi*) and, secondly, by representing it in its presentness in art.[14] In its affirmation of the transitoriness of novelty (*la nouveauté*) as a value, Baudelaire's 'The Painter of Modern Life' is the first articulation of a general—that is, a proto-philosophical— concept of modernism.

[11] I take the notion of a time-determination from Kant's 'On the Schematism of the Pure Concepts of the Understanding', in Immanuel Kant, *Critique of Pure Reason* (1781; 1787), trans. Paul Guyer and Allen W. Wood (Cambridge: Cambridge University Press, 1997), 271–7. For Kant, a time-determination is the schema of a concept, which mediates its intellectual form with sensible representation. Such schemata are conditions of possibility of cognitive experience. Modernism affirms the historical schema, or time- determination, of the modern, in this sense.

[12] See Marshall Berman, *All That Is Solid Melts Into Air: The Experience of Modernity* (New York: Simon & Schuster, 1982).

[13] Peter Osborne, 'Modernism as Translation', in *Philosophy in Cultural Theory* (London: Routledge, 2000), 53–62.

[14] Baudelaire, 'The Painter of Modern Life', 9; translation amended. Before 'The Painter of Modern Life' (composed 1859–60) came 'The Heroism of Modern Life'—title of sect. 18 of 'The Salon of 1846'; Charles Baudelaire, *Art in Paris 1845–1862: Salons and Other Exhibitions Reviewed by Charles Baudelaire*, ed. and trans. Jonathan Mayne (London: Phaidon Press, 1965), 116–20. See Walter Benjamin, 'Central Park', in *Selected Writings*, iv: *1938–1940*, ed. Howard Eiland and Michael W. Jennings (Cambridge, Mass.: Belknap Press, 2003), 161–99, where Benjamin associates Baudelaire's sense of modernity as a 'conquest' with what Jules Laforgue called his 'Americanism' (p. 166).

This proto-philosophical concept of modernism derives its universality from its condensation of the generalization of 'correspondences' between particular types of metropolitan experience of modernity: paradigmatically, the crowd and the commodity (in the Universal Expositions and the Salons, in particular), gambling, prostitution, fashion, the machine. Its subject, 'the lover of universal life', is 'an "I" with an insatiable appetite for the "non-I"' (*un moi insatiable de non-moi*). This is an 'I' that absolutizes the present in its passing, rather than merely experiencing it (in the sense of *Erlebnis*, living through it) as a historical condition. As such, it exhibits a quasi-Nietzschean character, as an affirmer of the present. It is from its transcendental character with respect to each particular instance of the new, however, that its most distinctively philosophical meanings, dynamics, and difficulties arise. For such an affirmation of novelty in its transitoriness is *the same* across the totality of manifestations of the new. As a structure, 'the new' is the 'ever-selfsame'; it represses the very duration it affirms.[15] As a philosophical concept, modernism thus poses the problem of nihilism within the very heart of the creative act.

MODERNISM AS A PHILOSOPHICAL CONCEPT 2: TRANSCENDENTAL OPERATION AND HISTORICAL MULTIPLICITY

As the affirmation of the time-determination of the new, modernism gains meaning in any particular cultural field or domain of experience from the application of a performative logic of temporal negation to the field in question. In so doing, it makes a claim for the production of the qualitatively new within that field. More precisely, it makes a claim for the production of something constitutive of the qualitative novelty of the historical present itself (this is its difference from 'mere' fashion). This claim carries with it certain expectations about the future. These expectations differ from the more determinate orientation towards the future of the avant-gardes. As the modern intensified, it increasingly incorporated the future's prospective negation of the present into its sense of the present itself, as transitoriness. Here, the future is projected as an abstract negation of the present (the present of the negation of the past), irrespective of any particular historical content, in a pure temporal formalism. This formalism is a crucial difference from the avant-gardes, which always act in the name of particular, determinate futures. Avant-gardes 'fail', but in its transcendental determination, modernism (thus far) simply moves on.

[15] Benjamin, 'Central Park', 175; Theodor W. Adorno, *Aesthetic Theory*, trans. Robert Hullot-Kentor (Minneapolis: University of Minnesota Press, 1997), 27. Fashion, Benjamin remarks, is 'the eternal recurrence of the new'. See 'Central Park', 178.

Something may thus be said to be 'modernist' here in two distinct senses, corresponding to that mobile 'empirico-transcendental doublet' that characterizes not only Kant's thought of the human, but *all* thought of the historical a priori as well.[16] On the one hand, something may be described as 'modernist' in the quasi-transcendental sense of gaining its intelligibility from its affirmation, within a particular cultural field, of the performative temporal logic of negation that constitutes the structure of modernism in general (the performance of the negation *affirms the structure* of production of the new, and not merely its particular result). This is modernism as a *transcendental structure of temporalization*, an *operation* or a *generative logic*. On the other hand, something may be called 'modernist' in the more historically specific sense of having been the modernism of its day: that is, constituted as a particular form of negation of a particular historically received cultural field. In the first case, modernism is a meta-critical term; in the second, it is a term of an empirical historical criticism. There is thus both a 'general economy' of modernism and a *plurality* of 'restricted economies' or modernism*s*—an overlapping historically successive *multiplicity* of modernisms within and across particular cultural fields.

The critical difficulty we inherit from this conceptual doubling lies in the prevalence of the fixing of the term 'modernism' to particular occurrences of the latter sense, as a *name* for particular hegemonic modernisms. For the reduction of 'modernism' to an empirical historical concept effaces its more fundamental transcendental operation as an *ongoing* affirmation of a structure of temporal negation, in the ongoing production of a competing multiplicity of modernisms. This dual logic of modernism (transcendental and empirical), and the hegemony of particular reified modernisms that it produces, can be seen at work in the philosophical field itself, as elsewhere.

It is characteristic of the philosophical field that the term 'modernism' was self-consciously embraced only belatedly (in the 1960s), and then retrospectively applied, although the adjective 'modern' (German *neu*—more literally, 'new', as in *neuen Philosophie*, modern philosophy) had been used as a periodizing term in the history of philosophy since its beginnings, and its mid-nineteenth-century substantive form ('the modern') was quickly picked up by philosophers. Indeed—readers beware!—in translations of German philosophical texts, such as Adorno's, it is this term, *der Moderne*, rather than *Modernismus*, which is usually being translated by the English 'modernism'. (*Modernismus* is a more pejorative usage.) A similar point applies to some uses of the English 'modernity' (in the translation of the title of Habermas's influential twelve lectures on the topic, for example); and even on

[16] Michel Foucault, 'Man and His Doubles', in *The Order of Things: An Archaeology of the Human Sciences* (London: Tavistock, 1970), ch. 9. For Foucault, this doubling was a defect. However, following Balibar, we may read it instead as the structure of a complex and paradoxical historical unity of universality and finitude, i.e. a structure characteristic of all genuinely historical concepts; Étienne Balibar, 'Citizen Subject', in Eduardo Cadava, Peter Connor, and Jean-Luc Nancy (eds), *Who Comes After the Subject?* (New York: Routledge, 1991), 54–5.

occasion 'avant-garde'.[17] In order to reconstruct a history of modernist philosophies, however, it is the affirmation of the structure of temporal negation, within the philosophical field—and the constitution of historico-philosophical meaning through such affirmations—to which we need attend, rather than the presence of the term 'modernism' itself. Such an optic directs us, in the first instance, to the main staging posts in the 150-year history of German philosophy from Kant to the early Heidegger and Walter Benjamin. For, as Pippin acknowledges, modernity (let alone modernism as the affirmation of its intensified temporal form) 'is not a philosophical or, really, any other sort of "problem" within [the British and American] *philosophical* traditions'.[18] It became an issue within French philosophy in the twentieth century, largely as a result of the convergence of the legacy of Baudelaire with the reception of Nietzsche and Heidegger.

NOT KANT

Our story begins with Kant, not because he is 'the first thoroughgoing philosophical modernist', but because it has been claimed that he is.[19] Understanding why, and why the claim does not survive scrutiny, is instructive in a number of respects. Not least because the claim has as one confusing consequence that anti-Kantian philosophers (such as Nietzsche and Heidegger, in particular) appear as fundamentally opposed to philosophical modernism, rather than, as they are, paradigms of its affirmative structure and symptoms of its profound paradoxes and problems. The claim derives from a dual conflation: firstly, of the notion of philosophical modernism with the philosophical discourse of modernity; and secondly, of the philosophical discourse of modernity with a certain understanding of the Enlightenment. Philosophical modernism is thereby reduced to a series of variants of Kant's version of the Enlightenment project.

 The ground of the claim that Kant is a philosophical modernist lies in the historical self-consciousness of the German Enlightenment as the intellectual representative of a new beginning, for which the radicalization of the critique of the authority of tradition dictated that modernity 'create its normativity out of itself'. Habermas, who has done most to elaborate this concept of modernity, initially claimed it was Hegel who was 'the first to raise [this] to the level of a philosophical

[17] Jürgen Habermas, *The Philosophical Discourse of Modernity: Twelve Lectures* (1985), trans. Frederick Lawrence (Cambridge, Mass.: MIT Press, 1987)—the German is *Diskurs der Moderne*. Ch. 11 of Adorno's *Introduction to the Sociology of Music*, trans. E. B. Ashton (New York: Continuum, 1989), is entitled 'Avant-Garde'—where the German is simply '*Moderne*'.

[18] Pippin, *Modernism as a Philosophical Problem*, p. xix. The exception is the work of Stanley Cavell; see n. 3, above.

[19] Ibid. 12.

problem'. However, in his lecture on Kant's 'What Is Enlightenment?' Foucault argued that the problem was explicitly present in Kant, and Habermas subsequently conceded the point. Pippin follows this consensus, extending the claim into a reading of Kant's philosophy as a whole.[20] In Pippin's version, the self-transcending temporal structure of modernity finds its philosophical basis and legitimization in the self-determining character of autonomous reason in Kant's philosophy (and German idealism more generally). The problem here does not lie in the identification of Kant as a philosopher of modernity, in the specific sense of *Neuzeit* identified by Koselleck; even in Foucault's extended, retrospective construction of Kant as a practitioner of the critical ontology of the present, and hence also of ourselves—although this surpasses Kant's self-understanding by some distance.[21] Rather, the problem lies in understanding Kant's account of rational self-determination as a modern*ism* on the basis of the 'ruptural' character of the structure of self-grounding alone.

Kant was not the first philosopher to have conceived of his thought as a self-grounding new beginning. That role has traditionally been assigned to Descartes. It is the basis for the conventional identification of Descartes's thought as the first truly 'modern' philosophy. This epistemological self-grounding (via the method of doubt) has no consequence for practical philosophy in Descartes, and remains the activity of a metaphysically conceived substance (soul)—this explains the import of the word 'thoroughgoing' in Pippin's claim for Kant. However, these aspects are separate from the claim for the identification of 'modernism' with the temporal structure of the self-grounding break with the authority of tradition. Such a break is undoubtedly 'modern', in its declaration of a new historical beginning (and radically so, in its self-grounding), but it is far from being specifically modern*ist*, in the sense of affirming the temporality of the new, in either Descartes or Kant. Indeed, like most modern philosophers, both Descartes and Kant conceived their philosophies as new beginnings that were also decisively philosophically self-completing. No *ongoing* production of philosophical novelty was envisaged. However unending Kant may have envisaged the *process* of Enlightenment to be, in its successive approximation of

[20] Habermas, *The Philosophical Discourse of Modernity*, 7, 16; Michel Foucault, 'What Is Enlightenment?', trans. Catherine Porter, in Paul Rabinow (ed.), *The Foucault Reader* (Harmondsworth: Penguin, 1986), 32–50; Jürgen Habermas, 'Taking Aim at the Heart of the Present: On Foucault's Lecture on Kant's *What Is Enlightenment?*', in *The New Conservatism*, trans. Shierry Weber Nicholsen (Cambridge, Mass.: MIT Press, 1989), 173–9; Pippin, *Modernism as a Philosophical Problem*, 45–60; Robert Pippin, *Idealism as Modernism: Hegelian Variations* (Cambridge: Cambridge University Press, 2004), 29–184. The first person to claim Kant as 'the first real Modernist' was probably the American art critic Clement Greenberg in his 1960 essay 'Modernist Painting', which reads Kant's 'criticism of reason by reason alone' as the first instance of modernism as self-criticism of a medium. Clement Greenberg, 'Modernist Painting', in *The Collected Essays and Criticism*, ix: *Modernism with a Vengeance, 1957–1969* (Chicago: University of Chicago Press, 1993), 85–93. Cf. Friedrich Schlegel: 'Poetry can only be criticized by way of poetry' ('Critical Fragment' 117, in *Philosophical Fragments*, 14).
[21] Michel Foucault, 'Kant on Enlightenment and Revolution' (1984), trans. Colin Gordon, *Economy and Society*, 15/1 (Feb. 1986), 96; 'What Is Enlightenment?', 50. As the structure of this chapter shows, the late Foucault's Enlightenment Kant is a thoroughly Baudelairean concoction. See Michel Foucault, 'What Is Critique?', in *The Politics of Truth* (New York: Semiotext(e), 1997), 23–81, for a rather different, earlier view.

human conduct to rational principles, it was nonetheless based on essentially timeless rational universals. This is the *philosophically completed* modernity of the Enlightenment's *practically 'incomplete'* project. The subject of Kantian Enlightenment may need to break with tradition—indeed with the heteronomous determinations of all social norms—again and again, with each act; but not so as to produce the new; rather, to give actuality to a universal reason; to *conform* to reason. As Foucault pointed out, this is the 'piety' and 'most touching of treasons' of 'those who wish us to preserve alive and intact the heritage of *Aufklärung*': they fail to subject the event to reflection on its own historical limits.[22] They fail to acknowledge the fundamental *iterability* of modernity as such. They fail to see that the logic of self-transcendence dictates that it too transcend its own inaugural forms. This is its paradoxical core as a cultural form, enacted in, but comically misrecognized by, the (swiftly passing) concept of the postmodern. And it is precisely the consciousness of this iterability—and its affirmation—that constitutes modernism as a transcendental operation or philosophical form.[23]

In fact, it is the self-limiting, rule-governed character of Kantian reason that Pippin values—its projection of freedom as self-limitation—rather than the proto-Baudelairean aspects of the Kantian subject. In Kant's 'thoroughgoing' version of philosophical self-grounding, the *spontaneity* of the subject (spontaneity of apperception, spontaneity of imagination, spontaneity of the understanding, and spontaneity of 'the subject as a thing-in-itself', or 'absolute spontaneity of freedom'[24]) is, crucially, not merely self-determining (and hence self-transcending) but rationally self-limiting. Here, spontaneity is the medium of self-limitation, rather than willed self-dissolution into the multitude. In Kant, the meaning of an action derives from the rationality of its determination (its claim to universality), not from the temporal relations between a present affirmed as the production of the new, a negated past and a projected future. There is no modern*ism* there. The best one might say of Kant in this regard, following Foucault, is that *the question* of the philosophical meaning of the present is raised by the historical writings—a question to which philosophical modernism offers a series of alternative answers.

None of the discourses of the modern, modernity, and modernism in philosophy are tied to 'reason' at a conceptual level, although the first two (modern and modernity) are historically associated with it. Contra Habermas and Pippin, the association of philosophical modernity with the Kantian form of rationally self-limiting spontaneity was thus historically passing, in a deep sense, in much the same way that the association between artistic modernism and aestheticism was the historical starting point for a series of (at times explicitly *anti*-aesthetic) artistic modernisms.[25] However, if the modern, modernity, and modernism in philosophy are not necessarily tied to 'reason', they are tied, structurally, to the philosophical

[22] Foucault, 'Kant on Enlightenment and Revolution', 95.

[23] As even Jameson eventually, if inconsistently, grudgingly acknowledged; Fredric Jameson, *A Singular Modernity: Essay on the Ontology of the Present* (London: Verso, 2002).

[24] Kant, *Critique of Pure Reason*, 146, 257, 193; Immanuel Kant, *Critique of Practical Reason*, trans. Mary Gregor (Cambridge: Cambridge University Press, 1997), 83.

[25] Osborne, 'Modernism and Mediations', 167.

concept of *the subject* (and its predecessors and successors) by virtue of their basis in the phenomenological temporality of the threefold present. The primary determination of the philosophy of the subject lies not in its relations to 'consciousness' and 'reason' but in its relations to time—ultimately, this is true even of Kant himself.[26] It was through the mediation of the concept of the subject that the problematic relationship between reason and modernity as a form of historical time was played out in early nineteenth-century philosophy—paradigmatically, in Hegel, in the self-positing and reflective self-appropriation of spirit (*Geist*), that (rational) substance that is 'equally' subject.[27] For the subject of modernity is a collective one. As Ricœur has put it: the 'full and precise formulation' of the concept of modernity is achieved only 'when one says and writes "our" modernity'.[28] And one can say and write 'our' modernity philosophically only by positing 'I that is We and We that is I'[29] as its speculative subject. 'Modernity' becomes a fully formed philosophical concept at the point at which it comes to denote the experience of this subject: 'history' in the collective singular. However, it becomes the central category of the philosophy of history—transformed into a philosophy of historical time—only *after* the critique of Hegel's absolute (in which time is ultimately abolished),[30] via *the extraction of the formal structure of temporal negation from the totalizing narrative of necessary development* in Hegel's philosophy of history. Modernism is the *affirmation* of this formal temporal structure, the new. As such, the philosophical concept of modernism finds certain of its problems foreshadowed both in Hegel's philosophy and in the philosophical romanticism to which it was a response. These concern, principally, the concept of negation and its relationship to affirmation.

NEGATION, AFFIRMATION, THE NEW

The central philosophical issue at stake in modernism is: how does the *affirmation* of the new stand in relation to its *negation* of the old? The two main traditions of

[26] Martin Heidegger, *Kant and the Problem of Metaphysics*, trans. Richard Taft (Bloomington: Indiana University Press, 1990).

[27] G. W. F. Hegel, *Phenomenology of Spirit*, trans. A. V. Miller (Oxford: Oxford University Press, 1977), 10. The idea that 'modern' philosophy is a philosophy of 'subjectivity' is Hegel's. G. W. F. Hegel, *Lectures on the History of Philosophy*, iii, trans. E. S. Haldane and Frances H. Simson (Lincoln Nebr.: University of Nebraska Press, 1995), 161. For the philological complexities of the philosophical concept of the subject, see the indispensable entry 'Sujet', by Étienne Balibar, Barbara Cassin, and Alain de Libera, in Barbara Cassin (ed.), *Vocabulaire européen des philosophies* (Paris: Éditions du Seuil/Dictionnaires Le Robert, 2004), trans. David Macey, *Radical Philosophy*, 138 (July–Aug. 2006), 15–42.

[28] Ricœur, *Memory, History, Forgetting*, 305.

[29] Hegel, *Phenomenology of Spirit*, 110.

[30] Ludwig Feuerbach, 'Towards a Critique of Hegel's Philosophy', in *The Fiery Brook: Selected Writings of Ludwig Feuerbach*, ed. and trans. Zawar Hanfi (New York: Anchor Books, 1972), 53–96.

philosophical modernism—the Hegelian and the Nietzschean—are defined by their differences on this issue. Broadly speaking, in the first instance, these are the differences between an understanding of temporal negation as dialectical negation, in which what is affirmed is affirmed through negation (Hegel), and a conception of temporal negation as itself a mode of being of affirmation (Nietzsche). More specifically, in the first case, the structure of the temporal negation constitutive of 'the affirmation of the new' is the result of the subtraction of the form of dialectical development from the systematic context that makes such development a progressive definition of the absolute, and hence ultimately a supersession (*Aufhebung*) of finitude itself. Nonetheless, it avoids the neo-Kantian regression of dialectic to a general method, by repositioning this dialectical temporal formalism, historically and ontologically, as the structure of experience of a specific subject: the subject of metropolitan modernity. On its Hegelian coding, this subject displays the immanent (self-)transcendence characteristic of dialectical development in general, in which affirmation is the ultimate meaning of negation itself: 'The highest form of nothing for itself would be freedom, but this is negativity, insofar as it deepens itself to its highest intensity and is itself affirmation—indeed absolute affirmation.'[31]

From this perspective, the modernist affirmation of the new may be understood as an enactment of the affirmative essence of negativity itself. This 'deepening of negativity to its highest intensity' takes the logical form of a double negation (negation of negation): the new as the not-old (first negation) must itself be negated in its being-for the old (second negation), in order to be understood as something for-itself. Yet the first negation (its being-for the old as its other) is nonetheless 'preserved' within this process of supersession, such that the determinacy or *meaning* of the new continues to derive from its negation of the old, within its independent positivity. (Hegel is fond of misquoting Spinoza: *omnis determinatio est negativo*, all determination is negation.[32]) In so far as the new necessarily involves this double negation, its modernist affirmation affirms both negations together: that is, both its determinate negativity and the negation of its being-for-another that registers its positivity as an independent thing. Furthermore, this for-itself-ness of the new is the prospective starting point for subsequent negations, and hence transitory. The intensification of the experience of novelty depends upon this anticipation of its 'death'. This is the Hegelian meaning of Baudelairean modernism, for which both intelligibility and affirmation derive from negativity. It has the form of what Hegel called a 'spurious or negative' infinity: 'Something becomes an other, but the other is itself a something, so it likewise becomes an other, and so on *ad infinitum*.'[33]

[31] G. W. F. Hegel, *The Encyclopedia Logic: Part One of the Encyclopedia of Philosophical Sciences*, trans. T. F. Geraets, W. A. Suchting, and H. S. Harris (Indianapolis: Hackett, 1991), 140, translation amended; *Enzyklopädie der philosophischen Wissenschaften im Grundrisse*, i: *Die Wissenschaft der Logik* (Frankfurt am Main: Suhrkamp, 1970), no. lxxxvii, p. 187.

[32] Hegel, *Enzyklopädie der philosophischen Wissenschaften im Grundrisse*, no. lxxxxi, addition, p. 96; trans., p. 147. The Spinoza (Epistle 50) actually reads more simply: *determinatio negativo est*, 'determination is negation'.

[33] Ibid., nos lxxxxiii–lxxxxiv, pp. 198–9; trans., p. 149.

From Hegel's own point of view this is a profound defect (one might even call it nihilism), since for him 'the genuine (*wahrhafte*) infinite' was 'the basic concept of philosophy'.[34] From the point of view of the critique of Hegel's absolute, however, such an endless series marks both the openness of the future and the ultimately allegorical character of the philosophical meaning of the new. This can be discerned in Hegel's own account of Romantic art, on which the modern principle of subjectivity (subjective freedom) dictates that sensuous representation 'be posited as negative, absorbed and reflected into spiritual unity'. The 'sensuous externality of concrete form' of the 'vehicle of expression' of such art thus appears (in Bosanquet's appropriately Baudelairean 1886 translation of the Introduction to the *Lectures on the Philosophy of Fine Art*) 'as something transient and fugitive (*unwesentliche, vorüber-gehende*) . . . committed to contingency (*Zufälligkeit*)'.[35] Baudelairean modernism is the consummation of what appears here as the Romantic commitment to a philosophically subjectively interpreted contingency. However, the modernist extraction of the temporal form of dialectical negation from the context of Hegel's system profoundly problematizes its relationship to history. On the one hand, history becomes the history of the new, the comprehension of which becomes a condition of further novelty, further negations—since only if the present is properly understood in its novelty can that novelty itself be made an object of meaningful negation. Historical consciousness is thus increasingly important; and modernism is itself a form of historical consciousness. On the other hand, however, the production of the qualitatively historically new requires a rupture with the historically comprehended present for which there appears to be no basis or rationale, once the standpoint of the absolute has been forsaken as the ground of the dialectic. In the absence of a systematic determination of development, the question arises as to the source and meaning of the new. The future becomes a void, and into this void flow 'philosophies of the future'.[36] The problem is registered in Nietzsche's second Untimely Meditation, 'On the Uses and Disadvantages of History for Life' (1874), and then purportedly overcome in *Thus Spoke Zarathustra* (1883–5) and his 1883–8 notebooks, published as *The Will to Power*.[37] Nietzsche thereby inaugurated a second, anti-Hegelian, anti-historical stream of philosophical modernism.

'The Uses and Disadvantages of History for Life' was a challenge to the increasingly historical culture of modernity, on behalf of modernity itself, which there takes

[34] Ibid., no. lxxxxv, p. 203; trans., p. 152.

[35] G. W. F. Hegel, *Introductory Lectures on Aesthetics*, trans. Bernard Bosanquet (Harmondsworth: Penguin, 1993), 87.

[36] Ludwig Feuerbach, 'Principles of the Philosophy of the Future', in *The Fiery Brook*, 175–245. Nietzsche's *Beyond Good and Evil* (1886), written immediately after *Thus Spoke Zarathustra*, bears the subtitle *Prelude to a Philosophy of the Future*, trans. Judith Norman (Cambridge: Cambridge University Press, 2001).

[37] Friedrich Nietzsche, 'On the Uses and Disadvantages of History for Life', in *Untimely Meditations*, trans. R. J. Hollingdale (Cambridge: Cambridge University Press, 1997), 57–123; *Thus Spoke Zarathustra*, trans. Adrian Del Caro (Cambridge: Cambridge University Press, 2006); *The Will to Power*, trans. Walter Kaufmann and R. G. Hollingdale (New York: Random House, 1968).

the name 'life'.[38] Life is not a biological category for Nietzsche, but the name of whatever is able *to forget* and thereby *to act*. It is, however, understood as 'an unhistorical power'. Baudelaire's experience of the beauty of the feeling of time is transformed here into the experience of the power of life. There is a philosophical basis for this move in Kant; not the Kant of rational self-determination, however, but the Kant of the *Critique of the Aesthetic Power of Judgment* (1790), in which 'an entirely special faculty for discriminating and judging that contributes nothing to cognition' is grounded upon the subject's 'feeling of life' (*Lebensgefühl*), 'under the name of the feeling of pleasure or displeasure'.[39] Indeed, Kant maintained: 'it cannot be denied that *all* representations in us, whether they are objectively merely sensible or else entirely intellectual . . . affect the feeling of life, and none of them, insofar as it is a modification of the subject, can be indifferent . . . because the mind for itself is entirely life (the principle of life itself)'.[40]

There is a textual prompt in Nietzsche's opening quotation from Goethe on 'quickening activity'—quickening, or animation (*Belebung*), being the word Kant famously used to describe 'the sensation whose universal communicability is postulated by the judgement of taste'.[41] Nietzsche's philosophical modernism is thus 'aesthetic' in a manner that the dialectical tradition is not; and in a way associated at that time with the work of art: 'only if history can endure to be transformed into a work of art will it perhaps be able to preserve instincts or even evoke them'.[42]

Ultimately, however, 'On the Uses and Disadvantages of History for Life' itself remains an aporetic dialectical text, committed to the position that '*the unhistorical and the historical are necessary in equal measure for the health of an individual, of a people and of a culture*'. For the critical historian does not so much forget as *decide against* the historical culture of the present, in the name of a power of action invested in a purer present. In severing oneself from the past absolutely, one would sever oneself from the present as well, and hence also from its critique. '[The] same life that requires forgetting demands a temporary forgetting of this forgetfulness; it wants to be clear as to how unjust the existence of anything . . . is, and how greatly this thing deserves to perish. Then its past is regarded critically, then one takes the knife to its roots, then one cruelly tramples over every kind of piety.'[43] The association of the future with critical negation thus remains here, in part. Indeed, perhaps the greatest of Nietzsche's legacies to the modernist tradition has been the contribution of his concept of genealogy to its sense of history: '*If you are to venture to interpret the past*

[38] See Paul de Man, 'Literary History and Literary Modernity', in *Blindness and Insight: Essays in the Rhetoric of Contemporary Criticism* (Minneapolis: University of Minnesota Press, 1983), esp. p. 146.

[39] Immanuel Kant, *Critique of the Power of Judgment*, trans. Paul Guyer and Eric Matthews (Cambridge: Cambridge University Press, 2000), 90.

[40] Ibid. 159; my emphasis.

[41] Ibid. 104; Nietzsche, *Untimely Meditations*, 59. Unfortunately, this edition covers over the connection by translating *zu beleben* as 'invigorating'.

[42] Ibid. 95. [43] Ibid. 63, 21.

you can do so only out of the fullest exertion of the vigour the present....[44] This principle, exemplified in his own 'polemic' *On the Genealogy of Morality* (1887), is fundamental to the modernist historiographies of both Benjamin and Foucault.[45] Genealogy is modernist historiography.

In *Thus Spoke Zarathustra*, however, the temporalizing self-reflection that succeeded Hegel's logicist 'absolute reflection' of history, and which makes up only one side of the aporia of the second of the *Untimely Meditations*, is itself absolutized. As if in response to Rimbaud's 1873 imperative 'to be absolutely modern',[46] with the idea of transvaluation or the transmutation of values, Nietzsche absolutizes affirmation: 'life' is philosophically transformed into 'will to power', the '*inner* will' of force.[47] In the process, the dialectical account of the relation of the affirmation of the new to the negation of the old is inverted. If everything is affirmation, the difference between negation and affirmation must be internal to affirmation itself, as the difference between a 'reactive' and nihilistic affirmation of negation (dialectics) and an 'active' affirmation of affirmation itself (transvaluation). Such an active, 'secondary' affirmation, it is claimed, converts negation itself into an affirmative power. On Deleuze's account:

The negative becomes a power of affirming: it is subordinated to affirmation and passes into the service of an excess of life. Negation is no longer the form under which life conserves all that is reactive in itself, but is, on the contrary, the act by which it sacrifices all its reactive forms. In the man who wants to perish, the man who wants to be overcome, negation changes sense...

Only affirmation exists as an independent power; the negative shoots out from it like lightning, but also becomes absorbed into it, disappearing into it like a soluble fire. In the man who wants to perish the negative announces the superhuman, but only affirmation produces what the negative announces.[48]

For Nietzsche, to affirm is to 'make use of excess in order to invent new forms of life'. As a mode of being of affirmation, the negative no longer gives *meaning* to the new (as a conceptually constitutive logical negation), but partakes in its creation through 'the warlike play of differences' and 'the joy of destruction'. This is Nietzsche's great 'anti-dialectical discovery': 'negativity as negativity of the positive'.[49] Its modernism lies in its radical transformation of the philosophical meaning of 'affirmation' in the affirmation of the time-determination of the new. With Nietzsche, modernism is *ontologized*: history is reduced to a new sense of becoming, the becoming of the new.

[44] Ibid. 94.

[45] Friedrich Nietzsche, *On the Genealogy of Morality*, trans. Carol Diethe (Cambridge: Cambridge University Press, 1997).

[46] Arthur Rimbaud, 'Une Saison en enfer', in *Collected Poems* (London: Penguin, 1962), 346.

[47] Nietzsche, *The Will to Power*, 619.

[48] Gilles Deleuze, *Nietzsche and Philosophy*, trans. Hugh Tomlinson (London: Athlone Press, 1983), 176. For the distinction between a primary (Dionysian) and secondary (Zarathustrean) affirmation, and the claim that only 'the two affirmations constitute the power of affirming as whole', see pp. 186, 189–94. For a more comprehensive discussion, see Robert Gooding-Williams, *Zarathustra's Dionysian Modernism* (Stanford, Calif.: Stanford University Press, 2001).

[49] Deleuze, *Nietzsche and Philosophy*, 185, 191, 198.

This truly is a properly philosophical modernism. However, in rejecting negation as the means to giving determinacy to the new, it immediately runs up against the problem of the transcendental structure of the new as *the same*: the threat of nihilism that lurks within modernism—a negative nihilism of no difference, as opposed to the reactive nihilism of conceptual difference.

Nietzsche's solution is the famously obscure doctrine of eternal return: the imperative that, when you will something, you will to do it an infinite number of times. Such a return is itself 'the most extreme form of nihilism', but, in completing (absolutizing?) nihilism, it is understood to break its connection to reactive forces, negating their function of conservation ('the same') and converting them into forces of active self-destruction. To will the eternal return was, for Nietzsche, to become active. In the eternal return, nihilism is 'vanquished by itself'.[50] The consequence, however, is that while 'the new' may no longer be 'the same', it is also no longer new. In the eternal return, Nietzsche's modernism consumes itself. At their highest points, Hegel's 'negativity that is itself absolute affirmation' and Nietzsche's 'negativity as a mode of being of affirmation as such' are thus perhaps less different than Deleuze supposed—not as a result of some 'compromise',[51] but as a result of the precise character of their difference.

Both Hegel and Nietzsche, in their very different ways, absolutized the temporality of the modern to the point of the dissolution of historical time, and with it the very notion of qualitative historical novelty upon which modernism depends. Yet the new itself is abstract; 'it gives no satisfaction', as Marx put it. It is, rather, the emblem of the promise of a future, a future in which, for Marx, wealth will have become 'the absolute working out of creative potentialities... the development of all human powers as such [as] the end in itself... Where humanity... Strives not to remain something it has become, but is in the absolute movement of becoming.'[52] There is a Nietzschean aspect to Marx's imagining here, although 'the absolute movement of becoming' derives from the restlessness of Hegel's absolute rather than Nietzsche's becoming-active; and it has determinate historical conditions, in capitalism's 'constant revolutionizing' of the instruments of production 'and thereby the relations of production, and with them the whole relations of society'.[53] In this respect, modernism is a capitalist cultural form, even—perhaps especially—as it points beyond its current conditions of existence.

[50] Deleuze, *Nietzsche and Philosophy*, 68–72; Nietzsche, *The Will to Power*, 1053, 1056, 58, 28.

[51] 'There is no possible compromise between Hegel and Nietzsche' (Deleuze, *Nietzsche and Philosophy*, 195).

[52] Karl Marx, *Grundrisse: Foundations of the Critique of Political Economy (Rough Draft)*, trans. Martin Nicolaus (Harmondsworth: Penguin/New Left Books, 1973), 488; translation amended.

[53] Karl Marx and Frederick Engels, *The Communist Manifesto*, in *Collected Works*, vi (London: Lawrence & Wishart, 1976), 477–512. See Peter Osborne, 'Remember the Future? *The Communist Manifesto* as Cultural-Historical Form', in *Philosophy in Cultural Theory*, 63–77; and more generally, Peter Osborne, 'Marx and the Philosophy of Time', *Radical Philosophy*, 147 (Jan.–Feb. 2008), 15–22. Marx's modernism was historico-philosophical, rather than ontological.

For Benjamin, Nietzsche's idea of eternal recurrence was itself a reflection of those conditions, in transforming the historical event into 'a mass-produced article'. Benjamin attributed its 'sudden topicality' in the 1930s to the accelerated succession of capitalist crises, whereby 'it was no longer possible, in all circumstances, to expect a recurrence of conditions across any interval of time shorter than that provided by eternity', leading to 'the obscure presentiment that henceforth one must rest content with cosmic constellations'.[54] He was interested in the way the idea of eternal recurrence emerged at about the same time, inflected in different directions, in Baudelaire, Blanqui, and Nietzsche. Its equivalent in Benjamin's own time is to be found in Heidegger's concept of repetition. In the wake of Nietzsche, Benjamin and Heidegger were the foremost philosophical modernists of the first part of the twentieth century, in whose writings the philosophical thought of the new was refracted through the prisms of its two main political ideologies, communism and fascism, respectively.

HEIDEGGER AND BENJAMIN

It is symptomatic that as Heidegger struggled with the political implications of his 'critique of the present' (the phrase recurs in his manuscripts of the early 1920s), in the late 1930s, in the aftermath of his formal participation in National Socialism, he did so through an extended confrontation with Nietzsche.[55] He sought, in particular, to expose the failure of Nietzsche's concept of will to power to overcome both metaphysics and nihilism in order to highlight his own (in his view successful) overcoming, derived from his rethinking of the relationship between being and time. Heidegger was explicitly opposed to the interpretation of his own work in terms of the modern, and most critics (associating fascism with a backward-looking historical consciousness) have agreed. However, the structural prioritization of futurity in its conception of existential temporalization, and, indeed, the very notion of originary temporalization, mark *Being and Time* (1927) as a work of philosophical modernism. The notion of a time-determination through which I have characterized philosophical modernism (as the affirmation of the time-determination of the new) is here taken up and integrated into the 'ecstatic-horizonal' structure of 'originary temporalization' itself. In this respect, Heidegger follows Nietzsche in ontologizing

[54] Benjamin, 'Central Park', 167.

[55] Martin Heidegger, *Nietzsche*, trans. David Farrell Krell, Frank A. Capuzzi, and Joan Stambaugh, 4 vols (San Francisco: Harper and Row, 1979–87). The lectures were delivered 1936–40. For a review of the literature on the relationship of Heidegger's philosophy to his politics, occasioned by Victor Farias's *Heidegger and Nazism* (1987), trans. Paul Burrell (Philadelphia: Temple University Press, 1989), see Peter Osborne, 'Tactics, Ethics, or Temporality? Heidegger's Politics Reviewed', *Radical Philosophy*, 70 (Mar.–Apr. 1995), 16–28.

the time-consciousness of modernism. The historical self-consciousness of his philosophy was modernist too in so far as it involved the ongoing negation of a totalized past—'the history of metaphysics'—to which previous such negations were successively retrospectively consigned. This is a structure to which Heidegger would subsequently subject his own early thought, and to which Derrida would subject Heidegger's philosophy as a whole, thereby establishing a distinctive Germanic–French lineage of philosophical modernism.[56]

Heidegger's philosophical modernism is an offshoot of a field in which the concept of modernism was established early on—theology (Pope Pius X condemned 'de modernistarum doctrinis' in the encyclical *Pascendi gregis* of 8 September 1907)— and of Heidegger's ambivalent relationship to it. While he accepted what he described in 1922 as 'the fundamental atheism of philosophy', Heidegger nonetheless still conceived his project as 'an ontological founding of Christian theology as a science', even after the publication of *Being and Time*.[57] This explains the peculiar temporal dynamics of his thought. For the 'critique of the present' on which he embarked understood the present to be defined by the 'system' of Catholicism, with its roots in the medieval reception of Aristotle. Heidegger's 'destruction' of that system set out from the standpoint of the philosophical modernity of Husserl's phenomenology; hence his theological modernism. (Indeed, if there is a claim to be made for the modernism of a self-grounding transcendental subject—on account of its time-consciousness—it is with regard to Husserl, not Kant.[58]) However, it proceeded, via a phenomenological recovery of Aristotle's ontology from the Scholastic tradition, which fed back into Heidegger's radicalization of Husserl's critique of neo-Kantianism, to produce what Kisiel has called a 'neo-Hellenic phenomenology of λογος corresponding to the ontological phenomenology of the παθος of the question of being as such'.[59] Heidegger's (Husserlian) modernity was thus radicalized into a philosophical modernism by the *archaic* character of his other sources, in a manner structurally analogous to the temporal form of the reactionary modernism of conservative revolution and National Socialism in inter-war Germany,[60] which derived its energy from the historical distance of its ideal from its present, representing dead (and thereby idealized and mythologized) tradition as novelty. This is reflected in the internal structure of Heidegger's account of originary temporalization, in particular his concept of 'resolute repetition'.

[56] See e.g. Jacques Derrida, 'Ousia and Gramme: A Note on a Note from *Being and Time*' (1968), in *Margins of Philosophy* (Chicago: University of Chicago Press, 1982), 29–67.

[57] Theodore Kisiel, *The Genesis of Heidegger's Being and Time* (Berkeley: University of California Press, 1993), 113, 452—the second phrase comes from a letter to Rudolf Bultmann.

[58] Edmund Husserl, *The Phenomenology of Internal Time-Consciousness*, trans. James S. Churchill (Bloomington: Indiana University Press, 1964).

[59] Ibid. 369.

[60] See Jeffery Herf, *Reactionary Modernism: Technology, Culture and Politics in Weimar and the Third Reich* (Cambridge: Cambridge University Press, 1984); Roger Griffin, *Modernism and Fascism: The Sense of a Beginning Under Mussolini and Hitler* (Basingstoke: Palgrave Macmillan, 2007).

In *Being and Time*, the existential priority of the future is famously secured by the role of the anticipation of death in 'temporalizing' a temporality that 'has the unity of a future which makes itself present in the process of having been'. Being-towards-death, as 'potentiality for being-a-whole', is anticipation of possibility; it is 'what first *makes* this possibility *possible*, and sets it free as possibility'. However, such futurity exists only as the projected horizon of a present defined by the mode of its taking up of a specific past; and for Heidegger himself such taking up is only 'authentic' if it takes the form of a 'resolute repetition'. 'Authentic' existence involves 'appropriat-ing' the existential structure of time by showing 'resoluteness' in the face of death by choosing a 'fate' (*Schicksal*). This choice is understood by Heidegger in the restricted form of the repetition of a heritage of possibilities. And it is here that the reactionary character of his philosophical modernism emerges, as this already constitutively backward-looking heritage of possibilities is identified with the destiny (*Geschick*) of a people (*Volk*). The new is the '*resolute* repetition' of the old. The temporal formalism of a future-orientated philosophical modernism is filled with the content of the past.[61]

But why might not the past be taken up via a determinate *not-repeating* negation? Heidegger's only response is to declare such a taking-up inauthentic, even though on his own terms the criterion of authenticity here ought to be its 'resoluteness'. Those who seek the modern (*das Moderne*), he argues, do so because the past has become 'unrecognizable' (*unkenntlich*) to them.[62] In a dialectical modernism, however, it is precisely recognition of the past in its pastness (recognition without identification) that leads to the negation of past and present alike, in a process that corresponds, quite precisely, to what Heidegger called 'finite transcendence', albeit one that is not merely temporal, but qualitatively historical. Benjamin's modernist philosophy of history opposes itself directly to Heidegger's reactionary modernism by working the post-Nietzschean problematic in a different way, in order to emphasize the 'explosive' *negative* power of 'the now of recognizability' (*Jetzt der Erkennbarkeit*) itself[63]—a recognizability that has nothing to do with repetition.

Benjamin plays the genealogical perspective of the Nietzsche of the second of the *Untimely Meditations* against the repetitions of the later Nietzsche and Heidegger alike:

[61] Martin Heidegger, *Being and Time*, trans. John Macquarrie and Edward Robinson (Oxford: Blackwell, 1962), 374, 307, 424–4.

[62] Ibid. 444.

[63] Walter Benjamin, *The Arcades Project*, trans. Howard Eiland and Kevin McLaughlin (Cambridge, Mass.: Harvard University Press, 1999), 'Convolut N: On the Theory of Knowledge, Theory of Progress', [N 3a], 464. For the claim that Benjamin's entire intellectual project was shaped by its opposition to Heidegger, see Howard Caygill, 'Benjamin, Heidegger and the Destruction of Tradition', in Andrew Benjamin and Peter Osborne (eds), *Walter Benjamin's Philosophy: Destruction and Experience* (London: Routledge, 1994), 1–31. See also in that volume, Peter Osborne, 'Small-Scale Victories, Large-Scale Defeats: Walter Benjamin's Politics of Time', for an overview of Benjamin's work as a politics of time, 59–109.

For the materialist historian, every epoch with which he occupies himself is only prehistory for the epoch he himself must live. And so, for him, there can be no appearance of repetition in history, since precisely those moments in the course of history which matter most to him, by virtue of their index as 'fore-history', become moments of the present day and change their specific character according to the catastrophic or triumphant nature of the day.[64]

Benjamin's historical perspective is that of a radical presentism that derives its futurity not from the general structure of existential temporalization, but from the dialectical power of the image as an historical index:

It's not that what is past casts its light on what is present, or what is present casts its light on what is past; rather, image is that wherein what has been comes together in a flash with the now to form a constellation. In other words, image is dialectics at a standstill. For while the relation of the present to the past is a purely temporal, continuous one, the relation of the then to the now is dialectical: is not progression but image, leaping forth. . . . the historical index of the images not only says that they belong to a particular time; it says, above all, that they attain to legibility only at a particular time. . . . each 'now' is the now of a particular recognizability. . . . Only dialectical images are genuinely historical—that is, not archaic—images.[65]

This famously interruptive flash gives rise to 'the notion of a present which is not a transition, but in which time takes a stand and has come to a standstill'; 'a conception of the present as now-time', which, as the sign of 'a messianic arrest of happening' is 'shot through with splinters of messianic time'—that is, a time external to history, from the standpoint of which history is figured as a whole.[66]

This is a philosophical modernism in two main respects. First, such 'interferences' in temporal continuity are understood as the means whereby 'the truly new makes itself felt for the first time'.[67] And it is the job of the materialist historiographer–cultural critic–philosopher of history of the new (the roles converge) to produce such interferences, thereby securing the conditions of effectivity of the 'truly' (i.e. qualitatively historically) new. Benjamin is the first to incorporate the temporal paradox of modernity (that it is simultaneously constitutive of history as development and yet de-historicizing in its absolutization of the present as the time of the new) into his concept of the new. Secondly, the means for doing this are themselves modernist, in the sense of being drawn from the (constructivist) artistic modernism of the day, montage: 'the art of citing without quotation marks' taken to 'the very highest level' (*zur höchsten Höhe*).[68] This may appear to be modernist merely by analogy with

[64] Benjamin, *The Arcades Project*, [N 9a, 8], 474. Nietzsche's 'On the Uses and Disadvantages' furnishes the epigram to the twelfth fragment of the so-called 'theses', 'On the Concept of History' (1940), in Benjamin, *Selected Writings*, iv. 394.

[65] Benjamin, *The Arcades Project*, [N 2a, 3] (translation amended), [N 3, 1], pp. 462–3; Walter Benjamin, *Das Passagen-Werk*, in *Gesammelte Schriften*, v (Frankfurt am Main: Suhrkamp, 1991), 576–8.

[66] Benjamin, 'On the Concept of History', pp. 396–7. In this well-known text, Benjamin's reflections acquire a melancholic air, absent from the more activist 'Convolut N' in *The Arcades Project*, from which they largely derive.

[67] Benjamin, *The Arcades Project*, [N 9a, 7], 474.

[68] Ibid., [N 1, 10], 458, translation amended; *Das Passagen-Werk*, 572.

artistic modernism, but there is a deeper sense at work. It is the crossing of genres
here—the understanding of the necessity to philosophy of a new sense of presenta-
tional form—that is distinctively philosophically modernistic. This is the heritage of
early German Romanticism, which, developed prior to Hegel, takes on its full
significance only after the critique of Hegel's philosophy. Early German Romanti-
cism—and its philosophical conception of the fragment in particular—is a philo-
sophical modernism *après la lettre*: it affirms the new, philosophically, as an
imperative of philosophical presentation.[69] There is a *nachträglich* (afterwards) effect
here, grasped by Benjamin himself in his concept of afterlife (*Nachleben*): 'Historical
"understanding" is to be grasped, in principle, as an afterlife of that which is
understood.'[70] Philosophical modernism is part of the afterlife of early German
Romanticism.

MODERNIST PHILOSOPHY?

The two main, closely related, ways in which the question of modernism is raised
in European philosophy in the second half of the twentieth century are with respect
to philosophical interpretations of artistic modernism and the literary or more
broadly artistic qualities of philosophical writing. Each has its source in early German
Romanticism, inflected by post-Hegelian historical consciousness and the experience
of the historical avant-gardes. The two dominant figures here are Adorno and
Derrida, in Germany and France, respectively: the former representing a post-
Hegelian, negative dialectical modernism derived from Schönberg and Walter Ben-
jamin; the latter, a post-Nietzschean, deconstructive poetic modernism, derived from
Mallarmé and Heidegger.[71] Adorno's writings exhibit a consistent concern with both
issues from his inaugural lecture, 'The Actuality of Philosophy' (1931), to his death
in 1969 and the posthumously published *Aesthetic Theory*, in which they achieve
perhaps their most profound speculative unity since the *Athenaeum* itself, the

[69] Maurice Blanchot, 'The Athenaeum', in *The Infinite Conversation*, trans. Susan Hanson
(Minneapolis: University of Minnesota Press, 1993), 351–9; Philippe Lacoue-Labarthe and Jean-Luc
Nancy, *The Literary Absolute: The Theory of Literature in German Romanticism*, trans. Philip Barnard and
Cheryl Lester (New York: SUNY Press, 1988). This was fundamental to Benjamin's own intellectual
development. See his doctoral dissertation, *The Concept of Criticism in German Romanticism* (1920), in
Selected Writings, i: *1913–1926*, ed. Marcus Bullock and Michael W. Jennings (Cambridge, Mass.: Harvard
University Press, 1996), 116–200.
[70] Benjamin, *The Arcades Project*, [N 2, 3], 460.
[71] See Andrew Bowie, *From Romanticism to Critical Theory: The Philosophy of German Literary Theory*
(London: Routledge, 1996); Fredric Jameson, *Late Marxism: Adorno, or, The Persistence of Dialectic*
(London: Verso, 1990); Rodolphe Gasché, *The Tain of the Mirror: Derrida and the Philosophy of Reflection*
(Cambridge, Mass.: Harvard University Press, 1986); Geoff Bennington and Jacques Derrida, *Jacques
Derrida* (Chicago: University of Chicago Press, 1993).

short-lived journal of Jena Romanticism, 1798–1800, in which Friedrich Schlegel's 'Fragments' first appeared.[72] Derrida's engagement with modernism is more restricted, taking off from more or less the moment Adorno's ends, running from the elaboration of the concept of writing in *Of Grammatology* (1967) until the end of the 'middle' period of his work in 1987 (effectively terminated by the debate on Heidegger's politics, after which his theoretical orientation shifts towards a deconstructive version of a post-Levinasian Benjaminian messianism). Its high point is the 1974 *Glas*, a book, appropriately, on Hegel, which consists of two parallel texts set adjacently, in columns, in which the left-hand text alone discusses Hegel, the right-hand column containing a series of interrupted and overlaying literary fragments.[73] Both are versions of now classical literary modernisms within the philosophical field, in which the presentational form carries with it an additional philosophical significance derived from the specific form of its resistance to the idealist illusions of the self-sufficient conceptuality of philosophical texts.

The historical closure of the period represented within Europe by these now canonical philosophical modernisms (we might call it 'the epoch of historical communism', 1917–89) raises the question: what does it mean to be a modernist in philosophy today? The answer is, of course, relative to the traditions and trajectories out of which philosophy is written, each of which carries with it sets of presuppositions and arguments forming the starting point for the affirmations of systematically orientated negations. The harder aspect of the question concerns the relations of the qualitative historical novelty of such positions within the philosophical field to that most elusive of creatures, the historical present. This is a question of the politics of modernism. Furthermore, the deeper modernism of the philosophical present is concerned not merely with the affirmation of the ongoing negation of philosophical tradition, but rather, the construction of new 'traditions', or new series, through which to think the history to be negated. If Benjamin was a forerunner here, with the philosophical series Baudelaire–Marx–Blanqui–Nietzsche constituting his 'then' of the nineteenth century, Gilles Deleuze is the current exemplar with his overlapping series of reconfigurations of the history of philosophy (Spinoza–Nietzsche–Bergson–Dewey and Leibniz–Hume–Nietzsche–Foucault) laying the ground for his own philosophy of difference. To each philosopher (of which there are few), his or her own history of philosophy. Yet the internality of these Deleuzean series (and there are others) to a conventionally construed philosophical field posits this trajectory—in line with his dialectical counterpart in recent French philosophy Alain Badiou—as a

[72] Theodor W. Adorno, 'The Actuality of Philosophy', *Telos*, 31 (1977), 120–33; Friedrich Schlegel, 'Athenaeum Fragments', in Friedrich Schlegel, *Philosophical Fragments*, trans. Peter Firchow (Minneapolis: University of Minnesota Press, 1991), 23.

[73] Jacques Derrida, *Of Grammatology*, trans. Gayatri Chakravorty Spivak (Baltimore: Johns Hopkins University Press, 1974); *Of Spirit: Heidegger and the Question*, trans. Geoffrey Bennington and Rachel Bowlby (Chicago: University of Chicago Press, 1989); *Glas*, trans. John P. Leavey, Jr, and Richard Rand (Lincoln Nebr.: University of Nebraska Press, 1986).

neo-classical modernism, to the extent to which they sidestep that most important of tendencies since Romanticism, the critique of philosophy itself.[74]

This is the final aspect of philosophical modernism that I wish to stress: the transdisciplinarity of a post-Marxian philosophical modernism that affirms the temporal logic of the new through the openness of philosophical discourse to the present as a whole—of which Deleuze's two-volume *Capitalism and Schizophrenia* (with Félix Guattari) is itself a model.[75] If, as Adorno argued at the start of the 1960s, the 'Rimbaudian "*il faut être absolument moderne*" is neither an aesthetic programme nor a programme for aesthetics, but a categorical imperative of philosophy', then it is equally an imperative to philosophize beyond philosophy.[76]

[74] This aspect is most pronounced in Gilles Deleuze and Félix Guattari, *What Is Philosophy?*, trans. Graham Burchill and Hugh Tomlinson (London: Verso, 1994). For the argument with respect to Badiou, see Peter Osborne, 'Neo-Classic: Alain Badiou's *Being and Event*', *Radical Philosophy*, 142 (Mar.–Apr. 2007), 19–29.

[75] Gilles Deleuze and Félix Guattari, *Anti-Oedipus: Capitalism and Schizophrenia*, trans. Robert Hurley et al. (Minneapolis: University of Minnesota Press, 1983); *A Thousand Plateaus: Capitalism and Schizophrenia*, trans. Brian Massumi (Minneapolis: University of Minnesota Press, 1987).

[76] Theodor W. Adorno, 'Why Still Philosophy?', in *Critical Models: Interventions and Catchwords*, trans. Henry W. Pickford (New York: Columbia University Press, 1989), 5–17. For the beginnings of a confrontation between Adornoian and Deleuzean problematics on this issue, see Peter Osborne and Éric Alliez, 'Philosophy and Contemporary Art, After Adorno and Deleuze: An Exchange', in Robert Garnet and Andrew Hunt (eds), *Gest: Laboratory of Synthesis* (London: Bookworks, 2008), 35–64.

CHAPTER 23

..

THE MODERNIST
ROAD TO THE
UNCONSCIOUS

..

MATT FFYTCHE

OUR understanding of the encounters between modernism and psychoanalysis have, for much of the last century, been dominated by too programmatic a conception of that relationship. Most obviously this concerns the typical associations of Freud with the sexual. 'What did Freud find?', asked Lawrence. 'Nothing but a huge slimy serpent of sex, and heaps of excrement.'[1] What Rilke knew of Freud was 'to be sure, uncongenial and in places hair-raising',[2] while for Pound 'the Viennese sewage' had been going forty years 'and not produced ONE interesting work'.[3] But it is not just what was focused *on* so insistently—the sources of creativity in neurosis, the transcription of creative works into the language of unconscious sexual instincts, the reading of texts for their specific Oedipal subtexts. It is as much the *form* of the engagement—the sense that when psychoanalysis comes to literature, it comes as science, from the outside; it renders literature as project or evidence, turns the ambiguities and complexities of narration into knowledge of a more typical kind. Wyndham Lewis spurned the 'dogma of the Unconscious';[4] but Thomas Mann, too,

[1] D. H. Lawrence, *Fantasia of the Unconscious and Psychoanalysis and the Unconscious* (Harmondsworth: Penguin, 1975), 203.
[2] Rainer Maria Rilke, letter to Lou Andreas Salomé, 20 Jan. 1912, in Rilke and Salomé, *The Correspondence* (New York: Norton, 2006), 184.
[3] Ezra Pound, letter to Wyndham Lewis, Jan. 1952, *Pound/Lewis: The Letters of Ezra Pound and Wyndham Lewis*, ed. Timothy Materer (London: Faber and Faber, 1985), 269.
[4] Wyndham Lewis, *The Art of Being Ruled* (London: Chatto & Windus, 1926), 400.

in his lengthy encomium to Freud, conceived of the relationship as an 'official meeting between the two spheres' of literature and science, an 'hour of formal encounter', which maintains an equally formal distance between them.[5] Auden's 1934 attempt to sum up the implications of Freud for modern literature was also convinced of the necessity of that engagement, but this conviction again takes very positive form in a set of numbered points: 'The driving force in all forms of life is instinctive'; 'the nature of our moral ideas depends on the nature of our relations with our parents'; 'Cure consists of taking away the guilt feeling.'[6] Literature and psychology thus share a task: 'To understand the mechanism of the trap.'[7] But compare this with Leonard Woolf's review of Freud's *Psychopathology of Everyday Life*, written as early as June 1914 for the *New Weekly*. Here we gain a fleeting glimpse of a psychoanalysis that does not come to literature from the outside, but is already suggestively and metaphorically entwined with it. Freud, for Woolf, is a 'difficult and elusive writer'—'mysterious' and 'peculiar' are the terms to which the review constantly resorts—while his 'sweeping imagination' is 'more characteristic of the poet than the scientist or medical practitioner'.[8] This is a Freud who rarely gives a systematic exposition of any subject. His books appeal to those who have 'felt the fascination of speculating upon the mysteries of the memories of childhood'.[9]

If for much of the century we have been reading the 'wrong' Freud—the one who cures literature of its detours, and renders self-knowledge newly positive—it has also been hard not to read the dialogue with modernism as one bound to failure. On the one hand, psychoanalysis fails to respond to modernism with any real interest in its alternative creative and psychological possibilities. Thus, what André Breton hoped might be an explosive encounter with Freud, when he engineered a trip to Vienna at the tail-end of his honeymoon in 1921, only confirmed the impossibility of fruitful dialogue.[10] Freud was later to write to Breton: 'I am not in the position to explain what surrealism is and what it is after. It could be that I am not in any way made to understand it.'[11] Likewise, for all its penetrating insights into Joyce's attack on sentimentality, Carl Jung's 1932 essay on *Ulysses* insistently underlines his boredom with the text. Jung read to page 135 'with despair in my heart, falling asleep twice on the way', and he compared the book to a tapeworm.[12]

[5] Thomas Mann, 'Freud and the Future', *International Journal of Psychoanalysis*, 37 (1952), 106, 111.
[6] W. H. Auden, 'Psychology and Art To-day', in *The Complete Works of W. H. Auden: Prose and Travel Books in Prose and Verse*, i: *1926–1938*, ed. Edward Mendelson (London: Faber and Faber, 1996), 101–3. See Edward Mendelson, *W. H. Auden: A Biography* (London: George Allen & Unwin, 1981), 56, for details of Auden's reading of Freud and Jung in the mid-1920s.
[7] Ibid. 103.
[8] Leonard Woolf, 'Freud's *Psychopathology of Everyday Life*', in S. P. Rosenbaum (ed.), *A Bloomsbury Group Reader* (Oxford: Blackwell, 1993), 189.
[9] Ibid. 190.
[10] See André Breton's disparaging 'Interview du Professeur Freud', in *Les Pas perdus* (Paris: Gallimard, 1969), 94–5.
[11] Freud, letter to André Breton, 26 Dec. 1932, in Breton, *Communicating Vessels*, trans. Mary Ann Caws and Geoffrey T. Harris (Lincoln, Nebr.: University of Nebraska Press, 1997), 152.
[12] C. G. Jung, '*Ulysses*: A Monologue', in *The Spirit in Man, Art, and Literature, The Collected Works of C. G. Jung*, xv, trans. Gerhard Adler and R. F. C. Hull (London: Routledge & Kegan Paul, 1971), 111.

From the other side of the divide, there are various examples of modernist writers who refused analysis on the grounds that it might destroy their sources of creativity. This was certainly the case for Rilke, who considered undergoing analysis to cure himself of symptoms including depression, exhaustion, and hypersensitivity in the period 1911–12, around the time of work on the *Duino Elegies*. The connection came partly through his close companion Lou Andreas Salomé, who attended the First Psychoanalytic Congress at the end of 1911 and would soon begin psychoanalytic training as well as becoming an important correspondent of Freud's. However, though keen to 'track down this malaise and discover the source from which this misery forever stalks me',[13] in the end he shied instinctively away from 'getting swept clean', which might result in a 'disinfected soul', and Lou herself sought to persuade him against it.[14] Alix Strachey arrived at a very similar conclusion as to why Virginia Woolf was not persuaded to seek psychoanalytic help for her nervous breakdowns: 'Virginia's imagination, apart from her artistic creativity, was so interwoven with fantasies—and indeed with her madness—that if you stopped the madness you might have stopped the creativeness too.'[15] This mistrust of what psychoanalysis had to offer writers also found its way into modernist literature in the form of caricatures of psychoanalytic technique. Dr Krokowski in Thomas Mann's *The Magic Mountain* parodies contemporary psychotherapy, while the main conceit of Italo Svevo's *The Confessions of Zeno* (1923) is that the novel is a piece of autobiographical writing, begun as part of a course of psychoanalysis undertaken in order to cure the author of his addiction to smoking. The novel takes shape by spiralling garrulously out of the control of Dr S. and his Oedipal interpretations.[16]

But looking back at psychoanalysis and modernism from beyond the boundaries of the so-called Freudian century, the picture begins to look rather different. It is as if the unconscious or repressed moments of that cultural interchange can finally be heard. Firstly, our own understanding of modernism is more alive to its cultural and technical diversity, to the micro-histories rather than the canonical authors, and this necessarily shifts our understanding of the way psychoanalysis is implicated in that culture. Alongside the more obvious statements, we can now observe a huge range of experiments, interventions, and developments of psychoanalytic ideas happening across a range of international experimental cultures, and in response to diverse

[13] Rainer Maria Rilke, letter to Marie von Thurn und Taxis, in Wolfgang Leppmann, *Rilke: A Life* (New York: Fromm International, 1984), 268.

[14] Rilke and Salomé, *Correspondence*, 184. Rilke and Freud were to meet a couple of times in the following years; see Leppmann, *Rilke*, 270.

[15] Alix Strachey, quoted in *Bloomsbury/Freud: The Letters of James and Alix Strachey 1924–1925*, ed. Perry Meisel and Walter Kendrick (London: Chatto and Windus, 1986), 309. Compare also Katherine Mansfield's observation on May Sinclair that her work suffered 'the eclipse of psychoanalysis', in 'Ask No Questions', in John Middleton Murry (ed.), *Novels and Novelists* (London: Constable, 1930), 274.

[16] Svevo, in reality Ettore Schmitz, had intended to translate Freud's 'On Dreams' into Italian. However, his interest in psychoanalysis soured after the failure of the analysis of his brother-in-law, sent to Vienna in 1910 and seen by Freud and Tausk. 'It was he', wrote Schmitz, 'who convinced me how dangerous it was to explain to a man how he is made' (quoted in Aaron Esman, 'Italo Svevo and the First Psychoanalytic Novel', *International Journal of Psycho-Analysis*, 82 (2001), 1228).

points of contact with the theory itself. Neurosis and sexual desire feature promi-
nently, but so also do dreams, myths, memories, jokes, symbolization, free associa-
tion, aggression, melancholia, and the structure of the mind and its unconscious
mental processes. By following these kinds of routes one never arrives at a psycho-
analytic 'message' of the kind that Auden proposed, but one does get a powerful
sense of just how much the period *belonged* to psychoanalysis; how broadly and
variously it infiltrated the culture of its day.

Alongside this, one could place shifts in psychoanalytic historiography itself that
are beginning to stress its diversity, its own ceaseless transitions. Here, too, it now
seems less appropriate to extract from Freud's work a single dogmatic code.[17]
Instead, psychoanalysis appears increasingly as an incredibly suggestive but also
mobile set of ideas that underwent various transformations in the 1920s and 1930s,
which have led to the construction of quite different 'Freuds' (the hysterical Freud;
the Freud of the id and the ego; the Freud of the death drive, or the transference; but
also the Freud concerned with the field of speech and the Other; the neuroscientific
Freud, and so on). More importantly, our sense of psychoanalysis in relation to
modernist culture is now less wholly dominated by the figure of Freud himself. What,
for instance, of the role of Jung, whose markedly different perspectives on the
collective unconscious found their way into the *Arcades Project* of Walter Benjamin
and the work of Thomas Mann? What of Otto Rank's enthusiastic responses to
Expressionist cinema, or Eric Neumann's to Kafka?[18] What of the further develop-
ment of psychoanalytic ideas around the concepts of phantasy and depression by
Melanie Klein, or by W. R. Bion, who psychoanalysed Beckett and whose psycho-
analytic novel of the 1970s was influenced by experimental modernist techniques.[19]

Finally, one could argue that our view of the cultural reception of psychoanalysis
must become even more complex than this, because our understanding of modernist
interpretations of neurosis, the unconscious, dream, and desire remains incomplete
so long as we fail to see that this dialogue was mediated by yet other voices falling
outside the sphere of psychoanalysis, and yet which, from the point of view of the
time, may have appeared thoroughly entangled with it. How much of the modernists'
attitude to sex was acquired from Freud, and how much from Havelock Ellis, Kraft-
Ebbing, or Otto Weininger? How 'Freudian' is their understanding of the uncon-
scious, and what do they owe instead to readings of Henri Bergson, Pierre Janet, or
Samuel Butler? Bearing these complexities in mind, the following is an attempt to
indicate some key points of reference in the dialogue of psychoanalysis with mod-
ernism. It can by no means pretend to be exhaustive, but it aims to sample that
encounter from a more diverse set of viewpoints than has often previously been
allowed.

[17] See e.g. the critique of reductive psychoanalytic criticism in Maud Ellmann (ed.), *Psychoanalytic Literary Criticism* (London: Longman, 1994), 25.

[18] Otto Rank, *The Double: A Psychoanalytic Study* (London: Maresfield Library, 1989); Erich Neumann, *Creative Man: Five Essays* (Princeton: Princeton University Press, 1979).

[19] W. R. Bion, *A Memoir of the Future* (London: Karnac, 1991).

FREUD AND LONDON LIFE:
THE BLOOMSBURY SET

The Bloomsbury set provides one of the best examples of the early cultural reception of Freud in Britain (let alone in modernist circles) and of how ubiquitous psycho-analysis appears, once one directs one's gaze away from single works and towards the broader network of intellectual affiliations in which they are embedded. One of the earliest of these points of contact was via the Society for Psychical Research, founded in 1882, and by the early 1900s centred in Cambridge around the figure of Arthur Verrall. The Society had come together initially to investigate spiritualism and the paranormal, but the nature of these researches led to the Society in turn becoming a conduit for knowledge of new European psychologies. F. W. H. Myers, one of the founding members of the Society, provided a report on Breuer's and Freud's work on hysteria as early as 1893. Freud was elected an honorary member in 1911.[20] James Strachey joined the Society in 1908, but it also attracted the attentions of James's brother Lytton, Leonard Woolf, and John Maynard Keynes—all of them friends of Thoby Stephen at Cambridge (brother of Virginia Woolf, née Stephen) as well as members of the overlapping intellectual society the Cambridge Apostles. It was this group of Cambridge friends, along with Virginia and her younger brother Adrian, who formed the nucleus of the early Bloomsbury group. So already in the early years of the new century, the future Bloomsbury participants were marginally aware of developments in the psychology of the unconscious.

On a second front, there were Bloomsbury's sexological interests—that side of the group associated with a measured libertarian revolt against Victorian sexual mores and frank sexual discussion. Virginia Woolf's diary for January 1918 records how Lytton Strachey 'gave an amazing account of the British Sex Society', which had met to discuss the theme of 'Incest between parent & child when they are both uncon-scious of it . . . derived from Freud'.[21] Back in 1911 Strachey had delivered an address to the Apostles in which he wondered what there was in 'self-consciousness to distrust the current of our emotions, and make impossible the impulsive, spontan-eous, exquisite expressions of our love?'[22] By 1914 he had written a psychoanalytic skit in which two characters meet seemingly by accident in a summer house. Rosamund has been reading Freud's *The Psychopathology of Everyday Life* (just translated into English) and aims to teach her companion 'all about the impossibility of accidents, and the unconscious self, and the sexual symbolism of fountain-pens [she takes his up], and—but I see you're blushing already'.[23] In the same year, Leonard Woolf's review of *The Psychopathology of Everyday Life* suggested that Freud's book was fascinating both for dealing with the mysterious recesses of the heart, but also for

[20] See Roger Luckhurst, Ch. 24 in this volume.
[21] Virginia Woolf, *The Diary of Virginia Woolf*, i: *1915–1919* (London: Hogarth Press, 1983), 110.
[22] Lytton Strachey, 'The Really Interesting Question', in *The Really Interesting Question and Other Papers* (London: Weidenfeld & Nicolson, 1972), 126.
[23] Lytton Strachey, 'According to Freud', in *The Really Interesting Question*, 113–14.

its 'subtle analysis of many other ordinary mental processes', including 'writing a letter, forgetting a name, or misquoting lines of poetry'.[24] Virginia Woolf, in turn, reported in a letter of 1911 that Leonard had interpreted her dreams one night, applying 'the Freud system to my mind, and analysed it down to Clytemnestra and the watch fires'.[25] Psychoanalysis is thus being woven into the fabric of daily life on all sorts of different fronts.

It was no doubt the Bloomsbury tendency towards social experimentation that enabled them to pick up on psychoanalytic tendencies at such early dates. By the late 1920s the impact on certain members of the group was strong enough for them to take on the burden of formal psychoanalytic training. This includes both Virginia Woolf's younger brother Adrian and his wife, Karin Stephen, as well as James and Alix Strachey, who went to study with Freud in Vienna in 1920. Soon after, the Stracheys began to translate Freud's clinical papers into English, and in 1924, on James's initiative, the Woolfs' own Hogarth Press began publishing volumes for the International Psycho-Analytic Library, and eventually the *Standard Edition of the Complete Psychological Works of Freud*, under Strachey's editorship.

Beyond these 'official' projects, further ones deserve notice, for example Lytton Strachey's historical work *Elizabeth and Essex* (1928), which incorporates psychoanalytic theory in its reconstruction of Elizabeth's emotional life. A copy was sent to Freud, and Freud wrote back explaining he had read all Lytton's earlier works with great enjoyment, but this time 'you have moved me more deeply, for you yourself have reached greater depths'.[26] Even more at a tangent, the economist John Maynard Keynes, associated with Bloomsbury from its earliest days, was well acquainted with Freud's thought and deepened his researches in the mid-1920s with a view to developing aspects of his economic theory. His *Treatise on Money* (1930) cites both Sandor Ferenczi and Freud as sources for his own investigations into the motives for monetary hoarding: 'Dr. Freud relates that there are peculiar reasons deep in our subconsciousness, why gold in particular should satisfy strong instincts and serve as a symbol.'[27]

SINCLAIR, LAWRENCE, H.D.:
UNCONSCIOUS INTERIORS

Not a single message, then, but so many different Freuds and so many different ways of knowing Freud. Freud is a ubiquitous reference point within modernist culture,

[24] Woolf, 'Freud's *Psychopathology of Everyday Life*', 189–91.

[25] Virginia Woolf, letter to Saxon Sydney-Turner, 3 Feb. 1917, in *The Question of Things Happening: The Letters of Virginia Woolf*, ii: *1912–1922*, ed. Nigel Nicolson and Joanne Trautmann Woolf (London: Hogarth Press, 1976), 141.

[26] Sigmund Freud, letter to Lytton Strachey, 25 Dec. 1928, in *Bloomsbury/Freud*, 332.

[27] John Maynard Keynes, *A Treatise on Money*, ii: *The Applied Theory of Money* (London: Macmillan, 1930), 290.

a radical psychological thinker for a self-styled radical age. 'I am going to prove that I belong to the present day—that I'm a contemporary of Dr Freud,' says Rosamund in Strachey's sketch.[28] But what of deeper engagements with psychoanalysis on specifically literary ground? The novels of Virginia Woolf have attracted a lot of psychoanalytic attention in recent years, much of it focusing on the nature of Freud's presence, or absence, in her work.[29] Woolf can hardly be considered as a 'Freudian' novelist, but when it came to explaining the writing of *To the Lighthouse*, she described it as an exorcism for the obsessive memories of her mother, who had died when she was 13. Once it was written, she reflected, 'I no longer heard her voice; I do not see her,' adding, 'I suppose I did for myself what psychoanalysts do for their patients. I expressed some very long felt and deeply felt emotion,' and in doing so 'laid it to rest'.[30] This is a sidelong acknowledgement of the presence of Freud, as a point of reference, if not a point of departure, in her reflections on the psychical legacy of motherhood. But there were other writers who took Freud more closely to heart than this, who felt their own narrations of subjectivity to be deeply implicated in psychoanalytic terrain. If much modernist writing was committed to overturning outworn accounts of the ethos of the self, it also involved a reinvention of the interior life; Proust, Joyce, Woolf, Rilke, and the Surrealists give very different examples of this. But such explorations necessarily proceed across psychoanalytic terrain, if only to develop alternative strategies, an independent version of depth psychology.

May Sinclair

May Sinclair is an intriguing example of the complex ways in which modernism could engage with psychoanalytic notions of the unconscious.[31] She was a Georgian novelist who by the early 1920s had developed an increasingly psychological approach to narrative. *Mary Olivier: A Life* (1919) and *The Life and Death of Harriett Frean* (1922) are oriented substantially around the inner life of their central protagonists, lives which still in adulthood are struggling to get beyond the deep impressions of childhood. Sinclair is credited with introducing the term 'stream of consciousness' in a review of Dorothy Richardson's narrative experiments:[32] her own explorations of the production of 'womanhood', out of the development of childhood

[28] Strachey, *The Really Interesting Question*, 117.

[29] See e.g. Elizabeth Abel, *Virginia Woolf and the Fictions of Psychoanalysis* (Chicago: Chicago University Press, 1989); Daniel Ferrer, *Virginia Woolf and the Madness of Language* (London: Routledge, 1990); Robert Hinshelwood, 'Virginia Woolf and Psychoanalysis', *International Review of Psycho-Analysis*, 17 (1990), 367–71; Thomas Szasz, *'My Madness Saved Me': The Madness and Marriage of Virginia Woolf* (London: Transaction, 2006); Sanja Bahun, 'Virginia Woolf and Psychoanalytic Theory', in Jane Goldman and Bryony Randall (eds), *Virginia Woolf in Context* (Cambridge: Cambridge University Press, 2010).

[30] Virginia Woolf, *Moments of Being: Unpublished Autobiographical Writings* (London: Chatto & Windus, 1976), 94.

[31] See Suzanne Raitt, *May Sinclair: A Modern Victorian* (Oxford: Oxford University Press, 2000).

[32] May Sinclair, 'The Novels of Dorothy Richardson', *The Egoist*, 5 (Apr. 1918), 57–9.

consciousness, were strongly motivated by feminist purposes (from 1908 to 1912 she was involved in the Women's Freedom League). However, they also combined naturally enough with an interest in psychoanalysis. Already in 1913 Sinclair was administratively involved in the founding of the Medico-Psychological Clinic in Brunswick Square, the first British institution formally committed to the exploration of psychoanalytic techniques in psychotherapy (during the war years it was soon to capitalize on a stream of shell-shocked patients). By 1916 she was publishing 'Clinical Lectures on Symbolism and Sublimation' in the *Medical Press and Circular. The Three Sisters* (1914) is an early example of how such ideas as neurosis and sexual repression found their way into her writing, but by *Mary Olivier: A Life* her explorations of sexual knowledge and childhood fantasy had become much more sophisticated, the stream of consciousness technique lending complexity to the interweaving of memory, fantasy, and perception. The infant Mary lies in her cot—or remembers it— toying with the knob in the green-painted railing for reassurance, as with her mother's nipple: 'your finger pushed it back into the breast'.[33] In between such dependable objects is an unstable world of images and anxieties: 'When the door in the hedge opened you saw the man in the night-shirt. He had only half a face[...] You opened your mouth, but before you could scream you were back in the cot[...] behind the curtain Papa and Mamma were lying in the big bed.'[34]

Life opens with a classically Freudian scene; but there are also 'rogue facets' to these coincidences of feminism and psychoanalysis. For instance, Sinclair orients her reading of the theory around her own assumptions concerning celibacy, aired in *Feminism* (published by the Women's Suffrage League in 1912). The idea that sexual enjoyment should be renounced in order to liberate creative powers winds its way through her understanding of the formation of female writers in both *Mary Olivier* and her critical work on the Brontës.[35] Essentially it is the route by which some women (not all) may achieve their independence from the families which have sought to silence them, but this is not wholly a Freudian idea. In a different way, her 1916 review of Jung's *Psychology of the Unconscious* (the English translation of *Wandlungen und Symbole der Libido*, 1912) is fascinating for the way it takes Jung's analysis of the psychical importance of symbolization and reads it in conjunction with concerns of her own. On the one hand, this meant her interest in the modernist mediation of myth (in the war years Sinclair wrote on Eliot, Pound, and H.D.). Thus, 'Language is a perpetual Orphic song' that goes 'sounding away into the dark underworld we came from, evoking endless reverberations there'.[36] The psychoanalyst 'is Mercury and Orpheus, the enabler of bridges between past and future'.[37] On the other hand, she was reading Jung in relation to her own theories of celibacy and sublimation. Jung was himself already diverging from Freud at this point,

[33] May Sinclair, *Mary Olivier: A Life* (London: Virago, 1980), 4.
[34] Ibid. 3–4.
[35] May Sinclair, *The Three Brontës* (London: Hutchinson, 1912).
[36] May Sinclair, 'Clinical Lectures on Symbolism and Sublimation, 1', *Medical Press*, 152 (9 Aug. 1916), 121.
[37] Ibid.

particularly over his interpretation of libido in a more transhistorical and vitalist sense, as an impulse towards life. Civilization, then, is 'one vast system of sublimations' of the 'eternal indestructible Libido'.[38] But these sublimations are more than the redirection of repressed sexual impulses. Sublimation is also the capacity for a once primitive instinct to transform itself into ever higher cultural syntheses: it is 'the freedom of the Self in obedience to a higher law than preceding generations have laid upon him'.[39] Such ideas in turn fed back into the contemporary psychoanalytic community. The *Psychoanalytic Review* for 1923 reported on Sinclair's *Anne Severn and the Fieldings*: 'In May Sinclair's latest and incomparable novel, the core of [sublimation] is exposed, turned hither and yon to flash with diamond facets upon her story of human striving.'[40]

Sinclair's engagement with psychoanalysis also stretches ambiguously beyond it. Her work on the Brontës testified to a concern with the supernatural, and in 1914 she joined the Society for Psychical Research. In the mid-1920s (in parallel with her more psychological novels) she was praising not William but Henry James, for 'The Turn of the Screw', suggesting that 'Ghosts have their own atmosphere and their own reality.'[41] The boundaries of psychoanalysis as seen by modernists are hard to determine here. After all, it was in those immediate post-war years that Freud, too, was publishing 'The Uncanny' and 'On Telepathy'. Looking in yet another direction, 1917 saw the publication of a philosophical work, *A Defence of Idealism*, which found Sinclair exploring the ultimate nature of identity with reference to yet other notions of the psyche and the unconscious, drawn from William McDougall and Samuel Butler, though again, these are seen by her as the corollary of psychoanalysis, rather than as its displacement.[42]

D. H. Lawrence

D. H. Lawrence also encountered psychoanalysis at an early stage in its international development.[43] As with Sinclair, one learns more about his understanding of psychoanalysis by reconstructing conversations among early psychoanalytic experimenters in Britain than by focusing on the impact of canonical Freudian texts. When Lawrence met David Eder in 1914, their intense discussions probably ranged over the

[38] Sinclair, 'Clinical Lectures on Symbolism and Sublimation, 119.
[39] May Sinclair, 'Clinical Lectures on Symbolism and Sublimation, 2', *Medical Press*, 153 (16 Aug. 1916), 144.
[40] S. Stragnell, 'A Study in Sublimations', *Psychoanalytic Review*, 10 (1923), 209.
[41] Suppl. to *The Bookman* (Dec. 1923), 144.
[42] May Sinclair, *A Defence of Idealism* (London: Macmillan, 1917).
[43] According to Reinald Hoops's 1934 study, '*Sons and Lovers* is the first English novel influenced by psychoanalysis' (*Der Einfluß der Psychoanalyse auf die englische Literatur* (Heidelberg: Winters Universitätsbuchhandlung, 1934), 73).

work of both Freud and Jung.[44] Eder had published 'Freud's Theory of Dreams' in 1912, but was drawn to Jungian theory, like May Sinclair, partly because of the allowance Jung made for metaphysical impulses. As Sinclair was reviewing *The Psychology of the Unconscious* for the *Medical Press*, Eder was doing so for the *New Age*, and Lawrence himself would read it in 1918. Jung's central concern with the need to sacrifice the yearning for maternal security was bound to appeal to him: '"Mother!" he whispered—"mother!" She was the only thing that held him up, himself, amid all this.'[45] As with Sinclair, too, the interest ran both ways. Psychoanalysts early on picked up on Lawrence's novels as corroborating Freudian theory. A. B. Kuttner's commentary on *Sons and Lovers* in the *Psychoanalytic Review* (1916) found that Lawrence was able 'to attest the truth of what is perhaps the most far-reaching psychological theory ever propounded'[46]—this is 'the struggle of a man to emancipate himself from his maternal allegiance and to transfer his affections to a woman who stands outside of his family circle'.[47] With the aid of Freudian theory, *Sons and Lovers* would help one to see the role played by 'abnormal fixation upon the parent' in the psychic development of the individual.[48]

Once more, caution has to be exercised in how literally these connections with psychoanalysis are to be understood. The assumption is easily made that Lawrence's concentration on sexual initiation and sexual vitality is explicitly Freudian, but there was a much wider set of influences here, all operating, ultimately, in the service of Lawrence's own reconstruction of subjective life. Lawrence's relationship with Frieda Weekley back in 1912 had already introduced him to the ideas of Austrian psychoanalyst Otto Gross, with whom Weekley had had an affair in 1907. But Gross's work was a radical departure from the psychoanalytic mainstream, a conflation of Freud with Nietzsche (Gross was a major influence on German Expressionism). An early draft of *Sons and Lovers* from 1911 testifies also to the influence of Schopenhauer on Lawrence, and alongside this he had read widely in German biological and vitalist theory.[49] When Lawrence wrote to Bertrand Russell in 1915 about 'another seat of consciousness than the brain and the nerve system'—one that has 'a sexual connection'—he did not frame this in Freudian terminology, but developed his own account of a 'blood consciousness'.[50]

More importantly, when Lawrence in 1919 began to set down his own interpretation of unconscious life—published as *Psychoanalysis and the Unconscious* (1921), followed by *Fantasia of the Unconscious* (1922)—it was specifically as a critique of the

[44] See John Turner, 'David Eder: Between Freud and Jung', *D. H. Lawrence Review*, 27/2–3 (1997–8), 289–309.

[45] D. H. Lawrence, *Sons and Lovers* (London: Heinemann, 1974), 420.

[46] A. B. Kuttner, '*Sons and Lovers*: A Freudian Appreciation', *Psychoanalytic Review*, 3 (1916), 317.

[47] Ibid. 296.

[48] Ibid. 311.

[49] See David Ellis, 'Lawrence and the Biological Psyche', in *D. H. Lawrence: Centenary Essays*, ed. Mara Kalnins (Bristol: Bristol Classical Press, 1986), 89–109.

[50] D. H. Lawrence, *The Letters of D. H. Lawrence*, ed. James T. Boulton, ii: *June 1913–October 1916* (Cambridge: Cambridge University Press, 1981), 470.

Freudian notion that 'at the root of almost every neurosis lies some incest craving'.[51] For Lawrence, such fantasies were at most logical deductions, perverse products of cultural repression projected inwards, thus muddying the true and primal sources of the self. By contrast, what he set out to communicate was the nature of the 'pristine unconscious in man', the 'fountain of real motivity'.[52] Here he again reverted to non-psychoanalytic, vitalist, and Schopenhauerian ideas, mingled with theosophical influences concerning 'the passional nerve centre of the solar plexus' and in the thorax, from which 'the unconscious goes forth seeking its object'.[53]

H.D.

Ten years later, Lawrence was to ghost his way into the dreams of H.D., who was at that time in analysis with Freud in Vienna: 'in my dream, I take out a volume from a shelf of Lawrence novels. I open it; disappointed, I say, "But his psychology is nonsense." '[54] Freud, in turn, said that Lawrence impressed him as 'being unsatisfied but a man of real power'.[55] H.D.'s companion and lover, Bryher, was an early supporter of psychoanalysis, subscribing to the *International Journal* from the early 1920s, and it was at her instigation that H.D. entered analysis, first with Mary Chadwick at Tavistock Square in 1931, and eventually for five days a week with Freud for some months in 1933 and again in October 1934. H.D.'s account of her analysis, written up as *Tribute to Freud* in 1944, is both fascinatingly indirect (attention in the opening sections centres on the patient she always passes in the stairwell) and full of intriguing insights into the more informal aspects of Freud's practice. This is a Freud who 'will sit there quietly, like an owl in a tree', but who also pounds the head-piece of the horsehair sofa with his hand and complains: 'The trouble is—I am an old man—*you do not think it worth your while to love me*'.[56] The indirectness stems partly from H.D.'s quasi-Imagist technique, which eschews linear narrative in favour of a subtle and elusive system of vignettes—a mosaic of memory. At its heart (or perhaps ultimately displaced from it, preserved from analysis) is the series of visions she experienced on a wall in Greece while on a trip with Bryher in 1920—a face, a chalice, a tripod, a Nike. These are things which 'had happened in my life ... actual psychic or occult experiences';[57] they channel the writer's memories of

[51] D. H. Lawrence, *Fantasia of the Unconscious and Psychoanalysis and the Unconscious* (Harmondsworth: Penguin, 1975), 205.

[52] Ibid. 207.

[53] Ibid. 221, 230.

[54] H.D., *Tribute to Freud*, rev. edn (Boston: David R. Godine, 1974), 140. This edition contains, in addition, her diary 'Advent', a journal of notes on dreams from the time of the analysis itself, and from which this dream is quoted. See also Susan Stanford Friedman (ed.), *Analyzing Freud: Letters of H.D., Bryher, and Their Circle* (New York: New Directions, 2002), and H.D.'s poem 'The Master', in *Collected Poems, 1912–1944* (New York: New Directions, 1983), 451–60.

[55] Ibid. 144. [56] Ibid. 22, 16. [57] Ibid. 9.

the trauma of war, her own mental disturbance, and her anxieties concerning the return of conflict in Europe. H.D. sought Freud's opinion of these experiences, but also resisted it. Thus, alongside memories and premonitions of real and unreal wars, a subtle war emerges in the text between her sense of where Freud wants to take her—an insight into her own narcissistic desire for wonder and religious renewal—and where she wants to take him, 'outside the province of established psychoanalysis'. Beyond Freud's 'caustic implied criticism' there is 'another region of cause and effect, another region of question and answer'.[58] Thus, while Freud is keen to pursue her 'Princess dream', in which she witnesses the finding of Moses in the bulrushes, back to its material connections (an image in the Doré Bible she read as a child), her own impulse is to lift the memory out of the causal flow of experience: 'it is a perfect moment in time or out of time'—an image of transcendence.[59]

The *Tribute* is ultimately a testimony to how one must circumvent Freud: 'I was here because I must not be broken.'[60] The Nike, for H.D., is a premonition of war, but also of her own future release from depressive anxiety: when the war had ended, 'I . . . would be free, I myself would go on in another, a winged dimension.'[61] The return of myth not as symptom then, but cure. Gradually, out of the numinous fragments of memory, emerges not the psychoanalytic solution of her neuroses, but her mystical solution to the puzzle of Freud's: 'It worried me to feel that he had no idea . . . that he would "wake up" when he shed the frail locust-husk of his years, and find himself alive.'[62]

SURREALISM: DREAMING THE REVOLUTION

There remains one other key area of psychoanalytic influence on modernist experimentation and this is dreams. Dreams occupy a strange position with respect to the Freudian corpus. *The Interpretation of Dreams* is perhaps the foundational work of psychoanalysis in the sense that it inaugurated the psychoanalytic era and brought together most of Freud's original insights—into unconscious thought processes, the structure of neurotic symptoms, and nascent ideas concerning the Oedipus complex. However, the discovery of the meaning of dreams itself was in some ways tangential to the main framework of psychoanalytic inquiry. The modernist movement most pervasively interested in dreams was Surrealism. In Breton's 'Manifesto of Surrealism' (1924) man is introduced as 'that inveterate dreamer', and dream is quickly

[58] Ibid. 99. [59] Ibid. 37. [60] Ibid. 16.
[61] Ibid. 83. [62] Ibid. 43.

imbricated in a series of terms—freedom, imagination, childhood, the marvellous. Most famously, dreams are a constituent part of the project of Surrealism itself: 'I believe in the future resolution of these two states, dream and reality[...]into a kind of absolute reality, a *surreality*.'[63]

If the Manifesto returns again and again to the dream, it also gives thanks specifically to Freud for recovering this neglected aspect of mental life. The homage is by no means superficially meant. Breton had already encountered the technique of free association while working with psychiatric patients as a war-time nurse at Saint-Dizier. Thus, as early as 1916 he was discovering links between psychoanalytic and poetic technique. Writing to Guillaume Apollinaire, he described the ability of the insane to produce 'the most distant relations between ideas, the rarest verbal alliances'.[64] The Manifesto recalls that period in order to link it to Breton's breakthrough experimentation with automatic writing in 1919. After being struck by the spontaneous emergence of word and image combinations at the point of falling asleep, Breton sought consciously to reproduce such conditions by obtaining from himself 'a monologue spoken as rapidly as possible without any intervention on the part of the critical faculties'.[65] Freud thus shadows Breton's own triangulation of dream, madness, and free association. The result of these experiments with psychical techniques (which drew also on the example of Pierre Janet and Fredric Myers) was *Magnetic Fields*, written in collaboration with Philippe Soupault and often named as the first Surrealist publication (an inscribed copy was sent by Breton to Freud).

Freud's interest in the operation of particular symbolic processes, such as condensation and displacement, behind the dream's absurd juxtapositions and compound images are reminiscent of the montage explored by Cubism and Dada. But Freud's assumption of an underlying logic behind the confusion, his evocation of depths of subjectivity and secret motives of desire, mark Surrealism's own shift from games with chance and spontaneity towards a more organic interest in nature, fate, and the unconscious. However, key aspects of the Surrealist dream run very much counter to Freudian theory. There is the Surrealist fascination with nineteenth-century precursors, including Saint-Pol-Roux and the marquis d'Hervey-Saint-Denis. A more crucial divergence involves the status of the dream image itself. Where for Freud the dream needs to be dissected into its elements, translated, and related to specific kinds of experiences in the recent past, and in the dreamer's infantile life, Breton appears to be struck by the luminous, revelatory quality of the image itself. The 'light of the image' is one to which we are 'infinitely sensitive'; its value depends 'on the beauty of the spark obtained'.[66] For Louis Aragon it is equally the 'light radiating from the unusual' which rivets the attention of modern man.[67] In contrast, Freud

[63] André Breton, 'Manifesto of Surrealism', in *Manifestoes of Surrealism*, trans. Richard Seaver and Helen R. Lane (Ann Arbor: University of Michigan Press, 1972), 14.
[64] Letter to Apollinaire, 15 Aug. 1916, cited in Mark Polizzotti, *Revolution of the Mind: The Life of André Breton* (London: Bloomsbury, 1995), 52.
[65] Breton, *Manifestoes of Surrealism*, 23.
[66] Ibid. 37.
[67] Louis Aragon, *Paris Peasant* (London: Pan, 1980), 28.

wrote to Breton in 1937, after being asked to contribute to a volume called *Trajectory of the Dream*, explaining that

> The superficial aspect of dreams, holds no interest to me. I have been concerned with the 'latent content' which can be derived from the manifest dream by psychoanalytical interpretation. A collection of dreams without associations and knowledge of the context in which it was dreamed does not tell me anything, and it is hard from me to imagine what it can mean to anyone else.[68]

A third important departure from psychoanalytic theory is the Surrealists' association of dream with radical freedom. Surrealism 'asserts our complete non-conformism';[69] the imagination revolts against its enslavement by the rational; the depths of our mind contain 'strange forces capable of augmenting those on the surface, or of waging a victorious battle against them'.[70] Such sentiments depart from Freud in a double sense. Firstly, at the level of social ideology, Freud's instincts are far more conservative—one never finds him seeking to reverse the relations between reality and desire, or to unseat the structures of authority with which the language of psychic structures are so heavily encoded (the superego, the censor). His attitude to social revolution, for instance in the work of Marxist psychoanalyst Wilhelm Reich, was entirely sceptical, his assumptions concerning human instincts bound to those of Darwin and Hobbes. But secondly, what comes through in Surrealism's concentration on the image itself, and its assertion *against* external reality, are not strictly Freudian notions, but idealist ones. Breton, when he first came across Freud's ideas, partly assimilated them to his own previous readings of Hegel and the German Romantics. Hence the evocation of dream life as the language of an inner objectivity, more real than the empirical pact between consciousness and external objects. Aragon, confronted by a phosphorescent vision of a mermaid in the *Passage de l'Opéra*, cries out 'The Ideal'.[71] In a later description of the same venue, Freud has been downgraded to a puppy-dog, taken for a walk by the divine figure of Libido, whose temple is built of medical books; it is Hegel whom Aragon goes on to quote at length about the relations between individuals and the sexes.[72]

The nod to idealism helps to clarify why Freud was important to the Surrealists up to a point, but also how they purposefully misread him. For all their fascination with sexual desire, the reality the Surrealists posited in dreams was not the psychoanalytic one of unconscious infantile wishes. When Breton talks about childhood, it is as a realm of freedom, strangely closer to German Romantic associations of childhood with the marvellous. Childhood is 'where everything nevertheless conspires to bring about the effective, risk-free possession of oneself';[73] children 'set off each day

[68] Polizzotti, *Revolution of the Mind*, 453. [69] Breton, *Manifestoes of Surrealism*, 47.
[70] Ibid. 10. [71] Aragon, *Paris Peasant*, 37. [72] Ibid. 47–8.
[73] Breton, *Manifestoes of Surrealism*, 40.

without a worry in the world'.[74] This is not the Freud of *Three Essays on Sexuality*; nor even of *The Interpretation of Dreams*.[75]

If dreams are more 'real' than external life, they are also revelatory of that life's untapped potential. What they reveal is not the distorted vestiges of archaic instincts, but the most intensely significant features of emergent futures: 'Freud is again quite surely mistaken in concluding that the prophetic dream does not exist'.[76] This more teleological reading of dreams, in which the historicity of the present in relation to the future is emphasized (rather than to the past), is in fact closer to Jung's psychology, for which dreams also reveal processes of development within individual and historical life. Dreams point forwards, they resolve or develop issues (rather than repeating and disguising them). But, for Breton, to hold that the dream is 'exclusively revelatory of the past is to deny the value of motion'.[77]

THE MYTHS OUTSIDE: BENJAMIN AND MANN

This interest in a dialectics of desire connects the Surrealists back with trends in German Romanticism, as well as across to Jung. However, these same points of reference would enable Breton and Aragon from 1930 onwards to link their interests ever more closely to Marxism and dialectical materialism; to transform the imperatives of the dream from creative to political ones. After arguing that the dream is in historical motion, Breton quite naturally moves on to ally his project with that of Lenin. The dream confronts the new image of things with the old one (its unexpected juxtapositions now primarily historical) and aids the dreamer in eliminating 'the least assimilable part of the past'.[78] Its primary usefulness is 'taking a stand against the past, a stand that gives us our momentum'.[79] The dream thus parallels, in the life of the individual, the process of revolution in the sociopolitical field.

This reading of the dream image in terms of historical dialectics had a galvanizing effect on another significant project of the 1930s, Walter Benjamin's monumental and unfinished account of Paris in the nineteenth century, which exemplifies the extension of psychoanalytic ideas to the wider cultural sphere. For Benjamin, Freud

[74] Breton, *Manifestoes of Surrealism*, 3–4.
[75] Likewise when the Surrealist group met, between 1928 and 1932, for a series of controversial discussions on the nature of their own sexual lives, what organized their lines of inquiry was not the nature of instinct, or the Oedipus complex, but the desire to sustain a more absolute and philosophical demand concerning the nature of passion and the possibility of reciprocity. See José Pierre (ed.), *Investigating Sex: Surrealist Discussions, 1928–1932* (London: Verso, 1992).
[76] Breton, *Communicating Vessels*, 13.
[77] Ibid. [78] Ibid. 46. [79] Ibid.

enabled the Surrealists to find a modernist viewpoint on the dream, one which in his view protected them from mere mysteriousness, via the stress on a materialist investigation, as well as the dream's own implication in the daily experience of the metropolis.[80] These influences from Surrealism fused in Benjamin's work with concepts taken from other aspects of Freud. For instance, Adorno urged Benjamin to read everything he could by Freud and Ferenczi to help shed light on the fetish character of commodities.[81] But Freud's impact was exerted most decisively in relation to Benjamin's conception of memory. In connection with Proustian *mémoire involontaire*, Benjamin drew on ideas put forward by Freud in *Beyond the Pleasure Principle* which shed new light on the relation between memory and consciousness. Quoting the interpretation of Freud given by another early psychoanalyst, Theodor Reik, Benjamin sought to examine the way in which the act of conscious recollection could dissolve memory traces: 'The function of memory is to protect our impressions; reminiscence aims at their dissolution. Memory is essentially conservative; reminiscence, destructive.'[82]

In the mid-1930s these two concerns—memory and dream, awakening and remembering—started to merge and to form the basis of a grand theoretical enterprise. If dreams are themselves a historical phenomenon, and history equally contains its own collective dreams, then to remember the nineteenth century, to actively recollect its various forms of commodity fetishism and consumer mythos, might enable one to free oneself from its repetition, to awake from the dream.[83] This train of thought led Benjamin to write to Adorno asking if he knew of any psychoanalytic study of waking.[84] There are also indications that he was preparing a critique of Jung, 'whose Fascist armature I had promised myself to expose'.[85] Famously, Adorno was to criticize these developments in Benjamin's work, for 'the disenchantment of the dialectical image as a "dream"' runs the risk of psychologizing it, thus trapping it within 'the spell of bourgeois psychology'.[86] That is to say, the attempt to think oneself beyond the myths of capitalism was itself in danger of situating itself methodologically within the very domain of bourgeois private consciousness which both Benjamin and Adorno were keen to overcome.

[80] See Walter Benjamin, 'Surrealism: The Last Snapshot of the European Intelligentsia', *Selected Writings*, ii: *1927–1934*, trans. Rodney Livingstone, ed. Michael W. Jennings, Howard Eiland, and Gary Smith (Cambridge, Mass.: Belknap Press, 1999), 207–21.

[81] Theodor Adorno and Walter Benjamin, *The Complete Correspondence, 1928–1940* (Cambridge, Mass.: Harvard University Press, 1999), 93.

[82] Walter Benjamin, *Selected Writings*, iv: *1938–1940*, ed. Howard Eiland and Michael W. Jennings (Cambridge, Mass.: Harvard University Press, 2003), 316.

[83] Walter Benjamin, *The Arcades Project*, trans. Howard Eiland and Kevin McLaughlin (Cambridge, Mass.: Harvard University Press, 1999), 908.

[84] Adorno and Benjamin, *Correspondence*, 99.

[85] Walter Benjamin, letter to Fritz Leib, 9 July 1937, in *The Correspondence of Walter Benjamin, 1910–1940* (Chicago: University of Chicago Press, 1994), 542.

[86] Adorno and Benjamin, *Correspondence*, 106–7.

It is interesting to compare these uses of Freud with another from the mid-1930s which equally sees the analytic revelation as a 'revolutionary force', one capable of overcoming the 'systematic glorification of the primitive and the irrational' in the present day, robbing it of its charge of energy by 'becoming conscious through the analytic procedure'.[87] This is the speech 'Freud and the Future' delivered by Thomas Mann to the Viennese academy for Medical Psychology in honour of Freud's eightieth birthday. As with Benjamin, Mann is concerned with the intersection between the terms of individual psychology and much larger issues of social experience. Freud's therapeutic method has long outgrown its purely medical implications and 'become a world movement which has penetrated into every field of science', but also into religion and prehistory, mythology, folklore, and pedagogy.[88] Mann thus found himself coming upon Freud precisely when, in his late work *Joseph and His Brothers*, he 'took the step in my subject-matter from the bourgeois and individual to the mythical and typical'.[89] However, in contrast with Benjamin, the Freud that Mann was drawing on was not the unraveller of dreams, but the anthropologist who had emerged in *Totem and Taboo* and in the 1912 postscript to the study of Judge Schreber: '"In dreams and in neuroses," so our thesis has run, "we come once more upon the *child*"'—but we also come upon '"the *primitive* man, as he stands revealed to us in the light of the researches of archaeology and ethnology"'.[90] For Mann, then, psychoanalytic penetration into the childhood of the individual soul 'is at the same time a penetration into the childhood of mankind, into the primitive and mythical'.[91] It is thus a Freud who, rather than exposing inner myths to the concrete experience of the everyday, returns the everyday to 'those profound time-sources where the myth has its home and shapes the primeval norms and forms of life'.[92] Mann is interested in a Freud who can retrace certain guiding mythical patterns within a life which has become derailed by even more irrational and threatening subjective impulses. Thus, 'myth, for Mann, is the legitimization of life',[93] and it is this aspect of psychoanalysis that one might look to for 'a new and coming sense of our humanity'.[94]

[87] Mann, 'Freud and the Future', 109, 115. [88] Ibid. 108.
[89] Ibid. 112.
[90] Sigmund Freud, *The Standard Edition of the Complete Psychological Works of Sigmund Freud*, ed. and trans. James Strachey, xii: *1911–1913* (London: Hogarth Press, 1958), 82.
[91] Mann, 'Freud and the Future', 112.
[92] Ibid.
[93] Though compare also Carl Jung, 'Wotan', in *Civilization in Transition, The Collected Works of C. G. Jung*, x, trans. Gerhard Adler and R. F. C. Hall (London: Routledge & Kegan Paul, 1970), for a description of Nazism as the welling up of an archetypal pattern from the past—that of Odin, the storm-bringer. See also Paul Bishop, 'Thomas Mann and C. G. Jung', in Bishop (ed.), *Jung in Contexts: A Reader* (London: Routledge, 1999).
[94] Mann, 'Freud and the Future', 115.

CODA: THE DESTRUCTIVE ELEMENT

There is no single modernist conception of psychoanalysis or response to Freud. The psychoanalytic understanding of dream, sexuality, the unconscious, intersect with different kinds of radical, sceptical, and conservative agendas. Psychoanalysis both founds and dissolves the myths of the future; it now confirms, now subverts, aesthetic practices; it sometimes illuminates the mechanism of the trap, sometimes *is* the trap, and in yet other cases opens a way beyond the most alienating traps of modernity. We have seen how many modernist writers—Sinclair, Lawrence, Breton, and members of the Bloomsbury set—came upon psychoanalysis at a very early stage in its international reception, before many of Freud's or Jung's works had been widely translated. By 1920, according to Bryher, 'you could not have escaped Freud in the literary world'.[95] But which Freud? In the same years that modernist writers were beginning to talk in terms of sublimation, repression, and neurosis, Freud's model was already shifting: initially through his metapsychological explorations of the war years (including the development of the concept of narcissism) and then, by the early 1920s, towards the later topographical description of the psyche in terms of the id, the ego, and the superego, as well as the concept of the death drive. By the end of the 1920s, then, there were yet new Freuds to discover, as well as the first glimmerings of further radical departures in psychoanalytic theory which would foreground not so much sexuality and the dream, in the classical Freudian sense, but phantasy, destruction, and paranoia. The modernism of the 1930s saw the emergence of quite different engagements with psychoanalytic ideas than those addressed so far. A prime example of this appeared in the work of the Surrealist Salvador Dalí, who probably read *Beyond the Pleasure Principle* in the late 1920s and began to fuse that work's conceptualization of the death drive with his own pre-existing interest in the imagery of excrement and bodily corruption.[96] At the same time, Dalí's development of a 'critical paranoiac' method in his artworks, concerning the creation of images capable of double readings, had an impact on the young Jacques Lacan, who was associating with the circles of Surrealism at this time, and who came across Dalí's article 'The Rotting Donkey' in 1930.[97] According to Élisabeth Roudinesco, this paper, and subsequent meetings with Dalí, made it possible for Lacan to break with the theory of constitutionalism and to develop a new understanding of psychosis, which he aired in his doctoral thesis on paranoid psychosis (published in 1932).[98]

[95] Bryher, letter to Susan Stanford Friedman, 1 Oct. 1971, in *Psyche Reborn: The Emergence of H.D.* (Bloomington: Indiana University Press, 1981), 18.

[96] See Dawn Ades, 'Morphologies of Desire', in Michael Raeburn (ed.), *Salvador Dalí: The Early Years* (London: Thames & Hudson, 1994), and Margaret Iversen, *Beyond Pleasure: Freud, Lacan, Barthes* (Pittsburgh: Pennsylvania State University Press, 2007).

[97] Salvador Dalí, 'L'Âne pourri', in *La Femme Visible* (Paris: Éditions Surréalistes, 1930).

[98] See Élisabeth Roudinesco, *Jacques Lacan* (Cambridge: Polity Press, 1997), 31–2.

On a different front, much recent work on psychoanalysis and modernism has shifted its focus from the influence of Freud to that of the young Melanie Klein, who published throughout the 1920s and who by the early to mid-1930s had begun to develop a conceptual focus on mourning and anxiety in the earliest years of infancy. For Lyndsey Stonebridge, the death drive and destruction insistently 'curl around our consciousness of the early twentieth century'.[99] Such narratives of modernism through the lens of Klein, rather than Freud or Jung, have seemed increasingly compelling, not just because of the demonstrable overlap between Klein's early work and that of British modernism (Klein was, after all, based in London from 1926), but also because of the way Klein's concern with hostility, mourning, and internal fragmentation tie in so successfully with modernist preoccupations—during and between the wars—as well as with modernist experiments with fragmentation at the level of aesthetic practices.[100] While the psychoanalytic criticism of modernist literary texts in classical Freudian terms has long seemed to be in eclipse (eclipsed most markedly by the influence of Jacques Lacan on literary theory from the 1970s onwards),[101] new psychoanalytic readings of modernism, and archaeologies of modernist contact with psychoanalysis, are still in the process of unfolding. As in certain models of therapy itself, the narration of psychoanalysis in the 1920s and 1930s is still being unearthed and being reinvented.

[99] Lyndsey Stonebridge, *The Destructive Element: British Psychoanalysis and Modernism* (London: Routledge, 1998), 1.

[100] See also Jacqueline Rose, *Why War? Psychoanalysis, Politics, and the Return to Melanie Klein* (Oxford: Blackwell, 1993); John Phillips and Lyndsey Stonebridge (eds), *Reading Melanie Klein* (London: Routledge, 1998); Esther Sanchez-Pardo, *Cultures of the Death Drive: Melanie Klein and Modernist Melancholia* (Durham, NC: Duke University Press, 2003).

[101] See e.g. Elizabeth Wright, *Psychoanalytic Criticism: A Reappraisal* (Cambridge: Polity, 1998), and Ellmann (ed.), *Psychoanalytic Literary Criticism*.

CHAPTER 24

..

RELIGION, PSYCHICAL RESEARCH, SPIRITUALISM, AND THE OCCULT

..

ROGER LUCKHURST

ONE central way of defining modernity is to emphasize its rejection of religion. Reason wages war on superstition and enthusiasm, on divine right, on the unexamined power of priestcraft. Scientific naturalism and historicism undercut the authority of the Bible as Word of God. Comparative religion imports cultural relativism. Modern capitalism results in urban migrations and new divisions of labour that rip up traditionally static parishes and squirearchies: the modern metropolis is a godless place. In modernity, Max Weber announces, there are no more 'mysterious incalculable forces': 'This means that the world is disenchanted. One need no longer have recourse to magical means in order to master or implore the spirit... Technical means and calculations perform the service.'[1]

Modernism, too, premises its rhetoric of rupture on this kind of announcement. It dreamt of burning down the museums and mocked the Christian earnestness and evangelism in nineteenth-century life and art. In Friedrich Nietzsche, modernist

[1] Max Weber, 'Science as a Vocation', in *From Max Weber: Essays in Sociology*, trans. H. H. Gerth and C. Wright Mills (London: Routledge & Kegan Paul, 1948), 139.

rupture found its most virulent anti-Christian denunciatory mode: 'Christianity has taken the side of everything weak, base, ill-constituted,' Nietzsche proclaimed in *The Anti-Christ*. 'Only we, we *emancipated* spirits, possess the need for understanding something nineteen centuries have misunderstood.'[2]

If we believe in this rupture, then there is little to say about modernism and religion. Radical art, like radical Nietzscheanism or the radical politics of anarchism, Marxism, or communism of the same era, must be allergic to religion and supersede its authority. Residual belief is at best eccentric (W. B. Yeats's magical pursuits or Walter Benjamin's Jewish messianism) and at worst reactionary and antimodern (as in T. S. Eliot's conversion to Anglo-Catholicism). Frequently, it is both. Modernism, at its radical core, should be another facet of how modernity toppled traditional religious beliefs.

Yet pronouncements of historical ends or ruptures rarely survive much close analysis. Modernity does not demolish religious belief. If anything, Nietzsche's philosophizing with a hammer only shattered the theistic impulse into pieces that have developed several numinous lives of their own. Marina Warner premises her encyclopedic study *Phantasmagoria* on the view that 'Modernity did not by any means put an end to the quest for spirit' but actively promoted new avenues of curiosity and research in which the spirit leaked back into the grid of secular knowledge.[3] John Jervis has similarly argued that while the Enlightenment dethroned religion from uncontested authority, the language and affect of the sacred was displaced into other discourses: the sublime, the erotic, and various kinds of transgressive, communal experience such as mystical union or rapture. Jervis notes that the term 'supernatural' (like the 'uncanny') was an eighteenth-century coinage, 'a product of modernity, since it only makes sense by contrast with the category of the "natural," the notion of nature as secular, law-governed, available for scientific investigation'.[4] Modernity therefore produces its own secret sharers. Thus, Jervis suggests that the cultural fascination with ghosts or with sublime experience performs 'the presence of the absence of God' in modernity.[5]

If we narrow the historical focus to the turn of the twentieth century, the moment of modernism, then this persistence of the displaced sacred takes on very distinct forms. Across Europe, the demotic religion of spiritualism imported from America in 1848 found a new impetus in the 1870s with the full materialization of spirits in embodied form. Spiritualism was then given the trappings of science by the emergence of the Society for Psychical Research (SPR) in 1882. The theological strand, never far away, re-emerged after 1914, when thousands of the spirit-dead from the First World War struggled to contact those who survived them. Hosts of spirits were

[2] Friedrich Nietzsche, *Twilight of the Idols and The Anti-Christ*, trans. R. J. Hollingdale (Harmondsworth: Penguin, 1979), 117, 148.

[3] Marina Warner, *Phantasmagoria: Spirit Visions, Metaphors and Media into the 21st Century* (Oxford: Oxford University Press, 2006), 10.

[4] John Jervis, *Exploring the Modern: Patterns of Western Culture and Civilization* (Oxford: Blackwell, 1998), 183.

[5] Ibid. 197.

seen in the sky above the retreating forces at Mons; thousands of the dead were photographed hovering over the Cenotaph in London in the 1920s.[6] The same era saw a significant occult revival. This included the esoteric teachings of Madame Blavatsky's Theosophical Society, which developed a London base in the 1880s. Theosophy was an Anglo-Indian attempt to reunify all religion and science, a forgotten synthetic wisdom carried by adepts of Hermeticism and communicated by astral letter from superhuman beings hidden away in the closed kingdom of Tibet. Societies of ritual magic prospered in France, Germany, and England. The comic shenanigans of the Hermetic Order of the Golden Dawn in London produced a domestic Antichrist, Aleister Crowley, the self-proclaimed Beast of the Apocalypse, who haunted the Edwardian imagination. Other mystics flooded the intellectual scene. G. R. S. Mead abandoned theosophy for a different mode of scholarly comparative mysticism through the collaborative work of the Quest Society (1909–30). Blavatsky's foreign exoticism had rivals in the charismatic itinerant mystics Rudolf Steiner, Pietr Ouspensky, and George Gurdjieff, who exerted varying degrees of cultural influence in England. Another 'occult' belief was regularly equated to magical thinking: the psychoanalysis of Sigmund Freud and the analytic psychology of Carl Jung. The *Saturday Review* reported: 'Trances and spirit-photographs are no longer the mode; the far-seeing occultist has abandoned the necromantic arts, and now poses as a psychoanalyst.'[7] Both Freud and Jung were indeed obsessed with the occult phenomena of séances and telepathy, and the alien notion of the Unconscious was by definition a mysterious occult force working invisibly to derange the rational subjects of modernity.

Where these movements were historically entangled with cultural modernism, they were long ignored as embarrassments (aside from Freud). While there has been an explosion of interest in rethinking the relation of modernism and the occult, these treatments have often resorted to theories of compensation. That is to say, eccentric beliefs are seen as the result of secularizing pressure distorting traditional faith into improbable shapes. Most particularly, these generations, it is argued, suffered the traumatic impact of Darwin's biological reduction of the human spirit to hereditary determinism. Janet Oppenheim called spiritualism, theosophy, and psychical research 'surrogate faiths', the desperate compensation for the loss of religion accounting for their bizarre and delusory forms.[8] The compensation thesis still recurs in modernist histories. It is a reading that sees in key strands of modernism 'therapeutic abatement of the pressures of modernity'.[9]

This approach inoculates the critic from eccentricity by decoding occult practice within a generic crisis of faith or as an allegory of detraditionalizing modernity.

[6] See e.g. Jay Winter, *Sites of Memory, Sites of Mourning: The Great War in European Cultural History* (Cambridge: Cambridge University Press, 1995).

[7] Alex Owen, 'Psycho-Analysis à la Mode', *Saturday Review* (21 Feb. 1921), 129.

[8] Janet Oppenheim, *The Other World: Spiritualism and Psychical Research in England, 1850–1914* (Cambridge: Cambridge University Press, 1985).

[9] Tim Armstrong, *Modernism: A Cultural History* (Cambridge: Polity Press, 2005), 4.

Yet these interpretations ignore significant details about the state of late Victorian
and early Edwardian religion. In England the number of Anglican priests rose by four
thousand between 1850 and 1880 alongside an extensive church-building programme
and the expansion of urban parishes. There were anxious debates about the decline
of church attendance, with a popular press panic about 'Godless London' in 1902
and the large survey by the *Daily Telegraph* entitled 'Do We Believe?' in 1904. Yet
the Church of England succeeded in maintaining religion at the heart of the new
School Board compulsory education system, and the law continued to prosecute
overenthusiastic atheist advocacy and blasphemy. The Protestant consensus binding
Church, state, and civil society continued largely unshaken and, Hugh McLeod
argues, 'secularism remained a relatively marginal problem'.[10] Historians of science
have also interrogated the narrative that has cultural authority shifting from religion
to science after the disputes of Darwin's theory of evolution in the 1860s. Jim Moore
has traced how Protestants, particularly progressive groups like the Unitarians, could
comfortably incorporate Darwinism into religious beliefs, neutering controversy by
assimilation.[11] Thomas Huxley certainly led Darwinians in an ideological and insti-
tutional mission to contest religious authority, but the scientific community
contained many natural theologists, not least Lord Kelvin, whose energy physics
was fully integrated into his Protestantism.[12] Secularists were bewildered that every
advance seemed to be entwined with religious resurgence. 'Our age of science', as
Liberal MP and editor John Morley put it, was also 'the age of deepening superstition
and reviving sacerdotalism'.[13]

The era of modernist manifestos was also the era of the so-called New Theology.
R. J. Campbell attracted thousands to the City Temple in Holborn with a liberal,
quasi-socialist creed he issued in book form in 1907. Campbell challenged biblical
truth and ecclesiastical authority, proclaiming the human immanence of Christian
faith (in contrast to the transcendental, dualist orthodoxy). His personal, politicized
Protestantism used the same denunciatory tactics about traditional authority as did
the small groups nurturing early modernism.[14] Catholic liberalism, meanwhile,
attracted the kind of outrage the artistic avant-garde could only dream about. In
1907, before modernism was modernism, Pope Pius X issued an encyclical condemn-
ing the teaching of 'Catholic modernism' for its challenge to biblical truth and
church hierarchy and for its support of immanentism and relativism. 'Nothing', the
encyclical thundered, 'could be more destructive of the whole supernatural order';

[10] Hugh McLeod, *Religion and Society in England, 1850–1914* (Basingstoke: Macmillan, 1996), 2.

[11] J. R. Moore, *The Post-Darwinian Controversies: A Study of the Protestant Struggle to Come to Terms with Darwin in Great Britain and America, 1870–1900* (Cambridge: Cambridge University Press, 1979).

[12] See Crosbie Smith and M. Norton Wise, *Energy and Empire: A Biographical Study of Lord Kelvin* (Cambridge: Cambridge University Press, 1989).

[13] Cited in Frank M. Turner, *Contesting Cultural Authority: Essays in Victorian Intellectual Life* (Cambridge: Cambridge University Press, 1993), 193.

[14] See R. J. Campbell, *The New Theology*, popular edn (London: Mills & Boon, 1909). For the history of the City Temple, see Warren Sylvester Smith, *The London Heretics 1870–1914* (London: Constable, 1967).

modernism was denounced as 'the synthesis of all heresies'.[15] The liberal Irish Catholic convert George Tyrrell issued an apologia entitled *The Programme of Modernism*, pleading for tolerance of liberal theology, for which he was excommunicated. When he died, he was refused Catholic burial. It was Campbell and Tyrrell who prompted the Catholic writer G. K. Chesterton to issue his polemic *Orthodoxy*, in which he proposed that most modern thought from Nietzsche and scientific materialism onwards was touched by a 'suicidal mania' that only religious belief could constrain: 'Mysticism keeps men sane . . . when you destroy mystery you create morbidity.'[16]

These details have been accumulated to question ideas of a simple rupture and crisis of faith or accounts of a decline of orthodoxy for an efflorescence of heterodox supernaturalism. Rather, forms of modernism appeared in cultures that remained saturated with religious ideas, running across the spectrum. Understanding this, it seems more valuable to follow Alex Owen's acute readings of the occult revival that suggest that far from being anti- or counter-modern, these experiments in supernatural experience were a 'thoroughly modern project', existing in parallel with the exploration of subjectivity by Nietzsche, Bergson, and Freud.[17]

Modernist art was consistently imbricated in this matrix of ideas and beliefs. In what follows, I want to demonstrate this by trying to order a spectrum of numinous knowledges along which we might situate significant works or artists. Often a generic crisis of faith account will lump these practices together as indifferent eccentricities, but this was not how the often highly discriminating practitioners made their careful distinctions between knowledges at the time. This spectrum will run on an axis from psychical research, through spiritualism, mysticism, and the occult. With the space merely to begin to elaborate this taxonomy, the conclusion will point to how a central modernist text, *The Waste Land*, might be understood to collapse this spectrum in its collage aesthetic.

PSYCHICAL RESEARCH

The Society for Psychical Research was founded in 1882 by a group of Cambridge scholars around Henry Sidgwick, Professor of Moral Philosophy at Trinity College. The Society was an exemplary instance of the late Victorian pressure of secularizing science on traditional supernatural conceptions of the soul. The core members of the Society, Sidgwick and his former students Frederic Myers and Edmund Gurney, had

[15] The encyclical of Pope Pius X *Pascendi Dominici Gregis*, 'On the Doctrines of the Modernists', is reproduced in full in George Tyrrell, *The Programme of Modernism* (London: Fisher Unwin, 1908), 175–290; citations from pp. 190, 253.

[16] Gilbert K. Chesterton, *Orthodoxy* (London: John Lane, 1909), 63, 46.

[17] Alex Owen, *The Place of Enchantment: British Occultism and the Culture of the Modern* (Chicago: Chicago University Press, 2004), 255.

all privately attended spiritualistic séances in the 1870s, but were disconcerted by the low company and the plebeian theology of a 'Summerland' where spirits congregated having survived bodily death.[18] The séance display was distressingly close to the music hall, part of the world of enchanting entertainment that produced 'a fuzzy and variegated vernacular modern magic' that Simon During argues is typical of modernity.[19] Instead, the Society would seek respectability by taking 'the large group of debatable phenomena designated by such terms as mesmeric, psychical and Spiritualistic' and subject them to the empirical method of experimental science.[20] These researches were premissed on suspending the hypothesis of surviving spirit or indeed any theological belief. Their tests were also intended to eliminate the standard tricks of 'mentalist' music hall performers. The psychical researcher was to be rigorously agnostic, and his or her investigation of séances, haunted houses, or weird hypnotic rapports did 'not imply the acceptance of any particular explanation of the phenomena investigated, nor any belief as to the operation, in the physical world, of forces other than those recognized by Physical Science'.[21] Procedures of experiment, observation, and induction of general scientific laws were to be assiduously followed. The Society, in other words, aimed to produce positive proofs of phenomena previously regarded as strictly 'spiritual'. Psychical research did not recognize the 'supernatural', only anomalous events which awaited inscription within a universal natural law. Soul or psyche would be definitively captured in the lab.

The term that Frederic Myers coined for the occulted but natural phenomenon that united their diverse researches was telepathy, a puzzling word that combined distance (*tele*) and intimacy (the *pathos* of touch). Telepathy covered 'all cases of impression received at a distance without the operation of the recognised sense organs'.[22] Mental communications of messages without any apparent visible support were documented in drawing rooms, tested in the Society's impromptu laboratories, and 'proved' by thousands of correspondents to the Society. Spiritualistic mediums were likely receiving messages not from the dead, but from beneath the threshold of their own conscious minds, which possessed remarkable hypersensitivity in some instances. Ghosts were 'veridical hallucinations', projections of intense psychic energy directed at loved ones at moments of extreme distress. Haunted houses were phantasmo-genetic centres, places where psychic energies curdled and could be activated by certain sensitives. The weirdly intimate link between the hypnotist and his entranced patient was also telepathic.

[18] The best study of this remains Logie Barrow, *Independent Spirits: Spiritualism and English Plebeians 1850–1919* (London: Routledge, 1986). Biographical treatments of the SPR, in 'crisis of faith' mode, include Alan Gauld, *The Founders of Psychical Research* (London: Routledge & Kegan Paul, 1968), and Frank M. Turner, *Between Science and Religion: The Reaction to Scientific Naturalism in Late Victorian England* (New Haven: Yale University Press, 1974).

[19] Simon During, *Modern Enchantments: The Cultural Power of Secular Magic* (Cambridge, Mass.: Harvard University Press, 2002), 37.

[20] 'Objects of the Society', *Proceedings of the Society for Psychical Research (PSPR)*, 1 (1882–3), 3.

[21] Ibid. 4.

[22] 'Report of the Literary Committee', *PSPR* 1 (1882–3), 147. For a full history, see Roger Luckhurst, *The Invention of Telepathy, 1870–1901* (Oxford: Oxford University Press, 2002).

The experimental rigour of the evidence for telepathy remained controversial. It failed to meet the newly professionalized standards of laboratory science and was often ridiculed as credulous and anachronistic amateurism. The boundaries between sceptical psychical research and the strong desire for final proof of the survival of bodily death were hard to maintain. Myers ultimately came to believe in the primacy of a telepathic law that undergirded every relation in the universe, including that between life and death. He affirmed his own belief in psychic survival of death in texts like *Science and the Future Life*. Initial authoritative figures who gave scientific credibility to the SPR, like the energy physicist Sir Oliver Lodge, shifted stance and also became public advocates of spiritualism.

Yet in the 1880s and 1890s Myers alongside Gurney produced an extraordinary body of work that was central to the emerging discipline of dynamic psychology. Edmund Gurney wrote a series of essays on hypnotism which helped to establish the serious medical study of these trance states, rescuing it from the discredited world of mesmerism, whose practitioners claimed to be manipulating the invisible *physical* force of 'animal magnetism' to cure the sick. Gurney documented the evidence that trance states heightened the purely *psychical* powers of perception and memory, as investigated by the eminences of the New Psychology Jean-Martin Charcot and Pierre Janet.[23] Gurney argued that these heightened conditions shaded into telepathic potentials, passing imperceptibly from normal to a host of supernormal states. Gurney experimented with hypnotism 'at a distance' alongside Janet, and such work was later supported by Sigmund Freud, who was prepared to believe that telepathic connections could occur in dreams, across distance, and between analyst and patient.

Myers used the metaphor of the spectrum in his *magnum opus, The Subliminal Consciousness*, published 1891–5. For Myers, the ordinary self was 'but a floating island upon the "abysmal deep" of the total individuality beneath it'.[24] Below the threshold of the 'empirical' self, 'this subliminal consciousness and subliminal memory may embrace a far wider range both of physiological activity and of psychical activity than is open to our supraliminal consciousness, to our supraliminal memory. The spectrum of consciousness, if I may so call it, is in the subliminal self infinitely extended at both ends.'[25] The implication was that supraliminal consciousness was situated in a very narrow band of the spectrum, but might be visited by what Myers called 'uprushes' from the subliminal level. These phenomena from below the threshold were carefully taxonomized, working from ordinary dream states and heightened perception or memory towards the strange cases of double or multiple personality, the inspirations of poetic genius, moments of telepathy or clairvoyance, accesses to

[23] See Edmund Gurney, 'The Stages of Hypnotism' and 'The Problems of Hypnotism', *Mind*, 9 (1884), 110–21, 477–508.

[24] F. W. H. Myers, 'The Subliminal Consciousness', chs 1–2, *PSPR* 7 (1891–2), 301.

[25] Ibid. 306.

mystical experiences, and finally even 'the Interpenetration of Worlds;—some statement in terms as scientific as possible of the ancient belief in a spiritual universe'.[26]

Myers's vast accumulation and sorting of evidence and his theory of the subliminal mind is worth rediscovering, since its influence on conceptions of self and subjectivity reached to the heart of a key strand of modernism. When Myers died in 1901, the leading psychologist William James (brother of Henry) declared Myers 'the founder of a new science' and that psychology would now need to address the 'Myers problem'.[27] In 1911 the Swiss psychologist Théodore Flournoy ratcheted up the rhetoric, believing that Myers would soon join Copernicus and Darwin 'to complete the triad of geniuses who have most profoundly revolutionised scientific thought'.[28] Henri Bergson's important philosophical view that 'pure intellect is a contraction . . . of a more extensive power' that he conceived of as uninterrupted 'duration' beneath the mechanistic divisions of reason shared many similarities with Myers's subliminal consciousness.[29] This was because Bergson had been persuaded by Myers's work on telepathy as early as 1886. In 1913, at the height of his influence on English culture, Bergson became president of the SPR. 'The more we become accustomed to this idea of consciousness overflowing the organism,' Bergson argued in his presidential address, 'the more natural we find it to suppose that the soul survives the body.'[30]

The Myersian conception of the subject had an influence on psychology and philosophy, and was directly cited by Campbell to locate the divine as a question of consciousness in the New Theology.[31] It also influenced modernist writers such as May Sinclair, who, through her membership of the Medico-Psychological Clinic in Bloomsbury, was familiar with contemporary theories of subconsciousness. Her ghost stories are suffused with Myersian principles, part of a general interest in mental states at the extremes of the spectrum.[32] The metaphor of the 'stream' of consciousness was shared by Myers, William James, and Henri Bergson, and the tinges of supernormal subliminal uprushes continually attend its exercise in, for instance, the novels of Virginia Woolf. The traces of Myers even extend into D. H. Lawrence's conception of character, Tom Gibbons has argued.[33] George Johnson has tracked an even wider diffusion.[34] The most explicit European modernist debt was in Surrealism. In 1933 André Breton reminded his followers that their project of deranging the strictures of rationalism was not solely indebted to

[26] F. W. H. Myers, 'The Subliminal Consciousness', chs 3–5, PSPR 8 (1892), 534.

[27] William James, review of Myers, Human Personality and its Survival of Bodily Death, PSPR 18 (1903–4), 22.

[28] Théodore Flournoy, Spiritism and Psychology, trans. H. Carrington (London: Harper, 1911), 66.

[29] Henri Bergson, Creative Evolution (Mineola, NY: Dover, 1998), 46.

[30] Henri Bergson, Mind-Energy: Lectures and Essays (London: Macmillan, 1920), 78.

[31] See Campbell, The New Theology, 25–8.

[32] Sinclair's 1923 collection Uncanny Stories is frequently reprinted. For more context, see Suzanne Raitt, May Sinclair: A Modern Victorian (Oxford: Oxford University Press, 2000).

[33] Tom Gibbons, ' "Allotropic States" and "Fiddle-Bow": D. H. Lawrence's Occult Sources', Notes and Queries, 233 (1988), 338–41.

[34] George M. Johnson, Dynamic Psychology in Modernist British Fiction (Basingstoke: Palgrave, 2005).

psychoanalysis: 'I think we owe more than is generally conceded to what William James justly called the *gothic psychology* of F. W. H. Myers.'[35]

For much of the era of modernism, then, psychical research and advanced dynamic psychology were difficult to disentangle. The psychical framework invented by Gurney and Myers for extreme states of consciousness, from telepathy to automatism to visionary transports, allowed intellectuals to avow these experiences while distancing themselves from what they perceived as the abject world of plebeian spiritualism or the debased languages of orthodox religion. If psychical research exasperated scientific materialists, it was to others a thoroughly modern synthesis.

SPIRITUALISM

Psychical research was intended to displace the theological beliefs of spiritualism, but, as already indicated, the apparent proofs of psychical phenomena often led researchers back to the spiritualist precept of the survival of bodily death. The revival of spiritualism in the First World War was indicated by the success of Oliver Lodge's *Raymond*, a record of his son killed at the front in 1915. The book began with a 'Normal' section of Raymond's letters home from the front; the 'Supernormal' section was the record of spirit communications from Raymond, which began ten days after his death with the assistance of the spirit Myers.[36] Raymond's details of his posthumous existence, including complaints about the poor puff on ethereal cigars, have the whiff of quaint Victoriana. Yet, as Jenny Hazelgrove records, spiritualist societies doubled between 1914 and 1919 and reached their peak in 1937, with mass gatherings at the Royal Albert Hall, centred on the star mediums of the age.[37] This success prompted the Church of England to set up an Archbishop's Committee on Spiritualism, which reported in 1939 on the continued rise of this heterodox rival.[38] Anglican or Catholic condemnation only had the effect of affirming the democratic, anti-authoritarian strand of the movement. Spiritualism rejected the theology of punishment, offering solace precisely through low-level, empirical proofs of survival, the banal continuities of domestic chatter between mundane and ultra-mundane worlds.

[35] André Breton, 'The Automatic Message', in *What Is Surrealism? Selected Writings*, ed. Franklin Rosemont (London: Pluto Press, 1978), 100.

[36] Oliver Lodge, *Raymond, or, Life and Death* (London: Methuen, 1916). For commentary, see Victoria Stewart, 'War Memoirs of the Death: Writing and Remembrance in the First World War', *Literature and History*, 14/2 (2005), 37–52.

[37] Jenny Hazelgrove, *Spiritualism and British Society Between the Wars* (Manchester: Manchester University Press, 2000).

[38] See Rene Kollar, *Searching for Raymond: Anglicanism, Spiritualism, and Bereavement Between the Two World Wars* (Lanham, Md: Lexington, 2000).

The switching centre for spiritualist practice remained the female medium, her delicate apparatus the standard mechanism for communication between worlds. Such technological metaphors were made literal by the newspaper mogul and spiritualist W. T. Stead, who wanted to set up 'Julia's Switchboard' in 1909, intended to connect the bereaved to the dead via mediumistic women telephonists. The arena of the séance evidently remained a space for sexual exploration and gender performance; this, also, resists being caricatured simply as Victorian sublimation. In the 1910s and 1920s women mediums were often examined vaginally and rectally for concealment of the gauze sometimes suspected to form the material for ectoplasmic extrusions. A researcher like Harry Price, who set up the National Laboratory of Psychical Research in 1923, detailed these checks with prurient delight. The punishment and abjection of the female medium was never far away from this fascination: one of Price's mediums, Helen Duncan, was imprisoned in 1944 under witchcraft laws.[39] Meanwhile, W. B. Yeats's intensive séances with his new wife, Georgie, often produced 'spiritual' advice on detailed matters of sexual conduct.[40]

The quasi-scientific language of psychical research, however, allowed many who were interested in feminine subjectivity to explore sexuality, trance states, and occult communication entirely shorn of the demotic associations and religious framework of spiritualism. This is where it is most plausible to connect modernism and spiritualism. Many writers engaged in the practice of automatic writing, one of the standard trance devices for allegedly receiving mediumistic messages. Rainer Maria Rilke and Gertrude Stein, for instance, toyed with the method. For the Surrealists, the early investigations in the 1920s were principally centred on trance and automatic writing. While they celebrated the female hysteric, close cousin to the medium, they had no interest in spiritualist content: the device was entirely secularized as a route to unconscious derangement. Nevertheless, Helen Sword has argued that 'spiritualism anticipates many of literary modernism's central principles, mirroring modernist writers' attempts to establish a dialectic that might embrace both authority and iconoclasm, both tradition and innovation, both continuity and fragmentation'.[41] Sword observes that spiritualist communications use 'virtually all the major tropes of literary modernism—linguistic playfulness, decenterings of the unconscious, fracturings of convention gender roles'.[42] This 'ghostwritten modernism' is perhaps overstated, but it does point to a fascinating parallel interest in disabling conscious control to allow 'subliminal uprush', whether supernatural or not. This in turn overthrew notions of authorial inauguration and ownership, ideas integral to the avant-garde.

As a psychological device associated with the feminine, it is unsurprising that many women modernists explored this practice. Indeed, the fringes of psychic

[39] Malcolm Gaskill, *Hellish Nell: The Last of Britain's Witches* (London: Fourth Estate, 2001).

[40] Brenda Maddox, *George's Ghosts: A New Life of W. B. Yeats* (London: Picador, 2000).

[41] Helen Sword, 'Modernist Mediumship', in Lisa Rado (ed.), *Modernism, Gender, and Culture: A Cultural Studies Approach* (New York: Garland, 1997), 65.

[42] Helen Sword, 'Necrobibliography: Books in the Spirit World', *Modern Language Quarterly*, 60/1 (1999), 87.

investigation seemed to help figure that emergent new sexual subject—the lesbian.[43] Such psychic explorations returned to forms of fairly explicit spiritualist belief in figures like May Sinclair, H.D., Radclyffe Hall, and Vita Sackville-West.[44] H.D. and her partner, Bryher, conducted séance investigations for decades. H.D. recorded messages from dead Royal Air Force pilots and even managed to contact her former analyst, Sigmund Freud. Perhaps he would not have been so surprised, having noticed the proliferation of spiritualist gatherings in the most advanced Western cities, evidence used in passing of 'the uncanny'.[45] H.D.'s researches fed directly into her poetry. Even these investigations, however, were a long way from the mass movement of plebeian spiritualism. Modernists interiorized these explorations, using them to map unknown psychic terrains. These exercises did not reinforce democratic spiritualism or any theology. They had more in common with the training of adepts that was more associated with mysticism. As H.D. claimed in 1919: 'I believe there are artists coming in the next generation, some of whom will have the secret of using their over-minds.'[46]

MYSTICISM AND THE OCCULT

Evelyn Underhill, the influential Christian scholar, complained that the proper religious experience of mysticism had suffered 'mutilation at the hands of the psychologists' and needed rescuing.[47] The mystic A. E. Waite similarly decried the inexact use of 'occultism', which had expanded to include hypnotism and psychical research. Waite's careful distinctions are typical. The occultist was defined as 'the disciple of one or all of the secret sciences', such as alchemy, the Hermetic tradition, or magic. The mystic, however, did not work on materials outside himself: 'he endeavours, by a certain training and application of a defined rule of life to re-establish correspondence with the divine nature from which, in his belief, he originated'.[48] Occultism was an epistemology, a project of uncovering hidden knowledge, but mysticism was a phenomenology, an often incommunicable experience of the

[43] The links between same-sex desire and these psychical researches are best examined in Pamela Thurschwell, *Literature, Technology and Magical Thinking 1880–1920* (Cambridge: Cambridge University Press, 2001).

[44] May Sinclair wrote an introduction to the spiritualist communications in Catherine Dawson Scott, *From Four Who Are Dead* (London: Arrowsmith, 1926). Radclyffe Hall and her partner Una Troubridge attended séances with the medium Mrs Osbourne Leonard and were active members of the SPR. H.D. and Bryher's spiritualist researches are discussed in Rachel Connor, *H.D. and the Image* (Manchester: Manchester University Press, 2004). Vita Sackville West's interest in mysticism is explored in Suzanne Raitt, *Vita and Virginia: The Work and Friendship of V. Sackville West and Virginia Woolf* (Oxford: Oxford University Press, 2002).

[45] Sigmund Freud, *The Uncanny*, Penguin Freud Library, xiv (Harmondsworth: Penguin, 1990).

[46] H.D., *Notes on Thought and Vision* (London: Peter Owen, 1988), 21.

[47] Evelyn Underhill, *The Essentials of Mysticism, and Other Essays* (London: Dent, 1920), 2.

[48] A. E. Waite, 'The Life of the Mystic', *Occult Review*, 1 (1905), 29–30.

numinous. Occultism tends to have more distinct boundaries than mysticism. The rituals and hierarchies of training in magical society bind initiates to a strict and closed regime of practices. Yet while the narrowly defined occult magical revival associated with the Golden Dawn had only peripheral contact with modernism, Alex Owen convincingly suggests that its rituals offered 'a self-conscious exploration of subjectivity' in parallel with the new psychology.[49] Nevertheless, that psychology seems closer to the phenomenology of the vaguer mystical experience. William James in his discussion of mysticism dispensed entirely with outer doctrinal, ritualistic, or ecclesiastical questions to focus on its inner psychology, those 'experiences of individual men in their solitude, so far as they apprehend themselves to stand in relation to whatever they may consider the divine'.[50]

We can examine these different strands and their possible relation to modernism by examining two different journals and their editors, G. R. S. Mead's *The Quest* (1909–30) and the *New Age* (under A. R. Orage's editorship, 1907–22). Mead, an oriental philosophy and classics scholar, had joined the Theosophical Society in 1884 and acted as the private secretary to Madame Blavatsky in the last three years of her life. He was the secretary of the European branch of the Society for nearly twenty years before resigning over sexual scandals within the movement. His founding of the Quest Society was an openly inclusive project, aimed to promote the comparative study of religion, philosophy, and science. Beneath all human endeavours, Mead believed, was *the quest*. It united different folklores, myths, and sacred stories, and it sought 'relief and rest from our present state of strain and tension, freedom from the separateness of bondage, the reconciliation of all opposites in the all-embracing immediacy of self-realisation'.[51] In contrast to Waite, who was a Christian mystic, Mead defined the quest with extremely wide margins. 'It is difficult', he said, discussing the fashions of psychical research and Bergsonian philosophy, 'to see where the limits of the psychical are to be set; for human personality can contact the divine.'[52] This psychological immanentism links Mead to the New Theology. Mead also wanted to direct readers away from the vulgar spectacles of phenomenal supernaturalism (spirit materialization and so on) towards the inner asceticism of the mystical life, yet the journal was open to discussions of hypnotism, psychical research, Bergsonism, and even, in one memorable essay, 'The Appalling Nuptials of Insect Life'. In *The Quest* Evelyn Underhill also linked mysticism with a certain conception of aesthetics. If the mystical life concerned 'the development of a sense, an intuition, which lies deep in every conscious Self', then it was artists who 'stand in a peculiar relation to the phenomenal world, discovering truths and beauties which are hidden from other men'.[53] Leon Surette has made much of Ezra Pound's lecture on the troubadour poets to the Quest Society as evidence that there is an occultist

[49] Alex Owen, 'The Sorcerer and His Apprentice: Aleister Crowley and the Magical Exploration of Edwardian Subjectivity', *Journal of British Studies*, 36 (1997), 100.

[50] William James, *Varieties of Religious Experience* (Harmondsworth: Penguin, 1982), 31.

[51] G. R. S. Mead, 'On the Nature of the Quest', *The Quest: A Quarterly Review*, 1 (Mar. 1909), 33.

[52] G. R. S. Mead, 'The Rising Psychic Tide', *The Quest*, 3 (Apr. 1912), 403.

[53] Evelyn Underhill, 'A Note Upon Mysticism', *The Quest*, 1 (July 1910), 742, 745.

imperative behind English modernism.[54] *The Quest* was also where A. E. Waite and Jessie Weston explored the mystical significance of the Grail romances, which have fed so much scholarship on the occulted meanings of Eliot's *The Waste Land*. Waite and Mead had inevitable influence on Yeats's indiscriminate occultist fascinations. Underhill's aesthetics, however, were derived from the metaphysical horror novelist Arthur Machen, who had followed the Gothic monstrosity of *The Great God Pan* in 1896 with brief membership of the Hermetic Order of the Golden Dawn and a string of mystical novels that hinted that the Grail might be glimpsed in ecstatic quest experiences roaming the dusty streets of Shepherd's Bush or Finsbury. Machen's choked, decadent style was resolutely outside the modernist avant-garde.

A. R. Orage's editorship of the *New Age* has been at the centre of significant revisionist modernist scholarship, the eclectic nature of jostling styles, ideologies, and aesthetic positions recontextualizing the birth of English modernism back into the noisy and disputatious terrain of weeklies and monthlies.[55] Orage, already a socialist, Nietzschean, and theosophist when he became editor in 1907, gave space to debates about Guild Socialism, Bergsonism, Post-Impressionism, Futurism, and Vorticism, and the theories of Social Credit that so obsessed Pound. He published Katherine Mansfield, T. E. Hulme, F. S. Flint, Middleton Murry, and Pound in the formative years of London modernism, where his unofficial salon took place over the *New Age* proofs in the ABC café in Chancery Lane.[56] In such accounts, Orage's turn to mysticism in the early 1920s and his resignation to study at Gurdjieff's Institute of Harmonious Development in Fontainebleau is seen as an embarrassing lapse. Orage's openness to 'some of the most extravagant spiritual views circulating in Europe' made him lose, as one critic puts it, 'the power of scrutiny'.[57] Another critic contemptuously, but inaccurately, regards Orage's interest in spiritualism as his 'fatal weakness'.[58] Certainly, Orage's own account of his intellectual progress in 1926 offered a trajectory towards God, the First World War leaving 'no hope in the brotherhood of man secularly conceived'.[59] Yet this model of his career tends to ignore that Orage *began* as an occultist, an active member of the Theosophical Society, studying the Hermetic tradition. Like Evelyn Underhill, Orage's early aesthetic theory was built on Arthur Machen's decadent style handbook *Hieroglyphics*, arguing that 'Literature is the expression of ecstasy, and ecstasy is the withdrawal of consciousness from the ordinary into the inner and more real world.'[60] His early books on Nietzsche elided the

[54] Pound's lecture 'Psychology and the Troubadours' was given in 1912 and was incorporated into his *Spirit of Romance*. See Leon Surette, *The Birth of Modernism: Ezra Pound, T. S. Eliot, W. B. Yeats and the Occult* (Montreal: McGill-Queen's University Press, 1993).

[55] See Ann Ardis, *Modernism and Cultural Conflict 1880–1922* (Cambridge: Cambridge University Press, 2002), or Charles Ferrall, *Modernist Writing and Reactionary Politics* (Cambridge: Cambridge University Press, 2001).

[56] Paul Selver, *Orage and the New Age Circle* (London: Allen & Unwin, 1959).

[57] Gary Taylor, *Orage and the New Age* (Sheffield: Sheffield Hallam University Press, 2000), 126, 135.

[58] Wallace Martin, *The New Age Under Orage: Chapters in English Cultural History* (Manchester: Manchester University Press, 1967), 291.

[59] A. R. Orage, 'In Search of God', *New Age* (22 Apr. 1926), 295.

[60] A.J.O. [A. R. Orage], 'The Mystic Valuation of Literature', *Theosophical Review*, 31 (1903), 431.

Übermensch with the adepts of secret theosophical wisdom or the Myersian concep-tion of the supersensitive 'over-mind'. In his book *Consciousness*, he argued that 'the main problem of all ages has been the problem of how to develop superconsciousness, of how to become supermen'.[61] It is reasonable, as Tom Gibbons argues, to see Orage's occult interests as entirely equivalent to and fully coterminous with his political and economic theories, rather than as a subsequent, weak deviation from them.[62]

It is connections of this kind that make Leon Surette suspect that there is an occult conspiracy hidden at the core of English modernism, a unifying esoteric truth beneath the exoteric fragments. Occultists and avant-gardists share the belief in modes of wisdom 'which they have preserved in a form comprehensible only to the enlightened and which is passed on in texts whose esoteric interpretation is preserved in secret societies'.[63] Establishing Pound's debts to Mead, Orage, and Yeats, the *Cantos* becomes testament to the 'nearly complete conquest' of modernism by the occult revival.[64] Surette's overheated rhetoric about the 'scandal' of this overlooked secret is a reminder that the correspondences and hidden harmonies that occultists discern can easily tip into paranoia, another kind of apophenia that was being theorized for the first time in the same era. Modernism was not *determined* by the explorations of psychical research, spiritualism, mysticism, and the occult, but this rapid survey reveals how complex were the cross-connections and echoes with the modernist project. The language of rupture can't inoculate modernism from these researches any more.

RECAPITULATION: *THE WASTE LAND*

This spectrum of beliefs can be recapitulated across the fragments of T. S. Eliot's *The Waste Land*. Eliot's rapid and restless traverse of aesthetic, philosophical, and reli-gious beliefs between 1909 and 1922 left a trail of rubble that critics have been trying to sort into meaningful structures ever since. This recapitulation tends to suggest that the possibility of finding a hidden order to be shored against the ruins is *itself* fractured across different systems of psychical, occult, or theological unity, and thus the reader can only trace fugitive, phantasmal shapes of coherence across the poem. There is no occulted 'solution'.

The Waste Land despises the clairvoyant medium Madame Sosostris, yet Michael Levenson has observed how the opening lines of the poem offer overlapping voices

[61] A. R. Orage, *Consciousness: Animal, Human, and Superman* (London: Theosophical Society, 1907), 72.

[62] Tom Gibbons, *Rooms in the Darwin Hotel: Studies in English Literary Criticism and Ideas, 1880–1920* (Crawley WA: University of Western Australia Press, 1973).

[63] Surette, *The Birth of Modernism*, 14.

[64] Ibid. 36.

whose boundaries waver and appear to speak from beneath the ground, jostled by 'dried tubers' and covered in 'forgetful snow'. The poem begins, like the *Cantos*, with the voices of the dead. The conjuration of the dead is the dominant trope in 'Tradition and the Individual Talent' (1919), in which the poet must, like the medium in trance, seek an 'extinction of personality' so that he can be set down 'among the dead'.[65] *The Waste Land* is thus 'a kind of ghost story with protagonists both haunted and haunting'.[66] This risks stretching Eliot's metaphors into the empty discourse of modern spectrality, however, whereas Eliot consistently despised spiritualism. Evidence is more intriguing for psychical research. Eliot attended Bergson's lectures in 1910, took notes on Pierre Janet's essays on the treatment of spiritualist mediums as hysterics, and studied psychology with William McDougall, pioneer of dynamic psychology and another president of the SPR. Yet Eliot explicitly rejected the practice of automatic writing in his essay on Pascal, and the 'automatic hand' of the secretary in *The Waste Land* is the clinching epithet for the death of soul. The late Romanticism of Myersian prose and philosophy was Eliot's polar opposite.

Occultism always promises a solution to the poem, divining through the exoteric fragments the esoteric truth. The tarot reading given by Madame Sosostris does seem to exercise a provisional marshalling of the fragments. Eliot clearly knew A. E. Waite's *The Pictorial Key to the Tarot* and used its iconography.[67] This can be just about brought into alignment with the most overt occult schema of the poem, Jessie Weston's study of the Grail legends, *From Ritual to Romance*. Weston sifted the competing body of medieval texts and the symbolism that survived into the tarot. These survivals she believed were, in a wonderfully Eliotic phrase, 'the debris of ritual' now lost or hidden by adepts.[68] These myths provide the glimpsed framework in the poem of a quest across a wounded, infertile land, through false gods and promises, and towards a possible glimpse of grace. Famously, Eliot upheld the schema of myth to provide formal coherence in his essay on Joyce, '*Ulysses*, Order and Myth'. Critics from Cleanth Brooks onwards have used this framework to make the poem cohere; others, like Lawrence Rainey, have fought to retain the radical modernist potential of the irresolvable fragment.[69] Once again, the poem cannot hang on Weston alone. While an early review deemed the poem 'Theosophical' in its dependence on Weston, Eliot seemed to have a more distanced anthropological and comparative attitude to these possibilities of mythic coherence.[70] Yet the occult possibilities of coherence are not later critical impositions. Rather, Eliot demonstrates the chaotic 'spiritual' materials circulating at the time. *The Waste Land*, finally, also displays evidence of Eliot's reflections on mysticism. Eliot had read and

[65] T. S. Eliot, 'Tradition and the Individual Talent', in *Selected Essays* (London: Faber and Faber, 1999), 17, 15.

[66] Michael Levenson, *A Genealogy of Modernism: A Study of English Literary Doctrine 1908–22* (Cambridge: Cambridge University Press, 1984), 174.

[67] Tom Gibbons, '*The Waste Land* Tarot Identified', *Journal of Modern Literature*, 2 (1972), 560–5.

[68] Jessie Weston, 'The Quest of the Holy Grail', *The Quest*, 1 (Mar. 1910), 528.

[69] Lawrence Rainey, *Revisiting The Waste Land* (New Haven: Yale University Press, 2005).

[70] Review, *New Statesman* (Nov. 1923), cited in Surette, *The Birth of Modernism*, 235.

annotated William James's and Evelyn Underhill's studies, possibly after his own mystical experience in 1910.[71] *The Waste Land* continually hints at moments of ecstatic revelation or annihilation, from the hyacinth garden to the opaque lessons of 'What the Thunder Said'. These moments promise to some readers the final autobiographical clue,[72] but they seem to serve more as dislocated islands of intensity that precisely fail to find resolution.

Of course, what we might call these paradoxical fragments of holism have to be read through Eliot's subsequent conversion, in 1927, to the Anglican Church. Part V of 'Dry Salvages' opens with a list of occultisms that are now dismissed as 'pastimes and drugs', pseudo-religions for those unwilling to accept the hierarchy and discipline of Christianity. His renewed classicism rejected psychics, mystics, and occultists as Romantics deluded by the 'inner voice'. As he put it in his commentary on A. R. Orage, they were all in pursuit of 'the wrong supernatural'.[73]

Eliot will always leave us with an extremely conservative trajectory, towards a disciplinarian religious belief that curtails the radicalism of modernism. Yet these occultisms did not necessarily tend towards the conservative magical thinking so condemned by Theodor Adorno.[74] The political valences of such a large and heterogeneous field cannot be simply and finally determined, particularly as it provided such a crucial matrix for so many different modernisms.

[71] See Lyndall Gordon, *Eliot's Early Years* (Oxford: Oxford University Press, 1977).

[72] Donald J. Childs, *T. S. Eliot: Mystic, Son and Lover* (London: Athlone Press, 1997).

[73] T. S. Eliot, 'Commentary', *Criterion*, 14 (1935), 262.

[74] See Theodor W. Adorno, 'Theses Against Occultism', in *Minima Moralia*, trans. E. F. N. Jephcott (London: Verso, 1974), 238–44.

CHAPTER 25

..

SCIENCE IN THE AGE OF MODERNISM

..

MICHAEL H. WHITWORTH

FOR a long time, modernism and science appeared to be the antitheses of each other. For as long as modernism was theorized as a reaction against modernity, if modernity was understood as dependent on scientific rationality, then modernism appeared incompatible with science, and its investment in the irrational and the mythological appeared to be an attempt to escape from the scientific world-view. So it seemed to New Criticism.[1] Similarly, if one follows Theodor Adorno's lead, and takes modernity to be characterized by instrumental reason, then it is possible to see science as the embodiment of such reason, and as the antithesis of modernist art's approach to the world. However, it is also possible to see science, as an open-minded inquiry into the physical world, as a discipline that maintained the ideals of Enlightenment, and that resisted their assimilation into instrumentalism; it is possible to find in individual sciences a willingness to explore new logics and epistemologies that resisted the reversion of Enlightenment to mythology. As an institution, science was an unavoidable social fact, and it offered a way of approaching the world that appeared to render literature and the humanities redundant. But it was not monolithic, and it also offered much to stimulate modernist writers and thinkers.

T. S. Eliot's championing of the seventeenth-century metaphysical poets encouraged not only the idea that science might find a place in literature, but that a literature that ignored the full breadth of modern thought could not be truly modern. In 1923, writing in the shadow of Eliot's 'The Metaphysical Poets', Herbert Read surveyed the characteristics of his age, in order to ask what scope there was for a continuation of the

[1] René Wellek, 'The New Criticism: Pro and Contra', *Critical Inquiry*, 4 (1978), 618–19.

tradition of metaphysical poetry. He expressed concern about the decline of religion and even of 'crowd-emotions' like patriotism, which had in the past been 'powerful sources of poetic inspiration'. But the poet, he believed, stood aloof:

And however pitiful our social life may be, yet there does exist an intelligent minority of considerable vigour and positive achievement: I refer particularly to the modern physicists, whose work would seem ready to provide a whole system of thought and imagery ready for fertilization in the mind of the poet. For, if the assumptions of this essay are accepted, it will be seen that science and poetry have but one ideal, which is the satisfaction of the reason.[2]

There are many cross-currents in this passage: the legacy of Romanticism is confronted by neo-scholastic intellectualism; the responsibility of the individual poet for the future of poetry is set against a larger social context. Although Read directs attention explicitly to the work of the physicists, the metaphor of fertilization suggests that biology was also on his mind: if what Read advocates is a kind of cross-pollination in order to strengthen the species 'literature', then eugenics underlies the idea. Most interesting of all is the tension implicit in Read's rhetoric: though he asserts the unity of poetry and science, the necessity of drawing attention to the work of the physicists, and the suggestion that their work might only *seem* ready for fertilization, both imply that the institutional context made their union anything but natural or inevitable.

Read goes on to claim that although science has established many 'phenomena', they lack 'harmonic unity' and that, alongside mathematical philosophy, metaphysical poetry might, 'without presumption', work to establish such a unity.[3] The denial of presumptuousness signifies a repressed anxiety: it surely was presumptuous for poetry to propose itself as a master discourse that could unify the findings of modern science, even if such a project had a precedent in Matthew Arnold's vision of culture. Yet such presumptuousness is a characteristic of modernism at its most ambitious: like an avant-garde artist, Read seeks to engage poetry with social practice, and thereby to release poetry from its institutionalized context.[4] While such a project may have achieved no notable results, the extent of its ambition suggests that modernism's relations to science were far more complex and contradictory than the reactionary stance envisioned by the New Criticism.

INSTITUTIONS OF SCIENCE AND LITERATURE

The relations of literature and science may be examined at the level of the individual text and the scientific ideas that inform it; there is undoubtedly research still to be

[2] Herbert Read, *Reason and Romanticism* (London: Faber and Gywer, 1926), 57–8.
[3] Ibid.
[4] This theorization of the avant-garde is most strongly associated with Peter Bürger's *Theory of the Avant-Garde*, trans. Michael Shaw (Minneapolis: University of Minnesota Press, 1984).

done tracing the 'fugitive appropriation'[5] of scientific ideas by individual writers. However, the relations of the two disciplines consist of more than the aggregation of individual instances. As Read's essay implied, all such appropriations occur in a larger institutional context. That context helps to explain what was at stake in the interactions of literature and science, how literary writers might have encountered scientific ideas, and why the relations of literature and science were received as they were.

A chronology of scientific discoveries in the period tells only half the story. Such a chronology would include Wilhelm Röntgen's discovery of the X-ray in 1895, Max Planck's paper on quanta in 1900, Albert Einstein's paper on special relativity in 1905, Ernest Rutherford's discovery (or invention) of the orbital model of the atom in 1910, Niels Bohr's 'solar' atom in 1913, Einstein's paper on general relativity theory in 1916, A. S. Eddington's experimental test of general relativity in 1919, and the rapid developments in quantum mechanics from 1925 onwards. The reduction of events to a bare chronological list fails to differentiate the very different forms in which they made, or failed to make, a public impact. Röntgen's discovery was widely publicized in popular media, and, as the technology of the Crookes tube was relatively cheap and simple, it was soon being demonstrated to the general public. Einstein's 1905 and 1916 papers were little noticed outside the scientific community, but the announcement on 6 November 1919 of Eddington's experimental proof was the occasion for a wide range of non-specialist accounts. Like Röntgen's discovery, relativity was sensational, but unlike the X-ray, it could not be demonstrated visually; many felt that it resisted explanation in simple terms. Many developments in modern science therefore posed problems of representation.

A chronology cannot so readily accommodate sciences which survived from earlier periods, sciences which developed gradually, and philosophies of science. We may note, for example, the continuing influence of mid-nineteenth-century sciences such as thermodynamics and evolution. Evolutionary biology was stimulated by the rediscovery around 1900 of the work of Gregor Mendel. The *OED* dates the noun 'Mendelian' to 1903; by 1910 there had been many pro- and anti-Mendelian articles in non-specialist journals, but there was no sensational announcement. A chronology rarely finds space for sciences that were later seen as wrong, misleading, or unproductive. For example, theories of the ether were of some significance in physics in the late nineteenth century; they gradually faded from view on account of the failure of Michelson and Morley's experimental efforts to detect the ether, and because the hypothesized substance was being invoked in mutually contradictory explanations of a wide range of phenomena. Nevertheless, accounts of ether theory persisted: as late as 1925, Oliver Lodge was broadcasting about it on the BBC.

A chronology of science also has difficulty accommodating philosophies of science, yet, given the centrality to modernism of questions of perception and knowledge, epistemology was the point at which science became most immediately

[5] Gillian Beer, 'Science and Literature', in R. C. Olby, G. N. Cantor, J. R. R. Christie, and M. J. S. Hodge (eds), *Companion to the History of Modern Science* (London: Routledge, 1990), 797.

relevant to art and literature, and the most immediately intelligible. The late nineteenth century saw an increasing willingness among scientists to accept that scientific theories were inventions rather than discoveries. Such a position could lead to a radical empiricism, in which conceptions such as 'force' were rejected for being unwarranted hypotheses, and in which Euclidean geometry became a convenient system of geometry rather than a true one;[6] but it could also lead to a form of subjective idealism, in which the scientist claimed to know nothing of reality as such, but only the pointer readings that indicated its measurable properties. Scientists' motivations for subscribing to such a position varied: for some it was a genuine philosophical commitment; for others, in a period when paradigms were rapidly shifting, it created a space within which scientists could agree to differ; for others still, it allowed an accommodation with humanists. In so far as the history of epistemological debates can be presented in a chronology, it is by reference to key works: Ernst Mach's insistence that science be the 'economy of thought', presented in 'Ueber die oekonomische Natur der physikalischen Forschung' (1882), which was translated as part of his *Popular Scientific Lectures* (1898); Karl Pearson's popularization of Mach's ideas in *The Grammar of Science* (1892); Henri Poincaré's *La Science et l'hypothèse* (1902, English translation 1905) and *Science et méthode* (1908, English translation 1914). However, the dissemination of such ideas depended on many other books, articles, reviews, and lectures.

Though Einstein's creation of the special and general theories was almost entirely independent, the vast majority of scientific work had an institutional base in the most material sense, in that it required physical infrastructure. Even an independent scientist like the young Einstein drew on that infrastructure: his education depended upon it, as did the publication of his papers in a learned journal. The institutional aspect of modern science, and particularly physics, has important consequences for its social profile. Even if physics had not been the most innovative of the sciences in the early twentieth century, it would warrant attention as the most expensive. Taking 1900 as a pivotal year, J. L. Heilbron has noted that the cost of building a physics institute rose significantly at the *fin de siècle*: in Germany the cost of those built in 1905 to 1914 was almost double that of those built in the 1890s.[7] This was due not only to increased student numbers, but also to the nature of the science being practised. Modern science required a more elaborate infrastructure for the supply of gas and electricity, for example: the increasing importance of precise measurement meant that physicists required more specialized laboratory spaces.[8] Although their requirements seem modest by modern standards, they were nevertheless unprecedentedly expensive. The extent of investment, and the rate of its growth, differed widely. The US was the biggest spender, and moreover in the early twentieth century its

[6] Joan Richards, *Mathematical Visions: The Pursuit of Geometry in Victorian England* (Boston: Academic Press, 1988).

[7] J. L. Heilbron, 'Fin-de-Siècle Physics', in Carl Gustaf Bernhard, Elisabeth Crawford, and Per Sörbom (eds), *Science, Technology and Society in the Time of Alfred Nobel: Nobel Symposium 52* (Oxford: Pergamon, 1982), 62.

[8] Ibid.

expenditure was growing at a rate of 10 per cent per year, compared to 5 per cent in Britain and Germany, and 2 per cent in France.[9]

There were differences in the sources of funding: in the US, the state was less significant than philanthropical foundations such as that established by John D. Rockefeller, Sr; in Europe, funds were controlled by civil servants and by the heads of universities and university colleges, whose educational backgrounds were predominantly humanist.[10] In 1916 only four colleges in Cambridge were presided over by men of scientific training, and in Oxford, none; of the thirty-five 'largest and best known' public schools, thirty-four had 'classical men' as headmasters; the entrance examinations for the Civil Service were biased heavily against those offering scientific subjects.[11] In this regard, modern science in Europe was confronted by the same vested interests that confronted modernist artists. As Perry Anderson has noted, though modernist artists rebelled against the *ancien régime* and the official academicism it endorsed, they shared with it a set of 'codes and resources from which the ravages of the market as an organizing principle of culture and society . . . could also be resisted'.[12] The difference for scientists was that the academicism against which they fought was far removed from their own discipline: modern physical science could learn little from the classics. However, like modernist artists, scientists could find a common cause with the classicists when united against the common enemy of 'the market', particularly in the form of instrumentalist approaches to scientific knowledge.

POPULAR SCIENCE WRITING

Popular science writing forms another significant context for science, and particularly for its relations to literature. The expense of doing modern science no doubt made scientists aware of the importance of justifying their activities to a lay audience, and may have stimulated the growth of non-technical writing, but there must also have been a felt demand from generalist readers; moreover, popular science writing soon developed as a semi-autonomous institution with its own internal generic rules.

Claims that science was part of the modernist intellectual atmosphere lack specificity: knowledge is not dispersed by a medium uniformly distributed through society, but is conveyed differentially by material media. For modernist authors who read the right periodicals, there was a regular supply of expositions of science and discussions

[9] Ibid. 63.

[10] Ibid. 63–4; Stanley Coben, 'The Scientific Establishment and the Transmission of Quantum Mechanics to the United States, 1919–32', *American Historical Review*, 76/2 (Apr. 1971), 446–7.

[11] Memorandum of the Reorganization Committee, repr. in 'Neglect of Science', *The Times*, 2 Feb. 1916, 10. Subsequently, the committee was more commonly known as the Neglect of Science Committee.

[12] Perry Anderson, 'Modernity and Revolution', *New Left Review*, 144 (Mar.–Apr. 1984), 105.

of the place of science in contemporary culture; there were regular reviews of popular science books, and advertisements for them. Such material was not to be found in the 'little magazines', if by that term we mean publications such as the *Little Review* or *Blast*, but it was to be found in some of the monthlies and quarterlies founded in the Victorian period, as well as in political and cultural weeklies such as *The Nation* (London, founded 1907) and the *New Statesman* (founded 1913). Because the most innovative modernist texts to appear in periodical form appeared in the little magazines, the role played by more conventional periodicals has been neglected. They were a significant part of the cultural scene, and modernist writers were among their readers and, in some cases, their contributors.

Desmond MacCarthy's short-lived *New Quarterly* (1907–10) provided outstanding coverage of the sciences; so too did *The Athenaeum* under the editorship of John Middleton Murry from 1919 to 1921. Both drew attention to this aspect of their content in their subtitles, 'A Review of Science and Literature' and 'A Journal of Literature, Science and the Arts' respectively. The first issue of the *New Quarterly* featured Lord Rayleigh on the perception of sound, Bertrand Russell on mathematics, Rayleigh's son R. J. Strutt on the ether, and G. A. Paley on Mendelian biology and eugenics. Science articles were interleaved with literary, and the arrangement gave no indication that one was more important than the other. Later issues included articles by Oliver Lodge, Norman R. Campbell (a notably advanced thinker in the realm of physics and its philosophy), and the Mendelian biologist R. C. Punnett. Murry's *Athenaeum* featured a weekly column on science, as well as frequent book reviews. The majority of the weekly science columns were written by J. W. N. Sullivan, and concentrated on physics and the wider implications of developments in the philosophy of science; Geoffrey Keynes contributed occasional columns on medicine, and Julian Huxley on biology.[13]

While the *New Quarterly* and *The Athenaeum* were exceptional in the number of popular scientific articles that appeared, many other journals differed only in quantity, not in kind. It is true that some weekly political journals rarely if ever included science, and that others, such as *The Spectator*, limited themselves to 'natural history'; but for a significant proportion of the journal-reading public, popular science was an acceptable part of the weekly diet; one might go further, and say that for this group it was considered desirable to remain abreast of recent developments in science, regardless of one's professional identity. In general, science was given a better hearing in the liberal and socialist press than in the conservative; conservative editors and readers often characterized science as atheistic, amoral, and materialistic. In its first decade, the *New Statesman* was notable for its provision of regular science articles, contributed by the natural historian J. Arthur Thomson (1861–1933), the eugenicist C. W. Saleeby (1878–1940, under the pseudonym 'Lens'), and less frequently the chemists Alexander Findlay (1874–1966) and E. N. da C. Andrade (1887–1971); there

[13] The majority of contributions are unsigned or initialled. My identifications have been made using the marked copies held at City University, London.

were also frequent unsigned reviews of non-technical scientific books.[14] In the early twentieth century, the *Times Literary Supplement* regularly reviewed non-technical scientific works.

Journals that did not host a regular science column nevertheless reviewed major works of science writing. Eddington's *Space, Time, and Gravitation* (1920), for example, a relatively expensive (15s.), semi-technical account of Einstein's special and general theories, was reviewed not only in *The Athenaeum*, the *New Statesman*, and the *Times Literary Supplement*, but also in the *London Mercury, The Nation* (London), the *New Age*, and the *Saturday Review*. Major popular works such as Eddington's *The Nature of the Physical World* (1928) and James Jeans's *The Mysterious Universe* (1930) were reviewed in these and in many other weeklies and monthlies. Reviews themselves could be sources of scientific knowledge and scientific rhetoric. When, in 1924, Hugh MacDiarmid quoted in passing from Eddington's *Mathematical Theory of Relativity* (1923), his source was a *Times Literary Supplement* review rather than the book itself. At a later date the *Times Literary Supplement* was MacDiarmid's source for some of the scientific phrases in 'On a Raised Beach'.[15] Though MacDiarmid's plagiaristic strategies were idiosyncratic, his use of periodical sources vividly illuminates the routes by which the latest thinking reached modernist writers.

The possibility that literature might unify the specialized intellectual disciplines is an important one in understanding literature's relation to science in this period, and it was necessarily important to the generalist journals. The difficulty of communicating across disciplinary boundaries had been a prominent theme in the Neglect of Science debate of 1916–17, and remained important in the post-war era. In the interests of mollifying disciplinary disputes, some argued that no single discipline had a monopoly on truth; if this were true, however, the universe had become unknowable, or knowable only in fragments. Many expressed nostalgia for a presumed prelapsarian state of knowledge, and a hope that the shortcomings of one's own limited professional or disciplinary perspective might be ameliorated if not overcome. Such nostalgia was, at the very least, a useful marketing tool for a generalist journal: *The Athenaeum* under Murry promised 'a comprehensive survey of Ideas' which would be 'indispensable for all who desire to keep themselves abreast of the intellectual activities of the Age'; it identified its ideal reader as a 'layman' without specialized training.[16] Murry may genuinely have believed that *The Athenaeum* could redress the damage caused by the fragmentation of knowledge. In this

[14] For the identification of 'Lens', see G. R. Searle's *Oxford Dictionary of National Biography* entry on Saleeby.

[15] MacDiarmid was on this occasion writing under his own name, C. M. Grieve: 'Contemporary Criticism I', *New Age*, 35 (5 June 1924), 65–7, and 'Contemporary Criticism, II', *New Age*, 35 (12 June 1924), 78–9; anon., 'The Mathematics of Relativity', *Times Literary Supplement*, 28 June 1923, 434; MacDiarmid quotes the text of the review as well as Eddington's book. For MacDiarmid's use of the *Times Literary Supplement* in his poetry, see Michael H. Whitworth, 'Three Prose Sources for Hugh MacDiarmid's "On a Raised Beach"', *Notes and Queries*, 54 (2007), 175–7.

[16] Advertisement, *Times Literary Supplement*, 3 Apr. 1919, 185; advertisement, *Times Educational Supplement*, 27 Nov. 1919, 595.

regard his journal continued an Arnoldian project of culture, as a process that will enable one 'to see life whole', but on a greatly expanded basis: the fractures in modernity are not only those between Hebraism and Hellenism, but between all specialized forms of knowledge. It is notable that J. W. N. Sullivan, writing the 'Marginalia' column in *The Athenaeum* in 1920, quoted an Arnoldian phrase about 'seeing life steadily and seeing it whole' as coming from the mouth of a young literary friend. The young man had been 'deploring the "short-windedness" of modern poets; he thought the time had come to essay "comprehension"'.[17] The idea that a truly comprehensive poetry might, like a generalist journal, redress the fragmentation of knowledge was a common one in the period.

The version of science which the weeklies produced was different from that found in daily newspapers and other popular periodicals. Though generally the difference was implicit, explicit references to it occasionally emerge. Bertrand Russell's essay 'Science as an Element in Culture' (1913), first published in the *New Statesman*, began by distinguishing science as it was presented to 'the ordinary reader of newspapers' from the aspect of science which he wished to emphasize as important. The newspapers represented science as consisting of 'a varying selection of sensational triumphs, such as wireless telegraphy and aeroplanes, radio-activity and the marvels of modern alchemy'.[18] In the newspapers, science was prized for what we might now term its instrumental qualities—'command over nature'—whereas Russell wished to emphasize 'the intrinsic value of a scientific habit of mind'.[19] For Russell, and by implication the *New Statesman*'s readers, theoretical science was of more importance than 'mechanical details' and practical inventions: Faraday, Maxwell, and Hertz were of more importance than the technicians who had a practical and working system of telegraphy. The details of applied science lacked 'that broad sweep and that universality which could give them intrinsic interest as an object of disinterested contemplation'.[20] Implicit in Russell's vocabulary is an analogy between science and art: disinterested aesthetic contemplation was a crucial element in Bloomsbury aesthetics.[21]

Russell was not alone in this approach. In 1920 J. W. N. Sullivan argued that in the nineteenth century the exact sciences, lacking the controversial element of biology and geology, had presented themselves in terms of 'marvels': 'the unsophisticated public were stunned by figures: the distances of the stars, the number of molecules in a cubic centimetre of water, the weight, in tons, of the earth, the incredible minuteness of light-waves, and so on'.[22] Sullivan favoured an emphasis on the disciplined creativity of the scientific theorist. He defined his approach as being perhaps

[17] [J. W. N. Sullivan], 'Marginalia', *The Athenaeum* (21 May 1920), 672. David Bradshaw has argued persuasively that the young literary friend was Aldous Huxley: 'The Best of Companions: J. W. N. Sullivan, Aldous Huxley, and the New Physics', pt I, *Review of English Studies*, 47 (1996), 195 n. 30.

[18] Bertrand Russell, 'Science as an Element in Culture', *New Statesman*, 1 (24 May 1913), 202.

[19] Ibid.

[20] Ibid.

[21] Roger Fry, 'An Essay in Aesthetics', *New Quarterly*, 2 (1909), 171–90.

[22] J. W. N. Sullivan, 'Popular Science', *The Athenaeum* (1 Oct. 1920), 444–5.

'aesthetic', but he preferred the term 'humanistic', because it approached scientific ideas 'as part of the general intellectual and emotional life of man'.[23] The tendency to distinguish pure and applied science, or to distinguish between the intellectually appealing and the instrumentally effective aspects of science, was common in the weeklies, and particularly prominent during the First World War.[24]

To emphasize periodicals is not to neglect books as sources of scientific knowledge for modernist writers; rather, the periodicals enable us to characterize the readership and reception of books more accurately. Knowing that non-technical science books were published is nothing unless we know whether they reached literary readers and writers. Given that we lack detailed evidence about the reading habits of many modernist writers, and that there is at best fragmentary evidence for the content of their conversations, the periodicals provide the best approximation to the cultural contexts of modernism. It is not enough to know that (for example) Eddington's *Nature of the Physical World* was a surprising success, selling just over ten thousand copies in its first thirteen months in print:[25] those sales could have been achieved without its making the slightest impression on the cultural outlook of modernist writers. There were indeed many popular science publications which were rarely mentioned in the highbrow press.[26] Conversely, while it is useful and interesting to know, for example, that Lawrence read Einstein's *Relativity* (1920), that Forster read Eddington's *Nature of the Physical World*, and that Woolf read Jeans's *The Mysterious Universe*, such reading might be idiosyncratic.[27] Evidence that such texts were reviewed, advertised, and discussed demonstrates that they were part of the culture, or, at least, part of a subculture.

In the era of modernism, science and modern literature stood in delicately ambivalent relations to each other. Though science appeared more closely aligned with the instrumentality of modernity than did literature, in the academy science required the cooperation of humanists. Such a context encouraged scientists and writers sympathetic to science to value its imaginative and creative aspects and depreciate its practical applications. While such an approach had the potential to exacerbate the tensions between the disciplines, because it allowed science to annex territory previously reserved for the arts, it also opened up the possibility of literary

[23] J. W. N. Sullivan, *Aspects of Science* (London: Cobden-Sanderson, 1923), 5.

[24] The importance of pure science was one of Alexander Findlay's recurrent themes in the *New Statesman*—see e.g. 'The Claims of Pure Science', *New Statesman*, 7 (5 Aug. 1916), 419–20—though he was also author of *Chemistry in the Service of Man* (1916).

[25] Michael H. Whitworth, 'The Clothbound Universe: Popular Physics Books, 1919–1939', *Publishing History*, 40 (1996), 53–82.

[26] Peter Bowler, 'Presidential Address: Experts and Publishers', *British Journal for the History of Science (BJHS)*, 39/2 (June 2006), 159–87.

[27] D. H. Lawrence, letter to S. S. Koteliansky, 16 June 1921, in *The Letters of D. H. Lawrence*, ed. James T. Boulton, 8 vols (Cambridge: Cambridge University Press, 1979–2000), 4, 37; E. M. Forster, entry for 5 Jan. 1929, *Commonplace Book*, ed. Philip Gardner (London: Scholar Press, 1985), 45–7; Virginia Woolf, diary entries for 18 Dec. 1930, 11 Aug. 1937, in *Diary of Virginia Woolf*, ed. Anne Olivier Bell and Andrew McNeillie, 5 vols (London: Hogarth Press, 1979–85), iii. 337 and v. 107.

writers understanding their work in terms derived from science, and borrowing, in Read's terms, from its stock of thought and imagery.

THE CRITICAL DISCOURSE ON LITERATURE AND SCIENCE

The scholarly study of the relations of literature and science began towards the end of the recognized modernist period (if we take modernism as ending in the 1930s) but informal discussions are to be found throughout. The earliest scholarly study, Carl Grabo's *A Newton Among Poets* (1930), includes among its ancestors A. N. Whitehead's *Science and the Modern World* (1926), a book which attempted to place the world-view of the new physics in a longer historical and cultural context. The beginnings of the informal discussions may be traced back at least as far as *The Grammar of Science*, in which Pearson had insisted on the importance of imagination in scientific theorization. The theme was further stimulated from 1916 onwards by the Neglect of Science debate, by J. B. S. Haldane's *Daedalus* (1924), and by I. A. Richards's *Science and Poetry* (1926). However, while posterity has made these books the major landmarks, the terrain is populated by many other journal articles and lesser-known books.

Wordsworth's equivocal remarks in the Preface to the *Lyrical Ballads* set the terms for the debate.[28] Some writers felt that the 'remote discoveries' of science were no closer to being the 'proper objects of the Poet's art' than they had been in 1802; if anything, increasing specialization made them more inaccessible than ever. Others felt that because scientific theorization was understood to be an imaginative process, and because physical science was further removed than ever from practical concerns, dealing as it did with scales far greater or smaller than those of the human body, the day when science might be made available to poetry was moving ever closer. Wordsworth had remarked that when science was 'familiarized' to men, the poet would 'lend his divine spirit' to assist its transfiguration into 'a form of flesh and blood'.[29] To those in favour of a reconciliation between science and literature, it seemed as if all that was required was a small push from a suitable poet.

[28] William Wordsworth, 'Preface' (1802), in *William Wordsworth*, ed. Stephen Gill, Oxford Authors (Oxford: Oxford University Press, 1984), 607. Explicit references to the Preface appear in Aldous Huxley, 'Subject-Matter of Poetry', in *On the Margin* (London: Chatto & Windus, 1923), 26–38; Edwin Muir, 'The Present State of Poetry', *Calendar of Modern Letters*, 2/11 (Jan. 1926), 322–31; John L. Beevers, 'Some Modern Verse', *New English Weekly*, 2 (19 Jan. 1933), 322–4; Hugh MacDiarmid, 'Science and Culture' (27 Apr. 1933), in *The Raucle Tongue*, ed. Angus Calder, Glen Murray, and Alan Riach, 3 vols (Manchester: Carcanet, 1997), ii. 480–3.
[29] Wordsworth, 'Preface', 607.

A typical and early case is Aldous Huxley's 1919 review 'Poetry and Science'. Huxley dismissed the example of eighteenth-century didactic poets like Erasmus Darwin. Their imaginations had not digested or assimilated the scientific ideas; for science to become poetry, the author 'must be passioné by his subject'.[30] Huxley could imagine that someone might be 'so much haunted by the notion of geological time, so over-whelmed, like Pascal, at the thought of his own littleness compared with the infinities and eternities of his contemplation, that he would be able to make great poetry of the fact that the world has existed a good many million years'.[31] T. S. Eliot's later assertion that 'A thought to Donne was an experience,' and his criticism of Tennyson and Browning for being poets and thinkers who, nevertheless, did not 'feel their thought', are cut from the same cloth; so too is Murry's assertion that scientific theory 'has to be translated into emotional terms' for it to affect literature; likewise Michael Roberts's insistence that the subject matter of metaphysical poetry is 'not metaphysics but the intellectual emotion produced by metaphysics'.[32] Critics very often emphasized the poet's ability to feel thought, neglecting formal considerations of the correlates of such feeling. However, Edgell Rickword's criticism of Alfred Noyes's *The Torch-Bearers* made the poem the focus: had science 'really meant anything' to Noyes, claimed Rickword, 'it would have altered his universe; would have created metaphors'.[33] Contemporary critics not only gave cautious encouragement to writers engaging with science, but they laid down criteria as to how it might best be done. In this the use of science as a source of models and metaphors was particularly important.

SCIENTIFIC MODELS

The prestige of science encouraged writers to seek scientific models for their vocation, their creative processes, and their literary forms. Ezra Pound's use of the scientist as a model for the poet has been particularly well documented.[34] The rhetoric of science allowed modernists to distance themselves from the poetics of inspiration: both scientist and modernist had to make new discoveries, and neither could do so without undergoing an apprenticeship. For Pound, the scientist 'begins

[30] A.L.H. [Aldous Huxley], 'Poetry and Science', *The Athenaeum* (22 Aug. 1919), 783.
[31] Ibid.
[32] T. S. Eliot, 'The Metaphysical Poets', in *Selected Prose*, ed. Frank Kermode (London: Faber, 1975), 64; J. M. Murry, 'Literature and Science', *The Times*, 26 May 1922, 16; Michael Roberts, 'Beyond the Golden Bars', *Poetry Review*, 20/2 (Mar.–Apr. 1929), 111.
[33] E.R. [Edgell Rickword], Review of Laurence Binyon, *The Sirens*, and Alfred Noyes, *The Torch-Bearers*, *Calendar of Modern Letters*, 2/7 (Sept. 1925), 65–8.
[34] Ian F. A. Bell, *Critic as Scientist: The Modernist Poetics of Ezra Pound* (London: Methuen, 1981); Martin Kayman, *The Modernism of Ezra Pound* (London: Macmillan, 1986).

by learning what has been discovered already'.[35] T. S. Eliot expressed his idea of tradition in similar terms: 'A poet, like a scientist, is contributing toward the organic development of culture: it is just as absurd for him not to know the work of his predecessors or of men writing in other languages as it would be for a biologist to be ignorant of Mendel or De Vries.'[36]

Eliot's developing ideas of impersonality and tradition were shaped further by the debate about scientific innovation and tradition that followed Einstein's deposition of Newtonian theory in 1919.[37] A scientific theory does not express its author's emotions or personality; nevertheless, there were some who argued that a scientific theory might possess individuality. As Eliot said, the great scientist surrenders himself to his work, submerges himself in it, and yet there is 'a cachet of the man' all over the work: 'No one else could have drawn those inferences, constructed those demonstrations, seen those relations. His personality has not been lost, but has gone, all the important part of it, into the work.'[38] J. W. N. Sullivan had written in similar terms about Lord Rayleigh in *The Athenaeum*, and had developed his ideas in more general terms in a later article.[39] Such accounts downplay the element of teamwork in science, but they also downplay the ideas of inspiration and expression that often accompany the idea of the solitary genius. The scientist, like the poet, collaborates with the tradition, not with his contemporaries.

The rhetoric of efficiency and energy was not identified solely with the physical sciences. The early years of the twentieth century had been the era of 'national efficiency' and of industrial efficiency. To Rebecca West it appeared that the Imagists wished to reorganize poetry much as F. W. Taylor had reorganized business. Nevertheless, the terms in which she expressed this idea take us back to physics: 'the imagistes want to discover the most puissant way of whirling the scattered star dust of words into a new star of passion'.[40] Moreover, the language of power and efficiency could also be found within the philosophy of science. Ernst Mach's idea that science was the 'economy of thought' was invoked explicitly by Herbert Read in his account of metaphysical poetry: 'economy of thought' bred an intensity of thought which led to its 'emotional apprehension'.[41]

Modernists who did not explicitly define their vocation in terms of science, and who appeared hostile to the instrumental aspects of science, nevertheless recruited

[35] Ezra Pound, 'A Few Don'ts for Imagists', in *Literary Essays of Ezra Pound*, ed. T. S. Eliot (London: Faber and Faber, 1954), 6.

[36] T. S. Eliot, 'Contemporanea', *The Egoist*, 5/6 (June–July 1918), 84. Eliot also compared the critic to the scientist in 'Studies in Contemporary Criticism', *The Egoist*, 5/9 (Oct. 1918), 113–14.

[37] Michael H. Whitworth, '*Pièces d'identité*: T. S. Eliot, J. W. N. Sullivan and Poetic Impersonality', *English Literature in Transition*, 39 (1996), 149–70, and *Einstein's Wake: Relativity, Metaphor, and Modernist Literature* (Oxford: Oxford University Press, 2001), 135–45.

[38] T. S. Eliot, 'Modern Tendencies in Poetry', *Shama'a*, 1/1 (Apr. 1920), 10–11; first delivered as a lecture, 28 Oct. 1919.

[39] J. W. N. Sullivan, 'A Stylist in Science', *The Athenaeum* (11 July 1919), 593, and 'Science and Personality', *The Athenaeum* (18 July 1919), 624.

[40] Rebecca West, 'Imagisme', *New Freewoman* (15 Aug. 1913), 86–7.

[41] Read, *Reason and Romanticism*, 55.

scientific terms to describe both their own formal experiments in literature and those of others. Such metaphors are often tentative and fragmentary, sometimes amounting to no more than the importation of one suggestive term into literary discourse. For example, in her account of the Hades episode of *Ulysses*, Virginia Woolf refers to 'its restless scintillations', 'its irrelevance', and 'its flashes of deep significance succeeded by incoherent inanities'.[42] 'Scintillations' need not be scientific, but when it is found in close proximity to 'flashes', the scientific sense of the term is strongly suggested. The scientific sense was not the exclusive preserve of high-energy physicists: Strutt had used it in a review of a non-technical science book, in a periodical to which Woolf contributed.[43] Recruiting such a term in an assault on novelists she had termed 'materialists', Woolf implies that Joyce's practice and her own might be aligned with the physicists who had revealed the porosity, if not the immateriality, of matter.

A similarly fragmentary example of scientific metaphor comes in T. S. Eliot's 1919 essay 'Ben Jonson'. Eliot attempts to redeem the valuation of Jonson's art as an art 'of the surface' by suggesting that such as thing might be as valuable as a deep art: 'We cannot call a man's work superficial when it is the creation of a world; a man cannot be accused of dealing superficially with the world which he himself has created; the *superficies is* the world.'[44] The talk of dimensions and depth leads almost inevitably to a consideration of Jonson as a geometer: 'It is a world like Lobatchevsky's; the worlds created by artists like Jonson are like systems of non-Euclidean geometry. They are not fancy, because they have a logic of their own; and this logic illuminates the actual world, because it gives us a new point of view from which to inspect it.'[45]

Unlike Woolf's 'scintillation', Eliot's crucial terms are unambiguously scientific, and they were even more topical, given the importance of non-Euclidean geometry to Einstein's general theory.[46] If we take Eliot's account of Ben Jonson's plays to apply to modernist writing too, it suggests that its inhuman qualities and its distortions of familiar perspectives are the products of rational calculation, not the writer's psychopathology. Eliot was not alone in finding geometry suggestive: theorists of Cubist painting found Helmholtz's and Poincaré's writings on geometry immensely so.[47]

[42] Virginia Woolf, 'Modern Novels' (1919), in *Essays of Virginia Woolf*, ed. Andrew McNeillie, 6 vols (London: Hogarth Press, 1986–94), iii. 34. I have discussed this passage in Whitworth, *Virginia Woolf* (Oxford: Oxford University Press, 2005), 179–80.

[43] R. J. Strutt, 'A Popular Book on Radioactivity', *The Speaker*, 13/320 (18 Nov. 1905), 162–3.

[44] T. S. Eliot, 'Ben Jonson', in *The Sacred Wood: Essays on Poetry and Criticism* (London: Methuen, 1920), 115, 116.

[45] Ibid. 116–17.

[46] Einstein's description of the curvature of space-time used Riemann's geometry, however, not Lobatchevsky's.

[47] Linda Dalrymple Henderson, *The Fourth Dimension and Non-Euclidean Geometry in Modern Art* (Princeton: Princeton University Press, 1983), 11–17, 37–41.

SCIENCE AS LANGUAGE

..

The difficulty involved in discussions of literary form and its relation to science lies in the incommensurability of the evidence available on both sides. Scientific ideas can be summarized verbally, and though a mathematical physicist might argue that such summaries leave us at one remove from the science itself, reference to contemporaneous popular science writing at least situates the discussion in relation to science as it was verbally represented at the time. However, given that modernist 'form' is a matter of more than metre and rhyme scheme, it too remains inaccessible. Metaphors of scintillation or non-Euclidean geometry, however suggestive, do not always reach to the core of what happens when one phrase is juxtaposed to another, or to the experience of reading such works.

If we consider the employment of scientific terminology in literary texts, other problems of definition become prominent. When, in the Ithaca episode of *Ulysses*, Joyce uses terms like 'paraheliotropic', 'imbalsamation', or 'fluxion', the scientific flavour is unmistakable. However, as Andrew Gibson remarks, Joyce's engagement with such a vocabulary is often a matter of travesty and burlesque. In some cases, references to a dictionary will reveal the archaic nature of the term (as with 'imbalsamation'); in others, more extensive research is needed to determine its currency.[48] Moreover, it is possible to convey a scientific idea with a language that is not distinctively technical. For example, Hugh MacDiarmid in 'Empty Vessel' speaks in synthetic Scots of 'The licht that bends owre a' thing', with a suggestion of light bending in a curved space-time.[49] The same idea occurs in Charles Madge's 'Poem by Stages': 'A little light in a great space | Curving upon itself, like a lover's dream'.[50] Madge's poem is baffling to a reader who does not recognize that space-time might be spoken of as curved. In such cases the scientific idea is prominent and is important to the poem, but a distinctively scientific vocabulary is not.

With the passage of time, it is possible to lose sight of how unfamiliar a term might have been. Eliot's phrase 'strange synthetic perfumes' in *The Waste Land* clearly implies the artificiality of the woman at the start of 'A Game of Chess', but without reading Empson's 1929 account of the poem, a modern reader might not realize that in the early twentieth century the word 'synthetic' appeared a 'scientific word' that stood out as a 'dramatic and lyrical high light'.[51] While 'etherized' at the opening of 'The Love Song of J. Alfred Prufrock' is more clearly scientific, it is nevertheless

[48] Andrew Gibson, *Joyce's Revenge: History, Politics, and Aesthetics in Ulysses* (Oxford: Oxford University Press, 2002), 243.

[49] Hugh MacDiarmid, 'Empty Vessel', in *Complete Poems*, ed. Michael Grieve and W. R. Aitken, 2 vols (Manchester: Carcanet, 1993), i. 66. I am grateful to Louisa Gairn for drawing this poem to my attention in her paper 'Planetary Consciousness: Hugh MacDiarmid, Patrick Geddes and the Poetics of Ecology', Conference of the British Society for Literature and Science, 2006.

[50] Charles Madge, 'Poem by Stages', in *Of Love, Time and Places* (London: Anvil, 1994), 160.

[51] William Empson, 'Some Notes on Mr Eliot', *Experiment*, 4 (Nov. 1929), 6. The discussion was incorporated into Empson's *Seven Types of Ambiguity* (1930).

surprising to find C. Day-Lewis referring to it in 1947 as 'that harshly modern word'.[52] Nor, of course, should Empson and Day-Lewis be taken as final authorities on the matter: Empson in 1929 had his own reasons for alerting the reader to the possibilities of scientific language. Some critics were more hostile than Day-Lewis, others more welcoming. If the nineteenth century had seen any consensus about poetic diction, it was fragmented in the first decade of the twentieth, and the status of scientific terminology was at the heart of the disagreement.

Objections to the incorporation of scientific language into poetry were often justified in the name of the organic unity of the poem. The converse argument, that poetry should engage with all aspects of the modern world, including science and its language, was sometimes made in the name of the renewal of the social standing of poetry, and sometimes in the name of the revitalization of poetry through an expansion of its verbal resources; the two arguments were not mutually exclusive. Theodora Bosanquet maintained that the 'strange hybrid vocabulary' of psychologists, for example, 'would have much the same effect on the texture of a poem as the addition of a serviceable patch of mackintosh on the texture of a butterfly's wings'.[53] Hugh MacDiarmid, quoting this passage, rejected Bosanquet's adherence to outmoded ideas of poetic diction: there was no virtue in 'restricting our linguistic medium to a miserable fraction of our expressive resources'.[54] His own 'synthetic English' poems in *Stony Limits and Other Poems* (1934) bear out the idea, but it is notable that his defence does not directly engage with Bosanquet's concerns about, in effect, organic unity.

A similar metaphor occurs in a dialogue between L. A. G. Strong and C. Day-Lewis published in 1941. Day-Lewis suggests that a poet cannot use 'new data' for 'metaphor or simile until they have become familiar to ordinary people'. Strong offers a variant on the same position, with echoes of Wordsworth: the new material must be 'assimilated' by the poet's imagination:

I have felt, in reading certain poems of the last ten years, that many of the abstract terms used by the poets have no overtones. It is as if a painter suddenly stuck on his canvas a piece of actual material, cabbage leaf, corduroy, whatever it might be, instead of painting it. The patch, the abstract word snatched from contemporary life, has not been assimilated.[55]

The metaphor is intriguing, not least because it exists in seeming ignorance of the practice of collage by modernist artists, most notably Picasso. The modernist extension of materials had not extended to vegetable leaves, but both in poetry and art it had embraced techniques of collage. In such works, the concept of 'organic unity' is brought into question: the unity of the work exists in tension with the independent lives of its component parts.

[52] C. Day-Lewis, *The Poetic Image* (London: Cape, 1947), 93.

[53] Theodora Bosanquet, *Paul Valéry*, quoted in MacDiarmid, *The Raucle Tongue*, ii. 483–4.

[54] MacDiarmid, *The Raucle Tongue*, ii. 484.

[55] C. Day-Lewis and L. A. G. Strong, 'Introduction', in *A New Anthology of Modern Verse, 1920–1940* (London: Methuen, 1941), pp. xvii–xviii.

Peter Middleton has deployed the metaphor of collage with a more positive valuation, writing of a later generation of poets: reading a postmodern or late modernist poem, one encounters 'a torn strip of language peeling at one edge stuck on the surface of the poem like imitation wood paper in a Cubist painting. Seen from one inner perspective it merges with the aesthetic medium; from another it breaks out at right angles to the plane of the art.'[56] It seems possible that for some readers at least, scientific terms incorporated into poetry yielded similar pleasures, rather than the dissatisfaction registered by Bosanquet and Strong. However, there are distinct formal differences between the poems described by Middleton and those of the modernist era: Middleton can legitimately speak of 'strips' of language, whole phrases torn from technical contexts, in the works of Charles Olson, J. H. Prynne, and Ron Silliman, but when we turn to poems by John Rodker, Michael Roberts, and others, scientific terms typically appear as isolated words, even if they constellate with other words from the same lexicon elsewhere in the poem. MacDiarmid's practice in, for example, 'On a Raised Beach' is relatively unusual, and led to his being accused of plagiarism.[57]

From a present-day perspective, the modernist practice may appear tentative. Answers to the question of why modernists borrow words rather than phrases must be speculative. However, it may be that to incorporate whole scientific phrases appeared to grant too much power to science; to borrow individual words was to subordinate them to the poet's voice or presence. Another, non-exclusive explanation is that the majority of poets were interested primarily in scientific ideas, not in the distinctively linguistic qualities of scientific discourse. To say this is not to controvert the widely accepted view that modernist poets drew attention to the verbal texture of their works; rather, it is to suggest that the incorporation of scientific language was rarely employed specifically as means to this end; it primarily served other purposes.

Modernist writers had many motivations for drawing upon scientific material. In an era when science appeared to be the dominant form of knowledge, to expose its limitations, or to note its inability to speak of matters of permanent human interest, was undoubtedly a motivating factor: Joyce's use of science in 'Ithaca' appears primarily oriented towards this humanist end. But for other writers, science's incommensurability with the conventionally 'human' suggested its potential as a resource for articulating new notions of being. Sciences which spoke of non-human scales, temporalities, and dimensions offered means by which the miraculous and transcendent could be brought back into literature without recourse to an outworn Romantic vocabulary; but more than this, they offered ways of articulating the strangeness of modernity in a language free of unwanted associations.

[56] Peter Middleton, 'From *Abaxial* to *Zeolite*: Poetry and Scientific Discourse' (Mar. 2003), <http://www.soton.ac.uk/english/docs/PMabaxial.doc>. The essay is a paper presented by Middleton at the SubVoicive Conference, Mar. 2003. See also Middleton, 'Can Poetry Be Scientific?', in Philip Coleman (ed.), *On Literature and Science: Essays, Reflections, Provocations* (Dublin: Four Courts, 2007), 196.
[57] For the accusations, see Hugh Gordon Porteus, letter, *Times Literary Supplement*, 4 Feb. 1965, 87.

CHAPTER 26

..

VIOLENCE, ART, AND WAR

..

MARINA MACKAY

Now and again some glass tinkled in the cupboard as if a giant voice had shrieked so loud in its agony that tumblers stood inside a cupboard vibrated too. Then again silence fell; and then, night after night, and sometimes in plain mid-day when the roses were bright and light turned on the wall its shape clearly there seemed to drop into this silence, this indifference, this integrity, the thud of something falling.

[A shell exploded. Twenty or thirty young men were blown up in France, among them Andrew Ramsay, whose death, mercifully, was instantaneous.]

(Virginia Woolf, *To the Lighthouse*)

THE sudden death of the scholar-turned-soldier Andrew Ramsay in the First World War is the third shock and occasion for mourning in the middle section of Woolf's *To the Lighthouse* (1927). As their remote Hebridean holiday house skirts its obliteration after the Ramsays' departure, Mrs Ramsay ('having died rather suddenly the night before'), then her beautiful daughter Prue ('a tragedy, people said, everything had promised so well'), and finally her scholarly son Andrew ('blown up in France') are killed off in glibly conversational parentheses.[1] The 'Angel in the House' whose killing Woolf advocated is dead. So too are her natural heirs, those models of masculine and feminine virtue that the Ramsays' eldest son and daughter represent: 'Andrew would be a better man than he had been,' Mr Ramsay thinks, consoling

[1] Virginia Woolf, *To the Lighthouse* (Oxford: Oxford University Press, 1992), 175, 180, 181.

himself for his own academic failures; 'Prue would be a beauty, her mother said.'[2] In the summary killings of Prue in childbirth and Andrew in war, the children reap what their parents have sown.

RITES OF SPRING, SITES OF MOURNING: MODERNIST STUDIES AND THE FIRST WORLD WAR

To propose that the 'mercifully . . . instantaneous' deaths in combat of this exemplary modernist novel are both symbolic executions and causes for grief is to suggest that modernism's relationship with the First World War is an ambivalent one, both triumphant and elegiac. When Wyndham Lewis opened his memoir of the period from 1914 (when the First World War broke out) to 1926 (the year of the General Strike) by promising his readers that they would be 'astonished' to discover the similarity between war and modernism, he was pointing to the ways in which they both outraged the cultural norms of what modernist writers present as the fool's paradise of pre-war culture—'a long-established blank of genteel fatuity', Lewis calls it in *Blasting and Bombardiering* (1937).[3] His story is that of 'a little group of people crossing a bridge. The bridge is red, the people are red, the sky is red. Of course the bridge is symbolic. The bridge *stands for* something else. The bridge, you see, is *the war*.'[4] Like Woolf, displacing the war onto the Ramsay house in the run-up to Andrew's death, Lewis stands at a stubbornly anti-sentimental distance from the war itself. Still, there is real pathos in this image of fragile human figures dwarfed by a blood-red landscape, just as there is pathos in the image of a house that falls with the soldier who once lived there. Notwithstanding the enormous temperamental as well as formal differences between Lewis and Woolf, sorrow and bitter triumph unite their accounts of how you get from pre-1914 to post-1914 culture, whether you cross the bridge of *Blasting and Bombardiering* or pass through what Woolf called the corridor of 'Time Passes'.[5]

That there is a connection between the First World War and the emergence of literary modernism is familiar—perhaps overly familiar—critical territory. Such terms as 'Men of 1914' and 'Lost Generation', Vincent Sherry writes, have a 'nearly sacral character', the quality of 'ritual invocation'.[6] Some important attempts have

[2] Woolf, *To the Lighthouse*, 175, 180, 181.

[3] Wyndham Lewis, *Blasting and Bombardiering* (London: John Calder, 1982), 4, 47.

[4] Ibid. 2.

[5] Woolf described the novel's tripartite structure as 'two blocks joined by a corridor' (quoted in Hermione Lee, *Virginia Woolf* (New York: Vintage, 1999), 469).

[6] Vincent Sherry, *The Great War and the Language of Modernism* (Oxford: Oxford University Press, 1993), 6–7.

been made to unpack the connections implicit in those terms, and to make good on Lewis's promise that war and modernism are alike. One of the most compelling is Modris Eksteins's *Rites of Spring: The Great War and The Birth of the Modern Age* (1989), which presents the historical coincidence of modernism and the First World War as a relationship of reciprocal causality. By titling his book after Stravinsky's scandalous *Le Sacre du printemps*, first performed a year before the war broke out, Eksteins implies that it wasn't simply that the war created modernism—as if unprecedented historical conditions required new forms of expression—but also that the modernist sensibility helped to make the war. Horror 'was turned into spiritual fulfillment', Eksteins writes. 'War became peace. Death, life. Annihilation, freedom. Machine, poetry. Amorality, truth.' The First World War would see 'a re-enactment, writ large, of the sacrificial sequence of *Le Sacre du printemps*'.[7]

However, in what initially seems the starkest of contrasts, the historian Jay Winter suggests that literary and cultural critics have strongly overstated the association of the First World War with modernism. In *Sites of Memory, Sites of Mourning* (1995), a powerful study of the war's culture of grief, Winter describes the traditionalism of the period's mourning and memorial practices: 'The Great War, the most "modern" of wars, triggered an avalanche of the "unmodern".'[8] Spiritualism, superstition, sacralization, the erection of monuments and memorials, a renewed romanticism, the rebuilding of supportive communities: all these overlooked aspects of wartime and post-war culture speak to 'the power of traditional languages, rituals, and forms to mediate bereavement . . . Irony's cutting edge . . . could express anger and despair, and did so *in enduring ways*; but it could not heal.'[9]

I have emphasized Winter's 'in enduring ways'—a shorthand for the period's high cultural canon—because it explains why what seems an irreconcilable disagreement with Eksteins isn't really a disagreement at all. Rather, they are talking about quite different things when they speak of 'modernism'. It isn't that modernism and the First World War have either everything (Eksteins) or nothing (Winter) to do with one another, but that Winter anticipates the New Modernist Studies in understanding 'modernism' as fully embedded in, and in some sense representative of, mainstream culture, and takes the dominance of traditional modes to disprove the long-standing association of modernism with the First World War. Eksteins, in contrast, thinks of modernism as the elite, minority enterprise it has traditionally been considered. Much of the interest of *Rites of Spring* lies in its account of how what was once an avant-garde sensibility gradually *became* the mainstream (it would find its apotheosis, Eksteins later claims, in Nazism's populist fusion of technique-mindedness, irrationalism, and subjectivism).[10] That Eksteins and Winter understand distinctly different things by 'modernism' indicates, most generally, how the transitional

[7] Modris Eksteins, *Rites of Spring: The Great War and the Birth of the Modern Age* (Boston: Houghton Mifflin, 1989), 202.

[8] Jay Winter, *Sites of Memory, Sites of Mourning: The Great War in European Cultural History* (Cambridge: Cambridge University Press, 1995), 54.

[9] Ibid. 115; my emphasis.

[10] Eksteins, *Rites of Spring*, p. xvi.

condition of modernist studies has rendered newly unwieldy even a critical question as familiar as the relationship between modernism and the First World War. More specifically, it helps to explain why both arguments are, in their different ways, entirely convincing: both Eksteins's death-driven modernism and Winter's elegiac unmodernity are demonstrable presences in this culture.

What has 'endured', to use Winter's word, is a canon of literary works that expresses alienated despair rather than forms of traditional consolation. Or, rather, two parallel canons have survived. There is the canon of First World War writing that includes combatants such as Wilfred Owen, Siegfried Sassoon, Henri Barbusse, Erich Maria Remarque, Ernst Jünger, and others. The English members of this cohort are the focus of Paul Fussell's classic *The Great War and Modern Memory* (1975). These are writers whose 'stylistic traditionalism' renders them 'clearly writers of the second rank', and whose radicalism operates primarily on the level of content rather than form.[11] Running parallel to this is the canon of writers, typically (but not, so to speak, uniformly) non-combatant, who engaged with the war in formally more oblique and experimental ways: Eliot, Woolf, Pound, Hemingway, and Ford, among others. In *The Great War and the Language of Modernism* (2003) Vincent Sherry explains how the iconoclasm of the London-based modernists finds a textual corollary, or, to put it another way, how these writings became something other than the formally traditional expressions of denunciation and anger associated with the trench poets. For Sherry, modernism emerges out of a new linguistic predicament: the new tortuousness of the languages of civic reason associated with a Liberal elite that had, against its own most cherished values, taken the country to war: 'A deep mainstream of established attitudes—call it public reason, call it civic rationality—was convulsing under the effort to legitimize this war.'[12] For all the time that, as Wyndham Lewis put it, 'the British Empire, covered in blood, was gasping its way through an immense and disastrous war, upon which it should never have entered', Britain's establishment was forced, in increasingly twisted terms, to defend what it knew to be indefensible.[13] In Sherry's reading, that crisis in public reason—a textual and linguistic crisis, crucially, as well as a political and moral one—provoked London's literary modernism into existence.

While Margot Norris has shown how disturbingly close modernism's formalist abstraction came to erasing both the materiality of the war experience and the trench poetry that documented it, critics such as Trudi Tate and Allyson Booth have argued that the two canons of modernist and First World War writing share common features. 'Modernism's suppression of the war dead—which was repeated in its suppression of trench poetry—provides a particularly useful example of the collusion of its aesthetic and ideological agendas,' Norris writes. Since 'the mass is the enemy of form, the mass killing of the Great War confronted the modernists with an aesthetic unintelligibility that they nonetheless coded politically as "the crowd" or

[11] Paul Fussell, *The Great War and Modern Memory* (Oxford: Oxford University Press, 2000), 313–14.
[12] Sherry, *The Great War and the Language of Modernism*, 9.
[13] Lewis, *Blasting and Bombardiering*, 59.

"anarchy".[14] In contrast, Tate suggests that when modernism and First World War writing are read together, the distinction between the two begins to break down, with modernism representing 'a peculiar but significant form of war writing'.[15] Some of these similarities are already, I think, implicit in the criticism that modernist and First World War writing produced. Fussell and Sherry are both talking about a mordantly ironic impulse in representations of the First World War and its aftermath, as are Winter (an irony that 'could express despair and anger') and Eksteins, who notes how 'bitter and black' was the wartime sense of humour.[16] Fussell's main argument—'that there seems to be one dominating form of modern understanding, that it is essentially ironic, and that it originates largely in the application of mind and memory to the events of the Great War'—is probably no less applicable to the major modernists than to the trench poets, whether we think of modernist writers as active participants in the initial production of that 'dominating form of modern understanding' or as simply among the first to assimilate and disseminate it.[17]

No More Parades: A War Outlived

'Irony is the attendant of hope', Fussell writes, 'and the fuel of hope is innocence.'[18] Woolf's tactic of slaughtering the Ramsay children in whom their parents' hopes are most personally invested exemplifies Fussell's point, but post-war knowledge mocks pre-war naivety whenever she writes about the war. Take, for example, this immediately pre-war passage from *Jacob's Room* (1922): 'Rose Shaw, talking in rather an emotional manner to Mr Bowley at Mrs Durrant's evening party a few nights back, said that life was wicked because a man called Jimmy refused to marry a woman called (if memory serves) Helen Aitken.'[19] The innocent dance of a romantic courtship between two beautiful people isn't quite working out, and the narrator asks us not to take it too seriously. Rose is being silly ('rather . . . emotional') and the other personalities are fairly insignificant people ('if memory serves'). In the following paragraphs, friends and family will intervene to bring Jimmy and Helen together—and then the story breaks off, and the section concludes, with a brutally airy confirmation of Rose's feeling that life is, indeed, 'wicked': 'And now Jimmy feeds

[14] Margot Norris, *Writing War in the Twentieth Century* (Charlottesville: University Press of Virginia, 2000), 35–6.

[15] Trudi Tate, *Modernism, History and the First World War* (Manchester: Manchester University Press, 1996), 3. See Allyson Booth's *Postcards from the Trenches: Negotiating the Space Between Modernism and the First World War* (Oxford: Oxford University Press, 1996) for an account of structural and affective commonalities of realist First World War writing and the work of non-combatant modernists.

[16] Eksteins, *Rites of Spring*, 202.

[17] Fussell, *The Great War and Modern Memory*, 35.

[18] Ibid. 18.

[19] Virginia Woolf, *Jacob's Room* (Oxford: Oxford University Press, 1999), 130.

crows in Flanders and Helen visits hospitals. Oh, life is damnable, life is wicked, as Rose Shaw said.'[20] This deadpan literal-mindedness—life *is* wicked, just not for the reasons Rose thought—recalls a staple resource of trench poetry: the deflation of easy verbal formulas by showing their unintended truth. In Siegfried Sassoon's grim satirical sonnet 'They', a pompous bishop warns his congregation that the returning men

> will not be the same; for they'll have fought
> In a just cause: they lead the last attack
> On Anti-Christ.[21]

The second half of the poem details the syphilis, blindness, gassings, and amputations that mark the more tangibly life-altering transformations that the men have undergone. No, the returning soldiers will *not* be the same.

This savagely deflationary impulse perhaps reaches its height, or depth, in Louis-Ferdinand Céline's classic work of modernist nihilism *Voyage au bout de la nuit* (1932), which opens with the novel's autobiographical narrator–anti-hero Ferdinand Bardamu on the Western Front. In an exemplary passage of debunking, one of Bardamu's fellow inmates in the mental asylum where the state detains people 'whose patriotism was either impaired or dangerously sick' punctures wartime calls to posterity, to family honour and national regeneration: 'I can see my family on fine Sundays...joyfully gamboling on the lawns of a new summer...while three feet under papa, that's me, dripping with worms and infinitely more disgusting than ten pounds of turds on the Fourteenth of July, will be rotting stupendously with all my deluded flesh.'[22] Much canonical modernist writing addresses itself like this to the question whose answer Sassoon's oblivious bishop takes for granted. What moral ends can come of the war's brutal means? And is there a way of imagining a post-war homecoming in which the men 'not being the same' means something more than, on the one hand, the bigoted jingoistic whitewash Sassoon associates with the clergy, and, on the other, the material realities of maiming, death, and dissolution?

With its emphasis on metamorphosis, its concern with the transformation of the tortured body, T. S. Eliot's *The Waste Land* (1922) might be seen to engage similar questions. Here, for example, Eliot uses the Philomel myth—raped and mutilated by her royal brother-in-law, the brutalized Philomel is compensated for her missing tongue with the beautiful voice of a nightingale—as if to evoke the familiar trope of poetry's emergence out of pain. But *The Waste Land* also contains more disturbing images of beauty growing out of violence, especially, and instructively, when the violence in question is war itself, as when the speaker hails an old comrade:

[20] Woolf, *Jacob's Room*, 131.

[21] Siegfried Sassoon, 'They', in *Selected Poems* (London: Faber, 1961), 23.

[22] Louis-Ferdinand Céline, *Journey to the End of the Night*, trans. Ralph Manheim (New York: New Directions, 2006), 50, 56.

> You who were with me in the ships at Mylae!
> That corpse you planted last year in your garden
> Has it begun to sprout? Will it bloom this year?[23]

The transformation of suffering into beauty is rendered grotesque, the aesthetic triumph over the finality of violent death only the efflorescence of a putrefying corpse. By its very nature the heroism of war depends on the corporeal getting converted into something grander, on human bodies being treated as material means to elevated and abstract political ends, but efforts at transcendence fail in *The Waste Land*. Perhaps the only thing worse than a rotten corpse is a rotten corpse in the process of becoming something else.

Woolf's efforts in *To the Lighthouse* to redeem a war she disliked as the final blow to the Victorian gender roles she loathed—another way of trying to make war mean something beyond and better than itself—would be made anew in *A Room of One's Own* (1929), but, even so, a telling hesitation attends her efforts there. Romantic idealism has been destroyed in her lifetime, she claims. 'Shall we lay the blame on the war?'

When the guns fired in August 1914, did the faces of men and women show so plain in each other's eyes that romance was killed? Certainly it was a shock . . . to see the faces of our rulers in the light of the shell-fire. So ugly they looked—German, English, French—so stupid . . . But why say 'blame'? Why, if it was an illusion, not praise the catastrophe, whatever it was, that destroyed illusion and put truth in its place?[24]

Why not indeed? In fact, it is because 'the catastrophe' resists facile transcendence that Lily Briscoe in *To the Lighthouse* cannot enjoy for long her triumph over the dead Mrs Ramsay ('Mrs Ramsay has faded and gone, she thought. We can over-ride her wishes, improve away her limited, old-fashioned ideas').[25] Soon afterwards, Lily breaks down and cries out for Mrs Ramsay, and in the final parenthetical comment—parentheses being, famously, the device through which Woolf recounted the wartime deaths of 'Time Passes'—a fish is destroyed for bait and its 'mutilated body (it was alive still) was thrown back into the sea'.[26] Post-war life means bereaved survivorhood rather than an easy victory over a benighted past. 'He who was living is now dead,' writes Eliot in the final section of *The Waste Land*: 'We who were living are now dying | With a little patience.'[27] The same mood of the temporary reprieve attends the conclusion of Woolf's *Mrs. Dalloway* (1925), when Clarissa Dalloway learns of the suicide of the war veteran Septimus Smith: 'She had escaped. But that young man had killed himself.'[28]

'[O]ne of the first to volunteer', Septimus 'went to France to save an England which consisted almost entirely of Shakespeare's plays and Miss Isabel Pole [his

[23] T. S. Eliot, *The Waste Land*, in *Collected Poems: 1909–1962* (New York: Harcourt Brace, 1991), 55.
[24] Virginia Woolf, *A Room of One's Own* (San Diego: Harcourt, 1989), 15.
[25] Woolf, *To the Lighthouse*, 236. [26] Ibid. 243.
[27] Eliot, *The Waste Land*, 66.
[28] Woolf, *Mrs. Dalloway* (Oxford: Oxford University Press, 1992), 242.

Shakespeare tutor] in a green dress walking in a square.'[29] It is at the front that this
gallant volunteer, an idealist, a patriot, and a lover, has most fully 'developed
manliness', but the startling phenomenon of shell shock means that the war which
inculcates the masculine ideal is also the very thing that destroys it.[30] The attrition of
conventional norms of masculinity and all its increasingly suspect prerogatives is a
recurring theme in the writing of this period, as much recent scholarship of First
World War literature and culture has shown.[31] Often cited is Rebecca West's *The
Return of the Soldier* (1918), a novel that exploits the discoveries in limited narrative
perspective made by proto- or early modernists like James and Conrad. An English-
woman recounts the mid-war return to his aristocratic country house of her cousin
Chris Baldry, formerly a country gentleman, paternalistic landlord, and heroic
officer, and now a shell-shocked veteran who has lost his memory of his entire
adult life: marriage, fatherhood, business, the war, and all. Enabling Chris's amnesiac
bliss not only means ensuring his happiness by liberating him from masculine duties
he must have subconsciously despised (as a psychoanalyst in the novel points out)
but also guarantees his survival. Nonetheless, the soldier must be cured and sent back
to die on the front or 'He who was as a flag flying from our tower would become a
queer-shaped patch of eccentricity on the country-side . . . He would not be quite a
man.'[32] The mixture of the sexual and the snobbish in that metaphor of the flag flying
from the tower of a stately home (as opposed to a socially insignificant and sexually
feminized 'queer-shaped patch on the country-side') points unambiguously to the
suffragette, socialist West's indictment of the psychology and sociology of militarism.

 Twenty years later, Woolf would famously elaborate the relationships between
militarism and masculine identity in her pacifist polemic *Three Guineas* (1938), but
she had been concerned with this issue at least since *Jacob's Room*, the story of Jacob
Flanders, whose very name dooms him to death in the First World War. With his
'violent reversion towards male society, cloistered rooms, and the works of the
classics', Jacob is entirely the product of the misogynistic and unconsciously milita-
ristic Oxbridge culture that Woolf would deride in *Three Guineas*.[33] 'Civilizations
stood round them like flowers ready for picking,' she writes of Jacob and his like.

[29] Woolf, *Mrs. Dalloway*, 112. [30] Ibid.
[31] See e.g. Sandra M. Gilbert and Susan Gubar, *No Man's Land: The Place of the Woman Writer in the
Twentieth-Century*, ii: *Sexchanges* (New Haven: Yale University Press, 1988); Clare M. Tylee, *The Great
War and Women's Consciousness: Images of Militarism and Womanhood in Women's Writings, 1914–1964*
(London: Macmillan, 1990); Sharon Ouditt, *Fighting Forces, Writing Women: Identity and Ideology in the
First World War* (London: Routledge, 1994); Joanna Bourke, *Dismembering the Male: Men's Bodies,
Britain, and the Great War* (London: Reaktion, 1996); and Sarah Cole, *Modernism, Male Friendship, and
the First World War* (Cambridge: Cambridge University Press, 2003). See also Eric Leed's discussion of
shell shock in *No Man's Land: Combat and Identity in World War One* (Cambridge: Cambridge University
Press, 1979) and Elaine Showalter's extension of Leed's argument in *The Female Malady: Women,
Madness, and English Culture, 1830–1980* (New York: Pantheon, 1985). Santanu Das's *Touch and Intimacy
in First World War Writing* (Cambridge: Cambridge University Press, 2005) offers an unusually oblique
and eloquent account of combatant masculinity.
[32] Rebecca West, *The Return of the Soldier* (London: Virago, 1996), 183.
[33] Woolf, *Jacob's Room*, 110.

'Ages lapped at their feet like waves fit for sailing.'[34] But—just as another world war provoked one of Woolf's contemporaries to propose—there is no document of civilization that is not also a document of barbarism.[35] Seduced by the serene beauty of classical antiquity's cultural remnants, those Greek sculptures he is so often said to resemble, Jacob is incapable of recognizing the invisible exploitation, the violent exclusions, and the imperial aggrandizements that made them possible.

A former soldier, Ford Madox Ford also wondered if the abstract masculine ideals of his European patrimony might be serving a disingenuous licensing function. In his war tetralogy *Parade's End*, both the pacifist heroine Valentine Wannop and her treacherous rival Sylvia Tietjens suspect that 'at the bottom of male honour, of male virtue, observance of treaties, upholding of the flag' is a 'warlock's carnival of appetites, lusts, ebrieties'.[36] Ford's *Some Do Not* (1924), *No More Parades* (1925), *A Man Could Stand Up* (1926), and *The Last Post* (1928) tell the story of England's transition through the First World War through the progress of 'the last surviving Tory'.[37] Christopher Tietjens is a country gentleman, officer, and intellectual, and what he learns in the course of the war is that 'it is not a good thing to belong to the seventeenth or eighteenth centuries in the twentieth'.[38] The first novel of the series opens by introducing Tietjens and his best friend, the ambitious, self-made Vincent Macmaster, as members of a class that 'administered the world': 'If they saw police-men misbehave, railway porters lack civility, an insufficiency of street lamps, defects in public services or in foreign countries, they saw to it, either with nonchalant Balliol voices, or with letters to the *Times*, asking in regretful indignation: "Has the British This or That come to *this*!" '[39] We meet Tietjens and Macmaster on a train in the south-east of England, a train that 'ran as smoothly—Tietjens remembered thinking—as British gilt-edged securities', but the real journey they are undertaking is towards a world in which all 'securities' have proved illusory.[40]

Private redemption comes for the Tory Tietjens in the surprising shape of Valentine Wannop, a former servant, suffragette, socialist, and pacifist. Publicly, too, everything has changed because 'there will be no more parades': 'For there won't. There won't, there damn well won't . . . No more Hope, no more Glory, no more parades for you and me any more. Nor for the country . . . nor for the world, I dare say.'[41] *Parade's End* is about a cultural transformation that comes to feel as inevitable as it does crushingly painful to those who thought they were fighting to preserve a pre-war way of life. Predictably, the hero of Ernest Hemingway's *A Farewell to Arms* (1929) takes more stoically that end to 1914-style pomp and circumstance:

[34] Ibid. 101.
[35] See Walter Benjamin, 'Theses on the Philosophy of History', in *Illuminations*, ed. Hannah Arendt, trans. Harry Zorn (London: Pimlico, 1999), 258.
[36] Ford Madox Ford, *Parade's End* (New York: Vintage, 1979), 438.
[37] Ibid. 598. [38] Ibid. 490. [39] Ibid. 3.
[40] Ibid. [41] Ibid. 306–7.

'I was always embarrassed by the words sacred, glorious, and sacrifice,' he tells the reader. 'Abstract words such as glory, honor, courage, or hallow were obscene beside the concrete names of villages, the numbers of roads, the names of rivers, the numbers of regiments and the dates.'[42] *A Farewell to Arms* is, of course, a war novel in all the usual ways, loosely based on the short time Hemingway spent with the Red Cross in Italy, but the same mood of puncturing post-war scepticism is perhaps most famously expressed in a novel not remotely about the war: 'I fear those big words... which make us so unhappy,' Stephen Dedalus tells the bigoted Mr Deasy early in Joyce's *Ulysses* (1922).[43]

No more parades? Of course the reality is more complicated than the clean break with the past implied in conventional stories about the disillusioned 1920s. In this respect, Jay Winter is absolutely right to emphasize the persistence of earlier modes, although this persistence did not pass unremarked or uncriticized. Running throughout novels like *Mrs. Dalloway* is an indictment of a war-haunted world that refuses to shed obsessions that the war should have rendered obsolete:

The War was over except for someone like Mrs Foxcroft at the Embassy last night eating her heart out because that nice boy was killed and now the Manor House must go to a cousin; or Lady Bexborough who opened a bazaar, they said, with the telegram in her hand, John, her favourite, killed; but it was over; thank Heaven—over.[44]

Which is to say that the war both is and isn't over. In a sense, it will never be over for the people who have lost their sons, but, in a more enduringly bleak sense, the war is prematurely over because its implications have too swiftly been forgotten. After all, class-bound priorities remain what they always were. To lose your heir is even worse than losing your son; the same culture of the stiff upper lip that will kill Septimus Smith is something to be warmly admired. If anything, the war has only reinforced pre-war ways of being: 'This late age of world's experience had bred in them all, all men and women, a well of tears,' Clarissa thinks. 'Tears and sorrows, courage and endurance; a perfectly upright and stoical bearing. Think, for example of the woman she admired most, Lady Bexborough, opening the bazaar.'[45]

Although Clarissa cannot see it, those stiff, bereaved aristocrats she admires find an ominous counterpart a little later in the novel when Peter Walsh watches soldiers march to the Tomb of the Unknown Warrior: 'Boys in uniform, carrying guns, marched with their eyes ahead of them, marched, their arms stiff, and on their faces an expression like the letters of a legend written round the base of a statue praising duty, gratitude, fidelity, love of England.'[46] Just as Clarissa fails to see what is so crushingly misguided about Lady Bexborough's marble stoicism, Peter cannot see

[42] Ernest Hemingway, *A Farewell to Arms* (New York: Scribner, 1957), 184–5.
[43] James Joyce, *Ulysses* (New York: Vintage, 1990), 31.
[44] Woolf, *Mrs. Dalloway*, 5. [45] Ibid. 11. [46] Ibid. 65–6.

what is so blindly counter-productive about a post-war public mourning that takes the form of a renascent, even fascistic, militarism:

on they marched, past him, past everyone, in their steady way, as if one will worked legs and arms uniformly, and life, with its varieties, its irreticences, had been laid under a pavement of monuments and wreaths and drugged into a stiff yet staring corpse by discipline. One had to respect it; one might laugh; but one had to respect it, he thought.[47]

Military 'discipline' has rendered the marching boys as dead as the anonymous First World War soldier at whose tomb they remember the fallen. This form of mourning ends up replicating the values responsible for the losses that it was supposed to grieve.

Woolf is here offering a public counterpart to the failed acts of private mourning described in Katherine Mansfield's modernist short stories about the war. 'The Fly' (1923) opens in a city office with a conversation between two businessmen and war-bereaved fathers. One of the men recounts to the other how his daughters have just visited the Belgian war graves where the two dead sons lie buried, but it is the less conventional forms of mourning with which Mansfield is concerned. On the first man's departure, attention shifts to the other, known only as 'the boss', and the rest of the story describes him rescuing, endangering, rescuing, endangering, and finally killing a fly with ink. Periodically the boss splashes the fly to watch it recover: 'He's a plucky little devil, thought the boss, and he felt a real admiration for the fly's courage. That was the way to tackle things; that was the right spirit. Never say die; it was only a question of'[48] He goes too far and the fly is dead. Only three years earlier Freud had described the 'fort-da' game in his classic, war-inspired work on trauma *Beyond the Pleasure Principle* (1920). In the boss's act of Freudian replay, he does not realize, although of course the reader does, that he is simply rehearsing his son's death in the mud of the Western Front. Symbolically, the patriarch kills his son all over again as he plays out his unmastered loss. Even the inanely moralistic clichés of the armchair general—'plucky', 'the right spirit', 'never say die'—are those that unknowingly mocked the disempowerments of soldiers in a mechanized trench war. New kinds of war demand new languages and new forms of acknowledging loss, Mansfield thought; she herself had lost a brother in the First World War. 'There *must* have been a change of heart,' she wrote in a famous letter to her husband, John Middleton Murry, on the post-war condition. 'It is really fearful to me the "settling down" of human beings. I feel in the *profoundest* sense that nothing can ever be the same.'[49]

[47] Ibid. 66.
[48] Katherine Mansfield, 'The Fly', in *The Collected Stories* (London: Penguin, 2001), 417.
[49] Katherine Mansfield, letter to John Middleton Murry, 10 Nov. 1919, in *The Collected Letters of Katherine Mansfield*, ed. Vincent O'Sullivan and Margaret Scott, 4 vols (Oxford: Oxford University Press, 1984–96), iii. 82.

'IT IS LATER THAN YOU THINK':
THE WAR TO COME

Alongside Woolf and Mansfield, a third writer also associated with the Bloomsbury group, though he was a writer of a different kind, also denounced a culture destructively intent on putting the war too quickly behind it—with devastating implications for the coming decades. Published shortly after his resignation from the British Treasury contingent at the Paris Peace Conference, John Maynard Keynes's *The Economic Consequences of the Peace* (1919) opens by attacking its Anglo-American audience for clinging to a delusional sense of security. 'In England the outward aspect of life does not yet teach us to feel or realize in the least that an age is over,' Keynes writes. 'We are busy picking up the threads of our life where we dropped them.'

But perhaps it is only in England (and America) that it is possible to be so unconscious. In continental Europe the earth heaves and no one but is aware of the rumblings. There it is not just a matter of extravagance or 'labor troubles'; but of life and death, of starvation and existence, and of the fearful convulsions of a dying civilization.[50]

Ultimately, subsequent events—most notably the social, political, and economic collapse of Germany that enabled the Nazi takeover—turned the dramatic opening chapter of *The Economic Consequences of the Peace* into a kind of prophecy. The entente powers of the First World War would, in their punitive treatment of a defeated Germany, unknowingly make the Second World War possible.

Writing early in the Second World War, however, George Orwell wondered that the major writers of the 1920s managed not to notice those, as it were, 'fearful convulsions of a dying civilization'. Orwell's essay 'Inside the Whale' described how, intent on looking backward at prior civilizations and inward at the individual psyche, modernists refused to look outward at the disastrous political situation of their own inter-war time and forward to its potentially cataclysmic destination:

Our eyes are directed to Rome, to Byzantium, to Montparnasse, to Mexico, to the Etruscans, to the Subconscious, to the solar plexus—to everywhere except the places where things are actually happening. When one looks back at the 'twenties, nothing is queerer than the way in which every important event in Europe escaped the notice of the English intelligentsia. The Russian Revolution, for instance, all but vanishes from the English consciousness between the death of Lenin and the Ukraine famine—about ten years. Throughout those years Russia means Tolstoy, Dostoievski, and exiled counts driving taxi-cabs. Italy means picture-galleries, ruins, churches, and museums—but not Blackshirts. Germany means films, nudism and psycho-analysis—but not Hitler, of whom hardly anyone had heard till 1931.[51]

[50] John Maynard Keynes, *The Economic Consequences of the Peace* (Harmondsworth: Penguin, 1995), 4.
[51] George Orwell, 'Inside the Whale', in *A Collection of Essays* (New York: Harcourt, 1981), 229.

Famously, writers of the 1930s (including Orwell himself) would redress this balance in left-leaning poetry and prose about their own political and social present. As the conventional wisdom has it, 1920s introspection would give way to 1930s activism, formal density and difficulty to the documentary plain style.

How far it makes sense to extend the term 'modernist' to include the writers of the so-called 'Auden generation' is arguable. Its very self-conscious sociability and accessibility certainly suggest a sharp break with the major modernist writers of the previous decade: Auden's often quoted declaration in a 1933 poem that 'we rebuild our cities, not dream of islands' is as good a way as any of registering the distinction between the era of high modernism and what succeeded it.[52] Or, say, the distinction between a modernism stunned into disaffection by the trauma of the First World War and a writing compelled into and out of commitment by the Spanish Civil War. Arthur Koestler's *Spanish Testament* (1937), Auden's 'Spain' (1937), Orwell's *Homage to Catalonia* (1938), and Hemingway's *For Whom the Bell Tolls* (1940) are among a number of very widely read literary documents of this time, but, as far as 'modernism' is concerned, the truly iconic experimental work of the Spanish Civil War remains not a literary text but a visual one: Picasso's mural *Guernica* (1937).

Although the Spanish Civil War was, famously, a writer's war from the Anglo-American viewpoint, some of the most important so-called late modernist 'war writing' is essentially proleptic, concerned with the war to come rather than with wars ongoing. 'It is later than you think,' announces the voice from nowhere in Auden's brilliantly chilling and obscure 'Consider this and in our time' (1930).[53] This is the kind of modernism that would largely accrue its historical meanings only after the fact. So, for example, the American expatriate Djuna Barnes's *Nightwood* (1936) is as verbally intricate and as emotionally inward as any novel the 1920s produced, but, with its cast of Jews, homosexuals, and other racialized 'undesirables'—the novel opens in the virulently anti-Semitic context of late nineteenth-century Vienna, where a Jew 'passing' as a Christian has married a goose-stepping Aryan—its hauntingly tragic qualities would find their political justification soon afterwards. Or there is Henry Green's *Party Going* (1939), an opaque, ominous novel about fog-stranded travellers waiting in a London railway station for a disaster that they cannot name. Only at the end of the novel does a character come close to voicing the book's war-dread when he looks at the assembled masses and realizes that they are 'targets for a bomb'.[54] Woolf's *Between the Acts*, set on a June day in 1939 but published posthumously in 1941, shares something of *Party Going*'s mood. On their often absurd and funny surfaces, they are both social comedies about communal festivities going awry—the main characters in Green's novel are a group of squabbling rich people caught by the fog on their way to a holiday in the South of France; *Between the Acts* is set on the day of a village pageant play that never quite comes together—but these are also novels darkly overshadowed by an unknowable but no less inevitable coming war.

[52] W. H. Auden, 'Hearing of harvests rotting in the valleys', in *Selected Poems*, ed. Edward Mendelson (London: Faber, 1979), 29.
[53] W. H. Auden, 'Consider this and in our time', in *Selected Poems*, 15.
[54] Henry Green, *Loving, Living, Party Going* (Harmondsworth: Penguin, 1993), 483.

But if their more usually reportage-based aesthetic and left-minded extroversion make the 1930s awkward to classify as 'modernist' according to the terms set by the 1920s, the Second World War saw what can more confidently be termed a modernist renaissance, if only because much of the war's major work was produced by survivors of the 1920s, as the example of *Between the Acts* implies. This is especially true of the war's best-known poetic output, to which I will return, but one belated prose masterpiece deserves a mention because, although under-read, it is highly characteristic of the ways in which the writers who had worked through the high modernist period kept trying to extrapolate form and meaning out of war. Rebecca West's epic *Black Lamb and Grey Falcon* (1941) begins like a transparent, discursive travelogue of a familiar 1930s type when the author arrives in the unfamiliar Balkans. However, the artistic pattern and the wartime relevance of the book simultaneously emerge as West moves forward in space and backward in time to Byzantium. What we think of as history, *Black Lamb and Grey Falcon* proposes, is really the record of the human death-drive. Hence the book's title: the 'black lamb' sacrificed on the Kosovo plains represents pacifism, our desire to be killed rather than to kill; the 'grey falcon' of medieval Serbia, of a people subjected to half a millennium of foreign occupation, represents the promise that a nation and a culture can survive its defeat. That the book ends in the bombed London of 1940—when Britain looked likely to follow the rest of Europe in falling to Nazism—gives its political purpose to West's rediscovery of modernism's characteristic strategy of shaping the chaos of historical experience into mythic patterns, grown from ancient or primitive roots, in an effort to make the present legible.

In the 1910s, West had been closely involved with modernist publication culture—with the radical press, with the landmark 'little magazine' the *New Freewoman*—but far better known than her Second World War writing is the late modernist poetry produced by some of those whom her friend Wyndham Lewis had called 'the men of 1914': Eliot's *Four Quartets* (1943) and Ezra Pound's *Pisan Cantos* (1948). Perhaps they are not war poetry by the strictest definitions—*Four Quartets*, for instance, begins with 'Burnt Norton', a meditation on time and memory written well before the Second World War; the *Pisan Cantos* are about a war essentially over—but nor do they make sense without being understood as substantially products of the poets' wartime experiences. This is very dramatically the case in relation to Pound, of course, since he wrote these poems while incarcerated as a fascist traitor in the custody of the American occupying forces in Italy at the end of the war. Notoriously awarded the inaugural Bollingen Prize in 1949, *The Pisan Cantos* remain intractably unsettling. They can be abrasively anti-Semitic. Here it is the 'goyim' and not the 'yidd' who go like 'cattle' to 'slaughter | with the maximum docility', as if Pound were, at the very least, playing the Holocaust dead against the military dead—although, coming right after an attack on Jewish banking houses, this passage carries the even more perverse and poisonous implication that the Jews were to blame for all the war's non-Jewish casualties.[55] And the obdurately fascist tenor of the poems is

[55] Ezra Pound, *The Pisan Cantos* (New York: New Directions, 2003), 17.

plain from the opening, which elegizes Mussolini and his mistress Clara Petacci, who, summarily shot, had their corpses hung upside down in the Piazzale Loreto in Milan—'twice crucified' is how Pound characterizes a punishment that he considers unprecedentedly exorbitant ('where in history will you find it?').[56]

And yet for all their moments of, not to put too fine a point on it, moral idiocy, *The Pisan Cantos* can be extraordinarily moving, especially when they touch on the poet's own suffering in his prison cage, and on what that suffering means. In these passages, Pound creates strange fusions of anguished blurting and self-effacing reticence by switching into what is literally another language, but also figuratively the different language of traditional poetic stylization. Here, for example, he 'translates'—into French, and into a rhetorically apostrophic mode—his breakdown in a death cell:

> Les larmes que j'ai créees m'inondent
> Tard, très tard je t'ai connue, la Tristesse,
> I have been hard as youth sixty years.[57]

Although they formally don't have much in common with Eliot's more serenely eloquent *Four Quartets*, in the many passages like this one the *Pisan Cantos* share Eliot's attention to the abasements and degradations of war. Pound calls it the 'magna nox animae' of war and Eliot refers to it as the Christian *via negativa*, but they are talking about something very similar: 'In order to arrive at what you do not know | You must go by a way which is the way of ignorance,' writes Eliot in 'East Coker'. 'And what you do not know is the only thing you know.'[58]

In their shared concern with the potentially redemptive power of loss, privation, and defeat, these Second World War works by the 1914-era modernists West, Eliot, and Pound return to the question left unanswered a quarter of a century earlier, of how to make moral and aesthetic sense of war's seeming senselessness. Ultimately, *Four Quartets* offers a contentiously callous answer to this question with its late image of Luftwaffe planes descending on London like the Holy Ghost, 'the dark dove with the flickering tongue' bringing terror and revelation:[59]

> And all shall be well and
> All manner of thing shall be well
> When the tongues of flame are in-folded
> Into the crowned knot of fire
> And the fire and the rose are one.[60]

In modernism's end is modernism's beginning, as Eliot himself might have put it. This conception of national salvation ('the rose') married to apocalyptic destruction

[56] Ibid. 3.

[57] 'I am flooded by the tears I've wept | Only late, very late, have I come to know you, sadness' (Ibid. 91).

[58] T. S. Eliot, 'East Coker', in *Collected Poems: 1909–1962* (New York: Harcourt Brace, 1991), 187.

[59] T. S. Eliot, 'Little Gidding', in *Collected Poems*, 203.

[60] Ibid. 209.

('the fire') recalls Modris Eksteins's argument about modernism's thanatophiliac embrace thirty years earlier of state-sponsored violence.

But not even the Second World War, however deadly and sublime, was Armageddon, and perhaps the story of war and modernism should continue into the cold war, beyond Eliot's apocalyptic consolations and towards the unconsoling endurances of Beckett's post-apocalyptic endgames. 'Can there be misery . . . loftier than mine?' asks Beckett's broken megalomaniac Hamm, named for Noah's cursed son and for the actor who overplays his part. 'No doubt. Formerly. But now?'[61] By the end of the Second World War, suffering has lost the pathos and outrage, and violence the grandeur, with which modernists were tempted to overwrite them. Hence the enduring power to disturb of another broken megalomaniac, another pariah, and another showman, with his Pisan self-portrait of the late modernist poet as resilient bug: 'As a lone ant from a broken ant-hill | from the wreckage of Europe, ego scriptor'.[62]

[61] Samuel Beckett, *Endgame* (London: Faber, 1964), 12.
[62] Pound, *The Pisan Cantos*, 36.

..

MODERNIST POLITICS

SOCIALISM, ANARCHISM, FASCISM

..

ALAN MUNTON

POLITICS, in one of its definitions, is about hope. It is the practical expression of the wish for change, the expectation that never again will things be as they have been, which energizes political movements. It is easy to see why some kind of socialism should be attractive to those who wish for change, since—in its various forms—it has always offered itself as the accessible means for collective action from below that will improve the lives of the majority. Anarchism is somewhat different. It is a radically decentralist theory of political action that demands intense participation by those involved. The anarchist collective is an activist group which organizes itself, always at a local level, to ensure economic and personal success for everyone who participates. The collective will work with other, similar groups, but in a decentralist way that resists bureaucracy. Its tendency is revolutionary, as socialism—certainly in its reformist state forms—is not. But what of fascism? German and Italian fascism gave Europe a world war, corporate economic structures, and the Holocaust. It burned books, violated language, and vilified modernist art and music. Yet, viewed from below, from the position of those who joined or supported the fascist parties, these were not the objectives of fascism—the Holocaust was kept secret, as far as possible—but emerged from a movement which ordinary people supported because it was nationalistic, presented itself as anti-capitalist and anti-religious, and may have

seemed to offer hope for changes of a kind that substantial parts of the working class, and most of the bourgeoisie, could support.[1] Fascist Germany offered the opportunity for ordinary people to succeed; to take an extreme case, for Rudolf Höss it offered the lonely son of a lower-middle-class family from Baden-Baden the chance to join the SS in 1933. Why did he join? 'Because of the likely prospect of swift promotion and the salary that accompanied it, I was convinced that I had to take this step.'[2] Eventually he became the first commandant of Auschwitz. In a 'democracy' of the brutal, this was success.

Politics can have consequences for writers. Consider the two following instances. On 3 May 1945 the poet Ezra Pound was arrested by Italian partisans in Sant'Ambrogio, near Rapallo (where he had lived for many years), and was handed over to the US Counter Intelligence Corps in Genoa. He was subsequently held in a disciplinary training centre near Pisa and was returned to the United States to face charges of treason concerning radio broadcasts he had made from Rome during the war. There he was declared insane and transferred to St Elizabeths Hospital for the Insane in Washington DC, where he remained for twelve years until 1958.[3] Pound continued to write poetry, and in 1949 he was awarded the Bollingen Prize for *The Pisan Cantos*. The case of the French writer Robert Brasillach had a different outcome: he was shot. Brasillach had edited a collaborationist newspaper, *Je Suis Partout*, during the German occupation of France, writing polemically against communists, socialists, Jews, Catholics, Protestants, freemasonry, and the financial world. But it was as much for his attacks on the Third Republic, and de Gaulle, that he was condemned to death. In September 1942 he wrote that it was 'necessary to separate from the Jews *en bloc* and not keep any of the little ones' ('Il faut se séparer des Juifs en bloc et ne pas garder de petits').[4] On 19 August 1944 he went into hiding in Paris, as the Liberation began. On 14 September he gave himself up to the police. His trial, on a charge of 'intelligence with the enemy', took place on 19 January 1945, and he was found guilty after six hours. Among the evidence brought was his sinister threat towards French Jews. General de Gaulle rejected a request for a pardon signed by fifty-nine French writers, and on 6 February Brasillach was shot at Montrouge.

In his war memoirs de Gaulle wrote that he refused a pardon because 'in literature as in everything, talent confers responsibility' ('le talent est un titre de responsabilité').[5] This question of the particular responsibility of the writer is one that writers have always understood, even when they have not accepted it, and is intimately bound up with the complex matters under discussion here. Pound was not tried for

[1] This account of fascism is inadequate. For an outstanding discussion of the issues raised here, and a definition of fascism that can be worked with, see Roger Griffin, *Modernism and Fascism: The Sense of a Beginning Under Mussolini and Hitler* (Basingstoke: Palgrave Macmillan, 2007), 181–2 and *passim*.

[2] Laurence Rees, *Auschwitz: The Nazis and 'the Final Solution'* (London: BBC Books, 2005), 29.

[3] Robert Spoo, 'Introduction', in *Ezra and Dorothy Pound: Letters in Captivity, 1945–1946*, ed. Omar Pound and Robert Spoo (New York: Oxford University Press, 1999), 5–6, 11, 21–4, 33.

[4] Alice Kaplan, *The Collaborator: The Trial and Execution of Robert Brasillach* (Chicago: University of Chicago Press, 2000), 49–50.

[5] Quoted Ibid. 212.

the content of his poetry, nor Brasillach for his fiction. Pound would have been charged with treason for—among other things—'proposing and advocating . . . ideas and thoughts . . . which [Pound] believed suitable and useful to the Kingdom of Italy for propaganda purposes in the prosecution of said war'.[6] Pound's admiration for Mussolini grew out of his attachment to the economic theories of C. H. Douglas (1879–1952), which were argued for in *Economic Democracy* (1920) and known as Social Credit. Pound met Douglas in 1918 when both contributed to the *New Age* magazine, and Pound underwent 'a blinding revelation' over an economic theory that could also explain why cultures succeeded or failed.[7] Douglas wanted the state to distribute a dividend (or credit) to make up for individuals' lack of purchasing power, because (as Hugh Kenner put it) for any product, 'Total cost exceeds total purchasing power.'[8] In this theory, lending at interest to create debt—usury—was the great offence, and in Pound's thinking *usura* eventually became attached to the belief that Jewish bankers controlled the world's economies. This developed into a virulent anti-Semitism. Economics came to permeate everything Pound wrote, notably his major work, *The Cantos*.

It is the view of some legally qualified people that Pound would not have been convicted on treason charges, since it could not have been shown that 'it was Pound's purpose in his broadcasts to harm the United States in its pursuit of the war', as Tim Redman writes. He adds emphatically: 'Pound did not intend harm to his native land.'[9] This is probably true; but why in that case did he, in 1944, prepare propaganda for the last-ditch effort of Mussolini's regime, the Republic of Salò, just as Allied forces—including Americans—made their way up the Italian peninsula? Naively, he proposed reprinting books by C. H. Douglas, and pamphlets discussing Marx and Lenin. Salò has been defended on the basis that these last two names (promoted by others as well as Pound) showed that it now embodied left-wing fascism, with Mussolini turning from supporting business to supporting peasants and working people. In fact the Republic of Salò was a wholly dependent German puppet state. Pound prepared texts and wrote dozens of letters, and showed a touchingly naive belief in the efficacy of education: as Italy fell, the act of reading about Social Credit and Marxism would help. There comes a point where either such naivety becomes culpable, or one must question Pound's understanding of the real world.[10]

[6] Quoted in Tim Redman, *Ezra Pound and Italian Fascism* (Cambridge: Cambridge University Press, 1991), 230.

[7] A. David Moody, *Ezra Pound, Poet: A Portrait of the Man and His Work*, i: *The Young Genius, 1885–1920* (Oxford: Oxford University Press, 2007), 372.

[8] Hugh Kenner, *The Pound Era* (London: Faber and Faber, 1972), 306. See Kenner's discussion, pp. 301–17, for an account close to advocacy. Social Credit tends to attract right-wing thinkers (as Kenner was), rather than socialists, even though it is radically redistributive. In so far as it urges the more rapid circulation of money, it is relevant to the credit crisis of 2008–10.

[9] Redman, *Ezra Pound and Italian Fascism*, 230.

[10] On both these issues, Redman is generous to Pound; see ibid., ch. 8: 'The Republic of Salò and Left-Wing Fascism'. Kenner ignores this entirely, but finds a 'rare vision' in Pound's account of being at Salò in Canto LXXIV.

Both Pound and Brasillach were accused of expressing unacceptable 'ideas and thoughts', as distinct from having committed an act causing actual harm. Both engaged in what today would be called hate speech, something that would now constitute a harmful act under the laws of many countries, but not one that would be punished by death. That words were involved opened a possible line of defence to Pound, because what he said was (in legal terms) 'mere words', and words alone do not amount to a 'specific intent to betray'.[11] Others charged in France at the same time as Brasillach used a variant of this defence, arguing that their polemics were (variously) literary criticism, or else 'confession', or indeed literature, as if 'literature' did not count politically.[12] According to this argument, 'literature' is not an act or intervention in the real world. Opposed to this is the argument for the responsibility of the writer: it is the business of the writer to defend freedom, and to speak truth to power. In the Brasillach trial, the prosecution wished to show that a writer's skills made him all the more effective, while the defence argued that the writer had a right to fail. Gisèle Sapiro has set out the issues in this case: 'While the indictment tried to show that a writer's talent made his propaganda all the more effective, and that celebrity increased responsibility, the defence separated the two planes of literature and politics. The polemicist might have been in error, but the writer had to be saved at all costs.'[13]

The division proposed by Brasillach's defence is particularly significant for a consideration of the conservative modernists Ezra Pound, T. S. Eliot, and Wyndham Lewis, because their work divides into 'literature' (which includes literary criticism) and 'polemic'. Every reader of Pound, Eliot, and Lewis is aware of a decline in quality and intensity in the political polemics. Yet there is a counter-argument, for *not* to speak out at a time of political crisis—and particularly in the 1930s—would have shown a lack of writerly responsibility. Nevertheless, the same person wrote both kinds of texts, and the reverse question also applies: is the literature affected, or infected, by the polemics? In Eliot's case, Anthony Julius has argued, convincingly in my view, that 'Eliot made poetry out of anti-Semitism.'[14] In the case of Pound, Peter Nicholls has argued, equally convincingly, that his poetics merge effortlessly with the metaphysics of fascism, such that 'the inscription of absolute authority [Mussolini's, or that of the fascist state] comes to reproduce itself in his own text'.[15] In Lewis's case, the quality of the political novel *The Revenge for Love* (1937) is in stark contrast to the political writings of the mid-1930s, such as *Count Your Dead! They Are Alive*, an anti-war polemic of 1937, or *Left Wings Over Europe*, of 1936. In the latter book, which was

[11] Redman, *Ezra Pound and Italian Fascism*, 227.

[12] Gisèle Sapiro, 'Portrait of the Writer as a Traitor: The French Purge Trials (1944–1953)', in Jennifer Birkett and Stan Smith (eds), *Right/Left/Right: Revolving Commitments: France and Britain, 1929–1950* (Newcastle: Cambridge Scholars, 2008), 197.

[13] Ibid. 198.

[14] Anthony Julius, *T. S. Eliot, Anti-Semitism, and Literary Form* (Cambridge: Cambridge University Press, 1995), 218.

[15] Peter Nicholls, *Ezra Pound: Politics, Economics and Writing: A Study of The Cantos* (London: Macmillan, 1984), 216.

pacifist in intent but over-insistently argumentative in execution, Lewis wrote of a supposed sympathy for the Soviet Union that he found in newspapers of the time: 'the Press . . . tending to show how absurdly genial, "democratic", "kindly", in a word, *un-bolshie* (and in short *British*) the gentlemen of the Comintern are'.[16]

Apart from the delusion as to fact, it is the awkward rhythms, oddly placed emphases, and the elusive use of quotation marks that interfere with the reception of this. Lewis cannot find a stable tone by which to address his audience. He, Eliot, and Pound all relied upon quotation in their literary writing—one thinks of *The Waste Land* and *The Cantos* particularly—but none of them can establish a consistent tone when they write in their own voices, and Lewis's voice seems often to be someone else's.

A number of questions arise at this point. Are extreme cases, such as those of Pound and Brasillach, the most secure basis upon which to decide the terms by which we discuss the responsibility that the writer has towards freedom or the exercise of power? Do writers of the right have as great a claim upon our attention as those of other political persuasions? For is not some of our interest provoked by our incredulity that they should hold the views that they do? And does not that incredulity arise from the modern belief that writers are the incarnation of the freedom of imagination, 'assumed to obey only the dictates of his free subjectivity and his immediate inner convictions'?[17] Beyond that lies the assumption that the free imagination is invariably benevolent. This sentiment, grounded in Romanticism, and separately confirmed by Western humanism, proved to be inadequate in the face of crucial aspects of twentieth-century modernity.

JAMES JOYCE: SOCIALISM AND ANARCHISM

The discussion so far has concentrated upon the end of the modernist period, primarily the years of the Second World War, and the post-Holocaust period. But modernism—both written and visual—originated before and during the First World War, in a more innocent world in which people were only beginning to recognize that modernity was transforming the environment (urban life in particular), altering the relationships between people, and consequently creating a new subjectivity which required representation in texts or visual images. The major texts of early modernism concern the subject in new relationships, and the characteristic move is inwards. Joyce's *Ulysses* (1922; excerpts first published 1918) is the primary example of the turn towards the subject when the physical world begins to impose itself in such a way as

[16] Wyndham Lewis, *Left Wings Over Europe, or, How to Make a War About Nothing* (London: Jonathan Cape, 1936), 84.
[17] Sapiro, 'Portrait of the Writer as a Traitor', 187.

to constrain or damage the subject. Lewis caught well this sense of the necessity of a new self when he wrote in 1914 that 'new egos' were needed for new circumstances: 'THE ACTUAL HUMAN BODY BECOMES OF LESS IMPORTANCE EVERY DAY,' and under such pressure 'It now, literally, EXISTS much less.'[18] The new subject in modernity required a new politics, and socialism and anarchism were these new politics. Anarchism had been largely defeated as a political force by the end of the nineteenth century, but it survived in Europe as an idea, and in Spanish and Italian politics as a practice. As a young man, Joyce embraced the idea of both socialism and anarchism.

He was in Rome in 1906, where he followed closely the discussions at the Congress of the Italian Socialist Party of that year, and was much interested by the revolutionary syndicalist Arturo Labriola (1873–1959), of whom he wrote that 'He wishes to hasten *directly* the emergence of the proletariat' and would 'include in his ranks Catholics and Jews, liberals and conservatives'.[19] Syndicalism was a movement based on trade unions and on work- or trade-based organization, and it stood in opposition to parliamentary democracy. Organization took place at the level of factory or trade (syndic), and was therefore radically decentralized, and inevitably took on anarchist characteristics: anarcho-syndicalism was a significant presence in the politics of work at this time. Joyce was prepared to say to his brother Stanislaus—to whom these political letters were addressed in late 1906—that 'Of course you find my socialism thin. It is so and unsteady and ill-informed,'[20] but in fact he shows himself well informed and precise as to political belief and activity. Nevertheless, by March 1907 Joyce wrote that 'The interest I took in socialism and the rest has left me....I have no wish to codify myself as anarchist or socialist or reactionary.'[21]

It is important to emphasize how widely Joyce had read in anarchist theory. His first biographer, Herbert Gorman, wrote—presumably on the basis of discussions with Joyce himself—that

Among the many whose works he had read may be mentioned Most, Malatesta, Stirner, Bakunin, Kropotkin, Eliseé Reclus, Spencer and Benjamin Tucker, whose *Instead of a Book* [1893] proclaimed the liberty of the non-invasive individual. He never read anything by Karl Marx except the first sentence of *Das Kapital* and he found it so absurd that he immediately returned the book to its lender.[22]

This list includes all kinds of anarchists. Johann Most (1846–1906), was an advocate of violent anarchism—'propaganda of the deed'—and one would not expect Joyce to be sympathetic to the author of the first pamphlet showing how to make bombs; but Dominic Manganiello has shown that in the 'Scylla and Charybdis' episode of

[18] Wyndham Lewis, 'The New Egos', in Lewis (ed.), *Blast: Review of the Great English Vortex*, 1 (Santa Barbara, Calif.: Black Sparrow Press, 1981), 141.

[19] *The Letters of James Joyce*, ed. Richard Ellmann, ii (London: Faber and Faber, 1966), 188.

[20] Ibid. 187. [21] Ibid. 217.

[22] Herbert Gorman, *James Joyce: A Definitive Biography* (London: John Lane/Bodley Head, 1941), 183 n. 1.

Ulysses, Joyce pastiches a pamphlet by Most, *The Deistic Pestilence* (1902; also translated as *The God Pestilence*). Most wrote of Christ that he was 'held in contempt and derided by his enemies, was nailed to a cross, like a bat on a barn door', and Joyce writes: 'Who, put upon by His fiends, stripped and whipped, was nailed like bat to barndoor.'[23] Most is present here as a mocker of Christ, like Buck Mulligan (based on Joyce's friend Oliver St John Gogarty), who at this point in the text has just entered the conversation in the National Library. The irruption of an anarchist text into Stephen's consciousness at this moment is crucial to important themes in *Ulysses*.

Max Stirner (1805–56) was the post-Hegelian whose book *Der Einzige und sein Eigenthum* (1844) had been translated as *The Ego and His Own* in 1907 (New York) and 1912 (London); it influenced Wyndham Lewis, among others, and remains a key text of philosophical anarchism. It is based on the concept that the ego owns everything. Jean-Michel Rabaté has proposed that when Stephen says to Bloom (in 'Eumaeus') '—But I suspect . . . that Ireland must be important because it belongs to me,'[24] he is being Stirnerian; further, what is to be owned is not only the objective world but also 'the entire world of discourse', something that radically changes 'our usual apprehension of the structure of the subject'.[25] Anarchist theory has consequences for the text as well as the world.

Joyce may have been interested by the French anarchist Elisée Reclus (1830–1905) because he was strongly opposed to marriage, as was Joyce himself. It was the collectivist anarchism of Mikhail Bakunin (1814–76) that Joyce found most attractive, according to Richard Ellmann, though his evidence is speculative rather than precise. He quotes Bakunin as saying that 'All religions are cruel, all founded on blood,' and Joyce's Leopold Bloom as thinking, 'God wants blood victim. Birth, hymen, martyr, war, foundation of a building, sacrifice, kidney burntoffering, druid's altars.'[26] Manganiello establishes many more parallels between anarchist theory and Joyce's texts than Ellmann does. Among the *Ulysses* notesheets in the British Museum he finds a critique of the state that can be found, differently expressed, in *Ulysses* itself, where an example is the imagined execution of the Croppy Boy by Sir Horace Rumbold, a British minister.[27] Joyce's detailed knowledge of anarchist theory can be inferred from an error made by Bloom (who often makes mistakes). He is made to say, 'Everyone according to his needs and everyone according to his deeds.'[28] This confuses the anarcho-communist principle advocated by Kropotkin, that communal storehouses could supply everyone's needs, and Bakunin's very different proposal

[23] Dominic Manganiello, *Joyce's Politics* (London: Routledge & Kegan Paul, 1980), 102; James Joyce, *Ulysses*, Annotated Students' Edition (Harmondsworth: Penguin, 1992), 253.

[24] Joyce, *Ulysses*, 748.

[25] Jean-Michel Rabaté, *James Joyce and the Politics of Egoism* (Cambridge: Cambridge University Press, 2001), 40.

[26] Richard Ellmann, *The Consciousness of Joyce* (London: Faber and Faber, 1977), 83; Joyce, *Ulysses*, 190.

[27] Manganiello, *Joyce's Politics*, 104; Joyce, *Ulysses*, 691.

[28] Joyce, *Ulysses*, 713.

'From each according to his deeds', that is, for work done.[29] Only someone with a very close knowledge of anarchist theory could have constructed such a joke.

Benjamin R. Tucker was an American anarchist, and the full title of his book is *Instead of a Book by a Man Too Busy to Write One: A Fragmentary Exposition of Philosophical Anarchism* (Tucker also published Stirner in translation). Ellmann writes in his biography of Joyce that Tucker's theories 'also attracted him for a time', but one senses a distinct listlessness in this account of what might be positive in Joyce's politics, as though Ellmann believed that really he had none at all.[30] This view has been endorsed all too readily by literary critics writing about Joyce, and it is noticeable that although Manganiello brings forward substantial evidence of an interest in anarchism, this theme has not persisted very strongly in Joyce criticism. Perhaps it is felt necessary to keep the virtuous Joyce away from the taint of extremism that has affected some of his contemporaries. It is nevertheless a falsification: he was indeed interested by anarchist theory.

On Joyce's opposition to nationalism there is substantial agreement. The young Joyce was attracted to Sinn Féin, and then he moved away from it. He was aged 24 when wrote to Stanislaus in 1906:

You ask me what I would substitute for parliamentary agitation in Ireland. I think the *Sinn Fein* policy would be more effective. Of course I see that its success would be to substitute Irish for English capital... The Irish proletariat has yet to be created... For either Sinn Fein or Imperialism will conquer the present Ireland. If the Irish programme did not insist on the Irish language I suppose I could call myself a nationalist. As it is, I am content to recognise myself an exile... I would call such people as Gogarty and Yeats and Col[u]m the blacklegs of literature.[31]

This was written in November 1906, about a year after the effective founding of Sinn Féin. The primary issue here is whether parliamentary action was the way forward, or whether a popular movement—perhaps nationalist and socialist—would achieve Irish independence. Within this lay the question of armed insurrection, which eventually broke out in the 1916 Easter Rising in Dublin. Under the leadership of Arthur Griffith, Sinn Féin—which had nothing to do with the Easter Rising—followed the principle of the 'dual monarchy' as it then existed in Hungary, and which would have meant Ireland being ruled from both a parliament in Dublin and another in London, in accordance with a scheme which had existed in 1782 ('Grattan's Parliament'), by which it was agreed that 'the people of Ireland... be bound only by laws enacted by his Majesty [in London] and the Parliament of that kingdom [Ireland]'. This was the policy as it stood when Joyce wrote in 1906. Of more interest to him, evidently, were the possibilities for socialism—'revolutionary socialism' according to Colin MacCabe[32]—which he picked up in Rome at the same time

[29] Manganiello, *Joyce's Politics*, 111–12.
[30] Richard Ellmann, *James Joyce*, rev. edn (Oxford: Oxford University Press, 1982), 142.
[31] Quoted Ibid. 238.
[32] Colin MacCabe, *James Joyce and the Revolution of the Word* (London: Palgrave Macmillan, 1979), 160.

as he was endorsing the policies of Arthur Griffith. Yet Joyce had not lost his earlier Parnellite (parliamentary) tendencies either, and Ellmann reports that in 1921–2 'He was briefly exhilarated at the foundation of the Irish Free State' and—with typical egoism—linked this event with the near-completion of *Ulysses*, published in February 1922: 'at the very time that he was giving his country a new conscience by completing *Ulysses*, his old associate Arthur Griffith—a lifetime advocate of independence—was taking office as its new president'.[33] But Griffith died in August 1922, and Joyce became disillusioned by what appeared to him as a new repression by the Catholic Church, and a repressive sexual regime of supposed Irish 'purity'. He told his friend Arthur Power: 'Now I hear since the Free State came in there is less freedom. The Church has made inroads everywhere, so that we are in fact becoming a bourgeois nation, with the Church supplying our aristocracy . . . and I do not see much hope for us intellectually. Once the Church is in command, she will devour everything'.[34]

From this point forward, Joyce's politics essentially do not change, but they move into the all-absorbing language-world of *Finnegans Wake*, published in 1939. Éamon de Valéra, as leader of the Irish Free State, appears there variously as 'devil era', and 'D.V.'—meaning *Deo Volente* ('God wills it'):[35] here the anarchist in Joyce is writing, within an Irish context, against both secular and religious authority. The way in which real politics becomes text in *Finnegans Wake*—a text which might be characterized as a Stirnerian effort to possess the world of discourse, if not the world itself—can be a matter of concern as much as exhilaration. Joyce refused to answer the questionnaire circulated by Nancy Cunard, and published by *Left Review* in 1937 as *Authors Take Sides on the Spanish War*, on the grounds that 'it is politics. Now politics is getting into everything.' Yet—in Manganiello's words—he 'emphasised the humour in *Finnegans Wake* as a counteracting agent to the bombing in places like Spain'.[36] Joyce seems to have preferred to speak within a difficult text than to raise his voice in the real world. His politics were both public and often highly personal, and are located somewhere between his anarchism and his egotism. What is certain is that politically he was not a liberal, which is what so much recent discussion has tried to make him.

WYNDHAM LEWIS

The politics of Wyndham Lewis (1882–1957) are perhaps the most difficult to grasp of any among the modernist writers. He is repeatedly denounced as a fascist, more often

[33] Ellmann, *James Joyce*, 533. In 1912 Griffith had supported Joyce in his attempts to get *Dubliners* published.
[34] Arthur Power, *Conversations with James Joyce*, ed. Clive Hart (London: Millington, 1974), 65.
[35] Manganiello, *Joyce's Politics*, 175.
[36] Ibid. 233, 231.

indeed than Pound, even though Pound was personally and politically committed to Mussolini and Italian fascism, while Lewis was attached to no movement at all.[37] Lewis was often politically perceptive, but lacked the ability to think politically. In 1931 he published the first book written anywhere on Hitler, and it was undoubtedly shrewd of him to identify the German leader's likely future significance. For this he gets no credit because he characterized him as 'a Man of Peace'.[38] He also believed that what Hitler said against the Jews was not to be taken seriously. These are appalling misjudgements, but at least he is advocating neither violence nor anti-Semitism. That is the most that can be said for *Hitler*, which is one of the most comprehensively disastrous books written by a significant author during the twentieth century. The other incautious phrase consistently used to define Lewis's politics appeared in *The Art of Being Ruled*, his major political book of 1926. In a chapter entitled 'Fascism as an Alternative' he wrote that 'And yet for anglo-saxon countries as they are constituted today some modified form of fascism would probably be the best.'[39] The words 'And yet' indicate that this sentence has an antecedent, and in it Lewis makes what must still seem a remarkable (and remarkably contradictory) statement: 'I have already said that in the abstract I believe the sovietic system to be the best . . . It springs ostensibly from a desire to alleviate the lot of the poor and outcast, and not merely to set up a cast-iron, militaristic-looking state.'[40] This prelude is not often quoted by commentators, but it requires emphasis because it shows human sympathy for the poor. This antithetical structure—here, 'sovietic' against 'fascist'—illustrates a characteristic of Lewis's mind: the need to set up opposed politics as alternatives, and to mediate between them. He shows himself open to the Soviet system for better reasons than did any other modernist writer; yet within a very few years he is an adamant anti-communist. With regard to Mussolini's policies, it is worth noting that *The Art of Being Ruled* was published in March 1926. The Italian socialist leader Giacomo Matteotti was murdered on 10 June 1924, and suppression of the Socialist Party began in 1925. It would not have been clear to Lewis, writing perhaps in mid- or late 1925, what Italian fascism would become, though the Matteotti killing should have been a warning.

The prominence of *Hitler* in accounts of Lewis's politics makes an extended discussion necessary. Lewis visited Berlin in November 1930, a short time after the Nazi success in the elections of 14 September, when the Nazi Party came second, achieving 107 seats in the Reichstag, against twelve previously. The Social Democratic Party came first with 143, the Communists third with seventy-seven. In January and February 1931 Lewis published five articles in the weekly *Time and Tide*, and these were revised as *Hitler*, published in April. The alarm felt throughout Europe apparently did not reach Lewis, whose tendency to get his information almost exclusively

[37] See the letters addressed by Pound to Mussolini in C. David Heymann, *Ezra Pound: The Last Rower: A Political Profile* (London: Faber and Faber, 1976), 317–27.

[38] Wyndham Lewis, *Hitler* (London: Chatto & Windus, 1931), title of pt 2, ch. 3.

[39] Wyndham Lewis, *The Art of Being Ruled* (1926), ed. Reed Way Dasenbrock (Santa Rosa, Calif.: Black Sparrow Press, 1989), 320–1.

[40] Ibid. 320.

from newspapers did not do him a service. Yet if he was not alarmed by the Nazi Party's *Völkischer Beobachter*, did he not notice something amiss with *Der Stürmer*, 'the rabidly anti-Semitic rag edited by...Julius Streicher'?[41] Lewis presents himself as someone impartially expounding Hitlerism, but this was not the case: advocacy is mixed with the supposed impartiality. The failure of *Hitler* is a failure of tone, a failure of political understanding, a failure of human sympathy, and a failure to recognize danger.

Lewis's accounts of political events have an unreal and ungrounded feel to them. For example, Hitler's attempts to restrain the Sturmabteilung (Storm Troopers, SA) in September 1930 led to a court statement in which he said: 'The National Socialist movement will try to achieve its aim with constitutional means in this state...In the constitutional way we shall try to gain decisive majorities in the legislative bodies so that...we can give the state the form that corresponds to our ideas.'[42] This occurred not long before Lewis's visit, and seems to have persuaded him that Nazism really was committed to what was legal (*nur legal*) and constitutional. He seems not to have known that Hitler said this in order to prevent the SA—aggressive and revolutionary as it was—from damaging the Party's efforts to avoid being banned by the state, and to effect a reconciliation that allowed Nazi Party members to join the army.[43] Lewis writes, as if it were an absolute good, that 'Any Nationalsocialist carrying firearms is expelled from the Party—that is the order that has gone out since the September elections.'[44] This was another part of the effort to restrain the SA and make the Party appear respectable; but Lewis does not recognize this as a political motive; for him, the firearms ban shows a particular virtue in the Nazi Party as a whole. It is these persistent attempts to show that Nazism was not riven by competing factions, was not intrinsically violent, was not fundamentally anti-Semitic, that is most objectionable about *Hitler*. Lewis does not hold a pro-Hitler position that he is trying to disguise, for he means what he says; but what he says shows that he partly (and sometimes fully) recognizes what he is dealing with, but cannot acknowledge its full, and fatal, meaning. When he writes that 'In the *Dritte Reich*, as conceived by Hitler, that great jewish [*sic*] man of science, Einstein, would, I think, be honoured as he deserves,'[45] we can recognize that he knows, at some level, that Einstein was indeed at risk, and that he would *not* be treated well—for why raise this question at all if persecution was not likely? Lewis's writing fails because the reader becomes aware of the persistent presence of an alternative interpretation that the text cannot suppress.

Only on his own ground, art, is he secure and consequently critical: 'In matters of the technique of art...in fields where a great deal of taste and intelligence is required, the Hitlerist's arch-enemy, the Jew, can make rings round him [the Nazi]

[41] Corey Ross, *Media and the Making of Modern Germany: Mass Communications, Society, and Politics from the Empire to the Third Reich* (Oxford: Oxford University Press, 2008), 239–40.

[42] Jeremy Noakes and Geoffrey Pridham, *Nazism 1919–1945*, i: *The Rise to Power, 1919–1934: A Documentary Reader* (1983; Exeter: University of Exeter Press, 1998), 90.

[43] Ibid. [44] Lewis, *Hitler*, 47. [45] Ibid. 48.

in all that universe that is not war, or mechanical technique.'[46] Yet this implicitly concedes that 'Hitlerism' was warlike, and contradicts the claim that Hitler was 'a Man of Peace'. It was Lewis's 1937 visit to Berlin and Warsaw—where he visited the ghetto, and was appalled—that at last changed his politics and 'brought about a revolution in Lewis's political sympathies', as Paul Edwards has put it.[47]

Lewis's account of this visit, 'Berlin Revisited', was not published until 1997, but his disillusion is apparent in it. The exact terms of what had gone wrong are not what one might expect. Hitler, it appears, had failed to fulfil Lewis's hopes of a cultural revolution of the kind proposed in his book of political theory *The Art of Being Ruled*. Edwards writes that 'the specific form of his disillusion suggests that he had secretly cherished an illusion of the Nazi regime as fulfilling his vision of a Modernist, anti-bourgeois political culture'.[48] If this was the case, it means that Lewis's self-deception ran deep, in that the aberrations of the 1930s were not based on a superficial political enthusiasm, but on a misrecognition that went to the heart of Lewis's politics and indeed to the heart of his work as a modernist artist and writer. On the other hand, if what he says about Hitler reached him through his own politics, he cannot have been a spokesman for German fascism itself.

The illusions ended in 1937, and from that date 'he no longer had any political aspirations invested in Nazism as a vehicle for the institution of a creative anti-bourgeois culture'.[49] Apart from the explicit renunciation of his earlier politics in *The Jews: Are They Human?* and *The Hitler Cult* (both 1939), he began to write *The Vulgar Streak* (1941), a novel that satirized the cult of action as it was characteristic of Mussolini's fascism and German Nazism. From the early years of the Second World War onwards he was a convinced internationalist, and invented the non-divisive concept of 'the global village', which has since entered general discourse.[50]

By concentrating on the more radical aspects of *The Art of Being Ruled* it is possible to construct a reading of Lewis's politics that does not wholly turn upon the question of whether he was, or was not, 'a fascist'. This alternative narrative is an uneven and contradictory one, but has the advantage of not being predicated upon condemnation. Early in this text Lewis quotes a famous passage from Marx's *Capital*, in which he argues the essentially revolutionary nature of capitalism, its commitment to constant change. The standard translation reads:

Modern industry never views or treats the existing form of a production process as the definitive one. Its technical basis is therefore revolutionary, whereas all earlier modes of production were essentially conservative. By means of machinery, chemical processes and other methods, it is continually transforming not only the technical basis of production but

[46] Lewis, *Hitler*, 137.
[47] Paul Edwards, *Wyndham Lewis: Painter and Writer* (New Haven: Yale University Press, 2000), 390.
[48] Ibid.. [49] Ibid. 391.
[50] See Wyndham Lewis, *America and Cosmic Man* (New York: Doubleday, 1949), 21: 'now that the earth has become one big village, with telephones laid on from one end to the other, and air transport, both speedy and safe'. Marshall McLuhan wrote 'global village' in the margin of his copy (University of Toronto Libraries), and took the concept as his own.

also the functions of the worker and the social combinations of the labour process. At the same time, it thereby also revolutionizes the division of labour within society, and incessantly throws masses of capital and of workers from one branch of production to another.[51]

From this Lewis develops several crucial position statements concerning modern technology (he calls it 'science') and its consequences for politics, art, culture, and the stability of the personality. He writes:

revolution, as we understand it today, is in origin a purely technical process . . . we are in the midst of a frenzied evolutionary war of the machines. This affects our view of everything; our life, its objects and uses, love, health, friendship, politics: even art to a certain extent. . . . Science makes us strangers to ourselves. Science destroys our personally useful self-love. It instals a principle of impersonality in the heart of our life that is anti-vital.[52]

That is the critique provoked by Marx. The response is to ask 'how far it [daily life] can be improved without radical transformation',[53] since Lewis dislikes the options on offer from two figures from his own intellectual past, Bergson (offering transcendence of the human condition) and Nietzsche (offering the superman). These rejections are surely to Lewis's credit; but they involve rejecting also the idea of political revolution. Perhaps the problems begin here.

In The Hitler Cult of 1939, the first of the two 'apology' works of that year, Lewis sets out what he believed his politics to have been: 'Though favouring always Proudhon rather than Marx as a political thinker, some species of authoritarian control, it seemed to me, some "planning" from a creative centre, were imposed upon us.'[54] The French socialist and anarchist Pierre-Joseph Proudhon (1809–65) was an immense influence upon Lewis's political thinking, which cannot be understood without him. Early Proudhon is well known for the assertion that 'property is theft', argued in What Is Property? (Qu'est-ce que la propriété?, 1840), but Lewis was more interested by the federalism of the later Proudhon, specifically in Du principe fédératif of 1863, which he characterized as follows:

In 1851 Proudhon described himself as 'a theorist of anarchy.' In 1862 he became what he described as a 'federalist'. That is to say, he abandoned his position of intransigeance with regard to authority. Anarchy is the affirmation of liberty and the negation of authority, he would tell us; whereas federation was the balancing of the two.[55]

When the term 'authoritarian control' occurs in The Hitler Cult, it is to be understood in this sense, particularly so when associated with the idea of '"planning" from a creative centre'. There is always liberty, and there is always authority, and out of their interaction arises political activity. Proudhon, in Lewis's view, was associational,

[51] Karl Marx, Capital: A Critique of Political Economy, i, trans. Ben Fowkes (Harmondsworth: Penguin in association with New Left Review, 1976), 617. Lewis found the passage in Edouard Fimmen, Labour's Alternative: The United States of Europe or Europe Limited, trans. Eden and Cedar Paul (London: Labour, 1924). This was a prescient account of the necessity for European integration, from a left-wing position.
[52] Lewis, The Art of Being Ruled, 23–4. [53] Ibid. 24.
[54] Wyndham Lewis, The Hitler Cult (London: Dent, 1939), 21.
[55] Lewis, The Art of Being Ruled, 301.

and believed in organization on 'highly socialized, "free", utopian lines'.[56] Lewis was socialized in the same way. Portraits apart, his art very frequently shows two or more figures in relationship, while his fiction generally shows a set of complex social and political relationships, from *Tarr* (1918), through *The Apes of God* (1930) and *The Revenge for Love* (1937), to *Self Condemned* (1954). There are no single dominant characters in these works because Lewis's sense of the world was essentially relational.

In the 1930s his politics showed a remarkable reversal, a change of political direction from right to left. In 1937 he wrote for the *British Union Quarterly*, the 'intellectual' journal of Mosley's British Union of Fascists, an article entitled '"Left Wings" and the C3 Mind'. This was not an endorsement of that Party's policies, but an attack on left-wing intellectuals in Britain, among them Aldous Huxley, J. B. Priestley, Virginia Woolf, W. H. Auden, and (surely astonishingly) T. S. Eliot: 'The Marxist has had it all his own way.'[57] Lewis urged his 'highbrow colleagues' to show 'a little critical detachment' in dealing with contemporary politics, instead of producing biased judgements '*all upon one side*',[58] that is, to the political left. This call for 'balance' between left and right is an eroded and misapplied version of the relationship between Proudhonian decentralism and Marxist centralization. 'You as a Fascist', Lewis declared, 'stand for the small trader against the chain-store . . . for personal business against Big Business.'[59] German Nazism was in practice centralizing and authoritarian, but Lewis had yet to recognize this. He has scarcely moved on from *Hitler*, which was, indeed, praised in this same number of the *British Union Quarterly* as 'still about the best study of the man and the movement'.[60] In August 1937 Lewis and his wife visited Berlin and Warsaw, and the change in his view was immediate and comprehensive.

In 1939 (written 1938) Lewis published an extended and persuasive philo-Semitic statement, *The Jews: Are They Human?*—a question expecting the answer yes, as was well understood at the time.[61] Among other favourable reviews was one in the *Jewish Chronicle*, which ended with an extended quotation which made Lewis's philo-Semitic position clear:

We must make up for the doings of the so-called 'Christians' of yesterday—who degraded the Jew, and then mocked at him for being degraded [Lewis wrote]. We must give all people of Jewish race a new deal among us. Let us for Heaven's sake make an end of this silly nightmare once and for all, and turn our backs upon this dark chapter of our history.[62]

[56] Lewis, *The Art of Being Ruled*, 298.
[57] Wyndham Lewis, '"Left Wings" and the C3 Mind', *British Union Quarterly*, 1/1 (Jan.–Apr. 1937), 24. C3 was the lowest category of physical fitness in the armed services.
[58] Ibid. 28. [59] Ibid. 33. [60] Ibid. 125.
[61] Lewis's title was an allusion to a well-known humorous book, G. J. Renier's *The English: Are They Human?* (1935). No reviewer at the time objected to the title; objections today are usually allied with efforts to ignore the book's arguments.
[62] Anon., 'Justice for the Jew', *Jewish Chronicle*, suppl., 193 (Mar. 1939), 10.

Within a period of two years, Lewis had moved from receiving the approbation of Mosley's theorists to establishing an unequivocal position on one of the most important questions of the twentieth century. This statement, and others like it, show beyond doubt that Lewis was not an anti-Semite. It follows that it would be very difficult to characterize him as 'a fascist' without speaking in bad faith. We may hope that this accusation will soon cease to be made. The permanent interest of Lewis's politics lies in his sustained interest in questions of centralization and decentralization, which must lead inevitably to discussions of anarchism and Marxism, and to the most important political question of all: how are we to be governed? Lewis made many mistakes, and there was much that he did not understand, or understood too slowly or too late, but he tried consistently to write from the position of the governed, as the title of *The Art of Being Ruled* indicates. Politically, he has more to offer than any other literary modernist.

T. S. Eliot

Eliot's politics are not often in accord with his poetry. There is a mismatch between the conceptual revolution and the radical new rhetorics of *The Waste Land* (1922) and Eliot's declaration that the 'general point of view' of his thought during the 1920s 'may be described as classicist in literature, royalist in politics, and anglo-catholic in religion'.[63] We shall see that these ideas derived from Eliot's pre-1914 reading of the French writers Charles Maurras and Pierre Lasserre. Readers at the time were dismayed by this declaration because it contradicted the widespread interpretation of the poem as a disruptive and implicitly 'left-wing' intervention in culture. Yet by 1922 Eliot had already published four of the poems upon which the case for his anti-Semitism is now based. They had appeared in *Ara Vos Prec* in 1920 (as *Poems* in the US), where the major problematic poem is 'Gerontion'. Subsequent political developments take place largely in the prose: first in *For Lancelot Andrewes* in 1928; next in *After Strange Gods* in 1934, and subsequently in journalism and articles published in the journal that he edited, *The Criterion* (until its closure in 1939), and in the *New English Weekly* in the later 1930s and the 1940s. *The Idea of a Christian Society* (1939), and *Notes Towards the Definition of Culture* (1948, rev. edn 1963) confirm the essential conservatism of Eliot's mind. It was not a mistake to read *The Waste Land*—or the earlier 'The Love Song of J. Alfred Prufrock', among many other poems—as disruptive modernist texts. The mistake may have been to consider that such work represented the normative tendency of Eliot's mind.

[63] T. S. Eliot, 'Preface' to *For Lancelot Andrewes: Essays on Style and Order* (London: Faber and Faber, 1970), 7.

The case that anti-Semitism is intrinsic to certain of Eliot's pre-*Waste Land* poems has been made most effectively by Anthony Julius, where his strongest attack is upon 'Gerontion', which is 'a condensed instance of [many] anti-Semitic themes' which Eliot 'economically renders...in the image of the squatting Jew, perched on a window-sill'. Eliot is skilful, a great writer who can condense in an image 'a horror picture, drawn with loathing'.[64] Eventually 'the unremitting negativity of the poem aborts the anti-Semitism, leaving it undeveloped and lifeless'.[65] Eliot's anti-Semitism is neither a prejudice nor a success, but an aspect of writing that can fail as any writing may fail.

What can we make today of the arguments in *For Lancelot Andrewes*? These essays have become obscure, relics of disputes no longer significant, and of interest today only as part of the history of Eliot's development. It was not always so. By the late 1920s there had occurred what Aaron Jaffe describes as 'the growing coherence of Eliot's political and religious conservatism and [the] growing coherence of Eliot as signifier'.[66] He signified nothing less than the state of culture. Yet Eliot's advocacy of Bishop Andrewes over John Donne has failed. The essay on Irving Babbitt—the conservative-minded Harvard professor who influenced Eliot against Rousseau and Romanticism—omits to explain why Eliot is now rejecting him, though the phrase that great thinkers should not be 'torn from their contexts of race, place, and time'[67] remains important because it tells us Eliot believed that there were 'races', and that they should remain in the places they originally occupied. This is repeatedly argued in the 1930s, notably in *After Strange Gods*, which reprints three lectures delivered at the University of Virginia, in which Eliot sets out to redefine the term 'tradition', which had been associated with his thinking since 'Tradition and the Individual Talent' of 1919. The first essay is about tradition and orthodoxy, the second about the crippling effects on contemporary writing of the absence of a tradition, and the third is about blasphemy. Orthodoxy, of which he approves, is opposed by heresy. Together, these essays assert the importance of community, in the sense of a community of religious believers. Eliot values Virginia, as a place, because 'you have been less industrialised and less invaded by foreign races', and the soil is 'opulent'.[68] The notorious remark about Jews emerges, like a bolt from the blue, out of an apparently measured discussion of place:

Stability is obviously necessary...The population should be homogenous...What is still more important is unity of religious background; and reasons of race and religion combine to make any large number of free-thinking Jews undesirable...And a spirit of excessive tolerance is to be deprecated. We must also remember that...the local community must always be the most permanent.[69]

[64] Julius, *T. S. Eliot, Anti-Semitism, and Literary Form*, 49.
[65] Ibid. 61.
[66] Aaron Jaffe, *Modernism and the Culture of Celebrity* (Cambridge: Cambridge University Press, 2005), 72.
[67] Eliot, *For Lancelot Andrewes*, 104.
[68] T. S. Eliot, *After Strange Gods: A Primer of Modern Heresy* (London: Faber and Faber, 1934), 16.
[69] Ibid. 20.

A powerful emotional charge erupts into the text, and as suddenly dies down, though not before carrying with it a deliberate jibe at the 'Liberal' concept of tolerance: Eliot considered contemporary society to be 'worm-eaten with Liberalism'.[70] It is difficult to understand how his reputation for detachment, careful thought, and intellectual control could have survived such an episode as this. Yet it has survived, and those characteristics remain part of his cultural authority. Eliot never allowed *After Strange Gods* to be reprinted, but its arguments do not lie outside the canon in any way. They are an extreme statement of ideas central to his thinking.

Although it is probably true that in certain poems Eliot makes poetry out of anti-Semitism, the question of whether he was, or remained, a consistent anti-Semite is a different one, and one that almost certainly cannot be answered in the affirmative. It is difficult to maintain that Eliot was anti-Semitic in the years after the Second World War, because nothing culpable is said, though there are lapses of understanding. One reason for this, it has been argued persuasively, is the long correspondence between him and the philosopher Horace M. Kallen, who was Jewish. A close sympathy developed. Eliot wrote to Kallen in 1954: 'The only problem that seems to me vital is the religious problem. The racial problem, as between Jews and Gentiles, ought not to exist . . . What I feel sure of is, that a *culture* is the outcome of, the living garment of, a religion.'[71] Again culture is impossible without religion. The essential difficulty with Eliot's politics is the persistence of what he learned from Maurras and Lasserre, mentioned earlier. Irrespective of all the changes in modernity, these ideas persist, notably in the desire for hierarchy and order, and in the assertion that there can be no culture without religion. If we are to challenge Eliot politically, it is these ideas that must be challenged.

Sometimes Eliot's thinking was exposed by historical events. On the eve of the Second World War, an event which was to transform democracy from below and result in the Labour government of 1945 (which would set up the National Health Service), Eliot wrote a corrosive review that ironized the term 'democracy' and implied, without actually arguing or producing evidence, that most people are incapable of the thinking necessary to participate in a working democracy. Politics and economics 'are matters that few can understand, and fewer still can do anything about: the great majority of people should be taught to understand what they can understand, and to think about those things to which their thinking can make some difference'.[72] In other words, accept your distance from power, and then think only about what you already know, for (since you *are* distant from power) there will be no opportunity to change anything other than what you know. This is a polemic that arises from the arguments about local communities and not moving about: 'keep

[70] Ibid. 13.
[71] T. S. Eliot, quoted in Ranen Omer, '"It Is I Who Have Been Defending a Religion Called Judaism": The T. S. Eliot and Horace M. Kallen Correspondence', *Texas Studies in Literature and Language*, 39/4 (1997), 331.
[72] T. S Eliot, 'On Reading Official Reports', *New English Weekly*, 15/3 (11 May 1939), 61.

your place', in more senses than one. Polemical Eliot was not always a competent thinker, however, and this kind of insinuating argument requires our alert criticism.

It is anarchism that has most surprised us, as Joyce and Lewis turn its theories to their own particular uses. Eliot resembles Pound, in that there are no major figures in his background: no Marx, or Proudhon, or Bakunin. The figures behind T. S. Eliot are Charles Maurras, Pierre Lasserre, and Irving Babbitt. The first two were right-wing French intellectuals of the later nineteenth and early twentieth century, and Babbitt (1865–1933) was the Harvard professor who persuaded Eliot (and more than one generation of US students) of the importance of Maurras and Lasserre. Eliot's politics were settled early, and his self-description in *For Lancelot Andrewes* derives from a description of Maurras as 'classique, catholique, monarchique' made in March 1913 in the French journal *Nouvelle Revue Française*. The significance of this, as Peter Ackroyd has pointed out, is that Eliot was in Paris at that date, and almost certainly read those words. He had, after all, gone to France to read Maurras and Lasserre, in order to explore for himself the intellectual formation urged by Babbitt.[73] Eliot's politics were settled early, and did not greatly change.

Who then was Charles Maurras (1868–1952)? He founded the Action Française movement in 1899, and propagated an extreme form of nationalism (*nationalisme intégrale*) and monarchism, through the *Action Française* newspaper. Like Brasillach, he was arrested in September 1944, accused of complicity with the enemy, and sentenced to life imprisonment. It is another case of seeking the physical control of a person holding certain ideas. The question of whether Eliot ever repudiated Maurras remains open, according to Craig Raine. He cites Eliot writing in the *Christian News-Letter* of 3 September 1941 against the Nuremberg laws as applied in Vichy France: 'we can only hope that there has been, or that there will be, some organised protest against such injustice, by the French ecclesiastical hierarchy'.[74] This repudiation of anti-Semitism logically requires the repudiation of Maurras's anti-Semitism, it is argued, but Raine concedes that elsewhere 'Eliot does not absolutely repudiate Maurras,' but since we do not know precisely what it was in Maurras that Eliot found '"exasperating" and "deplorable"',[75] the matter remains open.

Pierre Lasserre (1867–1930) was a prominent intellectual, who published the first book on Maurras in 1902. An example of Lasserre's writing may usefully indicate what Eliot owed to him. *Le Romantisme français*, first published in 1907, is a sustained attack on the Romantic movement as it originated with Jean-Jacques Rousseau. In a chapter entitled 'Rousseau is Romanticism', Lasserre attacks Romantic individualism because the thoughts that individuals can generate in isolation are inadequate, whereas 'richness of spirit requires a full and generous engagement with life'. This conception of community means that there must be a culture of order: 'Taking into account its attributes of intelligence, intellectual sensitivity, sociability, and morality, human nature is an organization or—more accurately—a culture, one which may be

[73] Peter Ackroyd, *T. S. Eliot* (Harmondsworth: Penguin, 1993), 41.
[74] Craig Raine, *T. S. Eliot* (New York: Oxford University Press, 2006), 174.
[75] Ibid. 175.

as delicate and fragile as it is rich, but which is unable either to succeed or to sustain itself except in the best-ordered political situations.'[76]

Culture means order, and order requires a particular politics. We need not doubt that this politics will be conservative, or reactionary. Culture includes, but is not limited to, literature, art, and philosophy. That became Eliot's view: 'Eliot considered modern life and modern art and literature to be aspects of the same condition.'[77]

Lasserre speaks calmly here, but his language is often intemperate. In Romanticism, he wrote, 'disorder is renamed liberty, confusion is called genius, instinct becomes reason, and anarchy is renamed energy'.[78] His chapters on Rousseau's influence could be entitled, he tells us, 'the organic growth of a virus'.[79] Eliot, despite a reputation for austerity and self-control, writes with a similar extravagance and contemptuousness. There is such a passage in his late work *Notes Towards the Definition of Culture*, which begins calmly:

I dare say that some readers will draw political inferences from this discussion: what is more likely is that particular minds will read into my text a confirmation or repudiation of their own political convictions and prejudices. The writer himself [i.e. Eliot] is not without political convictions and prejudices; but the imposition of them is not part of his present intentions. What I try to say is this: here are what I believe to be essential conditions for the growth and for the survival of culture.

That sounds reasonable, though we should note how close 'the growth and . . . the survival of culture' is to Lasserre's sense of the need for culture to succeed and sustain itself ('réussir [et] s'entretenir'). But Eliot goes on in quite a different manner, in effect insulting those who may disagree with him:

If they [the 'essential conditions'] conflict with any passionate faith of the reader—if, for instance, he finds it shocking that culture and equalitarianism should conflict, if it seems monstrous to him that anyone should have 'advantages of birth'—I do not ask him to change his faith, I merely ask him to stop paying lip-service to culture.[80]

The reader can only participate in these definitions of culture by submitting at the outset to a set of disabling requirements imposed by the author. This is Eliot's version of Lasserre's calculated insult, and we have seen such emotional outbreaks before. It is the revenge of Lasserre's classicism, and it is an indication of the consistent French influence upon Eliot's political thinking. By emphasizing the importance of Lasserre

[76] 'La richesse de l'esprit consiste dans une communication abondante et généreuse avec la vie . . . la nature humaine, dans ses attributs propres d'intelligence, de sensibilité intellectuelle, de sociabilité et de moralité, est une organisation ou, pour mieux dire, une culture, culture aussi délicate et fragile que riche, qui n'a pu réussir, comme elle ne peut s'entretenir, que dans les milieux politiques les mieux ordonnés' (Pierre Lasserre, *Le Romantisme français: Essai sur la révolution dans les sentiments et dans les idées au XIX siècle* (Paris: Garnier Frères, 1919), 17).

[77] Louis Menand, 'T. S. Eliot', in A. Walton Litz, Louis Menand, and Lawrence Rainey (eds), *The Cambridge History of Literary Criticism*, vii: *Modernism and the New Criticism* (Cambridge: Cambridge University Press, 2000), 17.

[78] Lasserre, *Le Romantisme français*, 18.

[79] Ibid. 19.

[80] T. S. Eliot, *Notes Towards the Definition of Culture* (London: Faber and Faber, 1948), 16.

(and Maurras) to the origins of Eliot's political thinking, I am suggesting that the politics were in place very early, and that the important poems followed upon them, and are in many respects at variance with those politics, or can be read as though they were at variance with them. The politics themselves do not develop; they vary, for classicism, royalism, a distrust of democracy, and (after his conversion in 1927) a belief in original sin, are already present in Maurras. If we are to understand Eliot's politics, we must go back to their origins in reactionary French thought.

VIRGINIA WOOLF

Virginia Woolf (1882–1941) belonged to one of the great liberal nineteenth-century families, the Stephens. Her father, Leslie Stephen, was compiler of the *Dictionary of National Biography*, one of the supreme nineteenth-century educational institutions. In 1913 she attended, with her husband, Leonard, a Fabian Society conference. This represents a move to the left. At the conference she made notes: 'Nothing ignoble in being a consumer . . . Man wage-earner can make his power felt, woman consumer very little power. Wage earner's view predominates.'[81] One source for Woolf's feminist politics lay, therefore, in an encounter with socialism; yet her feminism, as it develops, cannot be called socialist feminism, just as the place given to working-class characters in her fiction suggests that she recognizes the importance of class, without herself being a socialist. Woolf belonged to a liberal political and cultural elite, and was attracted by, but never committed to, positions on the left. She was committed to influential cultural networks of a kind that survived from the nineteenth century, and the phenomenon known as 'Bloomsbury' is a survival of that kind. Its influence in defining and promoting culture cannot be underestimated. Woolf played an important part in this, and today her name lends powerful legitimacy to certain cultural positions within academic discussion, notably Bloomsbury itself, and a certain position in cultural feminism.

Woolf's direct political involvement can be tantalizingly indistinct. During the General Strike of May 1926, her husband, Leonard Woolf—who was wholly committed to the striking workers—resisted a suggestion from Maynard Keynes, the economist, 'to print a pro-strike edition of the *Nation* [a weekly magazine of politics and literature] on the Hogarth press machine'—the Woolfs owned the Hogarth Press. 'Virginia disagreed with him,' writes Hermione Lee, but adds no more.[82] No doubt evidence is lacking; but this suggests Virginia Woolf's own position must have been in some way socialist, and was evidently activist. She was interested—sceptically and satirically—in the language men used to describe the General Strike, whether on

[81] Quoted in Hermione Lee, *Virginia Woolf* (London: Chatto & Windus, 1996), 329.
[82] Ibid. 533.

the radio or between themselves, but the literary consequences were delayed, and went into *A Room of One's Own* (1929) and *Three Guineas* (1938), the latter arguably her political masterpiece. Woolf's interest in what we might call the politics of institutions, notably parliament, and the politics of left and right among writers and artists of her time, is relatively slight, and tends to be dismissive. When Stephen Spender sent her his left-wing political poem *Vienna* (1934), she responded to his request for comment with 'but d'you think criticism is any use? If so, why? I mean of the living, by the living?'[83] This was evidently not her view when she wrote 'The Leaning Tower', in which she does not hesitate to criticize, and at length, Louis MacNeice's *Autumn Journal* (1939). The imaginary tower that gave the writer a position from which to look down upon the world stood upright throughout the nineteenth century, and until 1914. It relied upon an education that derived from class position and money (something that Woolf was in a position to recognize, since she benefited from it herself), but produced writers who 'wished to help the working class to enjoy the advantages of the tower class', not to destroy it, but 'rather to make it accessible to all'.[84]

This is the patrician liberal speaking. The new post-1925 generation are different; for Cecil Day-Lewis, W. H. Auden, Stephen Spender, Christopher Isherwood, 'Louis MacNeice and so on',[85] the tower is leaning, because since the First World War so much has changed in Germany, Russia, Italy, and Spain. There are new feelings: 'Discomfort; pity for themselves; anger against society'.[86] Woolf makes it sound as though these writers are at fault in being angry at current social and political conditions: 'They read Marx. They became communists; they became anti-fascists,' and as a result 'their state of mind as we see it reflected in their poems and plays and novels is full of discord and bitterness'. So MacNeice's *Autumn Journal* is for Woolf 'feeble as poetry, but interesting as autobiography';[87] he, like the other Leaning Tower poets, is 'profiting by a society which they abuse', and this 'explains the destructiveness of their work, and also its emptiness'.[88] MacNeice's long, reflective poem, with its controlled rhetoric and ironic poise, technically skilful to a remarkable degree, is not recognizable here; and she does not dare to take on Auden. Why does she not quote from MacNeice's fine pages on the Spanish Civil War, an event which had meant so much to her in *Three Guineas*? When she writes that 'The influence of the films explains the lack of transitions in their work and the violently opposed contrasts,'[89] Woolf is dismissing exactly what is interesting in these writers, their modernity. (The word 'violence' is applied to them suspiciously often.) Then Woolf

[83] Letter, 12 May 1935, in *The Sickle Side of the Moon, The Letters of Virginia Woolf*, v: *1932–1935*, ed. Nigel Nicolson (London: Hogarth Press, 1979), 392.

[84] Virginia Woolf, 'The Leaning Tower', in *Collected Essays*, ed. Leonard Woolf, ii (London: Hogarth Press, 1966), 169.

[85] Ibid. 170. [86] Ibid. 171. [87] Ibid. 172.

[88] Ibid. 175. [89] Ibid.

asks the impossible: 'They can destroy bourgeois society ... but what have they put in its place?' As a writer possessing political understanding herself, she must have known that this was an unreasonable question. Her peroration is inflated: 'It is thus that English literature will survive this war and cross the gulf—if commoners and outsiders like ourselves make that country our own country, if we teach ourselves how to read and to write, how to preserve, and how to create.'[90] The implication is clear: Spender, Auden, and MacNeice were left-wing writers who could not write and were in some way not of the country (the two last went to the United States for part of the war, and were heavily criticized for doing so). This is not only ungenerous, it is apolitical.

Given Woolf's very high reputation, it comes as a surprise to find a recent biographer, Julia Briggs, asking 'Was Virginia Woolf anti-Semitic?'[91] Briggs quotes from a 1938 short story entitled 'The Duchess and the Jeweller', in which a Jewish jeweller called (of all things) Bacon, allows himself to be sold false pearls by a duchess because he is in love with her daughter, and will be permitted to meet the daughter if he does not question the pearls' authenticity. He is 'the richest jeweller in England', but he wants more, and the daughter is imaged as a truffle which he searches out with his nose: 'but his nose, which was long and flexible, like an elephant's trunk, seemed to say by its curious quiver at the nostrils (but it seemed as though the whole nose quivered, not only the nostrils) that he was not satisfied yet'.[92] Briggs asks all the right questions of this—but ends by exonerating Woolf: 'Different kinds of apology may be offered for this story,' she writes, concluding that 'Woolf's anti-Semitism is characteristic of her class and her moment—casual, unsystematic, and apparently thoughtless': yet by her own account this story was revised as the result of objections from an agent that it was 'racist'.[93] Hermione Lee is also ready to exonerate this story: 'She [Woolf] spells out her complicity in bigotry and offensiveness by way of self-accusation and social critique.'[94] This is difficult to believe. Briggs outlines a long history of anti-Semitic remarks and characterizations in Woolf's writing, going back to 1909, but recurring most noticeably in the novel *The Years* (1937), where Sara Pargiter feels contaminated by a Jew named Abrahamson with whom she has to share a bath: 'And tomorrow there'll be a line of grease round the bath,' she says, and sings: 'the Jew's in my bath'.[95] Again Woolf is excused: she 'might simply have overlooked the myth of Jewish contamination on which it depends': yet her husband, Leonard, was himself a Jew—the 'penniless Jew' she called him.[96] Are we to assume that the

[90] Woolf, 'The Leaning Tower', 181.
[91] Julia Briggs, *Virginia Woolf: An Inner Life* (London: Allen Lane, 2005), 305.
[92] Virginia Woolf, *A Haunted House: The Complete Shorter Fiction*, ed. Susan Dick, introd. Helen Simpson (London: Vintage, 1985), 243.
[93] Briggs, *Virginia Woolf*, 307.
[94] Lee, *Virginia Woolf*, 680.
[95] Briggs, *Virginia Woolf*, 305.
[96] Ibid. 307.

question of anti-Semitic myths did not come up between them, in the intensely talkative intellectual atmosphere of Bloomsbury?

It is not difficult to imagine the sustained critical denigration that would have descended upon Lewis, Pound, or Eliot if they had written about Jewish noses and truffles, or contamination, in this way. The matter would never have been forgotten and there would have been no easy excuses. It does appear that anti-Semitism is treated by some recent criticism as being a relative matter. Christine Froula has taken the question a step further. In her discussion of *The Years*—which she reads as an essay–novel, that is, a novel with something explicit to say, rather as 'The Leaning Tower' does—she concludes by saying that the novel may be saying two things: that the present (*c.*1936–7) is better than the past, and that the present is a refuge (my own view); alternatively, Maggie's final outburst of laughter is as impotent as any 'new word'—written text—in acting 'against the economic and political engines of fascism and war'.[97] Here, the male modernists are implicated: 'Like Pound's radio speeches, Eliot's religious incantations, and Joyce's laminate dream-language, Maggie's laughter sounds at a moment of impending violence no word will forestall.' Nothing can be done by culture, this reading says. (It is almost certainly wrong: 'Laughter took her and shook her. . . .No idols, no idols, no idols, her laughter seemed to chime . . . and he [North] laughed too';[98] if this means no *political* idols, it is liberating.) Yet the much more optimistic and politically effective *Three Guineas* was to be published in the following year, and that—rather than easy excuses from contemporary critics—mitigates the difficulties and confusions of Woolf's late politics. There she concludes by establishing a parallel between the domestic domination of the father figure and the rise of dictators in Europe, a move in which private and public are related, for 'the tyrannies and servilities of the one are the tyrannies and servilities of the other'.[99]

Finally, given the emphasis in the opening pages of this discussion upon the arrest and conviction of writers after the war, let us recall that had the Germans successfully invaded Britain in 1940, there existed a list of intellectuals and writers who would be held, and that Leonard and Virginia Woolf were near the top of it. Woolf was described as *Schriftstellerin*, 'a writer of distinction'.[100] Evidently there could be different reasons for arresting writers, and the different occasions tell us much. Froula ends by asserting that 'Woolf's legacy and Bloomsbury's is the unfinished and unfinishable fight for civilization—peace, freedom, art, beauty, sociability—that they hand on to the later generations.'[101] To limit civilization to a highly specific cultural formation called 'Bloomsbury' is absurd; for this group, of which Woolf herself is almost the only distinguished member, did not own civilization. Nor should we wish to mimic their 'sociability' and expect to be taken seriously. Other modernist writers believed equally in the values of civilization, art, and sociability, and several of

[97] Christine Froula, *Virginia Woolf and the Bloomsbury Avant-Garde: War, Civilization, Modernity* (New York: Columbia University Press, 2004), 255.
[98] Virginia Woolf, *The Years* (London: Hogarth Press, 1951), 458.
[99] Virginia Woolf, *Three Guineas* (London: Hogarth Press, 1986), 162.
[100] Froula, *Virginia Woolf*, 323.
[101] Ibid. 324.

them got the politics wrong. They nevertheless deserve the cultural good that is in them to be recognized. If necessary, they should be forgiven, as Woolf has been.

CONCLUSION

Since writers do not lead political parties, they cannot practise the politics of hope on a large scale, but must instead find small communities to work from. Woolf found in Bloomsbury a secure location and an influential cultural community that supported her work, but other modernists found themselves in very different political and cultural contexts. Joyce's exile took him away from community, and not only away from those Irish origins that could never have sustained him, but into intellectual isolation in Trieste and Zurich; eventually there gathered around him in Paris in the 1930s a group of intellectuals and writers who supported him and propagated his work. Pound isolated himself in Rapallo, and his community was the community of his many correspondents, to whom he wrote thousands of letters every year, often in the attempt to propagate, by an act of will, the economic theories that possessed him. Lewis remained committed to the city and to modernity, for he did not take the rural option, as Pound and Eliot did. Yet he had relatively little influence in London, even though, of all the modernists, he was most committed to the idea of relationship as something representable in art and writing, and of culture as a relational activity. Eliot was the most politically successful modernist. Although he committed himself to a religious community of elite Anglicans (a culture that we find difficult to value today), he established an immense cultural and political authority—through his poetry and criticism, through his ownership of the journal *The Criterion*, and by his participation in the publishing house Faber and Faber. To be effective, hope has to be institutionalized. All these modernist writers, different as they were, used their particular communities to turn political belief into cultural power.

IMAGE, PERFORMANCE, AND THE NEW MEDIA

CINEMA, MODERNISM, AND MODERNITY

JAMES DONALD

ON 3–7 September 1929, six weeks before the Wall Street Crash, many of the world's leading independent film-makers gathered together at the ancient castle of La Sarraz in Zurich for the first Congrès International du Cinéma Indépendant—usually translated, with a slight twist, as 'International Congress of Avant-Garde Film'. The star attraction was Sergei Eisenstein, Soviet director of the still widely banned *Battleship Potemkin*. Also taking part were Grigori Alexandrov, Béla Balázs, Alberto Cavalcanti, László Moholy-Nagy, Ivor Montagu, Léon Moussinac, Hans Richter, Walter Ruttmann, Eduard Tissé, and other guests from Europe, Japan, and the US. The topic was 'The Art of Cinema, its Social and Aesthetic Purposes'.

At the end of the Congress, plans were announced to establish an International League for Independent Film. The League was to be a cooperative of national organizations, all committed 'as an absolute principle' to 'the difference in practice and spirit between the independent cinema and the commercial cinema', and all working to create the 'commercially, politically and religiously independent film'.[1] In the same spirit, though more playfully, the delegates, led by Eisenstein, improvised a short film. One of them, Jeannine Boussinouss, was dressed up as the Virgin Independent Film, and imprisoned, ostentatiously, high on one of the castle's towers. Below her, an Army of Independent Film, commanded by Eisenstein, mounted astride a camera tripod, attempted to rescue this damsel in distress from the wicked

[1] James Donald, Anne Friedberg, and Laura Marcus (eds), *Close Up, 1927–1933: Cinema and Modernism* (London: Cassell, 1998; Princeton: Princeton University Press, 1999), 32. See also Ian Christie, 'French Avant-Garde Film in the Twenties: from "Specificity" to Surrealism', in *Film as Film: Formal Experiment in Film, 1910–1975* (London: Hayward Gallery/Arts Council of Great Britain, 1979), 37.

Army of the Industrial Film, led by a heavily armed Béla Balázs. ('The enthusiasm of Eisenstein was so infectious', commented Jean Lenauer in his report for the journal *Close Up*, 'that all the serious minded were tempted to forget their dignity and do as he instructed.'[2])

Here is one possible take on modernist cinema. Although, at the time, no one at La Sarraz would have used the word—'modernism', as a critical or historical term, appears not to have been applied to cinema until the 1940s, after the art historian Clement Greenberg had given it cultural currency—the melodramatic opposition between Independence and Commerce, and the equation of virtuous, critical Art with Independence from the corrupting influence of evil Market Forces, has always been a tempting image of cinema as cultural institution. But the brutal simplicity of 'Art for art's sake, money for God's sake!' is misleading. Even at La Sarraz, there was no agreement about the relationship between art, independence, and any particular style of film-making. G. W. Pabst, the director of critically acclaimed films like *Joyless Street* (1925) and *Pandora's Box* (1929), had been invited to the Congress and intended to be there. The abstract experimentalist Hans Richter was, according to Lenauer's understated report, 'rather perturbed' on the grounds that 'Pabst made "spielfilms", that is films with plot and action, with professional actors.' For Richter, such truck with narrative fiction, let alone with commercial cinema, set Pabst beyond the pale of independence—clearly itself a problematic term, as when Lenauer refers to 'the independent film (formerly *avant garde film*)'.[3]

The consensus that emerged from the Congress was that 'independence' could refer to a gamut of films, running from the kind of pure, abstract experimentalism of people like Richter, Viking Eggeling, and Oskar Fischinger, through to fictional narratives addressing serious issues in aesthetically self-reflective ways—films like those, in their different styles, of Pabst in Germany, Eisenstein in the Soviet Union, or the French 'Impressionists' like Jean Epstein, Abel Gance, Marcel L'Herbier, and Germaine Dulac. What the delegates wanted was not just new sources of funding to support production, but a different, often state-endorsed mechanism for distributing such films. An alternative exhibition circuit would make them commercially viable, by delivering them to a specific cinema audience; that was, as Lenauer saw it, 'a public already educated and intelligent'.[4] To use another anachronism, the delegates at La Sarraz were talking about 'art cinema', and the audience to whom it appeals.

This inclusive vision of a sustainable minority cinema did not last long. There was only one more meeting of the Congress, in Brussels, in 1930. In the course of one year, optimism had largely evaporated, and the tone had become both elegiac and more militant. The 1920s avant-garde movement 'expired', according to Hans Richter, because emerging political tensions 'made poetry no longer suitable ... Our age

[2] Jean Lenauer, 'The Independent Cinema Congress', *Close Up*, 4/6 (June 1929); repr. in Donald et al. (eds), *Close Up, 1927–1933*, 277.

[3] Ibid. 274. [4] Ibid. 277.

demands the documented fact.'[5] It was the social purpose of film, rather than film aesthetics, that was increasingly taking first place, at the same time as the coming of sound cinema and the impact of the Depression were pushing mainstream industries towards more standardized commercial 'product'.

WHEN WAS MODERNIST CINEMA?

Hans Richter declared that the independent or avant-garde cinema of the 1920s, which might have some claims to being described as a modernist phenomenon, was over by 1930. So how come that, more recently, we find Laura Mulvey hailing Roberto Rossellini's *Journey to Italy* (*Viaggio in Italia*), a film released as late as 1953, as 'the first modern film'?[6]

To put that question another way: when was modernist cinema? It is not an innocent question. When Raymond Williams asked 'when was modernism?' it was less in a spirit of disinterested historical inquiry than with ideological intent. In an attempt to rescue modernism from the postmodernism he disliked, Williams wanted to shift its literary origins from 'the conventionally Modernist names of Proust, Kafka, or Joyce' to the city-inspired social realism of the mid-nineteenth century and 'the metaphoric control and economy of seeing discovered and refined by Gogol, Flaubert or Dickens from the 1840s on'.[7] Similarly, any periodization of modernist cinema will not only imply a critical perspective, but may also entail an ideological agenda.

In his selection entitled *Masterpieces of Modernist Cinema* (2006), Ted Perry posits an ideal type of a 'modernist film' as a challenging, *sui generis* work that exists at a threshold 'where abstraction and realism meet', and which is, thus, never either purely abstract or wholly mimetic. Perry then constructs a canonical narrative around a capacious, if slippery, definition: 'By the term "modernist," I merely mean that the films were made under the influence of the various ideologies associated with and defined by what is called Modernism, however diverse and disparate those ideologies may be.'[8] Despite his disregard for chronology, the films Perry selects come from certain moments far more than from others. The majority date either from the 1920s (*Caligari, Entr'acte, Man with a Movie Camera,* with *L'Âge d'or* on the cusp of the 1930s) or from the 1960s (Warhol's *Sleep*, Resnais's *Last Year at Marienbad*, Bruce Conner's *Report*, Bresson's *Au hasard Balthazar*, and, again on the

[5] A. L. Ress, 'Foreword', in Hans Richter, *The Struggle for Film: Towards a Socially Responsible Cinema* (Aldershot: Wildwood House, 1986), 9–10.

[6] Laura Mulvey, 'Satellites of Love', *Sight and Sound*, 10/12 (2000), 20–4. In her sleeve notes for the BFI DVD release of *Viaggio in Italia* (British Film Institute, 2003), she refers to it as a 'landmark in the development of modern cinema', and as 'a revolutionary moment for modern film aesthetics'.

[7] Raymond Williams, *The Politics of Modernism: Against the New Conformists*, ed. Tony Pinkney (London: Verso, 1989), 32, 33.

[8] Ted Perry (ed.), *Masterpieces of Modernist Cinema* (Bloomington: Indiana University Press, 2006), 1.

cusp, Ernie Gehr's *Still*), along with Maya Deren and Alexander Hammid's *Meshes of the Afternoon* (1943), Stan Brakhage's work from the 1950s on, and Chantal Akerman's *Lives of Performers* (1972).

One way to make sense of that clumping would be to identify the 1920s films as 'modernist', and the 1960s and 1970s films as belonging to that 'modern cinema' which Mulvey implies got going after the Second World War. But that begs a series of questions. What is 'modernist'? What is 'modern'? And what's the difference? Well, if what made *Journey to Italy* modern was its elliptical, apparently almost careless, approach to narration, its use of landscape to project psychological states, and its imbrication of character and landscape with philosophical ideas, then the modernity of this cinema was the modernity (or, confusingly, in some accounts, the modernism) of the reflexive European Art Cinema that flourished from the 1950s through the 1970s—the cinema of Antonioni, Bergman, Bresson, Fassbinder, Fellini, Godard, Pasolini, Resnais, Straub and Huillet, Tarkovsky, Truffaut, et al. But even that move does not explain why such film-makers and film styles should be categorized as *modern*. The answer may be as simple as the impact of Gilles Deleuze's distinction, in his two volumes on cinema, between the *time-image* that is explored in what he calls 'modern' (post-war art) cinema and the *movement-image* that had driven what he names, following Bazin perhaps, as 'classical' (pre-war) cinema. The problem is that, as the Hollywood adage has it, 'nobody knows everything', and it is far from clear that Deleuze, for all the philosophical ingenuity of his arguments about temporality, virtuality, and cinema, should be given the last word on naming and periodizing movements in film history.

In Deleuze's wake, András Bálint Kovács uses the title *Screening Modernism* for his book on European Art Cinema, in the period 1950–80, even though he rejects Deleuze's 'evolutionary' model of a transition from classical to modern. (Instead, adapting the cinematic poetics of David Bordwell and his collaborators, Kovács sees the distinction between modern and classical in stylistic terms: that is, modern/ modernist cinema as an alternative to, and to some extent a critique of, classical cinema.) Kovács acknowledges that there was a 'first encounter' between cinema and modernism in the early 1920s. However, because he accepts Greenberg's premiss that modernism is 'nothing but the aesthetic self-criticism of art', and so infers that a modernist film-making practice must be one that reflects on cinema's own artistic traditions, Kovács decides that cinema in the 1920s had simply not been around long enough to consolidate into the sort of tradition that would be susceptible to that sort of modernist self-critique. To support this view, Kovács invokes Jean-Luc Godard: 'A contemporary writer knows that authors such as Molière or Shakespeare existed. We are the first filmmakers who know that a Griffith existed. At the time when Carné, Delluc and Clair made their first films, there was no critical or historical tradition yet.'[9] Ergo, for Kovács, no modernist avant-garde in the 1920s, and 'modernism' in cinema starts in 1950.

[9] András Bálint Kovács, *Screening Modernism: European Art Cinema, 1950–1980* (Chicago: University of Chicago Press, 2007), 12, 16.

The alternative to the post-Deleuzean orthodoxy is that, if it ever existed, modernist cinema was pretty much done and dusted by 1930. This periodization follows the literary-critical and art-historical consensus that modernism, as an historical aesthetic and cultural movement, ran roughly from 1890 to 1940. It was certainly finished by the Second World War, well before the start of the 'modern cinema' proposed by Deleuze or Kovács. In this view, although the beginnings of modernism and the beginnings of cinema were roughly contemporary, the 'independent' or 'avant-garde' film-making of the 1920s would figure as a phenomenon of 'late modernism', a *lateness* embodied in ultimately forlorn attempts to adapt the aesthetic and cultural logic of modernism to the circumstances and experience of a world radically changed by the emergence of a new media ecology and new forms of mass society, and by the trauma of the First World War. Later, post-Second World War movements may then be seen as, in some sense or other, a negotiation of the modernist tradition, or a reinvention of it, or a reaction against it. Garrett Stewart, for example, refers to the films of the 1960s as 'modernist valedictions'. To get round the problem, Fredric Jameson makes the ingenious argument that *silent* film and *sound* film should be regarded as 'two distinct evolutionary species or subspecies', with the result that each should be regarded as having its own distinctive moment of cinematic modernism as part of its own historical trajectory through the stages of realism, modernism, and postmodernism.[10]

Jameson's differentiation between silent cinematic modernism and sound cinematic modernism is based on the premiss that naming and timing such movements involves not just stylistic features, but 'a designation of culture, and its logic as a whole'. Their nomenclature 'sets us the technical problem of constructing a mediation between a formal or aesthetic concept and a periodizing or historiographic one'.[11] Whether or not the designation of a total logic of culture is really necessary, it is clear that the differences between the 1920s and the 1950s–1970s were not just stylistic. The later manifestations were something different and something new, not least because modernism had changed as understandings of the possible functions of aesthetics had changed. As cultural critic Lee Siegel argues:

Modernism was modernism only when the rising foundations, beams and struts of modernity were still visible. Once modernity became an enveloping condition, artists who were part of that condition—from Pollock to Warhol, from Robbe-Grillet to Grass, from Artaud to Pinter—rebelled as much against modernist Prometheanism as against the modern inadequacies that provoked it.[12]

[10] Garrett Stewart, *Between Film and Screen: Modernism's Photo Synthesis* (Chicago: University of Chicago Press, 1999), 293; Fredric Jameson, *Signatures of the Visible* (London: Routledge, 1992), 216. Jameson speculates whether 'the independent or experimental film in the post-World War II era (e.g., *Dog Star Man* [1959–64] of Stan Brakhage) developed in the empty space of a silent film postmodernism that never happened' (Ibid. 157).

[11] Jameson, *Signatures of the Visible*, 213.

[12] Lee Siegel, 'The Blush of the New', *New York Times*, 30 Dec. 2007, <http://www.nytimes.com/2007/12/30/books/review/Siegel-t.html?pagewanted=print>.

It is in that spirit, and without undervaluing the importance of the later phenome-
non, that this chapter concentrates on the 1920s, a moment when the function and
future of cinema still seemed to be up for grabs. That indeterminacy makes it possible
to tease out a story about how ideologies of modernism shaped certain styles and
practices of film-making, against a backdrop of the ineluctable standardization of
cinema. So the question addressed in the next section is this: are there films from the
1920s that deliver what Wallace Stevens saw as the defining feature of modernism,
which is 'freshness of transformation' in perception, thought, and feeling?[13] At the
same time, remembering that the traffic between cinema and modernism went both
ways, the story will also suggest how cinema helped to define the social, cultural, and
existential moment to which modernism was an aesthetic response.

MODERNIST CINEMA

In the aftermath of the First World War, one film above all appeared to inaugurate
the possibility of modernist cinema. *The Cabinet of Dr Caligari* (Robert Wiene, 1920)
was, at any rate, the film that prompted many modernists to take cinema seriously.
The poet Marianne Moore admitted that *Caligari* was 'the only movie except the Kid
that I have gone to voluntarily in New York . . . It is a German film and the settings are
modern.'[14] Moore's interest in the modernism of the film's design was echoed in the
New York Times review, which invoked New York's avant-garde Armory Show in 1913
to frame *Caligari* and to make sense of its novelty: 'The conspicuous individual
characteristic of the photoplay', wrote the *Times* critic, 'is that it is cubistic, or
expressionistic. Its settings bear a somewhat closer resemblance to reality than, say,
[Marcel Duchamp's] famous "Nude Descending a Staircase". But they are sufficiently
unlike anything ever done on the screen before to belong to a separate scenic species.'[15]

To the Bloomsbury art theorist Clive Bell, the newness of *Caligari* lay in the
unintended, and ambivalent, consequences that cinema might have for 'real art'. If
this new 'machine art' could produce a work of *Caligari*'s compromised quality,
might cinema push 'personal art'—true art—in ever more esoteric directions?

Caligari, so far as I know, is the first attempt to create an art of the cinema. To begin with the
story is not wholly contemptible; and it is well chosen because there are things in the

[13] Wallace Stevens, *Notes Toward a Supreme Fiction*, in *The Palm at the End of the Mind: Selected Poems
and a Play*, ed. Holly Stevens (New York: Random-Vintage, 1971), 224; quoted and discussed in Vicki
Mahaffey, *Modernist Literature: Challenging Fictions* (Oxford: Blackwell, 2007), p. vii. It is Mahaffey who
specifies perception, thought, and feeling as that which is transformed.

[14] Quoted in Laura Marcus, *The Tenth Muse: Writing About Cinema in the Modernist Period* (Oxford:
Oxford University Press, 2007), 127.

[15] Quoted in Anton Kaes, '*The Cabinet of Dr Caligari*: Expressionism and Cinema', in Perry (ed.),
Masterpieces of Modernist Cinema, 43.

nightmare of a lunatic that can be perhaps better expressed by the cinema than by any other means . . . And it is because the Caligari film seems to suggest an invasion of the middle country, of the territory hitherto occupied by those painters and writers who stood between the uncompromising artists and the barbarous horde—painters and writers who while giving the semicivilized public what it wanted inveigled that public into wanting something better than the worst—it is because, in a word, the Caligari film forebodes another victory for the machine on the frontiers of art, for the standardized on the frontiers of the personal, that I am inclined to regard its appearance as an event of some importance.[16]

Taken together, the responses by Moore, the *Times* reviewer, and Bell suggest that what came into being with the *Caligari* phenomenon was less a new *style* for cinema than Jean Leanauer's desired new *audience*: 'a public already educated and intelligent'. The film's appeal to this audience lay in its packaging of the 'daring', or 'heretical', characteristics of modernism. By projecting its topos of madness onto the Expressionist design, mise-en-scène, and performance styles of the film, even more than through its apparently unconventional narration, the film shoved big-A Art in its audience's face. But it did so at a price. Jean Cocteau complained that the film was uncinematic, opting for 'flatly photographing eccentric sets, instead of achieving surprises through camera work'.[17] Ezra Pound railed against the way it appropriated, and trivialized, the work of contemporary artists for its own commercial ends: 'Caligari cribbed its visual effects, with craven impertinences, and then flashed up a notice, "This film isn't cubism; it represents the ravings et cetera." Precisely, ravings the inventors couldn't have thought of without the anterior work of new artists.'[18]

Certainly, by the time *Caligari* was released, its techniques of distortion and exaggeration were hardly radical. At least since 1916, Dadaists had been deriding Expressionist literature and theatre for their pathos and idealism, their disregard for reality, and their belief in the power of the individual, especially the artist. This subjectivism, they objected, was rendered redundant or obscene by the brutal inhumanity of the war.[19] In Fritz Lang's *Dr. Mabuse, the Gambler*, made only two years after *Caligari*, Mabuse is asked: 'Tell me, Doctor, what is Expressionism?' To which he replies: 'Oh, it's just another game'.[20] Aesthetically, *Caligari*'s legacy is to be found less in avant-garde or independent cinema than in Universal horror pictures of the 1930s and Hollywood *film noir* in the 1940s.

The point is that the Expressionism of *Caligari* represents as much a technique of modern niche marketing as a triumph of modernist formal experimentation. The film offered to an emerging 'middlebrow' audience the lure of a challenging but not too difficult artistic respectability, with the additional pleasure of being able to claim a degree of distinction from mass culture. This creation of an 'art-house' audience was not accidental. Having been wrecked by the war, and with desperately inadequate resources, the German industry needed to produce films that would make themselves

[16] Quoted in Marcus, *The Tenth Muse*, 126.
[17] Ibid.
[18] Harriet Zinnes (ed.), *Ezra Pound and the Visual Arts* (New York: New Directions, 1980), 176.
[19] Kaes, '*The Cabinet of Dr Caligari*', 44. [20] Ibid.

noticeable in the States, where a certain number had to be shown to meet the terms of the quota deal that opened up the German market to Hollywood. If the highbrow cachet of *Caligari*, especially in export markets, was achieved through its assertive but digestible claims to being both artistic and modern, as well as still transgressively German, the film's success with audiences as a movie experience may be a tribute to its ingenious repackaging of more familiar experiences. This was how Gilbert Seldes saw it, subversively, in *The Seven Lively Arts* as early as 1924.

The Cabinet of Dr Caligari... owes its success to the skillfully concealed exploitation of the materials and technique of the spectacle and of the comic film, and not to the dramatic quality of its story. The studio settings in distortion represent the spectacle; they are variations of scenery or 'location'; the chase over the roofs is a psychological parallel to the Keystone cops; and the weak moment of this superb picture is that in which the moving picture always fails, in the double revelation at the end, like that of *Seven Keys to Baldpate*, representing 'drama'.[21]

If, at the beginning of the 1920s, *The Cabinet of Dr Caligari* helped to create an audience for modernist film, whether or not it is usefully described as a modernist film itself, then it is worth considering which films may be illuminated by thinking about them through the critical prism of modernism.

At the time, this impulse might well have been articulated through the question of how film could offer new ways of seeing, impossible in any other medium. Did the camera have the inherent capacity to deliver Stevens's 'freshness of transformation' in *perception*, by seeing and showing the world in ways that the human eye could not? And, if it did, how might the temporal dimension of film be harnessed, through the techniques of montage, to transform and refresh *thought* and *feeling*?

Jean Epstein hoped that the technology of the camera might purify the act of vision, by detaching observation from the taint of cultural habit: 'The lens of the camera is an eye without prejudice, without morals, untouched by any influence; it sees in the face and in gesture features that we, consumed with our likes and dislikes, habits and thoughts, are no longer able to see.'[22]

One term used by the Impressionists to capture the uniqueness and novelty of cinematic vision was *photogénie*: an elusive and sometimes almost mystical term, but one that does capture the potential modernism of cinematic vision, in so far as it delivers glimpses or flashes of the eternal in the contingency of the film's passing movement. (The reference, of course, is to Baudelaire's definition of 'modernity' as 'the ephemeral, the fugitive, the contingent, the half of art whose other half is the eternal and the immutable'.[23]) The critic and theorist Louis Delluc articulated the principle of cinematic beauty: 'For a long time, I have realized that the cinema was destined to provide us with impressions of evanescent eternal beauty, since it alone offers us the spectacle of beauty and sometimes even the spectacle of real human

[21] Quoted in Marcus, *The Tenth Muse*, 125.

[22] Quoted in Francesco Casetti, *Eye of the Century: Film, Experience, Modernity* (New York: Columbia University Press, 2008), 8.

[23] Charles Baudelaire, 'The Painter of Modern Life', in *The Painter of Modern Life and Other Essays*, ed. and trans. Jonathan Mayne (Oxford: Phaidon Press, 1964), 13.

activity.'[24] The art historian Élie Faure likewise identified that sublime combination of evanescence and the eternal as the promise of cinema: 'The revelation of what the cinema of the future can be came to me one day: I retain an exact memory of it, of the commotion that I experienced when I observed, in a flash, the magnificence there was in the relationship of a piece of black clothing to the grey wall of an inn.'[25]

Faure's recollection suggests that the aesthetic of *photogénie* was not just about how the camera saw, or revealed, the world. Rather, *photogénie* also implied, or entailed, the recognition and appreciation of those unique flashes of insight by the film spectator, or at least by some film spectators. The modernism of the Impressionists resides in an aesthetic of *individual* refinement rather than in *Caligari*'s art-house 'public already educated and intelligent': that is, in the minority in the audience who can see the beauty, both momentary and eternal, of the photogenic in a visual culture degraded by mass culture.

Despite their emphasis on the visual dimension of film, the Impressionists generally worked with narrative fiction, even if they often pushed beyond its conventional limits. (The British censor memorably rejected Germaine Dulac's film of Artaud's *Le Coquille et le clergyman* (1926) on the grounds that 'This film is so cryptic as to be meaningless. If there is a meaning, it is doubtless objectionable.'[26]) For purists like Richter, as we have seen, photographed fictional narration already betrays film to the dead hand of theatre. For them it was neither fiction, nor narrative, nor even photography that defines the medium, but the temporal and kinetic dimension of the way that a film is assembled: that is, the movement of shapes over time, and so the promise of a purely visual rhythm, but so also, more broadly, the dynamic aesthetic of montage.

The choreographic impetus in montage is perhaps most evident, in the first half of the 1920s, in *Ballet mécanique* (1923). Although primarily a collaboration between the French Cubist painter Fernand Léger, looking to add a temporal dimension to his machine aesthetic, and the young American film-maker Dudley Murphy, several other modernist artists had a hand in its production and left their mark. There are traces of Man Ray's Dadaism, for example, as well as Ezra Pound's Vorticism and the machine-noise music of his protégé George Antheil. Although often viewed as an exercise in purely abstract film-making, much of the interest of *Ballet mécanique* lies in the way that the film takes contemporary images and issues and transmutes them into abstract visual rhythm: the new visual culture alluded to through Léger's marionette of Charlie Chaplin or the cod newspaper headline about a jewel robbery, for example; the themes of sexuality and the 'new woman' evident in the mise-en-scène of Katherine Murphy and Kiki de Montparnasse; or the stop-frame Charleston of a mannequin's legs. And part of the pleasure of the film lies in the tension between Murphy's exuberantly hedonistic Californian experimentalism and Léger's emerging Purist adherence to a new kind of neo-classical discipline—the

[24] Quoted in Marcus, *The Tenth Muse*, 182. [25] Ibid.
[26] Donald et al. (eds), *Close Up, 1927–1933*, 271.

rappel à l'ordre announced by Jean Cocteau in his 1925 book of that name, a reaction against post-war disorientation, pleasure-seeking, and anything-goes relativism in favour of traditional virtues of order, discipline, and beauty in a modern form. 'The romantic pushes to the left—an excess of subjectivity (a warm state),' observed Léger in 1923. 'His opposite pushes toward the right—an excess of objectivity (a cold state).' If Murphy veered towards this version of the left, here Léger knew himself to be (if only in this sense) a man of the right, predisposed to objectivity above all. The experience of working on *Ballet mécanique*, says Léger, taught him 'to consider the event of objectivity as a very new contemporary value'.[27]

The objectivism at the heart of *Ballet mécanique* suggests a very different version of cinematic modernism from the extreme subjectivism of *Caligari*'s Expressionism or the connoisseurship of *photogénie*. This new value chimes with T. S. Eliot's claim that poetry is 'not the expression of personality, but an escape from personality'—at least, and only, for 'those who have personality and emotions' and so 'know what it means to want to escape from these things'.[28] There thus appears to be a possible affinity between a modernist aesthetic and film technology, which emerges as the search for an impersonal, yet uniquely individual, recording eye. This was certainly evident (and not only in film) in the 'new objectivity', or new sobriety, of the Neue Sachlichkeit movement in Germany or in much Constructivist art in the Soviet Union—the cinematic move from poetry to art grounded in documented facts, to recall Hans Richter's terms.

This 'objectivity' did not in any way entail a withdrawal into an ambiguous neutrality, nor a renunciation of political partisanship. Rather, it reinforced a post-war disgust for the consolations of old fictions, and a thirst for new truths. If the camera promised ways of seeing freed from contaminated habits of observation, then, building on this refreshed vision, montage promised a principle of assemblage through which to articulate new perceptions of the world, or projections of new and different worlds. This is what Walter Benjamin was getting at, in the 'Work of Art' essay, when he wrote: 'On the one hand, film furthers insight into the necessities governing our lives by its use of close-ups, by its accentuation of hidden details in familiar objects, and by its exploration of commonplace milieux through the ingenious guidance of the camera; on the other hand, it manages to assure us of a vast and unexpected field of action.'[29]

This was certainly the agenda of one of the most intransigently objectivist films of the 1920s, Dziga Vertov's *Man with the Movie Camera* (1929). In his attempt to purify perception, Vertov stressed the camera's uniquely *mechanical* gaze: 'I, a machine, am

[27] Fernand Léger, *Functions of Painting*, trans. Alexandra Anderson (New York: Viking Press, 1973), 30, 50. See also James Donald, 'Jazz Modernism and Movie Art: *Ballet mécanique*', *Modernism/Modernity*, 16/1 (Spring 2009), 25–49.

[28] T. S. Eliot, 'Tradition and the Individual Talent', in *Selected Prose*, ed. Frank Kermode (London: Faber, 1975), 43.

[29] Walter Benjamin, 'The Work of Art in the Age of its Technological Reproducibility', in *Selected Writings*, iii: *1935–1938*, ed. Howard Eiland and Michael W. Jennings (Cambridge, Mass.: Belknap Press, 2002), 117.

showing you a world, the like of which only I can see. My road leads toward the creation of a fresh perception of the world...I decipher, in a new way, a world unknown to you.'[30] If this cinematic epistemology was to be pressed into the service of the new way of life promised by the Soviet experiment, it had to be rescued from any generic or fictional contamination, and certainly from the conventions of literature and theatre. In terms of transforming thought and feeling, Vertov wanted cinema to 'open the working masses' eyes to the links (neither of the love story nor the detective story) uniting visual phenomena':

The film is the sum of events recoded on the film stock, not merely a summation of facts. It is a higher mathematics of facts. Visual documents are combined with the intention to preserve the unity of conceptually linked pieces which concur with the concatenation of images and coincide with visual linkages, dependent not on intertitles but, ultimately, on the overall synthesis of these linkages in order to create an indissoluble organic whole.[31]

Sergei Eisenstein, the champion of independent film at La Sarraz, famously found Vertov's work too modernist by half, denouncing it as 'formalist jack-straws and unmotivated camera mischief'.[32] In human terms, this was in part a response to Vertov's accusation that, by having an actor play Lenin in his re-creation of the 1917 Revolution in *October* (1928), Eisenstein had sold out and passed off 'acted film in newsreel trousers'.[33] Again, as in the debates about 'pure cinema' and 'independent cinema', the issue is the uses to which cinema's capacity for fresh perspectives and new visions was to be put. One modernist Marxist's disinfected revolutionary vision could well be another Marxist modernist's self-indulgent formalism.

The point of this brief survey of avant-garde or independent cinema in the late modernist moment of the 1920s is less to establish an historical canon of modernist cinema—which would have to include Luis Buñuel's Surrealist *Un Chien Andalou* (1929) and *L'Âge d'or* (1930) as well as many other films from the period—than to suggest what a heterodox set of non-mainstream films may have had in common. A modernist cinema can only ever be a playful critical reconstruction, but the exercise does at least provoke a further question. That is: what, if any, was the relationship between cinema as a modernist avant-garde, and cinema as a new type of industry and a definitively modern type of experience? How, in other words, was the relationship between modernism and modernity played out in the institution of cinema? If modernist literature, and modernist literary study, embodied a militant pedagogic imperative to make reading difficult as a prophylactic against the over-easy consumption of popular narratives, then it might be inferred that modernist cinema would be similarly difficult and oppositional. Modernist

[30] Dziga Vertov, quoted in Vlada Petric, *Constructivism in Film: A Cinematic Analysis: The Man with the Movie Camera* (Cambridge: Cambridge University Press, 1987), 12–13.

[31] Ibid. 130.

[32] Sergei Eisenstein, 'The Cinematographic Principle and the Ideogram', in *Film Form* (Cleveland, Ohio: Cleveland World, 1957), 43.

[33] Dziga Vertov, 'In Defense of Newsreel', in *Kino-Eye: The Writings of Dziga Vertov*, ed. Annette Michelson, trans. Kevin O'Brien (Berkeley: University of California Press, 1984), 146.

cinema would comprise the body of films that attempted, really from surprisingly early on, to cleanse ways of seeing, which had been recuperated for the conventions of nineteenth-century storytelling, characterization, and morality, through the stylistic and industrial innovations of Hollywood directors like D. W. Griffith and Thomas Ince. Again, however, the heroic imagery of truth-seeking modernist art against corrupting modern entertainment is too black-and-white, too conveniently melodramatic. Another way of looking at this picks up on Raymond Williams's observation that one precondition for the appearance of modernist aesthetics was the emerging media ecology of the late nineteenth and early twentieth century. But rather than see the relationship, as Williams does, in terms of a defensive reaction, the more interesting question is whether, if modernism was supposed to be all about disrupting habits of perception, norms of behaviour, and common sense, those modernist transformations were in part *achieved* by mainstream cinema in its earliest decades. Cinema, on this view, not only gave form to new ways of seeing, which were themselves shaped by new ways of being in the world, but also provided the means for making this new disposition part of an affective reality for modern men and modern women. The modernism of cinema, as well as its modernity, may be found just as much in the vernacular experience of cinema as in supposedly modernist films.

Cinema, Modernity, Modernism

In the 1910s and 1920s, popular cinema appeared mostly to be about speed, America, mass society, the spectacle, globalization, and a certain utopianism. Films embodied a new regime of representation and a new type of commodity. With the global spread of the burgeoning industry, Hollywood films, above all, taught modern citizens, certainly, how to *act* and, arguably, although more contentiously, how to *feel*. Quite literally, movies defined and disseminated a twentieth-century *habitus*—a term used in the 1930s, in relation to the way Hollywood taught young women to walk in a new way, by the anthropologist Marcel Mauss:

I was ill in New York. I wondered where previously I had seen girls walking as my nurses walked. I had time to think about it. At last I realized that it was at the cinema. Returning to France, I noticed how common this gait was, especially in Paris; the girls were French and they, too, were walking in this way. In fact, American walking fashions had begun to arrive over here, thanks to cinema.[34]

[34] Marcel Mauss, *Sociology and Psychology: Essays* (London: Routledge & Kegan Paul, 1979), 100; quoted in Bruno Latour, *Reassembling the Social: An Introduction to Actor-Network Theory* (Oxford: Oxford University Press, 2005), 210.

According to Winifred Holtby's popular novel *South Riding*, in 1936, Hollywood also taught English country girls how to speak in new ways, at least some of the time: 'Like most of her generation and locality, Elsie was trilingual. She spoke BBC English to her employer, Cinema American to her companions, and Yorkshire dialect to old milkmen like Eli Dickson.'[35] At the time, some observers believed that cinema was changing not just mannerisms of walking and talking, but ways of being in the world. Hence Walter Benjamin's famous description of a cinema-age ontology: 'Our bars and our city streets, our offices and furnished rooms, our railroad stations and our factories seemed to close relentlessly around us. Then came film and exploded this prison-world with the dynamite of the split second, so that now we can set off calmly on journeys of adventure among its far-flung debris.'[36]

One side of this modern way of being was the ability for everyone, anywhere, to experience as present that which is absent: to have mediated access to the world through technologies of communication (telephone, radio) and representation (cinema). The dark corollary of this new freedom was a subtle sense that, even as the world became virtually closer, somehow reality was becoming less real, and even that the certainty of a substantial self was being diluted.[37] This is the sense in which Martin Heidegger criticized twentieth-century modernity as 'the age of the world picture'. For Heidegger, media like radio and the movies were substituting a spurious experience of illusory closeness for a real, if narrower, relationship of nearness to things and people.[38] A similar, though less fearful, perception lies behind Benjamin's aphorism that the 'vision of immediate reality' had become 'the Blue Flower of immediate experience in the land of technology'.[39]

It is this dimension of modern experience, somewhere between irony and the uncanny, that writers like Benjamin and Siegfried Kracauer articulated as the *distraction* of cinema. For Benjamin, reception in a state of distraction was a necessary component of the *pedagogic* function of cinema in retraining modern citizens for the sensory universe of modernity. In the streets, the novelty of this universe lay in a ceaseless barrage of visual, aural, and informational shocks. Moving through the traffic of a big city, he observed, 'involves the individual in a series of shocks and collisions', which requires a degree of alertness and responsiveness—the 'complex kind of training' to which technology subjected the 'human sensorium'. It was this kind of experience that produced the need for cinema: 'There came a day when a new and urgent need for stimuli was met by the film. In film, perception in the form of shocks was established as a formal principle.'[40] And film, *because* premissed on the

[35] Winifred Holtby, *South Riding: An English Landscape* (Glasgow: Fontana, 1954), 35.

[36] Benjamin, 'The Work of Art in the Age of its Technological Reproducibility', 117.

[37] Casetti, *Eye of the Century*, 21.

[38] Martin Heidegger, *Poetry, Language, Thought*, trans. Albert Hofstadter (New York: Harper, 1971), 165–6; see Michael North, 'Visual Culture', in Walter Kalaidjian (ed.), *The Cambridge Companion to American Modernism* (Cambridge: Cambridge University Press, 2005), 184.

[39] Benjamin, 'The Work of Art in the Age of its Technological Reproducibility', 115.

[40] Walter Benjamin, *Charles Baudelaire: A Lyric Poet in the Era of High Capitalism*, trans. Harry Zohn (London: New Left Books, 1973), 132.

experience of shocks, is 'predisposed' to 'reception in distraction'; that is, 'the sort of reception which is increasingly noticeable in all areas of art and is a symptom of profound changes in apperception'. Hence the pedagogic function of moviegoing: reception in distraction 'finds in film its true training ground'.[41]

Kracauer's deployment of 'distraction', in his Weimar articles on 'Little Shopgirls Go to the Movies', was perhaps more conventionally ideological, although he gave the term a positive spin. The virtue of 'stupid and unreal film fantasies', he insisted, was that they rendered 'the *daydreams of society*, in which its actual reality comes to the fore and its otherwise repressed wishes take on form'. When, in 'The Cult of Distraction', Kracauer rejects the 'petit bourgeois reproach' that Berliners are 'addicted to distraction', he moves closer to Benjamin's emphasis on reception, insisting that the penchant for distraction, over puffed-up cultural offerings, has at least the virtue of *sincerity*.

> In a profound sense, Berlin audiences act truthfully when they increasingly shun these art events (which, for good reason, remain caught in mere pretence), preferring instead the surface glamour of the stars, films, revues, and spectacular shows. Here, in pure externality, the audience encounters itself; its own reality is revealed in the fragmented sequence of splendid sense impressions. Were this reality to remain hidden from the viewers, they could neither attack nor change it; its disclosure in distraction is therefore of *moral* significance.[42]

It is on the basis of observations like these that Miriam Hansen, who played a key role in engineering the 'modernist turn' in cinema studies, through her critical advocacy of Kracauer and Benjamin, made the case that, in Weimar Berlin, cinema provided 'the single most expansive discursive horizon in which the effects of modernity were reflected, rejected or denied, transmuted or negotiated'. 'It was both part and prominent symptom of the crisis as which modernity was perceived, and at the same time it evolved into a social discourse in which a wide variety of groups sought to come to terms with the traumatic impact of modernization.'[43]

An almost anthropological account of this pedagogy of cinematic distraction as the negotiation of modernization was offered, in the pages of the Swiss-based English avant-garde film journal *Close Up* (1927–33), by the novelist Dorothy Richardson, author of the multi-volume, stream-of-consciousness work, *Pilgrimage*. In her regular column 'Continuous Performance', she observed the function of cinema in the everyday lives of ordinary people. In her first column, for example, in July 1927, Richardson describes, in concrete detail, the experience of going to a movie theatre 'in a strident, north London street', where she found 'tired women, their faces sheened with toil'. 'Watching these I took comfort. At last the world of entertainment

[41] Benjamin, 'The Work of Art in the Age of its Technological Reproducibility', 120.

[42] Siegfried Kracauer, *The Mass Ornament: Weimar Essays*, ed. and trans. Thomas Y. Levin (Cambridge, Mass.: Harvard University Press, 1995), 292, 326.

[43] Miriam Bratu Hansen, 'America, Paris, the Alps: Kracauer (and Benjamin) on Cinema and Modernity', in Leo Charney and Vanessa Schwartz (eds), *Cinema and the Invention of Modern Life* (Berkeley: University of California Press, 1995), 365–6.

had provided for a few pence, tea thrown in, a sanctuary for mothers, an escape from the everlasting qui vive into eternity on a Monday afternoon.'[44]

Richardson, like Benjamin and Kracauer, concentrates on the pedagogy, not of individual films, but of cinema-going as a habit, an experience that was always new but also always structurally the same—hence, perhaps, the emphasis on *continuous* performance: 'They are there in their millions, the front rowers, a vast audience born and made in the last few years, initiated, disciplined, and waiting.' This is the public waiting to be trained for modernity by cinema: 'And here we all are, as never before. What will it do with us?'[45]

In London's slums, although unabashedly commercial 'in the manner of the gin-palace at every corner: it's your money we want', what cinema did for 'the front rowers' was to offer a certain kind of impersonal salvation through its innocently encountered illustrations: 'While they follow events they are being played upon in a thousand ways. And all pictures are not bad or base or foolish. But even the irreducible minimum of whatever kind of goodness there is in any kind of picture not deliberately vicious, is civilization working unawares.'[46] Observing a young audience in England's rural West Country, Richardson speculates on the mediated cosmopolitanism of cinema: 'These youths and maidens in becoming world citizens, in getting into communications with the unknown, become also recruits available, as their earth-and-cottage-bound forebears never could have been for the world-wide conversations now increasingly upon us in which the cinema may play, amongst its numerous other roles, so powerful a part.'[47]

In her own style, and with her own emphases, Richardson worked with a sophisticated understanding of cinema's role in sustaining modernity's dislocating ontology of distraction, as it was theorized by Kracauer and Benjamin—and earlier by Georg Simmel in his work on the 'mental life' of the modern metropolis, even before cinema had become so dominant a part of its culture.[48] She came closest to giving it explicit articulation in her column for December 1931, 'This Spoon-Fed Generation?'

Everyman lives in a world grown transparent and uncertain. Behind his experience of a rapidity and unpredictability of change in the detail of his immediate surroundings is a varying measure of vicarious experience of the rapidity and unpredictability of change all over the world, and a dim sense that nobody knows with any certainty anything whatever about the universe of which his world is a part.

A new mental climate is in existence. Inhabited not only by those few whose lives are spent in research and those who are keenly on the lookout for the results of further research, but also in their degree by the myriads who have been born into the new world and remember no other. Uncertainty, noise, speed, movement, rapidity of external change that has taught them

[44] Donald et al. (eds), *Close Up, 1927–1933*, 161.
[45] Ibid. 174, 171. [46] Ibid. 181. [47] Ibid. 186.
[48] Georg Simmel, 'The Metropolis and Mental Life', in *Simmel on Culture: Selected Writings*, ed. David Frisby and Mike Featherstone (London: Sage, 1997).

to realize that to-morrow will not be as to-day, all these factors have helped to make the younger generation shock-proof in a manner unthinkable to the majority of their forebears.

And more than any other single factor . . . has the Cinema contributed to the change in the mental climate wherein Everyman has his being.

Insidiously. Not blatantly, after the manner of the accredited teacher is the film educating Everyman, making him at home in a new world.[49]

This distracted acculturation, as described by Richardson, is very much the experience that Italo Calvino recalls in his memoir of being a teenage moviegoer in Fascist Italy:

The cinema as evasion, it's been said so many times, with the intention of writing the medium off—and certainly evasion was what I got out of the cinema in those years, it satisfied a need for disorientation, for the projection of my attention into a different space, a need which I believe corresponds to a primary function of assuming our place in the world, an indispensable stage in any character formation.[50]

This is what it felt like to be socialized by cinema. In the modern world, Calvino takes it counter-intuitively for granted, people have a *need*, not for belonging as might be assumed, but for *disorientation*. Far from disabling us as social beings, that disorientation has become a precondition for *assuming our place in the world*. It enables us to operate effectively in a world in which the certainties of presence and absence, closeness and distance, and even self and other have been destabilized and have become uncertain. Paradigmatically, it is cinema that provides the pedagogy for this acculturation, through mastery of the ability to project 'attention into a different space'. It is not just that an imitated gait or a Hollywood idiom of speech can be appropriated as personal style. More importantly, cinema tutors us in the existential toolkit of imagination and fantasy: primary techniques through which we negotiate a largely mediated reality.

This view of cinema, in effect, restates Miriam Hansen's hypothesis about 'vernacular modernism'. Expanding on the Weimar precedent, she proposes that Hollywood cinema, especially, was able for several decades after the 1920s 'to provide, to mass audiences both at home and abroad, a sensory-reflexive horizon for the experience of modernization and modernity'. Hansen's emphasis on the *sensory*-reflexive implicitly recognizes that the world, and thus also social change in the world, is perceived sensually before being processed cognitively or ideologically as experience. This justifies Hansen's broadening of the term, or returning to its original emphasis on sensory perception, by taking 'the aesthetic' to refer to

the entire domain of human perception and sensation, as part of a history and changing economy of the senses which Walter Benjamin for one saw as the decisive battleground for the meaning and fate of modernity. This claim extends the scope of modernist aesthetics to

[49] Simmel, 'The Metropolis and Mental Life', 204.

[50] Italo Calvino, 'A Cinema-Goer's Autobiography', in *The Road to San Giovanni*, trans. Tim Parks (London: Vintage, 1994), 38.

include the cultural manifestations of mass-produced, mass-mediated, and mass-consumed modernity, a wide variety of discourses that both articulated and responded to economic, political, and social processes of modernization—fashion, design, advertising, architecture and urban environment, the changing fabric of everyday life, new forms of experience, interaction, and publicness.[51]

Whether in Kracauer's Weimar Germany, in 1930s Shanghai, or in the worldwide reach of classical Hollywood, cinema's sensory-reflexive *horizon* bounded a world in which individual experience, however disorientated and comprised, found expression and was recognized by others, including strangers.

This new form of acculturation and the new public sphere associated with cinema represented a significant transformation in the way people felt and thought. To that extent, mainstream cinema, as a sensory–social phenomenon, turns out to have met Wallace Stevens's criterion of modernism—'freshness of transformation' in perception, thought, and feeling. So: the habit of cinema as modernist, and not just as modern.

CONCLUSION

Putting aside reassuring pantomime battles between the virtuous art of modernism and the corrupting culture of modernity, this account of cinema and modernism has highlighted two aspects of the relationship. One is the way that a modernist aesthetic informed independent and avant-garde film-making in the 1920s. The other is a more sociological argument about the function of mainstream cinema, in acculturating twentieth-century men and women to the increasing 'virtuality' of modern life. Although avant-garde film-makers may have been attempting to cleanse commercial and cultural prejudices from Hollywood's emerging lens of perception, mainstream cinema, along with other technologies of communication and information, turned out to be both the vehicle, and a sign, of a paradoxical tension, between mediated closeness and affective distance, that has been definitive of modern being. Cinema helped to create, and yet at the same time opened up an imaginative space in which to negotiate, the inherent strangeness of being-in-the-(modern)-world.

There is a third dimension to cinematic modernism, to which less attention has been paid here. That is the extent to which cinema not only posed a challenge to literary modernists, as part of a modern culture whose norms and consolations they opposed or reworked, through the militant resistance to easy reading of their own texts, but also opened up, to cine-literate writers like James Joyce or Virginia Woolf, new ways of understanding time and movement and observation, and so also offered

[51] Miriam Hansen, 'Fallen Women, Rising Stars, New Horizons: Shanghai Silent Film as Vernacular Modernism', *Film Quarterly*, 4/1 (Fall 2000), 10–11.

one possible route to the self-abnegating modernist objectivity championed by T. S. Eliot. Such works as David Trotter's *Cinema and Modernism* and Laura Marcus's *The Tenth Muse: Writing About Cinema in the Modernist Period*[52] reinforce the lesson that no historically grounded understanding of modernism in the first half of the twentieth century, whether 'high modernism' or 'vernacular modernism', can any longer afford to leave out the question of cinema.

[52] David Trotter, *Cinema and Modernism* (Oxford: Blackwell, 2007); Marcus, *The Tenth Muse*.

..

PHOTOGRAPHY AND THE AGE OF THE SNAPSHOT

..

ELENA GUALTIERI

AMONG the many moments that we could take as symbolic beginnings of photography's engagement with modernity, the last two issues of Alfred Stieglitz's *Camera Work* stand out as one of the most emphatic and self-conscious. The magazine had been founded by Stieglitz in 1903 to promote recognition of the artistic merits of pictorialist photography by publishing the work of the American Photo-Secessionists and of leading European photographers. By 1917, when the last issue was published, it had acquired a much wider remit to include the most recent developments in European art as well as continuing to publish the work of indigenous photographers. For the last two issues Stieglitz decided to return the magazine to its original focus on contemporary American photography and dedicated them exclusively to the work of a then unknown photographer, Paul Strand.

Strand was 27 years old when his photographs appeared in *Camera Work*. He had known Stieglitz for almost ten years, since first visiting the Little Galleries at 291 Fifth Avenue as a photography student taking Lewis Hine's extracurricular classes at the Ethical Culture School. The Little Galleries had then just opened and had been meant, like *Camera Work*, to showcase the work of the Photo-Secessionists; as with the magazine, they also ended up exhibiting the paintings and sculptures of European artists such as Rodin, Cézanne, Brancusi, Picasso, Matisse, and Picabia. Both magazine and gallery closed down in 1917 when the building on Fifth Avenue was demolished, marking the end of the Photo-Secession and pictorialist phase in American photography Stieglitz had done much to promote.

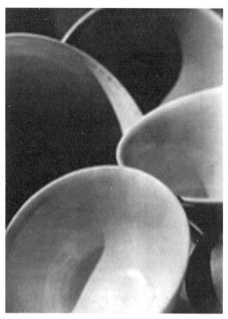

Fig. 29.1 Paul Strand, *Abstraction, Bowls,*
Twin Lakes, Connecticut, 1916
© Aperture Foundation Inc., Paul
Strand Archive

The Strand photographs Stieglitz selected for *Camera Work* indicated the new
direction taken by American photography after Stieglitz's long campaign in support
of the development of art photography and pictorialism. They showed a willingness
to experiment with abstraction and formalism (*Abstraction, Bowls,* Fig. 29.1) and an
attempt to reimagine the urban landscape along the lines suggested by the Cubist
paintings Stieglitz had shown at the Little Galleries. Most strikingly, though, Strand's
photographs displayed an urgent need for giving expression to the New York urban
experience in six portraits shot with a candid camera arrangement, for which Strand
had used an English-made reflex plate camera fitted with a false lens on its side. The
portraits exposed their subjects with a nakedness that was very far from the soft-
focus approach of pictorialist photography. The most famous of these portraits,
Blind (Fig. 29.2), would become for a later generation of photographers a landmark
opening up the way for modern photography.[1]

[1] As Belinda Rathbone tells the story, an unsuccessful encounter with Stieglitz when Walker Evans was
starting out as a photographer in the late 1920s sent the younger man to the New York Public Library to
consult *Camera Work*, out of which he felt that only Strand's work, and specifically *Blind*, offered
inspiration: ' "That's the stuff, that's the thing to do," Evans thought to himself.' See Belinda Rathbone,
Walker Evans: A Biography (Boston: Houghton Mifflin, 1995), 39. Rathbone is quoting from Jerry
Thompson and John T. Hill (eds), *Walker Evans at Work* (New York: Harper and Row, 1982), 24.

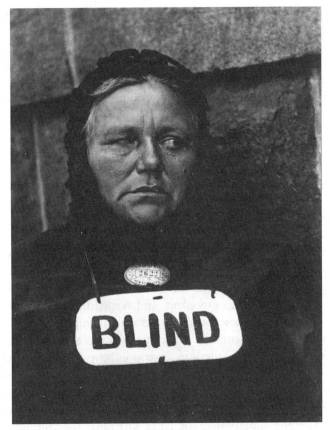

Fig. 29.2 Paul Strand, *Blind*, New York, 1916
© Aperture Foundation Inc., Paul Strand Archive

These startling, innovative images were accompanied by a short essay by Strand in which he showed clear awareness of what he was attempting to do, and of the place photography deserved in the panorama of twentieth-century art forms. Strand recognized in photography 'the first and only important contribution, thus far, of science to the arts' and he insisted that the 'complete uniqueness of means' which defines the medium is 'an absolute unqualified objectivity'. Pictorialist photography, with 'the gum-print, oil-print...hand work and manipulation', was for Strand simply 'the expression of an impotent desire to paint' and a failure to realize that 'the full potential power of every medium is dependent upon the purity of its use'. In photography, that purity was to be achieved through 'a real respect for the thing in front of [the photographer], expressed in terms of chiaroscuro...through a range of almost infinite tonal values which lie beyond the skill of human hand' and which should be realized 'without tricks of process or manipulation, through the use of

straight photographic methods'.[2] Although the notion of 'straight photography' was to become associated with Strand's images, it was in fact borrowed from the critic Sadakichi Hartmann, who had first articulated it in his review of the Photo-Secession exhibition at the Carnegie Institute in 1904. While welcoming the efforts of the pictorialists, Hartmann had invited them to 'compose the picture which you intend to take so well that the negative will be absolutely perfect... Brush marks and lines... are not natural to photography, and I object... to the use of the brush, to finger daubs, to scrawling, scratching and scribbling on the plate.'[3] But while for Hartmann 'straight photography' was simply a commentary on photographic processes, in Strand's hands it became the rallying cry for a whole new way of conceiving photography—not just a question of processing, but a matter of seeing differently.

A defining feature of straight photography for Strand was its indigenous quality. The contemporary photographers published in *Camera Work* had managed to express 'America... in terms of America without the outside influence of Paris art-schools or their dilute offspring'. Locating the beginning of this renaissance movement in photography around 'the years between 1895 and 1910', Strand compared contemporary photographers to 'the creators of our skyscrapers [who] had to face the similar circumstance of no precedent' and turned this lack of history into an opportunity for 'evolving a new form'.[4] Modern photography, with its emphasis on objectivity, on the direct presentation of the thing in front of the photographer's eyes, was for Strand an explicitly American invention, one of the first native artistic expressions of a modern America that had managed to emancipate itself from the cultural tyranny of the old continent. In Strand's vision modern photography and modern America existed in a symbiotic bond, the former giving cultural legitimacy to the new, emerging superpower, the latter providing the cultural humus from which this new art form could emerge.

Written and published in the midst of the First World War and in the year of the Russian Revolution, Strand's manifesto precedes by a few years the renewal of photographic practice which will take shape in post-war Europe. It has most in common with László Moholy-Nagy's 'new vision' and with the Neue Sachlichkeit movement that emerged in Germany in the 1920s. In all of these cases what is being emphasized is the fact of photography as a separate, unique medium which requires the development of equally unique techniques and ways of seeing. For Moholy photography was essentially a way of 'painting with light'; the camera was an instrument for capturing light of which only a limited, 'secondary' use had been made in order 'to capture (reproduce) particular objects as they reflect or absorb the light'. His photograms were ways of trying to demonstrate how 'to capture and

[2] Paul Strand, 'Photography', *Camera Work*, 49–50 (1917), 780.
[3] Sadakichi Hartmann, 'A Plea for Straight Photography', *American Amateur Photographer*, 16 (1904), 101–9, quoted in Beaumont Newhall, *The History of Photography from 1839 to the Present*, rev. and enlarged edn (New York: Museum of Modern Art, 1982), 166.
[4] Strand, 'Photography', 780.

fix light effects' for their own sake and in their own right.[5] In this he differed significantly from Albert Renger-Patzsch, author of the popular *Die Welt ist Schön* (1928), for whom the new vision of modernity, as for Strand, was identifiable with a new realism. Where Strand had compared the work of the modern photographer to the pioneering creators of skyscrapers, Renger-Patzsch similarly argued that photography was ideally placed to capture the essence of a technological modernity, 'to do justice to modern technology's rigid linear structure, to the lofty gridwork of cranes and bridges, to the dynamism of machines operating at one thousand horsepower'.[6]

The new photography was defined, then, as a reproduction of technological modernity in an objectively produced beautiful image demonstrating the photographer's skill in selecting the image, using the camera, and developing the negative without recourse to special effects or manipulations. In the post-Second World War era this understanding became synonymous with modernist photography itself. Strand was the first photographer to have a retrospective dedicated to him at the Museum of Modern Art in New York in 1945,[7] a show curated by Nancy Newhall, who had taken over the position of curator of photography while her husband, Beaumont, was in the army. The show sealed as authoritative the Newhalls' and Strand's understanding of what modernist photography might be and do. Modernist photography as practised by Strand and championed by the Newhalls was a pure medium for impure times, distilling the chaotic multiplicity of modern life into the poise and stillness of monochromatic compositions.

THE AGE OF THE SNAPSHOT

There is no explicit or implicit mention in Strand's 1917 essay that one of the great American inventions that might have contributed to turning photography into the expression of a new modern era was the Kodak, which had first appeared for sale almost thirty years earlier in 1888. The Kodak seems to have had at best only a liminal, unacknowledged influence on the ways in which art photography was being practised and understood. But it did fundamentally change how amateurs viewed and approached photography. Until the last two decades of the nineteenth century photography had been a cumbersome and expensive activity. The wet collodion process, which had dominated photography between the 1850s and the 1870s, had required

[5] László Moholy-Nagy, 'Produktion-Reproduktion', *De Stijl* (Leiden), 5/7 (July 1922); repr. and trans. as 'Production-Reproduction', in Christopher Phillips (ed.), *Photography in the Modern Era: European Documents and Critical Writings, 1913–1940* (New York: Museum of Modern Art and Aperture, 1989), 81.

[6] Albert Renger-Patzsch, 'Ziele', in *Das Deutsche Lichtbild* (1927), p. xviii; repr. as 'Aims', trans. Joel Agee, in Phillips (ed.), *Photography in the Modern Era*, 105.

[7] John Rohrbach, '*Time in New England*: Creating a Usable Past', in Maren Stange (ed.), *Paul Strand: Essays on His Life and Work* (New York: Aperture, 1990), 164.

that photographers prepare their plates by hand prior to exposure in the camera, and that they then develop and fix the plates immediately after, before the coating had a chance to dry out. The equipment was bulky and expensive; practising photography even as an amateur entailed a commitment and a range of technical expertise that were likely to put off all but the most serious practitioners. This only started to change in the 1870s, when a new process was introduced in which light-sensitive gelatin could be left to dry on a glass plate and subsequently exposed and developed. As they did not require immediate preparation and then development by the photographers, the dry gelatin plates could be manufactured for sale in great quantities and therefore opened up photography to the full process of industrialization, emancipating it from the still artisan-like fashion in which it had been practised for much of the nineteenth century.

One of the first manufacturers of dry gelatin plates in the United States was George Eastman, then a bank employee who had taken up photography as an amateur when the wet process was still dominant, but who quickly realized the business potential of the newer one. Once the industrialization of photography was under way, Eastman sought to extend it further by simplifying the procedures and equipment with the aim of creating a mass amateur market.[8] In the second half of the 1880s he experimented with various solutions for manufacturing a camera that would be simple to operate, light enough to carry around, and so cheap to produce that its market price would appeal to the largest possible number of consumers. The Kodak was launched in June 1888 in the US, and shortly after in Europe. Because the American paper film with which it came loaded proved especially difficult to develop, Eastman decided to sell the camera with the option of a developing and printing service from Kodak. The resulting advertising slogan for the new camera and service 'You press the button, we do the rest' became the byword for the new era of mass amateur photography.

The birth of the Kodak is significant because it marks the point at which the mechanical production of images undergoes both a quantitative and a qualitative shift. Quantitatively, the Kodak turned photographs into commonplace images, images that were everywhere to be seen and that seemed to produce themselves automatically, since most of the amateurs operating a Kodak elected to use the Eastman Corporation developing and printing service. Qualitatively, photography changed from an activity reserved for professionals or serious amateurs to a mass practice pursued during the newly invented category of leisure time.[9] It no longer approximated, however remotely, the practices of art or craft. The age of the Kodak is the age of the photograph as industrial and mass product.

This quantitative and qualitative shift in the practice of photography became embodied in the notion of the snapshot, the product of the new point-and-shoot

[8] On the rise of the Eastman Company in the context of the American photographic industry, see Reese V. Jenkins, *Images and Enterprise: Technology and the American Photographic Industry, 1839 to 1925* (Baltimore: Johns Hopkins University Press, 1975), 94–120.

[9] On the exploitation of the notion of leisure time in Kodak advertising, see Nancy Martha West, *Kodak and the Lens of Nostalgia* (Charlottesville: University Press of Virginia, 2000), 36–73.

way of practising photography made necessary by the fact that the first Kodaks were simple boxes without a viewfinder.[10] The snapshot had in fact first been named already in 1860 by John Herschel, the astronomer and scientist also responsible for suggesting the name 'photography' to replace William Fox Talbot's more cumbersome 'photogenic drawing'. Writing in the *Photographic News*, Herschel had described his 'dream' of a photography capable of offering

the vivid and lifelike reproduction and handing down to the latest posterity of any transaction of real life—a battle, a debate, a public solemnity, a pugilistic conflict, a harvest home, a launch—anything, in short, where any matter of interest is enacted within a reasonably short time . . . the possibility of taking a photograph, as it were, by a snap-shot.[11]

The term was borrowed from hunting, where it designated a shot taken quickly, without careful aim. By 1860 Herschel thought that it should have been within the purview of contemporary photographers and photographic technology to be able to take arrested images of moving subjects in the same fashion. For much of the nineteenth century, though, true instantaneity in photography remained the dream it had been for Herschel. 'Instantaneous' was then used not in a strictly technical sense, to indicate an image taken in a fraction of a second, but rather in the looser, stylistic sense of a synonym of 'from life' and 'from nature', designating photographs that were perceived to be artless and unposed.[12]

True instantaneity of the kind envisaged by Herschel first became possible in the late 1870s, when the higher light sensitivity of the dry gelatin plates and new, faster lenses drastically reduced exposure times. This technological revolution found its most striking expression in one of the best-known developments of late nineteenth-century photography: chronophotography. The symbolic beginnings of chronophotography are usually located in Eadweard Muybridge's image of the horse Occident at a trot, taken sometime after 1873. Occident belonged to Leland Stanford, former governor of California, president of the Central Pacific Railroad, and a keen horseman. Stanford had become convinced that the conventional representation of the motion of horses at a trot was wrong and thought that only an instantaneous photograph of the horse hurrying past the camera would settle the matter. He engaged Muybridge to produce that image, now lost, which was obtained still using the old wet process, though Muybridge soon afterwards graduated to the dry plates.[13] Muybridge's instantaneous photograph proved that Stanford's theory of equine motion was right; he then set about producing more images of horses in

[10] For the technical specifications of the early Kodaks, see Jenkins, *Images and Enterprise*, 114–16; Brian Coe and Paul Gates, *The Snapshot Photograph: The Rise of Popular Photography, 1888–1939* (London: Ash & Grant, 1977), 16–21.

[11] J. F. W. Herschel, 'Instantaneous Photography', *Photographic News*, 4/88 (11 May 1860).

[12] Phillip Prodger, *Time Stands Still: Muybridge and the Instantaneous Photography Movement* (New York: Oxford University Press in association with the Iris and B. Gerald Cantor Center for Visual Arts at Stanford University, 2003), 43.

[13] Ibid. 141.

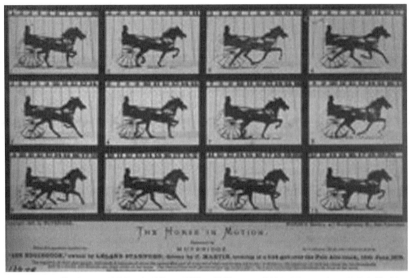

Fig. 29.3 Eadweard Muybridge, 'Abe Edington' Trotting at a 2:24 Gait, 15 June 1878

motion until in 1878 he finally managed to produce some which were of good enough quality to be published and which were widely circulated (Fig. 29.3).[14]

Muybridge's images are today seen as decisive precedents on the road to the development of cinema.[15] But to his contemporaries, for whom the invention of cinema was still a few decades away, they appeared to be not the beginnings of a new medium but the culmination of a long history of photographic experimentation in search of the instantaneous image. The desire for instantaneity was an integral part of the impetus that had led to the invention of photography in the early nineteenth century.[16] In 1839 William Fox Talbot had already described the unique appeal of what he called 'the art of photogenic drawing' in terms of its ability to take 'the most

[14] Prodger, *Time Stands Still: Muybridge and the Instantaneous Photography Movement*, 145.

[15] Both of the early monographs dedicated to Muybridge's work cast him in the role of pioneer of cinema; see Robert Bartlett Haas, *Muybridge: Man in Motion* (Berkeley and Los Angeles: University of California Press, 1976), and Gordon Hendricks, *Eadweard Muybridge: The Father of the Motion Picture* (London: Secker and Warburg, 1975). As Tom Gunning points out, these claims have a long history that dates back to the early days after Muybridge's death and were principally put forward by his friends. Muybridge himself, though recognizing the link between his work and the cinema, 'would have been surprised by the suggestion that these inventions [the Kinetoscope, Vitascope, and Cinématographe] were the culmination of his work' ('Never Seen This Picture Before: Muybridge in Multiplicity', in Prodger, *Time Stands Still*, 223).

[16] In *Burning with Desire: The Conception of Photography* (Cambridge, Mass.: MIT Press, 1997), 56, Geoffrey Batchen persuasively shows how prevalent the 'desire to have an otherwise fleeting picture of nature fix itself within the confines of a camera obscura' was already in the years around 1800 well before the desire found a technical realization.

transitory of things, a shadow, the proverbial emblem of all that is fleeting and momentary', and fix it 'for ever in the position which it seemed only destined for a single instant to occupy'.[17] In a photographic rather than cinematographic history, Muybridge's experiments marked the point at which the photographic and the instantaneous became irremediably welded together; they offered the realization of both Talbot's and Herschel's dream of a photography capable of capturing the most transitory of impressions in the blink of an eye. Going beyond Herschel and Talbot, Muybridge's photographs showed that photographic instantaneity was possible, but that it remained beyond the reach of human perception and could only be captured through the prosthetic aid of camera technology. After Muybridge, photography came to be defined in terms of its capacity to arrest and capture a movement which occurs in a fraction of time so infinitesimal that the human eye could not have perceived it.

Muybridge's and others' experimentations with chronophotography bequeathed a new conception of the medium to the idea and practice of the snapshot. Speed and rapidity became defining characteristics of photographic practice, to which the snapshot added its own, distinctive sense of the photographic image being stolen from the never-ending rush of sensory experiences. This new understanding of what photography was for and could do informed not just the high-end experiments of the chronophotographers, but also the everyday images shot by anonymous amateurs whose photographs of family and friends in their leisure activities soon broke away from the stiff poses of the nineteenth-century portrait to convey the vitality and energy of movement.[18] Effectively, the snapshot carried over into the late nineteenth and early twentieth century the meanings that had accrued to instantaneous photography in the first few decades of the development of the medium, a sense of images 'taken from life' and retaining from life a sense of spontaneity and immediacy. But the speed at which the snapshot must be fired also brought with it a recognition of the casual and contingent nature of any image thus captured, of its accidentality. In combining these two sets of meanings the snapshot became the symbolic image of the age, in which the speed and suddenness which denote one conception of modernity coexisted with the sense of immanence and immersion in the present which is another, often antithetical way of understanding the modern.

Not everybody was enchanted by the snapshot's version of what being modern meant. Most professional and long-standing amateur photographers saw in the snapshot a degradation of photographic practice, its dehiscence from art to unthinking reflex. Lewis Hine, Strand's old photography teacher at the Ethical School, had set up his extracurricular classes on photography in the 1900s with the explicit intention of teaching children 'that success cannot be attained by snapping at everything, but

[17] William Fox Talbot, 'Some Account of the Art of Photogenic Drawing', in Vicky Goldberg (ed.), *Photography in Print: Writings from 1816 to the Present* (New York: Simon & Schuster, 1981), 41.
[18] For an overview and analysis of anonymous early snapshot photography in the US, see the catalogue of a recent exhibition at the National Gallery of Art in Washington, including Diana Waggoner's article 'Photographic Amusements 1888–1919', in Sarah Greenough and Diane Waggoner, *The Art of the American Snapshot, 1888–1978* (Washington: National Gallery of Art in association with Princeton University Press, 2007), 7–44.

by patient, careful, orderly work'.[19] Strand's practice kept faith with Hine's teachings by choosing long exposure times and old-fashioned glass-plate large-format cameras, even well after the lighter, hand-held 35 mm had finally conquered the world. Unlike his friend Henri Cartier-Bresson, Strand did not set out to capture the decisive, fugitive moment. What he wanted was to immortalize his subjects by amplifying the temporal fragment, turning it into what John Berger has called the 'biographical or historic moment, whose duration is ideally measured not by seconds but by its relation to a lifetime'.[20] This search for the absolute image capable of summing up an entire life stands at the opposite pole from the casual snaps taken by the amateur Kodak photographer, whose aim was not to immortalize its subjects but to still life for an instant only.

Yet the candid images Strand shot in New York and published in *Camera Work* in 1917 share with the practice of the Kodak photographer if not an aesthetic, then certainly a fortuitous positioning of the camera, the need for a speedy execution, a sense of images only just arrested and isolated from the ever-moving flow of urban life. The blind woman, the man caught on a bench in Five Points Square, the street vendor are all urban subjects capable of reflecting the city they inhabit because and not in spite of the very speed with which Strand had to try to isolate their existence from the ebb and flow of the urban crowd. This tension between speed and stillness is characteristic of Strand's New York images and a reflection of how much photographic practice itself had changed in the three decades since the invention of the Kodak. It suggests that while Strand and most practising professional photographers continued to use large-format cameras, by 1917 the Kodak had already contaminated their ways of seeing the world around them, even as they, as in Strand's case, sought to define their own vision of art photography in both explicit and implicit contrast to popular photography.

A NEW TIME

The invention of the Kodak and the attendant emergence of popular photography did not just challenge the practice of art photography. It also participated in a more generalized sense of unsettling changes happening in the conception and experience of time at the turn of the century. The introduction of the Kodak happened at the end of a decade that had already seen the Prime Meridian Conference, held in Washington in 1884, which 'proposed to establish Greenwich as the zero meridian, determined the exact length of the day, divided the earth into twenty-four time zones one hour apart, and fixed a precise beginning of the universal day'. Though this new

[19] Naomi Rosenblum, 'The Early Years', in Stange (ed.), *Paul Strand*, 32.
[20] John Berger, *About Looking* (New York: Vintage, 1980), 47.

system was only slowly taken up by individual countries, it eventually managed to do away with the myriad local times on which most communities, towns, and cities had been running for much of the nineteenth century and before.[21] While the Prime Meridian Conference initiated a process of homogenization of different times into a universally applicable grid, a few years later Einstein's theory of relativity moved in the opposite direction, showing the measurement of time to be a location- and observation-dependent quantity, and the absolute time of Newtonian physics a convenient, but outmoded, fiction.[22]

Within this historical context of perplexing changes, philosophy too took up the challenge of rethinking the problem of the nature of time. Henri Bergson's thought explicitly engaged with the new scientific discoveries of the early twentieth century, for which Bergson claimed that a new metaphysics must be elaborated.[23] He argued that philosophy continued to rely on the metaphysics it had inherited from the Greeks, for which time was not the essential manifestation of being, but rather a problematic entity whose own being was in question. This is because Greek philosophy had elaborated a logical conception of being, based on the principle of identity and non-contradiction, whereby being was defined in opposition to non-being, to nothingness. This logical conception of being could not accommodate or account for the experience of time as duration, of the unfolding of becoming, which is our intuitive apprehension of time.[24] The Presocratic thinkers of the Eleatic school were therefore forced to deny time any being. Zeno's paradoxes demonstrated precisely this impasse: that time cannot be conceived as divisible into smaller parts, since to do so would necessitate a passage or transition from being—the particle which constitutes time, the point on the line traversed by the arrow—to non-being—the intervals between those particles, the spaces in between time and not-time.[25]

Bergson's philosophy thus addressed one of the oldest problems raised by the Greek conception of time: that of the nature of the instant. In his dialogue on Parmenides, the founder of the Eleatic school, Plato had the older philosopher articulate the problem illustrated in Zeno's paradoxes in terms of a new concept:

For the instant (to exaiphnes) seems to signify something such that change proceeds from it into either state. There is no change from rest while resting, nor from motion while moving;

[21] Stephen Kern, *The Culture of Time and Space, 1880–1918* (Cambridge, Mass.: Harvard University Press, 1983), 12.

[22] For an account of relativity theory in relation to the literary and visual experiments of modernism, see Thomas Vargish and Delo E. Mook, *Inside Modernism: Relativity Theory, Cubism, Narrative* (New Haven: Yale University Press, 1999).

[23] Bergson directly engaged with relativity theory in *Durée et simultanéité*, first published in 1922, when it immediately created a controversy about Bergson's understanding of Einstein. For a succinct account of the controversy, and of the ways in which *Duration and Simultaneity* also disturbed the coherence of Bergson's philosophy, see Robin Durie's introduction to *Duration and Simultaneity: Bergson and the Einsteinian Universe*, ed. Robin Durie, trans. Leon Jacobson (Manchester: Clinamen Press, 1999), pp. xiv–xxi. See also Timothy S. Murphy, 'Beneath Relativity: Bergson and Bohm on Absolute Time', in John Mullarkey (ed.), *The New Bergson* (Manchester: Manchester University Press, 1999), 66–81.

[24] Henri Bergson, *Creative Evolution*, trans. Arthur Mitchell (Mineola, NY: Dover, 1998), 276–7, 298.

[25] Ibid. 308–10.

but this instant, a strange nature, is something inserted between motion and rest, and it is no time at all; but into it and from it what is moved changes to being at rest, and what is at rest to being moved.[26]

The instant appears in Western philosophy in the guise of 'no time at all', the moment of change from one state to another, from rest to motion, the point at which becoming itself takes place and which for Zeno could not exist. Plato's invention of the instant as the antinomy at the heart of time is a product of his desire to affirm the transcendence of Being already asserted by Parmenides, while also wanting to provide an explanation and a point of contact between that transcendental being and the flux and transformation of phenomena, the order of things.[27] In this passage he gives the name of the instant (*to exaiphnes*) to that antinomy. The instant then first appears in the history of Western thought as a strange being indeed, a concept that is meant to reconcile eternity and flux, the world of objects and things with that of ideas.

But for Bergson this naming of the instant as the moment of becoming illustrates not the true nature of time, but rather the way in which our perception naturally works. Driven by the need for action, perception must select from the ever-moving fluidity of the *durée* a series of condensed views: 'of becoming we perceive only states, of duration only instants'.[28] Perception consists then of 'a work of condensation',[29] of extracting from the eternal flux of becoming a series of 'discontinuous images' into which 'our perception manages to solidify . . . the fluid continuity of the real'. These images for Bergson are what we call 'form', but form in its turn 'is only a snapshot view of a transition'.[30]

For Bergson this theory of perception as a 'snapshot' view of reality explains the difficulties which Western philosophy has encountered from its very beginning in thinking through the nature of movement and change. Greek philosophy took the work of human perception at its face value, starting to speculate about the nature of reality and of being not from an intuitive immersion in the fluidity of life, but from the end-result of perception, the 'snapshot' views we take of reality. It mistook those snapshots for the immutable and eternal Ideas of which it considered the phenomenal world to be but a pale reflection. 'Eidos', Bergson suggested, should be more appropriately translated not as Idea but 'by "view" or rather by "moment"', since Ideas are in fact nothing else but 'the stable view taken of the instability of things'.[31]

Having started from these stable views, or Ideas, Greek philosophy could not for Bergson do anything else but elaborate a static conception of the real, from which it

[26] Plato, *Parmenides*, trans. R. E. Allen, rev. edn (New Haven: Yale University Press, 1997), 156d–e, quoted in Robin Durie (ed.), *Time and the Instant: Essays in the Physics and Philosophy of Time* (Manchester: Clinamen Press, 2000), 11.

[27] My discussion of the problem of time in Presocratic and Platonic philosophy is indebted to Robin Durie's in 'The Strange Nature of the Instant', in Durie (ed.), *Time and the Instant*.

[28] Bergson, *Creative Evolution*, 273.

[29] Ibid. 301. [30] Ibid. 302. [31] Ibid. 315.

then became impossible to derive movement. In one of the most quoted and better-known passages of *Creative Evolution* (1907), he proceeded to compare the predicament of Greek philosophy to that of photography before cinema. For the Greeks to have attempted to elaborate an understanding of movement that started from an eternal and static being was as impossible as trying to derive the movement of a regiment of marching soldiers from 'photographs each of which represents the regiment in a fixed attitude'. Like the snapshots of reality we take in normal perception, the photographs of the regiment are extracted from the continuous flux of reality which we inhabit and which constitutes us. Putting them side by side would never produce the movement of the regiment, just as putting Ideas next to each other in Greek philosophy cannot produce movement. The only way to animate the snapshot views of reality is to add movement from somewhere else: in the case of cinema, from the apparatus; in the case of Greek philosophy, it is an abstract idea of movement, '*movement in general*', that is added to their fundamentally static conception of the real.[32]

The only way to rectify the difficulties encountered by Greek philosophy in thinking through the notion of becoming is simply to 'reverse the bent of our intellectual habits'[33] and to recognize in the isolated photographs of the marching regiments not the fundamental components of reality, but the images produced by the work of perception as it selects from the flux of becoming the series of snapshots which we must necessarily take of it. Though Bergson's philosophy is best known for having made of cinema an object of speculative thinking,[34] it is in fact the snapshot that works as the linch-pin of his theory of perception, and of the metaphysical errors it generates. Part of the reason why the snapshot is capable of doing so much work for Bergson's rewriting of the history of Western philosophy is precisely because in French the snapshot is an *instantané*, in a felicitous naming that seals the coincidence of photographic imaging with the instant. There is effectively no distinction for Bergson between photography and time; the *instantané* is both the archetypal image and the interruption in the continuity of the dureé which the image produces and which for Bergson is what we mean when we speak of 'instants' of time.

Bergson's philosophy foregrounds the impact that the everyday object of the snapshot had on early twentieth-century thought. It shows how the snapshot was perceived to have given a material form to one of the most problematic concepts in the history of Western thought, the instant. This materialization of the instant was first effected, as we saw, through Muybridge's and others' experiments in chrono-photography. Bergson recognizes in chronophotography simply a more precise rendition of the work of human perception. Whereas the eye perceives the galloping horse in 'a characteristic, essential, or rather schematic attitude, a form that appears

[32] Ibid. 305. [33] Ibid. 314.

[34] See Gilles Deleuze, *Cinema I: The Movement-Image*, trans. Hugh Tomlinson and Barbara Habberjam (London: Athlone Press, 1986); Deleuze, *Cinema II: The Time-Image*, trans. Hugh Tomlinson and Roberta Galeta (London: Athlone Press, 1989); and the commentary on Deleuze's cinema texts by D. N. Rodowick, *Gilles Deleuze's Time Machine* (Durham, NC: Duke University Press, 1997).

to radiate over a whole period and so fill up a time of gallop', as can be seen on the friezes of the Parthenon, 'instantaneous photography isolates any moment' without privileging any particular pose. Chronophotography and the human eye stand in the same relation that Greek philosophy has to classical, Newtonian physics, the first thinking in terms of privileged moments, the second in terms of a succession of equally measurable instants.[35]

But another way to look at chronophotography would see in it the realization of what Zeno had thought to be impossible. In chronophotography the arrow can both be stilled, suspended in time, and be in motion in the sequence of images. The point of change from one state to the next which troubled the logic of Greek metaphysics came into being over two thousand years later in the images produced by chrono-photography. But since for Zeno that point of change was a logical impossibility, this means that late nineteenth-century photography produced an order of phenomena which challenged the rules of Greek dialectical thought. The logos that subtends Zeno's paradoxes did not seem to apply to the world depicted in chronophotography, where horses could appear to be both at full gallop and suspended in mid-air, bullets could be seen travelling towards their target without moving. This world was effectively an a-logical one, an order of reality that escapes the dominance of the logos.[36] The instant that is captured in chronophotography is then a strange kind of being indeed: it is the instant as the problematic form of modern time, the instant as the form of modern time which defies the logos.

To be more precise, we should in fact say that the instant to which chronophotog-raphy gives a material form, the instant which chronophotography made visible, is Plato's *to exaiphnes*, an adverb which denotes suddenness and surprise and which is used as a noun in the *Parmenides*. The instant as we know and speak it is in fact derived not from Greek but from Latin: it indicates a state of immanence and presence; it is the *in-stans*, that which stands in the here and now. But if we combine *in-stans* with Plato's *to exaiphnes*, what we get is a concept that brings together suddenness, surprise, and speed with immanence and presence: in other words, the photographic snapshot.

Despite its reliance on the figure of the *instantané* as a favourite and yet troubling metaphor, Bergson's philosophy of time is in fact predicated on separating precisely these two sets of meaning that have accrued to the material object of the snapshot. In Bergson's philosophy, Plato's *to exaiphnes* becomes the lighting-speed work of condensation which perception must perform and which we mistake for the

[35] Bergson, *Creative Evolution*, 332.

[36] In *The Emergence of Cinematic Time: Modernity, Contingency, the Archive* (Cambridge, Mass.: Harvard University Press, 2002), Mary Ann Doane has argued that Thom Andersen's 1974 documentary on Muybridge (*Eadweard Muybridge, Zoopraxographer*) shows that 'both modernity and the cinema have a stake in refuting Zeno, in affirming the reality, indeed the allure, of a mobility that is, in film, quite simply not there' (p. 205). But Doane fails to see that Muybridge's series do not need to be turned into film to defy the logos of Zeno's paradoxes. While cinema may well be ontologically and historically defined by a covering-up of its material basis in the photogram, chronophotography and instantaneous photography work in the opposite direction—their desire is to still movement, not reproduce it.

minimum constituent part of time; the *in-stans*, the time as immanence in the here and now, is the *durée* as that which endures and persists. In setting out to elaborate a philosophy that articulates the view of common sense, Bergson had taken the snapshot as the symptom of a long-standing distortion in the conception of time. But by splitting up the temporality of the snapshot into its constituent parts of *to exaiphnes* and the *in-stans*, of surprise and immanence, he had in fact attempted to return philosophy to a pre-photographic world where time and the logos could be reconciled anew.

MODERNISM'S PHOTOGRAPHY

The instant as the problematic form of modern time reactivated by snapshot photography inevitably had a significant impact on the ways in which narrative temporality came to be understood, deconstructed, and then reconstructed. We can already see this impact in Muybridge's series *Animals and Humans in Motion* (Fig. 29.4), especially when we compare them with the more rigorously scientific experiments conducted by the French physiologist Etienne-Jules Marey (Fig. 29.5). While Marey's intentions were clearly to be able to dissect animal and human movement into its constituent parts,[37] in Muybridge's case the motivations behind his series are still contained within the realm of the aesthetic rather than the scientific. What interests Muybridge in the composition of his plates is not the taking apart of human and animal motion, but rather the recomposition and reassembling of movement into a different kind of story, one in which the erotic charge of the naked human body is both contained and heightened by its sequential presentation. There is a surfeit of nakedness in Muybridge's plates that has nothing scientific about it, but that tantalizingly adumbrates a narrative, a story that seems to be beckoning us. It is as if photography had gone behind the many painterly illustrations of the nude to give us a prehistory of the final product. Muybridge's plates are not building up to a story the final form of which is, as it is often claimed, the cinema, but rather an unravelling backwards of the condensed image of the painting. If they do prefigure the moving image, they do so by excavating much older forms of visual representation.

A similar work of dissection and excavation of older forms of narrative temporality occurs in Marcel Proust's *A la recherche du temps perdu*, where the negotiation between the nineteenth-century temporal order and the twentieth-century one is often carried out via a reflection on the different ways in which photography operates

[37] On Marey's scientific work, and the precedents to his chronophotographic experiments, see Martha Braun, *Picturing Time: The Work of Etienne-Jules Marey (1830–1904)* (Chicago: University of Chicago Press, 1992).

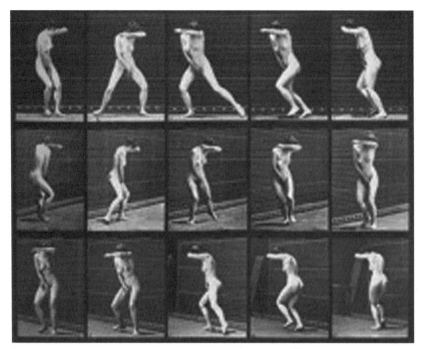

Fig. 29.4 Eadweard Muybridge, *Turning Away and Running Back*, 10 July 1885

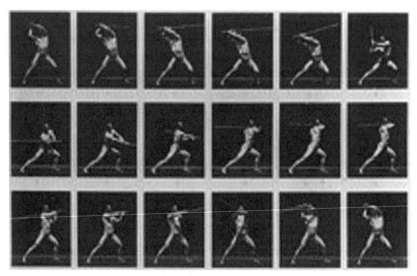

Fig. 29.5 Etienne-Jules Marey and Georges Demeny, 'Un coup de bâton', 1892

within them. From the perspective of the nineteenth century, photography is understood in Proust's text primarily as a means of reproduction of other kinds of image-making—for example, paintings or prints. 'Photographs of the most beautiful monuments or landscapes' are meant to play an important part in the aesthetic education of the young narrator; yet they are rejected 'at the moment of buying them' because of the 'vulgarity and utility [which] too quickly resumed their places in that mechanical mode of representation, the photograph'.[38] Photography infects aesthetically valuable subjects—Chartres Cathedral, the Fountains of Saint-Cloud, Mount Vesuvius—with the whiff both of consumption (it is at the time of buying that their 'vulgarity' becomes apparent; perhaps, indeed, it is precisely *because* they can be bought that they are perceived to be vulgar) and of industry (they are mechanical rather than hand-made). The terms of this rejection of photography are familiar, echoing as they do Charles Baudelaire's review of the Salon of 1859, in which he condemned photography for reinforcing the fundamental confusion between art and the reproduction of nature that was typical of a philistine public and for having introduced industry into the realm of art.[39]

But in the historical panorama offered by the *Recherche*, this understanding of photography as an inadequate, poor substitute for art is superseded by a newer form of photographic imaging, one whose challenge is directed not at art, but rather at the ways in which human perception contributes to the making of art. The snapshot, or *instantané*, is invoked repeatedly in Proust's text, and plays an especially important part in the aesthetic discourse that seals the *Recherche* in the last volume and which is often taken to be the aesthetic informing the text itself. The *instantanés* that Bergson had taken to be a model for the ways in which natural perception arrests the flow of becoming figure in the *Recherche* as the waste products both of cultural and of mental processes. In a crucial passage of *Le Temps retrouvé*, the word *instantané* conveys with one stroke the full extent of the narrator's, and of his readership's, distance from true aesthetic experience:

I told myself again that I had not experienced, when I attempted that description [of the line that separated shadow from light on the trees], anything of the enthusiasm which, if not the only one, is one of the main criteria of talent. I tried now to extract from my memory other 'snapshots,' particularly the snapshots it had taken in Venice, but the very word made it as boring as a photograph exhibition, and I felt that I had no more taste, or talent, for describing now what I had seen earlier, than yesterday for describing what I was observing, at that very moment, with a doleful and meticulous eye.[40]

By the time Proust wrote this passage in the early 1910s, the word *instantané* had only been in circulation for a few years (Larousse records its first usage in 1902). Yet for Proust the word itself has already become a deadly weapon, capable of draining the

[38] Marcel Proust, *The Way by Swann's*, trans. Lydia Davis (Harmondsworth: Penguin, 2002), 43.
[39] Charles Baudelaire, 'The Modern Public and Photography', in Alan Trachtenberg (ed.), *Classic Essays on Photography* (New Haven: Leete's Island Books, 1980), 83–9.
[40] Marcel Proust, *Finding Time Again*, trans. Ian Patterson (Harmondsworth: Penguin, 2002), 173–4.

life out of even the most significant and intense of experiences, the romance of Venice or the beauty of the French countryside. Linguistically, then, *instantanés* have always already been 'desiccated images... "views" in which we transform the things that we have both lived and perceived with all our senses' as if we had witnessed them second-hand, 'in an album or in a museum'.[41]

Instantanés can only be written within inverted commas, with the punctuation marks registering the scepticism of Proust's narrator about the ability of the snapshot to convey the immediacy of the experience it claims to have captured. If Talbot, Herschel, and Muybridge had believed in the possibility of stopping time to net the most fugitive of impressions, Proust's narrator emphatically puts paid to that belief and finds *instantanés* neither instantaneous nor a slice of life. For Proust's narrator and in the aesthetic that is meant to guide the text, the snapshot fails to deliver precisely on that promise of immanence and immersion in the present which the very notion of instantaneity evokes.

What does deliver on that promise is in fact the accidental, unplanned, and surprising coincidence of sensations called the *moments bienheureux*, those 'happy moments' in which the taste of the madeleine dipped in tea, the clinking of the teaspoon on a saucer, or the uneven cobblestones on the pavement open up the gateway to the past and let it flood the present. Against 'the so-called snapshots taken by my memory (*les prétendus instantanés pris par ma mémoire*)' stand the much more vivid, synaesthetic images—'a profound azure... impressions of coolness and dazzling light'[42]—brought about by all those happy accidents which release the memories of the past much better than the pressing of a button ever could, *pace* Kodak. Placing the *instantanés* within inverted commas is then tantamount to hitting photography where it hurts most, at the very heart of what defines its unique appeal: the ability to capture the moment as it flashes by, to preserve the immanence of that present which can only be known once it is past, *perdu*, both wasted and lost, lost *because* it has been wasted.

The aim of Proust's narrator is very clear. It is to take the wasted time of the *instantanés* in which his life has so far resolved itself and to transform them into a sequence of significant moments, in which the collusion of past and present releases a meaning that had not been discernible in the reified, wasted instants. This is not just the predicament of the leisurely, rentier class to which Proust himself belonged; it is in fact the existential condition of modernity itself, in which, as Walter Benjamin will point out a few years later, the meaning of experience has been substituted by the counting of it, by its arrangement in a sequential line.[43] Proust's text undoes this

[41] Marcel Proust, *Matinée chez la princesse de Guermantes*, ed. Henri Bonnet (Paris: Gallimard, 1982), 291: 'images desséchées... "vues" en lesquelles nous transformons les choses que nous avons vécues et perçues à la fois avec tous nos sens et qui du même coup s'extériorisent si bien de vie que nous pouvons croire les avoir regardées seulement dans un album ou dans un musée'; my trans.

[42] Proust, *Le Temps retrouvé*, ed. Jean-Yves Tadié iv. (Paris: Gallimard, 1989), 445–6; trans. in *Finding Time Again*, 175.

[43] Walter Benjamin, 'On Some Motifs in Baudelaire', in *Selected Writings*, iv, ed. Michael W. Jennings and Howard Eiland, trans. Edmund Jephcott et al. (Cambridge, Mass.: Harvard University Press, 2003), 314–16.

trend by overturning the order of the nineteenth-century novel in which the sequence of events gives shape to temporality. In the *Recherche* temporality is in fact the very agent of disruption of the sequence of events; it is time that undoes narrative order rather than emerging from it. As Deleuze pointed out in his book on Proust, the *Recherche* is a machine for the production of time, but the time it produces is the time as antilogos, the time that works against the logos, which is also, as we saw, the time of the snapshot.[44]

The snapshot as *instantané* reveals for Proust's narrator the wasted temporality of the instant that can never be recaptured or relived; it is *against* this waste of time that the great work of art which is still to come by the end of the *Recherche* will be written. But this leaves the *Recherche* itself as we know it taking up the place of the rejected, failed work, the record of the narrator's (and our) wasted hours and years. As the prototypical product of modernism's engagement with the challenge posed by the instantaneity of the snapshot, the *Recherche* tells us much about the kinds of time we have been having, and the ways in which we have been spending it. It tells us that the advent of the snapshot brings about a new kind of time, time as the wasteful production of an infinity of never-ending instants. It is to this challenging mode of time that modernist literature, and modernist photography, address themselves, attempting to give shape and meaning to what is both 'time and no time at all'.

[44] Gilles Deleuze, *Proust and Signs*, trans. Richard Howard (Minneapolis: University of Minnesota Press, 2000), 105–15.

MODERNISM AND THE VISUAL ARTS

SARAH VICTORIA TURNER

> So far as the arts are concerned, the meaning and values of modernity are now irretrievably associated with those theories and practices of Modernism which have been the subject of considerable dispute since the 1960s.
>
> (Charles Harrison, 'A Kind of Context', in *Essays on Art and Language*)

LOOKING AT MODERNISM

WHAT does modernism look like? Of course, there is no single answer to such a deceptively simple yet treacherously broad question. How the visual arts were made 'modern' remains a controversial topic for historians of art and visual culture. Is artistic modernism best represented by the work of Édouard Manet, Henri Matisse, Pablo Picasso, Wassily Kandinsky, Vanessa Bell, Alfred Stieglitz, Frieda Kahlo, Wilfredo Lam, or Abanindranath Tagore? The answer is probably 'all of the above', plus many more besides. Jessica R. Feldman's question 'But of which Modernism do I speak?' is a significant one for scholars of nineteenth- and twentieth-century art and visual culture, as well as its literature. It depends, Feldman suggests, on 'one's own Modernism', since there is little agreement about its formal qualities, its year of origin, its longevity ('has it ended?' she asks teasingly), and its groupings of artists

and texts whether historical, national, or philosophical.[1] Speaking of, or looking at, modernism in tandem with visual art raises numerous questions about its formal, chronological, and geographical boundaries. Charles Harrison usefully summarizes some of the disciplinary issues encountered when thinking about modernism. He writes that there are

few terms upon which the weight of implication, of innuendo, and of aspiration bears down so heavily as it now does upon modernism . . . It is a problem for any broadly conceived inquiry into the meaning of 'modernism' that the term acquires a different scope and penetration in each academic discipline. The inception of modernism in music is typically located at the close of the nineteenth-century, while to talk of modernism in English literature is to focus upon a relatively limited if highly influential body of work produced in the first two decades of the twentieth century. In the history of art, on the other hand, the student of modernism can expect to run a gamut from the French painting of the 1860s to the American art of a century later and may even be directed as far back as the later eighteenth century . . . there is always a strong possibility of confusion in art-historical discussions of modernity.[2]

The once fairly well-defined parameters of visual modernism are under pressure. Increasingly, there is 'more than one kind of modernism (and modernity) at stake'.[3]

What constituted 'the modern' was constantly shifting within the landscape of art in the late nineteenth and early twentieth centuries. To be 'modern' could mean a radical approach to facture and the formal qualities of the artistic medium and the creation of new visual languages through which to assess modernity, as is clearly demonstrated in early Cubist work (e.g. Pablo Picasso, *Fruit-Dish, Violin and Wine-glass*, 1912–13). Or it might refer to the new subjects for art which registered the (often entwined) alienating and exhilarating experiences of mechanized, industrialized, urbanized life, as captured in the work of a diverse range of artists from the Futurists in Italy to the Camden Town and Vorticist groups in Britain. In Umberto Boccioni's *The Street Enters the House* (Fig. 30.1), the rapidly expanding city (which is in the process of being built by an incessant small army of labourers) threatens to swallow up the precariously perched woman standing on the domestic balcony. In fact, the woman's body already appears to be morphing into the cityscape that surrounds her. The title of Marshall Berman's book on the experience of modernity, lifted from Marx's *Communist Manifesto*, seems appropriate here: 'All that is solid melts into air.'[4] The word 'modern' could also signify certain attitudes, identities, beliefs, and practices which occurred well beyond the picture frame. Artists forged 'modern' identities for themselves; they had to learn how to become modern artists. This often involved striking a pose, putting on a costume, or stepping into character. J. M. Whistler's aesthetic dandyism, Augustus John's bohemian jaunts in his gypsy

[1] Jessica R. Feldman, *Victorian Modernism: Pragmatism and the Varieties of Aesthetic Experience* (Cambridge: Cambridge University Press, 2002), 6.

[2] Charles Harrison, 'Modernism', in Robert S. Nelson and Richard Schiff (eds), *Critical Terms for Art History*, 2nd edn (Chicago: University of Chicago Press, 2003), 188–9.

[3] Lisa Tickner, *Modern Life and Modern Subjects: British Art in the Early Twentieth Century* (New Haven: Yale University Press, 2000), 184.

[4] Marshall Berman, *All That Is Solid Melts Into Air: The Experience of Modernity* (London: Verso, 1982).

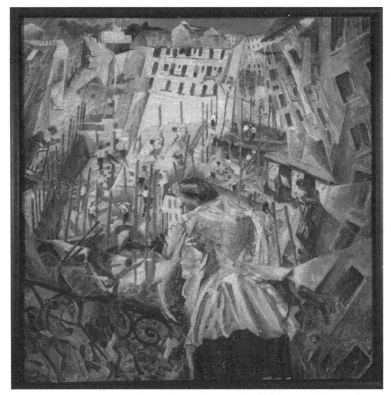

Fig. 30.1 Umberto Boccioni, *The Street Enters the House*, 1911

caravan, and Wyndham Lewis's combative aggression towards his artistic rivals (especially those associated with the Bloomsbury group) can all be understood as responses to the change in the position of artists under the conditions of modernity. There was also a great rise in the number of women practising as artists. Although there were still numerous barriers and hurdles to negotiate, the early twentieth century witnessed the increased visibility of women training and exhibiting as artists.

Henri Gaudier-Brzeska, a young French sculptor who came to live and work in London in 1911, used the word 'modern' as a descriptive category for a group of artists with which he identified: 'WE the moderns'.[5] Here, the 'modern' becomes a badge of allegiance, an ideologically loaded position which binds certain artists together, while excluding others at the same time. We see the politics and performances of groups, associations, gangs, coteries, and clubs of artists take an increasingly central, but by no means unproblematic, position within discussions of modernism. In fact, one might go so far as to say that accounts of artistic modernism have increasingly focused on movements. Cubism, Futurism, Vorticism, Dada, Surrealism are all familiar within narratives of visual modernism. In the cultural welter of the years before the First

[5] Henri Gaudier-Brzeska, 'Vortex: Gaudier Brzeska', in Wyndham Lewis (ed.), *Blast: Review of the Great English Vortex*, 1 (Santa Barbara, Calif.: Black Sparrow Press, 1981), 158.

World War, artists found it beneficial to form alliances with one another based on shared attitudes, sympathetic practices, and more loosely (though not less importantly) ties of friendship and social association. As well as operating on an ideological level, coming together to exhibit, to make public announcements, and jointly to generate publicity could be economically advantageous in an increasingly overcrowded marketplace. The trouble with modern movements is that they have often become static labels associated with formal style. Not to be in a movement has come to mean not being 'modern'. This is particularly true of histories of modern European art, and in particular, an obsession with singling out the 'avant-garde' from its near and distant cousins, the 'modern' and the 'academic'. There is still much work to be done tracing the delicate networks of shared ideas, positions, and approaches which connected artists, but which did not necessarily bind them in distinct and static groups or 'isms'.

The 'modern' does not necessarily carry the same meaning as the 'contemporary', and Henri Gaudier-Brzeska was certainly not addressing all the artists of his generation in his essay on sculpture. The 'moderns', in this case, were a very select few. Gaudier's phrase appropriately appeared in the pages of *Blast*, the short-lived organ of the Vorticist movement (which is often seen as representative of the most advanced form of modernism in Britain in the early twentieth century). The text and images in the pages of *Blast* signal both an interest in formal experimentation with the constitutive elements of art, a critical positioning towards the experiences of modernity (oscillating between the celebratory and the oppositional), and a shared sense of hostility towards those artists who were not the right kind of 'moderns', or just not 'modern' at all. The relationship between text and image is incredibly important for modernism (this claim is supported by the number of magazines and manifestos issued by modern artists and groups), and certainly so for the aggressive version of modernism which is promoted in *Blast*, where friends and foes are either 'blessed' or 'blasted'. David Peters Corbett has suggested that for certain modern artists the visual was incapable of operating entirely on its own terms. Language, at least in early modernism, remained 'the instrument of modernity', making the work of visual art 'an adjunct to the "rhetorical din" of the time'.[6]

As will already be obvious, how the 'modern' was made visible and tactile through the physical, material, and often messy practices and processes of art is far from straightforward. Charles Harrison suggests in the epigraph to this chapter that scholars have frequently connected the social processes of modernity with the appearance of artistic practices which have been gathered under the banner of 'Modernism' (with or without the capital 'M'). Although modernism is not a style per se, it is often 'bound up with an interest in the formal procedures of art and the elements of picturing'.[7] These interests and responses were, however, heterogeneous and varied (no matter how hard subsequent histories have tried to neaten up the

[6] David Peters Corbett, *The World in Paint: Modern Art and Visuality in England, 1848–1914* (Manchester: Manchester University Press, 2004), 226.
[7] Tickner, *Modern Life and Modern Subjects*, 189.

edges). A breakdown in the traditional viewer–image relations; the move towards abstraction; the shunning of pictorial narrative; a heightened awareness of form and colour—all these, and more, could be claimed to be chief components of visual modernism. If new art forms and languages were being made, so too were new audiences for art. Modern art also found new spaces, dealers, and buyers away from traditional arenas for art, such as the Church and the official academies. Modernists like Clive Bell saw the art of the recent past as particularly redundant, if annoyingly persistent. He wrote contemptuously: 'we are not yet clear of the Victorian slough. The spent dip stinks on into the dawn.'[8] This rupture with the past is one of the foundation stones of modernism—'the myth of the *tabula rasa*, the cleared ground, whereby modernity requires for its expression the erasure of all pasts . . . and their replacement with a single point of initiation, a clean, focused clarity of understanding within which the confusion of history has finally been stilled'.[9] If this 'cleared ground' could in some way be enacted through the 'significant forms' of the modernist artwork, modernism itself is better understood as a series of overlapping developments: it represents an ongoing dialogue between what was perceived to be the new and the old, the traditional and the modern, the past and the future.

The task of unravelling and attempting to understand the tangled web of relationships between modernity and the visual arts has preoccupied scores of writers, critics, and curators—generating, as Harrison's quote also makes clear, much difference of opinion. For the French poet Charles Baudelaire, the 'painter of modern life' was the artist who could depict the experience of living in the modern age: 'the ephemeral, the fugitive, the contingent, the half of art whose other half is the eternal and the immutable'.[10] Painted in the same year that Baudelaire's essay was published (1863) Manet's *Olympia* (Fig. 30.2), depicting a naked Parisian prostitute, has become the perfect partner through which to unpick how the material marks of paint on the surface of cloth stretched over a wooden frame can communicate something particular about witnessing and being part of contemporary social life.

As the nineteenth turned into the twentieth century, the modern was frequently diagnosed as mechanized. For Walter Gropius, writing in inter-war Germany, the machine was central for the aesthetics of the new century: 'The Bauhaus believes the machine to be our modern medium of design.'[11] Technological inventions provided new subjects for art; electric lighting, the cinema, motorized public transport had all appeared in the last two decades of the nineteenth century. In his essay 'Modern Art and its Philosophy' (1914), the poet and critic T. E. Hulme observed: 'You will find artists expressing admiration for engineers' drawings, where the lines are clean, the

[8] Clive Bell, *Art* (1914), quoted in Charles Harrison, *English Art and Modernism, 1900–1939* (London: Allen Lane; Bloomington: Indiana University Press, 1981), 53.

[9] Corbett, *The World in Paint*, 218.

[10] Charles Baudelaire, *The Painter of Modern Life and Other Essays*, ed. and trans. Jonathan Mayne (Oxford: Phaidon Press, 1964), 12.

[11] Walter Gropius, 'The Theory and Organisation of the Bauhaus', in Herbert Bayer, Walter Gropius, and Ise Gropius (eds), *Bauhaus, 1919–1928* (Boston: Branford, 1952), 21.

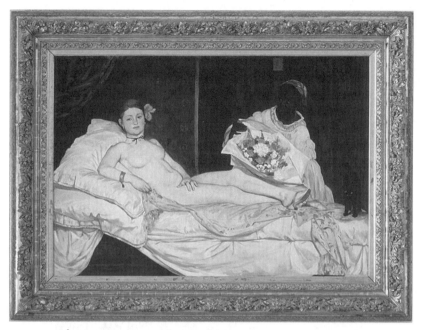

Fig. 30.2 Édouard Manet, *Olympia*, 1863

curves all geometrical, and the colour laid on to show the shape of a cylinder.'[12] Hulme qualifies this a little further on, remarking that it is not so much that the new art will have to look like machinery or be like machinery 'in spirit' but will have 'an organisation' and be 'governed by principles, which are at present exemplified unintentionally, as it were, in machinery'.[13] The geometrical line, Hulme confirms, is 'something absolutely distinct from the messiness, the confusion, and the accidental details of existing things'.[14] The work of Jacob Epstein, an American-born, but London-based, sculptor, was paramount to Hulme's thinking about art. Epstein's *Rock Drill* (1913–16), with its strange combination of a robotic plaster figure astride a mechanical rock drill, has been accorded a prominent place in narratives of modern sculpture in the twentieth century. The sculpture presented the viewer with some disquieting juxtapositions by means of its form, materials, and construction methods: the man-made figure atop a ready-made drill; the differing surface qualities of the chalky white plaster and the cold, hard metal; the curious proximity of industrial and 'primitive' forms; and the symbolic yet perilous union (for the early twentieth-century viewer) of the human and the robotic. The inclusion of the machine proved too much for some critics. One wrote that 'even if the figure is to

[12] T. E. Hulme, *Speculations: Essays on Humanism and the Philosophy of Art*, ed. Herbert Read (London: Routledge, 1936), 97.
[13] Ibid. 104. [14] Ibid. 87.

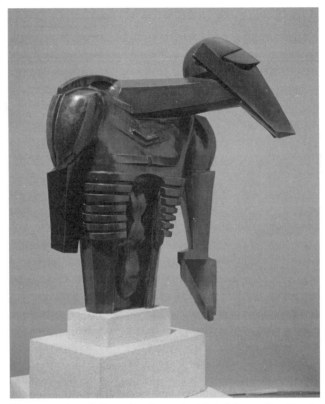

Fig. 30.3 Jacob Epstein, *Torso in Metal from the 'Rock Drill'*, 1913–16

be cast in iron, the incongruity between an engine with every detail insistent and a synthetic man is too difficult for the mind to grasp'.[15] In 1916 the sculpture was exhibited for a second time, but it now displayed some significant revisions (Fig. 30.3). Gone was the drill and the lower part of the figure's body. The arm that operated the machine had also been amputated. These major modifications, which altered the sculpture from an icon of phallic and aggressive masculinity to a drastically severed torso cast in gunmetal, have been usually understood as signifying the horrors wrought on the male body and the decimation of the artistic avant-garde and the figure of the male artist resulting from the circumstances of the First World War. Yet, as Sue Malvern has suggested, artists associated with the avant-garde were in the years before 1914 already concerned with formulating a critical response that addressed the

[15] *Manchester Evening Guardian*, 15 Mar. 1915, quoted in Richard Cork, *Jacob Epstein* (London: Tate Gallery, 1999), 39.

fragile existence of the body (the male body in particular), the status afforded to the artist in modern society, and the dismantling of a humanist artistic tradition.[16]

Construction as well as destruction had a significant role to play in the vocabularies of visual modernism, particularly in the inter-war period. The Bolshevik Revolution of 1917 in Russia was instrumental in furthering the connections made between the language of construction and revolutionary social, political, and aesthetic change. Artists in Russia, inspired by the social utopianism of the revolutionary government, began to explore ways in which the arts might contribute to social progress under the new Communist order. In March 1921 a Working Group of Constructivism was established by artists, including Alexandr Rodchenko, who wanted to redefine the relationships between art, utility, and function, and ultimately to challenge the specialized category of 'art' itself. How an artwork could relate to the world was explored through exhibitions, such as the Obmokhu (Society of Young Artists) in May 1921, which was designed along the lines of practical, scientific experiments rather than a traditional 'salon'. The Constructivist artists saw their creations not as art but as 'laboratory works' which broke down the barriers between artistic practice and the everyday by using materials such as cardboard, glass, and wire in their work, thus referencing the technologized worlds of modern engineering and building. Christina Lodder observes that artistic construction was in this work 'a metaphor for, and indeed stimulus to, reconstruction in the broadest possible sense'.[17] In the 1920s, the geometric language of construction crossed numerous geographical boundaries on its move westward from Russia to Europe, attracting a great many artists as it did so. Briony Fer has argued that because the geometric had become such a potent symbol for modern culture it could be deployed in many different contexts, although as with any such deployment, the meaning and application of the geometric was subtly transformed in the process of these migrations.[18]

Is the 'painting of modern life' (or the 'sculpting' or 'drawing' of modern life) the same thing as modernism? Grappling with such a question instantly highlights the thorny problems faced in trying to secure a definition of artistic modernism or to pin it to a particular group of artworks or artists. It is very easy to pluck from the canon of visual modernism paintings and sculptures which can happily be described as 'modern' but which do not immediately register obvious visual signifiers of modernity or modern life upon their surfaces. Modern works of art sometimes represent the outward effects of modernity, but they also frequently offer an escape from it, another space in which the fragmentation of modernity can possibly be ameliorated. The abstract canvases and designs of such artists as Kandinsky and Vanessa Bell (Figs 30.4 and 30.5) presented, it might be argued, an alternative to the maelstrom

[16] Sue Malvern, *Modern Art, Britain and the Great War: Witnessing, Testimony and Remembrance* (New Haven: Paul Mellon Centre for Studies in British Art and Yale University Press, 2004), 4.

[17] Christina Lodder, 'Art into Life: International Constructivism in Central and Eastern Europe', in Timothy O. Benson (ed.), *Central European Avant-Gardes: Exchange and Transformation, 1910–1930*, exh. cat. (Cambridge, Mass.: MIT Press; Los Angeles: Los Angeles County Museum of Art, 2002), 173.

[18] Briony Fer, 'The Language of Construction', in Briony Fer, David Batchelor, Paul Wood (eds), *Realism, Rationalism, Surrealism: Art Between the Wars* (New Haven: Yale University Press in association with Open University Press, 1994), 95.

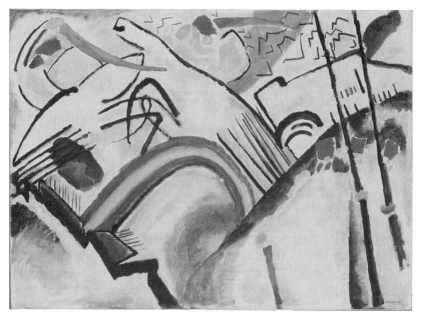

Fig. 30.4 Wassily Kandinsky, *Cossacks*, 1910–11

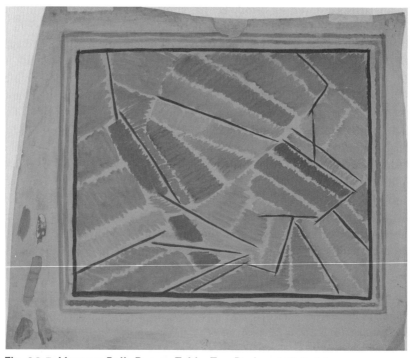

Fig. 30.5 Vanessa Bell, *Rug or Table-Top Design*, 1913–14

of modern life, drawing attention instead to the pictorial relationships between forms, colours, and shapes, and giving life through these relations to unspoken hopes, dreams, and fears about modernity. More fantastical and imaginative works also register what José Harris has described as the 'other face' of modernity, exposing 'a lurking grief at the memory of a lost domain—a sense that change was inevitable, and in many respects desirable, but that its gains were being purchased at a terrible price'.[19]

MAPPING MODERNISM

For art history, as for many disciplines, modernism is conventionally associated with what Raymond Williams has described as a 'highly selected [sic] version of the modern'.[20] This selective tradition has been predominantly mapped around the avant-garde practices of artists working and living in Europe's cultural centres, namely Paris, Berlin, Munich, Milan, and London, between the mid-nineteenth century and the first decades of the twentieth. (The date parameters of modernism are highly controversial, in terms of both commencement and termination.) The maps of modernism created in the first half of the twentieth century, which essentially chart a canonical, formalist, 'modernist' version of modernism, now seem extremely outmoded; no longer can they offer us a safe passage through the choppy waters of modern art. Having said this, their legacy for the understanding of modern art is extremely persistent. Alfred Barr's diagram (Fig. 30.6), created in 1936 for the exhibition *Cubism and Abstract Art* he curated at the Museum of Modern Art, is perhaps the most famous of such 'modernist' guides to artistic modernism. Barr secured what, and who, was 'modern' by confidently guiding the spectator via a series of one-way arrows from the nineteenth to the twentieth century. This is artistic 'progress' in action. We are chronologically guided from one movement to the next, conquering and colonizing new spaces and styles as art is made modern through 'influence and reaction'.[21] The chart is supported by a column of dates on either side as if to underline the relentless forward march of modernism. The sharp, neat arrows assertively push us on to what comes next. The arrows only point in one direction: to the future. Barr produces a history of linear developments describing the 'ascent of

[19] José Harris, *Public Lives, Public Spirit: A Social History of Britain, 1870–1914* (Oxford: Oxford University Press, 1993), 36.

[20] Raymond Williams, 'When Was Modernism?', in *The Politics of Modernism: Against the New Conformists*, ed. Tony Pinkey (London: Verso, 1989), 33.

[21] Griselda Pollock, 'Modernity and the Spaces of Femininity', in *Vision and Difference: Feminism, Femininity and the Histories of Art* (London: Routledge, 2003), 71.

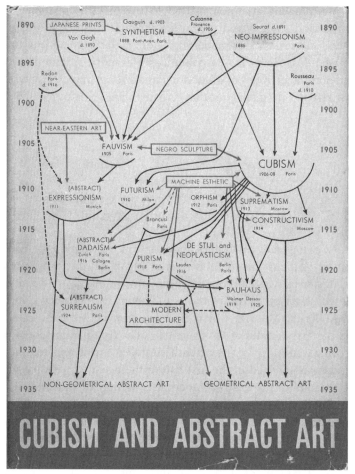

Fig. 30.6 Alfred Hamilton Barr, Jr, Cover of the exhibition catalogue *Cubism and Abstract Art* (MoMA 1936)

movements'.[22] This is a modernism which, to adapt Ezra Pound's phrase, 'makes it new'. Yet a neat chronology is not the same thing as history, with all its conflicting richness. Dislocated from the real social spaces in which they were formed, artistic practices and movements become linked through formal and stylistic correspondence. Just taking one possible route on the map clearly illustrates this. Starting at the neatly boxed 'Japanese Prints', we follow the arrows to 'Fauvism', then to 'Negro Sculpture', arriving at 'Cubism', which seems to be, as it is the largest word printed on the page, the ultimate destination on Barr's map.[23]

[22] Christopher Green, *Art in France, 1900–1940* (New Haven: Yale University Press, 2000), 13.

[23] For an interesting discussion of Cubism's place in Barr's schema, see David Cottington, *Cubism and its Histories* (Manchester: Manchester University Press, 2004), esp. ch. 6.

The movements are anchored to particular cities, not to countries (Cubism to Paris, Suprematism to Moscow, Futurism to Milan), and are presided over by the names of a few key artists (Van Gogh, Gauguin, Cézanne, Seurat).[24] Interestingly, 'Japanese Prints', 'Near Eastern Art', and 'Negro Sculpture' are not linked to specific places or people. Safely boxed and thus contained, these artistic forms and cultures are emptied of their particular cultural, temporal, and historical specificity, only gaining value once they are incorporated into the histories of Western modernism. The artists named are those who have, as Griselda Pollock writes, been 'canonized as the initiators of modern art'.[25] For Pollock, this modernist history celebrates a 'selective tradition which normalizes, as the *only* modernism, a particular and gendered set of practices'.[26] The more one looks at Barr's map, the more strikingly apparent its gaps and omissions become. There are numerous large, empty spaces amid the busy network of arrows; these are the voids 'uncolonized' or ignored by modernist critics and curators, the areas where artists and artworks have literally fallen off the map.

The 'classic' explanation of modernism as a visual style was forcefully articulated by the American art critic and writer Clement Greenberg. Modernism, for Greenberg, meant painting, and painting meant pigment and the 'ineluctable flatness of the support'.[27] In this exposition, art becomes limited to the visual medium. This formalist version of modernism is neatly framed. Modernism is seen as occupying some pure, autonomous space whose borders are sealed against contamination from the untidy circumstances of social and psychic modern lives. Modernist painters are described as exploiting the world of painting—testing the 'constraints of pigment and the two-dimensional bounded canvas'—and thus art becomes a self-involved practice which is purposefully estranged from the social matrix.[28] In the late 1930s, Barr's book and exhibition had made the first move in what Christopher Green has described as the 'globalisation of the story of modernism'. Barr, and others, initiated a kind of formalist, historical writing about art that 'would represent the succession of movements as supranational' and ultimately make the 'global modernism and post-modernism of the late twentieth century'.[29] Yet how truly 'global' could such a canonical version of modernism be when so much had been left off the map?

[24] Ramsay Burt, writing about modernity, modern dance, and the metropolitan, remarks: 'Be it Paris, New York, Berlin, London, or whichever metropolitan centre, the metropolis exudes a special allure ... Cities, and capital cities in particular, have been crucial in the development of the modern arts' (*Alien Bodies: Representations of Modernity, 'Race' and Nation in Early Modern Dance* (London: Routledge, 1998), 20).

[25] Pollock, 'Modernity and the Spaces of Femininity', 71. [26] Ibid.

[27] Clement Greenberg, 'Modernist Painting', in Charles Harrison and Paul Wood (eds), *Art in Theory, 1900–1990: An Anthology of Changing Ideas* (Oxford: Blackwell, 1992), 756.

[28] This is David Peters Corbett's phrase in *The Modernity of English Art, 1914–30* (Manchester: Manchester University Press, 1997), 6. See also Jessica Feldman's description of the modernist object as something to be admired 'for its self-sufficiency and self-involvement'. The 'Modern work of art', she writes, 'has often been imagined, by artists and critics alike, as purely sculpted, paradoxically spiritual or cerebral for all its hardness, and preferably not for sale' (Feldman, *Victorian Modernism*, 6).

[29] Green, *Art in France*, 13.

REMAPPING MODERNISM

If the work of Pollock and others, most notably Carol Duncan, Linda Nochlin, Katy Deepwell, and Lisa Tickner, has laid bare the glaring exclusion of women from the narratives of modern art and the explicit gendering of modernism as masculine and virile, more recently, the omission of artists from outside of Europe and the United States has been underlined. In his recent article 'Interventions: Decentering Modernism: Art History and Avant-Garde Art from the Periphery', Partha Mitter argues that monolithic definitions of Western modernism have failed to 'take into account either the progressive heterogenization of art or the richness and creativity of art practices in the peripheries'.[30] What is needed, he suggests, is an art history which entertains the multiple local possibilities of the global processes of modernity.[31] Shackled by what Mitter calls a 'pathology of influence', modernism has failed to recognize the cross-fertilization of ideas and forms between cultures, preferring an overdetermined analysis 'based on the relationship between the borrower and his or her source'.[32] Describing what he has dubbed the 'Picasso Manqué Syndrome', Mitter asks why, for example, Picasso's borrowings from ethnographic objects in paintings such as *Les Demoiselles d'Avignon* in no way compromised his cultural identity as an artist, whereas when artists from the colonial periphery adapt the representational strategies of the Western avant-garde, they may be described as creating derivative, imitative, and unoriginal works? Using the example of Gaganendranath Tagore, who was among the first Indian painters to experiment with Cubist visual languages in his paintings, Mitter argues that there are no limits to what Western artists can appropriate, whereas the use of Cubism by an Indian artist who belonged to the colonized world 'immediately locked him into a dependent relationship, the colonized mimicking the superior art of the colonizer'.[33]

Saloni Mathur argues (in response to Mitter's article) that art history is stuck in 'the impasse of Eurocentricism'.[34] Why is art history, and particularly the history of modernism, so resistant to the voices and marks of difference? What is it about the visual which keeps it locked in these persistent genealogies of style and form? However, Mathur warns against an 'additive' approach, reminding us of a lesson learnt from early feminism—that to "add women and stir" does not fundamentally change the contents of the pot'.[35] Instead of simply incorporating the names of non-Western artists in the existing canon of modern art, she proposes that we need to 'tell

[30] Partha Mitter, 'Interventions: Decentering Modernism: Art History and Avant-Garde Art from the Periphery', *Art Bulletin* (Dec. 2008), 544.
[31] See also Geeta Kapur, *When Was Modernism? Essays on Contemporary Cultural Practice in India* (New Delhi: Tulika Books, 2000). The 'modern', she writes, 'is not an identical narrative in reckonings across nations' (p. xiii). And see Supriya Chaudhuri, Ch. 52 in this volume.
[32] Kapur, *When Was Modernism?*, 538.
[33] Ibid. 537.
[34] Saloni Mathur, 'Response: Belonging to Modernism', *Art Bulletin* (Dec. 2009), 560.
[35] Ibid.

the story of artistic connections between the avant-garde movements of Europe, India, Africa, East Asia, and North and South America, in part by highlighting the global incursions of artists and ideas in and out of the dominant centres and thus capturing the dizzying cosmopolitanism and internationalism of the era'.[36]

Modernism has long been recognized as being shaped by the experiences of travel, exile, and migrations—journeys characterized by dreams of new beginnings and of ruptures with old ways of life. If 'migrants have made modernity what it is', as Nikos Papastergiadis has argued, then it must also be said that migrants have made *modernism* what it is.[37] But the 'endless border crossing' which contributed to the experimentation with new representational strategies, and to the creation of radical visual language through which critically to assess the experiences of modernity, have not been fully understood within the history of art.[38] This might have something to do with the persistence of the concept of 'national schools' of art in museums, universities, and publication projects. Art history quite happily accommodates the narratives of migration to dominant centres, especially seeing Paris at the end of the nineteenth century as a crucible for artistic training, exhibition, and display, but it appears less well equipped to deal with the international shuttling of ideas, forms, and visual languages between 'centre' and 'periphery'. As Kobena Mercer observes, the 'converse journey of artists moving from colonial periphery to western metropolis has received much less art historical attention, even though it further highlights an on-going narrative of two-way traffic'.[39]

Breaching the Boundaries of British Art

In the final section of this chapter, I want to use the case of 'British modernism' to explore the idea of remapping the histories of modern art to incorporate this 'two-way traffic'. Modernism in Britain has typically been seen as a somewhat delayed and second-hand response to more exciting developments elsewhere. For some, Lisa Tickner observes, this pairing is 'almost an oxymoron'.[40] So to look for the global in art that has been largely characterized as at best playing a game of catch-up with its more glamorous Continental neighbours, and as, at worst, decidedly provincial, might seem somewhat misguided. What I want to suggest, however, is that the development of modern art in Britain was very much shaped by cultural exchange

[36] Ibid.

[37] Nikos Papastergiadis, *Modernity as Exile: The Stranger in John Berger's Writings* (Manchester: Manchester University Press, 1993), 1.

[38] Williams, 'When Was Modernism?', 34.

[39] Kobena Mercer (ed.), *Cosmopolitan Modernisms* (London: InIVA, 2005), 10.

[40] To quote Tickner in full: 'For some, British (or English) modernism is almost an oxymoron' (*Modern Life and Modern Subjects*, 192).

across national boundaries. In 1900 London was the largest city in the world and 'the Heart of Empire'.[41] London can be seen as both a central and a marginal site: central to any history of empire and modernity (as one of the most heavily industrialized cities in the world at the turn of the century), yet marginal within the narratives of visual modernism. We need to expand our concepts of modernism to incorporate the impact of cross-cultural, international encounters on artists and to include the global context which undoubtedly shaped local versions of artistic modernity. Elleke Boehmer writes that 'The interdiscursivity of modernism, in other words, its layered intersection of diverse aesthetic, spiritual, and political approaches, was informed by—whilst itself informing—other pathways of cross-cultural, cross-border exchange'.[42] An imperial hub with porous boundaries, London was a 'site productive not just of imperial policy or attitudes directed outward', as Antoinette Burton has cogently argued, but 'of colonial encounters within'.[43] Understanding the transnational relation-ships that helped to shape artistic modernism is about more than simply tracing visual influences and stylistic borrowings. It concerns acts of cross-cultural transmission, movement, and travel between Britain, Europe, and other, more geographically distant, parts of the world.

Roger Fry's Post-Impressionist exhibitions held in London in 1910 and 1912 have become somewhat legendary events within the formalist narrative of British art history. They have often been seen as the catalyst for encouraging British artists to look outwards and to be 'made modern' through contact with European (read French) art. It is certainly true that they brought the work of Cézanne, Van Gogh, Gauguin, and other European painters to the attention of a large number of British viewers and critics for the first time. Paul Edwards's summary that what 'was happening during this period in British art was a fairly unsystematic assimilation of the innovatory styles of European art, from Cézanne to Matisse, Picasso and Kandinsky'[44] represents the common assessment of the impact of Fry's exhibitions, and the somewhat patchy influence and embrace of modern European art on artists in Britain. Lisa Tickner has observed that histories of British art are 'riven by the tension between two opposing narratives'.[45] One she describes as a modernist account of the avant-gardes which places British artists in the shadow of their Continental counterparts, and the other is a genealogy of eccentrics (think Blake, Spencer, Freud, etc.). 'The terms', she writes, 'of the first narrative are largely formalist and cosmopolitan. It stresses sameness and is embarrassed by difference';

[41] Lynda Nead, ' "Highways and Byways": London's Modern Life *c.*1900', in Robert Upstone (ed.), *Modern Painters: The Camden Town Group*, exh. cat. (London: Tate, 2008), 40.

[42] Elleke Boehmer, *Empire, the National, and the Postcolonial, 1890–1920: Resistance in Interaction* (Oxford: Oxford University Press, 2002), 22.

[43] Antoinette Burton, *At the Heart of Empire: Indians and the Colonial Encounter in Late-Victorian Britain* (Berkeley: University of California Press, 1998), 8.

[44] 'Introduction', in Paul Edwards (ed.), *Blast: Vorticism, 1914–1918* (Aldershot: Ashgate, 2000), 11.

[45] Lisa Tickner, 'English Modernism in the Cultural Field', in David Peters Corbett and Lara Perry (eds), *English Art 1860–1914: Modern Artists and Identity* (Manchester: Manchester University Press, 2000), 30.

the second, in contrast, 'stakes everything on difference and is embarrassed by connections, which can only compromise the idiosyncrasies of its maverick heroes'.[46]

We cannot, and should not, underplay the powerful importance of Continental artists on those working in Britain, or the vocal cultural response to Fry's exhibitions. Anna Gruetzner Robins's *Modern Art in Britain, 1910–1914* gives an illuminating impression of the range of exhibitions of art from Europe during this short period alone, including work by Kandinsky at the Allied Artists' Association and the Futurists at the Sackville Gallery in 1912.[47] Grace Brockington's work has revealed other, less well-explored international networks in this period, including the International Lyceum Club and the *Exhibition of Works of Contemporary German Artists in London* in 1906.[48] Yet what Brockington describes as a 'bias towards Anglo-French relations' and the 'increasingly restrictive emphasis on modernist artists (narrowly defined)' has meant that such events and projects which encouraged artistic exchange and dialogue across national borders have been evacuated from cultural histories of modernism, much to the detriment of narrating the full richness and eclecticism of the early twentieth-century British art world.

A sense of developing new visual languages and cultural responses to modernity came not only from across the Channel but through the global networks of empire. The year before Fry's first Post-Impressionist exhibition, the poet and curator Laurence Binyon published an article entitled 'The Art of India' in the *Saturday Review*. He commented that ideas about the East—'ideas which have been so large in their vagueness and so limited in their knowledge'—were beginning to alter.[49] The 'East', he asserted, could no longer afford to be used as an 'idle epithet', a 'rich, wild background for restless fancy to wander in'. 'The East begins to touch us, to affect us, in many and subtle ways,' Binyon argued.[50] In the same year he continued to promote these ideas in his lecture series 'Art & Thought in East & West: Parallels and Contrasts'.[51] Binyon's article evokes the physicality, even the intimacy, of the new encounters between India and Britain: this is a cultural 'touch' beyond the 'practical relations of commerce and the shifting apprehensions of war perils'.[52] Touch, the

[46] Ibid.

[47] Anna Gruetzner Robins, *Modern Art in Britain, 1910–1914*, exh. cat. (London: Merrell Holberton in association with the Barbican Art Gallery, 1997).

[48] Grace Brockington, '"A World Fellowship": The Founding of the International Lyceum Club', *Transnational Associations*, 1 (Mar. 2005), 15–22; '"A Jacob's Ladder Between Country and Country": Art and Diplomacy Before the First World War', in Brockington (ed.), *Internationalism and the Arts in Britain and Europe at the Fin de Siècle* (Oxford: Peter Lang, 2009), 304.

[49] Laurence Binyon, 'The Art of India', *Saturday Review* (8 Jan. 1909), 38.

[50] Ibid.

[51] A handbill in the William Rothenstein papers at Harvard University advertised that the lectures were illustrated with lantern slides and were given in the small theatre of the Albert Hall, Kensington, at 5.30 p.m. on Wednesday afternoons. There were four lectures in total and the first one focused on 'Sculpture and Religious Art'. Binyon wrote to William Rothenstein to tell him about them and to ask for Rothenstein's help in making them more widely known. Ezra Pound also attended and was an admirer of Binyon's work at this time. Houghton Library, Harvard University, William Rothenstein Papers, BMS Eng. 1148, items 126 (1) and 126 (97).

[52] Binyon, 'The Art of India', 38.

most 'liminal' and taboo-laden of the senses, since it directly involves the thresholds of the self and other, was a loaded metaphor for Binyon to employ when describing cultural relations between colonizer and colonized.[53] For Binyon, there was a growing reciprocity between the arts and artists of the 'East' and 'West', a sympathy shared by a growing number of artists and art writers based at the 'Heart of Empire'.

Chief among these figures was Ananda Kentish Coomaraswamy, who was born to a Sri Lankan father and a British mother.[54] He developed an Arts and Crafts-inspired criticism of colonialism in the East and industrialism in the West which formed the basis of most of his books before the First World War, such as *Mediaeval Sinhalese Art* (1908) and *Essays in National Idealism* (1909), which earned him high regard in Indian nationalist circles.[55] Reviving national and traditional arts could, Coomaraswamy argued, return India (and the East) to the spiritual idealism and harmonious communal relations of the pre-industrial, pre-colonial era which would, in turn, have a positive influence on the materialistic West. These were ideas which made his residence in Britain increasingly difficult in the years leading up to the First World War, but which were warmly received by artists in Britain such as Eric Gill, William Rothenstein, and Walter Crane, and in India too, where he found particular support among the Tagore family. Coomaraswamy's ideas concerning art and culture were fostered by the transnational contacts made with those involved in anti-imperial and anti-industrial movements in Britain and in India. The development of these ideas was assisted, somewhat paradoxically, by the connective webs of communication and travel within the British Empire. This highlights the 'double nature of the imperial system': it extended power and domination over colonized countries on the one hand, and brought the imperial city (London, in this case) into contact with other subjectivities on the other hand, thereby creating interconnected networks of encounter and encouraging cultural mobility.[56]

Publishing in the *Burlington Magazine*, edited by Roger Fry, Coomaraswamy did much to bring Indian art to the attention of a British readership. His article 'Indian Images with Many Arms', first published in the *Burlington* in January 1913 (then

[53] For an interesting discussion of touch, see Susan Stewart, 'Prologue: From the Museum of Touch', in Marius Kwint, Christopher Breward, and Jeremy Aynsley (eds), *Material Memories* (Oxford: Berg, 1999), 17–38. The concept of 'liminality' was developed by the anthropologist Arnold Van Gennep in his 1909 study *The Rites of Passage*, trans. M. B. Vizedom and G. L. Cafee (Chicago: University of Chicago Press, 1960).

[54] Roger Lipsey, *Coomaraswamy, iii: His Life and Work*, Bollingen Series (Princeton: Princeton University Press, 1977), 89. By the time of the First World War, Coomaraswamy was viewed as an extremely subversive figure and was finally allowed to emigrate to the United States in 1917 only after agreeing never to return to the United Kingdom and to hand over a portion of his property. For an interesting discussion of Coomaraswamy's activities in the United States, see Allan Antliff, *Anarchist Modernism: Art, Politics, and the First American Avant-Garde* (Chicago: University of Chicago Press, 2001), 123–44.

[55] Ananda K. Coomaraswamy, *Mediaeval Sinhalese Art: Being a monograph of mediaeval Sinhalese arts and crafts in the eighteenth century, with an account of the structure of society and the status of the craftsmen* (Broad Campden: Essex House Press, 1908) and *Essays in National Idealism* (Madras: Natesan, 1909).

[56] Tony Ballantyne and Antoinette Burton, 'Introduction', in Ballantyne and Burton (eds), *Bodies in Contact: Rethinking Colonial Encounters in World History* (Durham, NC: Duke University Press, 2005), 3.

reprinted as a central essay in Coomaraswamy's celebrated book *The Dance of Śiva* in 1918), confronted the widespread criticisms of these sculptures by the likes of Vincent Smith and George Birdwood, who found them monstrous and grotesque.[57] One figure which was reproduced frequently in Coomaraswamy's publications was a four-armed dancing Nataraja (Siva) sculpture from southern India in the Madras Museum. His reading of it is extremely interesting. He appeals to his *Burlington* audience through a language of contemporary modernist aesthetics, movement, dance, and modernity. This was an 'image of the primal rhythmic energy underlying all phenomenal appearance and activity'.[58] The dancer was an 'embodiment of ecstasy and rhythm'. The figure of the many-limbed dancer is 'perfectly balanced and in no sense restless, [it] moves perpetually before our eyes. It represents no frozen movement, but a thing going on: again, the rhythm, of the spirit in the movement of the living thing. This continuity and this infinity are especially suggested by the many arms.'[59] Coomaraswamy suggests how 'modern' such a method of representing movement was. The desire to represent continuity of movement, he implied, could be seen in the work of Futurists, as well as other artists. This modern tendency should, he argued, make it easier for a contemporary Western viewer to 'understand and appreciate' the multi-armed deities. Henri Gaudier-Brzeska's *Red Stone Dancer* (Fig. 30.7) and the drawing for the sculpture reproduced in the *New Age* on 9 March 1914 makes these links to the modern representation of dance and movement more concrete.

Often criticized in his own day, and also more recently, as the leader, the 'high priest' even, of a snobbish cult of elitist, formalist aesthetics in awe of modern French painting, Fry's promotion of new ideas about the visual arts of Asia has been little studied. Henry Tonks's *The Unknown God: Roger Fry preaching the New Faith and Clive Bell ringing the Bell* is symptomatic of the common assumptions made about Roger Fry and his artistic doctrines. Caricaturing Fry's position within what has become conveniently labelled as 'Bloomsbury', Tonks depicts him as a wide-eyed, ecstatic prophet figure lecturing to an unimpressed audience (betraying a mixture of shock, weariness, and boredom) with a diminutive Clive Bell professing 'CEZANNAH, CEZANNAH'. However, as Christopher Green and Christopher Reed have argued, Fry, and the close circle of Bloomsbury artists, were in fact part of the subcultural, counter-hegemonic movements of pre-war Britain.[60] Following on from their assessments, I want to place Fry within a wider cosmopolitan network of artists and writers who contributed to this cultural landscape by looking to the arts of other, often geographically distant, countries in search of alternatives through which to reinvigorate contemporary European art and society.

[57] Ananda K. Coomaraswamy, 'Indian Images with Many Arms', *Burlington Magazine*, 22/118 (1913), 189–96.

[58] Ibid. 190.

[59] Ibid.

[60] Christopher Green, *Art Made Modern: Roger Fry's Vision of Art* (London: Merrell Holberton in association with the Courtauld Institute of Art, 1999); Christopher Reed, *Bloomsbury Rooms: Modernism, Subculture, and Domesticity* (New Haven: Yale University Press, 2004).

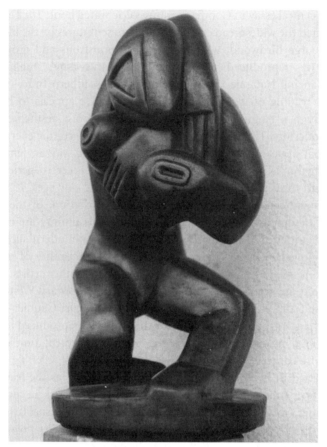

Fig. 30.7 Henri Gaudier–Brzeska, *Red Stone Dancer*, 1913

In an article of 1910 entitled 'Oriental Art', Fry confronted the nineteenth-century
legacy that had promoted the Oriental 'decorative' at the expense of painting and
sculpture. He appealed for an understanding between the arts of East and West based
on underlying shared, universal values. Eastern art, he argued, could teach modern
artists in Europe to 'develop a new conscience', thus relinquishing a pointless quest
for verisimilitude in favour of depicting the essential and expressive elements of
things. This kind of approach to representation, which probed beneath superficial
appearances, was not, according to Fry, the exclusive preserve of Eastern artists but
was merely a 'long forgotten tradition' in the West.[61] 'What will be the effect upon
Western art of the amazing revelations of these last twenty years?', Fry asked. 'One can
scarcely doubt that it will be almost wholly good,' he immediately replied.[62] This

[61] Roger Fry, 'Oriental Art', *Quarterly Review*, 212/422 (1910), 239.
[62] Ibid.

knowledge of the visual arts of the East also contributed to Fry's suspicions about the Western aesthetic canon.[63] Summarizing this opening up of 'new worlds', Fry sees this new research into the arts of the East as the culmination of a series of changes in opinion about what qualifies as 'art':

Scarcely more than a hundred years ago art meant for a cultivated European, Graeco-Roman sculpture and the art of the high Renaissance, with the acceptance of a few Chinese lacquers and porcelains as curious decorative trifles. Then came the admission that Gothic art was not barbarous, that the Primitives must be reckoned with, and the discovery of early Greek art. The acceptance of Gothic and Byzantine art as great and noble expressions of human feeling, which was due in no small degree to Ruskin's teaching, made a breach in the well-arranged scheme of our aesthetics, a breach through which ever new claimants to our admiring recognition have poured.[64]

In this last sentence, the possessive pronoun ('our aesthetics') reminds us that the article was written from a position which, to a certain extent, still upheld the centrality of Western aesthetics to which other cultures made 'claims' for acceptance and attention, and if successful were then acknowledged as 'art'. However, in Fry's eyes this expansion of the Western artistic canon was both inevitable and desirable for the sake of the future of modern art. 'These claims have got to be faced; we can no longer hide behind the Elgin marbles and refuse to look,' he argued. In his April 1910 editorial for the *Burlington Magazine*, Fry commented that the West had turned to 'Oriental art' for 'novelty, refreshment and inspiration'. He perceived that the current interest in India would be more 'intense, and produce a profounder impression on our own views, than any previous phase of Orientalism', and he concluded that

we are more disillusioned, more tired with our own tradition, which seems to have landed us at length in a too frequent representation of the obvious or the sensational. To us the art of the East presents the hope of discovering a more *spiritual, more expressive* idea of design ... the feeling of dissatisfaction at what we have done is taking practical shape.[65]

The words 'international', 'modernism', and 'Britain' are usually only brought together in discussions of the art of the 1930s—a period which is conventionally viewed as a moment of increasing awareness of the developments on the Continent after the 'hiatus' of the insular 1920s.[66] A new receptivity to the visual experiments of Surrealist artists and those working with abstract forms can be identified in the

[63] Christopher Green has argued that Fry in fact 'suspected all canonical evaluations of works of art, including his own. He is often charged with having erected a canon, but actually disliked the very idea of canons' ('Expanding the Canon: Roger Fry's Evaluation of the "Civilized" and the "Savage"', in *Art Made Modern*, 119).

[64] Fry, 'Oriental Art', 226.

[65] Roger Fry, 'Editorial Articles—Oriental Art', *Burlington Magazine*, 17/85 (Apr. 1910), 3.

[66] This is the narrative influentially communicated by Charles Harrison in *English Art and Modernism*. This has been questioned by, among others, Chris Stephens, who argues for a 'cultural continuity' between the 1920s and 1930s in relation to Ben Nicholson's work. See Chris Stephens, 'Ben Nicholson: Modernism, Craft and the English Vernacular', in David Peters Corbett, Ysanne Holt, and Fiona Russell (eds), *The Geographies of Englishness: Landscape the National Past in English Art, 1880–1940* (New Haven: Yale University Press, 2002), 225–47.

Fig. 30.8 Barbara Hepworth, *Three Forms*, 1935

objects and images made by British artists such as Barbara Hepworth (Fig. 30.8), Ben Nicholson, Paul Nash, and Henry Moore, as well as in art reviews such as *Axis: A Quarterly Review of Contemporary 'Abstract' Painting & Sculpture* (launched in January 1935), which was envisaged as the English-language equivalent to the French painter Jean Hélion's own journal *Abstraction-Création*. With the arrival of numerous émigré artists to London, including Naum Gabo, László Moholy-Nagy, Piet Mondrian, and Le Corbusier, to name but a few, the 1930s are usually defined as the most 'cosmopolitan' decade in the story of British modernism. For the architect Norman Foster, 'Modernism only really arrived in Britain with the émigrés'.[67]Abstraction, according to Hepworth, provided a way of communication across national boundaries and a means of uniting artists together in support of social progress. Writing in 1937, Hepworth claimed that abstract art was 'universal and not for a special class ... it is a thought which gives the same life, the same expansion, the same universal freedom to everyone'.[68] While one strategy of recent scholarship in the unpacking of such statements has been to stress the importance of national identity, and particularly the "Englishness" of the work of the likes of Nicholson, Hepworth, and Moore, I want to retain the vital link between cosmopolitanism and modernism. It is important to stress, however, that the 1930s was not the sole moment of connection between the 'international' and the 'modern' in Britain.

As I hope this final section has shown, the indelible global cultural impact of the imperial on British art has, until very recently, been all but ignored. The central premiss of Tim Barringer, Geoff Quilley, and Douglas Fordham's introduction to their ground-breaking collection of essays *Art and the British Empire* is that the concept of empire belongs at the centre, rather than in the margins, of the history of British art—a position which is alien to virtually the entire historiography of the

[67] Norman Foster, 'Foreword', in James Peto and Donna Loveday (eds), *Modern Britain, 1929–1939*, exh. cat. (London: Design Museum, 1999), 11–12.

[68] Barbara Hepworth, 'Sculpture', in J. L. Martin, Ben Nicholson, and Naum Gabo, *Circle: International Survey of Constructive Art* (London: Faber and Faber, 1937), 116.

subject. 'British art', they argue, 'has been conceived as work produced in Britain and overwhelmingly representing subjects in the British Isles.'[69] Following on from this, Michael Hatt argues that rather than viewing empire as no more than a theme or form of subject matter in British art, we should conceptualize British art as something *in the empire*, to think of imperial art, necessarily and concretely contextualized by the colonial adventure and its history. He suggests that only to identify images which actively participate in imperial debate as 'falling under the sign of empire' is to misunderstand what imperial culture is.[70] London thus becomes one node in a much wider global network, and the possibilities of how art was made 'modern' and how to make art histories of the 'modern' begin to look very different. Tracing the evidence of these cross-cultural encounters in the visual works of art themselves can be difficult, but perhaps to search for obvious, superficial signs of these contacts misses the point. For modernism, as I have demonstrated, often registered its connections with modern life somewhat obliquely.

[69] Tim Barringer, Geoff Quilley, and Douglas Fordham (eds), *Art and the British Empire* (Manchester: Manchester University Press, 2007), 3.

[70] Michael Hatt, 'Uranians and Imperialists: Boys and Empire in Edwardian Britain', in Barringer et al. (eds), *Art and the British Empire*, 153.

CHAPTER 31

...

DANCING BODIES
AND MODERNITY

...

RAMSAY BURT

THIS chapter explores the emergence of modernist dance and ballet in the early twentieth century, identifying within it a set of responses to the impact of modernization. It does this by focusing on two key events: Vaslav Nijinsky's famous production of *Sacre du printemps* ('Rite of Spring') performed by Diaghilev's Ballets Russes in May and June 1913 in Paris and London, and the premier of Mary Wigman's first *Hexentanz* ('Witch Dance') in Munich in February 1914. Some of the most interesting critical responses to these performances celebrated theatre dance's emerging autonomy as an art form in its own right through its modernist break with the conventions and traditions of nineteenth-century European culture. My aim in this chapter is to draw on recent interdisciplinary approaches that suggest we consider early modernist artworks as a series of pluralist and contingent solutions to emergent artistic problems, and on research into the relation between modernism and the social experience of modernity.[1] Through applying these approaches to early modern dance and modern ballet, this chapter interrogates the way that the dancing body in Wigman's and Nijinsky's dance works mediated new ideas about the embodiment of subjectivities in modern times.

Far more is known about Nijinsky's *Sacre* than about Wigman's first *Hexentanz*. A wealth of surviving evidence from *Sacre* includes photographs, drawings, reviews, reminiscences, Nicholas Roerich's costumes, and his paintings on which the ballet's backdrops were based. While there is no notation of the dance material, there are

[1] See Jonathan Crary, *Suspensions of Perception: Attention, Spectacle, and Modern Culture* (Cambridge, Mass.: MIT Press, 1999), 99.

copies of Igor Stravinsky's score, which were marked up at the time with notes about the choreography.[2] In the late 1980s and early 1990s Millicent Hodson assembled all of this material and used it to create a reconstruction of the ballet.[3] Stravinsky's music, although it was perceived by many at the time as difficult, has gone on to become a modern classic that is regularly performed at orchestral concerts. It has also been used by over two hundred choreographers to create new ballets and dance pieces.[4] The simple narrative premiss for the 1913 ballet was devised by Roerich and Stravinsky. It concerns a prehistoric Slavonic tribe which performs rituals including complex circle dances to try to bring about the end of the harsh Russian winter; when these fail, a young woman is selected for sacrifice and she dances herself to death through exhaustion. Many of the reviewers in 1913, however, found the programme notes about the ballet's narrative hard to relate to what was performed on stage, as this was not presented in a conventional way.[5] Left without a clear story to discuss, some began to write about the dance movement itself, in particular the powerfully affective qualities of the complex, irregular rhythms stamped out by a largely undifferentiated mass of brightly costumed dancers.

Wigman's first *Hexentanz* was one of two solos she performed at a programme of student work organized by her teacher Rudolf von Laban. The performance venue was a small concert hall in a baroque Munich town house, the Palais Porcia, which was, at the time, the base for a cultural association called the Museum. Because it was Wigman's first public performance of her own work, the event was often mentioned in later articles and books, particularly in the 1920s and 1930s when Wigman was seen as Germany's leading modern dancer. We know that her two solos *Hexentanz* and *Lento* were performed without music, this being an almost unprecedented break at that time with conventional ideas about theatre dance. There are a few surviving photographs (see Fig. 31.1). As Maggie Odom observes, these show Wigman wearing 'a shapeless bag of a costume that exposed her bare legs from the knee down. Her long hair streamed out from beneath a cap. The photographs of *Hexentanz* show tension in contorted hands, hard energy, angularity, and the costume billowing around in an image of grotesque animation.'[6] What is also striking in the photographs is the contrast between the harshly expressive movement that the dancer, in her billowing cape, performs, and her blank, almost masklike face. There is only one surviving review from 1914, by the critic Rudolf von Delius. As Susan Manning notes,

[2] Dance notation was still undeveloped at the time. The only ballets for which a notated score was produced were those in the repertoire of the major Russian ballet companies in Moscow and St Petersburg. See Anne Hutchinson Guest, *Choreographics: A Comparison of Dance Notation Systems from the Fifteenth Century to the Present* (London: Routledge, 1989).
[3] For Hodson's published notebook of source material, see Millicent Hodson, *Nijinsky's Crime Against Grace: Reconstruction Score of the Original Choreography for Le Sacre du printemps* (Stuyvesant, NY: Pendragon Press, 1996). For an overview of critical responses to Hodson's reconstruction, see Marcia Siegel, 'Afternoon of a Legend: Nijinsky, the Choreographer', *Dance Now*, 11/2 (Summer 2002), 3–11.
[4] See the online database at <http://www.roehampton.ac.uk/stravinsky/index.asp>.
[5] See Hanna Järvinen, *The Myth of Genius in Movement: Historical Deconstruction of the Nijinsky Legend* (Turku: Turun Yliopisto, 2003), 343–8.
[6] Maggie Odom, 'Mary Wigman: The Early Years, 1913–1925', *Drama Review*, 24/4 (1980), 82.

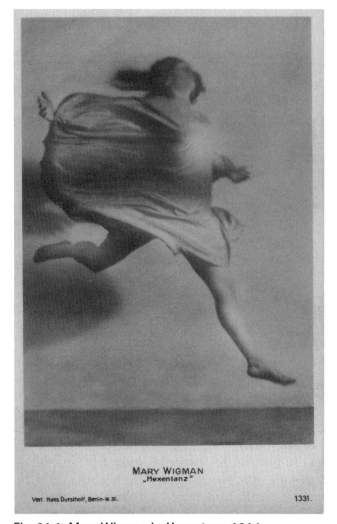

MARY WIGMAN
„Hexentanz"

Verl. Hans Durstholf, Berlin-W. 30. 1331.

Fig. 31.1 Mary Wigman in *Hexentanz*, 1914

his review doesn't describe either of Wigman's solos, not even mentioning them by name. Instead von Delius focuses on the artistic breakthrough that, in his view, Wigman's dances were making, and he discusses their significance. Dance, he wrote, could now stand on its own as a sovereign art equal to music and painting.[7]

There are correspondences between what von Delius identified within Wigman's debut solos and what some of the critics wrote about Nijinsky's *Sacre*. In both cases the critics suggest that audiences had been presented with expressive, powerfully

[7] Susan Manning, *Ecstasy and the Demon: The Dances of Mary Wigman* (Minneapolis: University of Minnesota Press, 2006), 15–16.

energetic dance movements that challenged conventional notions of beauty and harmony. This movement material was performed by dancers who were almost disturbingly anonymous or de-individuated. The nature of the two events was, of course, very different: on the one hand, an internationally celebrated ballet company dancing with a symphony orchestra in a large theatre before an audience made up of the city's social and artistic elite; on the other hand, two short solos performed in a small concert hall as part of a programme by young dancers who were beginning to attract the interest of a few artists and intellectuals. In each case, however, the critical response indicates a recognition that the new dance and the new ballet were breaking with the conventions and traditions of theatre dance. These were not isolated incidents. They were part of a broader phenomenon in which the modern dancing body was emerging as a key site for the definition of new ideas about the embodiment of subjectivities within modernity. In order to investigate this more fully, I shall first discuss the social and cultural contexts in which Nijinsky and Wigman participated, before I go on to examine what *Sacre* and *Hexentanz*, and their reception, reveal about the relationship between modernism and modernity.

DANCING, MODERNISM, AND MODERNITY

Hannah Arendt has argued that Walter Benjamin was the first writer to recognize that modernity had created an impassable barrier between past and present. For Benjamin, quotations from the culture of the past always appear to lose their authority. He wrote that, as a collector puts the items of his collection together, he tears them out of the environment in which they had been meaningful but in doing so 'liberates them from the drudgery of usefulness'.[8] Benjamin, along with other German writers including Georg Simmel and Siegfried Kracauer, recognized that this gap between the traditional past and the modern present was at its most evident in the experience of living in the metropolis. As Raymond Williams recognized, many of the pioneers of modernist art lived and worked as migrants within a foreign metropolis.[9] When not on tour, Nijinsky was a Russian exile living in Paris. Although Wigman had been born in Hanover, Laban was born in Bratislava, then a small, provincial town in the Austro-Hungarian Empire, and he lived and worked in Munich and, during the war, in Zurich. Some of the critics writing about the work of the Ballets Russes saw analogues between the avant-garde fragmentation of modernist ballet and the disruptive social experience of modern life.

[8] Walter Benjamin, *Illuminations* (London: Fontana, 1973), 42.
[9] Raymond Williams, *The Politics of Modernism: Against the New Conformists*, ed. Tony Pinkney (London: Verso, 1989).

For Laban and Wigman, dancing seemed to be a means for healing the deleterious experience of living in the modern metropolis, and they spent the summer of 1913 and much of the war years as members of a utopian artists' colony at Monte Verita near Ascona above the shores of Lake Maggiore. To understand the social and artistic context of Wigman's work, it is necessary to examine Laban's writings and Wigman's own later statements and reminiscences about dance. The analogue I am postulating between *Sacre*'s modernist fragmentation and modernity takes a different form in Laban's and Wigman's writings. These suggest that the practice of modern dance answers a need for cultural renewal as a response to the social and cultural ills caused by modernity. Early modern European dance and the modernist ballet developed by Nijinsky therefore developed within, and in response to, different social and political contexts. This is not, however, to ignore elements of avant-gardism in Wigman's work, nor the ways in which the idea of cultural renewal was, at times, relevant for some of the artists involved with Ballets Russes.

Early modern dance and modern ballet emerged during a period when there were significant changes in attitudes towards the dance profession and the status of dance as a cultural product. Dancing as a profession was beginning to be accepted as a respectable activity for middle-class women, and both ballet and the new modern dance were beginning to be accepted as serious forms of art rather than just as popular entertainment. In England, the popularity of the Ballets Russes helped to make ballet and 'interpretative dance' classes a fashionable activity for middle-class women and children.[10] Dance and dancelike movement practices were being taken up in Germany as ways through which to promote healthy living as part of the Körpekultur (Body Culture) and Lebensreform (Life Reform) movements.[11] One such practice was the rhythmic gymnastic method Eurythmics, developed by Émile Jaques-Dalcroze. Wigman's parents were initially unwilling to allow their daughter to study dance, and it was only by going against their will that she enrolled at Jaques-Dalcroze's new academy, the Bildungsdangsansalt für Musik und Rhythmus in 1910 in Hellerau.

These changes came during a period when Symbolist and modernist poets such as Mallarmé and Yeats were fascinated by dance. As dance historian Ann Daly has demonstrated, Isadora Duncan deliberately publicized her connections with well-known writers and artists like Rodin in order to distance herself from dancers involved in popular entertainment.[12] Amy Koritz has argued that around 1912 Diaghilev began promoting Nijinsky in newspaper interviews as a choreographer rather than as a dancer and star in order to gain more serious acceptance of his company's work.[13] This was part of Diaghilev's strategy to reorientate the Ballets

[10] See Lynn Garafola, *Diaghilev's Ballets Russes* (New York: Oxford University Press, 1989).

[11] Ross Cahd, *Naked Germany: Health, Race, and Nation* (Oxford: Berg, 2005); Anton Kaes, Martin Jay, and Edward Dimendberg (eds), *The Weimar Republic Sourcebook* (Berkeley: University of California Press, 1994); Karl Toepfer, *Empire of Ecstasy: Nudity and Movement in German Body Culture, 1910–1935* (Berkeley: University of California Press, 1997).

[12] Ann Daly, 'Isadora Duncan and the Distinction of Dance', *American Studies*, 35/1 (Spring 1994), 5–23.

[13] Amy Koritz, *Gendering Bodies/Performing Art: Dance and Literature in Early Twentieth-Century British Culture* (Ann Arbor: University of Michigan Press, 1995).

Russes away from the lavish, exotic orientalism of the productions that initially won over Paris's social and cultural elite groups towards a more avant-garde position. David Cottington argues that Diaghilev's move towards the avant-garde around 1912 and 1913 played a catalytic role in the acceptance of modernist painting by the Parisian elite.[14]

Nijinsky and Wigman emerged as artists within very different social and cultural contexts. Where questions about the expressivity of the modern dancing body are concerned, there is nevertheless an intriguing overlap in their concerns. Key to this new approach was the idea that expression came through the performance of dance material itself and not through mime or acting. Both dance artists sought to utilize a depersonalized expressivity within their choreography. This was at a time when new scientific ideas were developing about the way movement is perceived. The English neurologist Henry Charlton Bastian invented the term 'kinaesthesia' in 1880. Although in the early 1900s the term was only beginning to be used in relation to dance, it is significant that scientific ideas about perception were radically changing by the beginning of the twentieth century in ways that supported more serious discussions about dance as art.[15] An emerging recognition that it was possible to perceive dance movement on an energetic, affective level separate from any narrative content created a climate receptive to the development of the kinds of innovative new dance pieces and ballets like Sacre and Hexentanz.

The Italian philosopher Giorgio Agamben has proposed that, by the end of the nineteenth century, the European bourgeoisie had lost its gestures.[16] Citing the dances of Isadora Duncan, the work of the Ballets Russes, and the early silent cinema as examples, Agamben argues that the particular fascination such work had at that time exemplified humanity 'trying for the very last time to evoke what was slipping through its fingers'.[17] There is a significant difference between Fokine's choreography for the Ballet Russes between 1909 and 1912—including Firebird (1910), Shéhérazade (1910), and Petrouchka (1911), all of which had made Nijinsky famous—and the innovations the latter introduced in the pieces he himself choreographed: L'Après-midi d'un faune (1912), and Jeu and Sacre (both 1913).[18] A similar distinction can be made between Isadora Duncan's use of mimetic gesture and characterization and the more austerely impersonal, Expressionist use of the dancing body in Wigman's work. Fokine and Duncan tried, in Agamben's terms, to evoke the memory of gestures that were already slipping away, while their absence in Sacre and Hexentanz emphasized

[14] David Cottington, Cubism in the Shadow of War: The Avant-Garde and Politics in Paris, 1905–1914 (New Haven: Yale University Press, 1998).

[15] Hanna Järvinen, 'Some Steps Towards a Historical Epistemology of Corporeality', in Proceedings of the 30th Annual Conference of the Society for Dance History Scholars, Paris, 21–24 June 2007, 145–8.

[16] Giorgio Agamben, 'Notes on Gesture', in Means Without Ends: Notes on Politics (Theory Out of Bounds) (Minneapolis: University of Minnesota Press, 2000), 49.

[17] Ibid. 54.

[18] On Faune, see Ramsay Burt, 'Modernism, Masculinity, and Sexuality in Nijinsky's L'Après-midi d'un faune', in Valerie Briginshaw and Ramsay Burt (eds), Writing Dancing Together (Basingstoke: Palgrave, 2009); on Jeux, see Hanna Järvinen, 'Stillness and Modernity in Nijinsky's Jeux', Discourses in Dance, 5/1–2 (forthcoming).

the impassable barrier between past and present that, in Walter Benjamin's view, modernity had created. By doing so, Nijinsky and Wigman drew attention to the inadequacy of older models of spectatorship, contemplation, and experience for understanding modern life.

What was unsettling about artistic modernism was the loss of the familiar and its replacement with absences that reminded beholders of their own experience of modern living. As Jonathan Crary points out: 'modernization was not a one-time set of changes but an on-going and perpetually modulating process that would never pause for individual subjectivity to accommodate and "catch up" with it'.[19] Works like *Sacre* and *Hexentanz* eschewed older modes of dramaturgy and symbolism in favour of abstracted expressive movement. By doing so they offered their beholders opportunities to see the dancer not as a static being but as someone in a perpetual process of becoming. Crary suggests that discontinuities and fragmentation within the montage of early silent films seem to exemplify and indeed unintentionally corroborate new scientific thinking about perception. In this context he points in particular to the late nineteenth-century neurologist Charles Sherrington's discussion of the problem of defining attention. This, Crary argues, proposes a new model of the human subject in which

perception is no longer conceived in terms of a classical model of acquiring knowledge but is instead synonymous with the possibilities of motor activity. But it is motor activity advancing towards and in some way constructing a perpetually open future of proliferating possibilities and choices. At the same time it is a model of a subject capable of a creative as well as an efficient and productive interface with the dynamic and mobile complexity of a modernizing lifeworld.[20]

For those who were becoming aware of the intensity and dynamic complexity of modern life, dance works like *Sacre* and *Hexentanz* allowed beholders to recognize the potential for new ways of interfacing with the world. It is this potential that I shall now identify within these two dance works.

SACRE

A mythology has grown up around the riot during the first performance of *Sacre*. For much of the twentieth century this mythology, together with popular speculation about Nijinsky's psychological breakdown in 1919, has obscured the innovative nature of his choreographic experiments. Much of what was written about Nijinsky has suffered from bias. A faction within the Ballets Russes supported Fokine, who

[19] Crary, *Suspensions of Perception*, 30. [20] Ibid. 352.

created the repertoire of new ballets with which the Ballets Russes gained international acclaim and which established Nijinsky as a star. For them, Nijinsky's own choreography was an act of betrayal. Many of the reminiscences written by Diaghilev's Russian associates and supporters—for example, by the painter André Benois (1941) and by Prince Peter Lieven (1980)—were clearly aimed at discrediting Nijinsky because his choreography threatened their conservative aesthetic values. Romola Pulsky, whose marriage to Nijinsky in 1913 precipitated his dismissal by Diaghilev, published her sensationalized account of his life and her heavily edited version of his diaries in the 1930s to elicit public sympathy and raise money to look after him.[21]

The 1970s and 1980s saw the beginning of a reconsideration of Nijinsky's life and work.[22] Igor Stravinsky played a questionable role in these changing attitudes towards Nijinsky. In his 1936 autobiography he dismissed Nijinsky's choreography for *Sacre* as a failure and wrongly stated that the choreographer neither could play any musical instrument nor had any knowledge of music. (He was actually a highly skilled pianist with an extraordinary musical memory.) In 1967, however, Stravinsky changed his mind when a piano score of *Sacre* came to light on which he had made pencil notes for Nijinsky. Stravinsky was finally prepared to admit that Nijinsky's was the best ballet version he had seen.[23]

Even if Stravinsky may not always have got on well with Nijinsky while working on *Sacre*, he thought highly of the latter's potential as a choreographer. This was partly because of his growing dissatisfaction with Fokine. Writing to his mother in 1912, Stravinsky complained that Fokine only went halfway: 'At the beginnings of his career he appeared to be extraordinarily progressive. But the more I knew of his work, the more I saw that in essence he was not new at all. . . . New forms must be created, and the evil, the gifted, the greedy Fokine has not even dreamed of them.'[24] In 1913, interviewed by Henry Postel du Mas, Stravinsky said: 'Nijinsky is capable of giving life to the whole art of ballet. Not for a moment have we ceased to think along the same lines. Later you will see what he can do . . . he is capable of innovation and creation.'[25] The English writer Geoffrey Whitworth argued in 1913 that the problem in Fokine's ballets was that 'dramatic intensity could only be maintained at the expense of a weakening of choreographic interest', so that 'we have to thank Nijinsky for finding a new outlet for ballet on legitimately choreographic lines'.[26] Jacques Rivière

[21] Joan Acocella (ed.), *The Diaries of Vaslav Nijinsky: Unexpurgated Edition* (New York: Farrar, Straus, Giroux, 1999).

[22] See Marie Rambert, *Quicksilver* (Basingstoke: Macmillan, 1972); Bronislava Nijinska, *Early Memoirs* (London: Faber and Faber, 1981); Garafola, *Diaghilev's Ballets Russes*.

[23] Robert Craft, 'Nijinsky and *Le Sacre*', *New York Review of Books*, 23/6 (15 Apr. 1976), 37; Anton Dolin, *Last Words: A Final Autobiography* (London: Century, 1985). Stephanie Jordan suggests that Stravinsky wanted to position his work as an exercise in Formalist modernist abstraction and thus align it with developments in Anglo-American musicology; see Stephanie Jordan, *Stravinsky Dances: Re-Visions Across a Century* (Alton: Dance Books, 2007), 417–18, 421–3.

[24] Cited in Richard Buckle, *Nijinsky* (Harmondsworth: Penguin, 1975), 269–70.

[25] Ibid. 362.

[26] Geoffrey Arundel Whitworth, *The Art of Nijinsky*, facs. of 1913 edn (New York: B. Blom, 1972), 81, 82. Whitworth (1883–1951) was a novelist and drama critic who went on to found the British Drama League.

detected in Fokine's work 'a certain artfulness, a certain vacillation, some sort of inner vagueness', and he felt that the originality of Nijinsky's choreographic innovations lay 'in doing away with dynamic artificiality, in the return to the body, in the effort to adhere more closely to its natural movements, in lending an ear only to its most immediate, most radical, most etymological expressions'.[27]

The 1913 production of *Sacre* received only seven performances, four in Paris and three in London, where its title was variously translated in the newspapers as *The Crowning of Spring, The Spring Ritual,* and *The Spring Rite.*[28] Unlike the uproar accompanying the first performance at the new Théâtre des Champs Elysées on 29 May, audiences at London's Drury Lane Theatre four weeks later were generally respectful. Indeed, at the end of the company's London season Nijinsky thanked audiences for their appreciative attention. But most of the Parisian critics dismissed the ballet as a joke that didn't deserve serious consideration. Adolphe Julien, for example, wrote that the ballet mocked the public, dismissing both Stravinsky's bizarre music and Nijinsky's monotonous, insignificant, pretentious choreography.[29] The London critics as a whole seem to have liked the ballet less than their audience, some noting that, while there was some hissing, most of the audience applauded vehemently. An anonymous 'Letter of an Englishman' in the *Daily Mail* was less reticent, complaining that

the spirit of the age has gone to M. Nijinski's head, as it has gone to the head of many other artists. The same lawlessness, the same contempt of order which afflicts the politics of today afflicts also the humanities....Discarding the wise learning of the centuries, they would re-create the world anew. And the implements of their creation are the hammer and the bomb. M. Marinetti, the Italian Futurist, and the militant suffragette differ only in the object of their attack.[30]

Although stated in an explicitly conservative and extreme fashion, this is in some ways typical of the manner in which critics in both London and Paris tried to dismiss art that made them uncomfortable. Francis Toye, writing in *The Nation,* felt that *Sacre* was splendid and exhilarating, and astutely observed that its strength 'is, indeed, the cause of its unpopularity, because people do not bother to hate what is merely feeble. They just smile and change the subject.'[31] I am suggesting that *Sacre*'s strength was partly due to the way it reminded them of what was new and disturbing in modern metropolitan life. 'Bad' reviews of *Sacre* can therefore be read against the grain as evidence of this unease.

Some critics mentioned the ballet's relationship to Post-Impressionist or Cubist painting as a way of discussing its modernism. Richard Capell suggested that the ballet's appeal 'is allied to recent manifestations in the other arts, and may perhaps be

[27] Jacques Rivière, 'Le Sacre du printemps', in Roger Copeland and Marshall Cohen (eds), *What Is Dance?* (Oxford: Oxford University Press, 1983), 117.
[28] It did not acquire the English title *The Rite of Spring* until 1920, when Diaghilev programmed a new version of the ballet with choreography by Massine.
[29] Adolphe Julien, 'Revue musicale', *Journal des Débats* (8 June 1913), 1–2.
[30] 'An Englishman', 'M. Nijinski on Beauty', *Daily Mail,* 19 July 1913, n.p.
[31] Francis Toye, 'The Newer Russian Ballets', *The Nation* (1 Aug. 1913), 676.

called "cubist dancing" (according to a recent definition—"twenty-four dances danced by twenty-four dancers to twenty-four different tunes played simultaneously").[32] This light-heartedly sums up a key question about *Sacre*'s modernism: how did the dance material relate to the music's complex, irregular rhythms, and blocks—or 'cells'—of musical motifs? Geoffrey Whitworth doubted 'if the music would prove effective in the concert hall, but its inseparable connection with the ballet must be accounted a virtue rather than an evidence of limitation'.[33] In a similar vein the *Times* critic suggested that 'M. Nijinsky and M. Stravinsky, working together, have achieved something that, in spite of its defects, is a step closer to a real fusion of music and dancing'.[34] Stephanie Jordan, reviewing archival evidence, concludes that although there may have been some counterpoint between music and choreography during some of the ballet's scenes, for much of the time dance steps were set on and phrased with the overlapping musical lines of Stravinsky's music.[35] Thus the *Times* critic appreciated 'the employment of rhythmic counterpoint in the choral movements', giving as an example the end of the first scene 'where figures in scarlet run wildly round the stage in a great circle while the shaking masses within are ceaselessly splitting up into tiny groups revolving on eccentric axes'.[36]

Those critics who appreciated *Sacre* seemed to value its discovery of new sources of expressive power rather than valuing it for its formal complexity. Geoffrey Whitworth, for example, observed that 'Almost every quality of beauty or dramatic interest which we had grown to expect in a ballet was absent from this one'; this, he felt, was 'not a destruction of what had been valued in the past ... but a gradual evolution towards a new expressiveness and a new technique'.[37] The final sacrificial solo danced by Maria Piltz exemplifies this. Those critics on each side of the English Channel who disliked *Sacre* nevertheless often appreciated 'the charming Mlle. Piltz'. The critic in the *Daily Telegraph* applauded her for 'dancing a dance in the second act of the ballet that must have been a brain-racking concern to learn'.[38]

The final sacrificial dance of the Chosen One was the first part of the ballet that Nijinsky choreographed, working with his sister Bronislava Nijinska. Piltz only took over the role later when Nijinska's pregnancy forced her to give it up, much to her brother's anger. Millicent Hodson argues that the solo 'established the stylistic principles of the whole work: compact jumps; inverted postures; head and arms held in contorted positions as the body moves beneath them to irregular rhythms; ordealistic repetition; and the demonstration of effort, rather than the concealment of it which is characteristic of classical ballet' (Fig. 31.2).[39] Bronislava Nijinska recalls

[32] Richard Capell, 'Cannibal Music: Amazing Production of the Russian Ballet', *Daily Mail*, 12 July 1913, n.p.
[33] Whitworth, *The Art of Nijinsky*, 97.
[34] Anon., 'Russian Ballet: Le Sacre du printemps', *Daily Telegraph*, 12 July 1913.
[35] Jordan, *Stravinsky Dances*, 420–1.
[36] Anon., 'The Fusion of Music and Dancing: Le Sacre du printemps', The Times, 26 July 1913.
[37] Whitworth, *The Art of Nijinsky*, 98, 99.
[38] Anon., 'Russian Ballet', n.p.
[39] Hodson, *Nijinsky's Crime Against Grace*, 167.

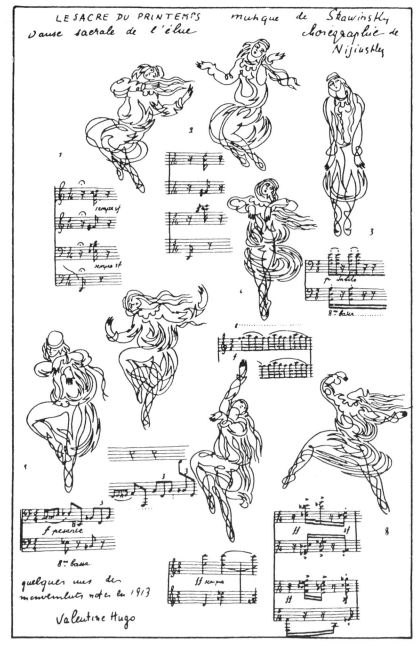

Fig. 31.2 Valentine Gross, 'Drawing of *Sacre du Printemps*'

working on this with her brother in Monte Carlo in November 1912, before Stravinsky had finished work on the musical score. The composer had sent Nijinsky an orchestral sketch which a rehearsal pianist transposed with difficulty for him. Nijinska says they listened to it repeatedly, Nijinsky memorizing it as a whole before starting to set any steps. The movement material was set to the 'breath' of the music, and she talks about sensing its mood and spirit, its inner rhythm. She describes the exciting rhythms of Stravinsky's music and the discoveries her brother made while working with them, and she stresses the precision necessary to render each movement accurately while correctly rendering the inner rhythm. In Nijinska's view, the value of the solo lay in the new qualities of expressive movement that Nijinsky was discovering: 'Strong, brusque, spontaneous movements seemed to fight the elements as the Chosen Maiden protected the earth against the menacing elements. The Chosen Maiden danced as if possessed, as she must until her frenzied dance in the primitive sacrificial ritual killed her.'[40]

Underlying Nijinska's description here are some key ideas about the performance of modernist theatre dance. She describes the Chosen Maiden in a surprisingly detached way. It is not the dancer herself but her movements that fight the elements. To perform the role properly there is no need to reveal how the character feels; one merely has to execute the movement as accurately as possible, and feel the music's inner rhythm. It is the body as a whole rather than any dramatic acting or pantomime that conveys meaning. This modernist notion of performance, I suggest, corresponds with the new ideas about attention and perception which, as I noted earlier, Jonathan Crary has suggested were emerging during the late nineteenth and early twentieth centuries. As the dancers in *Sacre* executed the violent and fragmented movement material of Nijinsky's choreography, both they and the viewers of early silent films needed to be 'capable of a creative as well as an efficient and productive interface with the dynamic and mobile complexity of a modernizing lifeworld'.[41]

HEXENTANZ

As I noted earlier, Rudolf von Delius, in his review of Wigman's first concert appearance, didn't describe what she actually performed but was only concerned with his opinion of its significance. In doing so he places Wigman (or Weigmann, as she spelt her name until 1918) in what he saw as the gradual development of early modern dance towards abstraction:

[40] Nijinska, *Early Memoirs*, 450. [41] Crary, *Suspensions of Perception*, 352.

The inner logic with which the new dance approaches its goal is astonishing. Fifteen years ago Isadora Duncan set the programme: free, natural movement after the model of the Greeks. Then Mary Weigmann from Hanover arrives on stage. And immediately we feel: the chain of development reaches its peak in her dancing. The breakthrough to the elemental finally is achieved. Everything historical falls away as totally uninteresting. The person again stands alone in opposition to primal forces. Finally dance becomes entirely self-sufficient, the pure art of bodily movement.[42]

Von Delius recognized in Wigman's dancing a necessary development of modernist dance towards new and innovative forms that break with older conventions and cultural traditions. In some ways this corresponds with what excited Rivière, Stravinsky, and Whitworth about Nijinsky's work. Von Delius also made two significant claims about Wigman's 'elemental' dancing. First, he suggested that it expressed a struggle 'in opposition to primal forces'. Second, when he says she again stands against primal forces, his use of the word 'again' suggests a desire for cultural renewal. Nijinsky's work, I have argued, faced resistance from many critics who felt uncomfortable about what was new and disturbing in modern metropolitan life. For Wigman, Laban, and their supporters, modern dance was a way of getting back in touch with something that modern life was in danger of destroying.

Mary Wigman had only been studying with Laban for a few months when she performed *Hexentanz* and *Lento* in the concert in January 1914. According to Selma Odom, Wigman showed *Lento* to Jaques-Dalcroze in 1911 or 1912 while studying with him in Hellerau.[43] She may have started work on *Hexentanz* a little later as she recalls showing a sketch of it to Laban, though Susan Manning suggests that it can be seen as an abstraction from her role of a Fury that she had performed in Jaques-Dalcroze and Appia's 1912–13 production of Gluck's opera *Orpheus und Euridice*.[44] In 1925 von Delius remembered *Hexentanz* as 'wild, vast, electrically charged, almost like rage'.[45] Wigman recalled that *Hexentanz* 'became part of my first solo program. It had to undergo many changes and pass through many different stages of development until, twelve years later, it received its definitive artistic form.'[46] The *Hexentanz* of 1926 was made as part of a longer cycle of solos called *Visions* that Wigman made between 1925 and 1928, and it was filmed around 1930.[47] While this suggests that the underlying idea of the solo remained constant, in terms of actual movement material, the two versions were very different. The 1914 *Hexentanz* was danced upright with jagged leaps and whirls, while in the surviving film of the final version Wigman performs squatting on the ground. The costume changed also, a rich silk brocade replacing the

[42] Quoted in Manning, *Ecstasy and the Demon*, 15–16.
[43] Selma Odom, 'Wigman at Hellerau', *Ballet Review*, 14/2 (1986), 50.
[44] Manning, *Ecstasy and the Demon*, 79.
[45] Quoted in Maggie Odom, 'Mary Wigman: The Early Years, 1913–1925', *Drama Review*, 24/4 (1980), 82.
[46] Mary Wigman, *The Mary Wigman Book: Her Writings*, ed. and trans. Walter Sorell (Middletown, Conn.: Wesleyan University Press, 1975), 36.
[47] This can be seen in the video recording *Mary Wigman: Mein Leben ist Tanz*, written and directed by Ulrich Tegeder (Bonn: Inter Nationes, 1986).

earlier plain, shapeless dress. In 1914 her hair spilled out from beneath a large cap; in the final version there is no cap but she wears a mask.

While Nijinsky found inspiration working with the exciting new musical forms of Stravinsky's music, Wigman's *Hexentanz* seems to have been made in reaction against Jaques-Dalcroze's work. As Wigman wrote in 1931:

My first tentative attempts to compose were made when I was studying the Dalcroze system. Though I have always had a strong feeling for music, it seemed from the very start most natural for me to express my own nature by means of pure movement. Perhaps it was just because there was so much musical work to be done at the time, that all these little dances and dance studies took form without music.[48]

In the 1920s Wigman devised a way of choreographing dance material in silence for which an accompaniment was then created, often using percussion or piano. By pure dance, she means dance that finds its own form independently of any music or narrative. As the composer Carl Orff, who later collaborated with Wigman, wrote: 'Mary Wigman sought dance in its absolute state. Not a kind of dance that, like ivy, needed music as a house to climb on.'[49] Wigman's dance in its absolute state was not completely abstract. As well as *Hexentanz*, she also created dances of Death, Lust, Sorrow, a Song of the Sword, a Dance of the Demon, and a Seraphic Song.[50] What was 'pure' in these pieces was the way the dance movement expressed an abstracted essence of these subjects that was, in von Delius's terms, elemental.

The difference between Wigman's idea of pure dance and Jaques-Dalcroze's work was a question not just of method but of philosophy. Jaques-Dalcroze claimed to run 'a preparatory school for the arts and for the enjoyment of life' and sought to reunite musical and bodily rhythm which in his view modern life had impaired.[51] At his school, he aimed to teach 'the expression of the order of all human beings, [which] penetrates through the body into the soul, and harmony is taught through the gymnastic dance'; for Jaques-Dalcroze, dancing was a means for getting back in touch with a natural, harmonious sense of rhythm and 'bring[ing] out the music that is sleeping inside'.[52] His large-scale production of *Orpheus und Euridice* with Adolphe Appia demonstrated this sense of harmony through the graceful dancing of Euridice and her accompanying nymphs. Wigman, however, was one of the Furies along with Rosalia Chladek, Bertha von Zoete, Grete Wiesenthal, and Micho Ito, all of whom, as Tamara Levitz has pointed out, went on to have significant careers as dancers, while nothing more was heard of those who had played the more graceful, harmonious roles.[53] There was no room in Jaques-Dalcroze's system for a dance that was not

[48] Quoted in Odom, 'Wigman at Hellerau', 50. [49] Ibid. 51.

[50] For a detailed list of her pieces, see Mary Wigman, *The Language of Dance* (Middletown, Conn.: Wesleyan University Press, 1966), app.

[51] Quoted in Hedwig Müller, 'Émile Jaques-Dalcroze: The Beginnings of Rhythmic Gymnastics in Hellerau', *Ballett-International*, 8/6–7 (June–July 1985), 24.

[52] Ibid.

[53] Tamara Levitz, 'In the Footsteps of Euridice: Gluck's *Orpheus und Euridice* in Hellerau, 1913', *Echo*, 3/2 (2002), <http://www.echo.ucla.edu>.

grounded in pre-existing music, and his notions of order and harmony seem not to have appealed to his most talented students.

While Jaques-Dalcroze aimed to bring out the music that is sleeping inside, Wigman's next teacher, Laban, sought cultural renewal through finding dance energies that are *hidden* inside. This aim is exemplified in a section titled 'The Birth of a Demon' in Laban's 1920 book *Die Welt des Tanzers*, which, John Hodgson suggests, includes material he had initially written over the previous ten years.[54] Although Laban doesn't identify the dancer he writes about, he is surely thinking about Wigman and may even be describing here her first performance in 1914:

Who has not been present at the birth of a demon? A room full of people. In front upon a raised platform the dancer moves. Sometimes considering, then passionately twirling, gestural strength speaks from him. The initial slumbering reverie of the audience is slowly kindled by these waves. Soon invisible currents appear from man to man and he who can see can see the tensions of an immense net of crystallized force which surrounds everything. Nobody, not even the coldest of observers, can escape this dance when rousing applause rushes through the room. . . .A demon is born. Or was he only unchained and was present invisibly before that?[55]

Laban is perhaps a little ambivalent about this electrifying dance performance. He goes on to say: 'No being on earth has greater power to unchain the demon that the dancer.'[56] But he argues that this power carries responsibilities. It should lead the dancer to greater self-knowledge and he or she should never let themselves be taken over by it: 'The stimulation of egoism destroys the power of gesture . . . the dancer knows that it is a basic law of gestural power that he must not be misused by egotistical purposes.'[57] What Laban is saying here is that, when a dancer allows the stimulation of egoism to destroy the power of dance material, he or she is closing down the possibilities for interpreting the material. This is a lesson that Wigman herself acknowledges she learnt from Laban, as the following anecdote demonstrates.

Laban worked in the studio with Wigman to create what became his movement scales; these explored harmonious proportion through dance movements that swing through points in space in what Laban called a 'kinaesphere' surrounding the body (Fig. 31.3).[58] Wigman wryly suggests that she became Laban's 'first victim to help prove his theoretical findings' as she worked with him demonstrating his movement scales. She wrote: 'Every movement had to be done over and over again until it was controlled and could be analyzed, transposed, and transformed into an adequate

[54] John Hodgson, *Mastering Movement: The Life and Work of Rudolf Laban* (London: Methuen, 2001), 117–18.

[55] Rudolf von Laban, *Die Welt des Tanzers* (Stuttgart: Walter Sieffert, 1920), 101.

[56] Ibid. 102. [57] Ibid.

[58] These scales explored new possibilities of dance movement through three-dimensional space around the body, whereas the vocabulary of classical body presented the shapes created by the dancer in a way that presupposed their framing through the theatre's proscenium arch. This new focus on three-dimensional space in turn facilitated Laban's subsequent development of what is now one of two internationally recognized systems for notating movement.

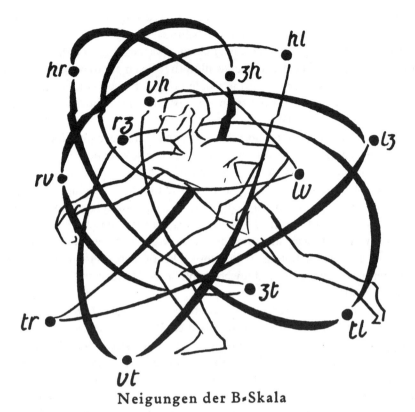

Neigungen der B∙Skala

Fig. 31.3 'Diagram of the B-scale', from Rudolf Laban, *Choréographie* (1926)

symbol.'[59] Wigman recalled that her own dynamic way of moving expressively came into conflict with Laban's 'indefatigable attempts at objectivity'.[60] Things came to a head when Laban let on that he had given to some of the dynamic values of the movement qualities names like 'pride', 'joy', and 'wrath'. Hearing the word 'wrath', Wigman was delighted to do the movements once more in a more personally expressive way. Laban, however,

jumped up as if bitten by a tarantula, hammered with his fists on the table so that the papers whirled around the room. He shouted 'You clown, you grotesque monster, with your terrific intensity you ruin my whole theory of harmony'. He was furious about my super-self-expression, declaring that the movement *was* wrath and needed no individual interpretation.[61]

[59] Wigman, *The Mary Wigman Book*, 38, 39.
[60] Ibid. 39. [61] Ibid.

The lesson Wigman was learning from Laban here complements what Nijinska said about the solo of the Chosen Maiden. For Nijinska, it is the body as a whole rather than any dramatic acting or pantomime that conveys meaning, and she implied that, in order to convey this, the dancer had to allow the movement to possess her.[62] Laban was saying that the movement of the whole body conveyed emotion and that an imposition of egotistical self-expression will close down the movement's expressive potential.

I noted earlier von Delius's idea that Wigman's dance represented a struggle against primal forces. Wigman herself describes her solo dances in similar terms. In every solo, she suggests, 'there always seems to be enacted something like a dialogue for the spectator, a dialogue in which the dancer holds a conversation with himself and with an invisible partner'.[63] As an example of this in her own work she discusses her feelings while performing her 1931 solo *Death Call*, where she felt that she was fighting against some power on stage: 'But there it was, an opposite pole, a point in space, arresting eye and foot. This probably self-created and space-reflected tension, however, forced my body into a sudden turn and twisted my body into a deep bend'.[64]

Writing in 1966 about the process of rechoreographing *Hexentanz* in 1926, Wigman gave another example of this invisible partner. Returning home one night after working on the solo in the studio, she says she caught sight of herself in the mirror. In her exhaustion and disarray she felt she saw a witchlike figure: 'I shuddered at my own image, at the exposure of this facet of my ego which I had never allowed to emerge in such unashamed nakedness.'[65] The process of making the final version of *Hexentanz* was one in which Wigman tried to keep alive the energy in this repressed aspect of herself that she had glimpsed. She writes:

The artistic form is not an end in itself, is not being created to turn numb and torpid the fermenting matter from which it arises. It is the receptacle which, time and again, grows hot with, and is inflamed by, the living content until the mutual melting-down process is fully completed, and from this point on only the artistic action speaks to us. My witch figure also had to be brought to the point of this entity and had to receive her profile in an outward and plastic manifestation that was hers.[66]

What Wigman describes here is a process of abstraction through which she creates, in movement form, an essence of the witch figure. Her use of heat and melting as a

[62] An incident concerning Nijinsky's first ballet, *L'Après-midi d'un faune* (1912), further exemplifies this. There is a moment where the faun (originally Nijinsky himself) turns suddenly towards one of the nymphs and startles her, causing her to jump in the air and run away from him. The role of this startled nymph was originally performed by his sister Nijinska. When the latter became pregnant, another dancer had to take over the role. Marie Rambert tells a story about Nijinsky rehearsing this new dancer. He told her off for acting out a moment when the faun frightens her. He wasn't interested in facial mannerisms. All she had to do was get the movements right. See Rambert, *Quicksilver*, 62.

[63] Wigman, *The Language of Dance*, 16.
[64] Ibid. 17. [65] Ibid. 41. [66] Ibid.

metaphor for this is striking. Although she is writing about her 1926 version, one can surmise that this corresponds on some level with what she went through when making her first version in 1914. As von Delius suggests, this essence is elemental and in tension with her ordinary self. In Laban's terms, Wigman could only recognize the witch figure's plastic manifestation through overcoming her own egotistical desire for self-expression, and by doing so was able to express something with burning intensity.

I proposed earlier that, for audiences watching *Sacre*, the dancers suggested a model of fluid, dynamic subjectivity that was in tune with the complexity of modern life. Jonathan Crary argues that, for artists at the beginning of the twentieth century, the problem of dealing with modernity 'is not a question of simply intellectually grasping the idea of a plurality of perspectives but of experiencing how each perspective is a particular lived relation of forces, of intensities'.[67] Wigman's 1914 *Hexentanz*, I suggest, proposed a model of subjectivity that was capable of grasping these intensities.

Hexentanz, *Sacre*, and Modernism in the Other Arts

Thus far I have given accounts of *Hexentanz* and *Sacre* that have related their performance to contemporary lived experiences of modernity. To do this I have used what evidence there is about their choreography, together with some indications about how they were performed, in order to interrogate the contemporary critical discourses that the performances generated. In some cases, critics tried to characterize what they found new and exciting, or disturbing, about the work by referring to what they saw as similar developments in other contemporary art forms. In other cases, critics have abandoned trying to read the work in terms of narrative meaning in order to focus on the way in which it exemplified new developments in art that had some theoretical basis. In order to identify more clearly the ways in which early modern dance and modern ballet signified aspects of the impact of modernity, I shall conclude by looking briefly at ways in which *Hexentanz* and *Sacre* related to contemporary developments in other art forms.

The notion of progress and artistic breakthrough figures in the critical discourse about both *Hexentanz* and *Sacre*. Von Delius's 1914 review of Wigman resonates with notions of the artist as visionary that were circulating within the other arts. Christopher Butler notes that Kandinsky and Schoenberg believed the visionary artist was someone 'who saw himself as a medium of change within an evolutionary process

[67] Crary, *Suspensions of Perception*, 354.

rather than its inventor or discoverer'.[68] This kind of progress was one which was driven by inner necessity. Kandinsky wrote: 'Just as in music or in painting, there exist no "ugly" sounds and no external "dissonance" . . . every sound or concordance of sounds is beautiful providing that it arises from inner necessity.'[69] Both Nijinsky and Wigman appear to have appreciated the inner necessity of movements that some might find ugly. Distaste with conventional notions of charm and grace surely led Wigman to dance as one of the Furies in Jaques-Dalcroze and Appia's *Orpheus und Euridice* and then to create *Hexentanz*. In a 1913 interview, Nijinsky complained that some people believed that, because he had danced in ballets by Fokine 'which aim at grace pure and simple, I am tied down to "grace" for ever. Really I begin to have horror of the very word; "grace" and "charm" make me feel seasick.'[70]

Charm and grace were qualities ballet dancers learnt alongside the vocabulary of ballet movement, and it is this that Nijinsky was rejecting. Butler has suggested that the early modernists 'were perhaps the last avant-garde to apprentice themselves to the production of major work in earlier styles. An acute awareness of the past and the technical ability to reproduce it ensured that the early advances of the Modernists were made through a stylistic metamorphosis of the genres of the previous tradition.'[71] Thus, Picasso could draw like Ingres, Matisse studied with salon painters William-Adolphe Bouguereau and Gustave Moreau, and Schoenberg's early work showed his ability to synthesize the late Romantic styles of Brahms and Mahler. Nijinsky began his career in the Imperial Russian Ballet performing principal roles in nineteenth-century ballets. Marie Rambert, who assisted Nijinsky while he was making *Sacre*, notes that he needed to work with dancers who had 'a perfect ballet technique and then broke it down consciously for his own purposes'.[72]

Where *Sacre*, in effect, deconstructed the tradition in which its choreographer had trained, *Hexentanz* exemplified, in an almost Deleuzean way, the immanent potential of the new dance to find new kinds of expressive energies and new intensities of experience within new ways of moving. Modern dance did not have the kind of relationship with the past that Butler describes. Wigman, writing an article in 1925 that was titled 'We Are Standing at the Beginning', noted that modern dancers did not have the same tradition as composers: 'Even if today's composers have broken with tradition a thousand times, a red thread runs through all music, connecting past, present, and future.'[73] The dancers of the Imperial Russian Ballet, she argued, 'were and are exquisite instruments, but their dances convey the spirit of the Rococo.

[68] Christopher Butler, *Early Modernism: Literature, Music, and Painting in Europe, 1900–1916* (Oxford: Oxford University Press, 1994), 56.

[69] Quoted in Dee Reynolds, *Rhythmic Subjects: Uses of Energy in the Dances of Mary Wigman, Martha Graham, and Merce Cunningham* (London: Dance Books, 2007), 53.

[70] Vaslav Nijinsky, 'M. Nijinsky's Critics: "The word 'grace' makes me feel sea sick"', *Daily Mail*, 14 July 1913, 5.

[71] Butler, *Early Modernism*, 73.

[72] Rambert, *Quicksilver*, 61. Rambert was one of the teachers in Hellerau while Wigman was studying there.

[73] Wigman, *The Mary Wigman Book*, 81.

They echo neither our time nor us.'[74] The way Wigman distances her work here from ballet is typical of modern dance pioneers on both sides of the Atlantic at that time. She went on, in a somewhat rhetorical vein, to argue that 'We dancers of today are in a difficult position. We have no tradition.' She concluded: 'But these shortcomings are, at the same time, our strength. An entire world of dance experiences is spread out before us, and our time is ready for the new dance.'[75] Wigman does not elaborate on why she thought in 1925 that the new dance was part of the Zeitgeist, but I have tried to show ways in which the modernism of *Sacre* and *Hexentanz* in 1913–14 mediated contemporary experiences of modernity. It is because their modernism was conveyed through the fluid, dynamic medium of moving bodies, which were in tune with transformed notions of cognition and experience, that the time was ready for this new dance.

[74] Ibid. [75] Ibid.

MODERNISM ON RADIO

DEBRA RAE COHEN

EPHEMERA

THE history of radio modernism has been a secret history—rendered secret by the ephemeral nature of the medium, the impossibility, early on, of making recordings, the dearth of later ones, the gap between conceptions of the medium and their actualization, between planned broadcast experiments and their institutional renderings. It has been a shadowed history as well, shadowed, historiographically, in part by the influence of the Frankfurt School and its critiques of mass culture. The recirculation of broadcasts from the late 1930s and after—and their associations with both fascism and capitalism—has occluded both early broadcasts and those idealist conceptions of the medium that marked its advent. From a post-Second World War, post-*Dialectic of Enlightenment* vantage point, it is perhaps not surprising that for years the best-remembered 'canonical' modernist radio moments were Orson Welles's 1938 *War of the Worlds* enactment and Ezra Pound's wartime propaganda broadcasts for Rome Radio. Both exemplified, or could be seen to exemplify, a notion of radio as primarily an instrument of power, deception, and control. Yet from the outset the singular power of radio as a cultural construction relied on tensions between promise and threat, in the paradoxical uncanniness of its intimacy and omnipresence.

Recent attempts to write radio back into histories of modernism thus necessarily involve both resistance and reconstruction. On the one hand, a new attention to radio is part of the more general 'new modernist' re-evaluation of traditional models

that stressed perceived anti-technological bias and rejection of mass culture; modernism is now often read not in opposition to mass modernity, but as an interactive part of a newly complex media ecology that transformed both subjectivities and the public sphere. On the other hand, reanimating that ecology in order to plumb its complex interrelations involves the imaginative reconstitution of a developing aural environment now nearly unimaginable in its emotional resonance and associative scope. Recapturing that environment (not merely the lost moments of radio aurality but their vibration within their contemporary imaginary) involves 'sounding' the past for traces of what modernists heard, and how that auditory environment manifested itself in their own artistic voices. Doing so involves scrutinizing our own critical practice to register and redress not only historic concentration on the visual, but also the extent to which even new theories of modernism and sound tend to foreground technologies of inscription and reproduction.

Beyond the explicit presence of modernists on the airwaves, or modernist experimental engagement with the new medium (in theory or practice), the very idea of radio served as a constitutive pressure in the formation of modernist subjectivities, aesthetics, and texts; the ephemeral, unrecoverable, works of radio are legible—or, more appropriately, *sound*—through their traces in other modernist production. A full account of modernism 'on' radio, then, would comprise not only T. S. Eliot intoning 'East Coker' over the BBC's Indian Service, the radio plays of Artaud, Pound, and Beckett, and the explicit references to radio in modernist works, but also wireless presence in the dynamics of modernist textuality. These are forms, as Melba Cuddy-Keane has pointed out, that we should think of less as *produced* by new sound technologies than as reflecting a reciprocal relation, the circulation of 'broad currents of thinking'.[1] The historicized modes of hearing and listening that radio helped effect recirculated as form and content in modernist works, in dialogue with the voice of radio itself.

OCCULT

If recuperating radio sometimes feels like a séance, like summoning the voices of the dead, the image is an appropriate one. Jeffrey Sconce has detailed the ways in which turn-of-the-century discussions of wireless were imbued with the language of spiritualism, dwelling on the occult manifestations of voices in the air, voices separated from bodies. As Carolyn Marvin has shown, these occult metaphorics return to the rhetoric surrounding nineteenth-century electrical experimentation and

[1] Melba Cuddy-Keane, 'Virginia Woolf, Sound Technology and the New Orality', in Pamela Caughie (ed.), *Virginia Woolf in the Age of Mechanical Reproduction* (New York: Garland, 2000), 73.

technologies.[2] Indeed, some electrical pioneers, like Sir Oliver Lodge, whose 1890s experiments with wireless telegraphy paralleled those of Tesla and Marconi, were also active spiritualists. Both investigations partook of the nostalgic romance of the ether, that mysterious and mystical substance conceived of as somehow permeating both inner and outer space.

As if to make clear the extent to which it guided early conceptions of wireless, this linkage between the spiritual and the technological was explicitly registered in artistic form. In his 1886 novel *Tomorrow's Eve*, Villiers de l'Isle Adam renders Thomas Edison bemoaning the loss of 'dead voices, lost sounds, forgotten noises, vibrations lockstepping into the abyss'.[3] To capture a sound, to achieve fidelity, is represented as akin to resurrection. The spiritualist impulse underlying many modernisms—the urge to derive authentic meaning through ghostly, fragmentary contact with the voicings of the past (as in Pound's first Ur-Canto, where 'Gods float in the azure air'[4])—found a technological echo in early, pre-broadcast wireless. In the late 1910s and early 1920s, wireless was a solitary and largely amateur affair, with individual enthusiasts deploying home-built apparatus to trawl for connection. As for the fisher of Eliot's *The Waste Land*, casting his net into the past, the phenomenon of 'fishing' involved searching the haunted and unnerving seas of the ether, trying to sort signal from noise, from the static of 'empty bottles, sandwich papers, | Silk handkerchiefs, cardboard boxes, cigarette ends'[5] that floated to its soupy surface. Such sporadic and challenged connection emphasized the isolation of practitioners, and the modern social atomization it bespoke. Much of the uncanniness of sound technologies is thus vested in this simultaneous evocation of rupture and reunion, in that they are often metaphorically construed as a means of bandaging the wounds of a modernity they help to bring about. Such paradoxical impulses of union and dispersal effected by sound mark, for instance, the novels of Virginia Woolf, especially *Mrs Dalloway* (1925), in which shared sonic impulses now induce, now fragment, connection (a commentary not only on the newly mediated modes of aural perception, but on the growing claims of the BBC, by the time of the novel's composition, to a constructed aural citizenship).

Futurist visions of the possibilities of radio involved various alternative, utopian modes of spiritual rhetoric: F. T. Marinetti, as Jeffrey Schnapp and Timothy Campbell have argued, demonstrated in his May 1912 'Technical Manifesto' a literary analogue for the rhythm of ceaseless transmission, here invoked by the propeller sounds he translates into language. At this interface of machine and body Marinetti finds the potential for the liberation of language from the 'ridiculous inanity of the old syntax inherited from Homer' and the potential for 'words-in-freedom'.[6] The

[2] Carolyn Marvin, *When Old Technologies Were New: Thinking About Communication in the Late Nineteenth Century* (New York: Oxford University Press, 1988).
[3] Auguste Villiers de l'Isle Adam, *L'Eve Future* (Urbana: University of Illinois Press, 1982), 20.
[4] Ezra Pound, *Personae* (New York: New Directions, 1990), 232.
[5] T. S. Eliot, *The Waste Land and Other Poems* (London: Faber, 1990), 30.
[6] Filippo Tommaso Marinetti, 'Technical Manifesto of Futurist Literature (May 1912)', in Lawrence Rainey (ed.), *Modernism: An Anthology* (Oxford: Blackwell, 2005), 15, 19.

simultaneity of transmission explodes the old structures: Marinetti, in his manifestos, evokes both the vastness of the ether and its heterogeneity, revelling in its babble and reverberation. The space of radio is that which can accommodate and provoke new analogical relations, binding together things that are 'remote, seemingly diverse or inimical'; the constraining force of logic and syntax is to give way to the essential, non-abstract, intuitive art of the 'wireless imagination'.[7] Though in a very different sense from that of nostalgic fishers for dead voices, this is also a vision that seeks to defy, and even to destroy, death, 'the supreme definition of the logical mind', through a mystical fusion with the machine.[8]

Velimir Khlebnikov's 1921 'The Radio of the Future', depicting radio as 'The Great Sorcerer',[9] also embraces radio as a means of bootstrapping evolution through the eradication of old linguistic modes. The 'stream of lightning'[10] emanating from this sorcerous medium recalls the terms of the original Russian Futurist manifesto, 'A Slap in the Face of Public Taste': 'if for the time being the filthy stigmas of your "common sense" and "good taste" are still present in our lines, these same lines for the first time already glimmer with the Summer Lightning of the New Coming Beauty of the Self-sufficient (self-centered) Word'.[11] In Khlebnikov's utopian vision, radio overcomes the stasis and distortions of stagnant language, substituting a direct and organic—magically and paradoxically unmediated—connection that seems to subsume all senses: 'In the future, even odors will obey the will of Radio: in the dead of winter the honey scent of linden trees will mingle with the odor of snow, a true gift of Radio to the nation.'[12] More than a mere vehicle, radio is both 'a new way to cope with our endless undertakings'—a formal mode of managing the crisis of modernity—and the creator of a new consciousness, forging 'continuous links in the universal soul' in its capacity as the 'spiritual sun of the country' that 'has solved a problem that the church itself was unable to solve'.[13]

Already implicit in Khlebnikov's visionary rendering of unification, however, is an uncomfortable awareness of the way in which top-down broadcast serves to regulate and discipline both its audience and the multiple, chaotic potentialities of wireless. The 'song' that uses the 'obedient . . . metallic apparatus' of radio imposes 'healing' on its audience; the 'trumpet mouth' delivers guiding and shaping messages that both benevolently deceive ('people will drink water and imagine it to be wine. . . . And thus will Radio acquire an even greater power over the minds of the nation') and foreclose the possibility of choice: 'It is a known fact that certain notes like "la" and "ti" are

[7] Ibid. 16, 19. [8] Ibid. 19.

[9] Velimir Khlebnikov, 'The Radio of the Future', in *The King of Time: Selected Writings of the Russian Futurian*, ed. Charlotte Douglas, trans. Paul Schmidt (Cambridge, Mass.: Harvard University Press, 1985), 158.

[10] Ibid. 155.

[11] David Burliuk, Alexander Kruchenykh, Vladimir Mayakovsky, and Victor Khlebnikov, 'A Slap in the Face of Public Taste', 1912, <http://www.unknown.nu/futurism/slap.html>.

[12] Khlebnikov, 'The Radio of the Future', 158.

[13] Ibid. 155, 156.

able to increase muscular capacity, sometimes as much as sixty-four times, since they thicken the muscle for a certain length of time. During periods of intense hard work like summer harvest, or during the construction of great buildings, these sounds can be broadcast by Radio over the entire country, increasing its collective strength enormously.'[14] Also, the stimulation of radio appears to be addictive, replacing individual thought: 'the least disruption of Radio operations would produce a mental blackout over the entire country, a temporary loss of consciousness'.[15]

APPARATUS

The contradictions of Khlebnikov's vision demonstrate the extent to which, at the very moment of its inception *as* broadcast, radio was already a medium of paradoxical tensions—both infinite and contained, uncanny and domesticated—and the manner in which these tensions shaped the modernist imaginary. Behind the rhetoric of connection lurked the stridencies of control; beyond the finely tuned limits of the regulated broadcast signal lay, still, the terrifying absences, noises, and uncertainties of the etheric sea. The various national modalities of broadcast institutionalization— each designed, in its own way, to regulate and control the airwaves, and thus effectively to limit the free play of the 'wireless imagination'—variously codified the new proprieties of the ether. Whether by the commodification of frequencies (as in the United States, where the Radio Acts of 1912 and 1927 preserved, but regulated, contained, and finally helped squeeze out amateur radio) or by the imposition of national monopoly, as in Britain, the 1920s saw the simultaneous unfolding and limitation of radio's possibilities.

The contrasts between various national systems of broadcasting, while important, have perhaps been historically exaggerated—here a battlefield of noises, there a monolith—to the extent that these shared structural tensions have been effaced. This oversimplification is to some extent a by-product of the way in which the different national apparatuses operated rhetorically in deliberate contradistinction. In particular, much of the shaping of the British Broadcasting Company (later Corporation) ethic of public service broadcasting evolved in response to a routinely invoked spectre of American vulgarity that threatened, in Director-General John Reith's term, to 'debase the currency'[16] of broadcasting. There was also a consistent underscoring of the distinction between a public corporation like the BBC and an explicitly governmental institution. In the US, the spectre of state monopoly, and later, state propaganda, similarly operated as a defence of commercial 'pluralism'. Yet

[14] Khlebnikov, 'The Radio of the Future', 158, 156, 158, 159. [15] Ibid. 155.
[16] John Reith, *Into the Wind* (London: Hodder and Stoughton, 1949), 144.

in reality divisions were rarely this distinct. In the late 1930s leftist disparagers of American radio pointed to the similarity between market propagandists and their nationalist counterparts, and US networks, especially after 1929, invoked an ideal of a national monoculture, while the BBC sought to stress its variety of voices even as critics likened its operation to a homogenizing 'sausage-machine',[17] and commented on the thin line between 'public service' and overt propaganda. Some European systems in fact began as mixed operations. In France, for instance, there was a balance of public and private stations until the state takeover during the German Occupation. (This nationalization was not reversed after Liberation.) In Germany, state-run radio maintained some degree of decentralized private subcontracting through the 1920s, a set-up that in practice allowed for greater artistic freedom.

Within each administrative mode the years between the introduction of broadcasting and the Second World War were marked by a similar trend towards coordination, consolidation, and control. If, throughout the early years of the twentieth century, and even into the broadcast era, commentators saw radio as analogous to— or even as proving the existence of—telepathy, by the late 1920s such analogies were turned to the service of the apparatus itself. Both NBC and the BBC promoted radio telepathy experiments, in which impressions were projected out over the airwaves, or gathered in from the concerted concentration of the listening public. Though such 'thought experiments' were meant to amuse, they also invoked (in order to manage) the insecurities of the medium, thereby demonstrating a disciplined control of wireless potentialities. As in Khlebnikov's manifesto, spiritualized simultaneity informs and conjoins listeners, in 'an inundation of the whole country. . . . the unification of its consciousness into a single will'.[18]

The professed goal of John Reith was, similarly, to 'make the nation as one man'.[19] Reith's 1924 book *Broadcast Over Britain* is bathed in the spiritualized language that attended notions of the early wireless; it concludes with a positively orchestral paean to the mysteries of the ether, and the role of radio in attuning mankind with 'the infinite', as an aspirational simulacrum of the instrumental word of god. Wireless, says Reith, 'operates on a plane of its own'; it 'ignores the puny and often artificial barriers which have estranged men from their fellows. It will soon take continents in its stride, outstripping the winds; the divisions of oceans, mountain ranges, and deserts will be passed unheeded. It will cast a girdle around the earth with bands that are all the stronger because invisible.'[20] In Reith's rhetoric, the power of broadcast to effect communication becomes imperial and evangelical, the means not simply to bind nations, but to build them. Here we see the slippage between divergent utopian possibilities articulated by the new medium: technological utopianism, offering the possibility for individual development, is recast as democratization, the means to

[17] Malcolm Muggeridge, *The Thirties* (London: Hamish Hamilton, 1940), 44.
[18] Khlebnikov, 'The Radio of the Future', 159.
[19] Quoted in Paddy Scannell and David Cardiff, *A Social History of British Broadcasting*, i: *1929–1939: Serving the Nation* (London: Blackwell, 1991), 7.
[20] John Reith, *Broadcast Over Britain* (London: Hodder and Stoughton, 1924), 222, 219.

build a 'more intelligent and enlightened electorate', and that very building reveals the potential for manipulation and social control.[21]

Reith explicitly resisted the notion that one should entertain the broadcast audience, embracing instead a policy of elevation. Culture, in the Arnoldian sense, was newly portable, offering the opportunity of shaping a national unity utilizing a 'mass' medium, but explicitly opposed to the 'mass' as construed along American lines. Anticipating by nearly a decade Bertolt Brecht's critical characterization of broadcasting as a 'distribution' system,[22] Reith saw his role as that of an etheric pioneer, laying roads 'not merely for the passage of transport wagons . . . but for influences and developments which shall be permanent and good and widespread'.[23] His goals, in the shaping of the BBC's 'public service' broadcasting, were always articulated in explicitly Arnoldian terms. 'As we conceive it,' he wrote,

> our responsibility is to carry into the greatest number of homes everything that is best in every department of human knowledge, endeavour and achievement, and to avoid the things which are, or may be, hurtful. It is occasionally indicated to us that we are apparently setting out to give the public what they need—and not what they want, but few know what they want, and very few what they need.[24]

It's hard, in retrospect, given the extent of Reith's influence on the shape, scope, and orientation of broadcasting, to see his use of 'we' as genuinely plural. His assumption of the need for cultural elevation, and his arrogation of the role of designated elevator, earned the BBC permanent identification with the term 'middlebrow', coined by *Punch* in 1925 to identify a 'new type' discovered by the BBC: 'It consists of people who are hoping that some day they will get used to the stuff they ought to like.'[25] Virginia Woolf, in a 1932 letter to the *New Statesman* posthumously published as the essay 'Middlebrow', famously dubbed the Corporation 'the Betwixt and Between Company'.[26] If what one 'ought to like', in Reithian terms, meant first and foremost the canonical, it was nevertheless true that by aiming at roping in a variety of intellectuals (including, notably, Woolf herself and much of her circle) to help legitimize radio's claim to respectability, the BBC opened the door to the participation of modernists and modernist aesthetics. While the institution engaged in routine pre-airing censorship, and Reith himself maintained tight control over 'doubtful'[27] matter—most overtly when he forbade Harold Nicolson to praise *Ulysses* and *Lady Chatterley's Lover* during his talk series *The New Spirit in Literature*—the very controversy stirred by that censorship provoked more discussion of modernist

[21] John Reith, *Broadcast Over Britain*, 113.
[22] Bertolt Brecht, 'The Radio as an Apparatus of Communication', in *Brecht on Theatre*, ed. and trans. John Willett (London: Methuen, 1964), 52.
[23] Reith, *Broadcast Over Britain*, 28. [24] Ibid. 34.
[25] 'Charivaria', *Punch* (23 Dec. 1925).
[26] Virginia Woolf, 'Middlebrow', in *The Death of the Moth and Other Essays* (New York: Harcourt, 2009), 184.
[27] Quoted in Todd Avery, *Radio Modernism: Literature, Ethics, and the BBC, 1922–1938* (Aldershot: Ashgate, 2006), 25.

aesthetics. The pedagogical function of the BBC made possible the circulation of authorized dollops of modernism offered up under carefully managed conditions. Archaeologist and art scholar Stanley Casson, for instance, contributed successful introductions to modernist architecture that stressed its accessibility to the common man.

One can argue, however, that radio was in all national contexts always less about the dissemination of specific content than about the production of the listener, whether as consumer, citizen, or subject. For the evangelical and moralistic Reith, the notion of listening as basking like a 'Rajah in a Low Back Chair' (as a 1926 poem in the American *Radio Digest* put it)[28] and languidly selecting among diversions was anathema. It was productive of no civic virtues, and encouraged slackness and self-indulgence. Thus, the Reithian pedagogical vision of radio demanded supervision and regulation of the listening process itself. Yet the production of listenership meant, as well, managing those contradictions of the medium that might encourage free play. Nowhere are the evidences of the uncertainties of radio, and its contradictions, more apparent than in the BBC's official publications, where they stand out by the very effort made to subdue them. The introductory editorial of the BBC's weekly *The Listener* (founded in 1929) seemed to evince an insecurity about the independent viability of radio, promising that the paper, as 'a necessary auxiliary to the microphone',[29] would deliver to the listener 'the necessary auxiliaries—the printed word, the picture, and the diagram'. Yet even as it engaged in this reassuring demystification, much of *The Listener*'s early content worked to reinscribe (as it were) the spiritual nature of the medium, partaking of the etheric grandiosity of Reith's early claims for broadcasting. The magazine's mission statement referred to broadcasting as 'the great experiment'.[30] Editorials stressed its astonishing immediacy and its 'miraculous nature', whereby sound is imbued with borrowed 'dignity' and speech lent 'the attributes of an oracle' by virtue of their transmission.[31] Simultaneously gesturing to the limitless potential of wireless and cautioning against its possible misuse, the BBC cast itself as guide and intermediary between the listener and the infinite. If the 'fabric of life' was now 'magic', as Woolf's *Orlando* put it, due to the reception of voices in the air, it was necessary that that magic be institutionalized. From the outset, the *Listener* commentary stressed the goals of 'proper' listenership, implicitly hinting at the dangers of uncontrolled 'wrong' reception: it urged the establishment of listening groups in order to minimize 'the dangers of mechanising thoughts through broadcasting'—to be headed by trained leaders 'in direct touch with the B.B.C.'.[32] Sidney Moseley, the 'Fond Uncle' of the *Radio Times*, prescribed in 1928 the proper preparations for listening:

[28] Thomas L. Williams, 'Rajah in a Low Back Chair', *Radio Digest Illustrated* (17 Apr. 1926), 18.
[29] 'A New Venture', *The Listener* (16 Jan. 1929), 14. [30] Ibid.
[31] 'The Oracle from the Microphone', *The Listener* (10 July 1929), 48.
[32] 'Discussion Groups', *The Listener* (23 Jan. 1929), 60; 'The Speaker on the Hearth', *The Listener* (11 Sept. 1929), 355.

The art of listening is to make a selection from the many and varied items of the day. Mark those to which you would listen and attend to them in much the same way as if you were at a public performance. If you are able to dim the lights and prepare your mental attitude for what is coming, you get the full measure of realism every time.[33]

The reassuring phrase 'full measure of realism' promises the suspension, with proper practice, of the medium's uncanniness, and the perceptual tensions that underlay the listening experience.

PERCEPTION

It's worth taking a closer look at the elements of these perceptual tensions, which, mingling opportunity and anxiety, contributed to the way radio circulated in the modern imaginary, explicitly provoked experiments in radiogenic art, and found their corollaries in modernist textuality. Although not all of the series of anxieties set out here were solely centred on radio, they formed part of a broader technologically mediated crisis of perception, clustered around the phenomenon of the broadcast voice.

In *displacing visuality* as the dominant sensory mode, radio placed listeners in a position of both unsettling lack of focus (the horror of nothing to see?) and potential imaginative power. While proponents of experimental radio drama lauded the possibilities of 'blind art' and the scope it offered for individualizing the listening experience, even hinting at the possibility of synaesthesia, the recurrent critical use of the term and its variants—'invisible' art, 'seeing through the sense of hearing'— constructed even such creative listening as compensatory rather than sufficient. Also, the denial of a visual dimension served, as well, as synecdoche for a more generalized *bodilessness*. Although radio could equate to a prosthesis for the listening ear—an extension of auditory capacity—it also offered up voices detached from bodies, floating unanchored in an often unmarked space. The gradual professionalization of broadcasting meant among other things the elimination of unplanned noises that served as markers of embodiment, of corporeal life. If this separation allowed for the possibility of reanimating or reclaiming the voices of the past, it also challenged the notion of what it meant to live, to be live, destabilizing the very idea of the unified subject.

Moreover, the experience of disembodied sound contributed to a new perception of aural *space*. While radio, on one hand, opened a window in one's living room to a vertiginous, limitless universe, to space without place, it also prompted attention to the sounding of distances through ambient noise and modes of resonance.

[33] Sidney Moseley, 'Letters from a Fond Uncle, 11: Do We Listen Reasonably?' *Radio Times* (3 Feb. 1928), quoted in Alan Beck, *Listening to Radio Plays: Fictional Soundscapes* (1997), World Forum for Acoustic Ecology, sect. 1.1, <http://interact.uoregon.edu/mediaLit/wfae/library/articles/beck_list_radioplays.pdf>.

Although we are used to thinking about modernist 'spatial form' as the stuff of the eye, radio (paradoxically, through a single focal apparatus) stimulated sensitivity to the multiplicity of the soundscape, and, more ominously, the omnipresence of sound. A consciousness of the varying processes of what Melba Cuddy-Keane terms 'auscultation',[34] or aural focalization, derived from radio listening techniques, suffuses the complex soundscapes of modernist texts. This sense that sound is always present—as 'radio' is there even when the receiver is turned off—contributed in turn to the *erosion of boundaries* between public and private. Broadcasting quite literally took up residence in one's living room. On the one hand, it afforded one the luxurious sense of eavesdropping on public events, but on the other, it could be seen as an invasion and tainting of the domestic space of the home—a violation that could never be undone, that might possibly dissolve the private sphere altogether.

Reactions to this new permeability of space were so strongly emotionally coloured because of the power of radio *presence*, its immediacy and intimacy. Radio 'talkers', trained to an artificial naturalness, became regular visitors, part of the domestic ménage; the power of broadcast drama to convey interiority allowed one to share the workings of another mind. Alternatively, that same quality of presence could infuse the disembodied voice with an oracular, even godlike, authority; a thin line separated intimacy and possession. In turn, this 'thereness' of presence derived in part from a sense of 'now-ness', the immediacy conveyed—especially before recorded programmes became common—by the terrifying 'miracle' of simultaneity of broadcast and reception, a manipulation of time that also erased distance. This sense of immediacy often made the fact of reception more important than its content, just as the phenomenon of presence made personality more immediate than words. Rebecca West wrote of the experience of listening to Woolf broadcast:

It seems to me that . . . a talk records the personality of the speaker as a similar number of printed words cannot do. I find that I do not remember what Virginia Woolf said in her [broadcast] the other night with anything like the detail with which I would remember anything that she had written; but while I was listening to her I got almost as vivid a sense of her as if she were standing in the room. From the tones of her voice one realized her fineness, her fastidiousness, her inheritance of a great cultural tradition, and, over and above everything else, the light grace with which she can run on ahead of the ordinary person's understanding . . .[35]

Even as the presence of radio in one's home emphasized the isolation of individual listening, the simultaneous experience of reception folded the one into the many, constructing an electronic *community* (or, as Gertrude Stein put it, an 'everybody'[36])—or, alternatively, subsuming the individual into an electronic *mass* (what

[34] Cuddy-Keane, 'Virginia Woolf, Sound Technology and the New Orality', 71.

[35] Rebecca West, 'Listening to Broadcasting' (1929), Rebecca West Papers, McFarlin Library, Series 2, Box 36, Folder 28.

[36] Gertrude Stein, 'I Came and Here I Am', *Cosmopolitan* (Feb. 1936); repr. in Robert Bartlett Haas (ed.), *How Writing Is Written*, vol. ii of *The Previously Uncollected Writings of Gertrude Stein* (Los Angeles: Black Sparrow Press, 1974), 72.

John Dos Passos sarcastically termed a 'youandme'[37]). The portmanteau term 'the listener' performed an act of rhetorical reassurance by balancing on a semantic knife-blade, simultaneously conjoining the audience into a single identity and reassuring members of their singularity. In this connection, the promise of national community vied with the sense that radio could render boundaries useless, immersing one in stimuli literally foreign. Marinetti, in a never-broadcast playlet for radio called *Drama of Distances*, scripted a broadcast sequence that leapfrogged national borders:

11 seconds of a military march in Rome.
11 seconds of a tango danced in Santos.
11 seconds of Japanese religious music being played in Tokyo.
11 seconds of a lively rustic dance in the Varese countryside.
11 seconds of a boxing match in New York.
11 seconds of street noise in Milan.
11 seconds of a Neapolitan song sung in the Copacabana Hotel in Rio de Janeiro.[38]

This very ability to snatch and proffer snippets of the exotic recalled the old image of the ether as a place of lingering voices, only gradually dissipating waves. The very sounds of the silence of radio—the never quite empty soundspace between voices and programmes (what Joyce calls in *Finnegans Wake* 'sonorous silence'[39])—could summon up uncanny notions of decay and drift. 'Dead air'—with all that the term implies—had to be reconfigured as a mere pause for digestion, a sorbet to cleanse the aural palate, an authoritative silence rather than echo chamber.

All of these anxieties overlap, and all can be rearticulated in terms of the issue of *fidelity*. The medium affords the possibility not merely for the incidental distortion of 'real' sounds, the muffled transmission of language, or the insufficient rendering of meaning; it opens up a range of terrifying modes of deception, undecodable by the 'evidence of one's eyes', and tied to the very suspension of disbelief on which 'blind art' depends. That which is 'now' can be fabricated; place can be counterfeited; sound may be 'sound effect'. The radio voice can disguise (in a phenomenon Pamela Caughie has described as radio 'passing'[40]) class, race, and even gender; most importantly, it can avail itself of radio presence and authority in order to *lie*.

Debates about the authenticity of the radio voice had been common for over a decade by the time Rudolph Arnheim, in 1937 (at a time when the propaganda uses of radio were so obvious as to make his words redundant), warned of the dangers of passive listenership, that 'mental laxity and nervousness that destroys every possibility for genuine attention and artistic enjoyment', and urged vigilance against the

[37] John Dos Passos, 'The Radio Voice', *Common Sense* (Feb. 1934), 17.
[38] Filippo Tommaso Marinetti, 'Drama of Distances', trans. Jeffrey T. Schnapp, *Modernism/Modernity*, 16/2 (2009), 417.
[39] James Joyce, *Finnegans Wake* (London: Faber and Faber, 1975), 230.
[40] Pamela Caughie, 'Audible identities: passing and sound technologies'. Humanities Research Vol. xvi. No. 1. 2010: *Passing, Imitations, Crossings*, ed. Monique Rooney and Carolyn Strange (ANU E Press, 2010). <http://epress.anu.edu.au/apps/bookworm/view/Humanities+Research+Vol+XVI.+No.+1.+2010/185/ch05>

'seductions of inertia and passivity'.[41] Though in 1935 University of Wisconsin president Glenn Frank was still describing the microphone as 'the deadly enemy of the demagogue—a ruthless revealer of "hokum"',[42] such claims were by then rare; as the BBC's own 'training' of listenership emphasized, active engagement did not eliminate, but only repressed, the medium's contradictions. The reassurances implicit in early broadcast decisions, however (the predominance of music, which could be judged according to merely acoustic measures of fidelity, the training-into-naturalness of the vocal style for the radio talk), made it difficult for many to surrender confidence in broadcast transparency. John Dos Passos's essay–prose poem 'The Radio Voice' (1934), for example, ironically channels the illusory intimacy of F.D.R.'s fireside chats:

There is a man leaning across his desk, speaking clearly and cordially to youandme, painstakingly explaining how he's sitting at his desk there in Washington, leaning toward youandme across his desk, speaking clearly and cordially so that youandme shall completely understand that he sits there at his desk in Washington.... we edge our chairs closer, we are flattered and pleased, we feel we are right in the White House.
 When the cordial explaining voice stops, we want to say: Thank you, Frank...[43]

The sensuous transmission of presence registered by West as she listened to Woolf rendered more complete her later horror at the 'radio traitor' Lord Haw-Haw.[44]

Perhaps even more salient than the difficulties of maintaining resistant listening, however, were those encountered by modernist broadcasters who were forced to ignore exactly those aspects of the medium most resonant with modernist notions of perception if they were to make use of the medium to promote modernist works and concerns. Such broadcasting required not simply, as Todd Avery has argued in relation to Bloomsbury broadcasters, the embrace by highbrows of a medium whose ideological foundations it rejected in order to help counter its characteristic 'intellectual dimness',[45] but also a kind of 'as if' suspension of disbelief, a situational endorsement of a suspect transparency. Such mental gymnastics were later to enable Pound's insistence, during the Rome Radio broadcasts, that, unlike the 'brain monopolisers' of the BBC, *he* was independent of apparatus—a remarkable claim for someone as concerned as Pound with all aspects of the medium—and thus 'not speakin' officially'.[46]

[41] Rudolf Arnheim, 'Disciplining the Gramophone, Radio, Telephone, and Television', *Sapere* (15 Dec. 1937), trans. Christy Wampole; repr. in *Modernism/Modernity*, 16/2 (2009), 423–4, 426.
[42] Glenn Frank, 'Radio as an Educational Force', *Annals of the American Academy of Political and Social Science*, 177/1 (Jan. 1935), 120.
[43] Dos Passos, 'The Radio Voice', 17.
[44] Rebecca West, *The New Meaning of Treason* (New York: Viking Press, 1964), 3.
[45] Avery, *Radio Modernism*, 36.
[46] Leonard Doob (ed.), *Ezra Pound Speaking: Radio Speeches of World War II* (Westport, Conn.: Greenwood, 1978), 154, 148.

DISCIPLINING THE AVANT-GARDE

The widespread emphasis on the domestication of radio listenership and the constraining sponsorship that regulated modernist contributions underscore the fact that, while it may be true in a very literal sense that, as Mark Cory puts it, 'radio in its early years was synonymous with experimentation',[47] 'experimentation' equated unproblematically neither with open-endedness nor with avant-gardism, but involved the gradual refinement and codification of broadcast techniques that often rendered avant-garde experiment marginal, oppositional, or excluded altogether. Such complexly challenged (and nationally differing) postures of the avant-garde vis-à-vis the radio landscape as a whole have often been obscured in studies that focus explicitly *on* sound experiment, and in particular on the radio drama as avant-garde vehicle.

Joe Milutis has argued convincingly that it was exactly the possibilities of 'noise, misprision and appropriation' in radio—those elements oppositional to the 'standardization of the radio waves'[48]—that made it attractive, as medium and metaphor, to the avant-garde. Yet by definition these elements were unlikely to be underwritten by the institutions of that standardization. Rare were circumstances like those in post-revolutionary Mexico, where the Estridentista movement, drawing from both Italian Futurism and Spanish Ultraismo and embracing a similarly inflected vision of radio, also helped shape its actual emergence. Manuel Maples Arce's 1921 broadsheet manifesto for the movement rhetorically links technology and artistic revolution, with classic Marinettian destructive flourishes such as 'I affirm my position at the explosive apex of my unique modernity' and 'Chopin to the electric chair!'[49] Yet, as Rubén Gallo has chronicled, Estridentismo, though oppositional, was grounded in an embrace of its political moment, a moment that allowed its practitioners more than metaphorical access to the technology they celebrated. 'Any technical art is intended to fill a spiritual role in a given time,' declares Arce in the manifesto, and that ideal was made explicit when Arce himself helped inaugurate Mexican broadcasting, on 8 May 1923, by reading his poem 'TSH', itself a celebration of wireless. That radio appears in the poem as 'the nuthouse of Hertz, Marconi and Edison' attests to the as yet freewheeling nature of its Mexican manifestation; indeed, though this first station was sponsored by a literary magazine, the Estridentists found the second, owned by a cigar manufacturer, equally pliable.[50]

[47] Mark Cory, 'Soundplay: The Polyphonous Tradition of German Radio Art', in Douglas Kahn and Gregory Whitehead (eds), *Wireless Imagination: Sound, Radio, and the Avant-Garde* (Cambridge, Mass.: MIT Press, 1992), 333.

[48] Joe Milutis, *Ether: The Nothing That Connects Everything* (Minneapolis: University of Minnesota Press, 2006), 80.

[49] For one translation of the manifesto, see Dawn Ades, *Art in Latin America: The Modern Era, 1820–1980* (New Haven: Yale University Press, 1993), 306–9.

[50] Rubén Gallo, *Mexican Modernity: The Avant-Garde and the Technological Revolution* (Cambridge, Mass.: MIT Press, 2005), 123–4.

In large part, radio apparatuses, as we have seen, however, were designed to manage the very uncanniness that inspired radiogenic art. Those producers and sound engineers most attuned to sound experiment were gradually sidelined over the course of broadcasting's first two decades. Experimentalism found airspace again only in the 1950s and 1960s, when radio was being supplanted by television as the most important mass medium (and, in Britain, after the creation of the BBC Third Programme provided a ghetto-space for the 'highbrow'). In Germany, as Cory has detailed, decentralized regional production in the 1920s allowed for the development of a variety of 'Horspiel' or 'sound play' experiments. Moving beyond adaptation of stage drama, one variety of radio production achieved medium-specificity through a reflexive incorporation of broadcast itself. Like the 1924 French drama *Marémoto*, which purported to be a news broadcast of a sinking ship, plays like Friedrich Wolf's 1925 *SOS Rao-Rao-Foyn/Krassin rettet Italia* exploited radio's deceptive potential, as Welles would later do (in fact, although *Marémoto* was translated and broadcast in Germany and England, it was not allowed on French radio until 1937 for this very reason). More radical sound experiments attempted to jettison literary convention altogether in radiogenic sound art: Hans Flesch, director of the Berlin Radio Hour, as well as film directors such as Walter Ruttman and Friedrich Bischoff, applied the lessons of cinema montage to create 'acoustical mosaics' using early pre-recorded and recombined elements.[51]

In Britain, Lance Sieveking, head of the BBC's Research Section, was the foremost exponent of radiogenic experiment, what he called 'pure radio'. Recruited by Reith in 1928 to explore the form of radio, Sieveking pushed for the fullest possible exploration of the medium as 'harnessed telepathy',[52] the exploitation of what he termed 'the ghastly impermanence of the medium'.[53] Sieveking felt that the radio producer—aided by the BBC's distinctive 'dramatic control panel', which allowed him, conductor-like, to combine the live elements of many separate studios—should be a new kind of innovator, rejecting all literary models, including plot. Like the Horspiel artists, Sieveking imported montage and fade techniques from the cinema, creating impressionistic portraits and ambient works as well as more linear dramas. His 1928 *Kaleidoscope*, billed as a 'rhythm representing the life of man from the cradle to the grave',[54] conjoined music, verse, declamation, and sound effect in a hallucinatory modernist whirl of fragments that dissipated into a storm of confused reaction ('extraordinary ... experiment ... new technique ... recalled one's impression of gas in the dentist's chair'[55])—the only traces that remain, other than a snippet in the appendix to Sieveking's memoirs.

Even the word 'kaleidoscope' itself became for anti-experimentalists a term of parodic disdain and a further means of disciplining the medium. V. C. Clinton-Baddeley,

[51] Cory, 'Soundplay', 341.
[52] Lance Sieveking, *The Stuff of Radio* (London: Cassell, 1934), 111.
[53] Ibid. 15.
[54] Scannell and Cardiff, *A Social History of British Broadcasting*, 136.
[55] Sieveking, *The Stuff of Radio*, 24.

in *The Listener*, criticized 'the naïve belief that the microphone stands apart from the general rules of straight and normal thinking':

It is patently true that the stage play, as written for the stage, is suitable for neither the screen nor the microphone. But it is not true, and it is dangerously wrong-headed to imply, that either screen or microphone should seek a method 'peculiar to nothing else', and utterly apart from theatrical art in general. Screen, microphone, and theatre have each individual opportunities for entirely peculiar development: but all are bound to a far greater extent to the expression of one dramatic canon. The present danger in both cinema and radio is the temptation to develop their idiosyncrasies at the expense of what should be the first consideration—their dramatic value to the performance. The verbal kaleidoscope, for instance, is not a sovereign nostrum—though the peculiar contribution of radio to dramatic art, it is not the art itself. Such a misconception has already crippled the cinema. . . . it is surely purposeless for the microphone to go kaleidoscopic about nothing in particular.[56]

Sieveking's last important production, *The End of Savoy Hill*, offered a retrospective of the BBC's own history as it prepared to leave its old studios for the grandiose new Broadcasting House. It marked virtually the last gasp of 'pure radio' in Britain, though its montage techniques were widely recycled for news 'actuality' programmes. By the early 1930s, both Sieveking and his associate Archie Harding, who had produced Ezra Pound's 1931 radio 'opera' *The Testament of Francis Villon*, had lost influence within the BBC hierarchy, as their aesthetic (and in the case of Harding, left-wing) views fell from favour. In Germany, the rise of the Nazis saw the purging of discomfiting or politically suspect experimentalism as nationalization of the apparatus became complete; by 1932 Flesch and other important innovators were dismissed, later to be imprisoned.

 Many of the most important experimental radio works of the 1930s and 1940s were thus relegated to being doubly ephemeral, not broadcast (if at all) until decades later. Pound's second opera, *Cavalcanti*, languished after Harding's exile to the regional station in Manchester and was only staged in 1983, though *not* broadcast (perhaps because of the inescapable propaganda associations between Pound and radio even after his death), thus losing its specific compositional and thematic connection to radiospace. Marinetti's 1933 Radio *sintesi* (five short experimental pieces that interspersed various mechanical and other noises with stretches of silence) were also never broadcast. Perhaps most notably, one of the most written-about works for (and also quite explicitly *against*) radio, Artaud's scabrous and glossolalic *To Have Done with the Judgment of God*, recorded for French radio in 1947, was banned for broadcast and only once privately auditioned twenty-five years later.

 Small wonder, then, that increasingly, as the 1930s wore on, idealist, political, and avant-garde evocations of the potentiality of the wireless—what radio could or should be—were increasingly grounded in a condemnation of its real-world manifestations. Though Brecht's 1932 characterization of existing radio as a mere 'distribution' system for capitalist culture could serve as an umbrella term for all these critiques, they derived from a number of differing political positions and

[56] V. C. Clinton-Baddeley, 'The Case for Wireless Drama', *The Listener* (11 June 1930), 1033.

utopian models. Brecht himself, who as far back as 1927 had pointed to the 'shameful' uses of radio in relation to public praise of its 'unlimited possibilities',[57] called, in 1932, for a true revolutionary use of radio as real 'communication', arguing that 'radio is one-sided when it should be two'.[58] Brecht's own 1929 radio play *Der Lindberghflug* had been designed to demand active involvement, to operate as a kind of joint performance of radio broadcast and listener participants, with radio providing music, choruses, and sound effects, while listener–actors read many of the main speeches. As a didactic enterprise, such participation was a discipline, he argued, that 'is not intended to be of use to the present day radio but to alter it'[59]—to bring about a new radio public sphere. If, like Woolf and Stein, Brecht could see in radio the potential for the democratic construction of an 'everybody', it was nevertheless clear to him as a Marxist that neither commercial nor existing state broadcast apparatuses would or could potentiate such possibilities. In his view:

> The increasing concentration of mechanical means and the increasingly specialized training—tendencies that should be accelerated—call for a kind of resistance by the listener, and for his mobilization and redrafting as a producer . . . This exercise is an aid to discipline, which is the basis of freedom. The individual will reach spontaneously for a means to pleasure, but not for an object of instruction that offers him neither profit nor social advantages. Such exercises only serve the individual in so far as they serve the State, and they only serve a State that wishes to serve all men equally.[60]

Brecht's brand of radio experimentalism involved a number of ironies: neither was listener participation genuinely plural, nor did audience members become active 'producers'. In the distribution of shared supplementary text (much as with *The Listener*) Brecht undercut the claim to sufficiency and specificity of the medium itself—even as he criticized contemporary radio for being overly imitative of existing institutions, not properly radiogenic. There are additional ironies, of course, in his utilizing the state mechanism of control to undermine top-down control, a revolution from within that he to some extent acknowledged was impossible. This last was a persistent contradiction that troubled many left-wing writers, particularly those chafing within and in opposition to the BBC (or, indeed, both), and provoked a number of late-1930s attempts to channel in print a version of broadcasting's oracular presence, to wrest away some element of its phatic power.

By contrast, for many members of the avant-garde, the formation and 'programming' of the listenership by existing institutions had already rendered the medium itself inert: thus the condemnation, for instance, implicit in André Breton's 1930 'Second Manifesto of Surrealism', which states that 'the approval of the public is to be

[57] Quoted in Cory, 'Soundplay', 345.

[58] Brecht, 'The Radio as an Apparatus of Communication', 52.

[59] Brecht is repeating here sections of 'An Example of Pedagogics' (his notes on the Lindburgh opera), in *Brecht on Theatre*, 32.

[60] Ibid.

avoided like the plague'.[61] For Breton, as Anke Berkenmaier explains, the 'occulta-tion' he demanded of Surrealism was not accessible by engagement with a mass radio audience[62]—an index of the extent to which the training of the radio listener was already seen to have drained broadcasting of revolutionary potential. In Marinetti's 1933 'La Radia', written with Pino Masnata, the impatience of the Futurist elite with the as-yet-achieved produced an even more explicitly anti-mass vision: 'La radia, the name that we futurists have given to the great manifestations of the radio is STILL TODAY' (they declare emphatically), enclosed, constrained by conventions of real-ism, 'idiotized' by monotonous music and otherwise limited by imitation and timidity.[63] 'La radia' in its full flowering—'without time or space without yesterday or tomorrow'—would be free of 'the audience as self-appointed judging mass systematically hostile and servile always against the new'.[64]

The implication here is that radio art cannot *be* radio art in the presence of the apparatus; but without the apparatus, the medium is only theoretical. In the end this fundamental paradox underlies all radio in the modernist period: it can only fulfil its potential as a medium by erasing the conditions of its generation. One could argue that perhaps, paradoxically, it's only in its decanting into print—in the 'sonorous silence' from which the radiobody of HCE, in Joyce's *Finnegans Wake*, receives and redeems language, in the disembodied voices of Virginia Woolf's *The Waves*, or the undulating wave-forms of Apollinaire's 'Ocean Letter'—that the radio as modernist medium is most truly itself.

[61] André Breton, *Manifestoes of Surrealism*, ed. Richard Seaver and Helen R. Lane (Ann Arbor: University of Michigan Press, 1972), 177.

[62] Anke Birkenmaier, 'From Surrealism to Popular Art: Paul Deharme's Radio Theory', *Modernism/Modernity*, 16/2 (2009), 359.

[63] Filippo Tommaso Marinetti and Pino Masnata, 'La Radia', *Gazetta del Popolo* (Oct. 1933); repr. in Douglas Kahn and Gregory Whitehead (eds), *Wireless Imagination: Sound, Radio, and the Avant-Garde* (Cambridge, Mass.: MIT Press, 1992), 266.

[64] Ibid. 267.

..

MODERNIST MUSIC

..

SIMON SHAW-MILLER

THIS chapter will consider the concept of modernism in two main ways. It will argue that music and its associated ideas are central to the concept of modernism for all the arts, but perhaps especially for the so-called 'visual' arts. Music acted as *the* paradigm for the revolution that constituted the artistic response to the impact of modernity. This response was a radical questioning of the legitimacy of conventional artistic modes and languages of expression: it evaluated these modes' ability to match, or to speak accurately for, the new and the modern. In seeking solutions to this crisis in representation, music suggested a model because it was seen as the most abstract of the arts. This chapter will trace the background to this perception. It will go on to consider the modernist condition of music itself, which, while offering a model of abstract formalism, was simultaneously undergoing a re-evaluation of its own means of expression.

The concept of musical modernism has many facets, most of which refract from two main angles: modernism as stylistic taxonomy and modernism as ideology. There is no doubt that what is commonly called musical modernism is marked by a plurality of tongues: neo-classicism, serialism, aleatoricism, minimalism, nationalism, and so on. These are not directly comparable concepts, since, for example, serialism is a technique, neo-classicism a movement, nationalism an ideology. I shall be proposing a limited definition (within a single chapter it would be hard to do anything else) which, while being less expansive in scope, aims to capture the advantages of adhesion.

Modernism can be generally defined as the pursuit of artistic strategies that seek relevance to the social forces of modernity. The responses of modernists to modernity can be celebratory or condemnatory, and can figure at the level of both content and form. In what follows I shall define modernism in music as a normative shift that often figures at the level of form; indeed, formalism is a defining characteristic of the

major branch of modernism as I shall be employing it. Modernism emerged from Romantic sensibilities and maintained continuity with many of Romanticism's dominant modes. Indeed, it could be argued that modernism is a further refinement of Romanticism, not its replacement. From the nineteenth century onwards, modernism in general moved from the margins of cultural practice to the centre of institutionalized convention (including scholarship). How we tune ourselves to cultural rhythms will determine whether we still detect modernism's fading echo or recognize a new cultural paradigm: postmodernism.

Many accounts of modernism have a literary or visual bias. They fail to acknowledge the profound interaction between the arts, and to recognize the leading role music played as both a technical model and an ideological paradigm for emerging modernist sensibilities. We might put it more boldly: music, at least what was understood as music's essential characteristics, became modernism's guiding legitimizing principle, its primary symbolic image. Walter Pater put it most famously and categorically in 1873, asserting that 'all art constantly aspires to the condition of music'.[1] But what was this condition?

It was essentially the view of music that had been developed within German Romantic philosophy. Its roots can be detected in the soil that was cultivated by E. T. A. Hoffmann in the name of Ludwig van Beethoven. In 1810 Hoffmann published two seminal articles, a review of Beethoven's most recent symphony, his Fifth, and a marvellously synaesthetic text, 'Kapellmeister Johannes Kreisler's Musical Sufferings'. Both of these would a little later be revised and expanded to become part of his *Kreisleriana* papers. Probably no musical writing by Hoffmann has been more republished and quoted than his essay on Beethoven's Fifth Symphony, an essay that may be said to mark the birth of modern musicology. In this essay, Hoffmann positions instrumental music as 'the most romantic of all arts'. The essay begins:

When music is spoken of as an independent art, does not the term properly apply only to instrumental music, which scorns all aid, all admixture of other arts (the art of poetry), and gives pure expression to its own peculiar artistic nature? It is the most romantic of all arts, since its only subject matter is infinity. Orpheus's lyre opened the gates of Orcus. Music reveals to man an unknown realm, a world quite separate from the outer sensual world surrounding him, a world in which he leaves behind all precise feelings in order to embrace an inexpressible longing.

Were you even aware of this peculiar nature of music, you poor instrumental composers who have laboriously struggled to represent precise sensations, or even events? How could it ever occur to you to treat sculpturally the art most utterly opposed to sculpture [plastic art]? Your sunrises, your storms, your *Batailles des Trois Empereurs*, etc. are clearly just ridiculous aberrations, and have been deservedly condemned to total oblivion . . . Such is the power of music's spell that it grows ever stronger and can only burst the fetters of any other art.

[1] See Walter Pater, 'The School of Giorgione', in *The Renaissance: Studies in Art and Poetry* (London: Jonathan Cape, 1928), 128–49.

It is certainly not merely an improvement in the means of expression . . . but also a deeper awareness of the peculiar nature of music, that has enabled great composers to raise instrumental music to its present level.[2]

This is a plea for the status of instrumental music as paradigmatic: to counter definitions of music as song (music and words), and to raise music above language. However, Hoffmann's position is gripped within a paradox. On the one hand, music becomes dematerialized; it loosens its bonds to the other arts, loses its contact with the earth, and floats off like a balloon into an unknown, invisible realm. On the other, Hoffmann has to tether music, he has to set about demonstrating how a specific earth-bound work, Beethoven's Fifth Symphony, can capture and, ironically, make visible and audible the infinite within the finite bounds of symphonic form and notation. The remarkable thing about Hoffmann's prose is the extent of synaesthesia he employs in fashioning a critical language for explaining the abstract nature of music as paradigm.

However, we should not necessarily seek a resolution to this paradox. It may be more appropriate to register it and to move on. Indeed, as Mark Evan Bonds has explained, 'The inherent incompatibility . . . defies rational reconciliation. This kind of paradox manifests the ultimate inaccessibility of the Absolute on any enduring basis. In the end, however, this inaccessibility was something to be embraced, not avoided or explained away.'[3] The birth of absolute music brought with it such a paradoxical situation.

Just under a decade later Arthur Schopenhauer was to formulate the definitive philosophical statement of music's uniquely privileged status as an artistic medium: 'Our world is nothing but the phenomenon or appearance of the Ideas . . . music, since it passes over the Ideas, is also quite independent of the phenomenal world, *positively ignores it, and could, to a certain extent, still exist even if there were no world at all,* which cannot be said of the other arts.'[4] For Schopenhauer, all the arts except music communicate knowledge that is *intermediate*, situated between the noumenon and the phenomenon. As Bryan Magee has put it: 'in so far as these arts [the arts other than music] give us glimpses of the *noumenal* it is indirectly, via what is intermediate, and their capacity to do even this rests on their ability to represent things which instantiate the intermediate'.[5] Music alone speaks directly of the noumenon. Music is an alternative to the world, being a 'copy of the whole *will* as the world itself is, indeed as the Ideas are'.[6] Music is a manifestation of that which lies behind the world—ultimate reality. It achieves this 'in nothing but tones, and with

[2] David Charlton (ed.), *E. T. A. Hoffmann's Musical Writings: Kreisleriana, the Poet and the Composer, Music Criticism* (Cambridge: Cambridge University Press 1989), 96–7. The reference to *Bataille des trois* is to *La Grande Bataille d'Austerlitz* by Louise Jadin or J. M. Beauvarlet-Charpentier (1806).

[3] Mark Evan Bonds, *Music as Thought: Listening to the Symphony in the Age of Beethoven* (Princeton: Princeton University Press, 2006), 59.

[4] Arthur Schopenhauer, *The World as Will and Representation*, trans. E. F. J. Payne, 2 vols (New York: Dover, 1966), i. 257; my emphasis.

[5] Bryan Magee, *The Philosophy of Schopenhauer* (Oxford: Oxford University Press, 1997), 182.

[6] Schopenhauer, *The World as Will and Representation*, i. 257.

the greatest distinctness and truth, the inner being, the in-it-self, of the world'.[7] It follows, therefore, that 'we could just as well call the world embodied music as embodied will'.[8]

This is why music is said to be a more profound signifier than ordinary language. Words are too definite, too fixed to concepts in the process of worldly generalization, to be able to access the noumenon directly. According to this argument, this is why music is unique in being able directly to impinge on the will of the listener, without any clutter from the real world. It speaks straight to the soul: 'the effect of music is so very much more powerful and penetrating than is that of the other arts; for these speak only of shadow, but music of the essence'.[9] This is the nature of the Romantic musical revolution; it is what Hoffmann, before Schopenhauer, is indicating in his celebration of Beethoven. Music breaks with language and the everyday, becoming absolute and abstract.

The modernist conception of music 'purified' (or reduced) holds it tight within the frame that separates it from the other arts and the everyday world. Instrumental music and song are divided: 'Thus, if music is too closely united with words, and tries to form itself according to the events, it is striving to speak a language which is not its own.'[10] The sound-structure of music is isolated and ring-fenced. But to be so corralled it first had to become tangible. To become this sort of object, as Lydia Goehr has shown, music first needed to define itself in relation to what she has called 'the work concept'; a 'work' is, in this sense, an identity that exists, rather like the idea of the soul, as something separate from the material world.[11] Gerald Abraham has made a related point in connection to musical ontology in performance: 'Not only during the Middle Ages, but for centuries after them, the conception of a single "correct" method of performance did not yet exist.'[12] With the advent of the 'work concept' music sought to move beyond the condition of ephemeral performance, to become an art of framed works, and thus, ironically, it 'aspired to the condition of fine art'. This culminates in Franz Liszt's 1835 proposal for the 'foundation of a musical Museum':

In the name of all musicians, of art, and of social progress, we require: the foundation of an assembly to be held every five years for religious, dramatic, and symphonic music, by which all the works that are considered best in these three categories shall be ceremonially performed every day for a whole month in the Louvre, being afterwards purchased by the government, and published at their expense.[13]

[7] Schopenhauer, *The World as Will and Representation*, i. 264.

[8] Ibid. 262. [9] Ibid. 257. [10] Ibid. 338.

[11] Lydia Goehr, *The Imaginary Museum of Musical Works: An Essay on the Philosophy of Music* (Oxford: Clarendon Press, 1992).

[12] Gerald Abraham, *The Concise Oxford History of Music* (Oxford: Oxford University Press, 1979), 105–6.

[13] Franz Liszt, 'On the Position of Artists and their Place in Society', cited in Goehr, *The Imaginary Museum of Musical Works*, 205.

By this means music was to take its place alongside other works of fine art in the Louvre museum, where it could be shown to the public, preserved for all time as a published object. Music had achieved the status of a fine art, grounded in musical objects, the score acting as the container of musical identity. Yet music's distinctiveness was grounded in its abstraction; it was not tied to language and the depiction of the everyday world as other fine arts might be.

Absolute (abstract) music was now equipped to become, in its turn, a paradigm for modernism: 'Painting could become like music, an art contained in its own form and thus capable of infinitely more variety than before.'[14] This is music understood as pure form, a signifying system beyond words but a system of rules, what Wassily Kandinsky referred to as *malerische Generalbass* and a *Harmonielehre der Malerei* ('theories of figured bass' and a 'harmony for painting'). This purism became fundamental to one of the most widespread characterizations of modernism, that made by the cultural critic cited above, Clement Greenberg.

In 'Towards a Newer Laocoön', published in 1940, Greenberg took up the ontology first laid down by Gotthold Lessing in 1766: 'Purism is the terminus of a salutary reaction against the mistakes of painting and sculpture in the past several centuries which were due to such confusion.'[15] His starting point is that purity exists and is desirable, and, therefore, that any 'confusion' between art forms is a mistake and to be avoided. The attempt to locate this Garden of Eden, the site of such purity, is not pursued. Instead, he takes the 'infection' of art by literature in the seventeenth century as his point of departure. Every age, he contends, has a dominant art form, and it is the fate of this single art to become the 'prototype of all art: the others try to shed their proper characteristics and imitate its effects'. This is an important point, for whereas the dominance of literature is seen as corrupting, by the nineteenth century the dominant art form, as we have seen, had in some eyes become music, and Greenberg sees its influence on painting as positive. It is important to understand that, for Greenberg, this is because music becomes a model as a *method*, rather than as a kind of *effect*. Cause and effect are separated and, within this conception of modernism, emphasis is placed on the conception process (method), rather than on the mechanisms of reception (effect). The role of the creator takes ontological precedence over the role of the viewer or listener.

Throughout Greenberg's arguments on modernism music plays a central role: 'Only by accepting the example of music and defining each of the other arts solely in the terms of the sense or faculty which perceived its effects and by excluding from each art whatever is intelligible in the terms of any other sense or faculty would the non-musical arts attain the "purity" and self-sufficiency which they desired.'[16] This status is the state of modernism. The shift to an understanding of instrumental music

[14] Clement Greenberg, 'Obituary and Review of an Exhibition of Kandinsky', in *The Collected Essays and Criticism*, ii, ed. John O'Brien (Chicago: University of Chicago Press, 1986), 4.

[15] Clement Greenberg, 'Towards a Newer Laocoön', in Charles Harrison and Paul Wood (eds), *Art in Theory 1900–2000* (Oxford: Blackwell, 2000), 563. The reference is to Gotthold Lessing, *Laocoön: An Essay Upon the Limits of Poetry and Painting* (1766).

[16] Ibid. 565.

as paradigm is profound, for it separates music from what became known as the 'extra-musical' (as opposed to the 'non-musical'). It collapses music down to a formal object, defining its character as simply a sound-structure. While music is a sound-structure, it is more than that. This formalism stands in opposition to an understanding of music as a discursive field, as a 'discourse' in Foucault's terms.

Another way of considering this issue is to invoke Roland Barthes's essay 'From Work to Text'.[17] Barthes differentiates a 'work' involving an object that can be seen, held, and displayed from a 'text', which he defines as a methodological field, rather than as a concrete object. A text exists in the functions of discourse, as an activity of production or performance. In this way, while the work becomes a commodity, the text escapes such identification through play and performance. Thus, the reader (or the viewer or listener) constructs the text rather than being the passive consumer of the work. For Barthes, pleasure here arises from the connection between listener and text, a conjunction without separation: *jouissance*. This type of listening engages responsibility and connects back to Romantic thinkers such as Hoffmann and Friedrich Schleiermacher. The latter, in his writings on the kinship between religious and aesthetic experience, proposed an astonishingly radical conception for the time, an idea that Marcel Duchamp was later to take up.[18] Schleiermacher wrote: 'all of those who actively share in the experience of art works . . . are also to be regarded as artists'.[19] Hoffmann had likewise assigned to listeners an active, interpretative role, a confluence of the creative and interpretative processes. We can, then, characterize modernism's understanding of music as object-centred and formalist, with meaning residing in the object, whereas in pre-modern and postmodern sensibilities, contrarily, music is seen as a discourse and is text-centred.

FORMAL AND CONTEXTUAL MODERNISM

At the birth of modernism we have two streams developing, both generated from music: one sees it as a paradigm of abstract formal techniques, the other regards it as a powerful multi-sensory or multidimensional model. We might call these 'formal modernism' and 'contextual modernism' respectively. The first regards music as an exemplar of autonomy, a methodological model; the second sees music as an exemplar of connectivity, an effectual model. My contention is that, although modernism consists of these two strains, formal modernism becomes the dominant

[17] Roland Barthes, 'From Work to Text', in *Image–Music–Text*, trans. Stephen Heath (Glasgow: Fontana Press, 1982), 155–64.

[18] Marcel Duchamp, 'The Creative Act', in Robert Lebel, *Marcel Duchamp*, ed. Robert Lebel (New York: Paragraphic Books, 1959), 77–8.

[19] Friedrich Schleiermacher, 'On the Concept of Art', in Charles Harrison, Paul Wood, and Jason Gaiger (eds), *Art in Theory 1815–1900* (Oxford: Blackwell, 1998), 74.

model for the first half of the twentieth century. Contextual modernism begins to re-emerge in the second half of the twentieth century and eventually becomes equated with postmodernism.

We can characterize modernism as in large part a response to the rising power of the vernacular. The rise of kitsch, popular culture, entertainment industries, 'low' culture, and the vernacular is central to modernity. But modernism's response to it, as I observed at the outset, was not uniform; it could be celebratory, or at least inclusive (contextual) or combative and exclusive (formal). What I am characterizing as my limited definition of modernism is the dominance of the formal paradigm, which specifically rejects the embrace of 'low' culture by 'high' culture. While modernism, as a general concept, includes a shift in relationships between cultural registrations, what I shall be calling 'formal modernism' aims to remain pure; it rejects contamination, while 'contextual modernism' is more hybrid. As the dominance of formalist modernism wanes in the 1960s, so contextual modernism re-emerges. This could be seen as the emergence of postmodernism, but I would rather see it as the re-emergence of a strain of modernism that was always bubbling under dominant views of modernist culture, and which occasionally broke through, but only came to the fore as the grip of formalist modernism subsided.

This counterpoint is still evident in contemporary debates about culture. Outstanding formal modernist composers such as Milton Babbitt (b. 1916), whose active career now spans almost the entire modern period, and his younger compatriot Charles Wuorinen (b. 1938) both embraced (to dramatic and often beautiful effect) complex, dense, and difficult forms of expression, rejecting the vernacular and commercial. Babbitt is well known, in addition to his serial and electronic works, as the author of an article 'Who Cares If You Listen?' (his original preferred title was 'The Composer as Specialist'). Written in 1958, it argues for the protection of 'advanced' music against the popular: 'if this music is not supported, the whistling repertory of the man in the street will be little affected, the concert-going activity of the conspicuous consumer of musical culture will be little disturbed. But music will cease to evolve, and, in that important sense, will cease to live.'[20] Wuorinen has also, more recently, railed against what he sees as the lamentable collapse in standards through the conflation of art and entertainment.[21] This explicit connection to the classical music tradition is a key element of modernist self-identity. On the other hand, composers such as Michael Daugherty (b. 1954, a former pupil of Wuorinen) and Philip Glass (b. 1937), to stay with American examples, both of whom might be defined as postmodernists (or contextual modernists), are much happier to embrace popular culture. Glass's Fourth Symphony, for example, is a development of themes from the 1977 album *Heroes* by David Bowie (and Brian Eno).

American composers and musicians have been especially alive to this issue, as New York took over from Paris as the site of modernism. Jazz and the skyscraper

[20] Milton Babbitt, 'Who Cares If You Listen?', *High Fidelity*, 8 (Feb. 1958), 38–40.
[21] See Charles Wuorinen, 'An Elevated Wind Music', *Journal of the World Association for Symphonic Bands and Ensembles*, 7 (2000), 15–18.

became more potent than the Moulin Rouge and the Eiffel Tower. The tension between European and American culture was played out in these terms. Leonard Bernstein, a great champion of Mahler, was European in sensibility when directing music, yet American as a composer (*West Side Story*). Aaron Copland composed European music with an American accent, whereas Charles Ives, who was in touch with what I am calling contextual modernist sensibilities, placed the two traditions side by side, displaying little interest in mixing them.

Formal modernism was the dominant cultural form in the first half of the twentieth century, and remains very much alive in the pluralist present. If a major taproot of formal modernism was set in the soil of Romantic German philosophy, as we saw above, it is also the case that this soil incubated its other: contextual modernism. To appreciate this we should briefly return to Germany and to a musical figure who occupies an ambivalent position in relation to modernism and modernity.

Richard Wagner (1813–83) is fundamental to modernist culture. Before Wagner, the idea of the modern was largely interchangeable with that of the 'new'. Wagner is responsible for establishing the term 'absolute music', to refer to the view of music I traced above. He also characterized absolute music's opposite: the 'artwork of the future', sometimes called the *Gesamtkunstwerk* ('total work of art'). Wagner invoked the artwork of the future to answer what he perceived as a crisis in the sincerity of musical and artistic expression. He argued that ancient culture had first produced art unified at the level of form and linked to the spiritual lives of the people. Tragic drama saw all the arts working together. Modern art needed to return to this condition. The collapse of Greek civilization caused a rift that had led to the dissipation and separation of the arts into individual elements: 'Hand-in-hand with the dissolution of the Athenian state, marched the downfall of Tragedy . . . the great united work of Tragedy disintegrated into its individual factors.'[22] For Wagner the pure (original) state of music was one where it was unified with vision and text, closer to song. Instrumental music alone was a withered version of what it could be. His artwork of the future was one of synthesis, not one of purity.

For Wagner, *die Moderne* was a deeply problematic category and one that ran counter to the idea of nationalist music, which was grounded in the *Volk*, as Greek tragedy supposedly had been. The modern was associated with the shallows of contemporary culture, commercial life, and popular options. Wagner's view of the modern was driven by a concern with race and the opposition between authentic and false cultural expression. This later opposition is an idea Greenberg characterized as 'avant-garde' versus 'kitsch',[23] and which we have seen above in relation to the embrace of popular culture by contextual modernism or postmodernism. The former issue of race is addressed by a supporter and critic of Wagner: Nietzsche. In his first major work, *The Birth of Tragedy: Out of the Spirit of Music* of 1872, Nietzsche places Wagner as a saviour of modern (German) art and culture. Wagner's work

[22] *Richard Wagner's Prose Works*, i: *The Art-Work of the Future and Other Works*, trans. William Ashton Ellis (Lincoln: Bison Books/University of Nebraska Press, 1993–5), 32.

[23] See Clement Greenberg, 'Avant-Garde and Kitsch', *Partisan Review*, 6/5 (1939), 34–49.

provides a combination of dissonant form and mythical content.[24] It is the modern rebirth of Attic tragedy with Dionysian power. While Nietzsche later turned from his overt admiration for Wagner and his music, both of which he saw as contaminated by Christianity, he nevertheless continued to worry away at him.[25] In this way Wagner is Nietzsche's constant cultural companion. For Nietzsche he is *the* modern artist, because he ultimately finds Wagner ambivalent and contradictory.

Another writer who saw Wagner in these terms was Charles Baudelaire: 'It is true that an ideal ambition presides over all of Wagner's compositions; but if in choice of subject and dramatic method he comes near to antiquity, in his passionate energy of expression he is at the moment the truest representative of modernity.'[26] Baudelaire had famously defined modernism in dialectical terms, in an opposition, similar to Nietzsche's of the Apollonian and Dionysian, of the ephemeral and the eternal: 'By modernity', wrote Baudelaire, 'I mean the ephemeral, the fugitive, the contingent, the half of art whose other half is the eternal and the immutable.'[27] Again, Baudelaire followed Nietzsche in declaring Wagner 'the truest representative of modernity'.[28] But, following E. T. A. Hoffmann, he also allows synaesthesia as the only adequate method for capturing the power of music. Wagner's music is especially rich as a source able to conjure correspondences. In a letter he wrote to the composer, he describes listening to his music: 'I imagine a vast extent of red spreading before my eyes. If this red represents passion, I see it gradually, through all the shades of red and pink, until it reaches the incandescence of a furnace.'[29] For Baudelaire, this truest representative of modernism is a musician, but one who evokes hybrid sensory experiences rather than pure formal architecture.

Wagner's impact on modernism in the arts would be hard to overemphasize, but it was engendered by the impact of his music as well as the influence of his ideas. Baudelaire, in the same letter quoted above, described the visceral impact of Wagner's music: 'Your music is full of something that is both uplifted and uplifting, something that longs to climb higher, something excessive and superlative . . . the final cry of a soul that has soared to paroxysms of ecstasy.'[30] Nietzsche's *Birth of Tragedy* had concluded its paean to Wagner and Dionysian phenomena in a similar vein, equating musical dissonance with Dionysian joy in dissolution and negation: 'even the ugly and the disharmonious is an artistic game that the will, in its eternal and inexhaustible desire, plays with itself . . . the desire produced by tragic myth has the same home

[24] This outline is essentially the same as Adorno's characterization of formal experimentation and atavistic primitivism in the work of Schoenberg and Stravinsky respectively. See Theodor W. Adorno, *Philosophy of Modern Music* (London: Sheed and Ward, 1987).

[25] See Friedrich Nietzsche, *The Case of Wagner, Nietzsche Contra Wagner, and Selected Aphorisms*, trans. Anthony M. Ludovici (Gloucester: Dodo Press, 2008).

[26] Charles Baudelaire, *The Painter of Modern Life and Other Essays*, ed. and trans. Jonathan Mayne (London: Phaidon Press, 1964), 13.

[27] Charles Baudelaire, 'Richard Wagner and *Tannhäuser* in Paris', in *The Painter of Modern Life*, 137.

[28] Ibid.

[29] See *Selected Letters of Charles Baudelaire*, ed. and trans. Rosemary Lloyd (Chicago: University of Chicago Press, 1986), 145–6.

[30] Ibid.

as the erotic experience of dissonance in music'.[31] This emphasis on the role of conflict and negation as elements of the sublime, as Nietzsche recognized, had its direct technical corollary in Wagner's practice of 'endless melody', where cadential harmonic resolution is constantly deferred through shifting modulation.

Wagner's musical language elaborates harmonic ambiguity. The triadic substructure of conventional harmony was inclined to dissolve through the use of chromatic saturation, yielding continuously unfolding melodic lines (endless melody). However, Wagner remained in thrall to the triad as a structural norm, even when it was overlaid by chromaticism, leading to ultimate tonic resolution. For example, the opening 'Liebesmahl' from Wagner's final opera, *Parsifal* (Fig. 33.1), has been analysed by Walter Frisch, who draws out this ambiguity:

> The initial gesture is an A flat-major triad that climbs upward and is completed by a scalar ascent to the high A flat an octave above its point of departure . . . Just as the theme completes its octave ascent, harmonic stability is undermined. Rather than serving as a point of resolution for the rising scale the high A flat is unstable. It falls on a weak beat, lasts only an eighth note, then slides down to G. This G is, in fact, the first note of the theme to fall on a strong beat—the downbeat—and its *forte* dynamic represents the culmination of a crescendo. This is an extraordinary moment because as the leading tone, G represents the least stable note in an A flat-major scale. And yet this G is made to serve as the endpoint of the opening gesture and proceeds to derail or redefine the harmonic trajectory of the theme. It shifts its identity from the leading tone of A flat to the dominant of C minor . . . The D natural on the second beat [bar 3] is the first nondiatonic note to be heard . . . and confirms the motion towards the realm of C minor.[32]

Fig. 33.1 Richard Wagner, 'Liebesmahl' theme from the Prelude of *Parsifal* (1882)

Frisch goes on to show how, from this mid-point of the phrase (Fig. 33.1, in the third bar) the shift to C minor is 'corrected'. The E flat acts as V of A flat, the tied D flat corrects the previous D natural, and once the C is reached the orchestra joins to confirm the A flat major harmony. The rhythmic dislocation and implied harmonic shifts finally resolve in orchestral harmony and the re-establishment of the home key. In fact, as Frisch shows, this germ cell of six bars contains the essence of what is to follow as the opera unfolds over the next five hours.

The concepts of dissonance and resolution, the dismantling or radical questioning of tonal and rhythmic syntax, became widespread in the generation of composers

[31] Friedrich Nietzsche, *The Birth of Tragedy and Other Writings*, trans. Ronald Speirs (Cambridge: Cambridge University Press, 1999), 113.

[32] Walter Frisch, *German Modernism: Music and the Arts* (Berkeley and Los Angeles: University of California Press, 2005), 32–3.

who followed Wagner, and this revolution supplied the technical foundation for musical modernism. Once again, the relationships between art and music in this period invite further exploration of this technical foundation.

The essential nature of modernism, according to Clement Greenberg, lies in the determination of each art's unique and irreducible character. This process would render the art 'pure', and this 'purity' would establish its standards of quality and independence. For Greenberg, purity meant self-definition, and this comes down to an issue of medium. In painting, this limit is constituted by 'the flat surface, the shape of the support, the properties of pigment', but it 'was the stressing, however, of the ineluctable flatness of the support that remained most fundamental in the process by which pictorial art criticized and defined itself under Modernism'.[33] The consequence of this is that the picture plane becomes a point of focus; any sense of illusional depth is reduced to a point where background and foreground are compressed. Euclidean space allowed the depiction of a measurable set of proportions between supposed three-dimensional objects on a two-dimensional plane, but for modernist painters the reality of the picture plane is fundamental. The space becomes purely pictorial, not sculptural: 'Where the Old Masters created an illusion of space into which one could imagine oneself walking, the illusion created by a Modernist is one into which one can only look, can travel through, only with the eye'.[34]

It is this focus on the picture plane that has commonly been seen to lead to abstraction. Yet it should be noted that Greenberg is not arguing for abstraction per se, although he is arguing at a time when abstraction was the *locus classicus*. The so-called 'drip' paintings of Jackson Pollock make this clear. They are unavoidably paintings about paint, with no distinction between line and colour, as line and colour are unified. A tight weave of interpenetrating skeins of paint drips in, around, and on the picture plane. The eye is constantly drawn across the surface and can only negotiate shallow depth before it meets the colour saturated into the surface of the unprimed canvas. Irregular visual rhythms are built up, but only across the painting's surface, not into its fictive spatial depths. In a compositional sense it is exemplary of Greenberg's formal modernism.

In music, a similar technical compression between foreground and background took place. These two territories, while not being exactly cognate phenomena in both music and painting, do share a nomenclature that compels analogies within modernist debates. In the effort to reinvent painting as more than illusion, and music as more than conventional tonality, the surface, or foreground, takes on a central role as the screen against which the tension between convention and modernism is played out.

As we have already seen, in Wagner the foundation of triadic harmony is severely weakened, if not completely abandoned. There emerges a tension between the compositional foreground surface and the formal substructure. With the next generation of composers the structural underpinning begins to fall apart. While all

[33] Clement Greenberg, 'Modernist Painting', *Art and Literature*, 4 (Spring 1965), 193–201; repr. in Francis Frascina and Charles Harrison (eds), *Modernist Art and Modernism: A Critical Anthology* (London: Open University/Paul Chapman, 1982), 6.

[34] Ibid. 8.

Western art music consists of interactions between these elements, approved background relationships and permissible foreground tensions and digressions, the nineteenth century saw the increasing deployment of more complex chromatic surface digressions. Motivic and thematic elements are developed at the expense of architectural ones. It is this potential collapse that Wagner conjures so skilfully over such vast architectural expanses.

In the case of Arnold Schoenberg (1874–1951), the governing function of tonality was gradually abandoned. In his works between 1900 and 1910 foreground motifs were developed to a point where they took precedence over background structures. As Pierre Boulez has put it: 'Preference [is given] to *melodic* rather than the co-ordinating *harmonic* intervals.'[35] Although this may have been done earlier (by Beethoven and, especially, by Wagner), in Schoenberg's work there is an actual break between harmony and counterpoint, or the vertical and horizontal, in his compositions of mid-1908. The structural role of harmony, in works of this so-called Expressionist phase, disappears, and by way of compensation, to quote Oliver Neighbour, 'motivic work and the tendency to equate the horizontal and the vertical dimensions—in fact the essential elements later codified in the serial method—assume greater responsibility'.[36]

Fundamental to Schoenberg's aesthetic is the view that harmonic dissonance is relative. Consonance and dissonance are not opposites; rather, they are merely at different extremes of a continuous scale. This 'emancipation of dissonance', the idea of 'extended tonality' (espoused in Schoenberg's 1911 publication *Harmonielehre*), were seen by some at this time as counter to the very concept of music itself. The disquiet caused by the presentation of these ideas to a musical public in Vienna, through a series of concerts organized by Schoenberg around 1913, even provoked the intervention of the police. The development by Schoenberg of his twelve-note system ('method of composing with twelve tones which are related only with one another') consolidated and later allowed the wider employment of a chromatic, non-diatonic method of composition.[37]

The harmonic disorientation this caused, to those used to traditional forms of composition, was compounded by the concomitant re-evaluation of rhythmic organization. The modernist dismantling of regular metric subdivisions, and the use of frequent changes of pulse and meter, are, perhaps, even more disorientating than harmonic disruptions to the centrality of key, distancing music from its simple connection to the body, to heartbeat, and, perhaps more importantly, bipedalism. A well-known early modernist example is Stravinsky's music for the ballet *Le Sacre du printemps* of 1912 (Fig. 33.2). The fact that it was music for a dance that plays against

[35] Pierre Boulez, 'Schoenberg the Unloved?', in *Orientations: Collected Writings*, ed. Jean Jacques Nattiez, trans. Martin Cooper (London: Faber, 1986), 327.

[36] Oliver Neighbour on Schoenberg's songs from 'Das Buch der hängended Gärten', in *The New Grove: Second Viennese School* (Oxford: Oxford University Press, 1983), 39.

[37] Schoenberg was not alone in this. His fellow Austrian J. M. Hauer worked on a rather different system, as did Nikolai Roslavets in Russia and Jefim Golyscheff in Germany, for example, but Schoenberg's system gained a place as the dominant model.

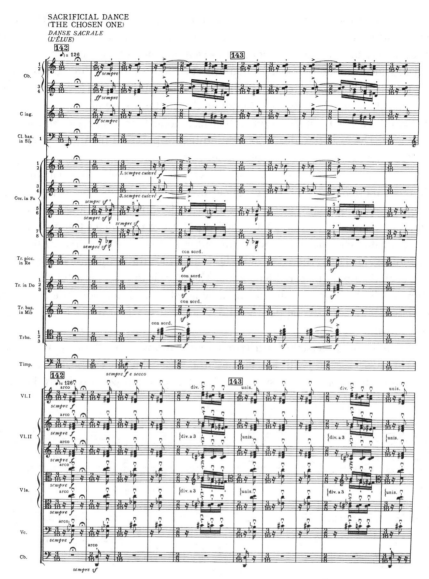

Fig. 33.2 Igor Stravinsky, opening of 'Danse sacrale (L'Élue)' from
Le Sacre du printemps (1912)

this regular bodily pattern is significant. In Fig. 33.2, from the final section of the ballet, the 'Sacrificial Dance', there is a constant change of meter with play by rhythmic patterns against it that offsets any sense of predictable physical placement.

The idea of metrical modulations and the development of complex temporal and harmonic structures is exemplified by the work of a composer whose musical life could be used as a model of musical modernism itself. I write this in the year of Elliott

Carter's 100th birthday. Carter's magisterial musical career bestrides the entire period of modernism's cultural dominance, and he is still remarkably active, having produced nine major new works in 2007 and seven in 2008.

Carter's ideas about tempo modulations (or metric modulations, to use Goldman's terms), proportional tempo, and polyrhythms appear first in his cello sonata of 1948, and still occupy him today.[38] Although these interests are not unique to Carter (Harrison Birtwistle is interested in similar techniques), he has developed them to a high degree. The essential idea is to set up different pulses in the music at the same time. One simple example—simple in technique, but complex in result—is the second of Carter's *Two Diversions* (1999). This piece is effectively a two-part invention with diverging material: one part gradually accelerates, the other decelerates, resulting in pulls and pushes against the pulse. In the cello sonata the piano, after a chordal opening statement, sets up a regular crotchet pulse around which a tranquil and free-flowing rubato cello melody winds. This pulse is restated at the close of the work, three movements later, when the solo cello echoes the crotchet phrase of the opening piano, until the final whispered harmonic. The piece is thus set between chronometric time at the start and finish, and psychological time throughout the core of the work. Something similar happens in the gigantic first string quartet that he composed in 1951.

Carter uses, and prefers, the term 'tempo modulations' rather than 'metric modulation'. The quartet opens with a cello cadenza, after which it establishes a crotchet pulse against the second violin's syncopated dotted quaver, pizzicato chords (Fig. 33.3).

Fig. 33.3 Carter, String Quartet No. 1 (1951), bars 13–14

The first violin adds a tranquillo slowly moving theme in tied notes across the bar lines, joined after four bars by the viola in triplet crotchets. This is within a basic tempo of 120 crotchets to the minute (Fig. 33.4). When the tranquillo theme returns

[38] Richard F. Goldman, 'The Music of Elliott Carter', *Musical Quarterly*, 63/2 (Apr. 1957), 161.

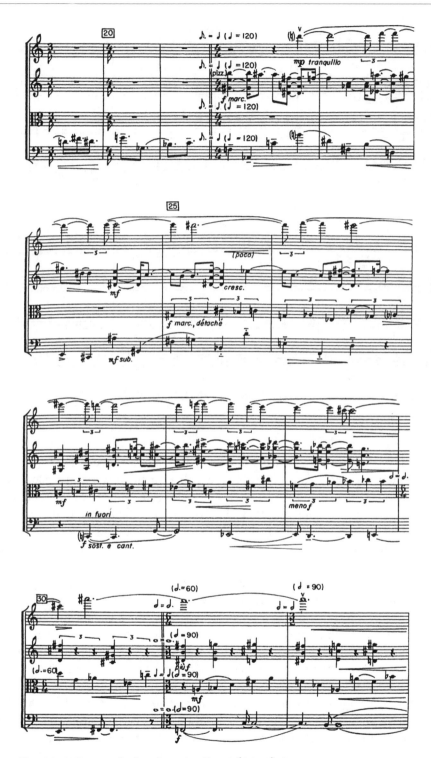

Fig. 33.4 Carter, String Quartet No. 1 (1951), bars 19–32

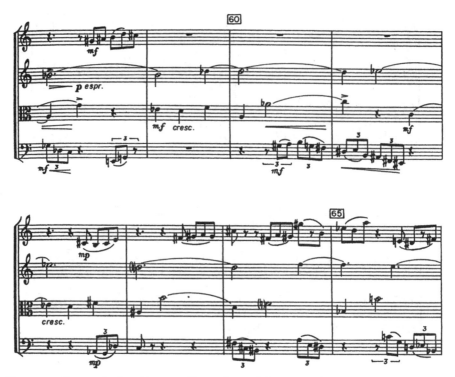

Fig. 33.5 Carter, String Quartet No. 1 (1951), bars 58–65

(around bar 58), the note values in the second violin are extended to five beats, as the basic tempo has increased to 180 (dotted crotchet for the first violin = 180, dotted minim = 60 for the second violin, viola, and cello) (Fig. 33.5). Such tempo changes often emerge from a complex layering of polyphony. For example, around 420 in the last section of this quartet, the first violin is moving in quintuplets (5), against the second violin in triplets (3), the viola in semiquavers (4), and the cello in tied quavers (1—across the bar line) (Fig. 33.6). This polyrhythm is evident at the macro level also. The work has four movements—'Fantasia', 'Allegro scorrevole', 'Adagio', and 'Varia-tions'—of which three sections are marked ('Fantasia', 'Allegro scorrevole', and 'Variations'), but with only two breaks. These are, however, not at the ends of movements or sections but within movements, in the middle of the 'Allegro scorre-vole' and shortly after the beginning of the 'Variations'. The organic continuity, and the transition between one type of material and another and between movements, is thus maintained. The effect of these two breaks is to emphasize the time-world set up by the quartet as opposed to the everyday temporal flow that surrounds it. This effect is further amplified by the solo cello cadenza at the very beginning of the work, mirrored by the solo first violin some forty minutes later at the work's end, as if to

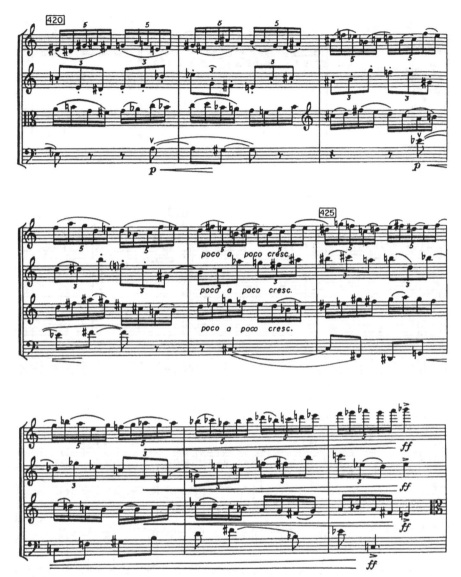

Fig. 33.6 Carter, String Quartet No. 1 (1951), bars 420–8

suggest brackets around the unfolding of time within the work's continuous three-section structure (Fig. 33.7).[39]

Carter's First Quartet remains one of his most expansive works. Only the *Symphonia: Sum Fluxae Pretium Spei* for symphony orchestra (1993–6), at around forty-five minutes, is close in length. The challenge that this music presents is partly

[39] It is interesting that the stimulus for this particular musical bracketing was visual: the collapsing chimney at the start and conclusion of Jean Cocteau's first full-length film, *Le Sang d'un poète* (1930).

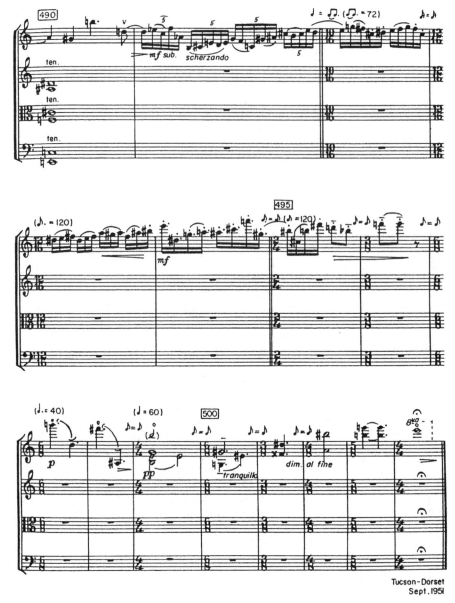

Fig. 33.7 Carter, String Quartet No. 1 (1951), bars 490–504

harmonic (it rarely employs functional harmonies), but it is also rhythmic. Most popular music is dance music, grounded in repetition and relatively simple metric and rhythmic structures (polyrhythms may be employed, but a regular metrical underpinning is usually maintained). The superimposed, shifting polyrhythms of harmonically advanced modernist music, be it Elliott Carter's, Harrison Birtwistle's,

Luciano Berio's, Luigi Nono's, Pierre Boulez's, György Ligeti's, Brian Ferneyhough's, or Per Nørgård's, are challenging to conventional modes of listening.[40]

This challenge to the vernacular is evident enough in formal modernism, but the radical politics of the 1960s gave rise to a democratized popular culture that was uncomfortable with anything perceived as elitism. Modernism was not able to secure a large public. Some composers responded by attempting to recompose music from the ground up. Minimalism was an aesthetic that rejected the sophistication and complexity of formalist modernism, seeing it as unnecessarily exclusive, and countered it by re-establishing tonality and focusing on regular (if shifting) meter. Minimalism sits on the cusp of modernism and its post.

If the term 'postmodernism' as a concept is helpful, it in part signifies what I have been calling 'contextual modernism'. It registers a reaction against formal modernism and a re-establishment of the vernacular; a partial consequence of cultural shifts resulting from technological developments. The expansion of recording devices, from radio in the early years of the twentieth century, to MP3s at the beginning of the twenty-first, has led to the displacement of the piano as the prime instrument of musical culture. More recently music has become dispensable in many education curricula, and traditional forms of musical training have declined. This trend has not worked to modernism's advantage as it requires a high degree of conventional musical literacy. Most recently, however, this same technological shift has begun to work again to the advantage of formal modernism. With the repertoire of musics now available via the Internet and specialist CD production and download services, modernist music, an obscure repertory, is now almost as widely available, if not as visible, as rock and popular music. This diversity and access allows the study and enjoyment of complex music in ways that were unimaginable in the early years of the twentieth century.

[40] I choose these as they are relatively recent examples: Birtwistle's *Earth Dances* (1986), Berio's *Ritorno degli snovidenia* (1976), Nono's *Prometeo* (1984), Boulez's *Sur incises* (1998), Ligeti's *Études for Piano* (1985–2001), Ferneyhough's *Chronos-Aion* (2007), Nørgård's *Terrains vagues* (2000).

ARCHITECTURE, DESIGN, AND MODERN LIVING

CHRISTOPHER CROUCH

DESIGNING MODERNITY

OF all the arts, it can be argued that the forms and functions of modern architecture and design are the most intimately linked to the physical conditions of modernity and daily life. Architects and designers were responsible for the formation of the industrial infrastructure that ruptured traditional ways of making and thinking, as well as being part of the great artistic response to those conditions. Designers (though they were not known by that name then) created new machines and exploited ways of using coal to drive machinery that was previously powered by water, wind, and the muscles of men and animals. The form of modern objects was not solely the result of the imaginative speculation of individuals liberated by the growing cultural irrelevance of traditional cultural practices in a mechanized world, but also the consequence of profound structural changes in the role of architecture and design in an industrial society. The growth of new technology, materials, and manufacturing processes at the start of the nineteenth century was as important as designers in determining the appearance of modern objects and buildings.

Modernism as an architectural and design style may be characterized in its early stages as an attempt to create a form suitable for the new machine age, reflecting the view that society had come to a significant destination point in its development, a point where history could no longer provide precedents for the material culture

produced by industrialization. The changes in the social and functional use of objects stimulated the evolution of utilitarian forms and undecorated surfaces, and involved shaking off the legacy of traditional historical styles. Prior to industrialization, stylistic evolution was a much slower process based on the cultural discourses of fashion, often rooted in the vernacular with forays into the perceived exoticism of other cultures, as can be seen so clearly in the European embrace of chinoiserie in the middle of the eighteenth century. As in the other creative arts, the rise of the modern autonomous individual and the erosion of traditional values by industrialization made it easier for designers to play imaginatively with form and invent novel design solutions.

At the end of the nineteenth century the mainstream architectural historian James Fergusson commented favourably on the way the old academic styles of architecture had been dispersed by the symbolic embracing of industrial art embodied in Joseph Paxton's prefabricated iron and glass Crystal Palace. The formal antecedent of Paxton's building was a greenhouse, not a temple. Fergusson remarked that 'we soon leave behind us the constrained and pedantic "Fine Art of Architecture" of the academical books, applying itself to certain accepted kinds of dogmatically glorified building and to nothing else', for 'we find ourselves in a far wider sphere of influence'.[1] A substantial part of that influence, which was not always greeted as enthusiastically as a reading of Fergusson might suggest, was the development of Britain's industrial mills and factories with their functional forms laid bare in undecorated materials, these forms emerging from economic considerations, not aesthetic ones.

The transformation in the appearance of objects and the rupture of traditional practices caused by modernity and articulated in the modern were the result of the aesthetic and cultural theorizing that went alongside an understanding of the structural and plastic qualities of the new industrial materials. Important though the new concepts of form were functionally and symbolically, and important as those debates in determining the new forms of modernism were, there was another debate that centred on the attempt to determine the *purpose* of architecture and design. The social transformations effected by an industrial world—the unplanned growth of cities, the rise of mass production, the environmental consequences of the production and consumption of industrial goods—were physically tangible and resulted in a change of the role of architecture and design, as well as a change in its forms.

The industrial world smashed the conditions that had sustained the aesthetic practices of the past. The impact of machinery and machine culture was to mould both forms and ideologies, transforming the physical appearance of the natural world and the way in which the built environment and its objects were conceived. This is the central premise of twentieth-century design historians such as Nicholas Pevsner and Pierre Francastel, whose historical analyses and interpretations of modernity and modernism (Pevsner's Anglo-German perspective and Francastel's

[1] James Fergusson, *History of the Modern Styles of Architecture* (London: John Murray, 1891), p. vi.

French) are still central to our understanding of modernism in architecture and design. These writers may have differed in their emphasis upon the role of the individual in moulding technology and the way in which technology impacted deterministically upon the individual, but both found common ground in rejecting the idea of a fundamental incompatibility between art and technology. This might seem a commonplace observation now, but at the end of the nineteenth century there was a strongly held belief that the arts (including architecture and design) and the machine were antithetical. This was not so much an aesthetic argument as a social one. Both John Ruskin and William Morris, figures associated with the Arts and Crafts movement, argued against the dehumanizing process that machine labour instigated. On the one hand, Ruskin could call for designers to find a style 'worthy of our engines and telegraphs; as expansive as steam, and as sparkling as electricity'.[2] On the other hand, he could castigate the products of industrial society (in this particular instance the cast-iron railings outside a public house) that were the product of labour 'partly cramped and perilous in the mine; partly grievous and horrible, at the furnace; partly foolish and sedentary, of ill taught students making bad designs; work from the beginning to the last fruits of it, and in all the branches of it, venomous, deathful, and miserable'.[3]

It can be argued that modern architecture and design are in essence social practices, even if they are not always functional or rational. Framing architecture and design sociologically as well as stylistically, rather than solely in terms of individual aesthetics (important though the individual designer is), allows historians and the readers of history an interpretation of modern architecture and design that incorporates the architect's and designer's negotiation between physical needs, material conditions, and stylistic aspirations. It also alerts the reader to the dialogue than runs throughout modern design, positioning the modern individual either as fully autonomous or as part of an industrial community.

The physical needs that the modern architect or designer fulfilled were central to their role, from providing bridges that spanned gorges, building vast sheds in which aeroplanes were stored, producing motor cars for travel, or making dinner plates and wine glasses. Architects and designers responded to modernity's need for objects and so facilitated quotidian modern existence. The material conditions in which those needs existed had to be carefully managed, however, for there is a huge gulf between the need to use materials practically and the desire to use them symbolically. The beginning of modernity saw modern architects use cast iron with glass after Joseph Paxton's lead, creating novel structural forms along the way. Steel technology assisted the great internal spans and soaring heights of early modern office buildings in Chicago at the end of the nineteenth century, but despite the aspirations of the Russian Constructivist architect Vladimir Tatlin in 1917 to construct his gigantic Monument to the Third International (it was to be taller than the Eiffel Tower), the

[2] John Ruskin, *The Two Paths: Being Lectures in Art, and its Application to Decoration, Delivered in 1858–9* (London: George Allen, 1901), 137.
[3] John Ruskin, *The Crown of Wild Olive* (London: George Allen, 1900), 5.

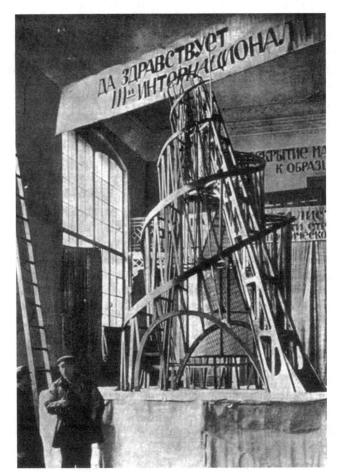

Fig. 34.1 Vladimir Tatlin standing in front of a model of
his Monument to the Third International, Moscow, 1920

material conditions were such that there was not enough steel in the whole of the
young Soviet Union to build it (Fig. 34.1). Neither was there the technology to turn its
proposed great rotating debating chambers, nor the industrial base to produce the
mass of cars he envisaged swarming out from its cavernous basement garages. Tatlin's
tower was a stylistic response to the conditions of modernity: modern to its sky-
scraping tip, it was a powerful symbol of modernity, a dazzling triumph of modern
form, but sadly lacking in practical application.

The relationship between material and its transformation by design ideologies is a
particularly dynamic one in the modern period. The use of the new plastic materials
of modernity that allowed modern geometric forms to be mass-produced in the 1930s
was dependent upon designers insisting, first, that Bakelite was every bit as attractive
as tortoiseshell, and second, that a radio produced in a circular form, for example,

was a legitimate design solution. This was Wells Coates's solution for his 'ECKO Model AD-65' radio of 1932; he proposed that the radio casing should echo the shape of the internal loudspeaker. Raymond Williams's analysis of the evolution of television identified that the component parts of television technology were available decades before they were combined to satisfy new material conditions and desires.[4] This is a powerful model by which one can consider the relationship between needs, materials, and ideology in modern design. It is not that this relationship was a necessarily new one, but what makes it special in modern architecture and design—in addition to the massive carbon energy input identified earlier—is the unparalleled mass production, distribution, and consumption of objects and the ideas about them.

A brief review of the established historical model of the modern built environment and its objects can establish their context, before the objects themselves are subjected to a closer scrutiny later on in this chapter. There are many unresolved issues in any history of modernism, not least when it begins and when or where it might end. What follows is a generic history that incorporates the main features that one would expect, and also identifies other issues that might impact upon an established view. One of the main problems with histories of modern architecture and design is the legacy of another modern institution, that of the nation state. When modern design principles reached the US a decade or so after the experiments at the German Bauhaus and the Soviet Vkhutemas (the Higher State Artistic and Technical Work-shops), it was completely to alter perceptions of commercial design in that country. Does it matter that the ideas were imported? They caused a radical cultural transformation regardless of their ten-year pedigree. Despite the unifying aspects of industrialization in its erosion of tradition, and despite the fact that technology demands similar conditions for its maintenance wherever it may be located geographically, there lies a huge unbridgeable space between those who are within a national culture and those who are situated outside it. Given this qualification, an English-speaking, and largely Eurocentric, review of modern architecture and design might run as follows.

MODERNIZING DESIGN

In industrial Britain in the middle of the nineteenth century, and later in France, Germany, and the US, new materials of manufacture were used to imitate the materials of tradition. This adoption of traditional form by new materials—cast iron and gutta-percha in the form of carved wood, for example—was considered inappropriate in two ways. First, those in the Arts and Crafts movement saw the erosion of traditional design and manufacturing skills as a problem, identifying an

[4] Raymond Williams, *Television: Technology and Cultural Form* (London: Routledge, 2003).

intrinsic lack of value in machine-produced materials and goods. Second, industrial designers at the end of the nineteenth century found it equally inappropriate that machine-made objects parodied the forms of a pre-industrial past. Architects struggled with the symbolic representation of hand-crafted historical forms (such as the Gothic or the neo-classical) reproduced in cast iron or terracotta, since they were concerned that these had become empty historical signifiers. Those who adopted the functional forms of mills and factories for application in civic architecture were in a minority.

By the 1920s, the debate about an appropriate modern form was solidifying into a set of identifiable tropes. In Europe, designers abandoned traditional decorative forms in favour of smooth surfaces that emphasized planar relationships. They largely adopted geometry as a unifying device for all aspects of design as an indication of the rationality and dynamism of a machine culture. This can be seen in the Dutch grouping of designers and architects in De Stijl, in Germany at the Bauhaus, and in the constructivist theorizing in the early years of the Union of Soviet Socialist Republics. Fascism too had its cult of the modern. In Italy, Gruppo 7 provided Mussolini with a modern form tempered by a light seasoning of classicism. The totalitarian cultures of Stalin and Hitler largely rejected modern form. Despite being industrialized societies, the tendency in these essentially nationalistic cultures was to ask individuals to identify with a traditional style. Such a style's readily recognizable qualities had great potential for framing a national identity for its citizens in an industrialized world where industrialization was eroding cultural differences and replacing them with an affinity for generic consumer objects.

The most technologically advanced society during the first half of the century was the United States. While Europeans endlessly debated over the 'correct' form of the skyscraper, it was in the US that skyscrapers were actually built, and with a variety of traditional decorative toppings until the Empire State Building became the exemplar of the modern geometric skyscraper in 1931. The potential for white goods and cars to frame the identity of the industrially disembedded citizen as a consumer, and to create a global mass market for designed objects, was first fully glimpsed at the 1939 New York World's Fair, the US's largest international foray into modern design.

The shift of cultural authority from Europe to the US after the Second World War saw a shift in focus for the purposes of architecture and design, and the consolidation of modern design into what is known as International Modernism. In Europe before the war modernism had been an avant-garde position. While Art Deco was a popularized version of the modern before the Second World War, it was the postwar consumer-led demand for objects that transformed the Bauhaus's radical experiments in industrial design into mainstream industrial production. All over the industrialized world new architecture was largely modelled on the steel frame, glass-fronted building, in both the commercial, civic, and industrial arenas. Transcending national boundaries and reinforcing the beginnings of a globalized culture, International Modernism can be seen as the solidification of early modernity, a consolidation of the dominant role of technology, and a reinforcement of an aesthetic based on the minimum of decoration.

As what was once an innovative modern design principle became the industrial norm in the 1970s, a new phase in architecture and design began to be elaborated in reaction to the perceived stasis in design. In an economy in which the encouragement of the consumer's desire for novelty was the engine that drove production, the aspiration towards an ahistorical, functional design that was so central to the initial phases of modern design became redundant. In design the final catalyst for a change in appearance was the work of the Memphis Group in Milan in the 1980s; their highly decorated, eccentric forms stimulated a self-referential quoting of decorative and formal devices in mass-produced objects. This practice of what Charles Jencks called 'double coding' is perceived to be the key element of what was then called 'postmodern' design.[5] Purely stylistic, and rooted in the principles of a consumer economy, the postmodern move away from the supposed style-free, or style-less, aspirations of the modern exposed the modern as a historical style. In its turn, the postmodern can be seen in retrospect to be a historicist reworking of old themes, incorporating the geometric styling of modernity. Modern form, far from being a universal, logical outcome of technological function, was revealed at the end of the twentieth century to be also a style *symbolic* of industrial technology.

Late twentieth-century design became increasingly self-referential, but in architecture various other issues had an impact upon the change of the International Modern style into a new form of global architecture. Economic pressures on modern designers had led to a reductionist vision of modern functionality resulting in cost-efficient but aesthetically impoverished architecture in the civic sector. Consumers needed to be encouraged back into increasingly bleak urban environments, and the polyglot language of commercial architecture was seen to provide a safe haven for the citizen alienated by the single-mindedness of the International Modern style.

Architecture at the start of the twenty-first century is characterized by its huge scale and a manipulation of materials into novel shapes that have been made possible by the use of computers at every stage of the design process. The revelations of the formal possibilities that digital culture has allowed contemporary design, combined with the impact a maturing globalized economy makes upon the circulation of symbolically designed goods, suggests that the supposed break from modern form attested by postmodern objects was quite limited in scope. Sociologists such as Anthony Giddens and cultural theorists like Fredric Jameson have framed 'postmodernity' as Late Modernity and a phase of late capitalism; Ulrich Beck, in turn, refers to a Second Modernity that is a globalized, cosmopolitan phenomenon that flows on from modernity, rather than breaking from it as is suggested by the appellation 'post'.[6] This conceptual construction makes more sense in understanding the contemporary evolution of architecture and design where multiple cultures are

[5] Charles Jencks, *The Language of Postmodern Architecture* (New York: Rizzoli, 1977).
[6] Anthony Giddens, *Modernity and Self-Identity: Self and Society in the Late Modern Age* (Cambridge: Polity Press, 1991); Fredric Jameson, *Postmodernism, or, The Cultural Logic of Late Capitalism* (Durham, NC: Duke University Press, 1992); Ulrich Beck, *World Risk Society* (Cambridge: Polity, 1992).

interacting on a scale unimaginable in the past, where the transfer of imagery from culture to culture is unprecedented and digital technologies facilitate the realization of structures on a previously inconceivable scale. The ranks of draftsmen seated in rows in numerous offices that were necessary to provide the calculations and working drawings for a structure like the Empire State Building have been replaced by computer programmes capable of calculating stresses and allowing for the development of huge structures whose forms seem to defy the intrinsic logic of materials.

If there is a historical juncture at which the synthesis of physical needs, material conditions, and stylistic aspirations that characterized modern design is ruptured, then it could be argued that digital technology is the marker between a first and a second modernism. Modern design suggested that an irreducible essence of the mechanical could be distilled into a significant form that was both functional yet eloquent in expressing its internal design logic. That aspiration for stability and order, based on European notions of geometry as the underlying truth of all structures, replicated itself into the late twentieth century. The golden ratio, for example (the proportion derived from classical Greek mathematics), can be found in the vertical tower of Le Corbusier's United Nations building and its horizontal subdivisions, as well as in the proportion of the credit card. It will take a long while for this proportion to disappear as a cultural signifier of order and stability, but a combination of a globalized cosmopolitan culture and the ability of digitally aided structural design to exceed the perceived logic of balance has eroded this European-derived proportion as a necessary signifier of design. Taipei 101, for a brief moment the tallest building in the world, seems to contradict the entire canon of modern design. Set in grounds designed according to Feng Shui principles, the half-kilometre-tall building draws its iconography from the traditional pagoda and its structure from that of a bamboo stalk, and makes a direct reference to stacked Chinese money boxes.

Contemporary architecture and design have another issue to contend with that is a logical consequence of modern design and the associated ideologies of modernity: environmental degradation. This perhaps is the truly postmodern condition, not for stylistic reasons but because it has been the relentless energy consumption of industrial society, reinforced through its buildings and objects, which has contributed to our contemporary environmental crisis. The geometric form of international modernism is really quite irrelevant when compared with the modern design principles of conspicuous consumption and planned obsolescence. In celebrating the beauty of the form of much modern industrial design—Alec Issigonis's 1959 Mini Minor, for example, or the Fiat company's rooftop racetrack in Turin (designed by Giacomo Mattè-Trucco in 1921)—it is easy to forget the social consequences the motor car has had upon the built environment and the way our daily lives have been designed around it. It is also easy to elide the purposefully designed imbecility of mass weapons systems when looking at the perfect relationship between geometry, surface, and function possessed by the Northrop Grumman B-2 Spirit (Stealth) Bomber. And yet, often the beginnings of modern design and architecture were

rooted in issues of social justice, or at least a desire to transform the material world so as to order it to humankind's benefit.

Our generic history might be summarized in this way. Industrial production created new cultural and physical circumstances in which the established forms of traditional architecture and design were functionally inadequate. Out of this practical experience a debate about stylistic appropriateness stimulated the development of an early modern style, in which the languages of form considered to be symbolically fitting to the new conditions and materials of industrialization were established. In the next phase, what had been avant-garde forms became established as the standard practice in all industrial societies. This 'International Modernism' can also be thought of as a period of 'high modernism'. In the last third of the twentieth century the forms and practices of modern architecture and design became recycled and repeated to a point of parody, and the idea of the avant-garde finally became a redundant one.[7] Modernism as a style had neither been abolished nor superseded by what in retrospect can be seen as a brief transitional style—the 'postmodern'—but instead, as Edward Lucie Smith has remarked, continued 'to enjoy a kind of half life in mass culture'.[8] At the start of the twenty-first century the legacy of modernism is tempered by a design aesthetic in which a new gigantism and flamboyancy of structure is enabled by a digital culture that runs parallel with, and sometimes in opposition to, attempts to devise an aesthetic suitable for an environmentally sustainable design strategy. Any attempt to create a unifying conceptual structure is riddled with inconsistencies and anomalies, which is why this chapter now turns to examine in more detail the context of the modern built environment and some significant individual objects of architecture and design that contributed to the formation of the historical discourse of modernism.

DESIGNING THE MODERN

Without the social organization of the city, modern architecture and the modern object could not exist. Just as they are dependent upon the processes of industrialization, so too the processes of industrialization are dependent upon a built environment that supports its endeavours through structures to transport raw materials and goods, provide energy, and support a nearby supply of labour. The modern city was conceived as a unified space, a space where the civic, the industrial, and the domestic worked in a harmonious symbiosis. Its modern origins lie both in pragmatic solutions to the social problems caused by industrialization and in the ideological

[7] Andreas Huyssen, *After the Great Divide: Modernism, Mass Culture, Postmodernism* (London: Macmillan, 1999).
[8] Edward Lucie-Smith, *Art in the Seventies* (Ithaca, NY: Cornell University Press, 1980), 11.

agendas of architects and city planners (or designers) who imagined the city as a space where architecture, art, and design could be unified for the purpose of benign social use.

There is a terrifying chasm between the modern city as it was imagined and as it exists and existed. At the beginning of the twenty-first century it is easy to look back at the legacy of modernist functionalism as something that is profoundly anti-human. The great undisciplined industrial cities of contemporary life (like Chongqing, with a municipal population of 30 million) have the dystopian air of a twentieth-century science fiction film. But the original intent of modern city design was to control such entropic tendencies and to control the inhuman aspects of industrial urban life that were so obviously inherent in the British industrial cities of the nineteenth century.

The social imperative for the design of early industrial cities and the conditions imposed by modernity together formed a praxis in which the theoretical intentions for, and imaginative visions of, the modern city were set into a dialogue with the reality of organizing daily industrial life. The need for a designed city came from awareness that the industrial cities that had grown unregulated from the chaos caused by the industrial revolution were unhealthy, inefficient, and ethically distasteful places. Engels, for example, wrote of the stinking thoroughfares and the dank and putrid buildings that housed people huddled together in revolting confusion.[9] For Matthew Arnold the industrial city was a 'brazen prison', and in his poem *The City of Dreadful Night* James Thomson identifies the city as the place where Faith, Love, and Hope died—poisoned, stabbed, and starved.[10] Melodramatic as this may seem to contemporary sensibilities, the deleterious effects of an urban environment in disarray upon the broad mass of industrial society was of such concern that, 'impervious to even the most extreme forms of non-interventionist ideology', the processes of material change in the built environment in order to create social change continued apace.[11] What happened in an industrial urban environment was increasingly the concern of a whole society, and the role of the planned modern city as a rational template for social well-being was forged at the end of the nineteenth century.

The struggle for public roads, sewerage, fire-resistant buildings, and an unpolluted atmosphere may seem disconnected from modern design, but concern with these issues actually lies at the heart of early modern life. The aspirations for the Garden City proposed by Ebenezer Howard and developed by Raymond Unwin involved both social and aesthetic considerations. The city was to be zoned, that is, divided into sections for industry, domestic, leisure, and civic activities. The architecture within those zones was to be carefully considered (in terms of function and symbol), with the aim of building an environment suitable to the creation of well-socialized

[9] Friedrich Engels, *The Condition of the Working Class in England* (London: Penguin, 1987).

[10] Matthew Arnold, 'A Summer Night', in Miriam Allott (ed.), *Matthew Arnold: Selected Poems and Prose* (London: J. M. Dent, 1978), 93; James Thomson, *The City of Dreadful Night*, in N. P. Messenger and J. R. Watson (eds), *Victorian Poetry: The City of Dreadful Night and Other Poems* (London: J. M. Dent, 1974) 136.

[11] Anthony Sutcliffe, *Towards the Planned City* (Oxford: Blackwell, 1981), 5.

modern citizens. The modernist tenet that form should have a direct relationship to function is as evident in issues surrounding the design of the built environment as it was to be in the design of cups and saucers and middle-class dining rooms. The role of the aesthetic in determining the relationship between life and ethical practice was deep-seated. Building on Ruskin's and Morris's ideas, Unwin proposed that social coherence could be determined through visual coherence, and that a sense of social unity in daily living could be encouraged by the controlled use of materials, architecture, and civic design.

Thus, the function of the city conceived in early modernity, and then partially realized in the form of the modern city, was the creation of a social space for the production of decent citizens living a decent life. Stanley Adshead, a British advocate of town planning based on the cosmopolitan, industrialized version of the *beaux arts* style so popular in the US (known as the City Beautiful), wrote before the start of the First World War that the formality of the planned city's streets 'arouses in the heart of the citizen that pride of citizenship alone engendered by civic art'.[12] Tony Garnier's *Une Cité industrielle* was published in 1917 and further developed this notion of the city built to model social behaviour. Using the idea of zoning the city for social use, by now a modern urban design trope, he proposed a vision of urban industrial life which was the antithesis of his contemporary urban reality. But it was Le Corbusier who stamped an identifiable modern form on these ideas. Garnier's architectural designs still had the occasional historicist decorative element in them. His housing designs, though modern in form—undecorated and relying for their effect on the sensitive placement of geometrically conceived masses—were small in scale and traditional in their conception of everyday life. Le Corbusier made the city industrial rather than domestic in scale and took the idea of zoning the city still further. In his 1925 book *The City of Tomorrow and its Planning*, the architect took city planning from the horizontal plane into the vertical.

Le Corbusier's vision of the city was one of forty-storey towers in the centre of the city in a grid, surrounded by parkland and gardens. He celebrated the mechanical and engineering feats of the age and imagined them in terms of an architecture that mediated between the qualities of the machine and the demands of civic society. Although his vision for the city was only realized in his design for the Indian city of Chandigarh (his radical plans for the redesign of the centre of Paris were turned down consistently by the city's municipal authorities), his theorizing (based on his individual point of view rather than any reasoned social research and interpretation) was to be enormously influential in the designing and rebuilding of European cities after the Second World War. The city of skyscrapers was not his invention, of course. Chicago and New York were already in existence as cities of tall buildings, and in 1914 in *La città nuova*, the architect Antonio Sant'Elia had imagined a modern, futuristic, high-rise city. The physical reality of Chicago and New York was one of mix-and-match buildings, which were unified by the sense of their verticality and the

[12] Stanley Adshead, 'An Introduction to Civic Design', *Town Planning Review*, 1/1 (1909), 14.

city grid but by little else. Le Corbusier, in turn, tended to envisage the modern city as unified in style, as austere and functional. This austerity is in complete opposition to Sant'Elia's expressive vision of a city of walkways, vast interconnecting structures, and a built environment of such architectural density that there is no space for parkland.

Le Corbusier's views were technocratic. He believed order played a central role in design and the impact that design could have in directing social life. His vision of the built environment, especially the concept of the single building that is a residential, office, and retail block unit, is a modernist commonplace. He effectively incorporated the US business skyscraper into the European city as a domestic phenomenon. Having no interest in pre-industrial practices, his vision for the city was a unified ahistorical one that effectively created an international template for industrial societies and their products.

The US at this time saw attempts to design the city in order to incorporate the phenomenon of the personal automobile. In his 1939 conception of the 'Broadacre city', Frank Lloyd Wright imagined the dissolution of the urban centre and the city reconstituted into blocks interconnected by private cars. Although it responded to industrial society and embraced its products, this was a vision of suburban individualism at odds with European ideas. Lewis Mumford was also an American, but he envisaged the city quite differently. Mumford was deeply influenced by the work of the Scottish town planner Patrick Geddes. He imagined a humanized North American industrial city based on an understanding of how transportation and communication structures could contribute to the harmonious formation of interlocking urban communities. Rather than imagining an endless, unfocused suburban sprawl—the destiny of the Broadacre conception as it became unravelled at the edges—Mumford viewed the community as the centre of urban planning, not the individual.

Outside of the cities of the planned economies of the eastern European socialist states such as Elektrėnai in Lithuania, Magnitogorsk in the USSR, and Nowa Huta in Poland, Brasilia occupies an important place as an example of a planned modern city in the middle of the twentieth century. Driven by both ideology and practicality, and declared a World Heritage site by Unesco in 1987, its design by Lúcio Costa and Oscar Niemeyer not only observes the functional but also celebrates the symbolic role of modern form in marking modern civic life. It has, too, a colloquial reputation for being difficult, if not impossible, to live in.

In 1977 Charles Jencks identified the symbolic end of modern urban design with the demolition of St Louis's infamous Pruitt-Igoe housing complex. This mass housing block, conceived not as part of a planned city, but as a single measure to provide housing for those unsuccessful within a competitive commodity culture, was a dismal failure from the outset. Although planned with the intention of taking Le Corbusier's idea of 'sun, space and greenery' as the basis of successful urban design, the architect Minoru Yamasaki saw his attempts to provide landscaping and social amenities for the thirty-three eleven-storey apartment blocks dismissed on economic grounds. Less a domestic space and more a space of containment, the failure of the

design in part indicates the failure of the modernist dream that wanted to reinvent social life through design. It must also be borne in mind that such piecemeal urban modelling was not the intention of modern ambitions for the built environment. Their vision was total, not partial. Therein lay the pleasure and tragedy of modern city planning.

It could be argued that the origins of modern architecture in industrial form created a space that contradicted a traditionally intuitive view of comfort. When Adolf Loos published *Ornament and Crime* in 1908, his argument was that architecture and design should express the value of the modern period. That could be achieved, he opined, by the adoption of austere undecorated forms and by the eradication of ornament from objects, freeing them from any decorative reference to history or the natural world. Like many architects and designers, he expressed the contradictions of the period. He admired the anonymous tradition of hand crafts, valued the potential of classical architecture as the base for a cosmopolitan style (a very Eurocentric view), yet saw the functionality of the modern world—its newness and its erasure of the past—as the template for modern design. Thus, pure form as the sign of machine age design—where form derives from its function and nothing more—is also used to symbolically express modernity.

Modern architecture might have had aspirations to pure functionalism, and it may have derived its forms from a passionate regard for industry and engineering, but only in its most debased forms is stylistic expression absent. In 1922 Auguste Perret's Notre-Dame du Raincy demonstrated the decorative possibilities of prefabricated concrete components as a material, and Erich Mendelsohn's Einstein Tower in Potsdam of 1925 owes its sweeping organic forms to the skilful use of concrete stucco over masonry. Le Corbusier's adoption of *béton brut* (raw concrete) as a material was not just a purely functional choice. It had a symbolic aspect to it as well. Concrete was the material of industrial engineering projects, and the way it was used challenged accepted views about the traditional use of worked materials. It also enabled new structural forms to be created. By creating a mould with wood, new forms could be modelled, their void being filled with poured concrete. This moulding process allowed the vocabulary of form to be extended and also permitted a new kind of decoration: the textures and patterns left by the mould. The roof of Le Corbusier's 1955 chapel at Ronchamp is a good example of this.

It is possible to argue that the commercial and symbolic architecture of modernity in its early and late stages draws from the logic of industrial building, but invests it with a sense of importance that industrial architecture may not have, important though it may be historically. By 1913 Walter Gropius, who was soon to head the Bauhaus, the influential German school of art and design, had completed the Fagus Factory. He had designed the factory with Adolf Meyer, and with its flat roof and glass façade it is an important marker of the development of the modern style and the modern movement's relationship with functional architecture. However, it is the Bauhaus building of 1925 in Dessau, with its flat roof and glass façades, that is most commonly acknowledged as the marker of the modern and as a building that is representative of its age. The materials of industrial architecture and the building's

glass curtain walls were well suited to the function of the school with its need for light and the provision of space for its workshops. The role of the building as an intellectual centre is also of significance, as its form becomes symbolic of the kinds of radical cultural activities taking place within its walls.

Pierre Chareau's 1932 Maison de Verre, with its concrete slab and steel beam interior and external walls of glass bricks, is also important because it symbolically relates the industrial to the domestic, thus making real Le Corbusier's premiss (first raised in his 1923 book *Vers une architecture* and running throughout it) that 'a house is a machine for living in'.[13] Gerrit Reitveld's Schroder House applied concrete slab construction to a domestic house in 1925, creating a domestic form that emphasized undecorated form, as Le Corbusier was to do with his Villa Stein (1927) and the Villa Savoye (1929). Further symbolic use of industrial style can be discovered in Mies van der Rohe's Seagram Building of 1958. What at first looks to be the perfect example of functional aesthetics, an unadorned glass-fronted skyscraper, reveals on closer examination that its supposed structural integrity is expressed symbolically. What seem to be visible structural beams are façade additions, in effect a form of illusionist decoration. The stylistic aspirations of the modern architect to represent the material conditions of modernity can be clearly identified in the attempts to define what it was to be a modern architect, and the coining of the phrase 'international style'— colloquially known as International Modernism—after the Second World War. Walter Gropius first used the phrase in his eponymous book published in 1925. It was popularized in the US when, in 1932, Alfred Barr at the Museum of Modern Art in New York commissioned Henry-Russell Hitchcock, Philip Johnston, and Lewis Mumford to curate an exhibition that could define the new contemporary architecture that transcended traditional cultural boundaries.

Ironically, the restitution of traditional styling occurred as the globalized economy took hold at the end of the twentieth century. The great shopping malls of late modernity have turned the principles of modern design inside out, for while the construction techniques of modernity allow the building of these great internal spaces, their *raison d'être* attempts to sidestep the modern and their form draws on all manner of stylistic reference points. Their origin lies in the arcades of the nineteenth-century European city that fascinated Walter Benjamin so much at the end of his career. In what is now known as *The Arcades Project*, Benjamin began to examine the effect of industry and urbanization on inherited cultural forms. He observed that the shopping arcade became a city in itself—'a world in miniature in which customers will find everything they need'.[14] The unravelling of late modernity is most evident in its shopping centres, especially in the shift from conceptions of the civic to private concerns of consumption. Jean Baudrillard's analysis of the effects of consumption—and by implication design—on the individual (the artist Barbara

[13] Le Corbusier, *Towards a New Architecture* (New York: Dover, 1985).
[14] Walter Benjamin, *The Arcades Project*, trans. Howard Eiland and Kevin McLaughlin (Cambridge, Mass.: Harvard University Press, 1999), 31.

Kruger sums it up admirably with her slogan 'I shop therefore I am') is a summary of the culmination of the global process started by European modernity. This was facilitated by the moving of the global cultural centre from Europe to the US in the 1950s, and by the consequent rise and validation of commodity culture and planned obsolescence. The planned future, so evident in the work of modern designers where modern individuals find themselves formed by considered rationality, becomes an endless irrational present where the sense of identity is engendered by belonging to a cosmopolitan culture of designed goods.

The imperative for novelty that is stimulated in a contemporary consumer culture stems perhaps from the experiments in form that characterized the expressive tendencies in modern design at the start of the twentieth century. While it is easy to characterize the principles of design for industrial production (espoused in varying degrees of absoluteness by the Russian Constructivists, the designers and architects of De Stijl, and the Bauhaus) as a rational phenomenon, two quite different processes were at work. There was an attempt to find ways in which simple materials and established processes could be made to produce efficient and cost-effective goods, but there was also an expressive and aesthetic delight in ways in which new materials and processes could be used by the designer. Modern design, on the one hand, aspires to the functional, while, on the other hand, it is experimental and expressive.

This dichotomy can be explored by looking at the 1936 glass designs of Alvar Aalto, and those of Wilhelm Wagenfeld of 1938. Aalto's Savoy Vase is an irregular organic shape extended vertically into a form. Blown and shaped on a mould and primarily decorative, it differs in style and approach from Wagenfeld's Kubus stacking containers. Wagenfeld's pressed-glass rectangular containers were conceived as modular storage and serving dishes. Designed for mass production, they epitomize modern product design, yet do not possess the iconic status of Aalto's vase. Marcel Breuer's B64 chair, a cantilevered chair in chrome-covered steel, has become a design commonplace that has spawned a multitude of derivatives. Yet it is Gerrit Rietveld's iconic Red and Blue Armchair that continues to jolt us out of our everyday conception of what a chair should be with its still-dramatic appearance. It remains noticeable by its absence from contemporary furniture stores.

It is difficult to reconcile these contradictory tendencies in modern design. It may be that the legacy of the Arts and Crafts to modern design was the desire to find pleasure in the object. This pleasure was to be found in the way in which materials were used, the way in which design fulfilled its functional purposes in an ingenious and successful way, and the way in which the object can fulfil ethical demands and still give emotional satisfaction. Modern objects may be expressive, but they do not need to be, for their value is that they directly link us to our daily lives, and so give meaning to the most mundane of tasks. Such objects were mass-produced, however. No matter how skilfully they were designed, they often seemed to lack the emotional effect that symbolically styled objects could instil. The plastic ware of East Germany, for example, was well designed and functional, but it never captured the imagination

of its captive audience.[15] Stylized design often makes reference to ideas (and pleasures) that lie outside of the object, and so the object links us to those ideas by proxy. The modern object, on the other hand, sought pleasure in the object itself, and yet this pleasure was most obvious when the object was also styled to represent modernity. Dieter Rams's designs for Braun electrical products in the 1960s were minimal functional designs that symbolized modern design at its very unobtrusive best, but they were expensive, indicative of luxury because of this, and thus almost ironic in their design.

The nature of graphic design avoids the economic confusions of physical objects and has affinities with the appearance of modern art, but the aesthetic relationship of the expressive and the functional can be found in two-dimensional design just as it is found in three-dimensional objects, architecture, and the built environment. The expressive typographic experiments in the first part of the twentieth century by the Russian Constructivist El Lissitsky, like those of Theo van Doesburg in the Netherlands and Herbert Bayer in Germany, drew upon the generic new industrial type forms (sans serif, or simple undecorated letter forms derived from the late nineteenth-century printing industry), and combined them in dynamic and provocative arrangements that pushed at the limits of legibility. Bayer designed the Univers face, which reduced the letterform down to a set of geometric combinations, but it was Jan Tschichold who systematized the avant-garde approaches to layout and design to make them applicable to a mass market. His 1928 book *Die neue Typographie* advocated the clearest possible formal communication of the message conveyed, while at the same time advocating a dynamic asymmetrical approach to composition. The role of expression was thus not completely erased in the quest for functionalism.

The international typographic style of the 1950s centred on Switzerland and especially the Ulm Institute for Design. Building on the principles of the Bauhaus, the practitioners linked with the Institute argued that the function of the graphic designer was to approach the design task from as objective and scientific a position as was feasible, always striving to structure and to disseminate information in as lucid a way as possible. Like many modern design projects, the two-dimensional design of this period is immediately recognizable, drawing on visual tropes identifiable in architecture and the fine arts. Such austere projects are framed by the persuasive, silver-tongued strategies of mainstream advertising, symbolically representing the intangible benefits of industrial commodities.

The intention of modern designers to demonstrate that art and industrial technology were not antithetical to the empowerment of the individual's daily life has become a commonplace. The designer's negotiation between physical needs, material conditions, and stylistic aspirations continues apace, given urgency by the legacy of the largely unknown modern designers of our industrial world, the depletion of

[15] Raymond Stokes, 'Plastics and the New Society: The German Democratic Republic in the 1950s and 1960s', in Susan Reid and David Crowley (eds), *Style and Socialism: Modernity and Material Culture in Post-War Eastern Europe* (Oxford: Berg, 2000).

carbon resources, and the legacy of industrial pollution. Those modern architects and designers whose work we acknowledge are increasingly de-contextualized, and their work is identified as representative of a modern style. Style is the pinnacle of achievement in a contemporary design culture in which we have accepted objects that are useless, destructive, and pointless because they create the illusion of well-being. The intention of modern design and architecture to liberate the individual and to tame the industrial has manifestly failed. Yet it remains like an intermittently blinking beacon marking the debates of the past, indicating how lives can be organized by design, for good or bad. Its objects still stand as testament to the modern struggles of their designers.

PART V

METROPOLITAN MOVEMENTS

CHAPTER 35

···

IMAGINING THE MODERNIST CITY

···

SCOTT McCRACKEN

ESCAPING over enemy lines during the siege of Paris in 1870, the French balloonist Jules Durouf was mesmerized by the sight of Prussian cannonballs rising towards him then falling away in parabolic arcs.[1] This arresting image—Paris besieged, the balloon passing out of the city, eluding the missiles aimed to bring it down to earth— might act as a metaphor for the modernist city, which is best captured by startling perspectives and images of movement. This was the case even though Paris under siege was the quintessential modern city: for three months between November 1870 and January 1871, it was completely cut off, making Parisian life a purely urban experience. There was no access to the surrounding countryside. Livestock had been herded into the city before the siege began, but food supplies gradually ran out (although apparently wine did not) and the city turned to urban sources of meat: the animals in the zoo, dogs, cats, and rats. Parisian industry was reorganized to produce guns and munitions. Women were directed off the street into workshops to make uniforms. The city even found within its walls the resources to manufacture the balloons that could take news out to the rest of France.

However, if one of the abiding images of the siege was a dish of rat at the Jockey Club served with a strongly flavoured sauce, it was the movement of Durouf's balloon that best captures Parisian modernity. The distinction between the *modern* and the *modernist* city lies in the difference between the historical city of the industrial age and the ways in which that city was imagined. In this sense, the

[1] Alistair Horne, *The Fall of Paris: the Siege and the Commune 1870–1871* (London: Macmillan, 1965), 125.

image of Durouf's balloon is a modernist one because it conjures up multiple imaginary perspectives on the city, from above and below, as well as the ever-changing views of the receding city from the perspective of the moving balloon.[2] Modernist aesthetics might be understood as an attempt to represent the modern city on the move: the flows of traffic along its streets; in and out of the city; between the urban and the rural, the capitalist and pre-capitalist parts of the French economy; between Paris and other modern cities; and between the imperial centre and the colonized periphery.[3]

However, the image of Durouf's balloon is also relevant to another aspect of the modernist city. It was always imagined in relation to other cities, never just on its own terms. Variously described by cultural historians as the 'capital of the nineteenth century'[4] and 'the capital of modernity',[5] Paris's status as a modern city was achieved because it was a key node in a network that linked it with the rest of France and the world. As Steven Beller has written about the cities of central Europe in the same period, 'the lines which are drawn around territories are not as important . . . as the lines which link cities. . . . Urban culture is . . . as much about networks as it is about boundaries'.[6] By the end of the nineteenth century, it had become impossible to imagine the modern city except in relation to other cities.

Earlier in the century, novelists such as Honoré de Balzac and Charles Dickens had pushed realism to its limits; but as the century progressed, writers and artists started to experiment with new aesthetics that were adequate to cities whose imaginative limits spilled over their geographical boundaries. Paris after 1870 emerged as not just a modern city, but the modernist city par excellence, not only because it was the centre of the European art market, but as a consequence of its key place in a widening series of cultural networks. These networks encompassed other European cities, but soon extended to have a global reach. If Paris was the centre for the avant-garde movements that pioneered reimagination of the urban, that reimagination was always about Paris's key position in a widening international scene.

What was true of Paris was also true of the other modern cities after 1870: London, Berlin, Vienna, Milan, Prague, New York, Buenos Aires, and Mexico City. To understand a city's modernisms, we have to understand its networks. Durouf's fascination with the parabola of cannonballs fired to shoot him out of the sky is at one with modernism's fascination with the movement of things, goods, and people, through, in and out of, and between cities. Modernist responses included not just high-cultural (art and literature) but also the vernacular modernisms of mass

[2] For a good example, see the balloon in Édouard Manet's painting *The Universal Exhibition* (1867).

[3] On the relationship between modernism and movement, see Andrew Thacker, *Moving Through Modernity: Space and Geography in Modernism* (Manchester: Manchester University Press, 2003).

[4] See Walter Benjamin, 'Paris, the Capital of the Nineteenth Century', in *Selected Writings*, iii: *1935–1938*, ed. Howard Eiland and Michael W. Jennings (Cambridge, Mass.: Belknap Press, 2002), 32–49.

[5] See David Harvey, *Paris: Capital of Modernity* (London: Routledge, 2003).

[6] Steven Beller, 'Big-City Jews: Jewish Big City—The Dialectics of Assimilation in Vienna c.1900', in Malcolm Gee, Tim Kirk, and Jill Steward (eds), *The City in Central Europe: Culture and Society from 1800 to the Present* (Aldershot: Ashgate, 2003), 145.

journalism and advertising. Both elite and demotic forms were part of a reimagination of the urban, which in turn had an impact on the development of the city itself. The modernist city became not just a response but also a project for architects and urban planners.

CITIES IN PERSPECTIVE: PARIS, BRUSSELS, LONDON

However important the concept of a break or rupture with the past came to be for modernism, modernist responses to and visions of the urban did not, of course, emerge from nowhere. A popular fascination with representations of the modern city preceded artistic and literary modernism. From the late eighteenth century, panoramas and dioramas were popular spectacles. These theatrical devices, where pictures of a landscape or urban scene were viewed from a central position, offered spectators an opportunity of viewing an imagined city, a landscape, or a historical scene as a whole. Such perspectives prepared the way for modernist aesthetics. The most spectacular celebrations of a world viewed from one place were the Great Exhibitions. The Paris Exhibition of 1869 was, like the first Great Exhibition in London in 1851, designed to show off a distinctively national modernity; but it was at the same time a profoundly international affair, visited by the King of Prussia, the Russian Tsar, and international workers' delegations, and featuring exhibits from around the world. If the origins of the exhibitions lay in the vastly increased productive industrial capacity of the new industrial nations, the exhibits themselves, torn from their origins and placed in displays for public view, suggested that the new technologies would abolish scarcity, promising an unprecedented abundance of goods for all. A growth in advertising accompanied the new exhibitions, so that the dreamlands of the exhibitions spilled out onto the city streets where few, as yet, could afford the commodities on offer.[7] New modes of street lighting, first gas, then electric, illuminated the growing commercial districts of large cities, creating new exhibition spaces for a phantasmagoria of commodities from across the world.

The growth in international trade led to increased contact between nation states. The Franco-Prussian War itself was played out on an international stage. Yankee generals, fresh from victory over the South, came to watch from the Prussian side. English journalists reported the siege and the subsequent uprising, the Paris Commune, in London's papers. France's defeat sparked uprisings in colonial Algeria and rebellion among Algerian troops stationed in France, while Italian and Polish

[7] See Thomas Richards, *The Commodity Culture of Victorian England: Advertising and Spectacle, 1851–1914* (London: Verso, 1991), 28.

nationalists, and Hungarian, Russian, and English socialists fought for the Commune. Although the relationship between these events and the emergence of the Parisian avant-garde was not straightforward, the 1870s saw a marked change in visual and poetic form. The Second Empire, under Napoleon Bonaparte's nephew Louis Napoleon Bonaparte III, which lasted from 1851 until France's defeat, had pursued its own vision of the modern city. The capital had been redesigned, with wide boulevards radiating out from the Arc de Triomphe replacing the narrow medieval streets. The visual arts, however, had been subject to the conservatism of the Academy, which excluded the realism of Gustav Courbet and Édouard Manet as well as the innovations of the younger, and as yet unnamed, 'Impressionists'.

Two figures in the Impressionist movement, Camille Pissarro and Claude Monet, spent the war in London, where their airy paintings of Crystal Palace and Green Park offered a striking contrast to the carnage of war and revolution. They only returned to France after the suppression of the Commune. Thus, their view of post-war Paris was reached through the prism of London. Although both sympathized with the Commune (Pissarro was a committed anarchist, Monet, less militant, was appalled by the massacres committed by the Versaillese (French government) forces), Albert Boime argues that the Impressionist movement collaborated in the Third Republic's elision of the history of the Commune, and in particular its bloody aftermath.[8] Impressionist landscapes instead occluded the damage inflicted on Paris.

Boime picks out Monet's picture *The Tuileries* (*c.*1876) as an example. The painting portrays the garden area, relegating the ruins of the palace to the side of the picture. In fact, to the untutored eye, it is not clear that the palace is damaged at all. Boime's thesis is that such paintings assisted in the reconstruction of a bourgeois modernity. However, Boime's focus on the content of such paintings perhaps gives too little attention to the Impressionists' revolutionary innovations in form. The timing and place of Monet's 1872 painting *Impression, Sunrise* seems significant here. The painting is far more abstract than his earlier paintings. A fiery sun rises through a smoky fog, leaving a bloody stain on the water, suggestive of the fires that burnt across Paris as the Communards tried desperately to block the advance of the Versaillese forces. The painting, which gives its name to the first recognized movement of modernist artists, seems to make reference to the explosive events a year earlier.[9] However, as important as the painting's political meaning is its setting. It seems significant that the harbour is Le Havre, a port that connects France to England. Monet's new art finds its inspiration not in one city, but along the lines between cities.

The exact relationship between the politics of urban revolution and the revolution in poetic form that also occurred after the Paris Commune is equally difficult to establish, but a relationship existed nonetheless. Paul Verlaine's distinctive style

[8] Between 20,000 and 30,000 people were massacred by the victorious government forces; see Albert Boime, *Art and the French Commune: Imagining Paris After War and Revolution* (Princeton: Princeton University Press, 1995).

[9] Paul Tucker agrees that the painting makes reference to the war, but sees it as a patriotic statement; 'The First Impressionist Exhibition and Monet's *Impression, Sunrise*: A Tale of Timing, Commerce, and Patriotism', *Art History*, 7/4 (1984), 465–76.

emerged in his fifth collection of poetry, *Romance sans paroles*, published in 1874. Verlaine had been a (not very assiduous) member of the Paris city bureaucracy during the Commune, having refused to decamp to Versailles after the revolution of 18 March. However, the months that followed the defeat of the Commune coincided with his tempestuous affair with the young poet Arthur Rimbaud. Rimbaud, who had been inspired by Verlaine's earlier poetry and had come to Paris to meet him, is often seen as the poet of the Commune.[10] The couple's travels away from and back to Paris, to Brussels, and to London were motivated partly by Verlaine's desire to escape his disintegrating marriage, but also by his waxing and waning fears of government retribution for the part he and Rimbaud had played in the Commune. *Romance sans paroles* was written partly in Brussels and partly in London, both cities of refuge for exiled Communards. A poem such as 'Streets II', written in London, creates an urban sensibility that is the product not just of Paris or London, but of both cities at the same time.[11]

> O the river in the road!
> Which appeared fantastically
> Behind a five-foot wall,
> It rolls without a murmur
> Its opaque and yet pure wave,
> Coursing through the pacified streets.
>
> The road is very broad, such
> That the yellow water, like a dead woman
> Hurtles full and without any hope
> Reflecting nothing but the fog,
> Even as dawn lights up
> The yellow and black cottages.[12]

While the fog clearly signifies London, the deathly presence of the river in the streets might be read as the extinguishing of revolutionary hopes after the Commune. However different, the new visual forms found in Impressionism and its successors and the new poetic forms found after Verlaine and Rimbaud emerged in the context of urban revolution. While such innovations are not necessarily a signifier for revolutionary politics, two elements in the birth of the Impressionist movement and the new poetry are significant for our understanding of the modernist city.

First, the modernist city is imagined in terms of a rupture with the past. The end of the Second Empire and the revolution of 1871 are a particularly stark example of such a historical break, although the rapid pace of change experienced by modern cities

[10] See Kristin Ross, *The Emergence of Social Space: Rimbaud and the Paris Commune* (London: Verso, 2008).

[11] Paul Verlaine, 'Streets II', in *Romances sans paroles: Œuvres poétiques* (Paris: Éditions Garnières Frères, 1969), 164.

[12] 'O la rivière dans la rue! | Fantastiquement apparue | Derrière un mur haut de cinq pieds, | Elle roule sans un murmure | Son onde opaque et pourtant pure, | Par les faubourgs pacifiés. | La chaussée est très large, en sorte | Que l'eau jaune comme une morte | Dévale ample et sans nuls espoirs | De rien refléter que la brume, | Même alors que l'aurore allume | Les cottages jaune et noirs.'

meant that discontinuity was the universal experience of urban life. Such ruptures, while they may not figure in the content of all modernist artworks, are registered in innovations in form. Second, the modernist city is imagined from a distance. Monet's 1876 painting of the Tuileries is a typical, if partial, panoramic view. Whether seen from a natural upland, a balloon, or a high window, such views incorporate not just the city depicted, but the knowledge of other cities. *The Tuileries* has a clear relationship to Monet's painting of Green Park in London in 1871. His Impressionism tries to capture movement rather than the static scene. Movement was a characteristic of revolutionary Paris, which was a prototype for the cosmopolitan cities of the twentieth century, inhabited by a population in motion: travellers, migrants, exiles, and refugees. Later modernist movements, the members of which were often also immigrants, such as Pointillism, Expressionism, Cubism, Vorticism, and Surrealism, to name but a few, followed the Impressionists with further, more radical, innovations in visual form that attempted to track a world that was speeding up. This acceleration in the pace of life was a result of industrialization and new technologies, but it had psychological consequences.

MENTAL LIFE: BERLIN, VIENNA

After 1871, aided by the spread of railways, no major European city could be imagined except in relation to its peers. In the same period, telegraph and the steamship started to bring non-European cultures and cities into closer imaginative proximity.[13] Art and literature responded to a world that was experiencing what David Harvey calls a process of 'time–space compression': 'processes that so revolutionize the objective qualities of space and time that we are forced to alter, sometimes in quite radical ways, how we represent the world to ourselves'.[14] The period between 1880 and 1920 saw an intensification of the sense that the modern city produced a particular urban sensibility. Such a sense could already be found in the novels of Balzac and Dickens; but if the classic realist novelists of the mid-nineteenth century still strove to represent the city as a whole—even while the city's perpetual motion always seemed to exceed their grasp—already from 1848 a few French poets and novelists, such as Charles Baudelaire and Gustave Flaubert, had started to experiment with forms that emphasized the fragmented, alienated experiences the modern city generated. No wonder nineteenth-century literature was filled with the contrasting experiences of village or small-town life and the excitement of the big city, or that revolutionary Parisians were contemptuous of the more conservative *ruraux* (inhabitants of the

[13] See Stephen Kern, *The Culture of Time and Space, 1880–1918* (Cambridge, Mass.: Harvard University Press, 2003).

[14] David Harvey, *The Condition of Postmodernity* (Oxford: Blackwell, 1990), 240.

countryside). Urban life was qualitatively different, if contradictory. On the one hand, the opportunity was there to break free from family ties, religious supervision, social prejudices, and the inhibiting oversight of one's neighbours. On the other, the lack of these social anchors could be disorientating, leaving the city dweller lost and rootless, lacking a history or the common memories that give rise to community and solidarity. Nor should the primary economic reason for growing urban populations be forgotten. People were drawn to the city by the prospect of work. The breakdown of traditional bonds was useful to the owners of large industrial concerns as it offered a workforce without other resources. The experience of the urban was, therefore, caught between the excitement of liberation and the fear of isolation and exploitation. This contradiction was explored by many modernist writers and artists— Edvard Munch's *The Scream* (1893) or Franz Kafka's *Metamorphosis* (1915) might stand as significant examples—but it was also a matter of concern for philosophers and members of a new discipline, sociology, provoked into being by a desire to understand and to control the effects of modern industrial life.

The founding essay in the new science of urban sociology was Georg Simmel's 'Die Großstädte und das Geistesleben' (1903), usually translated into English as 'The Metropolis and Mental Life'. The translation preserves the alliteration of the original; however, it is worth noting that Simmel's *Großstädte* (literally 'big cities') is plural and *Geist* can mean intellect or spirit as well as mentality. Simmel's particular big city is usually taken to be Berlin, although, as David Frisby points out, the city is never mentioned by name.[15] The title is suggestive because it implies that the mental, intellectual, and spiritual lives of all large cities have something in common. It is not, therefore, surprising that Simmel's argument became the target for more conservative commentators, who saw his vision of a cosmopolitan urban spirit as an affront to the traditional values of an ethnically pure German *Volk*. That Simmel was Jewish was used to bolster a nationalist discourse already open to anti-Semitism.[16]

Simmel observed that the city imposes a kind of sensory overload on the individual. Bombarded and buffeted by objects, people, sounds, sights, and smells, exposed to a vast range of new tastes, the city dweller responded defensively with an attitude of indifference. He or she becomes blasé in the face of the city's excesses. Simmel's account of urban psychology was influential and was repeated in different forms by a number of different theorists of modernity. Karl Marx had already identified the alienation of the industrial worker, who receives just a small part of the fruits of his or her labour in *Capital* (1867). The German sociologist Max Weber focused on the process of rationalization that occurs in large organizations, such as offices or government departments, where work is parcelled up into small tasks and individual bureaucrats lose their sense of the overall process and its purpose. The Hungarian

[15] Frisby also points out that the occasion for the essay was 'the representation of the city' at a big exhibition, the First German Municipal Exhibition in Dresden in 1903. See David Frisby, 'The City Interpreted: Georg Simmel's Metropolis', in *Cityscapes of Modernity: Critical Explorations* (Cambridge: Polity Press, 2001), 101.

[16] Ibid. 141.

Marxist Georg Lukács combined these insights into his concept of 'reification' which describes the process by which abstract notions, such as time, become the objects of scientific measurement and control in modernity.[17] Thus, work and leisure are quantified in industrial society as delimited periods—shifts and breaks, working days and time off, for example. Processes of thought and reason become regimented and instrumental, that is, always directed to a particular end.

Marx's theory of alienation, Weber's rationalization, and Lukács's reification might all be understood as negative critiques of modernity. But Marx at least recognized that there was another side to the question. On the one hand, the capitalist mode of production detached the majority from the fruits of their labour. On the other, as we have seen, the commodities produced, devoid of the taint of their origin, assumed a remarkable, almost mystical, quality, which he called commodity fetishism. Spectacular commodity displays began, as we have seen, in the great exhibitions, but then moved to the shop windows of the new department stores—Le Bon Marché in Paris, Selfridges in London, Kaufhaus des Westens in Berlin, GUM in Moscow, Macy's in New York. Images of consumer goods proliferated in newspapers and magazines, on walls and vehicles plastered with advertisements. The new technologies of lighting illuminated the displays, extending the spectacle into the night.[18]

The impact on consciousness was, if anything, to exacerbate the sense of the fragmentation of experience, even while the senses were dazzled and delighted. Modernist reactions tended to move between the mimetic and the responsive. Juxtaposed impressions, thoughts, images, and perspectives abound in modern art and literature; but, at the same time, there is almost always an attempt to understand urban experience through a formal aesthetic. Walter Benjamin's engagements with both the city and urban modernisms led him to distinguish between two types of modern experience that matched these two reactions. The mimetic function of modernism expressed the experience described by Benjamin using the German word *Erlebnis*, which is usually translated as 'shock experience'. However, in his study of the poet Charles Baudelaire, Benjamin found another counter-process at work, *Erfahrung*. Baudelaire's poetry not only recorded the fleeting, transient, ephemeral images encountered in the city, it attempted to respond to and reflect upon them. Baudelaire's modernism gave the city's fragments a new order so that they not only regained meaning, but made new connections. Far from being a jumble of unrelated parts, Baudelaire's 'correspondences' establish unexpected affinities between modernity's fragments, the ancient and the modern, the past and the present.[19]

Such moments occur in later modernist works as well, most famously in Marcel Proust's long novel *In Search of Lost Time* (1913–27). The narrator is prompted by the

[17] See Georg Lukács, *History and Class Consciousness* (Cambridge, Mass.: MIT Press, 1990), 83–110.

[18] See Wolfgang Schivelbusch, *Disenchanted Night: The Industrialization of Light in the Nineteenth Century* (Berkeley: University of California Press, 1992).

[19] See Walter Benjamin, 'On Some Motifs in Baudelaire', in *Selected Writings*, iv: *1935–1938*, ed. Howard Eiland and Michael W. Jennings (Cambridge, Mass.: Belknap Press, 2003), 313–55.

familiar taste of a cake, a madeleine, to recollect the memories of his childhood, which have not so much been forgotten, but rather have become *disagrégé*, disaggregated, scattered, or fragmented. *In Search of Lost Time* is an exercise in the kind of reassessment that *Erfahrung* entails. Its lengthy descriptions and reflective digressions mask a deep structure, which attempts to return meaning to modernity. For Benjamin, who translated Proust into German, the root of *Erlebnis*—the fragmentation of experience—lies in the exploited and alienated conditions of the urban working class,[20] yet the city abounds in thresholds and boundaries which enable the possibility of reconnection, where different temporal and spatial experiences meet and absorb one another. Against the divisions and indifference the city inspires, Benjamin also saw the potential for new revolutionary, resistant, and cosmopolitan collectivities. It was this potential that made the relationship between the city and modernism so politically explosive. New and unfamiliar forms, social and aesthetic, threatened to blast open existing regimes of power.

STREET-LEVEL

In Benjamin's view, the impact of urban modernity was more than mental. It affected the entire body. Late nineteenth-century and early twentieth-century representations commonly depicted the nervous anxiety that affected city dwellers, relating it to new technologies and forms of mechanized transport, such as railways, trams, and motor cars. But Benjamin, inspired by Surrealism, also saw the possibility of a positive collective 'bodily innervation' that would lead to revolutionary change.[21] As we have seen, for Benjamin, the mental life and bodily experience of the city comes into being in its material spaces—in its streets, offices, shops, cafés, and restaurants, its apartment blocks and suburban villas, and through the routes and modes of transport that connect these spaces. It is, in fact, the points at which different kinds of spaces meet that produce the city's most interesting encounters, when a space is two things at the same time. The city street, for example, so different from the older country 'way',[22] is both thoroughfare and home.[23] To a greater or lesser extent, the city street achieves a degree of individuality that means its name signifies more than just a

[20] Ibid. 328–9.

[21] Walter Benjamin, 'Surrealism, the Last Snapshot of the European Intelligentsia', in *Selected Writings*, ii: *1927–1934*, ed. Michael W. Jennings, Howard Eiland, and Gary Smith (Cambridge, Mass.: Belknap Press, 1999), 217–19.

[22] Walter Benjamin, *The Arcades Project*, trans. Howard Eiland and Kevin McLaughlin (Cambridge, Mass.: Harvard University Press, 1999), P2, 1, p. 519.

[23] 'For what do we know of street-corners, curb-stones, the architecture of the pavement—we who have never felt heat, filth, and the edges of the stone beneath our naked soles, and have never scrutinized the uneven placement of the paving stones with an eye toward bedding down on them' (Ibid., P1, 10, p. 517).

position on a map. The Boulevard St Germain in Paris, the Strand in London, the Kurfürstendamm in Berlin, Nevsky Prospekt in St Petersburg, or Fifth Avenue in New York, all signify what Pierre Bourdieu would call a 'habitus': a mode of living and consumption as well as a place. For Henri Lefebvre, the street is the point at which different rhythm's interact, from the bodily rhythm of the pedestrian, to the rhythms imposed by the physical structures of the road, pavement, and buildings, to the rhythms of vehicular motion.[24]

Both modernist art and modernist fiction take street encounters or the clash of street rhythms as their point of departure. The Italian school of painters known as 'I Scapigliati' (literally, 'the wild-haired ones'), based in Milan, painted urban scenes in which buildings, trams, and people seem to be engaged in a wild, colourful clash of movement. The Scapigliati were followed by the Futurists, who took further an art that found its power in a fusion of speed, technology, and violence. Perhaps the most famous attempt to capture movement in art is Umberto Boccioni's Futurist sculpture *Unique Forms of Continuity in Space*. However, the shock of other, new modernist paintings, such as Pablo Picasso's *Les Demoiselles d'Avignon* (1907) or Marcel Duchamp's *A Nude Descending a Staircase* (1912), can be attributed to the refusal of the painter to be bound to a still-life, interior, or pastoral, carefully chosen landscape, embracing instead the points at which the city transgressed notions of interior and exterior, of private and public space.

Street encounters punctuate the great works of modernist fiction, structuring their episodic narratives. In James Joyce's *Ulysses* (1922), Leopold Bloom's odyssey around Dublin brings him into contact with the range of characters found in English Victorian painting such as William Powell Frith's *Derby Day* (1858) or Ford Madox Brown's *Work* (1863). However, where the Victorian paintings attempt to capture a moment, characters in *Ulysses* reappear in different places as the narrative proceeds, each encounter creating a new constellation that illuminates another aspect of Dublin society. In modernist fiction, the street is a place of encounters and transactions, commercial and otherwise. Just as the modern city is best captured from the point of view of a spectator in motion, as from a balloon moving away from the city, so the internal life of the city is best characterized in terms of its traffic. When the city stops moving, it indicates a social crisis. In Virginia Woolf's *Mrs Dalloway* (1925), the mental distress of the character Septimus Smith, who is suffering from shell shock, is indicated by abortive encounters and a failure to move on with the traffic. Being not part of, but an obstacle to, the city's traffic signifies the extent to which he has become separated from society.

In the modernist city, traffic is both material fact and metaphor.[25] The concentration of population in the city necessitates the mass distribution of goods and the mass movement of people from one part of the city to another. The exchanges and transactions that occur in the course of this movement were constitutive of the new

[24] Henri Lefebvre, *Writings on Cities* (Oxford: Blackwell, 1999), 11.
[25] On the concept of traffic in literary modernism, see Mark Anderson, *Kafka's Clothes: Ornament and Aestheticism in the Hapsburg Fin de Siècle* (Oxford: Clarendon, 1992).

forms of social relations that formed the foundation of modern urban culture; and perhaps no social relationship was changed more profoundly than that between men and women.

Historians have shown that the persistent and effective Victorian ideology that confined women to the private sphere was contradicted by the lives of the majority of women in the nineteenth century. Working-class women did work, when they could, and middle-class women often took a role in business or participated in some aspects of public life. Most women, like most men, were drawn to the city by the demand for labour, but before systematic attempts were made to plan and improve working-class areas, they were characterized by inadequate housing and little access to running water or sanitation. As a consequence, private life was limited. Families would often share rooms and beds or sleep in shifts. Community and social life was conducted in the courtyards, tenement landings and stairways, and narrow streets.

Street life permitted frank exchanges between men and women, both verbal and physical. Opportunities for women to work outside the home changed the relationship between men and women, and early accounts of the industrial city expressed horror at examples of young women who broke away from the patriarchal family and set up home on their own; but high levels of poverty and exploitation meant that violence and prostitution were also commonplace. While there was some loosening of familial control and religious surveillance, men's control over women could still be brutal. In addition, measures were taken by the state to control and regulate women's sexuality. In Britain the Contagious Diseases Acts of the 1860s allowed the authorities in towns to perform a medical examination on any woman who looked as though she might be a prostitute.[26] Such measures and the exclusion of women from democratic reforms fuelled the emergence of women's movements in modern cities.

As a consequence, women's artistic responses to the modern city were different from men's. Although most women modernists came from the middle and upper classes—Virginia Woolf famously saw an income of £500 a year as a necessary minimum for a woman to become a writer—the ability or inability of women to move from the home into the street is a key focus for many women's texts. Stepping into the street becomes the first move in a journey to independence. Whereas the world of Leopold Bloom is made outside the home, even while the domestic and its anxieties prey on his mind all day, for Mrs Dalloway or the characters in Katherine Mansfield's short stories, the boundaries between the public and the private have to be carefully negotiated.

One of the most perceptive observers of these negotiations was Dorothy Richardson. Richardson never reached Woolf's minimum income. She worked for a pound a week as a dental receptionist in London's Harley Street. Having been close to poverty herself, often choosing books over food, Richardson portrays the heroine of her long prose work *Pilgrimage* (published between 1915 and 1967) as a skilled navigator of London's streets. Willing to venture out after dark, Miriam runs the risk of

[26] See Judith Walkowitz, *Prostitution and Victorian Society: Women, Class, and the State* (Cambridge: Cambridge University Press, 1982).

unrespectability, or being classified as a prostitute by male pedestrians or policemen. But she reaps the rewards of the freedom the city can offer to a single woman.

Jean Rhys, in contrast, wrote about the other side of being a lone woman in London and Paris. Her female characters suffer the consequences of economic dependence and rejection. Novels such as *After Leaving Mr Mackenzie* (1930) and *Good Morning, Midnight* (1939) are studies in abjection. Yet even here the sense is of cities full of possibility. The Paris of *Good Morning, Midnight* is full of lost souls with whom Rhys's protagonist might (but does not quite) experience a meaningful relationship. The failure to overcome the barriers is not because they are necessarily insurmountable. It was just that, by the 1930s, the promise of the cosmopolitan, modernist city announced by Simmel had been thwarted by the shadows of war, fascism, and Stalinism. Rhys explores, from a woman's point of view, a much more pessimistic version of the city, versions of which had already been conceived by earlier writers such as George Gissing and Franz Kafka.

There is a pleasing paradox here, because male modernists' negative reactions to the city had been partly about their response to the increasing presence of women in the urban public sphere. As women's earning power grew, female spaces, such as department stores, cafés, and movie theatres, multiplied. There was even a kind of virtuous circle whereby—in addition to office work—theatres, shops, cafés, and restaurants also employed women workers, allowing more women to get closer to economic independence (although wages in these sectors were still very low). Women's increasing public presence was reflected in an anxiety in men's writing about the decline of the power of fathers. For some writers, such as George Gissing, whose fiction is still bound to a form of late nineteenth-century realism, this anxiety was crippling. But for others, it was a liberation. Modernist fiction written by both men and women experimented with new forms that enabled new masculinities and new femininities, as well as new identities not recognizable as either masculine or feminine in the traditional sense. A novel such as Djuna Barnes's *Nightwood* (1936), created a carnivalesque cast of characters who populate Paris after dark.

URBAN PLANNING—URBAN SPRAWL

Modernist fiction's interest was in how new forms of gender relations are made in the circulation and movement of men and women through the city's private and public spaces. But if one modernist project was to chart and map such movements, another was to reshape them through changing the city itself. Cities had always been a combination of planned and unplanned growth. With a few notable exceptions, such as St Petersburg in the eighteenth or Brasilia in the twentieth century, the city has come first and attempts to plan it have been after the fact. Urban populations grew (and are still growing), with such rapidity that planning always lagged behind.

Designing a better city which would control or erase its less regulated aspects was always an aspect of the modernist project. Three categories of planned modernization can be identified.

First, there was the improvement of existing urban districts through, for example, slum clearance and the construction of new roads, and new houses with improved services and sanitation. Second, there were examples of the wholesale replanning of existing cities, for example Georges-Eugène Haussmann's reorganization of central Paris. This plan, like many reimaginations of the modern city, had a political element. It aimed to replace narrow medieval and easily defended streets with wide boulevards, which it would be less easy to barricade during Paris's periodic revolutionary insurgencies. However, it also had a more practical function of increasing the speed of movement through the city, creating, in effect, a networked city. Such wholesale reorderings would also include the construction of sewer systems and public transport networks, both designed to increase the efficiency with which the city dealt with its inhabitants and their waste. Joyce's *Ulysses* in particular tracks the infrastructure that connects the city. Building these networks enacted a process of creative destruction, in which the old city, with its peculiar spatial configurations, was swept away and new urban formations took its place, a process noticed in literature as early as Dickens's *Dombey and Son* (1848). The construction of a new infrastructure meant that new forms of social interaction emerged. Third, whole new cities were planned, such as St Petersburg in the eighteenth century and Brasilia in the twentieth, or, on a smaller scale, new neighbourhoods. The movement for garden suburbs is an example of the latter. It began in England, but spread to Germany and central Europe, notably Czechoslovakia.[27] Such forms of modernization could extend to the micro level. Movements such as the Arts and Crafts in Britain and Bauhaus in Germany sought to transform domestic space in ways that then appeared revolutionary, but which, in the case of an ergonomic fitted kitchen, now seem everyday.

However, modern cities were in a state of permanent revolution, so that planning, even the building of new cities, was always overtaken by the city's own dynamics. The desire to plan and order cities demonstrated the extent to which the city was imagined as much as it was real. Images of the unruly, unregulated city competed with images of the city as an ordered utopia, such as Le Corbusier's vertical cities in the sky. The city dweller experienced her or his individual identity reflected back at her or himself through the city's reflective surfaces, mirrors, and shop windows, and the images reproduced in advertising and print culture. Modernist responses to the city addressed these subjective responses through dreamscapes and fantasy. However, as Walter Benjamin pointed out, the city itself was a kind of dream factory: 'arcades, winter gardens, panoramas, factories, wax museums, casinos, railway

[27] See Jane Pavitt, 'From the Garden to the Factory: Urban Visions in Czechoslovakia Between the Wars', in Malcolm Gee, Tim Kirk, and Jill Steward (eds), *The City in Central Europe: Culture and Society from 1800 to the Present* (Aldershot: Ashgate, 2003), 27–44.

stations', as much as theatres, exhibitions, cinemas, and advertising, produced urban dreamscapes.[28]

Such dreamscapes have always had a gendered dimension. As Rachel Bowlby has written, as women became increasingly visible in the public sphere they were placed in a paradoxical situation in relation to the city's visual culture. In the act of consumption, at theatres or department stores, they were also consumed. Theatres, music halls, and concert halls were a space for public display.[29] Fashion offered an opportunity to remake a public identity, but also positioned women as objects of a male gaze. However, men weren't immune from the new visual culture and were themselves the objects of the gazes of both women and men. Parts of London, such as Regent's Park, were cruising grounds for homosexual men.[30]

In volume ii of *In Search of Lost Time*, the narrator, Marcel, is both subject and object of the male gaze. At the seaside resort of Balbec, he is fixed by the gaze of Baron de Charlus. But he himself gazes frankly at his friend-to-be, Saint-Loup. Gazing almost daily at a group of young women, he experiences a desire, not for an individual, but for a kind of composite, not unlike a Cubist painting, made up of the fleeting impressions of the collective.[31] Desire here does not exist on one plane, and the gaze is more than an instrument of power. Rather it is more akin to a wager, thrown out in the hope of rich, but unknown, returns. While it is undoubtedly true that the odds were stacked in favour of men, the city did offer women chances, to desire and to act upon desire, that had not previously been available.

DAKAR, PARIS, NEW YORK, BUENOS AIRES

One of the things that set Simmel's *Großstädte* apart was their international nature. Imperial cities, such as Paris, London, and Berlin, drew in visitors, students, and immigrants from around the world. We have already seen how a small number of Algerian soldiers took part in the Paris Commune. Capitals of empires were both the hub, but also paradoxically often the sites of resistance to imperialism. Imperial cities afforded the meeting points and spaces that fed the cosmopolitan cultures that challenged colonialism in Africa and Asia. Paris in particular acted as a point of connection for intellectuals, artists, and writers of African descent. Although France had colonies in Africa and the West Indies, the French republican ideal was that

[28] Benjamin, *The Arcades Project*, L1, 3, p. 405.

[29] Rachel Bowlby, *Just Looking: Consumer Culture in Dreiser, Gissing and Zola* (London: Methuen, 1982).

[30] See Matt Cook, *London and the Culture of Homosexuality, 1880–1914* (Cambridge: Cambridge University Press, 2003).

[31] See Marcel Proust, *Within a Budding Grove*, vol. ii of *In Search of Lost Time*, trans. C. K. Scott Moncrieff and Terence Kilmartin (London: Vintage, 1996).

French citizens living in France had equal rights. African-American intellectuals active in the struggle for civil rights in the US, such as W. E. B. DuBois, visited Paris in the years before the 1914–18 war. Dubois helped to organize the first Pan-African Congress in Paris in 1919, an attempt to bring together and organize people of African descent in Africa and the Americas.[32] African-American troops found they were welcomed and given more respect in wartime France than in the US. West African troops fighting for France and Indian troops fighting for Britain were politicized by the contrast between their sacrifice and their subject status in their respective empires.

In the inter-war years, Paris became a meeting place for writers from the Anglophone and Francophone Caribbean, from the United States, and from colonial Africa. The Harlem Renaissance, the flowering of art and literature that was located in the predominantly black part of Manhattan, had a strong influence on writers from French colonies and Haiti. But these influences were not one-way. Rather, there was a circulation of people, texts, and images around what Paul Gilroy calls the 'Black Atlantic'.[33] Cities such as Paris and London were important nodes in international networks, facilitating an exchange of ideas. The writer Claude McKay, for example, moved from his native Jamaica to New York, where he was an important figure in the Harlem Renaissance. Later he travelled to France, including Paris and Marseilles, where he set his novel *Banjo*, and then to Morocco, then part of the French empire. The future president of Senegal Léopold Senghor lived in Paris between 1928 and 1935. The Negritude movement he helped to create with the Martiniquan poet Aimé Césaire was inspired by the Harlem Renaissance, French Surrealism, and existentialism, but fed back into African nationalism, influencing post-war struggles for independence and post-colonial African literature.[34] London was also a meeting point for West Indian intellectuals in the 1930s such as C. L. R. James, who wrote *The Black Jacobins* (1938), a history of the Haitian Revolution (1791–1804), the first Caribbean struggle for independence.[35]

Thus, the better-known exchanges between Europe and its colonies, such as the influence of African art on Picasso,[36] are best understood in the context of a notion of urban traffic that extends beyond Europe to have a global reach. Inevitably, these exchanges were unequal and open to characterizations that portrayed non-European art and cultural traditions as little more than an infusion of raw, natural energy into the European Enlightenment tradition. In the same vein, the journeys made to Paris,

[32] See Michel Fabre, *From Harlem to Paris: Black American Writers in France, 1840–1980* (Urbana: University of Illinois Press, 1991), 46–62.

[33] Paul Gilroy, *The Black Atlantic: Modernity and Double Consciousness* (London: Verso, 1993).

[34] On Claude McKay, see Fabre, *From Harlem to Paris*, 92–113; on Negritude and the Harlem Renaissance, see ibid. 146–59 and F. Abiola Irele, 'The Harlem Renaissance and the Negritude Movement', in F. Abiola Irele and Simon Gikandi (eds), *The Cambridge History of African and Caribbean Literature*, ii (Cambridge: Cambridge University Press, 2004), 759–84.

[35] See Bill Schwarz (ed.), *West Indian Intellectuals in Britain* (Manchester: Manchester University Press, 2003).

[36] See Simon Gikandi, 'Picasso, Africa, and the Schemata of Difference', *Modernism/Modernity*, 10/3 (Sept. 2003), 455–80.

London, or New York by artists from the colonies could be depicted as pilgrimages from savagery to civilization, or, from the point of view of nascent anti-colonial nationalisms, as a dangerous dilution of native cultures in the melting pot of the city.

Such debates had something in common with the original, nationalist and ruralist, attacks on Simmel's description of the great cities as a cosmopolitan mix of peoples and cultures. If the original function of imperial cities was the domination and exploitation of the colonies, their evolving relationship with non-European peoples and practices changed indigenous cultures on both sides. Despite taking place in the context of the hegemony of the imperial culture, such exchanges were characterized by resistance as well as oppression. The consequence is that it is often difficult to extract a single national tradition out of the transaction that constituted either the culture of the modern city or the emergent national cultures of the emergent post-colonial states.

The relationship between Latin American literature and European modernism is illustrative here. At the same time as black modernisms were in circulation around the Atlantic, Latin American states, relatively isolated since independence in the early nineteenth century, were coming to the end of their 'hundred years of solitude'[37] and becoming involved in a comparable process of internationalization. The three writers who constituted what Gerald Martin calls the 'ABC of magical realism', the Guatemalan Miguel Asturias, the Argentine Jorge Borges, and the Cuban Alejo Carpentier, developed a form of writing that took a dialogic relationship between European culture and the Americas as its starting point.[38] Magical or, as Carpentier named it, *maravilloso* (marvellous) realism confronted Europe's classification of the Americas as exotic with the claim that the continent's physical and social terrains exceeded European structures of representation. As Martin argues, magical realism set up dialogues between the growing Latin American cities and their rural hinterlands, between a literate urban and pre-literate indigenous cultures, and between a new Latin American literature and European modernisms.

Alejo Carpentier associated with the Surrealists while in political exile in Paris in the 1920s. His 'marvellous realist' novel *The Kingdom of This World* (1949) is set during the first anti-colonial revolution in Haiti, and explores the importance of African religious beliefs to the slaves' revolt. Asturias's *Men of Maize* (also 1949) incorporated Mayan myth to write a Guatemalan national epic. However, Asturias's knowledge of Mayan culture came from his studies in Paris in the 1920s, where he was acquainted with Carpentier. *Men of Maize*, like *The Kingdom of This World*, or Borges's short stories, is the product of a circulation of ideas between Europe and Latin America. European modernist authors, including translations of Joyce and Woolf, Albert Camus and Jean-Paul Sartre, were published in Latin America in

[37] The title of perhaps the most famous magical realist work, the Colombian Gabriel García Marquéz's *Cien años de soledad* (1967).

[38] Gerald Martin, *Journeys Through the Labyrinth: Latin American Fiction in the Twentieth Century* (London: Verso, 1989).

journals such as *Sur*, in Buenos Aires, edited by Victoria Ocampo.[39] Borges, who had spent much of his early life in Europe, was a regular contributor. The cheap franc meant that Paris was a popular destination for Latin Americans in the 1920s.[40] But Latin America had its own modernist cities, notably Buenos Aires, São Paulo, and Mexico City, which developed their own distinctive urban cultures. Mexico City, in particular, was a centre for artists such as Diego Rivera and Frieda Kahlo, as well as political refugees such as Trotsky.[41]

In other words, from the 1920s at least, Simmel's *Großstädte* were no longer confined to Europe. After 1945 Asian and African cities, as they freed themselves from colonialism, started to be the new big cities, outgrowing the European proto-types. However, the question now arises whether these can properly be called modernist cities, and, if so, what relationship do they bear to the European modern-ist city? This is a complex question raising issues of time, space, and form. But it is important, as these issues have a bearing on the original modernist cities, as well as their successors.

Fredric Jameson has argued for a 'singular modernity'; that is, one modernizing process: capitalism.[42] Different cities find themselves at different stages in the same process. Thus, Jameson has made a convincing argument that certain Third World cities now find themselves at the same point as European cities in the early nineteenth century, populated largely by rural immigrants.[43] It would therefore be possible to talk of realist cities, which then become modernist cities, and then postmodern cities, in which the complete commodification of society and consciousness has occurred. Other, post-colonial critics have argued that new nations represent not a stage in the same process, but alternative modernities.[44] They accuse Marxist critics, such as Jameson, of a teleological approach, which suggests that all cultures go through the stages experienced by the first capitalist nations. Third World cultures, according to this teleology, would simply reflect a European pattern, whereas in fact they have their own distinctive trajectories.

However, it is not clear that Jameson's argument is as determinist as it has been painted.[45] In order to reconcile the two positions, it is necessary to return to our balloonist Durouf, who is still travelling over enemy lines. He can see more and more

[39] See John King, *Sur: A Study of the Argentine Literary Journal and its Role in the Development of a Culture, 1931–1970* (Cambridge: Cambridge University Press, 1986).

[40] Gerald Martin, who argues strongly for the influence of *Ulysses* on magical realism, comments that there were more young Latin American writers in Paris in the 1920s than ever before or since; *Journeys Through the Labyrinth*, 136.

[41] There is undoubtedly more to be said also about modernism and the Japanese city between the wars.

[42] Fredric Jameson, *A Singular Modernity: Essay on the Ontology of the Present* (London: Verso, 2002).

[43] See Fredric Jameson, 'Third World Literature in the Era of Multinational Capital', *Social Text*, 15 (Fall 1986), 65–88. For a Marxist critique of this essay, see Aijaz Ahmed, *In Theory: Classes, Nations, Literatures* (London: Verso, 1992), 95–122.

[44] See Dilip Parameshwar Gaonkar (ed.), *Alternative Modernities* (Durham, NC: Duke University Press, 2001).

[45] For a reconsideration of the debates, see Ian Buchanan, 'National Allegory Today: A Return to Jameson', *New Formations*, 51 (Winter 2003–4), 66–79.

of Paris, as it spreads out behind him, but he is unsure of where the wind will take him. In this chapter, I have argued that one of the things that characterize the modernist city is an aesthetic that attempts to capture the city as a whole, but from a moving position, so that what is achieved is not a static totality, but one in constant motion, where the end-point remains unclear. The modernist city is characterized by its traffic, through and between cities. Thus, it cannot be conceived except as part of a network. Monet's Paris becomes visible through London, his London through Paris. City streets in Verlaine or Rimbaud's poetry are both London and Paris. Modernist movements existed in and between cities.

This is not to deny that London and Paris have their own, distinctive histories, their own relationships with the English and French countryside, with the nation, and indeed with the British and French empires. But it is the connectedness of the imagined city of modernism that gives it a recognizable aesthetic. The period of high modernism is usually seen as the 1920s, and is certainly over by 1945 in Europe. But the network of cities continues to grow. Post-colonial modernisms do not echo an earlier European pattern; they offer an aesthetic appropriate to a wider, global, more complex network. The term 'postmodernist' has been used to describe such new city narratives as Gabriel García Marquéz's *One Hundred Years of Solitude* (1967) or Salman Rushdie's *The Satanic Verses* (1988), but it is difficult to arrive at an agreed definition of what an aesthetic after modernism might be. The modernist cities that existed before and after the 1914–18 war are no longer with us, but their legacies continue to reverberate in the ways the world imagines the twenty-first-century cities, where now more than half the world's population lives.[46]

[46] See Mike Davis, *Planet of Slums* (London: Verso, 2006).

CHAPTER 36

PARIS: SYMBOLISM, IMPRESSIONISM, CUBISM, SURREALISM

ANDREW HUSSEY

DURING a period of less than a hundred years, roughly speaking the years that stretched from 1860 to 1939, Paris was without equal as the world capital city of modernity. During these years Paris grew denser and richer than ever before in its history. It was also unquestionably the most beautiful and important city in the world. Parisian ideas, style, and manners—in political revolution, literature, art, sex, fashion, and gastronomy—had an immeasurable influence across Europe, the New World, and the colonies. This status was underlined and enhanced by ambitious projects for urban planning and architecture which reinvented the classical ideals of harmony and precision and remade the city as a paradigm of order and beauty. So much of the world's present-day idea of the physical nature of Paris—the arcades, the hidden passages, the great boulevards, the flat, grey façades of apartment buildings, the elegant squares, the ornate and delicate street furniture of fountains, cobbles, and street lamps, the bridges and hidden and sometimes strange and secret gardens— dates from that hundred-year period that it commonly seems as if the nineteenth

century must have had a smooth and effortless movement towards progress in the name of modernity.[1]

The reality was, however, that Parisians encountered destruction and death on a scale that was entirely unprecedented in the city's history. In the years from 1860 onwards the city streets flowed with blood, mostly that of ordinary people who were locked into a deadly cycle of insurrection and counter-insurrection, in pursuit of the liberties claimed by the revolution but which were all too often obscured or ignored by venal politicians, vengeful aristocrats, or ambitious charlatans on the make.[2] This was to be the age of great technological progress, but it was also an age of great hatreds and contempt for the way in which commodities and capital were reshaping everyday life beyond the control of ordinary people. The convulsions of the age were not simply violent outbursts in the name of theoretical or abstract definitions of liberty, equality, and fraternity but rather volcanic eruptions of forces that were driven underground by politicians and power brokers but that could not be kept in check for long.

For this reason, the nineteenth and early twentieth centuries have attracted more historians, critics, and historiographers than any other period in the city's history.[3] Some of these, such as Karl Marx, found there in the most direct form the contradictory forces of thesis and antithesis—between progress and freedom—which explained, even if they did not quite justify, the very meaning of history itself. 'And so— to Paris, to the old university of philosophy and the new capital of the new world,' wrote the 25-year-old Marx to a comrade in Germany during his first exile in the city:

[1] An account of this defining period in the history of Paris modernity is provided in David Harvey, *Paris: Capital of Modernity* (New York: Routledge, 2003), 1–23. In this book Harvey stresses the crucial role of urban planning in the development of key modernist tropes in Parisian culture. An important parallel account of this trajectory, with the emphasis on the visual as well as the spatial development of the city, is to be found in T. J. Clark, *The Painting of Modern Life: Paris in the Art of Manet and His Followers* (New York: Knopf, 1985).

[2] The most vivid account of these convulsions, written from first-hand experience, was the series of lectures given at the Collège de France between 1838 and 1850. Michelet was at this point writing his seven-volume history of the French Revolution, but he interspersed his lectures with reflection on the betrayal of democratic ideals which was undermining French political life in the first part of the nineteenth century. Accordingly, he saw in the failure of the February (1848) Revolution the end of republican dreams of liberty. He relates the failure of democracy most directly to the history and development of Paris in the Cours de 1938, entitled 'Moi-Paris'. See Jules Michelet, *Cours au Collège de France, 1838–1848* (Paris: Gallimard, 1995), 80–95.

[3] Among the key texts cited for the purposes of this chapter are the following: Louis Chevalier, *Labouring Classes and Dangerous Classes*, trans. Frank Jellinek (London: Routledge & Kegan Paul, 1973); Rupert Christiansen, *Tales of the New Babylon: Paris 1869–1875* (London: Sinclair-Stevenson, 1994); Priscilla Parkhurst Ferguson, *Paris as Revolution: Writing the Nineteenth-Century City* (Berkeley: University of California Press, 1994); Alistair Horne, *The Fall of Paris: The Siege and the Commune, 1870–1871* (New York: St Martin's Press, 1965); Joanna Richardson, *The Bohemians: La Vie de Bohème in Paris 1890–1914* (London: Macmillan, 1969); and Roger Shattuck, *The Banquet Years: The Arts in France, 1885–1918* (London: Faber and Faber, 1957).

'[this is] the nerve-centre of European history, sending out shocks at regular intervals which shocked the world'.[4]

Writing in the 1930s, Walter Benjamin, another German exile in Paris and an unruly disciple of Marx, devoted hundreds of pages of notes to deciphering the secrets of the city. His key notion was that this was to be found in tracing the movement and meaning of places and objects in the city against the unfolding background of everyday life in Paris. It was in the interplay between ordinary people and the city that was being created around them, Benjamin argued, that the past, present, and future of the city could be glimpsed dialectically. Once this much was understood, or rather experienced, the Parisian nineteenth and early twentieth centuries would be revealed as the most dynamic and convulsive period in human history.[5]

It would be impossible to begin any discussion of this period without mentioning the remodelling of Paris which took place in the mid- to late nineteenth century under Baron Haussmann. The most prominent aspect of Haussmann's legacy to contemporary Paris is not, however, his contribution to making the traffic flow, or ensuring that the government held political and military control over the 'storm-centres' of the eastern part of the city, but rather the establishment of a common style for the apartment blocks that were built along his miraculously straight roads. The aim was to create an effect of grandeur through the uniformity of decoration and a long horizontal perspective, fixed by the line of wrought-iron balconies running together down the street. Individuality was much less important than the impression of the street as a continuous and harmonized sequence. The interior decor of a typical bourgeois apartment was, in contrast, heavy and rich, often loaded with Romano-Byzantine trappings or Orientalist paraphernalia. This pointedly contradictory aesthetic—a delicate interplay between the severity of grey and austere street decoration and domestic opulence—is still a defining feature of Francophone urban planning, from Rabat to Bucharest. In mid-nineteenth-century Paris, it not only represented a new form of modernity in which urban spectacle took prominence over individual style, but also indicated, in its refinement of the art of paradox, the deep uncertainty which lay at the centre of Louis Napoleon's regime.

This also helps to explain the deep mediocrity of the architecture that is termed 'Second Empire'. The city built by Haussmann was both superb and chilling. But this was a triumph of organization and technology over the past. The architectural design of churches and other public monuments was, however, mainly backward-looking when it was not simply a copy or a pastiche of past styles. One of the best places to see

[4] Letter from Karl Marx to Arnold Ruge, in the *Deutsch-Französische Jahrbucher* (1844); first pub. in English in *Writings of the Young Marx on Philosophy and Society*, ed. and trans. Loyd D. Easton and Kurt H. Guddat (New York: Doubleday, 1967).

[5] For a lucid explanation of Benjamin's method, see the Translators' Foreword by Howard Eiland and Kevin McLaughlin in Walter Benjamin, *The Arcades Project* (Cambridge, Mass.: Harvard University Press, 1999), pp. xi–xiv. For further explanation of Benjamin's historical method, see also Martin Jay, *Downcast Eyes: The Denigration of Vision in Twentieth-Century French Thought* (Berkeley: University of California Press, 1994), 114–18.

the 'Second Empire' at work in all its monumental and strangely impressive vulgarity is from the doorway of Brentano's bookshop on the avenue de l'Opéra looking at the new Opéra, built by Charles Garnier. The avenue itself is magnificent and inhuman, too long to walk without boredom or fatigue and too wide to cross without a serious risk of being run down. Crowned by the Opéra in all its absurd and ornate exoticism—a Romano-Byzantine temple crammed into a busy city intersection—it conveys all the grandeur, ambition, and folly of the Second Empire. It seems all the more appropriate that its construction was not finished until the Empire had collapsed, by which time even its architect had to pay for his own seat.[6]

Historians of the Parisian nineteenth century are often shocked by the extreme nature of violence in the name of justice which, from the revolutionary days of 1830 to 1848 to the Commune of 1870, brought fire, gunshots, and more dead bodies to the city streets. This was an era of plotters, pamphleteers, and ruthless utopian fanatics. Parisian political violence was, in this sense, only the demon brother of the wild and unstoppable capitalist energy which coursed through the city itself, through banks, businesses, theatres, brothels, and cabarets. It was an age of traumas. From the Commune to the horrors of First World War battlefields, the diseases that ravaged the city in the war's aftermath, the riots and near-civil war of the 1930s, to the Nazi Occupation of the 1940s, Parisians were all too often betrayed and humiliated by their political leaders, who told them lies and were indifferent to their suffering. The revolutionary promises of the working and dangerous classes of the nineteenth century were lost in the clamour of argument between a Communist Party which for far too long into the century saw Moscow as the only beacon of hope for humanity and the various parties of the Right, who embraced quietism, cynicism, and occasionally fascism in the name of a republic they did not really believe in. Paris was the world capital of ideas and ideologies and also a place where intellectuals of all sides made excuses for some of the greatest crimes ever committed in the name of advancing human history. This period also saw the rise of the avant-gardes, from Impressionism, to Symbolism, to Cubism, and to Surrealism. These groups thought of themselves as providing cultural and political resistance to the cruelty of the historic forces that at times threatened to engulf the city. Most notably, they sought not only to remake the art forms that produced them—whether art or poetry—but also to offer a new, truly democratic and redemptive version of human existence. Their 'modernity' was predicated upon this impossible utopian promise as well as their eventual and inevitable ultimate failure.[7]

The term 'le Symbolisme', referring specifically to a form of poetry, properly entered the French language on 18 September 1886 in an article published in *Le Figaro* newspaper of that day. This was in the form of the famous 'Manifeste

[6] The architecture and urbanism of Paris during the Second Empire are convincingly explored as motifs of political failure in Patrice Higonnet, *Paris: Capital of the World* (Cambridge, Mass.: Harvard University Press, 2002), 177–222.

[7] It is for this reason that Roger Shattuck in *The Banquet Years* describes the 'truculent stance' of the Eiffel Tower as the most ambiguous 'monument to Modernism'; Shattuck, *The Banquet Years*, 14.

Symboliste' drawn up by the critic and poet Jean Moréas (1856–1910), who was up until this point known in Parisian artistic circles for his two collections of sonnets and lyrics (*Les Syrtes*, 1884, and *Les Cantilènes*, 1886) and his energetic contribution to a variety of avant-garde groups known variously as the Hydropathes and the Zutistes. The publication of the 'Manifeste Symboliste' in *Le Figaro* was a deliberately provocative incident. *Le Figaro* was known at this stage in its history for its literary criticism; politics, as was the case with most newspapers and magazines under the Second Empire, were notable by their absence. There is a case to be made that Moréas's 'Manifesto', which would go on to influence work in the visual arts and music, was in its own way a carefully calibrated political message.[8]

Moréas laid out the technical aspects of the poetic style that he now termed 'Symbolist'. The chief characteristic of this form of poetry was that it prized feeling over meaning. In other words, rather than aiming to convey precise moral or philosophical messages as had largely been the case with traditional forms of poetry, the Symbolist poet sought to capture the flux of moods and emotions in all their hazy imprecision. To this extent, 'Symbolist poetry' already existed long before Moréas wrote his 'Manifesto'. The poems of Paul Verlaine, Arthur Rimbaud, Jules Laforgue, and Henri de Régnier, to cite the most well-known names, had already explored this previously uncharted territory. Their work was published alongside the other notable Symbolists of this generation in journals such as *Le Mercure de France*, *La Conque*, *La Revue Blanche*, and *La Revue Indépendante*, among others.[9] The singular significance of Moréas's article was that he sought to separate the Symbolists from the self-styled poets who called themselves 'décadents' (many of whom were in fact the same figures). Symbolists and 'décadents' were drawn together in literature and philosophy in their arguments for novelty against boredom, or horror against the banalities of beauty. Their heroes were Baudelaire, Rimbaud, and every other writer who was for revolt and against orthodox society. The diverse and apparently unrelated writings of J. K. Huysmans, Lautréamont, or Stéphane Mallarmé—none of whom were in the strict sense 'décadents' in the sense that they belonged to no single movement—were all drawn together by this same purposeful revolt.

Moréas also identified Charles Baudelaire (1821–61) as the precursor of Symbolism. This was less because of his taste for blasphemy and revolt and more for his poetic theory of 'Correspondances'. This was essentially a poetic theory of the interrelation of the senses sometimes called 'synaesthesia'. For Baudelaire, it followed from this

[8] The political aspect of the history of Symbolism is explored in Jennifer Birkett, 'Disinterested Narcissus: The Play of Politics in Decadent Form', in Patrick McGuinness (ed.), *Symbolism, Decadence and the Fin de Siècle* (Exeter: University of Exeter Press, 2000). For wider-ranging histories of Symbolism and the period, see Jennifer Birkett, *The Sins of the Fathers: Decadence in France and Europe, 1870–1914* (London: Quartet Books, 1986); Barbara Johnson, 'The Liberation of Verse', in Denis Hollier with R. Howard Bloch et al. (eds), *A New History of French Literature* (Cambridge, Mass.: Harvard University Press, 1989), 798–801; ead., *Défigurations du langage poétique* (Paris: Flammarion, 1979); Henri Lemaître, *La Poésie depuis Baudelaire* (Paris: Armand Colin, 1975); and Clive Scott, *Vers Libre: The Emergence of Free Verse in France, 1886–1914* (Oxford: Oxford University Press, 1990).
[9] For the chronology and context of this period, see Maurice Caillard and Charles Forot (eds), *Les Revues d'avant-garde: 1870–1914* (Paris: Jean-Michel Place, 1995).

initial perception that all external objects were expressions of an essential, possibly spiritual essence. The key significance of this insight for the Symbolist generation was that this vision or perception of a world in which all things are complementary to each other and even interchangeable led to an extension of the possibilities of metaphor and simile. The Symbolist poet, following in Baudelaire's footsteps, was acutely aware that language itself, in all its complexity and rich musicality, was also an object. He therefore prized 'fluidité'—meaning the evocation of indeterminate sensations or moods—over static, fixed meaning, which was regarded as a false illusion of reality. This was Baudelaire's first definition of modernity as articulated in his essay 'Le Peintre de la vie moderne' ('The Painter of Modern Life').[10] In this respect, the Symbolist poet can be seen as a reaction against the nineteenth-century fascination with realism and Naturalism in fiction, as well as the Hugolien desire to make poetry the binding myth of nation and nationhood. (Hugo's death in 1885 marked for the Symbolist generation a violent rupture with outmoded forms of expression.)

The Symbolist poet par excellence is of course Stéphane Mallarmé (1842–98), whose career traversed the political and artistic convulsions of a volatile age but whose poetry was deliberately and notoriously obscure. A commonly used term when referring to Mallarmé is 'hermetic': sense is so finely occluded in the dense textual web of some of Mallarmé's poems that they defy explanation or explication. Mallarmé's poetry in fact begins in philosophy: he was, at least in his early career, a close reader of both Hegel and Schopenhauer. In Mallarmé's early poetry there is accordingly a fascination with the possibility of a realm of pure spirit or mind (taken from Hegel) and a preoccupation with the illusory nature of being (borrowed from Schopenhauer). Mallarmé's first poem of any significance, published when he was 24 years old, was 'L'Azur', and this poem betrays an appalled consciousness of the impossibility of attaining any form of spirituality through the empty, infinite blue wastes of the sky. Mallarmé returned to this image—if it indeed can properly be called an image—throughout his career, endlessly refining and redefining it. Ultimately, he developed the notion of the principle underlying the universe as what he called *Le Néant* ('Nothingness')—that is, pure spirit emptied of all physical or material content. He sometimes identified with this principle so intimately that he came close to losing all sense of himself. He reported in his correspondence that he was unable to realize that he existed as a genuine, physical presence unless he occasionally verified this with a mirror.[11]

[10] Baudelaire wrote: 'La modernité, c'est le fugitif, le transitoire, le contingent, la moitié de l'art, dont l'autre moitié est l'éternel et l'immutable' ('Modernity is the fleeting, the transient, the contingent; it is the one half of art, the other being the eternal and the immutable') (Charles Baudelaire, 'Le Peintre de la vie moderne', in *Œuvres complètes*, ed. Y. G. Le Dantec (Paris: Gallimard, 1961), 1163).

[11] For discussions of this aspect of Mallarmé's work, see Jay, *Downcast Eyes*, 176–80; Suzanne Bernard, *Le Poème en prose de Baudelaire à nos jours* (Paris: Nizet, 1959); Malcolm Bowie, *Mallarmé and the Art of Being Difficult* (Cambridge: Cambridge University Press, 1978); and Johnson, *Défigurations du langage poétique*.

The poet's task began when the philosopher abandoned the pursuit of self as a pure abstraction. In other words, having annihilated the universe with this destructive insight into the pure nothingness beyond the material domain, the poet had to reconstruct the world again in language. This language was not mere imitation of the world—which is the function of metaphor—but instead the construction of an autonomous work of art which, as a beautiful object, is it own justification. This was indeed Mallarmé's own definition of the Symbolist at work in poetry. Much of Mallarmé's poetic work remains unfinished. Appropriately, one of his chief techniques as a poet was to avoid directness of meaning: completion of a poem was therefore as much anathema to him as was the conventional use of syntax or vocabulary. Instead, Mallarmé's writing remains necessarily incomplete because that is the very nature of its function. Perhaps his most famous poem is 'Un coup de dés n'abolira jamais le hasard', which was published posthumously in 1914. With its elliptical syntax, careful typography, and breaking of the contract between reader and poet—which depends on sense rather than music, visual effects and/or simply noise—this is certainly the poem that would have the greatest influence on poetry in the twentieth century.

The art movement called 'Impressionism' is, in many ways, the visual corollary of the Symbolist tendency in poetry in philosophy. The term itself was coined as a satirical joke by the critic Louis Leroy, who, in the pages of the journal *Le Charivari* on 25 April 1874, described Claude Monet's painting *Impression: soleil levant* as an unfinished 'impression' of a potential painting. This insult was taken up by a generation of painters whose loose affiliation to the movement was defined by their collective ambition to direct painting away from the fixed, static image towards flux, immediacy, and the interminable play of light. Among those who at some point defined themselves as Impressionists were Degas, Cézanne, Caillebotte, Pissarro, Manet, Monet, Sisley, Renoir, Berthe Morisot, Bazille, and Guillaumin. Monet, Sisley, and Morisot are often considered to be the most consistent avatars of Impressionism in that their work is primarily concerned with light, shadow, and spontaneity. It is this version of Impressionism which has impinged on the public perception of Impressionism as primarily an art of the everyday. There is, however, a harder, more theoretical, even ideological force at work in the paintings of Manet and Degas which has to do with capturing the movement of everyday life in a way that disrupts and subverts the iconic status traditionally given to art. Impressionism, in other words, is not simply about painting but about the politics of representation in every sense.[12]

The painting of the Impressionists first entered the Parisian consciousness over a decade earlier, in 1863, at the so-called Salon des Refusés. This was an exhibition, organized on the authority of Napoleon III, of all those who had been refused an exhibition space in the annual exhibition of the Académie des Beaux Arts de Paris. Traditionally, the Académie upheld classical standards of composition and allegorical

[12] See Clark, *The Painting of Modern Life*, 12–21.

painting which could be traced to their origins in the seventeenth century or even further back. The emphasis was on polished and refined works that provided a photographic version of reality, while at the same time privileging mythical, religious, and antique themes.

The work of the Impressionists, and other related artists such as Courbet, was a deliberate assault on this sensibility. The aim was to be 'modern' not in the sense that Impressionist paintings were 'realist' or provided a 'realistic' version of life but in the sense that they sought to convey the movement and energy of modern life in both form and content. Thus, the most scandalous painting at the Salon des Refusés was Édouard Manet's *Déjeuner sur l'herbe*, which features a nude woman in the company of two fully dressed contemporary male figures. Manet was being deliberately provocative: his aim was to shatter the closeted hypocrisy and prudery which made the naked human form acceptable in 'Academic' painting but treated it as a severe transgression when it occurred in an everyday setting. To this extent, Manet's *Déjeuner sur l'herbe* has often been considered a foundational work of what came to be called 'modern art'.

The group of artists gathered around the flag of modernity coalesced properly into a movement with the foundation in 1873 of the Société Anonyme des Artistes, Peintres, Sculpteurs, Graveurs. This was partly in response to the authorities' refusal to set up a Salon de Refusés in 1867 and 1872. Louis Leroy's attack on Manet was also an attack on the exhibition set up by these artists in 1874 at the house of the photographer Nadar. Despite facing scepticism and hostility, these Impressionist artworks had a straightforward appeal for a public among whom were many who understood that their own era, and indeed their own physical environment, was undergoing seismic changes that could not properly be acknowledged, understood, or expressed in 'classical' painting.[13]

To a large extent Impressionist painting is defined by technique: heavy strokes of paint, the separation of individual colours, a heavy physical texture as wet paint is applied onto wet paint, and paintings made outdoors in *plein air*, which means that light and shadow are subject to variegations in shade and meaning. These techniques were not necessarily all used at once, and the Impressionists were not the first to discover them. But they were the first to integrate them consistently into the making of their art. More to the point, the collective aim of the Impressionists was to depict modern life as a complicated matrix of gestures, movements, signs, and symbols, all of which expressed meaning through detail.[14] For this reason the Impressionists not only introduced new, bolder techniques into art but also disrupted the compositional structures of painting. For example, instead of foregrounding the subject of a painting, the Impressionists relaxed the boundaries between subject and background,

[13] Convincing histories of the Impressionist movement can be found in Robert L. Herbert, *Impressionism: Art, Leisure and Parisian Society* (New Haven: Yale University Press, 1988); Charles Moffet, *The New Painting: Impressionism, 1874–1886* (San Francisco: Fine Arts Museums of San Francisco, 1986); James H. Rubin, *Impressionism* (London: Phaidon Press, 1999); and Gary Tinterow and Henri Loyrette, *Origins of Impressionism* (New York: Metropolitan Museum of Art, 1994).

[14] This is argued in Anthea Callen, *Techniques of the Impressionists* (London: Orbis, 1982).

expressing, as they saw it, modern life as a totality composed of fragments rather than as a source of allegorical or mythical meaning. This was, in part, a reaction against the new technology of photography, which challenged painters by seemingly doing their work for them in terms of providing a more direct 'reflection' of reality. The Impressionists sought to move beyond the limitation of the fixed image by introducing subjective consciousness into the work. Impressionism was not so much then a question of technique as of thinking a way into the philosophical snares of modernity.

As T. J. Clark has pointed out, there was clearly a political aspect to the Impressionist movement. Clark focuses especially on the destruction and reconstruction of Paris, under the orders and according to the plans of Baron Haussmann, as the catalyst for a painting of modernity which reflected that modernity not as a form of utopianism but rather as a historical force with a specifically ideological content.[15] Clark is correct to the extent that while all of the painters of the Impressionist generation refused to succumb to the spell of false nostalgia for a lost, folkloric Paris, they also recognized that Haussmann's new Paris, emerging out of the real and metaphorical wreckage of the city, was also a myth, albeit a myth in the service of a new economic imperative (capitalism) which would henceforth shape the city. For this reason, Impressionism is a precursor of later twentieth-century avant-garde art movements (such as Cubism, Dada, and Surrealism, most obviously), all of which positioned themselves explicitly against the narratives of progress and development on the nineteenth-century capitalist model.

It is therefore no surprise to find that artists in the late nineteenth and early twentieth centuries began turning away from Europe and finding inspiration in so-called 'primitive art'—work produced by African, Micronesian, and Native American cultures. One of the liberating discoveries that artists made when exploring this work was a new form of visual language that did not depend on the fixed perspective which had hitherto prevailed in Western art. The Impressionists had also stumbled on this insight and this is what motivated their pursuit of a world in perpetual motion. The Impressionists were aware that all visual forms of representation are in essence a construct that deforms and refracts reality. The later Cézanne took this insight to an extraordinary length in the way in which he reduced painted images to individuated spaces that he then reassembled to make a complete new image. Similarly, he began the process of reducing natural shapes to spheres and cones which would result in Cubism.[16]

[15] Clark, *The Painting of Modern Life*, 6.

[16] For an account of the development of Cubism and its relation to the urban topography of Paris, see Nicholas Hewitt, 'Montmartre: Artistic Revolution', in Sarah Wilson (ed.), *Paris: Capital of the Arts, 1900–1968* (London: Royal Academy of Arts, 2002), 22–38; see also David Cottington, *Cubism and its Histories* (Manchester: Manchester University Press, 2004); Robert Rosenblum, *Cubism and Twentieth-Century Art* (New York: Harry N. Abrams, 1966); Douglas Cooper, *The Cubist Epoch* (London: Phaidon Press, 1971); and Christopher Green, *Cubism and its Enemies: Modern Movements and Reaction in French Art, 1916–1928* (Ithaca, NY: Yale University Press, 1987).

The term 'Cubism' was first used in 1908 by the art critic Louis Vauxcelles in the journal *L'Art et la Vie*, in the course of a description of a picture by Georges Braque. The real force behind Cubism at this stage was, however, Pablo Picasso, who collaborated closely with Braque on the development of what was called Analytical Cubism. This period lasted for about four years. It began in 1907 with Picasso unveiling his painting *Les Demoiselles d'Avignon*, which left his literary admirers such as André Salmon and Max Jacob lost for words to describe this new form of art. Braque and Picasso had set out to find a completely new form of expression in painting. They eschewed colour for shapes and forms, edging always towards abstraction and leaving only traces of the real world as clues and signposts to where they were heading. There were obvious parallels with the poetry of Mallarmé, which also abolished concrete materiality and replaced it with pure form. As in the poetic work of Mallarmé, the Cubist project had a spiritual dimension in the sense that it aimed at an impossible abstraction which both denied and transformed meaning in the material world. This logic was then pursued in the next stage of the development of Cubism, which was called Synthetic Cubism and which dates from about 1912 onwards. This technique was a reversal of Analytic Cubism, which sought to reveal the plasticity of objects by separating and analysing their form. Instead, Synthetic Cubism was a type of collage which pushed objects together to emphasize their essential mutability. With the use of mixed media and 'found objects', this was really a step beyond painting, a gesturing towards sculpture and music as art forms which depended on the mutability of the surface.

It is from this period onwards that we can trace also a literary Cubism and the influence of Symbolism and Cubism in music and text. In music the first performances in April 1902 of Debussy's opera *Pelléas et Mélisande*, based on the Symbolist play by Maurice Maeterlinck, introduced a new spirit of adventure into the traditional linear structures of operatic theatre. First responses ranged from the lukewarm to the openly hostile (Maeterlinck himself was so incensed by Debussy's choice of the Scots American singer Mary Garden that it provoked him to violence), but in its rich and elaborate forms (although they were clearly indebted to Symbolism) it also represented an original way of conceiving musical theatre not merely as spectacle but as living poetry, and as such it was a genuinely new departure. A less portentous but no less subversive note was struck in the popular novel with the appearance in the same year of Colette's *Claudine à Paris*, which recounted the mildly sapphic adventures of Colette herself, a figure who was one of the most energetic and daring lesbians in a largely male-dominated city.

For a variety of reasons, literary critics have often seen 1913 as the turning point in the early history of the century, the year when the twentieth century really began. This was the year in which Marcel Proust's *Du côté de chez Swann* was published, André Gide was putting the finishing touches to his first proper masterpiece, *Les Caves du Vatican*, and the 33-year-old poet Guillaume Apollinaire produced his collection *Alcools*. Each of these works, following on from the experiments of Impressionists, Symbolists, or Cubists, seemed to announce a new sensibility which prized the subjective vision of the individual over the fixed and immobile narratives of the nineteenth century, which from Hugo to Zola were predicated on

the omniscient presence of the author. (This 'new spirit', in part at least, temporarily blinded many readers to the homosexuality of Gide and Proust.)

For Léon-Paul Fargue, the meaning of modernity was to be literally in the streets of Paris: the city was a dream world made up of intricately nuanced and related sensations. This way of seeing was close to Symbolism, but Fargue was also in real life an indefatigable walker in the city and his Paris is intensely alive with what Baudelaire called the 'anarchy of detail' to be found in a city street.[17] For Apollinaire, modernity meant doubting the authenticity of all previous literary languages. The poems of *Alcools*, like the Cubist painting which was contemporaneous with them, did not describe the world in conventional language (or, in the case of painting, describe the world with representational figures) but instead tried to reshape the world through language. Apollinaire, who had been born in Rome to a Polish mother, centred his poetic vision on Paris, where he had arrived penniless in 1898. The cityscape he evoked as a newcomer to the city was no longer recognizable as the homely clatter of 'Old Paris'. Rather, Apollinaire described a city of margins, industrial landscapes, wrecked buildings, and workers' quarters. Each section of the city was alive with its own ghosts and myths:

> Maintenant tu marches dans Paris tout seul parmi la foule
> Des troupeaux d'autobus mugissants près de toi roulent
> L'angoisse de l'amour te serre le gosier
>
>
>
> Aujourd'hui tu marches dans Paris les femmes sont ensanglantées
> C'était et je voudrais ne pas m'en souvenir c'était au déclin de la beauté.
>
> (Now you are walking in Paris all alone among the crowd
> Bellowing herds of buses roll past you
> The anguish of love catches at your throat
>
>
>
> Today you are walking in Paris the women are stained with blood
> It was and would I could forget it was at the twilight of beauty.)[18]

All of this is determinedly anti-realistic and constructed with reference to myth, mythology, and the geography and history of Europe, and indeed Christendom. Paris is the capital of modernity but, as is the case not much later with T. S. Eliot's *The Waste Land* (1922), the very meaning of modernity is itself a textual as well as a philosophical problem. Most crucially, the hallucinatory energy and distorted logic of the poem perfectly capture the mood of French political and cultural life at the end of 'the beautiful epoch', when the world was spinning too quickly off its axis and Paris, once again, was heading towards war.

The word 'civilization' had been a guiding article of faith among Parisians since the Enlightenment, and civilization was considered to be an integral quality in French life: a non-negotiable value on a par with liberty, equality, or fraternity. The revolution had supposedly been made for all citizens in the name of these values. The war had, however, cruelly exposed the supposedly noblest values of humanity as a lie. The

[17] This was very much the Paris of the early twentieth century as recalled by Léon-Paul Fargue in his *Le Piéton de Paris* (Paris: Gallimard, 1939).

[18] Guillaume Apollinaire, *Alcools* (Paris: Gallimard, 1987), 10.

capitalist 'civilization' of the twentieth century, the great project of progress and improvement which flowed directly out of the republican belief in man-made utopias, seemed to many to have produced little more than better machines for the mass killing of workers to protect vested interests.

Such rhetoric was common to all parties of the Left throughout the 1920s. It was also of central importance to the burgeoning avant-garde groups who were beginning to emerge as the most powerful and influential dissident voices in Paris in the aftermath of the First World War. The most strident of these voices during and immediately after the war was that of the Dadaist movement, which had been founded in Berlin and Zurich in 1916 and was brought to Paris in 1918. Dada (the name was essentially meaningless, although it could mean anything from a rocking horse to 'Daddy') was conceived as a negation of the entire system of moral values underpinning Western thought. It opposed reason, order, meaning, and hierarchies in equal measure; it was in favour of limitless irrationalism, transgression, and anarchy. It was not meant as an art movement but as a political weapon, carefully calibrated, loaded, and aiming directly at the beating heart of the rotten capitalist order which, for the Dadaists, was responsible for the murder of millions. When Dada arrived in Paris, in the form of the Romanian poet Tristan Tzara, it found a ready audience among a generation of young men who had grown up despising everything around them.

Among those who were listening most closely to Tzara were the likes of Louis Aragon, André Breton, and Philippe Soupault, all young conscripts who had hated the war and were now setting out on careers as poets and intellectuals with a programme for revenge against the society which had tried to kill them. The Dadaist group such as it was (Tzara and a few allies) held performances, organized debates, and published freely. Soupault, Breton, and Aragon took it upon themselves to found the journal *Littérature* to publish this new poetry of negation. As the negative force of Dada burnt itself out, its spirit was carried over into a new movement, 'Surréalisme', founded by Breton, Soupault, and Aragon, which would remain faithful to Dada's destructive sensibility but this time with the aim of founding a new society.

The word 'Surrealism' had actually been coined in 1917 by Guillaume Apollinaire to describe his proto-Dadaist 'play' *Les Mamelles de Tirésias*, which had ended in a mini-riot in the minuscule space of the Salle Maubel in Montmartre. Under the leadership of Breton, the Surrealists announced a programme for reinventing society according to the laws of the unconscious, replacing reason with desire. Their aim, following from this, was no less than the transformation of the totality of human existence—the revolution of the mind which the poet Arthur Rimbaud had called for a generation earlier amid the wreckage of the Commune.[19] The Surrealist movement

[19] The following are among the most precise and convincing accounts of Surrealism: Anna Balakian, *Surrealism: The Road to the Absolute* (Chicago: University of Chicago Press, 1986); Willard Bohn, *The Rise of Surrealism: Cubism, Dada, and the Pursuit of the Marvelous* (New York: Albany, 2002); Mary Ann Caws, *The Poetry of Dada and Surrealism: Aragon, Breton, Tzara, Éluard, and Desnos* (Princeton: Princeton University Press, 1970); Whitney Chadwick, *Women Artists and the Surrealist Movement* (London: Thames & Hudson, 1985); Matthew Gale, *Dada and Surrealism* (London: Phaidon Press, 1997); J. H. Matthews, *Toward the Poetics of Surrealism* (Syracuse, NY: Syracuse University Press, 1976);

was properly announced to the world in 1924 with the First Manifesto of Surrealism by André Breton. This document emphasized the primacy of the unconscious in all Surrealist activity.

Le surréalisme repose sur la croyance à la réalité supérieure de certaines formes d'associations négligées jusqu'à lui, à la toute-puissance du rêve, au jeu désintéressé de la pensée. Il tend à ruiner définitivement tous les autres mécanismes psychiques et à se substituer à eux dans la résolution des principaux problèmes de la vie...

(Surrealism is based on the belief in the superior reality of certain forms of previously neglected associations, in the omnipotence of dream, in the disinterested play of thought. It tends to ruin once and for all other psychic mechanisms and to substitute itself for them in solving all the principal problems of life.)[20]

In addition to Breton, Aragon, and Soupault the original Surrealists included Paul Éluard, Benjamin Péret, René Crevel, Robert Desnos, Pierre Naville, Roger Vitrac, Simone Breton, Gala Éluard, Max Ernst, Man Ray, Hans Arp, Georges Malkine, Michel Leiris, Georges Limbour, Antonin Artaud, Raymond Queneau, André Masson, Joan Miró, Marcel Duchamp, Jacques Prévert, and Yves Tanguy. Later on the group would include Giorgio de Chirico, Salvador Dalí, Alberto Giacometti, Grégoire Michonze, Luis Buñuel, René Char, Georges Sadoul, André Thirion, and Maurice Heine. Appropriately enough, the Surrealists seized on Paris as the battleground for what they saw as the true meaning of modernity, where they would oppose the rational demands of the 'machine civilization' with dreams, poems, and plays. In his short but dense compendium of Surrealist experiences in the city Le Paysan de Paris ('The Paris Peasant'), Louis Aragon called for a new mythology of the city which would install it as the capital of the new utopia of untrammelled subjectivity and vision. This was a ludicrously grandiose demand (and as such entirely typical of the Surrealist groups as a whole). But Aragon did nonetheless compose an effective and convincing picture of Paris at the cusp of the early twentieth century, depicting it as a place where capitalism stood opposed by all those who still dared to dream of freedom. Above all, Aragon, like the other Surrealists, understood its human scale to be the defining quality of Parisian urban experience.

The Surrealists were obsessed with images and objects which were just about to become out of date and lose their original meaning or function. They endlessly patrolled the passages of the Right Bank, now a network of dusty arcades and passages with greenhouse roofs which ran between Haussmann's great boulevards and which were still cluttered with specialist shops, selling anything from a truss to a mannequin. The passages are still pretty much intact in this form: you can still walk for hours without ever entirely being sure where you are in the city or what you are looking for. This was indeed the whole point about Surrealist activity as it was

C. B. Morris, *Surrealism and Spain, 1920–1936* (Cambridge: Cambridge University Press, 1972); and Maurice Nadeau, *Histoire du Surréalisme* (Paris: Gallimard, 1947).

[20] André Breton, *Premier Manifeste du Surréalisme* (Paris: Jean-Jacques Pauvert, 1962), 40.

theorized and practised in the early 1920s: to create visionary experience out of the everyday, to make the city, in the formula of André Breton and Philippe Soupault, a 'magnetic field' where the detritus of modern life could be magically transformed through the power of the individual mind. One of the best and most famous photographs of André Breton was taken in the early 1920s; it shows him standing in a characteristically imperious pose on the boulevard Montparnasse, just in front of the *bar américain* of the restaurant La Coupole. The photograph is fascinating for a variety of reasons—it is, for example, despite the much-vaunted Surrealist faith in the poetry of the urban dialectic, one of the few portraits of Breton in a Parisian street. Most importantly, it captures him at the outset of the Surrealist adventure, before fame and politics had wearied him.

This precise geographical setting also signals the post-war shift from Montmartre to Montparnasse as the centre of Parisian pleasures and literary politics. Most importantly, the photograph places in close proximity two emblems of Parisian life in the 1920s: the flashy and newly fashionable *bar américain*, and a 'hero' of the revolutionary avant-garde. Despite the close and frequent contact, the cultural distance between these two icons could not have been greater: Breton was a determined enemy of all forms of American culture in Paris; the *bar américain*, in contrast, not only was a new invention in the city but introduced new, freewheeling forms of behaviour to Paris (jazz, new dances, exotic cocktails, and so on) which, even at this early stage in the twentieth century, were identified by many Parisians as the enemies of the city's traditions.

The common wisdom is that the Surrealist movement was destroyed by the coming of the Second World War. There is a lot to be said for this argument. Certainly, although Surrealist-inspired artists continued to write, paint, argue, and produce journals, it is also true that Surrealism, as it became more truly international, had lost both its headquarters in Paris and the momentum and prestige it had acquired under Breton's leadership. The war not only disrupted the lives of Surrealists, forcing them into exile or (in some cases) driving them towards suicide, but also challenged the political credentials of Surrealism as a real revolutionary force in human existence—rather than, as its enemies had it, a fetishized artistic technique. The end of Parisian Surrealism can then be read as marking the beginning of the end for the avant-gardes of modernity. If this is right, then the break-up of Surrealism marks the end-point of a process that had begun in the nineteenth century, with the convulsions of Symbolism and Impressionism—movements which had sought to reinvent language and the visual arts at the high point of modernity, and which prefigured both Cubism and Surrealism as movements which, in turn, sought to remake the totality of human existence. What all of these movements had in common—and what truly defined them as 'modernist' adventures—was that all transcended their origins in poetry or art and aimed at a completely new way of living for all social classes. But for all their promises of redemption the avant-gardes only ever belonged to an elite and failed time and again to connect with the masses. This indeed is how they heralded the fragmented perspectives of the coming postmodern age.

CHAPTER 37

...

BERLIN: EXPRESSIONISM, DADA, NEUE SACHLICHKEIT

...

RICHARD J. MURPHY

EXPRESSIONISM

...

'BERLIN for us was despicable, corrupt, metropolitan, anonymous, gigantic, seminal, literary, political, painterly... in short, a hellhole and paradise all in one.'[1] This observation by Hans Flesch-Brunningen encapsulates the significance of Berlin as a centre of modernity for so many of the young artists and writers during the so-called Expressionist decade of 1910–20. At that time Berlin exerted a more powerful attraction than scarcely any other city upon aspiring poets, dramatists, painters, photographers, film-makers, and artists of all kinds and from many different countries. For Berlin, as Flesch-Brunningen goes on to say, was a place where they would 'read poems aloud in cabarets' and 'print everything that is new and modern'.[2]

[1] Hans Flesch-Brunningen, quoted in Wilhelm Haefs, 'Zentren und Zeitschriften des Expressionismus', in York-Gothart Mix (ed.), *Sozialgeschichte der deutschen Literatur* (Munich: Hanser, 2000), 440–1. All translations are mine unless otherwise indicated.
[2] Ibid.

Despite Berlin's embodiment of modernity and its fascination with everything new, it seems that even here Expressionism remained very much a subculture, and that for most of this decade the broader public and the commercial media in the city scarcely registered the existence of the Expressionist groups, other than as a minor or marginalized artistic and intellectual avant-garde.[3] Yet even in this respect Berlin was crucial for the development of just such subcultures in providing a counter-cultural network. And rather than simple cosmopolitanism, or the glittering salons of previous generations, it offered a variety of public spaces and public spheres, such as the cafés, cabarets, and clubs in which circles of writers and artists could perform their pieces, exchange their ideas, engage with a form of community, and cultivate a group identity. Furthermore, Berlin offered unprecedented access to a range of minor presses—no less than 130 of the publishing houses in which Expressionist authors published their books were situated in Berlin—but also periodicals and magazines, in which the new generation of writers were readily able to publish their experimental texts, air their radical concepts, and issue their manifestos.

Such was the city's dominance at this time that we might think of Berlin, as Thomas Anz has suggested, as the 'capital city of the modern'.[4] But it is worth noting that this was a very different notion of 'the modern' from that which had attracted the previous generation of city writers to Berlin around 1890. Associated with the naturalist movement, those earlier writers such as Julius Hart and Arno Holz had been oriented towards a conception of 'the modern' which was identified with science and technological progress, and they aimed to borrow from scientific endeavour the high regard in which it was held in the nineteenth century. Correspondingly, these writers had operated under the rather different principle of emulating in literature the objectivity, impartiality, and detachment associated with scientific observation and logical investigation. Dispassionate recording of the wretched conditions of the city's poor and underprivileged, minute documentation of social injustice and the lower depths, were linked to the overriding goal of revealing the causal links and natural laws which determine humankind's social existence. Such a literary method was invariably related to the question of authorial restraint, detachment, and the degree to which the writer's own temperament could be suspended.

It was such coolness and objectivity, as well as the earlier scientific version of 'the modern' from which it derived, that the Expressionists categorically rejected in favour of open passion and partiality, or what they frequently referred to as 'Ekstase': their 'ecstatic' and unrestrained outpourings. In a programmatic statement from July 1911, significantly entitled 'The New Berliners', a leading spokesperson of Expressionism, Kurt Hiller, demonstrated the clear divide separating the previous generation of naturalist writers from the new movement of Expressionism. 'Those aesthetes

[3] Indeed it seems that at this time a good number of the key figures of Expressionist literature remained largely unknown to the wider public. Thomas Anz has discussed the marginalized position of the Expressionist groups in 'Berlin, Hauptstadt der Moderne', in Klaus Siebenhaar (ed.), *Das poetische Berlin: Metropolenkultur zwischen Gründerzeit und Nationalsozialismus* (Wiesbaden: DUV, 1992), 89.

[4] Ibid. 85.

who are mere wax disks for recording impressions, or who function as precise and finely tuned description machines, appear to us as genuinely inferior. We are Expressionists. For us what matters is once again the content, the will, the ethos.'[5] In the somewhat strident tone typical of such programmatic statements by the Expressionists—always on the brink of turning into a manifesto—Hiller here maintains that the goal of the Expressionist writers was precisely to avoid the straightforwardly mimetic approach corresponding to that stance of coolness and lack of involvement associated with the earlier literary conception of 'the modern'.

The writing of the Expressionist period registers a distinct form of metropolitan sensibility related to the particularities of Berlin city life. Above all it is the directness of the encounter with technological modernity, and the typical consciousness and cognitive experiences associated with the daily passage of the city dweller through the crowded streets, that give this literature a particular colouring. As Hiller goes on to say, 'Our conscious goal in literature is the characterization of the intellectual city dweller's experiences. We maintain, for example, that the Potsdamerplatz has just as much power to fill us with strong inner sensations as the smallest village in the valley of Herr Hesse.'[6] With this observation we discern the general sentiment among the Expressionists that in pursuing themes relating to their experience of the city—not only oriented towards social wretchedness but also characterized by an aesthetics of the ugly—they were aware of being unashamedly at odds with the very different expectations of an audience more attuned by convention to the gentler, nature-oriented topoi of traditional literary realms.

The city was in key respects the paradigm for technological modernity during this period, and it became central for texts in which the Expressionists pictorialize their experience of contemporary reality. With rapid economic growth, accelerating scientific and technological progress, and the mass migration of a newly industrialized workforce into the busy and ever-expanding metropolis there were enormous changes in the face of everyday reality, and it could be argued that for Germany it was here that the process of modernization was first experienced at full force.[7] Technical innovations such as electrification, radio, automobiles, aeroplanes, as well as the expanding system of transport, the mass media, and the cinema, appeared

[5] Kurt Hiller, 'Die Jüngst-Berliner', in *Literatur und Wissenschaft*, monthly suppl. to *Heidelberger Zeitung*, 7 (22 July 1911), special edn, 2–6; repr. in Thomas Anz and Michael Stark (eds), *Expressionismus: Manifeste und Dokumente zur deutschen Literatur, 1910–1920* (Stuttgart: Metzler, 1981), 34–5. As we shall see, towards the end of the Expressionist period the new artistic dominant of 'Neue Sachlichkeit' ('New Objectivity') shifted the attitude towards realist representation back again in favour of detachment, impersonal observation, and minute recording.

[6] Hiller in Anz and Stark (eds), *Expressionismus*, 35. In 1914 the Expressionist painter Ludwig Meidner expressed a similar desire to turn away from conventional settings and orient painting unashamedly towards this new metropolitan environment when he said, 'ultimately we must really begin to paint our home, the city, which we love infinitely', cited in Thomas Anz, *Literatur des Expressionismus* (Stuttgart: Metzler, 2002), 103.

[7] Towards the end of the nineteenth century Berlin became the fastest-growing city in Europe. From 1880 to 1910 the population doubled from 1 million to 2 million, and despite the war it doubled again in just a decade, reaching 4 million inhabitants by 1920. On this issue, see Silvio Vietta (ed.), *Lyrik des Expressionismus* (Tubingen: DTV, 1976), 30.

on the scene within a short period of time.[8] The city signified an energized, heterogeneous, and often overwhelming environment, with its electrified tempo, its semioticized cityscape of street signs, its advertising hoardings, and not least with the crass contrasts on the street between the smug and prosperous bourgeoisie on the one hand and society's outcasts and deprived classes on the other.

Much of the Expressionist prose and early poetry consequently reflected the experience of a 'cognitive overload', in which the sheer mass of data pouring in upon the individual from all sides in the city overwhelmed the subject's ability to make sense of it.[9] The sociologist and philosopher Georg Simmel, whose lectures were regularly attended by several of the young Expressionist writers and members of the movement's Der Neue Club (New Club), encapsulated this crucial metropolitan experience in his classic essay from 1903 'Die Großstadt und das Geistesleben' ('The Metropolis and Mental Life'). Here he characterized the city individual as a 'type' who is affected by the 'brisk and uninterrupted changes of external and internal impressions' encountered in the city and by the 'quickening of the nervous system' that the city experience brings about.[10] In contrast to the slow and regular rhythms of small towns and the countryside, life in the city means that 'with every crossing of the street' the city dweller encounters 'the tempo and multifarious nature of economic, occupational and social life'.[11] As a consequence, the cognitive experience of the individual in the metropolis is deeply affected by the 'rapidly changing views, the harsh contrasts between those images which one can embrace with a single glance, and the unexpectedness of onrushing impressions'.[12]

A key observer and later anthologist of the Expressionist movement, Kurt Pinthus, registered a similar experience of the city in a newspaper article from 1925 which looked back to this earlier period:

What a barrage of previously unimagined monstrosities has been clattering down upon our nerves for the last decade . . . and what a volume of noise, excitations, and stimuli the average person now has to fight through on a daily basis, with the commute to and from work, with the hazardous tumult on streets crowded with vehicles, with telephones, illuminated advertisements, and thousands of noises and distractions . . .[13]

Like Simmel, Pinthus also viewed the process of modernization, together with some of the most visible new products of technological progress, in terms of the way in

[8] On the point, see also Silvio Vietta and Hans-Georg Kemper, *Expressionismus* (Munich: Fink, 1975), 110–17.

[9] On the notion of the 'cognitive overload' in modernity, see Silvio Vietta, 'Großstadtwahrnehmung und ihre literarische Darstellung: Expressionistischer Reihungsstil und Collage', *Deutsche Vierteljahrsschrift für Literaturwissenschaft und Geistesgeschichte*, 48 (1974), 354–73; also Vietta and Kemper, *Expressionismus*, 30–40.

[10] Georg Simmel, 'Die Großstadt und das Geistesleben', in *Die Großstadt: Jahrbuch der Gehe-Stiftung* (Dresden, 1903), 187. The standard English translation is 'The Metropolis and Mental Life', in *The Sociology of Georg Simmel*, trans. Kurt Wolff (New York: Free Press, 1950), 409–24.

[11] Ibid. [12] Ibid.

[13] Kurt Pinthus, in an article in *Die Berliner Illustrierte* (1925); cited in Vietta and Kemper, *Expressionismus*, 11.

which they affect the very conditions of perception, and thereby create that characteristic experience for the subject of being overwhelmed by the chaos of simultaneously completing stimuli and 'cognitive inputs'.

Rather than representing this experience of the city, its chaos, simultaneity, and cognitive overloading, in a conventionally mimetic fashion by creating coherent and organically organized texts, the Expressionists instead took as their starting point this undermining of established modes of perception and meaning. If reality came across as fragmented and discontinuous, then rather than covering over the perceived gaps and fissures by representing the world in conventionally rounded, realistic forms—the false reconciliations described by Benjamin[14]—the Expressionists instead took up this challenge by creating a provocative aesthetics which did not shy away from the ugly, the grotesque, the non-organic, or the discontinuous.[15] The Expressionists consequently responded to this changed environment by developing a range of non-organic and ambiguous forms, often associated with varieties of parataxis, disjointedness, fragmentation, and montage, whose function was not only to destabilize realistic representation, but, more to the point, to question the epistemological and ideological assumptions which underpinned it.[16]

These texts manifested a preponderance of paratactical forms in which a number of images, perceptions, words, or sentences were thrown together one after another in an uncoordinated fashion. In addition, there was frequently little attempt to link sentences or syntactical elements together, or to organize them by means of the conventional categories of time, space, and causality. In this fashion the texts responded to a new set of conditions affecting the collective consciousness of the city and of technological modernity. This was characterized by intensity, dynamism, a disparate and uncoordinated visual field, and above all by a feverish sense of speed and the simultaneity of experience.[17] For example, the response of the Expressionist poets to this metropolitan experience frequently took the form of the 'telegram style', a kind of creative aphasia in which logical associations and linking words were omitted. Corresponding to the notional situation of the poet overwhelmed by the

[14] Walter Benjamin, 'Der Autor als Produzent', in *Gesammelte Schriften*, ed. R. Tiedemann and H. Schweppenhäuser, ii/2 (Frankfurt: Suhrkamp, 1980), 692–3; trans. Anna Bostock as 'The Author and Producer', in *Understanding Brecht* (London: New Left Books, 1973), 94–5.

[15] During the so-called 'Expressionism debates' of the 1930s Georg Lukács was consequently highly critical of the Expressionists—and of their technique of montage in particular—for 'abandoning the objective representation of reality'. See his essay 'Es geht um den Realismus', 211. This piece, along with most of the essays which made up these debates, have been collected in Hans-Jürgen Schmitt (ed.), *Die Expressionismusdebatte: Materialien zu einer marxistischen Realismuskonzeption* (Frankfurt: Suhrkamp, 1973). Translations of some of these essays, together with commentaries, appear in Ronald Taylor (ed.), *Aesthetics and Politics: The Key Texts of the Classic Debate Within German Marxism: Theodor Adorno, Walter Benjamin, Ernst Bloch, Bertolt Brecht, George Lukács* (London: New Left Books, 1979).

[16] I have discussed this epistemological and ideological scepticism in the context of the 'Expressionism debates' elsewhere; see Richard Murphy, *Theorizing the Avant-Garde: Modernism, Expressionism, and the Problem of Postmodernity* (Cambridge: Cambridge University Press, 1999), esp. 12–16.

[17] Here we may also see the influence of the Italian Futurists and in particular Marinetti, whose manifestos were published in the Expressionist journal *Sturm* in 1912.

pulsating city surroundings and struggling to make cognitive and semantic sense of the surrounding turmoil, any pretence of producing complete, syntactically ordered, and grammatically correct sentences was abandoned in favour of a breathless juxtaposition of isolated perceptions and images, as they streamed in upon the writer. In the 'one-line' style of the 'Reihungsstil' ('telegram style') poetry especially, disparate perceptions and events could only be registered in the form of a list of images. These poems do not hold together 'organically', and there is little sense of an obvious semantic wholeness to link together the various parts of the text. Instead, the reader is called upon to create an aggregate picture on the basis of these heterogeneous images and fragments.[18]

Alongside parataxis we should also highlight the central importance of the related techniques of montage and collage—which might indeed be thought of as an 'aesthetics of the city'. For there is a clear link here (described by Simmel and Pinthus and also dramatized in the early Expressionist poetry) between the shocks and disjointed cognitive experience in the city on the one hand, and, on the other, the strategies of crass juxtaposition, cuts, and editing deployed in other artistic fields, such as the method of montage in the recently created artistic medium of film. Similarly, in this poetry the juxtaposition of 'uprooted' or of seemingly unrelated material, fragments of images and momentary perceptions, can also be related to the collage techniques in the Cubist painting of Picasso and Braque of around 1907, a technique which would in turn become particularly important for the placards, manifestos, and designs of the Dadaist writers and visual artists (such as Hausmann, Höch, Baader, and Heartfield). Similar montage structures can be observed in Expressionist theatre, such as the 'Ich-Drama' (or 'Drama of the Self') and 'Stationendrama' ('Drama of Stations [of the Cross]'). These plays lacked a conventionally linear plot and were usually devoid of traditional dramatic tension, consisting instead of a series of relatively independent and causally unrelated scenes. Reinhard Sorge's *Der Bettler* ('The Beggar', 1911) is a paradigmatic example, being constructed around a central figure as he wanders among reflections of his own persona on a vaguely defined path towards redemption or spiritual enlightenment. Again the crucial structural feature here is a variation on the montage format shared by a variety of Expressionist structures. Alongside the one-line method of the 'Reihungsstil' poetry, we also find similarly disjunctive configurations in the 'epic' form of Döblin's prose and, most famously, in Brecht's plays. In all of these 'open' forms, meaning depends less upon the direct interrelation of individual parts of the text; that is, on a traditional organic relationship between them, than upon the creation of an overall, aggregate image. Consequently, individual components, images, or scenes could be left out without detriment to the effect of the whole.

The very form of these texts, their disjunctive and fragmented structure, as well as their increased demands upon the audience's participation, were vital in mediating a corresponding sense of fragmentation, breathlessness, confusion, and strain

[18] Murphy, *Theorizing the Avant-Garde*, 79–80.

analogous to the subject's experience of the city and, by extension, of technological modernity. In the so-called 'Simultangedicht' ('simultaneity poem') the rapid succession of heterogeneous items from different sources also has the defamiliarizing and levelling effect of bringing them all down to the same plane. Jakob van Hoddis's pointedly disjointed early poem 'Weltende' ('End of the World', 1910–11) took up the strategy of juxtaposing a series of spatially and ontologically disparate images to shocking effect:

> the wild seas hop
> Onto land, to flatten thick dams.
> Most people have a cold.
> Trains are falling from the bridges.[19]

The images in this poem demand a particular effort on the part of the reader faced with linking them together. For example, the threat of a devastating flood is juxtaposed with other spectacular disasters without further explanation or logical links. In the context created by several of the other images—those that seem to register nature's effortless devastation of humankind's technological accomplishments—the head cold from which everyone seems to be suffering then becomes odd and mysterious. Precisely on account of its relative insignificance (when measured against the images of destruction) it then adds an eerie dimension to the overall theme of apocalyptic devastation. Corresponding to the cognitive and ontological experience of the city dweller who is overwhelmed by an environment that appears ever more dynamic and autonomous—and so increasingly resembles a subject in its own right—the very form of the poem reinforces a sense of uncertainty in the reader: it offers no stable perspective and no elevated standpoint from which this chaos can be organized, let alone mastered. With its shocking tone and its violently discordant images this poem is often regarded as an opening salvo, the 'Marseillaise' that signalled the call to arms for the Expressionist 'revolution'.[20]

Van Hoddis's later city poem 'Morgens' ('Morning', 1914) appears at first glance to subordinate its multifarious views more closely to the theme in the title:

> The morning sun sooty. Trains thunder along embankments.
> Golden angelflights plow through clouds.
> Powerful wind over the pale city.
> Steamers and cranes awaken along the dirty flowing stream.
> Gloomily the bells peal on the weatherbeaten cathedral.[21]

Yet, despite the spatial and temporal contiguity implied in its title, this poem also turns out not to be a coherent entity. In a series of staccato outbursts and short, one-line images, it throws together instead a variety of fragmentary and ultimately disparate views with little overt syntactical or logical connection between them.

[19] Jakob van Hoddis, 'Weltende', in Vietta (ed.), *Lyrik des Expressionismus*, 93.

[20] Vietta describes the enormous impact of this first poem in Vietta and Kemper, *Expressionismus*, 30–1.

[21] Jakob van Hoddis, 'Morgens', in Vietta (ed.), *Lyrik des Expressionismus*, 34.

This produces an element of shock. But the lack of obvious coherence is also associated with a further significant aesthetic principle that in all modernist literature is perhaps most extreme in Expressionism. For corresponding to the weakened position of the cognitive subject in the city (and, beyond this important paradigm, within technological modernity more generally), the poem signally refuses to satisfy the conventional expectations made of the poet, namely the sovereign ability to stand above the chaos, and to unify or conceptually integrate these multifarious perceptions. Rather than the convention of a clear lyrical voice or poetic 'self' emerging from the text, we are presented instead with a series of largely dissociated images of the outside world. And if the object world appears confused and fragmented in these images, then by extension so too does the poet who is the implied subject of these disparate perceptions and who by indirection is reflected in them. For the disjointedness of these images is also the reflex of an incoherent subject who is struggling not only to organize perceptions and language but also to preserve a sense of internal unity, of selfhood, over against a modern world that is increasingly experienced as dynamic and overpowering.

To the extent that the environment, and in particular the city, is presented in these Expressionist texts as chaotic, overwhelming, and threatening, it frequently begins to appear as an autonomous being in its own right. Correspondingly, the subject takes on a subordinate and passive position, and is associated increasingly with images of objecthood: the subject becomes a 'thing' and is described in terms of reification, coldness, death, or dissolution.[22] This depiction of the crucial change in the subject's experience of the object world, and the reversal in the normal hierarchy of relations with the environment, frequently culminated in a full-scale 'dissociation of the self' in which the subject's experience of alienation both from the world and from the body is combined with a sense of psychological dissolution.[23] This is often pictorialized in texts by presenting a figure in synecdochic terms, that is, either by reducing the person to a single characteristic or physical attribute, or emphasizing the physical dis-integration of the individual, as, for example, in the way the various parts of a character's body may begin to act independently. A prime example of the latter mode is Alfred Döblin's early Expressionist short story 'Die Ermordung einer Butterblume' ('The Murder of a Buttercup', 1910), in which an agitated and extremely nervous bourgeois figure escapes the town for a walk in the forest. With little obvious provocation various parts of his body appear to begin functioning autonomously: 'The feet began to infuriate him. They too wanted to take over as the boss . . .'.[24]

[22] The theme of the reification of the subject is often linked in Expressionist texts to issues of anxiety, psychological alienation, spiritual disorientation, and 'transcendental homelessness'. See Thomas Anz, *Die Literatur der Existenz: Literarische Psychopathographie und ihre soziale Bedeutung im Frühexpressionismus* (Stuttgart: Metzler, 1977). On the issue of humankind's spiritual abandonment, see also Murphy, *Theorizing the Avant-Garde*, 49–73, esp. 59.

[23] Vietta and Kemper, *Expressionismus*, 30–49. See also Anz, *Die Literatur der Existenz, passim*.

[24] Alfred Döblin, 'Die Ermordung einer Butterblume', repr. in Fritz Martini (ed.), *Prosa des Expressionismus* (Stuttgart: Reclam, 1970), 106. The earliest drafts of this story may be dated to 1904–5, to Döblin's early period in Freiburg im Breisgau.

Similarly, when the evening sunlight falls between the trees, it has an odd effect which brings out his dissociated physical condition: it 'made the eyes squint; the head jerked, the hands made indignant, hasty, defensive movements'. This synecdochic treatment of the body is combined with a metonymic reversal of subject and object: 'Puffing out air loudly, the man went on with flashing eyes. The trees marched quickly past him; the man paid no attention to anything.'[25] Here the manner in which the trees are described pointedly reverses subject and object, projecting the movement outwards and attributing it to the object world in a fashion typical of the cognitive confusions and altered (or 'overloaded') conditions of perception in modernity, and particularly in the city. And while the story takes place largely in the natural surroundings of the forest, there are indications that it is the changes in consciousness and the conceptualization of self brought about by modernity and by the city in particular that are seen as the root cause. As the disturbed protagonists says: 'One gets nervous in town. The town makes me nervous.'[26]

This characteristic inversion of the subject–object relationship is also evident in the poetry of Gottfried Benn, in which the human subject is defamiliarized in the most negative fashion, and frequently reduced to materiality and mere flesh. In his poem 'Nachtcafé' ('Night Café'), describing the seedy night-time milieu of Berlin, the musicians are reduced synecdochically to the instruments they play: 'The cello drinks quickly. The flute | belches deeply for three beats . . .'. But more radically the other human figures are reduced to the diseases or physical blemishes that they bear: 'Green teeth, pimples on the face | waves to conjunctivitis.'[27] In the poem 'Schöne Jugend' ('Lovely Childhood'), taken from Benn's poetry of the dissection table (featured in his *Morgue* collection), any conventional romantic expectations aroused in the reader by the title are quickly disappointed.[28] A young girl's mouth figures not because it is the romantic object of a lover's desire, but rather because it 'looked so gnawed-at' on account of the rats that had found a comfortable refuge in her body after her death by drowning. Thus, the girl appears to signify merely as an object, a store of flesh for the young rats, rather than on a more elevated plane, for example in the form of a vessel of the spirit. Typically this representational structure reverses the hierarchical relationship between the subject (along with an associated sense of transcendent spirit), on the one hand, and the object world and sheer materiality, on the other. The 'lovely childhood' of the title turns out to refer not to the human subject but to the life of the young rodents.

This reversal of subject and object was very common also in the imagery of early Expressionist poetry, and usually combined with a negative slant. For example, in Alfred Lichtenstein's poem 'Die Nacht' ('Night') the city's beggars appear 'broken', in

[25] Ibid. 102, 103. [26] Ibid. 103.
[27] Gottfried Benn, 'Nachtcafé', in Vietta (ed.), *Lyrik des Expressionismus*, 56. Similarly, in the poem 'Man and Woman Walk Through the Cancer Ward' ('Mann und Frau gehn durch die Krebsbaracke') the patients are referred to reductively only in terms of their diseases, the cancerous wombs or breasts; ibid. 73.
[28] Benn, 'Schöne Jugend', in Vietta (ed.), *Lyrik des Expressionismus*, 77.

678 RICHARD J. MURPHY

other words as 'things' belonging to a reified world, whereas on the street the trams by contrast have the human ability to 'stutter'.[29] Other phenomena of the external world too are given qualities more commonly associated with the human, to which once more a negative connotation is added (frequently associated with disease or death). Thus, Lichtenstein's trees are 'bloodless', the night is 'swollen',[30] and the sky is 'tear-stained and melancholy'.[31] Similarly, when van Hoddis describes natural phenomena, he also gives them human characteristics, but adds the usual negative slant. Thus, birdsong becomes an expression of pain: 'The sparrows scream.'[32]

Clearly the poet's relationship to the external world of the city has undergone a radical transformation in these texts. The environment has become an active and destructive force threatening the subject. The first lines of Lichtenstein's poem 'Punkt' ('Point') pinpoint this loss of boundaries and the corresponding experience of dissociation of the self:

> The desolate streets flow all ablaze
> Through my extinguished head. And cause me pain.
> I feel clearly that I will soon fade away.[33]

As is often the case in Expressionist poetry, there appear here to be no clear boundaries between an aggressive object world and the weakened subject, so that the streets seem to run without halt, straight through the head of the writer. In the city the crowded streets and the close proximity of the masses seem to contribute to this sense of defencelessness and dislocation of the self. Alfred Wolfenstein evokes this combination of spatial and ontological anxieties in a poem of the city in which he describes the paradox of the city dweller's alienation: he remains isolated and alone ('untouched and unseen') even though the windows of buildings are 'as close as the holes of a sieve' and the walls are 'as thin as skin, | So that everyone is involved when I cry'.[34] By contrast to the energized and often aggressive character of the metropolis, the Expressionist subject was inevitably presented as weak, ephemeral, alienated, and on the point of dissolution or death.

Another important aspect of this 'dissociation of the self' was the experience of alienation from the prevailing social, familial, and moral–religious structures. The Expressionist writers were almost exclusively male, from well-to-do, often Jewish, bourgeois families, and were in their early twenties when the movement began (most were born around 1890). They shared the need to break out from what was perceived to be a stifling, conservative, and restrictive society—the hierarchical structure inherited by Wilhelminian society appeared outmoded and out of step with the

[29] Alfred Lichtenstein, 'Die Nacht', ibid. 35.
[30] Alfred Lichtenstein, 'Nebel' ('Fog'), in Kurt Pinthus (ed.), *Menschheitsdämmerung: Ein Dokument des Expressionismus* (Reinbek: Rowohlt, 1983), 59.
[31] Alfred Lichtenstein, 'Trüber Abend' ('Gloomy Evening'), in Vietta (ed.), *Lyrik des Expressionismus*, 36.
[32] Van Hoddis, 'Morgens', 77.
[33] Alfred Lichtenstein, 'Punkt', in Vietta (ed.), *Lyrik des Expressionismus*, 35.
[34] Alfred Wolfenstein, 'Städter' ('City Dwellers'), in Vietta (ed.), *Lyrik des Expressionismus*, 46.

early twentieth century—and in particular from the patriarchal family structure associated with the overbearing figure of the father. Expressionists were obsessed by Oedipal antagonisms, and in their texts the father–son conflicts took on a symbolic dimension, often playing out the younger generation's rebellion against a traditional and philistine form of civilization. Hasenclever's play *Der Sohn* ('The Son', 1914) is the paradigm of these Oedipal texts, in which a monstrous patriarch figure imposes rigid constraints on his son's every spiritual, artistic, and erotic desire, resulting in a revolutionary uprising by the younger generation and a call to oppose the dominating force of all fathers. Along with the figure of the smug, self-satisfied citizen and philistine 'Bürger' (burgher), the father-figure was seen as the primary representative of an outdated form of civilization, a form that did not fit the Expressionists' image of modernity, and together these figures became their principal targets.

Dada

Inevitably perhaps, voices announcing a crisis in Expressionism or even its passing began to be heard even before the end of the Expressionist decade. Paradoxically this was at a time when Expressionist literature, theatre, and art were receiving a degree of public attention as never before, when there was a boom in journals and publishing houses devoted to its works, and when the movement's important effects were only just beginning to be felt in the area of cinema—arguably the field in which the movement eventually became best known worldwide. Indeed, many key films that were either directly associated with, or unthinkable without, Expressionism only appeared after its recognizable decline, such as *The Cabinet of Dr Caligari* (1920), *Nosferatu* (1922), *Der müde Tod* ('Destiny', 1921), and *Das Wachsfigurenkabinett* ('Waxworks', 1924).

To a large degree Expressionism suffered the perennial fate of many radical cultural movements: a victim of its own eventual success, its innovations began to be viewed as conventions, and as an established canon it began to be associated not only with the aesthetic status quo but also with the social and political conservatives. To this extent it became difficult to maintain the bohemian role of the outsider pertaining to a provocative, progressive, and critical artistic avant-garde. If the target of Expressionism had always been the stuffy bourgeois establishment and restrictive patriarchal conventions of Wilhelmine Germany, epitomized in their favourite hate figure of the bourgeois philistine ('der Bürger'), now new groups of artists and intellectuals attached to the Dada movement, using similar tactics of radical provocation and shock, cleared a space for their own work by turning this very criticism against the Expressionists themselves and by aligning the earlier movement with the old bourgeois order. Against the historical background of the bloodshed both of the First

World War and also of the social and political chaos that ensued (including the murder of political activists, heavy fighting on the streets of Berlin, and the brutal crushing of the uprisings of 1919), many were galvanized into opposing not only militarism but also the conservative political establishment that had brought it about.[35] In this context the utopian politics and some of the more grandiose aspects of Expressionism and proclamations by certain of its figures may indeed have sounded somewhat hollow, such as its open emotionalism, or 'Pathos', the belief in forms of messianic redemption, and the associated abstract faith in the development of a 'neuer Mensch' (or 'New Man'). Similarly, for groups such as the Dadaists, the Expressionists' 'Aktivist' slogan 'Der Mensch ist gut' ('Man/Humanity Is Good') began to sound particularly lofty and distanced from the real world to the extent that it represented a form of idealism that appeared blind to the human destruction and brutality that characterized this decisive historical period. Leonhard Frank's cycle of short prose texts, also entitled *Der Mensch ist gut*, illustrates the problem. In presenting a series of scenes depicting the response of ordinary people to the war and to the loss of their sons and husbands, it targets the emptiness of the patriotic rhetoric that had accompanied the young soldiers as they went off to die 'on the field of honour' and 'on the altar of the fatherland'.[36] Yet at the same time it lacks a certain self-consciousness, not to mention the facility for self-irony typical not only of Dada but also of the more significant Expressionist writers (such as Kafka, Döblin, Einstein, or even Benn). As a result it becomes a 'monological' mouthpiece for the author to such an extent that it scarcely acknowledges the free subjectivity of the reader, who is left with no ideological or discursive contradictions to resolve.[37]

In this post-war context the conclusion of both Expressionists and Dadaists alike was that if the world was absurd then rationality was scarcely an alternative, in so far as it had been rationality that had also led to the horrors of the war. However, to the extent that the Expressionists remained attached to art and sought what the Dadaists considered purely artistic solutions to pressing social problems, they were now deemed to be part of the problem, part of a 'Kulturideologie', as Richard Huelsenbeck put it.[38] His indictment of the Expressionists was that they had simply turned in upon themselves, and were less concerned with the problems of humankind than with their own posterity and their own role as artists: for Huelsenbeck they were 'a generation which is already looking forward to honourable mention in histories of

[35] An official reading of 'revolutionary' poems by the Expressionists Becher, Hasenclever, Werfel, and Zech only weeks after the March 1919 street fighting, and the murders of Rosa Luxemburg and Karl Liebknecht, may typify the loftiness of Expressionist utopian politics. However, the question, of course, is whether even the anti-aesthetic response of the Dadaists engages such a situation any more closely. For a discussion of this incident and the differences between Dada and Expressionism, see J. C. Middleton, 'Dada versus Expressionism, or, The Red King's Dream', *German Life and Letters*, 15 (1961–2), 37–52.

[36] Leonhard Frank, *Der Mensch ist gut* (Zurich: Max Rascher, 1918), 9, 22.

[37] For a discussion of the problematic political stance of Frank's cycle of short prose texts *Der Mensch ist gut*, see Murphy, *Theorizing the Avant-Garde*, 87–8.

[38] Cited in Middleton, 'Dada versus Expressionism', 47.

literature and art and aspiring to the most respectable civic distinctions'.[39] Similarly, in his account the Expressionists' undue concern for purely aesthetic questions, such as their focus on other artistic movements (naturalism, for example), allowed them to turn away from the real world, so that 'on the pretext of carrying on propaganda for the soul, they have, in their struggle with naturalism, found their way back to the abstract, pathetic gestures which presuppose a comfortable life free from content or strife'.[40] For the Dadaists the only art form that seemed appropriate to this context was necessarily a form of anti-art.

The roots of Dada were intertwined with Expressionism, and Expressionism clearly still had an impact on Dada during the earlier, Zurich phase of the movement, with poems by the Expressionists regularly read out in the Cabaret Voltaire in the months from January to July of 1916.[41] But when leading light Richard Huelsenbeck moved definitively to Berlin in January 1917, effectively taking Dada with him from Zurich and merging it with the existing nascent group in Berlin connected to Hannah Höch and Raoul Hausmann,[42] the new movement quickly attracted writers based there (such as Wieland Herzfelde and Franz Jung) who had previously contributed regularly to key Expressionist journals such as *Die Aktion*, but who now changed their primary allegiance.[43] However, in a good number of their key texts the Berlin Dadaists carried on an almost obsessive polemic against Expressionism with the aim presumably of defining themselves by setting out the differences between Dada and the earlier movement—a curious response, not least given Huelsenbeck's criticism (cited above) that Expressionism itself was misguided in waging its earlier struggle with naturalism. The first 'dadaistic manifesto' of 1918, for example, asks provocatively, 'Have the Expressionists fulfilled our expectations for an art which burns the essence of life into one's flesh? No! No! No!'[44]

The character of Dada also changed with the switch from the close-knit events of its small literary cabarets and galleries in Zurich, to the more widely publicized (and publicity-seeking) 'happenings' in Berlin: for example, when Johannes Baader, the self-styled 'President of the Universe' or 'Oberdada' ('Dada in chief'), interrupted the preacher at the Berlin Cathedral with the words 'What is Jesus Christ? He is irrelevant to you (ist euch Wurscht)!', or when he scattered his pamphlet 'The Green Corpse' in the national parliament of Weimar. Whether or not these spectacles should be

[39] Richard Huelsenbeck, 'En avant dada' ('Dada Forward'); repr. in Lucy Lippard (ed.), *Dadas on Art* (Upper Saddle River, NJ: Prentice Hall, 1971), 47.

[40] Ibid.

[41] On the links between the two movements, see Richard Sheppard, 'Dada and Expressionism', *Papers of the English Goethe Society*, 49 (1979), 48–9.

[42] See the chronology of Berlin Dada in the catalogue by Laurent Le Bon (ed.), *Dada* (Paris: Éditions du Centre Pompidou, 2005), 27.

[43] In addition, Berlin Dada involved key visual artists and figures such as Georg Grosz, Hans Richter, Walter Mehring, Johannes Baader, John Heartfield, and Hannah Höch. Dada exhibitions in Berlin also included work by Otto Dix, Francis Picabia, Hans (Jean) Arp, Max Ernst, Rudolf Schlichter, and Johannes Baargeld, among others.

[44] The author of this first manifesto was Richard Huelsenbeck; see Hanne Bergius and Karl Riha (eds), *Dada Berlin: Texte, Manifeste, Actionen* (Stuttgart: Reclam, 1977), 22.

considered as political interventions aimed at the social institutions of Church and state, they illustrated the Dadaists' goal of ridiculing the Weimar Republic and exposing the new regime as a simple return of conservative powers rather than a new beginning.[45] Corresponding to the sense of social engagement illustrated by Franz Jung's statement in the aftermath of the failed social revolution that Berlin Dada should be an attempt to 'affect' or 'hit' ('treffen') society 'in a different way',[46] the Dadaists' 'artistic' texts often took the form of political pamphlets, manifestos, posters, handbills, and 'actions' (or happenings) attacking the Weimar state. The titles of these items give a sense of their political direction: 'Against the Exploiters!!', 'Bloody Seriousness' (George Grosz, John Heartfield); 'The German Philistine Gets Annoyed', 'Pamphlet Against the Conception of Life in Weimar' (Raoul Hausmann).[47] Similarly, the text 'Dadaists Against Weimar' was a flyer (created by the Dada collective) announcing a meeting for all those 'interested in the welfare of humankind', and promising that they intended to 'blow up Weimar'.[48] Georg Grosz's illustration for the front cover of the Berlin journal *Die Pleite* published in April 1919 (just after the street riots of March were put down in a bloody fashion) was entitled 'Cheers Noske!—The Proletariat Is Disarmed' and depicted a military figure holding a bloody sword and making a toast, while all around him on the Berlin streets lie dead and fragmented bodies.[49]

As Richard Sheppard has argued, the Dadaists were opposed not to art as such but to the kind of art which propagated a 'harmonious classical ideal or anthropocentric view of reality; art which associated itself with the corrupt social establishment and allowed itself to be used to propagate a spurious image of order, concentricity and well-being'.[50] But it should also be observed that precisely in rejecting the form and function of the kind of harmonious art that compensated for, or deflected attention from, a deficient reality, Dada still had a great deal in common with the Expressionist avant-garde, and with what I have described elsewhere as Expressionism's fundamentally ideology-critical stance in its attack on organic and affirmative art.[51] If a central goal of Dada was to demonstrate that humankind was not the centre of the universe, and if the Dadaists aimed correspondingly to decentre their texts using such means as montage—'the new art is a decentralization, the breaking up of the centre, a dissolution', writes Hausmann—then this clearly echoed the decentring strategies in the earlier avant-garde texts of Expressionism.[52] For, as we have seen, in such paratactical and quasi-montage forms as the 'Reihungsstil', or 'one-line style', the

[45] As Hugo Ball noted in April 1916, for Dada art was 'not a goal in its own right but an opportunity for a critique of the historical period' (cited in Richard Sheppard, 'What Is Dada?', *Orbis Litterarum*, 34 (1979), 195).

[46] Cited in Hanne Bergius and Karl Riha, 'Nachwort', in Bergius and Riha (eds), *Dada Berlin*, 171.

[47] These texts can be found in Bergius and Riha (eds), *Dada Berlin*, 76, 66, 49.

[48] Ibid. 44. [49] Ibid. 48.

[50] Sheppard, 'What Is Dada?', 196–7.

[51] Murphy, *Theorizing the Avant-Garde*, 12–26 and *passim*.

[52] Hausmann, cited in Sheppard, 'What Is Dada?', 196.

effect is precisely to highlight the weakened position and lack of centrality of the subject within the world (frequently culminating in a dissolution of the self), and to stress the consequent inability of the subject to 'master' and organize reality in a conventionally orderly and 'centred' fashion.

The metropolitan context of Berlin and the corresponding experience of the decentring of the human subject in modernity leave their traces in the simultaneity, cacophony, and montage forms characteristic of the Dada texts. The Dada 'simultaneous poem', for example, consisted of the live performance by several performers all reciting unrelated texts at the same time so as to produce a cacophony of conflicting voices and sounds.[53] Similarly, the Dada 'sound poem' created a (seemingly) chance assemblage of sounds and a play with puns, rhymes, neologisms, and random associations, but minus grammatical and syntactical structures. These forms seem to call for the kind of reading that does not aim to pin down the text to determinate meanings. Instead, they require a general openness on the part of the reader: first, a willingness to associate freely with language when it is subjected to these extreme forms of estrangement and fragmentation; and, second, an openness towards the energy and vigour of the text. Something analogous applies to the Dada visual texts. A key example is Grosz and Heartfield's collage *Universal City, 12.05 Midday*,[54] which similarly juxtaposes a variety of cut-out photographic images and printed words, mostly linked loosely to the themes of the metropolis, play, film, and fotoplay, but which allows no determinate meaning or visual perspective to arise. Instead the text encourages the viewer to pursue associations with the experience of simultaneity, accelerated tempo, and energy produced by the technological modernity of the city.[55] Notably the collage juxtaposes human faces crassly with mechanical images, and indeed this equation was an ever-present theme in Dada, where the human is frequently seen as integral to the banal world of machines, the mechanized work process, and the predictability of the quotidian, and where the human frequently takes on a mechanical, often robotic, form.

Neue Sachlichkeit

There are links here to a further form of 'post-Expressionism', for alongside Dada it is worth noting that from around 1925 the 'Neue Sachlichkeit' movement ('New Objectivity', or 'New Sobriety') formed a further counter-movement to

[53] See Richard Sheppard's discussion of the simultaneous poem in his *Modernism—Dada—Postmodernism* (Evanston, Ill.: Northwestern University Press, 2000), 139.

[54] Repr. in Le Bon (ed.), *Dada*, 479.

[55] This image is discussed in Hanne Bergius's article 'The Ambiguous Aesthetic of Dada: Towards a Definition of its Categories', *Journal of European Studies*, 9 (1979), 26–38.

Expressionism and developed a more realistic focus by similarly highlighting the mechanical aspects of technological modernity and the city. The emphasis on concrete objects, technology, the everyday world, and particularly the contemporary metropolis was accompanied by a new sobriety, a 'cool' and detached attitude, and was frequently firmly grounded in a documentary-style method. And even when this tended to amount to a shared approach and vision rather than a coherent and rigorously consistent artistic style, what linked the artists associated with New Objectivity was above all the reaction against Expressionism, and in this case the ecstasies, excesses, and irrationality associated with it. In its photographic images in particular, the new movement sought out the aesthetic qualities of the metropolis and often contemplated the mechanically produced items of the industrial world. Something similar may be said for one of the key films of the period, namely Walter Ruttman's celebrated *Berlin: Symphony of a City* (1927), which documents a day in the life of the city, its streets, shops, and inhabitants. And while it has been argued that it may be inaccurate to regard this film as a straightforward example of New Objectivity, it nonetheless shares with the new movement an interest in looking at the city in a manner that simultaneously succeeds in finding unexpected patterns and forms of beauty in both machine 'life' and the mechanized environment of the city.[56]

G. F. Hartlaub is usually credited with having coined the term 'New Objectivity' for painting in May 1923, although three years earlier he had already identified this nascent artistic tendency as a form of 'neo-naturalism', linking the movement to the phrase 'back to the object'.[57] This new interest in the contemporary world of objects was pursued in the literary texts associated with New Objectivity via forms of industrial and social 'reportage', and was often taken up with relish by politically engaged writers. But despite this commitment, the documentary novels were frequently viewed by potentially sympathetic critics such as Siegfried Kracauer and Walter Benjamin as merely lapsing into a form of superficial realism that reproduced facts but was unable to penetrate appearances and interpret reality in a productive or critical fashion. An exception here is the colossal city novel of German modernism that stands out by balancing its own form of documentary approach to the wretched urban milieu with a response to the challenges posed by the modernist avant-garde, namely Alfred Döblin's *Berlin Alexanderplatz* (1929). The novel shares the 'new objective' tendency to shock any conventional expectations of the bourgeois reader by focusing on the city's lower-class inhabitants, particularly those on the margins, such as the protagonist, former prisoner, and labourer Franz Biberkopf. Yet in one sense, of course, the real protagonist is the city itself and its discourses. For Döblin creates a montage text which appears to take in the totality of the city and embraces textual fragments and excerpts from a variety of documentary material:

[56] Dietrich Scheunemann has argued against viewing the film as 'neo-objective'; see Scheunemann (ed.), *Expressionist Film—New Perspectives* (Rochester, NY: Camden House, 2003), 242.

[57] In fact Hermann Muthesius had already used the phrase 'Neue Sachlichkeit' at the turn of the century; see Anton Kaes, Martin Jay, and Edward Dimendberg (eds), *The Weimar Republic Sourcebook* (Berkeley: University of California Press, 1994), 475. The New Objectivity movement is usually dated between 1923 and 1933.

advertisements, lists of tram stops, population statistics, government departments, weather reports, political speeches, excerpts from books, fragments of songs, and a variety of other items of the kind that would have filled the semiotic landscape of Berlin in the years 1928 to 1929.

Rather than a single, consistent and omniscient narrator of the kind we would associate with New Objectivity, the novel instead deploys a variety of narrative voices. In this regard Döblin perhaps intended to demonstrate a certain scepticism regarding the kind of cool, detached, and scientific forms of external observation associated with New Objectivity. For example, in one particular passage describing an attack by Franz on his fiancée, Ida, it is the very impartiality and cold objectivity of the narration, the tendency to remain on the surface of things, to list and document data dispassionately and almost in the fashion of a post-mortem report, that is ironized: 'the following organs of the woman were slightly damaged: the skin on the end of her nose and in the middle, the bone and cartilage underneath . . . further-more the right and left shoulder sustained slight bruises, with loss of blood'.[58] When the emotional explosiveness and violence of his attack with a 'cream-whipper' on the woman is reduced to an impassive account, it is the shortcomings of a purely scientific rendering of such events—and with it, the rationality that underpins such an approach—that comes to the fore: 'he had brought the cream-whipper with its wire spiral, in contact with the diaphragm of Ida, who was the second party to the dialogue . . . the second encounter with the cream-whipper occurred with Franz holding an upright position after a quarter turn to the right on Ida's part. Whereupon Ida said nothing at all . . .'.[59] The narrator then pushes this ironization to an extreme by attempting to explain what happens to the woman by invoking 'the laws of statistics, elasticity, shock, and resistance' and by maintaining that the event 'is wholly incomprehensible without a knowledge of those laws'. The narrator then proceeds to list Newton's laws of motion, including the corresponding scientific formulae as a demonstration of the extent to which scientific logic may explain such events (or not).[60] In the painting and photography of New Objectivity, the tendency to represent every detail with an equal degree of accuracy and sharpness often came at the expense of the image as a whole.[61] So in this case, Döblin's text ironizes the way that such an approach to precision, clarity, and the facts risks missing the point.

With Döblin's monumental city novel the realist-documentary urge of New Objectivity is pushed to such an extent that it tips over into modernism's radical testing of boundaries and new forms. For the juxtaposition of various uprooted texts accounts for the metropolitan experience of simultaneity, dissociation, and fragmen-tation in a manner more obviously linked to the earlier Expressionist city texts. And with this the trajectory of cultural history appears to switch once more. For if the

[58] Alfred Döblin, *Berlin Alexanderplatz*, trans. Eugene Jolas (London: Continuum, 2004), 74.
[59] Ibid. [60] Ibid. 74–5.
[61] See Wieland Schmied, *Neue Sachlichkeit and the German Realism of the Twenties* (London: Arts Council of Great Britain, 1978).

New Objectivity was a reaction against the liberated emotionalism of the Expression-
ists, which in its turn had been a reaction against the relative sobriety and detailed
realism of the naturalists, then with *Berlin Alexanderplatz* the pendulum appears to
swing away from naturalism and New Objectivity, and back once more in the
direction of the experimentalism we associate with Expressionism and the modernist
avant-garde.

LONDON: RHYMERS, IMAGISTS, AND VORTICISTS

ANDREW THACKER

WRITING in the *New Age* in July 1914, the editor, Alfred Orage, commented in typically acerbic fashion upon the appearance of the Vorticist movement in London as signalled by the publication of *Blast*:

Mr Wyndham Lewis' new quarterly magazine, 'Blast' . . . has been announced as the successor of the 'Yellow Book'. But that, I imagine is no great credit to it, for who, looking back to that period, can admit that there was any philosophy in it? Aubrey Beardsley was something of a genius, but his mind was never equal to his talents; in other words, he was a decadent genius; and who else was there of smallest importance on the 'Yellow Book'? 'Blast' has the relative disadvantage of being launched without even a decadent genius to give it a symptomatic importance. It is, I find, not unintelligible—as most of the reviewers will doubtless say—but not worth the understanding. . . . What, from this point of view, is its significance? My answer is that it is another sign of the spiritual anarchism of modern society.[1]

Orage's critique is intimately bound up with his own concerns in promoting the intellectual agenda of the *New Age*, with its mixture of Guild Socialism, Nietzschean philosophy, and a commitment to the modern in art. However, the very fact that parallels are here drawn between the avant-garde project of Lewis's Vorticism and the Decadent movement of nearly twenty years previously merits further consideration.

[1] R.H.C. [Alfred Orage], 'Readers and Writers', *New Age*, 15/10 (9 July 1914), 229.

Often the story told of the emergence of modernism in London in the early twentieth century, in movements such as Vorticism or Imagism, is one whereby the shadowy and effete poet of the 1890s is superseded by the virile and angular shapes of modernism. Ezra Pound, for example, had published a poem in 1909 called 'Revolt Against the Crepuscular Spirit in Modern Poetry', and by 1915 he was referring to the 'softness of the "nineties"' poets, a 'softness derived . . . not from books but from impressionist painting. They riot with half-decayed fruit.'[2] *Blast* itself had 'blasted' the 'Britannic Aesthete'.[3]

However, a closer examination of *Blast* and the *Yellow Book* indicates that the division between modernist and Decadent was not as clear-cut as might appear. Both magazines were published by John Lane, who was in charge of one of the most important institutions of independent publishing in London. Lane, along with Elkin Mathews, started the Bodley Head press in 1887, a press forever associated with publishing aesthetic and Decadent writers and artists such as Oscar Wilde and Aubrey Beardsley, Ernest Dowson, Lionel Johnson, and Arthur Symons.[4] Indeed, the final four pages of the first *Blast* were taken up with adverts for Lane's publications, including works by Wilde, Vernon Lee, and the painter James Whistler, with the last page displaying a full-page advert for a thirteen-volume reprint set of the *Yellow Book* for £3 5s.

The fact that *Blast*'s puce cover contained more than a tint of 1890s yellow might be taken as somewhat of a coincidence. However, I think that it points to two features that are crucial for understanding the role played by various London cultural movements in promoting modernism. First, we can note how some of the key institutional features of modernism were already in place in 1914, when both Vorticism and Imagism burst onto the literary scene. The role of a figure like John Lane shows just how important independent cultural institutions such as magazines, presses, bookshops, and publishers were for incipient artistic movements. Second, we can note that the structural format of a modernist movement or 'ism' was also highly developed in metropolitan cities such as London by this time. Though Vorticism might have been received as the unintelligible noise of an avant-garde sensibility, as predicted by Orage, he was also correct to note the similarities with earlier 'isms'. Such movements as Imagism seemed to show the embattled artists marshalling together against a philistine society, aware that without the support of other like-minded individuals their voice would be silenced or ignored. Thus, the antipathy to the 'public' shown by many in the 1910s—('damn the man in the street', said Pound in a 1914 essay in *The Egoist*[5])—is only a small step from the Decadent aesthete in a Wilde play or a Lionel Johnson poem who turns away with a contemptuous shrug from the restrictive morality of the Victorian bourgeoisie. In fact, these two features

[2] Ezra Pound, 'Lionel Johnson', in *Literary Essays of Ezra Pound*, ed. T. S. Eliot (London: Faber and Faber, 1954), 363. This was originally a Preface to a collected works of Johnson, whom, interestingly, Pound praises for his 'neatness' and 'hardness'.
[3] *Blast: Review of the Great English Vortex*, 1 (London: John Lane, 1914), 11.
[4] See James G. Nelson, *The Early Nineties: A View from the Bodley Head* (Cambridge, Mass.: Harvard University Press, 1971).
[5] Ezra Pound, 'Wyndham Lewis', *The Egoist*, 1 (15 June 1914), 233.

are linked: the rise of independent institutions of publishing was part of a rejection of Victorian society and the narrow morality of its publishing industry, which had prevented late nineteenth-century authors such as Thomas Hardy and George Moore from expressing themselves freely. Banding together into a coterie, school, movement, or 'ism', and taking one's cultural productions to an independent publisher, or starting one's own press or magazine, was by 1914 a well-established feature of the cultural field, as Bourdieu terms it, of literary publishing in London.[6]

Noting these structural features indicates that we can only really understand the modernist movements of Imagism and Vorticism by situating them within a longer cultural history. David Peters Corbett, in his impressive discussion of painting in Britain from 1848 to 1914, argues that the 'brutal absolutism of the historiographical distinctions we have inherited from the modernist period' hides the continuity of concerns between the mid-Victorian period and the epoch just prior to the First World War. In the case of painting Corbett suggests, 'it is possible to trace a "tradition" or unfolding project in English painting' which attempts 'to imagine the visual as a medium capable of registering and understanding modern experience against a cultural situation that offered both powerfully positive and negative visions of its potential'.[7] This is not an argument for a simple stylistic continuity across the decades, argues Corbett, but rather a 'shared and developing response to a cultural situation'.[8] A somewhat similar argument, I want to suggest, can be made about how the modernist movements of Imagism and Vorticism share a cultural response with certain Decadent, aesthetic, and Symbolist groupings in the 1880s and 1890s. The shared literary field of the period between 1880 and 1914 is one, as noted above, where the artist must somehow retreat from the mainstream institutions of culture, to find new outlets in other independent bodies (such as John Lane the publisher), only to re-engage, once again, with the commercial situation surrounding them. Crucial to this dialectic of engagement and retreat is the form and nature of the movement or 'ism' itself and the particular urban locations in which movements meet, plan, and advance projects.

A useful concept with which to understand the nature of artistic movements in this period is that of Raymond Williams's idea of a 'cultural formation', a term he uses to analyse culture in the late nineteenth and early twentieth century. Since the end of the nineteenth century, notes Williams, 'it is a cultural fact that relatively informal movements, schools, and campaigning tendencies have carried a major part of our most important artistic and intellectual development'.[9] These groups, movements, tendencies, and circles are related by Williams to the institutions of culture—such as presses, exhibitions, galleries, or publishers—but are separate in character from

[6] See Pierre Bourdieu, *The Field of Cultural Production: Essays on Art and Literature*, ed. Randal Johnson, trans. Richard Nice (Cambridge: Polity Press, 1993), 29–73.
[7] David Peters Corbett, *The World in Paint: Modern Art and Visuality in England, 1848–1914* (Manchester: Manchester University Press, 2004), 10.
[8] Ibid. 16.
[9] Raymond Williams, *The Politics of Modernism: Against the New Conformists*, ed. Tony Pinkney (London: Verso, 1989), 174.

them. A cultural formation thus describes how these various cultural producers are organized—from a loose affiliation of like-minded friends who choose to publish an anthology, to a well-defined 'ism' with an agreed manifesto stating their artistic preferences. Williams characterizes formations in two main ways: first, by noting different types of *internal organization*—whether by formal membership; a collective public manifestation such as an exhibition, publication, or manifesto (the Futurists, for example); or a looser group association (the Bloomsbury group). Second, he considers the *external relations* of a formation to other groups and to society—whether they specialized in a certain style or medium; where they provided an alternative facility for production, exhibition, or publication (Lane's Bodley Head press, the Imagist anthologies); or cases where the lack of an outlet for alternative views is raised to an active opposition to society and its institutions (Dadaism).[10] Some cultural formations thus wished to smash the commercial institutions that they believed hampered genuine creativity, while others wanted to work within them, perhaps adapting commercial culture to publicize and promote their own work. Williams's work is very helpful in understanding the complex connections between the various institutions of early modernism (presses, magazines, etc.) and the multiple movements of the period. It also enables us to understand that what appears to be a radically new 'modernist' cultural formation in 1914 belongs to a tradition of organizing artistic production that reaches back into the nineteenth century, if not earlier.[11] Williams himself counselled us to be aware of a 'selective tradition' when historicizing modernism, and that we should reject the too simple view that 'the Symbolist poets of the 1880s are superannuated by the Imagists, Surrealists, Futurists, Formalists, and others from 1910 onwards'.[12]

Recent work on modernist institutions (by, among others, Lawrence Rainey, Mark Morrisson, and Kevin Dettmar and Stephen Watt) has suggested that the modernist artist did not reject commercial culture, but was instead deeply imbricated within it.[13] While not disagreeing with these interpretations overall, I think that in some ways these points have oversimplified the complex engagement between the modernist and the marketplace. Rather than a sudden dismissal or embrace of commercial culture, the structural features that governed the emergence of metropolitan movements saw a more fluid to and fro motion. Rejection, distancing, re-engagement, compromise—these seem part of the more multifaceted scenario governing how cultural formations emerge and organize themselves in order to get their voices heard, perhaps detaching themselves from certain mainstream aspects of

[10] See Raymond Williams, *Culture* (London: Fontana, 1981), 68–71.

[11] Williams traces the idea of the 'cultural formation' back to that of the Pre-Raphaelites in the 1840s and earlier, to William Godwin's circle in the Romantic period.

[12] Williams, *The Politics of Modernism*, 32–3.

[13] See Lawrence Rainey, *Institutions of Modernism: Literary Elites and Public Culture* (New Haven: Yale University Press, 1998); Mark Morrisson, *The Public Face of Modernism: Little Magazines, Audiences, and Reception, 1905–1920* (Madison: University of Wisconsin Press, 2001); and Kevin J. H. Dettmar and Stephen Watt (eds), *Marketing Modernisms: Self-Promotion, Canonization, Rereading* (Ann Arbor: University of Michigan Press, 1996).

culture, only to re-engage with other aspects of commercial culture and thus compromise some of their own artistic rhetoric. Understanding this complexity in the case of London can best be achieved by analysing closely a key set of cultural formations.

The Rhymers' Club

The story of modernism's emergence in London might be told by reference to a number of key locations in which movements such as Symbolism, Imagism, and Vorticism gathered together and flourished as companions in the struggle to innovate and experiment. One of the most famous cultural formations in the prehistory of modernist poetry is that of the Rhymers' Club, and this group is normally linked to a series of Friday evening meetings in Ye Olde Cheshire Cheese, a pub just off Fleet Street, then London's main location for newspaper production. This location, the centre of the Grub Street of London journalism, perhaps seems surprising for a group conventionally painted as a Decadent band of poets upholding aesthetic values against those of paid journalism. Symbolically, however, the Cheshire Cheese seems perfect, being located between a key Decadent site on the Strand such as the Savoy Hotel (later scene of Oscar Wilde's downfall) and to the east the heart of London's financial empire, the City. We might, therefore, suggest that the roots of modernist poetry in London can be found midway between aesthetic pleasure and financial know-how, a geographical position that parallels their location in the wider cultural field.[14]

The relation, however, of the Rhymers' Club to commercial journalism is quite complex, as is the history of the actual group. W. B. Yeats, perhaps the most well-known Rhymer, constructed a myth in his retrospective history of a 'tragic generation' of dissolute poets who by 1900 had either gone insane or drunk themselves to death. Karl Beckson has shown how Yeats misconstrued the history of the Rhymers partly in order to construct his own literary persona: far from being decadent affairs, Rhymers' 'meetings were often dull'.[15] Yeats's history also helped shape the idea that a sharper division existed between these 1890s poets and the modernist writers of the 1910s. For Beckson, the Rhymers 'represented a significant attempt to form an organized group...to advance their own poetic agenda by attacking the sentimentality and didacticism in Victorian verse'.[16] As a description of a project this could quite easily, *mutatis mutandis*, be used of the Imagists in 1913–14.

[14] For more on this theme, see Patrick Collier, *Modernism on Fleet Street* (Aldershot: Ashgate, 2006).
[15] See Karl Beckson, *London in the 1890s: A Cultural History* (New York: Norton, 1992), 71–2; the description of the meetings as 'dull' is found in George Mills Harper and Karl Beckson, 'Victor Plarr on "The Rhymers' Club": An Unpublished Lecture', *English Literature in Transition (1880–1920)*, 45/4 (2002), 380.
[16] Ibid. 73.

The Rhymers' Club numbered many of the leading figures of the 1890s and published two anthologies of their verse in 1892 and 1894; a planned third anthology never appeared. Lionel Johnson described a meeting in 1891 of some eighteen poets including Yeats, Arthur Symons, Oscar Wilde, and the artist Walter Crane, although the latter two never published in the anthologies. The Scottish poet John Davidson was another figure who attended the meetings but was not represented in the anthologies. Other published members included Ernest Dowson, G. A. Greene, Richard Le Gallienne, Victor Plarr, Ernest Rhys, T. W. Rolleston, and John Todhunter. Along with Yeats, several of these poets (Todhunter, Greene, and Rolleston) were also linked to the Irish Literary Society started in London. The Rhymers did not, however, only meet at the Cheshire Cheese but also in members' houses and at the headquarters of the Arts and Crafts organization the Century Guild in Fitzroy Street, where Lionel Johnson lived with Guild members Arthur Mackmurdo, Herbert Horne, and Selwyn Image. In addition to this Arts and Crafts element, at least two members, Ernest Rhys and Ernest Radford, had close links with London socialist groups such as the Fabians. Radford's poem 'Song in the Labour Movement', published in the second Rhymers' anthology, attacks the 'rule of Mammon' and looks forward to the days

> When we have righted what is wrong
> Great singing shall your ears entreat;
> Meanwhile in movement there is song,
> And music in the pulse of feet.[17]

As a group, then, the Rhymers were not homogeneous and the air of Decadence or Symbolism associated with members such as Symons or Yeats was not necessarily the dominant feature of the group. Victor Plarr, for example, noted that, though 'they always remained a distinct and independent group', they were 'unidentified with any particular cult or movement, though comprising the exponents of more than one'.[18] Unlike later modernist groups, this cultural formation did not enforce a single style upon members. Yeats noted that the Rhymers were engaged in a search for 'new subject matter, new emotions', and 'new forms', but that they were not 'a school of poets in the French sense', with an agreed agenda for poetic production.[19] This is borne out by the published poetry, which includes diverse elements such as Radford's socialist hymn; the Celtic mysticism of Yeats's 'A Man Who Dreamed of Fairyland', and Todhunter's 'The Song of Tristram'; Symbolist work such as 'Javanese Dancers' by Symons and 'Villanelle of Sunset' by Dowson; and a number of poems taking contemporary London as the setting.

The internal organization of the Rhymers was, however, more formal and coherent than one might expect from their diverse poetic styles. The 'Rhymesters' Club', as it

[17] Ernest Radford, 'Song in the Labour Movement', in *The Second Book of The Rhymers' Club* (London: Elkin Mathews and John Lane, 1894), 72.

[18] Victor Plarr, 'The Rhymers' Club', *English Literature in Transition (1880–1920)*, 45/4 (2002), 387. This is the text of a lecture given to the Poets' Club in 1910.

[19] W. B. Yeats, 'The Rhymers Club' (1892), cited in Nelson, *The Early Nineties*, 156–7.

was originally known, first met early in 1890 and had a clear sense of there being full members of the group, those invited to read poetry to the group as a one-off, and those who were 'permanent guests', such as their publisher Elkin Mathews, who 'did not rhyme' but attended their gatherings.[20] John Davidson once tried to propose four fellow Scottish poets as members in order to add some 'blood and guts' to the group, only for Yeats and other members to block them from joining.[21] Greene was named as the secretary of the Club and an editorial committee of Greene, Johnson, Le Gallienne, Todhunter, and Dowson oversaw the publication of the anthology. Discussing the arrangements for selecting material for the anthology, Dowson indicates that the 'selection is either to be made by the whole Club in council . . . or by a committee of 3 to be subsequently selected'; poems submitted by members for selection will then 'be put before the House at the next meeting of the Rhymers'.[22] Again, it sounds rather more orderly, and in keeping with the notion of an English 'Club' with rules and regulations, rather than a debauched gang of poets full of absinthe and anger. The Rhymers may have lacked blood and guts, but they at least knew the value of a Club with a 'council' and 'committee'.

What such relatively formal arrangements demonstrate is a keen awareness that poets required some organizational structure in order to obtain success in the cultural field of London at this time. According to Roy Foster, Yeats had been pleased to meet Rhys in 1888 since the Irish poet desired to establish himself as part of a 'little school': Rhys, said Yeats, had a mind 'which runs in the direction of schools'.[23] So although Yeats rejected the idea of the Rhymers functioning as a school with a shared poetic sensibility, he clearly perceived the need for the group to function as a cultural formation, in Williams's sense. Symons later complained that the Rhymers displayed 'a desperate and ineffectual attempt to get into key with the Latin Quarter' but that they could never forget that they were in London and not Paris, 'and the atmosphere of London is not the atmosphere of movements or of societies'.[24] If the Rhymers did not live up to Symons's French model of a fully fledged stylistic movement, the atmosphere of London was one that encouraged a formation that appeared as a club for gentlemen poets.

One of the most interesting external relationships defining the cultural formation of the Rhymers is that towards the mainstream world of journalism and publishing, centred on nearby Fleet Street. The 1880s had seen a tremendous growth in the power and influence of London journalism, seen in the so-called 'New Journalism' of figures such as W. T. Stead and T. P. O'Connor, increased pay for editors of newspapers, and the rise of mass-circulation weeklies and, soon after, dailies, such as the *Daily Mail*.

[20] See James G. Nelson, *Elkin Mathews: Publisher to Yeats, Joyce, Pound* (Madison: University of Wisconsin Press, 1989), 73.
[21] Ibid. 161–2. [22] Ibid. 163.
[23] R. F. Foster, *W. B. Yeats: A Life*, i: *The Apprentice Mage* (Oxford: Oxford University Press, 1997), 79.
[24] Arthur Symons, *Studies in Prose and Verse* (London: J. M. Dent, 1904), 263. For a discussion of Symons on Paris and London, see Peter Brooker, *Bohemia in London: The Social Scene of Early Modernism* (Basingstoke: Palgrave Macmillan, 2007), ch. 2.

In the 1880s London already had six morning papers and four evening papers; by 1900, according to John Stokes, a London journalist had twenty-four daily papers to submit work to—and even more monthly or quarterly publications to choose between.[25] Other institutions sprung up to support the profession: advice columns in magazines for budding writers, along with schools for journalism such as David Anderson's London School of Journalism, formed in 1887 and located just off Fleet Street; in 1889 a charter was granted to the Institute of Journalists, placing it on a par with law and medicine.[26] Roy Foster notes that one of the reasons Yeats appreciated the Rhymers' Club was for its links to a literary establishment with close associations to Fleet Street journalism. Foster describes the Rhymers as 'a reviewing mafia' with influence on important papers such as *The Star*, the *Pall Mall Gazette*, *The Speaker*, the *Daily Chronicle*, and *The Bookman*.[27] This view of the intertwined relations between Fleet Street and the Rhymers is supported by Karl Beckson's account of the group. When John Davidson submitted his intriguingly named *Fleet Street Eclogues* to the Bodley Head press, the chief reader was Le Gallienne, his fellow Rhymer. When the book appeared, Le Gallienne also reviewed it enthusiastically in *The Star* under the signature 'Logroller'; another Rhymer, Lionel Johnson, reviewed it in *The Chronicle*, and Selwyn Image reviewed it for the *Church Reformer*. Such logrolling practices were bemoaned by outsiders such as Arthur Waugh, who noted that the Rhymers seemed to have taken over the literary pages of the *Daily Chronicle*.[28] Victor Plarr's later memoir of the Rhymers claimed that 'We were not any of us of Fleet Street', only to admit that he had served an 'apprenticeship there as an assistant sub-editor on a service of news to a paper long since dead in 1887–1888'.[29] Ernest Rhys was later to work as editor of Dent's successful Everyman Library series, launched in 1906, but he had also worked for the Camelot Series of Classics, published by the Walter Scott Company in the 1880s.[30] From Rhys the young Arthur Symons had obtained his first literary commission, writing an introduction to Leigh Hunt, about whom he knew very little.[31]

In drawing upon this network of connections to Fleet Street publishing, the Rhymers' Club were only acknowledging the brute necessities facing a poet in the period, as summed up by Davidson in a newspaper article in 1893: 'The ever-increasing numbers, ambitious of literary distinction, who flock to London yearly, to become hacks and journalists, regard the work by which they gain a livelihood as a mere industry, a stepping-stone to higher things—alas! a stepping-stone on which

[25] John Stokes, *In the Nineties* (London: Harvester Wheatsheaf, 1989), 17, and ch. 1, *passim*.

[26] For details, see Peter Keating, *The Haunted Study: A Social History of the English Novel, 1875–1914* (London: Secker and Warburg, 1989), 293–303; Philip Waller, *Writers, Readers, and Reputations: Literary Life in Britain, 1870–1918* (Oxford: Oxford University Press, 2006), ch. 10.

[27] Foster, *Yeats*, 108.

[28] See Beckson, *London in the 1890s*, 78.

[29] Plarr, 'The Rhymers' Club', 389.

[30] See John Gross, *The Rise and Fall of the Man of Letters: English Literary Life Since 1800* (Harmondsworth: Penguin, 1991), 222–3.

[31] Waller, *Writers, Readers, and Reputations*, 169.

the majority of them have to maintain a precarious footing all their lives.'[32] One way to understand the operations of a formation such as that of the Rhymers is to see it as a way for an individual poet or writer to keep a foothold, as it were, in both the aesthetic and commercial camps. Drawing upon networks offered by fellow members of the formation, a writer could gain a livelihood through journalistic industry. Simultaneously the cultural formation presented itself to the world as a purely aesthetic project by appearing as a coterie or 'school', upholding a distance from Fleet Street by being associated with a small independent press, and by publishing a limited edition volume (only 350 copies of the first Rhymers' volume were printed for sale). All of these features marked the group as bearers of what Bourdieu terms high-cultural or symbolic value, rather than commercial value.[33] In this way, the Rhymers perhaps set out a position in the cultural field that was to be adopted by many later modernist groups in London: neither rejecting nor totally accepting commercial culture, they moved into, then out of, this commercial zone, in a regular pattern of engagement, retreat, and re-engagement.

Such a structure can perhaps also be discerned in Davidson's two volumes of *Fleet Street Eclogues*. These present dialogues between journalists bemoaning their grubby lot in Fleet Street, imagining an escape to a world of pastoral bliss, only to return to their chosen lot. The first poem in the first volume, 'New Year's Day', has 'Brian' spell out his position:

> This trade that we ply with the pen,
> Unworthy of heroes or men,
> Assorts ever less with my humour:
> Mere tongues in the raiment of rumour,
> We review and report and invent:
> In drivel our virtue is spent.[34]

However, Brian's remorseless negativity is countered in the poem by 'Sandy', who proposes a more glorious view of the journalist:

> To us the hour belongs;
> Our daily victory is
> O'er hydras, giant wrongs,
> And dwarf iniquities.
> We also may behold,
> How the future of the world
> Was shaped by journalists.[35]

The poem ends, typically, with the journalists toasting themselves with 'ale a-frothing brimmed'.

There is little that is modernist in the style of these poems, other perhaps than a directness of diction (Fleet Street is 'a traffic of lies', evinces Brian later), and the

[32] Cited in Beckson, *London in the 1890s*, 78.
[33] Bourdieu, *The Field of Cultural Production*, 46–50.
[34] John Davidson, 'New Year's Day', in *Fleet Street Eclogues* (London: John Lane, 1893), 3.
[35] Ibid. 13.

choice of the Virgilian eclogue form seems to represent the verse as embedded within tradition rather than modernity. However, this contrast between contemporary urban decay and past beauty is not dissimilar to parts of T. S. Eliot's *The Waste Land*, and Eliot himself acknowledged that his early reading of Davidson (especially his poem *Thirty Bob a Week*) had made him aware that English verse could use a more 'colloquial idiom' and present a form in which 'a good many dingy urban images' could be revealed.[36]

Discussing the influence of the Rhymers on Eliot, Yeats, and Pound, James Longenbach writes that, although the earlier group failed in their opposition to modern commerce, 'they alone opposed a suffocating literary climate. Pound and Eliot thought themselves as the inheritors of that struggle.'[37] Reading Davidson's poems more attentively and understanding the Rhymers' close, though often ambiguous, relationship to Fleet Street shows a very different picture from that of pure opposition, a picture that has been somewhat occluded in the later depictions by modernist writers of the Rhymers as beaten down by commercial journalism (such as Pound's depiction of Plarr as Monsieur Verog in *Hugh Selwyn Mauberley* or Yeats's account of the group in 'The Grey Rock'). By 1903 Arthur Symons would write: 'The newspaper is the plague, or black death of the modern world. It is an open sewer, running down each side of the street, and displaying the foulness of every day.'[38] That Symons could speak with such bile was, however, probably because he, like his other fellow Rhymers, had spent so much time working for, or alongside, this plague, often sharing a drink or three with other 'journalists' in the Cheshire Cheese.

POETS' CLUBS AND IMAGIST GANGS

There are many starting points for the Imagist group, often considered the first truly modernist poets in English, and whose first anthology, *Des Imagistes*, was edited by Pound. One interesting point of connection back to the Rhymers is that of the Poets' Club, started in 1908. From this Club a breakaway group emerged, led by T. E. Hulme and F. S. Flint, whom Pound dubbed the 'forgotten school of 1909'; the Imagists, he noted, were their 'descendants'.[39] The Poets' Club met in another intriguing location, west from Fleet Street, in St James's Street, a street famous in the eighteenth century

[36] From T. S. Eliot, 'Preface' to *John Davidson: A Selection of His Poems* (1961); cited in Eliot, *Inventions of the March Hare: Poems 1909–1917*, ed. Christopher Ricks (London: Faber, 1996), 398. The many other Rhymers poems that took London as a subject may also have influenced Eliot.

[37] James Longenbach, *Stone Cottage: Pound, Yeats, and Modernism* (New York: Oxford University Press, 1998), 170.

[38] Symons, *Studies in Prose and Verse*, 3.

[39] Ezra Pound, 'Prefatory Note' to 'The Complete Poetical Works of T. E. Hulme', in Pound, *Collected Shorter Poems* (London: Faber, 1984), 251.

for its coffee houses and by the early twentieth century home to many of London's most fashionable gentlemen's clubs, such as Brooks's, White's, and Boodle's. The Poets' Club met once a month at the United Arts Club, above Rumpelmayer's restaurant, and shared their premises with the Junior Army and Navy Club. The Poets' Club was run by a Scottish banker, Henry Simpson, and by Henry Newbolt, later to find fame as a patriotic poet. They published three anthologies in 1909, 1911, and 1913. The Club seemed consciously to look back to the Rhymers, as members from the earlier group such as Plarr, Rhys, Todhunter, Image, and Greene all attended. Plarr delivered a lecture at the Poets' Club in December 1910 entitled 'The Rhymers' Club', drawing attention to those in his audience who were members of the earlier formation.[40] T. E. Hulme, recently returned to London after spending eight months in Canada and further time in Brussels, became honorary secretary of the group and drew up a set of rules that indicate the rather formal nature of the venture: there would be no more than fifty members; officers such as president, honorary secretary, and so on; a committee of five; and an annual membership fee of five shillings. After dinner had been served, the Chairman would invite members to read 'original compositions in verse', followed by a twenty-minute paper on 'a subject connected with poetry'.[41] Clearly this was a small cultural formation with a well-organized internal structure, its London location adding to the rather masculine flavour of an exclusive club, although women were clearly present and two poets, Lady Margaret Sackville and Marion Cran, were published in the anthologies. At one such meeting, towards the end of 1908, Hulme delivered 'A Lecture on Modern Poetry', a key document for the theory of Imagist poetry. He described how he could not find models for the poetry he wanted to write until he read French *vers libre* (free verse) in poets such as Gustave Kahn; this discovery aided his thinking that modern poetry must match the times, for each 'age must have its own special form of expression', and that what 'has found expression in painting as Impressionism will soon find expression in poetry in free verse'.[42] This verse will be written without a regular metre, argued Hulme, and will work by the 'juxtaposition of distinct images in different lines'; the poetry will resemble 'sculpture rather than music' as it has to 'mould images, a kind of spiritual clay, into definite shapes'.[43] How Hulme's theory—one he himself described, in an early use of this term, as a 'standpoint of extreme modernism'—was received by the other poets is not recorded. That it did have an impact is demonstrated by the fact that the essence of Pound's first manifesto for Imagism, 'Imagisme' (1913), can be found in the ideas espoused in Hulme's lecture. The impact of Hulme's theories is also evident in a classic Imagist poem such as H.D.'s 'Oread', which sharply juxtaposes 'distinct images in different lines':

[40] Plarr, 'The Rhymers' Club', 386.
[41] See Robert Ferguson, *The Short Sharp Life of T. E. Hulme* (London: Penguin/Allen Lane, 2002), 44.
[42] T. E. Hulme, 'A Lecture on Modern Poetry', in *Selected Writings*, ed. Patrick McGuinness (Manchester: Carcanet, 1998), 61, 64.
[43] Ibid. 64, 66.

> Whirl up, sea—
> Whirl your pointed pines,
> Splash your great pines
> On our rocks,
> Hurl your green over us,
> Cover us with your pools of fir.[44]

Here the waves of the sea are compared to pine trees, a startling optical comparison in many ways, since the similarity is between the separate realms of sea and land. The free verse here also employs Hulme's idea of a sculptural language, seen in the references to the shape and colour of the pines, and in the general simplicity of vocabulary and syntax. 'Oread' offers a set of 'definite shapes' which, as Hulme had called for, 'arrests your mind all the time with a picture'.[45]

Other differences between the verse of the Rhymers and that of the Imagists can be illustrated by a comparison between two poems addressing a very similar topic. Here is an extract from a poem, 'Sunset in the City', by Richard Le Gallienne, published in the first Rhymers anthology:

> Above the town a monstrous wheel is turning,
> With glowing spokes of red,
> Low in the west its fiery axle burning;
> And, lost amid the spaces overhead,
> A vague white moth, the moon, is fluttering.
>
> Above the town an azure sea is flowing,
> 'Mid long peninsulas of shining sand,
> From opal unto pearl the moon is growing,
> Dropped like a shell upon the changing strand.[46]

'Sunset in the City' is, to an extent, a successful evocation of its subject matter, one of a number of poems by Le Gallienne and other Rhymers depicting urban themes, especially based on London. However, the formal techniques used here are the conventional ones of English poetry that Hulme sought to reject: the poem has a tight metrical pattern, a familiar rhyme scheme, and a use of syntactic devices that are also predictable ('fiery axle burning' is often described as a Miltonic construction). None of these features make this a bad poem, but to an Imagist poet espousing 'extreme modernism' this would be an example of 'dated' poetry. Consider Richard Aldington's poem 'Sunsets', from the 1916 *Some Imagist Poets*, which takes a similar subject matter to that of Le Gallienne:

> The white body of the evening
> Is torn into scarlet,
> Slashed and gouged and seared
> Into crimson,

[44] H.D., 'Oread', in *Some Imagist Poets 1915: An Anthology* (Boston: Houghton Mifflin, 1915), 28.
[45] Hulme, 'A Lecture on Modern Poetry', 65.
[46] Richard Le Gallienne, 'Sunset in the City', in *The Book of the Rhymers' Club* (London: Elkin Mathews, 1892), 98.

And hung ironically
With garlands of mist.
And the wind
Blowing over London from Flanders
Has a bitter taste.[47]

Formally this poem departs markedly from the earlier text. There is no regular rhyme, metre, or stanza—it is clearly an example of *vers libre*. The syntax has no inversions such as 'fiery axle burning' and mostly follows the quality of speech, especially the use of 'And' to start a sentence. Comparing the central trope of the sky in both poems is also instructive: Le Gallienne's moon is compared to a 'vague white moth' amid a sky marked by the red tones of the setting sun, described in turn by a series of terms, 'monstrous', 'glowing', and the burning axle. Tellingly, Le Gallienne feels the need to spell out to the reader that the fluttering white moth is actually the moon. Aldington's imagery is sharper, shorter, and generally more allusive; the evening sky is compared to a body violently attacked, but the simile is now suppressed. Following Hulme's notion of juxtaposing distinct images, Aldington does not write, for example, that the evening sky *is like* a human body but rather presents it in a distinct fashion. The visual imagery here seems more controlled and integrated into the subject matter of the poem than in Le Gallienne. The red and white colouring implies a bloodied body, revealed at the end of the poem to be connected with the 'bitter' wind from the First World War battlefields of Flanders. In contrast one is always unsure why Le Gallienne's sunset evinces such fiery and monstrous characteristics.

To understand how Aldington could produce a poem so formally distinct from that of Le Gallienne one has to consider the role played not only by Hulme, in breaking away from the Poets' Club and the Rhymers, but also, crucially, the impact of Ezra Pound upon London cultural formations. Pound, arriving in London in 1908, had attended meetings of the Poets' Club through his friendship with Elkin Mathews, the first being on 23 February.[48] Pound was eager to meet members of the Rhymers, particularly Yeats, and probably recognized that the Poets' Club had strong links with them. In 1911 Pound praised the Rhymers as they 'did valuable work in knocking bombast & rhetoric & victorian syrup out of our verse . . . they ring true, as much of Tennyson & parts of Browning do not'.[49] Selwyn Image was described by Pound as 'one of the gang with Dowson, Johnson, Symons, Yeats etc.', and in 1909 Pound wrote to his father that Plarr, 'of the old Rhymers' Club', is 'most congenial' and that he was attending meetings of 'a sort of new Rhymers gang on Thursdays'.[50] This new 'gang' was Hulme's breakaway group from the Poets' Club and Pound's

[47] Richard Aldington, 'Sunsets', in *Some Imagist Poets 1916: An Anthology* (Boston: Houghton Mifflin, 1916), 10.

[48] See Robert M. Crunden, *American Salons: Encounters with European Modernism, 1885–1917* (New York: Oxford University Press, 1993), 208.

[49] Cited ibid. 201.

[50] See Longenbach, *Stone Cottage*, 11–13.

epithet illustrates something of how this cultural formation was structured in a far less formal fashion than those who met in St James's. Although this group was to form the basis of the Imagists, it is significant that Pound views them through the lens of the Rhymers, once again illustrating the continuities in the shape of these modernist formations in London.

Hulme's breakaway from the Poets' Club was stimulated by Flint's review in the *New Age* of the first anthology of the group. Flint, a working-class Londoner with an extensive familiarity with modern French verse, attacked the Poets' Club not for its poetry but rather for what it represented as a cultural formation: unlike the innovations of French poets, 'whose discussions in obscure cafés regenerated, remade French poetry', this London group is 'apparently a dining-club and after-dinner discussion association. Evening dress is, I believe, the correct uniform; and correct persons—professors, I am told!—lecture portentously to the band of happy and replete rhymesters.' Flint vaguely praises poems by Image, Simpson, Cran, and Hulme, but when he thinks 'of this club and its after-dinner ratiocinations, its tea-parties, in "suave South Audley Street"; and then of Verlaine at the Hotel de Ville . . . I laugh'.[51] Hulme replied decisively the following week, lambasting Flint's obsession with French poets in cafés and 'the illusion that poets must be addicted to circean excess and disordered linen'. Hulme also noted that the meeting place for the poets was in keeping with the London environment: 'We, like Verlaine, are natural. It was natural for a Frenchman to frequent cafés. It would be dangerous as well as affected for us to recite verse in a saloon bar.'[52] It is a fascinating exchange, for its focus is not on poetic technique but on *how* and *where* a group of modern poets in London should meet and recalls Symons's critique of the London Rhymers for what he saw as their obsession with all things French. Getting the structure of their formation right was clearly a matter of some importance.

Being in a 'gang' rather than a 'club' now seemed the way forward, and after this initial spat Flint and Hulme, perhaps surprisingly, became friends and started to meet on Thursdays in a new venue, the Tour d'Eiffel on Percy Street, off Tottenham Court Road. Here gathered ex-Rhymers Radford and Rhys, as well as Edward Storer, Francis Tancred (a Poets' Club member), Florence Farr (a mystic and close friend of Yeats), and three Irish poets, Joseph Campbell, Desmond Fitzgerald, and Padraic Colum. This proto-Imagist formation also met in another location, at the London branch of the Irish Literary Society, in Hanover Square in plush Mayfair, once again demonstrating an overlap with the Irish element in the Rhymers. The Tour d'Eiffel was to become a fabled venue for both the Imagists and Vorticists, with Wyndham Lewis painting a 'Vorticist Room' upstairs and the site becoming memorialized in William Roberts's painting in 1961–2 *The Vorticists in the Eiffel Tower Restaurant: Spring 1915*.[53] Neither Fleet Street nor St James's clubland, the restaurant was on the eastern edge of the bohemian area of Soho, in an area later to become known as

[51] F. S. Flint, 'Book of the Week', *New Age*, 4/16 (11 Feb. 1909), 327.

[52] T. E. Hulme, 'Belated Romanticism', *New Age*, 4/17 (18 Feb. 1909), 348.

[53] See Brooker, *Bohemia in London*, 123–31, for the role of the restaurant in these groups.

Fitzrovia, and close to Bloomsbury and the British Library. As a venue it was somewhere between Hulme's dining club and Flint's Frenchified café (as signalled by its title), but, as Brooker points out, another restaurant, Dieudonné's, was probably more closely associated with the later Imagist and Vorticist groups.[54] Dieudonné's was a fairly expensive restaurant and certainly not a place to find the 'disordered linen' Hulme complained about in French cafés. Nevertheless, Dieudonné's hosted a Vorticist dinner to launch *Blast* in July 1914, and an Imagist dinner just after this date, which was organized by Amy Lowell, the rich American pretender to the crown of the Imagist group started by Pound. Interestingly, Dieudonné's was located in Ryder Street, a road running off St James's Street, and thus no distance from where the Poets' Club met. Again this vacillation between the bohemia of Soho to the west and the wealth and status of St James's or Mayfair to the east seems symbolic of the way in which these two important movements positioned themselves in the available cultural field.

PROMOTING IMAGISM AND VORTICISM

Both Pound and Lowell understood the value of advertising the work of a cultural formation, although they differed somewhat in their understanding of how such a group should be organized. Banding together via shared manifesto, group exhibition, or anthology bolstered promotion of one's own career. These are all examples of what Morrisson terms the 'promotional culture' of modernism[55]—the product being both the shared 'ism' and the individual artist. By 1914 this was a crowded marketplace with a mystifying range of 'isms' from which the reading public could choose (Futurism, Impressionism, Cubism, Imagism, et al.). There was, therefore, much jostling for position in this market, shown, for example, in the way that the Vorticist movement in *Blast* repeatedly tries to distinguish itself from the competing movement of Futurism.[56]

The history of Imagism reveals both Ezra Pound and Amy Lowell as skilful promoters of the movement, as versions in fact of advertising agents. In his first contact with James Joyce, for example, Pound indicated that he might get the Irish writer published in various magazines. Some American magazines pay well, others less so, but, notes Pound, 'Appearance in the Egoist may have a slight advertisement

[54] Ibid. 114–23.

[55] Morrisson, *The Public Face of Modernism*, 6.

[56] See, for example, the comments 'AUTOMOBILISM (Marinettism) bores us' and 'The futurist is a sensational and sentimental mixture of the aesthete of 1890 and the realist of 1870'; see 'Long Live the Vortex!', in *Blast*, 1.

value if you want to keep your name familiar.'[57] Soon after, early in 1914, Pound received Joyce's poem 'I hear an army' and agreed to publish it in *Des Imagistes*. Though Joyce was paid for the poem, the 'advertisement value' of the publication was clearly of more cultural value for an aspiring writer, as Pound was aware. Some years earlier Pound had written to his parents to encourage them to promote his early volume of poetry *A lume spento* back home in his native America: 'It pays to advertise, ergo spread this precious seed. . . . What I want now is advance orders culled from general curiosity. The sale on pure & exalted merit will begin later . . . Boom—Boom—cast delicacy to the wind for I must eat.'[58] Of course, all writers like their work to be read, and most like to eat, but Pound's sense of the value of 'booming' literature was soon adapted to the Imagist movement as well.

It soon became clear to the other Imagists that cohabitation between the large personalities of Pound and Lowell would not work; it also became clear that the two Americans exhibited differing modes for leading the promotional culture of Imagism and, indeed, for the internal organization of the group. Richard Aldington, H.D., F. S. Flint, John Gould Fletcher, and D. H. Lawrence all opted, for diverse reasons, to join Lowell against Pound when she decided to publish a new Imagist anthology, but one organized on different principles. As Aldington reports it, Lowell desired a number of changes to the formation:

the immediate abolition of his [Pound's] despotism and the substitution of a pure democracy. There was to be no more of the Duce business, with arbitrary inclusions and exclusions and a capricious censorship. We were to publish quietly and modestly as a little group of friends with similar tendencies, rather than water-tight dogmatic principles. Each poet was to choose for himself what he considered best in his year's output. . . . To preserve democratic equality names would appear in alphabetical order.[59]

If we trust Aldington's account, it brings Pound's Imagism closer to a movement such as Futurism, dominated by the persona of Marinetti, while also suggesting that Lowell's Imagism was organized more like the Rhymers' or Poets' Clubs. Pound was invited to contribute to *Some Imagist Poets* (1915) but, perhaps not surprisingly given that he felt it was his invention, refused to join a 'democratic beer-garden'.[60] At one level this was because Pound was now busy with the Vorticist movement, which he viewed as a stronger challenger to Futurism, but in another sense the dispute over 'democracy' is a crucial one for understanding the formation of Imagism. Pound had written enthusiastically in an *Egoist* article that the 'aristocracy of the arts' was now in the ascendancy over the traditional aristocracy of British society.[61] The distinction between an Imagist aristocracy and an Imagist democracy is more than merely

[57] *Pound/Joyce: The Letters of Ezra Pound to James Joyce, with Pound's Essays on Joyce*, ed. Forrest Read (New York: New Directions, 1967), 18.

[58] Letter from Pound to his parents, n.d.; cited in Helen Carr, *The Verse Revolutionaries: Ezra Pound, H.D. and the Imagists* (London: Jonathan Cape, 2009), 89.

[59] Richard Aldington, *Life for Life's Sake* (London: Cassell, 1969), 127.

[60] Ezra Pound, *Selected Letters, 1907–1941*, ed. D. D. Paige (London: Faber, 1950), 48.

[61] Ezra Pound, 'The New Sculpture', *The Egoist* (Feb. 1914), 68.

terminological, since it indicates how the leader viewed the character of the group, and also how it might present itself to the external world.

Both parties were highly aware of the value of a marketable image or brand for Imagism. This concern for marketing was not, however, at the expense of the quality of the poetry itself. Writing of the schism between herself and Pound to Harriet Monroe, Lowell noted that Pound's *Des Imagistes* did not sell well, arguing that 'Advertising is all very well but one must have some goods to deliver, and the goods must be up to the advertisement.'[62]

Pound objected to Lowell's new plans for publishing the anthologies along demo-cratic lines, feeling that he did not want to be constrained by a 'dam'd contentious, probably incompetent committee' and that he would not 'waste time to argue with a committee'.[63] The tension between the individual and the group within a cultural movement is strongly in evidence here. Pound's objection is to how Lowell wishes to change the internal organization of the formation: by 1914 aristocratic artists did not bother with committees, as had the Rhymers' or Poets' Clubs.

Whether the new arrangement produced a better anthology than Pound's 'arbi-trary' editorial choices in *Des Imagistes* is a question of debate. The significant point here is to note how Lowell's actions altered the cultural formation of Imagism, both in its relations between the members and in its external relations to the cultural marketplace of modernism. Regardless of whether we agree with Pound that Imag-ism was 'diluted' by Lowell's leadership, it is indisputable that Lowell succeeded in publicizing the group. For Aldington, Pound was the inventor of the Imagist 'move-ment' and Lowell 'put it across'.[64] Lowell conceded that Pound invented the name 'Imagism' but argued that 'changing the whole public attitude from derision to consideration came from my work'.[65] T. S. Eliot dubbed her the 'demon saleswoman', and indeed Lowell ensured that the public bought the Imagist anthologies, eschewing the notion that modernist verse was only ever an elitist phenomenon.[66] Of the 750 copies printed of the 1915 *Some Imagist Poets*, some 481 were sold in advance; after six months a second edition was printed and overall the volume sold around 1,300 in the first year, figures also achieved by the 1916 anthology.[67] The first two Imagist anthologies only went out of print in 1924, and Lowell continued to send small royalties to contributors for a number of years.[68]

[62] Letter from Amy Lowell, 15 Sept. 1914, in Joseph Parisi and Stephen Young (eds), *Dear Editor: A History of Poetry in Letters: The First Fifty Years* (New York: Norton, 2002), 159.

[63] Pound, *Selected Letters*, 38.

[64] Aldington, *Life for Life's Sake*, 121.

[65] Cited in Jean Gould, *Amy: The World of Amy Lowell and the Imagist Movement* (New York: Dodd, Mead, 1975), 353.

[66] T. S. Eliot, cited in *Selected Poems of Amy Lowell*, ed. Melissa Bradshaw and Adrienne Munich (New Brunswick, NJ: Rutgers University Press, 2002), p. xv.

[67] See Gould, *Amy*, 176; S. Foster Damon, *Amy Lowell: A Chronicle* (Boston: Houghton Mifflin, 1935), 368.

[68] For information, see *The Letters of D. H. Lawrence and Amy Lowell 1914–1925*, ed. E. Claire Healey and Keith Cushman (Santa Barbara, Calif.: Black Sparrow Press, 1985).

Perhaps of more interest than mere sales of the volume, however, were the promotional activities carried out by Lowell for the new 'school'. Writing to her editor at her American publishers Houghton Mifflin, Lowell noted, 'you have not only an author in me, but an extremely good advertiser. My lectures have been worth more to you than all the advertising in the papers or efforts of salesmen.'[69] Lowell not only arranged the publication of the three anthologies (1915, 1916, 1917) but also promoted Imagism through numerous articles and reviews, flamboyant readings, and extensive lecture tours across America in 1916 and 1917. As Jayne Marek comments on Lowell's activities: 'Lowell's energetic promotion of poetry on both commercial and aesthetic grounds is particularly significant because the flux between high and low culture helped bring about literary modernism.'[70] Though Imagism was clearly not a cultural product geared to a mass market, Lowell's promotional work did utilize many of the strategies employed in that cultural field and showed that fluctuation between Fleet Street and pure aesthetics delineated in the earlier two groups.

Pound, however, took little notice of Lowell's success, channelling his energies from 1914 onwards into the Vorticist and other projects. The story of Vorticism, and what its leader Wyndham Lewis saw as the failure of the only British-based avant-garde movement, is by now a familiar one and there is not the space here to rehearse it once more.[71] One point to make, however, is that though the dominant tone of the first volume of *Blast* is that of a magazine presented by a tightly organized formation, operating around a central manifesto, the evidence of the contents is much more heterogeneous. Perhaps only in the visual arts and Lewis's play *Enemy of the Stars* can we easily discern a Vorticist style. Pound's few poems hardly define a Vorticist poetry, and likewise the prose of Ford and Rebecca West cannot be considered Vorticist in any meaningful way. Readers aware of Imagism were most likely to have been puzzled by Pound's claim that the Vorticist relies on the 'primary pigment' and that 'the primary pigment of poetry is the IMAGE', a claim he demonstrated by quoting H.D.'s quintessential Imagist poem 'The Pool'.[72] The prevailing sense is that of the cultural value of being in a formation of the avant-garde type—what it produces seems much less important than its attitude or stance.

Both Imagism and Vorticism are, like the Rhymers, heterogeneous formations in terms of their artistic production: Joyce and Lawrence are not really Imagists; the work by Lowell and Fletcher differs greatly from that of H.D. and Pound, and from Aldington and Flint yet again. But in terms of presenting themselves as a unified 'mouvemong', as Pound put it, the two formations that appeared in 1914 are much stronger. It is revealing, I think, to trace the genealogy of the 'men and women of 1914' in order to see how the idea of the modernist cultural formation emerged and

[69] Quoted in Jayne E. Marek, 'Amy Lowell, *Some Imagist Poets*, and the Context of the New Poetry', in Adrienne Munich and Melissa Bradshaw (eds), *Amy Lowell: American Modern* (New Brunswick, NJ: Rutgers University Press, 2004), 164.

[70] Ibid.

[71] See e.g. Paul Edwards (ed.), *Blast: Vorticism, 1914–1918* (Aldershot: Ashgate, 2000).

[72] Ezra Pound, 'Vortex. Pound', in *Blast*, 1. 154.

also for how the structure of its internal and external organization is prefigured in earlier groups such as the Rhymers and Poets' Club. A constant presence in the stories of these movements is the ambiguous engagement with commercial culture, often represented by the spectre of paid journalism. Pound's 'Salutation the Third', published in *Blast* 1, typifies how modernists, grouped protectively together in a formation, could venture forth to attack commercialism:

> Let us deride the smugness of 'The Times':
> GUFFAW!
> So much the gagged reviewers,
> It will pay them when the worms are wriggling in their vitals;
> These were they who objected to newness,
> HERE are their TOMB-STONES.

Only a few years earlier, around the time he attended Hulme's breakaway poet group, Pound was trying to bring 'newness' to the press, in the shape of his poem 'Ballad of the Goodly Fere' (a poem whose 'newness' would stylistically have fitted the Rhymers anthologies quite well). After writing the poem in the British Museum, he decided to try to get it placed: 'I peddled the poem about Fleet Street.... The poem was not accepted. I think the Evening Standard was the only office where it was even considered.'[73] Perhaps if the *Evening Standard* had taken the poem, things might have been different. Probably not, however, for the pressures that impelled individual poets in London to cohere into small movements were too strong to ignore or reject. And after 1914 modernists had to find other ways to peddle their poems.

[73] Ezra Pound, 'How I Began', cited in Noel Stock, *The Life of Ezra Pound* (Harmondsworth: Penguin, 1974), 84. The poem later appeared in Ford's *English Review* in October 1909, a magazine itself existing perilously between Fleet Street and an elevated French-style literary review.

CHAPTER 39

···

FUTURISM IN EUROPE

···

JOHN J. WHITE

'ALL the Futurisms in the world are the children of Italian Futurism', Filippo Tommaso Marinetti once claimed, while at the same time stressing that 'all Futurist movements are autonomous' because 'all races had or still have a traditionalism of their own to overturn'.[1] The Italian Futurist painters, writers, musicians, sculptors, and architects of the second decade of the twentieth century belonged to the first European avant-garde to define itself as a 'movement', although the group was to prove less coherent than its orchestrated programme of interlocking manifestos and collaborative activities at first suggested. Most other European Futurisms tended to fragment into even looser networks of artistic and literary coteries, in varying degrees influenced by—or more often reacting against—Italian Futurism's ambitious agenda of 'preparing the way for a Tomorrow dominated by us'.[2] As a matter of national pride, some Futurisms (Czech Devĕtsil, Yugoslav Zenitism, and Spanish Ultraismo, for example) signalled their independence by avoiding the label 'Futurism'. Others acknowledged often tenuous Futurist connections, among them Ukrainian Panfuturism, Russian Ego- and Cubo-Futurisms, and Soviet Kom-Fut, because of the advantages of association with the founding movement. By far the most significant in terms of Europe-wide impact and creative ingenuity was Italian Futurism itself, closely followed by the protean complex usually referred to as 'Russian Futurism'.

[1] F. T. Marinetti, 'Beyond Communism' (1919), in *Critical Writings*, ed. Günter Berghaus, trans. Doug Thompson (New York: Farrar, Straus, Giroux, 2006), 345.
[2] F. T. Marinetti, 'In This Futurist Year' (1915), in *Critical Writings*, 234.

This chapter concentrates on these two Futurisms, their manifesto programmes, literary achievements, and importance within early twentieth-century modernism.

Thinking about relationships between west and east European avant-gardes for a long time remained bedevilled by issues of influence, ideological tendency, and claims concerning *priorità*, i.e. who did what first.[3] Although some east European avant-gardes had a vested interest in understating their debts to Italian Futurism and Western modernism in general, it is now accepted that the Italians had a greater impact in Russia than was initially conceded. Calling one's movement 'Futurism' was, of course, intended to conjure up a picture of an aggressively anti-traditionalist avant-garde, part of a global programme to liberate countries from their obsolete cultural baggage. 'Throw Pushkin, Dostoevsky, Tolstoy, etc., etc. overboard from the Ship of Modernity,' Russia's first Futurist manifesto ordered.[4] 'We wish to destroy museums, libraries, academies [and] free our country from the stinking canker of its professors, archaeologists, tour guides and antiquarians,' its Italian equivalent proclaimed.[5] Such sentiments were part manifesto rhetoric and part a matter of tactical self-positioning. Despite surface similarities, the two movements in fact displayed radically divergent attitudes to their cultural heritage. Italian Futurism adopted a stridently polemical stance: 'destroy', 'tear up', 'burn', 'abolish', and 'get rid of' were the favourite manifesto imperatives of an iconoclastic aesthetic that in theory advocated the use of verbs only in the infinitive. Russian Futurist innovators, on the other hand, drew much of their strength from a programmatic renewal of folk traditions and their country's language roots, although they too established a rogues' gallery of canonical works and prior 'isms' singled out for ritual castigation. The two movements were anyway predicated on grossly incompatible conceptions of the future for which they saw themselves actively preparing: a patriotic, yet otherwise anti-sentimental, ruthless, machine-dominated world, in the Italian case, and one less politically motivated, yet open to active collaboration with Bolshevism, in Russia's. Marinetti's championing of war as the world's 'only hygiene' and his praise for the First World War as 'the finest Futurist poem that has materialized up to now'[6] find no echo in the writings of such leading Russian Futurists as Velimir Khlebnikov, Alexei Kruchenykh, and Vladimir Mayakovsky.

[3] On the relationship between Italian and Russian Futurism, see Vladimir Markov, *Russian Futurism: A History* (London: MacGibbon & Kee, 1969), *passim*; Vahan D. Barooshian, *Russian Cubo-Futurism, 1910–1930: A Study in Avant-Gardism* (The Hague: Mouton, 1974), 145–52; Anna Lawton, 'Russian and Italian Futurist Manifestoes', *Slavic and East European Journal*, 20 (Winter 1976), 405–20; and John Milner, *A Slap in the Face: Futurists in Russia* (London: Philip Wilson, 2007).

[4] David Burliuk, Alexander Kruchenykh, Vladmir Mayakovsky, and Victor Khlebnikov, 'A Slap in the Face of Public Taste' (1912), in Anna Lawton (ed.), *Russian Futurism Through its Manifestoes, 1912–1928* (Ithaca, NY: Cornell University Press, 1988), 51.

[5] F. T. Marinetti, 'The Foundation and Manifesto of Futurism' (1909), in *Critical Writings*, 14. For a close reading of Italian Futurism's founding manifesto, see Andrew J. Webber, *The European Avant-Garde, 1900–1940* (Cambridge: Polity Press, 2004), 20–6.

[6] Marinetti, *Critical Writings*, 53–4 and 235, respectively.

'The word "Futurism"', it has been claimed, 'is almost all that unites the Russian and Italian movements.'[7] The objectives, thematic and stylistic innovations, and principal preoccupations of these two virtually simultaneous European avant-gardes were largely the result of different socio-economic and historical factors, although stark national differences also coloured their responses to the pace of modernity. From the Interventionist Crisis of 1914–15 onwards, the First World War was the single most important historical event to leave its mark on Italian Futurism. The major turning point for the Russian avant-garde, on the other hand, came with the October Revolution and ensuing civil war. The two Futurisms' responses to these cataclysmic events—and to a less developed modernity, in Russia's case—were by no means confined to literature, although literature rapidly became the most politicized Italian Futurist medium, with painting coming a close second.[8]

In both Italy and Russia, Futurism was conceived of as a call for artistic revolution in all media and art forms (a broader innovative spectrum in the eyes of the leaders of the Italian avant-garde). The outcome was a rich period of influence and cross-fertilization between painting, poetry, and the performing arts, coupled with an experimental climate conducive to the systematic exploration of new genres and fresh modes of delivery. The excitement Italian Futurism generated, especially among the young in the cities of northern Italy, was largely attributable to the movement's rare breadth of vision and the passion with which the need for a 'Futurist Reconstruction of the Universe'[9] was communicated. Italian Futurism's numerous manifestos, translated into virtually all European languages and heralding the arrival of the twentieth-century machine aesthetic, were a powerful genre in their own right. Similarly, Futurist *serate*, combining manifesto declamations, poetry readings, and mixed-media events, became the most effective propaganda medium for raising public consciousness of the movement's artistic and political agendas. Such events made Italian Futurism's impact notoriously immediate and dramatic. While Marinetti's role as the movement's leader and artistic impresario, his literary inspiration—invariably leading by example—and his tireless organizational work in promoting European Futurism have been recognized, his 'marketing' methods have only recently been examined.[10] Without Marinetti, there would quite simply have been no Futurism. Although vestiges of Futurism lingered for longer in post-war Italy than in the USSR, both movements had set their sights on a more distant future than they

[7] Camilla Gray, *The Russian Experiment in Art, 1863–1922* (London: Thames & Hudson, 1986), 94.

[8] Anthologies of Futurist poetry in English translation can be found in Zbigniew Folejewski, *Futurism in its Place in the Development of Modern Poetry: A Comparative Study and Anthology* (Ottawa: University of Ottawa Press, 1980), 123–275, Ellendea Proffer and Carl R. Proffer (eds), *The Ardis Anthology of Russian Futurism* (Ann Arbor: University of Michigan Press, 1980), and Lawrence Rainey, Christine Poggi, and Laura Wittman (eds), *Futurism: An Anthology* (New Haven: Yale University Press, 2009), 409–506.

[9] This is the title of a 1915 manifesto by Giacomo Balla and Fortunato Depero, in Umbro Apollonio (ed.), *Futurist Manifestos* (London: Thames & Hudson, 1973), 197–200.

[10] Claudia Salaris, 'Marketing Modernism: Marinetti as Publisher', *Modernism/Modernity*, 1, special issue: *Marinetti and the Italian Futurists* (1994), 109–27.

proved able to construct. Because of their future-orientation and strong political support for the extreme Right or radical Left, respectively, Italian and Russian Futurists had for a while hoped to survive their countries' drastic regime changes. In the event, radical shifts in cultural politics and new power structures led to their being marginalized and ultimately neutralized.

MODERNITY, 'MODERNOLATRIA', AND THE FUTURIST SENSIBILITY

Sensibilità was one of Italian Futurism's buzzwords. 'Our Futurist sensibility', Marinetti proclaimed, 'is no longer moved by an unexplored valley or by a mountain gorge', it draws inspiration from the 'elegant [Futurist] white road' and the passing car 'gleaming with progress'.[11] The Futurist painters justified their new aesthetic on the grounds that 'science makes profound changes in humanity inevitable'.[12] In 1912 they presented themselves to London as 'the primitives of a completely renovated sensibility'.[13] What they were referring to was a new state of mind, not just the technological advances that gave rise to the wave of 'modernolatria' associated with Italian Futurism. Marinetti refers to a 'complete renewal of human sensibility brought about by the great discoveries of science': 'the telegraph, the telephone, and the gramophone, the train, the bicycle, the motorcycle, the automobile, the ocean liner, the airship, the aeroplane, the cinema, the great daily newspaper (which synthesizes the daily events of the whole world)'. Marinetti's subsequent list of 'elements of the new Futurist sensibility' ranges from the increased pace of living, a love of speed and danger and passion for cities, to the machine-induced global sense of 'the earth [shrunk by speed]'.[14] While inventories of such 'modifiers of our sensibility' were common among European avant-gardes, a feature of the Italian variant is the extent to which these influenced the movement's reactions to obsolescent genres and its search for fresh innovative techniques appropriate to hyper-modernity. Marinetti's description of a 'great, humming electric power station . . . its four distribution columns bristling with meters, control panels and levers' ends

[11] F. T. Marinetti, 'We Renounce Our Symbolist Masters, the Last of All Lovers of the Moonlight' (1911), in *Critical Writings*, 44.

[12] Umberto Boccioni, Carlo Carrà, Luigi Russolo, Giacomo Balla, and Gino Severini, 'Manifesto of the Futurist Painters' (1910), in Apollonio (ed.), *Futurist Manifestos*, 24.

[13] Giacomo Balla, Umberto Boccioni, Carlo Carrà, Luigi Russolo, and Gino Severini, 'The Exhibitors to the Public', in Apollonio (ed.), *Futurist Manifestos*, 49

[14] F. T. Marinetti, 'Destruction of Syntax—Untrammeled Imagination—Words-in-Freedom' (1914), in *Critical Writings*, 120–31.

with these being advocated as the 'sole models for poetry'.[15] More significant than Marinetti's often ill-thought-through analogies between science, technology, and artistic creative processes was the role they played in shaping the Futurist conception of experiment and the belief that correctly designed experimental sequences would help literary Futurism adjust its aesthetic to contemporary modernity. (There is no equivalent in Russian Futurism, nor before the October Revolution was there felt to be a need for one.) One illustration of such teleological thinking is Marinetti's declaration that 'the continuous perfection and endless progress of humankind, both physiological and intellectual' are 'absolute principles of Futurism'.[16] As well as influencing the movement's approach to literary experimentation, these principles strengthened its belief in 'the necessary intervention of artists in public affairs'.[17] Italian Futurism assigned itself the dual task of *reflecting* an elite's already existent modernist sensibility while at the same time using literature and the other arts to *engineer* an appropriate response to modernity in the decades and, they hoped, centuries to come.

Given the proliferation of city motifs in Futurist painting,[18] one might have expected urban themes to figure more often in European Futurist poetry. While the 'salon' urbanist writers of St Petersburg and Moscow tended to create modernist images which had little to do with even the sedate cities of old imperial Russia, the modern city for Marinetti's circle was a thrilling place of trams, cars, stations, building sites, political skirmishes, and bustling hyperactivity. In Russia, a number of Ego-Futurists and urbanist poets belonging to the Mezzanine of Poetry group shared Italian Futurism's conception of the city.[19] Even Russian 'street' urbanism, as a later development was called, was less intent on evoking actual twentieth-century cities—or even futuristic cities—than on portraying phantasmagorical cities of the mind, places of fear and hallucinations rather than Marinettian enthusiasms.[20] As a Futurist phenomenon, the city is more vividly evoked in the work of such painters as Nataliya Goncharova and Mikhail Larionov and in the poetry of Elena Guro and

[15] F. T. Marinetti, 'Geometrical and Mechanical Splendor and Sensitivity Toward Numbers' (1914), in *Critical Writings*, 136.

[16] F. T. Marinetti, 'War, the World's Only Hygiene' (1915), pub. as 'War, the Sole Cleanser of the World', in *Critical Writings*, 53–4.

[17] F. T. Marinetti, 'The Necessity and Beauty of Violence' (1910), in *Critical Writings*, 63.

[18] On Futurist city images, see Marianne W. Martin, *Futurist Art and Theory, 1909–1915* (Oxford: Clarendon Press, 1968), *passim*. Futurism's contribution to urban architecture is assessed in Esther da Costa Meyer, *The Work of Antonio Sant'Elia: Retreat into the Future* (New Haven: Yale University Press, 1996).

[19] e.g. Vadim Shershenevich's *Green Street* (*Zelenaya ulitsa*, 1916) and Konstantin Bolshakov's *A Heart Wearing a Glove* (*Serdtse v perchatke*, 1913). Shershenevich's role as mediator between Italian and Russian Futurism is documented in Anna Lawton, *Vadim Shershenevich: From Futurism to Imaginism* (Ann Arbor: Ardis, 1981).

[20] For a detailed survey, see Kjeld Bjørnager Jensen, 'The Urbanism of Russian Futurism', in *Russian Futurism, Urbanism and Elena Guro* (Aarhus: Arkona, 1977), 131–82.

Vladimir Mayakovsky. Unfortunately, Italian Futurism tended to find 'the Futurist moment' more on the battlefront than in cities and factories.[21] Marinetti's dynamic war poems undoubtedly played a greater role in spreading the new sensibility than did the often tame city poetry in the movement's first showcase anthology, *I poeti futuristi*.[22]

'We intend to glorify aggressive action,' point 3 of Italian Futurism's founding manifesto declared.[23] In Marinetti's case, communicating such an optimistic, positively welcoming Futurist sensibility also had its dark side: for example, in his prediction that the future 'nonhuman, mechanical species, built for speed, will quite naturally be cruel, omniscient and warlike'[24] and in his account of the siege of Adrianopolis (Edirne) describing how 'the bright, insistent volley of a cannon, made red-hot by the sun and by an increased rate of firing, [made] the spectacle of mangled, dying human flesh almost negligible'.[25] Marinetti welcomed mechanical warfare as 'Futurism intensified'.[26] Not surprisingly, after the 'militarization' of the movement's writers,[27] literary Futurism became largely synonymous with pro-war propaganda in the public mind. In the words of one manifesto,[28] the Futurists were working 'to prepare the Italian sensibility for the great hour of maximum danger'. This in practice required an effective combination of literary sabre-rattling, war reporting, and political propaganda.

FUTURISM AND POLITICS

Despite Mussolini's statement that 'without Futurism there would never have been a Fascist movement',[29] the entry 'Ideology' in the 'Dictionary of Futurism' claims that Italian Futurism 'had no ideology, nor did it want one'.[30] During Futurism's rehabilitation after the Second World War, there was a tendency to minimize the movement's political activities in an attempt to sanitize much of its literary output. Yet many of its trail-blazing experiments only make sense in their historical and political context.

[21] On the various modernist forms assumed by 'the Futurist moment', see Marjorie Perloff, *The Futurist Moment: Avant-Garde, Avant-Guerre and the Language of Rupture* (Chicago: University of Chicago Press, 1986).

[22] F. T. Marinetti (ed.), *I poeti futuristi* (Milan: Edizioni futuriste di 'Poesia', 1912).

[23] Marinetti, 'The Foundation and Manifesto of Futurism', in *Critical Writings*, 13.

[24] F. T. Marinetti, 'Extended Man and the Kingdom of the Machine' (1915), in *Critical Writings*, 86.

[25] Marinetti, 'Geometrical and Mechanical Splendor and Sensitivity Toward Numbers', in *Critical Writings*, 137.

[26] Marinetti, 'In This Futurist Year', in *Critical Writings*, 236.

[27] F. T. Marinetti, 'The Meaning of War for Futurism' (1915), in *Critical Writings*, 239.

[28] 'The Futurist Synthetic Theatre' (1915), in Apollonio (ed.), *Futurist Manifestos*, 183.

[29] Quoted in Emilio Gentile, 'The Conquest of Modernity: From Modernist Nationalism to Fascism', *Modernism/Modernity*, 1, special issue: *Marinetti and the Italian Futurists* (1994), 55.

[30] Pontus Hulten (ed.), *Futurismo & futurismi* (Milan: Bompiani, 1986), 488.

It does Italian literary Futurism a disservice to ignore the fact that many of its achievements, some the work of Marinetti himself, were within the framework of a nowadays unacceptable political and philosophical programme. While it is right to reject any crude equation of Futurism with Italian Fascism, recent research has documented the extent to which the 'heroic' phase of Italian Futurism was part of a wider revolutionary movement that embraced the nationalist politics of the day.[31]

It may clarify the picture to distinguish between three phases of Italian Futurism: (1) that of Marinetti's 1910 novel *Mafarka the Futurist: An African Novel* (*Mafarka le futuriste: Roman africain*), a work in many respects echoing the mood and anarchist-cum-nationalist stance of the early manifestos and the belligerent tone of much proto-Futurist verse; (2) the time from 1913 until the end of the First World War, during which the movement, now highly politicized, produced an imposing corpus of paintings, dramas, and poems in support of the Irredentist and Interventionist causes;[32] and (3) the years following Marinetti's break with Fascism in 1920, a period characterized by a return to literary concerns. Neither discrete nor of equal significance, these three periods at times overlapped. And even when Futurism's representatives claimed to be acting outside politics while actively supporting the contemporary nationalist agenda, their utterances were often so inconsistent or opportunistically phrased as to require cautious treatment.

Following hard on the heels of 'The Foundation and Manifesto of Futurism' (1909), the Italian Futurists, now styling themselves 'Futurist Nationalists', issued the 'First Futurist Political Manifesto'. With a programme of 'opposition to the Triple Alliance [Austria, Germany, and Italy] and reviving irredentism', their platform was one of 'national pride, energy and expansion' plus hostility to 'every sort of pacifist cowardice'.[33] Although two more Futurist political manifestos contained further nationalist propaganda, the relationship between literary and political Futurism remained nebulous. While Günter Berghaus has meticulously charted Marinetti's path from 'anarchist rebellion to fascist reaction', it would be wrong to equate the leader's politics with the position of all Futurists. In any case, it would be hard to detect signs of the political direction the movement would take on the evidence of Marinetti's first novel or the thrust of his pro-violence manifestos of Futurism's early years.[34] Italy's political situation was continually changing and Futurist responses evolved rapidly.

Mafarka the Futurist itself is an unapologetically primitivist novel, dwelling voyeuristically on scenes of violence, including mass rape, the slaughter of captives,

[31] On the relationship between Futurism and Italian Fascism, see George Mosse, 'The Political Culture of Italian Futurism', *Journal of Contemporary History*, 24 (1989), 5–26, and Günter Berghaus, *Futurism and Politics: Between Anarchist Rebellion and Fascist Reaction, 1909–1944* (Providence, RI: Berghahn, 1996).

[32] Italian Futurism's support for the Irredentist campaign to accelerate the return to Italy of the *terra irredenta* (border territories deemed Italian, though currently under Austrian rule), and its Interventionist propaganda seeking to persuade procrastinating Italy to leave the Triple Alliance and join the war on the Entente side, are discussed in detail in Berghaus, *Futurism and Politics*, 47–91.

[33] F. T. Marinetti, 'First Futurist Political Manifesto' (1909), in *Critical Writings*, 49–50.

[34] For an analysis, see Andrew Hewitt, 'Fascist Modernism, Futurism and "Post-Modernity"', in Richard J. Golsan (ed.), *Fascism, Aesthetics and Culture* (Hanover, NH: University Press of New England, 1992), 38–55.

aggressive displays of misogyny, and racially motivated conflict.[35] Although the eponymous Mafarka is presented as a Futurist, he shows few of the Milanese group's political concerns—nor can he, given the work's timeless setting. The novel's proto-fascism is as a consequence also largely proto-Futurist. In manufacturing an artificial machine son, Mafarka does loosely prefigure the mechanical man prophesied in the manifesto 'Extended Man and the Kingdom of the Machine',[36] but this is the closest the novel comes to a genuine Futurism of the future, or the immediate present. Marinetti settles for prolonged scenes of orchestrated violence, shrill evocations of the ecstasy of combat, and various other predictable male fantasies of the time. The novel at best fleshes out certain infamous passages from Futurist manifestos concerning 'scorn for women',[37] the 'aesthetic of violence and blood',[38] and Futurist man's need to 'celebrate the salutary incision of the scalpel in the gigantic boil of fear'.[39] Later in the century, long after *Mafarka*, when close combat has been partly replaced by mechanical slaughter, we hear that 'the only things [Futurists] can admire today are the immense symphonies of shrapnel and the bizarre sculptures [their] inspirational artillery is creating among the enemy masses'.[40] Despite talk of the 'necessary intervention of artists in public affairs',[41] we are assured that their activities will be 'entirely free of any political agenda'.[42] Yet in political terms the cocktail of Social Darwinism, Nietzschean Superman morality, Sorel's *Réflexions sur la violence*, and Bergsonian vitalism served up in *Mafarka* and the early manifestos was potentially lethal. Fortunately, when the Italian Futurists eventually aligned themselves to specific political causes, their goals become less barbaric and more pragmatically defined.

While *Mafarka*'s North African setting and its scenes of desert warfare can be read against the backdrop of Italian colonial expansionist expectations in the wake of the Triple Alliance, the work pre-dates Marinetti's involvement in the Libyan War documented in his poem 'Battle Weight + Smell' ('Battaglia peso + odore').[43] In retrospect, the 'African novel' has usually been seen as a glorification of war per se. Only later did Marinetti & Co. mount a major political crusade, using literature as their weapon of choice, with the aim of hastening Italy's involvement in the First

[35] F. T. Marinetti, *Mafarka le futuriste: Roman africain* (Paris: Sansot, 1910). For detailed assessments of the work, see F. T. Marinetti, *Mafarka the Futurist: An African Novel*, ed. and trans. Carol Diethe and Steve Cox (London: Middlesex University Press, 1997), vii–xxiii; Cinzia Sartini Blum, 'The Superman and the Abject: *Mafarka le futuriste*', in *The Other Modernism: F. T. Marinetti's Futurist Fictions of Power* (Berkeley and Los Angeles: University of California Press, 1996), 55–78; and Barbara Spackman, 'Mafarka and Son: Homophobic Economics', *Modernism/Modernity*, 1, special issue: *Marinetti and the Italian Futurists* (1994), 89–107.
[36] The immediate, albeit apolitical, source for such fantasies was Mario Morasso's *La nuova arma (la macchina)* (Turin: Bocca, 1905).
[37] F. T. Marinetti, 'The Foundation and Manifesto of Futurism' (1909), in *Critical Writings*, 14.
[38] Marinetti, 'The Necessity and Beauty of Violence', in *Critical Writings*, 72.
[39] Ibid., 72. [40] Ibid., 74.
[41] Ibid., 63. [42] Ibid., 60.
[43] An English translation of Marinetti's 'Battaglia peso + odore' can be found in *Critical Writings*, 117–19.

World War. What is most striking about this campaign is not its political fervour, but the outstanding calibre of work it introduced.

With his map poem 'Words-in-Freedom (Irredentism)' ('Parole in libertà (Irredentismo)') of 1914,[44] Marinetti sought to goad armchair Irredentists into action by literally mapping out the route a recovery expedition might take. Within the year, a parallel, yet more pressing, Interventionist campaign was beginning to inspire some of Marinetti's new genre of political propaganda communicated via dynamically shaped poetry. Outstanding innovative work in this medium includes the verbal collages 'After the Marne, Joffre Toured the Front by Car' ('Après la Marne, Joffre visita le front en auto'), '9-Storey Battle of Mount Altissimo' ('Bataille à 9 étages du Mont Altissimo'), and 'At night, lying in bed, she rereads the letter from her gunner at the front' ('Le Soir, couchée dans son lit, elle relisait la lettre de son artilleur au front').[45] These examples of Futurist political collage at its best were to enjoy pride of place in the anthology *Futurist Words-in-Freedom* (*Les Mots en liberté futuristes*, 1919).[46] Uniquely dynamic, they owe much of their authority to the bold layouts used to convey sense impressions of what Marinetti saw as the exhilaration of battle. Their raucous onomatopoeias and explosive typography were supposed to communicate the feel of conflict at the cutting edge. Modern battle experience was presented as characterized by an acoustic collage of inanimate noises (exploding bombs, mortar shells, grenades, machine-guns, tanks, aeroplanes, etc.), although tellingly seldom the sounds of the wounded and dying.

A distinctive feature of many of Marinetti's war poems is the way they are tied to specific places and events. The location of *Zang tumb tumb* is identified as Adrianopolis during the Bulgarian–Serbian siege of October 1912–March 1913. An inscription in 'At night, lying in bed' relates the letter poem to the bombardment of Mount Kuk, an episode during the Tenth Battle of the Isonzo (1917), while '9-Storey Battle' was a product of the bombardment of Dosso Casina (1915), the last two chosen as symbolic victories over the Austrians. Such poems functioned as postcards from the front, works designed to support the Irredentist–Interventionist case[47] through reader empathy with those engaged in battle. A regular item at Futurist *serate* was the appearance of Marinetti, arriving hot-foot from the front, giving a vivid account of his latest battle experiences. The politicization of shaped poetry remains one of Italian literary Futurism's most important accomplishments. With the support of

[44] Repr. in Richard Cork, *A Bitter Truth: Avant-Garde Art and the Great War* (New Haven: Yale University Press, 1994), 62.

[45] English translations can be found in F. T. Marinetti, *Selected Poems and Related Prose*, ed. and trans. Elizabeth R. Napier and Barbara R. Studholme (New Haven: Yale University Press, 2002), 118–22. For close readings, see Johanna Drucker, *The Visible Word: Experimental Typography and Modern Art, 1909–1923* (Chicago: University of Chicago Press, 1994), 131–7.

[46] A facsimile of the original 1919 Edizioni futuriste di 'Poesia' volume *Les Mots en libertés futuristes* has been published by Mondadori (Milan, 1986).

[47] Although the majority of Italian Futurism's Interventionist 'words-in-freedom' and literary collages were published during the 1914–15 campaign, others date from later and some were even not published until after 1918. By then, their function was either to confirm in retrospect the stand taken or to suggest that the Irredentist struggle had not yet been concluded to the Futurists' satisfaction.

Balla, Buzzi, Cangiullo, Depero, Severini, and Soffici, Marinetti successfully harnessed Futurist war poetry to contemporary causes. Yet the resultant poems have often been interpreted exclusively as evidence of a 'typograpical revolution', the jingoistic subtext being airbrushed out of the picture in an attempt to put 'words-in-freedom' on a par with the visual poetry of Dada, Surrealism, and Russian Futurism. Yet it was not a new primitive sensibility that produced Italian Futurism's best visual work; nor was it modernity. It was the movement's pressing need for effective political propaganda.

In contrast to such artistic high points in First Futurism's pro-war poetry, Second Futurism was a relatively apolitical late episode in the movement's history. However, purveyors of 'aero-poetry', 'aero-painting',[48] and patriotic murals still needed to find themselves temporary niches in the new, largely unappreciative, Fascist Italy. With the exception of some impressive abstract visual work (including stage sets) by Balla and Depero, Second Futurism lacked material worthy of a place alongside the internationally acclaimed achievements of early Futurism. While the final phase's meagre results were not intended to glorify Fascism, individual Futurist writers did turn to political hack work during Mussolini's regime.

Italian 'Words-in-Freedom' and Russian Cubo-Futurism's Verbal Experiments

In 1913 Marinetti set out a series of stringent prescriptions for a new elliptical style of poetry.[49] They were unambiguously radical: put verbs in the infinitive, avoid adjectives and adverbs, jettison punctuation, use mathematical and musical signs in the interest of brevity. According to Marinetti, the speed of contemporary experience obliges Futurist poets to communicate with the 'economical rapidity that the telegraph imposes on reporters and war correspondents'.[50] Although Marinetti's preferred illustrations, 'Battle of Tripoli' ('Battaglia di Tripoli', 1911), 'Battle Weight + Smell' ('Battaglia peso + odore', 1912), and *Zang tumb tumb* (1914), were all war poems, the liberation of language from antiquated syntax was usually presented as appropriate to the depiction of modernity in general. Just as Futurist painting's 'visual foreshortening', 'synthesis' of impressions, and dynamic force-lines were a response to 'the speed of cars and trains', so the new 'telegraphic laconicism' was presented in terms invoking the pace of life. Other manifestos made the case for

[48] For illustrations, see Bruno Mantura, Patrizia Rosazza-Ferraris, and Livia Velani (eds), *Futurism in Flight: 'Aeropittura' Paintings and Sculptures of Man's Conquest of Space* (Rome: De Luca, 1990).

[49] In F. T. Marinetti, 'Technical Manifesto of Futurist Literature' and 'Destruction of Syntax—Untrammeled Imagination—Words-in-Freedom', in *Critical Writings*, 107–31.

[50] Ibid. 123.

'essential brevity', a concept associated with Futurism's preoccupation with matter and materiality: only the poet 'detached from syntax and in command of words-in-freedom will know how to penetrate the essence of matter', as Marinetti put it.[51]

Many of the movement's early 'words-in-freedom' (*parole in libertà*) derived their success from Marinetti's booming, staccato declamations, whereas other potentially bold innovations were at first deployed all too timidly. Futurist poets also remained subject to the constraints of printing techniques and conventions retained largely for economic reasons (black-on-white horizontal lines, justified margins, and left-to-right reading patterning). It was only with the advent of a technology able to produce non-horizontal, mimetically shaped typography, so-called 'auto-illustrations', that the way was opened up for the 'typographical revolution' heralded in the 'Destruction of Syntax' manifesto. Structurally reminiscent of Apollinaire's *calligrammes*, 'auto-illustrations' consisted of local clusters of shaped poetry deployed for purposes of dramatic intensification, within a conventionally linear layout. Their imitative element was strictly limited (a balloon shape, a biplane's wings, an aircraft looping the loop, the force-lines of explosions and howitzer fire). After the invention of 'designed analogies',[52] the relationship between sign and signified became less codified and more a matter of reader response. The Futurist 'designed analogy' prepared the ground for a series of more adventurous word collages. With the exception of Carrà's *Patriotic Festival* (*Festa patriottica*, 1914), a collage in the original sense of the word, the majority of these—including Cangiullo's *Milan-demonstation* (*Milano-dimostrazione*, 1915), Severini's *Serpentine Dance* (*Danza serpentina*, 1914), and Depero's *Skyscrapers* (*Grattacieli*, 1929)—combined graphic and typographical elements.[53] These impressive verbal collages, the crowning glory of literary Futurism's free-word 'typographic revolution', remained a largely Italian phenomenon. In the meantime, well before the emergence of the sub-genre of *literary* collage, the trajectories of the Italian and Russian avant-gardes had begun to diverge.

Throughout the First World War and over the following decade and a half, Italian Futurism concentrated with increasing ingenuity on making the printed page ever more 'expressive' (i.e. 'more imitative'): on the possibilities of typographical onomatopoeia, 'free expressive orthography' (elastic spelling), and acoustically motivated variations in type-size, colour, and layout.[54] In contrast, Russian Futurists directed their attention to 'the word as such' (i.e. isolated individual words explored

[51] Ibid. 112.

[52] The implicit analogy between smoke and boredom in Francesco Cangiullo's free-word poem 'Fumatori II' (1914) is analysed in Marinetti's 'Geometrical and Mechanical Splendor and Sensitivity Toward Numbers', *Critical Writings*, 138–9.

[53] On 'the level of overt propaganda found in Futurist collage' and the movement's consequential retreat from abstraction, see Christine Poggi, *In Defiance of Painting: Cubism, Futurism, and the Invention of Collage* (New Haven: Yale University Press, 1992), 25–6 and 177.

[54] For examples of Italian Futurist free-word poetry, see Luciano Caruso and Stelio Martini (eds), *Tavole parolibere futuriste, 1912–1944*, 2 vols (Naples: Liguori, 1974, 1977); Maria Carla Papini (ed.), *L'Italia futurista, 1915–1918* (Rome: Edizioni dell'Ateneo & Bizzarri, 1977); Anne Coffin Hanson (ed.), *The Futurist Imagination: Word + Image in Futurist Paintings, Drawings, Collage and Free-Word Poetry* (New Haven: Yale University Art Gallery, 1983); Giovanni Lista, *Le Livre futuriste: De la libération du mot au poème*

both typographically and semantically, often in non-syntactical sequences). They also delved into their language's real and putative etymological roots and experimented with what Kruchenykh called 'arbitrary word-novelty' (the creation of defamiliarizing neologisms out of the proposed reservoir).[55] Italian Futurist visual and performed poems were more easily able to cross borders and influence new trends. Russian writers, with a few notable exceptions, often turned a blind eye to developments in the West and resisted Italian attempts at infiltration. Such differences were already present in the contrasting contents of Russian and Italian Futurist literary manifestos.

With its iconoclastic bravado and bold claims ('*We* alone are the *face* of *our* Time', 'from the heights of our skyscrapers we gaze at [our predecessors'] insignificance'[56]), Russian Futurism's 'A Slap in the Face of Public Taste' (1912) was very much a launch manifesto in the manner of Marinetti's 'Foundation and Manifesto of Futurism'. Soon the theoretical manifestos of various Cubo-Futurist subgroups began setting out new 'principles of creativity' and a programme of experiments based on the 'self-sufficient word'. These involved mobilizing etymology in the service of creative neologism, enriching word roots with alien prefixes, infixes, and suffixes, as well as exploiting morphemic elements to generate a new poetic vocabulary. The literary manifestos also stressed the importance of semanticizing words 'on the basis of graphic and phonic characteristics' and exploiting handwriting's value as 'a component of the poetic impulse'.[57] Painted books with autographed covers, handwritten poems, and the use of primitive page materials became the hallmarks of Russian Futurism's old–new presentational style.[58] With the stress firmly on creativity, the closest the pan-Russian programme comes to Italian Futurism's war on 'passéiste' grammar and cultural icons was in occasional references to 'loosening syntax' or avoiding 'bookishness'. Even Russian Futurism's notorious 'transrational language' (*zaumnyy yazyk*) developed out of games played with single letters of the Cyrillic alphabet randomly placed in new consonantal and vocalic clusters was not just an abstract form of language experiment 'beyond logic' (*zaum'*), but part of a utopian

tactile (Modena: Panini, 1984); and John J. White, *Literary Futurism: Aspects of the First Avant-Garde* (Oxford: Clarendon Press, 1990), 8–142.

[55] Alexei Kruchenykh, 'New Ways of the Word' ('Novye puti slova', 1913), in Lawton (ed.), *Russian Futurism Through its Manifestoes*, 72. For examples, see Assya Humesky, *Majakovskij and His Neologisms* (New York: Rausen, 1964), and Bengt Jangfeldt, *Majakovskij and Futurism, 1917–1921* (Stockholm: Almqvist & Wiksell, 1976).

[56] David Burliuk et al., 'A Slap in the Face of Public Taste', 51.

[57] From *A Trap for Judges* (*Sadok sud' ei*, 2 (1913)), in Lawton (ed.), *Russian Futurism Through its Manifestoes*, 53. On the context, see Ronald Vroon, 'The Manifesto as a Literary Genre: Some Preliminary Observations', *International Journal of Slavic Linguistics and Poetics*, 38 (1995), 163–73.

[58] Many of the most innovative effects are analysed in Gerald Janacek, *The Look of Russian Literature: Avant-Garde Visual Experiments, 1900–1930* (Princeton: Princeton University Press, 1984); Susan P. Compton, *The World Backwards: Russian Futurist Books, 1912–1916* (London: British Library, 1978), and *Russian Avant-Garde Books, 1917–1934* (London: British Library, 1992); and Stephen Bury (ed.), *Breaking the Rules: The Printed Face of the European Avant-Garde, 1900–1937* (London: British Library, 2007).

project to invent a language of the future (a kind of futuristic Esperanto).[59] The most famous Cubo-Futurist poem, Khlebnikov's 'Incantation by Laughter' ('Zaklyatiye smekhom'), every invented word of which is derived from the same root,[60] and the movement's diverse *zaum'* works, including Kruchenykh's 'dyr bul shchyl', his libretto for Mikhail Matyushin's *Victory Over the Sun* (*Pobeda nad solntsem*) and Zdanevich's untranslatable *LidantJU fAram*, are more radical than any of the 'words-in-freedom' Marinetti once claimed were the equivalent of *zaum'*.[61] Yet while the Cubo-Futurists' poems and dramas entailed intrepid forms of linguistic experimentation (drawing them to the Formalists' attention[62]), there was an equally fertile Russian Futurist middle ground having more in common with the themes and techniques featured in Marinetti's poetry anthologies *Futurist Poets* (*I poeti futuristi*) and *New Futurist Poets* (*I nuovi poeti futuristi*).[63] That ground was occupied by Russian Futurism's leading playwright and urbanist poet Vladimir Mayakovsky, famous for the verbal inventiveness of such poetic impressions of city life as the poems 'Night' ('Noch''), 'Morning' ('Utro'), 'From Street to Street' ('Iz ulitsy v ulitsu'), and 'Streetways' ('Ulichnoe'). What the poet called the 'versified Cubism'[64] of his innovative use of internal rhyme, his acoustic wordplay, palindrome effects, distortions of syntax, rhymes between complete words and word fragments, and estranging bold metaphors were in relative terms less radical, but perhaps for that reason had a more enduring effect than the experimental poems of Khlebnikov, Kruchenykh, and Zdanevich. As a consequence, Mayakovsky's brand of Futurism travelled more easily, even during the first decade of the post-revolutionary USSR.

Russian Futurists did admittedly create the occasional counterpart to the Italians' verbal collages and 'synchronic charts'.[65] However, the visual poets among them as a rule tended to avoid mimetically shaped layouts and typographical dynamism. Vasily Kamensky's 'ferro-concrete' poems, e.g. 'Constantinople' ('Konstantinopel'), consist of word columns and vertical elongated triangles, organized within rigidly demarcated segments. The method remained the same, even when subjects were dynamic,

[59] On *zaum'*, see Gerald Janacek, *Zaum': The Transrational Poetry of Russian Futurism* (San Diego: University of San Diego Press, 1996), and Rosemarie Ziegler, 'Die *Zaum*-Dichtung der russischen "historischen" Avantgarde', *Sprachkunst*, 15 (1984), 358–68.

[60] See Raymond Cooke's analysis of the poem in *Velimir Khlebnikov: A Critical Study* (Cambridge: Cambridge University Press, 1987), 69–72.

[61] A put-down recorded in Vadim Shershenevich's *Futurism Without a Mask* (*Futurizm vez maski*, Moscow: Iskusstvo, 1914), 13.

[62] See Herbert Eagle's 'Cubo-Futurism and Russian Formalism', in Lawton (ed.), *Russian Futurism Through its Manifestoes*, 281–304.

[63] F. T. Marinetti (ed.), *I nuovi poeti futuristi* (Rome: Edizione futuristi di 'Poesia', 1925).

[64] For the implications of this term, see Edward J. Brown, 'Mayakovsky's Futurist Period', in George Gibian and H. W. Tjalsma (eds), *Russian Modernism: Culture and the Avant-Garde, 1900–1930* (Ithaca, NY: Cornell University Press, 1967), 7–20.

[65] The aerial perspective, looking vertically down to the ground immediately below, brings Italian Futurist 'synchronic charts' close to map layouts. *Bataille à 9 étages* rotates the angle by 90° to offer a cross-section of the lake and surrounding mountains that mark the front line. For English translations of the 'synchronic chart' in Marinetti's *Zang tumb tumb* and of *Bataille à 9 étages*, see Marinetti, *Selected Poems and Related Prose*, 61, 117.

as in 'Skating Rink'.[66] Such layouts reflect Russian Futurism's concentration on the individual word, although, as the generic term 'ferro-concrete' suggests, the end effect has much in common with the Constructivist aesthetic. The Ukrainian Pan-futurist Mykhail' Semenko's 'Cablepoem Across the Ocean' ('Kablepoema za okean'), a synthesis of telegram and poster slogan formats, exploits the resources of what its creator called 'poetry-painting' for minimalist effect.[67] The use of a fixed outline template within which isolated words, arranged in segmented layers of horizontal boxes, were printed on a series of separate cards was intended as a celebration of the new industrial world order. Yet despite, or perhaps because of, the uniqueness of such works, Russian Futurism's single most important—and eminently exportable—effect was the *lesenka*: Mayakovsky's stepped-line construction, a device which controlled the rhythms, visual impression, and semantics of much of his published poetry.

THE MATERIALITY OF THE FUTURIST BOOK: COLLABORATING POETS AND ARTISTS

Italian Futurist free-word poetry and literary collage often shared the pages of *Lacerba* and *L'Italia futurista* with the work of other European avant-gardes. Important manifestos, free-word poems, and monochrome reproductions of Futurist paintings featured in such cultural journals as *Lacerba* (Florence) and *Der Sturm* (Berlin) alongside commissioned contributions from French, German, and other non-Futurist European tendencies. Clearly neither of these journals was a Futurist house organ. Surprisingly, even the material in some volumes published under the Edizioni futuriste di 'Poesia' imprint was far from representative of 'words-in-freedom' at their best.[68] Often the series served as a showcase for an

[66] On Vasily Kamensky's visual poetry, see Janacek, *The Look of Russian Literature*, 123–47. A subsequent chapter (pp. 149–206) examines the brilliant typographical effects in Zdenevich's *LidantJU fAram* (Paris: 40, 1923), a work connected with Futurism by virtue of its 'liberated' typography and occasional use of *zaum'*.

[67] On Semenko's contribution to Ukrainian Panfuturism's visual poetry, see Oleh S. Ilnytzkyj, *Ukrainian Futurism, 1914–1930: A Historical and Critical Study* (Cambridge, Mass.: Harvard University Press, 1997), 218–62, and Natalia Burianyk, 'Painting with Words: Mikhail' Semenko's Poetic Experiments', *Canadian Slavonic Papers*, 37 (1993), 467–88.

[68] Salaris, 'Marketing Modernism: Marinetti as Publisher', 121, gives an inventory of the works of early Futurist poets associated with the Milan group. A cross-section of work by Futurist poets can be found in Felix Stefanile (ed.), *The Blue Moustache: Some Italian Futurist Poets* (Manchester: Carcanet New Press, 1981). Among these, Francesco Cangiullo stands out as a uniquely bold experimenter. His major volumes, *Piedigrotta* (1916), a 'magical' performance transforming itself into different typographical 'acts' with each new page, *Caffeconcerto: Alfabeto a sorpresa* (1918), using humanized letters of the alphabet to create a Variety Theatre performance, and *Poesia pentagrammata* (1923), superimposing 'words-in-freedom' on musical staves, are noteworthy, not on account of any dynamism or innovative effect, but because of their stylistic consistency and rigour.

older generation of Italian poets who, Marinetti wished to suggest, now collaborated on the Futurist project. Fortunately, a select group of experimental Futurist books, including Carrà's *War Painting* (*Guerrapittura*), Soffici's meaninglessly entitled *BIF§ZF+ 18: simultaneità e chimismi lirici*, and Marinetti's equally untranslatable *Zang tumb tumb*, reflect the new aesthetic stylistically, if not always thematically. It is clear from these works that the Futurists were not just content with changing the look of the individual printed page; some of them brought new approaches to the book as medium.

When Marinetti's wartime verbal collages appeared in *Futurist Words-in-Freedom*, they were included as large fold-ins, bound in together with the standard-format pages. Each individual collage needed to be opened out, map fashion, before it could be experienced synoptically. Initially, the reader was simply presented with the poem's title printed in conventional roman typeface on a separate, standard-format page before unfolding the collage itself. The contrast between the title's self-indulgently long, conventional pre-Futurist style and the explosive free-word collage was created manually as part of the reader's engagement with a new 'do-it-yourself' interactive book. Through a series of familiar 'tactile operations',[69] the reader encounters the unfamiliar materiality of the book as object. Marinetti's strategy here is a modest forerunner of various later, visually more revolutionary experiments with the book as object. These represent an important advance because of the way the very book format itself is challenged—resulting in an estranged medium as well as hinting at the potential material qualities of a Futurist book of the future. The principal works of this new genre were Martini's *Contemplations* (*Contemplazioni*, 1918), Depero's 'bolted book' *Depero Futurist* (*Depero futurista*, 1927), d'Albisola and Marinetti's sheet metal anthology also entitled *Futurist Words-in-Freedom* (*Parole in libertà futuriste*, 1932), and d'Albisola's *Lyrical Watermelon* (*L'anguria lirica*, 1934).[70] As visible and in some cases tangible artefacts, these could be received independently of any verbal content, although Depero's and Marinetti's works remain closer to the traditional book, employing recognizable typography and recognizable words. Martini's *Contemplazioni* pushes the genre to an extreme by replacing text with black blocks representing words and paragraphs. As its title suggests, the work demands we 'contemplate' the book as a piece of conceptual art (in the manner of Jiří Kolář's book constructs) rather than try to read it as we would a traditional book. Literary Futurism was not the first avant-garde movement to challenge conventional reading habits (witness Mallarmé's *Un coup de dés* and Queneau's *Cent Mille Milliards de poèmes*); yet the variety of ways in which it created such a challenge remains without precedent. Nothing divides Italian Futurism's defamiliarizing art book genre from

[69] The term is Mirella Bentivoglio's; 'Innovative Artists' Books of Italian Futurism', in Günter Berghaus (ed.), *International Futurism in Arts and Literature* (Berlin: de Gruyter, 2000), 478.

[70] The publishing details are: Arturo Martini, *Contemplazioni* (Faenza: privately printed, 1918); Fortunato Depero, *Depero futurista: Libromacchina*, ed. Dinamo Azari (Milan: Edizione Italiana Dinamo Azari, 1927); Tullio d'Albisola and F. T. Marinetti, *Parole in libertà futuriste olfattive tattilii termiche* (Savona: Litolatte, 1932), and d'Albisola, *L'anguria lirica (Lungo poema passionale)* (Savona: Litolatte: Edizioni futuriste di 'Poesia', 1934).

Russian Futurism's artistic volumes more than the underlying differences in purpose and motivation between these two anti-traditionalist forms, the one establishing an impact through reputation and provocation, the other being the happy product of collaboration between poets and painters sharing a common Futurist aesthetic.

The result of Italian Futurism's liberation of language from syntactical constraints and verbal clutter was often visually austere, yet 'expressive' on the movement's own terms. An early indication of the direction in which Russian Futurists would be taking liberated language, and at the same time the book as artefact, is given in Khlebnikov and Kruchenykh's extended metaphor in 'The Letter as Such' (1913):

The word is [in Russia] merely tolerated. Otherwise, why would they clothe it in a grey prisoner's uniform?... lined up in a row, humiliated with cropped hair and all equally colourless, grey... Any word written in individual longhand or composed with a particular typeface bears no resemblance at all to the same word in a different inscription.[71]

A feature of many Russian Futurist volumes combining theoretical essays with miscellanies of new poetry is the degree of collaboration between prominent painters (El Lissitzky, Exter, Goncharova, Larionov, Malevich, Rodchenko, and Rozanova) and such leading writers as Khlebnikov, Kruchenykh, and Mayakovsky. Italian Futurism could produce few mixed-media works comparable in calibre and importance to *Worldbackwords* (*Mirskontsa*), *A Game in Hell* (*Igra v adu*), *Explodity* (*Vzorval'*), *The Croaked Moon* (*Dokhlana luna*), *A Trap for Judges* (*Sadok sud' ei*), and *Old-Time Love* (*Starinnaya liubov*).[72] Not only were there few such dazzling mixed-media experiments in Italy, the country's seemingly endless torrent of Futurist manifestos was apparently at fault for having rigorously hived off painting, literature, drama, music, and sculpture into tidily discrete genre categories. On the plus side, Futurist *serate* were often staged in the context of major Futurist painting and sculpture exhibitions.[73] Despite this, painting and 'words-in-freedom' still seldom interacted on the same page, even though individual Futurist painter–poets such as Balla, Carrà, Depero, and Soffici had no personal difficulty in moving from one medium to another. Generally, the most fruitful exception was the relationship of stage set designers to Futurist dramatists. In seeking the cooperation of Futurist set designers and painters along with avant-garde musicians, both movements at last occupied common ground. While Italian Futurist dramatists commissioned sets and costumes by Balla, Depero, and Prampolini, Russian avant-garde directors engaged the services of such established modernist artists as Exter, Malevich, Popova, and Stepanova.[74]

[71] Victor Khlebnikov and Alexander Kruchenykh, 'The Letter as Such' ('Bukva kak takovaya'), in Lawton (ed.), *Russian Futurism Through its Manifestoes*, 63.
[72] For publication details and illustrations, see Compton, *The World Backwards*, and Bury (ed.), *Breaking the Rules*.
[73] Various Futurist *serate* are documented in great detail in Günter Berghaus, *Italian Futurist Theatre, 1909–1944* (Oxford: Clarendon Press, 1998), 85–155.
[74] For illustrations, see Konstantin Rudnitsky, *Russian and Soviet Theatre: Tradition and the Avant-Garde* (London: Thames & Hudson, 1988).

FUTURIST DRAMA AND ITS NEW GENRES

'The only way to inspire Italy with the warlike spirit today is through the theatre,' the 'Futurist Synthetic Theatre' manifesto of 1915 declared.[75] This may seem a surprising suggestion, given the way Futurism's theatre manifestos concentrated on bringing radical change to theatrical style and performance conventions, as well as promoting a new Futurist genre of mini-dramas (*sintesi*), exploiting elements of surprise, improvisation, and acoustic and visual provocation within a flaunted anti-psychological framework. The attention paid to theorizing this onslaught against a moribund traditional theatre and the distinct lack of any common ideological thread or 'sensibility' running through the Futurists' *sintesi* showed that, in matters theatrical, the Italian avant-garde was still engaged in rearguard anti-traditionalist posturing rather than delivering new content. Admittedly, the subtext of some *sintesi* was anti-Austrian, but, as was pointed out at the time, such theatre produced no equivalent to Futurist 'words-in-freedom', verbal collages, or contemporary war painting (*guerrapittura*) of the kind Carrà had published.[76] The appearance of a rash of manifestos promising theatre reform and outlining new sub-genres seemed to imply that Futurism's will to reform outweighed the proselytizing opportunities that were the main purpose behind theatrical reform. Many innovations associated with Futurist Synthetic Theatre resembled those found in other European avant-garde contexts during the early decades of the twentieth century: e.g., among the ideas of Appia, Craig, Meyerhold, Schlemmer, and Vachtangov. But one kind of *sintesi*, mechanical drama, was a promising development, given Italian Futurism's machine aesthetic.

'Our Futurist theatre will be: SYNTHETIC. That is, very brief,' the manifesto of 'Futurist Synthetic Theatre' declared, 'synthetic' in the sense that it would 'synthesize fact and idea in the smallest number of words and gestures'.[77] Where brevity called for the use of 'words-in-freedom', machine drama arguably already had a well-tested telegraphic idiom at its disposal. Marinetti and Cangiullo had in their different ways demonstrated the advantages of a style of declaration making use of the dehumanized voice as an appropriate medium for actors playing the part of robots, trains, and aeroplanes. Yet while Marinetti's 'Manifesto of Futurist Playwrights' spoke of the need 'to introduce into the theatre a sense of the rule of the Machine',[78] this remained a lost opportunity. There was too much of the unintentionally ridiculous and the music hall sketch about such works as *The Dance of the Propeller* (Prampolini and Depero, *La danza dell'elica*), *Dance of the Machine-Gun* (Marinetti, *Danza della*

[75] In Apollonio (ed.), *Futurist Manifestos*, 183.

[76] Carlo Carrà, *Guerrapittura: Futurismo politico, dinamismo plastico, disegni guerreschi, parole in libertà* (Milan: Edizioni futuriste di 'Poesia', 1915).

[77] F. T. Marinetti, Emilio Settimelli, and Bruno Corra, 'The Futurist Synthetic Theatre' (1915), in Apollonio (ed.), *Futurist Manifestos*, 184.

[78] F. T. Marinetti, 'Manifesto of Futurist Playwrights: The Pleasures of Being Booed' (1911), in *Critical Writings*, 182.

mitragliatrice), *Anihccam* [i.e. *macchina*] *of 3000* (Casavola), *A Birth* (Scaparro, *Un parto*), involving a plane giving multiple birth to a brood of aviators, *Three Moments* (Casavola and Folgore, staged in Paris as *Les Trois Moments*), performed entirely by machines, *The Futurist Prize* (Buzzi, *Il premio di futurismo*), where an entirely prosthetic man, the victim of an explosion, is rewarded for being 'the most artificial man in the world', *Mechanical Sensuality* (Fillia, *Sensualità meccanica*), and *The Printing Press* (Balla, *Macchina tipografica*). Such material[79] may have been sufficient to subvert audience expectations, to re-emphasize the cult of brevity and the machine aesthetic, but it failed to satisfy ideological aspirations. Italian Futurist drama's obituary was written by Bruno Corra, one of its theoreticians and practitioners: 'We tried to translate into theatrical language what had already been expressed in Futurist literature and painting...What we wrote...only in part matched up to these creations. Our battle did not progress much beyond the first phase of polemics and rupture.'[80] According to another experienced hand, one of the main causes of Futurist drama's decline was a dissipation of energy by attempting to do too many things at once.[81] This charge is borne out by the sheer volume of types of theatre the movement sought to invent: a 'Theatre of Essential Brevity', '...of Surprise', 'Tactile Theatre', 'Visionist Theatre', 'Aero-Theatre', plus the 'théâtre de pantomime futuriste', various transformations of cabaret and music hall, and even the 'theatre' of Futurist cookery. It was only after the *sintesi*'s heyday that a work rightly commended by Marinetti as 'one of the most important works Futurism has produced'[82] rescued the day. That work, Ruggero Vasari's *Anguish of the Machines* (*L'angoscia delle macchine*),[83] is the only Futurist drama able to hold its own alongside the masterpieces of the Russian Futurist stage: Khlebnikov's *Zangezi*, Mayakovsky's *Vladimir Mayakovsky*, and Kruchenykh and Matyushin's opera *Victory Over the Sun* (*Pobeda nad solntsem*).[84] One commentator has persuasively demonstrated in detail why Vasari's *Anguish of the Machines* merits Marinetti's praise, while at the same time representing an artistic and moral reckoning with so much that

[79] For a sampling of Italian Futurist *sintesi* and key theatre manifestos, see Michael Kirby, *Futurist Performance* (New York: Dutton, 1971), 154–318.

[80] Bruno Corra, 'Nascita del teatro sintetico', *Sipario*, 22 (1967), 28; quoted in Berghaus, *Italian Futurist Theatre, 1909–1944*, 217.

[81] Emilio Settimelli, *Inchiesta sulla vita italiana* (Rocca San Casciano: Cappelli, 1919), 97.

[82] F. T. Marinetti, 'Il futurismo mondiale: Conferenze di F. T. Marinetti alla Sorbonna', *L'impero* (20 May 1924); quoted in Berghaus, *Italian Futurist Theatre, 1909–1944*, 501.

[83] Ruggero Vasari, *L'angoscia delle macchine: Sintesi tragica in tre tempe* (1925), in Mario Verdone (ed.), *Teatro italiano d'avanguardia: Drammi e sintesi futuriste* (Rome: Officina, 1970), 168–87; no Eng. trans.

[84] The following English translations are available: Velimir Khlebnikov, 'Zangezi', in *Collected Works*, ii, ed. Charlotte Douglas and Ronald Vroon, trans. Paul Schmidt and Ronald Vroon (Cambridge, Mass.: Harvard University Press, 1989), 331–74; Vladimir Mayakovsky, 'Vladimir Mayakovsky: A Tragedy', in *The Compete Plays of Vladimir Mayakovsky*, trans. Guy Daniels (New York: Simon & Schuster, 1968), 19–38; and Aleksei Kruchenykh, 'Victory Over the Sun', trans. Ewa Bartos and Victoria Nes Kirby, *Drama Review*, 15 (1971), 106–24. For accounts of *Zangezi*, *Vladimir Mayakovsky: A Tragedy*, and *Victory Over the Sun*, see Edward Braun, 'Futurism in the Russian Theatre, 1913–1923', in Berghaus (ed.), *International Futurism in Arts and Literature*, 75–99.

early Italian Futurism had stood for.[85] It is to Marinetti's credit that, at the time of Second Futurism's desperate diversification, he recognized the artistic and thematic value of a work embodying the greatest challenge, not only to the machine aesthetic, but to Futurism's values as a whole. The subsequent demise of Italian and Russian Futurism has been chronicled.[86] In each case, politics and artistic impasses were major causal factors. However, Futurism's continuing influence on other avant-gardes, both of the time and throughout the twentieth century, is still being debated. There is as yet no satisfactory macro-survey of the relationship between the various European Futurisms or adequate analysis of Italian Futurism's influence on early twentieth-century modernism.

[85] Berghaus, *Italian Futurist Theatre, 1909–1944*, 504–7.
[86] On the demise of Italian Futurism, see Günter Berghaus, 'The Second Futurist Movement, 1920–1930', in *Italian Futurist Theatre, 1909–1944*, 329–520; and on that of Russian Futurism, Anna Lawton, 'Futurism in the USSR, 1917–1928', in Lawton (ed.), *Russian Futurism Through its Manifestoes*, 33–48.

CHAPTER 40

..

THE MODERNIST ATLANTIC

NEW YORK, CHICAGO, AND EUROPE

..

MARTIN HALLIWELL

TOWARDS the end of German American director Josef von Sternberg's 1932 film *Blonde Venus*, Marlene Dietrich's character, Helen Faraday, journeys west across the Atlantic, following a successful spell on the Parisian club circuit. Stimulated by the desire to earn money to help cure her scientist husband, Ned Faraday, from radium poisoning, Helen re-enters the Broadway show-business circuit after years of domestic contentment living on the Lower East Side of New York City with Ned and their son Johnny. Exploiting von Sternberg's and Dietrich's Germanic roots, the film's opening scene depicts the pair's first meeting (a decade earlier) when the American student Ned stumbles upon Helen bathing in a pool in the countryside near Dresden. The bathing scene is an eroticized version of a sequence in the silent modernist film *Menschen am Sonntag* (1930), which depicts Weimar Germans at leisure. *Blonde Venus* depicts the pastoral freedom of Weimar Germany in the late 1920s, and it contrasts this freedom with the hardships of working-class Manhattan in the 1930s. But the film was also notable for contributions by European filmmakers Billy Wilder and Fred Zinnemann, both of whom went on to successful careers in Hollywood after leaving Europe during the rise of Nazism.

Blonde Venus offers two interesting starting points for a consideration of the modernist Atlantic in the early twentieth century. First, the film suggests that the

Atlantic passage was rarely a one-way journey or with a fixed destination. It drama-
tizes the movement across the Atlantic and then back again; for Ned as he seeks a
medical cure in Dresden, and for Helen as she travels from Germany to America and
then to Paris, where she tries to start a new life when her marriage breaks down. Both
characters return to Manhattan during the course of the film. Ned returns from his
treatment in Germany to find that during his absence Helen has had an affair with
upper-class socialite Nick Townsend (Cary Grant), and much later in the film Helen
returns to New York with the help of Townsend, to reunite in the last scene with her
estranged husband and son. The two characters' separate journeys are linked through
their transatlantic family romance, but also by their individual quests. Ned must stay
healthy in order to complete his experiments and Helen needs to fulfil herself as a
creative performer. Mirroring the 'Lost Generation' writers who left the US for
Europe in the 1910s and 1920s, Helen and Ned leave behind domesticity and travel
to Germany and France to express their 'modern' identities.

The film also brought modernist aesthetics to the foreground. We first see Die-
trich's character as a young woman at ease in the domestic sphere while her husband,
an earnest scientist, carries out experiments with his prized microscope. In order to
raise funds for his treatment, Helen forces herself to play along with the auditioning
racket on Broadway. Aided by her striking features she lands a leading role as a
cabaret performer, and in her most iconic performance she is displayed as the centre-
piece of the act, disguised in an ape costume. Entering the midst of a tribal dance, she
provocatively removes the ape's head to reveal herself clad in a striking blonde Afro
wig to lead the chorus line in singing 'Hot Voodoo'. The spectacle draws closely on
Josephine Baker's extravagant performances in Paris in the 1920s, linking the elegance
of modern independent women with the primitivism of Baker's erotic stage pres-
ence.[1] But although Baker was an instant success in Paris when she began performing
at the Théâtre des Champs-Élysées in 1925, she found American audiences were not
'ready for a black woman who embodied both sexuality and sophistication'.[2] In its
juxtaposition of the civilized and primitive, the 'Hot Voodoo' sequence implied that
only a white European (a 'blonde venus') could make palatable Baker's performances
for an American market. It also suggests that cultural exchange in the early twentieth
century was rarely straightforward or ideologically free.

Another aspect of modernist aesthetics is dramatized late in the film when we see
an icy, streamlined, and androgynous Helen appear in a white tuxedo singing in a
Parisian club. Having hit a low point of vagrancy and alcoholism in the American
South after losing possession of her son, Helen casts off the late nineteenth-century
baggage of mother and wife to embody the sleek modernist design of her Parisian
musical performances. Helen's tuxedo again mirrors one of Josephine Baker's iconic
costumes; but it also connects with Dietrich's Berlin past and her previous film

[1] See Patrice Petro, *Aftershocks of the New: Feminism and Film History* (New Brunswick, NJ: Rutgers
University Press, 2002), 140. See also Eva Cherniavsky, *Incorporations: Race, Nation and the Body
Politics of Capital* (Minneapolis: University of Minnesota Press, 2006).

[2] Petro, *Aftershocks of the New*, 143.

performances, especially her androgynous appearance in a black tuxedo in the earlier von Sternberg film *Morocco* (1930). This modernist aesthetic is emphasized when Helen Faraday returns to her former home. In the final sequence Dietrich's angular features are exaggerated by an ultra-modern long black dress and her blonde hair is hidden beneath a sleek black turban. However, the film does not end with an affirmation of modernity at the expense of sentimentality. The studio demanded (against the director's wishes) that it should have a happy ending. In the final scene Helen removes her headwear to re-enact for her son the pastoral moment when she first met Ned by the pool in Dresden, but not before Dietrich's 'fascinatingly elusive' streamlined body, her series of 'erotic metamorphoses', and her criss-crossing movement over the Atlantic have dramatized the tensions between the aesthetics, culture, and commerce of modernity.[3]

Rather than functioning as a straightforward modernist icon, Dietrich in *Blonde Venus* epitomized a series of ambiguities. Her liminal character is caught between the devoted mother and the prostituting vagrant, between the transgressive primitivism of 'Hot Voodoo' and the flirtatious androgyny of the Parisian performances, between the Weimar water nymph of the opening sequence and the ultra-modern couture of the closing scene.[4] As Mary Beth Haralovich discusses, these diverse roles helped to sell Dietrich's star image to audiences on both sides of the Atlantic, but her multiple personae also destabilized national, racial, and sexual identities. Such multiplicity and instability is central to a reading of transatlantic modernism and invites a number of interconnecting perspectives.[5]

Paris: City of Exile

On a basic narrative level *Blonde Venus* updated Theodore Dreiser's turn-of-the-century tale of urban corruption *Sister Carrie* (1900) by layering new racial and sexual nuances onto a narrative in which small-town girl Carrie Meeber gave herself over to the forces of twentieth-century Chicago. Whereas Dreiser's *Sister Carrie* had the muckraking quality of early twentieth-century naturalist novels, in which urban conditions tended to reduce human relations to an animalistic level, modernist tales

[3] Gaylyn Studlar, 'Masochism, Masquerade, and the Erotic Metamorphoses of Marlene Dietrich', in Jane Gaines and Charlotte Herzog (eds), *Fabrications: Costume and the Female Body* (New York: Routledge, 1990), 249.

[4] *Blonde Venus* is riddled with tensions, particularly those between Dietrich as actress and von Sternberg as director, and between von Sternberg's auteurist vision and the demands of the studio (Paramount). See Donald Spoto, *Blue Angel: The Life of Marlene Dietrich* (New York: Cooper Square Press, 2000), 96–9.

[5] Mary Beth Haralovich, 'Marlene Dietrich in *Blonde Venus*: Advertising Dietrich in Seven Markets', in Gerd Gemünden and Mary R. Desjardins (eds), *Dietrich Icon* (Durham, NC: Duke University Press), 162–84.

such as *Blonde Venus* often used the journey east across the Atlantic as an escape from inevitability. For the Lost Generation writers Gertrude Stein, Ernest Hemingway, and Henry Miller, the Atlantic was a necessary vantage point by which they could more clearly see the forces at work in their homeland and where they could embrace an artistic and sexual freedom unavailable to them at home. And the choice of destination for all three writers was Paris.

From the mid-1910s to the 1930s Paris embodied the many options which modernity brought. It was often characterized as a magical city with an erotic charge, as Josephine Baker exclaimed: 'I had plotted to leave St Louis [her birthplace], I had longed to leave New York; I yearned to remain in Paris. I loved everything about the city.'[6] For many travellers Paris represented a mythical space of freedom, even if the freedom was somewhat paradoxical. Literary critic and journalist Malcolm Cowley best encapsulated this sense of freedom when in *Exile's Return* (1934) he explained the term 'Lost Generation':

It was lost, first of all, because it was uprooted, schooled away and almost wrenched away from its attachment to any region or tradition. It was lost because its training had prepared it for another world than existed after the war . . . It was lost because it tried to live in exile. It was lost because it accepted no older guides to conduct and because it had formed a false picture of society and the writer's place in it. The generation belonged to a period of transition from values already fixed to values that had to be created.[7]

To be 'lost' in this respect had both a positive and a negative charge. Lacking the security of nineteenth-century social values, and charged by the nihilistic energies of the First World War, to be 'lost' for these writers meant choosing individual experience over the nets of language, nationality, and religion that James Joyce's Stephen Dedalus flees in *A Portrait of the Artist as a Young Man* (1916). The 'exile' of which Cowley wrote was double-jointed, corresponding to the two classical definitions of freedom: 'freedom to' live and create in liberating ways and 'freedom from' the oppression that many American writers and artists felt, particularly those deriving from the Midwest and the South.

However, despite the allure of Paris and the strength of the American dollar in the 1920s, the French capital was never the absolute space of freedom it first seemed. Gertrude Stein and her art collector brother Leo moved to Paris in 1903, but they did not leave behind their sibling rivalry (leading to an irreconcilable rift between the Steins in 1912). Hemingway realized in the 1920s that he could only truly write about his American home when he was in Paris, and it is arguable that he re-created the Midwest through his European travels. In F. Scott Fitzgerald's short story 'Babylon Revisited' (1931) Paris is the scene of guilt and loss. And Henry Miller's Paris of the 1930s was both an escape from the 'hollow pit of nothingness' that New York had become to him after the stock-market crash of 1929, but also a reminder that he could

[6] Josephine Baker and Jo Bouillon, *Josephine*, trans. Marianna Fitzpatrick (New York: Paragon, 1988), 56.
[7] Malcolm Cowley, *Exile's Return: A Literary Odyssey of the 1920s* (New York: Viking, 1956), 9.

never fully leave behind the city in which he had been raised.[8] As such, the modernist Atlantic was simultaneously a space of distance between American and European versions of modernity and a fluid point of interconnection, particularly as transatlantic travel and commerce became frequent in the 1920s and 1930s, and again after the Second World War, when it was strategically important for there to be a strong American presence in western Europe to contest communism creeping in from the east.

THE ATLANTIC AND MODERNIST SPACE

The connections between the urban centres of American and European modernism were complex: full of exchanges, transportations, and complex journeys of ideas, products, and bodies. The Atlantic might suggest a two-way exchange but the movement between Europe and America was full of multiple border crossings. To take two examples: first, the pragmatist philosopher William James was quintessentially a New Englander, applying Emersonian ideas to the fields of anatomy, psychology, and religion, but in other ways he was thoroughly Europeanized, mixing his interest in French and German philosophy and science with a love of Wordsworth's poetry and another darker vision of Emerson as filtered through Nietzsche; second, Ezra Pound's modernist maxim 'Make it New' can be seen as an expression of American exceptionalism, but this reading is complicated by Pound's liminal status as an American traveller in England, France, and Italy. Indeed, this series of complex and interlinking exchanges lies at the heart of transatlantic modernism. Rather than fluctuating between the United States and Europe, and then back again, many modernist writers and artists actually moved between multiple points, revealing more complex geographies.

For example, throughout his career, from *The American* (1877) to *The Wings of the Dove* (1902), Henry James was fascinated by the triangulation of space. This was normally figured as a transatlantic loop between the United States, Great Britain, and continental Europe, but it was sometimes a European triangle with England, France, and Italy at the vertices. Indeed, the Atlantic could be seen as one of the coordinates of James's triangular imaginary, with the other points varying depending on whether his focus was on New York City or Boston, Paris or Venice. James complicated this territorial discourse by often using temporal metaphors, expressed as 'occasions' and 'breaks' in what he calls in his Preface to *The Wings of the Dove* 'an elastic but definite

[8] Henry Miller, *Tropic of Cancer* (London: Harper, 2005), 74. For a development of these themes, see Martin Halliwell, 'Tourists or Exiles? American Modernists in Paris in the 1920s and 1950s', *Nottingham French Studies*, 44/3 (Autumn 2005), 54–68.

system'.[9] This phrase links to a passage from a story James started in 1900. In 'The Sense of the Past', he envisaged a small group of Americans 'moving against a background of three or four European *milieux*... in search of, in flight from, something or other, and encountering also everywhere the something or other which the successive *milieux* threw up for them'.[10] Instead of Europe and America being doubles of each other, James envisaged movement between multiple points of reference in an intercontinental story.

The example of the James brothers implies that American modernism can neither be defined by questions of nationality and nationhood nor charted according to the historical transition from rural to urban environments (as Dreiser's *Sister Carrie* portrays). The fluctuating geographical spaces of modernity (in *Blonde Venus*, for example) suggest that linear narratives of movement were much more complicated. We might compare Dreiser's naturalist story of the 'spoiling' of Carrie Meeber in the commercial modernist city of Chicago with the tortured first-person narrative of Henry Miller's *Tropic of Cancer* (1934), in which Miller used the shadowy spaces of Paris to defamiliarize human activity, boldly claiming in the concluding page of a novel obsessed with temporality that 'space even more than time' is the true tropic of modernity.[11] Miller's spatial insight from the 1930s chimes with the transnational turn in early twenty-first-century literary and cultural scholarship, linking to Susan Manning's view of the ways in which 'diverse networks of travel, exchange and contact entail new and diverse ways of imagining space, place, and identity'.[12]

This chapter will return to ideas of transnationalism, but it is helpful to focus on specific modernist cultures emerging in New York and Chicago, particularly in their complex relationship to European culture. This provides a way of offsetting many modernist narratives which focused on Paris and London as the privileged sites of American modernity, with the Atlantic representing a medium of fluid exchange between ideas and cultures. This is not to make New York and Chicago the only American spaces of modernity. In his book *American Salons* (1993) Robert Crunden identifies New York and Chicago as central hubs of American modernism; but he also draws attention to Philadelphia (particularly the University of Pennsylvania), New Orleans (black culture), Baltimore (the German American community), and Hollywood (the emergent film industry), thereby revealing the diversity of modernist forms in a nation that experienced the challenges of the early century in different ways.[13] Nevertheless, as gathering points for modernist energies, Chicago and Manhattan offer alternatives to Paris, London, and Berlin for tracing the trajectory of modernism.

[9] Henry James, *The Wings of the Dove*, ed. Peter Brooks (Oxford: Oxford University Press, 1984), p. xlvii.
[10] *The Complete Notebooks of Henry James*, ed. Leon Edel and Lyall H. Powers (Oxford: Oxford University Press, 1987), 190–1.
[11] Miller, *Tropic of Cancer*, 318.
[12] Susan Manning and Andrew Taylor (eds), *Transatlantic Literary Studies: A Reader* (Edinburgh: Edinburgh University Press, 2007), 18.
[13] Robert Crunden, *American Salons: Encounters with European Modernism, 1885–1917* (New York: Oxford University Press, 1993), 81.

Both cities were undergoing a backlash against nineteenth-century ideas and values. The worlds of journalism and the creative gatherings on 57th Street in Chicago, for example, stimulated artistic practices that broke with late nineteenth-century ideas of propriety and order, while New York's Greenwich Village formed a vibrant subculture for painters and photographers who rejected the representational art of the post-bellum period. Reacting to Emerson's and Whitman's heroic attempts to cast off the mantle of European culture in the mid-nineteenth century, the East Coast writers William Dean Howells, Henry James, and Edith Wharton were keen to reconnect with a European past. It is tempting to identify the early currents of modernism as French (in the essays of Charles Baudelaire or the poems of Arthur Rimbaud), particularly as influential American writers and artists were drawn to France to replenish American culture in a period when mercantilism threatened the freedom which James, Stein, Wharton, and Hemingway glimpsed across the Atlantic. Crunden notes that even in its germinal phase 'American modernists borrowed most of their ideas from Europe', but he also identifies two areas in which American modernism remained free from European influence: the aesthetics of film, and the popular musical rhythms which were very different from the formal arrangements of European music.[14] We will return to film and music later in this chapter, but the American modernist trajectory can also be traced through literature and visual art, with the Atlantic offering an important crucible of exchange.

CHICAGO: CITY OF THE NEW CENTURY

The Chicago World's Fair, or the World's Columbian Exposition, was intended to celebrate four hundred years since Columbus landed in the New World. Held one year later than planned, in 1893, the Columbian Exposition was a key element in the nation's designs for the new century and a reassessment of its relationship with Europe. In *Nature's Metropolis* (1991) William Chronos commented that the choice of venue for the Columbian Exposition was to symbolize Chicago as the city which 'was itself the fulfillment of a destiny' that Columbus, an Italian explorer representing the Spanish court, 'had long ago set in motion'.[15] The spectacle was also a re-creation of Greece in the West, as R. W. Gilder commemorated in his poem 'The White City' (1893). The Exposition looked both backwards and forwards: back to a bygone Europe depicted in the picturesque re-creation of mid-eighteenth-century Vienna and, following the devastation of the Great Chicago Fire of 1871, forward to the speed, motion, and energy of the coming century. For urban planners it was a great

[14] Ibid., p. xiv.
[15] William Chronos, *Nature's Metropolis: Chicago and the Great West* (New York: Norton, 1992), 341.

opportunity to realize new designs, including a giant Ferris wheel that was constructed to rival the Eiffel Tower, completed four years earlier.

The Exposition had been carefully designed to showcase the varieties of American industry, but it split opinion as to its success. Henry Adams complained that it was a 'Babel of loose and ill-joined' features which only gave an impression of a unified whole, and even two of the most influential figures responsible for Chicago's architectural renaissance, Louis Sullivan and Frank Lloyd Wright, were disappointed with the results.[16] However, other visitors, such as Theodore Dreiser, were awed by 'the harmonious collection of perfectly constructed and snowy buildings' which had arisen from a 'wilderness of wet grass and mudflats' to contain within them art treasures from around the world. Dreiser concluded that the White City was a 'splendid picture of the world's own hope for itself'.[17] That Antonín Dvořák premiered his *New World Symphony* (1893) at Carnegie Hall after visiting the Exposition and that Scott Joplin played a version of ragtime at the Fair underlines its importance across the spectrum of modern arts. Several critics have argued that the Columbian Exposition did little to help the poor or the crime-infested parts of Chicago and, despite the presence of the ageing Frederick Douglass at the Haitian pavilion, the Fair can be read as a model of racial imperialism; despite its progressive intentions, it did not provide adequate jobs for African Americans, and exhibition space for black cultural products was severely restricted.[18] Given that the great black migration from the South to Chicago in the early years of the century was a major influence on Chicago modernism, the barely hidden racial tensions at the Fair reveal race as a major fault line running through American modernity.[19] Nevertheless, for many, like Dreiser, the Exposition symbolized a magical transformation from wilderness to futurity and ushered in the promise of a revitalized Chicago as the first modern American city.

Modernity in Chicago was held at arm's length from Europe. The buildings constructed after the Great Fire had strong steel frames and an ambitious vertical trajectory which surpassed the scale of European architecture. This was a technique mastered by Louis Sullivan and the Chicago School in the 1880s and 1890s. Within the distinctly modern American built environment of emerging skyscrapers—including the twenty-two-storey Masonic Temple (the nation's tallest building until 1899) and the cathedral-like Tribune Tower in 1925—modernist groupings began to flourish. The top floor of the Fine Arts Building (which opened in 1893), dubbed the Little Room, saw a series of gatherings in the 1890s and 1900s of figures drawn from literature, journalism, and theatre, notably the poet Harriet Monroe and novelist

[16] Henry Adams, *The Education of Henry Adams* (1906), cited in Chronos, *Nature's Metropolis*, 344.
[17] Theodore Dreiser, *A Book About Myself* (London: Read Books, 2007), 246.
[18] See Ida B. Wells, *The Reason Why the Colored American Is Not in the World's Columbian Exposition* (1893), http://www.hartford-hwp.com/archives/45a/149.html. See also Christopher Robert Reed, *All the World Is Here! The Black Presence at White City* (Bloomington: Indiana University Press, 2002), which contains Frederick Douglass's 'Speech at Colored American Day' (25 Aug. 1893), 193–5.
[19] See Davarian L. Baldwin, *Chicago's New Negroes: Modernity, the Great Migration, and Black Urban Life* (Chapel Hill: University of North Carolina Press, 2007).

Hamlin Garland. This was followed by the Little Theater in 1912 and a bohemian area for artists which grew up around 57th Street after 1900.[20]

Novels of early twentieth-century Chicago tended to focus on the working immigrant population of the city. Carrie Meeber in Dreiser's *Sister Carrie* only travelled across the state, from Wisconsin to Chicago, but Upton Sinclair's *The Jungle* (1906) focused upon a Lithuanian family facing the corrupt world of late nineteenth-century stock-yards, and Frank Norris's novel *The Pit* (1903) told a story of greed in the world of wheat speculation presided over by the Chicago Board of Trade. Although Dreiser, Sinclair, and Norris were very interested in the rise of the modern American city, their socio-logical viewpoint provided little room for the imaginative experiments emerging in Europe. There were other modes of writing though. Many notable Chicago literary figures were Midwesterners from elsewhere, such as Sherwood Anderson, who encapsulated the small-town mentality of his youth in the short-story cycle *Winesburg, Ohio* (1919), and Margaret Anderson, who founded the *Little Review* in 1914. The *Little Review* was on the leading edge of literary modernism in Chicago before it moved to Manhattan in 1917. The magazine published Ezra Pound, Ernest Hemingway, and Amy Lowell and was suffused with modern European ideas, from psychoanalysis to anar-chism. Pound, then living in London, provided Margaret Anderson with a European perspective between 1917 and 1922. And it was no coincidence that the *Review* went Parisian in the 1920s when Pound moved to the French capital, helping to popularize Dadaism and Surrealism in the United States up to its final issue in 1929.

European connections in the Midwest revolved around Chicago, but also around immigrant communities in Cleveland, St Louis, and Minneapolis, which derived from Germany and Scandinavia. But a number of Midwestern writers moved over to Europe in the 1910s and 1920s, such as Pound (from Idaho), Hemingway (from Michigan), and Fitzgerald (from Minnesota), to find the kind of creative freedom they could only dream about back home, as Malcolm Cowley documented in *Exile's Return*. The *Little Review* was not alone as an outlet for modernist creativity. In 1912 another Chicagoan, Harriet Monroe, whose poem 'Columbian Ode' was recited at the opening of the 1893 Chicago Fair, founded *Poetry: A Magazine of Verse*. This became an important channel for the 'new poetry' of Pound, H.D., T. S. Eliot, Marianne Moore, and William Carlos Williams, as well as that of Midwesterners Carl Sandburg and Sherwood Anderson. Monroe's aesthetic manifesto circulated in a 1912 advertisement as a rallying call to take poetry as seriously as visual art. She presented *Poetry* 'as a modest attempt to change conditions absolutely destructive to the most necessary and universal of the arts, it is proposed to publish a small monthly magazine of verse, which shall give the poets a chance to be heard, as our exhibitions give the chance for artists to be seen'.[21]

[20] For more detail of the Little Room and the 57th Street community, see Steven Watson, *Strange Bedfellows: The First American Avant-Garde* (New York: Abbeville Press, 1991), 12–27.

[21] Harriet Monroe, Circular for *Poetry*, 1912, quoted in Ann M. Fine, 'Harriet Monroe and *Poetry: A Magazine of Verse*', in Barbara Probst Solomon (ed.), *America—Meet Modernism! Women of the Little Magazine Movement* (New York: Great Marsh Press, 2003), 37.

Monroe had an 'open door' policy towards new poems and she was keenly interested in (and travelled to) both Europe and Asia. She needed a European correspondent though, and, like Margaret Anderson for the *Little Review,* Monroe found a willing champion in Ezra Pound, who provided her with suggestions for the inclusion of American expatriate writers and Europeans such as Richard Aldington, D. H. Lawrence, and W. B. Yeats. The pared-down techniques of Imagism briefly found a home in *Poetry* before Pound and Amy Lowell each, in very different ways, tried to impress their own aesthetic blueprints on it.

Despite the cosmopolitan and transatlantic remit of Anderson's *Little Review* and Monroe's *Poetry,* Chicago modernism was not affected as directly as its New York counterpart by events and trends across the Atlantic. Owing partly to its geographical location, Chicago suffered from provincial commercialism, which caused the likes of Hemingway to head to France. As Sue Ann Prince argues, modernism in Chicago before the First World War was characterized more by a 'strongly individualistic and idiosyncratic' attitude rather than a distinct style. During the Depression years of the 1930s an anti-modernist impulse took hold of the city (through groups like Sanity in Art) and there was a reluctance to cast off the representational art of the nineteenth century.[22] The influx of Southern blacks in the 1920s (bringing jazz and blues up the Mississippi) made a major difference to the complexion of Chicago modernism. As Davarian Baldwin comments, this revealed 'the larger spatial transformations, class conflict and ideological struggles that took place in both the physical and conceptual space of the emerging black metropolis' of Chicago.[23] These Southern cultural energies mingled with the sociological imagination of early-century naturalist writers to find an outlet in a landmark novel often used to symbolize the end of modernism: Richard Wright's *Native Son* (1941). But the novel also marks a period of transition in Wright's transatlantic biography. Racial intolerance and disagreements among factions of the Communist Party (which he had joined in 1932) stimulated Wright to leave for New York in 1937 and (after he severed his ties with the Communist Party) for Paris in 1946.

New York: City of Visual Delights

The modern development of New York City was more complex than that of Chicago. It was not until the Brooklyn Bridge was completed in 1883 and the city boundaries consolidated in 1898 that the five disparate boroughs started to feel like a city, aided by the opening of the New York subway in 1904. However, its status as a world city

[22] See Sue Ann Prince, *The Old Guard and the Avant-Garde* (Chicago: University of Chicago Press, 1990), p. xxii–xxiii.
[23] Baldwin, *Chicago's New Negroes: Modernity, the Great Migration, and Black Urban Life,* 22.

was easier to establish than Chicago, given that New York had long been a major port for European immigrants landing in the United States. Manhattan offered European cultural producers imaginative possibilities which the cities of the Midwest rarely did, inspiring Fritz Lang's science fiction film *Metropolis* (1927) and Franz Kafka's novel *Amerika* (1927), even though neither Lang nor Kafka had been to the city. If the Chicago World's Fair strove to unify disparate cultural and architectural elements, then New York City did not need to hide its eclectic diversity. European immigrants arriving via Ellis Island and African Americans migrating from the South were key constituents of metropolitan pluralism. This led to the ethnic and racial transformation of the Lower East Side and Harlem, dubbed by Alain Locke in the 1920s the 'race capital' of the world.[24] Nor did Manhattan need to strive hard for its status as the nation's cultural capital. Massive urban development in the first years of the century transformed the built environment and gave rise to the vogue for machine art, encapsulated by the Machine Art Exhibition of 1927, which showed off American industrial triumphs to the rest of the world. By the time New York held its own World's Fair in 1939–40 the modern skyline of Manhattan was virtually complete.

The rapid urban development of New York City inspired a number of modernist practitioners, particularly those specializing in visual art. Alfred Stieglitz, for example, whose photograph *The City of Ambition* (1910) was to encapsulate the urban thrust of the early century, provided a series of visual documents which traced the underdevelopment of Jacob Riis's *How the Other Half Lives* (1891) through to the series of skyscraper stunts which were to epitomize the Roaring Twenties. Stieglitz's photographs chart the urban changes in the first fifteen years of the century, depicting immigrants arriving in the city (*The Steerage*, 1907), a city under construction (*Old and New New York*, 1910), a working hub (*Lower Manhattan*, 1910), and a ghostly city swathed in snow (*Two Towers, New York*, 1913). In some photographs the skyscrapers and high-rises look insubstantial, as in one of Stieglitz's most memorable images—*Flat Iron Building* (1903), which emerges as a spectre from out of the fog. Inspired by Impressionism and soft-focus compositions while he was living in Paris in the 1890s, Stieglitz wished to accord photography the same status as painting. In doing so he shifted away from impressionist panoramas to focus on forms, contrasts, symmetries, and juxtapositions in which urban and natural imagery were sometimes in harmony with each other and at other times in deep tension.

Stieglitz's ambivalence towards Europe inflected his work. On returning to the United States after his student days in Germany, he commented that 'as a child, I had a glowing vision of America—of its promise. But then, once back in New York, I experienced an intense longing for Europe; for its vital tradition of music, theatre, art, craftsmanship.'[25] Nevertheless, his efforts to render New York through a photographic lens led to the publication of the magazine *Camera Work* in 1896 (it ran to 1917) and directly challenged European art traditions to forge a native mode of

[24] Alain Locke, quoted by Ann Douglas, *Terrible Honesty: Mongrel Manhattan in the 1920s* (London: Picador, 1996), 310.
[25] Cited by Dorothy Norman, *Alfred Stieglitz* (New York: Aperture, 1989), 5–6.

visual art through which the American photographer could 'work out his own . . . vision'.[26] The Photo-Secession movement (which Stieglitz originated in 1902) was a protest against the conventions of pictorial art. Stieglitz's gallery at 291 Fifth Avenue (the 291 Gallery which opened in 1905) championed other innovative American photographers and exhibited the first wave of transatlantic avant-gardists: Francis Picabia and Marcel Duchamp, who travelled to New York in 1913 (Duchamp moved to the city in 1915); European modernist painters Paul Cézanne, Henri Matisse, and Pablo Picasso; and Americans such as Arthur Dove and Max Weber.

The most important moment in the emergence of a transatlantic avant-garde was the International Exhibition of Modern Art (the Armory Show) in February 1913, sponsored by the American Association of Painters and Sculptors. The Armory Show represented a sweeping away of traditional art forms, which chimed with the new bohemia of Greenwich Village and Marcel Duchamp's assertion in 1915 that 'the art of Europe is finished—dead—and . . . America is the country of the art of the future'.[27] Visitors displayed a mixture of curiosity and disdain for the show, but the *New York Times* found exhibits such as Duchamp's *Nude Descending a Staircase, No. 2* (1912) degrading and destructive. Duchamp's now notorious artwork had been rejected by the Paris Salon d'Automne, but in Manhattan Duchamp not only found an interested patron in Stieglitz but a coterie of innovative artists he could not find in Paris. The Armory Show was a watershed moment for positioning New York City as a rival to Paris as the premier centre of modern art (Manhattan had sixty-two galleries by 1914 and one hundred art dealers by 1918), as well as foreshadowing the emergence of Dadaism in central Europe in the mid-1910s and its attempt to move away entirely from representational forms.[28]

Stieglitz was not alone in pioneering American alternatives to European visual art. The other great early-century New York photographer, Paul Strand, was directly influenced by Stieglitz and the modernist art on display at the Armory Show. Strand followed Stieglitz's preference for a hand-held camera to take instantaneous pictures, enabling events to come together by chance rather than treating composition in a fixed, unmoving way. Strand discussed his ideas with artists exhibited at the 291 Gallery, but whereas Duchamp's and Picabia's art explored mass production and the chaos of modernity, Strand sought a heightened objectivity epitomized by the modernity of Manhattan. Sometimes he appeared to celebrate urban designs through sharply focused images and his interest in light, line, and volume, whereas at other times his photographs were set against what critics of modernity saw as the destructive force of mechanization. Just as Stieglitz was interested in the relationship between industry and nature, so Strand was keen to rescue organicism from inanimate forms, but he also critiqued the ways in which the urban environment quashed

[26] Alfred Stieglitz, 'The Photo-Secession', in Beaumont Newhall (ed.), *Photography: Essays and Images* (New York: Museum of Modern Art, 1980), 167.

[27] Cited in Wanda Corn, *The Great American Thing: Modern Art and National Identity, 1915–1935* (Berkeley: University of California Press, 2000), 43.

[28] See William B. Scott and Peter M. Rutkoff, 'Paris and New York: From Cubism to Dada', in *New York Modern: The Arts and the City* (Baltimore: Johns Hopkins University Press, 1999), 44–72.

individualism. His famous image *Wall Street* (1915), for example, on one level portrays just another day in the life of the financial district. But the photograph depicts a group of figures reduced to little more than indistinct silhouettes: no facial features are discernible, and they walk mechanically and in isolation. Long shadows are cast by a restricted light source located outside the frame, and the sombre mood of Wall Street is exacerbated by a sequence of gigantic dark windows that loom over the figures.

Many of the still images of New York, including *Wall Street* and *City Hall Park* (1915), were reused in Strand's seven-minute documentary *Manhatta* (1921), made in collaboration with the precisionist painter Charles Sheeler. *Manhatta* is accepted as one of the first avant-garde films in America, pioneering the vogue for city symphonies in Europe which led to documentaries on Berlin (*Berlin: Symphony of a City*, Walter Ruttmann, 1926), Rotterdam (*Rain*, Joris Ivens, 1929), and Moscow (*Man With the Movie Camera*, Dziga Vertov, 1929). Strand and Sheeler used Walt Whitman's poetry as a lyrical contrast to the multiple perspectives on a working day in downtown Manhattan. Just as Strand's written statements shift between fascination with the modern city and a critique of the alienation created by urban development, so *Manhatta* can be read either as a paean to or a critique of city life: the plumes of smoke pumped out by boats in Hudson Bay contrast ironically with the still image of the celestial city that frames Whitman's celebratory lyrics. While *Manhatta* seems to be wholly an American product, Strand compared the film's abstract aesthetics to one of the most distinctive examples of silent German avant-garde films, *The Cabinet of Dr Caligari* (Robert Wiene, 1919), indicating that he and Sheeler were attempting to do in a 'scenic' way what *Caligari* did with interior sets.[29]

In 1983 Serge Guilbaut wrote his influential account *How New York Stole the Idea of Modern Art*, claiming that after the Second World War, with the rise of Abstract Expressionism, European artists such as Mark Rothko, Wilhelm de Kooning, and Arshile Gorky found a home in New York City. By the time Peggy Guggenheim had opened her Art of This Century Gallery in 1942 and modern art dealer Samuel Kootz the Kootz Gallery in 1945, Manhattan had become the centre of the art world.[30] The work of Stieglitz and Strand provides a different narrative from Guilbaut's story of the post-Second World War triumph of New York, suggesting that the transatlantic rivalry lies much earlier in the century. Some American artists such as Man Ray and Alexander Calder completed their most distinctive work in Paris, but despite the Depression years Manhattan proved a haven for experimental artists throughout the first half of the twentieth century.

Indeed, this interest in visuality was not just limited to a photograph like Paul Strand's *Wall Street* or a painting such as the Italian immigrant Joseph Stella's five-panel sequence *The Voice of the City of New York Interpreted* (1920–2). It often

[29] For more on Strand and *Manhatta*, see Jan-Christopher Horak (ed.), *Lovers of Cinema: The First American Film Avant-Garde, 1919–1945* (Madison: University of Wisconsin Press, 1995), 14–66, 267–86.

[30] See Serge Guilbaut, *How New York Stole the Idea of Modern Art: Abstract Expressionism, Freedom and the Cold War* (Chicago: University of Chicago Press, 1983).

crossed over between art forms, leading Man Ray, for example, to team up with René Clair in Paris for the short avant-garde film *Entr'acte* (1924), which starred Marcel Duchamp and musician Erik Satie. In John Dos Passos's modernist novel *Manhattan Transfer* (1925) visual motifs—some drawn from static visual art, others from a montage film aesthetic—suffuse the novel, tapping deeper into the sights, sounds, and textures of the modern metropolis than did Dreiser and Norris twenty years earlier. Another example of transatlantic modernism was the Spanish poet Federico García Lorca, who as a student visiting Columbia University in 1929–30 would have been unaware of the experiments of Stieglitz and Strand or the impact of the Armory Show. Nevertheless, in his account of the visit, *Poet in New York* (1934), Lorca provided a poetic equivalent to the experiments in visual art: the poet is 'cut down by the sky' ('After a Walk') in a city which buries light 'under chains and noises' as crowds stagger 'sleeplessly through the boroughs | as if they had just escaped a shipwreck of blood' ('Dawn').[31]

Lorca's Surrealist imagery did not emerge from a vacuum and nor was it simply born out of his Manhattan trip. Indeed Lorca's contact with Luis Buñuel back in Spain reveals another transatlantic loop. Buñuel and Salvador Dalí had collaborated on the Surrealist films *Un Chien Andalou* and *L'Âge d'or* in 1929–30, and Dalí was drawn to the American imaginary by working on film collaborations with Alfred Hitchcock and Walt Disney in the 1940s, and with Andy Warhol and Philippe Halsman in the 1960s. Famed for his indistinct, dream-like landscapes, Dalí had an idea for a film project entitled *The Surrealist Mysteries of New York* in 1934 (the same year as Lorca's *Poet in New York*), which would have specific locations such as Fifth Avenue and Radio City Music Hall. A development of the 1914 French serial *Les Mystères de New York*, Dalí's film linked the primitive energies he detected beneath the surface of urban life with the wave of crime and gangster films popular in Hollywood in the early 1930s. The film was to bring the New York skyscrapers anthropomorphically to life, tapping into what Dalí called the 'subconscious necrophilia' which 'animates' the 'secret clubs' of Manhattan.[32] Although the film project was unrealized, the examples of Lorca and Dalí reveal another rhythm in the modernist Atlantic which largely bypassed London and Paris.

ATLANTIC AESTHETICS

The movement back and forth across the Atlantic was arguably the defining journey for early twentieth-century modernists. For some it represented a lifeline and a way

[31] Federico García Lorca, *Poet in New York* (Harmondsworth: Penguin, 1990), 7, 11. For further discussion, see Martin Halliwell, *Transatlantic Modernism: Moral Dilemmas in Modernist Fiction* (Edinburgh: Edinburgh University Press, 2006), 133–53.

[32] Images and pages from the script of Dalí's *The Surrealist Mysteries of New York* were included among the Dalí: Painting and Film exhibition, Museum of Modern Art, New York, Summer 2008.

of locating personal and artistic freedom at a remove from home, or it offered a means of breaking the ties of inevitability that fascinated early-century naturalist writers. For others, including Sigmund Freud on his only visit to the United States in 1909, the transatlantic journey by sea was long and uninspiring, perhaps negatively affecting Freud's already jaundiced view of American commerce. For some writers, such as Henry James, the Atlantic was a way of binding together multiple geographical locations in a cultural and economic loop with urban centres as the nodal points: a version of what Stephen Shapiro has called the 'Atlantic world-system'.[33] Paris was often the destination or passing-through point of modernist writers and artists, but so too were Chicago and Manhattan, where machine age aesthetics jostled with eclectic experiments in prose, poetry, film, and music.

This chapter has followed the trend in recent scholarship to look beyond the borders of nation states to consider the ways in which American and European versions of modernism were intertwined rather than categorically distinct trends. Although the recent 'transnational turn' in scholarship helps to highlight these border crossings, in truth these geographical movements are deeply embedded in the cosmopolitan and international impulses of modernism. To return to the opening discussion, we can look to *Blonde Venus* to exemplify transatlantic modernism. Marlene Dietrich's imitation of Josephine Baker in 'Hot Voodoo' indicates that new expressions of gender and racial identity were never far from the modernist agenda. Dietrich's exile as a German in America during the rise of Nazism in central Europe leads Elisabeth Bronfen to identify travel, liminality, and hybridity as themes running through Dietrich's films, reminding the viewer that 'psychic, geographic, and cultural' exile and displacement were central to modernist aesthetics.[34] While *The Blue Angel* (1930) and *Blonde Venus* emphasized Dietrich's Germanness, in later films she became a synecdoche of European exile, playing a variety of seductive Russian, French, English, and Spanish characters. *Blonde Venus* reminds us that the liminal complexity of Dietrich's character was embodied in her character's journey to and fro across the Atlantic. So, while we might be tempted to read the modernist journey as unidirectional, a closer look reveals a complex transnational geography across land and water.

[33] See Stephen Shapiro, *The Culture and Commerce of the Early American Novel: Reading the Atlantic World-System* (Pittsburgh: Pennsylvania State University Press, 2008).

[34] Elisabeth Bronfen, 'Seductive Departures of Marlene Dietrich: Exile and Stardom in *The Blue Angel*', in Gemünden and Desjardins (eds), *Dietrich Icon*, 119–40.

CHAPTER 41

...

MODERNIST COTERIES AND COMMUNITIES

...

NATHAN WADDELL

COTERIES and communities are complex things. At first glance, the two terms might quite reasonably be seen as opposites, since, according to the *OED*, one of the time-honoured meanings of 'coterie' is 'a circle of persons associated together and distinguished from "outsiders", a "set"', just as 'community' conventionally means the 'quality of appertaining to or being held by all in common; joint or common ownership, tenure, liability'. Coteries, then, are sets or groupings formed on the basis of exclusivity. Communities, by contrast, are places of acceptance and reciprocally held beliefs and values, of commonwealth and kinship instead of clannish snobbery. A more sociologically inflected way of looking at the opposition between these two terms would be to say that coteries are *dystopian* in so far as they admit only an elect few, whereas communities are *utopian* in so far as they hold their doors open to all. But to put it like this is to ignore the very real issue of perspective contained within these descriptions (for instance, the fact that one person's utopia might be another's dystopia). One might ponder where the one becomes the other, where paradise-like consortiums become hellish nether worlds, or where a locked door in fact turns out to have been only partly closed. Numerous tensions and overlaps exist between the terms 'coterie' and 'community' that bald explanations of the words themselves imply but do not fully reveal. Communities, as has been shown by history time and again, can be put together on the basis of a 'chosen' people or in the service of a monological interest. As Raymond Williams writes, 'the moment the notion of community is appropriated for a version [of itself] which is going to be dominant,

and to which variations are going to be subordinate, then the same value has turned in an opposite direction'.[1] Equally, coteries can be formed by appeal to the welfare of some wider populace or group, as in the efforts of the Suffragettes, to draw on a historical example. We need to remember that even the most utopian community can turn out to be a product of dystopian impulses, and even seemingly patrician confederacies might set the stage for better kinds of cooperation or exchange.

It follows that the words 'coterie' and 'community' might usefully be seen as what George Eliot once called 'dangerous impostors', words 'which have an excellent genealogy [but] are apt to live a little too much on their reputation'.[2] As the other chapters in this volume show all too clearly, the same could be said of 'modernism' itself. Although the terms 'coterie' and 'community' have their roles (and I will be using them throughout this chapter), to discuss modernism without reference to or an awareness of the reductive binary framework they impose upon the histories of early twentieth-century cultural production is plainly inadequate. As we will see, the wide-ranging modernisms of Bloomsbury, Paris during the 1920s, and the Harlem Renaissance, for instance, all frustrate the easy identifications of *either* coterie *or* community as explanatory signifiers. In these instances, more kaleidoscopic categories (such as Walter Benjamin's idea of 'constellations' or Williams's notion of cultural 'formations') are necessary. For Williams, Bloomsbury is a good example of such a formation, one 'not based on formal membership or any sustained collective public manifestation, but in which there is *conscious association or group identification*, either informally or occasionally manifested, or at times limited to immediate working or more general relations'.[3] Williams's suggested category is a helpful one, but the sinuousness with which it is articulated ought to alert us to the terminological and descriptive lacunae that modernism's various collective identities bring to light. With these opening caveats in mind, it still must be insisted that modernism (especially early modernism) cannot easily be separated from notions of coterie and community. As the focus of modernist texts themselves and as a crucial means by which the modernists organized and marketed their endeavours, 'coterie' and 'community' should be seen as significant elements in modernism's varied aesthetic and material underpinnings. Peter Brooker has demonstrated that this list ought to be extended to include modernism's *social* beginnings as well.[4] These linkages are multifaceted, comprising different kinds of joint endeavours, brief associations, creative circuitries, and ideological segregations. Indeed, accounts of modernism might be written solely on the basis of its unions, short-lived alliances, and exclusions, its narratives of writers, painters, sculptors, intellectuals, music makers,

[1] Raymond Williams, *The Politics of Modernism: Against the New Conformists*, ed. Tony Pinkney (London: Verso, 1989), 194.
[2] George Eliot, *Selected Essays, Poems, and Other Writings*, ed. A. S. Byatt and Nicholas Warren (London: Penguin, 1990), 231.
[3] Raymond Williams, *Culture* (London: Fontana, 1981), 68.
[4] Peter Brooker, *Bohemia in London: The Social Scene of Early Modernism* (Basingstoke: Palgrave Macmillan, 2007).

patrons, and impresarios coming together in the form of fellowships, companies, and syndicates. To speak of modernism in these terms would have been impossible without the developments in modernist studies over the past few decades, developments that now enable us to abandon individualist models of literary history in favour of more inclusive, wide-ranging attitudes to modernism that call attention to collectivity, secession from and inclusion in the group, teamwork, and plurality.

Any account of modernism in relation to coterie and community needs to include (or, indeed, largely be constituted by) those moments of union in which the opposition between them becomes indistinct, or even breaks down entirely. Certainly, modernism has its moments of potential elitism (high modernism's emphasis on 'difficulty') and its parallel egalitarianisms (its various borrowings from popular culture) with much else in between, but it has also its instances of the few working for the many (modernist feminism and pacifism) and times at which the efforts of community portend authoritarian logics and economies (some of the historical avant-gardes). In this chapter I emphasize that always within these complex interweavings of personality and artistic intent there is a dialectical interplay between coterie and community that forces us to think carefully about, on the one hand, the political and cultural identities of modernism's assorted factions and sub-factions, and, on the other hand, the ways in which those identities inform the artworks and cultural commentaries of modernism themselves. That said, a chapter as brief as this cannot hope to do justice to all such alliances and networks, but what it might offer is some preliminary remarks on how a sampling of those movements and groupings formed, how long they lasted, and what interests and values united them. It can show which individuals were significant in those sodalities, ask whether they remained so, and ponder how modernism investigated the permeable gap between democratic camaraderie and high-handed exclusiveness.

This chapter, then, is about modernism's cultures of coterie and community as much as it is about modernism's *depictions* of the same. It covers the two decades or so from around 1908 to 1930, and it does so in the spirit of emphasizing cultural history as much as artistic production. I focus mainly on modernism's British and Parisian contexts by giving accounts of the following enablers and locations of modernist coterie and community: Ford's influential role as a facilitator of culture at the turn of the century; Imagism and Vorticism, with an emphasis on the difficulties of talking about 'isms'; Bloomsbury and Lawrence's vision of Rananim; the modernist scene of 1920s Paris, Eugene Jolas, and *transition*; and, finally, the Harlem Renaissance and New York (for more on 'black' and New York modernism, see Chapters 13 and 40 by Jonathan Gray and Martin Halliwell in this volume). My intention throughout is to show that we cannot reduce the various group contexts of modernism either to coterie or to community without serious elision, and to outline a selection of moments in cultural history defined variously by group effort and individual talent.

Such issues were particularly pressing for the Ford (then Hueffer) of *The Critical Attitude* (1911), who wrote that 'modern life has left behind old faiths, old illusions, old chivalries and old heroisms' and lamented that 'to be brought really into contact

with our fellow men, to become intimately acquainted with the lives of those around us, this is a thing which grows daily more difficult in the complexities of modern life'.[5] Metropolitan society, especially London society, was a key culprit here. Ford had already written in *The Soul of London* (1905) that the capital is 'a great, slip-shod, easy-going, good-humoured magnet', but he was also convinced that London was a place of deep, and often challenging, contradictions, marked at times by optimism but also at others by alienation, delinquency, and the worst excesses of modernization. That said, Ford was looking out and away from the urban at this moment in his writing, and in *The Heart of the Country* (1906) he writes of agrarian idylls in ways that clearly anticipate his much later promotion of Provençal culture, in *Provence* (1935) and *Great Trade Route* (1937), as a form of archetypal existence.[6] The 'Utopias' chapter of *The Heart of the Country* contrasts totalitarian forms of social engineering, 'those bright, cast-iron schemes in which all provision for development, for flux and reflux, all chances of change, are left out', with a pragmatist, meritocratic vision of society indebted to a Tory radical tradition that would 'give a chance to keen men of entering the lowest ranks and of striving up to the highest'.[7] While he was striving to create a forum for a transnational community of letters in the *English Review*, established in December 1908, Ford was establishing himself as an engaged evaluator of the very notion of 'community' itself.

Given these interests, it is perhaps no surprise that Ford was in many respects a product of groups and literary clusters, not least the Kent and East Sussex 'neighbourhood' that comprised Joseph Conrad, Stephen Crane, Ford, Henry James, and H. G. Wells at the end of the nineteenth century.[8] Ford was also a figure who helped *produce* many such groups and clusters, and in particular proved of great assistance to Ezra Pound, with whom he established a significant personal and working relationship. He was closely linked to Pre-Raphaelitism, both personally, through his grandfather Ford Madox Brown's attachment to the Pre-Raphaelite Brotherhood, and creatively, by way of several studies of the movement itself. In collaboration with Conrad, who was in many respects his most important ally, Ford co-authored *The Inheritors* (1901), *Romance* (1903), and *The Nature of a Crime* (1924). In addition to Ford's reminiscence of Conrad in the eponymous *Joseph Conrad* (1924), one sign of the significance of this relationship is the subtitle of Ford's *The English Novel* (1930), *From the Earliest Days to the Death of Joseph Conrad*, which canonizes Conrad's literary practice in advance of Ford's glowing endorsement of Conrad in *The March*

[5] Ford Madox Hueffer [Ford], *The Critical Attitude* (London: Duckworth, 1911), 104, 66–7.

[6] *The Heart of the Country* (1906) comprises part 2 of Ford's 'Englishness' trilogy, beginning with *The Soul of London* and ending with *The Spirit of the People* (1907), which was published in America as *England and the English* (1907).

[7] Ford Madox Ford, *England and the English*, ed. Sara Haslam (Manchester: Carcanet, 2003), 88, 213. For Ford's Tory radicalism, see Andrzej Gasiorek, 'The Politics of Cultural Nostalgia: History and Tradition in Ford Madox Ford's *Parade's End*', *Literature and History*, 11/2 (Autumn 2002), 52–77.

[8] For more on the working co-efforts of these figures, see Nicholas Delbanco, *Group Portrait: Joseph Conrad, Stephen Crane, Ford Madox Ford, Henry James, and H. G. Wells* (London: Faber, 1982). See also Ford Madox Ford, *Return to Yesterday*, ed. Bill Hutchings (Manchester: Carcanet, 1999).

of Literature (1938) as a constructive, but not idealist, figure who evoked 'whole republics in his books'.[9] As one of modernism's most successful networkers, as well as one of its foremost novelists and historians, Ford is a key figure in so far as he diagnosed and assessed particular forms of society and modernist community. This is particularly clear in his satiric fictions *The Simple Life Limited* (1911), *The New Humpty-Dumpty* (1912), and *Mr Fleight* (1913), all of which Pound saw as accurate portrayals of the 'utter imbecilities' of modern society.[10] Through his influential familial links, and his multiple roles as networker, transitionist, and facilitator of experimental forms of culture, Ford played a defining part in several of the loose collectives through which modernism emerged in its earliest days. His greatest achievement in this last respect was his establishment of the *English Review*, a feat that reconfigured the culture of 'little magazines' (then exemplified by journals like *Dana* and the *New Age*) and established Ford himself, as Max Saunders notes, as 'a central transforming force of early English modernism'.[11] Under Ford's editorial tenure, the magazine published work by a vibrant and multi-generational assemblage of writers, including Victorian and Edwardian figures as well as unheard-of individuals who would become rising stars. Ford wrote in *Thus to Revisit* (1921) that, with the aid of Arthur Pearson Marwood, the *English Review* aimed 'to afford a nucleus for some sort of Movement that should combine some of the already Eminent with some of the Young who were then knocking on the doors of our Athenaeum'.[12] In the first camp there were writers such as Thomas Hardy, George Meredith, Dante Gabriel Rossetti, and Theodore Watts-Dunton. Contemporaries included Granville-Barker, Arnold Bennett, Conrad, John Galsworthy, Henry James, H. G. Wells, and W. B. Yeats. Ford himself published in the *English Review*, and the magazine helped on their way such writers as Norman Douglas, Lawrence, Lewis, and Pound.

The *English Review* stressed the indebtedness of modern writing to preceding traditions by giving space to older literary voices and practices. But by promoting contemporary and forward-looking material it also entered into public dialogue with the peculiar forms and techniques of an emergent modernism. It sought, in Paul Peppis's words, to promote 'the art movements of the early twentieth century', just as the late Victorian *Yellow Book* 'had promoted the Decadent and Symbolist movements of the closing nineteenth'.[13] As its name seems to imply, the *English Review* foregrounded the nature of community and belonging in the terms of a specifically

[9] Ford Madox Ford, *The March of Literature: From Confucius' Day to Our Own* (Normal: Illinois State University Press, 1994), 835. For an overview of Ford's working relationship with Conrad, see Ann Barr Snitow, *Ford Madox Ford and the Voice of Uncertainty* (Baton Rouge: Louisiana State University Press, 1984), 29–69.

[10] *Pound/Ford: The Story of a Literary Friendship*, ed. Brita Lindberg-Seyersted (London: Faber and Faber, 1982), 70. See also David Trotter, *Paranoid Modernism: Literary Experiment, Psychosis, and the Professionalization of English Society* (Oxford: Oxford University Press, 2001), 202–10.

[11] Max Saunders, *Ford Madox Ford: A Dual Life*, i: *The World Before the War* (Oxford: Oxford University Press, 1996), p. vi.

[12] Ford Madox Hueffer [Ford], *Thus to Revisit* (New York: Dutton, 1921), 58.

[13] Paul Peppis, *Literature, Politics, and the English Avant-Garde: Nation and Empire, 1901–1918* (Cambridge: Cambridge University Press, 2000), 23.

English nationhood. But its title, described elsewhere by Ford as 'a contradiction in terms', is a crafty one.[14] Ford himself recalled in *Return to Yesterday* (1931) that

It was Conrad who chose the title. He felt a certain sardonic pleasure in the choosing of so national a name for a periodical that promised to be singularly international in tone, that was started mainly in his not very English interest and conducted by myself who was growing every day more and more alien to the normal English trend of thought, at any rate in matters of literary technique.[15]

The *English Review* was a periodical 'devoted to the arts, to letters and ideas', which was launched in order to remedy 'the extremely small hold which imaginative literature to-day has upon the body of the English people'.[16] The magazine sought writers who could challenge England's identity as 'the country of Accepted Ideas' and help to rectify a 'modern life in which intimacies are so rare, in which social contacts are so innumerable, in which it is no longer a matter of long letters but of the shortest notes'.[17] In spite of the localism of its title, as a space for Anglophone writing the *English Review* avoided jingoism in favour of evoking a global community of letters not limited by the markers of place or nation. It courted national and international offerings in order to restore a degraded public sphere and to nudge English culture out of what Ford saw as a kind of literary disenlightenment.

The *English Review* featured regular input from James, Yeats, Conrad, Dostoevsky, and Tolstoy, and it maintained a strong support for those 'young men', as Ford put it, 'who are loud-voiced, tapageux, vigorous, and determined to arrive'.[18] This last comment appeared in *The Outlook* in 1914, but it is important to compare these sentiments with Ford's oft-quoted nostalgic recollections of the same period in *Return to Yesterday*, in which he likens the effect of a pre-war literary and cultural revival caused almost entirely by non-native hands to 'another foreign invasion', an inevitable, necessary incursion into English letters by aliens and outsiders which functioned as a mechanism of cultural regeneration. Ford's reference to *another* invasion places the high jinks of *les jeunes* (as he called the protagonists of such movements as Cubism, Futurism, Imagism, and Vorticism) as coming after the earlier raids of the 'fourfold tradition' of Conrad, Crane, Hudson, and James at the turn of the twentieth century. It also evokes the politicized motifs of the 'invasion novel' tradition which was approaching a manner of apotheosis in the work of John Buchan, as figures like Pound and Lewis 'pranced and roared and blew blasts on their bugles [while] round them the monuments of London tottered'.[19] Like the German infiltrators at the end of Buchan's *The Thirty-Nine Steps* (1915), who penetrate England's borders by way of disturbingly credible imitations of English mannerisms,

[14] Hueffer [Ford], *The Critical Attitude*, 4.

[15] Ford, *Return to Yesterday*, 284.

[16] 'Editorial', *English Review*, 1/1 (Dec. 1908), 158, 159.

[17] Ibid. 160.

[18] Ford Madox Ford, *The Ford Madox Ford Reader*, ed. Sonda J. Stang (Manchester: Carcanet, 1986), 174.

[19] Ford, *Return to Yesterday*, 312, 30, 313.

Ford's determined young men blast their way through English culture as already assimilated Londoners. But if Buchan's Germans come on a mission of sabotage, Ford's young men come not to destroy but to provide England with a much-needed injection of cultural vigour; they come not to tear artistic community apart, but to strengthen it with an infusion of fresh blood from without. Thus Ford: 'I fancy that these young men are going to steamroller out this poor old world of ours. And I am very glad of it; it has been a dull place enough.'[20]

Ford's role as editor of the *English Review* transformed a significant part of English literary culture into, as Pound described the vortex, 'a radiant node or cluster ... from which, and through which, and into which, ideas are constantly rushing', that sign of a still centre surrounded by chaotic whirls by means of which Pound would define his version of the movement whose name he inspired (Vorticism), and through which that movement would evoke its art of controlled tension, cerebral detachment, and metamorphic intervention.[21] Ford's role also prefigured the extent to which many modernist formations and coteries came into being through magazine culture, a sign not only of intellectual and aesthetic convergence but of material and social interaction as well. Indeed, prior to, at the same time as, and in the wake of Ford's efforts not only English literary culture but also England's capital city became something of a vortex. As Lewis wrote in *Blast* (1914): 'Long live the great art vortex sprung up in the centre of this town!'[22] London in the immediately pre-war years was a place of rushing schemes and designs, of intellectual and artistic rivalries. Pound's contention that 'The revolution of the word began so far as it affected the men who were of my age in London in 1908, with the LONE whimper of Ford Madox Hueffer [Ford]' needs to be seen in conjunction with the continuing importance and influence of aestheticism, Impressionism, and naturalism, as well as the emergence of movements such as Imagism and Vorticism, and the London-based contingents of Futurism and Cubism (see Chapters 4, 5, and 38 in this volume).[23] This was a time of high debate and earnest sipping in cafés and tea shops, which Ford later described as places in which 'serious people discussing serious subjects mould civilisations'.[24] In painting, this was the era of Wyndham Lewis's Rebel Arts Centre, the Omega Workshops, the Camden Town Group, and the Allied Artists' Association. The Rebel Arts Centre, which hosted both Pound and Ford as lecturers, was supportive of Post-Impressionism, and the Omega Workshops, founded by Roger Fry in 1913, offered a corporate environment in which figures such as Vanessa Bell, Henri Doucet, Henri Gaudier-Brzeska, and Nina Hamnett found a home. It stood as one of the intellectual settings out of which Bloomsbury emerged. Culturally and socially, pre-war London was a patchy, palimpsestic bricolage.

[20] Ford, *The Ford Madox Ford Reader*, 177.
[21] Ezra Pound, *Gaudier-Brzeska: A Memoir* (New York: New Directions, 1974), 92.
[22] Wyndham Lewis (ed.), *Blast: Review of the Great English Vortex*, 1 (Santa Rosa, Calif.: Black Sparrow Press, 2002), unpaginated manifesto.
[23] Ezra Pound, quoted in *Pound/Ford*, 142.
[24] Ford Madox Ford, *Provence: From Minstrels to the Machine* (New York: Ecco, 1935), 58.

One significant patch was the room for literary gossip, dispute, and partying offered by Ford's literary salons at Violet Hunt's home, the celebrated South Lodge at Campden Hill in Kensington. Ford's South Lodge may be compared with Ottoline Morrell's role as Bloomsbury hostess at Garsington, a role she played in earnest until the 1916 Conscription Acts collapsed Bloomsbury's salon structures.[25] As Lawrence recalls in his letters, his presence at South Lodge would be an opportunity for contact- and network-making: '[David] Garnett is going to introduce me to quite a lot of people. I am not keen on it, but he says my business is to get known.'[26] South Lodge provided yet another space at this point in London's literary history where Pound's ideal of the artist as the keeper of civilized values could flourish and thrive in concert with others, at dinner tables as much as on tennis courts. If these salons were arenas set up by individual figures, they were nonetheless defined by open-endedness and autonomy. Douglas Goldring recalls that South Lodge was a place of vital chat as well as vivacious cheek, where 'Ezra's irreverence towards Eminent Literary Figures was a much needed corrective to Ford's excessive veneration for those of them he elected to admire.' As Goldring observes, Pound 'not only subjugated Ford by his American exuberance, but quickly established himself at South Lodge as a kind of social master of the ceremonies'.[27] We should remember that during this period the modernists were young and, for the most part, carefree. They were artists sharing in *lived* collective experience as much as figures engaging in innovatory forms and techniques.

London's cultural scene at this time was the battleground on which various groups and rival 'isms' contended for dominance. '*Putsches* took place every month or so,' Lewis later wrote.[28] These operations took the form of temporary alliances and strategic bands. Individuals came together to form groups determined to cement their artistic hegemony by promoting their particular projects, their 'isms', in semi- or total opposition to the claims of rival collectives. Milton A. Cohen puts the point well: 'the group structure intensified modernist innovation by enabling otherwise isolated artists to develop aesthetic ideas collectively, sometimes even to create the art expressing these ideas collaboratively, and, most important, to *dare* to present their innovative art to a hostile, yet potentially curious public'.[29] But we should be cautious of the risks in speaking of modernism at this time without due attention to the reductive implications of the term 'group'. London's cultural scene immediately prior to the First World War was, on the one hand, a place of established movements (such as the Rhymers, the Irish Literary Society, Symbolists, aesthetes, and the Arts and

[25] Victor Luftig, *Seeing Together: Friendship Between the Sexes in English Writing from Mill to Woolf* (Stanford, Calif.: Stanford University Press, 1993), 174.

[26] D. H. Lawrence, *The Letters of D. H. Lawrence*, ed. James T. Boulton, i: *September 1901–May 1913* (Cambridge: Cambridge University Press, 1979), 315.

[27] Douglas Goldring, *South Lodge: Reminiscences of Violet Hunt, Ford Madox Ford, and the English Review Circle* (London: Constable, 1943), 47.

[28] Wyndham Lewis, *Blasting and Bombardiering* (London: John Calder, 1982), 33.

[29] Milton A. Cohen, *Movement, Manifesto, Melee: The Modernist Group, 1910–1914* (Lanham, Md: Lexington, 2004), 1.

Crafts movement), and, on the other, a multifarious, kinetic site of *emergent* movements and practices, one of collisions and associations, half-identities and proto-characteristics. There is no straightforward sense of coterie and community here: modernism's 'groups', if that is the right word for them, came together, disbanded, re-formed, splintered, merged, and intermixed. Part of the difficulty in accurately mapping the terrain of literary history during this period stems from these partial agreements and coalitions, and further difficulties arise through the misleading unities bestowed upon 'groups' like Imagism and Vorticism by the proper nouns through which (for clarity's sake) we refer to them.

T. S. Eliot wrote in 'American Literature and Language' (1953) that

The *point de repère* usually and conveniently taken, as the starting-point of modern poetry, is the group denominated 'imagists' in London about 1910. I was not there. It was an Anglo-American group: literary history has not settled the question, and perhaps never will, whether imagism itself, or the name for it, was invented by the American Ezra Pound or the Englishman T. E. Hulme.[30]

Even in Eliot's formulation, with its qualifying phrases and hesitant inverted commas, the view of Imagism as a unitary 'group' begins to slide out of focus. Imagism took root in cafés where rising poets like Richard Aldington, Hilda Doolittle, F. S. Flint, Hulme, Pound, Lawrence, and Amy Lowell quarrelled and theorized. The Café Tour d'Eiffel was associated with T. E. Hulme and eventually with Wyndham Lewis, and both Imagism and Vorticism had key dinner gatherings, both in mid-July 1914, at Dieudonné's in Ryder Street.[31] The Piccadilly Café Royal, which had earlier been the haunt of James Whistler and Oscar Wilde, kept a table for A. R. Orage, the editor of the *New Age*, and it famously was the site of Nancy Cunard's entry into bohemian society.[32] If, as Scott McCracken notes, many early twentieth-century writers make cafés and tea shops 'a key locus for urban encounters', those same cafés and tearooms, notably the ABC and Lyons, function as indices for the multiplicity of fleeting unions to which the literary history of movements like Imagism (and, to a certain extent, early modernism more broadly) ought to be related.[33]

Andrew Thacker's chapter in this volume (Chapter 38) shows how all involved in Imagism participated in a general spirit of redefining the practice of poetry, of substituting lyrics and geometric haiku for what was rhetorically positioned as an amorphous Romanticism. That said, Imagism was a string of (often incompatible) miniature collectives that split, sundered, and switched sides as their members quarrelled, retheorized their endeavours, and became part of other projects. Claims

[30] T. S. Eliot, *To Criticize the Critic and Other Writings* (Lincoln, Nebr: University of Nebraska Press, 1992), 58.

[31] Brooker, *Bohemia in London*, 114.

[32] Ibid. 29, 102.

[33] Scott McCracken, 'Voyages by Teashop: An Urban Geography of Modernism', in Peter Brooker and Andrew Thacker (eds), *Geographies of Modernism: Literatures, Cultures, Spaces* (London: Routledge, 2005), 86.

such as Lewis's later statement that the geometric art sponsored by Hulme during this period amounted to Lewis 'doing' in advance of Hulme belatedly 'speaking' only further complicate a literary history coloured by elaborate assertions, bluffs, and counter-portrayals.[34] Charles Ashleigh's complaint, made in the *Little Review* in 1914, that Pound's *Des Imagistes* compilation 'dealt a blow to sectarian Imagism' by including non-Imagist and Imagist-esque poems by like-minded contemporary writers (which Ashleigh identified as John Cournos, Ford, Allen Upward, James Joyce, and Skipwith Cannell) implied the existence of a soon-to-be-lost, central Imagist aesthetic that, in the particular sense evoked by the word 'sectarian', was rhetorically persuasive but empirically misleading.[35] From its earliest appearances, the poetry produced by those associated with Imagism displayed a broad variety of styles and preoccupations, a multiplicity sometimes even in direct conflict with the principles expressed in those pieces, such as Flint's 'Imagisme' and Pound's 'A Few Don'ts by an Imagiste', upon which the majority of Imagism's efforts initially were mobilized. It is perhaps more accurate to speak of the 'movement' (prior to the split between Pound and Amy Lowell, at least) in portmanteau terms. Before the Lowell-edited Imagist anthologies of 1915–17 (what Pound dismissively referred to as 'Amygism'), it can be helpful to view the movement as a series of transitory leagues, fleeting joint enterprises, and momentary partnerships rather than in the unitary sense of a singular project. Imagism*s*, not Imagism.

A similar approach ought to be taken when dealing with the 'Men of 1914', as Lewis called them in *Blasting and Bombardiering* (1937). This term has long since passed into our academic vernacular, but even Lewis was all too aware that the term was a retrospective construction *imposed* upon history in order to shore up its various fragments. Lewis recognized that the proper nouns used by literary historians to differentiate between early modernisms were 'nicknames', and his repeated use of the term 'Men of 1914' in scare quotes suggests that he saw through its exclusionary undertones to a period 'dwelt in by strange shapes *labelled* "Pound", "Joyce", "Weaver", "Hulme"'.[36] But the group terms that Lewis and others like him problematized, blunt though they might be as markers of collective identity, do usefully point us to definite agendas and explorations of the nature of community. Vorticism, as represented in *Blast*, was explicitly announced as an effort 'to make the rich of the community shed their education skin, to destroy politeness, standardization and academic, that is civilized vision'.[37] Vorticism can be thought of in contrast to a cultural formation like Bloomsbury inasmuch as it was composed around a central publication (*Blast*) and had a key editorial and organizational figurehead in the guise

[34] Lewis, *Blasting and Bombardiering*, 100.
[35] Charles Ashleigh, cited in Peter Jones (ed.), *Imagist Poetry* (London: Penguin, 1972), 19.
[36] Lewis, *Blasting and Bombardiering*, 257, 254; my emphasis. For a good discussion of Lewis in relation to quotation and the use of quotation marks, see Alan Munton's essay in Andrzej Gasiorek, Alice Reeve-Tucker, and Nathan Waddell (eds), *Wyndham Lewis and the Cultures of Modernity* (Aldershot: Ashgate, forthcoming).
[37] *Blast*, 1, unpaginated manifesto.

of Wyndham Lewis, who was supported by Pound and William Roberts. As Helen Saunders put it, Vorticism was '*a group of very disparate artists each working out his [sic] own ideas under the aegis of the Group and its very able leader and publicist Wyndham Lewis*'.[38] In addition, Vorticism was a utopian and meta-utopian project that sought to dissect contemporary versions of social reform while offering its own account of a new psychology, one in which the very notion of 'collectivity' would have to be remodelled. In a 1915 letter to Augustus John, Lewis asserted that 'individual invention and not the refined custom of a community is the better thing'.[39] Under Lewis's direction Vorticism presented an art of individuals, but it also demanded a new conception of social reality, an urge that resulted in Lewis's post-war Vorticist text *The Caliph's Design* (1919). It is no small quirk of fate that the movement which comprised numerous individuals eventually came to be represented by Lewis as his movement *and his movement alone*.[40] 'Vorticism, in fact, was what I, personally, did, and said, at a certain period.'[41] For the older Lewis, Vorticism had been an oppositional coterie of one: the Enemy himself.

This was not the first time Lewis had distanced himself from others. *The Apes of God* (1930), Lewis's satire of 1920s life and society, attacked the Sitwell clan (Edith, Osbert, and Sacheverell) in the guise of Lady Harriet, Lord Osmund, and Lord Phoebus Finnian-Shaw. While working for Roger Fry's Omega group in 1913, Lewis was denied the chance to display his work at the Ideal Home Exhibition, resulting in the round robin letter signed by Frederick Etchells, Cuthbert Hamilton, Lewis, and Edward Wadsworth, in which Fry was implicitly characterized as 'the Pecksniff-shark, a timid but voracious journalistic monster, unscrupulous, smooth-tongued and, owing chiefly to its weakness, mischievous'.[42] This led to a lifelong tension between Lewis and the Bloomsbury set, the socio-intellectual coterie with which Fry was associated. 'Bloomsbury' can be said to refer to three interrelated things: the area of London located around the British Museum; a group of individuals, among which Fry, Duncan Grant, Clive and Vanessa Bell, Leonard and Virginia Woolf, Lytton Strachey, John Maynard Keynes, and Molly MacCarthy can be counted as members; and the ideas and politics of that same group, which included commentary on such key areas of society and culture as aesthetics, economics, pacifism, sexuality, and feminism.[43] According to David Garnett the Bloomsbury set were 'worshipped by

[38] Quoted in Brigid Peppin, *Helen Saunders, 1885–1963* (Oxford: Ashmolean Museum; Sheffield: Graves Art Gallery, 1996), 12–13.

[39] Wyndham Lewis, *The Letters of Wyndham Lewis*, ed. W. K. Rose (London: Methuen, 1963), 72.

[40] For more on the plural identity of Vorticism as a movement, see Andrzej Gasiorek, 'The "Little Magazine" as Weapon: *Blast*', in Peter Brooker and Andrew Thacker (eds), *The Oxford Critical and Cultural History of Modernist Magazines*, i: *Britain and Ireland, 1880–1955* (Oxford: Oxford University Press, 2009), 290–313.

[41] Wyndham Lewis, *Wyndham Lewis on Art: Collected Writings 1913–1956*, ed. Walter Michel and C. J. Fox (New York: Funk & Wagnalls, 1969), 451.

[42] Lewis, *Letters*, 50.

[43] Alex Zwerdling has interesting things to say about Bloomsbury's problematic identity as a coterie in *Virginia Woolf and the Real World* (Berkeley: University of California Press, 1986), 27–8.

some and abominated by others'.[44] John Buchan praised Woolf for her critical writing, but portrayed Bloomsbury in *The Three Hostages* (1924) as a den for diabolists, and, in *The Courts of the Morning* (1929), as a gossipy, Freud-obsessed hideaway. Roy Campbell's epic poem *The Georgiad* (1931) attacked Bloomsbury as a coterie, a move that contributed to his cultural marginalization and his flight to Provence. Others, among them E. M. Forster, Vita Sackville-West, and Harold Nicolson, were more sympathetic to Bloomsbury's progressivist intellectual atmosphere, a sympathy neatly captured in Sackville-West's view of Leonard and Virginia Woolf: 'How wrong people are about Bloomsbury, saying that it is devitalized and devitalizing. You couldn't find two people less devitalized or devitalizing than the Wolves.'[45]

Bloomsbury had tenuous links with the post-war *Coterie* magazine, which included Aldous Huxley, a regular contributor to the Sitwellian *Wheels*, among its founding editors. In spite of its title, *Coterie* was generally inclusive in character, and, in addition to Edith Sitwell, the magazine featured contributions from women writers such as Nancy Cunard, Iris Tree, and Helen Rootham. *Coterie* briefly served 'as a forum in which some of the competing accents of modernism were distinguishable amidst the more widespread cacophony of cultural modernity'.[46] Likewise, we should attend to the multiple identities at work within Bloomsbury itself even if, as I have pointed out, we might want to uphold Williams's view of the group as a formation not based on official membership but largely defined by planned collective identification. Strachey, one of Bloomsbury's most prominent anti-war voices, recalled finding little to talk about with Huxley, even though both figures shared pacifist sympathies. Moreover, Huxley's presence within Bloomsbury can hardly be considered typical, even if his pacifism strongly links him up with the other pacifists that Bloomsbury harboured. On this issue, for example, Bloomsbury was not a unified pacifist 'group' at all times and in all instances, and the various *kinds* of pacifism it attracted need to be set in their proper place, from Russell's philosophically grounded anti-militarism to James Strachey's less reflective style of dissent. At the same time, and like many of his peers, Duncan Grant supported the First World War in its earliest months, and Keynes contributed to the war effort through his work for the British government.[47] The life and writing of Strachey, like that of Virginia Woolf, can be considered as a definitive part of Bloomsbury's identity, even if the lives and careers of other figures that came into Bloomsbury's orbit, such as the soldier–poet Max Plowman and the medical relief worker Mabel St Clair Stobart, ought to be included in its modern-day histories. Bloomsbury pacifism changed over time,

[44] David Garnett, 'Forster and Bloomsbury', in Oliver Stallybrass (ed.), *Aspects of E. M. Forster* (London: Edward Arnold, 1969), 30.

[45] Stanford Patrick Rosenbaum (ed.), *The Bloomsbury Group: A Collection of Memoirs and Commentary*, rev. edn (Toronto: University of Toronto Press, 1995), 329.

[46] Patricia A. Evans, '*Coterie*, 1919–1921: A Study of an English Little Magazine', M.Phil. thesis, University of Birmingham, 2005, 1. See also Andrew Thacker, 'Aftermath of War: *Coterie* (1919–21), *New Coterie* (1925–7), Robert Graves and *The Owl* (1919–23)', in Brooker and Thacker (eds), *The Oxford Critical and Cultural History of Modernist Magazines*, i. 462–84.

[47] Jonathan Atkins, *A War of Individuals: Bloomsbury Attitudes to the Great War* (Manchester: Manchester University Press, 2002), 2–3.

especially in the years between the First and Second World War, during which period many members of the Bloomsbury set produced books with patriotic, pro-military overtones, A. A. Milne's *War with Honour* (1940) and Leonard Woolf's *War for Peace* (1940) among them.

As with the 'isms' discussed above, to speak of Bloomsbury as just that, a proper noun, is to evoke a deceptive unity that careful accounts of this complex matrix of friendships and like-minded individuals ought to avoid or, at least, problematize. David Medalie has written that 'there are great differences within the Bloomsbury Group itself and it is problematic to generalise in this way'.[48] So, for instance, whether Huxley and Bertrand Russell are to be seen as members of the set or not, we should remember that Huxley accused the Bloomsburies of having never read either Russell's or Alfred North Whitehead's work in spite of fashioning themselves, in his view, as the exponents of their systems of thought.[49] There is also the question of how far Bloomsbury can be deemed part of modernism itself. Particular figures within it are accepted modernists (Virginia Woolf is the most obvious example), but it would be imprudent to take a broad view of Bloomsbury as 'modernist' in general terms. There are multiple modernisms, and any account of Bloomsbury's links to these modernisms needs to be no less nuanced. The title of Jonathan Atkins' study of the Bloomsbury set's attitudes to the First World War, *A War of Individuals*, provides a good metaphor for describing the range of political identities, sexual prejudices, and versions of pacifism that Bloomsbury contained and enabled.

But to speak of peripheries and boundaries implies some kind of centre, even if the coordinates of that centre are mobile. One consistent figure within this mid-point is Virginia Woolf, and it is in her work that some of the best instances of the fault lines within Bloomsbury-as-coterie-culture can be found. If novels like *Mrs Dalloway* (1925), *To the Lighthouse* (1927), and *The Waves* (1931) present individual experience as inseparable from the demands of community, then it should also be emphasized that Woolf's subjectivist aesthetic (with its valorization of multi-perspectivalism and liminality) counters the logic of solipsism at the level of both individual psychology and group identity. The boundaries between open community and stopped-up coterie buckle and shift in Woolf's fictions, just as the undulating rhythms of her prose blur the distinctions between individual and collective points of view. *The Waves* may present a view of reality in terms of six distinct lives, but it does so in such a way as to stress the ebb and flow of identity, its continual definition in relation to the subjectivities of others. To pin down the lives of Bernard, Susan, Rhoda, Neville, Jinny, and Louis as forming *either* a coterie *or* a community is to miss the ways in which *The Waves* undercuts the either/or binary. This is not to imply that Woolf was unconcerned with 'ordinary' or 'everyday' matters of communal experience in her

[48] David Medalie, 'Bloomsbury and Other Values', in David Bradshaw (ed.), *The Cambridge Companion to E. M. Forster* (Cambridge: Cambridge University Press, 2007), 36.

[49] Aldous Huxley, 'By Their Speech Ye Shall Know Them', in *Complete Essays*, i: *1920–1925*, ed. Robert S. Baker and James Sexton (Chicago: Ivan R. Dee, 2000), 381–2. For Bloomsbury in relation to the philosophy of George Moore, see Paul Levy, *G. E. Moore and the Cambridge Apostles* (Oxford: Oxford University Press, 1979).

work. On the contrary, her writing comes from a 'privileged' angle of vision (both in the sense of 'materially fortunate' and in the sense of 'bound by a specific set of values'), but from her earliest fictional texts onwards she links privilege with impoverishment, as in the disturbing moment in *The Voyage Out* (1915) when Mrs Ambrose's mental response to London's destitute citizens is described as a mind 'like a wound exposed to dry in the air'.[50]

The intensity of this image brings to mind the powerful metaphors of another figure who was briefly linked to Bloomsbury: Lawrence. As with Huxley and Forster, Lawrence needs to be seen as related to Bloomsbury in terms of temporary assent and future discord, particularly in the context of his correspondence with Bertrand Russell, which began shortly after Lawrence had become friends with John Middleton Murry and Katherine Mansfield. Lawrence was introduced to Russell by Ottoline Morrell while he was writing *The Rainbow* (1915), and shortly before their disagreement over the nature of social reform.[51] Lawrence had written to Russell in February 1915 on precisely this issue, arguing that 'There must be a revolution in the state' and that only after the social edifice as it then existed had been smashed, 'then, and then only, shall we be able to *begin* living'.[52] Lawrence, for his part, continued with a letter in which he offered his 'vision of a life where men are freer from the immediate material things, where they need never be as they are now on the defensive against each other', wherein 'the great living experience for every man is his adventure into the woman'.[53] This eroticized vision of a pre-rational state of being founded on the primacy of blood consciousness was the community of Rananim, Lawrence's utopian revelation of an ideal society that he hoped to found in Florida and which anticipated in certain key respects the Mabel Dodge Luhan House in Taos (visited by Lawrence in 1922).[54] Rananim, discussed at great length with S. S. Koteliansky, among others, was a 'scheme' outlined by Lawrence in a letter to William Hopkin in the following terms: 'I want to gather together about twenty souls and sail away from this world of war and squalor and found a little colony where there shall be no money but a sort of communism as far as necessaries of life go, and some real decency.'[55] As this description suggests, this was to be an exclusive 'community' open only to those suitably virtuous to gain entry, a requisite strengthened by Lawrence's descriptions of his searches for Rananim through the vocabulary of chivalry as a quest for 'an Isle of the Blest, here on earth'.[56] Lawrence and Russell had planned to give a series of joint lectures on these and related issues, but the venture came to nothing in the wake of

[50] Virginia Woolf, *The Voyage Out*, ed. Lorna Sage (Oxford: Oxford University Press, 1992), 7.

[51] For a good overview of Russell and Bloomsbury, see S. P. Rosenbaum, 'Bertrand Russell in Bloomsbury', *Russell*, 4/1 (1984), 11–29.

[52] D. H. Lawrence, *The Letters of D. H. Lawrence*, ii: *June 1913–October 1916*, ed. George J. Zytaruk and James T. Boulton (Cambridge: Cambridge University Press, 1981), 282, 286.

[53] Ibid., 294.

[54] See Lois Palken Rudnick, *Utopian Vistas: The Mabel Dodge Luhan House and the American Counterculture* (Albuquerque: University of New Mexico Press, 1996).

[55] Lawrence, *Letters*, ii: 294, 259.

[56] *The Quest for Rananim: D. H. Lawrence's Letters to S. S. Koteliansky, 1914–1930*, ed. George J. Zytaruk (Montreal: McGill-Queen's University Press, 1970), 109.

Lawrence's gradual dissatisfaction with Russell's account of reformist sociology. As Lawrence put it, having taken Russell to task for his apparent egotism: 'One must retire out of the herd and then fire bombs into it.'[57] Russell rejected Lawrence's views in turn, and what might have been a fascinatingly creative partnership fell into mutual bitterness just as Lawrence's friendship with Murry led to angry estrangement.[58]

Lawrence's wartime dismissal of modern society and eventual rejection of Western modernity for his 'savage pilgrimage' to Italy, Sri Lanka, Mexico, and Australia, among other places, found two echoes in Pound's famous criticism of England as 'a botched civilization' in *Hugh Selwyn Mauberley* (1920), and in Lewis's belief in *The Caliph's Design* (1919) that 'The energy at present pent up ... in the canvas painted in the studio and sold at the dealer's, and written of with a monotonous emphasis of horror or facetiousness in the Press, must be released and used in the general life of the community.'[59] Comparable sentiments are evident in Ford's work, especially in *Return to Yesterday*, where, writing of Lawrence, Ford argued that a 'culture that is founded on the activities of the applied scientist, the financier, the commercial engineer is not only very little elevated above the state of savagedom but is foredoomed. Armageddon, as it was called, came upon us because of those activities.'[60] Ford left England in 1922 for the Latin Quarter of Paris, that bohemian enclave so memorably chronicled by Ernest Hemingway in *A Moveable Feast* (1964). In December 1923 Ford established the *transatlantic review*, the first issue of which was dated January 1924. Like the earlier *English Review*, the *transatlantic* was explicitly relativist in the sense that under Ford's tenure it sought to highlight the contingency of culture in an era marked by increasingly nationalistic interpretations of community. Ford's statement of purposes in the first issue puts the point well. He argued that a widening of the literary field would contribute to a mollifying of international relations by smoothing away the edges of political hostility and creating a global kinship of letters. 'When that day arrives', wrote Ford, 'we shall have a league of nations no diplomatists shall destroy, for into its comity no representatives of commercial interests or delimitators [*sic*] of frontiers can break.'[61] Ford's rejection of centralized forms of authority was not a pandemonic gesture but a sincere effort to help a more beneficent and diverse international culture come into being in a postwar modernity riven by competing forms of utopian thinking. As editor of the *transatlantic*, Ford published work by key modernist figures, among them James Joyce, Gertrude Stein, Hemingway, Jean Rhys, and Pound, who had moved to Paris in 1920 after growing dissatisfied both with life in London and with what he saw as his gradual exile from the English literary scene.

[57] Lawrence, *Letters*, ii. 546.

[58] Fiona Becket, *The Complete Critical Guide to D. H. Lawrence* (London: Routledge, 2002), 16.

[59] Ezra Pound, *Selected Poems, 1908–1959* (London: Faber, 1975), 101; Wyndham Lewis, *The Caliph's Design: Architects! Where Is Your Vortex?*, ed. Paul Edwards (Santa Barbara, Calif.: Black Sparrow Press, 1986), 11–12.

[60] Ford, *Return to Yesterday*, 295.

[61] Ford, quoted in Goldring, *South Lodge*, 144.

Ford's *transatlantic review* 'stands apart as, essentially, the bringer of America to Europe', in the words of Samuel Putnam, although, as Elena Lamberti points out, 'this was mostly due to Hemingway's (and of course to Pound's) efforts'.[62] In addition to those figures already mentioned, Ford published work by E. E. Cummings, William Carlos Williams, and Ring Lardner. Like the *English Review*, the *transatlantic*'s title was carefully chosen, signalling not just a broad reach and influence, but also dialogue and exchange across and between continents and cultures. The Paris of the 1920s was a place where European and American identities mingled (see Chapter 40), but in the immediately post-war years Paris was also seen as offering a kind of culture to which America's own should aspire. Malcolm Cowley noted in *Exile's Return* (1934) that

Almost everywhere one heard the intellectual life of America unfavorably compared with that of Europe. . . . American themes—so the older critics felt—were lacking in dignity. Art and ideas were products manufactured under a European patent; all we could furnish toward them was raw talent destined usually to be wasted. Everywhere, in every department of cultural life, Europe offered the models to imitate—in painting, composing, philosophy, folk music, folk drinking, the drama, sex, politics, national consciousness—indeed, some doubted that [America] was even a nation; it had no traditions except the fatal tradition of the pioneer.

This 'lesser' America was the America that F. Scott Fitzgerald satirized in novels like *This Side of Paradise* (1920), *The Beautiful and the Damned* (1922), and *The Great Gatsby* (1925), but, as Cowley points out, this America gradually came to change in key ways over the ensuing decade: 'People still said in 1930 that it was impossible to live in the United States, but not that it was impossible to write or paint there.' Cowley's remark that the *transatlantic review* was 'the magazine that showed the greatest interest in colloquial writing about American themes' attests a double focus on America as an 'other', but also as an 'other' with avant-garde concerns of its own.[63] Difficulties with publishing houses led to the *transatlantic*'s demise at the end of 1924, in spite of Ford's optimism that it might resurface after a brief deferment, and its cultural interventionism was soon taken up by alternative little magazines such as Ernest Walsh's *This Quarter* and Eugene Jolas's *transition*.[64]

The First World War, an event of 'Daring as never before, wastage as never before', put an end to the pre-war groups that had defined modernism as a fragmented phenomenon.[65] The London-based modernisms of the 1920s and beyond remained pluralized and interwoven, certainly, but they were no longer to be articulated

[62] Samuel Putnam, *Paris Was Our Mistress: Memoirs of a Lost and Found Generation* (London: Platin, 1987), 220; Elena Lamberti, 'Ford Madox Ford and Ernest Hemingway in the Literary Arena of Paris, 1924', in Robert Hampson and Max Saunders (eds), *Ford Madox Ford's Modernity* (Amsterdam: Rodopi, 2003), 242.

[63] Malcolm Cowley, *Exile's Return: A Literary Odyssey of the 1920s* (1934), ed. Donald W. Faulkner (London: Penguin, 1994), 94, 95, 96.

[64] For more on the end of the *transatlantic review*, see Max Saunders, *Ford Madox Ford: A Dual Life*, ii: *The After War World* (Oxford: Oxford University Press, 1996), ch. 12, and Bernard J. Poli, *Ford Madox Ford and the Transatlantic Review* (Syracuse, NY: Syracuse University Press, 1967), 99–134.

[65] Pound, *Selected Poems*, 100.

through the exchange between individuals and loose collectives that had character-
ized the pre-war years. London modernism was for the time being to be largely an
affair of personal voices rather than communal shouting. Eliot's *The Waste
Land* (1922) was produced in collaboration with Pound during the late 1910s, but
Pound had by the time of its appearance moved to the Continent. Paris, for the
disenchanted at least, seemed a place where modernism's ideals of experiment and
newness could be kept very much alive. In the same spirit as Ford's extolling of
Lawrence's lack of means as a 'release' from commerciality, Hemingway recalled that
he and his wife had been happiest in the Parisian artistic enclaves when they had been
most badly off: 'Paris was always worth it', he wrote, 'and you received return for
whatever you brought to it.'[66] Paris was a place where competing modernisms were
very much in evidence. *Transition*, the journal founded in 1927 by Jolas with Maria
McDonald and others, published work by Stein and Hemingway, and it featured
contributions from Franz Kafka, William Carlos Williams, H.D., Alfred Kreymborg,
Max Ernst, Samuel Beckett, and, pre-eminently, Joyce, among many others. Much to
the irritation of Lewis, who was frothing and vituperating back in London in the
pages of his *Enemy* journals (1927–9), *transition* was announced as an attempt 'to
present the quintessence of the modern spirit in evolution.'[67] The magazine's editors
stated: 'We believe in the ideology of revolt against all diluted and synthetic poetry,
against all artistic efforts that fail to subvert the existing concepts of beauty. Once and
for all let it be stated that if there is any real choice to be made, we prefer to skyscraper
spirituality, the immense lyricism and madness of illogic.'[68] This spirit, which so
exercised Lewis in 'The Diabolical Principle' (1929), courted the irrational in order to
counter the hackneyed modes of thought by which figures such as Jolas, Hart Crane,
and Kay Boyle felt themselves to be surrounded.

Like Ford's *transatlantic review*, Jolas's *transition* was international in spirit, defy-
ing nationalist idioms in an attempt to locate a more fundamental kind of response
to modernity that lay beneath the façade-like variances of national identity. This
effort was at least partly a product of Jolas's own diverse heritage: 'His attempts in
transition to find a stratum of experience and a language deeper than the surface
differences of national literatures were in part an attempt to reconcile the cultural
conflict which had troubled him from his childhood.'[69] These attempts produced a
magazine informed by Jolas's valorization of the primitive, pre-rational modes of the
unconscious self, and it was this emphasis that helped to facilitate *transition*'s initial
associations with surrealism. 'Jolas', Matthew Josephson recalled, 'was going to
transcribe dreams into a new poetry.'[70] *Transition* was edited by Jolas until 1938,

[66] Ernest Hemingway, *A Moveable Feast* (London: Arrow Books, 1996), 182.
[67] Eugene Jolas, 'Suggestions for a New Magic', in Vassiliki Kolocotroni, Jane Goldman, and Olga
Taxidou (eds), *Modernism: An Anthology of Sources and Documents* (Edinburgh: Edinburgh University
Press, 1998), 312.
[68] Ibid.
[69] Dougald McMillan, *Transition: The History of a Literary Era, 1927–1938* (London: Calder & Boyars,
1975), 9.
[70] Matthew Josephson, *Life Among the Surrealists: A Memoir* (New York: Holt, 1962), 322.

but one of the magazine's most sizeable early achievements was the 'Revolution of the Word' proclamation, announced in 1929. Aligning *transition* with the visionary energies of William Blake, Jolas and an assortment of signatories declared themselves to be dissatisfied with 'the spectacle of short stories, novels, poems and plays still under the hegemony of the banal word, monotonous syntax, static psychology, [and] descriptive naturalism'.[71] They offered instead a hallucinatory, lyrical refashioning of language that found its high point in the magazine's serialization of Joyce's *Finnegans Wake* (1939), then simply known as 'Work in Progress'. *Transition* was strongly associated with Surrealism during its early years, publishing works by, among others, André Breton, Louis Aragon, Philippe Soupault, Robert Desnos, Paul Éluard, and Julien Gracq. That said, *transition* was not a Surrealist 'organ' in the way *Blast* was solely associated with Vorticism, for instance. It evolved over time into an aesthetically plural and multi-political magazine, a point missed by Lewis when he simplistically aligned *transition* with communism owing to Surrealism's eventual communist linkages.[72]

In addition to having plural aesthetic and political identities, *transition* functioned in part as an index of the broader sexual diversity of the Parisian scene during the inter-war years. In addition to Stein and Boyle, *transition* published work by Laura Riding, Caresse Crosby, Bryher (Annie Winifred Ellerman), Martha Foley, and Kitty Cannell. These were only some of the women artists living in Paris at this time. The Parisian Left Bank, for instance, acquired a peculiar significance through the lives and work of Stein, Jean Rhys, Anaïs Nin, and Djuna Barnes, all of whom discovered distinctively gendered and professional identities for themselves in Paris as women writers. Barnes in particular found in Paris a space in which sexual identity could be explored and redefined, resulting in the superlative *Ryder* (1928), *Ladies Almanack* (1928), and *Nightwood* (1936), all of which locate psychosexual becoming within the mental boundaries of Parisian metropolitanism. As Shari Benstock notes, Barnes was a significant figure within 'a community of serious women writers in Paris', and was considered by many 'to be the most important woman writer of the Paris community, her work generally thought to be second only to that of Joyce, with whom she shared certain literary methods'.[73] In addition to that community, which found one major focal point in the form of Sylvia Beach's bookshop on the rue de l'Odéon, Paris was the home of Picasso, André Kertész, and the Ballets Russes, all of which contributed to the transitional atmosphere of post-war Continental modernism at this time.

However, it should be emphasized that Paris, for all its brilliance, was but one cultural centre among many, and the views Cowley reports above need to be set against the opinions of others that saw early 1920s America not as an exhausted, de-culturalized space, but as a nation undergoing a cultural rebirth that was inseparable from industrial and capitalist expansion. Matthew Josephson wrote in the modernist

[71] 'Proclamation', in Kolocotroni et al. (eds), *Modernism*, 313.
[72] McMillan, *Transition*, 34–5.
[73] Shari Benstock, *Women of the Left Bank: Paris, 1900–1940* (London: Virago, 1987), 233.

annus mirabilis of 1922 that American life had become a panorama of effervescent change and development, 'where athletes play upon the frenetic passions of baseball crowds, and skyscrapers rise lyrically to the exotic rhythms of jazz bands which upon waking up we find to be nothing but the drilling of pneumatic hammers on steel girders'.[74] During and immediately after the First World War, America was a place for the excitations and novelties of avant-gardism, particularly in New York, where Dadaism and little magazines such as the photography and arts journal *291* and the journal *Dial* all flourished in an optimistic climate in stark contrast to the disillusioned atmosphere of wartime and post-war Europe. New York Dada matched, and has been suggested by some as having informed, European Dada's celebration of 'anti-art' artworks, abstractionism, provocation, irrationalism, and aggressiveness. Arguably New York Dada's most famous work, Duchamp's 'ready-made' *Fountain* (1917), an upside-down urinal inscribed with the signature 'R. Mutt', playfully and ironically presented an everyday object taken out of its ordinary context in order to accentuate the performative nature of aesthetics *qua* aesthetics, inviting the viewer to consider whether art objects acquire meaning not through an innate kernel of significance but through the mechanisms of response and perception. Dada in New York was chiefly the affair of Francis Picabia, Marcel Duchamp, and Alfred Stieglitz, although other figures such as Man Ray, Morton Schamberg, and Charles Scheeler (all of whom frequented the aesthetic salons of Walter and Louise Arensberg) played important roles as well. Like Natalie Barney's salons in Paris, in which French figures (such as André Gide and Jean Cocteau) mingled with international intellectuals (such as Carl Van Vechten, Ford, and Sherwood Anderson), the Arensbergs encouraged debate and networking between international traditions.[75]

New York itself was similarly a focal point of alternative reactions and impressions, and when Pound valorized London as the 'intellectual capital of America', his ironic view was but one extreme among many different attitudes towards a metropolitan culture that from the First World War to the mid-1930s underwent a spectacular renewal in the form of the Harlem Renaissance.[76] In addition to Dada and the Greenwich Village activities of the Mabel Dodge circle, New York at this time witnessed the emergence of a distinctly American modernism, with its unabashed individuality, worldwide financial importance, futuristic architecture, and rampant consumerism intertwined with a hastily developing cultural identity that enabled new forms of racial consciousness. The term 'Harlem Renaissance' was coined by the philosopher and aesthetician Alain Locke in his edited anthology of poems *The New Negro* (1925), which featured work by Langston Hughes, Zora Neale Hurston, and Countee Cullen. The New Negro Movement, as the Renaissance was alternatively called, represented an effort to redefine and defend African American racial identity

[74] Quoted in Walter Kalaidjian, 'Introduction', in Kalaidjian (ed.), *The Cambridge Companion to American Modernism* (Cambridge: Cambridge University Press, 2005), 4.

[75] For more on Barney, see Benstock, *Women of the Left Bank*, 88.

[76] Cited in Peter Brooker, '"Our London, My London, Your London": The Modernist Moment in the Metropolis', in Laura Marcus and Peter Nicholls (eds), *The Cambridge History of Twentieth-Century English Literature* (Cambridge: Cambridge University Press, 2004), 118.

and community by means of a syncretic appraisal of black–white sociocultural interactions and exploitations.[77] The Renaissance produced key explorations of ontology and sexual experience in the guise of Rudolph Fisher's *The Conjure Man Dies* (1932) and Nella Larsen's *Quicksand* (1928) and *Passing* (1929), as well as formally complex textualities like Jean Toomer's *Cane* (1923) and the literatures of Jessie Fauset and Zora Neale Hurston. All of these works match the difficulties and diversities of the Anglo-American and European modernisms, in spite of massive differences in culture and climate. Indeed, one of the best signs of the complex significance of the Harlem Renaissance is its philosophical emphases. In the words of Leonard Harris, such emphases revealed the extent to which 'universal issues were addressed' by the Renaissance, 'and addressed with deep appreciation for the complexities of possible answers'.[78]

Locke is a key figure here. His philosophical pragmatism, shaped by studies with Josiah Royce and William James at Harvard, led him to advance claims that 'value' and 'reality' were, from top to bottom, entwined, and it was through such a concern with the value-laden nature of 'factual' reality that the campaign work upon which a significant portion of the Harlem Renaissance's activity was based came into being.

Epistemological claims such as Locke's contention that 'Values are not to be regarded as gratuitous additions to reality, made out of the superfluity of human perversity, but as its highest qualities and the culminating points of its significance for us' trickled down into rejections of ethnic paternalism and supremacy and the sociocultural hegemony of 'white' forms of aesthetics.[79] The Harlem Renaissance was a form of cultural nationalism articulated by black Americans in order to celebrate both their ethnic identity and diversity, as well as their belonging to the larger community of modern America itself. To quote Mark A. Sanders, the Renaissance 'witnessed the first African-American cultural expression of modernity'.[80] Indeed, in this sense the Renaissance leads us back to one of our starting points (with the nature of community as potentially a form of utopia), for it is arguable that the New Negro Movement, as its names and activities make clear, was geared towards a remodelling of modern realities in such a way as to better the social and cultural plight of African Americans in early twentieth-century America. If in some of its manifestations such an effort leaned towards eugenic aspirations, it may reasonably be suggested that the initial 'spirit' of the Harlem Renaissance was one rooted in an urge to change the conditions of black oppression rather than in the totalizing politics of fascism or

[77] See Laura Doyle, Ch. 14 above, and for more on this context, Adam McKible, *The Space and Place of Modernism: The Russian Revolution, Little Magazines and New York* (London: Routledge, 2002).

[78] Leonard Harris, 'The Harlem Renaissance and Philosophy', in Tommy L. Lott and John P. Pittman (eds), *A Companion to African-American Philosophy* (Oxford: Blackwell, 2006), 384.

[79] Alain LeRoy Locke, *The Philosophy of Alain Locke: Harlem Renaissance and Beyond*, ed. Leonard Harris (Philadelphia: Temple University Press, 1989), 126.

[80] Mark A. Sanders, 'American Modernism and the New Negro Renaissance', in Kalaidjian (ed.), *The Cambridge Companion to American Modernism*, 137.

revolutionary communism, even if that spirit, as some have argued, was ultimately contained by outside forces beyond its influence.[81]

A crucial part of the Renaissance's modernism lay precisely in this challenge to white authority, but another and no less significant element of that modernism lay in what Houston Baker has called a 'mastery of form' that necessitated 'the deformation of mastery', a resistance that meant 'If the younger generation was to proffer "artistic" gifts, such gifts had first to be recognizable as "artistic" by Western, formal standards, and not simply as unadorned or primitive *folk* creations.'[82] That said, as with the kinds of modernism discussed above, it is important not to reduce the Renaissance to a cohesive whole that its artistic products and intellectual traditions and trajectories will not support. A 'total' view of the Renaissance would need to include artists and thinkers as diverse as Jean Toomer, Langston Hughes, Walter White, Jessie Fauset, Nella Larsen, W. E. B. DuBois, Rudolph Fisher, Claude McKay, Wallace Thurman, Eric Walrond, and George Schuyler. It would need to include a view of a modernism articulated through the little magazine culture of productions such as the *Messenger, Crisis, Opportunity,* and *Negro World* periodicals. Like the Anglo-American tradition against which Harlem's Renaissance can be considered a revolt, New Negro modernism was multiple and internally fissured. Toomer's claim that he passed easily between racial groups 'with no loss of [his] own identity and integrity' may well serve as an intriguing entry point for any consideration of a literary-historical and political context that comprised many points of intersection and juncture between cultural and racial societies, and during a moment in which black identity was celebrated, discussed, and redefined.[83]

It is claims like Toomer's that make T. S. Eliot's view that groups 'are easier to find, easier to talk about, and their multiplied activity is more inspiring to watch than the silent struggles of a single man' problematic in the extreme.[84] As even this brief survey of modernist coteries and communities ought to have indicated, the opposition between group identity and individual effort put forward by Eliot here is continually torn down, reshaped, reconstructed, assailed, and challenged during the modernist period I have covered, and it is misleading to try to force any modernist group or individual from this time into too neatly fabricated a pigeonhole, however tempting it may be to do so. That said, imaginary (or, alternatively, *convenient*) constructions such as those bestowed upon the history of literary modernism by handy signifiers like 'group', 'band', 'coterie', and 'ism' do enable us to chart that history in legible ways, and thus to do away with them altogether not only would be premature but also would falsify the senses in which those terms historically

[81] For a discussion of eugenics and modernism in America, see Daylanne K. English, *Unnatural Selections: Eugenics in American Modernism and the Harlem Renaissance* (Chapel Hill: University of North Carolina Press, 2004).

[82] Houston Baker, *Modernism and the Harlem Renaissance* (Chicago: University of Chicago Press, 1989), 86.

[83] Jean Toomer, 'The Crock of Problems', in *Selected Essays and Literary Criticism,* ed. Robert B. Jones (Knoxville: University of Tennessee Press, 1996), 56.

[84] Eliot, 'The Post-Georgians', *Athenaeum,* 4641 (11 Apr. 1919), 171.

signify. We might, then, take a collective stance against Frederick Tarr, the eponymous anti-hero of Lewis's 1918 novel *Tarr*, who suggests that 'Co-operation, group-genius was, he was convinced, a slavish pretence and absurdity.'[85] Far from representing anything *simply* unoriginal, make-believe, or bizarre, the dialectic between modernist coterie and community sketched out above reveals a multifarious, cross-generational, transcontinental, and genuinely nebular cultural history. In its refusal to stay in one place or time, and in its commemorations of the small and the fragmentary along with the total and the all-encompassing, modernism challenges us to make sense of its seeming wholeness, its actual small forms, clique-like objectives, and collective dreams.

[85] Wyndham Lewis, *Tarr: The 1918 Version*, ed. Paul O'Keeffe (Santa Rosa, Calif.: Black Sparrow Press, 1996), 313.

NATIONAL AND TRANSNATIONAL MODERNISMS

CHAPTER 42

SCOTTISH MODERNISM

MARGERY PALMER MCCULLOCH

THIS chapter is about the cultural revival which took place in Scotland in the years after the end of the First World War. Initiated by C. M. Grieve (the poet Hugh MacDiarmid), it was primarily a literary movement, although there were individual visual artists and musicians who interacted with it. Popularly known in its own time as the 'Scottish Renaissance', the creative work of its principal writers is increasingly being recognized today as a Scottish manifestation of literary modernism.

There had been a previous visual art relationship with modernism in Scotland in the early years of the century when architect Charles Rennie Mackintosh and painters and designers such as Frances and Margaret Macdonald and Herbert MacNair exhibited at the Vienna Secession exhibitions. The artists who became known as the 'Scottish Colourists'—J. D. Fergusson, S. J. Peploe, F. C. B. Cadell, and Leslie Hunter—travelled and painted in the South of France, where their work was influenced by the new French Post-Impressionist painting as well as by the southern light. Fergusson, who was influenced by the Fauves, worked in France for many years, setting up an atelier in Paris and living for periods in the south, and between 1914 and 1916 was also art editor of J. Middleton Murry's London-based magazine *Rhythm*, which reported on French artistic developments. From 1904 onwards, the Glasgow dealer Alexander Reid, whose portrait was painted by Van Gogh, brought French Impressionist paintings to his gallery in West George Street, La Société des Beaux-Arts. Unfortunately this visual art connection with modernism did not survive the war: public taste and patronage as well as economic circumstances changed, Reid's Glasgow gallery eventually closed, painters went their individual ways, mostly out of Scotland. Significantly, there had been no ideological group or national agenda

behind this visual art flowering which might have enabled it to regenerate itself in the changed circumstances of the inter-war years.

Grieve MacDiarmid, 'Little Magazines', and the Challenge to Traditions

The situation was very different in relation to the writers who responded to Grieve MacDiarmid's call for supporters in the early 1920s. What made this post-First World War literary revival movement unique among Scottish cultural movements was the belief of those involved that any regeneration in the nation's aesthetic culture could not be separated from revival in the nation's wider social, economic, and political life. In the specific Scottish historical context, this meant that unlike the earlier visual arts modernism and unlike the turn-of-the-century 'Renascence' associated with Patrick Geddes and the Celtic revival movement, the inter-war Scottish Renaissance was a movement whose aim was to remove Scotland from the provincial North British status it had acquired as a result of the political union between Scotland and England and to recover a distinctive and modern cultural identity as well as, in the longer term, political self-determination. The campaign to transform existing outworn cultural traditions and 'make things new' to meet the challenges of a changed modern world was therefore from its outset related to political conflicts and commitments. In this Scottish manifestation of modernism the aesthetic, and in particular the aesthetic in literature, was also the political. While this may appear to be at far remove from what has in the past been the canonical view of modernism, increasingly, as research has shifted attention from what Wyndham Lewis called the 'Men of 1914' to manifestations of modernism across continents as well as nations, this political dimension in Scottish modernism can be seen to have its counterparts elsewhere: in the Irish Revival associated with Yeats and the Abbey Theatre; in Russian visual art modernism in the heady early days of the revolution when artists took their art out into the streets and the countryside in the belief that they had a part to play in building a new society; in the post-1917 experience of Harlem Renaissance activists in America who used their artistic skills to create a movement for a black national identity and political self-determination; and in the several short-lived political and avant-garde aesthetic movements of the early decades of the century documented in a variety of equally short-lived little magazines in Europe and other parts of the world.

Little magazines, in fact, acted as the midwife for modernist movements generally, both from metropolitan centres and the peripheries; and it was through the medium of little magazines that Grieve MacDiarmid initiated the Scottish revival movement in the immediate post-1918 years. His letters from Salonika and Marseilles during the

war make it clear that he was himself aware of artistic developments in continental Europe and London, including the little magazines with which Ezra Pound was involved and Wyndham Lewis's founding of *Blast* partly in response to the success of Marinetti's Futurist manifestos and campaigns. His own first post-war venture was a series of new poetry anthologies, *Northern Numbers*, the first two volumes published in 1920 and 1921 by Foulis in Edinburgh; the third, and most adventurous, published by himself in 1922 from the small east-coast town of Montrose when Foulis went out of business. Although the series could hardly be described as 'modernistic', being an amalgam of the traditional and the sometimes awkwardly experimental, it established Grieve's name as editor and in the existing depressed Scottish poetry context caused sufficient stir for newspaper reviewers to query whether a 'renaissance' might be taking place.[1]

Of more significance was his founding of the *Scottish Chapbook* (again edited and published by himself from Montrose) in August 1922, that remarkable year of Joyce's *Ulysses*, Eliot's *The Waste Land*, and the launching of *The Criterion* under Eliot's editorship. In identity, the *Chapbook* was probably closer to the idea of a little magazine—impecunious, impetuous, and short-lived—than was Eliot's more sober and more solidly founded *Criterion*. Its red cover, lion rampant cover image, and provocative motto, 'Not Traditions—Precedents', deliberately heralded its revolutionary self-image. Its aims included the encouragement and publication of 'the work of contemporary Scottish poets and dramatists, whether in English, Gaelic or Braid Scots'; 'to "meddle with the thistle" and to pick the figs'; and, importantly, 'to bring Scottish Literature into closer touch with current European tendencies in technique and ideation'.[2] All of these aims were potentially subversive in the context of a Scotland which had lost its languages and independent identity and had become 'North Britain'; and while fiction is notably absent from its programme (its editor holding firm to the traditional belief that poetry was *the* literary art form), the intention to encourage writing in all three of Scotland's indigenous languages demonstrates that, even if those involved had not yet had the opportunity to read Bakhtin, they were already well attuned to Scotland's polyphonic language situation and concerned to keep this as part of a revitalized identity. The European dimension of the *Chapbook* manifesto is particularly significant because it makes clear that from the outset the movement's agenda was an international and non-parochial one.

In addition to his interest in the avant-garde activities of *Blast* and European writers, MacDiarmid—and I think that for convenience he should be called MacDiarmid from now on—had been much influenced by Orage's *New Age*, which provided a kind of proto-Open University education for autodidacts such as himself and his fellow Scottish modernist Edwin Muir. Both were introduced through Orage's magazine not only to current European affairs but also to nineteenth-century

[1] See e.g. W.J. [William Jeffrey], 'Is a Renaissance Taking Place?', *Glasgow Bulletin* (17 Jan. 1921), 6.

[2] 'The Chapbook Programme', printed in the first issue of August 1922 and subsequent issues; repr. in Margery Palmer McCulloch (ed.), *Modernism and Nationalism: Literature and Society in Scotland, 1918–1939* (Glasgow: Association for Scottish Literary Studies, 2004), p. xii.

philosophers and writers influential in the modernist period such as Nietzsche and Dostoevsky. For Muir, Dostoevsky was 'a great psychologist' who 'depicted the subconscious as conscious',[3] while the Russian writer and the affinity MacDiarmid felt with him became translated into the important 'Letter to Dostoevski' section of his long poem *A Drunk Man Looks at the Thistle*. Nietzsche was similarly a significant presence both in *A Drunk Man* and in the *Scottish Chapbook*, where the editor's Causerie proclaimed that 'the slogan of a Scottish literary revival must be the Nietzschean "Become what you are"'.[4] For Muir, on the other hand, Nietzsche's influence was short-lived, providing a temporary philosophy in his struggle to overcome the personal trauma of emigration from pre-industrial Orkney to indus-trialized Glasgow in the early years of the century. Muir had eventually 'climbed out of these years'[5] and had himself become a regular contributor to the *New Age* when his first book, *We Moderns*, was published in 1918. Its success in America led to a contract with the *Freeman* magazine, which enabled him to travel with his wife, Willa, in Europe, so acquiring the knowledge of the German language which led to their later important translations of fiction by Franz Kafka and Hermann Broch. MacDiarmid had been introduced to the *New Age* as a schoolboy in Edinburgh and had a youthful contribution published in the magazine in 1911, although he did not become a regular contributor until the mid-1920s. Nevertheless, Orage's internation-alism and his belief in the expansion of human consciousness fitted well with MacDiarmid's own post-war intellectual and artistic agenda. His new Scottish magazines were therefore influenced by the format of the *New Age* as well as by his ambition to imitate 'the way the Dadaists go about the business' and provide what he called in his initial *Chapbook* editorial 'phenomena recognizable as a propaganda of ideas', the kind of 'significant little periodicals—crude, absurd, enthusiastic, vital'—which were lacking in Scotland.[6]

As things turned out, however, it was his second magazine, the *Scottish Nation*, that was most influenced by the format of the *New Age*, for the *Scottish Chapbook* became the platform for a controversy over whether the Scots language could be revived as a modern literary language. It is therefore for the editor's arguments leading up to and including the series 'A Theory of Scots Letters' in the spring of 1923, together with the appearance of the new, and modernist, Scots-language poet 'Hugh M'Diarmid' in its third issue of October 1922, that this first Scottish modernist little magazine is chiefly significant.

The *Scottish Chapbook* had been launched in the context of a dispute about the viability of Scots as a language for modern literary purposes in that its editor had been conducting an acrimonious correspondence in the pages of the *Aberdeen Free*

[3] Edward Moore [Edwin Muir], *We Moderns: Enigmas and Guesses* (London: George Allen & Unwin, 1918), 148, 147.

[4] C. M. Grieve, 'A Theory of Scots Letters', *Scottish Chapbook*, 1/8 (Mar. 1923), 214.

[5] Edwin Muir, *An Autobiography* (London: Hogarth Press, 1954), 110.

[6] C. M. Grieve, *Scottish Chapbook*, 1/1 (Aug. 1922), 4–5; repr. in *Hugh MacDiarmid: Selected Prose*, ed. Alan Riach (Manchester: Carcanet, 1992), 7.

Press since December of the previous year on the subject of the Burns Club of London's attempt to encourage a revival of Scots through speaking and essay-writing competitions in schools. While on the surface this might seem to fit with the *Scottish Chapbook*'s manifesto aim of encouraging the publication of writing in English, Scots, and Gaelic, it did not fit with MacDiarmid's ambition to initiate a modern Scottish literature in which he himself could be a leading modern writer. By the early twentieth century the Scots language had declined to a point at which it was no longer considered a medium suitable for ambitious writing or for formal communication of any kind. While, therefore, he might wish to halt the decline of Scotland's neglected languages, MacDiarmid envisaged that any new Scottish literature would at the present time of necessity be written in English; but an English, he insisted, that would be 'no more English in spirit than the literature of the Irish Literary Revival, most of which was written in the English language, was English in spirit'.[7] He therefore attacked the London Burns Club for what he saw as its interference and insisted that 'any attempt to create a Doric [i.e. Scots language] "boom" just now ... would be a gross disservice to Scottish life and letters'.[8]

What eventually brought about MacDiarmid's change of mind is uncertain, although by the time the *Scottish Chapbook* was launched in August 1922 his tone towards Scots had mellowed and the new Scots-language poet 'M'Diarmid' was an early and sophisticated contributor to its third issue, which hints at some previous serious experimentation with the language. MacDiarmid's biographer Alan Bold has suggested that he may have obtained an early copy of James Joyce's *Ulysses* when it was published by Sylvia Beach in Paris in February 1922 and that his excitement at Joyce's linguistic experimentation encouraged his own.[9] Whatever the background to his apparent conversion, however, what is noticeable in these early self-arguments about the viability of Scots is the frequency of his use of the word 'modern' or an expression that points to the modern: 'A modern consciousness cannot fully express itself in the Doric as it exists' is one early claim; then later: 'Whatever the potentialities of the Doric may be ... there cannot be a revival in the real sense of the word ... unless these potentialities are in accord with the newest tendencies of human thought.' What he does not want is some 'museum department of our consciousness', and he adds: 'The rooms of thought are choc-a-bloc with far too much dingy old rubbish as it is.' When, in March 1923, he has convinced himself that a modern literature in the Scots language is possible, his argument ends in a rhetorical flourish as he proclaims that 'the Scots Vernacular is a vast storehouse of just the very peculiar and subtle effects which modern European literature in general is assiduously seeking ... It is an inchoate Marcel Proust—a Dostoevskian debris of

[7] C. M. Grieve, 'Scottish Books and Bookmen', *Dunfermline Press* (5 Aug. 1922), 6; repr. in McCulloch (ed.), *Modernism and Nationalism*, 23.

[8] C. M. Grieve, *Aberdeen Free Press*, 30 Jan. 1922; repr. in *The Letters of Hugh MacDiarmid*, ed. Alan Bold (Athens, Ga.: University of Georgia Press, 1984), 755.

[9] Alan Bold, *MacDiarmid: Christopher Murray Grieve: A Critical Biography* (London: John Murray, 1988), 130.

ideas—an inexhaustible quarry of subtle and significant sound.'[10] From this point onwards, at least from MacDiarmid's perspective, the Scots language not only was something to be encouraged along with the Gaelic, but was to be the cornerstone of a modern literary revival, and at the same time a marker of a revitalized Scottish identity distinct from English; it had become the signifier of both the aesthetic and the political objectives of the revival movement and the symbol of his vision of a new Scotland.

MacDiarmid's second little magazine, the *Scottish Nation*, was a weekly publication which attempted to follow the international and broad cultural format of the *New Age*. It included articles on contemporary art, music, religion, and ethics, as well as specifically Scottish material on Gaelic affairs and the Irish in Scotland. It also reviewed European poetry in translation such as Deutsch and Yarmolinsky's *Modern Russian Poetry and Contemporary German Poetry*, collections which influenced Mac-Diarmid in his adaptations of European poets in *A Drunk Man Looks at the Thistle*. Without greater financial resources and a stronger contributor and readership base, however, such an ambitious project could not be long-lasting. The *New Age* itself did not make a profit, and although he had hoped for financial support from the Scottish nationalist and businessman R. H. Muirhead, MacDiarmid's *Scottish Nation* was again edited by himself from Montrose and funded by his own journalistic activities and the goodwill of his contributors—many of the most stimulating of these being the versatile editor himself wearing various pseudonymous disguises. The weekly *Scottish Nation* ran in parallel with the monthly *Scottish Chapbook* until December 1923, when both ceased publication. They were followed by a return to monthly publication with the *Northern Review*, which had the support of an assistant editor and a London agent, but was again without external funding. It ran for four issues only from May to September 1924.

Although MacDiarmid's little magazines were so short-lived, their impact had a longer duration. By the mid-1920s, the principal Scottish newspapers regularly contained articles and letters on the new developments in Scottish cultural life and the terminology 'Scottish Renaissance' was in common use in such discussions. In May 1925 the *Scottish Educational Journal* commissioned MacDiarmid to write a series of articles on Scottish literary figures, which resulted in much controversy and vituperation in the normally conservative journal's pages, but at the same time further increased awareness of the new movement and its iconoclastic agenda. Significantly, other periodicals were founded, not specifically literary or intended as avant-garde, but all committed to the idea of regeneration across Scottish life: social, economic, and political as well as aesthetic. The 'condition of Scotland' became a major theme in periodical and other forms of publication emanating both from Scotland and from the London media, as exemplified by the editorial policy announced by *The Spectator* in October 1933 of regular coverage of Scottish affairs because 'developments are in progress in Scotland that are far too little

[10] C. M. Grieve, *Scottish Chapbook*, 1/3 (Oct. 1922), 62; 1/7 (Feb. 1923), 182; 1/8 (Mar. 1923), 210; repr. in McCulloch (ed.), *Modernism and Nationalism*, 24, 26, 28.

understood or discussed outside Scotland... The cultivation of Gaelic and the conscious development of a modern Scottish literature are movements demanding not only observation but discussion.'[11] An important periodical development in the 1930s in relation to the arts was the founding in 1930 of the *Modern Scot*, a small magazine owned and edited from St Andrews by a wealthy young American, James Whyte, which took over the avant-garde Scottish and cosmopolitan role of Mac-Diarmid's little magazines of the early 1920s.

Creative Writing in the 1920s

Aesthetically, the most significant outcome in the 1920s of the campaign to create a modern, distinctive Scottish literature was the Scots-language poetry published in MacDiarmid's two collections of short lyrics *Sangschaw* (1925) and *Penny Wheep* (1926) and his long dramatic monologue *A Drunk Man Looks at the Thistle* (1926). MacDiarmid had been attracted to European poetry at an early stage of his life, having been introduced to Rilke in 1909 through the translations of Jethro Bithell. Later he became familiar with the Symbolist poetry of Alexander Blok, Stéphane Mallarmé, and his younger disciple Paul Valéry, while at the same time he was following with interest the development of Pound's Imagism. In his Scots-language poetry of the early 1920s, this series of eclectic, cosmopolitan influences interacted with indigenous Scottish influences, in particular with the ballad tradition whose narrative form shares some of the impersonality and enigmatic, elliptical communication of modernist poetry. The result was a poetry unique in the Scottish context yet with an identity quite distinct from its Imagist and Symbolist mentors. MacDiarmid was particularly fond of Mallarmé's prescription: 'Ce n'est pas avec des idées qu'on fait des vers, c'est avec des mots'—a quotation he was to use in his *New Age* essay on Valéry in 1927 and a poetic principle which might seem on the surface similar to his own insistence in the *Penny Wheep* poem 'Gairmscoile' ('School for Poets') that '*It's soon', no' sense, that faddoms the herts o' men.*'[12] Yet here, as so often in his creative and ideological pronouncements, one senses that MacDiarmid the poet is seizing on an idea that stimulates his imagination, then transforming it into something quite different to fit his own objectives. For there is an impersonality in Mallarmé's symbolism that is essentially different from the ballad-like anonymous voice of the

[11] *The Spectator* (6 Oct. 1933), 434.
[12] Hugh MacDiarmid, 'Paul Valéry', *New Age* (1 Dec. 1927), 54, repr. in *Selected Essays of Hugh MacDiarmid*, ed. Duncan Glen (London: Cape, 1969), 49–52; Hugh MacDiarmid, 'Gairmscoile', in *Complete Poems 1920–1976*, ed. Michael Grieve and W. R. Aitken (London: Martin Brian & O'Keeffe, 1978), i. 74.

speaker in MacDiarmid's lyrics, where what Valéry called 'la voix humaine'[13] is still very much in evidence. In addition, the emphasis on language, 'des mots', in both Mallarmé and Valéry does not include MacDiarmid's equally insistent emphasis on the *sound* of his chosen words. While their poetry is very much a poetry for the eyes, orality, and especially the evocative communicative quality in the sound of words, is an indispensable element in MacDiarmid. And although he learned from Pound how to present a clear image as in painting, the implications within his imagery almost always interact with other poetic features in order to create an (implicit) ideas context.

Such features can be seen, for example, in a poem such as 'The Eemis Stane' which opens with the clear (if phenomenologically ambiguous) image of the earth, like an unsteady stone, wobbling in the sky, watched by a speaker who is grounded in a mundane harvest field in the depths of the night:

> I' the how-dumb-deid o' the cauld hairst nicht
> The warl' like an eemis stane
> Wags i' the lift.[14]

Our human sense of reality as well as gravity is destabilized by this opening, and the uncertainty is deepened by the obscurity yet evocative quality of the sound of subsequent phrases such as 'my eerie memories fa' | Like a yowdendrift'. A 'yowdendrift' is a soft but heavy and obliterating fall of snow, and the repetition of this phrase with its falling rhythmic movement effects a transition to the second stanza of the poem, where the image of the unsteady stone in the sky is transformed into that of a gravestone, equally unsteady philosophically, since the writing on it is hidden by 'history's hazelraw' (the lichen of history). This is a poem which speaks powerfully of the philosophical instability felt in the early years of the century, and especially in the aftermath of the First World War, when there seemed no longer to be a reliable past on which a future might be built, either personally or in the wider social and political context. Yet this ideas context is not communicated overtly, but brought to us implicitly, equivocally, through the allusive potential in the poem's sounds and images. This provocative coming together of sound, image, and implicit 'sense' is the hallmark of these tiny but philosophically far-reaching lyrics. MacDiarmid, however, is a poet for whom ideas are an important part of his poetic practice, and by the end of the *Penny Wheep* collection there is a sense of the tight imagistic form of the modernist lyric being no longer capable of allowing him to develop his ideas satisfactorily. His answer to this dilemma was the long dramatic poem *A Drunk Man Looks at the Thistle*.

A Drunk Man Looks at the Thistle is manifestly a poem of the modernist period with its eclecticism and intertextual references, its shifting symbolism and modified

[13] Paul Valéry, 'Littérature', *Tel Quel*; quoted in Clive Scott, 'Symbolism, Decadence and Impressionism', in Malcolm Bradbury and James McFarlane (eds), *Modernism: A Guide to European Literature, 1890–1930* (Harmondsworth: Penguin, 1976), 207.

[14] MacDiarmid, *Complete Poems*, i. 27.

Joycean stream of consciousness, and the logic of the imagination which directs its course. The adoption of the Drunk Man persona or mask allows the author to create a characterization which is not only personally divorced from himself, but which already has within it a traditional licence to depart from what is considered 'normal' behaviour: to be inconsistent in mood and opinions, to talk 'non-sense', or in contrast a 'sense' released through drink: 'There's nocht sae sober as a man blin' drunk.'[15] The changing moods produced by drink also give validity to the use of surrealistic imagery and the unexpected juxtapositioning of extremes of language and idea.

While *A Drunk Man* is to some extent a poem about the condition of Scotland—'a scene | O' Scottish life A.D. one-nine-two-five'[16]—it is in the wider context a philosophical exploration about the nature and condition of human existence itself: an exploration which includes an investigation of artistic creativity and human sexuality and the relationship between them; the loss of religious belief and that destabilization of human identity captured imagistically in the earlier 'Eemis Stane' lyric. In addition to the persona of the Drunk Man, the poem proceeds through a number of shifting symbols such as whisky and moonlight, each of which can delude as well as inspire; and the female symbol of woman in the mystical persona of Blok's 'Beautiful Lady' and her mundane counterpart, the Drunk Man's wife, Jean, his earthly inspiration and (as in Burns's 'Tam o' Shanter') his scold.[17] The interpretation of the thistle with its jaggy leaves and unexpectedly beautiful soft purple flowers is constantly in flux: at times symbolizing the Drunk Man himself, this 'mongrel o' the fire and clay'[18] with his aspirations confounded by the negative elements in his nature; at other times his country, sometimes the human condition per se.

The interpolation of adaptations of European poems is part of this metaphorical context. Blok's 'The Lady Unknown', transformed into MacDiarmid's inspirational 'Silken Leddy' with her association with the ballads, is counterpointed by his 'The Unknown Woman' (called by MacDiarmid 'The Unknown Goddess'), whose 'face unkent' fills the speaker with terror as he contemplates his 'deid dreams'.[19] MacDiarmid's medieval predecessor Gavin Douglas, who translated Virgil's *Aeneid* into Scots, advised that in translation the aim should be to 'traste weill to follow a fixt sentens or mater' as opposed to writing 'all ways at liberte'.[20] Walter Benjamin, on the other hand, rejected a mimetic approach as deriving from a 'falsely static view of

[15] Ibid. 91. [16] Ibid. 92.

[17] The most helpful edition of *A Drunk Man Looks at the Thistle* is that edited by Kenneth Buthlay (Edinburgh: Scottish Academic Press for ASLS, 1987; repr. Polygon, 2008). This gives the Deutsch and Yarmolinsky translations of Blok used by MacDiarmid in his adaptations, as well as full discussions of the symbolism of the poem.

[18] Ibid. 126. [19] Ibid. 90.

[20] Gavin Douglas, *Virgil's Aeneid*, book 1, in *Selections from Gavin Douglas*, introd., notes, and glossary by David F. C. Coldwell (Oxford: Clarendon Press, 1964), 8.

language',[21] and 'writing at liberty' was certainly the process adopted by Pound, as well as by MacDiarmid, who succeeds in 'The Silken Leddy' passage in creating a poem very different in identity from its original source, but one which enriches and expands the Scots-language tradition: a poem which seems to belong with the eighteenth-century tradition of Fergusson and Burns, yet at the same time belongs also to the modernist world of *A Drunk Man*.

Another of the poem's outstanding features is its non-traditional use of natural world imagery. Sea imagery, surrealistic in its visual and tactile effects, points up the movement from artistic creativity to its loss:

> My harns [brains] are seaweed—when the tide is in
> They swall like blethers and in comfort float,
> But when the tide is oot they lie like gealed
> And runkled auld bluid-vessels in a knot!

Scotland's lost language and lost identity are called up in the image of the east-coast haar:

> Obliteratin' as the Easter rouk
> That rows up frae the howes and droons the heichs,
> And turns the country to a faceless spook.[22]

One of the most philosophically despairing passages is the 'Farewell to Dostoevski' section, where the Russian and the Drunk Man speaker wander in a world that has lost all meaning and in which they cannot even communicate with each other: '*I ken nae Russian and you ken nae Scots.*' As in 'The Eemis Stane', a principal image here is the snow, '*the cavaburd* [heavy snow fall] *in which Earth's tint* [lost]', a snow that '*is seekin' everywhere: oor herts | At last like roofless ingles it has f'und*'.[23] Despite its many humorous and satirical sections, and the questing nature of its main character, who continues to search for understanding in the face of many setbacks, *A Drunk Man* is a disturbing exploration of human thought and experience in an age of uncertainties: an open-ended journey appositely characterized by the novelist Neil M. Gunn as 'the terrible sobriety of *A Drunk Man*'.[24]

While MacDiarmid's poetry may have made the outstanding contribution to modernist writing in Scotland in the 1920s, the attempt to transform traditions, even if in varying degrees of formal experimentation, was characteristic of the decade. The Porpoise Press, established by two Edinburgh University students in 1922, provided a publication outlet for poetry to complement that of MacDiarmid's magazines. In English-language writing, Edwin Muir's *First Poems* were published by

[21] Walter Benjamin, 'The Task of the Translator', in Walter Benjamin, *Illuminations*, ed. Hannah Arendt, trans. Harry Zohn (New York: Schocken Books, 1969), 80.

[22] MacDiarmid, *Complete Poems*, i. 95, 107.

[23] Ibid. 151–2.

[24] Neil M. Gunn, quoted in Hugh MacDiarmid, 'Neil Gunn and the Scottish Renaissance', in Alexander Scott and Douglas Gifford (eds), *Neil M. Gunn: The Man and the Writer* (Edinburgh: Blackwood, 1973), 361.

the Hogarth Press in 1925. Muir's reputation at this point was as a critic of what MacDiarmid called '*welt-literatur*'[25] and he was also becoming increasingly known, with his wife, Willa, as a translator of German literature. However, the mature poetry that established his reputation as a significant poet of the modernist period did not come until after the outbreak of the Second World War.

Neil M. Gunn also began writing seriously in the early 1920s, with several of his short stories being published in MacDiarmid's magazines. 'Down to the Sea', published in the *Scottish Nation* in 1923, is one of his finest and captures in its brief form the essence of his reimagining of the history of the Highlands in his later fiction of the 1930s and early 1940s. Gunn commented in a 1960s article that he remembered reading the magazine *transition* in the Highlands when James Joyce's 'Work in Progress' was appearing in its pages, and his own historical reimagining was carried out in this context of awareness of the modern. Formally, his *Highland River* (1937) with its anachronistic bringing together of childhood and adulthood, is his most modernistic and Proustian novel, but, as a whole, his most successful explorations and recreations of Highland life reject the romanticizing model of Scott and seek to find a way to bring the Highland past into the present and future through his awareness of contemporary anthropological and psychological writing.

Another new development, arising in the 1920s and continuing into the 1930s, was the increase in professional female fiction writers. The significance of this phenomenon was not fully recognized in its own time, but with the coming of feminist criticism later in the century, it has resulted in a rewriting of the historical literary canon generally, and, in relation to modernism, a questioning and redirecting of earlier characterizations of modernist work. Virginia Woolf, for example, argued the need to bring 'women's values'[26] into literature, in relation to both theme and form, and her concerns were paralleled in Scottish writing, where women writers explored self-determination in the female context as opposed to the national. Catherine Carswell, friend and correspondent of D. H. Lawrence and author of the award-winning *Open the Door!* (1920) and its successor *The Camomile* (1922), thought that women should not strive 'to *force* ourselves to deal first through the intellect . . . not sufficiently trusting ourselves to the truths that would come to us through the deeper sensual and emotional channels';[27] while Willa Muir explored the difference in creativity between men and women in her 'Women: An Inquiry', published in the Hogarth Essays series in 1925, followed by two strong female-centred novels, *Imagined Corners* (1931) and *Mrs Ritchie* (1933). Other new novelists included Nan Shepherd, who brought a revitalized north-east Scots language into her fiction as well as issues of female self-determination; and Lorna Moon, a Hollywood scriptwriter, originally from north-east Strichen, who anticipated Lewis Grassic Gibbon in

[25] C. M. Grieve, 'Edwin Muir', in *Contemporary Scottish Studies* (London: Leonard Parsons, 1926), 108.

[26] Virginia Woolf, *Women and Writing*, introd. Michèle Barrett (London: Women's Press, 1979), 49.

[27] Catherine Carswell, letter to F. Marian McNeill, 30 Apr. 1928, in *Lying Awake: An Unfinished Autobiography and Other Posthumous Papers*, ed. John Carswell (1950; Edinburgh: Canongate Classics, 1997), 200.

her experimentation with dialect. In contrast, Dot Allan tackled issues of social class as well as gender in novels such as *Makeshift* (1928) and *Hunger March* (1934), while Nancy Brysson Morrison's *The Gowk Storm* (1933) answered Virginia Woolf's call for poetry in fiction. Most of these women were well educated and sophisticated in their interests, and in addition to their new focus on 'women's values', they brought a modern interplay of human relationships into a Scottish fiction that, almost from its beginning, had been dominated by historical, religious, national, and philosophical themes. Although none was as experimental in narrative form as, say, Woolf in *Mrs Dalloway* or the short fiction 'Kew Gardens', all in their various ways devised fresh forms of narrative in which to communicate their new themes and insights.

LITERATURE AND POLITICS IN THE 1930S

Although the political was from the outset part of the Scottish modernist agenda, in the 1930s this ideological dimension became more overt in creative as well as polemical writing. Nationalism continued to be important, with the National Party of Scotland founded in 1928 and merging with the Scottish Party to form the Scottish National Party in 1934. There was increasing involvement with the idea of Scotland's Celtic identity, as seen in MacDiarmid's *To Circumjack Cencrastus* (1930) and his essays 'English Ascendancy in British Literature' and 'The Caledonian Antisyzygy and the Gaelic Idea' (both published in 1931); and seen also in growing concerns about the impoverished condition of the Highlands and the decline of Gaelic, subjects debated in the periodical press and explored imaginatively in the fiction of Gunn. Increasingly, however, as economic conditions worsened and fascism in Europe threatened, socialism and its more extreme form, Marxism, became a dominant political and literary influence.

The outstanding example in the 1930s of this coming together of the literary and the political in Scottish modernism is Lewis Grassic Gibbon's trilogy *A Scots Quair*, which exploded without warning onto the literary revival stage in September 1932 with its first novel, *Sunset Song*. In a discussion of the proletarian novel in the 1930s in *Tradition and Dream* (1964), the critic Walter Allen comments that 'in the only sense in which it has meaning, in the Marxist sense, there were very few examples indeed of it in Britain, the only one that still has interest as a positive literary achievement being the trilogy *A Scots Quair* . . . by Lewis Grassic Gibbon'.[28] In the Scottish context, Gibbon's achievement was to communicate his Marxist perspective through the creation of a modernistic narrative form and language which would stand equal in fiction to MacDiarmid's earlier revitalization of Scots as a modern literary language

[28] Walter Allen, *Tradition and Dream: The English and American Novel from the Twenties to Our Time* (London: Phoenix House, 1964), 229.

for poetry. As he described it himself, Gibbon's method was 'to mould the English language into the rhythms and cadences of Scots spoken speech, and to inject into the English vocabulary such minimum number of words from Braid Scots as that remodelling requires':[29] a 'foreignizing' of English (as with the later James Kelman's Glasgow fiction) in order to create the illusion of narrated and spoken Scots. Beginning with a farming community in the Mearns area of north-east Scotland, Gibbon moves his fictional setting to the small rural factory village, and finally into the industrialized city; and in so doing presents his Marxist view of the deterministic onward movement of history while at the same interrogating the extent to which human beings have the power, if they are willing to exercise it, to shape that process if not to alter it. While his portrait of his *Sunset Song* heroine Chris Guthrie has made that book probably the most popular book in Scottish literature, it is the third book of the trilogy, *Grey Granite*, which is most revolutionary in its depiction of the proletarian city through a shifting focalization and modified stream of consciousness narrative, and the translation of the illusion of Scottish speech and idiom from the rural north-east to the urban scene.

Gibbon may have been the most stylistically adventurous novelist of the 1930s—and of the literary revival as a whole—but his creation of the fictional proletarian city of Duncairn in *Grey Granite* was followed by two fine novels of contemporary industrial Glasgow in James Barke's Marxist *Major Operation* (1936) and George Blake's *The Shipbuilders* (1935). Both novelists present the lives of the working and middle classes of Glasgow—Barke dialectically, Blake more fluidly—and both also cinematically capture the spirit of the modern city through their detail of everyday life and imagery of time and travel: the new language of 'motoring-speak', the subway and tramcars for the workers, private car and overnight sleeper for the business class; the psychological awareness of a life 'stilled' or one speeding out of control.

As might be expected, modernism and Marxism come together in poetry principally in MacDiarmid's Hymns to Lenin. Such poetry is very different from the contemporaneous politically oriented work of English writers such as Auden, Spender, and Day Lewis; and different also from expectations of what a socialist-realist or Marxist poetry might be, as MacDiarmid continues with his characteristic method of bringing diverse images and references into relationship with each other. Lenin is compared to Christ in the *First Hymn* (much as Burns previously was in *A Drunk Man*); and the expansion of human consciousness and the need for the artist to '*win through to the man in the street,* | *The wife by the hearth*' appear as main themes of the *Second Hymn* alongside the insistence that

> Poetry like politics maun cut
> The cackle and pursue real ends,
> Unerringly as Lenin.[30]

[29] Lewis Grassic Gibbon, 'Literary Lights', in Lewis Grassic Gibbon and Hugh MacDiarmid, *Scottish Scene, or, The Intelligent Man's Guide to Albyn* (London: Jarrolds, 1934), 205.
[30] MacDiarmid, *Complete Poems*, i. 323, 324.

The lengthy *Third Hymn to Lenin* (not published until the 1950s) reviews the Glasgow of the slums, 'this great human Sargasso', this 'sink', and ends with the concern for 'human wholeness' and a plea to the 'Spirit of Lenin' to 'light up this city now!'[31] MacDiarmid's communism (for which he was thrown out of the National Party; and out of the Communist Party for his nationalism) was never of an orthodox, doctrinal kind, being always more concerned with '*Freein' oor poo'ers for greater things*' as a result of freeing human beings from '*breid-and-butter problems*',[32] and his characteristic awareness in his poetry of the dark and light oppositions in human experience does not sit happily with the attempt to write political praise poems. His commitment is communicated more successfully in the collection titled *Second Hymn to Lenin* (1935) in poems such as the English-language 'Lo! A Child Is Born' and in imagistic lyrics or free-verse poems where the ideological element is implicit rather than directly stated.

The Second World War, Late Modernism, and Late Muir and MacDiarmid

While it has become customary to consider 1939 as the end of the revival movement known as the Scottish Renaissance—and it is certainly the case that the first revolutionary and optimistic phase of the movement had reached its end by 1939—I would suggest that in order to complete an understanding of Scottish literary modernism, it is necessary to move beyond the interruption of the Second World War to the late poetry of MacDiarmid and Muir: to the poetry that MacDiarmid could not find a publisher for until the 1950s and, especially, to the significant, mature poetry Muir published from *The Narrow Place* of 1943 to *One Foot in Eden* of 1956. It is also important to recognize that there was a 'legacy phase' in the 1940s and early 1950s when a number of younger poets, some of whom fought in the Hitler war, began a second phase of the Scots poetry revival, drawing on the inspiration of MacDiarmid's revitalization of Scots as a modern literary language and the ideas behind the interwar movement, but experimenting linguistically in new ways. In particular, Sydney Goodsir Smith's modernist-inspired poetry and his Joycean prose fiction work *Carotid Cornucopius* proved outstanding companions to the earlier modernism of MacDiarmid and Grassic Gibbon. The new writers were supported by magazines published by William Maclellan such as *Poetry Scotland, Million: New Left Writing*, and *Scottish Art and Letters*. William Maclellan was also to publish MacDiarmid's *In Memoriam James Joyce* in 1955, and in 1943 he published Sorley MacLean's *Dain do*

[31] MacDiarmid, *Complete Poems*, ii. 893, 900, 901. [32] Ibid. i. 325.

Eimhir ('Poems to Eimhir') with illustrations by the artist William Crosbie and English translations by MacLean himself—the first modernist collection of poems to come out of the attempt to revitalize the Gaelic language. An extension of Scottish modernism into the 1940s and 1950s allows such late developments to be accommodated within the movement as a whole, as opposed to leaving them as happenings in a kind of no man's land; or in the case of MacDiarmid's *Joyce* poem, to be incorporated into the postmodernist canon as a result of its seemingly playful methodology—much of which emanated from the inability to find publishers at its original date of writing.

Because of his ill health, Edwin Muir did not serve in the First World War. He says little about it in his various writings, although a brief passage in *An Autobiography* about his attempt to enlist suggests that his response to the war was absorbed into the 'state of incipient dissociation'[33] in which he felt himself living at that time. The Second World War was a different matter. Neil Gunn commented that Muir's poetry 'has caught a flame—from the fire that is burning the world',[34] and it is generally agreed that Muir's poetry from the 1940s onwards is of a different order from his early, more tentative work. Muir followed Eliot in believing in impersonality in art and he therefore does not deal with his themes directly, but through symbol and metaphor: a methodology that has led some critics to characterize him as unworldly. Yet, as these late poems show, Muir as poet was deeply involved in what he called 'the single, disunited world'[35] and had now found a mature poetic language in which to give this expression. His war poetry brings past and present human experience together in a series of clear visual images as the stream of history 'runs on into the day of time and Europe' showing

> a blackened field, a burning wood
> A bridge that stops half-way, a hill split open
> With scraps of houses clinging to its sides ...
> The disciplined soldiers come to conquer nothing,
> March upon emptiness and do not know
> Why all is dead and life has hidden itself.[36]

In 'The Return of the Greeks', soldiers returning from the siege of Troy come 'sleepwandering from the war',[37] unable to adjust to their everyday lives and families; and this use of Greek myth as an objectifying metaphor becomes an increasingly important part of his late poetry. Although he believed strongly in the impersonality of the artist, Muir was particularly susceptible to the atmosphere of place. The *Labyrinth* collection of 1949 thus captures in poetry his response to the communist takeover in post-war Prague, where he worked for the British Council, with its title

[33] Muir, *An Autobiography*, 147.
[34] Neil M. Gunn, Review of *The Narrow Place*, *Scots Magazine*, 39/2 (May 1943), 163.
[35] Muir, *An Autobiography*, 194.
[36] Edwin Muir, 'The River', in *The Complete Poems of Edwin Muir*, ed. Peter Butter (Aberdeen: Association for Scottish Literary Studies, 1991), 97.
[37] Muir, *Complete Poems*, 125.

poem in particular acting out through its images and rhythmic movement a Kafka-esque scenario of imprisonment and disorientation. *One Foot in Eden* is what MacDiarmid might have called an 'antisyzygial' collection, drawing on his positive experience of a short period of living in Rome and his return to the harsher climate of Calvinist Scotland. Poems such as 'Telemachos Remembers' and 'Orpheus' Dream' testify to the power of human love in the face of potential disaster, while the contrasting but linked 'The Horses' and 'After a Nuclear War' open up choices facing human beings in their modern technological world. Late poems (some first published posthumously) such as 'The Last War', 'The Day Before the Last Day', and 'The Refugees Born for a Land Unknown' continue to warn of the need to 'Choose again' before 'all the words | By which we forged earth, night and day' become the 'lexicon of a dream'.[38] Muir may have been a visionary poet, but he was firmly rooted in the modern human world.

MacDiarmid too was 'visionary' as well as 'revisionary' in his late poetry, continuing to pursue that expansion of human consciousness that had been his aim throughout his work. *The Kind of Poetry I Want*, first published in his autobiography *Lucky Poet* (1940), points to the potential within poetry rather than to fulfilment in the present: 'A poetry concerned with all that is needed | Of the sum of human knowledge and expression . . . To produce this super-individuality, Man'; 'I dream of poems like the bread-knife | Which cuts three slices at once'; 'A poetry with the power of assimilating foreign influences | As in the wonderful flowering of the Golden Age in Spain'; 'A poetry finding its universal material in the people, | And the people in turn giving life and continuity | To this poetry by its collective interest'.[39] This is a remarkably stimulating 'poem' despite its random organization, and one which keeps alive both Shelley's belief in the poet as 'unacknowledged legislator' and modernism's related prioritizing of the artwork and its transformative nature. MacDiarmid is too serious a believer in the power of art to stretch human awareness and potential ('*I'm no' the kind o' poet | That opens sales o' work*,'[40] as he complains in *Cencrastus*) to be a credible candidate for postmodernist interpretation, either in this poem or in *In Memoriam James Joyce*, which was published with decorations by the painter J. D. Fergusson and dedicated to his 'old friends' and colleagues John Tongue and James H. Whyte (of the *Modern Scot*) and Prince Dmitry Mirsky (who had been his *New Age* guide to Russian writers and affairs). Despite its eclectic borrowings and collage-like nature (about which there has been much controversy over the years), this long poem is a work about human potential and creativity and how that creativity and diversity might be encompassed and brought together globally. It is therefore also an anticipatory work, foreseeing the possibility (if not the mechanics) of the worldwide web of information and interactive intellectual and artistic communication developing in our present world: 'a vision of world language', as its expanded title proposes.

[38] Muir, *Complete Poems*, 270, 257.
[39] MacDiarmid, *Complete Poems*, ii. 1004, 1005, 1011.
[40] Ibid. i. 236.

These final poetry collections by MacDiarmid and Muir bring to a close one of the most vital periods in Scottish literary activity; and one which not only restored a distinctive and diversified identity to Scottish literary culture but also restored the connections with European art and thought which had been an intrinsic element of the Scottish culture of the late medieval and, to a lesser extent, eighteenth-century periods. Although forms of artistic expression changed in Scotland as in Britain generally from the 1950s onwards, and cultural and political nationalism temporarily retreated as a consequence of the Second World War, this Scottish modernism of the post-1918 years had laid lasting foundations for the building of the confident, outward-looking culture Scotland takes for granted today.

CHAPTER 43

··

IRISH MODERNISM

··

CAROL TAAFFE

THE contested position of modernism in Irish culture might be dramatized by a tale of two Joyces. One is the internationalist Joyce, the deracinated modernist who in much twentieth-century criticism was considered to have become 'European and modern to the extent that he transcended his Irishness';[1] the other, the Irish Joyce who has more recently emerged from the confluence of post-colonialism and Irish studies. It was the latter writer, his work intimately bound up with Ireland's cultural and political revolution (and with anti-colonial revenge on the English language itself), who was immediately claimed by his Irish contemporaries.[2] As Stephen Gwynn, a one-time nationalist MP, saw it, 'the poignant cry of the disinherited runs all through Joyce's writing'; the Anglo-Irish John Eglinton, who had featured unflatteringly in *Ulysses*, was less enamoured of this 'Romano-Celtic Joyce', an 'enemy' of the whole of the English tradition.[3] But in later years, the Irishness of a writer such as Joyce proved as awkward for modernist critics as the concept of an Irish modernism was to become for domestic literary historians. The cosmopolitanism of international modernism, its thematics of revolt, exile, and displacement, sat uneasily with the largely conservative, nationalist culture of the Irish state after 1922. In the climate of the post-Revival, the habit of emphasizing the uniqueness of Irish culture also fostered a certain suspicion of a pan-European modernism (and of those writers who appeared to adhere to it); for many international post-war critics, the

[1] Declan Kiberd, 'Introduction', in Andrew Gibson, *James Joyce* (London: Reaktion Books, 2006), 7.
[2] On this critical division and for a complementary reading of Joyce, see Andrew Gibson, *Joyce's Revenge: History, Politics and Aesthetics in Ulysses* (Oxford: Oxford University Press, 2002).
[3] Stephen Gwynn, *Irish Literature and Drama in the English Language: A Short History* (New York: Nelson, 1936), 195; John Eglinton, *Irish Literary Portraits* (London: Macmillan, 1935), 142–3.

reverse would be true.[4] For those Irish writers who came of age in the 1920s and 1930s, the internationalism of literary modernism presented both a liberation and a threat. Though it offered relief from the claustrophobia of a determinedly national culture, the danger of a vacant internationalism—a reflex deference to the culture of London or Paris—haunted even the most unlikely of writers.[5] The new critical establishment in Ireland, on the other hand, was less divided in its attitudes. For Daniel Corkery, an Irish literature was that produced at home for an Irish readership and referable to their ordinary lives, not the work of expatriates like James Joyce: 'those wild geese of the pen'.[6] Modernist studies, in its New Criticism phase, did not disturb this cultural separation between Ireland and its modernist writers, and Joyce's Dublin came ever more detached from Dublin's Joyce.[7] Yet the category of 'Irish modernism' itself assumes the necessity of a dual perspective, a local as much as an international context. The cultural history of late colonial Ireland may not be easily contained by the dominant critical narratives of European or Anglo-American modernism, but the work of Yeats and Joyce alone shows that it is intrinsic to them. Irish modernists can seem to occupy an ambiguous position between two worlds, but it is one that productively transgresses rigid critical and cultural boundaries.

The growing critical attention to national modernisms might bypass the tension between nationalism and internationalism which bedevilled the early reception of literary modernism in Ireland. But while a canon of Irish modernism clearly exists (in the work of Yeats, Joyce, and Beckett), its central importance to international developments can seem to draw it away from the Irish context, in which a broader culture of modernism is less self-evident. In a seminal essay on the subject, John Wilson Foster identified 'a fitful native Modernism'[8] in Ireland, while at the same time attempting to weaken the claims of international modernism upon traits it held in common with Irish writing. Irish literature may be more modernist than it appears, he implies, but perhaps modernism is also more Irish than is supposed. Joyce's *Ulysses*, the quintessential modernist novel, partly owes its narrative heterodoxy to the turn to medieval Irish literature during the Revival, as well as to the lack of a native realist tradition in the novel.[9] The conjunction is even more clearly seen in Flann O'Brien's *At Swim-Two-Birds*, in which the influences of the Gaelic literary

[4] See Declan Kiberd, 'Joyce's Ellmann, Ellmann's Joyce', in *The Irish Writer and the World* (Cambridge: Cambridge University Press, 2005), 241–2.
[5] The poet Charles Donnelly, who would be killed in the Spanish Civil War, articulated this felt conflict: 'The modern Irish artist cannot throw over modern thought. Neither can he agree to throw over Ireland. In his consciousness, the two must fuse. Modern Irish art must be in touch with the people ... [but] to be of any importance it must be in touch with more than the people' ('Literature in Ireland', *Comhthrom Féinne*, 5/4 (May 1933), 65).
[6] Daniel Corkery, *Synge and Anglo-Irish Literature* (Cork: Cork University Press, 1931), 4.
[7] Colin Graham argues that Irish criticism 'finds it difficult, even now, to situate Joyce in an Irish tradition and equally awkward to find a way in which to bring Modernism to bear with precision on the Irish context' ('Literary Historiography, 1890–2000', in Margaret Kelleher and Phillip O'Leary (eds), *The Cambridge History of Irish Literature*, ii (Cambridge: Cambridge University Press, 2006), 579).
[8] John Wilson Foster, 'Irish Modernism', in *Colonial Consequences: Essays in Irish Literature and Culture* (Dublin: Lilliput, 1991), 45.
[9] See ibid. 47–9, 55–6.

heritage and of Joycean innovation are wholly inextricable, producing an inescapably Irish brand of late modernism. In this respect, it is curious that not only are the distinctive features of an Irish modernism still largely open to question, but 'Irish modernism' itself long seemed something of an oxymoron. A conflict partly stemming from the image of an archaic, anti-modern Ireland produced during the Revival, from the Irish perspective it also bears the traces of the divisive cultural politics of the 1920s and 1930s. After 1922 there were new borders to protect, both political and cultural. The coincidence of the publication of *Ulysses* that year with the establishment of the Irish Free State might suggest that the emergence of Irish modernism is bound up with the radical energies of late colonial Ireland, but so too is its apparent failure. Over the following decades where Irish culture and international modernism depart—or perhaps where a distinctively Irish modernism begins—is not just in the tension between nationalism and internationalism (or between the provincial and the cosmopolitan, in pre-independence terms), but in a conflict between aestheticism and political engagement, between a suspected cultural elitism and the populism of a nationalist culture. These conflicts came to a head in the cultural debates of the post-independence years, as a naturalist aesthetic—and its preoccupation with notions of authenticity, with the demotic and the everyday—dominated over the radical irony and intellectual playfulness that characterized this branch of the Irish tradition. The second section of this chapter focuses on the work of Flann O'Brien, a second-generation modernist who managed a kind of reconciliation of these elements, being self-consciously (and ironically) both Irish and modernist. To begin with, it explores the implicit contradiction long lurking in the concept of 'Irish modernism' itself.

In an Irish collection of essays which flagged Joyce as 'quintessentially an Irishman,'[10] as a writer who could be uniquely elucidated by his fellow Irishmen, Arthur Power held out the image of the internationalist Joyce frustrated with provincial Ireland (and its literature): 'parish froth! I intend to lift it into the international sphere and get away from the parish pump.'[11] Samuel Beckett famously held no truck with the parish froth, protesting to the poet Thomas MacGreevy (who attempted to square modernist sensibilities with his own commitment to Catholicism and Irish nationalism) his 'chronic inability to understand ... a phrase like "the Irish People" or to imagine that it ever gave a fart in its corduroys for any form of art whatsoever.'[12] Yet Beckett's early work itself emerged in productive tension with the culture of the Irish Free State, his comic novel *Murphy* not merely satirizing the dying notes of the Literary Revival, but setting the unlucky Neary to head-butt the heroic buttocks of Cuchulain in the GPO. However, his 1934 review of contemporary Irish poetry so clearly drew the battle lines between Ireland's domestic revivalists and its expatriate

[10] John Ryan, 'Introduction', in Ryan (ed.), *A Bash in the Tunnel: James Joyce by the Irish* (Brighton: Clifton Books, 1970), 14.

[11] Arthur Power, 'James Joyce—The Internationalist', in Ryan (ed.), *A Bash in the Tunnel*, 181.

[12] Cited in Alan Gillis, *Irish Poetry in the 1930s* (Oxford: Oxford University Press, 2005), 137. See also his resistance to MacGreevy's critical assessment of Jack B. Yeats as primarily a *national* painter: Samuel Beckett, 'MacGreevy on Yeats', in *Disjecta* (London: John Calder, 1983), 95–7.

modernists, the 'antiquarians and others, the former in the majority',[13] that it set the tone for much later criticism.[14] By then, what had emerged out of Ireland's revolutionary maelstrom was a stifling adherence to a national tradition and to a Gaelic, Catholic identity above all else. Beckett's review is undoubtedly coloured by this reactionary mood, mapping a rising Irish parochialism onto the poets remaining in the Free State and still dominated by Yeats's influence, in contrast to the small band based in Paris and London who took their bearings from Eliot and Pound, French literature, and Surrealism. But arguably Beckett's review only exposes two versions of Irish modernism: the archaizing strain of Yeats's revivalism and a more introverted move towards fragmentation and obscurity, as in Joyce's later work. Yet the view from the disenchanted 1930s places Ireland's cultural nationalism and its literary modernism at opposite poles; as the culture of the independent state ossified, this monotone Ireland seemed far divorced from its radical beginnings. But in the colonial situation, the spirit of cultural revolt inevitably took very different forms from those in contemporary Europe. The retrospective look obscured the degree to which modernism and nationalism arguably emerged in Ireland as 'interdependent rather than opposed phenomena'.[15]

In one sense they are clear opposites, but perhaps only as mirror images of each other. As Elleke Boehmer argues, both modernism and anti-imperial nationalism might be seen as 'an outgrowth and an expression of modernity', each alternating between a self-conscious sense of newness and claims to 'lineage and deep history'.[16] The degree to which Irish modernism and nationalism might be read as analogous responses to modernity has been a significant feature of recent work in Irish studies, recognizing that in Ireland the 'shock of the new' was delivered first by colonization: 'at least as devastating and destructive to any idea of stable organic society or to the continuity of tradition'.[17] While its effect on the native culture might unambiguously cast the Irish experience of modernity as catastrophe, at the same time Ireland was also heavily invested in it—whether in the industrial development of Belfast, in the rise of nationalism as a political ideology, or in its complex relationship to imperialism. The paradox of Irish modernity might be illustrated in the remote *Gaeltacht* communities of the west of Ireland: vital to the revivalist imagination as the touchstones of an ancient Irish culture, in reality they were also in constant traffic (social and economic) with London and New York, the epitomes of the modern metropolis. The modern Irish experience is founded on such contradictions, the greatest perhaps being that by the early twentieth century in Ireland tradition *was* the new. The

[13] Beckett, 'Recent Irish Poetry', in *Disjecta*, 70.

[14] See Patricia Coughlan and Alex Davis (eds), *Modernism and Ireland: The Poetry of the 1930s* (Cork: Cork University Press, 1995).

[15] Derek Attridge and Marjorie Howes, 'Introduction', in Attridge and Howes (eds), *Semicolonial Joyce* (Cambridge: Cambridge University Press, 2000), 11.

[16] Elleke Boehmer, *Empire, the National and the Postcolonial, 1890–1920: Resistance in Interaction* (Oxford: Oxford University Press, 2002), 176.

[17] Joe Cleary, 'Introduction: Ireland and Modernity', in Joe Cleary and Claire Connolly (eds), *The Cambridge Companion to Modern Irish Culture* (Cambridge: Cambridge University Press, 2005), 7.

'rupture of the lines of communication'[18] which Beckett diagnosed in literary modernism had already taken place, not in terms of an aesthetic or philosophical proposition, but in painful historical fact. Ireland's modernist writers emerged from a strongly traditional society which had all too recently been atomized by famine, language change, and land reform. As Seamus Deane sees it:

For Joyce, the matter is both simple and involved. To be colonial is to be modern. It is possible to be modern without being colonial; but not to be colonial without being modern. Ireland exemplifies this latter condition and presents it in such a manner that the 'traditional' and the 'modern' elements seem to be in conflict with one another, like two competing chronologies. But in fact there is little of the traditional in Joyce's Ireland.[19]

The culture which brewed the conservative radicals of the Gaelic Revival alongside a linguistic iconoclast like Joyce was one which was already well familiar with the dislocations of modernity. And while Ireland's political and social unrest would foreshadow the end of the British Empire decades later, the rigid censorship policy of the new state would attempt a rejection of the seductions of the modern world in the name of a traditional culture that was already lost. The repair job was too late; in late colonial Ireland a radical break with its pasts—whether Gaelic, Anglo-Irish, or British—had already been achieved. And in this context, ideas of the traditional and the modern had far different connotations from those in the modernist centres of Paris or Berlin.

Ireland, then, was ripe for the development of what Terry Eagleton described as the 'archaic avant-garde'; in the aftermath of the Great Famine, in which so much of traditional Ireland was swept away, the conservative power of the past was transformed into the radical potential of the future. Modernity was both enemy and promise, and as such the 'radical conservatism' of much modernist art would be mirrored not only in the Literary Revival's archaism, but also in the anti-modern tenor of Ireland's wholly modern nationalism.[20] Indeed, the radical currency of the past in a nationalist culture was made central, through the work of Joyce and Yeats, to the development of international modernism itself.[21] However, the lingering influence of the conflict Beckett articulated between literary modernism and the 'antiquarian' Irish Revival has ensured that their underlying correspondences have received relatively little attention.[22] Yet besides the traces of Symbolism and

[18] Beckett, 'Recent Irish Poetry', 70.
[19] Seamus Deane, 'Dead Ends: Joyce's Finest Moments', in Attridge and Howes (eds), *Semicolonial Joyce*, 26.
[20] Terry Eagleton, 'The Archaic Avant-Garde', in *Heathcliff and the Great Hunger: Studies in Irish Culture* (London: Verso, 1995), 280.
[21] See T. S. Eliot, '*Ulysses*, Order, and Myth', in Seon Givens (ed.), *James Joyce: Two Decades of Criticism* (New York: Vanguard, 1948), 198–202.
[22] A notable exception is Alex Davis's reading of the Literary Revival as a movement within European poetic modernism; see his *A Broken Line: Denis Devlin and Irish Poetic Modernism* (Dublin: University College Press, 2000) and Alex Davis and Lee M. Jenkins (eds), *Locations of Literary Modernism: Region and Nation in British and American Modernist Poetry* (Cambridge: Cambridge University Press, 2000). Terence Brown gives a slightly more wry account in 'Ireland, Modernism and the 1930s', in Coughlan and Davis (eds), *Modernism and Ireland*, 24–42.

aestheticism in Yeats's poetry, the influence of Morris's Arts and Crafts movement on an enterprise like the Cuala Press, or the modernist primitivism which shaped their images of the west of Ireland, revivalist rhetoric stressed above all a new beginning, a foundational moment for modern Irish literature. The Literary Revival's myth of origins (seeing itself springing from the soil of Irish experience rather than the reading rooms of London) had as much authenticity as its 'discovery' of Irish tradition. But the national in the story drowned out the modern; the echoes of all those other movements concerned with making it new were lost in their insistence on the particularity of Irish experience. Yet even beyond the Revival itself, the anti-modern rhetoric of less cosmopolitan cultural nationalists provides a fairground reflection of modernist forms of cultural nostalgia. Yeats's open distaste for the 'filthy modern tide'[23] was shared, for example, by the scions of the Gaelic League, for whom the Irish language presented a prophylactic against the degeneracy of the modern world. The leading language revivalist Fr. Peter O'Leary encapsulated this idea of cultural decline in the process of translation itself; if the Irish language were used to translate an English novel it 'would be like a great, strong-minded, vigorous, muscular man, suddenly become an idiot'.[24] The Irish language was a spiritual resource, English the language of a mercantile civilization, the debased currency of the 'nouveau riche'.[25] The threat of a debasing Anglo-American popular culture partly motivated the stringent 1929 censorship legislation, and even into the 1930s some Irish commentators were still presenting Gaelic Ireland and other 'peasant lands' as the ultimate saviours of a European 'urban civilisation going down to-day in corruption of body and mind'.[26] This Ireland was the very antithesis of the modern industrialized Britain lambasted by high modernists—in Yeats's conservative imagination, a land of aristocrat and peasant cleansed of mercantile middle-class mores. Yet in other quarters, Irish nationalists were also heavily invested in the modernizing impulse. Yeats's contemporary D. P. Moran has become synonymous with an atavistic form of ethnic nationalism, but while his work is laced with appeals to an Irishness that is 'racy of the soil',[27] it also points to the need for modernized industrial and economic development in Ireland.[28] This was the side of Irish nationalism which wished to 'embrace a modernity from which, through British economic oppression, it had been excluded',[29] and which progressed only in fits and starts in the post-Revival climate of the Irish Free State.

It was this complex intellectual environment that would produce some of the most radical works of literary modernism, as well as some of the strongest critical

[23] W. B. Yeats, 'The Statues', in *The Collected Poems of W. B. Yeats* (London: Macmillan, 1950), 376.
[24] Peter O'Leary, 'The True Model', in *Irish Prose Composition* (Dublin: Irish Book Company, 1907), 5.
[25] Fr. Gearóid Ó Nualláin, *Duine Beatha a Thoil* (1950), cited in Breandán Ó Conaire, *Myles na Gaeilge* (Dublin: An Clóchomhar, 1986), 22.
[26] Aodh de Blácam, 'The Age-Lasting Peasant', *Capuchin Annual* (1935), 257.
[27] D. P. Moran, 'Is the Irish Nation Dying?', in *The Philosophy of Irish Ireland* (Dublin: Duffy, 1899), 7.
[28] See Moran, 'The Future of the Irish Nation', in *The Philosophy of Irish Ireland*, 17–21.
[29] Seamus Deane, *Strange Country: Modernity and Nationhood in Irish Writing Since 1790* (Oxford: Clarendon Press, 1997), 184.

resistance to them. As Joe Cleary has pointed out, a country which lacked a strong academic tradition and established national institutions could only produce a series of individual modernist writers without having the capability to develop 'an extended modernist culture'.[30] And while the populist ethos of cultural nationalism flourished in a society in which a high level of education was a matter of social privilege, its seductive appeal to a common national culture also ensured an ambivalent reception for modernist obscurity. All this combined with a growing Catholic and nationalist puritanism to give Ireland a sense of cultural jetlag by the 1930s. Though its cultural traffic back and forth to Europe was typical of international modernism (as it was of the Literary Revival), there was nevertheless a growing sense that modernism was something that happened elsewhere. In 1934, when the expatriate poet Thomas MacGreevy published a collection which refracted his experience of war (in Ireland and Europe) through techniques derived from Eliot and Joyce, the response it received was drily double-edged: 'the Modernist revolt has at last reached the Irish Free State'.[31] Ten years on, Herbert Read paid a similarly dubious compliment to Irish artists in his introduction to a local modernist exhibition, observing that the works on show 'seem to me to belong to the main stream of European culture. And that, I venture to say, is something new in the modern history of this country'.[32] Yet such enterprises had maintained a fitful appearance in Ireland from the early 1920s onwards—from the establishment of the Gate Theatre in 1928 with the aim of staging innovative European drama, to scattered 'little magazines' like *Klaxon: An Irish International Quarterly* (which managed one iconoclastic issue in the winter of 1923–4) and *To-morrow* (running more spectacularly to two issues the following year). After the demise of the *Irish Statesman* in 1930, a more established outlet for those of a modernist bent was the journal *Ireland Today*, which survived from 1936 until 1938 and whose intellectual compass included modern European culture as well as Irish life.[33] The revivalist legacy of W. B. Yeats may have still dominated Irish poetry in the 1930s, but the fiction of that decade was more diverse. Along with MacGreevy and the younger expatriate poets Denis Devlin and Brian Coffey, modernist techniques were adapted and reinvented in the early work of Francis Stuart, Elizabeth Bowen, and Flann O'Brien, and later in Máirtín Ó Cadhain's fiction in the Irish language. In terms of the visual arts, the image is somewhat distorted by the draw of the modern metropolis; the apparent late arrival of modernism in Ireland, for example with the establishment of the Irish Exhibition of Living Art in 1943, was partly due to the return of Irish artists to the neutral state after the outbreak of the Second World War.

[30] Joe Cleary, 'Capital and Culture in Twentieth-Century Ireland: Changing Configurations', in *Outrageous Fortune: Capital and Culture in Modern Ireland* (Dublin: Field Day, 2007), 93.

[31] Austin Clarke, *The Observer*, 9 Sept. 1934; cited in Susan Schreibman, 'Introduction', in *Collected Poems of Thomas MacGreevy* (Washington: Catholic University of America Press, 1991), p. xxxii.

[32] Herbert Read, 'On Subjective Art', *The Bell*, 7/5 (Feb. 1944), 425.

[33] See Terence Brown, *Ireland: A Social and Cultural History, 1922–2002*, rev. edn (London: HarperCollins, 2004), 157–8.

Yet while Joyce's 'Work in Progress' was appearing over the 1930s, a generation schooled in the War of Independence rejected his revolution of the word in favour of their own, very real, social revolution. The Irish avant-garde was to comprise a body of social realists whose commitment to producing a critical image of the new Ireland reflected the documentary turn of the time. By 1934 Beckett was framing Irish modernism as an inherently oppositional aesthetic, but the view from the other side was very different. Yeats's alienation from the conservative Catholic ethos of the Irish state went hand in hand with his revulsion at the cultural democracies of mass-market newspapers and modern education.[34] From the perspective of contemporary Irish writers, what might once have appeared radical in Irish modernism was now in retreat, much like the radical energies of the state itself. Fantasies of artistic autonomy, as voiced by a Stephen Dedalus, sat uneasily with the demands of a post-revolutionary culture. The conflict could be ignored if modernist art was taken in a dilettantist spirit, to be harmlessly appreciated. Or it could be challenged, adapted, and reinvented within a new set of cultural imperatives, an approach which in fact produced very different forms of late modernism in Ireland. One route was that taken by MacGreevy, whose personal and literary career confounds simple boundaries between nationalist Ireland and modernist Europe. An early advocate of a Catholic reading of Joyce and a signatory of Eugene Jolas's 'Revolution of the Word' manifesto, the studies of T. S. Eliot and Richard Aldington which he published in 1931 challenge modernist aestheticism in promoting 'a middle way between disengagement and popularism, abstraction and "reality", high and mass culture'.[35] His later profile of Jack B. Yeats could not find a publisher in London, a fact he attributed to 'English critical standards'; this Irish modernist's criticism was more closely informed by the influence of Daniel Corkery (describing Yeats as a national painter who fulfilled 'the need of the people to feel that their own life was being expressed in art'[36]). MacGreevy returned to Ireland in 1941, but a long poetic silence had effectively begun with his departure from Paris nearly two decades before. The trajectory of his career has prompted Terence Brown to suggest a disabling conflict in MacGreevy's sympathies, that Ireland and modernism were simply 'antithetical congeries of feeling and sensibility in the 1930s'.[37] The opposite might be suggested by the early work of Flann O'Brien, a writer whose distinct form of late modernism was wholly indebted to the conflicting cultural mores of the Irish Free State.

[34] See W. B. Yeats, 'Ireland After the Revolution', in *Explorations* (London: Macmillan, 1962), 438–43.
[35] Tim Armstrong, 'Muting the Klaxon: Poetry, History and Irish Modernism', in Coughlan and Davis (eds), *Modernism and Ireland*, 49.
[36] Thomas MacGreevy, *Jack B. Yeats* (Dublin: Victor Waddington, 1945), 3, 19.
[37] Brown, 'Ireland, Modernism and the 1930s', 28. See also Anthony Cronin, 'Thomas MacGreevy: Modernism Not Triumphant', in *Heritage Now: Irish Literature in the English Language* (Dingle: Brandon, 1982), 155–60.

A DOMESTICATED MODERNISM: FLANN O'BRIEN AND MYLES NA GCOPALEEN

The same cultural and historical determinants which promoted a radical aesthetic in Irish writing in the early twentieth century ironically also contributed to the Irish resistance to modernism. The relationship between modernism, mass society, and popular culture would be peculiarly complex in Ireland, where a long tradition (visible again in the Revival) of treating literature as a social instrument, as part of public and political life, would complicate attitudes towards the more austere works of high modernism. The hunt for schemas and allusions which dominated the early critical reception of *Ulysses* allowed Joyce's bewildering Dublin epic to be articulated in an international language. But those who were intimately familiar with its parade of garrulous nationalists, British soldiery, and Castle Catholics, of Revivalese, *Tit Bits*, and the *Freeman's Journal*, were often alienated from this appearance of a narrow formalism. In Ireland, the tension between a social and discursive model of literature—in part derived from the image of balladeer, the storyteller, and the oral tradition—and the very different notion of artistic autonomy associated with the modern, alienated intellectual produced one of the formative contradictions of Irish modernism, as dramatized by Stephen Dedalus in *A Portrait*. The Joyce who complained in 1901 of the Abbey Theatre's populist surrender to the rabble of 'the most belated race in Europe'[38] was also the writer who would later place the everyman Leopold Bloom at the heart of his Irish modernist epic. In this respect Declan Kiberd highlights 'the sheer oddness of *Ulysses* alongside other works of high modernism', arguing that while they 'feared the forces latent in the masses, Joyce showed that art might engage with those masses, by minutely documenting the half-articulated thoughts and half-conscious feelings of very ordinary people'.[39] The literary patchwork of *Ulysses*, which encompasses the popular song, the newspaper, and the speech from the dock, the linguistic history of English literature as well as the contemporary dialects of advertising, also reflects a sense of literature as a social rhetoric. At the same time, the author of *Finnegans Wake* was evidently little concerned with engaging Kiberd's masses, and these various discourses might be read as coalescing into one illegible literary code, to be unlocked only by the professional scholar. This contradiction in Joyce's work is echoed in the career of W. B. Yeats, which vacillated between the impulse to go 'to the people' and to preserve a social and aesthetic elite, to create a common national culture and to retreat to esotericism. In the polarizing climate of the post-independence years, the resistance to a modernist aestheticism translated for some into the 'narrow, anti-intellectual culture'[40] of the new state. Yet

[38] James Joyce, 'The Day of the Rabblement', in Kevin Barry (ed.), *Occasional, Critical and Political Writing* (Oxford: Oxford University Press, 2000), 50.

[39] Kiberd, 'Joyce's Ellmann, Ellmann's Joyce', 247.

[40] Coughlan and Davis, 'Introduction', 1.

Flann O'Brien, in managing an accommodation between the two, produced one of the most distinctive forms of Irish modernism.

The career of Flann O'Brien (only one of the pseudonyms of the novelist and columnist Brian O'Nolan) is unusual in this context for being conducted entirely in Ireland and for depending primarily on a local readership. In the canon of Irish modernism he occupies a somewhat insecure place alongside the trinity of Joyce, Yeats, and Beckett, but the fiction he wrote at the height of his powers in the late 1930s provides both a critical reflection on modernist techniques and an interrogation of Irish modernism itself. Like MacGreevy and other Irish modernists of his generation, his career would be marked by initial success in the 1930s followed by a long silence; a second, less successful phase as a novelist began with the critical rediscovery of his work in the 1960s. The difference in Brian O'Nolan's case is that in the interim he created a surreal column for the *Irish Times*, which appeared for twenty-six years under the byline of Myles na gCopaleen. 'Cruiskeen Lawn' instituted a genre all to itself, parodying the discursive modes of the newspaper, the persona of the artist, and the habits of Irish cultural rhetoric as much as it satirized Ireland's cultural and political establishments. But it was Flann O'Brien's debut novel, *At Swim-Two-Birds*, which fixed his reputation as a peculiarly ambivalent heir to Joyce's modernism. Published in 1939, it melds Yeatsian revivalism and Joycean techniques with mass-market fiction to reflect a new blend of aesthetic imperatives. *At Swim* is a novel about the writing of novels, and it charts the development of its fragmented narratives in a manner that is wryly self-critical, dramatizing in comic form the irony that shadows Stephen Dedalus in *A Portrait*. O'Brien himself affected to conflate the character with Joyce, seeing in him the monumental arrogance that his generation imputed to the author of *Ulysses* and *Finnegans Wake*: 'James Joyce was an artist. He has said so himself.'[41] But *At Swim* itself is not simply a series of literary parodies; in devising an accommodation between the modernist author and a disaffected local readership, between a tired anti-modern rhetoric and the realities of contemporary Ireland, this late modernist novel firmly situates itself within the cultural and intellectual milieu of the new state.

Seán O'Faoláin complained that the thing reeked of 'spilt Joyce',[42] and certainly the influence of the 'Cyclops' episode, in particular, is inescapable. *At Swim* is a novel of cut-ups; its abundance of literary styles and parodies, as well as apparently random scraps—a betting letter, a school reader—gives it the appearance of a *Ulysses* composed without design. A *Ulysses*, that is, which is innocent of any schema or allegory, the great modern epic stripped of its modernist scaffolding—the very antithesis of the 'European' Joyce that would emerge in post-war criticism. The meticulous, but elusive, structure of *Ulysses* is matched by a text which is equally disorientating but flaunts its haphazard construction. (The student who directs this work in progress has no compunction about replacing unsuccessful material with summaries, or

[41] Brian Nolan, 'A Bash in the Tunnel', in Ryan (ed.), *A Bash in the Tunnel*, 15.
[42] Quoted in Anthony Cronin, *No Laughing Matter: The Life and Times of Flann O'Brien* (London: Grafton, 1989), 92.

admitting to having lost pages of his manuscript.) Brian O'Nolan could be guilty of a facile reading of Joyce's works, or at least of one which merely recast Joyce in his own image: 'With laughs he palliates the sense of doom that is the heritage of the Irish Catholic.'[43] But if *At Swim-Two-Birds* presents a caricatured form of the modernist experimental novel, it also manages a brilliant revision of its aims. The formal innovations are still in place, but something is out of joint. The student, it is hinted, is a devotee of Joyce and Huxley, and, as he explains to his friend Brinsley: 'The modern novel should be largely a work of reference...A wealth of references to existing works would acquaint the reader instantaneously with the nature of each character, would obviate tiresome explanations and would effectively preclude mountebanks, upstarts, thimbleriggers and persons of inferior education from an understanding of contemporary literature.'[44]

This cuts two ways; the forbidding intertextuality of the works of high modernism is parodied in a novel which exploits all the conveniences of an era of cultural mass production. 'There are two ways to make big money,' Brinsley asserts, 'to write a book or to make a book';[45] and the pun notwithstanding, the student's habit of literary cut-and-paste points to the latter method. He is primarily writing about another author, Dermot Trellis, who is engaged on a puerile work of moral fiction which is to illuminate the dangers of 'sin and the wages attaching thereto'.[46] Trellis employs characters (in the literal sense) from existing works, mostly cowboy westerns and Gaelic epics, and the resulting concoction places popular genre fiction and Revivalist prose in sharp contention. This is in a sense an experiment in assembly-line fiction, which also borrows industrial efficiency in its concept of 'aestho-autogamy', a cross between eugenicist experiment and immaculate conception in a 'novel' means by which progeny are produced fully grown as 'finished breadwinners or marriageable daughters'.[47] The cynical nature of this rationalization of literary production is exemplified by Brinsley: 'Slaveys, he considered, were the Ford cars of humanity; they were created to a standard pattern by the hundred thousand.'[48] In O'Brien's hands, modernism and mass culture are not incommensurable concepts. Apparently even the experimental modernist work can be produced to order, though its theoretical precepts become strangely distorted. Where T. S. Eliot's seminal vision of literary tradition and the individual talent could arguably collapse a sense of history into 'a dialogue of artwork with artwork',[49] the mutual incomprehension of

[43] Nolan, 'A Bash in the Tunnel', 20.

[44] Flann O'Brien, *At Swim-Two-Birds* (Harmondsworth: Penguin, 2000), 25.

[45] Ibid. 24. [46] Ibid. 35.

[47] Ibid. 41. An earlier project reportedly devised with the modernist poet Denis Devlin, Niall Sheridan, and other friends was to construct 'the Great Irish Novel', a venture which would apply the principles of the industrial revolution to literature. Each contributor would write a chapter, and the book was to be constructed from a series of 'ready-made' fictional clichés. Niall Sheridan, 'Brian, Flann and Myles', in Timothy O'Keeffe (ed.), *Myles: Portraits of Brian O'Nolan* (London: Martin, Brien & O'Keeffe, 1973), 41–4.

[48] O'Brien, *At Swim-Two-Birds*, 32.

[49] Tim Armstrong, *Modernism: A Cultural History* (Cambridge: Polity Press, 2005), 10.

Finn MacCool and the cowboys from Dublin's Ringsend replays the concept as literal farce. Rather than Eliot's image of an enabling literary tradition—a canon of texts which exist in privileged relation to each other—O'Brien's novel instead exploits 'the illicit couplings made possible by the market',[50] where Celtic Twilight prose and the cowboy western sit side by side. *At Swim* reunites the most rarefied works of literary modernism with the culture of modernity which produced them, where the jarring fragmentation of the experimental text can evoke the Ford assembly-line as much as the accidents of the literary marketplace.

Yet while muddling high and low culture, the preciosity of literary composition and the techniques of mass production, it also casts a deeply ironic eye on Irish cultural politics. *At Swim*'s comic revision of Joycean techniques betrays not simply his influence on O'Brien, but also the uneasy challenge he presented to a post-independence generation caught between a cosmopolitan modernism and the demands of a national culture, between the attractions of the aestheticist impulse and the populist ethos of cultural nationalism. As Anthony Cronin saw it, for many of O'Brien's contemporaries Joyce could be

defused by making him a mere logomachic wordsmith, a great but demented genius who finally went mad in his ivory tower . . . On the other hand Joyce and a view of modernism as a predominantly aesthetic philosophy could still provide a sort of absolution and a sort of charm against infection for those who despised the new Ireland.[51]

The Irish poets based in Paris largely took the second route; Seán O'Faoláin, who led the revival of naturalism in Irish fiction, took the first (as in his response to 'Work in Progress': 'it comes from nowhere, goes nowhere, is not part of life at all. It has one reality only, the reality of the round and round of children's scrawls in their first copybooks, many circles of nothing').[52] Yet this conflicted view of the aesthetic emerges in *At Swim* as constitutive of its own comic modernism. The student's narrative starts with a humble abdication of authorial responsibility, or with a brazen challenge to the somnolent reader (depending on your attitude), with three alternative beginnings that are 'entirely dissimilar and inter-related only in the prescience of the author'.[53] The ambiguity is typical of the novel's rather ambivalent embrace of a modernist trickiness. Lamont, one of the Dublin cowboys employed in Trellis's narrative, baldly gives voice to the irony that dogs the student's experimental flourishes: 'I like to meet a man who can take in hand to tell a story and not make a balls of it while he's at it. I like to know where I am, do you know. Everything has a beginning and an end.'[54] Of course, he and the other characters eventually turn on Trellis and begin to rewrite his story as they see fit: effectively they are not just dissatisfied actors in his tale, but also its dissatisfied readers. The pattern is paralleled

[50] Declan Kiberd, 'Gaelic Absurdism: *At Swim-Two-Birds*', in *Irish Classics* (London: Granta, 2000), 512.
[51] Cronin, *No Laughing Matter*, 52.
[52] Seán O'Faoláin, 'Style and Limitations of Speech', *Criterion*, 4 (Sept. 1928), 86.
[53] O'Brien, *At Swim-Two-Birds*, 9.
[54] Ibid. 63.

in the frame narrative, where the student's quasi-modernist manifesto elicits an unimpressed response: 'That is all my bum, said Brinsley.'[55] In a novel built on parody, the act of writing is also an act of reception; while *At Swim* incorporates the dissonant voices and registers of the Joycean text, it also makes room for its dissident readers. Throughout, writing is seen as a kind of collaboration, not only in the form of the literary intertext, but also in the constant dialogue between authors and their audiences (when the cowboys decide to take literary revenge on Trellis, it takes another three hotly debated beginnings before they are off). Indeed, the student's manifesto effectively posits a farcical literary democracy in which each character is allowed 'a private life, self-determination and a decent standard of living'.[56] This literary egalitarianism is reflected in the novel as a whole, which encompasses (among others) Revivalist translatorese, Middle Irish poetry, and the inspirational odes of the working man:

> When things go wrong and will not come right,
> Though you do the best you can,
> When life looks black as the hour of night—
> A PINT OF PLAIN IS YOUR ONLY MAN.[57]

The stylistic maze of *Ulysses* has a more purely comic counterpart here, and one that reflects the competing strains in the Irish literary scene in the 1930s. At points, the satire plays as sharply on the levelling voices of the new Ireland as it does on Joyce himself. The Dublin cowboys who take over Trellis's novel are the least tolerant of literary innovation or aesthetic complexity, showing as much impatience with medieval Irish poetry, 'the real old stuff of the native land',[58] as they do with the rarefied intellectual punishment suggested for their employer Dermot Trellis: 'A nice simple story would be very nice . . . you take a lot of the good out of it when you start, you know, the other business. A nice simple story with plenty of the razor . . .'.[59] Yet *At Swim* is as much part of this bowsy Dublin as it is of a self-consciously post-Joycean literature; handing power from authors to readers, it devises a curiously popular form of modernist experiment.

Perhaps, then, this was the epitome of a Free State modernism; as Emer Nolan notes, *At Swim*'s experimentalism is combined with 'a curious inversion of modernism's cosmopolitan ambitions'.[60] O'Brien certainly pandered to the local environment in a literal sense by cutting sexual and religious material from the final draft, presumably in an attempt to escape Ireland's rigid censorship laws.[61] A native Irish speaker, he also pointedly abandoned the classical allusions of an Eliot or Joyce for

[55] O'Brien, *At Swim-Two-Birds*, 25. [56] Ibid.
[57] Ibid. 77. [58] Ibid. 75. [59] Ibid. 169.
[60] Emer Nolan, 'Revivalism and Modernism', in Cleary and Connolly (eds), *The Cambridge Companion to Modern Irish Culture*, 168.
[61] On O'Brien, sex, and censorship, see also Keith Hopper, *Flann O'Brien: A Portrait of the Artist as a Young Post-Modernist* (Cork: Cork University Press, 1995), 56–107.

the Gaelic tradition, employing the Middle Irish epic *Buile Suibhne*, or *The Madness of Sweeny*, as the spine of his erudite novel. But if *At Swim*'s localism is of a piece with the dominant mood of contemporary Irish culture, the novel also satirizes its insular tendencies. The villainous Trellis, who will only read green books (a colour 'not favoured by the publishers of London'[62]), is matched by the student's uncle, whose risible sense of cultural propriety forbids him to allow a waltz at an upcoming ceilidh. In contrast to the Gaelic utopia to which the Irish state officially aspired in the 1930s, *At Swim*—like *Ulysses*—makes a farce of such notions of cultural purity, faithfully depicting the multicultural muddle of any reader's (or writer's) mind. But it is telling that the cosmopolitan reach of O'Brien's Dublin largely stretches only as far as Anglo-American popular culture, from the Ringsend cowboys to the Sunday tabloids which, it is implied, inspire Trellis's cautionary tales of fornication.[63] It is only the exasperating Good Fairy (who originated as an angel until O'Brien's Catholic sensibilities reasserted themselves) who affects a kind of cultural urbanity: 'I always make a point of following the works of Mr Eliot and Mr Lewis and Mr Devlin. A good pome is a tonic.'[64] And though *At Swim* borrows the scaffolding of high modernism, its ambition is deliberately tempered; O'Brien himself pointed to the novel's 'erudite irresponsibility'.[65] Overall, Brian O'Nolan's career tends to betray a suspicion of modernist aestheticism that is wholly suggestive of its time and place. He reportedly professed hopes to produce a bestseller, and the twin poles of his literary ambition are reflected in his presentation of copies of *At Swim* to both James Joyce and the popular novelist Ethel Mannin.[66] In response to the latter's criticism, he sardonically denied any serious literary intention: 'I'm negotiating at present for a contract to write 6 Sexton Blake stories (25 to 30,000 words for £25 a time, so please do not send me any more sneers at my art). Sorry, "Art".'[67] His bombast was belied by the surreal detective story which followed, *The Third Policeman*, which was declined publication owing to the commercial failure of *At Swim*. This largely ensured that the 'Cruiskeen Lawn' column would become O'Nolan's main literary output thereafter, but his turn to a newspaper readership (together with the column's frequent satire of Dublin's aesthetes, or 'corduroys') only further illustrated his ambivalent attitude to the notion of 'Art', in all its guises. Elsewhere in Europe, such a response to the aesthetic and its institutions became the stuff of the artistic avant-garde; in the new Ireland, the cynicism ran deeper. Indeed, Myles exposed something of the true cultural economy of literary modernism itself:

You know the limited edition ramp. If you write very obscure verse (and why shouldn't you, pray?) for which there is little or no market, you pretend that there is an enormous demand,

[62] O'Brien, *At Swim-Two-Birds*, 100. [63] Ibid. 35. [64] Ibid. 120.
[65] Flann O'Brien, letter to A. M. Heath, 3 Oct. 1938; repr. in 'A Sheaf of Letters', *Journal of Irish Literature*, 3/1 (Jan. 1974), 66.
[66] See Cronin, *No Laughing Matter*, 94–5.
[67] Brian O'Nolan, letter to Ethel Mannin, 14 July 1939, quoted in Cronin, *No Laughing Matter*, 95.

and that the stuff has to be rationed. Only 300 copies will be printed, you say, and then the type will be broken up for ever . . . I beg to announce respectfully my coming volume of verse entitled 'Scorn for Taurus' . . . But look out for the catch. When the type has been set up, it will be instantly destroyed and NO COPY WHATEVER WILL BE PRINTED . . . Please do not make an exhibition of yourself by asking me what you get for your money. You get nothing you can see or feel, not even a receipt. But you do yourself the honour of participating in one of the most far-reaching experiments ever carried out in my literary work-shop.[68]

As Joseph Brooker points out, Myles's wry understanding of cultural capital anticipates much later accounts of modernist culture.[69] Under what has been called the modernist law of diminishing returns, in which the most unreadable literature is often the most critically celebrated, the corollary may also be that the most valuable work of art is the one which doesn't exist at all. For Brian O'Nolan's generation the ultimate embodiment of that paradox might be *Ulysses*, never banned in Ireland but nevertheless unavailable. For those who acquired it, or *Finnegans Wake*, it turned out to be an 'incommunicate' text in which Joyce's aim, Myles surmised, was not 'to be understood, certainly not to be misunderstood, but to be un-understood'.[70] Modernism was more a rumour than a real presence in post-independence Ireland, which of course did nothing to damage its cultural prestige. Yet Irish culture was a vital crucible of literary modernism, developing in national forms an aesthetic of international significance. But having largely broken with its native traditions and language, this was a culture not only radically open to the new, but also vulnerable to a compensating conservatism. In the end, the forms of modernism it developed would be contradictory and ironic, particularly in the writing which emerged in the polarized climate of post-independence Ireland. In its inherent subversion of literary genre, its interrogation of cultural and aesthetic value, and its running critique of modernism itself, 'Cruiskeen Lawn' may yet come to be seen as a late addition to the most radical and ironic forms of Irish modernism.

[68] 'Cruiskeen Lawn', *Irish Times*, 7 Jan. 1942; repr. in *The Best of Myles na Gopaleen*, ed. Kevin O'Nolan (London: Picador, 1968, 1977), 228.

[69] See Joseph Brooker, *Flann O'Brien* (London: Northcote, 2005), 107–8.

[70] 'Cruiskeen Lawn', *Irish Times*, 10 Apr. 1957.

CHAPTER 44

...

WELSH MODERNISM

...

DANIEL G. WILLIAMS

'THE culture that had been formulated by the great modernists', notes Marcus Klein, 'enabled them to propose the idea of an elite against the presumption of a rabble.'[1] Klein proceeds to argue that this elitist presumption was opposed in the United States by those who conceived of the rabble itself as a culture, 'and not only that, but the basic, emblematic integer of society'. Thus, an alternative strain of modernism developed which sought, in the creation of 'an entirely different aesthetic', to celebrate rather than to disdain the masses.[2] The narrative established here in Klein's history of ethnic American literature has become a characteristic feature of many recent revisionist accounts of modernism, in which those excluded from the modernist pantheon seek recognition and representation in a continual process of questioning and renegotiation. A capitalized Modernism once described in cosmopolitan and internationalist terms is replaced by a plurality of lower-case 'provincial' modernisms.

To discuss Welsh modernism is to contribute to this diversification of the field, for the most economically incorporated, but culturally distinct, of the 'Celtic' nations is generally excluded from revisionist accounts of British literature.[3] Chris Wigginton has noted that where Welsh modernism has been discussed it 'has been solely in

[1] Marcus Klein, *Foreigners: The Making of American Literature, 1900–1940* (Chicago: University of Chicago Press, 1981), 37.

[2] Ibid. 38.

[3] See e.g. Richard Begam and Michael Valdez Moses (eds), *Modernism and Colonialism: British and Irish Literature, 1899–1939* (Durham, NC: Duke University Press, 2007). This book has a section entitled 'Ireland and Scotland', while Wales doesn't appear in the index.

terms of its contribution to the definition of British (that is, English) Modernism in the figure of David Jones', and in attempting to take modernist studies forward Wigginton and John Goodby suggest that a distinctive Welsh modernism emerged as a 'belated' phenomenon, engaged in the pastiching of high modernist claims into a subversive 'internalised, imploded, even mimetic modernism'.[4] Two broad patterns in the discussion of Welsh modernism inform this kind of assertion.

The first, prevalent in both Welsh- and English-language criticism, sees Welsh modernism as emerging later than its European counterparts: in the late 1930s in English (Dylan Thomas, Lynette Roberts, Glyn Jones), and in the 1940s and 1950s in Welsh (Euros Bowen, Kitchener Davies, Alun Llywelyn-Williams).[5] In this respect, the revisionist shaft of John Goodby's observation that there is a 'sorely undervalued' tradition of 'experimental' poets comprising 'David Jones, Dylan Thomas, Lynette Roberts' is somewhat blunted by the fact that the first two are the most widely discussed and written about poets in the Welsh tradition, while the third has been a figure of central importance in the undervalued criticism of Tony Conran and John Pikoulis and is now undergoing a major process of revaluation by Patrick McGuinness.[6] Recent accounts of modernism in Wales have tended to reinforce the view that most Welsh writers of the first three decades of the twentieth century were formally rather conservative and conventional and therefore not fully 'modernist'. The assumption made in such pronouncements is that the noun 'modernism' has a clear referent, and thus the question as to whether a specific literary work is 'modernist' becomes a matter of relatively unproblematic empirical investigation. The difficulty here, as Perry Anderson notes, is that modernism 'designates no describable object in its own right at all: it is completely lacking in positive content'.[7] This impression is intensified by the tension in modernist studies between a narrowly focused inventorial approach that seeks to establish the formal characteristics of a distinct 'modernism', and a far more wide-ranging historical approach which registers the various forms of writing practised during the age of modernism. The strengths and limitations of the inventorial and historical approaches lie beyond the scope of this chapter, but both are useful in mapping out the basic contours of the field of study, and can be refined in relation to specific eras, and specific territories, as the definition of modernism becomes increasingly pluralized.[8] This chapter attempts to broaden the range of works designated 'modernist' within the Welsh literary tradition.

[4] Chris Wigginton, *Modernism from the Margins: The 1930s Poetry of Louis MacNeice and Dylan Thomas* (Cardiff: University of Wales Press, 2007), 111; John Goodby and Chris Wigginton, ' "Shut, too, in a tower of words": Dylan Thomas' Modernism', in Alex Davis and Lee M. Jenkins (eds), *Locations of Literary Modernism* (Cambridge: Cambridge University Press, 2000), 106.
[5] In Welsh, see Dafydd Johnston, 'Moderniaeth a Thraddodiad', *Taliesin*, 80 (Jan.–Feb. 1993), 13–24.
[6] John Goodby, *uncaged sea* (Hove: Waterloo Press, 2008), 78; Anthony Conran, *The Cost of Strangeness* (Llandysul: Gomer Press, 1982), 188–202; John Pikoulis, 'Lynette Roberts and Alun Lewis', *Poetry Wales*, 19/2 (1983), 9–29; Lynette Roberts, *Collected Poems*, ed. Patrick McGuinness (Manchester: Carcanet, 2005).
[7] Perry Anderson, 'Modernity and Revolution', *New Left Review*, 144 (Mar.–Apr. 1984), 112–13.
[8] On the tension between 'period' and 'genre', see Chana Kronfeld, *On the Margins of Modernism* (Berkeley: University of California Press, 1996), ch. 2.

The second pattern views modernist writing in Wales primarily in relation to a broader definition of a modernist project defined in Anglo-American literary terms. There is much work to be done in this area, ranging, for example, from the novelist Rhys Davies's friendship with D. H. Lawrence; T. S. Eliot's support for writers as diverse as Lynette Roberts and Idris Davies; Ernest Jones's relationship with Freud; or the Brecon-born educationalist and medic Frances Hoggan's connections with the African American philosopher, author, and activist W. E. B. DuBois.[9] The problem with reading Welsh modernism primarily in such terms is that Welsh culture becomes regarded as a peripheral appendage to an Anglo-American centre, thus reinforcing what Raymond Williams described as 'metropolitan perceptions'.

In his posthumously published *The Politics of Modernism*, Williams argued that 'the metropolitan interpretation of its own processes as universals' resulted in a highly selective reading of modernism. Williams took the title of his seminal post-humously published lecture 'When Was Modernism?' from his 'friend Professor Gwyn A. Williams's *When Was Wales?*', and his essays on modernism were informed by his increasing engagement with the work of a generation of historians who documented the transformation of Wales from an agricultural region of about 500,000 in 1800 into an urban nation of 2,500,000 by 1900.[10] This shift from a pastoral country with its population fairly evenly spread throughout its regions into a predominantly industrial nation with its urban majority packed into the southern coalfield was accompanied by significant cultural shifts that were the making of modern Wales: from country to city; from Liberal to Labour; from Nonconformity to secularism.[11] Williams noted that if 'there is one thing to insist on in analysing Welsh culture it is the complex of forced and acquired discontinu-ities: a broken series of radical shifts, within which we have to mark not only certain social and linguistic continuities but many acts of self-definition by negation, by alternation and by contrast'.[12] Thus, whereas Wales tends to be seen (when seen at all) from the imperial metropolis as 'unusually singular', Williams noted the 'harsh and persistent quarrels' that characterized the nation's culture.[13] In expanding this analysis to modernism he argued that critics should address not only the diversity between countries but also the various structures of feeling and expression 'within

[9] On Rhys Davies and Lawrence, see Jeff Wallace, 'Lawrentianisms', in Meic Stephens (ed.), *Rhys Davies: Decoding the Hare* (Cardiff: University of Wales Press, 2003), 175–90. On Eliot's relationship with Welsh writers, see James A. Davies, 'Dylan Thomas and His Contemporaries', in M. Wynn Thomas (ed.), *Welsh Writing in English* (Cardiff: University of Wales Press, 2003), 120–64; David Levering Lewis, *W. E. B. DuBois: Biography of a Race* (New York: Henry Holt, 1993), 370–1.

[10] Raymond Williams, *The Politics of Modernism: Against the New Conformists*, ed. Tony Pinkney (London: Verso, 1989), 31.

[11] R. Merfyn Jones offers a useful overview in 'Beyond Identity? The Reconstruction of the Welsh', *Journal of British Studies*, 31/4 (Oct. 1992), 330–57.

[12] Raymond Williams, 'Wales and England', in *Who Speaks for Wales? Nation, Culture, Identity*, ed. Daniel Williams (Cardiff: University of Wales Press, 2003), 20.

[13] Raymond Williams, 'Community', in *Who Speaks for Wales?*, 27.

particular countries, where the distances between capitals and provinces widened, socially and culturally, in the uneven development of industry and agriculture'.[14]

This chapter seeks to substantiate Williams's desire for an account of modernism which addresses internal differences. The account is, inevitably, highly selective, but for the purpose of analysis I have sought to isolate, within a varied and complex field, three divergent strains of thought that I take to be characteristic of Welsh modernist literature: the bourgeois, the proletarian, and the folk. While consciously avoiding the widespread tendency to divide Welsh literature into two linguistic streams, the question of language is central to the discussion, for between 1901 and 1951 the numbers of Welsh speakers declined calamitously from 50 per cent to 29 per cent of the population.[15] The modernist questioning of the material element of its existence took on a particular social significance within the context of a bitter linguistic struggle between the English and Welsh languages in which 'the very social processes and configurations which underwrote' the former seemed predicated on 'the destruction of the culture sustaining' the latter.[16] Welsh modernism was a product of this rivalry.

BOURGEOIS: CARADOC EVANS AND SAUNDERS LEWIS

Caradoc Evans's *My People* (1915) is a volume of short stories which, although written by a Welsh speaker, depicts the inhabitants of west Wales as morally and intellectually retarded. Evans had escaped what he saw as the crabbed and stifling world of his upbringing and had moved as a draper from Carmarthenshire to Cardiff and then London, before obtaining work in 1906 as a journalist. From his metropolitan, increasingly bourgeois vantage point, he offered a lacerating account of the Noncon-formist rural Wales that he had left behind. His work stimulated a virulent reaction upon its publication, but the most powerful and influential counter-response came some years later in a lecture entitled 'Is There an Anglo-Welsh Literature?' delivered in 1938 by the playwright, poet, and co-founder of Plaid Cymru (the Welsh national-ist party) Saunders Lewis. While English, argued Lewis, had established itself as the 'native speech of a traditional peasantry' in Ireland, English in Wales was the language of the industrial areas which had witnessed 'the impoverishment of personality and the depression of all local characteristics to a grey sub-human

[14] Williams, *The Politics of Modernism*, 44.

[15] John Aitchison and Harold Carter, *A Geography of the Welsh Language 1961–1991* (Cardiff: University of Wales Press, 1994).

[16] M. Wynn Thomas, 'Hidden Attachments: Aspects of the Two Literatures of Modern Wales', *Welsh Writing in English: A Yearbook*, 1 (1995), 145–6.

uniformity'.[17] For Lewis, therefore, there could be no such thing as 'Anglo-Welsh' literature. Welsh culture was by definition for Lewis, a rural, Welsh-speaking culture. Whereas Caradoc Evans had moved from Carmarthenshire to London before mounting his attack on the communities of rural Wales, Saunders Lewis was actually born and brought up in Wallasey, Cheshire, and educated at Liscard High School for Boys and Liverpool University, where he studied English and French. His idealized rural Welsh peasants were thus viewed from a distance.

Caradoc Evans and Saunders Lewis can therefore be placed at the opposite poles of the bitter cultural struggle taking place between the two linguistic cultures of Wales during the era of literary modernism. Yet their obvious differences hide surprising similarities. Houston A. Baker's argument that African American modernists differed from 'their Anglo-American, British and Irish counterparts' in that they were attempting to create rather than attack a bourgeois class can be usefully applied to Wales.[18] Unlike Scotland and Ireland, Wales never had an urban centre equivalent to Edinburgh or Dublin. In 1861 Merthyr was the most populous town in Wales with just under 50,000 inhabitants. It wasn't until the last two decades of the nineteenth century that Cardiff developed 'from a counting house' into a city.[19] Thus, there was in effect no established bourgeoisie to attack, and the scattered teachers and preachers that constituted a nineteenth-century Welsh intelligentsia never developed bourgeois art institutions of the kind that would become the targets of avant-gardist critique in the metropolitan centres of modernism. Welsh modernism arises with the emergence of a new bourgeois class made possible by the educational reforms of the late nineteenth century. The Nonconformist intelligentsia of the nineteenth century were losing their cultural authority in the face of secularization, and their political authority was waning as the Liberal Party was being challenged by the rise of the Labour movement. The cultural struggle embodied in the works of Caradoc Evans and Saunders Lewis was thus a struggle for cultural authority between different factions within a new Welsh bourgeoisie that was animated by a rejection of religious Nonconformity and the concept of the *gwerin*, or 'folk', upon which Nonconformist hegemony had been built.

Several historians have traced the ways in which the second half of the nineteenth century was dedicated to a 'resurrection' of the nation after the attacks upon it in the 1847 Royal Commission into the State of Education in Wales. The official 'blue books', written by three monoglot English commissioners, reported on much besides education, suggesting that the Welsh lived a life of moral laxity, dishonesty, perjury, and drunkenness, that Welsh women were unchaste, and that the language was 'a vast drawback to Wales and a manifold barrier to the moral progress and commercial

[17] Saunders Lewis, *Is There an Anglo-Welsh Literature?* (Cardiff: Urdd Graddedigion Prifysgol Cymru, 1939), 7, 9.

[18] Houston A. Baker, Jr, *Afro-American Poetics: Revisions of Harlem and the Black Aesthetic* (Madison: University of Wisconsin Press, 1988), 4.

[19] John Davies, *Cardiff* (Cardiff: University of Wales Press, 2002), 51.

prosperity of the people'.[20] In response the Welsh engaged in a process of ethnic reconstruction. 'Welshness', rooted in a pious, literate, cultured, and responsible *gwerin*, became associated with a moral struggle for the hearts and minds of the people and reached its apotheosis in the writings of Owen M. Edwards (1858–1920), who located a genuine Welshness in the egalitarian and highly moral culture of a rural Nonconformist Wales that contrasted with the debased character of the more populous industrial districts of the south.[21]

While Caradoc Evans's *My People* was quite obviously a revisionist critique of this moral and pious *gwerin*, Saunders Lewis also rejected the Nonconformist religion and culture of his immediate forebears. Evans would have concurred with Lewis's reference to the 'black barbarism of... Nonconformity', and Lewis, in turn, would have embraced the rhetoric of renewal voiced by Evans when he noted that 'We are not dead.... We have a group of writers and a group of politicians who are marching along... They and those who come after them will create a new Wales—a Wales for the Welsh.'[22] In creating this 'new Wales' both writers turned to Irish models. Lewis's initial goal was 'to begin for Wales what the Irish movement had done for Ireland', and his first play, *The Eve of Saint John*, was deeply indebted to J. M. Synge's *The Shadow of the Glen* (1903) and written in a vernacular English which aimed, like the Anglophone works of Ireland, to give English 'a new and utterly distinct accent and idiom'.[23] Evans also acknowledged Synge's influence as a critic of his native culture.[24] Neither Evans nor Lewis managed, however, to achieve Synge's discovery of an English that, in Declan Kiberd's words, 'still had the freshness and excitement of surprise'.[25] Lewis dedicated himself to write wholly in the medium in Welsh, while Evans created a form of debased English designed to convey the backwardness of the rural folk.

Evans forged a style of writing—part translation, partly biblical, part pure fabrication—which gave the English reader the impression that the deep structures of the Welsh psyche were being revealed:

Now the day the Big Man chastened him he drank much ale, and, unaware of what he was doing, he sinned against his daughter Matilda. In the morning he perceived what he had done, and was fearful lest his wife Hannah should revile him and speak aloud his wickedness. So,

[20] Quoted in Robert Owen Jones, *Hir Oes i'r Iaith: Agweddau ar Hanes y Gymraeg a'r Gymdeithas* (Llandysul: Gomer, 1997), 270.

[21] Hywel Teifi Edwards, ' "Y Pentre Gwyn" and "Manteg": From Blessed Plot to Hotspot', in Alyce Von Rothkirch and Daniel Williams (eds), *Beyond the Difference: Welsh Literature in Comparative Contexts* (Cardiff: University of Wales Press, 2004), 9–12.

[22] Saunders Lewis, *Letters to Margaret Gilcriest*, ed. Mair Saunders Jones, Ned Thomas, and Harri Pritchard Jones (Cardiff: University of Wales Press, 1993), 442; quoted in Gerwyn Williams, 'Gwerin Dau Garadog', in M. Wynn Thomas (ed.), *Diffinio Dwy Lenyddiaeth Cymru* (Cardiff: University of Wales Press, 1995), 53.

[23] Lewis, *Letters to Margaret Gilcriest*, 277. On Lewis and Synge, see Ioan Williams, *A Straitened Stage: A Study of the Theatre of J. Saunders Lewis* (Bridgend: Seren, 1991), 28–30.

[24] John Harris, 'Introduction', in Caradoc Evans, *My People* (Bridgend: Seren, 1987), 12.

[25] Declan Kiberd, *Synge and the Irish Language* (London: Macmillan, 1979), 201.

having laid a cunning snare for her, and finding that the woman did not know anything, he spoke to her harshly and without cause. This is what he said:

'Filthier you are than a cow.'

'Evan, indeed to goodness,' Hannah replied, 'iobish you talk.'[26]

This is taken from the story 'Lamentations', which concerns incest between the farmer Evan and his daughter Matilda. John Harris's argument that the narrator's reluctance to mention the incest 'mirrors that of the community to acknowledge the situation' is reinforced by the fact that Matilda is ultimately blamed for the forbidden deed and taken away to the lunatic asylum in Carmarthen.[27] While several critics have noted Evans's powerful depictions of defenceless and often voiceless women becoming the victims of male lasciviousness and greed, others view his debasing depictions of the rural folk as being wholly compatible with the ethnographic discourses of imperial Englishness.[28] *My People* appeared at a time when *Taffy Was A Welshman* (1912) and Laurence Cowen's comedy *The Joneses* (1913) were playing on the London stage, and its stories were seen at the time, and are still considered by many, to offer a slightly more sophisticated form of the ethnic stereotyping evinced in these plays. An alternative approach towards Evans's work is suggested, however, by the fact that Italian editor Nino Frank included a translation of *My People*'s opening story, 'A Father in Sion' ('Un Père a Sion'), alongside writers such as Sherwood Anderson, Jean Toomer, and James Joyce in his short-lived but influential French avant-gardist journal *Bifur* (1929–31).[29] *My People* may be best viewed as a distinctively modernist, inherently reflexive collection of stories; reflexive not only because it refers back to the environment in which Caradoc Evans was raised, but also because it foregrounds the material element of its existence—language itself.

If Caradoc Evans's fabricated Welsh vernacular functioned surrealistically to distort and to critique a rural reality, the 'linguistic turn' took on a particularly intense form in the work of Saunders Lewis. Having initially attempted to write an Anglo-Welsh drama in the style of Synge, Lewis proceeded to dedicate his life to the preservation of the Welsh language, which he viewed as the fundamental source of a distinctive national identity. As leader of Plaid Cymru from 1925 to 1943, Lewis insisted that linguistic preservation be placed above national self-determination in the party's list of priorities. During his period as an infantryman in France during the First World War, Lewis read the works of the novelist, journalist, and anti-semite Maurice Barrès. These convinced him to reject his early aestheticism in favour of an

[26] Evans, *My People*, 141.

[27] Harris, 'Introduction', 27.

[28] On the depiction of women, see Katie Gramich, 'The Madwoman in the Harness-Loft', in Katie Gramich and Andrew Hiscock (eds), *Dangerous Diversity: The Changing Faces of Wales* (Cardiff: University of Wales Press, 1998), 20–33. On imperial attitudes, see Stephen Knight, *A Hundred Years of Fiction* (Cardiff: University of Wales Press, 2003), 32.

[29] Knight, *A Hundred Years of Fiction*, 38. The French Surrealist Georges Limbour translated 'A Father in Sion' for *Bifur*, 2 (Paris: Éditions du Carrefour, 1929). The journal ceased publication with no. 8 (June 1931).

overt nationalism.[30] Upon his return to Wales, Lewis faced the problem of the bourgeois nationalist as described by Tom Nairn, for a desire to 'beat "progress" into a shape' that suited his own needs and class ambitions could only be achieved by 'harnessing the latent energies' of the common people whom he despised.[31] Lewis's bourgeois upbringing manifested itself in a belief that 'ar sylfaen ddiogel cymdeithas bourgeois y mae'n rhwyddaf cynnal bywyd yr artist' ('it is on the safe foundation of bourgeois society that the artist's life can be most easily maintained'), and in a contempt for the industrial working class which, inconveniently, constituted the majority of the Welsh people.[32] 'Yma bu unwaith Gymru' ('Here once was Wales') was his verdict as he viewed industrial Merthyr in his apocalyptic poem 'Y Dilyw 1939' ('The Deluge 1939').[33] In a letter to Kate Roberts, he expressed his exasperation at the audience of 'anwariaid syml' ('simple barbarians') who had turned out to listen to him in Blaen Dulais (Seven Sisters).[34]

The tension deriving from Lewis's desire to lead a nation made up of people he regarded with contempt is reflected in his plays, which often involve characters moving between incompatible worlds. In *Blodeuwedd* ('The Woman Made of Flowers'), for example, a nationalist desire to imagine a community based on place and tradition is challenged by a modernist aesthetic which questions all such forms of fusion and reconciliation. *Blodeuwedd*, drawn from the twelfth-century sequence of stories known as the *Mabinogi*, tells the story of Lleu Llaw Gyffes, who is cursed never to find a wife. Taking pity on his nephew, the magician Gwydion makes him a wife of flowers, a plan which backfires drastically as his creation, Blodeuwedd, has no respect for social conventions and takes another lover while plotting to murder her husband. Much of the play revolves around the tension between Lleu's respect for tradition, convention, and roots, and Blodeuwedd's unfettered sexuality and lack of historical moorings.

> chwilia Wynedd draw
> A Phrydain drwyddi, nid oes dim un bedd
> A berthyn i mi.
>
> (search the breadths of Gwynedd
> And the lengths of Britain, not a single grave
> Belongs to me.)[35]

[30] Dafydd Glyn Jones, 'His Politics', in Alun R. Jones and Gwyn Thomas (eds), *Presenting Saunders Lewis* (Cardiff: University of Wales Press, 1973), 23–78.

[31] Tom Nairn, *The Break-Up of Britain: Crisis and Neonationalism* (London: New Left Books, 1977), 100–1.

[32] Saunders Lewis, ' "Cyflwyniad" i Molière', in *Doctor Er Ei Waethaf* (Wrexham: Cyfres y Werin, 1924), 7; quoted and translated by Gareth Miles, 'A Personal View', in Jones and Thomas (eds), *Presenting Saunders Lewis*, 17–18.

[33] Saunders Lewis, *Cerddi*, ed. R. Geraint Gruffydd (Cardiff: University of Wales Press, 1992), 10; trans. Gwyn Thomas in Jones and Thomas (eds), *Presenting Saunders Lewis*, 177.

[34] Saunders Lewis and Kate Roberts, *Annwyl Kate, Annwyl Saunders*, ed. Dafydd Ifans (Aberystwyth: National Library of Wales, 1992), 16.

[35] Saunders Lewis, 1923–5 version of *Blodeuwedd*, in *Dramâu Saunders Lewis*, ed. Ioan Williams (Cardiff: University of Wales Press, 1996), 211. I have amended the translation that appears in *The Plays of Saunders Lewis*, i, ed. Joseph P. Clancy (Llandybie: Christopher Davies, 1985), 55.

Blodeuwedd literally has no past or origins, and her focus is wholly on the present. For Lleu the future can be constituted only through the reclamation of the past, and thus for him our origins tell us who we are and determine the choices that we can make in life. Although Lewis the politician had already dedicated himself to the nationalist cause by the 1920s and completed the first two acts of *Blodeuwedd* in 1925, he failed to complete the play until 1948. It would seem that, for Lewis the playwright, it was not clear in the 1920s how the struggle between modernist fragmentation and nationalist reconciliation would play itself out.

Blodeuwedd dramatizes a clash between two modes of historical interpretation that can be seen to struggle for dominance throughout the course of modernism. These modes are famously represented in Samuel Beckett's *En Attendant Godot* of 1952. In Beckett's play Estragon, like Blodeuwedd, is not interested in origins. Vladimir, like Lleu, wishes to hold onto memory. It is not surprising that Lewis translated Beckett's play into Welsh in 1970, for in doing so he was returning to a set of issues that had troubled his own dramatic works from the outset.[36] If Caradoc Evans could be viewed as the Estragon of Welsh modernism in his desire to reject the past, Saunders Lewis shared Vladimir's commitment to roots and tradition.

PROLETARIAT: D. GWENALLT JONES AND IDRIS DAVIES

Saunders Lewis, in his disdain for the working class, and his cultural conservationism and elitism, fits neatly within the great modernist pantheon of the Pound era. By the 1930s, in keeping with Marcus Klein's analysis, with which I began, a generation of writers had emerged who turned to Lewis's despised proletariat as a basis for their art. The 1930s saw the rise of the industrial novel as the predominant form of Welsh fiction in English, and while Lewis Jones's *Cwmardy* (1937) contains a surrealistic dream, and Jack Jones's *Rhondda Roundabout* (1934) juxtaposes the discourses of sermons, boxing bouts, and the popular press, in a mode reminiscent of Dos Passos's *USA* trilogy (1930–6), the works of these writers mark a depression era return to the conventions of nineteenth-century realism. It is in the language and form of the poetry of David James Jones (known by his bardic name, Gwenallt) and Idris Davies we find the lineaments of a proletarian modernism emerging from the fragments of the industrial experience.

While making an occasional reference back to a mythic Gwalia, 'where the pagan spirit has been slain' by 'the dull mechanic brain', at the heart of the 1930s poetry of

[36] Samuel Beckett, *Wrth Aros Godot/En Attendant Godot*, trans. Saunders Lewis (Cardiff: University of Wales Press, 1970).

the Rhymney-born poet Idris Davies lies the General Strike and lockout of 1926.[37] Davies, a miner at the age of 14 before escaping the pit via education to a career as a teacher, wrote two great sequences, *Gwalia Deserta* (1938) and *The Angry Summer* (1943), informed by the miners' experience of defeat. In *Gwalia Deserta* the retrospective look is enacted by Dai and Shinkin, representatives of the mass exodus out of Wales during the 1930s depression, as they stand 'on the kerb in Charing Cross Road':

> Do you remember 1926? The slogans and the penny concerts,
> The jazz-bands and the moorland picnics,
> And the slanderous tongues of famous cities?[38]

This reference to the 'slanderous tongues of famous cities' alludes to the ways in which the miners' struggle had been misrepresented by the metropolitan press. Davies's work, in which the inhabitants of the coal-mining communities are given a space to speak in their own range of vernacular voices—from Dai the miner to Dan the grocer, Shinkin Rees the tailor to the worrying Vicar, from Maggie Fach on her way to Barry Island to Hywel and Olwen 'alone in the fern'—attempts to answer those derogatory tongues. While Davies's conventional verse forms and occasional lapses into triteness and bathos have led some critics to view the poetry as enacting 'his own cultural disinheritance', the range of forms and allusions in the poetry— from Blake to Yeats, Housman to Eliot, Welsh hymnology to jazz lyrics—draws on his profound knowledge of English, and a residual knowledge of Welsh literary traditions.[39] The phrase 'slanderous tongues' is itself suggestive, and characteristically, allusive. It appears in Shakespeare's comedy of misrepresentation *Much Ado About Nothing*, where Leonato's daughter Hero is 'Done to death by slanderous tongues.'[40] This individual slander is generalized to represent a whole generation in one of W. B. Yeats's most specifically Decadent poems ('Into the Twilight') where 'hope fall from you and love decay, | Burning in fires of a slanderous tongue.'[41]

'Into the Twilight' was initially titled 'The Celtic Twilight', and both the Decadent movement and the Celtic nationalism of the late nineteenth century shared a hostility to what was perceived to be a philistine industrial society. Whereas Yeats could turn to 'mother Eire', who 'is always young', for salvation in the 1890s, by 1938 Idris Davies 'stood in the ruins of Dowlais' to observe 'the landscape of Gwalia stained for all time | By the bloody hands of progress.'[42] In using the archaic 'Gwalia' in his sequence, and in evoking 'Glyndŵr . . . bruised to the limb', Davies was adopting the forms of the Celtic Revival and romantic Welsh nationalism, where a stoic and defiant periphery

[37] Idris Davies, *The Complete Poems*, ed. Dafydd Johnston (Cardiff: University of Wales Press, 1994), 228. On the strike of 4–12 May 1926, and the seven-month lockout that followed, see Hywel Francis and David Smith, *The Fed: A History of the South Wales Miners in the Twentieth Century* (London: Lawrence & Wishart, 1980).

[38] Davies, *The Complete Poems*, 6.

[39] Robin Young, quoted in Dafydd Johnston, 'Introduction', in Davies, *The Collected Poems*, p. lxxx.

[40] Shakespeare, *Much Ado About Nothing*, V. iii. 3; in *The Norton Shakespeare*, ed. Stephen Greenblatt et al. (New York: Norton, 1997), 1440.

[41] W. B. Yeats, 'Into the Twilight', in *The Collected Poems*, ed. R. Finneran (New York: Collier, 1989), 59.

[42] Davies, *The Complete Poems*, 13.

retains a set of values which have largely been eroded in the dominant centre. This 'rural versus urban' dualism, central both to nineteenth-century Celticism and to Saunders Lewis's brand of cultural nationalism, is transformed by Davies into a struggle between the Welsh industrial proletariat and the unsympathetic bankers, government officials, and journalists of the imperial city 'Londinium'.[43]

If *Gwalia Deserta* and *The Angry Summer* may be read as ripostes to the 'slanderous tongues of famous cities', Davies's revisionism was in evidence again when he responded to Geoffrey Grigson's description of his sequence as the product of a 'simple and superficial mind' in *New Verse*:

> It would have been very easy to make *Gwalia Deserta* obscure. I could have used long words, and affected all kinds of post-1930 tantrums.... *New Verse* has gradually, but certainly, degenerated into a magazine of a clique. The same names appear and reappear in its pages. Auden, Allott, MacNeice, and Spender—it is like a refrain. When these people, and perhaps yourself, were learning their Latin verbs in cushy places, I had to do my job in the coal-mine. Since then, however, I have done a little Latin myself. But it is the Allotts and the Spenders who talk so much, and so glibly, about 'experience'.[44]

This critique of 1930s poetry is supplemented elsewhere in Davies's poetry by a subversive awareness that his work does not follow modernist conventions. 'Crossing the Waste Land behind the back streets of Aberglo', he thinks of T. S. Eliot and then of 'Ianto bach Rees who had never heard of T. S. Eliot', while in the playful 'Dai to Dalí', Davies's Welsh proletarian everyman asks the leading Surrealist to 'Come down and see our crooked, crowded valleys' since 'truth is stranger than any surrealistic art | Where the slag-heaps hold a mirror to the heart'.[45] Working against a backdrop of widely held stereotypes, reinforced in the 1920s by a fear of the proletarian masses, Idris Davies's emphasis on verisimilitude, 'truth', and 'experience' in his poetry suggests that he saw his work as part of 'a struggle over the nature of reality'.[46]

That struggle was, in Wales, a struggle over language. Idris Davies was overstating the case when he recalled that

> I lost my native language
> For the one the Saxon spake
> By going to school by order
> For education's sake,

as he continued to speak Welsh with family members throughout his life.[47] But the simple, childish stanza form, and the use of the word 'Saxon', is clearly designed to suggest that his English-language poetic persona is the result of an essentially colonial educational system. While Davies was to witness, and can be seen to have embodied, the passing of a Welsh-speaking proletarian culture in the Rhymney valley, the forces

[43] Ibid. 15.
[44] Idris Davies, 'Response to Geoffrey Grigson', in *The Complete Poems*, 328.
[45] Davies, *The Complete Poems*, 255, 275.
[46] Ralph Ellison's apt phrase in *Shadow and Act* (New York: Random House, 1953), 26.
[47] Davies, *The Complete Poems*, 78.

of Anglicization were less developed in D. Gwenallt Jones's Tawe valley to the west. As in the work of Idris Davies, Gwenallt often sympathizes with the experiences of proletarian societies, but in a poetry that is charged with ambivalence. While recalling playing cowboys and Indians on the coal tips of his youth, celebrating Welsh rugby heroes such as Billy Bancroft and Dici Owen, he is also the 'great poet of the obscenities of industrial civilisation'.[48] In the fragmented landscapes of Gwenallt's poems we encounter stacks opening their umbrellas of smoke, a mute funeral cortège winding its way between the thunder of steel mills and the groans of tin-plate works, coffins containing the cinders of flesh, and silicotic roses placed next to lilies pale as gas on the graves of the industrial dead. In the midst of this world of surreal juxtapositions, pigeons are released by their careful owners from the backs of their terraced houses, and as the 'white clouds' circle the columns of smoke, the pigeons take on a religious significance, as symbols of God's presence, and vehicles for the reconciliation of the poet's Christian faith and proletarian commitment.

> Amgylchynent yn yr wybr y pileri mwg
> Gan roi lliw ar y llwydni crwm;
> Talpiau o degwch ynghanol y tawch;
> Llun yr Ysbryd Glân uwch y cwm.
>
> (They'd surround the smoke stacks in the sky
> Colouring its crooked greyness;
> Slabs of beauty immersed in smog;
> An image of the Holy Spirit above the Valley.)[49]

This fusion of Christianity with proletarian sympathies is a characteristic of Gwenallt's verse. Gwenallt's father was killed by molten metal in the tin works, and as a young man the poet turned his back on the Methodism of his upbringing and embraced socialism. Following the formation of a Labour government in 1924, he became disillusioned. He argued that unions did not strike to establish socialism, but rather to bargain for more pay within the capitalist system, and he was convinced that it was the workers' leaders in Parliament who had betrayed the miners in 1926. He eventually returned to the Calvinistic Methodism of his youth, a seemingly conservative reversion by the standards of contemporary secular criticism, but described as a radical act of anti-bourgeois defiance by Gwenallt himself:

Ni pherthynai na Marx nac Engels na Lenin ychwaith i'r proletariad, ond meddylwyr bourgeois oeddynt, a syniadau bourgeois y ddeunawfed ganrif oedd y syniadau anffyddol a fynnai Engels eu lledaenu ymhlith y gweithwyr . . . [Gwelais] fod un peth yn gyffredin i gyfalafwyr ac i Gomiwnyddion—hunan-les.

[48] M. Wynn Thomas, 'The Welsh Anti-Capitalist', *New Welsh Review*, 56 (Summer 2002), 86.
[49] D. Gwenallt Jones, *Cerddi Gwenallt: Y Casgliad Cyflawn*, ed. Christine James (Llandysul: Gomer, 2001), 144; my trans.

(Neither Marx nor Engels, nor Lenin either, belonged to the proletariat. They were bourgeois thinkers, and the secular ideas that Engels spread among the workers were the bourgeois ideas of the eighteenth century ... I realized that capitalists and Communists shared one thing in common—self-interest.)[50]

Religion, for Gwenallt, was an oppositional force which, combined with the Welsh language, formed the bedrock of a cultural nationalism capable of resisting the spread of 'external' linguistic and political influences.

This religious view informed a belief in the salvationist power of the Welsh language. In Gwenallt's first novel, *Plasau'r Brenin* ('The King's Palaces', 1934), based on his own experiences as a jailed conscientious objector in Wormwood Scrubs and then in Dartmoor during the First World War, Myrddin Tomos retains his sense of individuality in a dehumanizing environment by reading his Welsh Bible.

Llawenydd i'w glustiau a hyfrydwch i'w galon oedd gwrando ar Gymraeg y Beibl yn ei gell, iaith y gorffennol pell, iaith yr haul a'r awelon, iaith yr ehangder a iaith rhyddid.

(Listening, in his cell, to the Welsh of the Bible was happiness to his ears and beauty to his heart—the language of the distant past, the language of the sun and the breeze, the language of open spaces and the language of freedom.)[51]

Myrddin soon begins to lose his grasp of reality, but fragments of hymns, poems, biblical passages, and vernacular phrases allow the memories of a previous life that refused to be forgotten to penetrate the 'nothingness' of the four walls.[52] If language is the vehicle for salvation for the individual in jail, it is also the vehicle for social and national salvation in Gwenallt's thought, where, as in Victorian Celticism, the ancient Welsh language carries an alternative set of values to those of English industrial civilization. Welsh is the language of 'ehangder' ('open spaces') and 'rhyddid' ('freedom'), whereas English is 'iaith fasnachol y ddaear hon' ('the language of finance on this earth').[53]

But Gwenallt's attitude towards language in his poetry is more complex and contradictory than this reconstruction of his thought suggests. This dimension of his work can be brought into focus by comparing his use of a proletarian vernacular with that of Idris Davies. In a famous stanza from *The Angry Summer*, Idris Davies greets Dai the miner:

> And what will you do for your butter, Dai,
> And your bread and your cheese and your fags,
> And how will you pay for a dress for the wife,
> And shall your children go in rags?[54]

[50] D. Gwenallt Jones, 'Credaf', in *Gwenallt: Bardd Crefyddol*, ed. J. E. Meredith (Llandysul: Gwasg Gomer, 1974), 66–7; my trans.

[51] D. Gwenallt Jones, *Plasau'r Brenin* (Llandysul: Gomer, 1976), 83; my trans.

[52] Ibid. 110.

[53] Ibid. 83; Gwenallt, 'Jesebel ac Elias', in *Casgliad Cyflawn*, 242.

[54] Davies, *The Complete Poems*, 23.

As Dafydd Johnston has noted, the poet speaks to the miner on equal terms and is a part of the community being described.[55] The voice of Gwenallt's apocalyptic poem of the depression 'Ar Gyfeiliorn' ('Unmoored', or 'Lost') is strikingly different:

> Dynion yn y Deheudir heb ddiod na bwyd na ffag,
> A balchder eu bro dan domennydd ysgrap, ysindrins, yslag.
>
> (Men in the South without drink or food or a fag,
> And their pride of place buried beneath mounds of scrap, cinders, slag.)[56]

While Idris Davies's sympathy for a proletarian world of 'bread and cheese and fags' is coupled harmoniously, at the level of language and form, with a celebration of working-class politics and cultural activities made possible by modernity, Gwenallt, while also sympathetic to working-class lives, sees the worker as the victim of inhuman social forces which are also contributing to the destruction of a valuable Welsh-language culture. Gwenallt's use of 'ffag' carries a critical charge which establishes a distance between the poetic voice and the poem's subject matter. There is, therefore, an uneasy and revealing tension in Gwenallt's writing between his conservationist nationalist politics and the achievement of his poetics. Politically, he deplores the way in which the Welsh landscape has been ravaged by industrialization, and seeks to curb the forces of Anglicization, but the linguistic power offered by Cymricized English words such as 'ysgrap, ysindrins, yslag' ('scrap, cinders, slag') suggests that the poet relishes the revivifying, direct impact of the words used by an industrial Welsh-speaking proletariat. These are the very words that linguistic purists, such as Saunders Lewis, would wish to purge from the language. At the level of content, Gwenallt deplores the dilution of an idealized Welshness, but his poetry revels in the linguistic juxtapositions made possible by the inherent hybridity of Welsh industrial society. If Idris Davies's *Gwalia Deserta* transforms the high modernism of Eliot's *The Waste Land* into a poetic sequence which speaks to the miner in his own vernacular, Gwenallt's poetry, in its juxtapositions of speech registers and images, consistently draws us back to language itself.

FOLK: MARGIAD EVANS AND KATE ROBERTS

Gwenallt and Idris Davies based their art on the experiences of the very proletariat that had been so reviled by Saunders Lewis. A third distinctive strain of Welsh modernism followed a similar trajectory in rooting itself in the experiences of the *gwerin* that had been ridiculed by Caradoc Evans. This modernist 'return to the folk'

[55] Dafydd Johnston, 'Dwy Lenyddiaeth Cymru yn y Tridegau', in John Rowlands (ed.), *Sglefrio ar Eiriau* (Llandysul: Gomer, 1992), 55–6.
[56] Gwenallt, *Casgliad Cyflawn*, 72; my trans.

did not directly replicate the paeans to the *gwerin* characteristic of much nineteenth-century writing however, for it could be aligned with other political and cultural forces, such as an emergent feminist consciousness. If, for Freud, civilization was based on the suppression of instinct, modernist writers were attracted to those aspects of human experience that had been suppressed. The search for the primitive and the exploration of female experience thus emerge as being among the most central, and widely discussed, themes of modernist art. In the writings of Kate Roberts and Margiad Evans, these themes converge with a meditation upon language itself, for the Welsh language in their writings is viewed, simultaneously, as having been repressed, and as offering a vehicle for the expression of repressed experiences.

Margiad Evans's *Country Dance* (1932) may be conceived of as a novelistic 'act of recovery of women's lost history' at both a thematic and a formal level; although the central character, a mid-nineteenth-century farmer's daughter, is eventually 'silenced by her death, her voice remains' in the form of the diary that constitutes the novel.[57] Initially, the diary is written in response to her male suitor's desire to control and observe her thoughts, but Ann Goodman soon decides that 'it is mine now'.[58] If questions of agency and authorship are central to the novel, they can also be related to Margiad Evans's own life and authorial identity. Born Peggy Whistler, in Uxbridge, London, she published her first novel under a pseudonym made up from the surname of her paternal grandmother and the North Walian version of her own name (Peggy/Margaret). The adoption of a 'Celtic' authorial persona reflects the perseverance of the Arnoldian concept of the poetic, feminine 'Celt', given a new lease of life by the neo-Romanticism of the 1930s, but it seems to have been more than a fashionable gesture for Evans. While Stephen Knight views Evans as a writer who was 'Welsh by choice', Evans noted in a revealing letter to Gwyn Jones:

And I'm *not* Welsh: I never posed as Welsh and it rather annoys me when R[obert] H[erring] advertises me among the Welsh short stories because I am the border—a very different thing. The English side of the border too; I don't speak fretfully: you know how I honour the Welsh writers and how hospitable they have been to me.[59]

Margiad Evans's own name thus reflects her own awareness of the 'liminality of her situation'.[60]

Country Dance can be read as an exploration of the borders between identities, as portrayed with particular force in the opening of the novel's second section where Ann describes her mother's death:

I take my father his tea in the bottom meadow, where he is loading hay with the rest: when I come back there is my mother on the floor beside her bed, gasping for breath.
 'What is it? What have you?' I cry, running to her.

[57] Ceridwen Lloyd-Morgan's phrase in *Margiad Evans* (Bridgend: Seren, 1998), 28.

[58] Margiad Evans, *Country Dance* (Cardigan: Parthian, 2006), 24.

[59] Knight, *A Hundred Years of Fiction*, 49; Evans, 'Letter to Gwyn Jones', 6 Mar. 1946, quoted in Lloyd-Morgan, *Margiad Evans*, 32. Robert Herring was the editor of *Life and Letters To-Day.*

[60] This is Tony Brown's phrase in '"Stories from Foreign Countries": The Short Stories of Kate Roberts and Margiad Evans', in Rothkirch and Williams (eds), *Beyond the Difference*, 24.

'My heart!' she answers.

I lift her up in my arms and lay her on the bed. Her face is grey like ashes and damp with sweat; every minute her breath comes shorter, every minute it seems to me that she must die under my hands.

'Mae arnafeisian gweld John,' she gasps. 'I want to see John.' She has fallen into her own tongue, that she has not spoken since she was married. . . .

'She is asking for you, Father.'

'Myfanwy, Myfanwy, I am here. Speak to her, Ann! Can't you? Speak her own tongue!'

'Father is here,' I tells her.

She grasps my wrists.

'Oh, be quick, Ann dear, be quick, I am dying.'

'He is here,' I cry over and over.

At last I tells my father to say:

'Rwaf yma wrtheich ymyl.'

He tries, word for word, after me, and she smiles as best she can. . . .

There is nothing we can do to hinder her, but she is still alive when the doctor comes into the room. He looks at her once, and a minute after we see that she is dead.[61]

The narrating daughter is a cultural mediator in this scene. She can speak and understand the Welsh that her mother 'has not spoken since she was married', and can thus translate her dying mother's words to her monolingual English father. The mother's last gesture is to smile 'as best she can' (whether ruefully or with pleasure is not clear) at the father's belated attempt at speaking her own language, and the whole passage meditates self-reflexively on the problems inherent in representing the Welsh female's experience through the medium of English. The Welsh language (printed with some revealing spelling errors) is the realm of the female, of unuttered and unutterable feelings repressed by marriage, while the English language belongs to the patriarchal realm of the husband and doctor. Although this draws on a Victorian tradition of equating Celticism with femininity, Ann's position in the novel can be seen to mirror that of Margiad Evans the novelist.

As a bilingual inhabitant of the Wales–England border, Ann is culturally situated to understand and express the whole range of languages and social dialects in her vicinity and to place them in dialogue with each other. That Margiad Evans may be seen to occupy a similar position to her fictional creation may be suggested by focusing on the understatement that characterizes her prose style, making *Country Dance* reminiscent of other modernist attempts at stripping sentences down to their basic constituents, as in Hemingway's short stories. Delmore Schwarz suggested that Hemingway's 'reticence' and his 'intensely emotional understatement' partly derived from 'the simplified speech which an American uses to a European ignorant of English' in the context of an ethnically diverse and multilingual America.[62] There may be some legitimacy in suggesting that Evans's style derives from the language an

[61] Evans, *Country Dance*, 41–3.
[62] Delmore Schwartz, 'The Fiction of Ernest Hemingway', in *Selected Essays of Delmore Schwartz*, ed. Donald Dike and David Zucker (Chicago: University of Chicago Press, 1970), 259. See Werner Sollors's discussion in *Ethnic Modernism* (Cambridge, Mass.: Harvard University Press, 2008), 128.

English person would use when communicating with monolingual Welsh speakers. Evans had stayed for some weeks in the summer of 1930 in the village of Pontllyfni in north-west Wales, an area with a high concentration of monolingual Welsh speakers at that time. She was to note later that 'I know not one word of Welsh (now) and very little of Wales, but I have never forgotten the fact that thousands of men and women and little children speak nothing else.'[63] If the writers discussed so far tend to view the Welsh- and English-language cultures of Wales as being in a state of conflict, Margiad Evans can be seen to engender a process of linguistic dialogue in *Country Dance*. By giving her main character a familiarity with the dominant and multiple subdominant discourses of the novel's ethnically divided and gendered society, Evans seems to equip Ann Goodman with the burden and the gift of speaking in tongues.

The tension between languages, enacted within a claustrophobic domestic setting in *Country Dance*, takes on a broader political significance in Kate Roberts's *Traed Mewn Cyffion* ('Feet in Chains', 1937). Roberts, born and brought up in the wholly Welsh-speaking quarrying village of Rhosgadfan, near Caernarfon, was a member of the Independent Labour Party in her youth, before becoming an active member of Plaid Cymru and the leader of its women's section. If Katherine Mansfield's example informed Roberts's narrow focus on the areas of Wales that she knew and, along with Chekhov, inspired her concentration on the short story as the primary vehicle for her art, Roberts's writings are also shot through with a Welsh speaker's awareness of an ethnic difference rooted in language.[64] This is powerfully evident in one of the final scenes of *Traed Mewn Cyffion* where Jane Gruffydd receives a letter informing her of the death of her son Twm in the First World War.

Rhyw bapurau Saesneg oedd y rhai hyn. Gwelodd enw Twm a'i rif yn y fyddin, ac yr oedd papur gwyn arall tew a dim ond tamaid bach ar hwnnw yn Saesneg.

Rhedodd â'r llythyr i'r siop.

'Rhyw hen lythyr Saesneg wedi dwad acw, Rhisiart Huws. Fasach chi ddim yn dweud beth ydi o? Rhywbeth ynghylch Twm ydi o, beth bynnag.'

Darllenodd y siopwr ef, a daliodd ef yn ei law sbel.

'Steddwch i lawr, Jane Gruffydd,' meddai'n dyner.

'Be sy?' meddai hithau. 'Does dim wedi digwydd?'

'Oes, mae arna i ofn,' meddai yntau.

'Ydi o'n fyw?'

'Nag ydi, mae arna i ofn.'

(These were sheets of paper, written in English. She saw Twm's name, and his army number, and there was another sheet of thick white paper with only a few words on it in English.

She ran the letter to the shop.

'Some letter in English has come here, Richard Hughes. Will you tell me what it is? Something to do with Twm, anyhow.'

The shopkeeper read it, and held it in his hand for a while.

'Sit down, Jane Gruffydd,' he said gently.

[63] Quoted in Brown, 'Stories from Foreign Countries', 22.

[64] Kate Roberts, 'Tsiechoff yn Gymraeg', *Y Faner*, 29 (Sept. 1954), 1, and 'Gwilym Rees Hughes yn Holi Kate Roberts', *Barn*, 139 (May 1974), 282.

'What is it?' she said. 'Has anything happened?'
'Yes, I'm afraid so,' he replied.
'Is he alive?'
'No, I'm afraid not.')[65]

If, as many have argued, the greatest test for the hegemonic power of a state is posed by its colonial subjects, then *Traed Mewn Cyffion* dramatizes the consequences of a situation, experienced by many minorities in the age of modernism, in which the 'state' is a foreign import, expressing itself in a different language. The reader is forced back yet again to language, and a linguistic sense of difference leads to a new consciousness among the inhabitants of north-west Wales, which Roberts conveys by shifting the narrative from the minds and thoughts of individuals to those of 'the people':

A dechreuodd y bobl oedd gartref eu holi eu hunain a holi ei gilydd beth oedd ystyr peth fel hyn.... Gwelsant ladd eu cyfeillion a'u plant wrth eu gwaith, ond ni welsant erioed fyned â'u plant oddi wrthynt i'w lladd mewn rhyfel.... Ni chredent o gwbl erbyn hyn mai achub cam gwledydd bychain oedd amcan y Rhyfel, ac mai rhyfel i orffen rhyfel ydoedd, ac ni chredent chwaith fod bai ar un wlad mwy na'r llall, ond daethant i gredu bod pobl ym mhob gwlad oedd yn dda ganddynt ryfel, a'u bod yn defnyddio eu bechgyn hwy i'w mantais eu hunain.

(Those people who were at home began to ask themselves and others what was the meaning of it all.... They had seen their friends and sons killed at work, but they had never seen their children being taken away from them to be killed in war.... They did not believe at all now that the war was being fought to save the smaller nations, or that it was a war to end all wars; neither did they believe that one nation was to blame more than another. They came to believe that in every country, there were people who regarded war as a good thing, and were taking advantage of their sons to promote their own interests.)[66]

The minority status of the Welsh is the basis for reaching outwards towards the experiences of other 'small' and increasingly disillusioned peoples. Roberts lost one of her own brothers in the First World War, and in a letter to Margiad Evans described her stories as 'the ripples of very great tragedies'.[67]

The 'ripples' of history can be traced in the conciseness of Roberts's writing and in the suppression of direct emotional description. While some have traced this to the influence of Mansfield, and described it in terms of Hemingway's use of understatement, Roberts suggested that it 'is not me, it is the Welsh language. A Welsh sentence, though difficult in its idiom, is simple and straightforward.'[68] The Welsh modernist's heightened awareness of language manifests itself in Roberts's response to H. E. Bates's review of a volume of her translated short stories. Bates commented positively on the stories but expressed bafflement at the 'political compulsion from Caernarvon to reject English'. Roberts responded that 'It is the compulsion of

[65] Kate Roberts, *Traed Mewn Cyffion* (1936; Llandysul: Gomer, 1988), 176–7; trans. John Idris Jones as *Feet in Chains* (1977; Ruthin: John Jones, 1996), 122.

[66] Roberts, *Traed Mewn Cyffion*, 172–3; *Feet in Chains*, 119–20, 154–5.

[67] Quoted in Brown, 'Stories from Foreign Countries', 25.

[68] See e.g. Ned Thomas, *The Welsh Extremist* (Talybont: Y Lolfa, 1991), 78. Roberts is quoted in John Harris, 'Kate Roberts in Translation', *Planet: The Welsh Internationalist*, 29 (June–July 1991), 28–9.

necessity. Welsh is my only medium.'[69] She would later express misgivings about the metropolitan reception of her work and would comment revealingly, in a letter to Margiad Evans, that Bates's review 'makes me think how often stories from foreign countries have been misinterpreted by English critics'.[70] Caradoc Evans used the English language to represent his native Wales as a 'foreign country' to be lampooned and condemned for its backwardness and narrow-mindedness; Margiad Evans's awareness of suppression at the levels of gender and language results in a depiction of the border country which, while emphasizing its 'otherness', respects and explores the play of cultural differences. In *Traed Mewn Cyffion* the ethnographic gaze is reversed as the 'foreign' British state becomes the source of a disruptive otherness.

CONCLUSION

If some writers sought to make a distinctively Welsh contribution to the enrichment of English literature by turning to the voices of the proletariat and the peasantry, while others struggled to stem the English language's corrupting influence on an indigenous culture, then there was another alternative, forged most notably by Dylan Thomas, in his early collections *18 Poems* (1934) and *25 Poems* (1936). Here the non-Welsh-speaking son of Welsh-speaking parents deployed English with such an original virtuosity that it seemed to be tearing the language apart. In 1952 Thomas reviewed the Nigerian novelist Amos Tutuola's *The Palm-Wine Drinkard* by way of a spirited synopsis that was reminiscent of Thomas's own poetry and prose: the awareness of sinister forces let loose in a nightmarish world of 'dubiously alive' creatures; the subversion of childhood innocence as 'the child turned out to be abnormal, a pyromaniac, a smasher to death of domestic animals, and a bigger drinkard than his father'; the representation of surreal events as the wife bears 'a child from her thumb'.[71] Chinua Achebe's notion that Thomas's review was the product of one 'blithe spirit' spontaneously recognizing another may be supplemented by an awareness of the fact that Thomas had himself successfully negotiated the shift from a Welsh periphery to the centre of Anglo-American literary production, and may therefore have been encouraging another writer—writing in what he revealingly describes as 'young English'—to follow his lead.[72] If the fact that the fractured,

[69] Bates and Roberts, quoted in Harris, 'Kate Roberts in Translation', 27.
[70] Quoted in Tony Brown, 'Stories from Foreign Countries', 21.
[71] Dylan Thomas, 'Blithe Spirits', *The Observer*, 6 July 1952; repr. in *New Welsh Review*, 60 (Summer 2003), 11.
[72] Chinua Achebe, *Home and Exile* (Oxford: Oxford University Press, 2000), 56; Thomas, 'Blithe Spirits', 11.

bilingual modernism of Wales was voiced in two languages contributes to its invisibility within the stubbornly monolingual milieu of Anglo-American literary criticism, this may yet prove to be its most internationally salient characteristic. For as the twentieth century progressed, Wales was far from unique in witnessing, simultaneously, a struggle to maintain an indigenous literary tradition, and the forging of a distinctive literature in English.

CENTRAL EUROPEAN MODERNISMS

TIMOTHY O. BENSON

AMBIGUITY AND PARADOX

NOWHERE were the geographical dimensions of modernism—notions of boundary, place, centre, and periphery—more contingent or ambiguous than in central Europe.[1] Even this terminology has been contested since a German politician used the term 'Mitteleuropa' in 1915 to suggest that the Germanic culture of Prussia and Austria-Hungary should remain dominant after the First World War.[2] While this region is where the great Latin and Greek cultures intermingled over the centuries,[3] it was perceived as exotic during the Orientalism of the eighteenth century. As the

[1] I am grateful to Éva Forgács and Michael Henry Heim for their suggestions. Accessible surveys in the visual arts include Elizabeth Clegg, *Art, Design, and Architecture in Central Europe, 1890–1920* (New Haven: Yale University Press, 2006); Steven A. Mansbach, *Modern Art in Eastern Europe: From the Baltic to the Balkans, ca.1890–1939* (Cambridge: Cambridge University Press, 1998); and Timothy O. Benson (ed.), *Central European Avant-Gardes: Exchange and Transformation, 1910–1930*, exh. cat. (Cambridge, Mass.: MIT Press; Los Angeles: Los Angeles County Museum of Art, 2002).

[2] Friedrich Naumann, *Mitteleuropa* (Berlin: Reimer Verlag, 1915). On earlier uses of the term 'central Europe', see Jacques Droz, *L'Europe centrale: Évolution historique de l'idée de 'Mitteleuropa'* (Paris: Payot, 1960), and Marcel Cornis-Pope and John Neubauer, *Towards a History of the Literary Cultures in East-Central Europe: Theoretical Reflections* (New York: American Council of Learned Societies, 2002).

[3] Andrzej Turowski, *Existe-t-il un art de l'Europe de l'Est? Utopie & idéologie* (Paris: Éditions de la Villette, 1986), 13–18.

Enlightenment progressed, Europe's eastern ranges were both excluded and included in the Western concept of Europe, which came to be defined by notions of 'nation' or 'progress'.[4] In western Europe, *state* (as a political–administrative formation) and *nation* (a broader social concept including ethnicity) evolved more or less in tandem through the social and economic revolutions of the nineteenth century.[5] Eastern Europe remained agrarian, and only gradually industrialized with local political entities controlled by the nobility. National affairs were governed by the Habsburg and Romanov dynasties, reigning over huge multinational empires of immense cultural diversity. National awakenings in the West led generally to the formation of nation states based on common languages and shared political, religious, and cultural beliefs; but in the East boundaries between ethnic and linguistic groups, cultural heritage, or religious and political identification were less consistent. German-speaking Catholics in the north might feel themselves closer to Catholic southern Europe—the Czech lands, Hungary, Croatia, and Italy—than to the Prussian Protestants of their linguistic group. Intellectuals in Budapest might feel more sympathy with their counterparts in cafés in Vienna, Berlin, and even Paris than to their agrarian countrymen.

The arts were deeply affected by the different paths taken by national awakenings. Given that east European nationalism did not produce the social, economic, and political advances fostered by Western nationalist movements,[6] it is not surprising that the utopian expectation typical of Western modernisms—that provocative acts in the present might lead directly to more perfect conditions for humanity in the future—was less prevalent in the East. Indeed, it has been suggested that it was a disbelief in 'absolute progress' in art as a formal language that most distinguished the central European avant-garde from its west European counterparts,[7] a scepticism that may account for the melancholy ambivalence so often ascribed to central European intellectuals. This disparity lingered even when the Romanov, Hohenzollern, Habsburg, and Ottoman empires disintegrated during and after the First World War and the modern nation states came into existence around burgeoning capitalist metropolises whose alienating anonymities were so well described by social critics like Georg Simmel (Berlin) and Georg (György) Lukács (Budapest) and writers like Franz Kafka (Prague) and Robert Musil (Vienna).

Yet the promise of modernism in central Europe was arguably unsurpassed, especially in an ambitious and unprecedented project of International Constructivism in the early 1920s in literature, the visual arts, and architecture (with variants in Berlin, Bucharest, Ljubljana, Vienna, Warsaw, Zagreb, at the Bauhaus, and in the

[4] Larry Wolff, *Inventing Eastern Europe: The Map of Civilization on the Mind of the Enlightenment* (Stanford, Calif.: Stanford University Press, 1994), 6–9.

[5] Peter F. Sugar, 'External and Domestic Roots of Eastern European Nationalism', in Peter F. Sugar and Ivo J. Lederer (eds), *Nationalism in Eastern Europe* (Seattle: University of Washington Press, 1969), 6–7.

[6] Ibid. 9.

[7] Tomasz Gryglewicz, *Malarstwo Europy Srodkowej, 1900–1914: Tendencje modernistyczne i wczesnoawangardowe* ('Painting in Middle Europe, 1900–1914: Modern and Early Avant-Garde Tendencies'; Cracow: Nakadem Uniwersytetu Jagiellońskiego, 1992), German summary, 107.

functionalist architecture and design of the Czech lands). This was matched in the realm of literature by the Poetism of Prague's Devětsil group of artists and writers and in the realm of language by the Prague Linguistic Circle around Roman Jakobson, Vilém Mathesius, and Nikolai Trubetzkoy.[8]

It is paradoxical that these ambitions for a universal culture contrasted so greatly with the reality of central Europe. Clearly the Marxist political ideology promoted by the Comintern in Russia prompted some of the hopes for a modernism of universal or at least pan-European dimensions based on technological advances and a belief in progress. Yet historians today must be wary of any claims of cultural homogenization or universal modernism in so diverse a social geography. We should rather look for events (such as exhibitions, congresses, literary soirées, etc.) and situations (such as artists' and writers' groups) that, in their blending of local and cosmopolitan meanings, may have a 'transnational' character.[9]

MODERNISMS OF EXCHANGE

The cultural geography of central Europe can be considered as myriad exchange events and situations across a 'field of cultural production',[10] with unique meanings generated in each immediate locale, resulting in a plurality of modernisms. This exchange was sustained by exhibitions, artists' associations, collectors, literary and artistic reviews, attendant manifestos, proclamations, and public disputes—all forming various 'sites' from which meaning must be wrested episodically, as contingent upon a complex web of 'cultural transfer' involving reception, behaviour, utilization, and processes of reification such as collective memory.[11] National cultures can thus be understood as intertwined with one another, rather than substantively opposed to one another, as they continually evolved their respective national identities. Moreover, in broad swaths of central Europe much of this discourse took place in German, not only as the language of the military command and bureaucratic officialdom of the Habsburg Empire, but also as the lingua franca between cosmopolitan centres,

[8] Jindřich Toman, *The Magic of a Common Language: Jakobson, Mathesius, Trubetzkoy, and the Prague Linguistic Circle* (Cambridge, Mass.: MIT Press, 1995).

[9] Andreas Huyssen, 'Geographies of Modernism in a Globalizing World', in Peter Brooker and Andrew Thacker (eds), *Geographies of Modernism: Literatures, Cultures, Spaces* (London: Routledge, 2005), 6–10.

[10] Pierre Bourdieu, *The Field of Cultural Production: Essays on Art and Literature*, ed. Randal Johnson, trans. Richard Nice (Cambridge: Cambridge University Press, 1993).

[11] Michael Espagne and Michael Werner (eds), *Transferts: Les relations interculturelles dans l'espace franco-allemand (XVIIIe–XIXe siècles)* (Paris: Éditions Recherche sur les Civilisations, 1988). Cf. Katharina Middell and Mathias Middell, 'Forschungen zum Kulturtransfer: Frankreich und Deutschland', in *Grenzgänge: Beiträge zu einer modernen Romanistik*, i/2 (Leipzig: Leipziger Universität Verlag, 1994), 107–22.

where artists, architects, composers, actors, as well as poets, playwrights, critics, and other literati coalesced into small and enthusiastic groups in cafés, galleries, literary salons, and ateliers, as well as in schools and art colonies. Yearning for the cutting edge, the participants travelled between Berlin, Budapest, Munich, Prague, Vienna, and Warsaw (each a cultural capital in its own right with a long heritage of both established 'official' culture and artistic innovation), and sojourned in Paris and Moscow—all with an effortlessness made possible by the rail network created during the late nineteenth century by the influx of Western capital.[12]

Accordingly there was a continual creative tension between the cosmopolitan ambience and the diversity of locales whose rich cultural heritage dated back to medieval tribal migrations and had been recognized by Johann Gottfried von Herder, celebrated by such influential minds as Wagner and Nietzsche, explored ethnographically by the Brothers Grimm, investigated musicologically by Johannes Brahms, Béla Bartók, and Zoltán Kodály, who incorporated folk melodies in modern compositions, linked to colloquial Moravian speech rhythms by Leoš Janáček, and tied to modernist abstraction by Wassily Kandinsky in his use of shamanistic drumhead patterns. Modernism arose as writers like the Hungarian János Arany, the Pole Henryk Sienkiewicz, and the Czech Alois Jiráček, who had revived national sources, yielded to advances inspired by the French Symbolists. Hungarian writers rallied around Endre Ady to found the monthly *Nyugat* ('West') in 1908. The Polish Symbolist Stanisław Przybyszewski expressed Polish national identity through cosmopolitan literary trends, bringing such writers as Zenon Przesmycki, Władysław Reymont, and Lucjan Rydel to his periodical *Życie* ('Life'), which also published works by Baudelaire, Strindberg, Ibsen, and Mallarmé. The Czech *Moderní Revue* ('Modern Review'), founded by the Decadent poet Jiří Karásek ze Lvovic, performed an analogous role for Czech literature. Formations were found throughout central Europe around the turn of the century where cosmopolitan Symbolism encountered regional traditions, often under the aegis of some evocation of the concept 'modern': Młoda Polska (Young Poland), Česka moderna (Czech modernism), Hrvatska moderna (Croatian modernism), Slovacka moderna (Slovak modernism)—appearing and developing (if not in precise synchrony) between about 1890 and 1914.[13] In the visual and decorative arts the *fin-de-siècle* intertwining of Naturalism and Symbolism led to secessionist movements throughout eastern and western Europe: among them the Vienna Secession, the Czech Secese at the Municipal House on the Náměstí Republiky and exhibited at the Mánes Union (the main artists' association in Prague), Budapest's Nemzeti Szalon, Bucharest's Arta 1900 group, and Cracow's Sztuka (Art) group—all cognates of the Munich Secession and Art Nouveau in

[12] Ivan T. Berend, *Decades of Crisis: Central and Eastern Europe Before World War II* (Berkeley: University of California Press, 2001), 13–14.
[13] For a brief comparative overview, see Ludmilla Charguina, 'The Typology of Symbolism in Central and Eastern Europe', in Béla Köpeczi and György M. Vajda (eds), *Actes du VIIIe Congrès de l'Association Internationale de Littérature Comparée* (Proceedings of the 8th Congress of the International Comparative Literature Association) (Stuttgart: Kunst und Wissen, Erich Bieber, 1980), 545–50.

Paris.[14] Yet regional differentiation was still expressed more as national identity than as modernist formal innovation.

The avant-garde that would break new artistic ground in central Europe took Art Nouveau, Impressionism, and Symbolism for granted as their starting point. In Bucharest the Romanian avant-garde's ambivalent attitude towards Symbolism was seen in *Simbolul* ('Symbol') the internationally significant literary periodical founded in 1912 by future Zurich Dadaists writer Tristan Tzara and artist Marcel Janco (with backing from Janco's wealthy parents) while still students at the Gheorghe Lazăr lyceum. Tzara (born Samy Rosenstock) had come from Moneşti, a modest Romanian town with a vital Yiddish culture and regional traditions, and his early sentimental, melancholic poetry was being transformed under the influence of leading Symbolist poets published in *Simbolul* including Alexandru Macedonski and Ion Minulescu,[15] just as later he would combine some aspects of Yiddish culture with Futurism and Expressionism in Zurich Dada. The nationalism of much Romanian Symbolism was being surpassed by an unprecedented absurdism in such periodicals as *Chemarea*, to which Tzara also contributed and which signalled a break with the past by declaring itself 'a question addressed to all'.[16] It featured the reigning absurdist Urmuz (Demetru Demetrescu-Buzău), who inspired the generation of Tzara and Janco, much as masters of the German grotesque like the Polish Jewish Mynona (Salomo Friedländer) would do for German Dada and artist–writers like Vienna-born Berlin-based Raoul Hausmann. In Prague Franz Kafka, one of many German-speaking Czech Jews who mediated between Czech and German culture, occupied a 'middle ground' between German liberals (exponents of *völkisch* Bohemian Germandom) and Czech Bohemia.[17] These writers followed their chosen ideological objectives: for Egon Erwin Kisch and Rudolf Fuchs it was socialism, for Max Brod it was Zionism, for Franz Werfel it was a Christian or Expressionist revolution. In a city with separate cultural infrastructures (theatres, universities, etc.) for Czech and German constituents, true interaction and collaboration was relatively rare. An exception was the artists' group Osma (Eight), founded in 1907 by four Czechs (Emil Filla, Antonín Procházka, Bohumil Kubišta, Otakar Kubín) and four ethnic Germans (Willi Nowak, Friedrich Feigl, Max Horb, Amil-Arthur Pittermann-Longen). The sensibility of this generation had been defined by the 1905 Edvard Munch exhibition at the Mánes Union in Prague. The influence of Munch's acrid representations of psychological alienation is immediately apparent in Filla's *Reader of Dostoevsky* (1907, National Gallery, Prague) and Kubišta's *Portrait of Arthur Schopenhauer* (1908, Moravian Gallery, Brno).

[14] Jeremy Howard, *Art Nouveau: International and National Styles in Europe* (Manchester: Manchester University Press, 1991), and Clegg, *Art, Design, and Architecture in Central Europe*, 80–7.
[15] Tom Sandqvist, *Dada East: The Romanians of Cabaret Voltaire* (Cambridge, Mass.: MIT Press, 2006), 74–5.
[16] Ion Vinea, 'Warning', *Chemarea* (4 Oct. 1915); trans. in Timothy O. Benson and Éva Forgács (eds), *Between Worlds: A Sourcebook of Central European Avant-Gardes, 1910–1930* (Cambridge, Mass.: MIT Press; Los Angeles: Los Angeles County Museum of Art, 2002), 138.
[17] Scott Spector, *Prague Territories: National Conflict and Cultural Innovation in Franz Kafka's Fin de Siècle* (Berkeley: University of California Press, 2000), 195–233.

REGIONAL AND TRANSNATIONAL
ARTISTIC IDENTITIES

While the continual interplay between regional and cosmopolitan tendencies rendered meaning as highly contingent and based not infrequently on 'local authenticities',[18] such locales were also defined by widely divergent social formations reflecting how political power was distributed. Whereas the Hungarian Dual Monarchy (established in 1867) gave such Hungarian cultural institutions as the Országos Magyar Képzőművészeti Társulat (Hungarian Fine Art Association) a sovereign status, in the Polish-speaking lands national art produced during the period of *modernizm* (1890–1918) led by artists of the Młoda Polska (Young Poland) movement was inherently subversive of the status quo simply because Poland existed only as an idea. The country had been partitioned in 1795 by Austria, Russia, and Germany, the latter being the most severe of the three in its suppression of the use of the Polish language and indigenous customs. Late nineteenth-century Polish artists derived their content less from the latest international styles they were absorbing from Paris than from national patriotic themes. The inherent contradictions became apparent as two mainstreams evolved to evoke nationalist and internationalist renewals.[19] It has been suggested that Jacek Malczewski's 1894 *Melancholy* (Raczyński Collection, National Museum, Poznań) can be considered 'an allegory of Poland' reinforcing a nationalist ideology that can be regarded as 'a substitute for an independent Polish state'.[20] Yet such a fictive projection may come at a cost: Malczewski renders himself in multiple identities, inside and beyond the painting, and hence embeds within the Symbolist melancholic moment his loss of a unified self and analogously the absence of a Polish state.[21] Malczewski may also be expressing the futility of a national art,[22] thus conveying a deep identity crisis. Such multiple allegiances, felt by the artist as he looked at culture while attempting to exist in culture, were typical for Malczewski's generation.

Among artists who would rise to prominence in the Sztuka (Art) group (founded in 1897) were Wojciech Weiss (*Radiant Sunset*, 1900–2, National Museum, Poznán) and poet–painter Stanisław Wyspiański (*Kazimierz the Great*, pastel design for stained glass window, 1901–2, Muzeum Narodowe, Cracow), who used Naturalist and Symbolist idioms learned in Munich and elsewhere abroad to combine modernism with nationalist themes.[23] The Polish Symbolist poet Stanisław Przybyszewski,

[18] James Clifford, *The Predicament of Culture* (Cambridge, Mass.: Harvard University Press, 1988), 4.
[19] Jan Cavanaugh, *Out Looking In: Early Modern Polish Art, 1890–1918* (Berkeley: University of California Press, 2000), 1–8.
[20] Piotr Piotrowski, 'Identity and Nationalism: Avant-Garde Art and Polish Independence, 1912 to 1922', in Benson (ed.), *Central European Avant-Gardes*, 313.
[21] Ibid.
[22] Cavanaugh, *Out Looking In*, 194.
[23] Ibid. and Mansbach, *Modern Art in Eastern Europe*, 86–96.

a friend of Munch's, helped spread his influence, as well as that of the German Expressionists, among Polish artists. That the relativism felt by these artists was endemic to the modern condition was captured in Nietzsche's rhetorical question and answer 'what, then, is truth? A mobile army of metaphors, metonyms, and anthropomorphisms.'[24] The great independent writer and painter of the next generation of the Polish avant-garde Stanisław Ignacy Witkiewicz showed in his intensely subjective photographic portraits (such as *Anna Oderfeld*, photograph, *c.*1912, Thomas Walter Collection), how such cultural relativism could be fully absorbed into the modern psyche, producing a crisis of identity wherein the self was by necessity conceived as 'fictional'.[25] Subsequent generations of central European artists would have to endure this decentralized identity of 'disintegrated biography'.[26]

EPISODES OF TRANSNATIONAL EXCHANGE

The interchange between cosmopolitan or transnational and local tendencies was never free of contention and conflicts over national identity. Whereas in the decorative arts French Art Nouveau had fairly easily attained international currency, imported styles in the fine arts, most notably Impressionism, were decried in Germany, Hungary, Romania, Poland, and throughout central Europe as 'foreign' by the cultural establishment.[27] Nonetheless, French art from Impressionism through Cubism was regularly exhibited. The first significant, comprehensive introduction of French Impressionism to the German-speaking world was conceived by Richard Muther and Julius Meier-Graefe and presented at the Vienna Secession in 1903. Numerous exhibitions continued during the pre-war years at the Ernst Museum and the Nemzeti Szalon in Budapest, in Prague at the galleries of the Mánes Union, and in many other venues. By around 1906 artistic rebellions were in full swing throughout central Europe. Fauvist influence was already being absorbed by Hungarian artists working in the colony of Nagybánya (now Baia Mare, Romania), hitherto a stronghold of *plein air* painting inflected by the Barbizons and German

[24] Friedrich Nietzsche, 'On Truth and Lie in the Extra-Moral Sense', in *The Portable Nietzsche*, ed. and trans. Walter Kaufmann (New York: Viking, 1954), 46.

[25] James Clifford, 'On Ethnographic Self-Fashioning: Conrad and Malinowski', in Thomas C. Heller, Morton Sosna, and David Wellberg (eds), *Reconstructing Individualism* (Stanford, Calif.: Stanford University Press, 1986), 140–62.

[26] Andrzej Turowski, 'The Phenomenon of Blurring', in Benson (ed.), *Central European Avant-Gardes*, 365.

[27] See Peter Paret, 'Modernism and the "Alien Element in German Art"', in *German Encounters with Modernism: 1840–1945* (New York: Cambridge University Press, 2001), 60–91, and Steven A. Mansbach, 'The Foreignness of Classical Modern Art in Romania', *Art Bulletin*, 80/3 (Sept. 1998), 534–54.

Symbolists. Travel was also crucial for these artists. Béla Czóbel had been to Paris and had exhibited at the Salon d'Automne 'Fauve' exhibition of 1905.[28] Vilmos Csaba Perlrott, Géza Bornemisza, and Róbert Berény were part of Matisse's circle, while also frequenting the Café Dôme and attending the salons at the legendary collection of Gertrude and Leo Stein, and studying art at the Academy Julian, along with József Rippl-Rónai, Sándor Galimberti, and Dezső Czigány. The bright palette of Fauvism, bold simplification of form of Gauguin, structured approach of Cézanne, and harmonious compositions of Matisse were strong influences among members of Nyolcak (Eight), founded in 1909 by Berény, Czóbel, Czigány, Károly Kernstock, Ödön Kárffy, Dezső Orbán, Bertalan Pór, and Lajos Tihanyi. They joined forces with the Galileo Circle of politically radical anarcho-socialist and social democratic students and intellectuals. Their work was also appreciated by the Sunday Circle of intellectuals (including Lukács, Béla Balázs, Károly (Karl) Mannheim, Frigyes (Frederick) Antal, Arnold Hauser, Anna Lesznai), and their exhibitions were often supported by the literary matinees of Ady, Gyula Juhász, and Ákos Dutka. Among the most progressive and talented artists of Nyolcak was Lajos Tihanyi, who would absorb and transform influences ranging from Expressionism to Cubism and Futurism and, like János Kmetty (also interested in Cubism), would pursue these interests as members of the Activists, formed in 1913.

In Prague a similar departure from Fauvist-inflected tendencies in favour of Cubism took place in the transition from Osma—the Czech counterpart to the Hungarian Nyolcak—to Skupina (Skupina výtvarných umělců, Visual Artist Group). Skupina was largely integrated in European modernism at large and cultivated artists from abroad whom its members regarded 'not as the apex and unattainable model, but . . . [as] colleagues of a common endeavour . . . involving all the progressive forces of Europe'.[29] Skupina included German Expressionism and French Cubism in its own exhibitions and reproduced and discussed these trends in its periodical *Umělecký měsíčník* ('Art Monthly'). Exhibited at the second Skupina exhibition in Prague in 1912, Emil Filla's *Head* (bronze, 1913, Los Angeles County Museum of Art), while indebted to Picasso and Braque, also showed affinities in its broad fractured forms with Expressionist works on view in the exhibition including Karl Schmidt-Rottluff's *Dahlias in Vase* (1912, Kunsthalle Bielefeld).[30] Living in a city that had produced Kafka and Rainer Maria Rilke, many Prague artists felt a close affinity with the metaphysical themes of Expressionism and its visionary

[28] Krisztina Passuth, 'Wild Beasts of Hungary Meet Fauves in France', in *Hungarian Fauves from Paris to Nagybánya, 1904–1914*, exh. cat. (Budapest: Hungarian National Gallery, 2006), 14.

[29] Václav Vilém Štech, 'Introduction', in *II. Výstava Skupiny Výtvarných Umelcu* (Prague: Obecní Dum Mesta Prahy, 1912); trans. as 'Introduction to the Second Skupina Exhibition', in Benson and Forgács (eds), *Between Worlds*, 98–9.

[30] For an installation view showing Filla's relief, see Jiri Svestka and Tomáš Vlček (eds), *1909–1925 Kubismus in Prag: Malerei, Skulptur, Kunstgewerbe, Architektur*, exh. cat. (Düsseldorf: Kunstverein für die Rheinlande und Westfalen; Stuttgart: G. Hatje, 1991), 81.

iconography.[31] For example, the cult of the crystal, which had made its potent appearance in Nietzsche's *Zarathustra*, Paul Scheerbart's *Glasarchitectur*,[32] and visionary architect Bruno Taut's early utopian architecture, also predominated in the fantasy architectural sketches of Czech-born Wenzel Hablik,[33] as well as in the works of Skupina members Antonín Procházka, Vlastislav Hofman, and Pavel Janák. Janák developed a new architecture based on 'prism-shaped building units' derived of natural forces,[34] and created a faceted exhibition space for the first Skupina exhibition. Hofman deployed such forms in ceramic objects and in the architectural fantasies he published as woodcuts in the Berlin periodicals *Der Sturm* ('The Storm') and *Die Aktion* ('The Action').

While their colleagues in the applied arts had trained in Vienna or Munich, the painters and sculptors of the Czech Osma and Skupina groups had been drawn to Paris frequently around 1910–12. Gutfreund studied with Antoine Bourdelle, Bohumil Kubišta encountered the work of Braque and Picasso, Josef Čapek studied there, and Otakar Kubín had taken up residence. In addition to Edvard Munch (who exhibited in Prague in 1905), the Skupina artists had been inspired by Paul Cézanne and August Rodin, often exhibited at the Mánes Union and discussed in the pages of Czech periodicals such as *Volné směry* ('Free Directions') and *Umělecký měsíčník*. Czech art historian and collector Vincenc Kramář (a student of Alois Riegl) had contacts with Daniel Henry Kahnweiler and Picasso in Paris that helped build a magnificent collection of French Cubism in Prague which the group drew upon for their own exhibitions.[35] Yet local traditions lingered—the Bohemian baroque is essential to the understanding of not only Czech 'Cubist' architecture,[36] but also the troubled visage and churning drapery of Gutfreund's bronze *Anxiety* (1911, Národní Galerie, Prague).[37] Like Gutfreund's expressive figures, Kubišta's melancholic faces (*Epileptic Woman*, 1911, Moravská Galerie, Brno) convey emotional states of

[31] Hana Rousová, *Deviace kubismu v Čechách/Deviationen des Kubismus in Böhmen*, exh. cat. (Cheb: Staatsgalerie der bildende Künste, 1995), and Stephan von Wiese, 'Metaphysisches Beefsteak? Zur Kubismus-Rezeption des Expressionismus', in Svestka and Vlček (eds), *1909–1925 Kubismus in Prag*, 38–43.

[32] Paul Scheerbart, *Glasarchitektur* (Berlin: Verlag Der Sturm, 1914).

[33] Timothy O. Benson (ed.), *Expressionist Utopias: Paradise, Metropolis, Architectural Fantasy*, exh. cat. (Seattle: University of Washington Press; Los Angeles: Los Angeles County Museum of Art, 1993), 193–6.

[34] Pavel Janák, 'Hranol a pyramida', *Umělecký měsíčník*, 1 (1911–12), 162–70; trans. as 'The Prism and the Pyramid', in Benson and Forgács (eds), *Between Worlds*, 86–91. On these architects' theories, see Rostislav Švácha, 'Die Kunstauffassungen der Architekten', in Svestka and Vlček (eds), *1909–1925 Kubismus in Prag*, 202–11, and Rostislav Švácha, *The Architecture of New Prague 1895–1945* (Cambridge, Mass.: MIT Press, 1995), 100–43.

[35] Pavla Sadílková, 'The Beginnings of Kramář's Art History Studies', in *Vincenc Kramář: From Old Masters to Picasso*, exh. cat. (Prague: National Gallery, 2000), 124–8.

[36] Alena Janatková, *Barockrezeption zwischen Historismus und Moderne: Die Architekturdiskussion in Prag, 1890–1914* (Zurich: gta Verlag; Berlin: Mann Verlag, 2000).

[37] Tomáš Vlček, 'Art Between Social Crisis and Utopia: The Czech Contribution to the Development of the Avant-Garde Movement in East-Central Europe, 1910–1930', *Art Journal*, 49/1 (Spring 1990), 28–35; Pavel Liška, 'Kubismus und Stil', in Svestka and Vlček (eds), *1909–1925 Kubismus in Prag*, 26–37; and Rousová, *Deviace kubismu v Čechách*.

being and existential anxiety that blend the abstract and the symbolic. Given the complexity of these influences, the application of such terms as Cubist, Expressionist, or Futurist had already become arbitrary in describing the emerging artistic idioms of the increasingly internationalization of Czech art, a movement that had its parallels in the Decadent prose of Julius Zeyer and Karel Hlaváček and Symbolist poetry of Otakar Březina.

By 1912, not only had Italian Futurism, Russian Cubo-Futurism, and Austrian and German Expressionism become well known throughout central Europe, but internationalism (then understood as a combining of distinct nationalist traditions) was becoming part of the ideology of the modernist utopia, at least implicitly, as exemplified in *Der Blaue Reiter* ('The Blue Rider'), the Munich group's almanac, which surveyed and tried to assimilate cultural artefacts from tribal cultures, folk traditions, and Far Eastern cultures, along with pre-modern and contemporary west European cultural production. An international blending of trends was also evident in the 1912 Berlin Neue Sezession exhibition (which included the Czech Skupina artists), the 1912 international Sonderbund exhibition in Cologne (which included artists from Austria, Czechoslovakia, Hungary, France, Switzerland, and Norway), and the 1914 Werkbund exhibition in Cologne (which included Czech designers). Herwarth Walden's Sturm Gallery in Berlin, founded in 1910, steadily propagated international tendencies over the next two decades including Futurism (in exhibitions seen in Berlin and Budapest), Fauvism, Cubism, and Orphism. His groundbreaking *Erster Deutscher Herbstsalon* ('First German Autumn Salon') of 1913 surveyed these tendencies together with recent Russian art (especially in a vein close to Expressionism as seen in Archipenko, David and Wladimir Burliuk, Chagall, Goncharova, and Larionoff) and the Cubist-inflected work of the Skupina group.[38]

By the outbreak of the First World War the avant-garde had become cosmopolitan and pluralistic, with innumerable if often ephemeral centres of development, nearly all blending sophisticated tendencies from abroad with regional traditions and priorities. Yet the various modernisms were not always synchronous. In Poland, for example, artists gained a deep familiarity with Expressionism only in 1913, when German Expressionism was brought for the first time to Poland with an exhibition in Lwów originated by Walden.[39] In Poznań, still part of the German Empire until 1918, Jerzy Hulewicz, Stanisław Kubicki, Stefan Szmaj, August Zamoyski, and others founded the artists' group Bunt (Revolt) in 1917, and they maintained close contacts with Berlin (in part through Kubicki's wife, the German artist Margarete Kubicka, and through Stanisław Przybyszewski, editor of their periodical *Zdrój* ('Source'), who had close contacts in Germany). Bunt held its second exhibition in June 1918 at the Berlin galleries maintained by *Die Aktion*, a radical periodical which devoted space in

[38] Barbara Alms and Wiebke Steinmetz (eds), *Der Sturm: Chagall, Feininger, Jawlensky, Kandinsky, Klee, Kokoschka, Macke, Marc, Schwitters und viele andere im Berlin der zehner Jahre*, exh. cat. (Bremen: Hauschild; Städtische Galerie Delmenhorst, Haus Coburg Sammlung Stuckenberg, 2000).

[39] On Expressionism in Poland, see Marek Bartelik, *Early Polish Modern Art: Unity in Multiplicity* (Manchester: Manchester University Press, 2005), 57–91.

an issue as the exhibition catalogue, accompanied by Kubicki's proclamation, 'the fight is on . . . we are art'.[40] Expressionism also prevailed among members of the Jung Idysz (Young Yiddish) group in Łódź (founded in 1918), which included Jankel Adler, Hennoch Barcinski (Nenryk Barciński), Icchak (Vincent) Brauner, Paula Linderfeld, and Marek Szwarc. They exhibited widely in Poznań, Berlin, Vienna, and New York.

In Cracow, Titus Cyżewski, Leon Chwistek, and Stanisław Ignacy Witkiewicz (Witkacy) were among the members of Formiści (Formists), who had been to Paris and had experienced Cubism first hand. Yet, together with Zbigniew and Andrzej Pronaszko, Jacek Mierzejewski, Konrad Winkler, August Zamoyski, and others, they exhibited first as Expressionists (then emerging as a covering term for 'new' art throughout Europe, including Germany) in Cracow in 1917 and only in 1919 as Formiści. Indeed the styles they exhibited were diverse, ranging from the dynamic quasi-Futurist composition of Chwistek's *Fencing* (*c.*1919, Muzeum Narodowe, Cracow) to Witkiewicz's nearly hallucinatory *General Confusion* (1920, Muzeum Narodowe, Cracow). They could not easily coalesce around Expressionism in part because of the diversity of attitudes towards 'foreign' influences. Artists in Cracow (under Habsburg dominance until 1918) generally resisted German influences and aspired to French modernism and its formal revolution, and their declaration of themselves as Formiści was meant to imply their resistance to the emphasis on content associated with both Expressionism and Młoda Polska. As was the case for Skupina in Prague (where disagreements split the group), disputes arose in the Cracow group, especially between Witkiewicz and Chwistek, the former challenging the latter's approach based on realism with a metaphysical art more open to 'pure form'.

SHIFTING GEOGRAPHIES

With the armistice in November 1918 avant-garde artists throughout Europe found themselves in the midst of widespread social turmoil and political uncertainty. While the great empires were now supplanted by nation states, skirmishes continued. Intermittent wars would persist in Poland for several years; during Germany's November Revolution sporadic soviets would be put down in Kiel, Munich, and other cities.

Many artists across Europe now saw greater promise in a social transformation along the lines of the Russian Revolution that would presumably take place beyond all borders. Some, such as Moscow-born ethnic Lithuanian Katarzyna Kobro, had familiarity with the progressive trends in art that were absorbed into the Russian Revolution in its early years. Kobro had contacts with the Moscow group

[40] Stanisław Kubicki, 'Anmerkungen', *Die Aktion*, special Bunt issue, 8/21–2 (1 June 1918); trans. in Benson and Forgács (eds), *Between Worlds*, 178.

OBMOKHU (the Union of Young Artists) and had been a member of UNOVIS (the Affirmation of New Art). She had already made a stunning breakthrough in bold spatial compositions such as *Suspended Construction 2* (1921–2, metal, reconstruction 1971–9, Muzeum Sztuki, Łódź) and assemblages like *ToS 75-Structure* (lost). Similarly, a departure from Cubism, critique of Kazimir Malevich, and embracing of principles learned during study in Moscow at VHuTEMAS (the Higher Artistic and Technical Workshops) and INCuUK (Institute of Artistic Culture) are conveyed in the work of Kobro's husband and collaborator, Władysław Strzemiński. His *Cubism—Tensions of the Material Structure* (1919, Muzeum Narodowe, Warsaw) and *Flat Construction (Break up of the Black Square)* (1923, illustrated in 1924 in the Polish Constructivist journal *Blok*) were part of a rebellion against the naturalism of the immediate past manifested at the public premiere of Polish Constructivism in May 1923 at the New Art Exhibition in Vilnius, Lithuania. Strzemiński and Kobro had departed Soviet Russia, fearing its growing political centrism and feeling uncomfortable with the ascendancy of the Russian 'productivists' over those still seeking an autonomous art, and they were soon exhibiting their unprecedented works with the Warsaw Blok group in 1924 (including Kobro's *Abstract Sculpture 1*, 1924).

The Blok group's most prominent members, Henryk Berlewi, Henryk Stażewski, Mieczysław Szczuka, and Teresa Żarnower, had all been born in Warsaw and shared a common interest in Russian productivism and the Suprematist vocabulary of Malevich. In search of a new era of mechanization and 'aesthetics of maximum economy',[41] they absorbed these tendencies, along with Szczuka and Żarnower's allusions to technology, in the design of their periodical *Blok* and in the photocollages they posed as an alternative to the conventions of easel painting, for example Szczuka's *Fumes Above a City* (*c*.1926, Muzeum Sztuki, Łódź). Blok's version of Constructivism was seen simultaneously in Berlin in 1923, when Szczuka and Żarnower exhibited in the Berlin Sturm Galleries. Among the conduits of communication was Berlewi, who had trained in Warsaw, Antwerp, and the École des Beaux-Arts in Paris, and was then living in Berlin. He chronicled the transition from chiliastic Expressionism to International Constructivism, heralded by the arrival from Russia of El Lissitzky and his periodical *Veshch, Objet, Gegenstand*, which appeared in spring 1922.[42] Berlewi responded with works such as *Mechanofaktura* (1923, Merrill C. Berman Collection), where Cubist collage and Purism yielded to severely reduced planar forms in homage to the mechanized forms of mass production—works departing from 'the fetishistic cult of materials' and relying on a 'schematic method' that he famously exhibited in 1924 in the Austro-Daimler automobile showroom in Warsaw.[43] The direction taken by Szczuka and Żarnower diverged from the more

[41] 'Editorial Statement', *Blok*, 1 (8 Mar. 1924); trans. in Benson and Forgács (eds), *Between Worlds*, 492.
[42] Henryk Berlewi, 'Platyka za granica' (1922–3), MS, 4 pp., in Getty Research Institute, Special Collections, Inv. 94-A44; trans. as 'The Arts Abroad', in Benson and Forgács (eds), *Between Worlds*, 472–3.
[43] Henryk Berlewi, 'Mechano-faktura', *Der Sturm*, 15/3 (1924); trans. in Benson and Forgács (eds), *Between Worlds*, 490.

puristic tendencies of Stażewski and the 'Unism' developed by Kobro and Strzemiński based entirely on 'flatness of the whole picture' and 'the unanimity of all pictorial elements' transcending even the relational compositions of Cubism, Suprematism, and Neoplatonism.[44] Blok Constructivism resonated with characteristics and conflicts shared by other artists of an emerging International Constructivism.

The early success of the October 1917 revolution in Russia and rise in communist and socialist political activity during the instability following the war also had repercussions for the avant-garde in Budapest, where a Hungarian Soviet Republic existed briefly from March to August 1919. As was the case also for the Munich soviet, conditions never attained the stability of the Russian model. But many artists and intellectuals (including Lukács, Robert Berény, and Lajos Kassák) found themselves in official positions of power in the Commune with its close ties to the Comintern and its ambitions for an international movement. Many artists rallied around Activism, defined by its leader, Lajos Kassák, as a 'movement toward individual revolution that will outlast all forms of government and party dictatorships'.[45] The Activists were an outgrowth of Nyolcak and they contributed to the revolutionary fervour in Kassák's periodical *Ma* ('Today'), albeit in a more democratic vein, demanding 'the moral and material support for the arts'.[46] In contrast with Nyolcak's absorption with Cézanne and Fauvism, they also adopted the bold forms of German Expressionism that were quickly being deployed for political objectives throughout central Europe. Sándor Bortnyik had already used the semi-abstract forms of the Expressionist woodcut aesthetic for the covers of Kassák's 'Activist' periodicals *A Tett* ('The Action') and *Ma* inspired by Franz Pfemfert's socialist Berlin journal *Die Aktion*. With the revolution, artists who had absorbed Cézanne's influence along with Expressionism and Futurism as members of Nyolcak now sought to elicit the social engagement of the populace.[47] Bortnyik's *Red Locomotive* (1918–19, Magyar Nemzeti Múzeum, Budapest) deployed Cubist faceting and the interpenetrating forms of Futurism in a proto-Constructivist celebration of the machine as part of the revolutionary change. Béla Uitz, who in earlier paintings such as *Woman in a White Dress* (1918, Magyar Nemzeti Galéria, Budapest) had rendered contemplative figures using massive forms derived from Cézanne, now energized his figures in rhythmic compositions of expressionistically rendered lines, as exemplified in the determined march forward in his poster *Red Soldiers Forward* (1919, Magyar Nemzeti Múzeum, Budapest).

[44] Władysław Strzemiński, *Unizm w malarstwie* (Warsaw, 1928); trans. as 'Unism in Painting', in Benson and Forgács (eds), *Between Worlds*, 657.

[45] Lajos Kassák, 'Activism', *Ma*, 4/4 (10 Apr. 1919); trans. in Benson and Forgács (eds), *Between Worlds*, 219.

[46] 'Kiáltvány a művészetért!', *Ma*, 3/11 (20 Nov. 1918); trans. as 'Proclamation for Art!', in Benson and Forgács (eds), *Between Worlds*, 214.

[47] Steven A. Mansbach, 'Revolutionary Engagements: The Hungarian Avant-Garde', in *Standing in the Tempest: Painters of the Hungarian Avant-Garde, 1908–1930*, exh. cat. (Santa Barbara, Calif.: Santa Barbara Museum of Art and Cambridge Mass.: MIT Press, 1991), 46–91.

However, as the Hungarian Commune became increasingly nationalistic in a desperate attempt to win a broader base, Kassák, at the forefront of the Ma group, became more adamant in his assertion of artistic autonomy against any expectations of political or national allegiances. He insisted that the 'goal of the struggle' was 'beyond party politics, beyond national or racial ideologies' and had as its subject 'man himself in the image of the universe'.[48] He called for just as much political independence—'We proclaim that art cannot tie itself down to any one party or social class!'[49]—and soon alienated the Commune's leader, Béla Kun, as the direct attack in the pages of *Ma* got the periodical banned.[50] The context swiftly changed once again when the commune fell and was replaced by the rightist Horthy regime, a situation forcing the Ma circle into immediate exile in Vienna and Berlin, former imperial capitals that had now become leading centres of avant-garde artistic exchange in central Europe.

The shifting sands of political and social conditions greatly altered the local conditions in which avant-garde production attained its meaning. Prior to 1918, nationhood (especially in the case of Poland) existed solely in culture—as art. After 1918 vanguard artists looked increasingly towards the international arena for social change. In Hungary (as in Russia) the 'outsiders' of radical art suddenly became the 'insiders' of a politically progressive government. Kassák, if remaining 'outside' by choice, asserted the autonomy of the artists and now appeared to the regime as recalcitrant while seeming conservative to the politically engaged. When the rightist Horthy regime took power, Kassák was again perceived as a dangerous radical.

Neither 'avant-garde' nor 'nation' are static, essentialist concepts. Rather they are signifiers that constantly shift through the dislocations of historical changes. 'Nation' has been suggested as a category of practice—rather than of analysis—which structures perception, informs thought, and organizes discourse and political action—a practical category, and contingent event, something that happens rather than an essence unfolding over time.[51] Avant-gardes—as a 24-year-old Devětsil member recently installed in Prague from Moscow, Roman Jakobson, recognized—also inhabit such a world: 'When every respectable man had his own *chez soi*, there suddenly appears the science of relativity...our space and our time were [once] the only possible ones...now they are proclaimed to [be] merely particular instances'.[52]

[48] Lajos Kassák, 'Levél Kun Bélához a művészet nevében', *Ma*, 4/4 (10 Apr. 1919); trans. as 'Letter to Béla Kun in the Name of Art', in Benson and Forgács (eds), *Between Worlds*, 231.

[49] Kassák, 'Proclamation: For Art!', 213.

[50] Kassák, 'Letter to Béla Kun in the Name of Art', 230–3.

[51] Rogers Brubaker, *Nationalism Reframed: Nationhood and the National Question in the New Europe* (Cambridge: Cambridge University Press, 1996), 19.

[52] Roman Jakobson, 'Dada', *Vestnik teatra*, 82 (8 Feb. 1921); trans. in Krystyna Pomorska and Stephen Rudy (eds), *Language in Literature* (Cambridge, Mass.: Harvard University Press, 1987), 35; repr. in Benson and Forgács (eds), *Between Worlds*, 359. On Jakobson's Devětsil activities, see Toman, *The Magic of a Common Language*.

THE INTERNATIONALIZATION OF
THE AVANT-GARDE

··

During the war, the avant-garde had begun a new and unprecedented phase of internationalization beginning with Dada, which quickly burst forth as an international movement from its origins in the neutral haven of Zurich. Dada saw itself as transcending national identity and in effect generating a pan-European social geography through its indexical operations of self-promotion.[53] Dada's internationalist ambitions culminated in the 1920 Erste Internationale Dada-Messe ('First International Dada Fair') in Berlin, an exhibition whose title was a clear gesture of solidarity with the Communist international. Concurrently, artists in Berlin, Vienna, Weimar (at the Bauhaus), and throughout the region sought to overcome national identity in a variety of exhibitions and congresses. A notable occasion was the Congress of International Progressive Artists held in Düsseldorf in May 1922, accompanied by the First International Exhibition, with its proclamation 'our slogan must now be: "Artists of all nationalities unite". Art must become international or it will perish.'[54] Participating were Expressionists (ranging from Theodor Däubler, Else Lasker-Schüler, and Oskar Kokoschka, to the Brücke artists, their Polish counterparts Stanisław Kubicki and Jankel Adler, the Blaue Reiter artists Gabriele Münter and Kandinsky), as well as Fauvists, Cubists, Futurists, Purists, Dadaists,[55] and 'a whole range of variants on these movements', as Berlewi remarked in his review.[56] The most 'radical group' for Berlewi was the Constructivists, represented by Hungarian László Péri's *Space Construction 16* (1922, Private Collection, Bremen), on the cutting edge of abstract art using a shaped ground to embody a spatial abstraction; László Moholy-Nagy's *Large Wheel* (1920, Van Abbemuseum, Eindhoven), which brought into painting the letters and numbers that had appeared prominently in the collages of the German, French, and American Dadaists; and *Nickel Sculpture* (1921, Museum of Modern Art, New York), which evoked Russian Vladimir Tatlin's emphasis on material qualities in abstract constructions. Lissitzky's *Proun 17N* (1920, Staatliche Galerie, Moritzburg, Halle) presented a vocabulary of universal architectonic forms, an ambition shared by the Dutch de Stijl movement represented with works by Theo van Doesburg, Gerrit Rietveld, and Jan Wils, among others. Rallying around

[53] Timothy O. Benson, 'Dada Geographies', in David Hopkins and Michael White (eds), *Dada: Virgin Microbe* (Evanston, Ill.: Northwestern University Press, forthcoming).

[54] 'Gründungsaufruf der Union internationaler fortschrittlicher Künstler', *De Stijl*, 5/4 (1922), 49–52; trans. as 'Founding Proclamation of the Union of Progressive International Artists', in Stephen Bann (ed.), *The Tradition of Constructivism* (New York: Viking Press, 1974), 59.

[55] Bernd Finkeldey, 'Die "1. Internationale Kunstausstellung" in Düsseldorf 28. Mai bis 3. Juli 1922', in Finkeldey et al. (eds), *Konstruktivistische internationale schöpferische Arbeitsgemeinschaft 1922–1927: Utopien für eine europäische Kultur* (Stuttgart: G. Hatje, 1992), 23–30.

[56] Henryk Berlewi, 'Miedzynarodowa wystawa w Düsseldorfie', *Nasz kurier* (2 Aug. 1922); trans. as 'The International Exhibition in Düsseldorf', in Benson and Forgács (eds), *Between Worlds*, 397–9.

Constructivism, which Lissitzky had just brought from the Soviet Russia in late 1921,[57] these progressive artists, some of whom had already issued 'A Call for Elementarist Art' the previous year,[58] formed an opposing 'International Faction of Constructivists' that disputed the conservative claim of the Congress organizers, the Union of Progressive International Artists, that art was a personal matter and insisted upon a 'universally comprehensible' art.[59] Continuing their debates in the pages of *De Stijl* and *Ma*,[60] they organized a Congress of Constructivists and Dadaists in Weimar in September, where van Doesburg declared: 'The international *must* come into existence.'[61] A few months later in October the full breadth of Russian Constructivism was presented at the First Russian Art Exhibition at the Van Diemen Gallery in Berlin.

Throughout its evolution International Constructivism benefited immensely from Hungarians forced into exile by the rightist Horthy regime in 1919.[62] Marcel Breuer, Alfréd Forbát, László Moholy-Nagy, Gyula Pap, and Andor Weininger helped make the Bauhaus an international centre and taught students from countries across Europe including Bulgaria, Croatia, Czechoslovakia, Hungary (including Farkas Molnár), Latvia, Poland, Serbia, Turkey, and Ukraine. Sándor Bortnyik maintained a studio in Weimar and developed elementalist images he called Picture Architecture (several examples are in the Janus Pannonius Muzeum, Pécs). Kassák had moved from 'Picture Poems' to 'Picture-Architecture', which he conceived as an 'absolute picture', that 'does not resemble anything, tells no story . . . it simply exists'.[63] Kassák had developed this Constructivist language from picture poem collages (such as *Noise*, 1920, Neues Museum—Staatliches Museum für Kunst und Design, Nürnberg) that conveyed the chaotic turbulence of his early bruitist poetry based on Futurist *parole in libertà*. His poetry also had reached a new maturity in such works as 'The Horse Dies, the Birds Fly Out' where streams of association alternate with pure sounds:

> Milk teeth long gone a man stares into nothingness at life biting its own tail
> Into nothingness
> *o dzsiramari*

[57] The word 'Constructivism' had arisen around the beginning of 1921 in the Moscow INCuUK (Institute for Artistic Culture). The group first exhibited at OBMOChU in Moscow on 22 May 1921. In March 1922 an installation photo was reproduced in *Vesch-Objet-Gegenstand* with a discussion of 'construction' and 'production' in art.

[58] Raoul Hausmann, Hans Arp, Ivan Puni, and László Moholy-Nagy, 'Aufruf zur elementaren Kunst'), *De Stijl*, 4/10 (Oct. 1921); trans. as 'A Call for Elementarist Art', in Benson and Forgács (eds), *Between Worlds*, 470.

[59] 'Erklärung der internationen Faktion der Konstruktivisten', *De Stijl*, 5/4 (1922); trans. as 'Statement by the International Faction of Constructivists', in Bann (ed.), *The Tradition of Constructivism*, 68.

[60] See Benson and Forgács (ed.), *Between Worlds*, 388–402.

[61] Unpub. document quoted in Kai-Uwe-Hemken, ' "Muß die neue Kunst den Massen dienen?" Zur Utopie und Wirklichkeit der "Konstruktivistischen Internationale" ', in Finkeldey et al. (eds), *Konstruktivistische internationale schöpferische Arbeitsgemeinschaft*, 65 n. 51; my trans.

[62] See Éva Forgács, 'Between Cultures: Hungarian Concepts of Constructivism', in Benson (ed.), *Central European Avant-Gardes*, 146–64.

[63] Lajos Kassák, 'Képarchitektúra', *Ma*, 7/4 (25 Mar. 1922); trans. as 'Picture Architecture', in Benson and Forgács (eds), *Between Worlds*, 429–30.

o lebli
o Bum Bumm

.

And over our heads the nickel samovar is flying.[64]

Kassák's periodical *Ma*, which he took with him to Vienna, is an essential document of the transition from Dada to International Constructivism.[65] A similar evolution from Dadaist collage to Constructivist-inspired principles took place among the Devĕtsil artists working in Prague and Brno led by Karel Teige.[66] In Teige's concept, the entire setting for the enjoyment of art was broadened beyond the exhibition into the world of media imagery (including book illustration, photography, and photomontage), music, film, and performance: 'The picture is either a poster—that is, public art, like the cinema, sports, and tourism, with its place in the street—or a poem, pure visual poetry.... The traditional framed picture is being gradually abandoned and is losing its true function.'[67] Existing art categories are liquidated as Teige's new aesthetic of 'poetism' merges with life.[68] With this the era of 'isms' is at an end. Constructivism had already transcended all previous 'isms' for it embodied 'the method of all productive work'. Similarly, for Teige, 'Poetism is not an –ism.'[69] Rather it is 'the necessary complement of constructivism'—a superstructure resting upon the Constructivist base of 'technical materialism', in the avowedly Marxist terminology Teige deploys.[70]

FROM LOCALE TO MOBILE SPACE: PERIODICALS AND MASS MEDIA

The avant-garde, having survived for so long in its predicament between progressive politics and the progressive aesthetics of the liberal bourgeois economic order, was

[64] Lajos Kassák, 'The Horse Dies, the Birds Fly Out', trans. Kenneth McRobbie and Mária Kőrösy, in *Kassák: 1887–1967, Arion 16: Nemzetközi Költői Almanach—Almanach International de Poésie* (Budapest: Corvina, 1988), 100–1, 110.
[65] See Éva Forgács, 'Constructivist Faith in Deconstruction: Dada in Hungarian Art', in Gerald Janacek and Toshiharu Omuka (eds), *The Eastern Dada Orbit: Russia, Georgia, Ukraine, Central Europe and Japan* (New York: G. K. Hall; London: Prentice Hall International, 1998), 63–91.
[66] The Umĕlecký svaz Devĕtsil (Art Union of Devĕtsil) had been founded in October 1920 by Joseph Šíma, Alois Wachsmann, František Muzika, Adolf Hoffmeister, Toyen, and Jindřich Štyrský—under the leadership of Karel Teige. See Karl Srp, 'Karel Teige in the Twenties: The Moment of Sweet Ejaculation', in Eric Dluhosch and Rostislav Švácha (eds), *Karel Teige: L'Enfant Terrible of the Czech Modernist Avant-Garde* (Cambridge, Mass.: MIT Press, 1999), 11–45, and František Šmejkal, 'Devĕtsil: An Introduction', in *Devĕtsil—Czech Avant-Garde Art, Architecture and Design of the 1920s and 1930s*, exh. cat. (Oxford: Museum of Modern Art: London: Design Museum, 1990), 8–27.
[67] Karel Teige, 'Malířství a poezie', *Disk*, 1 (May 1923); trans. as 'Painting and Poetry', in Benson and Forgács (eds), *Between Worlds*, 368.
[68] Karel Teige, 'Poetismus', *Host*, 3/9–10 (July 1924), 197–204; trans. as 'Poetism', in Benson and Forgács (eds), *Between Worlds*, 581. See Dluhosch and Švácha (eds), *Karel Teige*, 65–71.
[69] Teige, 'Poetism', 581. [70] Ibid. 579–80

now overshadowed by the increasing omnipresence of popular industrialized mass culture with its heterogeneous array of references and powerful imagery. It responded by embracing, and often reinventing, the means and imagery of popular culture. No image was more pervasive than the visage of Charlie Chaplin, and it was rapidly absorbed in the visual vocabulary of the international avant-garde, appearing, for example, in the pages of the Czech 'little magazine' *ReD* (*Revue Svazu moderní kultúry Devětsil*, 'Review of the Association for Modern Culture Devětsil'), edited by Teige, and in the collages of Slovenian artist August Černigoj of the Tank group (Černigoj, *Charlie Chaplin*, collage 1926, Slovenian Theatre Museum, Ljubljana). Photocollage, with its incorporation of mass media imagery and purported origins among the Berlin Dadaists, soon became the coin of the realm among avant-garde groups ranging from the Polish Blok (Szczuka, *Fumes Above a City*) to the Czech poetism of Karel Teige (*The Departure from Cythera*, collage, 1923–4, Galerie Hlavního Města, Prague) and Jindřich Štyrský (*White Star Line*, 1923, Merrill C. Berman Collection). As the avant-garde became more practically engaged in the burgeoning industry of mass media throughout Europe, the appearance of the page was revolutionized in magazines and commercial enterprises via the innovative typography of leading artists (e.g. Zdeněk Rossmann's *Fronta* covers (1927), Szczucka's and Żarnower's *Blok* covers, Teige's and Štyrský's book covers). Just how potent this revolution was visually is demonstrated by the magnificent collaboration *Abeceda*, an alphabet book created in 1926 by Teige's (as typographer), Karel Paspa (as photographer), Vítězslav Nezval (as poet), and Milča Majorová (as choreographer and dancer). Each letter is explored as a phonetic and visual sign, as well as a celebration of life and movement. With this, a new arena was gained in which the avant-garde text—whether poem, photomontage, or topographic layout—might be performed; that is, its meaning could be enacted in the immediate surroundings of the text rather than signifying a more distant, metaphysical referent.[71] The avant-garde had found a new entry point into the broader cultural discourse of the mass media publication.

Teige countered the opposition of instrumentalist and aesthetic priorities so pervasive throughout the avant-garde with a unique approach reflecting the intellectual and social ambience of the Devětsil group, especially the poet Nezval and the linguist Jakobson. Going beyond Jakobson's structural linguistics (which allowed for the 'poeticity' of non-objective words[72]), Teige distinguished between communicative language (a fixed vocabulary referring to objects) and poetic language (oriented towards expression itself and the celebration of life) in his typographic poems and picture poems.[73] In the picture poem *What Is Most Beautiful in a Coffee House?* (1924, Československá Akademie, Prague) Teige's typographic arrangement of Nezval's poem celebrating the sensual pleasure of coffee is superimposed upon a

[71] Timothy O. Benson, 'The Text and the Coming of Age of the Avant-Garde in Germany', *Visible Language*, special exh. cat. issue, 21/3–4 (1988), 365–411.
[72] Roman Jakobson, 'What Is Poetry?', in Pomorska and Rudy (eds), *Language in Literature*, 368–78.
[73] Esther Levinger, 'Czech Avant-Garde Art: Poetry for the Five Senses', *Art Bulletin*, 81/3 (Sept. 1999), 513–32.

Constructivist grid-like structure, implying a critique of Russian Constructivism. Jakobson believed that Nezval's poetry attained an essential 'poeticity' occurring 'when words and their composition, their meaning, their external and inner form, acquire a weight and value of their own instead of referring indifferently to reality'.[74] For Jakobson, 'language was only one of a number of possible sign systems' that make up culture.[75] Teige moved from the verbal to optical speech signs from the broader culture of popular media in such picture poems as *Travel Postcard* (1923) and *Departure from Cythera* of 1923–4 (both Galerie Hlavního Města, Prague). As in Štyrský's *White Star Line*, words and images complement one another to evoke the theme of travel favoured by the Devětsil poets and artists. Having found Hans Richter's abstract films of pulsating forms once intriguing but lacking in contact with living experience,[76] Teige imagined *Departure from Cythera* in motion, as 'one moment of the lyrical film', where boats disappear into the distance, and the crane turns.[77] Similarly, *Travel Postcard* presents the words 'greetings from a journey' across a map juxtaposed with a photograph of stellar constellations, while maps and photographs evoke the themes of travel and adventure of Jindřich Štyrský's *Souvenir* (1924, National Gallery, Prague) and his cover design for Nezval's book *Pantomima* (1924).

Like Teige's typographic poems, which he considered to be 'a sort of international hieroglyph',[78] these Devětsil works can be viewed as part of a greater exchange among avant-garde circles of artefacts inscribed with the utopian theme of 'internationalism'. As such we can consider each of them as a sort of potlatch given and received among the various 'exchange sites' of the avant-garde: Berlin, Brno, Bucharest, Ljubljana, Prague, Vienna, Vilnius, Warsaw, Weimar, and Zagreb, all of which held exhibitions intended as 'international' around 1923–5. These exhibitions signalled a change in the 'imagined community' of the avant-garde remarked upon by Berlewi in his review of the First International Exhibition in Düsseldorf:[79]

The notion of progress in art has until now been entirely relative and usually subject to local conditions. This kind of particularism in art could have no rationale. Recently, in some countries, artists have shown the will to break down barriers, to have mutual moral material support, to have a universal exchange of values, and to engage in common action. The internationalization of art—art belonging to the whole of humanity—has turned out to be an unavoidable necessity.[80]

[74] Jakobson, 'What Is Poetry?', 378.
[75] Ibid. 377.
[76] Karel Teige, 'Kinografie', in *Film* (Prague: Václav Petra, 1925).
[77] Karel Teige, 'Final Notes', in *Film*, 125.
[78] Karel Teige, 'Slova, Slova, Slova', *Horizont*, 1/1 (Jan. 1927), 1–3; 2 (Feb. 1927), 29–32; 3 (Mar. 1927), 44–7; 4 (Apr. 1927), 70–3; trans. as 'Words, Words, Words', in Levinger, 'Czech Avant-Garde Art', 517.
[79] Benedict Anderson, *Imagined Communities: Reflections on the Origin and Spread of Nationalism* (London: Verso, 1983).
[80] Berlewi, 'Miedzynarodowa wystawa w Düsseldorfie', 398.

Corresponding to the change was a mobile discourse conveyed in a vast array of periodicals that might be regarded as the glue joining together the international avant-garde like a giant collage. As Berlewi remarked: 'A worldwide network of periodicals has appeared, propagating and arguing for new ideas and new forms: the organization of cooperatives on economic and ideological grounds; the generally international character of the whole movement—all these substantiate the claim that we are going through a period of transformation of traditional notions about art.'[81]

At the dawn of the 1930s the central European avant-garde found itself at a crossroads. Not only had it forged the beginnings of a new international art, intended to surpass both nation and 'ism', but it had also integrated the modus operandi of capitalist mass communications. And yet, as leading Hungarian critic Ernő (Ernst) Kállai so well recognized, there were significant hazards on the horizon. 'Mass production and mass consumption of contemporary culture surrogates' *were* already leading to the extinction of folk and peasant art, so vital to the geographic diversity of central Europe and rendering 'all art bourgeois and proletarian'.[82] Now 'pseudo-art and pseudo-philosophy' would thrive, and where, for example, Impressionism was once revered, 'now kitsch derivatives of that same Impressionism' prevailed.[83] Moreover, 'the age of ferment, of "-isms" is over', Kállai admitted in his 'The Twilight of Ideologies'.[84] Even 'the artistic monopoly of Constructivism . . . is an ideological castle in the air'.[85] Kállai's observations were doubtless all the more agonizing for one who had written eloquently on Constructivism, and they turned out to be more prescient than he could have wished. He would soon have to write pseudonymously in his (unpublished) 'Politics of Art in the Third Reich' of 'arts based on resentment, slogans, and overturned principles'.[86]

[81] Berlewi, 'Miedzynarodowa wystawa w Düsseldorfie', 399.

[82] Ernő Kállai, 'Kunst und großes Publikum', *Der Kunstnarr* (Apr. 1929); trans. as 'Art and the General Public', in Benson and Forgács (eds), *Between Worlds*, 720.

[83] Ibid. 719, 720.

[84] Ernő Kállai, 'Ideológiák alkonya', *365* (Apr. 1925); trans. as 'The Twilight of Ideologies', in Benson and Forgács (eds), *Between Worlds*, 615.

[85] Ibid. 616.

[86] Danubius [Ernő Kállai], 'Kunstpolitik im Dritten Reich' (1934), trans. as 'Politics of Art in the Third Reich', in Benson and Forgács (eds), *Between Worlds*, 728.

CHAPTER 46

..

RUSSIAN MODERNISM

..

EMILY FINER

MODERNISM in Russia is uniquely resistant to the binary oppositions according to which Russian cultural movements and their protagonists have commonly defined themselves. Usually located between the 1890s and the early 1930s, it cannot be confined to one or the other side of the Revolution of 1917, to the nineteenth or twentieth century, or to any single decade. Its practitioners belong to the bourgeoisie and to the proletariat; they move backwards and forwards across the starkest of political divides. The conventional separation between the cultural traditions of Moscow and St Petersburg does not readily apply. Furthermore, modernism is at once enthusiastically Westernizing and vehemently Slavophile. There are few common factors among the movements usually attributed to modernism; however, they dilute the rigid polemics of identity that had obsessed Russian culture in the nineteenth century and would continue to preoccupy the Soviet Union.

It is generally acknowledged that 'Russian creative artists of this time were clearly influenced by and often themselves influenced West European and American modernism,'[1] yet the problematic nature of these relationships should be considered. This chapter will explore the premise that neither was Russian modernism consistently international or outward-looking, nor did it look exclusively to the future. After focusing on issues of terminology, we turn to some of the protagonists of Futurism and their attitudes towards their Russian literary inheritance and to their European contemporaries. Then, moving forward to the early 1920s, we observe the reactions of

[1] M. A. Nicholas, 'Russian Modernism and the Female Voice: A Case Study', *Russian Review*, 53/4 (Oct. 1994), Note 6, 530–48, 531.

leading Russian modernists confronted with a period of exile in a European city that was both new and familiar.

To twenty-first-century exhibition-goers, readers of biographies, and students of European literature and culture, Russian modernism signifies a rich and pluralistic culture within a broad time-frame. This was not the case a century ago, and observing early responses to this term is a useful introduction to the anxieties about identity and influence that are the subject of this chapter. In the 1910s the French adjective 'modern', transliterated into Cyrillic as 'модерн', was pejorative and associated exclusively with the first of the modernist movements: Russian Symbolism. For the second generation of modernists, the Futurists and their sympathizers, the 'modern' was consequently associated with the effete, the decadent, and the exclusive. When the translator and critic Kornei Chukovsky wanted to emphasize the reactionary nature of certain Moscow Futurists in 1914, he associated them with the 'modern':

These writers are pleasant enough but they are only pretending to be futurists. We must now take our leave of these children of the salons, of these little princelings with rickets. I hope it is clear to everyone that they are the leftovers of yesterday's modernists (*modernisty*) and they do not hide their connection to the modern (*modern*).[2]

Chukovsky felt that Futurism should have nothing in common with the Europeanized salon culture and reactionary hierarchies of the Symbolists.[3] Here, he strives to cement his alliance with certain Futurists by condemning their rivals as old-fashioned, inauthentic, and modernist.

Chukovsky's claim that Futurism is incompatible with the 'modern' raises the issue of whether movements such as Symbolism and Futurism can be classified under the same heading. One solution has been to separate Russian modernism into two chronological periods: the 'modern' and the 'avant-garde'. However, this sets up a series of artificial distinctions: Alexander Blok, author of the innovative hymn to the revolution 'The Twelve' (1918), and Andrei Bely, who wrote *St Petersburg* (1916, 1922), a vast modernist novel centred on the 1905 Revolution, were also key figures in Symbolist poetry. Futurists did not all combine formal innovation in language with left-wing, politically progressive, or internationalist views. Furthermore, Futurists who rejected the 'modern' did not replace it with the 'avant-garde'; this latter term was limited to describing military and political groups into the 1930s.[4]

The organization of modernism into discrete schools and movements frequently turns out to be a retrospective endeavour, the result of demands made by scholarship and academic curricula. Manifestos that were written or improvised on the spur of the moment are taken at face value, resulting in a situation where 'it seems that there were more splits and alliances in the history of Russian Futurism than there were

[2] K. Chukovsky, 'Futuristy', in *Sobranie sochinenie v shesti tomakh*, vi (Moscow: Izdatel'stvo khudozhestvennaia literatura, 1969), 234. All translations are my own unless otherwise indicated.

[3] Chukovsky disliked translations from English literature by Symbolist poets such as Konstantin Balmont (1867–1942); see R. Polonsky, *English Literature and the Russian Aesthetic Renaissance* (Cambridge: Cambridge University Press, 1998), 75.

[4] D. N. Ushakov (ed.), *Tolkovyi slovar' russkogo iazyka* (Moscow: OGIZ, 1934–40).

Futurists'.[5] In addition, the limited material available in English rarely allows sufficient insight into moments of uncertainty or consensus among Futurists. One example is the following account of a violent public confrontation between Chukovsky and Vladimir Mayakovsky. The dispute took place at Moscow's Polytechnic Museum in the summer of 1913; Chukovsky writes: 'I remember that at the very moment I started berating futurism, Mayakovsky appeared in his yellow blouse and began shrieking at me, bringing my reading to a standstill.'[6] However, Chukovsky's account reveals the relationship to be less acrimonious than might be assumed:

I was the one who had smuggled the yellow blouse onto the premises. The police had banned Mayakovsky from wearing it at public appearances. A sentry stood at the entrance and Mayakovsky was only allowed to pass after it had been ascertained that he was wearing a waistcoat. The blouse made it through under my arm, wrapped up in newspaper. I handed it over to Vladimir Vladimirovich [Mayakovsky] on the stairs; he must then have donned it in secret so as to appear with a flourish from the middle of the audience and unleash his thunder at me.[7]

This playful teamwork in smuggling Mayakovsky's trademark yellow blouse suggests that conflict was frequently performative and flexible. This staged factionalism among Russian Futurists would contrast sharply with their responses to their foreign counterparts or their Russian literary predecessors.

THE STEAMSHIP OF MODERNITY

Mayakovsky and the other signatories of a pivotal document of Russian Futurism, 'A Slap in the Face of Public Taste' (1912), jettisoned their literary inheritance in no uncertain terms: 'The past is stifling. The Academy and Pushkin are less comprehensible than hieroglyphics. Throw Pushkin, Dostoevsky, Tolstoy, etc. etc. overboard the steamship of Modernity. If you do not forget your first love, you will never recognize your last.'[8]

The brilliantly evocative image of the 'steamship of Modernity', and the proposal to harness technological potential to conquer the restrictive literature of the past, would resound for many years. 'A Slap' was the result of close and lengthy collaboration between Vladimir Mayakovsky, David Burliuk, Velimir Khlebnikov, and Alexander Kruchenykh, who wrote that 'we argued over every phrase, word and letter'.[9]

[5] Vladimir Markov, 'The Province of Russian Futurism', *Slavic and East European Journal*, 8/4 (1964), 401–6, 404.

[6] K. Chukovsky, *Sobranie sochinenie v shesti tomakh*, ii (Moscow: Izdatel'stvo khudozhestvennaia literatury, 1965).

[7] Ibid.

[8] 'Poshchechina obshchestvennomu vkusu', in S. B. Dzhimbinova (ed.), *Literaturnye manifesty ot simvolizm do nashikh dnei* (Moscow: Soglasie, 2000), 142.

[9] Velimir Khlebnikov, *Zverinets* (Moscow, 1930), 13.

Two versions appeared in the space of three months: an almanac with the same title (December 1912), and a four-page pamphlet (February 1913), to which Benedikt Livshits and Wassily Kandinsky also contributed. Confident and provocative, 'A Slap' rejected the most famous nineteenth-century Russian writers as well as the reactionary scholarship and old-fashioned philology curriculum of the Academy. The pamphlet version of 'A Slap' paired poems by Pushkin and Mikhail Lermontov with Futurist poems written in *zaum* (trans-rational language), creating a visual conflict between past and future on each page.

The message of 'A Slap' is overt and the reader familiar with works by Pushkin and his contemporaries can witness their overthrow on several levels. For example, the final phrase of the above quotation is from a poem by Fedor Tiutchev written just after Pushkin's death in a duel in 1837. The need to move beyond Pushkin's legacy by 'forgetting' one's love for this great writer was hardly new to the twentieth century. That the original date of 'A Slap' was also the seventy-fifth anniversary of Pushkin's death, a watershed in Russian literary history, would immediately be apparent to the Russian reader. These references, coupled with the inclusion of Pushkin's poems in the second edition of the pamphlet, argue that a knowledge of Pushkin and his cultural role was still fundamental to the renewal of literature in 1913.

In November 1913 a cartoon with the title *New Currents in Literature* appeared in the Petersburg *Sunday Evening News*.[10] It showed a hirsute giant wielding a club and chasing a collection of diminutive nineteenth-century writers—pale and sketchily drawn—from a series of labelled plinths. The caption, 'Make way, make way', reinforces a simple message: that the great writers of the past—immortalized as statues—are being knocked off their pedestals and sent packing by the aggressive 'new currents'. This cartoon was available to a far wider audience than 'A Slap'. As in the image of the steamship, the immobile figures of the past are put to flight by the dynamic power of the future. In contrast to 'A Slap', however, the Futurist is satirized as a primitive, pre-cultural figure; a composite and nameless 'Futurist'. The cartoon portrays the 'new trends' as cohesive, united in their goal of trampling on the past.

The cartoonist is prescient regarding a direction Futurism was to take in the late 1910s. In an attempt to rid Russian literature of Pushkin and end the tradition of commemorating great writers, Osip Brik argued that '*Eugene Onegin* would have been written even if there had been no Pushkin. America would have been discovered without Columbus.'[11] Brik was a founding member of OPOIAZ, the Society for the Study of Poetic Language, a loose grouping of philologists, Futurists, and others who would come to be known as the Russian Formalists. Members of OPOIAZ advocated the extrication of literary works from their historical and biographical contexts, the destruction of literary conventions, and the study of literary form rather than the writer's soul or the source of inspiration. The anonymous Futurist in the 1913

[10] Anon., 'Novye techeniia v literature', *Voskresenye vechernie novosti*, 53 (17 Nov. 1913), 3; repr. in V. Sazhin and M. Karasik (eds), *Kharmsizdat predstavliaet: Avangardnoe povedenie. Sbornik materialov* (St Petersburg: M. K. Kharmsizdat, 1998), 107.

[11] O. Brik, 'T. n. formal'nyi metod', *LEF* 1 (1923), 213–15, 213.

cartoon anticipates Brik's statement that 'there are no poets or writers; there is poetry and literature'.[12]

Viktor Shklovsky's essays are evidence that OPOIAZ's roots lay in Futurism. His performance of 'The Resurrection of the Word' at the Stray Dog Cabaret in St Petersburg in 1913 was enthusiastically received by Mayakovsky and Kruchenykh and established his position as a leading theoretician of Futurism. Kruchenykh helped Shklovsky prepare the proofs of the essay for publication and illustrated several of the printed copies by hand.[13] 'The Resurrection of the Word' is a compressed version of central tenets of the Formal Method. In particular, Shklovsky argued for the need to revitalize a literary canon that had become over-familiar:

The fate of the word in works by old artists is exactly the same as the fate of the word itself. They cease to be 'seen' and begin to be 'recognized'. The classics are shielded by a protective glass cover of familiarity: we understand them too well, we have been listening to them since childhood; we have read them in books, dropped quotations from them in our passing conversation, and by now, we are unable to experience them, they have rubbed against our souls so much that they created blisters. I'm speaking of the masses. Many people assume that they will endure old art. What an easy mistake to make![14]

Shklovsky went on to nominate the *zaum* poetry of Khlebnikov and Kruchenykh as successful examples of overturning poetic convention and 'old art'. His attack on the literary canon permitted the debate to progress beyond listing literary castaways and instead to focus on investigating formal prerequisites for new classics. Shklovsky's opposition to the recognizable in art reappeared as the key premise of 'Art as Device' (1916), where he coined the term *ostranenie* to describe the fundamental artistic principle of making the familiar strange, a process frequently translated as defamiliarization.

We should not assume, however, that the Futurists looked to new trends in western Europe in order to individuate from their stifling Russian heritage. A year after the publication of 'A Slap', a living legend from western Europe appeared in Russia: the leader of the Italian Futurists, Filippo Marinetti. In contrast to the nameless Russian Futurist depicted in the cartoon discussed above, Marinetti was easily recognizable in Russian newspaper caricatures. In *The Moscow Futurists welcome their king with appropriate pomp*, a riotous crowd of scrawny—and indistinguishable—figures hurl bottles, shoes, and brooms at their corpulent visitor.[15] Despite the heterogeneity of Russian Futurist movements and the temporary nature of their alliances, a 'firm resistance to Marinetti's claim of priority' proved a uniting force among them.[16]

[12] V. Shklovsky, *Theory of Prose*, trans. B. Sher (Normal, Ill.: Dalkey Archive Press, 1991), 213.

[13] V. Shklovsky and A. Galushkin (eds), *Gamburgskii schet: Stat'i—vospominaniia—esse (1914–1933)* (Moscow: Sovetskii pisatel', 1990), 488.

[14] Ibid. 38.

[15] Anon., 'Moskovskie futuristy', *Moskovskii listok*, 27 (2 Feb. 1914), 3; repr. in Sazhin and Karasik (eds), *Kharmsizdat predstavliaet*, 108.

[16] A. Lawton, 'Russian and Italian Futurist Manifestoes', *Slavic and East European Journal*, 20/4 (Winter 1976), 405–20.

Benedikt Livshits, one of the contributors to the almanac version of 'A Slap', described the situation in his memoir *The One-Eyed Archer* (1933):

We came to the conclusion—independently of each other—that Marinetti saw his journey to Russia as a visit from the head of an organization to one of its branch offices. We had to deliver a decisive rebuff to this: in no way did we see ourselves as an offshoot of Western Futurism; instead, we maintained, not without reason, that we had anticipated the Italians on many counts.[17]

The 'rebuff' was manifold. Typical Futurist strategies were employed: Marinetti's performances were interrupted with shouting and brawls, pamphlets were distributed, and fiery letters appeared in newspapers. Marinetti's influence on the Russian Futurists is now beyond doubt, yet the short history of Russian Futurism was altered by backdating the early manifestos, thus eradicating any chronological proof of Marinetti's influence.[18]

Khlebnikov's attack on Marinetti was firmly within the paradigm of the Slavophile and Westernizer debate. He argued that Marinetti would reverse Russia's progress in escaping European influences: 'Russian art has only just discovered its roots in the East, it has only just recognized itself as Asian; it is entering a new phase and throwing off the shameful and ludicrous yoke of Europe: the Europe we outgrew long ago.'[19] Khlebnikov addressed both Marinetti and the Russian organizers of his appearances as 'foreigners' and gave repetitive predictions of Russia's potential colonization and servitude: 'Those who fall at the feet of Marinetti are bending the neck of Asia under the yoke of Europe.'[20]

A need to differentiate the Russian and Italian movements persisted, even among those who found little to enjoy in either. Thus, Prince Dmitri Mirsky, literary critic, foreign correspondent, and translator of James Joyce, made a distinction between an Italian's soulless appreciation of machines and factories and the authentic aesthetic feeling experienced by a Russian such as Mayakovsky: 'In no way can Russian futurism be said to have inherited its genuine love of industrialism and mechanization from the Italian. Mayakovsky's love for factory chimneys is purely aesthetic, he simply prefers them to flowers or trees.'[21]

The most disparate of modernists came together to reject the possibility of any inheritance from Marinetti. His reception demonstrates that, far from reaching out to an international movement for support, Russian modernism can be seen as anxiously nationalist and lacking interest in interchange with the West.

[17] B. Livshits, *Polutoraglazyi strelets: Stikhotvoreniia, perevody, vospominaniia* (Leningrad: Sovetskii pisatel', 1989), 473.

[18] 'A Trap for Judges II' gave the publication date of 'A Trap for Judges I' as 1908 rather than 1910; Lawton, 'Russian and Italian Futurist Manifestoes', 417.

[19] Velimir Khlebnikov, 'Na priezd Marinetti v Rossiiu', in *Sobranie sochinenii v shesti tomakh*, ed. E. Arenzon, vi/1 (Moscow: Nasledie, 2000), 345.

[20] Ibid.

[21] D. S. Mirsky, 'O sovremennom sostoianii russkoi poezii', in G. S. Smith (ed.), *Uncollected Writings on Russian Literature*, Modern Russian Literature and Culture: Studies and Texts, 13 (Berkeley: Berkeley Slavic Studies, 1989), 95.

WESTWARD HO?

Marinetti's journey east reinforced a desire for isolationism among Russian Futurists. However, either by choice or to avoid the consequences of their previous political affiliations, a significant proportion of writers sympathetic to the new regime were obliged to leave the Soviet Union and travel west in the early 1920s. One important expatriate community was concentrated in central Berlin, earning Kurfürstendamm the nickname 'Nepsky Prospekt' in reference to Lenin's quasi-capitalist New Economic Policy and St Petersburg's Nevsky Prospekt.[22]

Lev Lunts, a disciple of OPOIAZ who spent time in Berlin, expressed his disappointment with his exiled compatriots, among them his literary mentors:

On the second day after my arrival I realized that Russians do not run into Germans at all, they never chat to them, never hobnob with them. There are emigrants who have been living 4–6 years in Berlin and their German hasn't ventured a step further than 'Bitte'. They only talk to each another. They go shopping in their Russian shops and read Russian newspapers. . . . They haven't once been to a German theatre, to a German museum, to a factory. They haven't read a single German book all the way through. They visit Potsdam only in order to say how *Tsarskoe Selo* or some other palace near Petersburg is so much better.[23]

One such exile was Viktor Shklovsky. On being warned that he would soon be arrested for his activities as a right-wing socialist revolutionary, he left Petrograd for Berlin early in 1922.[24] He found a Russian literary community that was alive and publishing, although suffering from poverty, homesickness, and nostalgia. Shklovsky's lack of German language skills, minimal interest in contemporary German culture, confinement to the area around the Berlin Zoo, and relentless pessimism confirm Lunts's account.[25] In turn, Shklovsky was reminded of zoo animals performing tricks in captivity when he saw his displaced colleagues: 'Here Remizov wilts, Andrei Bely dances, Khodasevich scratches, Mayakovsky is boorish, Alexei Tolstoy drinks, and the rest are speculating (*shiberuiut*).'[26] Shklovsky's anxiety about cross-contamination, whereby economically naive Russian writers would be transformed into literary speculators in Berlin, was compounded by a fear that 'Russian culture doesn't turn out to be exportable overseas.'[27]

[22] Vladimir Mayakovsky, 'Doklad "Chto delaet Berlin?"', in *Polnoe sobranie sochinenii*, xii (Moscow: Gosudarstvennoe izdatel'stvo khudozhestvennoi literatury, 1959), 462–3, 462.
[23] L. Lunts, 'Puteshestvie na bol'nichnoi koike', in *Obez'iany idut* (St Petersburg: Inapress, 2002), 69.
[24] M. Jansen (ed.), *The Socialist-Revolutionary Party After October 1917: Documents from the P.S.-R. Archives* (Amsterdam: Stichting Beheer IISG, 1989), 48.
[25] Shklovsky could not read German or English; B. Eikhenbaum, *Moi vremennik* (Leningrad: Izd-vo Pisatelei, 1929), 136.
[26] V. Shklovsky, letter to V. G. Shklovskaia-Kordi, 25 Oct. 1922; in 'Pochta veka: Iz perepiski Viktora Shklovskogo', in N. Panchenko and N. Bialosinskaia (eds), *Tarusskie stranitsy: Vtoroi vypusk* (Moscow: Grani, 2003), 394. A *shiber* was an NEP-era speculator, here in verb form.
[27] V. Shklovsky, letter to V. G. Shklovskaia-Kordi, 5 Aug. 1923; in 'Pochta veka', 395.

Shklovsky was unable to feel that he was aboard the 'steamship of Modernity' in Berlin and he adapted the image from 'A Slap' to reflect his experience: 'Russian Berlin is going nowhere. It has no destiny. No propulsion.... Foreigners have a mechanical propulsion—the propulsion of an ocean liner, on whose deck it's nice to dance the shimmy.'[28] This passage sees Shklovsky exploring his ambivalence about Russia and modernity, and his confinement to a diluted version in emigration. The passengers aboard the European steamship are unconcerned with weighty questions regarding cultural history and their country's destiny; instead, they entertain themselves with fashionable dances on deck. The comparison with the Futurist steamship bespeaks both admiration and envy. In Berlin, Shklovsky had no place on either vessel and was painfully aware of his lack of 'mechanical propulsion' and literary destiny.

Shklovsky saw his experience of Berlin as a microcosm of Europe's common fate: 'European culture is reaching its end. Nobody needs culture. Europe . . . is coming to an end owing to political immorality and nationalism. This is how sinners in hell will live after the last judgment.'[29] His petition to return to Russia was granted after a year and he attributed his success to having sent twenty copies of his novel *Zoo* to VTsIK (the All-Russian Central Executive Committee) and, with more credibility, to Mayakovsky's intercession.[30] Mayakovsky was still very much in favour with the regime and was able to visit Berlin and Paris in the autumn of 1922. He delivered his verdict on European culture in the Great Hall at Moscow's Polytechnic Museum: his lecture addressed 'the tragedy that is Western art' and presented a body of evidence to prove that 'the transition of hegemony in the cultural sphere to Moscow' was inevitable: 'In Berlin, expressionism occupies the main place in painting, but the Russians—Chagall and Kandinsky—took precedence in a recent survey of well-known artists in Germany. The only talented German was Otto Dix. . . . There is no interesting theatre in Berlin.'[31] Mayakovsky's subsequent lecture on Paris reiterated this rejection of German culture, with additional criticism of France's affluence in the aftermath of the Treaty of Versailles.

Having seen leading figures of Russian Futurism and OPOIAZ reject both European modernism and the nineteenth-century Russian literary canon, we might wonder who remained on board the Soviet steamship in the early 1920s and what they would create. Chukovsky was concerned that Russian literature might end up with an invented, nonsense language, incomprehensible to all alike: 'The Moscow Cubo-futurists have already thrown out grammar, logic, psychology, aesthetics and articulate speech; they shriek and squeal like animals: "Ziu tsiu e sprum!"'[32] This parody made its point by being indistinguishable in meaning or quality from the original *zaum* poetry. A group from Rostov-on-Don in southern Russia, the

[28] V. Shklovsky, *Zoo, or, Letters Not About Love*, trans. R. Sheldon (Ithaca, NY: Cornell University Press, 1971), 63.
[29] Shklovsky, letter to Shklovskaia-Kordi, 25 Oct. 1922, 394.
[30] L. Ginzburg, *Zapisnye knizhki: Vospominaniia. Esse* (St Petersburg: Iskusstvo-SPB, 2002), 369.
[31] Mayakovsky, 'Doklad "Chto delaet Berlin?"', 462–3.
[32] Chukovsky, *Sobranie sochinenie v shesti tomakh*, xii, 202–40, 207.

Nichevoki (Nothingists), also addressed the problem with a nihilistic manifesto: 'There is nothing in poetry other than the Nothingists. Write nothing! Read nothing! Say nothing! Print nothing!'[33]

Nevertheless, figures such as Shklovsky and Mayakovsky wrote, read, said, and printed more in the 1920s than in any other decade. They did so despite great adversity: the civil war, blockade, fuel shortages, and famine had reduced the population of Petrograd from 2.5 million in 1917 to 500,000 in 1920.[34] The already depleted literary community lost Alexander Blok to starvation and Nikolai Gumilev to the firing squad in a single month, August 1921, and shrank further as others emigrated west. In his memoir of these tumultuous years, *A Sentimental Journey,* Shklovsky made use of another nautical metaphor to account for his community's survival: 'Gorky was the Noah of the Russian intelligentsia. During the flood, people were saved in the arks of World Literature, the Grzhebin Publishing House and the House of Arts. They were saved, not to make counter revolution, but so that the literate people in Russia would not become extinct.'[35]

Between Petrograd, Berlin, and Moscow, a bizarre solution to the problem of how to write a modern novel had evolved, expressed most succinctly by Lev Lunts:

We Scythians can teach ourselves. This is the motto of contemporary Russian criticism. And Russian literature, hurling out this proud motto, turned its back on the West. . . .

What then is to be done?

Just this.

Do what you did before. Be revolutionary or counter-revolutionary writers, mystics or wrestlers with God, but don't be boring.

Therefore: Westward ho![36]

'Westward ho!' was Lunts's manifesto for the Serapion Brothers, a group of a dozen young students who began meeting regularly in 1921 and who had benefited from the material and intellectual support of Gorky's 'arks'.

In 1919 Maxim Gorky founded a new publishing house: World Literature. Translations of literary classics from the second half of the eighteenth century to the present were to be delivered to a modern audience by means of systematic selection and presentation; each volume was to include introductory remarks, detailed annotations, and a bibliographical reference section. The series conformed to the principles outlined in essays such as Shklovsky's 'The Resurrection of the Word': classics of world literature were to be revived and defamiliarized in new translations, with introductions written by a new generation of scholars. The anticipated scale of the project also required the training of new translators, as Gorky explained:

[33] N. L. Brodskii and N. P. Sidorov (eds), *Literaturnye manifesty: Ot simvolizma do 'Oktiabria'* (Moscow: Agraf, 2001), 291.

[34] J. Westwood, *Endurance and Endeavour: Russian History 1812–1980* (Oxford: Oxford University Press, 1981), 186.

[35] V. Shklovsky, *A Sentimental Journey: Memoirs, 1917–1922,* trans. R. Sheldon (Ithaca, NY: Cornell University Press, 1984), 189.

[36] L. Lunts, 'Go West', in Gary Kern and Christopher Collins (eds), *The Serapion Brothers: A Critical Anthology* (Ann Arbor: Ardis, 1975), 147–56, 153.

In 1919 the World Literature publishing house founded the Translators' Studio in accordance with its aim to present the Russian reader with the best works by centuries of writers from Europe and America. The studio was to give literary and artistic training to a cadre of translators, so that they would be capable, as far as possible, of acquainting the Russian reader with the secrets of words and the beauty of images in European literature. It is, of course, somewhat of a utopian task, but, as everyone knows, we in Russia are less afraid of utopia than anywhere else.[37]

Shklovsky, who was no translator, chafed at the systematic nature of the project: 'a Russian writer mustn't write what he wants to: he must translate the classics, all the classics . . . and all the writers, neatly classified and supervised, will work from diagrams and then shelves of books will be born'.[38] His scepticism was proved correct: Gorky's utopian plans for a 'Basic Library' of 1,500 major works and a 'Popular Library' of some 2,500 shorter titles intended for a mass readership were defeated by paper shortages, disputes with the State Publishing House, and his own departure from the Soviet Union in 1921.

Shklovsky was also correct in assuming that members of the Translators' Studio would be more interested in reading and producing literature than translating it.[39] Working closely with Shklovsky, Chukovsky, and the prose writer, Anglophile, and naval engineer Yevgeny Zamiatin, the Serapion Brothers decided not to return to the Russian classics or to embrace Western modernism, but to apprentice themselves to the borrowed canon published by Gorky's World Literature. In the light of the comments by Khlebnikov previously discussed, Veniamin Kaverin's statement that 'Hoffman and [R. L.] Stevenson are my favourite Russian writers' is both provocative and refreshingly irreverent in its ability to dismiss issues of nationality.[40]

Shklovsky occupied a special place among the Serapion Brothers as both teacher and practitioner. His choice of material for study shows that the translated classics of World Literature were far more attractive and accessible to him than any contemporary European literature or nineteenth-century Russian prose. Lunts's exhortations to 'go West' and to cease to 'be boring' reached an apogee in Shklovsky's series of autobiographical novels, assembled according to the structures and devices he discovered in the eighteenth-century English novel. In this way, Shklovsky's *A Sentimental Journey* (1923), a fragmentary and chronologically disruptive account of his activities during the revolution and civil war, imitates formal techniques from Laurence Sterne's *A Sentimental Journey* (1768) in addition to borrowing its title. *Zoo* (1923) is an experiment with the epistolary novel form as practised by Samuel Richardson; *Mustard Gas* (1925) and *Third Factory* (1926) rework Henry Fielding's picaresque novels with their focus on the organizing principle of the chapter. Shklovsky's novels also operated as experimental spaces where he could craft

[37] T. F. Prokopova (ed.), *Serapionovy brat' ia. Antologiia: Manifesty, deklaratsii, stat' i, izbrannaia proza, vospominaniia* (Moscow: Shklola-Press, 1998), 573.

[38] Shklovsky, *A Sentimental Journey*, 189.

[39] Anon., 'Khronika', *Dom iskusstv*, 1 (1921), 70.

[40] Prokopova (ed.), *Serapionovy brat' ia*, 32.

evidence to 'prove' his theories of plot, *ostranenie*, and literary influence; they can also be regarded as blueprints for a new Soviet prose.

The full title of Shklovsky's *Zoo, Letters Not About Love, or, The Third Eloiza*, is assembled from references to a canon of epistolary prose. The 'Third Eloiza' points to Rousseau's vast novel in letters *Julie, ou, La Nouvelle Héloïse* (1761) and to Laurence Sterne's *Letters from Yorick to Eliza* (published posthumously in 1775), both of which had spawned numerous translations and imitations in Russian throughout the nineteenth century. The title also subverts the conventions of the epistolary canon by claiming that this novel's letters are 'not about love'; it sets the novel form in conflict with its content from the outset. This claim is also problematic when we consider that the novel is dedicated to a 'third Eloiza', a real-life contemporary and love interest of Shklovsky's, Elsa Triolet. The reader is further prevented from constructing a biographical narrative because letters to and from 'Alya' appear in the novel. The identity of the correspondents is a fundamental tenet of the epistolary novel; Shklovsky destroys this convention with his references to Eloiza, Héloïse, Eliza, Elsa, Alya, and, in one case, Elya.

In *Zoo*, defamiliarization is used as a metaphor, a structural device, and an expression of the author's situation in exile. The author's preface is followed by a long poem by Khlebnikov, apparently mislabelled as an 'Epigraph' in that it is longer than any of the textual components it introduces. Khlebnikov's 'Zverinets' ('Ménagerie') provides a linguistic alternative to the 'zoo' of the title and lists examples of displacement, discomfort, and defamiliarization experienced by animals in captivity. After these extensive introductory texts, the 'letters not about love' provide accounts of the dancing, scratching, and speculating Russian writers removed from their natural habitats and the safety of Gorky's 'arks' to be put on display in the Berlin Zoo.[41] While exceeding the formal constraints of an epigraph, Khlebnikov's 'Zverinets' does describe and clarify the novel's content. Conversely, the epigraphs prefixed to each of the letters appear to provide concise and reliable summaries of their content when in fact they lead the reader astray with erroneous previews of the plot, false conclusions, and even exhortations to skip portions of the novel entirely.

In *Zoo*, Shklovsky presents the reader with a series of collisions between East and West, tradition and modernity, the familiar and the strange. As a result, the reader is able to experience the making of a novel whose subject is the resurrection and destruction of literary conventions. As Shklovsky argued in 'Art as Device', 'art is a means of experiencing the process of creativity; the [ready-made] artifact itself is quite unimportant'.[42] Jury Tynianov, another member of OPOIAZ, admired *Zoo* for its juxtaposition of literary theory and literature, for its ceaseless investigation of its own construction: 'We grew tired of weighty psychology long ago. The every-day artefact must be broken up into thousands of shards and then glued back together; only then can it become a new thing in literature.'[43]

[41] Shklovsky, letter to Shklovskaia-Kordi, 25 Oct. 1922.
[42] Shklovsky, *Theory of Prose*, 6.
[43] Iu. Tynianov, 'Literaturnoe segodnia', *Russkii sovremennik*, 1 (1924), 291–306, 305.

Shklovsky found an innovative solution to the problem of creating a modern literary identity that was neither enslaved by the Russian tradition nor excessively influenced by personalities from abroad. Rather than rejecting Pushkin's influence, or rearranging publication histories to give Russian Futurism precedent over the Italian movement, Shklovsky entirely disposes of a chronological or linear history of cause and effect. Thus, in *Zoo*, Sterne, Rousseau, Khlebnikov, and Shklovsky become contemporaries in a formal sense: all are subject to processes of defamiliarization and decanonization by their juxtaposition in a modern Formalist novel. Shklovsky conceptualized this as follows: 'When I speak of literary tradition, I do not imagine it in the form of one writer's dependence on another. I see the writer's tradition as his dependence on some sort of communal warehouse of literary norms. In the same way, the inventor's tradition depends on the sum total of the technical possibilities of his time.'[44] In his novels, Shklovsky finds ways to resurrect classics of world literature and create canons according to literary form, rather than the nationality, chronology, or identity of their authors.

Ten years after the publication of 'A Slap', it became possible for Shklovsky to invite Pushkin back aboard the steamship, to release his works from beneath the 'protective glass cover of familiarity'. He did so by demonstrating formal affinities between Pushkin's novel-in-verse *Evgenii Onegin* and Sterne's *Tristram Shandy*, the latter by then established in Shklovsky's theoretical work as 'the most typical novel in World Literature':

Why was *Eugene Onegin* in particular written in the form of a Sternian parody novel? It is an interesting question. The appearance of *Tristram Shandy* is explained by the petrifaction of the devices of the old adventure novel. All devices became completely imperceptible.... *Eugene Onegin* is like the eccentric who appears at the end of a variety performance and reveals all the tricks behind the devices of the previous acts.... It is necessary to understand the 'new Pushkin' because perhaps he will be the true Pushkin. It is possible to pay homage not just with blessed herbs, but with the happy business of destruction.[45]

MODERNISM OVERBOARD

The worldwide canonization of Russian modernism has been so successful in recent decades that it is easy to overlook the fact that it was deemed not to have existed at all in official Soviet cultural histories. The erasure of modernism is demonstrated by the *Soviet Literary Encyclopaedia* (1929–39), where we are confronted with an entry

[44] V. Shklovsky, 'Paralleli u Tolstogo', in *Khod konia* (Moscow: Gelikon, 1923), 115–25, 122.
[45] V. Shklovsky, 'Eugene Onegin (Pushkin and Sterne)', trans. E. Finer, *Comparative Critical Studies*, 1/1–2 (Feb. 2004), 171–93, 189.

entitled 'Modernism' that reads 'See: Symbolism'.[46] D. N. Ushakov's dictionary (1934–40) is more explicit: 'From the French *modernisme*. Inimical to realism with decadent characteristics and elements of mysticism.'[47] This takes us back to Chukovsky's critique of Symbolism, and his—seemingly unsuccessful—attempt to separate Futurism from the *modern*. The redefinition and backdating of Russian modernism in reference works of the 1930s was necessitated by the introduction of socialist realism as the new direction to be taken by Soviet literature. A new literary identity was once again forged through the invention of basic contrasts and incompatibilities with its predecessors.

The speeches at the 1934 Soviet Writers' Congress bore no small resemblance to Khlebnikov's attacks on Marinetti, or Mayakovsky's diatribes against German and French culture. Speakers resorted to the usual paradigms: socialist realism was Soviet, native, relevant, and modern; modernism was foreign, irrelevant, decadent, and old-fashioned. However, the destruction of modernism, with its range of ideologies flexible enough to survive the revolution, proved a significant challenge. In a familiar move, delegates solved this problem by 'going West' to find modernism's representative and scapegoat.

Karl Radek, the revolutionary leader and former Central Committee member keen to prove his allegiance to Stalin after exile as a Trotskyist, chose a literary castaway who was neither Pushkin nor Mayakovsky but a writer virtually unknown to the Soviet reader: James Joyce.[48] Radek's speech entitled 'Contemporary World Literature and the Tasks of Proletarian Art' presented a simple choice: 'James Joyce or Socialist Realism?' Having introduced Joyce, Radek was careful to discourage the audience from falling prey to his dangerous foreign mystique: 'Our writers are not sufficiently well acquainted with foreign literature. When they hear that a book of eight hundred pages, without any stops and without any commas, has appeared abroad, they ask: "Perhaps this is the new art which is rising out of chaos?" '[49] Radek capitalized on the anti-European sentiment in modernism, at the same time contributing to the erasure of figures like Shklovsky who did not fit neatly into his paradigm of conflict.

Recent scholarship has advanced the possibility of continuities and shared characteristics between modernism and socialist realism.[50] Gorky's World Literature

[46] 'Modernizm', in *Literaturnaia entsiklopediia*, vii (Moscow: OGIZ, 1934), 409.

[47] 'Modernizm', in Ushakov (ed.), *Tolkovyi slovar' russkogo iazyka*; see also M. Waller, 'The -Isms of Stalinism', *Soviet Studies*, 20/2 (Oct. 1968), 229–34, 233.

[48] Only fragments of Joyce's novels had been translated into Russian by 1934; E. Tall, 'The Reception of James Joyce in Russia', in G. Lernout and W. Van Mierlo (eds.), *The Reception of James Joyce in Europe*, i (London: Thoemmes Continuum, 2004), 244–58.

[49] H. G. Scott (ed.), *Soviet Writers' Congress 1934: The Debate on Socialist Realism and Modernism* (London: Lawrence & Wishart, 1977), 150.

[50] B. Groys, 'The Birth of Socialist Realism from the Spirit of the Russian Avant-Garde', in J. E. Bowlt and O. Matich (eds), *Laboratory of Dreams: The Russian Avant-Garde and Cultural Experiment* (Stanford, Calif.: Stanford University Press, 1996), 193–219.

may have failed in its aims, but its translations persisted as staples of the Soviet and post-Soviet literary canon. The socialist realist novel may have resisted the influence of Shklovsky's experiments with the eighteenth-century English novel; however, the Serapion Brothers' apprenticeship to Dickens was no obstacle to their ascent as practitioners of socialist realism and key members of the Writers' Union.

CHAPTER 47

NORDIC MODERNISMS

ANKER GEMZØE

NORDIC CONCEPTS OF MODERNISM

'MODERN' became a keyword in the self-understanding of Nordic literature in the 1870s, when the great Danish critic Georg Brandes proclaimed the 'Modern Break-through', a movement that would make Scandinavian literature interact more closely than ever and lead it to hitherto unknown international visibility. During the following decades the term 'modern' was used loosely to cover various kinds of renewed realism, naturalism—and important contributions to early modernism. 'Modernism as a conscious phenomenon existed among writers of Swedish in Finland . . . [a] few years after World War One, but its existence was insular.'[1] The Finland Swedish poets of the 1920s, including Edith Södergran, Hagar Olsson, Elmer Diktonius, Rabbe Enckell, and Gunnar Björling, constituted the first consciously modernist Nordic literary group. Their nearest successors, the experimental Swedish poets of the 1930s and 1940s, made some use of the term, and a number of introductory essays by the Swedish poet and critic Arthur Lundquist, especially the pioneering essays in *Ikarus' flykt* ('The Flight of Icarus', 1939), were extremely influential. But the wider use and general acceptance of 'modernism' as a key term appeared in the Nordic countries as late as the 1950s. In books by the Swedish poet and critic Göran Printz-Påhlsson,[2] the Norwegian poet and critic Paul Brekke, and

[1] P. M. Mitchell, 'The Concept of Modernism in Scandinavia', in Janet Garton (ed.), *Facets of European Modernism: Essays in Honour of James McFarlane* (Norwich: University of East Anglia, 1985), 244.
[2] Göran Printz-Påhlsson, *Solen i spegeln: Essäer om lyrisk modernism* (Stockholm: Bonniers, 1958).

the leading Danish critic Torben Brostrøm,[3] a broad variety of the currents of international modernism was introduced, and Nordic literature was rearranged according to this pattern. Important introductions to modernism in French prose followed.[4] A dominant point of view, especially in the Danish and Norwegian contributions, was the so-called 'figure of delay', referring to the 'belatedness' of national literatures, accused of lazy traditionalism and boring moderation as early as 1871 by Georg Brandes in an attempt to clear the way for a 'Modern Breakthrough'. Important modernist introductions and reinterpretations followed.[5] *Poetisk modernisme* ('Poetic Modernism') by the Danish poet and critic Poul Borum[6] represents an impressive international range of vision, in which the figure of delay is to some extent abandoned and important early Nordic contributions to modernism are noted.

From the end of the 1960s and during most of the 1970s, modernism, both as a concept and as a phenomenon, came under fire from many sides in all the Scandinavian countries. It was attacked by representatives of postmodernist formalism, of the political avant-garde, of neo-realism, and of some Marxist tendencies. But in practice the 1970s saw important developments in the concept of modernism as well as exciting literary contributions to late modernism. Malcolm Bradbury and James McFarlane's *Modernism: 1890–1930* (1976) marked an important reinterpretation of the role of Nordic literature in the history of modernism by recognizing the significance of the work of Scandinavian writers such as Knut Hamsun, Henrik Ibsen, and August Strindberg. This reassessment was linked with the replacement of poetry as the genre on which modernist studies usually focused, with fiction and drama. In this way Bradbury and McFarlane's *Modernism* anticipated the broad resurgence of interest in modernism and modernist studies in the Nordic countries during the 1980s and 1990s, evidence for which lay in the number of monographs on Scandinavian modernist writers; in new, voluminous national literary histories and national and Scandinavian literary histories in English; in broader studies and anthologies on Nordic modernism; and in studies in international modernism by Nordic scholars.[7]

[3] Torben Brostrøm, *Versets løvemanke* (Copenhagen: Borgens Forlag, 1960).

[4] Niels Egebak, *Eumeniderne* (Viborg: Arena, 1960).

[5] For example, in Jørn Vosmar (ed.), *Modernismen i dansk litteratur* (Copenhagen: Fremad, 1967).

[6] Poul Borum, *Poetisk modernisme: En kritisk introduktion* (Copenhagen: Stig Vendelkærs Forlag, 1966); trans. into Swedish as *Poetisk modernism* (Stockholm: Wahlström och Widstrand, 1968).

[7] See, respectively, of Scandinavian modernists: Anders Olsson, *Ekelöfs nej* (Stockholm: Bonniers, 1983). Of national literary histories: *Dansk litteraturhistorie*, 9 vols (Copenhagen: Gyldendal, 1984–5); *Den Svenska Litteraturen*, 7 vols (Stockholm: Bonniers, 1988–90); Villy Dahl, *Norges litteratur: Tid og tekst*, 3 vols (Oslo: Aschehoug, 1981–9). Of literary histories in English: Ingemar Algulin, *A History of Swedish Literature* (Stockholm: Swedish Institute, 1989); Sven Hakon Rossel, *A History of Scandinavian Literature, 1870–1980* (Minneapolis: University of Minnesota Press, 1982). Of broad studies and anthologies: Torben Brostrøm, *Modernisme før og nu* (Copenhagen: Gyldendal, 1983); Janet Garton (ed.), *Facets of European Modernism: Essays in Honour of James McFarlane* (Norwich: University of East Anglia, 1985); Aasmund Lien (ed.), *Modernismen i skandinavisk litteratur som historisk fenomen og teoretisk problem* (Trondheim: Universitet i Trondheim, 1991), where Torben Brostrøm presents an elegant revision of his own figure of delay. And finally, of studies of international modernism authored by Nordic scholars: Peter Luthersson, *Modernism och individualitet: En studie i den litterära modernismens kvalitative egenart* (Stockholm: Symposion, 1986); Astradur Eysteinsson, *The Concept of Modernism* (Ithaca, NY: Cornell University Press, 1990).

Around the turn of the millennium a renewed critique of modernism as a phenomenon and as a concept was formulated, especially in Denmark and Sweden. The main target of this critique has been the peculiarly Scandinavian tendency to combine an undogmatic left-wing radicalism—in Denmark the so-called *kulturradikalisme* ('cultural radicalism')—with a modernist conception of literature and art. A number of right-wing critics have become engaged in the *kulturkamp*, the battle of values declared by right-wing governments in several Scandinavian countries at the beginning of the twenty-first century. In Sweden this trend was seen in Peter Luthersson's 'dispute study' *Svensk litterär modernism: En stridsstudie* (2002). Other critics represent a formalist, postmodernist position. In Denmark this position is represented by a group of scholars around Anne-Marie Mai of the University of Southern Denmark.[8] These tendencies have been counterbalanced by a revival of interest in modernism, resulting in a number of national and multinational projects, research centres, and publications.[9] Far from rendering modernism obsolete, the international debate on postmodernism and the renewed interest in the avant-garde as a broad cultural phenomenon have challenged formerly established views of the nature and history of modernism, bringing to light aspects of it that were previously overlooked, thereby resulting in a wide-ranging transformation of the conception of modernism.

As a counterbalance to the 'figure of delay', once a universal conception of Nordic modernisms and still surprisingly widespread, this chapter will focus on the important Nordic contributions to modernism in its early phases.[10] It can be read as complementary to the account of Nordic modernisms in the second volume of

[8] And in publications such as Anne-Marie Mai (ed.), *Danske digtere i det 20. århundrede* (Copenhagen: Gads Forlag, 2000–2); Anne Borup et al. (eds), *Modernismen til debat* (Odense: Syddansk Universitetsforlag, 2005).

[9] Some important examples: the Danish–Nordic research project Significant Forms: The Rhetoric of Modernism, led by Anker Gemzøe, Aalborg University, supported by the Danish Research Council 1998–2002; followed by a locally supported Centre for Modernist Studies (2002–6). Main publications: *Modernismestudier*, 1–4 (*Metafiktion—selvrefleksionens retorik* (Copenhagen: Medusa, 2001); *Modernismens historie* (Copenhagen: Akademisk Forlag, 2003); *Modernismens betydende former* (Copenhagen: Akademisk Forlag, 2003); *På kant med værket* (Copenhagen: Akademisk Forlag, 2004). The Danish research network the Return and Actuality of the Avantgardes, supported by the Danish Research Council 2001–4 extended into the Nordic Network of Avant-Garde Studies, supported by Nordforsk 2004–9, led by Tania Ørum, University of Copenhagen. The network is aiming at a four-volume Cultural History of the Nordic Avant-Gardes. The Nordic Network of Avant-Garde Studies has helped establish the European Network of Avant-Garde and Modernist Studies, which held its first conference in Ghent, Belgium, in 2008. The Nordic research network Modernism in Nordic Poetry associated with Hadle Oftedal Andersen, University of Helsinki. Main publications: *Modernisme i nordisk lyrik*, i (Helsinki: Nordica Helsingiensia, 2005); *Stedet: Modernisme i nordisk lyrik*, ii (Helsinki: Nordica Helsingiensia, 2008). Finally, mention should be made of the Nordic network of modernist studies, including among others Mats Jansson (Gothenburg), Jakob Lothe (Oslo), Steen Klitgaard Poulsen (Aarhus), Hannu Riikonen (Helsinki), and Astradur Eysteinsson (Reykjavik), whose publications in English include *English and Nordic Modernisms* (Norwich: Norvik Press, 2002) and *European and Nordic Modernisms* (Norwich: Norvik Press, 2004). There are obvious (though partial) connections between this network and the Nordic contributions to Astradur Eysteinsson and Vivian Liska (eds), *Modernism*, 2 vols (Amsterdam: John Benjamins, 2007).

[10] To the detriment, unfortunately, of Finnish and Icelandic and Faroese modernism. For relevant studies, see n. 11.

Modernism, edited by Astradur Eysteinsson and Vivian Liska, which focuses mainly on the period after 1940.[11] In matters of genre, I will try to avoid the overemphasis on poetry that still tends to dominate modernist studies.

NORDIC MODERNISMS 1870–1913

The advent of modernity as a social condition deriving from a process of accelerated modernization—comprising an urbanization resulting in the metropoles of Paris, London, Vienna, and Berlin—has often been regarded as the necessary prerequisite for the development of a literary modernism. Moreover, modernism seems associated with the great established literary languages (primarily French, English, German, and secondarily Italian and Spanish). Denmark has often functioned as a gateway for new European ideas to the Nordic countries and, with Copenhagen as the biggest city of the region, a meeting place for experimental writers. But there have been a multitude of roads in and out of the decentred, manifold Nordic unity. The complex Nordic totality of different nationalities, languages, and cultures can in some respects be compared to similar phenomena in the Austro-Hungarian Empire and other multinational empires in which modernism is associated with a heightened friction between languages and cultures. The Nordic writers and artists compensated for their somewhat remote geographical position by their strong urge to travel and to live in the European centres. The minor status of Nordic languages was a stimulus, moreover, for intellectuals and writers to acquire good skills in foreign languages and so obtain direct access to a plurality of literatures and cultures.

Around 1870 Scandinavia was rather a backward region, populated mainly by peasants, sailors, and fishermen. After the Napoleonic Wars, Finland was part of the Russian Empire, and from 1814, after 400 years under the Danish king, Norway became a nation united with Sweden under the Swedish king. Iceland, the Faroe Islands, and Greenland were Danish colonies. Denmark proper had been divided in 1864 by the German conquest of the duchies of Lauenburg, Holstein, and Schleswig. North Schleswig (the south of Jutland), where Danish was the main language and the majority identified themselves as Danish, remained under German rule until 1920. Norway declared itself independent of Sweden in 1905. Iceland gained almost complete independence from Denmark in 1915, and claimed full sovereignty as a republic in 1944. Finland declared itself an independent republic in December 1917—soon after becoming the scene of a bloody civil war between Red sympathizers with the Russian Revolution and White Nationalists, supported by German troops.

[11] Mats Jansson, 'Swedish Modernism'; H. K. Riikonen, 'Modernism in Finnish Literature'; Steen Klitgård Povlsen, 'Danish Modernism'; Jakob Lothe and Bjørn Tysdahl, 'Modernism in Norway'; Astradur Eysteinsson, 'Icelandic Modernism'; Turid Sigurdardóttir, 'Modernism in Faroese Literature'; all in Eysteinsson and Liska (eds), *Modernism*, ii: *Borders of Modernism in the Nordic World*.

As a literary region Scandinavia started to change its status rather radically around 1870, thanks to the movement known as the 'Modern Breakthrough'. At the same time the Scandinavian countries were drawn into an accelerated process of modernization: urbanization, industrialization, and radical changes in political life. In Denmark, 1871 was a turning point, when Venstre, a liberal party representing mostly farmers, gained the majority in parliament, and popular movements such as the labour movement, the women's liberation movement, and the radical movement of the intellectuals were founded. In the following decades similar changes and popular movements were created in Sweden and Norway. During the late 1860s and early 1870s an impressive influx of contemporary European thinking and literature took place through a number of new journals and book publications. The Scandinavians were introduced to German biblical criticism and socialism, to French positivism and modern French literary critics like Sainte-Beuve and Taine, and to English Darwinism, utilitarianism, and feminism. The Russian novelist Ivan Turgenev was translated and introduced in the late 1860s and became very important, followed by French realists and naturalists—from Balzac and Stendhal to Flaubert and Zola. In the 1880s there were translations of Tolstoy and Dostoevsky.

The chief catalyst was Georg Brandes, who managed to inspire a literary renewal and give it a genuine inter-Scandinavian character, which became important for its scope and its international impact. In 1871 Brandes started a series of lectures on European literature in Copenhagen.[12] He diagnosed the literary situation in Denmark as one of stagnation and delay, and called for a breakthrough into a living, modern literature engaged in society and argument—at the same time as he urged new writers to be 'aristocrats' in matters of style. The impact on both already established writers (such as the Norwegian dramatist Henrik Ibsen) and new talents was such that Brandes could later portray the successful movement as 'Det moderne Gennembruds Mænd' ('the Men of the Modern Breakthrough', 1883). Brandes wrote the first serious study of Hans Christian Andersen's tales and the first important book on Søren Kierkegaard. He was an untiring European advocate for Ibsen—'the main architect of Ibsen's international fame', according to René Wellek[13]—and for Strindberg, though with some reservations. In 1887 he 'discovered' Friedrich Nietzsche. His published lectures (especially 'Aristocratic Radicalism', 1889) were decisive in preparing the ground for Nietzsche's fame, even in Germany—and were accompanied by a dismissal of Brandes's own optimistic liberalist programme from 1871 in favour of a new cult of the great personality. In many ways the new position anticipated the emergence of an anti-positivistic Symbolism in the Scandinavian literature of the 1890s—and Brandes's own subsequent biographies of great minds like Shakespeare, Goethe, Voltaire, César, and others.

[12] These continued over many years and resulted in *Hovedstrømninger i det 19de Aarhundredes Litteratur*, 6 vols (1872–90; first partial German trans., 1872–6); trans. as *Main Currents in Nineteenth-Century Literature*, 6 vols (London: Heinemann, 1901–5). This study was an important contribution to the development of comparative literature as an academic discipline.

[13] René Wellek, *A History of Modern Criticism, 1750–1950*, iv: *The Later Nineteenth Century* (London: Jonathan Cape, 1966), 364.

What was created in the 'Modern Breakthrough' was mainly modern realistic prose, first in the vein of Turgenev, and developing into variants of Naturalism and Impressionism during the 1880s. Jens Peter Jacobsen (1847–85), who was inspired by Brandes but did not fit well into his original programme, represents the first important Nordic contribution to early modernism, paralleling some contemporary tendencies in French literature. This appeared most obviously in his limited, exquisite lyrical output, mainly written between 1867 and 1875, but mostly published posthumously in 1886. Already in the poem cycle *Gurresange* ('Gurre Songs', 1869, in its German translation set to music by Arnold Schönberg in 1913) the refined treatment of the medieval motif, beloved by the Romantics, of the love tragedy of King Valdemar and Tove points beyond late Romanticism. Later poems such as 'I Seraillets Have' ('In the Garden of the Serail'), 'Genrebillede' ('Genre Picture'), and 'Irmelin Rose' go one step further. Here traditional topoi and genres, Orientalism, troubadour poetry, and medieval ballad are treated with self-reflexive Heinean irony and ultimately end up as vehicles of modernist meta-poetry. But Jacobsen's chief lyrical achievement lay in his arabesques, especially 'En Arabesk' ('An Arabesque', 1868) and 'Arabesk til en Haandtegning af Michel Angelo' ('Arabesque on a Sketch by Michelangelo', 1870–4). The arabesque, a genre of free association, of asymmetry, and of curbed lines, had already been praised by Friedrich Schlegel, but Jacobsen, like Baudelaire, took it from Edgar Allan Poe's *Tales of the Arabesque and Grotesque*, which he read in the Danish translation that came out in 1867. Jacobsen's arabesques are free-verse poems with a delicate rhythm, a daring, often oxymoronic imagery, an unsynthesized juxtaposition of different themes, and a complex psychology. 'An Arabesque' starts like this:

> Have you gone astray in shadowy forests?
> Do you know Pan?
> I have felt him,
> Not in the shadowy forests,
> While all things silently spoke,
> No! that Pan I have never known,
> But I have felt the Pan of love,
> When all things speaking fell silent.
>
> In warm sunny regions
> There grows a mysterious plant,
> Only in deepest silence,
> Beneath a blaze of a thousand sunbeams,
> Will its blossom open out
> A fleeting second,
> Looking like the eye of a crazed man,
> Like the ruddy cheeks of a corpse.
> This I have seen,
> This, in my love.[14]

[14] Quoted in Rossel, *A History of Scandinavian Literature*, 10; trans. David Colbert.

Jacobsen's prose works, two novels and some short stories, have usually been classified as realist. But the proverbial, meta-fictional fantasy 'Fra Skitsebogen' ('From the Sketch Book: There Should Have Been Roses', 1882) is an impressive instance of early modernist prose. The late novel *Niels Lyhne* (1880), the portrait of a 'problematic' atheist, by disclosing the anti-epic character of Jacobsen's work, exemplifies the modernist rejection of the narrative element.[15] Intrigue-like action is completely absent. The novel depicts—alluding to Kierkegaard's focus on discontinuity, choice, and the confrontation of different existential modes[16]—a man's painful problems with his identity and the world around him. Like its main character, the novel is devoid of development, the epic line is broken and discontinuous. In its place there is a series of tableaux in the form of finely detailed phenomenological descriptions of (failed) fusions of consciousness. *Niels Lyhne*, with its floating phenomenological bubbles, was not well received at the time, but after the 1890s it became a cult novel within central European modernism, important to readers such as Carl Snoilsky, Sigmund Freud, Stefan George, Rainer Maria Rilke, Thomas Mann, Hugo von Hofmannsthal, Arthur Schnitzler, Stefan Zweig, Gottfried Benn, Robert Musil, and James Joyce.

In his *Dikter på vers och prosa* ('Poems in Verse and Prose', 1983) August Strindberg often anticipated the informal, 'prosaic' tone of much later modernist verse. Their characteristic freedom of form, scientific vocabulary, baroque images, and decadent atmosphere appear in the following lines from 'Solnedgång på havet' ('Sundown on the Sea'):

> The sea is green,
> so dark absinthe green;
> it is bitter as chlorine-magnesium
> and more salt than chlorine-sodium;
> it is chaste as iodine-potassium;
> and oblivion, oblivion
> of great sins and great sorrows
> that gives only the sea,
> and absinthe![17]

Around 1890 an experimental group of Danish writers was formed, inspired by Poe, Baudelaire, Verlaine, Mallarmé, and Huysmans, and by Friedrich Nietzsche's philosophical–literary hybrids. They published in literary journals like *Ny Jord* ('New Soil') and *Taarnet* ('The Tower') and proclaimed themselves Symbolists. The most important Danish representative of this trend was Sophus Claussen. Out of a secular

[15] See Anker Gemzøe, 'Modernism, Narrativity and Bakhtinian Theory', in Astradur Eysteinsson and Vivian Liska (eds), *Modernism*, 2 vols (Amsterdam: John Benjamins, 2007), i. 125.

[16] These 'anticipations' of fundamental modernist features in Kierkegaard's existential philosophy have deeply influenced Nordic writers from Ibsen onwards.

[17] August Strindberg, *Samlade skrifter*, 13 (Stockholm: Albert Bonniers Förlag, 1913), 159. All translations are by the present author unless stated otherwise.

but mystic cult of Eros and Beauty he created a poetry of sublime, ethereal music, charging exotic words like 'Ekbátana' (an ancient, long-disappeared Persian city unexpectedly knit together with the experience of modern Paris) with suggestive, enigmatic meaning: 'Lad Syndflodens Vande mig bære herfra | —jeg har levet en Dag i Ekbátana' ('Let the waters of the deluge carry me from here | —I have lived one day in Ekbátana').[18] Claussen has been compared to W. B. Yeats[19] as a figure of transition, as a culmination of Romanticism, and opening up modernism: 'Symbolism tries to react to modern experience with ideas from a Romanticism that has itself already been problematized. The lyrical diction that Sophus Claussen holds onto is a diction that tries to protect itself against the language and formal experiments of modernity.'[20] A similar position can be attributed to the Swedish poet Gustaf Fröding. Already at the beginning of his rich and varied poetical career he had announced a 'Tronskifte', the accession of a new king, the dethronement of the old King Chronos in favour of the young adventurous king who would arrive with the speed of an express train.[21]

A more decisive renewal of the lyrical idiom was represented by the Norwegian poet Sigbjørn Obstfelder and the Danish writer Johannes V. Jensen, who both inclined towards the prose poem, the genre-transcending modernist 'text'. In a prose poem like 'Byen' ('The City'), from his posthumously published *Small Pieces in Prose*, Obstfelder gives forceful expression to the experience of alienation, and in his magnificent free-verse poem 'Jeg ser' ('I see') he demonstrates how the traditional role of the poet as prophet can be disturbed by a confrontation with modernity. The poem ends

> I see, I see...
> I seem to have come to the wrong world!
> Here it is so strange...[22]

In many ways Jensen represented the opposite position as an extrovert writer, combining literature with journalism and an interest in science, seeing himself as a spokesman for the machine and the city as emblems of a new world, demanding new ethics and aesthetics. In his chapter 'The Machines', a prose poem from his book *Den Gotiske Renaissance* ('The Gothic Renaissance', 1901) in the spirit of Walt Whitman, Jensen wrote, reporting from a World Exhibition in Paris: 'There lies an unborn

[18] Sophus Claussen, *Antonius i Paris & Valfart* (Copenhagen: Danske Klassikere, Det danske Sprog-og Litteraturselskab, Borgen, 1990), 170.

[19] For example, in Finn Stein Larsen, *Dansk lyrik, 1915–55* (Copenhagen: Gyldendal, 1979), 289.

[20] Peer E. Sørensen, *Udløb i uendeligheden: Læsninger i Sophus Claussens lyrik* (Copenhagen: Gyldendal, 1997), 162.

[21] See Sylvain Briens, 'Auf der Grenze zwischen alter und neuer Welt—Medium, Mythen und Modernität', in Wolfgang Behschnitt and Elisabeth Herrmann (eds), *Über Grenzen: Grenzgänge der Skandinavistik* (Würzburg: Ergon Verlag, 2007), 43–60.

[22] Sigbjørn Obstfelder, *Skrifter*, i (Christiania, Copenhagen: Gyldendalske Boghandel, 1917), 22.

morality, an unopened aesthetics in the air—these halls, these machines exist, *they want their soul!*' and 'Machines are common to all countries and all peoples, the future revolution of values takes place across all the world.'[23] Jensen's *Poems 1906*—which greatly influenced Danish and other Nordic poetry for the rest of the twentieth century—include various kinds of poetry along with translations of Whitman, but especially important is a section of free-verse poems. In the first programmatic poem, 'Interference', the self lies awake at night reflecting on the ontological clash between 'the monologues of space' and 'the toneless circles of time', corresponding to 'the transcendental vibrations of pain, | which constitute the form of my innermost I' and signifying that 'the glaring relationship between all the otherwise harmonious realities | is the penetrating tonality of my mind'.[24] The tonality, imbued with a technical vocabulary, is new, conveying a strong expression of the arch-modernist experience of the splitting of the self. Jensen's overall acceptance of modernity as an inescapable condition did not prevent him from being disturbed by its inherent contradictions, its painful contingency. 'At Memphis Station', another significant poem, was the result of Jensen's journey around the world in 1903–4, including quite a long stay among Danish immigrants in Chicago—with an excursion southwards through Memphis, Tennessee. Though the landscape of this travel poem is the railway station in Memphis, the self—at an enforced stop caused by a flood and an ensuing railway accident—finds itself split between worlds in a troubled soliloquy:

> Half-awake and half-dozing,
> rammed by a clammy reality but still off
> in an inner sea-fog of Danaid dreams,
> I stand here my teeth chattering
> at Memphis Station, Tennessee.
> It's raining.[25]

His state of mind is that dangerous hypnagogic state between sleep and wakefulness known from Poe to Kafka. The external location, Memphis Station, is depicted with a concise, prosaic realism:

> The day ruthlessly exposes
> the cold rails and the masses of black mud,
> the waiting room with its candy machines,
> the orange peels, the stumps of cigars and matches.[26]

'At Memphis Station' explores the modernist chronotope of the station in an untraditional form and a mixed tonality with a decisive prosaic touch. For many

[23] Ibid. 128.

[24] Johannes V. Jensen, *Samlede Digte*, i (Copenhagen: Gyldendal, 2006), 44.

[25] Line Jensen, Erik Vagn Jensen, Knud Mogensen, and Alexander D. Taylor (eds), *Contemporary Danish Poetry: An Anthology*, Library of Scandinavian Literature (Copenhagen: Gyldendal; Boston: Twayne, 1977), 23; trans. Alexander Taylor.

[26] Ibid.

years it remained an important source of inspiration in Scandinavian literature because of its juxtaposition of a mythical stratum, an emotional chaos in the form of a tacit but verbose psychomachia—and an acute sensual perception of modern reality.

In prose fiction and drama the Nordic contributions to early modernism were just as significant and probably more influential. In his short stories and novels Herman Bang developed a radical Impressionism, reinforcing the anti-narrative tendencies of J. P. Jacobsen. In *A History of Danish Literature* P. M. Mitchell reflects that, although Bang is classified as a realist, he can be remarkably unrealistic and may be considered a precursor of the more recent stream-of-consciousness technique.[27] Bang can be related to the novel poetics of Henry James and Percy Lubbock—of point of view, and showing, not telling—and anticipates such tendencies on the borderline between realism and modernism that favour the scenic confrontation of points of view and techniques for rendering the flow of consciousness. Ola Hansson, from Scania in southern Sweden, took a more purposeful step in the direction of modernism in using the first-person form in his short-story collection *Sensitiva amorosa* ('Sensitive Love') (1887), a subtle study in the decadent aspects of eroticism. Hansson has been credited with 'nuanced expressiveness in descriptions of elusive mental states'.[28]

For the young Knut Hamsun, Hansson was an important source of inspiration, together with August Strindberg, Dostoevsky, and decadent Norwegian and Danish prose fiction. By the end of the 1880s Hamsun had moved to Copenhagen and established contact with the group of experimental writers established there. The first fragments of the novel *Hunger* (in the final edition of 1890 becoming Part Two) were published in the journal *Ny Jord*. *Hunger* was sensational in its lack of action and its uncompromisingly direct rendering in the first person of the meanderings of consciousness of a dissolved character in an extreme state of existential and physical hunger and panic. In Part One there is a scene where, haunted by religious reminiscences, the narrator feels as if God has put his finger into his nervous system and then retracted it, with fine shreds of nerves still clinging to it. Later in the course of the same stream of consciousness, which constantly changes mood and direction, he feels how 'a strange and fantastic mood comes over me which I have never felt before. A delicate and wonderful shock ran through my nerves as though a stream of light had flowed through them.'[29] With tears in his eyes he senses his own shoes as a good friend and, moreover, 'as a soft whispering sound coming up toward me'.[30] In this and many other scenes of crisis the self is haunted by intense sensations while at the same time standing apart as a spectator of its own fantasies. At least since 1975 Hamsun's early novels *Hunger* (1890), *Mysteries* (1892), and *Pan* (1894) have been

[27] P. M. Mitchell, *A History of Danish Literature* (Copenhagen: Gyldendal, 1971).
[28] Algulin, *A History of Swedish Literature*, 135.
[29] Knut Hamsun, *Hunger*, trans. Robert Bly (New York: Noonday Press, 1967); quoted in Dorrit Cohn, *Transparent Minds: Narrative Modes for Presenting Consciousness in Fiction* (Princeton: Princeton University Press, 1983), 155.
[30] Ibid. 156.

characterized as modernist.[31] Martin Humpál claims that modernism 'sets out to liberate the individual subject's private world from the power of public constructs and assert it as truly private'.[32] Hence the modernist partiality for stream of consciousness, though rarely in the direct form and more often as different kinds of free, indirect discourse. As 'a strictly figural first-person narrative with an extensive employment of free indirect discourse for presenting consciousness',[33] *Hunger* is undoubtedly an important Nordic contribution to the development of modernist prose fiction. What is often ignored in the early Hamsun is the inner dialogue, the parodic, self-revealing dimension, and the particular complexity due to the unclear demarcation between the fictive and the biographical author.

Johannes V. Jensen admired and learned from Hamsun, matching his acute receptiveness to physical and mental sensations. But Jensen differed in his preference for the small form, the fragment, the 'text'. According to Bernhard Glienke, the 'radiological migraine' that modernity inflicts upon us was handled by Jensen in the form of 'petits poèmes en prose', which he used in different ways, integrating them into his best novels as chapters, developing them into his 'myths', and publishing them as prose poems, in later editions often revised as free-verse poems.[34] Jensen's many myths covered more than one genre, ranging from the prose-poetic 'vision' to a kind of short story, but their 'method' is the same: an immediate confrontation between modern and ancient, science and myth, through 'a leap into an image',[35] through montage, ellipses, and other modernist techniques of concentration: 'Leave out the plot, concentrate on those short flashes of the essence of things that illumine man and time, and you have the myth . . .'.[36] Jensen's myths have had an influence on Danish–Nordic prose of the twentieth century comparable to the fairy tales of Hans Christian Andersen on that of the nineteenth century. In many ways Jensen's early travel books *Intermezzo* (1899) and *Skovene* ('Forests', 1904) anticipated his later, voluminous work *The Long Journey* (one of the main reasons for Jensen's Nobel Prize in 1944), but they are, in themselves, experimental sensual mappings of modernity, charged with epiphanic energy and staggering irony, notable contributions to early modernist prose.[37] Jensen's principal novel, *Kongens Fald* ('The Fall of the King', 1900–1), is a strange, 'decadent', and fragmented kind of historical novel,

[31] Peter Kirkegaard, *Knut Hamsun som modernist* (Copenhagen: Medusa, 1975); Atle Kittang, *Luft, vind, ingenting: Hamsuns desillisjonsromaner frå Sult til Ringen sluttet* (Oslo: Gyldendal Norsk Forlag, 1984).

[32] Martin Humpál, *The Roots of Modernist Narrative: Knut Hamsun's Novels Hunger, Mysteries, and Pan* (Oslo: Solum Forlag, 1998), 21.

[33] Ibid. 72.

[34] Bernhard Glienke (ed.), *Expeditionen in die Moderne* (Münster: Kleinheinrich, 1991), 168.

[35] Jensen's own formulation is reflected in the title of this anthology on Jensen's myths: Aage Jørgensen et al. (eds), *Et spring ind i et billede: Johannes V. Jensens mytedigtning* (Odense: Odense Universitetsforlag, 2000).

[36] Quoted in Mitchell, *A History of Danish Literature*, 218.

[37] See Anker Gemzøe, 'Der Ton der Stadt und der Duft des Waldes: Johannes V. Jensen: *Intermezzo* (1899), *Skovene* (1904) und *Skovene* (1910)', in Aage Jørgensen and Sven Hakon Rossel (eds), *'Gelobt sei das Licht der Welt . . .': Der dänische Dichter Johannes V. Jensen. Eine Forschungsanthologie* (Vienna: Praesens Verlag, 2007), 83–110.

mirroring the historical and existential crises in Nordic history around 1500 in corresponding phenomena around 1900. This novel of fragments mixes the epic, the poetic, and the dramatic registers, the most heterogeneous narrative techniques and styles, leaping from the realistic to the fantastic, from historical report to magnificent descriptions of nature or ontological visions of life, from raw Expressionist splatter scenes to intimate movements of the soul, fusing high and low in the spirit of the Renaissance.[38]

Nordic drama has equally had a role to play in the birth of modernism. Ibsen stands as one of the principal creators of modern drama, and attracts, now more than ever, apparently unlimited critical attention. But how far can Ibsen's 'modern' dramas be characterized as 'modernist'? Almost completely, according to Toril Moi's thought-provoking study *Henrik Ibsen and the Birth of Modernism*.[39] Moi's book contains many interesting insights on Ibsen's work and demonstrates a bold use of the concept of modernism. Though sympathetic to a broader understanding of the significance of early modernism, I would argue that Moi stretches the concept of modernism beyond reason and assigns too many of Ibsen's dramatic works to this tendency. In common with the main stream of Ibsen scholarship, I would limit the modernist aspects of Ibsen's work to anticipations of this in the pre-realistic morality play and closet drama *Peer Gynt* (1867), and to even more important modernist elements in his late plays.[40] Ibsen's sensitivity to the new currents can be seen in works from the Nietzschean femme fatale drama *Hedda Gabler* (1890) to the meta-fictional dramatic parable *Naar vi Døde vaagner* ('When We Dead Awaken', 1899). The Swedish dramatist August Strindberg similarly anticipated aspects of modernism in his early work, for example in the resolute Nietzschean disintegration of character in *Fröken Julie* (1887). In his late dramas, however, Strindberg can rightly be acknowledged as the pioneer of modernist drama. The great mystery play *Ett drömspel* ('A Dream Play', 1902) follows, according to Strindberg's own introduction, the disconnected but seemingly logical form of a dream, transcending time and space, mixing memories, experiences, nonsense, and improvisation. Famous stagings by Max Reinhardt and Antonin Artaud were to ensue. In the scenography strange metamorphoses take place on stage. Equally unpredictable is the course of the action. The daughter of the Indian god Indra descends as an avatar to earth. Confronted with a cross-section of human life she encounters suffering and frustrated expectations everywhere. 'Man is to be pitied' is a leitmotif and a refrain in this astonishing play, which draws on Schopenhauer's pessimistic philosophy as well as on Oriental mysticism. At the end Indra's daughter (in Shakespearean blank verse in the Swedish original) summarizes the painful experience of the human life she has lived through, in an effort to balance misanthropic pessimism with heroic resignation:

[38] See Lars Handesten, *Johannes V. Jensen: Liv og værk* (Copenhagen: Gyldendal, 2000), 125.
[39] Toril Moi, *Henrik Ibsen and the Birth of Modernism: Art, Theater, Philosophy* (Oxford: Oxford University Press, 2006).
[40] For example, Inga-Stina Ewbank, 'The Last Plays', in James Walter McFarlane (ed.), *The Cambridge Companion to Ibsen* (Cambridge: Cambridge University Press, 1994), 126–53.

Oh, now I feel the agony of existence!
So this is to be mortal.
One even misses what one did not value.
One even regrets crimes one did not commit.
One wants to go, and one wants to stay.
The twin halves of the heart are wrenched asunder
And one is torn as between raging horses
Of contradictions, irresolution, discord.[41]

Strindberg's late chamber plays, written in connection with Intimteatren (the Intimate Theatre) in Stockholm, are, if possible, even more daringly experimental. This especially applies to *Spöksonaten* ('The Ghost Sonata', 1907). With its surprising but effective montage of scenes, its use of the nonsensical and the absurd, and its unmitigated pessimism, *Spöksonaten* has been most important to, for example, German Expressionist drama.

NORDIC MODERNISMS 1914–1940

The experimental atmosphere in Paris around 1910, seething with new 'isms' and manifestos, attracted many Nordic artists and writers. In 1913 the young Swedish writer Pär Lagerkvist visited Paris, where he came into contact with Picasso and the group around Apollinaire and gained access to Gertrude Stein's art collection. Decadent Nordic literature could learn a lot from the vitality of modernist art, he claimed in his important programmatic publication *Ordkunst och bildkonst* ('Word Art and Pictorial Art', 1913), preferring the intellectual and constructive Cubism to the more irrational and spontaneous Expressionism, while distancing himself even more from Futurism. Somewhat paradoxically, however, his first principal poetry collection, *Ångest* ('Anxiety', 1916), was an exquisite pioneering work in Nordic Expressionism:

Anxiety, anxiety is my heritage,
the wound in my throat,
the cry of my heart.[42]

In this title poem, written in a kind of exploded blank verse, an inner panic, akin to the Norwegian painter Edvard Munch's picture *Skrik* ('The Scream', 1893), is reflected in uncanny landscapes. Expressionism was the common denominator for the Nordic network around the Danish journal *Klingen* (1917–20), an unusually beautiful

[41] Quoted in Algulin, *A History of Swedish Literature*, 128.
[42] Pär Lagerkvist, *Dikter* (Stockholm: Albert Bonniers Förlag, 1942), 7.

meeting place for new art and literature and for contributions from all of the Nordic countries.

In these years Lagerkvist lived in Denmark, where he also wrote his next important manifesto, *Modern teater, synspunkter och angrepp* ('Modern Theatre, Points of View and Attacks', 1918), much in line with Strindberg's late dramas and accompanying his own experimental theatre. Characteristically, he wanted to combine the newest theatrical principles with a revival of the passionate spirit in the medieval mystery and morality plays. This combination also seems later to have influenced Ingmar Bergman's early films. *Himlens hemlighet* ('The Secret of Heaven') from the volume *Kaos* ('Chaos', 1919) is the most interesting of Lagerkvist's early dramas. On a semicircular stage, filled with emblematic figures such as fools, madmen, and cripples, a young man enters searching for 'the meaning', a quest that not surprisingly ends badly. We see the traces of the medieval world stage and of the allegorical psychomachia. Exciting contributions to prose modernism are also found in some of the stories in the early collection *Onda sagor* ('Evil Tales', 1924).

Danish Expressionism unfolded around the journal *Klingen*. But the principal writers behind this 'ism', influenced by close Danish connections to the German Expressionism of the Berlin journal *Der Sturm* and its leading poet August Stramm, represent rather different tendencies. Some of the best poems by Emil Bønnelycke, for example, the tumultuous and hyperbolic 'Aarhundredet' ('The Century') from *Asfaltens Sange* ('Songs of the Asphalt', 1918), are clearly Futurist in character, directly inspired by Marinetti's *Manifeste du futurisme* (1909). But Bønnelycke was also the author of even more daring experiments with visual forms and sound words, somewhere between Apollinaire and Dadaism. Tom Kristensen, the highly talented and most productive of these poets, explored the modern city's extreme bohemian and sub-proletarian environments, and in his personal poems the extreme tensions of a chaotic mind. Fearing that completely free forms would drive him insane, however, he stuck mostly to the strophic tradition, filling it out with mastery of metre and subtle sound symbolism. Among his prose works must be mentioned the radical, almost programmatic, Expressionist novel *Livets Arabesk* ('The Arabesque of Life', 1921), whose title alludes to Jacobsen and Poe. Kristensen's principal novel, *Hærværk* ('Havoc', 1930), could be called an auto-fiction, combining aggressive naturalism with the modernist elements of incorporated poems—such as the famous 'Angst' ('Anxiety')—and poetical-prose passages expressing sublime moments of terror or epiphany. Kristensen was also a prominent critic, writing highly competent introductions to T. S. Eliot and to James Joyce's *Ulysses*—one of the sources of inspiration for *Hærværk*.

A politically and formally more radical Expressionism, which could perhaps more aptly be classified as avant-garde, was represented by Rudolf Broby-Johansen in his collection *Blod* ('Blood', 1922). In all of the poems of this provocative collection, for which the author was brought to trial for pornography, shocking, bloody incidents take place, such as sexual murder, necrophilia, induced abortion, and birth. All the

words, written in capitals, acquire a thing-like or noun-like character, as in the following lines from a poem with a parodic dedication to the Danish film star Asta Nielsen:

ODALISQUE-BEAUTY
 FOR ASTA NIELSEN

METROPOLE IN MOON NIGHT
IN THE CHASMS OF HOUSES MEN WITH BLOODY BRAINS ARE SITTING
BENT OVER CHILDREN'S BODIES
COUPLES CLING SENSELESSLY TOGETHER (BLOOD VINES SWEATY SHEETS)
BLIND WOMEN KEY EMPTY BREASTS / STERILE WOMB.[43]

The poem and the collection as a whole reveal a familiarity with the desperate poetry of August Stramm, Gottfried Benn (e.g. *Morgue*, 1912), and Georg Trakl. According to Peter Stein Larsen, *Blod* condenses 'aetheticizing of the ugly, depersonalization of poetry, creation of the "absolute Wortkunst" ["absolute art of the word"] and the total rejection of tradition of the futurist movement'.[44] In his collection *Parole* (1922) and other poems Harald Landt Momberg was provocative, not so much in that he dwelt on the ugly and on revolting social conditions, as in his Dadaist experiments, which were close to those of Christian Morgenstern and Kurt Schwitters. Otto Gelsted was the author of slim volumes of intellectual poetry, the first important book on Johannes Jensen, and of *Ekspressionisme* (1919), an introduction to, and well-formed defence of, the flourishing of Danish modernism in the visual arts. He also translated Whitman and made the first Danish translation of Freud. Disliking the extreme forms of Futurism and Expressionism, he wrote a kind of parody in the great poem 'Reklameskibet' ('The Show Boat', 1923), fusing hyperbolic Expressionist style with the language of advertisement. Its parodic technique can be compared to that of Eliot's early poetry. This poem, along with other examples of his free-verse poems, further developed a critical, prosaic, and subtly multivocal poetic idiom in the style of Johannes Jensen and became an important inspiration for the Danish 'confrontation modernism' of the 1960s.

 In the period from the last years of the First World War to the 1930s, including the dramas of the Russian Revolution, the declaration of independence, and the civil war, a group of Finland Swedish poets was formed, constituting the first self-proclaimed Nordic modernist movement. The Swedish-speaking population in Finland formed a dwindling minority whose only prospect was an acceleration of this decline. This situation can be compared to that of the German-speaking minority in Prague, who made an astonishing contribution to modernism, and both cases assume a state of mind that I would venture to call 'productive distress'. No doubt the proximity of the city of Petrograd, one of the main contemporary laboratories for modernist

[43] Rudolf Broby-Johansen, *BLOD: EKSPRESSIONÆRE DIGTE* (Copenhagen: Gyldendals Spættebøger, 1968), 7.
[44] Peter Stein Larsen, *Modernistiske outsidere* (Odense: Odense Universitetsforlag, 1998), 83.

experiment, was also important to the Finland Swedish writers.[45] Edith Södergran is the earliest and most fascinating example. Her complete works consist of four slim volumes of poetry from her surprisingly mature debut, *Dikter* ('Poems', 1918), to *Framtidens skugga* ('Shadows of the Future', 1918), followed by the posthumous collection *Landet som icke är* ('The Land That Is Not', 1925), published by her friend and fellow writer Hagar Olsson. In the nature poems of *Dikter* a childlike, fairytale universe is created by means of suggestive colour symbolism, mainly of blue, red, and white. In the love poems the contradictions of female identity are exposed—that it is impossible to conform to traditional ideas of femininity without a serious loss of identity. 'Je est un autre,' Rimbaud proclaimed. Similar negative demarcations of identity can be found in Södergran's 'VIERGE MODERNE':

> I am not a woman. I am a neutrum.
> I am a child, a page and a bold decision,
> I am a laughing streak of a scarlet sun . . . [46]

Her bold redefinitions of metaphysical entities, with traces of a Nietzschean inspiration that becomes more outspoken in the collections that follow, can be seen in poems like 'GOD' and 'HELL':

> O how wonderful is hell!
> In hell nobody speaks of death.
> Hell is built in the entrails of the earth
> and adorned with glowing flowers . . .
> In hell nobody says an empty word . . . [47]

Through the logic of negation we witness a grotesque reversal of values. In her visionary farewell poem to life 'THE LAND THAT IS NOT', she longs for this land of non-existence, created by longing, but difficult to reach and only accessible through a will and power of vision that matches the distance. Södergran has rightly been considered one of the most fascinating Nordic poets of the twentieth century.

While Södergran lived in isolation, Elmer Diktonius was a most extrovert and versatile writer. Diktonius wrote both poetry and prose, and was a sharp literary critic and one of the leading forces in the circle around the modernist journal *Ultra* (1922). This journal, which had close connections to the milieu around *Klingen*, opened up a wide international modernist horizon. Diktonius translated poetry from several countries, including the American poets Edgar Lee Masters, Carl Sandburg, and, as early as 1924, eight poems by Ezra Pound, probably the first Pound poems in any Nordic language.[48] In the subsequent journal *Quosego*, Rabbe Enckell, also one of the important Finland Swedish modernists, assumed the role of a leading

[45] For a somewhat related conception, see Lars Kleberg, 'The Advantage of the Margin: The Avant-Garde Role of Finland-Swedish Modernism', in M. A. Packalén and S. Gustavsson (eds), *Swedish-Polish Modernism: Literature—Language—Culture* (Stockholm: Almquist & Wiksell, 2003), 56–89.

[46] Edith Södergran, *Samlade dikter* (Stockholm: Wahlström & Widstrand, 1989), 15.

[47] Ibid. 43.

[48] See Jansson, 'Swedish Modernism', 839.

theoretician. As a modernist in the Whitman tradition, Diktonius held poetical and social liberation to be equally important; his tonality is often aggressive, his imagery concrete and colourful. These tendencies are audible even in the title *Hårda sanger* ('Hard Songs', 1922), his second collection, which contains his famous programme poem 'The Jaguar', an appropriate animal with which to identify. The following less well-known self-portrait in the poem 'LIGHT UGLY BEAUTIFUL DARK' from the collection *Stenkol* ('Coke', 1927) is just as representative:

> Named Diktonius—
> lie like everybody else.
> Songs I do not sing,
> concrete,
> have no thoughts—
> an iron armature is my interior.
> My lines are those of the explosion,
> my warmth that of the crater—
> are you seeking refreshment
> I shall give you a block of ice,
> understand much,
> hardly know anything—
> but what does that concern you?[49]

Diktonius was bilingual and would occasionally mix Finnish with Swedish in his prose. He wrote one of the principal books about experiences of terror and prison camps in the civil war in *Janne Kubik* (1930), as a series of intense situations, appropriately subtitled *A Woodcut in Words*.

Gunnar Björling, though admired by Diktonius, was a modernist of quite a different kind, seeking to express the indefinite, floating feelings of existence through condensed images. To escape the restraints of language Björling invented his own words, often omitting prefixes or suffixes, and using his own peculiar syntax. An example from the famous *Kiri-ra!* (1930), one of an astonishing number of poetry collections, where Dadaist, Imagist, and Surrealist impulses strangely fuse, is as follows:

> Higher, higher
> the roar of the ocean,
> I seize scrap of bamboo
> and some man's strand of hair.
> Night, and my hour,
> and I dreamt—
> all![50]

[49] Elmer Diktonius, *Stenkol* (Helsinki: Holger Schildts Förlagsaktiebolag, 1927), 39.
[50] Gunnar Björling, *Kiri-ra!* (Helsinki: Författarens Förlag, 1930), 99. For an interesting reading of Björling (and several other important Nordic modernist poets), see Louse Mønster, *Nedbrydningens opbyggelighed: Litterære historier i det 20. århundredes nordiske modernistiske lyrik* (Aalborg: Aalborg Universitetsforlag, 2009).

The Finland-Swedish modernist group had contacts with the Finnish-speaking literary group associated with the journal *Tulankantajat*, which developed a Finnish idiom of lyrical modernism and published translations of Joyce and of American and Swedish poetry. Volter Kilpi, in the long novel *Alastalon salissa* ('In the Living Room of Alasalo', 1933) and other volumes of his Archipelago series, transplanted the advanced techniques of Proust and Joyce into Finnish prose.

In Sweden, the popular songwriter Birger Sjöberg surprised the public by his turn to modernism in the collection *Kriser och kransar* ('Crises and Wreaths', 1926), where he developed a dense and bold imagery in a new poetic idiom that was just as important to the coming boom in outstanding Swedish lyrical modernism as the impact of the Finland-Swedish poets. At the beginning of the 1930s something like a modernist breakthrough took place in Sweden. As usual it was accompanied by a wave of translations and introductions, such as Erik Mesterton's introductions to Eliot and the translation of *The Waste Land* by Mesterton and Karin Boye, one of the many talented young writers publishing their first books at this time. Arthur Lundquist, the Nobel prizewinner Harry Martinsson, and Gunnar Ekelöf are especially worthy of mention. Arthur Lundquist was very widely read and had an early interest in Anglo-American modernism as well as in French Surrealism. The supposed chasm between an Eliotic line in modernism and that of Surrealism or other trends bordering upon the avant-garde is not to be found in Swedish poetry of this and the following decades. Surrealism and refined forms of primitivism can be found in important collections like *Nattens broar* ('The Bridges of the Night', 1936) and *Sirensång* ('Song of the Sirens', 1937). Later Lundquist would excel in crossing genre borders in a hybridity recalling Whitman between poetry and prose.

Gunnar Ekelöf studied Oriental languages, and during a stay in Paris in the last years of the 1920s, like Lagerkvist before him, he established contacts with experimental literary and musical circles before publishing his debut work *Sent på jorden* ('Late on Earth', 1932). The French and Oriental elements would remain important in an impressive volume of lyrical work, characterized by a great stylistic variety, and displaying a mastery of language which would secure Ekelöf a position equal to that of Södergran in Nordic modernist poetry. In the practically untranslatable poem 'HELVETES-BRUEGHEL—*detalj*' ('Hell Brueghel—detail') from the marvellous collection with the Joycean title *Non Serviam* (1945) Ekelöf conducts a dialogue with Södergran's 'Hell', driving her reversal of values even further into the grotesque. It should be noted that Ekelöf's work, like that of Martinsson and Lundkvist came to a culmination after the Second World War.

In Norway, Rolf Jacobsen in *Jord og jern* ('Earth and Iron', 1933), with unerring stylistic assurance, redeveloped city poetry, fusing the new impulses from Eliot with the tradition from Johannes Jensen. There are obvious allusions to 'At Memphis Station' in Jacobsen's poem 'Journey':

> Waiting rooms in stations at night
> with the cool atmosphere of raw concrete
> and iron,

> with rows of withered sandwiches under
> the glass counters,
> piled up chairs in the shadow,
> the stream of washerwomen over the platforms
> in the moist hour of morning,
> can fill my soul with wildness.[51]

In the same period the novelist Aksel Sandemose, having recently moved from Denmark to Norway, made his first of several distinctive contributions to prose modernism with the psychoanalytic 'auto-fiction' *En flyktning krysser sitt spor* ('A Fugitive Crosses His Tracks', 1933), where he invented the (in)famous Jante Law. Like Sandemose, the Danish poet Gustaf Munch-Petersen was bilingual, having had a Swedish mother. Also a talented painter, he wrote poetry collections in Danish, in Swedish, and even in English. After university studies in Lund, Sweden, and years of travelling, from Greenland to Sicily, he returned to Denmark, where he came into contact with a group of Surrealist painters around the avant-garde journals *linien* ('the line') and *konkretion*. Munch-Petersen's first poetry collection, *det nøgne menneske* ('naked man', 1932), bears traces of Surrealism and of his strong commitment towards Finland Swedish and Swedish modernism. In the next, *det underste land* ('the land below', 1933) and *mod jerusalem* ('toward jerusalem', 1934) he developed a special kind of primitivist utopian socialist Surrealism. In his last collection, *Nitten Digte* ('Nineteen Poems', 1937), however, still adhering to a vision of solidarity, he turned to a serene, purified Imagism of great visual and rhythmic beauty, as exemplified in the first stanza of the poem 'Etching', where the clarity of a painting is complemented by a dizzy change of perspective:

> lapwing crying
> circle black
> crying circle white
> in the air—
> saltmarsh turning
> gray-green wet
> with a closed egg
> in the center—[52]

Munch-Petersen participated as a volunteer on the Republican side in the Spanish Civil War, where he was killed.

Jens August Schade became the author of a voluminous body of work, including poetry, prose, and drama, fusing Surrealism with the banalities of daily life, cosmic visions with satire and the bodily grotesque, decadent spleen with sensual vitality. His dramas and prose works are advanced Surrealist experiments, attracting still more attention in later years. Excerpts from his 'novel' *The Thief of the Chest of Drawers, or, Immortal Love* (1939) were published in Bréton's journal *La Révolution Surréaliste*.

[51] Rolf Jacobsen, *Jord og jern* (Oslo: Gyldendal Norsk Forlag, 1933), 59.
[52] Jensen et al. (eds), *Contemporary Danish Poetry*, 77; trans. Poul Borum.

His more popular novel *Mennesker mødes og sød Musik opstår i Hjertet* ('People Meet and Sweet Music Fills the Heart', 1944)—'the closest Danish literature has ever come to the primitivism of D. H. Lawrence'[53]—was translated into Swedish, Norwegian, and, in 1947, French. In post-war Paris it became a cult novel for a group of intellectuals who proclaimed Schadism as an antidote to the gloomy seriousness of Existentialism. Schade's poetry contains many variations, from caustic satire to grandiose declarations of love to the world in the Walt Whitman-like *Jordens Ansigt* ('The Face of the Earth', 1932), but is dominated by daring erotic poetry in a wide range of tonalities. In his collection *Kællinge-Digte eller Lykkelig Kærlighed* ('Bitch-Poems, or, Happy Love', 1944), his most uninhibited incantation to physical love, he placed as the first poem 'Konkyliens Sang' ('The Song of the Conch'), his debut poem from 1925. It is a long arabesque poem, a cosmic vision of the red thread of life, connecting womb to womb, generation to generation, while violent and demonic moments are also part of life's process:

> Immeasurable we are,
> loaded with almighty desires
> like an electric summer's day—
> when clouds darken the sun
> with gigantic plays of the gods—
> when white, winged little angels
> are chased by black imps,
> and the black ones triumph.[54]

During the Second World War, Denmark and Norway were occupied by Nazi Germany, and Finland's fate was even worse. In the decades to come, the repercussions of war would generate waves of anxiety, expressed in a yet greater variety of labyrinthine modernist literature than ever before. But Schade's (re)publication of 'Konkyliens Sang' in 1944 can be seen as an act of defiance, presenting an arabesque in another key, overcoming the anxiety of confrontation with the demonic forces of life by an optimistic long-term confidence in mankind's inherent power of survival and renewal.

ANATOMY OF NORDIC MODERNISMS:
ANXIETY AND ARABESQUES

While the term 'modern' from the 1870s became a keyword for Nordic writers, the concept of 'modernism' did not gain importance or general acceptance until after the

[53] Rossel, *A History of Scandinavian Literature*, 204.
[54] Jens August Schade, *Kællinge-Digte eller Lykkelig Kærlighed* (Copenhagen: Thaning og Appels Forlag, 1944), 13.

Second Word War. Thereafter it would play a prominent role in Nordic literary scholarship as well as in public debate. Modernism became, probably even more in the Nordic countries than elsewhere, a living stimulus to Nordic writers, readers, and scholars, triumphantly established as a (norm-breaking) norm, passionately attacked as a straitjacket, and meticulously explained as a category of literary history. So challenging is both the concept and the phenomenon that even today modernism in the Nordic countries is still attacked and defended with a passion rarely found in other aesthetic discussions.

In spite of the rather late arrival of the concept, there had been important Nordic contributions to modernism even in its early phases. From the last third of the nineteenth century, the Nordic countries were sucked into the accelerated process of modernization sweeping the world. The Nordic populations were early and active participants in the greatest migration in world history—the exodus from the rural parts of northern and eastern Europe to the United States and Canada. They were players and pawns in the waves of industrialization, the modernization of agriculture, of urbanization, democratization, and secularization that radically changed traditional ways of life. In one way or another, all of the important Nordic writers between 1870 and 1940 experienced a dramatic eye-opening cultural clash between tradition and a swiftly progressing modernity. The Nordic periphery was drawn into the dynamics of the centre, into a process of globalization expressed in imperialism, the international labour movement, the simultaneous growth of nationalism, and the inferno of two world wars. For most Nordic writers, a wide international horizon was opened, making them passionate travellers, cosmopolitans with a taste for foreign literatures and cultures, while at the same time they took part in the nation-building of Norway, Finland, and Iceland, and the reconstitution as nation states of Sweden (after the loss of Norway) and Denmark (after southern Jutland was regained and after the establishment of a lasting border with Germany). No current is more connected to its actual time than modernism. But Nordic modernists, like others, qualified the term by their refusal to conform to the norms of an easy, recognizable rendering of reality, preferring new, indirect, 'structural' or even 'negative' mimetic relations; they knew, in Jensen's words, that 'Reality paradoxically does not exist until it is elevated into a re-production,'[55] and even maintained the autonomous reality of literature and art as an alternative.

Just as international modernism is a manifold phenomenon, a movement of movements, so a plural 's' can be justified in the sense that Nordic modernisms cover a plurality of sub-currents, of national, regional, individual, ideological, and stylistic varieties. It is also clear that modernism in the Nordic countries developed not in isolation, but in the active search for and reception of catalysts from French, Anglo-American, German, Austrian, Russian, and other related modern and modernist movements. Nordic modernism is international in its origin, its character, and its scope, and has paid back its immense debt by important contributions in every

[55] Johannes V. Jensen, 'Myten som Kunstform' ('The Myth as an Art Form'), in *Aarbog 1916* (Christiania, Copenhagen: Gyldendalske Boghandel, 1916), 10.

phase and every genre. On the other hand, this active reception has taken place against a background of the distinctively Nordic complex unity of different nationalities, languages, and cultures. Every Nordic national unity has its own literary history, which is not reducible to a common denominator. At the same time the Nordic literatures and cultures have been involved in a closely knit, specific network of interactions—and never more closely than in this period. There are earlier literary figures who it could be argued form a specific national background for the developments of modernism, for instance multifaceted geniuses like Henrik Wergeland in Norway or C. J. L. Almquist in Sweden. A different role can be ascribed to the literary–philosophical writings of Søren Kierkegaard, who, with his prophetic focus on anxiety as a state of mind and on discontinuity and rupture as the modern rhythm of life, has profoundly influenced all succeeding forms of Nordic modernism. In the dialectic comprising the leitmotif of this chapter between 'anxiety', a Kierkegaardian keyword, and 'arabesque', borrowed from Edgar Allan Poe, the productive tension between the common Nordic and the international impulses can be seen. However, the arabesque could also be associated with another Nordic pre-modernist writer, in many respects complementary to Kierkegaard, namely Hans Christian Andersen with his sovereign handling of all the small prose genres, his extraordinary capacity of invention, his ability to personify every point of view, and his courage to follow the meanderings of fantasy to the end. In its development, moreover, Nordic modernism established an intertextual fund of its own. Figures like Ibsen, Jacobsen, Strindberg, Hamsun, Obstfelder, Jensen, and Södergran form a chorus of voices to be heard in most subsequent Nordic modernisms, responding to ever new dissonant signals from international modernism and the avant-garde.

MODERNISMS IN ENGLISH CANADA

DEAN IRVINE

IMMIGRANTS, EXILES, AND EXPATRIATES

WHEN Raymond Williams characterized modernism in Europe as a cultural forma-
tion defined by the 'the innovations in form' that correspond to 'the fact of immi-
gration to the metropolis' and that were practised by immigrants,[1] he could have
extrapolated from this to the concurrent emergence of modernism in Europe's
former colonies. The patterns of migration from colony to imperial metropolis are
reversed and rerouted in the processing of modernism's arrivals in Canada and its
connections to expatriate Canadians in Europe and the United States. At the same
time, the staging of innovative literary cultures and the setting of avant-garde texts in
non-urban environments are among the distinctive features of modernist cultural
formations in Canada.

Among the late nineteenth-century movements originating in Europe that gave
rise to modernism in the twentieth century, the quaternity of Symbolism, Impres-
sionism, Aestheticism, and Decadence exercised considerable influence among
Canada's *fin-de-siècle* generation, especially among those authors who migrated to
New York and Boston in the 1890s. Dubbed 'the American High Priest of Symbolism'
by the *New York World* in 1896, Bliss Carman and the expatriate cohort that included
his cousin Charles G. D. Roberts circulated in a cosmopolitan culture whose vogue

[1] Raymond Williams, 'Metropolitan Perceptions and the Emergence of Modernism', in *The Politics of
Modernism: Against the New Conformists*, ed. Tony Pinkney (London: Verso, 1989), 45.

for 'everything that's "New"'[2] comprised the latest literary fashions imported from Europe. After an acclaimed series of volumes in collaboration with American poet Richard Hovey (*Songs from Vagabondia*, 1894, *More Songs from Vagabondia*, 1896, and *Last Songs from Vagabondia*, 1901) and a string of solo collections (all published by Boston's avant-garde presses Copeland and Day and Lamson, Wolfe) and after a stint as literary adviser to publishers Herbert Stone and Ingalls Kimball's 'little magazine' *The Chap Book* (1894–8),[3] Carman had established himself at the forefront of the 'modern symbolism'[4] that he and fellow Canadians Roberts and Duncan Campbell Scott inherited from the Symbolists Maurice Maeterlinck and Stephane Mallarmé. To cast an eye over the lines and intersections and parallels that connect and divide the French, Belgian, English, American, and Canadian practitioners of Hovey's 'modern symbolism', writes D. M. R. Bentley, is . . . to uncover some of the Canadian tendrils of the root system from which Anglo-American Modernism was already beginning to grow as the nineteenth century waned into the twentieth.[5] Although Carman's reputation as a leading Canadian poet was all but obliterated by the derision and misprisions of later generations, his recognition by Ezra Pound has sustained a continued critical curiosity, not least for his publication of *Sappho: One Hundred Lyrics* in 1903, a work not of translation of the ancient Greek poet but of what Roberts in his Preface to the volume calls 'imaginative and, at the same time, interpretive construction'.[6] While few readers today may be aware of Carman's exquisitely wrought free-verse reconstructions of Sappho as the earliest and most extensive excursion by a Canadian-born author into the territory of the Anglo-American modernists, there is no longer any doubt that Carman must be regarded as an immediate precursor to the early Imagists such as Pound, H.D., and Richard Aldington and their well-documented imitations of Sappho's fragmentary lyrics.

Carman's cousin may not have suffered the same eclipse of reputation, but Roberts's contributions to literary modernism in Canada have been only rarely and sparsely noted. After spending a decade in New York (1897–1907) and moving to Europe for seventeen years (1907–25), Roberts returned to Canada after the First World War in time to witness the emergence of a generation of modernist poets who styled themselves as Canada's next avant-garde, successors to the *fin-de-siècle* group of poets that at its height in the 1890s included himself, Carman, Archibald

[2] Bliss Carman, 'A Spring Feeling', *Saturday Night*, 4 Apr. 1896, 14; quoted in Nick Mount, *When Canadian Literature Moved to New York* (Toronto: University of Toronto Press, 2005), 74.

[3] Margaret Lock, 'Bliss Carman and Book Design in the 1890s', *DA: A Journal of the Printing Arts*, 61 (Fall–Winter 2007), 13 ff.

[4] Richard Hovey, 'Modern Symbolism and Maurice Maeterlinck', in *The Plays of Maurice Maeterlinck*, trans. Richard Hovey (New York: Herbert Stone, 1902), 4–5.

[5] D. M. R. Bentley, '"The Thing Is Found to Be Symbolic": *Symboliste* Elements in the Early Short Stories of Gilbert Parker, Charles G. D. Roberts, and Duncan Campbell Scott', in Gerald Lynch and Angela Arnold Robbeson (eds), *Dominant Impressions: Essays on the Canadian Short Story* (Ottawa: University of Ottawa Press, 1999), 44–5.

[6] Charles G. D. Roberts, 'The Poetry of Sappho', in Bliss Carman, *Sappho: One Hundred Lyrics* (New York: De Vinne, 1903), p. xiv.

Lampman, Duncan Campbell Scott, Frederick George Roberts, and William Wilfred Campbell. In his 1931 essay 'A Note on Modernism', where he argued that the reaction of a younger generation against an older one 'is modernism, by whatever name it may be called and whether the phenomenon occurs in the 18th, 19th, or 20th century', Roberts claimed that he and his generation were moderns in so far as they 'had already initiated a departure, a partial departure, from the Victorian tradition of poetry, years before the movement began in England'.[7]

Of this same Canadian expatriate community in New York, Arthur Stringer, whose reputation at the time rested principally on his popularity as an author of crime fiction, later contributed Canadian modernism's first manifesto championing free verse in the Foreword to his poetry collection *Open Water* (1914) and its earliest stream-of-consciousness prose in his prairie trilogy (*The Prairie Wife*, 1915, *The Prairie Mother*, 1920, and *The Prairie Child*, 1922). While his manifesto on the dominant formal practice of poetic modernism went largely unnoticed at the time and apparently yielded no direct influence on the post-war generation, his trilogy seized the attention of one of Canada's major modernist authors, Sinclair Ross, whose canonical novel *As For Me and My House* (1941) was modelled on the 'blueprint' of Stringer's prairie trilogy.[8]

A later generation found its way across the Atlantic to Paris, where Canadian authors met and lived among the expatriate figures of Anglo-American modernism. Chronicled in duelling memoirs of the period, Morley Callaghan's *That Summer in Paris* (1963) and John Glassco's *Memoirs of Montparnasse* (1970), Canada's lost generation joined a transnational literary culture that included Anglo-American modernists such as Joyce, Hemingway, Stein, Barnes, Boyle, and McAlmon as well as the French Surrealists Aragon, Bréton, Desnos, and Jolas. Glassco famously faked the time-line of his memoir, claiming that he 'wrote the first three chapters of the book in Paris in 1928' and that 'the rest of the book was written in the Royal Victoria Hospital in Montreal during three months of the winter of 1932–3',[9] when in fact he completed the first draft of the manuscript in 1964.

Born in rural Ontario and raised in poverty on a cattle ranch in Alberta, Isabel Paterson made a modest and often overlooked contribution to the inter-war genre of the expatriate novel with *Never Ask the End* (1933). By far the most formally innovative and non-linear of her novels, *Never Ask the End* is less interesting for its love triangle plot and European settings (Paris, Antwerp, London) than for its emphatic philosophical and ideological commitment to the development of female characters imbued with an emergent feminism and staunch individualism and for its rewardingly complex stream-of-consciousness, temporally fluid, and allusive style.

[7] Charles G. D. Roberts, 'A Note on Modernism', in William Arthur Deacon and Wilfred Reeves (eds), *Open House* (Ottawa: Graphic, 1931), 20, 22.
[8] Colin Hill, 'As for Me and My Blueprint: Sinclair Ross's Debt to Arthur Stringer', in Dean Irvine (ed.), *The Canadian Modernists Meet* (Ottawa: University of Ottawa Press, 2005), 257–77.
[9] John Glassco, *Memoirs of Montparnasse* (Toronto: Oxford University Press, 1970), p. xiii.

In the decade after the stock-market crash of 1929 and the subsequent dissipation of the Paris expatriates during the Great Depression, Europe attracted a new wave of Canadian writers, many of whom were sympathetic to the coalition of leftists and fellow travellers united against fascism under the political banner of the Popular Front. Among them was a young Ted Allan, who covered the Spanish Civil War as a correspondent for the International Brigades and returned with Canada's first novel of the war, *This Time a Better Earth* (1939), a work of literary reportage that at once documented the Popular Front's anti-fascist politics and projected a socialist utopia onto Republican Spain. Years later Hugh Garner reprised his experiences as a soldier in the MacKenzie–Papineau Battalion during the war for his novel *Cabbagetown*, which was first published in an abridged mass-market version in 1950 and later revised and expanded in 1968. Garner's novel plots its protagonist's Depression-era education in the tradition of the socialist *Bildungsroman* and closes with his arrival on the Spanish battlefields to join in the international struggle against fascism.

The beginning of Elizabeth Smart's expatriate life in England (1942–86) and of her thirty-two years of creative exile coincided with the writing and publication of her first novel, *By Grand Central Station I Sat Down and Wept* (1945). Smart's departure from Canada and lapse into silence is anticipated by the novel's multiple tropes and narratives of exile, which configure the erotic relationship between the narrator and her beloved on the mythic level of the union of bridegroom and bride in the Song of Solomon and the exile of the Jews from Israel in Psalm 137. Exile even extends to the novel itself, for when *By Grand Central Station* was published by Poetry Editions London in a limited run of 2,000 copies, it was exported to Canada, but soon after Smart's mother learned of its appearance in Ottawa, she arranged with her friends in External Affairs to ensure that the book could no longer be imported.[10] Not until a 1966 paperback reprint appeared was Smart rescued from obscurity, and not until Rosemary Sullivan's 1991 biography *By Heart: Elizabeth Smart, a Life* was her reputation restored as one of Canada's major modernists. While critics have been understandably attracted to biographical readings of *By Grand Central Station*— which have been complemented by the publication of her journals and autobiographical writings—in relation to her affair with the British poet George Barker, the positioning of Smart's early career in relation to international modernist literature and the visual arts has taken hold in recent critical studies.

At the same time as the international origins of Canadian modernism can be located among expatriates, they can also be found among immigrants who moved to Canada, bringing with them a literary inheritance from Europe. Frederick Philip Grove, who was born in Germany under the name Felix Paul Greve, started off as a literary translator and novelist at the turn of the century before faking his own death to escape his creditors and reinventing himself in North America. During the inter-war period and after, Grove gained recognition for his novels *Settlers of the Marsh* (1925), *Our Daily Bread* (1928), *The Yoke of Life* (1930), and *Fruits of the Earth* (1933)

[10] Rosemary Sullivan, *By Heart: Elizabeth Smart, a Life* (Toronto: Viking Canada, 1991), 229.

and his fictionalized autobiographies *A Search for America* (1927) and *In Search of Myself* (1946). He was regarded as Canada's pre-eminent 'prairie realist', a somewhat misleading designation that masks the fact that his European alter ego underwent an apprenticeship in the decadent and Naturalist literary cultures of Germany and France. Grove's orientation to modernism is less pronounced than his leanings towards Realism and Naturalism, but in his later novels (*The Master of the Mill*, 1944, *The Seasons*, *c.*1938–45) the narratological experimentation with the compression, expansion, and distortion of space and time is decidedly modernist in technique.

Nearly always identified with Grove and Robert J. C. Stead among Canada's prairie realists, Martha Ostenso and her literary collaborator and partner Douglas Durkin were not unfamiliar with modernist aesthetics and incorporated montage sequences into their earliest works. Best known for her critically acclaimed novel *Wild Geese* (1925), Ostenso collaborated with her partner and fellow novelist on all of the sixteen novels that appeared under her name alone. Born in Norway, Ostenso emigrated as a small child to North America; this attachment to the diasporic experience and tendency to chronicle immigrant farm life in Manitoba and Minnesota in many of her novels gives credence to the prairie realist moniker so frequently attached to her name. Even so, to read *Wild Geese* or Durkin's *The Magpie* (1923) without an awareness of the filmic techniques of montage developed by the Russian film-maker Sergei Eisenstein is to ignore the emergent formations of literary modernism on the Canadian prairies.

From the western prairie to the eastern metropolis, the city provided a locus for the fiction of Canada's modernist immigrant authors. J. G. Sime, best known for her short-story cycle *Sister Woman* (1919) and novel *Our Little Life* (1921), emigrated from Scotland in 1907 and lived in Montreal for nearly fifty years. Fabian socialist and feminist in her politics, Sime's fiction has been categorized as urban and social realist. This has diminished the effect of her innovative formal strategies, such as the story cycle organized around a single city (a fictionalized Montreal in *Sister Woman*), that align her with Joyce's *Dubliners* (1914), or her attention to urban experience under the conditions of modernity, which, as she put it in *Orpheus in Quebec* (1942), give rise to 'the potentialities of quite another kind of art—disjointed, disconnected art that finds its expression in thumb-nail sketches, short stories, one-act scrappy plays, and the like'.[11] While her fiction shares little with the urban subjectivities represented by the fragmented, stream-of-consciousness, and elliptical styles of modernist prose associated with Joyce, Woolf, and Dos Passos, she echoes some of their preoccupations when she engages in a critique of metropolitan modernity, particularly the social and economic repercussions of urbanization, the effects of wartime industrialization, and the psychological conditions of urban alienation experienced by immigrant and working women.[12] Sime's 'disjointed, disconnected art' is a testament to the emergent tradition of a socialist-feminist modernism in Canada.

[11] J. G. Sime, *Orpheus in Quebec* (London: George Allen & Unwin, 1942), 36.
[12] Ann Martin, 'Visions of Canadian Modernism', *Canadian Literature*, 181 (Summer 2004), 56.

That Charles Yale Harrison's anti-war novel *Generals Die in Bed* (1930) is dedicated to 'the bewildered youths—British, Australian, Canadian and German—who were killed in that wood on August 8, 1918' speaks not only to the internationalism of his first major work of fiction but also to his own literary border crossings. American-born but living in Montreal, Harrison based his graphic depictions of trench warfare on the Western Front on his experiences as a private in the Royal Montreal Regiment during the First World War. *Generals Die in Bed* has been compared to anti-war classics such as Erich Maria Remarque's *All Quiet on the Western Front* (1929), Ernest Hemingway's *A Farewell to Arms* (1929), and Robert Graves's *Good-Bye to All That* (1929). It has also been noted that excerpts from it appeared as early as 1928 in American and German periodicals, which gave rise to critical speculation as to its influence on Remarque and to Hemingway's infamous anxiety-of-influence repudi-ation of Harrison.[13] Returning to Montreal after the war, Harrison came home a radical and, by the time he moved to New York in the early 1920s, joined the Communist Party, for which he led the agitation campaign on behalf of Sacco and Vanzetti, served as a contributing editor for the leftist magazine *New Masses*, and participated in the founding of the John Reed Clubs.[14] In 1933 he broke with the Communist Party and became a Trotskyist. Although none of his three later novels of the 1930s—*A Child Is Born* (1931), *There Are Victories* (1933), and *Meet Me on the Barricades* (1938)—attracted critical attention comparable to *Generals Die in Bed*, he deserves better recognition as a contributor to the international literary left and to socialist modernism in Canadian and American literatures.

The Second World War brought a new influx of modernists from England to cities across Canada: Malcolm Lowry to Vancouver, Wyndham Lewis to Toronto, Henry Kreisel to Edmonton, and Patrick Anderson to Montreal. Lowry's first decade near Vancouver saw him complete *Under the Volcano* (1947), but this would be the last of his major works published during his lifetime. A novella, *Lunar Caustic* (1963), a short-story collection, *Hear Us O Lord from Heaven Our Dwelling Place* (1961), and a series of unfinished novels were published after his death in 1957. Born on his American father's yacht off the coast of Amherst, Nova Scotia, Lewis served in the Canadian army as a war artist from 1917 to 1918; at the onset of the Second World War he moved to Canada, where he lived in Toronto from 1940 to 1943 and Windsor, Ontario, from 1943 to 1945. Lewis captured his time there in his autobiographical novel *Self Condemned* (1954)—set in the fictional city of Momaco (a hybrid of Montreal and Toronto)—which offers a devastating portrait from the perspective of an international modernist of Canadian provincialism. A native of Vienna, Kreisel fled the Nazi *Anschluss* to England, where he was arrested as an 'enemy alien' and interned in Canada—an experience captured in his wartime diary of 1940–1.[15] *The*

[13] Hemingway's swipe at Harrison appears in *Winner Take Nothing* (New York: Scribner, 1933). Harrison responded in 'Story for Mr. Hemingway', *Modern Monthly*, 8/12 (Feb. 1935), 731.

[14] Alan M. Wald, *The New York Intellectuals: The Rise and Decline of the Anti-Stalinist Left from the 1930s to the 1980s* (Chapel Hill: University of North Carolina Press, 1987), 152.

[15] Henry Kreisel, 'Diary of an Internment', in Shirley Neuman (ed.), *Another Country: Writings By and About Henry Kreisel* (Edmonton: NeWest, 1985), 18–44.

Rich Man (1948), which appeared shortly after he moved to Edmonton, tells the story of Jacob Grossman, a Jewish Austrian immigrant who works as a presser at a sweatshop in Toronto and returns to visit his family in Austria in the absurd guise of a wealthy businessman and unlikely aficionado of modern art. Set during the rise of Nazism in 1930s Austria, Kreisel's novel takes critical aim at the horrors of anti-Semitism in inter-war Europe. While Kreisel's subject of Nazism and anti-Semitism can be found in two earlier novels of the period, Claudius Gregory's *Solomon Levi* (1935) and Philip Child's *Day of Wrath* (1945), his deft enfolding of modernist aesthetics and social critique in an absurdist mode is unequalled and without precedent in Canadian fiction.

ANGLOS IN MONTREAL

Patrick Anderson's migration from Oxford to Montreal just as the Second World War entered its second year marks a cumulative moment in the convergence of the international and the local in the formation of Anglophone modernism in Quebec. Anderson's fusion of Surrealist poetics and socialist politics aligned him with the aesthetic and ideological tendencies of inter-war Surrealism in Europe as well as with Francophone authors and artists in Quebec, specifically the automatists, a collective that practised a localized, autonomous, and dissident variant of Surrealism that found its fullest articulation in the group manifesto *Refus Global* (1948). Through his marriage to an American-born artist, Marguerite Doernbach, who exhibited with members of the Contemporary Arts Society, and his aesthetic affinities with Surrealism, Anderson made connections with his Francophone contemporaries in the visual arts.[16] During his decade in Canada, before returning to England in 1950 and his subsequent travels to South-East Asia and the Mediterranean, Anderson published three collections of poetry—*A Tent for April* (1945), *The White Centre* (1946), and *The Colour as Naked* (1953)—and later, after a reading tour Canada in the 1970s, two retrospective collections, *A Visiting Distance* (1976) and *Return to Canada: Selected Poems* (1977). Studies of Anderson over the past two decades have re-examined his seminal work as a queer modernist, a distinction he resisted at the time (since he remained in the closet during his residence in Canada) but one that his poetry of the 1940s and early 1950s explicitly evidences.

By the time Anderson landed in Canada, the post-war generation of Montreal modernists—A. J. M. Smith, F. R. Scott, John Glassco, Leo Kennedy, A. M. Klein, Leon Edel—had disbanded and a second generation was emerging. That first generation is commonly known as the Montreal Group, the majority of whom attended McGill University in Montreal as undergraduates in the 1920s. Owing to its institutional

[16] Patrick Anderson, 'The Graphic Arts', in *Drawings, Prints, Sculpture/Dessins, Estampe, Sculpture*, Contemporary Arts Society Catalogue, Fifth Floor Gallery, Montreal, 1–31 Dec. 1941.

affiliation, the group is also known as the McGill Movement. Four periodicals were founded and edited by the Montreal Group: *The McGill Daily Literary Supplement* (1924–5), *The McGill Fortnightly Review* (1925–7), *The Canadian Mercury* (1928–9), and *The McGilliad* (1930–1). After the departure of key figures such as Smith, Glassco, Edel, and Kennedy from Montreal in the late 1920s, four of the poets from the group (Smith, Kennedy, Klein, and Scott) reunited for the publication of the anthology *New Provinces: Poems by Several Authors* (1936). Among literary critics and historians of the 1920s, the Montreal Group is defined not only by its little magazines, which published innovative prose and poetry influenced by contemporary movements in British and American modernisms, but also by its belated inheritance of a fin-de-siècle poetics from the aesthetic and decadent movements in Europe.[17] Of the group, only Leo Kennedy produced a collection at the time, *The Shrouding* (1932), while Smith's *News of the Phoenix and Other Poems* (1943) and *A Sort of Ecstasy* (1954), Scott's *Overture* (1945) and *Events and Signals* (1954), and Klein's *Hath Not a Jew* (1940), *Poems* (1944), and *The Rocking Chair and Other Poems* (1948) appeared several decades later, beginning in the midst of a modernist renaissance in wartime Montreal.

The second generation of Anglo-Montreal modernists consisted of some holdovers from the 1920s, principally Scott and Klein, who were joined by Anderson, P. K. Page, Neufville Shaw, and Bruce Ruddick, all of whom either wrote for, edited, or contributed to the production of *Preview*, a mimeographed little magazine that ran from 1942 to 1945. Anderson is most often remembered for his public disputes with John Sutherland, editor of a rival Montreal little magazine, *First Statement* (1942–5). While the prevailing critical narrative has it that *Preview* advocated a cosmopolitan, internationalist modernist poetry and poetics and that *First Statement* defended a native, nationalist modernism in Canada, the lines of separation were in fact regularly crossed and the supposedly opposed camps freely intermixed. Together with his co-editors Irving Layton and Louis Dudek, Sutherland sparred with his cosmopolite adversaries in a series of editorials, articles, and reviews, but the attacks were more often than not issued by *First Statement* without provocation by *Preview*. Although the two magazines eventually merged to form *Northern Review* (1946–54), the merger proved short-lived. It ended, after a series of disputes, with the resignation of the former *Preview* editors in 1947.

Although the native–cosmopolitan debate erupted in the 1940s, it originated not with the second generation of Montreal modernists but with the first generation of the 1920s. According to the original terms of the debate, as articulated by Smith, the nativist poets 'attempt to describe and interpret whatever is essentially Canadian' and the cosmopolitan poets attempt 'to transcend colonialism by entering into the universal, civilizing culture of ideas'.[18] Sutherland countered with a litany of

[17] See Brian Trehearne, *Aestheticism and the Canadian Modernists: Aspects of a Poetic Influence* (Montreal: McGill-Queen's University Press, 1989).

[18] A. J. M. Smith, 'Introduction', in *The Book of Canadian Poetry: A Critical and Historical Anthology* (Chicago: University of Chicago Press, 1943), 5.

editorials and articles in *First Statement*, culminating in his publication of an alternative anthology, *Other Canadians: An Anthology of the New Poets in Canada, 1940–1946* (1947), which predictably included not only a more generous selection of so-called nativist poets but also a polemical introduction that attacked Smith's cosmopolitanism. Despite his contrarian manner, Sutherland was not always as divisive as history has judged him: his publication of the early collections of Canada's second wave modernists in the First Statement Press's New Writers series demonstrated his receptivity to the poetry and poetics of a diverse range of modernisms by such writers as Layton, Anderson, Raymond Souster, Miriam Waddington, Anne Wilkinson, and Kay Smith.

Of Montreal's early modernists, Scott and Smith have been consecrated as canonical figures and recognized for their work as poets, editors, anthologists, and critics. Scott is most often remembered for his frequently anthologized and notoriously satirical poem 'The Canadian Authors Meet', which he first published in *The McGill Fortnightly Review* in April 1927. The object of satiric attack in the poem is the Canadian Authors' Association (CAA), an organization founded in Montreal in 1921 which epitomized the dominant literary and cultural values of the post-war period in Canada—late Romanticism and Victorianism, colonialism, nationalism, boosterism, commercialism, anti-modernism, effeminization, sentimentality—that were anathema to Scott, Smith, and their cohort of emergent modernists. The problem with Scott's account of the CAA is not only that it strikes a misogynist tone in damning a ladies' society of Miss Crotchets sipping tea and prattling about the Confederation poets and Poets Laureate but that it fails to notice that among the Association's predominantly female members were two of Canada's early innovators of modernist poetry: Louise Morey Bowman, who published *Moonlight and Common Day* in 1922 and *Dream Tapestries* in 1924, and Katherine Hale, who published *Morning in the West* in 1923.

The story of Smith's contribution to post-war modernism in Montreal begins with his early poem 'The Lonely Land', which first appeared in an early version in the 9 January 1926 issue of *The Fortnightly*. Originally subtitled 'Group of Seven', this version oriented itself in relation to Canada's modernist landscape artists, whose exhibitions of the 1920s were at once praised and disdained for their rejection of Naturalism and mimetic representation; whose canvases were influenced by European Post-Impressionism's unnatural palette, heavy application of paint, and bold brush-strokes; and whose attunement to the post-war period's cultural nationalism was embodied in their art's preoccupation with the Canadian north. The revised and now canonized version of the poem that Marianne Moore published in *The Dial* in June 1929 removed the subtitle and accentuated Smith's translocation of Anglo-American Imagist poetics to the Canadian Shield. By situating his poem between the aesthetics of the Group of Seven and of the Imagists, Smith positions 'The Lonely Land' at the intersection of national and international modernisms, a cultural location that is in many ways symptomatic of the field of aesthetic modernism in Canada during the post-war period. Far less known is Smith's migration from Imagism to Surrealist poetics in the 1930s, a shift that he and his fellow *Fortnightly*

alumni initiated with their reading of the French-based Surrealist little magazine *transition* in the late 1920s.[19]

Although Klein was a contemporary of Smith and Scott, his modernism was a delayed development. Not until the arrival of Montreal's second wave do we see him flourish as a poet, novelist, and critic who took an obsessive interest in Joyce's modernism and who adapted to an Anglo-Jewish context the densely allusive and elliptical style of the first-generation European and American modernists in his later poetry and prose fiction of the mid-1930s to the early 1950s. Klein's role as a progenitor of a Canadian Anglo-Jewish literature in general and modernism in particular extends from his influence on the careers of mid-century Montreal poets such as the early Layton and the young Leonard Cohen to infamy as the object of satire in Mordecai Richler's 1989 novel *Solomon Gursky Was Here*. His principal works include his meditation on the modernist artist figure in the poem 'Portrait of the Poet as Landscape', collected in his Governor General's Award-winning volume *The Rocking Chair and Other Poems* (1948), and his post-Holocaust novel *The Second Scroll* (1951), a complex work structured by the text-and-gloss form of the Talmud.

With the help of his early mentor Klein, Layton started to publish his poetry in periodicals in the 1930s. By the late 1950s he had published a dozen individual collections. Layton was not only the most outspoken and prolific of the Montreal modernists but also the best known outside of Canada. His third collection, *The Black Huntsmen* (1953), caught the attention of the American Black Mountain poet Robert Creeley, with whom Layton conducted an extensive correspondence and who published a selection of his poems, *In the Midst of My Fever*, in 1954. On Creeley's recommendation Jonathan Williams of Black Mountain College published another of Layton's selected volumes, *The Improved Binoculars* (1956), which included a laudatory introduction by William Carlos Williams. At home in Montreal, after the dissolution of the *First Statement* group, Layton continued to collaborate with Dudek on the anthology *Canadian Poems 1850–1952* (1952) and joined him as an editorial adviser to the little magazine *CIV/n* (1953–5), edited by Aileen Collins, which published the early poems of a new generation of poets, including Phyllis Webb, Eli Mandel, and Leonard Cohen. Layton and Dudek's energetic collaborations escalated to highly public bouts of verbal sparring through the 1950s and culminated in a final break in 1958.[20]

Even if the early Dudek of the 1940s preferred to regard himself as a social realist,[21] his emergence as one of Canada's leading modernist figures of the 1940s and 1950s can be credited as much to his involvement in the material practices of editing and publishing both his own work and that of his contemporaries in little magazines and anthologies as to his roles as a reviewer, critic, and historian of modernist poetry in Canada. As the editor, with Michael Gnarowski, of *The Making of Modern Poetry in*

[19] Leo Kennedy, 'The Future of Canadian Literature', *Canadian Mercury*, 5–6 (Dec. 1928), 99.
[20] Brian Trehearne, *The Montreal Forties: Modernism in Transition* (Toronto: University of Toronto Press, 1999), 177.
[21] Ibid. 289.

Canada: Essential Articles on Contemporary Canadian Poetry in English (1967), Dudek played a critical role in shaping the literary-historical narratives of modernist poetry that prevailed through the latter half of the twentieth century. Not surprisingly, he occupied a key position in this narrativization of modernism in Canada, not least of which were his apologias for Pound[22] and high valuation of the long poem. With the appearance of his first book-length long poem, *Europe*, in 1954, Dudek embarked on a lifelong odyssey in imitation of *The Cantos*.

Although P. K. Page's residence in Montreal between 1941 and 1944 was brief, the modernist communities in the literary and visual arts that she encountered there produced enduring relationships. As the only female poet among the members of the *Preview* group and as a woman working in wartime offices, Page quickly developed a socially and gender-conscious poetry and poetics, most notably in her series of office poems from the early to mid-1940s. Page's Montreal period was prolific, with poems collected in the anthology *Unit of 5* (1944), edited by Ronald Hambleton, and her collection *As Ten as Twenty* (1946). Under the pseudonym Judith Cape, Page published her only novel, *The Sun and the Moon*, a symbolic romance narrative influenced by Jungian psychology about a young woman's empathic power to identify with objects of her affection. Shortly after the publication of *The Metal and the Flower* (1954), Page stopped publishing poetry for over a decade, and during a period in Brazil started to develop her talent for visual art. During the 1960s, she exhibited her drawings and paintings under her married name, P. K. Irwin; her Mexico period (1960–4) brought her under the influence of the Surrealist painter Leonora Carrington, who inspired Irwin's exploration of fluid, biomorphic forms. Page's return to poetry in her 1967 volume *Cry Ararat! Poems New and Selected* was accompanied by a series of pen-and-ink drawings from her Brazil and Mexico periods.

Shuttling between Toronto and Montreal through the 1940s and 1950s, Miriam Waddington affiliated herself with both cities' literary cultures, but most importantly in her early career with the *First Statement* group. After John Sutherland published her first poetry collection, *Green World* (1945), she brought out *The Second Silence* (1955) and *The Season's Lovers* (1958). These collections bear distinct traces of her practice as a social worker and inform her poetry's advocacy for social justice. As a mid-century Jewish poet, Waddington articulates in these collections the experiences of diaspora Jewry and bears witness to the atrocities of the Holocaust. After her move to Toronto in 1963, she returned to her early years in Montreal, editing Sutherland's *Essays, Controversies, Poems* (1972) and Klein's *Collected Poems* (1974), as well as writing the critical study *A. M. Klein* (1970) and a collection of essays and memoirs, *Apartment Seven* (1989).

Regarded principally as a cultural nationalist and realist, Hugh MacLennan seems an unlikely candidate for inclusion among the Montreal modernists. But his modernist period began several years before his arrival in Montreal in 1935. He is known as the author of *Barometer Rising* (1941), a nationalist and anti-imperialist

[22] Louis Dudek (ed.), *Dk/Some Letters of Ezra Pound* (Montreal: DC Books, 1974).

Bildungsroman about Canada's coming of age during the Halifax Explosion of 1917, and of *Two Solitudes* (1945), an allegorical romance about French–English relations in Canada. While the case for the modernism of his later fiction has been unconvincingly argued,[23] there is an emerging consensus that the unpublished novels *So All Their Praises* (1933) and *A Man Should Rejoice* (1937) constitute an early modernist phase in his career during which, as MacLennan puts it, 'I cramped my style trying to write like James Joyce,'[24] and after which he matured into a traditional realist. Having in his first two novels employed a typical Joycean stream-of-consciousness mode of narration and developed what he considered an original 'kaleidoscopic' technique that juxtaposes fragments of multiple and competing voices of historical persons and anonymous figures in dramatic dialogue,[25] he discarded these in his published novels in favour of a conventional realism.

SECOND CITY

The mythologization of Montreal as the principal locus of modernism in post-war Canada has occluded Toronto's modernist arts communities, whose contributions to modernist literature and theatre have been overshadowed by critical attention to the Montreal modernists. At the centre of modernist Toronto were the Arts and Letters Club, the Hart House Theatre, and the Theosophical Society, where the city's avant-garde visual artists, playwrights, and poets—among them Roy Mitchell, Herman Voaden, Arthur Lismer, Lawren Harris, Bertram Brooker, and W. W. E. Ross—enjoyed a brotherhood committed to modernism, occultism, and mysticism. With the exception of the Group of Seven, whose members are celebrated for their spiritualism, Toronto's mystical modernist writers are more often than not marginalized; if represented at all, their occultism is overlooked or ignored.[26]

A prolific visual artist and author, Brooker wrote poetry, short stories, plays, and three novels: *Think of the Earth* (1936), *The Tangled Miracle* (1936), and *The Robber* (1949). As early as 1912 he developed his theory of 'ultimatism', by which he 'seems to have meant not only a non-Christian belief in "spiritism," but also a passionate revolt against materialism in philosophy and life and against realism in art'.[27] Brooker's

[23] Francis Zichy, 'MacLennan and Modernism', in Frank M. Tierney (ed.), *Hugh MacLennan* (Ottawa: University of Ottawa Press, 1994), 171–9.
[24] Hugh MacLennan, 'The Future of the Novel as an Art Form', in *Scotchman's Return and Other Essays* (Toronto: Macmillan, 1960), 143.
[25] Colin Hill, 'The Modern-Realist Movement in English-Canadian Fiction, 1919–1950', Ph.D. diss., McGill University, 2003, 330–1.
[26] Gregory Betts, '"The Destroyer": Modernism and Mystical Revolution in Bertram Brooker', Ph.D. diss., York University, 2005, 12, 223.
[27] Sherrill Grace, '"The Living Soul of Man": Bertram Brooker and Expressionist Theatre', *Theatre History in Canada* (Spring 1985), 7.

ultimatism and abstractionist paintings from this early period signal his simultaneous attraction and resistance to contemporary movements in European art such as Futurism, Vorticism, and Cubism. After his move in 1921 to Toronto, where he assumed the ownership and editorship of the trade journal *Marketing*, Brooker emerged as an influential arts critic with his nationally syndicated column 'The Seven Arts' (1928–9) and anthologist with the *Yearbook of the Arts in Canada* (1929, 1936).

Voaden's principal contribution to Canadian theatre is his theory of 'symphonic expressionism', which he announced in his 1932 manifesto[28] and staged in productions of his plays, including *Rocks* (1932), *Earth Song* (1932), *Hill-Land* (1934), and *Ascend As the Sun* (1942). Through the rhythmical orchestration of stylized movement and dance, abstract sculptural staging, fluid light and colour, emotive music, and lyrical speech, Voaden attempted to express the spiritual relation between humanity and the land. Because Voaden didn't publish texts of his plays, his scores and notes on staging remained unavailable until decades later when a handful appeared in print in the 1970s and 1980s and a critically edited selection was issued in 1993.[29]

Toronto's modernist poets E. J. Pratt, Dorothy Livesay, Raymond Knister, and Ross (in his non-mystical mode) are better remembered as the progenitors of Imagist poetry and poetics in Canada. Pratt's *Newfoundland Verse* (1923), Livesay's *Green Pitcher* (1928) and *Signpost* (1932), Knister's manuscript collections *Grass * Plaitings* (1925) and *Windfalls for Cider* (1926), and Ross's *Laconics* (1930) and *Experiment 1923–29* (1956) are the principal collections of Canadian Imagism from the post-war period. Although Pratt is more often remembered for his long narrative poems, his occasional practice of Imagist aesthetics in *Newfoundland Verse, Many Moods* (1932), *The Fable of the Goats* (1937), and *Still Life and Other Verse* (1943) answered the call to poets in Canada to practise free verse sounded by Stringer and echoed by Frank Oliver Call.[30] Pratt's reception as a major poet of national importance from the 1920s through the 1950s didn't always sit easily with the younger modernists of the period, but his role as a mediator between traditionalist and experimentalist figures in mid-century Canadian poetry proved invaluable, not least in his capacity as the founding editor of the CAA's *Canadian Poetry Magazine* (1936–63), which he edited from 1936 to 1943. Despite his brief career, cut short by his death at 33, Knister was productive and left behind a considerable legacy of innovative poetry and prose. Only one novel, *White Narcissus* (1929), one ghost-written novel, *Show Me Death!* (1930), and one edited anthology, *Canadian Short Stories* (1928), appeared during his lifetime. Published widely in avant-garde magazines of the period, he worked as an associate editor of *The Midland* in 1923–4 and was appointed Canadian correspondent for *This*

[28] Herman Voaden, 'Symphonic Expressionism: A Logical Non-Realistic Stage Method, or, Notes on a New Theatre', *The Globe* (Toronto), 17 Dec. 1932, 5.

[29] Herman Voaden, *A Vision of Canada: Herman Voaden's Dramatic Works 1928–1945*, ed. Anton Wagner (Toronto: Simon and Pierre, 1993).

[30] Arthur Stringer, 'Foreword', in *Open Water* (New York: John Lane, 1914), 9–18; Frank Oliver Call, 'Foreword', in *Acanthus and Wild Grape* (Toronto: McClelland and Stewart, 1920), 9–13.

Quarter in 1925. Although Knister has been at times claimed as one of Canada's post-war realists and rural regionalists, the avant-garde aesthetics and urban subjects of a significant proportion of his prose and poetry, much of it unpublished until the past few decades, make plain his place among the nation's modernists. Ross's legacy as one of Canada's pre-eminent Imagists has been complemented in recent years by the recovery of his automatic writing of the 1930s, Surrealist works that he titled 'hypnos' (hypnagogic writing), which he left uncollected during his lifetime.[31] Critical attention to his poetry written in response to the First World War[32] has expanded our conception of the social and psychological depths of his aesthetic practices beyond the Imagist manner presented in the poetry published during his lifetime and retrospectively collected in *Shapes and Sounds* (1968).

Following her conversion to communism in 1931, Livesay returned to Toronto from studies at the Sorbonne to repudiate her early Imagist collections as decadent, bourgeois modernist poetry. She henceforth committed herself to writing leftist, anti-bourgeois, anti-modernist, proletarian verse. As a member of the communist-affiliated Progressive Arts Club in Toronto and Montreal and as a contributor to its magazine *Masses* (1932–4), she produced agitprop poetry and mass chants in the early 1930s. Under the anti-fascist banner of the Popular Front from the mid- to late 1930s, she renewed her alignment with the socially and politically progressive modernism of the Auden generation, and oriented her writing towards the Republican cause in the Spanish Civil War. In 1936, when she moved to Vancouver and joined the editorial collective of the Popular Front magazine *New Frontier* (1936–7), she added short fiction and reportage to her repertoire. While most of her writing from the 1930s was left uncollected until her retrospective volumes of the 1970s, *Collected Poems* (1972) and the multi-generic documentary text *Right Hand Left Hand* (1977), a selection of her radical poems appeared in *Day and Night* (1944).

The Progressive Arts Club of Toronto that tutored Livesay in her leftist conversion made its mark in its production of the collaboratively written agitprop play *Eight Men Speak* (1934). Based on the 1931 arrest and imprisonment of eight members of the Communist Party of Canada and the attempted assassination of its leader, Tim Buck, the play was suppressed by the Toronto police after one performance. Subsequently published as a pamphlet by the Canadian Labor Defense League, the play was co-written by Oscar Ryan, Frank Love, Mildred Goldberg, and Ed Cecil Smith. It has resurfaced in recent decades as a classic of agitprop drama, not only for its incorporation of signature techniques from the avant-garde theatre of the Russian Constructivists and German Expressionists but also for its articulation of gender politics in the context of the Communist International's Third Period (1928–34).

[31] W. W. E. Ross, *Irrealities, Sonnets, and Laconics*, ed. Barry Callaghan and Gregory Betts (Toronto: Exile Editions, 2003).
[32] Joel Baetz, 'Battle Lines: English-Canadian Poetry of the First World War', Ph.D. diss., York University, 2005.

Beginning with his 1928 debut *Strange Fugitive*, Morley Callaghan leapt to the forefront of Canadian literature with a string of urban novels and short-story collections principally set in Toronto: *A Native Argosy* (1929), *It's Never Over* (1930), *A Broken Journey* (1932), *Such Is My Beloved* (1934), *They Shall Inherit the Earth* (1935), and *More Joy in Heaven* (1937). Callaghan's Toronto is an archetypal North American city, a symbolic metropolis populated with psychologically complex characters who embody the social, political, economic, moral, and spiritual crises of modernity and who engage with typical urban issues such as organized crime, prostitution, homosexuality, mass unemployment, labour unrest, and class conflict. Many consider Callaghan to be Canada's first internationally recognized urban realist and literary geographer of inter-war Toronto; others have compared his writing to the spare, impersonalist modernist style of Hemingway. But if Callaghan can be credited with putting Toronto on the modernist map, then Raymond Souster wears the laurel of the city's poet laureate. With his early collections *When We Are Young* (1946), *Go To Sleep, World* (1947), and *City Hall Street* (1951), he staked his claim to becoming Canada's leading urban poet.[33] Souster has openly acknowledged the influence of William Carlos Williams's long poem *Paterson* and Charles Olson's Gloucester in the *Maximus Poems* on his ideas of place, particularly the city.[34] His appearance with Dudek and Layton in a collaborative, self-published volume titled *Cerberus* (1952) launched Contact Press, one of the formative institutions of small press publishing in Canada through the 1950s and 1960s.

Callaghan's Torontonian contemporaries have been occluded by his sizeable shadow and formidable reputation. Sol Allen, whose novel *They Have Bodies* (1929) is the most formally experimental work of fiction set in Toronto from the inter-war period, is virtually unknown today. Its fragmented stream-of-consciousness prose combined with dramatic-text interludes (with a nod to Joyce) is without precedent in Canadian fiction. Allen's fiction is obsessed with the representation of women's bodies, an obsession that functions as a critique of hegemonic masculinities. Similarly, Len Peterson's Toronto novel *Chipmunk* (1949) performs a trenchant critique of heteronormative cold war masculinity through the construction of a neurotic anti-hero, the antithesis of the proletarian worker–hero of the 1920s and 1930s. Two other novels of the period deserve mention for their commentaries on the modernist and leftist arts communities in Toronto: Leslie Bishop's *Paper Kingdom* (1936), a *roman-à-clef* about a magazine called the *New Conquest*, which is modelled on the *Twentieth Century* (1932–3), a literary arts monthly that Bishop co-edited with his wife, Mary Davidson; and Francis Pollock's *Jupiter Eight* (1936), a retrospective jazz age *Künstlerroman* about a struggling writer of pulp melodrama who becomes obsessed with modern jazz rhythms and a futurist aesthetic of speed.

[33] Stephen Cain, 'Mapping Raymond Souster's Toronto', in Irvine (ed.), *The Canadian Modernists Meet*, 63.

[34] Raymond Souster, Interview with John Nause and J. Michael Heenan, *CV/2*, 3/2 (1977), 8.

Toronto in the 1940s and 1950s witnessed the emergence of what Northrop Frye calls a 'great mythopoeic age'.[35] Contemporary with the publication of Frye's *Fearful Symmetry: A Study of William Blake* (1947) and *Anatomy of Criticism: Four Essays* (1957), a group of late modernist mythopoeic poets surfaced in Toronto, including Margaret Atwood, Margaret Avison, Douglas Le Pan, Daryl Hine, Jay Macpherson, Gwendolyn MacEwen, Eli Mandel, James Reaney, Anne Wilkinson, and Wilfred Watson. While some critics credit Frye's myth criticism and his teaching at Victoria College with the generation of a Toronto mythopoeic movement, it should be noted that some of the poets identified with the group started writing before Frye and that his criticism may well have been responsive to the local literary culture.[36] Whatever the reciprocal effects between Frye and the mythopoeic poets, the synchronous development of his archetypal criticism and a revival of interest in the structures and symbols of ancient myth marks a decisive phase in the formation of late modernist poetry in Toronto and across Canada.

COASTS AND PRAIRIES

While early to mid-century Atlantic Canada is more typically considered a territory of romance, the prairies of this period are principally regarded as the region of realism. Generalizations of this kind have fostered the critical construction of Canada's coastal and prairie literatures according to principles of geographic determinism. However, as Glenn Willmott claims, if the most common setting of the modern Canadian novel 'is not the city' but rather 'an archetypal space of transition between country and city, the traditional and the modern, the past and the future' situated 'in regions on the colonized peripheries of the world's empire-driven modernity',[37] it follows that Canada's prairies and coasts provided prime locations for the emergence of peripheral modernist and anti-modernist literary cultures that were both local and cosmopolitan, in the country and in the city, regional and international.

Newfoundland author Margaret Duley imports modernism into her debut novel *The Eyes of the Gull* (1936) not only through an itinerant artist figure who talks of 'modern ideas or forces that couldn't be expressed in old forms' and 'the spirit of change, and the thought of Impressionism, Post-Impressionism, Cubism, or the idea of expressing abstractions in line or colour' but also through her female protagonist's

[35] Northrop Frye, *The Bush Garden: Essays on the Canadian Imagination* (Toronto: Anansi, 1971), p. viii.

[36] Melissa Dalgliesh, 'Revealing Reciprocity: Anne Wilkinson, Northrop Frye, and Mythopoetics in Canada', MA diss., Dalhousie University, 2007, 100–6.

[37] Glenn Willmott, *Unreal Country: Modernity in the Canadian Novel in English* (Montreal: McGill-Queen's University Press, 2002), 61, 51.

anti-realist, escapist fantasies.[38] Symptomatic of her ambivalence towards her native land, her third novel, *Highway to Valour* (1942), 'is dedicated to Newfoundland, a country which the author loves and hates'. This ambivalence is evident in her attraction to romance and local folklore in her second novel, *Cold Pastoral* (1939), which is counterbalanced by her portrait of cosmopolitan London as a corrupting force that provokes a return to outport Newfoundland. Most significant in Duley's fiction is her focus on women's encounters with the transformative ideas and forces of modernity, not least of which is a steadfast feminist consciousness that develops throughout her novels.

Not forgetting the modernist experiments of the *fin-de-siècle* expatriates, the Maritime provinces showed a stronger inclination towards literary strategies of anti-modernism than towards modernist innovations through the post-war and inter-war periods. Populated by the likes of Andrew Merkel, Robert Norwood, and Charles Bruce of the Song Fishermen's Circle, Halifax between the wars may have seemed an improbable host to modernist innovation, but from this staunchly conservative milieu came Kenneth Leslie, a poet who not only sought reconciliation between Christianity and Marxism but also balanced traditional and progressive tendencies in his poetics. Between 1934 and 1938 he published four collections of poetry, culminating in *By Stubborn Stars and Other Poems*, which won the Governor General's Award in 1938. From a similar literary environment, Elizabeth Brewster emerged out of Fredericton's Bliss Carman Poetry Society—which started publication of *The Fiddlehead* as a society magazine in 1945—with her early collection *East Coast* in 1951. By mid-century the Maritimes saw the rise of Ernest Buckler to prominence with the publication of *The Mountain and the Valley* (1952), a self-reflexive *Künstlerroman* about a failed modernist artist figure that performs a critique simultaneously of the genre itself and of modernist aesthetics. More typical of Atlantic Canadian fiction from early to mid-century were the nostalgic, anti-modernist novels and short fiction of Norman Duncan (*The Way of the Sea*, 1904), Frank Parker Day (*Rockbound*, 1928), Thomas Raddall (*The Pied Piper of Dipper Creek and Other Stories*, 1944, *The Wedding Gift and Other Stories*, 1947, *The Nymph and the Lamp*, 1950), and Charles Bruce (*The Channel Shore*, 1954, *The Township of Time*, 1959) with their blend of realist style and plots structured by patterns of romance.

Although prairie realism has long been accepted as the dominant aesthetic of the region and repeatedly invoked to impose unity on a heterogeneous literary phenomenon,[39] the first half of the twentieth century saw the uneven development of modernism in prairie fiction with the formal and stylistic innovations of Stringer (the prairie trilogy, 1915–22), Ostenso (*Wild Geese*, 1925), Durkin (*The Magpie*, 1923), and Grove (*Settlers of the Marsh*, 1925) in the 1910s and 1920s, with the critically acclaimed novels of Brooker (*Think of the Earth*, 1936) and Ross (*As for Me and My House*, 1941) in the 1930s and 1940s, and with the neglected late modernist works of Christine Van Der Mark (*In Due Season*, 1947), Vera Lysenko (*Yellow Boots*, 1954),

[38] Margaret Duley, *The Eyes of the Gull* (London: Arthur Barker, 1936), 77–8, 10.
[39] Alison Calder, 'Reassessing Prairie Realism', *Textual Studies in Canada*, 12 (1998), 51.

Adele Wiseman (*The Sacrifice*, 1954), and Patricia Blondal (*A Candle to Light the Sun*, 1960) from the 1950s. Birk Sproxton's 2006 collection *The Winnipeg Connection: Writing Lives at Mid-Century* is a recent and promising sign of the critical reconsideration of the modernism of the period's prairie fiction.

Sinclair Ross's 1941 novel *As for Me and My House* was distinguished at a conference on the Canadian novel held at the University of Calgary in 1978 as one of Canada's ten most important novels.[40] Long heralded as the pinnacle of prairie realism, *As for Me and My House* deserves to be recognized as a work of modernist fiction, not least for its unreliable diarist narrator and its portrait of an artist figure whose Post-Impressionist aesthetics of 'inner necessity' and 'significant form' can be traced to Roger Fry and Clive Bell, 'the principal aesthetic theoreticians of Bloomsbury'.[41] Ross's *Lamp at Noon and Other Stories* (1968) has found a similar reception as an exemplary case of prairie realism. Although the prairie setting is important to Ross's fiction, a more accurate view of his aesthetics should acknowledge that he was less preoccupied with geographic or regional determinism than with the same modern, cosmopolitan themes of alienation, isolation, and communal fragmentation as his urban counterparts in Canada, the United States, and Europe.

Although Canada's west coast has suffered less literary typecasting than its prairie and eastern counterparts, its visibility as a site and subject of modernist cultural history has been persistently overshadowed by Montreal and Toronto. Like Halifax in the 1920s and 1930s, inter-war Vancouver was full of literary anti-modernists, and like Toronto between the wars, the arts in the far west were steeped in the occult and mysticism. Under the direction of its theosophist president Ernest Fewster, the Vancouver Poetry Society (established in 1916) played host to formally traditional poets such as Annie Charlotte Dalton and A. M. Stephen, who held that 'Art must necessarily be the symbol of spiritual experience.'[42] By the mid-1930s the Society attracted the newly arrived Livesay to its fold and launched its own poetry magazine, *Full Tide* (1936–74).

Around this time Livesay met the editor and modern poetry enthusiast Alan Crawley. A publishing committee consisting of the Victoria poets Doris Ferne, Anne Marriott, Floris Clark McLaren, and Livesay approached Crawley in the spring of 1941 to edit the magazine *Contemporary Verse* (1941–52), a task which he undertook with assistance from McLaren and his wife, Jean. The *Contemporary Verse* group produced a remarkable body of modernist poetry that can be in part credited to Crawley's editorial labours, including McLaren's *Frozen Fire* (1937), Ferne's *Ebb Tide* (1941) and *Paschal Lamb and Other Poems* (1946), Marriott's *The Wind Our Enemy* (1939), *Calling Adventurers!* (1941), *Salt Marsh* (1943), and *Sandstone and Other Poems* (1945), and Livesay's *Poems for People* (1947) and *Call My People Home* (1950). Crawley's

[40] Charles Steele (ed.), *Taking Stock: The Calgary Conference on the Canadian Novel* (Downsview, Ont.: ECW, 1982).

[41] D. M. R. Bentley, 'As for Me and Significant Form', *Canadian Notes and Queries*, 48 (1994), 18.

[42] A. M. Stephen, quoted in Ernest Fewster, 'Foreword', in Lionel Stevenson (ed.), *The Vancouver Poetry Society 1916–1946: A Book of Days* (Toronto: Ryerson, 1946), p. v.

extensive correspondence with mid-century poets is legendary, and his critical support for and publication of major women poets at the beginning of their careers—such as Page, Waddington, Wilkinson, Macpherson, and Webb—is a matchless legacy in the history of modernism in Canada.

Prior to his move to Vancouver in 1946, Earle Birney lived in Toronto, Salt Lake City, and London. During his time in Toronto in the 1930s he was involved in Marxist politics, joined a Trotskyist cell, and devoted himself to organizing rallies and demonstrations and political journalism; he also served from 1936 to 1940 as literary editor of the Toronto-based socialist magazine *The Canadian Forum* (1921–2000). At the outbreak of the Second World War he enlisted and served in Europe, returning to Canada in 1945 to work for the CBC International Service. These political, military, and academic experiences fed Birney's poetry, fiction, and radio plays through the 1940s and 1950s, beginning with *David and Other Poems* (1942) and *Now Is Time* (1945), two more poetry collections, *The Strait of Anian* (1948) and *Trial of a City and Other Verse* (1952), and two novels, *Turvey: A Military Picaresque* (1949) and *Down the Long Table* (1955), a cold war narrative about the anti-communist witch-hunts of the early 1950s. His radio drama of this period was later collected by Howard Fink in *Words on Waves: Selected Radio Poems of Earle Birney* (1985). From 1946 to 1948 Birney edited the CAA's *Canadian Poetry Magazine*, a brief tenure that pitted him against the Association's executive but transformed its periodical into a forum for the leading modernist poets in Canada.

The growth of modernist fiction on the west coast followed the tides of British Columbia's resource-based industries. Beginning with M. Allerdale Grainger's 1908 novel *Woodsmen of the West*, with its ingénue, bourgeois narrator's unreliable account of turn-of-the-century Vancouver and logging camps of the Pacific north-west, the labour novel that featured idealized middle-class heroes with sympathies for the working class and that exhibited utopian socialist ideologies became a staple of 'antimodern modernism'[43] in early twentieth-century fiction. The middle-class hero who 'goes over' to the workers is featured in the fiction of Hubert Evans (*The New Front Line*, 1927), Bertrand Sinclair (*Poor Man's Rock*, 1920, *The Hidden Places*, 1922, and *The Inverted Pyramid*, 1924), and A. M. Stephen (*The Gleaming Archway*, 1929). These converted bourgeois heroes exhibit the post-war period's liberal sentiments about cross-class sympathies embedded in secular socialist ideologies. With the publication of Irene Baird's 1939 novel *Waste Heritage*, which tells the story of the 1938 sit-down strike at the Vancouver post office and the subsequent trek of the unemployed to protest in Victoria, the labour novel of the west coast reached its apex with her simultaneous practice and meta-fictional critique of the modernist-leftist genre of literary reportage.

With the appearance of her novellas *Hetty Dorval* (1947), *The Equations of Love* (1952), and *Love and Salt Water* (1956), her novels *The Innocent Traveller* (1949) and

[43] Lynda Jessup, 'Antimodernism and Artistic Experience: An Introduction', in Jessup (ed.), *Antimodernism and Artistic Experience: Policing the Boundaries of Modernity* (Toronto: University of Toronto Press, 2001), 6.

Swamp Angel (1954), and the short-story collection *Mrs. Golightly and Other Stories* (1961), Ethel Wilson accumulated a body of work that seemed at once Victorian and modernist in its technique. Of particular note is Wilson's predilection for narratorial intrusions, a technique that sometimes recalls the omniscient interjections of the Victorians and at other times the stream-of-consciousness style of the modernists. Combined with the staccato chapters of *Swamp Angel* that achieve montage effects, Wilson's occasionally fractured narrative and prose style bears a resemblance to the juxtapositions and fragmentation of modernist bricolage. If, as Robert Kroetsch infamously quipped, 'Canadian literature evolved directly from Victorian into Postmodern',[44] then Wilson's fiction stands at that crossroads of a contradictory and self-cancelling modernism.

Aboriginal Modernity and Modernist Indigeneity

The historical gap between the death of the mixed-race Mohawk poet E. Pauline Johnson/Tekahionwake in 1913 and the renaissance in aboriginal writing at the end of the 1960s has been variously characterized as the 'barren period'[45] or 'the "dark days" of the residential school period'.[46] Reasons for the decline in Native writing included government control of the aboriginal population through policies of assimilation and education, increased immigration rates and displacement of indigenous communities, and 'a notable lack of interest among publishers in anything pertaining to natives, although some of their narratives, as re-told by non-natives, were published'.[47] Although there was a conspicuous downturn in works of literature published by Native authors for a half-century following the First World War, the interest among non-native modernist authors in aboriginal cultures led to the production of literary works sympathetic to indigenous peoples. For instance, Chief William (K'HHarlserten) Sepass approached Sophia Jane White in 1911 to translate his songs into English, which were transcribed and later edited and published by her daughter Eliose Street. After Sepass's death in 1943 Ryerson Press rejected the manuscript 'on the grounds that it was not considered to be authentic', and

[44] Robert Kroetsch, 'A Canadian Issue', *Boundary 2*, 3/1 (Autumn 1974), 1.
[45] Penny Petrone, *Native Literature in Canada: From the Oral Tradition to the Present* (Toronto: Oxford University Press, 1990), 95.
[46] Armand Garnet Ruffo, 'Out of the Silence—The Legacy of E. Pauline Johnson: An Inquiry into the Lost and Found Work of Dawendine—Bernice Loft Winslow', in Christl Verduyn (ed.), *Literary Pluralities* (Peterborough, Ont.: Broadview, 1998), 212.
[47] Petrone, *Native Literature in Canada*, 95.

'Street later confessed to having elaborated upon several of the stories.'[48] Whatever the extent of Street's embellishments, the cycle of songs as they survive in *Sepass Poems* (1955) and *Songs of Y-Ail-Mihth* (1958), reissued in a later version under the title *Sepass Tales: Songs of Y-Ail-Mihth* (1974), may be read as modernist, free-verse 'interpretations' of Native songs, such as those collected by George W. Cronyn in his anthology *The Path on the Rainbow: An Anthology of Songs and Chants from the Indians of North America* (1918), which included lyrics and an afterword by Canadian poet Constance Lindsay Skinner.

Among Canada's first-generation modernists, Skinner first rose to international prominence with a sequence of Imagist lyrics, which appeared as a cycle under the title *Songs of the Coast Dwellers* in the October 1914 issue of *Poetry* (Chicago).[49] Expanded in 1930, *Songs of the Coast Dwellers* is not a collection of 'translations nor adaptations of Indian poems', as Skinner puts it, but a 'succession of lyrics [that] presents, in primitive symbolism, the characters of an imaginary community and the interweaving of their lives'.[50] Her reference to 'primitive symbolism' marks her contiguity with modernist visual artists, such as Picasso and Gauguin, who took inspiration for their abstract art from so-called primitive cultures in Africa and the South Pacific. The Native cultures from which Skinner draws her influence is an amalgam of north-west coast tribes, extending from the Kwakiutl and Squamish of the south coast of British Columbia to the Haida Gwaii in the north.

Skinner's lyric sequence runs parallel to the work of her famous contemporary Emily Carr, whose intimate connection to north-west coast and Haida Gwaii Native peoples and their abstract sculptural art is borne out on her canvases and in her autobiographical writings. Carr's inclusion in a National Gallery of Canada exhibition on west-coast Native art brought her to the attention of members of the Group of Seven, with whom she later exhibited. Towards the end of her career, when age and illness prevented her from painting, Carr produced several volumes of autobiographical sketches, including *Klee Wyck* (1941), *The Book of Small* (1942), and *The House of All Sorts* (1944). Her autobiography *Growing Pains* (1946) and an edited version of her journals, *Hundreds and Thousands* (1966), appeared posthumously.

Marius Barbeau's 1928 novel *The Downfall of Temlaham*, which is based in part on the historical events of the Skeena River rebellion in British Columbia in the 1880s, tells the story of Kamalmuk and Sunbeams, separated by their opposing attitudes towards policies of assimilation and resistance to colonization. The novel's anti-chronological structure places it alongside the experiments with temporality in more

[48] Frederick R. Edwards, 'A War of Wor(l)ds: Aboriginal Writing in Canada during the "Dark Days" of the Early Twentieth Century', Ph.D. diss., University of Saskatchewan, 2008, 15 n. 28.

[49] Jean Barman, *Constance Lindsay Skinner: Writing on the Frontier* (Toronto: University of Toronto Press, 2002), 69.

[50] Constance Lindsay Skinner, 'Foreword', in *Songs of the Coast Dwellers* (New York: Coward McCann, 1930), pp. viii, ix.

canonical modernist texts,[51] and its participation in the vanguard of ethnography pioneered by Barbeau's mentor Franz Boaz places it in the company of his more famous modernist protégé, Zora Neale Hurston.[52] The accompaniment of the text with colour reproductions of works by many of Canada's most prominent modernist painters, including Carr, A. Y. Jackson, Edwin Holgate, and Annie D. Savage, adds to the book's bricolage of multiple perspectives and representations of Gitk'san history.

Set in the mountains near Jasper at the turn of the century, Howard O'Hagan's 1939 novel *Tay John* tells the story of a mixed-blood man ('Tête Jaune') who is caught between his Native and European ancestry, neither at home among the Shuswaps, who welcome him as their blond messiah, nor among the dominant European settler society that regards him as a picturesque, noble savage. Born according to Tsimshian legend from the grave of his Shuswap mother, Tay John disappears at the end of the novel with his descent into the earth that birthed him. Celebrated by Michael Ondaatje as a work of 'mythic realism', *Tay John* openly rejects realist conventions and adopts alternative and successive modes of storytelling. A work of meta-fiction conscious of the imperialist histories attached to modes of narration, *Tay John* unsettles the narrative so that 'we are no longer part of the realistic novel, and no longer part of the European tradition'.[53]

At first, Sheila Watson's experiences among the Shuswap people as a schoolteacher in the Cariboo region of British Columbia during the 1930s produced but one short story, 'Rough Answer', published in the *Canadian Forum* in 1938. The manuscript of a novel she had written in the 1930s, *Deep Hollow Creek*, waited until 1992 before it saw publication. In the interim she gained widespread critical acclaim for her novel *The Double Hook* (1959), which perfectly renders high modernism's spare, fragmented, elliptical style, 'mythical method', and tropes of individual and communal alienation in a narrative that Watson says is 'about how people are driven, how if they have no art, how if they have no tradition, how if they have no ritual, they are driven in one of two ways, either towards violence or towards insensibility—if they have no mediating rituals which manifest themselves in what I suppose we call art forms'.[54] Watson's interest in mythic narratives is evident in her late modernist Oedipus cycle, a series of short stories from the 1950s and 1960s populated by characters from Greek myth but set in the twentieth century.[55] The late publication of an early short story from the 1930s, 'And the Four Animals' (1980), returns to the territory of the Native trickster figure in a coda to her career. Her essays, many of which address the Vorticist and Expressionist visual art and writings of Wyndham Lewis, were gathered in *Sheila Watson: A Collection* (1974).

[51] Glenn Willmott, 'Modernism and Aboriginal Modernity: The Appropriation of Products of West Coast Native Heritage as National Goods', *Essays on Canadian Writing*, 83 (2004), 75.

[52] Glenn Willmott, *Modernist Goods: Primitivism, the Market, and the Gift* (Toronto: University of Toronto Press, 2008), 276.

[53] Michael Ondaatje, 'Afterword', in Howard O'Hagan, *Tay John* (Toronto: McClelland and Stewart, 1989), 265, 272.

[54] Sheila Watson, 'What I'm Going to Do', Open Letter, 3rd ser., 1 (Winter 1974–5), 183.

[55] Sheila Watson, *Four Stories* (Toronto: Coach House Press, 1979).

Of the handful of Native authors writing during the 'dark days' of the early to mid-twentieth century, Dawendine (Bernice Loft Winslow) stands apart for her production of poems at times in the style of contemporary modernist poets. Like E. Pauline Johnson/Tekahionwake at the turn of the century, Dawendine performed in traditional Mohawk dress and recited stories and legends of the Six Nations throughout southern Ontario in the 1930s. In the mid-1940s, after she moved with her husband to Massachusetts, she started to 'set down on paper her "word pictures" and poems about the Six Nations'.[56] By 1947 she had assembled a manuscript collection under the title *Spirit Fires of the Iroquois*, which she hoped to have published by the Ryerson Press with illustrations by C. W. Jeffreys, but a deal of publication without royalties offered by the press came to nothing.[57] Alongside poems and stories about Mohawk customs and traditions, some of the material is 'modern, dealing with such issues as the role of present-day Indian women, the participation of Native airmen in World War Two, and the plight of the diasporic exile living off the reserve'.[58] The publication of Dawendine's first collection in 1995 at the age of 93 is not only symptomatic of the belated recognition of Native literary production during the half-century after the First World War but also emblematic of the dominant literary culture in Canada that romanticized aboriginal culture and appropriated its primitivist art in the name of modernism.

[56] Robert Stacey, Donald Smith, and Bryan Winslow Colwell, 'Introduction', in Dawendine [Bernice Loft Winslow], *Iroquois Fires: The Six Nations Lyrics and Lore of Dawendine (Bernice Loft Winslow)* (Ottawa: Penumbra Press, 1995), 20.

[57] Robert Stacey, 'Afterword', in Dawendine, *Iroquois Fires*, 149–50.

[58] Ibid. 144.

CHAPTER 49

..

HISPANIC
LITERATURE AND
MODERNISM

..

DONALD L. SHAW

AT the present time any attempt to deal with modernism in the Anglo-Saxon sense of the term is fraught with difficulty and must be regarded as largely provisional. This is because the term has only recently begun to take hold in relation to Spanish peninsular literature and is even less used in relation to Spanish American literature. There are several possible reasons for this. The chief one is probably that Spanish already uses the term *modernismo* to refer to a chiefly poetic movement (though it did produce some fiction), headed by the Nicaraguan poet Rubén Darío. It had pretty well run its course in Spanish America and Spain by the time of his death, and was finally overtaken by the emergence of vanguardism and other 'isms' in Spanish America with highly innovative poets like Jorge Luis Borges (Argentina) and Vicente Huidobro (Chile), and at the very latest by the emergence of the poets of the Generation of 1927 in Spain.[1] Another reason could simply be the resistance of Hispanic writers and critics to passively adopting Anglo-Saxon terms which may

[1] The situation is even more complicated in Brazil, whose literature and critical terminology I am not competent to discuss. But see Dario Fernández-Morera, 'The Term "Modernism" in Literary History', *Proceedings of the Xth Congress of the International Comparative Literature Association* (New York: Garland, 1985), i. 271–9, and his note on sources; and Randal Johnson, 'Brazilian Modernism: An Idea Out of Place?', in Anthony Giest and José Monleón (eds), *Modernism and its Margins: Reinscribing Cultural Modernity for Spain and Latin America* (New York: Garland, 1999), 186–214.

not, in their view, really fit their literature. On the other hand, it has to be said that the terms 'postmodern' and 'postmodernism' have been adopted enthusiastically both in Spain and in Spanish America, and critics have hastened to attach the label to many of their contemporary writers, appropriately and otherwise, simply because not to have 'postmodern' representatives implies cultural backwardness. Thus, we are faced with a paradoxical situation in which 'postmodern' and 'postmodernist' are prestigious and ever more widely used adjectives in the Hispanic world, but we have only the beginnings of an idea of what might constitute modernism in that area and only limited interest in finding the answer. Symbolic, in my view, of this situation, so far as Spain is concerned, are the facts that Cifuentes in his well-known *Teoría y mercado de la novela en España* covers major aspects of fiction between 1908 and 1930 without ever mentioning modernism, and that Navajas in his equally well-known *Teoría y práctica de la novela española posmoderna* makes no attempt whatever to distinguish postmodernism from modernism in Spain.[2]

So we find ourselves in an interesting position. On the one hand, we have the exciting possibility of attempting to formulate a systematic description of modernism and creating a critical body of work on the movement in Spain and Spanish America. This would involve the question of whether we can reinterpret aspects of *modernismo*, the work of members of the Generation of 1898 in Spain, the avant-garde, the early modern novel in Spain, the pre-Boom novel in Spanish America (and perhaps even a sector of the Boom), and some aspects of poetry and drama in the Hispanic area as manifesting aspects of modernism. In turn this would compel us to ask different questions about the relevant texts from those which we have been used to asking. But, on the other hand, we have signs that this possibility has caught the attention of only a handful of critics. There is as yet no clear consensus, especially with respect to Spanish America, about how to periodize the issue or about who the most relevant authors might be, or which texts to point to. We are not entirely in agreement about which are the new questions to be asked. But the crucial issue remains: how can we study Hispanic postmodernism or use the term persuasively when there is no consensus about Hispanic modernism and only few signs that one is in process of emerging?

SPAIN

To see what progress is being made we need to look first at Spain. Here things are on the move. The most detailed analysis of developments is in Santiáñez's essay

[2] Luis Fernández Cifuentes, *Teoría y mercado de la novela en España: Del 98 a la República* (Madrid: Gredos, 1982); Gonzalo Navajas, *Teoría y práctica de la novela española posmoderna* (Barcelona: Ediciones del Mall, 1987).

'Modernismo y modernismos'.[3] But briefly: if we think of the traditional critical approach to the turn of the nineteenth century in Spain, by which time modernism is usually thought to have begun to show signs of emergence, we see that the accepted postulate was roughly as follows. The end of the century in Europe was a period of acceleration of a crisis of ideals and beliefs which had been incubating since the rise of 'subversive' Romanticism, which in Spain, for example, had produced José de Espronceda's unfinished poem *El diablo mundo* ('The Devil World'), first beginning to appear in 1840. The defeat of Spain in Cuba in 1898 ('the Disaster') was thought to have intensified this sense of crisis in the peninsula, which French writers, recognizing it to be just as present at home and typical of the outlook of a large sector of the intellectual minority in Europe as a whole, have called 'la conscience malheureuse' ('the unhappy consciousness').[4] It could be perceived at the national level as involving the need to bring about the 'Regeneration' of Spain. This problem dominated much of the thinking of the writers of the Generation of 1898 (Angel Ganivet, Miguel de Unamuno, José Martínez Ruiz (Azorín), Pío Baroja, Antonio Machado, and Ramiro de Maeztu). However, they tended to see it not as it really was, that is (in Spain especially), as an economic, social, and political crisis of an underdeveloped, pre-industrial, oligarchically run country. Instead they interpreted it as an ideological and spiritual crisis among individuals, who found themselves bereft of guiding ideas and subject to widespread aboulia, or will-lessness. Critics, especially under the Franco regime, tended to emphasize this aspect of the outlook of the men of the Generation rather than seeing their thinking in the wider perspective of changing world-views and some degree of cultural pessimism in Europe as a whole. At the same time they were slow to recognize, until the economic take-off and democratization of Spain reconfigured the problem, that these were highly innovative writers who changed the course of literature in the Spain of their day. Critics were much more ready to use this approach for the group of writers who developed in parallel to the men of the Generation of 1898, namely the Spanish *modernistas*, including such figures as Juan Ramón Jiménez, Ramón de Valle-Inclán, and Manuel Machado.

It should be emphasized that belief in the separate existence of the Generation of 1898 is still very much alive today in certain quarters. However, a change has gradually taken place, in two stages. As interest in the identification of the men of '98 with the problem of Spain faded and emphasis on their creative work grew, the first stage was to collapse the idea of a Generation of 1898 into a broader definition of *modernismo*. Thus, by the early 1980s, leading critics including Ricardo Gullón and José-Carlos Mainer were engaged in this endeavour, and the latter could announce that the new-style *modernismo* had become 'El indiscutido vencedor de la mal avenida pareja modernismo-noventayocho' ('The indisputable victor over the

[3] Nil Santiáñez, 'Modernismo y modernismos', in *Investigaciones literarias: Modernidad, historia de la literatura y modernismos* (Barcelona: Editorial Crítica, 2002), 87–135.
[4] Donald L. Shaw, 'El 98 y la "conscience malheureuse" del siglo XX', in Jesús Torrecilla (ed.), *La generacion del 98 frente al nuevo fin de siglo* (Amsterdam: Rodopi, 2000), 293–300.

badly assorted pair modernismo–ninety-eight').[5] But already, this stage of the evolution was under pressure from a second stage, significantly launched by predominantly Anglo-Saxon Hispanists, led initially by Christopher Soufas and Alex Longhurst. They had become uncomfortable with what Soufas, in a major work on the topic, was later to call 'the nation-centered generational model that has long dominated critical orientation in Spain'.[6] In the back of their minds perhaps was the idea formulated at the conclusion of my book *The Generation of 1898 in Spain*[7] that the catastrophe of 1898 helped to focus a shift of sensibility in Spain *before* the First World War is supposed to have had a similar effect in the remainder of the West.

Hence my suggestion that nowhere else in Europe or the Americas in the early twentieth century can we find a similarly compact body of writers whose work illustrates so consistently a critical moment of transition.[8] That transition began to be seen as a transition from the notion of a broad-based *modernismo* to a notion that what this really constituted was the Spanish form of modernism. Already, as early as 1995, a far-sighted Spanish critic, Andrés Soria Olmedo, had articulated this view in a piece on the poet Jorge Guillén.[9] But it was Soufas who really opened the ball with a slashing article in 1998 in which he mounted a violent attack on the old Francoist and generationalist approach to modern Spanish literature, declaring roundly that 'Spanish literature of the early twentieth century requires a much stronger identification with the period concept known as Modernism.'[10] After criticizing the standard approach and clarifying its origins, Soufas offers suggestions pointing towards a description of modernism and implies that both the 'Generations' of 1898 and 1927 were modernist. But he does not specify authors or texts. However, in a series of writings beginning in 1999 with 'The Turn of the Novel in Spain: From Realism to Modernism in Spanish Fiction', Longhurst began to flesh out the issue, with regard to prose, arguing that in Spain '*Fin de siècle* disarray appears to have persisted until World War I,' and that at this time there was already 'a keen awareness of the aesthetic vacuum in which literature was developing and of the need to establish a new theoretical framework'.[11] In other words, the transition which I postulated was already operating before 1914 in Spain, and modernism was already taking shape.

[5] José-Carlos Mainer, 'La crisis de fin de siglo', in Francisco Rico (ed.), *Historia crítica de la literatura española*, vi: *Modernismo y 98* (Barcelona: Crítica, 1980), 5.

[6] Christopher Soufas, *The Subject in Question: Early Contemporary Spanish Literature and Modernism* (Washington, DC: Catholic University of America Press, 2007), 3.

[7] Donald L. Shaw, *The Generation of 1898 in Spain* (London: Ernest Benn, 1975; 7th Spanish edn, amplified, 1998).

[8] Ibid. 212.

[9] Andrés Soria Olmedo, 'Jorge Guillén y la "joven literatura"', in Antonio Piedra and Javier Blasco Pacual (eds), *Jorge Guillén, el hombre y la obra* (Valladolid: Valladolid University Press and the Fundación Jorge Guillén, 1995), 257–78.

[10] Christopher Soufas, 'Tradition as an Ideological Weapon: The Critical Redefinition of Modernity and Modernism in Early Twentieth Century Spanish Literature', *Anales de la Literatura Española Contemporánea*, 23/1 (1998), 465.

[11] C. Alex Longhurst, 'The Turn of the Novel in Spain: From Realism to Modernism in Spanish Fiction', in Anthony H. Clarke (ed.), *A Further Range: Studies in Spanish Literature from Galdós to Unamuno* (Exeter: University of Exeter Press, 1999), 26.

His conclusion, still with respect to prose, after a survey of the evidence in which Unamuno is the central figure, is that

It is now becoming widely accepted—except perhaps in Spain—that the novelists of the Generation of 1898 are *grosso modo* the Spanish counterparts of the European Modernist fiction writers of the first four decades of the twentieth century. Unamuno, Valle-Inclán, Baroja and Azorín, to whom we might reasonably add the slightly younger Pérez de Ayala and Gabriel Miró, all wrote novels at least some of which bear comparison in theme and approach with the works of fiction writers in Europe now recognized as Modernist.[12]

Nevertheless, in his contribution to Joseph Harrison and Alan Hoyle's *Spain's 1898 Crisis*, he correctly emphasized: 'No podemos concluir nada porque esa transición del realismo/naturalismo al modernismo todavía no la comprendemos plenamente' ('We cannot advance any conclusion because we do not fully understand that transition from realism/naturalism to *modernismo*').[13] Just as Soufas and Longhurst were formulating their ground-breaking views, Anthony Giest and José Monleón were in process of publishing their *Modernism and its Margins*, Mary Lee Bretz was at work on her *Encounters Across Borders*,[14] and Nil Santiáñez on his *Investigaciones literarias, historia de la literatura y modernismos*. Of these the first strikes one as rather unfocused. For our purpose, perhaps the most interesting essay is that by Carlos Blanco Aguinaga 'On Modernism from the Periphery', which argues strongly in favour of a Hispanic modernism and suggests helpfully some writers and creators whom it might include, such as Unamuno and Azorín, Buñuel, 'that amazing pleiad of poets born in the Americas and in Spain somewhere between 1895 and 1905', as well as Ramón Gómez de la Serna, Vicente Huidobro, César Vallejo, Federico García Lorca, and others.[15] Alejo Carpentier, an early Boom figure, features in other essays. All of which implies that modernism survived well into the period of the Generation of 1927 in Spain and into at least the 1950s in Spanish America. Santiáñez's erudite book is chiefly useful, as we have suggested, for its long historical discussion of the concept of modernism in Spain. Bretz's *Encounters Across Borders* offers the most comprehensive account of what she sees as Spanish modernism to have appeared so far. Dismissing the notion of a Generation of 1898 as a Francoist notion and ignoring older attempts to define *modernismo* as a parallel but separate movement, she gathers under one critical umbrella practically all the writers who were active in the span of time that her book covers, analysing the content and form of their work in the light of characteristics borrowed, as her bibliography indicates, from discussions of modernism and modernity in the non-Hispanic world. Her aim is to tease out a series of mainly thematic strands which in her view form a basis for 'a dialogic

[12] Longhurst, 'The Turn of the Novel in Spain', 30.
[13] C. Alex Longhurst, 'Noventayocho y novela: lo viejo y lo nuevo', in Joseph Harrison and Alan Hoyle (eds), *Spain's 1898 Crisis: Regeneration, Modernism, Post-Colonialism* (Manchester: Manchester University Press, 2000), 179.
[14] Mary Lee Bretz, *Encounters Across Borders: The Changing Visions of Spanish Modernism, 1890–1930* (Lewisburg, Pa.: Bucknell University Press, 2001).
[15] Carlos Blanco Aguinaga, 'On Modernism from the Periphery', in Giest and Monleón (eds), *Modernism and its Margins*, 3–16.

exchange between Spanish modernism and the other national modernisms that develop during the late nineteenth and early twentieth centuries'.[16] What emerges is a series of standpoints for viewing the contents of the work of the authors in question which differ significantly from those we were used to using. They include, for example, the notion of a reconceptualization of time, a sense of a multifaceted, unstable physical world, new modes of viewing reality, the development of new patterns of literary discourse, a different view of gender relationships, lack of confidence in the stability of the self, doubts about truth statements in literary works, and the establishment of a new relationship between author, text, and reader.

Two things are worthy of notice at this point. The first is that Bretz accepts the time-scale postulated by Bradbury and MacFarlane, that is, 1890–1930, thus making the modernist period in Spanish literature correspond to the one which is commonly attributed to the movement in the rest of Europe. The second is that this coincides quite well with the view of Longhurst, who sees Spanish modernism incubating in the 1890s, beginning to emerge in the *annus mirabilis* of 1902 when Unamuno, Baroja, Azorín, and Valle-Inclán all published highly innovative works, in full flower by 1914, and ending with an intensification of its insistence on writerliness by figures belonging to the avant-garde. We have here, in other words, the beginning of a basis for consensus. It is, however, unstable at the far end, since Bretz does not fully accept Longhurst's robust assertion that, at least at the epistemological level, 'there is no very meaningful distinction that can be drawn between the Modernists and the vanguardists of the 1920s', which is echoed by Soufas.[17] The latter writes: 'Spanish criticism has decisively rejected the broader notion of a European modernism in favor of an approach that has splintered the avant-garde into its individual fragments rather than to associate its positions with a mainstream consensus that understands the historical avant-garde as a vital, autonomous, yet nevertheless integral part of modernism.'[18] Bretz more cautiously remarks that 'the relationship between modernism and the vanguardist literature of the 1920s continues to puzzle critics and is even more problematic in the case of Spain'.[19] This reminds us that the need to extend the study of modernism in Spain is essential not only in order to better our understanding of its relationship to postmodernism, but also to clarify its links with, or differences from, vanguardism. An important contribution to the discussion of this issue was made in 2005 by Andrew Anderson, the eighth chapter of whose book *El veintisiete en tela de juicio*, 'Hacia una perspectiva más internacional', is crucial to our understanding of what is involved. Like Soufas, he insists on the need for 'una reconfiguración del canon, basada, a su vez, en una nueva y más profunda manera de entender la dinámica de la poesía española de entreguerras' ('a reconfiguration of the canon, based, in turn, on a new and deeper way of understanding the dynamics of

[16] Bretz, *Encounters Across Borders*, 20–1.
[17] C. Alex Longhurst, 'Ruptures and Continuities: From Realism to Modernism and the Avant-Garde', in Francis Clough (ed.), *Hacia la novela nueva* (Bern: Peter Lang, 2000), 33.
[18] Soufas, *The Subject in Question*, 10.
[19] Bretz, *Encounters Across Borders*, 22.

Spanish poetry between the wars').[20] In other words, a move towards acceptance of the term 'modernism' in the Anglo-Saxon sense (but still called, in Spanish, *modernismo*). He goes on to write of 'las múltiples ventajas de la aclimatación de la nocion del Modernismo dentro del contexto español' ('the many advantages of acclimatizing the notion of modernism into the Spanish context'), among which, as he shows in the previous chapter, is precisely a clearer idea of the relationship between the Generation of 1927 and vanguardism.[21] Soufas, in his *The Subject in Question*, echoes Bretz's strictures on earlier Spanish criticism. Asserting that 'Outdated generational paradigms of the 1940s and '50s have not been decisively challenged,' he once more laments the fact that 'few Spanish critics have been interested in linking Spanish writing of the early contemporary period to a transnational context'.[22] Developing the critique of the Spanish critical tradition which he had begun to elaborate in his earlier article, he once more traces it back to Golden Age critics like Alexander Parker, who set what Soufas regards as a regrettable pattern based on the idea of the fundamental Spanishness of Spanish literature. From there he goes on to present some sophisticated modes of approach to modernism, which need to be applied to relevant Spanish works. But what really characterizes his book is that it avoids the over-inclusiveness and overkill which are the defects of Bretz's nonetheless pioneering book, and concentrates in the later chapters on reinterpreting a number of novels and on examining the poetic work of several poets, as well as the theatre of Lorca, from a modernist perspective. That is to say, he sets to work on the overdue task of identifying more of the relevant authors and works which may henceforth figure as part of the canon of modernism in Spain. Longhurst had already begun to map out this territory with regard to prose in his various articles, considering critically, but all too briefly, in which sense novelists like Benito Pérez Galdós and Emilia Pardo Bazán in the late nineteenth century could be seen as marking the beginnings of a shift of sensibility. His main contribution, however, was to postulate the central importance of Unamuno as a modernist novelist and to suggest where Ganivet, Baroja, Azorín, Vicente Blasco Ibañez, and Ramón Pérez de Ayala might fit in. Soufas widens the focus to include individual works by Valle-Inclán and Rosa Chacel, before going on to discuss, from a modernist perspective, Jorge Guillén, Vicente Aleixandre, Luis Cernuda, and Rafael Alberti as poets, and Lorca as a dramatist. The value of *The Subject in Question*, therefore, is twofold. On the one hand, it offers a model for reinterpreting individual works and authors with a view to creating a Spanish modernist canon. On the other hand, as in the case of Anderson's book also, it breaks with the pattern of dealing with modernism as a movement primarily relevant to prose fiction.[23] A parallel model for fiction is offered by Robert Spires in his

[20] Andrew A. Anderson, *El veintisiete en tela de juicio* (Madrid: Gredos, 2005), 279.
[21] Ibid. 301.
[22] Soufas, *The Subject in Question*, 5, 55.
[23] It is perhaps worth noting that by 1999 Margaret Persin was already suggesting that Antonio Machado's major poem 'La tierra de Alvargonzález' (1912) might well be seen as 'Modernist from a broadly-based European perspective' (Margaret Persin, 'Antonio Machado's "La tierra de Alvargonzález" and the Questioning of Cultural Authority', in John P. Gabriele (ed.), *Nuevas perspectivas sobre el 98* (Frankfurt: Vervuert; Madrid: Iberoamericana, 1999), 100).

Beyond the Metafictional Mode and *Transparent Simulacra*.[24] These cover representative novels from those of Baroja, Azorín, Unamuno, and Valle-Inclán, published in the crucial year of 1902, to those of the Goytisolos, Carmen Martín Gaite, and Gonzalo Torrente Ballester from the 1960s and 1970s. In the second of these books he affirms that 'the very thesis of this study reflects the present tendency to discredit the concept of literary generations and to speak in the much broader terms of modernism or post-modernism (the European as opposed to the Hispanic versions of those terms)'.[25] To that extent his books usefully extend the pattern established by Longhurst and Soufas. But strangely, although in both books he analyses themes and techniques which are thought to be typical of modernism, he carefully avoids using the term to focus his approach in the way Soufas does, and he offers no indication of when modernism might be thought to have run its course and/or have been overtaken by postmodernism.

What the critical works so far mentioned show is the urgent need to formulate a description of modernism in Spain that will do justice to the individuality of that nation's modern literary culture, hitherto often obsessively overemphasized by Spanish critics and historians of literature. But at the same time it will need to be compatible with the general European and North American consensus about the meaning and characteristics of the movement, and therefore acceptable to non-Spanish critics. As is even more the case with regard to Spanish America, this tends to create a dilemma. Either one postulates a description which non-Hispanic critics find familiar and is assailed by accusations that one is flattening distinctions between manifestations of different literary cultures, or one attempts to stretch the description in order to accommodate alleged differences until one reaches a point (which may in fact have been reached already with respect to non-Hispanic modernism) where one is compelled reluctantly to envisage a plurality of modernisms. It is not clear which side of the alternative might prevail, always assuming that the task that has begun to be addressed by Soufas, Longhurst, Bretz, and others is in fact going to be taken on by a new group of critics.

SPANISH AMERICA

Soufas points out that 'the time frame of modernism has expanded considerably', and he goes on to note that 'one of the most prominent authorities on modernism, Marjorie Perloff, maintains that modernism does not abruptly conclude after 1945 but actually continued well into the second half of the twentieth century or even

[24] Robert Spires, *Beyond the Metafictional Mode: Directions in the Modern Spanish Novel* (Lexington: Kentucky University Press, 1984), and *Transparent Simulacra: Spanish Fiction 1902–1926* (Columbia: Missouri University Press, 1988).

[25] Spires, *Transparent Simulacra*, 146.

later'.[26] This is extremely relevant to modernism in Spanish America. Indeed, Raymond L. Williams in 1998 affirmed categorically that 'the roots of modernist fiction in this region originated in the 1940s with the short fiction of Jorge Luis Borges and the novels of the first generation of modernist writers, which included the Guatemalan Miguel Angel Asturias, the Cuban Alejo Carpentier, the Mexican Agustín Yañez, the Argentine Leopoldo Marechal, and the Brazilians Graciliano Ramos, Rachel de Queiroz, Jorge Amado, and José Lins do Rêgo.'[27] In this he was followed by Maarten van Delden, in one of the very few attempts to discuss modernism in a Spanish American context. Van Delden, that is, largely identifies modernism in Spanish American fiction with the work of the Boom writers, whose great decade was that of the 1960s.[28] But, like Spires in regard to Spain, he does not clarify the crucial issue in this area, which is whether all the Boom writers should be regarded as modernists during the whole of their career, or whether at some point the Boom evolved in a postmodernist direction.

Both Williams and Van Delden in fact echo the original assertion of Gerald Martin, who in 1990 declared that 'The 1960s was the moment at which the process of literary modernism (in the Anglo-Saxon sense) became generally visible and available to a wide range of Latin American writers.' Crucially, however, he went on to observe: 'But in that sense the Boom is the climax and culmination of a process, not its beginning.'[29] So, when was that beginning? Curiously, the previous year, Martin had included in his book *Journeys Through the Labyrinth* a subsection entitled 'The 1920s and Modernism in Latin America', in which he suggests that poetry at that time became modernist but was called vanguardist, while the predominant form of the novel (i.e. regionalist fiction) remained stuck 'somewhere between realism and Naturalism'.[30] This coincides with the view of the distinguished Paraguayan Boom novelist Augusto Roa Bastos, who in 1965 declared that the group of novelists and short-story writers to which he belonged 'son herederos de aquellos escritores que, a partir de la segunda década del siglo, bajo el estímulo de los experimentos de la vanguardia, en el período entre las dos guerras mundiales—es decir, al comienzo de una nueva época para la humanidad—iniciaron la transformación de nuestro arte narrativo' ('are the heirs of those writers who, beginning with the second decade of the [twentieth] century, under the stimulus of the experiments of the vanguard, in the period between the two world wars—that is, at the beginning of a new epoch for humanity—began the transformation of our narrative art').[31] This looks like a

[26] Soufas, *The Subject in Question*, 3–4.

[27] Raymond L. Williams, *The Modern Latin American Novel* (New York: Twayne, 1998), 3.

[28] Maarten Van Delden, 'The Spanish-American Novel and European Modernism', in Astradur Eysteinsson and Vivian Liska (eds), *Modernism*, 2 vols (Amsterdam: John Benjamins, 2007), ii. 947–65.

[29] Gerald Martin, 'Miguel Angel Asturias: El Señor Presidente', in Philip Swanson (ed.), *Landmarks in Modern Latin American Fiction* (London: Routledge, 1990), 54.

[30] Gerald Martin, *Journeys Through the Labyrinth: Latin American Fiction in the Twentieth Century* (London: Verso, 1989), 128.

[31] Augusto Roa Bastos, 'Imagen y perspectivas de la narrativa latinoamericana actual', in Juan Loveluck (ed.), *La novela hispanoamericana* (Santiago de Chile: Editorial Universitaria, 1969), 210.

possible source for Williams's assertion that 'The generation of Asturias and Car-
pentier [i.e. of the Boom] had been well acquainted with European modernist
writing and theory since the 1920s.'[32] But there is a clear difference: whereas Williams
is asserting that, with regard to prose, the early Boom writers were the first moder-
nists, Roa Bastos is suggesting that the 'transformation' began in the 1920s and was
related to vanguardism. In terms of periodization, this begins to resemble much
more what we are familiar with in the case of Europe. Another major novelist, the
Argentine Eduardo Mallea, seems to have agreed with Roa Bastos. In *La bahía de
silencio* (1940) he asked, '¿No hemos llegado acaso al fin de una retórica y al comienzo
de otra nueva?' ('Have we not perhaps come to the end of one rhetoric and to the
beginning of another?').[33] Rather than forecasting the Boom, which did not find full
creative expression for another twenty years, Mallea seems to have been bearing
witness to a shift to which he himself had contributed with his *Cuentos para una
inglesa desesperada* ('Stories for a Despairing Englishwoman'—the title itself is
revealing) in 1926. The repeated references in *La bahía de silencio* to Joyce, Proust,
and Kafka as the towering figures of European fiction seem to indicate that Mallea
was a modernist and that the 'new rhetoric' he identified as having emerged was what
we now call modernism.

So far, so good. But we are still not back to the origins. We recall the possible
consensus with regard to European modernism's having begun to show signs of
appearing in the 1890s. What about Spanish America? If there is one characteristic of
modernism that all critics agree about, it is its rejection of old-style pseudo-objective,
'photographic' realism. When did this begin in Spanish America? An obvious place
to look is *modernista* fiction and in particular the Colombian José Asunción Silva's
pioneering novel *De sobremesa* ('Afterdinner Talk', 1896). The central character, José
Fernández, totally rejects the mimetic contract underlying the fiction of his time (in
Spanish America *modernismo* was contemporary with Naturalism). 'Para mí,' Fer-
nández affirms, 'lo que se llama *percibir la realidad* quiere decir *no percibir toda la
realidad*, ver apenas una parte del ella, la despreciable, la nula, la que no me importa'
('For me, what is called *perceiving reality* means *not perceiving the whole of reality*,
seeing hardly a part of it, the contemptible part, the invalid part, the part that doesn't
matter to me'), and he dismisses naturalism out of hand.[34] What could point more
clearly towards modernism? We have not so far seen in Spanish America the working
out of a process similar to that which has taken place in Spain, by which *modernismo*
became broadened as a concept and then began to turn into modernism.[35] But here
we can surely perceive the beginnings of a parallel possibility. So far as what
happened subsequently in prose fiction, Martin's view is basically correct. For one

[32] Williams, *The Modern Latin American Novel*, 3.

[33] Eduardo Mallea, *Obras completas*, i (Buenos Aires: Emecé, 1961), 787.

[34] José Asunción Silva, *Obra completa* (Caracas: Biblioteca Ayacucho, 1985), 181.

[35] However, we do see an early indication that such a process might be possible in another of the rare
comments on modernism in Spanish America, when Dario Fernández-Morera writes, 'I confess that it is
tempting, at least for me as a comparatist, to effect such a merging' ('The Term "Modernism" in Literary
History', 272).

line of development led directly to regionalism, the novel of the Mexican Revolution, and the now forgotten anti-imperialist novel. This line of development represents *grosso modo* the prolongation of realism in writers like the founder of the novel of the Mexican Revolution, Mariano Azuela, who was quite categoric about his adhesion to realism, and the Venezuelan Rómulo Gallegos, whose novel *Doña Bárbara* (1929) was a best-seller until the arrival of the Boom. Regionalism represents the self-conscious Americanization of the Spanish American novel. It emphasizes the specificity to Spanish America which many Spanish American writers regard as a laudable characteristic of its literature.

But (nowadays half-hidden behind regionalist fiction) there was a secondary pattern of development which grew out of the *modernista* novel's rejection of old-style mimesis. Contributors to this development include Eduardo Barrios (Chile), Pedro Prado (Chile), Eduardo Mallea (Argentina), Jaime Torres Bodet (Mexico), Martín Adán (Peru), Teresa de la Parra (Venezuela), Felisberto Hernández (Uruguay), Vicente Huidobro (Chile) in his fiction, and María Luisa Bombal (Chile), most of whose relevant works were published in the 1920s. They revealed a quite different sensibility from that of the regionalists. Nor should it be overlooked that Huidobro, Prado, Torres Bodet, and Adán were all poets. While writers belonging to the Americanist group of regionalists, indigenists, and novelists of the Mexican Revolution were to a great extent social novelists, concerned primarily with Spanish American problems, those of this second group were far more concerned with the inner world of the individual and with his or her emotional, psychological, and even spiritual difficulties. Influences were also significantly different. Barrios cultivated an acquaintance with the work of Pascal, Schopenhauer, and Nietzsche; Prado with that of Bergson; Torres Bodet and the Mexican *Contemporáneos* group to which he belonged read Proust, Joyce, and Kafka, as did Mallea. Torres Bodet himself was a professor of French literature; Hernández lived in France and was friendly with Supervielle. Bombal even graduated from the Sorbonne, enjoyed Virginia Woolf, and was one of the very few Spanish American writers published by *Sur*, the leading avant-garde (dare we say modernist?) Spanish American review published by Victoria Ocampo (who translated Virginia Woolf). These writers were aggressively cosmopolitan in outlook and experimental in technique. With all due respect to the splendid critical work of Ana María Barrenechea, her notion that the crisis of the mimetic contract in Spanish American prose is really a characteristic of the 1960s surely does less than justice to the 1920s.[36]

There seem to be three reasons why this line of development of fiction in Spanish America has not been seen in a modernist perspective. One is that the authors in question, with the exception of Bombal (who has been re-evaluated by feminist critics), by and large did not produce works of comparable fame to those of high modernism elsewhere in Europe and North America and are nowadays really of interest only to a small handful of scholars like Unruh, Pérez Firmat, and Coonrod

[36] Ana María Barrenechea, 'La crisis del contrato mimético en los textos contemporáneos', *Revista Iberoamericana*, 48/118–19 (1982), 377–81.

Martínez.[37] Despite the fact that their break with old-style realism and the novel of protest in some respects looks forward to the paradigm shift of the 1940s (in itself inadequately researched and understood critically) and to the rise of the Boom, they remain a neglected group. A second reason is that their work provoked hostility both in its time and later. The early novelist of the Mexican Revolution Mariano Azuela tried to imitate modernist stylistic experimentalism in his novel *La luciérnaga* ('The Glow-Worm', 1932) but promptly abandoned it. Other writers, including the Peruvian indigenist novelist Ciro Alegría and the Guatemalan Nobel Laureate Miguel Angel Asturias, also later sharply criticized what they believed to be a pattern of fiction which was insufficiently Americanist. The writers to whom we are presently referring were culturally cosmopolitan and non-*engagés* at a time when many writers and critics were strongly in favour of social realism, protest, specificness to Spanish America, and political commitment. The *Contemporáneos* group in Mexico, to whom Torres Bodet belonged, for example, was belaboured by a part of the critical establishment in 1932 for their inadequate endorsement of revolutionary nationalism. Modernism and its flagship magazines, *Contemporáneos* and *Ulises* in Mexico, *Martín Fierro* and *Sur* in Argentina, the *Revista de Avance* in Cuba, and others of that ilk, being generally cosmopolitan, humanistic, subjectivist, and experimental in outlook, were vulnerable, like the groups they represented, to hostility from both the *engagé* Left and the nationalist Right.

A third reason is that, as we know, 'modernism' as a critical term has not taken hold in Spanish America and, with regard to the period after the *modernismo* which we associate with Darío had run its course, has been pre-empted by the term 'vanguardism' in both prose and poetry. This is the term used both by Unruh and Pérez Firmat. Only Coonrod Martínez has been willing to regard the 'innovative' novelists of the 1920s, among whom she includes the Guatemalan Arqueles Vela, the Ecuadorian Pablo Palacio, and the Argentine Roberto Arlt, as well as Adán, as modernists. Clearly, just as in Spain, we need to consider whether the term should gain acceptance and, if so, what it might mean in relation to vanguardism. My own view, for what it is worth, is that if we are prepared, following Van Delden, to extend the periodization of modernism in Spanish America to include at least the early part of the Boom, then we might be well advised to regard vanguardism as part of early modernism. But this in itself is problematic. For, as I have tried to show elsewhere, vanguardism itself is not very well understood, at least in one respect.[38] If we look at the majority of the vanguardist manifestos, we are struck by their tone of youthful optimism and euphoria. But the actual poetic production of the vanguardist poets tends to confirm the assertion of one of them, the Ecuadorian Jorge Carrera

[37] Vicky Unruh, *Latin American Vanguards* (Berkeley: University of California Press, 1994); Gustavo Pérez Firmat, *Idle Fictions: The Hispanic Vanguardist Novel, 1926–1934* (Durham, NC: Duke University Press, 1982); Elizabeth Coonrod Martínez, 'The Latin American Innovative Novel of the 1920s', in Sophia McClellan and Earle E. Fitz (eds), *Comparative Cultural Studies and Latin America* (West Lafayette, Ind.: Purdue University Press, 2004), 34–55.

[38] Donald L. Shaw, 'The Paradox of Spanish American Vanguardism', *A Contracorriente*, 1/2 (2004), 31–9.

Andrade, that 'la angustia existencial es el común denominador de los poemas que se escriben desde 1940 hasta nuestros días' ('existential anguish is the common denominator of the poems written from 1940 to out own time').[39] This may be too broad a generalization. But it is endorsed by two such major critics as Saúl Yurkievich and Juan Gustavo Cobo Borda, both of whom recognize that the malaise in question goes all the way back to *modernismo*.[40] If, then, we are going to relate vanguardism to modernism in Spanish America, we shall have to pay particular attention to those aspects of modernism, such as a sense of cultural crisis, alienation, the rise of a sense of chaos, and feelings of existential loneliness, which some critics have associated with the movement.[41]

Before closing, reference perhaps should be made to the possible impact on the discussion of modernism in Spanish America of cultural criticism. This takes many forms, but in Spanish America it tends to involve the assumption that the old distinction between 'central' or 'metropolitan' cultures and 'peripheral' ones (i.e. between 'First' and 'Third' World cultures) is obsolete and must be abandoned. It therefore concerns itself not with traditional questions about the emergence of certain themes and the evolution of literary forms and techniques but with what Claudia Ferman calls 'the processes of the transnationalization of economic and cultural production'.[42] It is suggested that there is a need for new theoretical concepts to handle these processes and to challenge the idea of cultural dependency through the elaboration of what Nelly Richard calls 'strategies of resistance to and questioning of the core countries' centralizations'.[43] This approach, then, has a clear ideological thrust, based on what Fernando Rosenberg calls 'the desire for a politically situated reading' of modernism based on what he calls 'geopolitical' and not, as hitherto, 'colonialist' postulates about European influence.[44] The difficulty is to explain (much less define) the relevance of the geopolitical to Spanish American literature of the twentieth century, as anyone who reads Rosenberg's book on geopolitics and the avant-garde in Latin America will readily perceive. We possess a recognizable 'diffusionist' paradigm for the spread of modernism to Spanish America in the outward progress of renaissance, baroque, neo-classical, romantic, and realist–naturalist models from 'the centre' to 'the periphery' in earlier cultural periods. It is not immediately obvious that the spread of modernism should be viewed any differently. Cultural criticism of modernism in Spanish

[39] Jorge Carrera Andrade, *Reflexiones sobre la poesía hispanoamericana* (Quito: Casa de la Cultura Ecuatoriana, 1987), 81.

[40] Saúl Yurkievich, *Fundadores de la nueva poesía latinoamericana* (Barcelona: Barral, 1971), 277; Juan Gustavo Cobo Borda, *Letras de esta América* (Bogotá: Empresa Editorial, Universidad Nacional de Colombia, 1986), 54.

[41] See Steve Giles, 'Afterword', in Giles (ed.), *Theorizing Modernism* (London: Routledge, 1993), 171–86.

[42] Claudia Ferman (ed.), *The Postmodern in Latin and Latino American Cultural Narratives* (New York: Garland, 1996), p. vii.

[43] Ibid. 3.

[44] Fernando Rosenberg, 'The Geopolitics of Affect in the Poetry of Brazilian Modernism', in Laura Doyle and Laura Winkiel (eds), *Geomodernisms: Race, Modernism, Modernity* (Bloomington: Indiana University Press, 2005), 77.

America at the beginning of the twenty-first century is long on theory but short on specific textual references. Time will show whether it will open new avenues of understanding.

Conclusion

It would be easy to conclude that the foregoing discussion suggests the possibility of an exciting new period opening in Hispanic criticism with respect to a significant area of twentieth-century literature. It could be viewed as a two-stage project. The first objective would be to popularize the notion of modernism as an overarching critical term generally applicable to much of literature in Spain between the *fin de siècle* and perhaps the outbreak of the civil war, and in Spanish America to a longer period of literary creativity stretching from the 1920s to perhaps the 1960s. This would naturally involve an effort to reach some degree of consensus about what the term might embrace, about its relation to vanguardism as a critical term, and about periodization. The second objective would be to reassess systematically in detail the literary production of the period on the basis of such a possible consensus. It seems likely that some progress in this direction will be made, probably in Britain and the US, given the attractiveness of such a project to the doctoral dissertation and academic publication industry. But it is clear that it is equally likely to face ongoing opposition from those (especially Hispanic) critics who prefer to cling to the use of (a broad-based) *modernismo* and other more narrow and specific terms despite the confusion that this engenders. An argument in this connection which is relevant to Spanish America is that modernism is connected to societal modernization, and that in Spanish America pre-modern, modern, and postmodern societies all coexist, so that the idea of an overarching modernism does not fit the situation. Nevertheless, Carlos Alonso's question 'If one cannot speak unequivocally about Spanish American *modernity*, how can one even begin to argue for the existence of specifically Spanish American postmodernity to oppose and surmount it?' remains relevant.[45] *Mutatis mutandis*, we can ask the same question about Spain.

[45] Carlos Alonso, *The Burden of Modernity* (Oxford: Oxford University Press, 1998), 155.

..

CARIBBEAN MODERNISM

..

DAVE GUNNING

Modernism patently and emphatically was *not* a spontaneous response of mainstream Euro-pean artists to a new historical reality. . . . It was and is an expression of bourgeois literary style and fashion: the capricious and arbitrary creation of a small, identifiable, and recondite element of the bourgeois avant-garde, whose neurotic egotism, distressing and unhealthy personal lives and political conservatism it expressed. . . . [A]n honest novel of black culture seeks to contribute to the evolving form, to the content and purpose of a vital modern tradition of black literature. It does not seek to latch onto the tail end of a moribund and thoroughly discredited colonial tradition which served only to exploit and mutilate those cultures for frivolous if not sinister purposes.[1]

[I]t seems to me vital—in a time when it is easy to succumb to fashionable tyrannies or optimisms—to break away from the conception so many people entertain that literature is an extension of a social order or a political platform. In fact it is one of the ironic things with West Indians of my generation that they may conceive of themselves in the most radical political light but their approach to art and literature is one which consolidates the most conventional and documentary techniques in the novel. . . . The fact is—even when sincerely held, political radicalism is merely a fashionable attitude unless it is accompanied by profound insights into the experimental nature of the arts and the sciences.[2]

The US-based Jamaican novelist Michael Thelwell's attack on what he sees as the solipsism and obsolescence of modernism within black writing seems especially

[1] Michael Thelwell, 'Modernist Fallacies and the Responsibility of the Black Writer', in *Duties, Pleasures, and Conflicts: Essays in Struggle* (Amherst: University of Massachusetts Press, 1987), 220, 231.

[2] Wilson Harris, 'Tradition and the West Indian Novel', in *Selected Essays of Wilson Harris: The Unfinished Genesis of the Imagination*, ed. A. J. M. Bundy (London: Routledge, 1999), 150.

vitriolic but is typical of a strand of argument within post-colonialist criticism that finds European modernism guilty of embodying many of the most pernicious strands of imperialist ideology. In Stephen Slemon's view, modernism can be seen as 'a wholesale appropriation and refiguration of non-Western artistic practices by a society utterly committed to the preservation of its traditional prerogatives for gender, race and class privilege'.[3] The distinctive features of the early twentieth-century response to encroaching modernity are here represented as the spoils of the colonial adventures of the previous century and earlier. A telling example of such exploitation at the heart of high modernism can be found in the Guyanese painter Aubrey Williams's anecdote of his meeting with Picasso in the mid-1950s: 'He said that I had a very fine African head and he would like me to pose for him.... He thought of me only as something he could use for his own work.'[4] Colonial and post-colonial peoples are reduced in this demeaning overture to a role simply as the objects, rather than the agents, of modernist practice. In addition, Thelwell is not alone in condemning the role of institutions such as universities and publishing houses in promoting modernism at the expense of the 'national cultural imperatives' which he feels should be driving writers of 'the African world, Black America, and the Caribbean'.[5] Given the imbrication of modernist style with imperial attitudes, it may then not seem surprising that 'realist, rather than (neo)-modernist styles... were so often favoured in the early, nationalist, phases of postcolonial literatures in the (to be) decolonized world'.[6]

However, although such realist models can be seen to have enjoyed a period of dominance in the Anglophone Caribbean in the 1930s and 1940s, particularly in the 'barrackyard' stories of lower-class life which were associated with *The Beacon* in Trinidad, it is nonetheless possible to trace a significant engagement with modernist forms in twentieth-century writing from across the region.[7] Indeed, as suggested by the quotation from Wilson Harris at the beginning of this discussion, one can detect a persistent belief that the specific modernity of the Caribbean could only be explored through sustained engagement with the experimental devices of modernism. Édouard Glissant describes the Caribbean as experiencing an 'irruption into modernity', and uses this sudden historical shift undergone across the archipelago with the arrival of the colonial powers to explain why 'We do not have a literary tradition that has slowly matured: ours was a brutal emergence that I think is an

[3] Stephen Slemon, 'Modernism's Last Post', in Ian Adam and Helen Tiffin (eds), *Past the Last Post* (Hemel Hempstead: Harvester Wheatsheaf, 1991), 1.

[4] Quoted in Simon Gikandi, 'Picasso, Africa, and the Schemata of Difference', *Modernism/Modernity*, 10/3 (Sept. 2003), 455. Williams's experiments with techniques drawn from Cubism and Abstract Expressionism established him as one of the most significant Caribbean modernist visual artists; he was also a key member of the Caribbean Artists' Movement in 1960s London. See Anne Walmsley (ed.), *Guyana Dreaming: The Art of Aubrey Williams* (Sydney: Dangeroo, 1990).

[5] Thelwell, 'Modernist Fallacies and the Responsibility of the Black Writer', 226.

[6] Bart Moore-Gilbert, 'Postcolonial Modernisms', in David Bradshaw and Kevin J. H. Dettmar (eds), *A Companion to Modernist Literature and Culture* (Malden, Mass.: Blackwell, 2006), 554.

[7] Victor J. Ramraj, 'Short Fiction', in James A. Arnold (ed.), *A History of Literature in the Caribbean*, ii: *English- and Dutch-Speaking Regions* (Amsterdam: John Benjamins, 2001), 203–4.

advantage and a failing.'[8] The capitalist systems that made possible the slave-based plantation colonies of the region ensured that the very structures of these societies were grounded in the dynamics of emergent modernity. The disturbance such a brutal history enacted upon the construction of a Caribbean subjectivity seems to demand artistic and intellectual practices capable of refusing the realist retreat to 'the stability and coherence of the racial self' and instead 'embrac[ing] the fragmentation of self (doubling and splitting) which modernity seems to promote'.[9] Originating from a culture that is elementally modern and plural, Caribbean literature repeatedly has had to engage with techniques capable of embodying multiplicity and discontinuity.

For Simon Gikandi, 'Caribbean writers cannot adopt the history and culture of European modernism, especially as defined by the colonizing structures, but neither can they escape from it because it has overdetermined Caribbean cultures in many ways.'[10] Gikandi's model of this literature as being profoundly 'revisionary' has been extremely influential, and his assertion that, within this writing, 'the central categories of European modernity—history, national language, subjectivity—have value only when they are fertilized by figures of the "other" imagination which colonialism sought to repress' offers an invaluable tool for reading modernism in the region.[11] However, in beginning his analysis with texts from the 1950s and 1960s, he can be seen as too easily accepting Caribbean modernism as a belated response to the period of modernism's dominance in Europe. While the most important developments and texts of the Caribbean modernist aesthetic may well be seen to date from this period, it is nonetheless valuable to trace interventions from earlier in the century in order to explore exactly how the dynamic of 'revisioning' has been played out.

J. Michael Dash has criticized Gikandi for restricting his study to the Anglophone Caribbean, which he sees as 'the least propitious ground for establishing a Caribbean modernism in the region'.[12] Dash's study is one of a number of recent works that look to conceptualize the region across the linguistic divides that segment it. It is certainly true that Caribbean modernist writers working in languages other than English, such as Aimé Césaire from Martinique and the Cuban Alejo Carpentier, have exercised profound influence across the region and beyond; equally, the various islands of the Caribbean share common historical experiences and therefore unsurprisingly share characteristics across their literatures (in Derek Walcott's Nobel Prize acceptance speech, he spoke of 'one literature in several imperial languages'[13]). But, despite the

[8] Édouard Glissant, *Caribbean Discourse: Selected Essays*, trans. J. Michael Dash (Charlottesville: University of Virginia Press, 1989), 146.

[9] Paul Gilroy, *The Black Atlantic: Modernity and Double Consciousness* (London: Verso, 1993), 187–8.

[10] Simon Gikandi, *Writing in Limbo: Modernism and Caribbean Literature* (Ithaca, NY: Cornell University Press, 1992), 3.

[11] Ibid. 4.

[12] J. Michael Dash, *The Other America: Caribbean Literature in a New World Context* (Charlottesville: University of Virginia Press, 1998), 16.

[13] Derek Walcott, *What the Twilight Says: Essays* (London: Faber and Faber, 1998), 73.

gains that can be made through a cross-regional approach, there are also potential losses. For Antonio Benítez-Rojo, one of the foremost theorists of the region as a whole, 'There are performers who were born in the Caribbean and who are not Caribbean by their performance; there are others who were born near or far away and nevertheless *are*.'[14] In this argument 'Caribbean' becomes the name of an aesthetic, rather than a geographical marker; it seems that in Benítez-Rojo's search to reveal and to explore a cross-Caribbean aesthetic, there is a danger of the model coming to determine its referents, rather than the other way round. An attention to some of the key Anglophone modernist writers of the Caribbean, in all of their diversity, may not lead to a unified model for understanding their practice, but may instead give some sense of the range of possibilities for Caribbean modernism.

WRITERS 'BEFORE THE BOOM': MCKAY, RHYS, AND MARSON

Alison Donnell's reconstruction of twentieth-century Caribbean literary history contains a sustained reflection on how the critical debates of the 1960s and 1970s which were especially productive in allowing for the recognition of a distinctive Caribbean literature were nonetheless often predicated on a supposed break (usually dated around 1950) with earlier writing, which, in the main, remained slavishly tied to colonial models. For Donnell, this division, which separates the 'derivative' writing that came before the 'boom' from the later work which displays a realized national consciousness, is overly simplistic. Rather, she suggests that 'many of this generation's works actually map out a complex, overlapping and mobile continuum along which content, form and language continually shift'.[15] She goes on to characterize this work as 'testify[ing] to the particular historical and cultural forces which created a destabilized series of identifications made within different, but not always separate, cultural registers and histories at this time'.[16] Much of the work she chooses to analyse (and which she and Sarah Lawson Welsh collect to represent this period in their important anthology) is pastoral poetry, written in traditional forms, but her notion of a 'destabilised series of identifications' can equally be applied to three of the writers of this period who engaged significantly with modernist aesthetics: Claude McKay and Una Marson from Jamaica, and the Dominican Jean Rhys.[17]

[14] Antonio Benítez-Rojo, *The Repeating Island: The Caribbean and the Postmodern Perspective*, trans. James E. Maraniss, 2nd edn (Durham, NC: Duke University Press, 1996), 24.

[15] Alison Donnell, *Twentieth-Century Caribbean Literature: Critical Moments in Anglophone Literary History* (London: Routledge, 2006), 70.

[16] Ibid.

[17] Alison Donnell and Sarah Lawson Welsh (eds), *The Routledge Reader in Caribbean Literature* (London: Routledge, 1996), 42–205.

Claude McKay's autobiography reveals him as ambivalent about modernism: he enjoys Joyce but prefers Lawrence, admires Hemingway but finds little of value in Stein. He is particularly cynical about the value of experimentation without clear purpose, decrying the 'punctuation-and-phraseology tricks' of 'modernists and futurists'.[18] However, outside of this 'definition of modernism in terms of European "high" modernism, which was suspected of celebrating pure aestheticism and thus of negating the value and power of cultural tradition and history', we can read both his poetry and fiction as striving to develop an appropriate response to the peculiar modernity of the Caribbean, while resisting the implied decadence of European modernism.[19]

The young McKay found a mentor in the English planter Walter Jekyll, who was a collector of Jamaican folk tales. Jekyll encouraged McKay to write poetry in Jamaican dialect and the results appeared in the volumes *Songs of Jamaica* and *Constab Ballads* (both published in 1912). However, although the vocabulary of the poems could be read as aligned with Jekyll's project, their contents differed from the celebrations of peasant existence that the Englishman had compiled.[20] In McKay's verse, the Creole voices that bear witness to a supposedly 'authentic' Jamaica are inextricably implicated in a world system that connects the island to the imperial motherland. The speaker of 'Old England' articulates his wish to travel to London, and in doing so demonstrates his easy familiarity with the city he has never visited:

> I'd go to de City Temple, where de old fait' is a wreck,
> An' de parson is a-preaching views dat most folk will not tek;
> I'd go where de men of science meet together in deir hall,
> To give light unto de real truths, to obey king Reason's call.
>
> I would view Westminster Abbey, where the great of England sleep,
> An' de solemn marble statues o'er deir ashes vigil keep;
> I would see immortal Milton an' de wul'-famous Shakespeare,
> Past'ral Wordsworth, gentle Gray, and de great souls buried there.[21]

The poem can be read as a paean to the colonizing centre, but within its seeming praise of English cultural superiority lies a more ambiguous vision of the relation between colony and imperial power. The images of Britain persistently evoke stasis and death in contrast to the vitality of the speaking voice. The only aspect of the tradition that is granted a continuing and vital determining power is that of 'king Reason's call'. McKay seems to be searching for a way to uncouple the universalist discourse of the European Enlightenment and English literary achievement from

[18] Claude McKay, *A Long Way From Home* (New York: Lee Furman, 1937; repr. London: Pluto Press, 1985), 251.

[19] Gikandi, *Writing in Limbo*, 252–3.

[20] Walter Jekyll (ed.), *Jamaican Song and Story: Annancy Stories, Digging Sings, Ring Tunes, and Dancing Tunes* (London: D. Nutt, 1907).

[21] Claude McKay, 'Old England', in *Complete Poems*, ed. William J. Maxwell (Urbana: University of Illinois Press, 2004), 45–6.

Europe's colonial subjugation of the Caribbean. Tradition is simultaneously celebrated and thrown into question.

Lee M. Jenkins has compared McKay's Creole verse with the modernist experimentation in Scots dialect of Hugh MacDiarmid but is forced to admit that the latter's 'vernacular agenda is conscious and deliberately avant-garde in a way that McKay's is not'.[22] In fact, his use of traditional English forms to try to convey the particularity of a Jamaican experience can be read as showing 'how little free space there was for McKay between traditionalism and modernism'.[23] Kamau Brathwaite sees McKay as 'imprisoned in the pentameter; he didn't let his language find its own parameters', but McKay retained the form of the English tradition precisely to defy a simplistic imperial view (perhaps present in Jekyll's romanticizing of Jamaican tradition) that saw the Caribbean as closer to nature, and consequently further from the achievements of European civilization.[24] Houston A. Baker subsumes McKay too easily into the currents of the Harlem Renaissance (in which the poet played an important part, following his move to New York in 1914), but is surely correct to identify what he calls a 'denigration of form' in McKay's verse that subverts the standard even as it occupies it.[25] McKay's modernism was forever couched in a determination to occupy a literary space that defied the patronizing discourse of primitivism.

In his 1933 novel *Banana Bottom*, McKay returned to a Jamaican focus to articulate both his faith in the value of Jamaican community, and his distrust of the European agenda that might see such a folk aesthetic as primitive. In the novel, the 12-year-old Bita Plant is shamed within the community of the eponymous village following a sexual encounter and is taken in by Malcolm and Priscilla Craig, a pair of white missionaries who send her abroad to receive a European education. On her return to the island seven years later, she finds herself increasingly moving away from the imported colonial culture embodied by the Craigs and embracing instead the lifestyles of the local people she had supposedly left behind. However, McKay is always determined to present Bita's development as more than a 'mere nostalgia and a sentimental recovery of lost origins', and throughout insists on a universal humanity that finds its expression in a local culture.[26] The novel ends with Bita (who has now married the inarticulate carter Jubban in clear defiance of the path laid out by her sophisticated education) reflecting on a passage from Pascal's *Pensées*. She finds this 'thought like food' to be something 'Unbounded by little national and racial lines,

[22] Lee M. Jenkins, *The Language of Caribbean Poetry: Boundaries of Expression* (Gainesville: University Press of Florida, 2004), 33.

[23] Michael North, *The Dialect of Modernism: Race, Language and Twentieth-Century Literature* (New York: Oxford University Press, 1994), 115.

[24] Edward Kamau Brathwaite, *History of the Voice: The Development of Nation Language in Anglophone Caribbean Poetry* (London: New Beacon, 1984), 20.

[25] Houston A. Baker, Jr, *Modernism and the Harlem Renaissance* (Chicago: University of Chicago Press, 1987), 85.

[26] David G. Nicholls, 'The Folk as Alternative Modernity: Claude McKay's *Banana Bottom* and the Romance of Nature', *Journal of Modern Literature*, 23/1 (Fall 1999), 94.

but a cosmic thing of all time for all minds . . . '.[27] McKay's celebration of the folk is not predicated on difference, but on an essential sameness.

McKay's view of a primitivist discourse that would denigrate the Caribbean subject is captured in the extraordinary scene of Priscilla Craig's waking nightmare before a set of African masks displayed as 'heathen idols with lectures on "The Customs and Superstitions of the Primitive Africans"'.[28] As Priscilla contemplates the masks, she sees in them an alternative to the Christianity in which she so strongly believes. At first, she is able to subdue this uncomfortable thought with the belief that they exist as a part of a teleology wherein Christian belief will spread to the dark places of the world. However, this ability 'to reconcile and reduce the unfamiliar' is short-lived and the masks begin instead to dance around her until at last 'she too was in motion and madly whirling round and round with the weird dancing masks'.[29] The responsibility to recognize shared humanity disturbs both Priscilla Craig and the modernist appropriation of the form of 'primitive' art while refusing its connection to those whose experience it embodies. If 'the Other needed to be evacuated from the scene of the modern' for the practice of primitivism to flourish, then McKay's version of modernism is one in which the excluded colonial subject must be accepted within the same universalized terms as the European.[30]

Leah Rosenberg sees both McKay and Jean Rhys as challenging the racial and gender assumptions that haunt primitivism and suggests that in 'creat[ing] Caribbean modernism, their work thus redefined the central figures and dynamics of European modernist aesthetics'.[31] Brathwaite famously dismissed Rhys as a Caribbean writer, arguing that 'White Creoles . . . have contributed too little culturally, as a group, to . . . meaningfully identify or be identified with the spiritual world on this side of the Sargasso Sea'.[32] Despite this rejection of Rhys, it is increasingly recognized that the alienation from a cold impersonal city that features so often in Rhys's work is 'the discomfort not just of the single woman, but of the single *colonial* woman, who occupies a doubly transgressive position in the metropole'.[33] As Mary Lou Emery has pointed out, there is something peculiarly Caribbean about Rhys's heroines who suffer the 'homelessness of [those] who never had a home'.[34]

Anna Morgan, the white West Indian heroine of *Voyage in the Dark*, is unable to 'fit' her current experience of England with her Caribbean childhood, always seeing

[27] Claude McKay, *Banana Bottom* (London: Serpent's Tail, 2005), 314.

[28] Ibid. 197. [29] Ibid. 199.

[30] Gikandi, 'Picasso, Africa, and the Schemata of Difference', 457.

[31] Leah Rosenberg, 'Caribbean Models for Modernism in the Work of Claude McKay and Jean Rhys', *Modernism/Modernity*, 11/2 (Apr. 2004), 222.

[32] Edward Kamau Brathwaite, *Contradictory Omens: Cultural Diversity and Integration in the Caribbean* (Mona: Savacou, 1974), 38.

[33] Anna Snaith, '"A Savage from the Cannibal Islands": Jean Rhys and London', in Peter Brooker and Andrew Thacker (eds), *Geographies of Modernism: Literatures, Cultures, Spaces* (London: Routledge, 2005), 76.

[34] Mary Lou Emery, *Jean Rhys at 'World's End': Novels of Colonial and Sexual Exile* (Austin: University of Texas Press, 1990), 14.

just one life as reality and the other as a dream. In *Wide Sargasso Sea* Rochester and Antoinette share a similar chasm of understanding between the real and the dream-like across the colonial divide.[35] The individual consciousness is unable to adopt a perspective from which both worlds might be comprehended. However, it is in 'Let Them Call It Jazz', Rhys's only narrative to feature a black Caribbean narrator, that the relations between a modernist sense of isolated subjectivity and the realities of colonial and post-colonial domination are most clearly linked. Selina Davis's strug-gles to stay afloat in 1950s London are crucially linked to her sense that her origins will determine that no one listens to her, no matter what efforts she makes towards articulacy. Before a judge after breaking the window of her intrusive next-door neighbours' house, she longs for a 'decent quiet voice' that could convince the court of how she was provoked but knows she will never be believed.[36] Imprisoned in Holloway, she hears a song that gives her a sense of hope; later, after her release, she whistles the song at a party. A songwriter present 'plays the tune, jazzing it up', and later sells it on, sending £5 to Selina. At first she is deeply upset by this, because she feels that 'that song was all I had', but she comes to resign herself to the appropria-tion: '"So let them call it jazz," I think, and let them play it wrong. That won't make no difference to the song I heard.'[37] Selina finds consolation in the reserve of her own experience, but it is only by accepting a profound monadic voicelessness. Rhys's modernist exploration of consciousness is filtered through an awareness of cultural difference that finally determines the Caribbean subject's isolation.

Una Marson had published two books of poetry in Jamaica (*Tropic Reveries* and *Heights and Depths*) in the two years before she moved to London in 1932. Once in Britain and working for Harold Moody's League for Coloured Peoples, she began to develop the style of her most important collection, *The Moth and the Star*, which was published after she arrived back in the Caribbean in 1937. Marson's earlier poetry was traditional in form although it was often parodic, both of traditional styles and of individual poems (including Blake's 'Little Black Boy' and Kipling's 'If'). However, *The Moth and the Star* offers a distinctly modernist Caribbean verse. Several critics have cautioned against a simplistic view of Marson's career 'as a development from purely derivative verse to more progressive experimentation with the blues', and argued that one can rather identify in her shifts in register 'different methods through which Marson explores the twinned questions of imitation and vision in all of their colonialist forms'.[38] Nonetheless, the stylistic variation between her earlier and later poems is significant and points clearly towards her increasing sense of how Carib-bean cultural integrity should be marked.

[35] Jean Rhys, *Voyage in the Dark* (London: Penguin, 2000), 7–8; Jean Rhys, *Wide Sargasso Sea* (London: Penguin, 2000), 49.
[36] Jean Rhys, 'Let Them Call It Jazz', *London Magazine*, 1/11 (Feb. 1962), 78.
[37] Ibid. 82–3.
[38] Mary Lou Emery, *Modernism, the Visual and Caribbean Literature* (Cambridge: Cambridge University Press, 2007), 123. See also Denise DeCaires Narain, *Contemporary Caribbean Women's Poetry: Making Style* (London: Routledge, 2004), 1–50.

Donnell's sense of Caribbean writing of the first half of the twentieth century being shaped by a 'destabilised series of identifications' seems to apply neatly to McKay and Rhys and their engagement with modernist strategies, but it fits Marson even better. During the 1930s, Marson seems to undergo a shift away from her often critical engagement with traditional forms as she searches for a more explicitly political and autonomous form of verse. However, as her biographer points out, she made herself 'no literary orphan' in this, but found her models by 'embracing another viable tradition—the African-American tradition'.[39] But while the blues rhythms of such poems as 'Kinky Hair Blues' reveal an explicit indebtedness to the Harlem Renaissance modernism of Langston Hughes, her search for an explicitly Caribbean vocabulary also brings echoes of McKay's dialect verse:

> See oder young girls
> So slick and smart
> See dose oder young girls
> So slick and smart.
> I jes gwine die on de shelf
> If I don't mek a start.
>
> I hate dat ironed hair
> And dat bleaching skin.
> Hate dat ironed hair
> And dat bleaching skin.
> But I'll be all alone
> If I don't fall in.[40]

Claude McKay and Jean Rhys never really returned to the Caribbean after leaving at young ages; Una Marson did, but the most significant development in her poetic style happened while she was living in London. Marson is increasingly read as a pioneer of a distinctive Caribbean poetic although her verse collections have still not been reprinted and her continuing reputation is reliant largely on slim selections within anthologies. Her combination of linguistic and formal experimentation and Caribbean cultural nationalism, however, can equally be detected in the generation of writers who succeeded her.

LONELY LONDONERS: LAMMING AND SELVON

The decades following the Second World War marked what can be seen as the greatest upheaval in Caribbean history since the abolition of slavery in the 1830s.

[39] Delia Jarrett Macauley, *The Life of Una Marson, 1905–65* (Manchester: Manchester University Press, 1998), 125–6.

[40] Una Marson, 'Kinky Hair Blues', in Donnell and Lawson Welsh (eds), *The Routledge Reader in Caribbean Literature*, 112.

The increasing cultural nationalism experienced across the islands culminated in the formation and dissolution of the West Indies Federation and then the wave of independence from the British Empire that began with Jamaica and Trinidad and Tobago in 1962. The same year also saw the introduction of the Commonwealth Immigrants Act, which drastically limited the rights of Caribbean people to live and work in the United Kingdom. The British Nationality Act 1948, which had established these rights, had at first only inspired low levels of migration from colony to metropolis, but between 1955 and 1962 over 250,000 West Indians had left for Britain.

Such significant political, cultural, and demographic changes had an inevitable impact on the literary cultures of the Anglophone Caribbean, and the 'boom' period of Caribbean writing dates from this time. George Lamming argued that 'the "emergence" of a dozen or so novelists in the British Caribbean with some fifty books to their credit or disgrace, and all published between 1948 and 1958, is in the nature of a phenomenon'.[41] This wealth of writing, however, was stylistically diverse and it is misleading to suggest that a distinctive aesthetic united these novels.[42] Equally, to suggest that writing of this period explicitly broke with earlier Caribbean literary models in forging a new tradition is to ignore the chains of continuity which can be detected. Emery sees Lamming's early work as 'develop[ing] a tradition of Caribbean modernism begun by Jean Rhys in the 1920s and 1930s' in that these later novels similarly 'depart from realist conventions to portray the effects of migration and exile on the sensory body and subjectivity of the Caribbean emigrant'.[43] Indeed, Lamming's concerns with language and form echo those of his Caribbean predecessors.

Like many of the earlier Caribbean modernists, Lamming found in exile the space to articulate a vision of his homeland. His dominant model for exploring the West Indian writer's situation, particularly within Britain, is that of Prospero and Caliban from *The Tempest*. However, while Shakespeare's native sees the acquisition of the knowledge of the colonizer's language as the opportunity to 'curse' and to set in motion a dynamic of retribution, Lamming instead suggests a future-orientated appropriation:

I am a direct descendant of Prospero worshipping in the same temple of endeavour, using his legacy of language—not to curse our meeting—but to push it further, reminding the descendants of both sides that what's done is done, and can only be seen as a soil from which other gifts, or the same gift endowed with different meanings, may grow.[44]

[41] George Lamming, *The Pleasures of Exile* (Ann Arbor: University of Michigan Press, 1992), 29.

[42] The other writers named by Lamming are Edgar Mittelholzer, V. S. Reid, Roger Mais, Sam Selvon, John Hearne, Jan Carew, V. S. Naipaul, Andrew Salkey, and Neville Dawes; see Lamming, *The Pleasures of Exile*, 41. The degree to which these writers might be considered modernist undoubtedly varies from case to case.

[43] Emery, *Modernism, the Visual and Caribbean Literature*, 152.

[44] Lamming, *The Pleasures of Exile*, 15.

For Gikandi, both this engagement with the central texts of the European tradition and the vision of Caliban as ringing in the future from the place of the colonial subject now ensconced in the heartland of the colonizer are indicative of the key strands of Caribbean modernism.[45]

Lamming's first novels—*In the Castle of My Skin* (1953) and *The Emigrants* (1954)— were greeted by a number of reviews that drew comparisons to writers in the high modernist tradition, particularly James Joyce.[46] Like Rhys, Lamming continually engaged with the isolation of the individual in the world, but shaped this modern anxiety into a distinctive colonial relation. Lamming recognized that all people living through modernity faced that 'distance which separates one man from another, and in the case of an acute reflective self-consciousness, separates a man from himself'.[47] However, for the orphaned cultures of the Caribbean, this segregation becomes even more noticeable. G., whose narration dominates *In the Castle of My Skin*, is paradoxically able metonymically to represent the fracture between his island and the parent British culture but also reveals his own profound separation from any community of his countrymen: 'My birth began with an almost total absence of family relations.'[48] His 'most important mode of consciousness is negative . . . an awareness of collective loss'.[49] Taught nothing of the brutality of Barbadian history at school, and encouraged only to read their island as 'Little England', the islanders reveal a lack of collective self-understanding that mirrors across a whole society the alienation of the subject under modernity. Proficiency in language, associated with success within the imposed system of British education, is understood as granting access to power, but also as enacting a separation from the modes of real experience. The boys contemplating the inadequacies of their expression aspire towards language as a way to 'kill' feeling, and long for access to this privileged zone of articulacy which would be sufficiently divorced from their everyday lives to count as genuine expression.[50] However, Lamming interweaves their longing for this impersonal (and self-effacing) mastery of the colonial language, with demonstrations of how such skill might already belong to them: the boys sharing the telling of comic stories of the island's inhabitants, passing the narrative among themselves, demonstrates their use of the 'resources of the oral tradition [to] weave a tapestry of feelings and sensibilities that counter the anesthetic effects of colonial education'.[51] Again, it is recourse to the vernacular that offers ballast against the dislocating currents of the modern.

[45] Gikandi, *Writing in Limbo*, 41.

[46] J. Dillon Brown, 'Exile and Cunning: The Tactical Difficulties of George Lamming', *Contemporary Literature*, 47/4 (Winter 2006), 675–6.

[47] George Lamming, 'The Negro Writer and His World', *Caribbean Quarterly*, 5/2 (Feb. 1958), 112.

[48] George Lamming, *In the Castle of My Skin* (Harlow: Longman, 1986), 4.

[49] Gikandi, *Writing in Limbo*, 76.

[50] Lamming, *In the Castle of My Skin*, 145–6.

[51] Nadi Edwards, 'George Lamming's Literary Nationalism: Language Between *The Tempest* and the Tonelle', *Small Axe*, 11 (Mar. 2002), 72.

CARIBBEAN MODERNISM 921

The apogee of the Caribbean vernacular voice in Britain is perhaps found in the work of Sam Selvon, who arrived in Britain on the same boat as Lamming in 1950. His 1956 novel *The Lonely Londoners* traces the experience of a number of immigrants from the Caribbean, and is centred around the basement of Moses Aloetta, a cynical father figure to the more recent arrivals. The narrative, which dips in and out of the consciousness of several of the West Indians, though focusing particularly on Moses and Henry Oliver (known as Sir Galahad), is written throughout in a 'consciously chosen Caribbean literary English' and as such 'was a pioneering work as it moved toward bridging that difficult gap of perspective between the teller of the tale and the tale itself'.[52] This voice 'is not the language of the people or of any one stratum in the society; it is a careful fabrication, a modified dialect which contains and expresses the sensibility of a whole society'.[53] Selvon's embrace of the vernacular, then, his endeavour at forging the conscience of his race, is knowingly artificial. It is a literary device divorced from the actual spoken language either of the islands, or of the London-based migrants, but expressly developed to enable the Caribbean subject to find a presence within the privileged spaces of literature.

The manner in which the spoken characteristics of Selvon's language ultimately cede to a more literary conception can clearly be seen in the structure of the novel. The situations and dynamics of individual scenes and vignettes owe much to the Trinidadian form of the calypso.[54] But the novel's 'loose episodic structure... resembles modernist storytelling as strongly as it does any folkloric tradition, because it revels in the exceptional social diversity supported by the city's compact geography'.[55] In the most famous passage of the novel, the nine-page unpunctuated flow across the consciousness of many characters clearly evokes passages of high modernist writing, not least in its final notes of sensory epiphany and resigned incomprehension:

under the trees in the park on the grass with the daffodils and tulips in full bloom and a sky of blue oh it really does be beautiful then to hear the birds whistling and see the green leaves come back on the trees and in the night the world turn upside down and everybody hustling that is life that is London oh lord Galahad say when the sweetness of summer get in him he say he would never leave the old Brit'n as long as he live and Moses sigh a long sigh like a man who live life and see nothing at all in it and who frighten as the years go by wondering what it is all about.[56]

[52] Susheila Nasta, 'Setting Up Home in a City of Words: Sam Selvon's London Novels', in A. Robert Lee (ed.), *Other Britain, Other British: Contemporary Multicultural Fiction* (London: Pluto Press, 1995), 53.

[53] Kenneth Ramchand, 'Song of Innocence, Song of Experience: Samuel Selvon's *The Lonely Londoners* as a Literary Work', in Susheila Nasta (ed.), *Critical Perspectives on Sam Selvon* (Boulder, Col.: Lynne Reiner, 1988), 229.

[54] For recent discussions of how the calypso aesthetic is played out in the novel, see John McLeod, *Postcolonial London: Rewriting the Metropolis* (London: Routledge, 2004), 24–40, and Ashley Dawson, *Mongrel Nation: Diasporic Culture and the Making of Postcolonial Britain* (Ann Arbor: University of Michigan Press, 2007), 27–48.

[55] Peter Kalliney, 'Metropolitan Modernism and its West Indian Interlocutors: 1950s London and the Emergence of Postcolonial Literature', *PMLA* 122/1 (Jan. 2007), 96.

[56] Sam Selvon, *The Lonely Londoners* (Harlow: Longman, 1985), 109–10.

DISCREPANT COSMOPOLITANISM: HARRIS, BRATHWAITE, AND WALCOTT

In the fiction of Wilson Harris, 'possibly the most self-conscious Caribbean modern-ist',[57] we find 'unconscious psychic dimensions, nonlinear narrative structure, the awareness of a rupture in the correlation between language and accepted reality, and a sense of cultural crisis . . . He radically undermines linear sequence, space, and time with a consequent alteration of conventional understandings of recollection, identity and casuality.'[58] Yet to link Harris to the traditions of European modernism seems to risk losing sight of the profound originality of his work. A. J. M. Bundy notes the resemblances in Harris's early poetry to Pound's *Cantos* and Eliot's *Four Quartets* but insists that these resemblances are merely 'contingent' and that Harris's debut novel, *The Palace of the Peacock* (1960), engages 'not with the modernists, but rather with one of the inspirations for literary modernism, Dante'.[59] Harris looks to the diverse sources of his Guyanese inheritance (English, African, Indian, Carib, Arawak) to connect with an enabling sense of mythology that is able to transcend the stifled historicity of the Caribbean. His blending of such elements in order to articulate the 'epic stratagems available to Caribbean man in the dilemmas of history which surround him' stands in complicated relation to the engagement with myth and fable associated with high modernism.[60] Whereas Gikandi sees Harris as modernist, Benítez-Rojo reads him as postmodernist, and Stuart Murray, in assessing the refusal of authorial codifying that informs such blending of discourses, reads aspects of his vision as 'pre-modern'.[61] Harris's engagement with the 'irruption into modernity' of the Caribbean region resists easy comparison with European modernism even as it employs similar strategies of representation.

This knotty relationship both with the emerging experiences of modernity and with the traditions of engaging the modern that might seem imbricated with the former colonial powers finds parallels in the works of the two most important poets of the late twentieth-century Anglophone Caribbean: Derek Walcott and Kamau Brathwaite. It has become a commonplace to read the aesthetic philosophies of these contemporaries (each was born in 1930) as diametrically opposed. As Patricia Ismond summarizes this simplification, Brathwaite is read as the 'public' poet who takes history as his focus, and Walcott as the 'private' poet who is vitally concerned with the nature of art.[62] Without meaning to dismiss the significant differences between

[57] Gikandi, *Writing in Limbo*, 4.

[58] Sandra E. Drake, *Wilson Harris and the Modern Tradition: A New Architecture of the World* (Westport, Conn.: Greenwood, 1986), 4–5.

[59] A. J. M. Bundy, 'Introduction', in *Selected Essays of Wilson Harris*, 3.

[60] Wilson Harris, 'History, Fable and Myth in the Caribbean and Guianas', in *Selected Essays of Wilson Harris*, 152.

[61] Benítez-Rojo, *The Repeating Island*, 187–96; Stuart Murray, 'Postcoloniality/Modernity: Wilson Harris and Postcolonial Theory', *Review of Contemporary Fiction*, 17/2 (Summer 1997), 56.

[62] Patricia Ismond, 'Walcott versus Brathwaite', *Caribbean Quarterly*, 17/3–4 (Sept.–Dec. 1971), 54–6.

them—'behind every cliché attitude is a hard core of significance'[63]—it is nonetheless useful to identify how their projects might be seen to coalesce in defining a Caribbean response to the modern world.

Each of the poets views the Caribbean as a place where a new conception of language and expression might be formed. For Walcott, the 'New World Negro' can only be freed from bondage to imperial pasts by 'forging a new language that went beyond mimicry, a dialect which had the force of revelation as it invented names for things'; Brathwaite, on the other hand, looks to the 'nation language' he finds 'submerged' in Caribbean English: 'the area . . . of dialect which is much more closely allied to the African experience in the Caribbean'.[64] However, despite the seeming dominance of ideas of novelty in Walcott's verse and of non-European tradition in Brathwaite's, it is misleading to assume these qualities to be exclusive. Even in Walcott's *Another Life*, with its seemingly defiant statement of originality of expression, 'We were blest with a virginal, unpainted world | with Adam's task of giving things their names,' we can find an acceptance that the reality of Caribbean life is overdetermined by its unrecorded history.[65] The child who puts the conch shell to his ear

> hears everything
> that the historian cannot hear, the howls
> of all the races that crossed the water,
> the howls of grandfathers drowned
> in that intricately swivelled Babel,
> hears the fellaheen, the Madrasi, the Mandingo, the Ashanti.[66]

Equally, at the conclusion of Brathwaite's *The Arrivants* trilogy, the prior journeys to an African past are considered as preamble to the 'hearts' of the islanders

> now waking
> making
>
> making
> with their
>
> rhythms some-
> thing torn
> and new.[67]

For Walcott and Brathwaite, as for Harris, the demand to 'make it new' must be recognized but also grounded in an experience that is authentic to the islands. They look towards an indigenous aesthetic in the search for a Caribbean literary response that can answer both global modernity and post-colonial cultural nationalism. This

[63] Ibid. 54.
[64] Walcott, *What the Twilight Says*, 15; Brathwaite, *History of the Voice*, 13.
[65] Derek Walcott, *Another Life* (London: Jonathan Cape, 1973), 152.
[66] Ibid. 143.
[67] Edward [Kamau] Brathwaite, 'Jou'vert', in *The Arrivants: A New World Trilogy* (Oxford: Oxford University Press, 1973), 269–70.

is not to suggest that they absolutely reject European traditions of modernism, or to insist on the 'pre-modernity' of the Caribbean, but rather that their attitudes to European tradition are far from being dependent on it.[68]

In a controversial address to the Conference of the Association of Commonwealth Literature and Language Studies held at the University of West Indies at Mona, Jamaica, in 1971, Brathwaite contrasted the 'Great Tradition' of European literature to the 'Little Tradition' embodied in Caribbean folk culture and insisted that the latter should be pursued in preference to the former.[69] There is a clear danger in this kind of statement in that it not only refuses evidence of contemporary syntheses between these aspects of Caribbean literary heritage but also devalues such work as was carried out within the Caribbean modernism practised by writers of the earlier twentieth century, like McKay, Marson, and Lamming. The engagement with modernism in twentieth-century Caribbean writing was always more complicated than such a division of inheritances might allow.

Charles W. Pollard has mapped in detail the relationship of both Brathwaite's and Walcott's engagements with the work of T. S. Eliot. His study is invaluable not only for its detail but also for its attempt to dismantle aspects of the division between 'metropolitan' and 'post-colonial' modernism. He argues that modernism itself can be seen as a 'discrepant cosmopolitanism' (the term is taken from James Clifford): 'an ideal that recognizes the fragmentation and diversity of any contemporary culture, but also seeks to bring those fragments together to form new, provisional and transnational cultural wholes'.[70] In this characterization, modernism is divorced from the Eurocentricity that many would suggest haunts it, and instead becomes a resource always open to evolution and redeployment globally. Pollard argues for a perspective that sees the Caribbean poets as 'neither exclusively literary orphans unrelated to Eliot and European modernism nor exclusively rebel sons rejecting his and its authority; instead, they are more like second cousins whose distinctly individual responses to modernity bear a common family resemblance'.[71] His study at times too easily dismisses the very real sense of opposition to European tradition that critics like Gikandi are right to find in Walcott and Brathwaite, but it does offer a

[68] While Stuart Murray's characterization of Wilson Harris as 'pre-modern' is echoed in the use of adjective by Shalini Puri and Paul Breslin to describe aspects of the work of Brathwaite and Walcott respectively, each of these critics evokes the idea that this is one element of a critical practice that operates on several layers. See Shalini Puri, *The Caribbean Postcolonial: Social Equality, Post-Nationalism, and Cultural Hybridity* (Basingstoke: Palgrave Macmillan, 2004), 100; Paul Breslin, 'The Cultural Address of Derek Walcott', *Modernism/Modernity*, 9/2 (May 2002), 323–4. The evocation of the pre-modern is certainly not intended to suggest the kind of images of a prelapsarian Caribbean that might feed primitivist discourse, but rather to challenge the applicability of a Western model of modernity to a post-colonial setting.

[69] This address, and the climate in which it was given, is discussed in detail in Donnell, *Twentieth-Century Caribbean Literature*, 27–32.

[70] Charles W. Pollard, *New World Modernisms: T. S. Eliot, Derek Walcott, and Kamau Brathwaite* (Charlottesville: University of Virginia Press, 2004), 8.

[71] Ibid. 22.

useful sense that modernism may be something that can be engaged with creatively, rather than simply contested or challenged.

It should be noted, however, in mapping their works against Eliot's so closely, he perhaps risks reasserting the sense of European primacy that the idea of discrepant cosmopolitanism seems intended to dispel. Equally, his focus on these later poets seems to reinforce an idea of Caribbean literature embracing modernism only after the European backlash against it. Modernism can in fact be traced as an element within Caribbean literary aesthetics from the first decades of the twentieth century. The consistent return to its possibilities (even as its limitations are questioned) perhaps demonstrates the determination of writers to utilize whichever tools might be most suitable for articulating the specifics of Caribbean experience. Each visiting and revisiting of modernist heritage results in new and different pathways taken within Caribbean writing. That they often take European modernism as a starting point for diverse explorations cannot be seen to make the results any less of an authentically Caribbean expression.

CHAPTER 51

···

MODERNISM AND AFRICAN LITERATURE

···

TIM WOODS

REFLECTING on the nature of African modernity, the character Salim in V. S. Naipaul's *A Bend in the River* characterizes it as 'Europe in Africa, post-colonial Africa. But it isn't Europe or Africa.'[1] Modernity in this context manipulates fetishized images of continents and illusions of identity; modernity acts as a post-colonial displacement for Africans that opens up neither a secure identity nor a self-reflexive consciousness. As an invasive process, modernism reached into spaces that other 'isms' had not. This chapter will examine the complex and often contradictory relationship of African culture (and writing in particular) to modernism and its cultural effects. It will principally seek to address the ways in which African writers have engaged with, probed, and interrogated the discourses of modernity, especially the cultural discourse of modernism.

European cultural modernism *is* often conceived of as an exploration of the cultural cul-de-sac of European culture, seeking to break with the dominant conventions and paradigms of nineteenth-century art such as realism, linear narrativity, perspective, and tonality. Yet an integral part of this very crisis in Europe's cultural self-reflexivity occurs with the discovery of cultures whose aesthetic practices and cultural models were a radical disruption to the prevailing European cultural assumptions. On the one hand, just as European powers were involved in violently

[1] V. S. Naipaul, *A Bend in the River* (London: André Deutsch, 1979), 150.

suppressing the 'savage' cultures of Africa, so, on the other hand, they were also importing into Europe, as booty, the disclosure of an alternative view of the world in the form of African masks, carvings, and jewellery—artefacts that were plundered and stored in museum basements until displayed in the early decades of the twentieth century. Through such exposés, Ashcroft, Griffiths, and Tiffin argue that 'Europeans were forced to realize that their culture was only one amongst a plurality of ways of conceiving of reality and organizing its representations in art and social practice.'[2] In particular, as Ashcroft, Griffiths, and Tiffin continue, while China and India were regarded as the decayed vestiges of earlier, alternative, and now superseded models of 'high culture', the cultural discoveries brought about by the 'scramble for Africa' in the 1880s and 1890s posed a radical challenge to European values: 'African culture could be viewed as the liberating Dionysiac force which could shatter the Apollonian certainty of nineteenth-century bourgeois society.'[3] Therefore, they argue that 'the more extreme forms of the self-critical and anarchic models of twentieth-century culture which modernism ushered in can be seen to depend on the existence of a post-colonial Other which provides its condition of formation'.[4] This is a view reinforced by Simon Gikandi, who investigates the central role that primitivism came to occupy in the ideology of modernism. Gikandi argues that this was largely predicated upon the differentiation of art and culture inculcated by ethnographers like the German Leo Frobenius. Asking how the modernist mode of epiphany might have required the imaginative encounter with Africans, Gikandi finds in Frobenius's work and ideas a model for the monumentalization of 'otherness' within modernism and in subsequent critical treatments of modernism. Gikandi concludes that 'Africa is the unconscious of modernism—its "absent cause"—a force whose presence can neither be negated nor endorsed and must hence be repressed. . . . If Africa did not exist as the site in which the fears and energies of modernism could be projected, it would have to be invented.'[5]

Indeed, in its attempt to revivify European culture, European modernism often turned to African cultures as a site or space of 'otherness' that in some cases also became a form of cultural appropriation, a negation of that 'otherness', an incorporation of that other space and culture. It has been noted that images of African art in D. H. Lawrence's *The Rainbow* (1915) were drawn from British Museum exhibitions;[6] while artists such as Picasso and Braque incorporated the African mask into such celebrated modernist pictures as Picasso's *Les Demoiselles d'Avignon* (1907) and other Cubist works. As Jon Hegglund observes, by turning Africa from content into a signifier, 'so completely separating the idea of "Africa" from its material reality, Conrad and Picasso reduce the diversity of a continent to a single

[2] Bill Ashcroft, Gareth Griffiths, and Helen Tiffin, *The Empire Writes Back* (London: Routledge, 1989), 156.
[3] Ibid. 159. [4] Ibid. 160.
[5] Simon Gikandi, 'Africa and the Epiphany of Modernism', in Laura Doyle and Laura Winkiel (eds), *Geomodernisms: Race, Modernism, Modernity* (Bloomington: Indiana University Press, 2005), 49.
[6] Ashcroft et al., *The Empire Writes Back*, 160.

abstraction'.[7] Elleke Boehmer goes on to add that some modernists went as far as arguing that Western cultural ideologies were themselves underpinned by a common primitive base. For example, the Scottish anthropologist Sir James G. Frazer's wide-ranging and influential comparative study of mythology and religion *The Golden Bough* (1890) sought to lay bare the shared structures between Western religious beliefs and other ancient belief systems, indicating that diverse cultures could well be allied by core ritualistic concepts.[8] With Yeats's interest in the work of Rabindranath Tagore and Indian literature, and Eliot's keen interest in Frazer's work and non-Western religions evident in *The Waste Land*, these and the texts of other writers gradually constructed a cumulative challenge to nineteenth-century hypotheses of Eurocentric superiority.

If African art gave European art an insight into what was perceived to be its 'other', what did European modernism offer African writers? Since modernity is fundamentally about conquest, imperial regulation, and exploitation of the land, clearly modernism as a discourse was awkwardly situated in relation to cultures seeking to represent new freedoms and cultural opportunities. Not surprisingly, therefore, African writers were wary of re-enslaving themselves to a kind of cultural neocolonialism, to non-African concepts and ideals whose relevance to their situations are questionable. The language of 'influence' was dealt a devastating blow by Ayi Kwei Armah's now famous challenge to Charles Larson's *The Emergence of African Fiction* (1972), which proposed Armah's supposed indebtedness to James Joyce. Armah's caustic rejoinder clarified that 'the language of borrowing and influence is usually a none too subtle way Western commentators have of saying Africa lacks original creativity'.[9] African writing by contrast often set out to challenge the very tenets of European culture that were usually part and parcel of the insidious project of colonialism. Nevertheless, it could also be argued that some forms of European modernity also offered African writers a space and rationale for criticizing the cultural and economic exploitations of colonialism. Boehmer points out that the 'new colonial writers stood to learn much from the techniques of dislocation which distinguished the modernist avant-garde. For expatriate and colonized artists, modernist urban reality correlated quite closely with their own experience, doubly or triply alienated from origins.'[10] Writers like Ngugi wa Thiong'o, Chinua Achebe, Buchi Emecheta, and Wole Soyinka, and, more recently, novelists like Chenjerai Hove and Tsitsi Dangarembga from Zimbabwe, have sought to dramatize the clash between modernity and traditional values, in ways that often borrowed concepts and ideas from the European modernist writers.

[7] Jon Hegglund, 'Modernism, Africa and the Myth of Continents', in Peter Brooker and Andrew Thacker (eds), *Geographies of Modernism: Literatures, Cultures, Spaces* (London: Routledge, 2005), 43.

[8] Elleke Boehmer, *Colonial and Postcolonial Literature*, 2nd edn (Oxford: Oxford University Press, 1995), 121.

[9] Charles Larson, *The Emergence of African Fiction* (Bloomington: Indiana University Press, 1972); Ayi Kwei Armah, 'Larsony, or, Fiction as Criticism of Fiction', *New Classic*, 4 (1977), 38.

[10] Boehmer, *Colonial and Postcolonial Literature*, 118.

David I. Ker strengthens and extends this argument in his analysis of key African novels side by side with British and American modernist novels. In *The African Novel and the Modernist Tradition*, he aims to demonstrate the manner in which several African novelists have taken full advantage of the experimentation that modernism offers to tackle their own 'crisis of culture'.[11] Arguing that 'modernism's consciousness of disorder, despair, and anarchy is the perfect medium for the African novelist for conveying on the one hand his [*sic*] nostalgia for the past, with all its imperfections and on the other hand his bitterly ironic indictments of the present . . . For the African novelist, colonialism is the strain that brought him into the international literary modernist scene.'[12] For Ker, the key issue lies in the way in which the modernist writer uses 'point of view', and he explores the various European models of narrative formalist techniques that African novelists have adapted, such as Ngugi wa Thiong'o's adaptation of Conrad, Ayi Kwei Armah's adaptation of Faulkner, and Kofi Awoonor's adaptation of Woolf and Joyce. Ker argues that 'The tendency of modernist writers to break with all traditions, has an attraction for the African novelist who is strategically placed to witness what may be described as the apocalyptic moment of transition into the new.'[13] Consequently, '[Modernism's] unique response to chaos is just what they need to address the African condition.'[14]

While Ker's overtly New Critical methodology, conclusions, and singular masculine focus are not endorsed here, it is the case that some African novelists undoubtedly did engage quite closely with European modernism. The fiction of the internationally famous Nigerian novelist Chinua Achebe, especially *The African Trilogy* (*Things Fall Apart, No Longer at Ease, Arrow of God*), has arguably been driven by its engagement with and interrogation of European modernist culture. In some ways, this culture has proved liberating for Achebe. His fiction resonates more fully with, and characters respond to, the representations of fragmentation and alienation characteristic of modernism more than the mawkish sentimentalism and nostalgia of late Victorian Romanticism. The title of *Things Fall Apart* (1958) derives from Yeats's poem 'The Second Coming', while the epigraph of *No Longer At Ease* (1960) is taken from Eliot's 'Journey of the Magi'. The protagonist of the latter novel, Obi Okonkwo, goes to England, and upon his return to Nigeria, he compares the Nigeria of his romantic poetic imagination with his contemporary experience:

Here was Lagos, thought Obi, the real Lagos he hadn't imagined existed until now. During his first winter in England he had written a callow, nostalgic poem about Nigeria. It wasn't about Lagos in particular, but Lagos was part of the Nigeria he had in mind.

> How sweet it is to lie beneath a tree
> At eventime and share the ecstasy
> Of jocund birds and flimsy butterflies;

[11] David I. Ker, *The African Novel and the Modernist Tradition* (New York: Peter Lang, 1997), 1.
[12] Ibid. 1–2. [13] Ibid. 184. [14] Ibid. 185.

> How sweet to leave our earthbound body in its mud,
> And rise towards the music of the spheres,
> Descending soft with wind,
> And the tender glow of the fading sun.

He recalled this poem and then turned and looked at the rotting dog in the storm drain and smiled. 'I have tasted putrid flesh in the spoon,' he said through clenched teeth. 'Far more apt.'[15]

In lines that echo the poetry of 'The Love Song of J. Alfred Prufrock', or *The Waste Land*, Okonkwo finds that his idealistic poetic imagination is jarred by the brutal and ugly daily experiences of metropolitan life. Later in the novel, he finds another of his poems in a volume of A. E. Housman's collected verse, entitled 'Nigeria', which has clichéd lines about patriotism, nobility, and nationhood. This too is discarded. Okonkwo clearly shuns verse inspired by the late Romanticism of poets like Housman in favour of poetry that emulates the disjointed and fractured styles of English modernism. Okonkwo's other points of literary reference include Conrad (a writer whom Achebe famously excoriated), and African fiction elsewhere demonstrates a similar indebtedness to European modernists—Gabriel Okara's *The Voice* is clearly influenced by Eliot and modernist poetry, as were Okot p'Bitek and I. N. C. Aniebo, while Eliot and Dylan Thomas were interested in and praised Amos Tutuola's writing. In some ways, modernism acted as a mirror held up to colonialism, and African writers saw reflected a style that addressed itself to the alienated and disjointed consciousnesses of the colonized subject in Africa. Nicholas Brown suggests that such a kinship should not be surprising given 'the prestige accorded modernist literary texts by colonial-style education at mid-century'.[16] Yet, as Brown continues, this kinship is always Janus-faced: 'The critical edge of the great modernisms presents a model, while their institutional weight as the vanguard of European culture presents both an obstacle and a formidable spur to new and sometimes aggressively oppositional literary production.'[17] Whereas European artists looked to Africa for borrowings to revitalize what was perceived to be a flagging and insipid Western *aesthetic*, African writers borrowed from European modernism for the purposes of promoting a radical *politics* of counter-colonialism.

Yet this borrowing was never straightforward; as David Ker acknowledges, and as Homi Bhabha has made a critical shibboleth in post-colonial theory, these African writers interrogate and subvert the cultural practices of European modernism, bending and hybridizing them in their own processes of indigenous cultural retrieval and questioning the ideas of progress and enlightenment embedded in modernity. Yet correspondingly, as Michael Janis cautions, within the context of Africa, one needs to be wary of the ways in which '"tradition" is problematically manipulated as

[15] Chinua Achebe, *The African Trilogy: No Longer at Ease* (London: Picador, 1988), 186.

[16] Nicholas Brown, *Utopian Generations: The Political Horizon of Twentieth-Century Literature* (Princeton: Princeton University Press, 2005), 1.

[17] Ibid.

a foil to modernity, or refashioned as a politics of authenticity'.[18] The trauma of colonialism clearly forced an intense address to the entire question of language and representation itself, aided and abetted by modernism's materialization of the signifier. For example, Achebe, in *Things Fall Apart* and *Arrow of God*, refashioned English as a way of rendering traditional Ibo discourse and mindsets. Some criticism would make writers like Achebe and Wole Soyinka into writers who speak of universal values, as modern metropolitan consciousnesses reconciling 'heritage' and 'progress'. Yet this modernity obscures the extent to which these writers participate in a sense of the traumatic nature of African culture and history—albeit without nostalgia for the primitivist authenticity that hovers over the polemic criticism of the 'Bolekaja' critics (see below).[19] These writers eschew the modernist exoticism of Africa while at the same time refusing to glorify and essentialize the African past; and in this tension, tradition should not be regarded as the opposition to the modern.

As many literary historians and cultural anthropologists have observed, oral narratives rely heavily upon the past through accumulated tradition.[20] Emmanuel Obiechina points out that oral tradition depends significantly on human memory for the perpetuation and communication of the cultural repertoire, and therefore it develops sophisticated mechanisms for aiding human memory.[21] Those writers who showed a marked dependence upon the major influence of oral traditions in everyday African culture implicitly embedded within their writing a retrieval of a past that was facing increasing pressure from modernity. Modernity was a rupture, and that rupture was largely consequent upon the arrival of European colonialism, and writers who sought to hold modernity at bay might be considered to be conservative. Several critics also point to the fact that some African novelists sought 'to rehabilitate the past by incorporating the oral tradition through a resort to local ethnic tenets and philosophy, beliefs, and attitudes to life and existence'.[22] In all this debate, there seems to be a debilitating conflation of several issues: a confusion of the oral with the folk tale and mythical; a mistaken postulation of the oral with a cultural conservatism in opposition to a thriving modernism; and the fact that the oral tradition is only to do with the moribund past rather than the dynamic present. It is a grave cultural error to equate a writer's admiration for the techniques of oral narrative as the mark

[18] Michael Janis, *Africa After Modernism: Transitions in Literature, Media and Philosophy* (London: Routledge, 2008), 2.

[19] See e.g. Kadiatu Kanneh, *African Identities: Race, Nation and Culture in Ethnography, Pan-Africanism and Black Literatures* (London: Routledge, 1998), in which she argues in agreement with Anthony Kwame Appiah that Chinweizu, Onwuchekwa Jemie, and Ihechukwu Madubuike's provocative thesis in *Toward the Decolonization of African Literature* (Washington, DC: Howard University Press, 1983) is flawed by a 'cultural essentialism haunting the arguments . . . where Africa becomes a totalised vision of otherness, summarised in the phrase, "Africa is simply not the West"' (p. 39).

[20] See e.g. Jan Vansina, *Oral Tradition: A Study in Historical Methodology* (London: Routledge & Kegan Paul, 1965), and J. O. J. Nwachukwu-Agbada, 'Nigerian Literature and Oral Tradition', in Ernest Emenyonu (ed.), *Goatskin Bags and Wisdom: New Critical Perspectives on African Literature* (Trenton, NJ: Africa World Press, 2000), 67–89.

[21] Emmanuel Obiechina, *Culture, Tradition and Society in the West African Novel* (Cambridge: Cambridge University Press, 1975), 33.

[22] Nwachukwu-Agbada, 'Nigerian Literature and Oral Tradition', 68.

of literary regression or as a sign of cultural conservatism. There is a rich complexity in oral narrative, with its swoops, spirals, digressions, and reiterations; and such eminent scholars as Ruth Finnegan have persuasively argued that oral literature is not a thing of the past but a part of the current vibrancy of cultures throughout Africa.[23] The oral tradition is not *lost*, since it pervades all aspects of African cultural life on a day-to-day basis. Furthermore, in some hands the folk tale representation can act as an incisive contemporary fable, cutting through the haze of colonial obfuscation and modern obeisance to received narrative versions.

Part of this interest in oral narratives was motivated by an interest in the *mythical or folk past*, an interest that emerged in numerous narratives and that has provoked considerable debate over the nature of the past that such narratives offer. A principal example of this folk style rests in the pasts evoked by Amos Tutuola's narratives, which are structured by oral folk tale and allegory, and that depend heavily upon the influence of the Yoruba folk tale writer D. O. Fagunwa. Tutuola was lauded in Europe by the likes of T. S. Eliot and Dylan Thomas when he first published *The Palm-Wine Drinkard and His Dead Palm-Wine Tapster in the Deads' Town* (1952), for what was perceived to be the linguistic exuberance and innovation that he brought to African literature.[24] However, he was somewhat ridiculed or criticized for derivation (or, at worst, outright plagiarism) in Nigeria, causing his reputation to undergo something of a re-evaluation in recent years. Abiola Irele has sought to disentangle the mis-perceptions about Fagunwa's influences over Tutuola, and has argued that Fagunwa's work in translating oral into written form has established him 'at the head of creative writing in the Yoruba language'.[25] Irele suggests that Tutuola 'merely took over a form developed out of the folk tradition to a new level of expressiveness by Fagunwa' and there was a shift in attention from Fagunwa in Yoruba to Tutuola in English.[26] Nevertheless, Tutuola individualized the Yoruba tradition that he bent to his purposes, and, in densely packed narratives, his 'imagery reflects an unusual capacity for perceiving and realizing in concretely sensuous terms a certain order of experience that lies beyond the range of the ordinarily "visible"'.[27]

The Palm-Wine Drinkard is a series of adventures that befall a man addicted to palm-wine, who goes in search of his dead palm-wine tapper. During the course of his search, he captures Death, overcomes the Skull, has a baby who plays all kinds of harmful pranks, is tortured by the inhabitants of the Heavenly Town, meets the 'Red-people in the Red-town', and finally arrives at the Deads' Town, where the dead palm-wine tapper is residing and who explains that he cannot leave; the protagonist eventually arrives back in time to help save his own town from famine. Like Fagunwa,

[23] See e.g. Ruth Finnegan, *Oral Literature in Africa* (Oxford: Clarendon Press, 1970), and Joel A. Adedji, 'The Genesis of African Folkloric Literature', *Yale French Studies*, 53 (1976), 5–18.

[24] Dylan Thomas, Review of Amos Tutuola, *The Palm-Wine Drinkard*, *The Observer*, 6 July 1952, quoted in Bernth Lindfors (ed.), *Critical Perspectives on Amos Tutuola* (Washington, DC: Three Continents Press, 1975), 8.

[25] F. Abiola Irele, *The African Experience in Literature and Ideology* (London: Heinemann, 1981), 177.

[26] Ibid. 182. [27] Ibid. 186.

Tutuola fuses the supernatural and natural realms into a drama of human projections of the terrors and obsessions that haunt the imagination and consciousnesses of people on an everyday basis. Like Fagunwa, Tutuola 'has created the universe of his novels directly out of the African, and specifically Yoruba, conception which sees the supernatural not merely as a prolongation of the natural world, but as co-existing with it'.[28] Indeed, O. R. Dathorne suggests that 'in the final resort Tutuola succeeds because his works remain enigmatic intrusions of the inexplicable past into an inquisitive present'.[29] Tutuola's main intervention is to give the narrative an inflection in English, although in his imaginative use of Yoruba folklore, many have criticized Tutuola for writing 'wrong' English, making him out to be 'quaint' or 'semi-literate' in the process, ignoring the fact that Tutuola's language is partly the palm-wine drinker's language and also reflective of the pidgin English spoken in West African speech.[30] Emmanuel Obiechina has sought to clarify Tutuola's achievement, distinguishing Tutuola's ability to 'assimilate elements peculiar to the oral tradition to elements of the literary tradition: in other words, to impose a literary organization over essentially oral narrative material'.[31] Tutuola's writing effectively revisits a West African past that has been mythologized in Yoruba folk tales and has been resurrected and thereby installed as part of the significant cultural history of Nigeria. In this respect, the oral tradition becomes the signifier of a past that has been censored by the rupturing cultural effects of colonial modernity.

In trying to combat a post-colonial situation in which English has been absorbed into African societies, and is at odds with the characteristics of the inner landscape that has been moulded by this entirely different culture and environment, Tutuola aims for an Africanization of the English idiom, almost a transliteration. Instead of turning to the language of the once-ruling power, Tutuola turns his English to the African continent. The deliberate manner in which Tutuola works his different rhetorical devices and idioms is evident in the entire novel, trying to keep as close as possible to the vernacular expressions with the repetition of words, phrases, sentences, images, and symbols, as well as short sentences and a high degree of the ritualization of belief, actions, and concepts. This symbolization acts as a means of concretizing experience and routinizing everyday actions, all drawing on the vernacular tendency of language to concretize experience. Abstract notions are rendered as physical realities. Reminiscent of modernists like Pound and Woolf, there is a 'reification' in Tutuola's practice that seeks to endow abstract qualities with 'thingness', although it is a process devoid of alienation. The metaphoric and hyberbolic elaborations, as well as the colloquial rhythms and the literalization of action, belong to the oral tradition. *The Palm-Wine Drinkard* emerges as a quest not only for the palm-wine drinkard's tapper, but also for the frame of reference that will blend the

[28] Ibid. 179.

[29] O. R. Dathorne, 'Amos Tutuola: The Nightmare of the Tribe', in Bruce King (ed.), *Introduction to Nigerian Literature* (Lagos: University of Lagos and Evans Bros, 1971), 72.

[30] Ibid.

[31] Emmanuel Obiechina, 'Amos Tutuola and the Oral Tradition', in Lindfors (ed.), *Critical Perspectives on Amos Tutuola*, 144.

past culture embedded in indigenous cultural oral forms with a modern consciousness of alienation and estrangement.

Tutuola resists presenting his mythical and folk pasts with any nostalgia. These are not pasts depicted for the purposes of envisaging a structural developmental progression into the future; nor are they pasts dependent upon some rose-tinted version of society before the ills attributed to the impact of an interruptive colonial modernism. Tutuola's narratives do not refrain from presenting the petty grievances, internal bickerings, family vengeances, political intrigues, intertribal rivalries, social corruptions, or other features of social rifts. These are not pasts established primarily in contradistinction to the colonial pasts, or the neocolonial presents, nor are they depictions of a past that is free from any social problems, economic hardships, or forms of exploitation, in other words, a past that is harmonious, equal, and democratic. They are indicative of a celebration of the characteristics of oral narratives, the free-and-easy nature of the protagonists, and the values of the societies that existed before colonialism. In this respect, they are narratives that utilize memory as much for the purpose of remembering the particular *modes of oral narrative* as for the purpose of remembering that past itself. If there is a remembrance occurring in these narratives, it is a memory of a style of telling, a form of narrating, which is itself indicative of a particular social structure that is coming under pressure from colonial forms of narrative (i.e. the novel or realism). Memory is therefore being used to preserve a form of the past in the *form* of the narrative. History is retrieved in form rather than content; the past is revisited principally in terms of a 'structure of feeling', rather than in terms of an ideological depiction of a certain way of life. The theatre of memory, in these cases, is a production of language, and, through this, memory acts to retrieve and preserve a syntax of the past, rooted in linguistic and narrative difference.

So far from succumbing to some quasi-nostalgic sentimentalism, Tutuola's narratives testify to a culture concerned with a disappearing past, a past being erased by new modes of narrative, new forms of genre, and new structures of syntax. Their narratives are part of a general anxiety that history is being eroded by alien cultural forms that are unattuned to the nuances and significances of tribal mythological structures and to the labilities and flexibilities of indigenous forms of articulation. In this respect, these narratives form part of a technology of memory that aims for preservation and conservation. Yet this is in no sense a static form of preservation. For these narratives embed within themselves a finely nuanced hybridity, as they imbricate their indigenous knowledges and forms of speech with European influences and structures of consciousness. So while these narratives are concerned with the impact of foreign cultures upon indigenous African cultures, they do not turn a blind eye to the alternative expression of other cultures. In their use of the oral and mythical modes as a departure from the more orthodox modes of European narrative structure and technique, their writing enlivens the diversity of African culture and demonstrates how the past can be reinvigorated by preserving and activating the memory of once-forgotten narrative styles. This memory is conceptualized as a force in conflict with the counter-force of repression and censorship; and, as such,

recalling memory acts as a politico-cultural tactic in the effort to combat historical marginalization.

It is also the case that different African 'spaces' have engaged with different modernisms—for example, we have seen how Anglophone writers often engaged with Eliot and Yeats and, later, the outcomes of the African American cultural renaissance during the Harlem Renaissance and civil rights periods. Francophone writers, on the other hand, were engaged with other cultural practices, and *négritude* clearly owes some of its ideology to the wrestle with French modernism. The Martinican poet Aimé Césaire, the future Senegalese president Léopold Senghor, and the Guyanese Léon Damas were the main proponents of *négritude* in the 1930s. The principal aim of *négritude* was to unite peoples living in different nations through their shared ancestry and common origins. In particular, *négritude* propounded a solidarity established upon a common black identity as a resistance to French colonialism; and furthermore, *négritude* argued that the shared black heritage of members of the African diaspora was the best weapon for fighting against French political and intellectual hegemony. *Négritude* derived particular impetus from the African American writers Claude McKay, W. E. B. DuBois, and the works of writers like Langston Hughes and Richard Wright, which addressed the themes of 'noireism' and racism. It gained further influence from Haiti, where there had been a similar flourishing of black culture in the early twentieth century, and which historically held particular pride of place in the African diaspora owing to the slave revolution led by Toussaint L'Ouverture in the 1790s. Additional influence and support came from Surrealism. During the 1920s and 1930s, a small group of black students and scholars from France's colonies and territories assembled in Paris, where they were introduced to the writers of the Harlem Renaissance by Paulette Nardal and her sister Jane.[32] The Nardal sisters and the Haitian Dr Leo Sajou founded *La Revue du Monde Noir* (1931–2), a literary journal published in English and French, which attempted to be a mouthpiece for the growing movement of African and Caribbean intellectuals in Paris. Connections between *négritude* and French modernism were further cemented in 1948, when Jean-Paul Sartre wrote a famous analysis of the *négritude* movement in an essay called 'Orphée Noir' (Black Orpheus). This essay introduced a volume of Francophone poetry called *Anthologie de la nouvelle poésie nègre et malgache*, compiled by Léopold Senghor. In this essay, Sartre characterizes *négritude* as the polar opposite of colonial racism in a Hegelian dialectic. In his view, *négritude* was an 'anti-racist racism' ('racisme antiraciste') necessary to the final goal of racial unity. Indeed, *négritude* attempted to rescue 'blackness' from its negative and derogatory definitions in a process of *cultural affirmation*; 'blackness' was conceived of not just as an issue of skin colour, but as a whole way of life grounded in unique African qualities. Once regarded as backward and 'primitive', 'blackness' was now celebrated as sophisticated and special. Diverging slightly from Senghor, as a West Indian whose experience was very different from that of Africans, Césaire regarded *négritude* as a shared

[32] See T. Denean Sharpley-Whiting, *Negritude Women* (Minneapolis: University of Minnesota Press, 2002).

experience of oppression by all black people; *négritude* was grounded less in *African-ness* and more in the common historical experiences of racial oppression. Solidarity of the black race moulded by its experience of historical exploitation and prejudice was the basis upon which to build resistance to Europeans. Yet both Césaire and Senghor were humanists, and for both men *négritude* was conceived of as merely the first stage in universal human emancipation.

Many African writers have been critical of *négritude*, for what they regard as its essentialist racial politics. Anxious about *négritude*'s potential promotion of a stereo-typical dichotomy of Western rationalism and African emotionalism, the Nigerian playwright Wole Soyinka reacted strongly against *négritude*, seeing it as complicit with colonial ideology. Soyinka believed that by deliberately and outspokenly taking pride in their colour, black people were automatically on the defensive, and he famously proclaimed that 'A tiger doesn't proclaim its tigritude; it jumps'. Elsewhere, other critics such as Abiola Irele argued that *négritude* was not radical enough owing to its complete absorption with French intellectual thought. Nevertheless, *négritude* has had considerable continuing influence over various political movements during the twentieth century, such as the Black Consciousness Movement in South Africa during the era of apartheid, a rival political movement to the African National Congress, opposed to racial segregation and organized upon black pride and black nationalist ideologies. *Négritude* also fed into the cultural essentialism of the so-called 'Bolekaja' critics. In Yoruba *bolekaja* means 'Come down, let's fight!' The term was appropriated by the critics Chinweizu, Jemie, and Madubuike in their book *Toward the Decolonization of African Literature* (1983), a manifesto for African literary production and interpretation. Committed to Afrocentric cultural nationalism, the book consists of resolute critiques of the universalist assumptions of 'Eurocentric criticism' of African fiction and poetry. By contrast, they propose a 'supportive' role for the critic. Supportive criticism provides writer and audience with the knowledge of 'things valued in traditional African orature'.[33] In this respect, African writers are urged to 'imitate' African oral discourse to simulate 'the flavour of African life', so critics should sustain their efforts by providing them with the raw material—'knowledge of things valued in traditional African orature'—of their craft.[34] Given their stress on oral discourse, their preference for '20th-century diction and idiom', and their insistence on the autonomy of African literature, it is hardly surprising that Chinweizu, Jemie, and Madubuike decry the impact of the 'Anglo pre-modernist sensibility' on some African writers.[35] In rejecting modernism and postmodernism as narcissistic, over-intellectual, and downright neocolonial in an African setting, they look to the African 'griots' (praise-singers, or wandering bards, considered as repositories of the oral traditions) as 'authentic' models for African authorship.[36]

[33] Chinweizu, Jemie, and Madubuike, *Toward the Decolonization of African Literature*, 1: *African Fiction and Poetry and Their Critics*, 286.
[34] Ibid. 241, 286. [35] Ibid. 243, 149. [36] Ibid. 71.

Such concentrations and emphasis upon the specificity of African 'blackness' and its history of oppression in relation to European thought and culture can miss the wider dimension of African engagement with other cultures. Paul Gilroy's opening chapter to his ground-breaking book *The Black Atlantic*, entitled 'The Black Atlantic as a Counterculture of Modernity', sought to argue just such a case. Gilroy presented a clear definition of his subject:

The specificity of the modern political and cultural formation I want to call the Black Atlantic can be defined, on one level, through [a] desire to transcend both the structures of the nation state and the constraints of ethnicity and national particularity. These desires are relevant to understanding political organizing and cultural criticism. They have always sat uneasily alongside the strategic choices forced on black movements and individuals embedded in national and political cultures and nation-states in America, the Caribbean, and Europe.[37]

His book explored the transnational connections, crossings, tensions, and affiliations between black people located in Africa, the Caribbean, the United States, and Britain. Opposing ideas of ethnic and 'racial' particularism and nationalism on the grounds that these are falsifications, Gilroy showed the extent to which black radical thinkers of the nineteenth and twentieth centuries were bound up with and contributed to European modernity. Such examinations undermined both the West as ethnically and racially homogenous, and ideas of an essentialized, common 'black' community separated from Western influence. Gilroy pits the *transnational* quality of black history and experience against those ideas of a community grounded in mistaken assumptions and concepts of purity and cultural essentialism. National borders are porous, and ideas move and change. Forms of culture circulate within the black diasporas. Expanding on DuBois's crucial notion of 'double consciousness', Gilroy argues for a modernity broad enough in scope not simply to include the marginal positions of slaves, but to put the 'ungenteel' aspects of slavery and terror as crucial to understanding them at the heart of modernity itself: 'A preoccupation with the striking doubleness that results from this unique position—in an expanded West but not completely of it—is a definitive characteristic of the intellectual history of the black atlantic.'[38]

While we should acknowledge such *transnational* spaces, at the same time we should not ignore that these writers were also intent on examining the emergence of 'modern' spaces and their occupants *within* their own cultures and nations. The city, the prostitute, the neocolonial bourgeois bureaucrat, the military dictator, the pressures placed by modernization upon the traditional spaces of the village and family compound, the clash of Christian values and traditional beliefs, the gradual erosion of rigorously defined traditional gendered spaces, and the interface of Western medical practices and those of the tribal doctors—are figures and instances of this cultural clash. Spatial metaphors are also frequently used as an expression of epistemological challenges and ontological changes: for example, the 'been-to'

[37] Paul Gilroy, *The Black Atlantic: Modernity and Double Consciousness* (London: Verso, 1993), 19.
[38] Ibid. 58.

character, who returns from a Western country to his or her home in Africa, with all the attendant cultural and domestic disruptions and conflicts (for example, Achebe's *African Trilogy*, Kole Omotoso's *The Edifice*, Soyinka's *The Interpreters*); or the journey that is figured as an allegory of social development, from village to city (for example, Ngugi's *Petals of Blood*), or as a fantasy of social consciousness (for example, Amos Tutuola's *The Palm-Wine Drinkard* or Ben Okri's *The Famished Road*).

Hence, modernism and modernity opened spaces of resistance for a great variety of Africans. One group that was particularly affected by modernity was women. The challenges and seductions of modernity, especially with regard to educational opportunities, economic independence, professional employment, and socially respectable social roles other than motherhood, were particularly appealing. Among other impacts, modernity acted as a set of European social values that were transported to existing gender relations in Africa, upsetting hitherto traditional (often patriarchal) values and causing psychological, emotional, physical, and social contradictions to emerge. These domestic and familial conflicts can be seen in novels by women like Grace Ogot, Tsitsi Dangarembga, Mariama Bâ, Flora Nwapa, Ama Ata Aidoo, and Bessie Head. Add to this the issues of monogamy versus polygamy and Islamic beliefs versus Christian values, and the complexity of the modern space for African women becomes clearly evident as shifting ideologies clash with inert forces. The encroachment of modernity on Africa caused systems that sought to perpetuate ahistorical and apolitical myths of universal women's experiences in Africa to be confronted with diverse meanings that reside in different combinations of time and space, the twin features of historical and geographical arrangement that contribute to the complex realities of diasporic women. Yet while African women's writing does not exclude the need to liberate African peoples from neocolonialism and other forms of race and class oppression, there is the recognition that a feminist consciousness is necessary in examining the position of women in African societies.

Yet African women writers do not all unite under a common feminist banner. Indeed, they do not all necessarily desire the same changes. Some defend traditional securities. Often they show their female protagonists as torn, confused in a milieu of cross-cultural conflict. Some of the principal features of many African women's writing are the tragic alienation caused by the desire for Europeanization, the persistent debilitating effects of constructing images of the African mother as Mother Africa, as well as the ways in which the images of African women as concubine, prostitute, supermother, wife, mother-earth-as-muse, support or distort the creation of a female *mythos*. Despite representations of positive possibilities of transcendence for women in Ngugi wa Thiong'o's depiction of Waaringa in *The River Between* (1965), or Sembene Ousmane's portrayal of N'Deye Touti in *God's Bits of Wood* (1962), women for the most part are consistently marginalized and 'othered' in past and current debates about African writing. Women's utilization of memory and oral history to resist and challenge the identification of women with the 'petrified' cultural traditions of the past and the allocation to male characters or narrators of the role of regaining control over the historical development of their

societies, is one of the main strategies of much African women's writing. This traditional alignment of women with space and men with time effectively removes women's agency, eliminating their ability to prompt historical change to their political conditions. African women's writing demonstrates the need to think history and the past from the perspective of gender as well as from the perspective of race. Without seeking to write a complete history of the development of African women's writing here, I shall use various examples to demonstrate how that writing is part of a collective effort to redefine the roles and spaces of womanhood, valuing memory as a viable alternative to oppressive history. Contemporary African women writers especially have been interested in reappropriating the past so as to transform people's understanding of themselves in their contemporary space. Their voices echo the submerged or repressed values of their cultures as they rewrite the 'feminine' by showing how Western culture constructs, distorts, and encodes arbitrary images and values as inferior by feminizing them. In carrying this out, many African women's novels take the form of a first-person narrative of self-discovery, determined to make sense of their past and write themselves within and against the cultures that underpin that experience. This process of discovery becomes the source of rebirth and reconciliation, the mode of healing of the narrating self. The processes of recognizing different pasts and articulating these alternatives are highly political—they trace the path to social consciousness and a new cultural space.

If colonial modernism posed a traumatic disruption to African male novelists, then African women novelists have suffered a 'double whammy' of traumatic disruption in their cultural histories. Not only have they had to contend with the alienation and dispossessing effects of colonial modernism, but they have had to navigate and negotiate the frequently strenuous and rigorous exclusions and marginalizations posed by a deeply entrenched structure of patriarchal power. As many African women's novels demonstrate, this 'double yoke' of oppression has taken some considerable effort to articulate, not least because in their eagerness to throw off colonialism and champion native culture, many influential male writers have, unwittingly or not, reinforced well-worn images and stereotypes of African womanhood. The consequence of this is that African women writers have had to contend not only with resisting the white colonists' negative portrayals of 'Africanness' (perpetuated later by some acquiescent white feminism[39]), but also with unpicking the complex mixture of African males' representations of *femaleness*. This has oscillated between negative denigrations of women and a celebration and idolization of African femaleness, which disguises a deeper-seated traditionalism and, in some cases, conservative fear of femininity. Omolara Ogundipe-Leslie has pointed out that the various stereotypes of African women in literature are those of being the 'mother'

[39] Barbara Bush, 'History, Memory, Myth? Reconstructing the History (or Histories) of Black Women in the African Diaspora', in Stephanie Newell (ed.), *Images of African and Caribbean Women: Migration, Displacement, Diaspora*, Occasional Paper No. 4 (Stirling: University of Stirling, Centre of Commonwealth Studies, 1996), 5.

and the 'houri', or the rural woman and the sophisticated city woman.[40] Perhaps the most famous character is Cyprian Ekwensi's portrayal of Jagua Nana in *Jagua Nana* (1961) and *Burning Grass* (1962), a charming, colourful, and impressive prostitute who moves through a whole panoply of vibrant, amoral characters who have rejected their rural origins and adopted the opportunistic, pleasure-seeking urban lifestyle of Lagos. Other portrayals of women as prostitutes include the figure of Kechi Ugboma in Eddie Iroh's *Toads of War* (1979) and abundant other examples in African literature, especially in the more sensationalist fiction. This eroticization of the African woman, Ogundipe-Leslie maintains, demonstrates 'that many male writers conceive of women only as phallic receptacles' and that the myth of the naive rural woman is necessary 'to buoy-up [the African male's] conservatism and his yearning for that pre-colonial and patriarchal past where he was definitely king as father, husband and ruler'.[41]

Again and again, critics have pointed to the way in which modernism invades, dehistoricizes, and despatializes. Yet repeatedly, those African texts marked out as 'modernist' or engaging with modernism in open and oblique ways do not abandon history or geography: if anything, they intensify the issue of memory, history, and geography, inserting politics into the very heart of their aesthetic styles and ideological concerns. These modern post-colonial fictions bring about an encounter between the dominant symbolic order and that which threatens its stability. Indeed, one might turn this perspective around. Instead of arguing that one has Western history and geography forming, influencing, or affecting African literature and forms, rather one could see it as African literature and forms shaping Western forms of history and spatial awareness. In other words, one might regard the case not as another example of the active West working on a passive Africa, but as an active Africa using its initiatives, its agency, its activity, to work on the shapes, structures, and orders of Western time and space. But more than this, it is finally a rejection of that history and spatialization: since to see it as a working on Western concepts of history and space suggests that those models of history and space are what is kept and remain important. Rather, African literature is engaged in establishing its own history, its own spaces, its own models, its own structures. Ultimately, that agency puts in place its own structures rather than simply responding to Western givens. As it developed, African modernism was always wary of the path of European modernism. It was not an aesthetic born out of distrust of a bourgeois art form or cultural values, aiming to tear down existing values. Rather, African modernism was motivated by a quest for freedom and power. In this respect, African modernism was not seeking an annihilation of expressive forms but was rather a kind of paradoxical destructive restructuration that rearranged the field of understanding or possibility. African modernism set out to redeem, not deny, the promissory notes of historical subjectivity. Unlike European modernism, in which diverse strands converged in hurling agency

[40] Omalara Ogundipe-Leslie, 'The Female Writer and Her Commitment', in Eldred Jones, Eustace Palmer, and Marjorie Jones (eds), *Women in African Literature Today* (London: James Currey; Trenton, NJ: Africa World Press, 1987), 6.

[41] Ibid. 6, 8.

into a 'crisis' that menaced the individual will and fractured communities, African modernism sought a freedom that dwells within, not beyond, collective resources of memory and desire.

Current criticism, therefore, urges a reconsideration of the positionality of modernism—the emplacement of modernity—which 'requires a rethinking of periodization, genealogies, affiliations and forms', and a new self-consciousness about positionality, where 'positionality is onto-social as well as geographical, entailing a sense of situated and disrupted social presence'.[42] Yet we should not rest complacently on this depiction of a revitalized and dynamic agency in African modernism, since this is itself predicated upon false dichotomies. Jolting critical reflection out of comfortable compartmentalizations of monolithic cultural spaces is just what Nicholas Brown seeks to do in *Utopian Generations*. Reminding readers of Neil Lazarus's critical interrogation of the mystification and fetishization of 'the West' and 'Third World',[43] Brown's reconceptualization of African modernism through a rigorous Marxian narrative of uneven development breaks apart the dichotomy of 'Western literatures' and 'non-Western literatures': 'If world literature does not spring spontaneously from a host of freely developing cultural equals but rather represents the exploitation of geographic and cultural diversity by a limited number of economic and cultural forms, we might ask to what extent "non-Western literature" is a contradiction in terms.'[44] Apart from acting as a heuristic device for describing the Manichaean superstructures of classical imperialism, Brown regards such terminology as outmoded and lacking explanatory power. Rather, he seeks a critical framework that undermines the fetishized bifurcation of modernism as the product of 'Western culture' and of African literature as 'non-Western'. As Brown sets up pairings of African and European writers, both these fetishized concepts are subjected to 'the always encroaching movement of capital and connection between this movement and colonialism, world war, and the containment of socialism'.[45] Brown's antidote is the development of a powerful interpretative framework which seeks to reconstellate modernism and African literature. Since African literature has commonly been seen as representationally naive vis-à-vis modernism, and canonical modernism has in turn been regarded as reactionary vis-à-vis post-colonial literature, Brown has argued that what brings these two bodies of literature together is their disposition towards utopia, or the horizon of a radical reconfiguration of social relations. Brown's forceful cautionary work insists on the continual opening of the context of modernist discourses into broader dialectical historical contexts rather than focusing narrowly upon 'Western' and 'non-Western' modernisms. The relationship between African and European modernisms continues to tremble and quiver in the grip of contradictions.

[42] Doyle and Winkiel, 'Introduction', in Doyle and Winkiel (eds), *Geomodernisms*, 3.

[43] See Neil Lazarus, 'The Fetish of "the West" in Postcolonial Studies', in Crystal Bartolovich and Neil Lazarus (eds), *Marxism, Modernity and Postcolonial Studies* (Cambridge: Cambridge University Press, 2002), 43–64.

[44] Brown, *Utopian Generations*, 6. [45] Ibid. 3.

CHAPTER 52

..

MODERNISMS IN INDIA

..

SUPRIYA CHAUDHURI

THE distinctions between modernity, modernization, and modernism are particularly complicated in the case of India, but remain crucial to a historical understanding of the 'modern' in all its senses. Modernity, as a social and intellectual project, and modernization, as its means, are associated with the influence in India of Europe and of Enlightenment rationality from the eighteenth century onwards. Modernism, as an aesthetic, is far more limited in period and scope. Nevertheless, just as recent cultural criticism has proposed the existence of 'alternative modernities'[1] not native to the West, so too our attention has been drawn to 'alternative modernisms', or 'modernisms at large'.[2] The question of periodicity, as of location, is complicated by the historical fact that modernism as an aesthetic was simultaneously restricted and elitist, and international and democratic. In India, moreover, the impact of the style of European modernism was intensified by the belief that its internationalism suited the experience of modernity and would further the modernization of public spaces and cultural life. A politics of modernism, setting this perception against a counter-argument that saw modernism as an essentially Western mode opposed both to tradition and to national or local experience, emerges in the early twentieth century.

[1] See Dilip Gaonkar, 'On Alternative Modernities', *Public Culture*, 11 (1999), 1–18.

[2] See Andreas Huyssen, 'Geographies of Modernism in a Globalizing World', in Peter Brooker and Andrew Thacker (eds), *Geographies of Modernism: Literatures, Cultures, Spaces* (London: Routledge, 2005), 6–18, esp. 11–12. The reference is to Arjun Appadurai, *Modernity at Large: Cultural Dimensions of Globalization* (Minneapolis: University of Minnesota Press, 1996).

Raymond Williams's phrase 'the politics of modernism' may remind us of another problem that he posed and left to some extent unanswered: 'When was modernism?'[3] This is a question that has been asked with particular urgency by Indian cultural critics such as Geeta Kapur, and, interestingly, Kapur's answer appears to involve a sense of the modern as a state of freedom: that is, as a set of social and historical conditions. Indeed Kapur argues that 'The characteristic feature of Indian modernism, as perhaps of many postcolonial modernisms, is that it is manifestly social and historical'—rather than being posited, as in the West, as 'a hypostasis of the new'.[4] Whether or not one agrees with Kapur's description of Indian modernism, Homi Bhabha's notion of the 'time-lagged colonial moment'[5] within modernity might serve to furnish the argument that modernism too was a late phenomenon in India. In fact, however, this is not the case. Both in respect of the influence of European modernist ideas, and in the development of indigenous modernisms, India offers striking evidence of the emergence of a new aesthetic in the first decades of the twentieth century. Partly this is because of the cultural work carried out by a highly educated bourgeoisie responsive to the latest international developments; but more importantly, it is rooted in political and social circumstances, in the disputes over a 'national' style, and in the struggle to find an authentic modern identity. As Partha Mitter urges in his account of the 'triumph of modernism' in Indian art, the study of influence, so integral to the discipline of art history, is not finally useful in understanding the complex mechanics of this process.[6] It is true that, by the end of the nineteenth century, the growth of a cosmopolitan culture, distributed over great urban centres located all across the globe (a 'virtual cosmopolis', in Mitter's phrase[7]), is conducive to the transmission of ideas: but at the same time the pressure of historical circumstances and political imperatives, as well the creative energy of the local, tends to disrupt and reconfigure patterns of 'reception'.

ART

On 7 May 1921 the Indian poet Rabindranath Tagore celebrated his sixtieth birthday in Weimar, and used the opportunity to visit the Bauhaus, where he found the

[3] Raymond Williams, 'When Was Modernism?', *New Left Review*, 1/175 (May–June 1989), 48–52, reconstructed from a lecture Williams delivered at the University of Bristol in 1987; repr. in Raymond Williams, *The Politics of Modernism: Against the New Conformists*, ed. Tony Pinkney (London: Verso, 1989).

[4] Geeta Kapur, *When Was Modernism? Essays on Contemporary Cultural Practice in India* (New Delhi: Tulika Books, 2000), 298.

[5] Homi Bhabha, *The Location of Culture* (London: Routledge, 1994), 250.

[6] Partha Mitter, *The Triumph of Modernism: India's Artists and the Avant-Garde, 1922–1947* (London: Reaktion Books, 2007), 7–8. I am indebted to Mitter's account for what follows.

[7] Ibid. 11.

teaching practices of Walter Gropius, Johannes Itten, and Georg Muche akin to his own radical educational experiments at Vishva Bharati, the university he had founded at Shantiniketan in Bengal. Two years previously, he had appointed Stella Kramrisch to teach art history there; now, at Tagore's suggestion, a selection of Bauhaus works was shipped to Calcutta to be exhibited, in December 1922, at the fourteenth annual exhibition of the Society of Oriental Art, patronized by the Tagores. Among the exhibits (which mysteriously never returned to Europe) were two watercolours by Wassily Kandinsky and nine by Paul Klee, as well as works by Johannes Itten, Georg Muche, Lyonel Feininger, Gerhardt Marcks, Lothar Schreyer, Sophie Körner, and Margit Tery-Adler, a single painting by the Vorticist Wyndham Lewis, and reproductions of contemporary art from Europe. The exhibition was well received, but, as Mitter shows, what was perhaps even more important about it was that a number of Cubist paintings by Rabindranath's nephew Gaganendranath Tagore and folk-primitivist works by his niece Sunayani Devi were also shown on this occasion. In earlier decades the example and influence of the Tagores, particularly of Rabindranath's other nephew Abanindranath, had been linked to the Orientalism of the Bengal School of art, which drew upon Mughal and Rajput miniatures and Japanese brush-and-ink techniques to create an anti-colonial, 'pan-Asian' style of narrative painting welcomed by bourgeois nationalists. By 1922, however, Rabindranath himself appears to have moved away from the Orientalism of the Bengal School, and to be seeking a new direction for his art school at Shantiniketan. Even before the December exhibition, the sociologist Benoy Sarkar, exposed to modernist art in Berlin and Paris, had initiated a heated dispute in the Orientalist journal *Rupam* by urging India's artists to adopt the international avant-garde's 'aesthetics of autonomy' in accordance with their quest for political autonomy.[8] In fact much of the cultural debate is carried out in journals such as *Rupam, Modern Review, Prabasi*, and *Bharati*. Sarkar and Kramrisch wrote approvingly of Gaganendranath's Cubist fantasies, and Kramrisch's careful critical evaluation of Sunayani's work is still relevant.[9]

If we admit the happy coincidence of 'the modernist moment' with the year 1922, in India as in Europe, it must be noted that it is not the influence of the Bauhaus, but the experiments of Gaganendranath and Sunayani, that initiate a modernist idiom.[10] Gaganendranath's Cubism, harshly dismissed as trivial by the colonial British critic W. G. Archer,[11] must be seen as a radical liberation of narrative art from naturalistic representation, substituting a dynamic, fluid, mysterious play of light and shade and colour for the relatively static geometry of Analytical Cubism. The titles of his works

[8] See Benoy Sarkar, 'The Aesthetics of Young India', *Rupam*, 9 (Jan. 1922), 8–24, and 'Agastya' [O. C. Gangoly], 'Aesthetics of Young India: A Rejoinder', *Rupam*, 9 (Jan. 1922), 24–7; cited in Mitter, *The Triumph of Modernism*, 16.

[9] Stella Kramrisch, 'Sunayani Devi', *Der Cicerone, Halbmonatsschrift für Künstler, Kunstfreude und Sammler*, 17/1 (1925), 87–93; cited in Mitter, *The Triumph of Modernism*, 43.

[10] Mitter, *The Triumph of Modernism*, 231 n. 40, notes the influence of Roger Fry, Clive Bell, and Herbert Read in the constitution of an aestheticist discourse.

[11] W. G. Archer, *India and Modern Art* (London: Macmillan, 1959), 43.

(*The Poet on the Island of the Birds, The House of Mystery, Aladdin and His Lamp, The City of Dvaraka, The Seven Brothers Champa*) suggest an imagination steeped in literature and myth, and his experiments with reflected and broken light create a haunting, fantastic world beyond naturalism, even leading towards Expressionism, as the avant-garde critic Max Osborn suggested in reviewing one of his paintings at an exhibition of modern Indian art in Berlin in 1923.[12] But his Cubism had no immediate following, while his sister Sunayani's adoption of subjects and styles from folk art appears to have been the first step in the constitution of an Indian primitivism.

Mitter associates the emergence of primitivism in Indian art with a number of social and political phenomena: 'the transformation of elite nationalism into a popular movement led by Mahatma Gandhi', the move towards ruralism and environmentalism in the social philosophies of both Gandhi and Tagore, and the admiration of nationalists, including painters of the Bengal School, for the bold simplicity of folk painting, notably that of the Kalighat *patuas*, popular artists associated with the area around the Kali Temple in Calcutta.[13] There is a difference, however, between these responses to indigenous traditions and the excitement of Picasso, Matisse, or Brancusi over African sculpture, tribal masks, and other non-Western art. Twentieth-century artistic primitivism sought to interrogate both the academic Naturalism of the past and a materialist urban culture. While this might take the form of Cubist admiration for the radical visions of tribal art, Abstract Expressionists such as Malevich, Kandinsky, and Mondrian also drew upon Eastern spiritual traditions in going beyond representation (Malevich was deeply moved by the Indian religious reformer Swami Vivekananda's Chicago address in 1893). Disentangling the Orientalist strands in these elements of Western modernism is a difficult task, but they do not exactly coincide with the influences upon Indian artists in the 1920s and 1930s. As Geeta Kapur shows, the discourse of modernism in Indian art is marked by a constant dialectic of the national and the modern; the well-documented 'turn' towards folk art, the representation of village life, and the environmental primitivism of the period are collectively a form of nationalism at odds, in some ways, with the internationalism of modernist aesthetics. At the same time, there are interesting congruities with modernisms elsewhere, and, among artists themselves, both an awareness of the European avant-garde and a sense of the need to resist, not just its implicitly imperialist cultural norms, but also the totalizing ideology of bourgeois nationalism. This might sometimes be achieved by a recourse to formalism, while at other times the value of local 'tradition' might be asserted. Kapur argues, therefore, that

modernism has no firm canonical position in India. It has a paradoxical value involving a continual double-take. Sometimes it serves to make indigenist issues and motifs progressive;

[12] Max Osborn, 'The Indian Exhibition in Berlin', *Rupam*, 15–16 (July–Dec. 1923), 74–8, esp. p. 77; cited in Mitter, *The Triumph of Modernism*, 27.

[13] Mitter, *The Triumph of Modernism*, 29–32.

sometimes it seems to subvert ... tradition. Thus paradoxically placed, modernism in India does not invite the same kind of periodization as in the west.'[14]

This is a valuable reminder, but it is worth recording some features of a temporal history. Sunayani Devi's use of folk motifs and styles arises partly from her exposure to them as a woman in the inner quarters of the family house, though she absorbed an eclectic mix of influences, from Ravi Varma to the Bengal School. At the same time, she reproduces the aristocratic–folk paradigm of her uncle Rabindranath Tagore's experiments at Shantiniketan. But her distinctive personal vision influenced the work of Jamini Roy, the most notable painter in the next decades to use the folk idiom for modernist expression. Roy's primitivism involved a deliberate formal simplification, accomplished by an extraordinary mastery of line. Drawing on the Kalighat *pat* style (a distinctively urban adaptation of the narrative scroll-painting of rural Bengal) and on the folk art of the Bankura region, Roy rooted his art in local artisanal practice, making many copies, selling his work cheaply, and deliberately rejecting the aura of the individual artist in favour of collective labour in his workshop. From his first exhibition in 1931 (inaugurated by Stella Kramrisch) to the height of his reputation in the 1940s, Roy was recognized as a modern master, idolized by the literary avant-garde including the modernist poets Bishnu Dey and Sudhindranath Datta, and admired by many Europeans, who saw his work as combining elements of Byzantine religious symbolism with Expressionist aesthetics. Mitter speaks of the ruthless elimination of detail that enables him to achieve 'a remarkable modernist brevity', but notes also that this is not a pure formalism;[15] it is an art that criticizes colonial urban culture through a radical valorization of the local and the communitarian.

Rabindranath Tagore's art school at Shantiniketan, presided over by Nandalal Bose, also generated a new aesthetic discourse rooted in the community. Bose had been associated with Abanindranath Tagore at the Indian Society of Oriental Art, had made copies of the Ajanta frescoes, and had been deeply influenced by the Japanese scholar and aesthetician Okakura Kakuzo. But at Shantiniketan he fostered a more eclectic practice, drawing upon folk styles and rejecting the miniaturization of the Bengal School in favour of bold brush-strokes and outdoor murals. Asked by Mahatma Gandhi to provide the wall panels for the Haripura Congress in 1938, he created a series of vigorous village scenes in contrast to the more decorative mytho- logical pieces later executed for the Kirti Mandir of the Gaekwad royal family in Baroda. To his pupils, notably the painter Benodebehari Mukhopadhyay and the sculptor Ramkinkar Baij, he communicated a strong formal clarity that became the ground of their modernist experiments, especially in representing the lives of the local tribal people, the Santals. Benodebehari, who lost his sight in middle age (he was the subject of a documentary film, *The Inner Eye*, made by his pupil the director Satyajit Ray), combined clear modernist influences (notably Cubism, which he

[14] Kapur, *When Was Modernism?*, 292.
[15] Mitter, *The Triumph of Modernism*, 122.

appears to have used to solve spatial problems) with indigenous traditions and Japanese wash techniques. K. G. Subramanyan, who trained under Nandalal Bose and later taught at Baroda and at Vishvabharati, developed a witty, expressive, figurative style. Ramkinkar Baij, probably the most extraordinary genius fostered at Shantiniketan, came from a humble family with little formal education, but was from the start drawn to avant-garde aesthetics, producing heroic outdoor sculptures of Santal subjects in 'rough' materials like cement, rubble, and concrete, recalling the expressive surfaces of Rodin and Epstein. These sculptures, like many of the murals produced at Shantiniketan, have not lasted well, but provide a remarkable index of subaltern modernism at work, contrasted to the naturalist Expressionism of his contemporary Deviprasad Roy Chowdhury, and influencing the powerfully expressive metalwork of Meera Mukherjee, using the tribal (Bastar) lost-wax process.

Rabindranath Tagore himself, however, was a late but radical innovator. Tagore had received painting lessons in his youth, but his modernist art appears to have originated in his sixties, and to have emerged from doodles in the manuscripts of his poems, connecting crossed-out words and lines to produce startling, masklike images that gradually dominate the text. On 2 May 1930 his Argentinian friend Victoria Ocampo organized an exhibition of his works at the avant-garde Galerie du Théâtre Pigalle in Paris. Mitter speculates on the influence of Jugendstil graphics, Art Nouveau, tribal masks, and totemic objects on Tagore's art, but sees it finally as an expression of 'the dark landscape of the psyche'.[16] Certainly the images he produces have a surreal, brooding, Expressionist intensity that does not readily yield to explanation, providing the dark obverse to the poetic idealism with which he is conventionally associated. Between 1928 and his death in 1941 he produced some 2,000 paintings, as if choosing a final form of self-expression, though his last poems are also modernist in theme and style. His interest in the unconscious appears to have developed in the 1920s (he met Freud in Vienna in 1926), but much earlier, in 1894, he had already referred to a stream of consciousness (since Tagore is writing in Bengali, it is not clear whether he has read William James's *Principles of Psychology* (1890), where the phrase first appears in English). Discussing children's rhymes, he associates their images with dreams:

In the normal way, echoes and reflections of the universe revolve in our minds in a scattered, disjointed manner. They take on various appearances and shift suddenly from one context to another. As in the atmosphere, roadside dust, flower-pollen, countless smells, assorted sounds, fallen leaves, water droplets, the vapours of the earth—all the ejected, whirling fragments of this turning, agitated universe—float and roam meaninglessly, so is it in our minds. There too, in *the ceaseless stream of our consciousness*, so many colours, scents and sounds; so many vapours of the imagination, traces of thoughts, broken fragments of language—hundreds of fallen, forgotten, discarded components of our practical life—float about, unobserved and purposeless... In one's normal state, sounds and shadows travel across one's mind's sky like dreams... If they could leave an impress of their reflections on

[16] Ibid. 71.

some canvas of the unconscious mind, we would find many resemblances to the rhymes we are discussing.[17]

In his doodles, drawings, and paintings, Tagore appears to reject the 'authoritarian' domination of the mind over the matter of thought, allowing expression to the dreamlike, or nightmarish, 'shadowy mirages' otherwise lost to consciousness. Whatever the final quality of his work, produced compulsively, without much formal training, it is uncompromisingly modernist in style, involving a total rejection of the aestheticism of the Bengal School and contemporary academic naturalism.

Away from Bengal, however, another cosmopolitan modernism was brought into being by the Indo-Hungarian painter Amrita Sher-Gil, trained in Paris but choosing a professional career in India. Sher-Gil's decision to return to India and to paint images of rural life, especially village women, appears to have been based on a near-epiphanic sense of the 'infinite submission and patience' of her subjects, in whom she located the true spirit of India.[18] Her primitivism uses the languages of neo-Impressionism and the Post-Impressionism of Gauguin, and owes very little to indigenous traditions, though she admired Basohli painting. But it creates an Indian modernism far in advance of its time, whose legacy is only now being understood (though it should be said that her art had many admirers during her life, including Jawaharlal Nehru). Her beauty, genius, sexual liaisons, unconventional behaviour, traumatic personal history, and tragic death at the age of 28 have made her life itself an object of iconic fascination (commemorated, for example, in film, photomontage, and installation art by her nephew the artist Vivan Sundaram). Geeta Kapur compares her to the Mexican artist Frida Kahlo, in respect of both the life and of the work, and the conversion of the one into the other.[19] The profound melancholy of her paintings, and their use of colour and line, do not abandon representation, but direct it towards the expression of an abstract aesthetic emotion.

Modernism is self-consciously professed only in the 1940s, by a number of artists' groups: the Calcutta Group (formed in the shadow of the 1943 famine), the Progressive Painters' Association of Madras (1944), the Progressive Artists' Group of Bombay (1947), the Delhi Shilpi Chakra (1949), and the Triveni Kala Sangam (1951). Many of the artists were Marxists, and had links with the communist Indian People's Theatre Association and with 'progressive' writers; several trained in Paris (though Satish Gujral went to Mexico). Prominent in the Calcutta Group were the sculptor Prodosh Das Gupta and the painters Paritosh Sen, Nirode Mazumdar, Sunil Madhav Sen, Gopal Ghosh, Gobardhan Ash, Chittaprasad Bhattacharya, Zainul Abedin, and Somnath Hore. The last three, as communists, produced a socially

[17] From 'Children's Rhymes' (first pub. as 'Women's Rhymes', in *Sadhana* (Ashwin–Kartik 1301; Sept.–Nov. 1894), in Rabindranath Tagore, *Selected Writings on Literature and Language*, ed. and trans. S. Chaudhuri et al. (Delhi: Oxford University Press, 2001), 103–4; my emphasis.

[18] See Amrita Sher-Gil, 'The Story of My Life', *The Usha*, 3/2, special issue (Aug. 1942), 96; cited in Mitter, *The Triumph of Modernism*, 55. For other material on Sher-Gil, see Vivan Sundaram et al., *Amrita Sher-Gil* (Bombay: Marg, 1972).

[19] Kapur, *When Was Modernism?*, 3–22, *passim*.

committed, progressive art of the people, especially through images of the famine, and, in the case of Hore, woodcuts, sculptures, and sketches of the Tebhaga land movement. The Calcutta Group held a joint exhibition with the Bombay Progressives in 1950, but was gradually eclipsed by the latter, which included Maqbool Fida Husain (who began as a painter of Bombay film posters), Francis Newton Souza, K. H. Ara, S. K. Bakre, H. K. Gade, and S. H. Raza, later joined by V. S. Gaitonde and Krishen Khanna. Influential in their development were three refugees from Hitler's Germany, the critics Walter Langhammer and Rudy van Leyden, and the collector Emmanuel Schlesinger. Unfortunately, the group broke up, and many artists (though not Husain) went abroad. Akbar Padamsee and Jehangir Sabavala of Bombay, Ram Kumar of the Delhi Shilpi Chakra, and Nirode Mazumdar and Paritosh Sen of the Calcutta Group trained under the Cubist André Lhote in Paris; Souza went to London, as did Tyeb Mehta.

Husain and Souza are possibly the most celebrated and flamboyant of Indian modernists, ceaselessly disrupting the tendency of the national to absorb and 'contain' the modern. Husain's exploration of popular and religious icons has drawn the wrath of fundamentalists, yet his art is deeply tied in with the self-understanding of the nation. Souza chose metropolitan exile and aesthetic autonomy, continuing in an Expressionist style. Sabavala continued in Synthetic Cubism; Raza, Nirode Mazumdar, and K. C. S. Paniker were drawn to Tantric geometry, and V. S. Gaitonde to minimalist abstraction. But perhaps the purest minimalism is to be seen in the much later work of Nasreen Mohamedi, only one of a number of exceptional women artists of the 1970s and 1980s, including Anjolie Ela Menon, Arpita Singh, Arpana Caur, and Nalini Malani. It is in this context that Kapur seeks to interrogate the formal regimes of modernism in India, drawing our attention to the impossibility of neat periodization and to 'the fraught social identity' of the Indian artist in the 'conceptually open, half-empty space of modernity'.[20]

ARCHITECTURE

In architecture, even more than in art, questions of modernity and modernization are intimately linked with modernist aesthetics, no doubt because modification of the built environment can scarcely be treated as a problem of style alone. In the early twentieth century, the 'classicism' of British imperial architecture was contested by a variety of other styles: the revivalist Indo-Saracenic; the primitivist-folk adopted by leaders like Tagore and Gandhi; a revivalist school calling itself the Modern Indian Architecture Movement; the incipient modernism of art deco and its adaptation as Indo-Deco; and international modernism. These developments could scarcely have

[20] Ibid. 370–3.

come about without the growth of the architectural and engineering professions, and the work of individuals and private firms as well as state public works departments.

The most celebrated expression of imperial power, using a modified classical style, is to be seen in the City Beautiful plan of New Delhi conceived in 1914 by Sir Edwin Landseer Lutyens. Lutyens fell out with his co-architect Sir Herbert Baker, and others shared in the planning, but Lutyens's Delhi remains one of the major architectural (and imperial) statements of the twentieth century. It is one point in a trajectory that has, at its other end, Prime Minister Jawaharlal Nehru's post-Independence choice of Le Corbusier (Charles-Édouard Jeanneret-Gris) to build the modernist city of Chandigarh in the 1950s. Justifying his choice at a seminar on architecture in Delhi in 1959, Nehru said:

> It is the biggest example in India of experimental architecture... You may squirm at the impact, but it makes you imbibe new ideas... what I like above all this is the creative approach—not being tied down to what has been done by our forefathers and the like, but thinking out in new terms; trying to think in terms of light and air, and ground and water and human beings, not in terms of rules and regulations laid down by our ancestors. Therefore Chandigarh is of enormous importance, regardless of whether something succeeds or does not... It is a thing of power coming out of a powerful mind, not a flat mind or a mind which is a mirror, and that too not a very clear mirror reflecting somebody else's mind. There is no doubt that Le Corbusier is a man with a powerful creative type of mind.[21]

Nevertheless, it would be a gross simplification to see the history of decolonization as a simple movement from Lutyens to Le Corbusier. Much intervened between the two, including other forms of modernism. In respect of urban planning and reconstruction, moreover, City Beautiful ideals, garden city concepts, or ruthless modernist notions of 'a place for everything and everything in its place' were equally out of harmony with the traditional mixed-use layout of Indian cities, as Henry Vaughan Lanchester found in Madras. The most thoughtful responses to this problem in terms of urban design were those of the British sociologist and urban planner Patrick Geddes, who had met Swami Vivekananda in 1900 and later grew close to Tagore. Geddes visited India a number of times between 1914 and 1928, spending nearly ten years in the country, and producing numerous studies that advocated an empiricist approach to town planning, retaining mixed-use areas.

Surendranath Kar, a cousin of Nandalal Bose, designed five houses for Tagore in Shantiniketan which drew variously upon pan-Asian (primarily Japanese), traditional Indian, and primitivist-folk sources of inspiration. Tagore's philosophical influence is everywhere evident, and colonial architecture is rejected for a local and nationalist aesthetics, especially in the mud house called Shyamali. Mahatma Gandhi's ashram at Sabarmati near Ahmedabad and the Sevagram at Wardha, built in the 1920s and 1930s, also employed simple local materials (in the 'sustainable environments' spirit) to create an ascetic, rural atmosphere. Gandhi's belief in 'the

[21] Jawaharlal Nehru, Inaugural Address, in *Seminar on Architecture* (Delhi: Lalit Kala Akademi, 1959), 8; cited in Jon Lang, Madhavi Desai, and Miki Desai, *Architecture and Independence: The Search for Identity—India 1880 to 1980* (Delhi: Oxford University Press, 1997), app. 3, p. 311.

frugality of means to achieve ends'[22] might evoke the functionality of Bauhaus design, which certainly left its mark on Tagore. Gandhi's influence extends to the modernist architect Charles Correa's design for the Gandhi Smarak Sangrahalaya (1958–63) near the Sabarmati Ashram: an understated open-grid structure with pyramidal roofs showing Le Corbusier's influence, but in a vernacular idiom.

But the more visible struggle over India's architectural destiny was being fought between the revivalist and nationalist Modern Indian Architecture Movement, led by Sris Chandra Chatterjee, and a somewhat more eclectic group of modernists. In 1913 E. B. Havell and A. K. Coomaraswamy, together with George Bernard Shaw, Alfred Austin, and others, had appealed unsuccessfully to the Secretary of State for India, the Marquess of Crewe, to allow Indian craftsmen a share in the design of New Delhi. The Modern Indian Architecture Movement sought to incorporate traditional Indian motifs in the new architecture of the time, as, for example, in the nationalist Banaras Hindu University, founded in 1916. Sris Chandra Chatterjee was particularly hostile to art deco, which emerged in the 1930s and 1940s as a fashionable new style imported from Europe.

The most dramatic art deco buildings in India are cinema houses, palaces of pleasure for the new bourgeoisie as well as for a growing population of urban workers: the Roxy, Metro, and Elite in Calcutta; the Eros, Metro, and Regal in Bombay; the Mayfair in Lucknow; and several others. A large number of art deco homes and apartment blocks were built in Bombay in the 1930s for wealthy traders and property developers, and the New India Assurance Building (1935) is a good example of the strengths of the style. Lanchester built an Indo-Deco palace (1927–44) for Maharajah Umaid Singh in Jodhpur, and Walter Burley Griffin and Marion Mahony Griffin, who had collaborated with Frank Lloyd Wright in Chicago, produced several Indo-Deco designs. Griffin, a theosophist who sympathized with Indian nationalism, felt that international modernism needed to be modified to suit India, and submitted a number of innovative designs which were unfortunately not executed in full. He died in Lucknow in 1937.

Modernism in the 1930s is largely imported, with some notable Indian exceptions such as Atmaram Gajjar and G. B. Mhatre. The 'International Style', launched in New York through an exhibition at the Museum of Modern Art in 1932 (and so named in the exhibition catalogue by H.-R. Hitchcock and Philip Johnson) celebrated the global reach of modernism, which was architecturally expressed through volume, balance, and the stripping away of ornament. By the 1930s, modernists employing the International Style such as Eckart Muthesius, Willem Marinus Dudok, Antonin Raymond, and Otto Koenigsberger were at work in India. Muthesius was engaged in 1930 to build the Manik Bagh Palace in Indore, an explicitly modernist structure with interiors furnished by E. J. Ruhlmann, Eileen Gray, Charlotte Perriand, and Le Corbusier himself. Dudok, who had absorbed the neoplasticism of De Stijl in the Netherlands, designed the Garden Theatre and Lighthouse Cinema in Calcutta.

[22] Lang et al., *Architecture and Independence*, 184.

Raymond had worked for Frank Lloyd Wright for eighteen years, and came to India from Japan to design, together with the woodcraftsman George Nakashima and François Sumner, a Czech disciple of Le Corbusier, the pure modernist Golconda building of the Aurobindo Ashram in Pondicherry. Otto Koenigsberger, a Jewish refugee from Hitler's Germany who trained under Bruno Taut, produced modernist buildings in Mysore and Bangalore, including the Dining Hall of the Indian Institute of Science.

Just before and after Independence (1947), however, modernism was adopted as the style of modernity in a conscious inflection of nationalism. Architecture, in the spirit of Le Corbusier's 'Architecture or Revolution',[23] was absorbed into the project of rebuilding the Indian identity: notably, of course, by Nehru, who was acquainted with the new generation of architects and supportive of modernist plans. With assistance from Matthew Nowicki and Indian engineers, Albert Mayer (whom Nehru knew personally) prepared a plan for the new city of Chandigarh in 1949–50. Otto Koenigsberger's contemporary design for another capital, Bhubaneswar, was not fully executed, but Chandigarh remains a monument to the spirit of modernism. Le Corbusier, his cousin Pierre Jeanneret, Jane Drew, and Maxwell Fry were among the team appointed to develop Mayer's plan. By this time Le Corbusier had moved away from his early, Gropius-inspired work to a more rugged, 'honest' style using exposed concrete (*béton brut*) and emphasizing geometric forms such as the cube, the cylinder, and the cone (the characteristic pilotis are also in evidence). Visually Chandigarh is an impressive departure from other Indian cities, exciting most Indians with the boldness and monumentality of its abstract forms and patterns, though displaying also the totalizing tendencies of international modernism. While the capital complex offered a liberating sense of space realized in reinforced concrete, Jeanneret, Drew, and Fry contributed exemplary brick masonry housing. Le Corbusier was invited to execute plans for a number of houses in Ahmedabad (the Millowners' Association Building, the Museum, and three residential houses, one of which was not built), providing important lessons to young Indian architects in innovative solutions to complex problems of design.

Le Corbusier is perhaps the architect who, in terms of both modernist statement and enduring influence, has left the deepest impact upon twentieth-century Indian architecture. Unfortunately, much of this impact was lost in unimaginative mimicry. But even before Le Corbusier's arrival, Indian architects were using a modernist vocabulary: G. B. Mhatre employed art deco, and a number of architects trained in Britain, Europe, or America brought international modernism home. Habib Rahman, who had worked for Gropius, designed the West Bengal New Secretariat Building (1944–54) in Calcutta under clear Bauhaus influence, as well as the Gandhi Ghat in Barrackpore (1948). Rahman is said to have submitted a pure Bauhaus boxlike design for the Rabindra Bhavan (1961) in New Delhi, but Nehru rejected it as 'nonsense' and Rahman's graceful modification, with some Indian features, is an

[23] The dictum was developed in Le Corbusier's contributions, in the 1920s, to the journal *L'Esprit Nouveau*, and adopted in his revolutionary *Vers une architecture* (1923).

important new statement.[24] Rahman designed other modernist buildings and memor-
ials in New Delhi, such as the General Post Office and the Mazar of Maulana Azad, as
did his successor in the Central Public Works Department, J. M. Benjamin, architect of
the Delhi High Court. Gropius also influenced the work of A. P. Kanvinde, who
designed the ATIRA building in Ahmedabad (inaugurated by Nehru in 1954) and the
Indian Institute of Technology in Kanpur (1959–65), introducing important features
widely copied elsewhere. Several other architects who trained abroad, such as Cyrus S.
H. Jhabvala, Bennett Pithavadian, Charles Correa, Hasmukh C. Patel, Ram Sharma,
and Piloo Mody, show elements of Gropius's influence, but often (like Pithavadian)
diverge from it. Others who trained with Frank Lloyd Wright, like Gautam and Gira
Sarabhai (who designed the National Institute of Design in Ahmedabad), use a gentler
empiricist vocabulary. The Sarabhais commissioned Frank Lloyd Wright to design the
Calico Mills Office in Ahmedabad: the design exists but was not executed. They were
instrumental in Louis I. Kahn's coming to Ahmedabad, where he designed the Indian
Institute of Management (1962–74); he also designed the National Assembly building
in Dhaka, now Bangladesh, and made preliminary plans for Gujarat's new capital,
Gandhinagar.[25] Other modernist influences, such as that of Oscar Niemeyer, can be
seen in the extraordinary Apsara Cinema building (1968), designed by Yahya Merchant,
in Bombay. Architecturally, northern India was more receptive to modernism than the
south.

Tracing the history of modern Indian architecture, Lang, Desai, and Desai argue
that 'If the first generation of Indian Modernists owed an intellectual and formal
debt to the Bauhaus, the second, highly productive between 1960 and 1980, owes
much to Le Corbusier.'[26] Le Corbusier's influence is evident in the Shri Ram Centre
(1966–9) in New Delhi, designed by Shiv Nath Prasad, and in the Institute of
Indology (1957–62), designed by Balkrishna V. Doshi, in Ahmedabad. The influence
of Wright and Kahn produced a more 'organic' modernist architecture sensitive to
local contexts. Richard Neutra's pupil Joseph Stein taught at the Bengal Engineer-
ing College before setting up a practice in Delhi, where he designed the India
International Centre (1959–62) and the Ford Foundation building (1969). A mod-
ernism adapted to context may be seen in M. M. Rana's Nehru Memorial Library
(1968–9) and Anant Raje's design for the Indian Statistical Institute in the same city,
as well as B. V. Doshi's plan for the Indian Institute of Management in Bangalore
(1963; based on the city of Fatehpur Sikri), and his School of Architecture (1967–8)
in Ahmedabad, and some work by Bernard Kohn. Indeed, Doshi, after training in
Bombay, worked under Le Corbusier in Chandigarh and Ahmedabad, and then
with Louis Kahn. He was co-director, with Bernard Kohn, of the School of Archi-
tecture at the Centre for Environmental Planning, Ahmedabad, founded in 1962.
He has since then established an international reputation, like Charles Correa, and

[24] See Lang et al., *Architecture and Independence*, 211.
[25] On Gandhinagar, see Ravi S. Kalia, *Gandhinagar: Building National Identity in Postcolonial India*
(Columbia: University of South Carolina Press, 2004).
[26] Lang et al., *Architecture and Independence*, 223.

both have evolved distinct styles based on their exploration of structure, materials, and volume.

Modernist architecture in India is identified with the Nehruvian period, which witnessed decisive foreign interventions as well as the emergence of a modern Indian idiom. Ideologically, it has been criticized for its universalist disdain for local conditions (heat, dust, damp, materials, and maintenance), its 'ugly' reinforced concrete fantasies, its neglect of the street, and its insensitive regulation of private and public spaces. The 'messy', mixed-use character of Indian built environments was never accommodated within the totalizing vision of modernist design, however democratic it might have been in intent. Looking back on his work in the late 1980s, Doshi said that while he had learnt from Le Corbusier to observe and react to climate, tradition, function, structure, economy, and landscape, the buildings he had designed now seemed to him unsuited to their contexts.[27] Modernism nevertheless produced some exceptional architectural statements in India. Architects like Doshi and Correa evolved by responding to environmental needs, anticipating later experiments (for example, by Laurie Baker) in a 'sustainable' vernacular conservation ethic.

LITERATURE

In their recourse to the verbal, literature and cinema may seem to articulate more clearly the ideological struggles within Indian modernism—most of all, the apparent lack of an avant-garde noted with irritation by Geeta Kapur.[28] If we accept Bürger's distinction between high modernism, which dehumanizes and dehistoricizes the aesthetic domain to overvalue the sign, and the avant-garde, which questions the institution of art itself, it is clear that the historical circumstances in which modernism was experienced in India made it more likely that the contestation would be at the level of material content, or the possibility of representation, rather than form per se. The emergence of the modern literatures of India, from the nineteenth century onwards, was itself deeply implicated in the constitution of the nation by its regions. Each of these literatures performs its own time-lagged transactions with modernity, in some cases engaging with the ideology of European modernism, in others producing its own formal solutions to the problems of disorder, violence, and mimetic lack. The break with the pre-modern, already experienced as a form of trauma by the colonial subject, and requiring the reconstitution of vernacular literary traditions, is compounded in the twentieth century by a new sense of the gap between urban and rural, literary and oral cultures, split further by caste and class divisions, and by

[27] See Doshi's statement in Mildred F. Schmertz (ed.), 'Balkrishna V. Doshi', in Ann Lee Morgan and Colin Naylor (eds), *Contemporary Architects* (Chicago: St James Press, 1987), 236.

[28] Kapur, *When Was Modernism?*, 288.

political ideologies. Modernism's obsession with the problem of the subject is one response to such traumas, but not the only one. Most modern Indian literatures have already experienced a 'progressive' phase when socialist realism is seen as the immediate solution to problems of both style and content in art. The harsh lessons of such realism may themselves point towards the subject's existentialist isolation and the inadequacy of representation: as John Frow points out, modernism simply expresses 'the internal contradictions of realism'.[29] In India, realism never loses its purpose, and modernism can never be experienced simply as a formalist alternative; it is tied in with the terror and violence that in Europe is claimed by the avant-garde, but is here made the property of the modern itself. Since India has at least twenty substantial literatures in the twentieth century, this discussion is principally confined to four: Bengali from the east, Hindi from the north, Marathi from the west, and Malayalam from the south.

Bengali literary modernism was experienced as a reaction to Tagore, though Tagore's influence (especially that of his late poetry) was inescapable. The moment of departure was marked by the foundation of a literary journal, *Kallol* ('The Surge'), in 1923. Since the nineteenth century, the arts in Bengal had been dominated by the culture of the literary journal, acting as a powerful vehicle for ideas transmitted from Europe as well as for indigenous critical thought. *Kallol*'s modernist and experimental outlook was later endorsed by *Kali o Kalam* ('Pen and Ink', 1927), edited by Premendra Mitra and others, *Pragati* ('Progress', 1928), with Buddhadeva Bose as one of the editors, and more importantly Sudhindranath Datta's *Parichay* ('Identity', 1931), Sanjay Bhattacharya's *Purbasha* ('The East', 1932), and Buddhadeva Bose's *Kabita* ('Poetry', 1935). Nevertheless, the first generation of modernists is still known as the *Kallol* generation, and included Samar Sen, Sudhindranath Datta, Buddhadeva Bose, Premendra Mitra, Bishnu Dey, and Jibanananda Das; all, except the last, communicating a distinctively urban modernity, and experimenting with the prose poem, *vers libre*, and new metrical patterns. The Marxist Samar Sen broke conspicuously with the romantic images of Tagore's generation, and ultimately abandoned poetry altogether. Datta, Bose, and Dey were perhaps the most scholarly, directly influenced by European modernism, and translating extensively from the European languages. Premendra Mitra wrote remarkable prose fiction as well as poetry. The most original of these poets was, however, Jibanananda Das, exploring the phantasmagorias of the everyday in metaphors that transform the familiar into the uncanny, the much-loved Bengal countryside into a mysterious and haunted landscape.

Modernist prose writers of the period would include Manik Bandyopadhyay, who wrote the novels *Padmanadir Majhi* ('The Boatmen of the River Padma', 1936) and *Putulnacher Itikatha* ('The Story of the Puppet Dance', 1936), as well as exceptional short stories; Satinath Bhaduri (*Jagari*, 'The Vigil', 1965), Advaita Mallabarman (*Titas Ekti Nadir Nam*, 'Titas is the Name of a River', 1962), and Kamal Kumar Majumdar

[29] John Frow, *Marxism and Literary History* (Oxford: Blackwell, 1986), 117.

(*Antarjali Jatra*, 'Final Passage', 1962, and *Nim Annapurna*, 'Bitter Rice', 1965). In the next generation, women poets and novelists such as Mahashveta Devi evolved radically oppositional modernisms rooted in subaltern experience. In theatre, the New Drama movement initiated by the Indian People's Theatre Association, the culture wing of the Communist Party of India, produced social-impact plays in the 1940s (including Bijon Bhattacharya's *Nabanna* 'Harvest', 1944), and was followed by the epic (though not actually Brechtian) theatre of Utpal Dutt and the avant-garde plays (Third Theatre) of Badal Sircar in the 1960s. Both the content and the period of literary modernism are made problematic, however, by an incomplete inventory of this kind. While writers of the Kallol generation make an unmistakable modernist statement in terms of ideological departures and formal experiment, many of the lessons of modernism are carried over to avant-garde poets of the next generation such as Shakti Chattopadhyay, associated with the journal *Krittibas* (1953). On the other hand, the social realism of Manik Bandyopadhyay, Satinath Bhaduri, and Advaita Mallabarman links them to their great contemporaries Bibhutibhusan and Tarashankar Bandyopadhyay. Perhaps it is only a certain radical *intention*, as well as the hypothesis of a beginning, that enables us to mark a modernist trajectory (or moment) in a literary history that subsumes modernism into a larger cultural process.

In Hindi, modernism is inaugurated in 1943 with the publication of *Tar Saptak* ('Upper Octave'), a collection of poems by seven poets edited with an important preface by Ajneya (S. H. Vatsyayan), setting out a new *prayogvadi* ('experimental') poetics, breaking with an earlier *pragativadi* ('progressive') literature (as practised, for example, by Premchand). Ajneya, acquainted with the New Critics and European modernism, himself writing a bookish and literary Hindi, edited the journal *Pratik* ('Image') from 1947 onwards, inspiring the poets of *Nayi Kavita* ('New Poetry': a journal by that name began to appear in 1954) and advocating a formalist concentration on poetic structure, rather than on social or historical problems. This formalist universalism (further enshrined in *Dusra Saptak*, 'Second Octave', 1951) was subsequently rejected by Gajanan Madhav Muktibodh, whose work had appeared in *Tar Saptak*, but whose intensely self-conscious, anguished poetic voice abandons the high modernism of Europe and America for experimental, radical, sometimes surreal sequences that draw equally upon the Bhakti tradition of late medieval India as upon other literatures of Asia, Africa, and Latin America. Myth is an important resource in the constitution of a modernist critique, both for Muktibodh and for Dharamvir Bharati in his apocalyptic play based on the *Mahabharata* epic *Andha Yug* ('Age of Blindness', 1954), Ajneya's novels, such as *Shekhar: Ek Jivani* ('Shekhar: A Life', 1941–4) and *Nadi Ke Dvip* ('Islands in the Stream', 1951), also emphasized the heroic isolation and alienation of the modern individual. But the chaste Sanskritized Hindi of Ajneya and his followers linked modernism to elite culture: in fiction, especially, the realist, 'progressive' tradition of Premchand and Phanishwar Renu still carried greater weight. The split between the literary communities of Hindi and Urdu, effected in the late nineteenth century, led to unresolved tensions: the most

striking modernist fiction was in fact produced in Urdu, by writers like Sa'adat Hasan Manto, Ismat Chugtai, and Qurratulain Haider.

Marathi poetry was decisively altered by the appearance of B. S. Mardhekar's *Kahi Kavita* ('Some Poems', 1947), a mordant series of reflections on post-war disillusionment and human degradation, using a radically reduced metrical system. Mardhekar was prosecuted for obscenity and remained a controversial figure until his death in 1956. Unmistakably influenced by the modernism of Europe and America, his was also a lonely, self-critical, auto-reflexive poetic voice, looking back to the 'saint' poetry of an earlier period. Too singular to start a movement, Mardhekar must nevertheless be placed beside poets like P. S. Rege, G. V. Karandikar, and Sharatchandra Muktibodh in the textual space of Marathi modernism. Sharatchandra Muktibodh, a less alienated voice than Mardhekar, also wrote novels of social commitment in the 1950s, at a time when modernist narrative was being explored by Gangadhar Gadgil and Arvind Gokhale (and in the next decade by Bhalchandra Nemade), and Vijay Tendulkar, the most significant modern Marathi dramatist, had begun producing 'experimental' theatre in a modernist idiom, but without abandoning realism. In the same period, Arun Kolatkar and Dilip Chitre, bilingual poets who wrote in both Marathi and English, begin to create a remarkable new modernist œuvre, densely allusive, rooted in the experiences of urban loneliness, the body, and sexuality. Chitre, who translated the medieval devotional poets Tukaram and Jnanadeva into English and Baudelaire, Rimbaud, and Mallarmé into Marathi, spoke of the profound influence these exercises had on his work. The bilingual poetics of Chitre and Kolatkar (comparable to that of Jayanta Mahapatra in Oriya and English or Kamala Das in English and Malayalam) should, simply because of their location, be linked to the English poetry of Nissim Ezekiel, perhaps the most linguistically inventive, wide-ranging, and flexible modernist writing in Mumbai from the 1950s.

Marathi literary culture was thrown into radical ferment in the late 1950s by the formal emergence of Dalit Sahitya, the writing of the oppressed (previously 'untouchable') castes. Social protest became inseparable from an avant-garde aesthetic seeking to radicalize the very language of utterance. Dalit writing questioned not just the institutions of art, but a history of violence and injustice that had denied representation, identity, and personhood to the dispossessed. In consequence, the rejection of a formal literary style is only one of the moves that can be adopted by writers attempting to record previously unacknowledged forms of experience. From the unsparing realism of Baburao Bagul in the late 1960s to the deliberate recourse to the language and experiences of street and brothel in Namdeo Dhasal's *Golpitha* (1973), and through the work of Arjun Dangle, Arun Kamble, Waman Nimbalkar, Tryambak Sapkale, Hira Bansode, Daya Pawar, Lakshman Mane, or Sharankumar Limbale, Dalit writing rubs literature against the grain, roughening its texture and blurring distinctions of voice and genre, autobiography and fiction, lyric and narrative.

As a literature of difference, Dalit writing in Marathi—however controversial the category itself has subsequently become—offers an alternative modernism not

amenable to the ideology of the aesthetic. In Malayalam, too, the representation of the underclass marks the real moment of departure from traditional poetry, especially in the work of the Ezhava poet Kumaran Asan in the early twentieth century (his epic fragment *Duravastha*, 'Misery', 1923, is particularly significant). But a modernist style emerges several decades later, with Ayyappa Paniker's long poem *Kurukshetram* (1960), a complex, free-verse treatment of the exhaustion and violence of the age, drawing upon myth in the same spirit as Eliot's *The Waste Land*. The spirit of the new poetry was sustained by periodicals like Paniker's *Kerala Kavita* ('Kerala Poetry') and M. Govindan's *Samiksha* ('Survey'); poets like Govindan himself, N. N. Kakkad, Kadammanitta Ramakrishnan, K. G. Shankara Pillai, and K. Satchidanandan employed, between the 1960s and 1980s, an unmistakably modernist idiom in treating of individual alienation in a rapidly changing culture. Satchidanandan, a leftist intellectual who translated Latin American, African, and European poetry, has continued to experiment with form and language. It was also in the 1960s that modernist fiction began to distance itself from the social realism of the great 'progressive' writers Thakazhi Shivashankara Pillai and Vaikom Muhammad Basheer, notably in the work of O. V. Vijayan, Zacharia, and Madhavikutty (Kamala Das).

CINEMA

Cinema as a form is modernist almost by definition, yet there is a lag between the high period of international modernism in all the arts and its accommodation in Indian cinema. In the *auteur* films of Satyajit Ray, Ritwik Ghatak, and Mrinal Sen during the 1950s, 1960s, and 1970s, a modernist film language appears assured and self-evident. In fact it is confined to a single region of India (Bengal), and it is only in the 1970s and 1980s that an alternative film movement emerges through the work of such directors as Shyam Benegal, Adoor Gopalakrishnan, Kumar Shahani, Govind Nihalani, G. Aravindan, Saeed Mirza, Girish Kasaravalli, M. S. Sathyu, Mani Kaul, and Jahnu Barua: a belatedness that inevitably compromises their 'modernist' legacy.

The project of modernity might be seen as Ray's principal cinematic subject, from the time he apprenticed himself to Jean Renoir when he came to India in 1949 to make *The River*, through his own first film, *Pather Panchali* ('Song of the Road', 1955), to his last, *Agantuk* ('The Stranger', 1991). In this he is an heir to Tagore (he had studied art at Shantiniketan with Benodebehari Mukhopadhyay), absorbing not just the moral and nationalist imperative of this examination, but also a sense of its delicacy, even peril, especially in respect of its treatment within a global aesthetic of modernism. Ray's cinema is taken to be neo-realist, on the model of Vittorio de Sica's *Bicycle Thieves* (1947), and the 'humanism' of his art has been as widely celebrated as his cosmopolitanism. Yet from the point when, in 1948, he began to educate the viewing public about the film medium, he unobtrusively noted his own debts to the

modernist masters: Truffaut's tracking camera, Kurosawa's editing, Godard's sound-track.[30] Siegfried Kracauer saw *Pather Panchali* and *Aparajito* ('The Unvanquished', 1956), as classic examples of the modernist use of memory to disrupt chronological sequence,[31] though in fact Ray departs from classical narrative only in the city films of the 1970s, which steep themselves in the logic of the street. Ray's modernism is most evident in his use of the honesty of the lens to enact a series of extremely complex negotiations with the ideology of realism (which, we should recall, has no real history in Indian cinema). Instead of a collection of objects to be grasped and represented, Ray's 'realist' world is a succession of enactments, where camera angle, the duration of the shot, attitude, voice, gesture, and soundtrack compose and recompose the subjectivity of the viewer. Insistently, he questioned what film as a medium could do, in respect of both producing illusion and dissolving it (as in *Devi*, 'The Goddess', 1960).

Ray's contemporaries Ritwik Ghatak and Mrinal Sen commenced their careers with the communist Indian People's Theatre Association, a background that may account to some extent for their bolder and more gestural cinematic language. Ghatak's *Nagarik* ('Citizen') was in fact completed before Ray's *Pather Panchali* in 1953, but released posthumously in 1977. His own experience of the uprooting and exile caused by the partition of India went into the trilogy of *Meghe Dhaka Tara* ('The Cloud-Capped Star', 1960), *Komal Gandhar* ('E Flat', 1961), and *Subarnarekha* (1962), producing an uneven, sometimes raw, sometimes melodramatic, but powerfully original cinematic corpus, constantly experimenting with the composition of frames, the intersection of the mechanical and the human where film begins. Surprisingly, it was Ghatak, the most unconventional artist of the three, who died at the age of 50, who left students (from the Film Institute at Pune) to carry on his legacy. Mrinal Sen's work in the cinema is arguably more varied, from *Neel Akasher Nichey* ('Under the Blue Sky', 1958) to *Khandahar* ('The Ruins', 1983) and beyond. His mature work, however, beginning from the Calcutta films of the 1970s, was both political and self-consciously modernist, using fragmented or double narratives and repeatedly disrupting the illusionist properties of the image and the complacencies of class.

The art cinema of the 1950s and 1960s, and its heirs in the alternative cinema movement, require us to address a central problem of modernism: the place of the popular. Indian popular cinema, both in Hindi, the medium of the 'Bombay film', and in other regional languages, clearly dominates the cultural space of modernity. In its various forms (mythological, social, sentimental, melodramatic) it comes to represent the commoditized mass culture against which art cinema defines itself, and allows for a visible break between modernist high art and popular entertainment provided by the 'culture industry', to use Adorno's phrase. It is arguable that in India this break is not visible in any other cultural sphere to the same degree as it is in cinema (with the possible exception of music); yet it is, we should note, the creation

[30] See Satyajit Ray, *Our Films, their Films* (Bombay: Orient Longman, 1976).

[31] Siegfried Kracauer, *Theory of Film: The Redemption of Physical Reality*, ed. M. Bratu Hansen (Princeton: Princeton University Press, 1997), 234–5.

of a highly restricted development that takes place from the 1950s onwards. In earlier film history it is non-existent, and postmodern cinema has already lost the battle against commoditization, though it may effect its own transactions between high and low, elite and popular, the intellectuals and the masses. In consequence, some would argue for a critical reassessment of the popular cinema and mass culture of the 1950s and 1960s as contested territory, not so much an oppositional space as a site of struggle and subversion, challenging art cinema's claim to modernist authenticity.

CONCLUSION

Modernisms in India are deeply implicated in the construction of a secular national identity at home in the world, and in this respect answer a historical need to fashion a style for the 'modern' as it is locally experienced. But the choice is itself ideologically determined by notions of the 'secular', the 'modern', the 'national', and the 'local'. How precisely are these to be understood? The apparently 'transnational' character of modernism, its 'break' with a past experienced only as fragment, ruin, or decay (the '*facies hippocratica* of history', to use Benjamin's phrase about allegory[32]), its preoccupation with existential loneliness and anguish, its abandoning of naturalism and narrative for an abstract, experimental, non-sequential aesthetic order, might indeed appear to fit the experiences of a colonial urban culture. But that 'fit' is not simply a matter of the transmission of a set of aesthetic practices, nor is mimicry the end of the exercise. Mitter comments acerbically, and with justice, on the discourse of authority, hierarchy, and power in the consideration of non-Western modernisms, making them appear merely derived or imitative.[33] Yet even in the case of the educated bourgeoisie, the modernism of the West contends with a variety of local responses to the intolerable pressures of tradition, colonial authority, and social oppression, producing completely *new* modernist projects. Modernism's effort to locate the means of release in a new aesthetic order is historically the most critical element of its enterprise (in a sense, implicating the avant-garde in a totalizing vision of the world remade by art). In India, that aesthetic order must carry, at different locations and at different times, other burdens as well: the idea of a secular culture, the project of the nation, the reaffirmation of regional or local identity, the self-expression of the oppressed, and the sense of a 'speeded-up', intensely concentrated, time.

[32] Walter Benjamin, *The Origin of German Tragic Drama*, trans. John Osborne (London: New Left Books, 1977), 166.
[33] Mitter, *The Triumph of Modernism*, 7.

CHAPTER 53

..

ANTIPODEAN MODERNISMS

AUSTRALIA AND NEW ZEALAND

..

PRUDENCE BLACK

STEPHEN MUECKE

'THE Birthplace of Modern Australia' is today one of the slogans of Sutherland Shire Council, encompassing Botany Bay, where Lieutenant James Cook first landed in Australia in 1770 en route from New Zealand. Taking Cook as a beginning for Antipodean modernisms stretches the usual time-frame for the modernist period. But this chapter wishes to begin with the point that without the era of exploration the European modernisms would not have burgeoned and come to be seen as originary and universal. Those modernisms could only have developed under the conditions provided by the eras of exploration and colonialism: wealth for the development of cultural infrastructure in Europe, accompanied by an expanding knowledge of a broader world with which to contrast and compare.

Having thus begun with the moment of colonization and settlement, the chapter traces the contours of the importation of, and responses to, various forms of European modernism in literature and the other arts. It concludes with a post-colonial gesture. For if indeed the European strains of the modernist 'virus' took hold in the Antipodes, did they not result in the development of local strains, indigenous versions of modernism, whose history remains unfinished and only partially described?

Australia and New Zealand were 'discovered' late in the era of European exploration, with Australia having a very long pre-colonial history, stretching back some 60,000 years, while the Maori settling of Aotearoa/New Zealand began about 1,000 years ago. As is well known, Cook was on a scientific expedition in the Pacific to observe the transit of Venus in Tahiti. As such, he, and especially Joseph Banks, were bearers of an early modern discourse of rational inquiry. They were also interested in territory: Australia and New Zealand were duly claimed for the Crown, and settled, in 1788 (Port Jackson, later Sydney), and Britain's settlement in New Zealand was ratified by the Treaty of Waitangi in 1840.

THE CONCEPTUAL FRAMEWORK

It could be said that Antipodean modernisms are determined first and foremost by historical and geographic factors. In both countries indigenous peoples were colonized and dispossessed of their lands, and the settler colonists formed the societies that provide the institutions that persist to the present day. Both countries were isolated geographically from Europe and North America, seen from the beginning as origins and sources of cultural influence for these two English-speaking countries. That said, none of these originating conditions has disappeared as influential factors in the way that Antipodean modernisms were conceived and transformed. This chapter argues that the 'double dislocation' set up by the colonization of the Antipodes is the key to its modernist conceptual architecture. There has been a temporal disjunction for two sets of peoples: first the colonials who thought they had to 'catch up' with European social and cultural trends, then 'behind' them the indigenous peoples who were thought to be civilizationally backward and therefore nowhere near modernism. We propose that, in parallel with other places, Antipodean modernisms were indeed part of a plurality of modernisms, that they developed their own character rather than simply lagging behind a Northern cutting edge, and that the indigenous cultures in both countries were influential in providing some of the character of Antipodean (settler) modernities, and in forging what might be called indigenous modernities as transformations of local cultures.

BILATERALIST EXCHANGE

The settlement of both Australia and New Zealand by those from the British Isles meant that those particular cultural traditions tended to be favoured, and that

considerable traffic went both ways. Despite the development of incipient nationalisms in both countries, the early twentieth century saw artists keen to escape what they saw as a colonial parochialism, and at the very least make the journey 'home' to the UK to experience life there, imbibe its influences, and to test their talent against those established traditions.

Katherine Mansfield's life is typical in this respect. One of the greatest modernist writers, she was born in New Zealand in 1888 in a wealthy Wellington family, and was sent to finish her schooling in England, where she attended Queen's College, London. In 1906 Mansfield returned to New Zealand, only then beginning to write the short stories that were to forge her reputation. She had several works published in the Australian magazine the *Native Companion*, which was her first paid writing work, and by this time she was rapidly maturing as a writer and outgrowing what she saw as the unbearable provincialism of her family and New Zealand life generally. A mere two years later, and only 20, she was headed again for London and the Continent, never to return. Two of her collections of short stories were published just after the First World War, *Bliss and Other Stories* and *The Garden Party*, but by 1923 she had died of tuberculosis at the age of 34. Only the early death was unusual; there was scarcely an Antipodean writer or artist in the 'high' to 'late modern' period, say from the turn of the century to the Vietnam War, who did not have a European experience. Some, identifiable with this period, are still having it—the poet Peter Porter, for instance, who lives in London, but regularly visits his county of origin, Australia.

This geopolitical bilateralism has tended to create something of a 'dialectic' of influence between the Antipodes and the UK, and to a lesser extent with Europe and the US. This has been the traditional way of analysing the relationships of influence and reaction, acceptance and rejection, with the Northern Hemisphere centres always taking the hegemonic position. It was never the case, as far as we know, despite the regular traffic across the Tasman Sea, that Australia and New Zealand were in some kind of multilateral relationship with, say, the UK. They each nurtured and critiqued their own bilateralism. Yet other minor 'multilateral' relationships are only starting to emerge, for instance with the Pacific islands, Indonesia, India, and China. The real historical intercolonial and international influences among these places are yet to be fully explored, and clearly they would complicate the picture in ways that Bernard Smith's ground-breaking work *European Vision and the South Pacific* (1960) had already established as possible. New Zealand, for example, is much more of a focus for Pacific island cultures today than is Australia, largely because of perceptions arising out of migration and travel around the South Pacific. In that sense, an Australian–New-Zealand–Pacific-and-Indian-Ocean cultural regionalism may be one day beyond the realm of mere speculation and beyond traditional bilateralism. We do hope here, nonetheless, to draw out the relationships of similarity and difference that have moved across the Tasman Sea as these countries forged their own versions of indigenized modernism.

Julian Croft, in a useful account of Australian literary modernism, begins with the generalization that in the visual arts as well as literature 'responses to modernism were quickly seen . . . but that reaction against modernism was deep-seated and long-

964 PRUDENCE BLACK AND STEPHEN MUECKE

lasting'.[1] Clearly an aspect of this was geographic, if not nationalist, for the virtues and evils of modernism could be seen, at least initially, as coming from *elsewhere* (as against Europeans, who had to be fully responsible for their own modernisms), leaving the sense of an Antipodean cultural *void*, which Australians and New Zealanders then attempted to fill in their own vigorous, yet somewhat neurotic, ways. This was the vigour of the pioneer settler, coupled with the neurosis of the exile in search of a new identity. Clearly this neurosis and struggle with existential emptiness was to find useful modes of expression in a modernist aesthetics forged in the Northern Hemisphere under quite different historically experienced conditions. And later, the barely papered-over guilt over colonial violence and dispossession on the part of these white settlers was already twisting and turning in the complexities of late modernism and postmodernism which we will visit below.

CONTROVERSIES IN THE ARTS

In literature, as we have already seen, the first stories of Katherine Mansfield had crossed the Tasman to be published in Australia, but those were not yet the works of genius that were to define her talent in Europe. In Australia, it was not until the 1930s that the first novels started to be written that emerged, stylistically, from what Patrick White was later famously to call 'dreary, dun-coloured realism'.[2] White's first novel, *Happy Valley*, was published in 1939, and he was later to be awarded the Nobel Prize for literature, in 1973. Christina Stead also strode the world stage of literary modernism (partly because she literally strode it with her diplomat husband). Unlike the Jungian symbolism which inflected White's work, Stead was more influenced by Fabianism, hence *Seven Poor Men of Sydney*, published in 1934, and cleverly glossed by Julian Croft as having a 'narrative voice that runs through the various tones of sympathy, irony, playfulness, and rhapsodic description, while the story line is let out several notches to accommodate a characterisation which has the genius of what [poet laureate] Les Murray was later to celebrate as "sprawl"'.[3] Katherine Mansfield, too, once exclaimed that her prose had '*no form!*', yet she seemed to be aware that it did have that modernist quality in the language that would survive structural incompleteness.[4]

[1] Julian Croft, 'Responses to Modernism', in L. Hergenan et al. (eds), *New Literary History of Australia* (Melbourne: Penguin, 1988), 409.
[2] Patrick White, 'The Prodigal Son', *Australian Letters*, 1/3 (1958), 39.
[3] Croft, 'Responses to Modernism', 416.
[4] Quoted in *The Stories of Katherine Mansfield*, ed. Antony Alpers (Auckland: Oxford University Press, 1984), p. xxviii.

This modernism in novels and short stories met with opposition from literary nationalists of a more classical and/or socialist position. Vitalists such as the major writer and painter Norman Lindsay, who espoused a classicism of natural life forces finding their aesthetic form, was joined by the politician (later prime minister) R. G. Menzies, state institutions and galleries, and newspaper opinion makers, who in their numbers denounced modernism as lacking any aesthetic merit. This censorious attitude carried through to book banning, which lasted until the late 1960s. Soviet social realism also had a counter-modernist influence, since writers considered within the Communist Party stable were given direct 'advice'. Writers such as Frank Hardy accordingly stuck to a social realist aesthetic, coupled with an ideological programme (*Power Without Glory*, self-published in 1950) but as the Communist Party's influence waned in the 1960s, he launched into full-blown modernist experimentation, as did novelist and playwright Dorothy Hewitt. Katharine Susannah Prichard, in Western Australia, will also be remembered for ignoring the Party to the extent of engaging in a significant way with the issue of Aboriginal Australians, as in her classic 1929 novel *Coonardoo*.

The debate over literary modernism in poetry came to a head in Australia in the form of a hoax perpetrated at the expense of an avant-gardist cravat-wearing poet and editor of an innovative journal in Adelaide, Max Harris. In 1944 the more conservative poets of the previous generation, James McAuley and Harold Stewart (with A. D. Hope looking on), used a quite innovative 'cut up' method to compose poems on modernist themes and submitted them to *Angry Penguins* (Harris's journal) under the name of Ern Malley, via his equally imaginary wife, Ethel, and accompanied by her explanatory letters, which supplied a quite convincing biographical context. Ern Malley's name conjured beautifully between Keats's Grecian urn and a particularly desolate part of the outback called the Malley. The affair was a sensation as it ricocheted through the courts with charges of obscenity against Harris as publisher. By the end, modernism in Australia had taken serious body blows, but the affair is now enshrined in legend, and it became the subject of renewed discussion through the postmodern period with its interests in identity, authenticity, and textual autonomy.

If the comet of Katherine Mansfield blazed early across the New Zealand sky before expiring in France too soon, then the light of C. K. Stead has been burning steadily there since the 1950s. As an intellectual and writer his life is typically modernist, yet he has also been accused of reactionary attitudes to Maori and feminist movements. While calling himself a realist writer, and writing across the range of poetry, short stories, novels, and essays, his early critical work *The New Poetic* (1964), a study of modernism based on his Ph.D. thesis, sold over 100,000 copies. Among many other publications, he also did a fairly early edition of the *Letters and Journals of Katherine Mansfield: A Selection* (1977) and a second study of modernist poetry, *Pound, Yeats, Eliot and the Modernist Movement* (1986). More recently a novel, *Mansfield* (2004), has explored her relationship with her husband, John Middleton Murry, plus her illustrious friends like the Lawrences, Bertrand Russell, Aldous Huxley, T. S. Eliot,

and Virginia Woolf, who wrote of Mansfield that hers was 'the only writing I have ever been jealous of'.[5]

In the field of Australian 'classical' music, Percy Grainger is a good case study of modernist experimental freedom. Grainger was at the forefront of the development of many forms of twentieth-century music before they became established by other composers. As early as 1899 he experimented with 'beatless' metric patterning, his use of 'chance music' in 1912 pre-dated John Cage by some forty years, and he wrote 'unplayable' music for player piano rolls twenty years before Conlon Nancarrow.

From 1901 to 1914, Grainger lived in London, where Norwegian composer Edvard Grieg became his friend and encouraged him to record rural English folk songs. During this period, Grainger also wrote and performed piano compositions that presaged the forthcoming popularization of the 'tone cluster' by Leo Ornstein. Grainger was anything if not eccentric and boundlessly energetic. He began designing and making his own clothing, ranging from jackets, to shorts, togas, leggings, and muumuus, all made from towels. In London, he would race through the streets to a concert, where he would leap on stage at the last minute because he apparently preferred to be in a state of exhaustion when playing. When travelling by ship on tour, he spent his free time shovelling coal in the boiler room. His career consisted of well over 3,000 concerts as a pianist or conductor.

Grainger moved to the US at the outbreak of the First World War, in 1914. His 1916 piano composition *In a Nutshell* is the first by a classical music professional in the Western tradition to require direct, non-keyed sounding of the strings—in this case, with a mallet—which would come to be known as 'string piano'. Grainger's piano solo *Country Gardens* became a popular hit, securing his reputation and wealth. Grainger, who was always very close to his (equally eccentric) mother, Rose, then moved to White Plains, New York, after the war. After his mother's suicide, Grainger married Swedish artist and poet Ella Viola Ström on the stage of the Hollywood Bowl, following a concert before an audience of 20,000, with an orchestra of 126 musicians, and an a cappella choir, which sang his new composition, *To a Nordic Princess*, dedicated to Ella. In 1932 he was appointed Dean of Music at New York University, and underscored his reputation as an experimenter by putting jazz on the syllabus and inviting Duke Ellington as a guest lecturer. It is hard to claim such an eccentric expatriate as a 'product' of Antipodean modernisms, yet it is hard not to do so if he escapes the notice of the regular canon.

In the visual arts, New Zealand critic Damian Skinner makes it clear there was considerable cross-Tasman activity, perhaps with the 'Big Island' exerting more pull than the other way around. Helen Stewart, he says, 'returning to New Zealand from a progressive art context' in Sydney, where she was hung alongside artists like Margaret Preston and Grace Cossington-Smith at the Macquarie Galleries and the Contemporary Group, was 'confronted by a culture that will not accept modernist

experimentation in art'.[6] Which, as he points out, is an exaggeration, but part of the myth-making that casts New Zealand as backward and conservative. In fact, he says, Wellington had a space welcoming modernism in the Central Library, where many modernist artists had exhibitions, including Gordon Walters, Colin McCahon, and Toss Woollaston. Then in Auckland, in the 1950s, Colin McCahon, Kase Jackson, and Louise Henderson were exploring the techniques of Cubism, encouraged by John Weeks and Eric Westbrook, director of the Auckland City Art Gallery. Interestingly, Skinner quotes Sydney critic Kenneth Wilkinson's 'startling' comments about international modernism's role in Australian art. Discussing Stewart, Wilkinson writes that she had 'shed a good deal of the abstraction and the intellectual self-consciousness which contact with European circles impressed upon her', and although many artists 'seem to experience a reaction against European modes of expression when they return, the fact of passing through these modes infallibly enriches and develops their style'.[7] This is typical of the critical attitude; the encounter with European modernism was essential, but it should be toned down or otherwise adapted to the local context on return.

Richard Haese's *Rebels and Precursors* (1981) fills out the details for the Australian scene, while similarly identifying the two main threads of the story of Australian modernism: 'The first was the discovery of the European modernist tradition and its transplantation. The second concerned the rediscovery and re-examination of an authentic Australian cultural tradition.'[8] Usefully, for the visual arts, *Rebels and Precursors* demonstrates just how vital and turbulent the modernist scene was, especially in the inter-war years, to the extent that one New Zealand reviewer wistfully regrets that 'in New Zealand the arguments simmered below the social surface... only occasionally becoming public', while with Australia 'the volcano erupted more spectacularly, throwing out a lava-flow of red-hot manifestos, pamphlets, articles; spawning a brood of academies, societies, coteries and cabals of all kinds'.[9]

FORMS OF POPULAR MODERNISM

Popular modernism came surging in on a demographic wave of post-war baby boomers. While the 'older generation' was debating the virtues or evils of modernist

[6] Damien Skinner, 'Making Modernism: Helen Stewart and the Wellington Art Scene 1946–1960', *Art New Zealand*, 96 (Spring 2000), 102–6.

[7] Kenneth Wilkinson, 'Miss Helen Stewart: Some Striking Portraits', *Sydney Morning Herald*, 7 Feb. 1934.

[8] Ross Fraser, Review of Richard Haese, *Rebels and Precursors*, *Art New Zealand*, 23 (Autumn 1982), <http://www.art-newzealand.com/Issues21to30/books2301.htm>.

[9] Ibid.

poetry in the pages of *Meanjin* (Australia's oldest literary magazine, founded in 1940) and *Landfall* (its New Zealand counterpart, founded in 1947), learning to appreciate good red wine ('claret'), and listening to a bit of jazz, their teenage offspring were cutting loose and screaming at Beatles concerts, or buying various, mostly imported, vinyl 45s.

The Beatles toured Australia and New Zealand in June 1964, but had been preceded by electrifying figures from the US, like Little Richard in 1958, who met, in Sydney, the amphetamine-fuelled rock 'n' roll local Johnny O'Keefe. O'Keefe went on to be the first Australian rock act to tour the States. This popular modernism clearly demonstrated that cultural trends could also work from the bottom up, and vigorous debates about ways of 'being modern' were engaged in the pages of popular magazines: questions of how high the hemline of a mini-skirt might creep, or how far past the collar men's hair could be allowed to grow. The Modern Girl became an urban figure of fashion and freedom of choice, and eventually, 'liberation'. Again, the style was often imported, for instance from Carnaby Street.

The appearance of English model Jean Shrimpton at the 1965 Melbourne Cup Carnival became a famous moment in Australian fashion history. She entered the exclusive Members' Enclosure wearing a simple white shiftlike dress, without a hat, gloves, or stockings. To her generation, she looked, as in the photograph taken at the time, like a breath of fresh air compared to the dowdy Melbourne matrons, with their gloved hands clutching their handbags and glaring at her through their horn-rimmed glasses. This image has become an iconic reference point for this revolutionary moment in 1960s fashion in Australia.[10]

The demographics that encouraged this popular modernism were also facilitated by international mobility. Antipodean versions of modernism now had the chance to participate in a new cosmopolitanism. In 1947 Qantas introduced the Howard Hughes-designed 'Connies', the beautiful twin-propped triple-tailed Constellation bought from Lockheed by Qantas (in defiance of the British wish to keep its aviation industry a Commonwealth one). For the first time, migration and travel to the Antipodes did not have to be principally by boat. But international air travel was still for an elite number (thirty-eight passengers on board the Constellations), and they were attended to with on-board Qantas service on the 'kangaroo route' to London, or across the Pacific to the US, by a new, absolutely modern and glamorous person, the Flight Hostess. This 'hostess' perhaps symbolized more than anyone else the kind of modern subject it was now possible to be. Australia was thus investing in this growing *international* modernism as a historical and cultural formation. This was modernist cosmopolitanism extending its style and influence in multiple ways, from cigarette smoking ('The International Passport to Smoking Pleasure', as one advertisement put it) to fashion and other forms of consumption. It was a significant moment for the development of a new urban Australian identity, contrasting

[10] See Prudence Black, 'When a Frock Is Not a Frock: Jean Shrimpton and the Rhetoric of the Image', in Liz Bradshaw et al. (eds), *Not My Department: Texts, Disciplines, Margins* (Sydney: University of Sydney, 1991), 42–56.

markedly with those slower and pastoral earlier forms of 'radical nationalism' of the late nineteenth century known as the 'bush legend'.

FROM INDIGENOUS ASSIMILATION
TO INDIGENOUS MODERNITIES

In both Australia and New Zealand the interest in indigenous arts and imagery became part of the settlers' quest for expressions of national identity, a quest that was continually fuelled by overseas exoticist interests in the native cultures, interests that continue to fuel the cultural and tourist industries today. While the Australians at first tended to use naturalist imagery (a kangaroo on the obverse of the penny coin, and the tail of Qantas jets, for instance), the New Zealanders more quickly adopted Maori motifs for their currency, stamps, and decorative arts, including the Air New Zealand livery. In Australia, in the 1920s and 1930s, Margaret Preston was among the more significant visual artists to take a serious interest in Aboriginal decorative form, which was how she (and probably every other colonial) saw it, a collective set of forms rather than the work of individual artists. Her work was seen by some as a set of slightly higher-quality 'appropriations' of the sort going into tea towels, ceramics, and kitsch artefacts, 'a popular modern hybrid Australiana for the home decor of its citizens', as critic Ian McLean has put it.[11] In her own words, speaking on radio in 1945, she said, 'I'm personally aiming at the simplification of all forms and to express the monumental form and dry colour of Australian land-scapes . . . I wish to continue the basic work of the Aborigines . . . What I am after in my work is to give the national, spiritual and characteristic features of this country.'[12] Her modernism was thus clearly a nationalist project, in which the 'basic work of the Aborigines' would be left behind, having been artistically incorporated. In New Zealand, the well-known Pakeha artist Gordon Walters attracted similar accusations of appropriation. An abstract artist through the 1950s and 1960s, he had focused on the Maori *koru* stem bulb as a motif. And, having given several of his paintings indigenous titles, caused some Maori critics to say that this was not mere formalism, but a theft of intellectual property. Even more dramatically, a modernist mural by one of New Zealand's most celebrated artists, Colin McCahon, was stolen in 1997 from the Urewera National Park visitors' centre, where it had been hanging. It had an abstracted tree symbol at the centre representing Tane, a Maori forest god of the Tuhoe tribe, and the painting was inscribed with various Maori words and names,

[11] Ian McLean, 'Gordon Bennett's Home Decor: The Joker in the Pack', in Colin Perrin (ed.), *In the Wake of Terra Nullius*, special issue of *Law . Text . Culture*, 4/1 (1998), 291.

[12] Margaret Preston, *Australian Artists Speak*, Radio 2FC (1945), <http://www.artgallery.nsw.gov.au/sub/preston/artist_words.html>.

large words in paint being something McCahon often does. The two activists from the local Tuhoe group who stole the painting did not indulge in any subtle aesthetic critique. For them, it was 'just another fucking colonial painting'.[13]

In Australian literature, a much gentler appropriation had happened much earlier. This was the project of the Jindiworobak movement based in Adelaide, on the southern fringes of the immense central deserts where a great tradition of oral narrative and poetry had been developed for millennia. Aware of this through the monumental translation work of T. G. H. Strehlow, from the Arrernte language, a group of poets in Adelaide began to look to Aboriginal poetic forms in search of a more natural integration with the local environment. At about the same time, Hans Heysen, of South Australian German origin, was discovering that the gum tree had enormous expressionist potential, and his projects took him out of the studio into the bush and the desert.

This argument about the significance of the concept of 'indigenous modernities' in Australia and Aotearoa/New Zealand is a complex one. Its history is as long as settlement, and it was never the case that these cultures, in dialogue or conflict, would ever totally displace each other, or quietly sink into some hybridized mixture. When Cook arrived in the South Pacific, he was not yet using the concept of the modern, but he was well on the way, equipped as he was with a scientific and universalist rationality, and a sense of technological and economic superiority. So was there not a hint of disappointment when Cook wrote, 'they seem'd to set no value upon any thing we gave them, nor would they ever part with anything of their own for any one article we could offer them'?[14] By definition, the indigenous people, it seemed, cannot be anything like 'modern', because they refused to participate in the economy whose logic would have them, in the end, assimilating.

We are careful today, in our relativistic way, not to designate the whole of European civilization as superior to the ones it would largely displace, but we are happy to allow one of its minor but key concepts—the modern—to continue on a search-and-destroy mission. For the settlers, 'modern' Australia *still* begins at Botany Bay with Cook, so where does that leave their co-citizens, the indigenous peoples? Once the Darwinian logic that would have them dying out in the face of civilizational superiority was proved not to have happened, the next policy was one of assimilation, not just in racial terms, but in cultural ones as well, and this appeared as policy in Australia in the 1950s.

Assimilation's logic had a strange similarity to being or becoming 'modern'. For either one is totally assimilated (in which case one is unrecognizable as Other), or one is not; and if not, then one has progressed part-way in the process and therefore in a state of lack. Identifying someone as a possible candidate for assimilation is a way of telling them, paradoxically, that they are 'not ready yet'. The promise is held out for

[13] Nicholas Thomas, *Possessions: Indigenous Art/Colonial Culture* (London: Thames & Hudson, 1999), 33.
[14] 'Cook's Journal, Daily Entries', 13 Apr. 1769, <http://southseas.nla.gov.au/journals/cook/17690413.html>.

some unknown time in the future when the transformation will have already taken place. It is therefore appropriate to see assimilation as part and parcel of the continual process of the colonization of any kind of Other. It is made possible by the practice of the idea of historicism, as explained by Dipesh Chakrabarty, as that conception of history as internally unified, unique to each period, and developing over time. 'Historicism enabled European domination of the world in the nineteenth century,' he says, adding that

it legitimated the idea of civilisation . . . it was an important form that the ideology of progress or 'development' took . . . [it] made modernity or capitalism look not simply global but something that became global *over time*, by originating in one place (Europe) and then spreading outside it . . . historicism—and even the modern, European idea of history—one might say, came to non-European peoples in the nineteenth century as somebody's way of saying 'not yet' to somebody else.[15]

Assimilationism, as an idea, is thus a late stage of colonialist historicism in that it functions to keep the not-yet-assimilated in their place. The project of modernity, conceptually equipped to maintain uneven development, is thus in the process of being revisited by post-colonial thought, or 'recalled' by philosopher Bruno Latour.[16]

ANCIENT AND MODERN HYBRIDS

So this framework enables us to analyse Antipodean modernisms in which indigenous cultures were (or are) seen to be *ordered* in relation to other cultures in Australia. In New Zealand the force of numbers has demanded a biculturalist policy; and it had already demanded a treaty (the 1840 Treaty of Waitangi) and greater political participation. Yet both countries had been subject to a mindset, call it 'the old order', prior to the 1970s, which was one which saw Western culture (modernized and modernist) on the one hand, and on the other traditional (or 'primitive') Aboriginal culture as the only viable one, but of antiquarian interest only, 'living relics of the Stone Age'. Any in-between 'part-Aboriginal' cultures were due for assimilation, just as the traditional one was supposed to die out under the impact of modernization.

The 'indigenous modern' may seem to be an oxymoron, but it is a phrase that should be as acceptable as 'modern Australian'. We take it as an inclusive category of the contemporaneous, and hence as part of a necessary argument, for without the concept of indigenous peoples also being 'modern' it is much more difficult to

[15] Dipesh Chakrabarty, *Provincializing Europe: Postcolonial Thought and Historical Difference* (Princeton: Princeton University Press, 2000), 7, 8.

[16] Bruno Latour, 'The *Recall* of Modernity—Anthropological Approaches', *Cultural Studies Review*, 13/1 (Mar. 2007), 11–30.

implement fully serviced and responsibility-bearing civil and cultural citizenship for Aboriginal people. How can one be seen to be a fully participating citizen if one is deemed to be from either a radically incommensurable traditional culture, or a perpetually disadvantaged urban one? At the very simplest, being modern means having a range of inventive responses to the contemporary world. In Europe this meant responding to rapid industrialization and urbanization. In Australia and New Zealand, for Maori and Aborigines, it meant adaptation to a highly dangerous invader, which included ambivalence about being co-opted as labourers for the market-based industries. Survival in these cases, especially in Australia, has literally meant a lot of creative work, not only of a modernist sort in culture, but also in the technological, bureaucratic, and economic systems which are usually associated with modernity rather than modernism.

So this democratization of modernism/modernity supports the very process of political democratization where minorities become enfranchised and included in the polity. This process is contrary to the logic of assimilation. Democratization comes hand in hand with modernity, and there are benefits as well as dangers which have some effect in political expression. The modern has been associated with negative qualities such as alienation, a loss of roots, a shrinking of the heroic dimension of life, including the sacred, and the full expression of human 'passions'. Some of these 'losses' are recycled in the complex overlay of romantic nostalgia. But if we maintain that the situation we are dealing with, the inherent quarrel in a culture, is never about leaving the ancient for the open blue skies of the modern, but that modern and ancient are locked together, then this new perspective on culture may be able to close the gap through which these losses are seen to flow.[17] This is helped by not seeing history itself as a flowing forwards, taking the settler concept of history out of our calculations about culture, and replacing it with the notion of the force of the ancient. To speak of force is to see events as immanent in bundles of agencies, articulations of words, concepts, bodily capacities, and strengths coming from animate and inanimate beings in movement. Present events have the greatest significance and power when they are made to resonate down to the mythic layers of the past. This is not just to see events historically as 'unfolding', observed from a safe perspective, it is also to see one's own modest capacities as intersubjectively linked into their workings. This means using the 'indigenous modern' instead of the older assimilatory aesthetics of 'neither–nor' where we find Aboriginal artists celebrated or denigrated for something other than their artistic work.

The 1950s artist Albert Namatjira, born on the Finke River, the most ancient streamed on the planet, was both modern and modernist in his artistic practice. At the beginning of his career, people who supported and promoted his work, especially the landscape painter Rex Battarbee, were happy to use the epithet 'modern Aboriginal' artist,[18] but we don't know how Namatjira responded to it. In

[17] Stephen Muecke, *Ancient & Modern: Time, Culture and Indigenous Philosophy* (Sydney: University of New South Wales Press, 2004).

[18] Rex Battarbee, *Modern Aboriginal Paintings* (Adelaide: Rigby, 1971).

the early stages his work was often seen as imitative of Western forms and was subject to condescension, for it was 'remarkable' that he could leap out of the Stone Age and acquire artistic skills so quickly. To white observers the product was a watercolour, not, as Namatjira might have seen it, a way of moving around his country to particular sites and *then* doing something supplementary on canvas. It is now well established that the sites Namatjira painted were chosen for their traditional significance and power rather than simply as picturesque material.

Then the 'narrative of failure' started to kick in, for how really could a Stone Age man survive the pressure? The 'modern' tag was dropped, so that the figure held up as an icon of assimilation (with honours and special rights given to him) was seen as suspended between two worlds and failing to make the transition to a promised assimilation which was never really desirable anyway. The story of Namatjira took a 'tragic' turn when he was convicted of supplying liquor to his relatives, liquor that he had the right to purchase and consume alone by virtue of his exemption from the Act.[19] His time in jail led to his decline and early death at 57. With the overriding racist connotations of 'clash of two worlds' or 'in between black and white', the word 'modern' simply vanishes, and has not been used about him again until now.

So while critics today might allow us to see Namatjira as a modernist, there is much equivocation. In the 1950s John Cummings watched him paint and was 'surprised to see him fill his brush with a colour and return again and again to different areas of the composition with variant washes before moving on to the next colour. It is this technique that enabled Namatjira to hold all the elements of his composition in balance.'[20]

In the same publication Alison French compares him to Hans Heysen, superficially similar as a painter, but dubbed a realist rather than a modernist because of his literalism, since he painted to reproduce what was there.[21] French endorses Burn and Stephen's view that Namatjira is 'tactile' and 'diagrammatic' and exploits the 'abstract possibilities derived from the formal process of painting'.[22] He is 'motivated by the twin frames of reference—making art and being in country—he could never distort the one for the other'.[23]

The immediate popular success of Namatjira's painting fifty years ago, and the sophisticated way we have of reading it now, combine to mark his achievement as one of the most significant in the history of landscape painting in Australia. French concludes that 'Albert Namatjira both mastered and invented conventions that

[19] Namatjira was given citizenship in 1957, which released him from being a ward of the state and allowed him to buy liquor, a house, etc., but limited access to his kin and country.

[20] Alison French, *Seeing the Centre: The Art of Albert Namatjira, 1902–1959* (Canberra: National Gallery of Australia, 2002), 131.

[21] Ibid. 133.

[22] Ian Burn and Ann Stephen, 'Namatjira's White Mask: A Partial Interpretation', in Jane Hardy, J. V. S. Megaw, and M. Ruth Megaw (eds), *The Heritage of Namatjira: The Watercolourists of Central Australia* (Melbourne: William Heinemann, 1992), 249–82; French, *Seeing the Centre*, 133.

[23] French, *Seeing the Centre*, 133.

present an alternative to the pastoral vision.'[24] So while the European artists like Battarbee and Heysen adapted their pastoral landscape traditions to the new material sources presented by gum trees and Central Australian country, this did not indicate the same degree of aesthetic revolution represented by Namatjira's modernism. If Namatjira met Heysen somewhere in the middle of the road, the former had come further and made more adaptations than the latter. When one considers that as the bearer of his own ancient traditions—painting on the body and on the ground contingently and impermanently for ceremony, painting as custodian or *kirda*, and so on—he must have approached the new medium with a quite different set of ideas. And yet a painting of Haast's Bluff (*c.*1956), for instance, magnificent in its execution, captures something ineffable about that place which is continuous with its overriding importance for the Dreaming stories which subsist there. It is this revolution in continuity which also adds to Namatjira's modernist achievement, and makes his role in the past a part of the Australian national *present*. It should, in principle, force the 'between two worlds' rhetoric to disappear into irrelevance.

But no. Even in the 1980s, Vivien Johnson saw the painting of the BMW (Michael Jagamara Nelson's *BMW Art Car Project,* 1989) as a complex entanglement of Western Desert iconography and the ideals (and nostalgias) of a modern global corporation. The Aboriginalized car symbolizes 'the collision of...two realities', according to Vivien Johnson.[25] And further, Margo Neale wrote recently that 'Trevor Nickolls, working in isolation, articulated themes that were typical of the time' (the 1980s). He described his paintings as 'a marriage of Aboriginal culture and Western culture to form a style called *Traditional Contemporary—From Dreamtime to Machinetime*'.[26] Similarly, 'Arone Raymond Meeks attempted to explore and strengthen the existing links between *urban* and *traditional* Aboriginal thought and culture.'[27] This culturally reconstructive project of linkage to the traditional may be very interesting and viable, but it seems to set up a conceptual geography (urban versus traditional) which is quite different from that of settler artists.[28] Where do the 'traditions' of the latter lie, in Europe, Australia, or elsewhere?

The New Zealand scene makes the Aboriginal artist in Australia look like a solitary battler. In Aotearoa, the Maori has always had greater numbers. This is evidenced by a recent exhibition. In late May 2006, the Waikato Museum celebrated, with a show called Aukaha—40 Years On, what was already a 'tradition' of Maori modernism. Forty years ago the same museum had put together a ground-breaking exhibition of contemporary work by artists including Ralph Hotere, Para Matchitt, Selwyn Muru, Fred Graham, John Bevan Ford, Cliff Whiting, Arnold Wilson, and Muru Walters. And now they were able to bring back many of those artists and some of their

[24] French, *Seeing the Centre,* 134.
[25] Quoted in Ken Gelder, 'Aborigines and Cars', in Sylvia Kleinert and Margo Neale (eds), *The Oxford Companion to Aboriginal Art and Culture* (Melbourne: Oxford University Press, 2000), 449.
[26] Margo Neale, 'United in the Struggle: Indigenous Art from Urban Areas', in Kleinert and Neale (eds), *The Oxford Companion to Aboriginal Art and Culture,* 270.
[27] Ibid.; our emphasis. [28] Ibid.

contemporaries. Co-curator Leafa Wilson said that this generation of artists challenged established views of Maori art. 'They were using something that wasn't foreign, it was just different. The means with which Maori stories were usually coming out were through kowhaiwhai panels, tekoteko, the carvings. Now they were coming out through paintings,' she said.[29] This changing cultural continuity would be supported by anthropologist Nicholas Thomas: 'Thomas sees both traditional and modernist approaches as part of a living historical process in which even traditional indigenous forms turn out always to have been slowly evolving,' says his reviewer.[30]

Few seem prepared to talk of these indigenous artists as if they were simply like Picasso, a modern artist responding in a highly creative fashion to the complications of their times, for instance by incorporating the primitivism of African masks, without the agonistics of a 'clash of cultures'. These agonistics constitute one of the triggers for a narrative of failure which is always on the point of emergence in the white discourses on Aborigines, while the success is transferred to the now collectable objects where the aesthetic lives on in Namatjira's famous watercolours, now trading at greater and greater value. Or an Aboriginal aesthetic can acquire grandeur and magnificence when it is coupled to technology and the major industry for tourist promotion: the airlines. The indigenous company Balarinji has painted Qantas jets with original artwork, and this produces a quite different effect. The 'modern' is finally allowed to stick: 'On the approach to Sydney, the chief steward may be heard to announce, proudly, that "You are now travelling in the world's largest modern art work."'[31]

The definition of modernism has been adapted in this chapter to accommodate indigenous Antipodean modernisms. It is an aesthetic involving cultural labour identified with creative, adaptive life in current milieux. To accept indigenous modernism and modernity means refusing the idea of aspiration to that modernity *some time in the future*. It is concomitant with a cultural citizenship that does not preclude cultural difference, and the emphasis on modernities in the plural means abandoning two sorts of colonialist temporal disjunctions indicated earlier: first the colonials who had to catch up to Europe, then the indigenous peoples who had to catch up to the colonials. The era of this double dislocation seems to be in the process of passing, if we are to believe the flight steward in the Qantas jet colourfully transformed by Balarinji.

[29] Leafa Wilson, *Waatea News Update*, <http://waatea.blogspot.com/2006/05/anne-delamere-influential-maori-civil.html>.

[30] Larry Shiner, Review of Nicholas Thomas, *Possessions: Indigenous Art/Colonial Culture*, *Journal of Aesthetics and Art Criticism*, 60/2 (Spring 2002), 197.

[31] Cited in Neale, 'United in the Struggle', 277.

CHINESE MODERNISMS

STEPHANIE HEMELRYK DONALD
YI ZHENG

POLITICAL AND CULTURAL MODERNITY

THE following short account of Chinese modernisms is neither complete nor without contention, but we do hope that three useful starting points will emerge. First, the modern is and has always been a political project, or a series of projects that emerge as part of a seismic shift in the way in which a social world experiences itself and the encroachments of the wider world, but also a direct result of action and decisions made by a new generation of intellectuals and artists. In China, the role of the intellectual has been closely related to political innovation and that relationship cannot be laid aside in literary history. Second, despite the political impetus to much of what we describe below, and much else besides, one must also recognize as independently valuable the aesthetic adventures on which so many writers, artists, and film-makers embarked over the 1920s–1940s. Whether or not one subscribes to the tendencies and groups as coherent movements, or as literary adventurers and enthusiastic experimenters, the best of the work of the period has had powerful effects on contemporary art and literary practice and provides startling aesthetic links across the phases of twentieth-century history and back into the imperial past. Third, the role of film in the shaping of a modern sensibility in China is a subject that we do not address here to the degree that the medium deserves, although it has been

discussed in more detail elsewhere.[1] We would therefore ask the reader to account for film in the Chinese modern, when pursuing the subject beyond this introduction. Finally, we acknowledge that the Chinese modern has had a separate rendition across the years between the Socialist Liberation in 1949 and 1980. This revolutionary modernity and its accompanying aesthetics are, however, so discrete from the Chinese modern of the early twentieth century that it would take a longer work to do justice to this complexity. Again we can only exhort the reader to bear in mind not only the current Reform era, but also the works of revolutionary consciousness (including, for example, the poster art of the 1950s–1970s) when investigating the formations of modernity in Chinese art and literature of the past century.

It is impossible to separate key periods of Chinese sociopolitical change from the modernist interventions of Chinese artists, writers, and scholars. From the early modernity of the late Qing dynasty (1644–1911) to the Reform era of today (1976–), highly charged debates on China's place in the modern world have been coterminous with cultural practice and political activism. And, while the contemporary avant-garde is not always as radical as one might expect, nonetheless, the habit of discussing politics through art continues. As a rule of thumb, there is a continuity across Chinese modernist experiments in literature and aesthetic theory that reiterates and critiques China's perceived mistakes on the political scale, however contradictory. On this trajectory, China's 'mistakes' include succumbing to colonial interference from the West, resisting the benefits of modernization through the key decades of 1950–80, and then falling headlong into the consumer modern in the Reform era.[2]

Despite the seeds of modern thinking evident in the poetry of the nineteenth century, the painting of the Ming (1368–1644), and their materialization in the political thoughts of Kang Youwei and Liang Qichao in the 1890s,[3] extant histories generally cite the New Culture movement (1917) as the beginning of cultural modernity in China. The New Culture movement was an intellectual cultural revolution culminating in the May Fourth (1919) student protest against the Treaty of Versailles and the continuing influence of Japan in China's trade and current affairs.[4] Here we would concur with those such as David D. W. Wang who consider the modern to

[1] S. H. Donald and P. Voci, 'China: Cinema, Politics and Scholarship', in J. Donald and M. Renov (eds), *The Sage Handbook of Film Studies* (London: Sage, 2008), 54–73.

[2] See Shu-mei Shih, *The Lure of the Modern: Writing Modernism in Semicolonial China, 1917–1937* (Berkeley: University of California Press, 2001), and Xudong Zhang, *Chinese Modernism in the Era of Reforms* (Durham, NC: Duke University Press, 1997).

[3] See Kang Youwei, *Ta T'ung Shu: The One-World Philosophy of K'ang Yu-wei*, trans. Laurence G. Thompson (London: Allen & Unwin, 1958); Teng Ssu-yu and John K. Fairbank, *China's Response to the West: A Documentary Survey, 1839–1923* (Cambridge, Mass.: Harvard University Press, 1979); Liang Qichao, *History of Chinese Political Thought During the Early Tsin Period*, trans. L. T. Chen (New York: AMS Press, 1969); Liang Qichao, 'Selections from *Diary of Travels Through the New World*', trans. Janet Ngt, Earl Tai, and Jesse Dudley, *Renditions*, 53–4 (Spring–Autumn 2000), 199–213.

[4] Wang Yao, *Zhongguo xinwenxueshi chugao* ('A Draft History of New Chinese Literature'; Hong Kong: Bowen shuju, 1972); Lin Yushen et al. (eds), *May Fourth: A Multi-Angled Reflection* (Hong Kong: United Publishers, 1989).

date from the Qing period,[5] while noting that the literary scholar and intellectual historian Wang Hui traces modernity's economic and cultural emergence in China to a much earlier period—to late Ming and the last Chinese imperium.[6] Wen-hsin Yeh, on the other hand, emphasizes that the spread of modernity in China rested on material and cultural change in the everyday sphere, which arose from gradual industrialization and new forms of urban organization. There was no single revolutionary moment prior to 1949 when the world turned upside down.[7]

Nevertheless, most historians and interpreters of Chinese modernity agree that certain events since late Qing (roughly the mid-nineteenth century) have imposed a direction upon how the modern is experienced and understood. The Opium Wars, also known as the Anglo-Chinese Wars, lasted from 1839 to 1842 and 1856 to 1860 respectively. China's defeat in both wars forced the Qing court into signing the Treaty of Nanking and the Treaty of Tianjin, also known in China as the Unequal Treaties. These agreements included provision for the opening of additional ports to foreign trade, for fixed tariffs, and the secession of Hong Kong to Britain. The British also gained extraterritorial rights. Several countries followed Britain and sought similar agreements with China. Many Chinese found this situation humiliating, and such sentiments are considered to have contributed to the Taiping Rebellion (1850–64), the Boxer Rebellion (1899–1901), and, eventually, the downfall of the Qing dynasty in 1911.[8] Thus, it is understandable that, while modernity and attendant modernisms were well under way in the nineteenth century, their provenance and context made it preferable to nominate a later inception, which could allow for radicalism without any imperial content. However, there was strong modern opposition to national humiliation far earlier than 1919.

The first collective political and intellectual response to the challenge of Western military and technological superiority was the Self-Strengthening movement (1860s–1870s). This arose when a number of Chinese officials and intellectuals became convinced that China needed to adopt the technologies and military practices of the West if it were to remain a sovereign state. From the 1860s to the 1890s, the Qing court instituted reforms designed to achieve these goals. Furthermore, the defeat in the First Sino-Japanese War (1894–5) convinced radical thinkers that sociopolitical changes were needed if the technological and military advancements were to succeed. Their response was the Wuxu Reform, or the Hundred Days' Reform, a 104-day national cultural, political, and educational reform movement in 1898, led by Kang Youwei and Liang Qichao. The reformists advocated the

[5] Wang David Der-wei, *Fin-de-Siècle Splendor: Repressed Modernities of Late Qing Fiction, 1848–1911* (Stanford, Calif.: Stanford University Press, 1997); see also Jon Kowallis, *The Subtle Revolution: Poets of the 'Old School' During Late Qing and Early Republic China* (Berkeley: Institute of East Asian Studies, 2006).

[6] Wang Hui, 'Dao Lun' ('Introduction'), in *Zhongguo xiangdai sixiang de xingqi* ('The Rise of Modern Chinese Thought'), 4 vols (Beijing: Sanlian shudian, 2004), 1–102.

[7] Wen-hsin Yeh, 'Introduction', in Yeh (ed.), *Becoming Chinese: Passages to Modernity and Beyond* (Berkeley: University of California Press, 2000), 1–30.

[8] J. Mason Gentzler, *Changing China: Readings in the History of China from the Opium War to the Present* (New York: Praeger, 1977).

imitation of measures taken in Japan and Russia regarding how best to manage political and social systems under imperial power. Their efforts ended in failure with a *coup d'état*, the Coup of 1898, by powerful conservative opponents. Despite the immediate disappointment, this failed reform did lead to far-reaching institutional and cultural changes. The most influential was the abolition of the Imperial Civil Service examination (1905), which until that point had determined the membership of the ruling class and the structure of the bureaucracy, and was the bedrock of the imperial system of officialdom. As a replacement to the examination system, the Qing government started building what they understood to be modern colleges. There were 60,000 of these by the time of the Republican Revolution in 1911. Meanwhile, the constitutionalism campaign started out with an elaborate outline of constitutionalism but ended with an already powerful prince (from the Qing imperial line) being chosen as prime minister, and seven out of the thirteen members of the cabinet being drawn from the imperial family. Radical constitutionalists changed their political methods after this failure, supporting revolution instead of constitutionalism in their effort to save the nation. Despite their limited success, these reform measures, plus the formation of new, Western-style, modern armies and rampant anti-Manchu (non-indigenous ruling class of the Qing) sentiment, were important precedents to the Xinhai Republican Revolution, which began with the Wuchang Uprising on 10 October 1911 and ended with the abdication of Emperor Puyi on 12 February 1912. The Xinhai Revolution effectively ended the Qing dynasty and millennia of powerful imperial rule. It is generally considered to have ushered in a new era and marked the beginning of Chinese political, economic, and cultural modernity.

Concurrent with these political and social upheavals, radical advocacy for cultural reform augmented the sense of crisis. There were those who questioned traditional Confucian values and facilitated the introduction of Western ideas through translation, both sentiments in turn supported by the rise of journalism and changing social expectations towards literature. The latter in particular resulted in the late Qing–early Republican boom in fiction as political tool and social critique. Of most lasting consequence to modern Chinese cultural history in both literary and visual domains, and including revolutionary modernism and post-revolutionary postmodernism, was the beginning (1895–1911) of what later became the Vernacular (*baihua*) movement of the 1910s and 1920s. In October 1919, the National Federation of Education Associations called for the government to sanction educational use of the vernacular language, instead of classical Chinese. In the first half of 1920, the Ministry of Education ordered that the written vernacular replace classical language in all grades of primary school. There are no exact equivalents to the magnitude of this shift, but Europeans might compare the move from Latin to the local vernacular as a primary form of written communication, and Arab speakers could reference the gap between modern spoken Arabic and the language used in classical Arabic scripture and literary texts. In all these cases, contemporary users of the older language must undertake instruction and long years of effort to access their written heritage. Likewise, older systems excluded all but the most privileged readers.

MAY FOURTH AND MODERNIST BEGINNINGS

The years immediately following the 1911 Revolution are remembered as a series of failed promises. The resulting de facto warlord governments (1916–27) proved no more promoters of modernization than guarantors of national interests. Recently, however, scholars have argued that there were elements of democratization evident in the leadership of some local power brokers, and indeed point out that 'warlordism' is a term that suits the historical perspective and self-legitimization of the Chinese Communist Party. Frank Dikötter has suggested, indeed, that the history of warlordism is 'counterfactual', and that a genuine comparison with the Qing era and the post-1949 period would suggest that 'dispersed government' was far from perfect, but not as much a failure as generally opined.[9] Furthermore, Louise Edwards has suggested that the gendered politics of the period were superior in some ways and some places to the generalized assumptions of chaos and corruption sustained through historical summaries written after 1949.[10]

With these caveats in mind, and recognizing that the history of the May Fourth movement is a legitimizing foundation of the Chinese Communist Party and is therefore politically sacrosanct, some of the historical givens are still warranted. The main issue that young intellectuals held against the federal system was continuing weakness in the face of foreign powers, and poor integration of regional and national interests. It was against this background of disenchantment that the intellectual revolution, the New Culture movement (1917), began. It was led by intellectuals who had decided that political reform should be preceded by a far-reaching cultural enlightenment. Thus, they held up for critical scrutiny nearly all aspects of Chinese culture and tradition. Inspired by alien concepts of individual liberty and equality, and the ideals of democracy and science, they sought a far more serious reform of China's institutions than that which had resulted from the Self-Strengthening movement and the early promise of the Republican revolution. They directed their efforts particularly to China's educated youth.

Young Chinese fury at the concessions to Japan embedded in the Treaty of Versailles, and especially at the continuation of colonial rule in Shandong Province, culminated in what was later called the May Fourth Incident. The anti-imperialist student protest which began on 4 May 1919 became a major cultural and political movement. It was no less than an attempt at a combined intellectual and sociopolitical movement to achieve national independence, the emancipation of the individual, and a just society. These huge aims were to be achieved through the modernization of China. The movement's leaders operated under the assumption that intellectual changes would lead to modernization through an embrace of intellectual, artistic,

[9] Frank Dikötter, *The Age of Openness: China Before Mao* (Hong Kong: Hong Kong University Press, 2008), 7–14.

[10] Louise Edwards, *Gender, Politics and Democracy: Women's Suffrage in China* (Stanford, Calif.: Stanford University Press, 2008).

and industrial development.[11] In reality, although the movement's iconoclastic attack on the socially fragmented, hierarchical structure of Chinese society may have contributed to the eradication of cognitive and social barriers to the consolidation of a nation state and to domestically driven industrialization, it was at heart a cultural revolution. Most significantly, although variously characterized as a Renaissance, the Chinese Enlightenment, or a Romantic Era,[12] the movement led to the embrace of Marxism both in the cultural sphere and as a political ideology. May Fourth is now considered the foundational cultural legacy of the second revolutionary war and victory, which established the People's Republic of China in 1949.

Cultural iconoclasm was a key mobilizing force within the events and activities of the movement. Passionate critiques of Confucianism, traditional customs and habits, oppression of women, superstition (*mixin*), and the ethical system of ritual (*li*) dominated the cultural debates and were the major themes of literary creation. They were aided by 'translingual practices' that translated, appropriated, and transformed Western ideas, systems of thought, and cultural forms.[13] While major universities, notably Peking, served as the location for the intellectual ferment, journals such as *New Youth* (1915–26), edited by Hu Shi and Chen Duxiu, functioned as the foundational forums for the New Culture movement, promoting science, democracy, and vernacular literature.

Modernist experimentation in literature and aesthetic thought was central to the May Fourth movement.[14] European and Japanese modernist writers had been translated and introduced to China from the beginning of the twentieth century. Modern Chinese literature is indeed self-defined as a component part of world literature. And, while key figures of both the New Culture movement and New Chinese literature such as Lu Xun and Guo Moruo are claimed as defining figures in the more dominant modes of social realism and Romanticism in received histories, they should be simultaneously credited as modernist in their aesthetic vision and formal practices.[15]

[11] Chow Tse-tung, *The May Fourth Movement: Intellectual Revolution in Modern China* (Cambridge, Mass.: Harvard University Press, 1960), 338–55.

[12] Vera Schwarcz, *The Chinese Enlightenment: Intellectuals and the Legacy of the May Fourth Movement of 1919* (Berkeley: University of California Press, 1986).

[13] Lydia H. Liu, *Translingual Practice: Literature, National Culture, and Translated Modernity—China, 1900–1937* (Stanford, Calif.: Stanford University Press, 1995).

[14] Kirk Denton, *Modern Chinese Literary Thought: Writings on Literature 1893–1945* (Stanford, Calif.: Stanford University Press, 1996). As Denton shows, there have been different waves of modernist movements in art, architecture, cinema, literature, and aesthetic theory in China since the beginning of the twentieth century. This present chapter focuses on the early twentieth-century Chinese modernist aesthetic and literary practices with brief discussions of their *fin-de-siècle* revival as a post-socialist avant-garde movement. For comprehensive accounts of Taiwanese modernist literature in relation to the cultural history of Taiwan, see David Der-wei Wang and Carlos Rojas (eds), *Writing Taiwan: A New Literary History* (Durham, NC: Duke University Press, 2007); Sung-sheng Yvonne Chang, *Modernism and the Nativist Resistance: Contemporary Chinese Fiction from Taiwan* (Durham, NC: Duke University Press, 1993).

[15] Marston Anderson, *The Limits of Realism* (Berkeley: University of California Press, 1990); Leo Ou-fan Lee, *The Romantic Generation of Modern Chinese Writers* (Cambridge, Mass.: Harvard University Press, 1973).

Modernist invention was significant in the years after the May Fourth moment. In 1920 Tian Han and Shen Yanbing, through the journals *New Youth* and *Transformation*, introduced neo-Romanticism as the newest development in modern Western literature.[16] They observed that, since the end of the nineteenth century, while capitalist material civilization had become highly developed, its social limitations were also apparent. The First World War was, in their opinion, the culmination of the social decay of capitalism. It led to a need for spiritual consolation rather than material wealth. This was for them the social-historical *raison d'être* of neo-Romanticism. Their position is especially interesting from the perspective of contemporary Chinese art practice, where the Reform era now evidences some dissatisfaction with wealth-based value systems and a generation of young people disillusioned with a post-ideological existence.

Neo-Romanticism was a reaction to nineteenth-century Naturalism, and emphasized the symbolic representation of the subjective and mythical realms of life. It was subsequently referred to as aestheticism, literature of decadence, and Symbolism, and its essence was epitomized for Chinese neo-Romantics by the works of Charles Baudelaire, Paul Verlaine, Arthur Rimbaud, and Stéphane Mallarmé. Futurism, Expressionism, Dadaism, Imagism, Surrealism, all followed the defeat of Naturalism.[17] Shen Yanbing (Mao Dun) in particular emphasized that the set path for the New Chinese Literature was neo-Romantic. He argued that if modern Chinese literature were to join the literatures of the world, then it must engage in a period of emulation of Western literary experiment.[18]

The early practices of modernism on the Chinese literary scene may be characterized as attempts at coherence with the literary development of the outside world, reflecting the sense of belatedness and urgency that plagues late-developing modernities. This has been pointed out by a number of critics and is sometimes perceived as a lack of critical originality. Some even conclude that this demonstrates that the Chinese modernist impulse is defined and limited by its semi-colonial condition.[19] However, their eagerness to be modern and culturally relevant in the international sphere did not necessarily indicate a lack of critical judgement on the part of Chinese intellectuals. The choices made by the innovators demonstrated not only an appreciation of newness but also an unmistakably critical approach to foreign cultures and sources. Modernism operated as a cultural inoculation against the overweening imperial power derived from European modernization, and thus especially as a riposte to the imperialism and sub-imperialism of China's own governance in the long period of humiliation leading up to the First World War and its immediate aftermath.

[16] Tian Han, 'Xinlangman zhuyi jiqita' ('Neo-Romanticism and Other Things'), *Youth of China*, 1/12 (June 1920), 24–52; Shen Yanbing, 'A Suggestion for the New Literature Specialists', *Transformation*, 3/1 (Sept. 1920), quoted from Ma Liangchun and Zhang Daming et al., *Zhongguo xiandai wenxue sicao* ('The History of Modern Chinese Literary Development'; Beijing: Shiyue wenxue chubanshe, 1995), 908.

[17] Ma and Zhang et al., *Zhongguo xiandai wenxue sicao*, 906–7.

[18] Ibid. [19] See e.g. Shih, *The Lure of the Modern*.

DISSONANCE AND CONTINUITY

Our contention is, then, that early twentieth-century Chinese modernists made evaluative and critical distinctions among different modernist movements. Chinese neo-Romanticism in 1920 involved a critical rethinking of capitalist modernity and its literary implications. Futurism, for instance, was introduced even though Chinese interpreters decided it was somewhat ridiculous and glossed it as such. As early as 1914, Zhang Xichen had already translated and presented Futurism in the context of transnational movements from Italy to Japan. In an article he translated from an unknown Japanese author, 'World-Wide Futurism', the subtitles captured the defining qualities and national presumptions of these aesthetic experiments: 'What Is Futurism?', 'Destruction of Old Civilization', 'Eulogizing Modern Mechanical Civilization', 'Eulogizing War Literature', 'English, American, and French Futurisms', 'Russian Futurism', 'Futurist Menu', and 'Japanese Futurism'.[20] In 1921 Song Chunfang translated Futurist plays and characterized them as mad and farcical.[21] Guo Moruo disavowed Futurism as a cultural expression, commenting that it was 'a freak birth out of extreme materialism ... It believes all that is now is worth representing. All human desire and ambition worth affirming, even the money-grabbing instincts. Therefore capitalism, even war, becomes something praise-worthy.'[22]

Guo's critique may be more reductionist than aesthetically discerning, but it does show that, even in their eagerness to catch up with the modernized world, the early twentieth-century Chinese modernists marked their differences and made their choices. Ambivalence to capitalist modernity as well as to its cultural expression runs throughout their judgements. Mao Dun, while he appreciated the aesthetic impulses of Futurism, most especially its fascination with power, speed, noise, and chaos, similarly critiqued its blind worship of these qualities, which he felt demonstrated the Futurists' wrongful capitalist consciousness.[23]

Symbolism, meanwhile, became one of the most influential aesthetic and poetic movements in the history of modern Chinese literary culture. It similarly began as a translated, transplanted modernist practice modelled on European prototypes, but it gradually emerged as a major creative component in the formation and transformation of modern Chinese poetry. From 1919 onwards, Symbolist poetry and drama were systematically translated and introduced. Translators of Symbolist poetry noted its emphasis on suggestion and ambiguity, and its reliance on the use of evocative

[20] Zhang Xichen, 'Worldwide Futurism', *Dongfang zaozi* ('Oriental Journal'), 11/2 (1 Aug. 1914); quoted in Ma and Zhang et al., *Zhongguo xiandai wenxue sicao*, 911.

[21] *Dongfang zaozi* ('Oriental Journal'), 18/13 (10 July 1921); *Xiju* ('Drama'), 1/5 (30 Sept. 1921); both quoted in Ma and Zhang et al., *Zhongguo xiandai wenxue sicao*, 911.

[22] Guo Moruo, 'Weilaipai de shiyue jiqi piping' ('The Poetic Covenant of Futurism and its Critique'), *Chuangzao zhoukan* ('Creation Weekly'), 17 (Sept. 1923); repr. in Guo, *Moruo wenji* ('Collected Works of Guo Moruo'), x (Beijing: Renmin wenxue chubanshe, 1959), 38–41.

[23] Fang Bi, *Xifang wenxue jieshao* ('Introduction to Western Literature'; Shanghai: Shijie shuju, 1930), 244–5.

subjects and images rather than explicit analogy or direct description. They also, however, pointed to Symbolism's interest in the concept of the inner life, the macabre, the mysterious, and the morbid, all of which were central to the fascinations of the European *fin de siècle*. The Chinese advocates of Symbolism unsurprisingly lauded the images of the profane, the decadent, and the sensual, introduced by poems such as those collected in Baudelaire's *Les Fleurs du mal* (1857).[24] What is of most interest, perhaps, is that, although many commentators and translators highlighted the timely quality of the movement as anti-Romantic and anti-realist, they also pointed out that the typical Symbolist practices of suggestion, ambiguity, and evocation were reminiscent of classical Chinese poetry. The latter was, of course, the target of the modern poetic revolution. Nonetheless, in the manner of the 'almost symbolic' mannerisms of Ming dynasty scholar painting, it now appeared that Chinese poetic practice had been modernist centuries before the event. Thus, the continuity between the late imperial Chinese modern and translated post-imperial modernism was especially evident in the Symbolist movement.

Symbolism is a rare instance in modern China where a non-mainstream literary trend has become relatively established and influential. It was introduced in the first decade of the New Culture, New Literature movement, and continued to be a noted literary practice until the late 1940s, just before the establishment of the People's Republic of China. In the later years of the Second World War and the post-war years, when nationalism and then a radicalized left cultural turn held sway, it had begun to sound a more dissonant note. Nonetheless, its imprint on modern Chinese poetry is irrevocable.

Li Jinfa, whose poetic career is mostly limited to the few years when he was studying in Paris, is usually regarded as the first Chinese Symbolist poet. His poetry collections *Wei Yu* ('Drizzle') and *Sike yu xiongnian* ('The Gourmand and the Year of Ill Fortune') were completed between 1920 to 1923, and published in 1925 and 1927 when he came back to China.[25] Li had aimed to seize the best of both the Chinese and European poetic traditions and to create new poetic possibilities in their harmonious correspondence. This, shown most often in a mixture of classical and modern diction, underpins his claim that poetry is not the clarion call of the times but a product of sensations and emotions. His insistence that the poet should capture images, record inspirations, and re-create them according to his associations free from external objects and consciousness, strikes a discordant note in the rhetoric of the modern Chinese literary revolution, and poses a particular problem for post-1949 literary historians. Even standard histories cannot discount him as a simple admirer of decadent Western tradition, for he was also critical, and powerfully so. He wrote in 'Life's Ennui' that the Europe he was witnessing was a morass, where

[24] Ma and Zhang et al., *Zhongguo xiandai wenxue sicao*, 370–81.
[25] Li Jinfa, *Wei Yu* ('Drizzle'; Beijing: Beixin shuju, 1925) and *Sike yu yiongnian* ('The Gourmand and the Year of Ill Fortune'; Beijing: Shangwu yinshuguan, 1927).

massacres of history
shrieks of hunger,
forever harass me outside my door,
my heart and soul cower.[26]

Li, however, was most devoted to recording the poet's sensations, expressing his unnameable moods, capturing human dreams and psychosexual details. He used symbols to describe melancholia, to suggest the soul's struggle through verse notorious for its mystery, emptiness, and obscurity. The first poem in *Drizzle*, 'Woman Forsaken', is an internal monologue of a forsaken woman. The poet expresses her sorrowful bitterness as a social outcast. For Li, the image of the forsaken woman is not a sign of proto-feminist outrage, but a mistier symbol of human fate, wherein life is no more than a woman forsaken, hovering between life and death at the graveyard.[27] Choosing the trope of a woman forsaken by men as the epitome of tragic inevitability, the poet rewrites modern life as unjust and lonely, and retains its masculinist centre.

POETIC MODERNISM

There are recurrent themes and frequently used metaphors in Li's poems: the graveyard, death, grey dreams, the lonely traveller, evening bells, moss, the mad soul, melancholia, the Devil, hell, a fallen flower petal. All would appear anathema to the progressive modernization themes of the New Culture movement. While opening up new poetic horizons both in terms of imagery and sensibility for the modern Chinese poetic experimentation, these figures and metaphors also earned Li the title of 'the poet of anomaly', which is perhaps code for historians having no idea how to place him effectively in the legitimate historical teleologies established after 1949.[28]

Dai Wangshu is acknowledged not only as a mature Symbolist but also as a major modern Chinese poet.[29] His influence crosses over different schools and extends over several decades. Dai studied French literature in Shanghai Zhen Dan University in the 1920s. He was an avid reader of Verlaine and Baudelaire in the original. He went to France in 1932 to study and travel, and returned to China in 1935. Dai started writing and publishing poetry in 1922. His acknowledged Symbolist years are the two decades after 1925. He published altogether ninety poems in four collections, *Wode*

[26] In Ma and Zhang et al., *Zhongguo xiandai wenxue sicao*, 467; trans. modified.
[27] Li Jinfa, 'Woman Forsaken', in Michelle Yeh (ed.), *Anthology of Modern Chinese Poetry* (New Haven: Yale University Press, 1992), 18.
[28] Ma and Zhang et al., *Zhongguo xiandai wenxue sicao*, 477.
[29] Ibid. 503.

jiyi ('My Memory'), *Wangshu cao* ('Wangshu Grass'), *Wangshu shige* ('Poems of Wangshu'), and *Zainan de suiyue* ('The Disastrous Years').[30]

Dai was also a major translator of modern French, English, and Spanish poetry into Chinese. Almost all his translations have supplementary explanations, detailing technical considerations as well as characterizing the translated poets and their practices. As a supplement to his translation of Baudelaire's *Les Fleurs du mal*, Dai comments, 'as to those who censure Baudelaire's work and claim it to be poisonous, who worry that he will mislead new Chinese poetry, the proven history of literature will give them a better answer. A more profound understanding of Baudelaire himself will also lead to a different opinion. This will be true if one does not imitate him superficially.'[31]

Dai's poetic vision and theory centred on the idea of poetic moods. The poet's mood defines the poem's content and its form. The change of moods determines changes within a poem, its colour, and its rhythm. A poem is thus 'an expression of the harmony of moods in words'.[32] Mood swings literally constitute the rhythm and rhyme, the musicality, of the verse. Also, in Dai's schema, poetry is not the sensory enjoyment of sound, vision, taste, or touch alone. Rather, it provides the summation of all sensual or super-sensory pleasures. Dai emphasizes the movement and structure of moods as both poetic form and content. Just as moods always change, so are they always in flux, and thus should all external poetic form move and sway. The same flower, grass, tree, leaf, ray of light, and bird in nature may produce different moods and poetic expressions if seen and experienced in different frames of mind and heart. This is the basis of Dai's symbolic correspondence, and again we recognize here the echoes of visual art practice in the landscape (*shanshui*) traditions, and in Buddhist-inspired renditions of tree, water, and stone in particular.

Dai's best-known poem, *Alley in the Rain*, can be described as a demonstration of the poet's pursuit of a modern musicality in the new vernacular lyrical form (as opposed to the classical Chinese metric system). It displays his poetic ideal of fluidity of form and suggestive thematic ambiguity. As a poem that emphatically embodies the poet's moods into suggestive but ambiguous symbols, it reveals subtle fusions of the late Tang (827–860) mode of poetic lamentation of life's inevitable melancholia and Verlaine's scheme of the necessary mixing of ambiguity and accuracy in poetic imagery:

> With an oil-paper umbrella, alone I
> Wander in a long
> Lonely alley in the rain,
> Hoping to meet
> A melancholy girl

[30] Dai Wangshu, *Wode jiyi* ('My Memory'; Shanghai: Shuimo shudian, 1929); *Wangshu cao* ('Wangshu Grass'; Shanghai: Xiandai shuju, 1933); *Wangshu shige* ('Poems of Wangshu'; Shanghai: Xiandai shuju, 1937); *Zainan de suiyue* ('The Disastrous Years'; Shanghai: Xingqun chubanshe, 1948).
[31] Dai, 'Houji' ('Supplement'), in *Les Fleurs du mal* (Shanghai: Huaizheng wenhua chubanshe, 1947).
[32] Dai, 'Wangshu lunshi' ('Wangshu on Poetry'), *Xiandai* (*Les Contemporaines*), 2/1 (Nov. 1932), 92–4.

Like a lilac ...
She drifts by like a lilac
In a dream;
The girl drifts by me.
She walks farther and farther
Until she reaches the broken fence
At the end of the alley in the rain.[33]

The poem has seven stanzas. It describes a lonely youth, presumed to be the poet, who wanders in an alley waiting for the passing of a girl who is like a lilac. Except for the sound of the raindrops on the umbrella, the alley is quiet and melancholic, as is the lilac-like girl in the youth's eyes. The poet–youth's moods take first priority in the poem. They are suggested in the image of the girl in transience, whose lilac-like melancholia is identified and coveted by the poet. The girl herself is drifting outside, indifferent to the poet's feelings and resisting the schema of the poem. The poet's moods are projected onto the drifting of the lilac-like girl, the lonely alley, and the dripping rain. They are ambiguous and unclear, the melancholy and the poet's loneliness are conveyed but unnameable. The images, as symbols of these transient moods and feelings, are also drifting and dripping; they appear only in passing.

Dai's moods and form are now considered the orthodox manifestation of Chinese Symbolism. This is something of a breakthrough, as for years they were judged by official literary historians in Mainland China to be too reminiscent of the old, the Western, and the unhealthy to be representative of the progressive Chinese modern.[34] Dai's poetic vision and practice are also considered by his contemporaries, as well as later Chinese modernists, as the forerunner and cornerstone of a Chinese modernist poetry movement (*xiandaipai*) that became prominent in the 1930s. Poets and critics who identified with this movement described themselves as being no longer content to introduce particular strands of European modernisms, unlike the earlier neo-Romanticists or Symbolists. Rather, they intended to create a 'pure' and 'purely modern' poetry which would capture 'modern life' and 'modern moods' for 'modern people' with 'modern vocabulary' and in 'modern form'.[35] The modern life to which they referred was that experienced in the fast-paced, noisy, greedy, and brutally competitive trappings of modernization in the early decades of the twentieth century. This was a modernity shared with their European and Japanese counterparts (industrial harbours, noisy factories, department stores, jazz clubs, and the First World War are the manifestations of modernity most frequently referenced in their poetic manifesto and practice). They pursued various poetic forms but concentrated on a free-verse form different from both the prosaic tendencies in the earlier vernacular poetic experimentations of the New Culture movement and the strict lines regulated by the classic metric system. They explicitly rejected the functionalist conception of

[33] Dai, 'Yu Xiang' ('Alley in the Rain'), in Yeh (ed.), *Anthology of Modern Chinese Poetry*, 31–2.

[34] Ma and Zhang et al., *Zhongguo xiandai wenxue sicao*, 515–17.

[35] Shi Zhecun, 'You guanyu benkan de shi' ('Again About the Poetry in Our Journal'), *Xiandai* (*Les Contemporaines*), 4/1 (Nov. 1933), 6.

poetry as a tool or weapon for social reform and politics, a stricture which was beginning to take hold in the 1930s in China, and would reach fruition at the Yan'an Talks in 1942, and implementation in the years post-1949.[36] But for now, for both the theorists and poets, modernist poetry, as the most desirable form of modern poetry, should pursue nothing else but pure modern poetic form and moods.

Besides Dai Wangshu, the most notable poets of this self-conscious poetic modernism were Bian Zhilin, Fei Ming, and Xu Chi. The first three were also the acknowledged precursors of the Taiwanese modernist movement in the 1960s. As presaged in Yan'an, this promising beginning of the maturation of modern Chinese poetry was soon ended by the Second World War and by subsequent nationalist and, crucially, socialist political and aesthetic demands.[37]

FICTION AND PSYCHOANALYSIS

The other notable and relatively established modernist literary practice both in its time and through subsequent Chinese cultural history is experimentation in psycho-analytical fiction. In 1920 Jun Chang introduced Freud and the libidinal in his redefinition of poetic creation as the satisfaction of sexual drive.[38] But it was Zhang Dongxun who systematically introduced psychoanalysis, through the work of Freud and Jung.[39] Throughout the 1920s, there were numerous translations and discussions of psychoanalysis and its literary cultural applications, both from European sources and through Japanese interpretation. Zhu Guangqian's studies *The Psychology of Literary Art* (1936) and *Abnormal Psychology* (1933) not only went further in systematically introducing and analysing the Freudian psychoanalytical enterprise, but also proposed that 'those who study literature and art have to understand the concept of sublimation and the function of sexual drives in the human unconscious ... It is therefore imperative to study abnormal psychology.'[40] The translation and study of psychoanalytic literature was carried out through the 1940s and re-emerged at the end of the 1970s to mid-1980s in the Reform era post-Mao.

[36] Ellen R. Judd, 'Prelude to the Yan'an Talks: Problems in Transforming a Literary Intelligentsia', *Modern China*, 11/3 (1985), 377–408.

[37] Ma and Zhang et al., *Zhongguo xiandai wenxue sicao*, 978–9.

[38] Jun Chang, 'Xingyu de kexue' ('The Science of Sexual Desire'), *Dongfang zazhi* ('Oriental Journal'), 17/15 (10 Aug. 1920); quoted in Ma and Zhang et al., *Zhongguo xiandai wenxue sicao*, 931.

[39] Zhang Dongxun, 'Lun jingshen fenxi' ('On Psychoanalysis'), *Mintuo*, 2/5 (5 Feb. 1921); cited in Ma and Zhang et al., *Zhongguo xiandai wenxue sicao*, 931.

[40] Zhu Guangqian, 'Qian yian' ('Preface'), in *Biantai xinlixue* ('Abnormal Psychology'; Shanghai: Shangwu shuju, 1933), 1.

New theories and interpretations of traditional as well as modern Chinese litera-
ture and culture have resulted from the introduction of Freudian psychology. Guo
Moruo was the first to use Freudian psychoanalysis to explicate the classic Yuan
dynasty (1271–1368) play *Romance of the Western Chamber* (by Wang Shifu). Guo
seemed to agree with the Freudian explanation that all literature originates from
libidinal drives, and proposed to reread classic Chinese romances as youthful and
rebellious expressions of sexual repression against patriarchy.[41] Zhou Zuoren, on the
other hand, used the theory of the unconscious to defend his contemporary Yu Dafu.
He argued that Yu's controversial novella *Chenlun* ('Sinking', 1921),[42] which records
in detail the protagonist's conflicts between the flesh and the soul, is a genuine work
of art, a bold psycho-emotional revelation of the self and the collective, and not at all
immoral (as many alleged). For him it is an excellent example of the artistic
sublimation of unconscious sexual repression and personal depression shared by
young people at the time. It is consequently the most representative work dealing
with the frustrations of modern Chinese youth.[43] Guo Moruo described his own
novella *Canchun* ('The Remains of Spring')[44] as a delineation of the characters'
psychological movement rather than a plot narration. He suggests that the story is
best read in terms of psychoanalysis or as an explication of dreams.[45]

Many fiction writers quickly understood the creative potential of the psychoana-
lytic turn in characterization and in the depiction of emotive, internal life. They
realized that the realms of human psyche, the conscious and unconscious, as well as
instincts and desires, were invaluable resources for fictional representations of life as
yet unexplored in Chinese literature. Lu Yin's *Li Shi riji* ('Li Shi's Diary', 1923) is a
poetic exploration of the friendship between two young women. Its homoerotic
overtones, although explicit, are nonetheless conveyed in symbols and dreams. One
day Li Shi finds herself falling deeper and deeper in love with Wan Qing and drifts
into a dream:

I dreamt there was a little stream. By its side stood a graceful cottage; in front there were two
gigantic willows, their branches gently touching the thatched roof; under the willows there
was a small boat. The sun was setting then, and white clouds blocked the sky, Wan Qing and
I were in the boat, rocking to and fro, we drifted further into the reeds. Suddenly it rained, we

[41] Guo Moruo, 'Xixiangji yishu shang de pipang yu qi zuozhe xingge' ('An Aesthetic Critique of *The Romance of the Western Chamber* and the Personality of the Author, 1921)', in *Guo Moruo quanji* ('Complete Works of Guo Moruo'; Beijing: Renmin wenxue chubanshe, 1985), xv. 322–3.

[42] Yu Dafu, 'Chenlun' ('Sinking'), in *Yu Dafu xiaoshuo quanji* ('The Complete Short Stories of Yu Dafu'; Hangzhou: Zhejiang wenyi chubanshe, 1991), 23–34.

[43] Zhou Zuoren, 'Chenlun' ('On Sinking'), *Chengbao fukan* ('Morning Post Supplement'), 26 Mar. 1922; repr. in Chen Zishan and Wang Zili (eds), *Yu Dafu yanjiu ziliao* ('Research Materials on Yu Dafu'; Hong Kong: Sanlian shudian, 1986), 1–5.

[44] Guo Moruo, 'Canchun' ('The Remains of Spring'), in *Guo Moruo quanji*, ix. 20–35.

[45] Guo Moruo, 'Piping yu meng' ('Criticism and Dreams'), *Chuangzao jikan* ('Creation Quarterly'), 2/1 (1 May 1923); repr. in Wang Xunzhao et al. (eds), *Guo Moruo yanjiu ziliao* ('Research Materials on Guo Moruo'; Beijing: Zhongguo shehui kexue chubanshe, 1986), i. 169.

were protected by the reeds so could not see the drops, but we heard the unceasing sound of their falling ... Now recalling the dream, isn't it what we always wanted?[46]

Clouds and rains are standard metaphors in classical Chinese for sexual intercourse. A thatched cottage, weeping willows, and a boat on the stream provide the typical setting for traditional love stories. These explicit references within the dream make the psychosexual evocation of the narrative very clear. Shi Zhecun, who was the editor of the journal *Xiandai* (*Les Contemporaines*), around which the previously discussed modernist poets gathered, not only writes about sexual libidinal drives and their effect on the human psyche, but also probes their distortion. His short story 'Meiyu zixi' ('Monsoon Eve', 1933) was understood as a demonstration of the unconscious, in particular of repressed sexual stirrings.[47] It tells the story of a city man on the way back from his work in the rain, and his encounter with an unknown young woman and consequent psycho-emotional activity. The whole story is a non-sequential process of free association of the protagonist's instincts, impressions, and fantasies; his conscious musings and unconscious desires. The pre-monsoon drizzle, the pedal-cab ride, the peep of a shop girl, and the pointed, phallic umbrella which the man holds in his hand, all contribute to a revelation of the psychosexual unconscious of the protagonist and of the city streets as an active player in modern human psycho-emotional consciousness. *Cun Yang* ('Spring Sunshine', 1936) is even more direct in its depiction of the effect of sexual repression on an old spinster whose unexpected riches had ruined her chances of marriage.[48] The narrative centres on her sudden sexual awakening one fine spring morning and the disturbing consequences thereof. The Freudian reference is here thematic rather than structurally employed. As an avowed modernist, Shi wrote numerous short stories and novellas about sexual repression, displacement, sublimation, and distortion, which also necessarily meant that he was consistently experimental in his narration. He relied on suggestive symbols, free association, and stream of consciousness, avoiding sequential accounts of temporal and spatial cause and effect. These works, and those of Li Jianwu among others, placed the individual psyche at the disposal of the first cultural revolution. Although dormant for most of the second half of the twentieth century, their gift has been recuperated in contemporary film, arts, and literature. The scope of this chapter does not permit us to investigate the cultural individualism of the twenty-first century, but we would suggest that the impact of the Freudian psyche is still under-estimated in scholarship on Chinese culture.

[46] Lu Yin, 'Li Shi riji' ('Li Shi's Diary'), in Ren Haideng (ed.), *Li Shi riji* (Beijing: Beijing yanshan chubanshe, 1998), 37.

[47] Shi Zhecun, 'Meiyu zixi' ('Monsoon Eve'; Beijing: Xinzhongguo shuju, 1933).

[48] Shi Zhecun, 'Spring Sunshine', in *One Rainy Evening*, trans. Rosemary Roberts (Beijing: Panda Books, 1994), 99–111.

NEW SENSATIONALISM

The New Sensationalist school grew from the precedents offered by both psychoanalytic knowledge and Symbolism. Its first practitioner, Liu Na'ou, introduced the term and its assertions from Japan in his translation of modern Japanese literature.[49] Liu and his fellow New Sensationalists were interested in the sensations of the moment and the use of symbols to capture the existential quality of human experience. They emphasized the subjective and the psycho-emotional in representing the external and experiential. While this made them seem part of the psychoanalytical experiment, or Symbolist in their technical pursuit, it is their exclusive focus on the modern Chinese urban that has earned them lasting attention.

Mu Shiying, the movement's key figure, was a minor writer but one who evinced a cinematic sense of space and time. His work was noted for its depiction of new urban youth and the cityscape of Shanghai, using Sensationalist techniques to highlight the fast-moving impressions of sound, light, colour, and shape. The fragmented piece 'Shanghai de Hubuwu' ('The Shanghai Foxtrot', 1932) was, he averred, only a technical experiment in preparation for a longer novel, and so we read it in that light.[50] The story has no plot, no visible structure, and breaks away from conventional narrative modes. It demonstrates the fast flow of metropolitan time, the fluidity of human consciousness, and recalls the Dada cinema of Leger and Andrews, and the photography of Man Ray.[51] In the story, foxtrot and waltz provide the rhythm of the piece, randomly listing contrastive urban images and objects: neon lights, dancing girls, Nestlé chocolates, jazz, and high-heels clipping along the tree-lined avenues in the French Concession. Indeed, one might also cite the lessons in montage which Eisenstein's cinema had taught the world, and the shimmering associative narrative of European–Hollywood's tale of urban attractions in *Seventh Heaven* (Borzage, US, 1927).

Shu-mei Shih describes Liu Na'ou's narrative technique in his rendition of a nightclub scene as 'synaesthetic listing', as the narrative angle behaves as a film camera, moving from an establishing shot of the scene into medium close-ups of the types and characters that give the location human texture:

Everything in this Tango palace is in melodious motion—male and female bodies, multi-coloured lights, shining wine goblets, red, green liquid, and slender fingers, garnet lips, burning eyes . . . The air is heavy with a mixture of alcohol, sweat, and oil, encouraging all to indulge in the high level of excitement. There is a middle-aged man laughing heartily with

[49] Liu Na'ou (trans.), *Sheqing wenhua* ('Culture of Eros'; Shanghai: Shuimo shudian, 1928).

[50] See 'The Shanghai Foxtrot (A Fragment)', trans. Mu Shiying, comm. Sean MacDonald, *Modernism/Modernity*, 11 (2004), 797–807.

[51] See Malcolm Turvey, 'The Avant-Garde and the "New Spirit": The Case of Ballet Méchanique', *October*, 102 (Autumn 2002), 35–58.

his teeth showing, a young lady speaking endearingly while her arms make charming, affected gestures . . . [52]

The writings of the New Sensationalists were thus, from the perspective of literary historians perhaps, indebted to the international and local cinematic cultures in which they developed and from which they learnt how to embody the speed and disorientation of the modern city in their prose. And, as befits the output of China's cinematic city, New Sensationalism is widely studied as representative of Chinese modernism and of the avant-garde of modern Chinese city literature.[53] The poets' pursuit of modern urban themes and modernist narrative techniques and their high-pitched manifesto of 'decadent, urban sensation', or perhaps 'art for art's sake' as long as it is truly meaningless, have marked them out as an important alternative cultural movement in the two decades before Liberation in 1949.

MODERNIST CONFRONTATION

Even a brief and incomplete account of Chinese modernism indicates that the relationship between sending and receiving cultures 'involves a far more complicated process than the simple transmission of a literary model from one culture to another; [and] that reception of influence is frequently predicated on intrinsic conditions and needs; that an influence cannot take place unless there is pre-existing predisposition'.[54] In his study *Milestones in Sino-Western Literary Confrontation*, Marian Galik defines 'influence' as 'confrontations', as a process to be understood 'in the broadest possible connections and parallels, in all their essential motions and contexts'.[55] Galik further elaborates by way of the Soviet comparativist A. S. Bushmin that 'literary continuity' (*snyatie/Aufheben*) in the encounter of two or more literatures is 'the highest contact-taking', which, as 'a creatively mastered-tradition, is in its essence in a dissolved, or philosophically speaking, in a "cancelled" state'.[56] This understanding of influence, for Galik, is to shift the emphasis to the 'receiving end':

If we divide the word *Aufheben* in its Hegelian connotation into its three meaningful components: to cancel, to preserve, and to lift up, then it becomes clear that the process

[52] Liu Na'ou, *Dushi fengjingxian* ('Scene'; Shanghai: Shuimo shudan, 1930), 3–6; quoted in Shi, *The Lure of the Modern*, 288.

[53] Sima Changfeng, *Zhongguo xinwenxue shi* ('History of New Chinese Literature'), ii (Hong Kong: Shaoming shudian, 1978), 35, 85, 86; Lee Ou-fan, *Shanghai Modern: The Flowering of a New Urban Culture in China, 1930–1945* (Cambridge, Mass.: Harvard University Press, 1999), 154–90; Shi, *The Lure of the Modern*, 231–370.

[54] Michelle Yeh, 'The Anxiety of Difference—a Rejoinder', *Jintian* ('Today'), 1 (1991), 94.

[55] Marian Galik, *Milestones in Sino-Western Literary Confrontation (1898–1979)* (Wiesbaden: O. Harrassowitz, 1986), 1.

[56] Ibid. 2.

(which may be understood as influence) may imply a new phenomenon which becomes relevantly modified in the prism of the receiving literary and social context, primarily in connection with the creative abilities of the receiving subject and the needs of the receiving literary structure.[57]

To be influenced in this sense is to make a historically implicated choice which presupposes transformation as a component of creativity. The idea of 'redisposition' foregrounds the needs and agencies of the new writers, adapters, translators, and transformers. They are not merely on the receiving end of the work of others, but become transformative and deliberative new voices referencing culturally distinct patterns of expression while finding their own timbre and reason. The case of the early twentieth-century Chinese modernist experimentation becomes most meaningful when understood in the prism of its historical and social context, that is, vis-à-vis its relations with China's protracted modernization process. Early twentieth-century Chinese modernist movements often strike discordant notes in the major tunes of their particular times. They have never been institutionalized as the highest achievement of modern literary development and, unlike their European counterparts, remain marginal in Chinese cultural history.

Reform and its Avant-Garde Literary Reflection

The economic Reform in Mainland China in the late 1970s was a political movement to change the historical direction of socialist modernization. It aimed to adopt reform measures that would rebuild a Chinese modernity then considered by both the state and the populace to have gone severely astray during many years of political strife and ideological cleansing. This political-economic revolution also sparked a literary reformation. Modernist forms and practices were once again appropriated as aesthetic and cultural interventions against the mainstream of reform and post-reform culture. Where mainstream reform literature functions predominantly as the thematic and affective testing ground for the new vision of developmental modernization, it is still as social-realist in form as it has been for the past thirty years. Modernist experiments, under such circumstances, intervene directly in both politics and the politics of culture. Wang Meng's trail-blazing exploration of the stream of consciousness is an outstanding case in point. His novellas *Chun zhi sheng* ('The Sound of Spring', 1980) and *Hu Die* ('Butterfly', 1980) are written as free associations of the psycho-emotional activities of reformed and reinstated party officials and ordinary people in the aftermath of the Cultural Revolution, and reveal

[57] Ibid. 4.

great ideological scepticism and post-ideological ennui.[58] The free-flowing associative internal monologues of his characters evince doubt and disillusionment in the wake of political extremism, rather than shared hope for the new era. Wang's own sense of disillusionment, aided by the psycho-emotional depth achieved by his use of the stream of consciousness, hints that the failure of thirty years of socialist modernization may not be merely tactical, but fundamentally historical. Wang's modernist formal experimentation, however, is pioneering in itself, as his free-flowing narrative structure showcased for the first time the possibility of multiple narrative forms in the literary history of the People's Republic of China. Wang's modernist exploration has finally allowed historical narrative its personal psychological manifestation.

The much-studied Menglongshi (Misty Poetry) movement is paradoxically hailed as the beginning of the literature of this new era. While 'the New Era' is an affirmative naming of the mainstream culture of the time, Menglongshi actually began as an underground poetic movement of political protest. Its targets were the institutions of the state and the cultures that they encouraged. Despite being the most forceful avant-garde of the literature of the New Era, its experimental form and deep scepticism quickly returned it to the margins in the reform and post-reform Chinese literary and artistic scene.[59] Bei Dao, Mangke, Duoduo, Gu Cheng, Su Ting, the leading poets of this movement, all consider themselves, and are considered by others, as cultural rebels. Not only does their poetry demonstrate their devotion to the creative and literary in restrictive circumstances, but the act of writing is itself the way by which they directly ponder, engage with, and counter social reality. Although the individual poets differ widely in their aesthetic visions and stylistic choices, the Menglongshi movement is in the avant-garde of contemporary Chinese literature owing to its collective breakaway from conventions of the socialist era, which might be briefly characterized as direct expression of positive emotions for politically sanctioned themes in simple metric systems and folksy language. Their reliance on metaphors and suggestion is as much political necessity as aesthetic deliberation. Thanks to the Menglongshi poets, Chinese poetry need no longer be a political tool. It is this aesthetic of political resistance that has laid the foundation for a different kind of modern Chinese literature. While the modernist formal experiments of these poets, from the use of complicated and elusive imagery to free-associative internal monologues, to the re-creation of free verse and epics, may not have gone very far beyond the limits of their predecessor modernist poets from the 1920s and 1930s, their achievement is nonetheless substantial. Their predecessors wrestled with the confines of tradition that were so tenacious in the past, while they have confronted the political and aesthetic restrictions of the present.

[58] Wang Meng, 'Chun zhi sheng' ('The Sound of Spring') and 'Hu die' ('Butterfly'), in *Wang Meng xiaoshuo baogaowenxue xuan* ('Selected Novelettes, Stories and Reportage by Wang Meng'; Beijing: Beijing chubanshe, 1981), 200–49, 316–40.

[59] Chen Xiaoming, *Anxiety of Expression: Historical Disillusionment and Contemporary Literary Reform* (Beijing: Central Translation Press, 2002), 29–30.

The most recent notable modernist literary movement in contemporary China is the avant-garde fiction experiment beginning in the 1980s. Writers such as Mo Yan, Yu Hua, Su Tong, and Ge Fei self-consciously experimented with narrative techniques and formal language, and pushed the limits of novelistic practice. Their works claim heritage from Latin American magical realism but also from a reconstructed classical Chinese narrative reliance on details. Novels, novellas, and short stories, sometimes dubbed meta- or anti-fiction, are wilfully deconstructive, either of the extant grand narratives in theme or of the mainstream storytelling conventions in style. Thus, they are sometimes considered postmodern pioneers.[60] The end of these experimental fiction writings, which came sooner than expected, was brought about not by complicity with the reform and post-reform cultural politics as is sometimes charged, but by the very successes of the reform of cultural institutions in post-socialist China.[61] That is, what began as aesthetic interventions in the cultural politics of an extremist socialist modernization became formulaic cultural productions in a thriving market. Now, the formal experiments of these avant-garde writers no longer pose challenges to the norms or conventions of oppressive political and cultural institutions. These late twentieth-century modernist practitioners, like their early-century predecessors, have become another dissonant echo of the modern in the great hall of China's modernization.

[60] Chen, *Anxiety of Expression*, 90–111.
[61] Zhang, *Chinese Modernism in the Era of Reforms*, 150–200.

MODERNISM AND COLONIAL MODERNITY IN EARLY TWENTIETH-CENTURY JAPAN

VERA MACKIE

TIME, SPACE, AND MODERNISM

IN January 2007 a major exhibition of Japanese art and design from the 1920s was shown in Tokyo. The site of the Taisho Chic exhibition was a lavish two-storey building in art deco style, the former residence of a member of Japan's royal family. Prince Asaka had visited Paris at the time of the Éxposition Internationale des Arts Décoratifs et Industriels Modernes (which would later give its name to the art deco style). On his return to Japan, the prince commissioned a residence which displayed all of the elements of the new style. The residence, completed in 1933, displayed clean lines, curved walls, Western-style rooms and furniture (rather than *tatami* mats and sliding screens), a round library room, Lalique chandeliers, doors with glass relief by Lalique, and bas-reliefs by Ivan-Léon Branchot. The building had various uses in the post-war period before being converted to a museum, now known as the Meguro

Teien Museum. The art deco mansion was a suitable backdrop for this major exhibition, and also provides a suitable departure point for a discussion of modernism in Japan. The former Asaka residence illustrates Japan's integration into international circuits of knowledge, cultural production and trade, and the early adoption and adaptation of modernist cultural forms, not to mention local innovations in modernist styles. The Taisho Chic exhibition, for example, included representations of 'modern girls' in Western dress alongside Japanese silk kimonos in stunning geometric patterns.

When we consider current circuits of exhibition, collection, curation, commentary, and consumption of modernist art and culture, we might also be reminded of the circuits of transmission for the styles of modernism in the early decades of the twentieth century, for this was nothing if not an international style. One of the strengths of the recent wave of touring exhibitions is that each local iteration has allowed an appreciation of the specific history of modernism in each place.[1] In recent years, a major exhibition of art deco from the Victoria and Albert Museum has toured London, Toronto, Boston, San Francisco, Tokyo, and Sydney.[2] This exhibition was subtly different in its London, Tokyo, and Melbourne versions. In each site, the curators were able to take advantage of local collections, which prompted reflections on the relationship between modernity, modernism, and colonialism in each site. In Australia, this stimulated reflections on the appropriation of indigenous culture and the relationship between metropolitan citizens, settlers/invaders, and indigenous peoples (see Chapter 53). In Japan, this prompted consideration of the twin reference points of Euro-American cultures and East Asian cultures, along with the complex hierarchies of value implied in each case.

In the manifestations of modernism in Europe and North America, the enmeshment of historicity, spatiality, and temporality is apparent. What was 'modern' was that which was *not* traditional, feudal, pre-modern, or 'primitive'. The 'other' to the modern could be identified in the local society's 'own' past. However, such difference could also be spatialized, with countries outside the Euro-American centres—particularly the colonies—being relegated to a putative pre-modern past. At the same time, the cultures of these other places were ripe for plunder as exotica.

In the case of Japan, questions of historicity, temporality, and spatiality are more complex. Elements of Japanese culture could serve as resources and exotic reference points for Euro-American experimentation. At the same time, Japan was a colonizing power, in the position of metropolis to its own colonial and semi-colonial peripheries in the East Asian region.

[1] Tokyo-To Bijutsukan (eds), *1920-nendai Nihon Ten* (Tokyo: Tokyo-To Bijutsukan, 1988); Jackie Menzies (ed.), *Modern Boy, Modern Girl: Modernity in Japanese Art, 1910–1935* (Sydney: Art Gallery of New South Wales, 1998); Elise Tipton and John Clark (eds), *Being Modern in Japan: Culture and Society from the 1910s to the 1930s* (Sydney: Australian Humanities Research Foundation with Fine Arts Press in association with Gordon and Breach Arts International, 2000); Lorna Price and Letitia O'Connor (eds), *Taisho Chic: Japanese Modernity, Nostalgia and Deco* (Honolulu: Academy of Fine Arts, 2001); Charlotte Benton, Tim Benton, and Ghislaine Wood (eds), *Art Deco, 1910–1939* (London: V & A, 2003).

[2] See Benton et al. (eds), *Art Deco*.

Japanese modernity also existed in a series of overlapping temporalities. In narratives of the transition from feudalism to capitalism (and possible socialist transformation), the modern period was measured against the feudalistic military regime of the shoguns. Another temporal frame referred to the time before and after the enforced opening to the West in the 1850s. While Euro-American histories of the twentieth century refer to the major turning points of the First World War, the Great Depression, and the Second World War, the history of twentieth-century Japan can also be broken up according to the era names identified with its emperors: Meiji (1868–1912), Taishō (1912–26), Shōwa (1926–89), and Heisei (from 1989).[3] The height of modernism roughly corresponds with the Taishō and early Shōwa periods. Although modernist cultural forms can actually be identified well before 1923,[4] the Great Kantō Earthquake of 1923, which led to the extensive rebuilding of the Tokyo metropolis, is a major turning point, both in terms of the physical infrastructure and architecture of the city, and in psychological terms. Changes which were well under way were accelerated by the catastrophic impact of the earthquake, while existing fissures of class, gender, and ethnicity were thrown into relief.

When the early decades of the twentieth century are looked back on from the vantage point of the present, this time is often viewed with a sense of nostalgia, as a time of optimism and potential before the onset of militarism, ultra-nationalism, fascism, and total war. The period known as 'Taishō democracy' (from 1918 to 1936, depending on definition) roughly corresponds with the peak of modernist cultural forms. Modernist culture has thus come to be associated with the period of parliamentary democracy, liberalism, feminism, socialism, and internationalism. It is moot, however, whether such a direct and simple connection can be made between social experimentation and cultural experimentation, and whether we can simply assume that the end of political liberalism in the 1930s coincided with the end of modernism.[5]

[3] Many contemporary leftist and anti-monarchist writers prefer to avoid the use of these imperial reign names in their description of modern Japanese history, but the names 'Taishō' and 'Shōwa' are unavoidable in this context. The label 'Taishō democracy' has taken on a life of its own as a descriptor of a period characterized by party government, the extension of the franchise to most adult males, the development of the labour and feminist movements, the creation of leftist political parties, the development of mass culture, and experimentation in a range of artistic genres.

[4] Tyler places Japanese modernism in the years 1910 to 1940; William J. Tyler, *Modanizumu: Modernist Fiction from Japan, 1913–1938* (Honolulu: University of Hawai'i Press, 2008), 19.

[5] The question of the end-point of artistic modernism is complex for several reasons. All of the arts were subject to increasing censorship and repression in the late 1930s and the wartime period. With respect to artists who collaborated with the state-sponsored cultural organizations during the war, critics of the post-war period have often been reluctant to deal with their artistic practice, which has been seen to be tainted with militarism and ultra-nationalism. The careers of some individual artists, however, do cross over into the post-war period. Echoes of early twentieth-century artistic practices can also be seen in the avant-garde movements of the 1960s. John Clark, 'Artistic Subjectivity in the Taisho and Early Showa Avant-Garde', in Alexandra Munroe (ed.), *Japanese Art After 1945: Scream Against the Sky* (New York: Harry N. Abrahams, 1994), 50; and see Munroe (ed.), *Japanese Art After 1945, passim.*

The terminology used to talk about the modern age, modernity, modernization, and modernism is complex in the Japanese language, which draws on Sino-Japanese ideograms to express abstract concepts, but also uses loanwords from English and other European languages. The modern age, or modernity, can be described with the Sino-Japanese compound *kindai*; adding the suffix -*ka* (to denote a transformation) produces *kindai-ka*, modernization. For modernist cultural forms, however, the local transliteration of modern, *modan*, and modernism, *modanizumu*, may be used.[6] This allows for fine nuances in the discussion of the relationship between the modern age, modern times, modernization, and modernist cultural forms, and also reflects the positioning of twentieth-century Japanese culture and society: conscious of the threat of Euro-American imperialism, subject to both cultural imperialism and exoticization, but also experiencing modernity on its own terms, while looking to its own peripheries, colonies, and quasi-colonies with an imperialist and colonizing gaze.

The literary works, poetry, and manifestos of European modernism were translated into Japanese relatively quickly.[7] Japanese artists also had access to the latest European visual culture, through travel to the European centres and through exhibitions and reproductions.[8] In 1911, in Tokyo, a production of Ibsen's *A Doll's House* prompted both theatrical experimentation and debates on the New Woman. (Similar debates would occur in China and Korea later in the decade.) Modernist architecture flourished in Tokyo, particularly after the earthquake of 1923, and new family forms were housed in the modern interiors of the *bunka jūtaku*, or culture house.[9] Frank Lloyd Wright's Imperial Hotel was completed just before the earthquake and survived to become a modernist icon, until its demolition in the 1960s. Graphic artists moved between commercial art and the provision of posters, handbills, graphics, and cartoons for the socialist, anarchist, and labour movements.[10] Technological change allowed for the production of collections of cheap, mass-marketed books known as *en-pon* (one yen books) and the inclusion of photographic illustrations in mass-market magazines.

[6] For more detailed discussion of the relevant terminology, see William O. Gardner, *Advertising Tower: Japanese Modernism and Modernity in the 1930s* (Cambridge, Mass.: Harvard University Press, 2006), 19–45.

[7] Tyler, *Modanizumu*, 21.

[8] See e.g. Nagata Isshū's book on the proletarian arts movement, which includes reproductions of the posters of Soviet Russia, the cartoons of Georg Grosz, the murals of Diego Rivera, and the paintings of Kathe Kollwitz, alongside local Japanese artists; Nagata Isshū, *Puroretaria Kaiga Ron* (Tokyo: Tenjinsha, 1930; repr. Tokyo: Yumani Shobō, 1991).

[9] Tokyo-To Bijutsukan (eds), *1920-nendai Nihon Ten*; Jordan Sand, *House and Home in Modern Japan: Architecture, Domestic Space and Bourgeois Culture, 1880–1930* (Cambridge, Mass.: Harvard University Asia Center, 2005).

[10] Gennifer Weisenfeld, 'Japanese Modernism and Consumerism: Forging the New Artistic Field of Shōgyō Bijutsu', in Tipton and Clark (eds), *Being Modern in Japan*, 75–98.

THE GENRES OF MODERNISM

Compulsory education was introduced in the 1870s, and relatively good school attendance rates for both boys and girls were achieved by the turn of the century. There was also a programme of modernization of the language itself. This means that there was a highly literate population which could consume mass-market newspapers, magazines, and popular novels. Fiction often first appeared in serial form in daily newspapers or mass-market magazines. In poetry and literature, there was a shift from the use of a specific literary language characterized by the use of archaic grammatical forms to a modern style somewhat closer to spoken language. Language was also affected by specific vocabulary and syntactical structures developed to deal with translation from European languages.[11]

While European modernist poets such as Ezra Pound placed Chinese characters on the page as a distancing technique, Japanese writers could play with multiple scripts: Sino-Japanese ideograms, the *hiragana* syllabary, the *katakana* syllabary (used for transliterating non-Japanese words), roman letters, arabic and roman numerals, and scientific and mathematical symbols. Even the *fuseji* used to black out censored words in publications could be redeployed for poetic purposes. Writers played with the materiality of the text on the page.[12] Thus, Hagiwara Kyōjirō's poetry collection of 1925, *Shikei Senkoku* ('Death Sentence'),[13] displayed 'characters of different sizes and orientations (to be read in multiple directions), combined with non-character elements such as dots, circles, triangles, lines, bars and arrows', and was produced in collaboration with the avant-garde artists of the Mavo group.[14] This collaboration reflects two features of early twentieth-century modernist cultural production: the use of montage and collage effects, and the crossing of generic boundaries.

Early examples of the modern novel had been in a genre known as the 'I-novel' (*shi-shōsetsu* or *watakushi-shōsetsu*). The focus of these semi-autobiographical narratives was individual experience and interiority.[15] The apparent naturalism of the 'I-novel' was challenged by avant-garde literature, popular fiction, and the proletarian arts movement.[16] Critic and novelist Yokomitsu Riichi challenged the orthodoxy of the movement for unification of writing and speech (known as *genbun itchi*), by advocating that, rather than 'writing as one speaks', one should 'write as one writes'.[17]

[11] Judy Wakabayashi, 'Translational Japanese: A Transformative Strangeness Within', *Portal Journal of Multidisciplinary International Studies*, 6/1 (2009), 1–20.
[12] Gardner, *Advertising Tower*, 40–1.
[13] Hagiwara Kyōjirō, *Shikei Senkoku* [1925] (Tokyo: Nihon Kindai Bungakukan, 1972).
[14] Gardner, *Advertising Tower*, 9. On Mavo, see Gennifer Weisenfeld, *Mavo: Japanese Artists and the Avant-Garde, 1905–1931* (Berkeley: University of California Press, 2002).
[15] Tomi Suzuki, *Narrating the Self: Fictions of Japanese Modernity* (Stanford, Calif.: Stanford University Press, 1996); Seiji M. Lippit, *Topographies of Japanese Modernism* (New York: Columbia University Press, 2002), 9–12.
[16] George T. Shea, *Leftwing Literature in Japan* (Tokyo: Hōsei University Press, 1964); Heather Bowen-Struyk, 'Rethinking Proletarian Literature', Ph.D. diss., University of Michigan, 2001.
[17] Yokomitsu Riichi, 'Bungei Jihyō', *Bungei Shunjū* (Dec. 1928); cited in Gardner, *Advertising Tower*, 28.

Yokomitsu's novel *Shanghai*, originally serialized in 1928 and 1929, would portray the subjectivity of a Japanese man positioned in Shanghai with the May 30 movement as a backdrop.[18]

Hayashi Fumiko's novel *Hōrōki* ('Diary of a Vagabond') was originally serialized in the left-wing women's arts journal *Nyonin Geijutsu* ('Women's Arts') between 1928 and 1930, before being published in book form, and then followed by a sequel. The text is a collage of diary entries, poetry, fragments of popular songs, and other intertextual references, with shifts in temporal and spatial reference points.[19] Its evocation of the daily life of a woman who moves between domestic work, factory work, and itinerant work is compatible with the concerns of the proletarian arts movement, while its stylistic innovation places it in the avant-garde.

The mass-market magazines included those directed at youth, with differentiated markets for boys and girls. This was one element of the development of 'girls' culture' (*shōjo bunka*).[20] The magazine *Shinseinen* ('New Youth') from 1920 became the focus for experimentation in fiction, including the development of the detective novel, and lurid stories in the genre of 'erotic-grotesque-nonsense' (*ero-guro-nansensu*).[21] The readers addressed in the pages of *Shinseinen* could be considered as 'modern boys', the masculine equivalents of the 'modern girls'.

In 1910 sculptor and poet Takamura Kōtarō published an article, 'A Green Sun', where he called on artists in Japan to liberate themselves from accepted conventions: 'If someone paints a "green sun", I will not say it is wrong . . . The good or bad of a painting has nothing to do with whether the sun is green or flaming scarlet.'[22] As in fiction and poetry, visual artists rebelled against expectations of realism and naturalism. The unromantic portrayal of the naked woman in Yorozu Tetsugorō's *Nude with Parasol* in 1913 was shocking to modern audiences, and a reaction against the academicism and romanticism of earlier painters who had been schooled in the European tradition.[23]

[18] Yokomitsu Riichi, *Shanghai* (Tokyo: Kōdansha, 1991); *Shanghai: A Novel by Yokomitsu Riichi*, trans. Dennis Washburn (Ann Arbor: Center for Japanese Studies, University of Michigan, 2001).

[19] Gardner, *Advertising Tower*, 11.

[20] Hiromi Tsuchiya Dollase, 'Early Twentieth Century Japanese Girls' Magazine Stories: Examining Shōjo Voice in *Hanamonogatari* (Flower Tales)', *Journal of Popular Culture*, 36/4 (May 2003), 724–55.

[21] Miriam Silverberg, *Erotic Grotesque Nonsense: The Mass Culture of Japanese Modern Times* (Berkeley: University of California Press, 2007), *passim*; Mark Driscoll, 'Introduction', in Yuasa Katsuei, *Kannani and Document of Flames: Two Japanese Colonial Novels*, trans. Mark Driscoll (Durham, NC: Duke University Press, 2005), 17, 34 n. 31.

[22] Takamura Kōtarō, 'Midori-iro no Taiyō', *Subaru* (Apr. 1910), trans. in *A Brief History of Imbecility: Poetry and Prose of Takamura Kōtarō*, trans. Hiroaki Sato (Honolulu: University of Hawai'i Press, 1992), 182.

[23] Yorozu Tetsugorō, *Nude with Parasol*, 1913, repr. in Menzies (ed.), *Modern Boy, Modern Girl*, 69. See also, in Menzies (ed.), *Modern Boy, Modern Girl*: Nakamura Tsune, *Girl in Nude*, 1914, p. 67; Hashiguchi Goyō, *Woman After the Bath*, 1920, p. 116; Sakata Kazuo, *Study of a Female Nude*, 1924, p. 85; Ishikawa Toraji, *Repose*, 1934, p. 35; Yasui Sōtarō, *Artist and a Model*, 1934, p. 75. For further discussion, see Mizusawa Tsutomu, 'The Artists Start to Dance: The Changing Image of the Body in the Taishō Period', in Tipton and Clark (eds), *Being Modern in Japan*, 15–24.

The words for 'construction' and 'reconstruction' came to be catchwords for the age, with one major leftist intellectual journal and publisher taking the name *Kaizō* ('Reconstruction'). The influence of the Constructivists was apparent in the visual culture of the time, particularly in the socialist press. For example, the cover of Hosoi Wakizō's semi-documentary text *Jokō Aishi* ('The Pitiful History of Female Factory Workers') was decorated with an abstract evocation of machinery and factory chimneys.[24] William Gardner has described Murayama Tomoyoshi's mixed-media assemblage *Construction*, which may now be seen in the National Museum of Modern Art in Tokyo: 'the upper right hand consists of a collage of photos clipped from the pages of a German newspaper, including modern factories, office buildings, automobiles, power, telephone or telegraph lines, radio towers, women's fashion photographs, a military review, a battleship, and the famous Potala Palace in the Tibetan capital of Lhasa'.[25] Murayama would also work as a graphic artist, dancer, performer, and installation artist, and his long career provides a bridge between the early twentieth century and the post-war period.

In mass magazines, photographic collages were employed to portray the life of the city. The pictorial magazine *Asahi Gurafu* ('Asahi Graphic'), which debuted in 1923 after the earthquake, regularly ran double-page spreads of photographic collages. The journal's photographers would roam the streets of Tokyo, assembling collections of snapshots of particular categories of people, such as 'modern girls', or the various occupations to be found in the modern metropolis, which would then be assembled in collage form on the pages of the magazine to give a sense of the vitality and variety of the streets of the city. At other times, the magazine would conduct vox pop surveys (on such topics as women's suffrage) and display the responses and photos in the magazine.[26] *Asahi Gurafu* also documented the rebuilding of the city after the earthquake, including the progress of construction of the new Diet building.[27] In the 1930s and 1940s, the pictorial magazine *Nippon* used the latest graphic techniques to present Japan and its colonies to the world.[28]

Avant-garde photographers experimented with photographic montage, treating the body as a landscape for the play of light and shadow.[29] Hanaya Kanbee's 1933 photograph *Woman and Glass* (Fig. 55.1) is just one example of the fashion for photographic montage.[30] A series of studies of a woman in a cocktail dress are juxtaposed with the neon light of a cocktail bar. In the neon sign, a woman is

[24] Yanase Masamu, Cover of Hosoi Wakizō, *Jokō Aishi* (Tokyo: Kaizōsha, 1925); repr. in Menzies (ed.), *Modern Boy, Modern Girl*, 103.
[25] Gardner, *Advertising Tower*, 36.
[26] *Asahi Gurafu* (11 Mar. 1925).
[27] *Asahi Gurafu* (31 Aug. 1927, 19 Feb. 1930). See also Jonathan M. Reynolds, 'Japan's Imperial Diet Building: Debates Over Construction of a National Identity', *Art Journal*, 55/3 (Fall 1996), 38–47.
[28] Gennifer Weisenfeld, 'Touring "Japan-as-Museum": NIPPON and Other Japanese Imperialist Travelogues', *positions: east asia cultures critique*, 8/3 (Winter 2000), 747–93; *Nippon*, 1–16 (Autumn 1934–Sept. 1944); facs. edn (Tokyo: Kokusho Kankōkai, 2002–5).
[29] John Dower, *A Century of Japanese Photography* (New York: Pantheon, 1980).
[30] See the photographic montages in Kanagawa Kenritsu Kindai Bijutsukan (ed.), *Jidai to Bijutsu no Tamentai: Kindai no Seiritsu ni Hikari o Atete* (Kamakura: Kanagawa Kenritsu Kindai Bijutsukan, 2007), 73–5. See also the artistic collages of Koga Harue, Murayama Tomoshi, and others on pp. 70–2 of the same publication, and Murayama Tomoyoshi's photomontage *Dai no nai e*, c.1922–3; illustration from solo exhibition pamphlet, repr. in Weisenfeld, *Mavo*, 41.

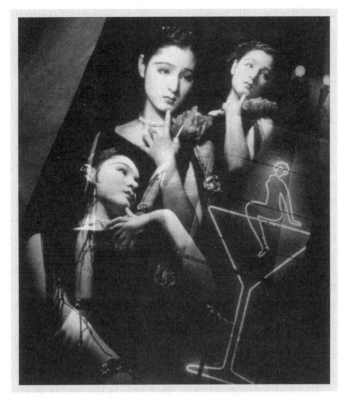

Fig. 55.1 Hanaya Kanbee, *Woman and Glass*, 1933

shown perched inside a cocktail glass, neatly encapsulating the twin themes of the woman as consumer and consumed.

The early years of the twentieth century saw the development of cinema, radio, jazz music, and dance halls. Writers moved between fiction and cinema, with novelists such as Tanizaki Jun'ichirō writing cinema scenarios for a time. Tanizaki reflected on cinema and visuality in his essays, and the main character of his novel *Chijin no Ai* ('A Fool's Love') is infatuated with a 'modern girl' who models herself on Mary Pickford. Kawabata Yasunari's scenario for 'A Page of Madness' has been celebrated as a modernist text in its own right, even at times when the fragmentary remains of the film itself have been difficult to access.[31] The figure of the *benshi*, who provided narration for the early cinema before the advent of 'talkies', has recently been described as a characteristically hybrid figure. The *benshi*'s narration was an adaption

[31] Kawabata Yasunari, 'Kurutta Ichipēji', scenario trans. as 'A Page of Madness', in Tyler, *Modanizumu*, 92–104. See also Aaron Gerow, *A Page of Madness: Cinema and Modernity in 1920s Japan* (Ann Arbor: Center for Japanese Studies, University of Michigan, 2008).

of earlier theatrical forms, and provided a specific localized and culturally embedded form of cinema spectatorship.[32]

MODERNISM AND THE METROPOLIS

The early decades of the twentieth century are marked by increasing industrialization, urbanization, and the development of mass culture. Modernism is the art of the metropolis, in the twin senses of the metropolis as mega-city, and the metropolis as an imperial centre, distinguished from peripheral, colonial, and semi-colonial spaces.[33] In opposition to the high art forms of the official art exhibitions, salons, and galleries, we see the development of avant-garde art, socialist iconography, advertising, and graphic design.[34] The streets of the metropolis provide a site for political demonstrations, petitions, the distribution of handbills, political and artistic manifestos, and the display of posters, illuminated advertising signs, and shop window displays.[35]

On the occasion of the opening of the first underground railway line in Tokyo, the Tokyo Underground Railway Company commissioned a poster from the graphic artist Sugiura Hisui. Sugiura's 1927 poster shows a subway station platform packed with people.[36] The underground railway track bisects the poster in an elegant line, the train itself advancing from the centre of the poster, the graduated lines of the ceiling providing depth and perspective. The people on the platform are variously dressed in Japanese and Western style, wearing their best dress to mark such an auspicious occasion. The women wear cloche hats, bobbed hair, fur coats, and stoles; their children are in suits, frilly dresses, or school uniforms. The fashions are in the urban style of the 'modern girl' and her male equivalent. Across the top of the poster in Japanese script, the heading proclaims, 'The Only Underground Railroad in the East' ('Tōyō Yuiitsu no Chikatetsudō'). Sugiura's poster demonstrates his facility in the conventions of modernist graphic design, in a poster which could proudly take its place alongside the posters for the London Underground. The words of the poster are

[32] Tyler, *Modanizumu*, 5.

[33] Between 1900 and 1932, Tokyo's population grew from 1 million to 6 million, to become the world's second-largest city after New York; Tyler, *Modanizumu*, 26.

[34] Clark, 'Artistic Subjectivity in the Taisho and Early Showa Avant-Garde', 41–53.

[35] See William Gardner's discussion of Hirato Renkichi's leaflet *Japanese Futurist Manifesto Movement*, which was distributed on the streets of Hibiya in 1921; Gardner, *Advertising Tower*, 57–8.

[36] Sugiura Hisui, *Tōyō Yūiitsu no Chikatetsudō*, photo lithograph poster produced for the Tokyo Underground Railroad Company, 1927, repr. in Tokyo Kokuritsu Kindai Bijutsukan (ed.), *Sugiura Hisui Ten: Toshi Seikatsu no Dezainā* (Tokyo: Tokyo Kokuritsu Kindai Bijutsukan, 2000), 27; another poster celebrating the same occasion appears on p. 28. A poster from 1929 celebrating an extension of the underground refers to Tokyo as 'Teito', the 'imperial capital'; Tokyo Kokuritsu Kindai Bijutsukan (ed.), *Sugiura Hisui Ten*, 29.

precisely symptomatic of perceptions of Japan's place in the world among the urban intelligentsia of the time. In boasting of 'the only underground railroad in the East', Tokyo's subway is placed alongside the Paris Metro, the London Underground, and the New York Subway system, and Tokyo is thus placed alongside these other metropolitan centres.

Tokyo is also, however, being compared here with other urban centres in East Asia: cities like Shanghai, Beijing, Taipei, and Seoul (known as Keijō by the Japanese during the colonial period). By claiming the 'only' underground railroad in the East, Tokyo is placed in a superior position with respect to these other centres, as the most modern city of the East. Japan is presented here as a metropolitan power in parallel with the United States, the United Kingdom, and France. Japan's relationship with Korea and Taiwan is clearly that of colonizer and colonized.[37] With respect to China, Japan enjoyed a semi-colonial relationship similar to Britain and the United States, with access to the Chinese treaty ports, and designated settlements in Shanghai and Beijing. The ships that departed from the former treaty ports of Hakodate, Yokohama, Kobe, and Nagasaki linked consumers in Japan with the products emanating from cities like London, Paris, New York, Shanghai, and Taipei.[38]

THE MODERN GIRL AS VERNACULAR MODERNIST ICON

Modernist representations are placed in a metropolitan space—a gendered urban space—imagined as being inhabited by such figures as the 'modern girl'. The modern girl (*modan gāru*, abbreviated as *moga*) is a ubiquitous figure in the visual culture of 1920s and 1930s Japan, appearing in cartoons, photography, painting, prints, graphic

[37] Taiwan had been annexed in 1895 after Japan's victory in the Sino-Japanese War; Korea had been subject to an unequal treaty with Japan and was finally annexed in 1910.

[38] Under the provisions of the 'unequal treaties' which were imposed on Japan by the Euro-American powers in the 1850s, the treaty partners would have access to the four ports of Yokohama, Hakodate, Nagasaki, and Kobe. By the turn of the century, Japan had been able to renegotiate its treaties with the United States and the European powers, and in turn had imposed a similar unequal treaty on Korea. The former 'treaty ports' still had an important function in linking the Japanese economy into international trading routes, and in facilitating the movement of people between the major metropolitan centres of Europe, Asia, and the US. For evidence of the place of these former treaty ports in early twentieth-century Japanese culture, see Kawanishi Hide's 1931 colour woodblock print *Miss Kōbe*, and his 1935 colour woodblock print *Silk Store*, which shows the streets of Kobe, with a group of shoppers from various countries shopping for silk and curios, repr. in Menzies (ed.), *Modern Boy, Modern Girl*, 51. See also the scenes of shopping in Yokohama in such novels as Tanizaki Jun'ichirō's *Chijin no Ai* ('A Fool's Love'; first pub. Tokyo: Kaizōsha, 1925; repr. Tokyo: Chūō Kōron Shinsha, 1985).

design, and cinema.[39] The *moga* has been seen as one of the archetypal gendered figures of early twentieth-century modernity.[40] Unlike her precursor of the 1910s, the 'new woman' (*atarashii onna*), who was often portrayed in Japanese dress, the modern girl of the 1920s and 1930s is associated with bobbed hair and Western dress.[41] She is also closely connected with the consumption of the products of modernity such as cocktails, chocolate, and cigarettes; with the mobility of the automobile, the bus, the streetcar, the railway, the subway, the ocean liner, and the aeroplane; and with the practices of social dancing, sports, and other outdoor activities.[42]

In Shimokawa Hekoten's cover of the satirical journal *Tokyo Puck* of January 1929, we can see the modern girl and her male equivalent, the modern boy. They are placed in Ginza, the site of consumerism and *flânerie*. Their nicknames, Marx Boy and Engels Girl, suggest the political orientations of some of the youth of the time. The girl has bobbed hair and a cloche hat; the boy wears a worker's cap. Their postures and profiles mimic each other; he smokes a pipe and she smokes a cigarette in a holder. Red highlights in their clothing draw attention to the red books under their arms. Generally, however, the modern girls and modern boys were mocked for their lack of political consciousness, through satirical cartoons and the commentaries of intellectuals.[43]

Despite some modest improvement in the political situation of women in the early 1920s, there was still a great degree of anxiety attached to the figure of the woman

[39] See Menzies (ed.), *Modern Boy, Modern Girl*; Tipton and Clark (eds), *Being Modern in Japan*; James Fraser, Steven Heller, and Seymour Chwast, *Japanese Modern: Graphic Design Between the Wars* (San Francisco: Chronicle Books, 1996); Price and O'Connor (eds), *Taisho Chic*; and Kanagawa Kenritsu Kindai Bijutsukan (ed.), *Jidai to Bijutsu no Tamentai*.

[40] Miriam Silverberg reports that the first documented reference to the 'modern girl' is in the women's magazine *Josei*, in August 1924; Miriam Silverberg, 'The Modern Girl as Militant', in Gail Lee Bernstein (ed.), *Recreating Japanese Women: 1600–1945* (Berkeley: University of California Press, 1991), 240. On the transnational dimensions of the 'modern girl' phenomenon, see 'Modern Girl Around the World Research Group': Tani E. Barlow, Madeleine Yue Dong, Uta G. Poiger, Priti Ramamurthy, Lynn M. Thomas, and Alys Eve Weinbaum, 'The Modern Girl Around the World: A Research Agenda and Preliminary Findings', *Gender and History*, 17/2 (Aug. 2005), 245–94.

[41] Barbara Sato, *The New Japanese Woman: Modernity, Media and Women in Interwar Japan* (Durham, NC: Duke University Press, 2003); Vera Mackie, *Feminism in Modern Japan: Citizenship, Embodiment and Sexuality* (Cambridge: Cambridge University Press, 2003), 45–72.

[42] See Yamagishi Kazue's colour woodcut *In California*, 1927; the women in the Shiseidō cosmetics advertising postcards, *Gendai Keshō Hyakutai* ('One Hundred Scenes of Contemporary Cosmetics'), 1935; the 'bathing beauties' on the paper and wood fan advertising Jintan medicine, with photographs of Irie Takako and Hamaguchi Fujiko, repr. in Price and O'Connor (eds), *Taisho Chic*, 71; the photograph of Hayama Michiko in bathing-beauty pose in publicity stills from the film *Amateur Club*, 1912, repr. in Thomas Lamarre, *Shadows on the Screen: Tanizaki Jun'ichirō on Cinema and 'Oriental' Aesthetics* (Ann Arbor: Center for Japanese Studies, University of Michigan, 2005), 55; Yorozu Tetsugorō's oil painting *Bather with Parasol*, 1926.

[43] Among the many such cartoons, see Fujiyama Tenpo, 'Kanojo no Namida', in *Tokyo Puck* (Sept. 1931), where a modern girl is moved to tears by a melodrama on the cinema screen, but blind to the plight of the poor people in the streets outside the cinema. See also Barbara Hamill Sato, 'The Moga Sensation: Perceptions of the Modan Gāru in Japanese Intellectual Circles during the 1920s', *Gender and History*, 5/3 (Autumn, 1993), 363–81.

who entered public space. Much of this anxiety centred on the *moga*, and attention was focused on her female body, which was seen to be out of place in the streets, the cafés, and the spaces of public discussion.[44] There was also criticism of consumerism, with one critic dismissing what he called 'flapper' modernism, providing evidence of the perceived feminization of vernacular modernist cultures and practices.[45] Although the modern boy does appear from time to time in the visual culture and cultural commentaries of the time, it is the modern girl who receives the most sustained attention.

The appearance of the modern girl in popular discourse is intimately connected with developments in the technology for the reproduction of illustrations in books, magazines, and newspapers.[46] Visual representations of the time place the modern girl in the streets, cafés, and dance halls of the metropolis of Tokyo, surrounded by the products of modernity. Kobayashi Kiyoshi's cartoon *The Modern Girl's Possessions*, which appeared in a satirical magazine in 1928, focuses on consumption. The modern girl has bobbed hair under a cloche hat. Her cheeks are coloured with rouge. Her possessions include cigarettes, chocolate, and a love letter. She wears a short dress of flimsy material which reveals the shape of her body.[47]

Kobayakawa Kiyoshi's 1930 print *Tipsy* demonstrates the association of modern girls with exotic alcoholic drinks. The tipsy young woman holds a cigarette in one hand, and the glass in front of her contains a pinkish drink. The shape and colour of the cherry in the cocktail glass is repeated endlessly in the polka dots on her dress.[48] Her cocktail, bobbed hair, and Western dress provide intertextual links with other contemporary representations of the 'modern girl'. Kobayakawa's print is a supreme example of the printmaker's art. The surface of the print is composed of flat fields of colour which draw on traditional printmaking methods while also being compatible with modernist graphic design. Depth is provided through the contrast between the pale skin of the modern girl and the intense scarlet of the background, the intensity of colour achieved through the repeated application of the red pigment.[49] These representations are evidence of the vernacularization of modernism, vernacular in the sense of being non-élite, but also in the sense of being localized. Modernist

[44] To explain briefly, women were prevented from voting, joining political organizations, and attending or speaking at public political meetings from the late 1890s. In an amendment to Article Five of the Public Peace Police Law in 1922, it became possible for women to attend and speak at political meetings and to join political associations, but women did not attain suffrage and the right to stand for political office until the Electoral Law was amended in December 1945.

[45] See Hirabayashi Hatsunosuke's criticism of modernism: 'Japan's modernists are still as sentimental as the lyric poets during the middle ages were. The modernity that is reflected in their eyes is all in hairdressing, skirts, cinema actresses, the department store mannequin girls and modern girls who stroll on the Ginza and frequent the [famous movie theatre] Hōga-za. It is nothing more than flapper modernism' (Hirabayashi Hatsunosuke, 'Shakai Jihyō: Shihonshugi no Sentanteki Shisō Urutora Modanizumu', *Shinchō* (Feb. 1930); trans. in Sato, *The New Japanese Woman*, 74).

[46] John Clark, 'Indices of Modernity: Changes in Popular Reprographic Representation', in Tipton and Clark (eds), *Being Modern in Japan*, 27–8.

[47] Kobayashi Kiyoshi, 'Moga-san no Mochimono' in *Manga Manbun* (1928).

[48] Kobayakawa Kiyoshi, *Moroyoi*, 1930.

[49] See Kendall Brown's discussion of this print in Price and O'Connor (eds), *Taisho Chic*.

designs, products, and practices were part of everyday life, and were apparent in interior design, architecture, graphic design, and fashion.

COLONIAL MODERNITY AND MODERNISM

Modernity might be described as a set of capitalist economic and social conditions marked by bureaucracy, technological development, and specific related experiences of temporality and history. It is a feature of modernity too that society is understood in terms of a series of oppositions between 'tradition' and the 'modern'. In the Japanese case, the 'tradition' against which modernity was defined was that of a feudal economy, hierarchical relationships, and the military rule of the shoguns. The 'modernization' process whereby societies are transformed from feudal to capitalist involves 'scientific and technological innovation, the industrialization of production, rapid urbanization, an ever-expanding capitalist market [and] the development of the nation-state'.[50] In the case of Japan, this process was condensed into just a few decades, possibly intensifying an uneasiness with 'the modern', which was expressed in the modernist modes of collage, montage, mixed-media assemblages, genre-crossing, generic indeterminacy, and fragmentation. Modernist cultural forms were not simply imitative of similar forms in the Euro-American centres. Rather, they were responding to the conditions and contradictions of modernity and moderniza-tion in Japan. In the Japanese case, too, the understanding of modernity and modernization was overlaid with theories of cultural difference. Japan, like other Asian countries, was the subject of Orientalist projections of an essential difference from European forms of modernity. Japanese intellectuals resisted these projections of their own country, but also developed ideas about Japan's own difference from neighbouring Asian countries.[51]

Japanese modernity was thus a specific form of colonial modernity. Japanese culture was imbued with the features of a colonial and imperial power, and the identity of Japanese people was the identity of imperial subjects: 'imperial' in the twin senses of serving an emperor, and in being expected to provide support for an imperialist state. Japanese colonialism and imperialism also developed as a response to the threat of European imperialism in the late nineteenth century, while projec-tions of Japan's difference from other Asian countries were linked with notions of a hierarchy of nations.

Colonial modernity has been defined and analysed by Tani Barlow, who argues that the concepts of 'modernity' and 'the colonial' are inextricable. Barlow

[50] Rita Felski, *The Gender of Modernity* (Cambridge, Mass.: Harvard University Press, 1995), 13.
[51] See Stefan Tanaka, *Japan's Orient: Rendering Pasts into History* (Berkeley: University of California Press, 1993).

emphasizes that 'the commodity economies (e.g. opium, tea, sugar, and tobacco) that integrated international trade as imperialists sought to establish colonial domains also drew and reshaped political, administrative, governmental, ideological, and intellectual lines of power'.[52] Modernist cultural forms reference the circulation of capital, finance, products, individuals, and signs and symbols which have been associated with the condition of colonial modernity in East Asia.

In 1924 the artist Yamamura Kōka produced a colour woodcut depicting the dance hall of the New Carlton Hotel in Shanghai. In this print, two women are seated at a round table. One has bobbed hair; the other wears a red hat. Both wear Western dress, but the embroidered jacket draped on one of the chairs suggests the fashion for chinoiserie. Two cocktail glasses on the table contain red cherries. Several couples dance in the background of the picture, the women all with similar bobbed hair. The male dancing partners are barely visible and the women are seen from behind, giving them a sense of anonymity. The lack of individual features of the women dancing in the background also suggests a degree of interchangeability between the women. They are most likely 'taxi dancers', who dance with the male patrons for a fee paid to the dance hall. The ethnicized and racialized positioning of the dancing women is unclear, but at least one of the seated women appears to be of 'European' appearance. The women in the dance hall, with their bobbed hair, Western dress, and cocktails, clearly reference the style of the 'modern girl'.[53] For the artistic connoisseur in the metropolis, Yamamura's depiction of the New Carlton Hotel allowed a vicarious form of travel, a sense of potential ownership of the urban spaces of colonialism. Yamamura's print interpellates the viewer as the holder of an artistic and connoisseurial gaze emanating from the metropolis.

At other times, metropolitan subjects could enjoy the creation of colonial spaces within the metropolis. One of the developments of the café culture of Tokyo of the time was the fashion for cafés which re-created colonial or semi-colonial spaces, complete with waitresses in ethnicized dress. Miriam Silverberg describes the Salon Manchuria, where patrons were served by waitresses in Chinese costume, in an interior decorated with chinoiserie.[54] The port city of Nagasaki also functioned as a semi-colonial space within Japan, where the masculine viewer could gaze on the exoticized spectacle of the women in Sinified brothels and opium dens.[55]

Modern girls were also represented, however, as figures who might themselves move between the metropolis and the peripheries. In 1935 the Shiseidō corporation

[52] Tani E. Barlow, *The Question of Women in Chinese Feminism* (Durham, NC: Duke University Press, 2004), 7. See also Tani E. Barlow, 'Introduction: On Colonial Modernity', in Barlow (ed.), *Formations of Colonial Modernity in East Asia* (Durham, NC: Duke University Press, 1997).

[53] For a brief biographical entry on Yamamura Kōka (Toyonari), see Menzies (ed.), *Modern Boy, Modern Girl*, 157. See also Kendall Brown's discussion of Yamamura and his woodcut of the New Carlton Hotel in Price and O'Connor (eds), *Taisho Chic*, 32; and Vera Mackie, 'Shanghai Dancers: Gender, Coloniality and the Modern Girl', in Devleena Ghosh and Barbara Leigh (eds), *Shadowlines: Women and Borders in Contemporary Asia* (Newcastle upon Tyne: Cambridge Scholars Press, forthcoming).

[54] Miriam Silverberg, 'The Café Waitress Serving Modern Japan', in Stephen Vlastos (ed.), *Mirror of Modernity: Invented Traditions of Modern Japan* (Berkeley: University of California Press, 1998), 215.

[55] See Takehisa Yumeji's series *Views of Nagasaki*.

produced a series of postcards in order to advertise its cosmetic products.[56] The postcards show a series of women dressed in the style of modern girls, applying make-up, and posed in situations of travel: in automobiles, trains, aeroplanes, or on cruise ships. These postcards reference the mobility of the modern girl, who appears to have the potential to move between the metropolis and the peripheries, or at least to imagine such mobility. The Japan Tourist Bureau's pamphlets and guides of the time addressed a traveller who might plan trips to Seoul (Keijō), Formosa (Taiwan), or China.[57]

The Shiseidō postcards address women as subjects of the metropolis who might enjoy the experience of travelling to Japan's peripheries. The Shiseidō corporation also, however, addressed colonial subjects. A notable example is the poster for Shiseidō soap which included the image of the woman known variously as Ri Kōran, Li Xianglan, or Yamaguchi Yoshiko.[58] Yamaguchi was an actress, fluent in both Japanese and Chinese, who appeared in films produced on the Chinese mainland with Japanese capital. She appeared under the Sinified name of Ri Kōran. These films often presented the relationships between the various participants in colonial relationships through the medium of romance.[59] Meanwhile, the Shiseidō corporation mobilized the ambiguous figure of Ri Kōran in its address to the consumer on the Chinese mainland. While the visual representations of the modern girl were producing a taxonomy of women according to gender, class, ethnicity, and racialized positioning, the marketing of the Shiseidō corporation was producing a precise taxonomy of consumers for its products.[60] These visual representations are suggestive of the mobility of capital, products, individuals, and representations under the conditions of colonial modernity in East Asia in the first half of the twentieth century.

[56] Shiseidō advertising postcards *Gendai Keshō Hyakutai* ('One Hundred Scenes of Contemporary Cosmetics'), 1935; some are repr. in Yamamoto Takeo et al. (eds), *Shiseidō Sendenshi 1: Rekishi* (Tokyo: Shiseidō, 1979), 92. On the mobilization of the figure of the modern girl by the Shiseidō corporation, see Adachi Mariko, 'Shashi to Shihon to Modan Gāru: Shiseidō to Kōiri Sekken', *Jendā Kenkyū*, 9 (2006), 19–38.

[57] See Sugiura Hisui's series of tourist maps for the Japan Tourist Bureau, which included Seoul (Keijō), Formosa (Taiwan), Shantung, and sites within Japan. The English lettering on these maps suggests that the Bureau also addressed an overseas traveller who might combine a trip to the Japanese metropolis with travel to Japan's colonial and semi-colonial peripheries; see Tokyo Kokuritsu Kindai Bijutsukan (ed.), *Sugiura Hisui Ten*, 78. See also the discussion of the pictorial magazine *Nippon* and its presentation of Japan and its colonies to an international audience in Weisenfeld, 'Touring "Japan-as-Museum"', 747–93.

[58] Shiseidō poster from 1941, showing Ri Kōran advertising soap for the Chinese market, repr. in Yamamoto et al. (eds), *Shiseidō Sendenshi*, i. 177. On the career of the woman known variously as Yamaguchi Yoshiko, Shirley Yamaguchi, Ri Kōran, or Li Xianglan, see Aiko Yoshioka, 'Cross-Cultural Encounters: Multiple Star Identities of Yamaguchi Yoshiko', Ph.D. diss., La Trobe University, 2003.

[59] Freda Freiberg, 'China Nights (Japan, 1940): The Sustaining Romance of Japan at War', in John Whiteclay Chambers II and David Culbert (eds), *World War II, Film, and History* (Oxford: Oxford University Press, 1996), 31–46.

[60] Adachi, 'Shashi to Shihon to Modan Gāru'.

THE AFTERLIFE OF MODERNISM

When we look back on early twentieth-century modernism, it is often with a sense of nostalgia, which has been intensified with a recent series of exhibitions and reflections on the cultural production of the first decades of the twentieth century. While some features of this nostalgia are specific to Japan, there is also an international circuit of exhibition, collection, commentary, and consumption. The Taisho Chic exhibition mentioned at the start of this chapter was based on a collection which had been donated to the Honolulu Academy of Arts, and the exhibition toured from Honolulu to Berkeley, Tokyo, Berlin, and Sydney. Overlapping with this circuit was the touring art deco exhibition from the Victoria and Albert Museum. A decade before, an exhibition on the modern boys and modern girls of Japan had been shared between Yokohama and Sydney. This was able to build on the 1920s exhibition which had been held in the National Museum of Modern Art in Tokyo in the early 1980s.[61]

There has also been a recent upsurge of interest in the cultures of modernism, characterized by the issue of important document collections and anthologies on modernist culture, a series of retrospectives of modernist artworks, and a re-evaluation of the cultural products of modernism.[62] Several recent scholarly works in English have attempted a re-evaluation of early twentieth-century modernist texts, many referred to here. These studies have reconsidered the worth of works previously dismissed, and have expanded the range of texts considered as part of the modernist movement. They have also brought new critical vocabularies to early twentieth-century modernism. By recognizing the international circulation of representations and artistic practices, they have attempted to go beyond simplistic discussions of mimesis, copying, and derivativeness. The concept of colonial modernity also reminds us that the cultural production of early twentieth-century Japan was embedded in regional and global relationships of inequality.[63] The boundaries of modernism are thus constantly shifting, suggesting that the definition of what constitutes a modernist artwork is a question of reading strategies as much as the identification of formal features.

[61] Tokyo-To Bijutsukan, *1920-nendai Nihon Ten*; Menzies (ed.), *Modern Boy, Modern Girl*; Tipton and Clark (eds), *Being Modern in Japan*; Price and O'Connor (eds), *Taisho Chic*; Benton et al. (eds), *Art Deco*.

[62] See Tyler, *Modanizumu*, 10–14.

[63] See Lippit, *Topographies of Japanese Modernism*; Tyler, *Modanizumu*; Gardner, *Advertising Tower*; and Silverberg, *Erotic Grotesque Nonsense*.

AFTERWORD

'NEWNESS' IN MODERNISMS, EARLY AND LATE

PETER BROOKER

MODERNISMS

THE very range of chapters in this volume is itself witness to the many types and different manifestations, in different media, and across uneven histories, of what we term 'modernism', or the 'avant-garde'. If in some ways this collection echoes a standard emphasis on Anglo-American and European modernisms, its informing perspective, it should be clear, is motivated by an awareness of what Andreas Huyssen, following Arjun Appadurai and Cesar Canclini, have termed 'modernism at large'.[1] In this perspective, the family of terms 'modern', 'modernization', 'modernity', 'modernism', and their more errant cousin 'avant-garde', have migrated so as to appear old and new at once in hybridized or realigned formations in non-European cultures. We tend to talk, consequently, of a spatialized geography of modernisms and of multiple and polycentric modernities.[2] This rightly unsettles any unexamined

[1] See Andreas Huyssen, 'Geographies of Modernism in a Globalizing World', in Peter Brooker and Andrew Thacker (eds), *Geographies of Modernism: Literatures, Cultures, Spaces* (London: Routledge, 2005), 6–18.
[2] See, for a synoptic set of positions, the set of papers collected in *Modernism/Modernity*, 13/3, special issue: *Modernism and Transnationalisms*, (Sept. 2006). See also Laura Doyle and Laura Winkiel, *Geomodernisms: Race, Modernism, Modernity* (Bloomington: Indiana University Press, 1996). Laura Doyle restates the case in the present volume (Ch. 14) for moving beyond a 'borrowing' or 'inheritance'

perception of the West and its others in terms of the model of centre and periphery. But a number of still-ravelled issues, of time and of space, are caught up in this sense of the changed composition and provenance of modernism. Is it, to begin with, so new and, if so, in what ways? As chapters by Doyle, Bell, and in other ways Youngs, make clear, Europe's long history of colonialist ambition and the primitivist appeal of non-European traditional art forms made nineteenth- and early twentieth-century modernism already a world phenomenon, albeit accompanied by an ambivalent sensibility that was shot through with prejudice and self-doubt.

The theorist of globalized artistic culture Noel Carroll points, on this same theme, to examples of cultural hybridity in the impact of Turkish music on Mozart, African art on Picasso, and the Japanese Ukiyo-e School on Impressionist painters. This he sees as a one-sided exchange in which national 'artworlds' and canons remained 'segregated' and 'parochial'.[3] The plethora of examples in chapters here by Chaudhuri, Donald and Zheng, Black and Muecke, Woods, and Mackie suggest otherwise. Chaudhuri (Chapter 52), for instance, shows how Indian artistic, design, and media culture has evolved from a combination of traditional or vernacular styles and a first-hand acquaintance with European art movements. Even where, in design and architecture, the 'imported' international modernism of the Bauhaus and Le Corbusier have had a very strong impact, these served to critique 'classical' imperialist models and, in the broader process of decolonization, coexisted with other modernisms, revivals, and adaptations such as Indo-Saracenic, primitivist-folk styles, and 'Indo-Deco'. Hemelryk Donald and Zheng (Chapter 54) show, similarly, how movements in twentieth-century Chinese modernism have drawn upon European Symbolism, Futurism, and visual and cinematic techniques, as well as upon Freud, and Western concepts of individual liberty, equality, and the ideals of democracy and science—not simply in a one-way process of assimilation but in a double critique of these sources and of traditional Chinese thought, political rule, and the effects of Chinese modernization. Hemelryk Donald and Zheng advance an understanding of the process of 'influence' which takes account of existing conditions and predispositions in the 'receiver' nation. Writers and artists, they suggest, in a description which can serve for other examples here, are engaged in a process of adaptation or cultural translation in which they 'become transformative and deliberative new voices referencing culturally distinct patterns of expression while finding their own timbre and reason'.

For Noel Carroll, the more recent dispensation of a new 'integrated, interconnected, transnational artworld'[4] differs significantly from earlier periods in that artists all over the world now 'share a number of conceptual frameworks

and inevitably binary model to a common 'global' model in conceptualizing the 'co-rooted' relations between Western and non-Western modernisms.

[3] Noel Carroll, 'Globalization and Art: Then and Now', *Journal of Aesthetics and Art Criticism*, 65/1 (2007), 138.
[4] Ibid. 139.

and hermeneutical strategies'.[5] Among these, Carroll cites the perspectives of post-coloniality, feminism, identity politics, and 'a generic anti-establishmentarianism' along with a 'toolkit' of methods, such as 'radical juxtaposition, de-familiarization, and the de-contextualization of objects and images from their customary milieus'.[6] The result, he believes, is a 'unified' transnational institution of art: 'a culturescape with its own language games and networks of communication, distribution, and reception'.[7] As a case in point, Carroll suggests how 'foreign language' and independent film workers help 'bring sophisticated work from everywhere to serious audiences in search of something different'.[8] The narrow internationalism of such a conception, however, centred upon 'serious audiences' in need of stimulation from the outside, comes all too readily to resemble the appropriative and universalizing cosmopolitanism of an earlier era which continues to ignore 'local' national language games, audiences, and networks.

To understand more fully these dual historical and spatialized relations, of porosity and power at once, we can neither afford to repeat the history of Western privilege, nor hope simply to dismiss 'the West' as if it were a homogeneous construct and its influence a straightforwardly imposed hegemonic regime. The governing process rather, as evidenced by many chapters in this volume, has been conspicuously one of dialogic interchange, across and between local, national, and globalizing cultural imperatives, marked variously by strategies of assimilation, negotiation, opposition, or rejection. This volume, then, tracks the production of differently inflected modernities and modernisms as a geo-historical and transnational process in which the Anglo-American and European examples remain of great interest and value at the same time as they are repositioned in this very process of dialogic exchange.

Many chapters here help us also appreciate the inner complexities and heterogeneity of this European history. The key metropolitan centres we associate with this phase, for example—Vienna, Paris, London, and Berlin, though this is itself a limited list—overlapped with and overtook one another in economic terms, while modernist initiatives combined or moved at a different pace and with distinctive inflections in relation to regional, national, and international artistic cultures, especially, as Timothy O. Benson shows (Chapter 45), in reaction to the dramatic changes in geopolitical identities consequent on the First World War. The internal collaborations comprising the coteries and movements by which we name European modernism were riven, moreover, by fractious competition and rivalry. In addition, emerging artists and writers had themselves to negotiate with or reject the leaders of the previous generation in order to move on. In this way, in English-based modernism, Wyndham Lewis felt the need to jettison the examples of Augustus John, or Ford Madox Ford and Joseph Conrad, just as later figures such as W. H. Auden, John Lehmann, Herbert Read, and I. A. Richards had to wean themselves from the already presiding

[5] Carroll, 'Globalization and Art: Then and Now', 140–10.
[6] Ibid. 141. [7] Ibid. 142. [8] Ibid. 133.

authority of T. S. Eliot. And this remains the case where different media and different arts comprised non-synchronous traditions. Thus, James Donald (Chapter 28) points to the complex periodization of silent and sound film (was the first or the second, or were somehow both, 'modernist'?) but maintains, all the same, that post-Second World War movements in cinema be seen as 'a negotiation of the modernist tradition, or a reinvention of it, or a reaction against it', as 'something different and something new'.

The dialogue within Europe extended too, of course, as cinema especially made plain, across the Atlantic. The encounter with Europe, or an idea of Europe, of American writers and artists reached its high point in the 1920s, at a time when many European writers and artists, in their turn, entered upon a complex engagement with the adventure and disenchantment symbolized by American modernity. What has followed in Anglo-American modernism from the late 1930s and 1940s has been the process of canonization but also, in a retrospect upon this process, the recovery of different, seemingly tangential trends and the emergence of newer forms and idioms. These tendencies criticism has chosen to call 'late modernism' or, with decreasing confidence, 'postmodernism'. Both take their form, nonetheless, from a now differently accented dialogue with a modernist past. There is some reason, by that very token, therefore, for viewing this fuller history, and not simply the more conspicuously spatialized global present, as comprising a typology of modernisms.

This development prompts us to ask not only 'What was modernism?' as if this were a question of a bygone era, but to pose the questions of *when* and *where* modernism both *was* and *is*. How could it be otherwise when neither the process of modernization nor the meaning of 'being modern' are confined to the past but always belong to the here and now. We know too, however, as soon as these words are spoken, that the 'here and now', for all its apparent immediacy, is never quite 'here' or 'now'. The modern, like the moment of presence, is always coming and going, and the unnerving paradox of a simultaneously punctual but passing moment—captured for modernity in the technologies of the snapshot or live broadcast—is at the heart of what we talk about when we talk about modernism.

This phenomenon is confirmed by the periodizing terms I have alluded to, 'late' or 'post' or 'pre-' and 'early', which prefix the apparently substantive core of 'modernism'. Modernism is seemingly 'there' even as it is being anticipated or superseded. In the process, too, as an inescapably relational term, modernism engages with the other, longer histories designated by the parent terms 'modernity' and 'modernization'. 'Modernization', though it tends to evoke the rush of early twentieth-century technologies, is perhaps the most narrowly defined and unproblematic of these terms. The more capacious 'modernity', however, has long been differently employed in the social sciences and in literary history and criticism as well as across different European intellectual and artistic traditions. If it is commonly understood to refer to epochal shifts in the social and political order which ushered in the modern age, modernity is variously dated from as early as the fifteenth century, or the eighteenth-century Enlightenment, or is associated with post-Victorian societies. Fredric Jameson has argued that we would do well to see this history as the unimpeded

manifestation of a 'singular' modernity, identical, to all intents and purposes, with capitalism. But one suspects that this provocative insistence is borne, as much as anything, out of frustration at the non-appearance of capitalism's opponent, the awaited offspring of the evanescent cultural imaginary Jameson terms 'the desire called Utopia'.[9]

If anything, the relations here between what we might describe as 'culture, society, and technology' have become more perplexing in recent decades. While Perry Anderson, for example, could detect the contiguous and converging political and cultural features of the earlier twentieth-century conjuncture which produced Anglo-American modernism, these spheres seem increasingly to be neither synchronous nor in evident alignment.[10] Jameson's stultifying 'singular modernity' and transformative utopian desire would seem in fact to bear this out. It remains the case, nonetheless, that to grasp these relationships across a dramatically changing history and expanding world is to grasp, or, in Fredric Jameson's earlier terms, to 'cognitively map', our position in contemporary geo-cultural time and culture. The terms 'transnationality' and 'globalization' or 'de-globalization' stand in for one attempt to do this. But though they point to evident if confusing features in the world economy and allied social and political developments—and bring 'us' to reflect more self-consciously on *whose* 'cognitive map' is in question—they do not substitute for the work terms like 'modernism' or 'late' or 'postmodernism' are called upon to do; that is to say, they do not in themselves offer a way of naming and mapping contemporary artistic culture. The chapters in this book on different modernisms will serve their purpose if they help draw part of this new map. I want to reflect further, in this Afterword, on some of the general questions I believe this discussion entails.

NEWNESS: MINORITY AND MASS

Zurich in 1915 was a cosmopolitan heterotopia, home to wartime refugees 'longing for a clean slate' and, as is well known, a temporary home to the celebrated transients Vladimir Ilyich Lenin, Tristan Tzara, and James Joyce.[11] While Joyce worked at this time on *Ulysses*, Tzara helped launch European Dada, and Lenin wrote the pamphlet published in 1917 as *Imperialism: The Highest Stage of Capitalism*. All three, we might say, were planning revolution. Marjorie Perloff writes of 'a short-lived but

[9] Fredric Jameson, *A Singular Modernity: Essay on the Ontology of the Present* (London: Verso, 2002), 215; and see Jameson's subsequent *Archaeologies of the Future: The Desire Called Utopia and Other Science Fictions* (London: Verso: 2005).
[10] Perry Anderson, 'Modernity and Revolution', in Cary Nelson and Lawrence Grossberg (eds), *Marxism and the Interpretation of Culture* (Urbana: University of Illinois Press, 1988), 317–33.
[11] Richard Ellmann, *James Joyce* (Oxford: Oxford University Press, 1959; repr., corr., 1976), 422; Robert Hughes, *The Shock of the New* (London: Thames & Hudson, 1991), 60–1.

remarkable rapprochement between avant-garde aesthetic, radical politics, and popular culture' occurring at the beginning of the twentieth century.[12] She is not thinking of Zurich, but, arguably, these three figures (Joyce, Tzara, and Lenin), comprising primary examples of experimental modernism, the European avant-garde, and political modernism, did in this instance coexist in one of the most astonishing chronotopes of all places and times. Lenin lived at 14 Spiegelgasse in the same street where at number 1 the Cabaret Voltaire took place. The Joyces lived at three different addresses before moving in 1916 to number 54 and then in 1917 to number 73 Seefeldstrasse, within walking distance of the Cabaret Voltaire and the Café Odéon. Here was 'a natural theatre of the new', in Robert Hughes's description, where everybody, so it is said, met everybody else.[13] In one report, Joyce and Lenin are said to have met at the Odéon, although there is no supporting account of this.[14] Marjorie Perloff is describing 'the moment of futurism' and has in mind figures such as Blaise Cendrars and Sonia Delaunay, Apollinaire, and the Italian and Russian Futurists of the *avant guerre*. This moment passed, however, she believes, into another phase of separated tendencies towards the nihilistic anarchism of Dada and 'a renewed longed for transcendence' from which was born both the Surrealist emphasis on the occult, the visionary and dream, and proto-fascism.[15] If, in Zurich, we were to substitute Ezra Pound for Joyce and Trotsky for Lenin, and trust to the gregarious go-getting young Pound to round up the other two, we could guarantee some conversational fireworks on aesthetics and economics. In Tom Stoppard's play *Travesties*, Lenin, Joyce, and Tzara do, of course, all meet. On stage, they wrangle and exchange texts and identities in the Zurich library and the home of a minor embassy official. The truth, however, is that these exemplary modernisms, near neighbours as they seemed, were not on speaking terms.[16]

Modernist studies has grown accustomed to modernist difference—indeed, it has promoted it—but we can still be pulled up, I believe, by the kind of difference which, as in this case, outside of the comic fantasy of Stoppard's *Travesties*, tells a story of non-communication between so-called 'high modernism', the avant-garde, and revolutionary political modernism. And this extends to deep-seated instincts in critical study. For while Anglo-American literary critics might choose whether or not to consider Joyce's œuvre in whole or in part as modernist or avant-garde

[12] Marjorie Perloff, *The Futurist Moment: Avant-Garde, Avant Guerre, and the Language of Rupture* (Chicago: University of Chicago Press, 1986), p. xvii.

[13] Hughes, *The Shock of the New*, 60.

[14] Ellmann, *James Joyce*, 423 n. 10.

[15] Perloff, *The Futurist Moment*, p. xvii.

[16] Hugo Ball, a founding impresario of Cabaret Voltaire, liked to speculate that Lenin was a witness to the activities of the Dadaists: 'Every evening he must surely have heard our music and our tirades,' he said, and went on to ask, 'Is Dadaism something of a mark and gesture of a counterplay to Bolshevism? Does it oppose to the destruction and thorough settling of accounts the utterly quixotic, unpurposeful, incomprehensible side of the world?' (quoted in Raymond Williams, *The Politics of Modernism* (London: Verso, 1989), 81). The answer on the side of Bolshevism can only be 'no'. Williams pursues this question, however, in a discussion of Soviet revolutionary theatre and Expressionist drama; Ibid. 81–94. As to the other participants, Joyce and Tzara did later appear together—in the pages of the *transatlantic review*, 1/4 (Apr. 1924) (Joyce, 215–23; Tzara, 224–9), along with a piece by Ernest Hemingway, 247–8, all three under the title of 'From Work in Progress'.

(or realist), few, if any, readers would think to describe Tzara as anything but avant-garde. Why this is so is unclear. What is clear, however, is that there has been far less conversation across transnational critical-cultural habits and traditions than across artistic and political movements.

To consider these questions fully would require a properly historicized account of the long-standing conventional usage of the terms 'avant-garde' and 'modernism' across different art forms in Anglo-American and European critical study. The conception of modernism, or the avant-garde, in an expanded field should encourage just such a dialogue across critical positions and academic disciplines. The relation of these discourses and different artistic tendencies to political modernisms, whether of the Left or Right, would embrace examples in continental Europe, high-profile figures such as Marinetti and Pound or Breton and Brecht, and the Marxist 1930s in the UK and US. These have been much studied in their national-cultural contexts or within the frameworks of particular critical paradigms, but have rarely inspired a comparative study. The conjunction in this volume, in close proximity, of chapters on modernist politics, on Italian and Russian Futurism, on London, Berlin, and the modernist Atlantic, among others, might help prompt such an inquiry.

I can do no more here than sketch out some of the riddles these questions pose. I want to probe some of the internal differences between these modes and tendencies but also to ask what the various modernisms—to call them this—might be said to share. First of all, perhaps, they share the history of naming and associated cultural authority I have indicated. The use of the term 'modernism', as is well known, came into being with most force in the post-war period with something like the hegemonic meanings it then assumed for a generation or more. The moment of institutionalized definition arose in Anglo-American literary studies as a response to the apparent threat from below and from mass society to the modernism that was then valued as occupying the centre rather than the margins of culture. The one-time emergent and alternative became dominant and to represent accepted cultural capital. As is also well known, this installed a blithely male and Eurocentric, or selectively Anglo-American, modernist tradition. But the fuller history has also produced its own dissident renaming, in an appeal to other readings or other modernisms, or to the avant-garde as a resolutely unincorporated commitment to experiment. We know, too, from more recent studies that the terms 'modernism' and indeed 'postmodernism' were used early in the century by some actors in this scene themselves (respectively, for example, by Middleton Murry and Randolph Bourne); that their meanings, like the work of this period, ran in diverse directions; and that the unified modernism of the post-war canon was a partial construction in its contents and analysis. The new readings across an expanded field to which again this book and others are witness have further loosened 'modernism's' anchorage.

This brings us again to acknowledge the difference between heterogeneous modernisms, but not to an idea of what modernisms might share. With this in mind, I want to explore the critical-cultural ramifications of 'newness', a term Peter Osborne investigates here (Chapter 22) as a shared structural feature of modernism as a philosophical concept. Susan Stanford Friedman, in a searching discussion of the

provenance of the triad 'modernism-modernity-modernization', has argued that 'what is shared . . . is the emphasis on rupture from the past . . . transformative change is a constant component of definition'.[17] In the first instance, this clearly echoes the self-understanding of modernist and avant-garde figures and movements themselves. Thus, 'il faut être absolument moderne', declared Arthur Rimbaud in 1873,[18] while William Carlos Williams was to announce in 1920 in the Prologue to *Kora in Hell*, 'Nothing is good save the new. If a thing have novelty it stands intrinsically beside every other work of artistic excellence.'[19] For Richard Huelsenbeck, the word 'Dada' represented 'the child's first sound' and expressed 'the primitiveness, the beginning at zero, the new in our art'.[20] Dziga Vertov spoke of how his 'camera eye' deciphered 'in a new way, a world unknown to you'.[21] And for Franz Marc, on a still broader scale, the projected but unpublished second volume of *Der Blaue Reiter* was to be concerned entirely with a new world: 'there is only one question', said Marc; 'has the time come to separate ourselves from the old world? Are we ready for the *vita nuova?*'[22]

Where this absolute commitment to the absolutely new has not been a nihilistic abandonment of the past and future alike, as in some Dadaist positions, it has given modernism and the avant-garde its utopian character. In striving to project the idea of a new art or civilization into a clean, open sphere, it aligns itself with the emergent forces of the present, including political ideologies of the Left and Right: its eye upon the future in the present. In the process the newness of being modern in present time becomes identical with its phonic neighbour 'nowness'; 'the "today" of the modern', as Osborne puts it. Susan Stanford Friedman, once more, summarizes: 'modernity is the insistence upon the Now—the present and its future as resistance to the past, especially the immediate past. It establishes a cult of the new that constructs retrospectively a sense of tradition from which it declares independence.'[23] These two impulses come together, we might think, in Gertrude Stein's statement that 'The business of Art . . . is to live in the actual present, that is the complete actual present, and to completely express that complete actual present'—a dictum that Marjorie Perloff cites in elaborating the case for a permanent, if suppressed, modernism, made new again in the present time of the twenty-first century.[24]

[17] Susan Stanford Friedman, 'Definitional Excursions: The Meanings of Modern/Modernity/ Modernism', *Modernism/Modernity*, 8/3 (Sept. 2001), 502.

[18] Arthur Rimbaud, 'Adieu', in *Une Saison en Enfer* (1873); repr. in *Collected Poems* (London: Penguin, 1962), 346.

[19] William Carlos Williams, *Selected Essays* (New York: New Directions, 1954), 21.

[20] Quoted in Alan Young, *Dada and After: Extremist Modernism and English Literature* (Manchester: Manchester University Press, 1981), 13.

[21] Quoted in Vlada Petric, *Constructivism in Film: A Cinematic Analysis: The Man with the Movie Camera* (Cambridge: Cambridge University Press, 1987), 13.

[22] Wassily Kandinsky and Franz Marc (eds), *The Blaue Reiter Almanac* (1914), Documentary Edition, ed. and introd. Klaus Lankheit, trans. Henning Falkenstein with the assistance of Manug Terzian and Gertrude Hinderlie (London: Tate, 2006), 260.

[23] Friedman, 'Definitional Excursions', 53.

[24] Marjorie Perloff, *21st-Century Modernism: The 'New' Poetics* (Oxford: Blackwell, 2002), 154.

The statements by such as Rimbaud, Gertrude Stein, William Carlos Williams, Dziga Vertov, and Franz Marc might suggest that this uncompromising invocation of newness now (and its claim on the future) helps define them and this mode as avant-gardist. But how, we might ask, is this different from the English 'Georgian' Harold Monro's belief in poets as the 'heralds, perhaps even the architects, of the new, free society that was surely coming' or from Rupert Brooke's praise of Monro as himself the originator of what Brooke termed the 'New Poetry'?[25] On another front, Émile Zola, the founder of literary Naturalism, described this new art, based upon science and not the imagination, as opening up a 'new world', as 'the force which is sweeping us onward, and which is working toward the molding of future centuries'.[26]

The fact is that an explicit appeal to newness and its simultaneous use as an evaluative term ('the new is the good', to paraphrase Williams) extends not only across different literary and artistic modes but surfaces everywhere else, too, across modernity in the open domain of mass society. This proximity and inter-animation of minority and mass, or popular, culture occupied much of the debate on the postmodernism of the 1980s and 1990s but, as some of the authors in this volume (Xiros Cooper, Crouch, and Halliwell) attest, the minority and the mass already ran in tandem and traversed each other in the earlier period too.

This insight is often associated with the pointedly named New Modernist Studies, which has widened the purview of criticism and scholarship across a range of modernisms and modernist contexts. As described by Marina MacKay (Chapter 26), the earlier, 'older' version of modernist study was elitist while the second recovers modernism's relation to and position inside the cultural mainstream. In the process, New Modernist Studies poses the challenge to itself, as to others, as to whether Rupert Brooke or Harold Monro or Émile Zola, George Gissing or Sherwood Anderson, or the trio, say, of Wells, Bennett, Galsworthy—from whom the modernist Virginia Woolf wished famously to distance herself—were also modernists, or a different kind of modernist. But what common ground does this establish? And did any of these writers, Woolf included, believe, with Carlos Williams, that 'nothing is good save the new'? Did they aim to begin again at zero or to express, with Stein, the 'complete actual present'? And what was the relation of these different ways of being new or modern to the newness pursued in the cultural mainstream of modernity?

The materialist turn in modernist studies, associated with this changed agenda and unsettled scale of value, has sought, indirectly addressing these questions, to set modernist art in relation to the harder facts of production, finance, and readership. This is particularly evident in the study of journals and periodicals, as discussed here by Suzanne W. Churchill and Adam McKible (Chapter 19) and currently understood

[25] Dominic Hibberd, 'The New Poetry, Georgians and Others', in Peter Brooker and Andrew Thacker (eds), *A Critical and Cultural History of Modernist Magazines*, i (Oxford: Oxford University Press, 2009), 176.

[26] Émile Zola, *The Experimental Novel and Other Essays*, trans. Belle M. Sherman (New York: Haskell House, 1964); excerpted in Vassiliki Kolocotroni, Jane Goldman, and Olga Taxidou (eds), *Modernism: An Anthology of Sources and Documents* (Edinburgh: Edinburgh University Press, 1998), 171.

as such a significant feature of the culture of modernity. The *Little Review*, with its slogan 'Making no compromise with the public taste', would appear to be a self-proclaimed example of the 'elitist' modernism which has occupied the 'older' modernist study. At the same time, contemporary periodicals such as *The Dial*, the *New Age*, the *London Mercury*, or *American Mercury*, or medium-circulation popular magazines, or so-called 'slicks', such as *Vanity Fair*, the *Smart Set*, or *Esquire* and the *New Yorker*, provide ready examples of a stratified public taste and assorted claims on newness. This is evident in some of their titles and self-promotion (thus, a 1916 advertisement for *Vanity Fair* promised 'an ALTOGETHER NEW KIND OF MAGAZINE ... an entertaining magazine for Moderns'),[27] but it is also clear in their contents, including cartoons and advertising, assumed readership, and working editorial criteria. Especially interesting, too, is who of otherwise named 'modernist' (here designating 'experimental') authors was included and excluded in these popular 'quality' magazines.

Lawrence Rainey's account of the publication of *The Waste Land* in *The Dial* magazine rather than in the *Little Review* or *Vanity Fair* highlights, as Edward Bishop sees it, 'the transition of modernism as a minority culture to one supported by an important institutional and financial apparatus'.[28] 'The *Dial*', Bishop writes, 'represented the present moment of modernism.' The *Little Review*, meanwhile, belonged to modernism's beginnings, and *Vanity Fair* 'represented modernism's future where the market economy could purchase and commodify works of literature' ideologically opposed to a market ethos.[29] John Xiros Cooper (Chapter 17) in the present volume takes a similar but more positive view of what he sees as the ubiquitous assimilation and dispersal of modernist tropes across the everyday life of modernism's future in postmodern culture. And in fact we can point to earlier examples of the commodification of literary and artistic works. In the world of 'little magazines', for instance, the Pre-Raphaelite *Germ*, a minority magazine with a small readership which ran for only four numbers, was twice reprinted by the end of the nineteenth century. In the process, the price of an original set increased from the already expensive 1s. to £30 and in one instance to £104.[30] What we are more inclined to ask of such examples, however, and of the entire process, is whether aesthetic value, and its concomitant symbolic cultural value, was *entirely* commodified and thus lost to market value.

The 'slicks' themselves offer some revealing evidence on this, for they too discriminated, in their own terms, according to their position *vis-à-vis* other competitor magazines and their target readerships, on which modern or modernist, or

[27] Faye Hammill and Karen Leick, 'Modernism and the Quality Magazines: *Vanity Fair* (1914–36); *American Mercury* (1924–81); *New Yorker* (1925–); *Esquire* (1933–)', in Brooker and Thacker (eds), *A Critical and Cultural History of Modernist Magazines*, ii (Oxford: Oxford University Press, forthcoming).
[28] Edward Bishop, 'Re-covering Modernism', in Ian Willison, Warwick Gould, and Warren Chernaik (eds), *Modernist Writers and the Market Place* (London: Macmillan, 1996), 310.
[29] Ibid. 311.
[30] Marysa Demoor, 'In the Beginning, There Was *The Germ*', in Brooker and Thacker (eds), *A Critical and Cultural History of Modernist Magazines*, i. 53.

avant-gardist, authors, or what aspect of their work or person, was marketable. Thus, Ernest Hemingway contributed to the *Little Review, transition,* and *This Quarter* among radical little magazines, but also to *Life, Cosmopolitan,* and, on a regular basis (along with Scott Fitzgerald) to *Esquire* in the 1930s. At this point *Esquire* was a new magazine which, in seeking out its own niche, aimed to become 'the common denominator of masculine interests—to be all things to all men...among other things, a fashion guide for men'.[31] In other examples, Joyce was reviewed, referenced, or quoted, but not himself published, in *Vanity Fair,* and both he and Gertrude Stein were parodied or pastiched—hilariously in the latter case, as Churchill and McKible show—but again not directly published, in *Esquire* or the *New Yorker.* Some writing was also simply rejected. Thus, *Esquire* found space for Pound's essays on art and Social Credit but not for his poetry. They rejected a piece on Brancusi and finally drew the line at his support of Mussolini. And in a further small but revealing instance, Gertrude Stein, who contributed from 1917 into the 1930s to *Vanity Fair,* the most open of these magazines to modernist authors and artists, had a piece rejected by the *New Yorker* on the grounds, said the editor, that 'she was not allowed to buy anything her boss didn't understand'.[32]

The mainstream, that is to say, drew its own clear boundary lines, with the result that a slap in the face of public taste could be simply greeted with a blunt rejection slip. The powerful role of the editors of popular magazines, the nervousness of printers, and the exercise of censorship—directly experienced by Ezra Pound, D. H. Lawrence, and Joyce, and the magazines *The Freewoman* and *Masses,* as well as later by the Beats—would have made it abundantly clear to authors what was and was not acceptable. Not everything, clearly enough, was deemed fit for commodification by the commodifiers. This did not mean, however, that writers and artists either simply succumbed to or resolutely defied this fate. And short of the extreme case of censorship—which in the above examples was partly circumvented or not permanent—it did not mean either that unpublished work was extinguished.

Gorham Munson, editor of the little magazine *Secession* (a call to secede from the modern US), spoke of the 'atmosphere of danger for ideas' necessary to a new movement and of the welcome appearance of 'danger' in the poetry of E. E. Cummings.[33] In rejecting Gertrude Stein, the *New Yorker* identified something similar— what was outré and beyond the pale. It was possible, then, to be too advanced, too new—a reaction which effectively set this otherness 'outside' rather than 'out in front'. What was at stake was, in fact, a place and influence in the public realm. If, in Peter Bürger terms, the avant-garde sought through provocation to intervene and

[31] The words of editor Arnold Gingrich in the first issue, Oct. 1933; cited in *Time Magazine* (16 Oct 1933), available at <http://www.time.com/time/magazine/article/0,9171,746216-1,00.html>.

[32] Thomas Kunkel, *Genius in Disguise: Harold Ross of the New Yorker* (New York: Carroll & Graf, 1995), 308; quoted in Hammill and Leick, 'Modernism and the Quality Magazines', to which this discussion is indebted.

[33] *S4N,* 23 (Dec. 1922), and 25 (Mar. 1923), no page numbers.

transform everyday modernity,[34] it met with the gains and losses of its absorption into the classy, middlebrow reaches of that world. In other words, this was a battle over being modern, in which one newness—the newness of literary experiment, experienced in a direct encounter with the experimental text—vied with another newness of being up to date, fashionable, and sufficiently au fait with names and trends. This latter 'smartness', moreover, as Churchill and McKible show—and Mackie's study of modernism in Japan (Chapter 55) confirms—was targeted specifically at the construction of the 'modern girl'. The material difference between these perceptions of the modern manifested itself in the world of magazines and the marketplace. We see this clearly in the generic and internal differences between, on the one hand, the little magazines *The Egoist*, the *Little Review*, and *transition*, where, to take a case in point, James Joyce's *Portrait of the Artist*, *Ulysses*, and *Finnegans Wake* ('Work in Progress') were published, and, on the other hand, the *Smart Set*, which published two stories from *Dubliners* in 1915, and the *New Yorker*, where Joyce was parodied but never published.

Newness: Modernization and Modernity

Newness, of course, also found expression, as a number of chapters above point out, in the material forms and experience of modernization and social modernity. As such it was associated in direct and visible ways with the new technologies of the car, the aeroplane, the underground, the typewriter, and the telephone, with steel-framed bridges and skyscraper buildings. Photography and radio (see Chapters 29 and 32) participated in the truism, as it has become, of modernity's accelerated transmission and representation. Thus, photography's capture of the 'instant' (the moment of now) delivered en masse the technology and experience of intervening in duration itself, while the 'thereness' and 'nowness' of early radio, as Debra Rae Cohen reports here, presented its listeners with 'the terrifying "miracle" of simultaneity of broadcast and reception', similarly manipulating time and distance. Cinema, in particular, would seem to be at once the quintessential modernist medium and industry, enacting, as James Donald points out, a pedagogic function in teaching its audiences how to 'negotiate the inherent strangeness of being-in-the-(modern)-world', whether in its adoption of an avant-gardist aesthetic or in the productions of mainstream film entertainment. Here, too, something 'lately' adopted could appear new enough, as in the example of the Expressionist film *The Cabinet of Dr Caligari*, which, says Donald, offered to an emerging middlebrow audience the lure of a challenging but not too difficult artistic respectability, with the additional pleasure of being able to claim a

[34] Peter Bürger, *Theory of the Avant-Garde*, trans. Michael Shaw (Minneapolis: University of Minnesota Press, 1984).

degree of distinction from mass culture—the net result 'as much a technique of modern niche marketing as a triumph of modernist formal experimentation'.

Often these technologies of transport, modes of communication, and media of representation and entertainment were associated with the modern city, in turn perceived as a contradictorily utopian and dystopian site, and associated in early twentieth-century modernism especially with the iconography and mythology of the American cities of Chicago and New York. Writers and artists, Bertolt Brecht, Georg Grosz, and Vladimir Mayakovsky among them, responded to the thrill of new materials and technologies and the architectural adventure which conveyed what Crouch (Chapter 34) describes as 'an attempt to create a form suitable for the new machine age' and the sense that 'society had come to a significant destination'. For Francis Picabia the 'Cubist city' of New York had revealed an ideal symbiosis between an avant-gardist aesthetic and modern cityscape. 'Futurists' of different persuasions, such as Antonio Sant'Elia, Vladimir Tatlin, or Le Corbusier, saw more a destiny than a destination, a future to be imagined now. Le Corbusier's faith in a geometric mechanization of the modern city was unqualified. His 'Voisin Plan' of 1925 for the rationalization of Paris would have entailed the total clearing of a 600-acre site, including Les Halles, the rue de Rivoli, the Opéra (classed as 'junk' by Le Corbusier), to be replaced by a motorway and new financial and residential centre 'rising to a height of over 600 feet'.[35] Here was the arch-exponent of 'international modernism', disparaged for decades since as a universalizing Western aesthetic and dehumanizing ideology. Nonetheless, the potency of these ideas extended, as Supriya Chaudhuri (Chapter 52) shows, beyond the West, *tout court*, to Indian-based architects thoroughly acquainted with European modernist aesthetics. Le Corbusier had a profound impact in India, stretching into the 1980s, but met with an adaptive rather than assimilative mentality. 'The "messy", mixed-use character of Indian built environments', Chaudhuri comments, 'was never accommodated within the totalizing vision of modernist design.'

But there was a newness, too, associated with the migration of people and ideas. This entailed not simply the imagined projection of modern structures, materials, and urban environments, or the before and after of the imagined and the real, but the newness of fragmented and redefined borders, cognate, as Youngs (Chapter 15) suggests, with collaged artistic composition, and a newness felt in the shock of a first encounter with all the ambiguity of the 'here and now'. This was the bewildering experience, felt as a bodily sensation, of enchantment and estrangement, as the new met the old at the moment of arrival. We know of this experience from colonial and post-colonial histories (see Chapter 14). But the experience of migrancy which marks these narratives was played out, as Raymond Williams and others have shown, equally in the earlier era of immigration to the modern city. One such example is the shock of the new experienced on arriving in Harlem by the figure King Solomon Gillis in Rudolph Fisher's story 'The City of Refuge' (1925). Here, to Gillis's stunned

[35] Hughes, *The Shock of the New*, 188.

amazement, the conventional order of things is turned around when he sees his first black policeman. John Cournos's first sight of London from the top of a bus in the novel *Babel* stirred in him the sense that here was a 'multi-tongued . . . many-tuned' jazz city, its cultural and ethnic differences a measure of its democratic composition.[36] Djuna Barnes was so affected on her first sight of Paris that she felt it 'cannot adequately be described'.[37]

What could not adequately be described—other than as 'indescribable'—could not be repeated either, or not by the same individual. This modernist sublime was associated, in these examples, we notice too, with an encounter with both historically new and older cities. Also, if the experience of a first encounter could not be individually repeated, it was collectively repeated for the generation who sailed back and forward across the modernist Atlantic and between the new and old in the 1910s and 1920s. In this period the iconic emblems of New York and Paris, in particular, enacted a curiously schizophrenic dance, pulling respectively towards modern(ized) society writ large, and the modern(ist) society of the street café and coterie (see Chapters 35, 40, 41). In the event, in the short and longer term, the excitement of modern urban experience on both sides of the Atlantic could prove profoundly disturbing, a scene of disillusionment and dystopian alienation and, day by day, of the changed mentality, at once blasé and withdrawn, described by Georg Simmel in his classic account of early twentieth-century Berlin.[38]

For many Europeans who travelled as visitors or were forced from fascist Europe to seek intellectual and artistic freedom in the US, the emergent 'culture industries' spawning Chaplin, jazz, and the funny papers were part of the attraction. Hollywood was a haven and a place of employment. For an émigré such as Bertolt Brecht, however, who, like others, had anticipated a different America, the actuality in the city of Angels was 'hell'. The artist, Baudelaire had said, goes to the marketplace seemingly to observe but in reality to find a buyer, and the harsh truth of this Brecht found in Hollywood, where 'Every day . . . I go to the market where lies are bought,' there hoping to 'sell the products of my mind'.[39]

These disillusioned moderns alert us, indirectly, to the crucial new 'art' of modernity: the parasitic art of advertising and companion to commerce which came both to inspire, as Timothy O. Benson shows (Chapter 45), and itself adapt the techniques of collage and montage developed in European art movements.[40] The new was delivered up to a new function which combined the innovations of aesthetic form with commercial intent according to the dictates of a market economy expanding into the new cultural industries. Here again—in the motif that accompanies this

[36] John Cournos, *Babel* (New York: Boni and Liveright, 1922), 89.

[37] Djuna Barnes, 'Vagaries Malicieux', *Double Dealer*, 3/17 (May 1922), 260.

[38] Georg Simmel, 'The Metropolis and Mental Life', in *Simmel on Culture: Selected Writings*, ed. David Frisby and Mike Featherstone (London: Sage, 1997), 174–85.

[39] Bertolt Brecht, *Poems 1913–1956*, ed. John Willett and Ralph Manheim (London: Eyre Methuen, 1976), 382, 366.

[40] See Matthew Teitelbaum (ed.), *Montage and Modern Life, 1919–1942* (Cambridge, Mass.: MIT Press, 1992).

entire development—the question we ask is whether or not this assimilation com-promised modernist method. For a commentator such as Theodor Adorno there was no doubt. Writing with a virulent pessimism in the 1940s, he detected a logic running from passages from Edgar Allen Poe and Charles Baudelaire to Hitler and the sensationalist display of fascist atrocities. Newness, to his eyes, had come to mean an unrelieved desensitizing conformity and sameness.[41]

Adorno's verdict on modernity was devastating but simplistic. Though explained, as Tyrus Miller points out, by the experience of fascism,[42] it ignored not only the internal complexities of American modernity and a 'nativist' modernist art and, most notoriously, the vibrant, indigenous modernism of jazz, but also the fluid, rather than starkly opposed, relations between European and United States culture.

Martin Halliwell (Chapter 40) outlines the earlier complex story of the rejection of American conformity and capitalism for the exile of freedom, licence, and civiliza-tion associated with old Europe and new modernism and the counterpart of a fascination with American technological modernity. Quite evidently, not all Ameri-can writers and artists were seduced by Europe, and another 'newness', elaborated, among others, by William Carlos Williams, Alfred Stieglitz, Charles Sheeler, Langs-ton Hughes, and John Dos Passos, was based in an appeal to local conditions. For all the tensions of race and ethnicity this sometimes entailed, being new, being modern, being modernist, and being American were not in these examples thought to be incompatible.

For those who criss-crossed the Atlantic, what was at stake was a sense of the meanings and values of culture, a concept including, in different versions, the idea of being modern and the signs and effects of modernization. In one version this described a consumerist mass society, in another it harboured an idea of artistic autonomy and the select minority. Both societies, America and Europe, were in different ways 'new' and offered liberation from a disparaged and frustrating past; both were thought of, and thought of themselves, as 'advanced'. In the complex stratifications and permutations of modernity, however, as the case of avant-gardist or modernist little magazines and big-city-based American 'slicks' demonstrates, this was not a stark, either/or distinction; nor, *pace* the Adorno of *Minima Moralia*, was America the dystopian landscape of paralysed subjects abandoned to a 'catastrophic degeneration', devoid of all quality and judgement.[43] Adorno's despair and his America belong to a specific period in European history and American cultural and economic development, but are part of a continuing transatlantic exchange. In the *arrière guerre* of the 1940s, Adorno could see nothing but an equation between European fascism and American capitalism. In an earlier letter to Walter Benjamin, he spoke with more subtlety of the necessary dialectical understanding of artistic autonomy and reification: 'both', he wrote, 'bear the stigma of capitalism, both

[41] Theodor Adorno, *Minima Moralia* (London: Verso, 2005), 235–8.
[42] Tyrus Miller, *Late Modernism: Politics, Fiction, and the Arts Between the World Wars* (Berkeley: University of California Press, 1999), 41–2.
[43] Adorno, *Minima Moralia*, 238.

contain elements of change . . . torn halves of an integral freedom to which however they do not add up'.[44]

MANIFESTOS

New artistic movements and schools, numbering hundreds across the twentieth century, pronounced their newness most visibly and loudly through the form of the manifesto. Though itself an apparently new form characteristic of modernism and the avant-garde, the manifesto derived from and adapted the political manifesto of earlier decades and thus retained some of the utopian rhetoric and declamatory style of political modernism.[45] Among the earliest, and certainly the most notorious, was Filippo Tommaso Marinetti's announcement of Futurism in *Le Figaro* in 1909— an outrageously polemical rejection of the past and tradition which, as Daniel Moore (Chapter 21) says, 'declared open season on history'. Here Marinetti rejected the tenets of Italian Symbolism in the name, as Martin Puchner puts it, of 'the absolute value of novelty',[46] summed up by the features of mechanized modernity: above all speed, introduced by the car and aeroplane, and new forms of communication. For the Futurists, profound change was inevitable; a new sensibility the automatic result of new science and the new technologies accelerating everyday life. As John White points out (Chapter 39), the manifesto became Futurism's primary genre, a fitting mode of widely disseminated communication in a world in which the daily newspaper each day synthesized the events of the whole world. The Futurist arts in poetry, painting, and drama responded in kind, in an insistence on brevity and rapid transmission. The result was the transformation of the human into a machine; a robotic soldier of revolution primed for the only event which would satisfy Futurism's destruction of the past: namely, war—famously described as being more beautiful than the Victory of Samothrace.[47]

For Futurism, the vital act comprised a simultaneous rejection of the old and birth of the new, a moment of rupture and violent annihilation of the past which would open in the same instant onto the future. In the extremity of its violence Marinetti's Futurism willed the destruction not of a past but of all the past, against which, as Puchner says, he set the 'future as such'.[48] Futurism's conception of history therefore amounts to a curiously aborted projection where the Futurist is already ahead of time

[44] Adorno, letter to Walter Benjamin, 18 Mar. 1936, in Ronald Taylor (ed.), *Aesthetics and Politics: The Key Texts of the Classic Debate Within German Marxism* (London: Verso, 1977), 123.

[45] Martin Puchner, *Poetry of the Revolution: Marx, Manifestoes and the Avant-Gardes* (Princeton: Princeton University Press, 2006).

[46] Ibid. 74.

[47] See 'The Founding and Manifesto of Futurism 1909', in Kolocotroni et al. (eds), *Modernism*, 249–53.

[48] Puchner, *Poetry of the Revolution*, 75.

and the others must catch up along a 'unified historical axis'.[49] Futurism was plainly, indeed literally, an 'avant-garde' movement, ahead of the game and the multitude, and to this extent akin to the vanguardist political party which similarly places itself already in the future. It is not altogether surprising, therefore, that prior to the First World War and Futurism's explosive appearance, Marinetti, like Mussolini, had adopted 'several core socialist positions'.[50] The Italian communist Antonio Gramsci, editor of *L'Ordine Nuovo* ('The New Order'), had in 1921 praised the Futurists' sense of the need in an age of 'big industry and the large proletarian city' for 'new forms of art, philosophy, behaviour and language'. In 'the field of culture', Gramsci commented, 'the Futurists are revolutionaries'.[51] The later identification between Futurism and Fascism was explicit, however, and came no doubt to help frame Walter Benjamin's gnomic distinction between on the one hand the Futurist–Fascist aestheticism of art and, on the other, the communist politicization of art.[52]

Futurism's logic of absolute transformation decided the only possible enactment of its theory: an elimination of the past and the present, or what we might term the 'past now', in war. It was founded, therefore, on the deluded perception of present time as a *tabula rasa* which would launch the future. Since, however, the present can never be emptied of the whole of the past, but is precisely composed of past traces and anticipations of a future, Futurism exposes the weakness, as demonstrated by Paul de Man, of all such thinking, including Gertrude Stein's determination to express 'the complete actual present'.[53] The attempted destruction of the past in an attempt to occupy the new now, through an 'event' which emerges out of nothing, will, as de Man shows, always fall victim to duration and the passage of time it has sought to annul. For newness, like modernism and the avant-garde, is inescapably tied to its partner: the ancient, the old, and traditional, or, in a word, the past. Either that or they are nothing.

But there was another much-cited example of modernist self-advertisement and sloganeering with a quite different implication to these avant-gardist protestations. Ezra Pound's call to 'make it new' has been frequently invoked as the watchword of modernism. It is a mistake, however, to set this alongside the destructive urge of Futurism or see it simply as evidence of Paul de Man's contention that modernity is

[49] Puchner, *Poetry of the Revolution*, 77.

[50] Ibid. 78.

[51] Antonio Gramsci, 'Marinetti the Revolutionary', in *Antonio Gramsci: Selections from Cultural Writings*, ed. David Forgacs and Geoffrey Nowell-Smith (Cambridge, Mass.: Harvard University Press, 1985), 51.

[52] See Walter Benjamin, *The Work of Art in the Age of its Technological Reproducibility and Other Writings on Media*, ed. Michael W. Jennings, Brigid Doherty, and Thomas Y. Leven (Cambridge, Mass.: Belknap Press, 2008), 42. Benjamin sees Futurism's glorification of war as the consummation of the tradition of 'art for art's sake'. '*Such*', he concludes, '*is the aestheticizing of politics, as practiced by fascism. Communism replies by politicizing art.*' See, on this much-discussed epigram, Susan Buck-Morss, 'Aesthetics and Anaesthetics: Walter Benjamin's Artwork Essay Reconsidered', *October*, 62 (Autumn 1992), 3–41.

[53] Paul de Man, 'Literary History and Literary Modernity', in *Blindness and Insight: Essays in the Rhetoric of Contemporary Criticism* (Minneapolis: University of Minnesota Press 1983), 142–65.

motivated by an act of 'ruthless forgetting' (or 'blindness') and takes 'the form of a desire to wipe out whatever came earlier in the hope of reaching at last a point that could be called a true present, a point of origin that marks a new departure'.[54] Pound drew the dictum of 'make it new' from the Chinese *Ta Hio*, and it appears both as a written ideogram in his Canto 53 and as the title, also accompanied by the ideogram, of a collection of his essays published in 1934. The contents of this volume are revealing. It consists of the following set of Pound's earlier essays, with their dates of first publication: 'Troubadours: Their Sorts and Conditions' (*c.*1912); 'Arnault Daniel' (1920); 'Notes on Elizabethan Classicists' (before 1918); 'Translators of Greek' (before 1918); 'French Poets' (February 1918); 'Henry James and Remy de Gourmont' (August 1918 and February 1919); 'A Stray Document' and 'Cavalcanti' (1910–31).

The book was in a sense a response to T. S. Eliot, and Faber, who wanted a collection of literary essays and not a set of essays propagating Pound's economic views—but this is not to say they wanted the collection he presented, where none of the literary essays were 'new' either in their date of composition or in being on contemporary material.[55] The one new item in the collection is an introductory essay, 'Date-Line'. Here Pound argues for a new culture or, in a term derived from the anthropologist Leo Frobenius, a new 'Paideuma', which would be informed, says Pound, by a comparative cultural perspective. Pound's title 'Date-Line' is accompanied not by '1934' but by the note 'Rapallo. Jan 28th, anno XII'—the year 12, a radical recasting of the calendar which doubly honoured the year 1922, as witnessing, firstly, the inauguration of a consummate literary modernism (Pound dated present time in the 'post-Christian era' from 31 October 1921, the date Joyce was said to have written the last words of *Ulysses*) and, secondly, the installation of Mussolini's Fascist regime in Italy. 'Making it new', therefore, for Pound, meant remaking literature and society according to these dual models in a rare, eccentric, and, as it turns out, contradictory pairing of artistic modernism and political modernity. For what one might term the 'Futurist' amputation of the past in Pound's revolutionary calendar starting from Joyce and Mussolini was incompatible with his practice and historical sense as a poet. For much of his own poetry, especially the 'creative translations' of the Provençal Poets, the Anglo-Saxon 'Seafarer', the Latin poet Sextus Propertius, as well as his use of Ovid, Homer, and Dante in *The Cantos*, is guided by the impulse to kick-start a moribund present society by renewing the best of past civilizations. 'Literature is news that stays news', as Pound announced in another slogan, thereby granting literature an originality and staying power which defeated the passage of time while administering to the ephemeral topicality of the day. The accent in 'making it new' must in this respect fall upon the 'it', which comprised, in utter contrast to Marinetti and Futurism's dismissal of all of the past, a selective past

[54] Ibid. 147, 148. Friedman writes of '"making it new" as a manifesto that refuses to acknowledge the presence of the past in the present and future' ('Definitional Excursions', 504). This is clearly not Pound's own understanding.

[55] See Humphrey Carpenter, *A Serious Character: The Life of Ezra Pound* (London: Faber, 1988), 526–7.

literature assembled in a newly invented tradition deemed to be of permanent aesthetic and cultural value.[56]

We might think we have arrived here, in the respective dismissal and retention of the past, at a difference between the 'avant-garde' and 'modernism', and that we see their internal disjuncture in Pound. If this is the case, it does not account for the appeal to the 'primitive' energies of early societies (or of the psyche) in the avant-gardist movements of Fauvism, Vorticism, Cubism, and Surrealism (see Chapters 20 and 36–8). For all the importance, too, of the conservative implications of 'tradition' in 'modernist' art, as notably in T. S. Eliot, this tendency, too, gave currency to a newly anthologized past which served to critique the present and *immediate* past in a radical rupture which looked in its own terms towards a transformed future.

Christopher Butler suggests that this interventionist renewal of the past was characteristic of the early modernists. They were, he says, 'perhaps the last avant-garde to apprentice themselves to the production of major work in earlier styles. An acute awareness of the past and the technical ability to reproduce it ensured that the early advances of the Modernists were made through a stylistic metamorphosis of the genres of the previous tradition.'[57] Thus, as Ramsay Burt (Chapter 31) summarizes: 'Picasso could draw like Ingres, Matisse studied with salon painters William-Adolphe Bouguereau and Gustave Moreau, and Schoenberg's early work showed his ability to synthesize the late Romantic styles of Brahms and Mahler.' The same might be said of other arts: of Nijinsky, as Burt points out, who had trained in the Imperial Russian Ballet and insisted that he needed to work in the Ballets Russes with dancers who had 'a perfect ballet technique', which he then adapted 'for his own purposes'.[58] Pound's 'creative translations' of past literatures were similarly part of a deliberate apprenticeship in verse forms, itself the sign of a new and disruptive professionalism.

The modernist use of the erstwhile political form of the manifesto was also an innovation, but the differences sketched out here between conceptions of the past, of history, the process of change, and systems of value show how problematic the appeal to newness in modernism and the avant-garde has been. To believe, with Paul de Man, that time and the past cannot simply be annulled and that there can be no absolute new beginning presents us with a spectrum of radical attitudes towards past literature, art, and civilization. The rhetoric of sheer revolution and interventionist renewal alike therefore express a view of the past and a position in history. Also, in so far as Futurists of the Right or Left, along with radical avant-gardists and conservative modernists, proselytized for an improved culture and social order, the commonly drawn distinction between first-generation twentieth-century modernists who supposedly eschewed an engagement with social and political affairs and 'late

[56] Shiach (Ch. 1 in this volume) emphasizes how modernism is constructed through its own contradictions: 'rooted in tradition and classicism but fascinated by the impulse towards the "new"'. See also David James's argument on the 'dialectic between tradition and experiment' in modernist prose fiction (Ch. 5). Understanding this dialectic, says James, helps us 'to correct the notion that fiction can be "modernist" only if it proves itself to be unprecedented'. Both speak to the internal tensions in conceptions of modernism I mean to draw out here.

[57] Christopher Butler, *Early Modernism: Literature, Music, and Painting in Europe, 1900–1916* (Oxford: Oxford University Press, 1994), 73.

[58] Marie Rambert, *Quicksilver* (Basingstoke: Macmillan, 1972), 61; cited in Burt, Ch. 31 in this volume.

modernists' who were committed to social and political causes is simply false.[59] The difference exists, instead, firstly in the form and political character of this commitment, but also in the fact that 'late modernists' had to be new in a new way because they inherited a different past, of which the early modernists themselves were a part. As Frank Kermode has put it of W. H. Auden, 'he was all for making it new but not in quite the same way as Ezra Pound'.[60]

THE POSTMODERN AND NOW AND NEXT

The above reflections reinforce the idea of a necessarily historicized diversity of modernisms: new in their *relation* to a past (but not the same past), even when this is absolutely rejected; modern in their response to the changing technologies of modernization and the manifold physical, political, and social changes of modernity, whether these are celebrated or deplored. I want to ask, finally, about the avant-garde or modernism's future, or, more precisely, how we name what is new now. One answer is that this future is to be found in modernism's ongoing academic study. In a sense this is only to make explicit the long-standing relation, elucidated by Sascha Bru (Chapter 2), of the modernist avant-garde with its Siamese twin, modern literary theory, and, in particular, poststructuralist theory. The two remain inseparable, in spite of the sense voiced by Bru, that modernism—if it is so named—'has always come both before and after theory'.

The obvious candidate and theory's own first choice for this future was 'postmodernism', a term and tendency which, having failed to stay news, is now past-tense and curiously older than a reinvigorated modernism. Under postmodernism, the Americanized West was doomed in the 1980s and 1990s, or so it seemed, to a culture of simulacra which had lost all sense of the real and history, all affective apparatus, and any claim to originality other than a recycled pastiche, since parody or satire were now beyond us. These ideas were derived, often indeed in pastiched versions, principally from original essays by Fredric Jameson and Jean Baudrillard. In a forlorn deflation of the historical avant-garde's ambitions, however, the concept of postmodernism could not survive its dissemination across the popular media of everyday life, nor the accusation that the cultural logic it was asked to name was complicit with late capitalism.

Other terms, in some inflection of 'globalization' and 'transnationality', have come to name the present and a context for present art. But how then is the latter to be

[59] See Tyrus Miller for the opposite view. Modernists, he contends, repressed history in favour of the 'gold standard' of aesthetic form. Late modernists by contrast 'in no way ignored their social context' (Miller, *Late Modernism*, 30–2).

[60] Frank Kermode, 'With Slip and Slapdash', Review of *The Complete Works of W. H. Auden*, iii: *Prose, 1949–55*, ed. Edward Mendelson (Princeton: Princeton University Press, 2007), *London Review of Books* (7 Feb. 2008), 19.

named and understood? One tendency, having dispatched postmodernism, sees a continuing currency in historical modernism; another sees a newly pluralist conception of renovated and realigned *modernisms*; while a third has referred more specifically to 'cosmopolitan' or 'post-colonial' or 'subaltern' modernisms, or, most recently, at the time of writing, to 'altermodernism'.

I want here, finally, to consider some of these examples and to propose less another new concept than a new adjective which implies a necessary perspective upon and condition for modernism.

In her study *21st-Century Modernism*, Marjorie Perloff expresses some dismay at the survival of the fatigued notion of postmodernism. Instead, in a reprise of her earlier *The Moment of Futurism*, she appeals, in a consciously conceived manifesto, to the 'short lived . . . avant-garde phase of modernism' exemplified by the early T. S. Eliot, Gertrude Stein, Marcel Duchamp, and Velimir Khlebnikov. These 'four early modernists (or call them avant-gardists)', says Perloff,[61] supply the precedents for a resurgent modernism alive in the work of a group of American poets associated with the school of 'Language Poetry': Susan Howe, Charles Bernstein, Lyn Hejinian, and Steve McCaffery. The initial avant-garde project, Perloff argues, had been 'at the very heart of early modernism' but had been deferred—'its radical and utopian aspirations . . . cut off' by wars and the repressive force of 'the great two totalitarian-isms'.[62] This last presumably alludes to communism under Stalin and to fascism, but perhaps to an advancing capitalism. No more is heard of these repressive forces, however, nor of the enabling conditions which allowed this modernist impulse to resurface in the contemporary US—home, with all its irregularities, to capitalism in its most advanced phase. Perloff's attention, however, is focused not upon this socio-economic history but upon 'the technological and formal inventions' of these earlier and latter-day modernisms. This inventiveness we can elicit from reading the 'mate-riality of the text' with 'new eyes'.[63] The resulting new language, Perloff proposes, with Wittgenstein, is tantamount to a new 'form of life'.[64] The terms of Perloff's judgement remain, however, unapologetically, at root aesthetic, just as her critical method is more technicist than historical or political. The results are seductive and illuminating, but the strong, and all-important, sense of lineage (a relation with the past) that both Perloff and her chosen authors draw upon does not materialize as a linkage across figures, movements, or conjunctures that would connect moments in a radical cultural and artistic history.

The narrower history informing Perloff's idea of a revived modernism contrasts markedly with Susan Friedman's injunction to recognize and actively respond to the present globalizing scene of multi- or polycentric modernities. 'Always spatialize!', she recommends in answer to Jameson's 'Always historicize!'[65] Friedman, too, names

[61] Perloff, *21st-Century Modernism*, 5.

[62] Ibid. 3. [63] Ibid. 6, 3. [64] Ibid. 6.

[65] Susan Stanford Friedman, 'Periodizing Modernism: Postcolonial Modernities and the Space/Time Borders of Modernist Studies', *Modernism/Modernity*, 13/3 (Sept. 2006), 426.

the new art and culture 'modernist'. 'Multiple modernities', she contends, 'create multiple modernisms.'[66] While she cautions at the same time that not all literature is modernist, Friedman's argument never recovers from this simple equation, devoid of all distinction between the aesthetic forms and ideological and political alignments that might emerge from the rupture, which, in her own view, identifies the onset of modernity. Challenging and instructive as it is, a spatialized modernity, so conceived, runs the risk of losing geo-historical and aesthetic specificity.

The related conception of 'altermodern' brings a contemporary agenda derived from academic theory in cultural studies and political and economic thought to the task of reconceptualizing modernism for the present day. The term is the coinage of Nicolas Bourriaud, curator of the Tate Triennial Exhibition for 2009, which show-cased British examples of this new art. Accompanying the exhibition was a seminar programme, a set of resulting essays, and a manifesto. Here Bourriaud calls for an art that will respond to the threat of 'fundamentalism and consumer-driven uniformi-zation, menaced by massification and the enforced re-abandonment of individual identity'.[67] Thus, 'art today needs to reinvent itself, and on a planetary scale'. The resulting 'altermodernism' is understood as 'a synthesis between modernism and post-colonialism' and, as such, participates 'for the first time' in a 'global dialogue' alive to the 'multicultural explosion and the proliferation of cultural strata' marking this era.[68]

Freed from the 'petrified' time of postmodernism and the 'linear vision' of modernism, 'altermodernism', says Bourriaud, works across multiple temporalities 'exploring all dimensions of the present, tracing lines in all directions of time and space'. 'Always spatialize!', Susan Stanford Friedman insists, and here geo-spatial metaphors abound; thus, 'our civilisation . . . resembles a structureless constellation, awaiting transformation into an archipelago'; the artist is a detached nomad who 'relocates' or 'transmits or "teleports" diverse materials in a narrative of planetary drift'.[69] But for all the sense of 'heterochronic time' which accompanies this analysis and, theoretically, opens up the resources of different registers, cultural traditions, and different periods, history too is spatialized. History is 'the last continent to be explored which can be traversed like a territory'—if, indeed, it is not ruled out of bounds altogether, since at the same time 'the historical counters' are 'reset to zero'.[70] The idea of contemporaneity, it follows, can be abandoned for 'intemporality' in 'a voluntary confusion of eras and genres'.[71] At best, to understand the present 'means carrying out a kind of rough and ready archaeological investigation of world culture'.[72] 'Altermodern' amounts, then, to the relaunch of an avant-gardist

[66] Ibid. 427.
[67] Nicolas Bourriaud (ed.), *Altermodern Tate Triennial*, exh. cat. (London: Tate, 2009), no page numbers. The exhibition was held between 3 February and 26 April 2009 at Tate Britain, London.
[68] Ibid. [69] Ibid. [70] Ibid. [71] Ibid. [72] Ibid.

impulse across the horizontal plane of a globalized surface, its diversity newly accessible at the click of a mouse off an open network that knows no centre, no power, or prohibitions—less a new modernism, one might think, than a now fully booted up 'perpetual present' of the earlier postmodernism.

I suggest that we can take instruction in all of this from the reflections of the modernist Walter Benjamin on the theme of 'newness' and 'nowness' which have directed the present discussion. As Peter Osborne points out, Benjamin draws on the inspiration of Baudelaire's conception of the time of modernity as 'the ephemeral, the fugitive, the contingent'. Modernism, conceived of 'as the affirmative cultural self-consciousness of the temporality of the new, starts here', comments Osborne.[73] What, importantly, Osborne draws out of this as modernism's transcendent structural feature is the 'iterability' of this affirmation (see Chapter 22). The result of this operation produces '*the same* across the totality of manifestations of the new' but also '*an ongoing* affirmation' of the temporality of the new. The initial affirmation is thereby negated but reignited in the production of the 'new again', or the 'new now', and what Osborne terms 'an overlapping historically successive *multiplicity* of modernisms'.

The significant outcome of this debt to Benjamin, and most particularly to Benjamin's 'Theses on the Philosophy of History', is a conception of temporality which radically departs from the conventional linear conception of time and its orderly succession of past, present, and future.[74] Benjamin's identification in the 'Theses' and *The Arcades Project* of the advent of radical change with punctual moments of discontinuity and interruption in historicism's narrative of linear progression effectively theorizes artistic modernism's commitment to the intensity of the moment as well as the common critical conception of the modernist avant-garde's estrangement of a taken-for-granted world. As Matt ffytch notes here (Chapter 23), Freud on memory and consciousness, and Surrealism's idea of the prophetic power of dream, also aided Benjamin's thinking on how the conscious recollection or reminiscence could awaken a dreaming populace from the phantasmagoria of a commodified existence. The moment of rupture, when such a recollection of the past and the present enter an electrically charged constellation 'at a moment of danger', is Benjamin's 'Jetztzeit', 'the time of the now'.[75] This Osborne directly associates with the avant-garde project which 'disrupts the linear time-consciousness of progress in such a way as to enable us, like the child, to "discover the new anew" and along with it, the possibility of a better future'.[76] As Benjamin writes, it is 'not in the continuity of elapsing time but in its interferences' that 'the truly new makes itself felt for the first time'.[77] This 'truly new' is distinguished in turn from the degraded

[73] Peter Osborne, *The Politics of Time: Modernity and the Avant-Garde* (London: Verso, 1995), 142.

[74] Walter Benjamin, 'Theses on the Philosophy of History', in *Illuminations*, ed. Hannah Arendt (London: Fontana, 1970), 255–66.

[75] Ibid. 257, 263.

[76] Osborne, *The Politics of Time*, 150.

[77] Walter Benjamin, *The Arcades Project*, trans. Howard Eiland and Kevin McLaughlin (Cambridge, Mass.: Belknap Press, 2002), 474.

newness of capitalist modernity which can only mass-produce 'the ever-always-the-same within the new' of recurrent novelty.[78]

In addition, it should be said, the force of this distinction and 'the possibility of a better future' were dependent on Benjamin's faith in the revolutionary agency of the organized working class. The profound difficulties and challenge finally lie here—in the question of how, and in what sociopolitical alignment, the 'truly new' experienced in an arrest of time when the dialectic is 'at a standstill' can re-enter so as to influence the world of practical action and historical narrative. In what terms can a revolutionary impulse, so conceived, join the history of capitalist modernity it has served to critique? Osborne believes that the answer—'a conceptual bridge back from now-time to a new narrativity'—lies in a new conception of open narrativity and of now-time's place as a critique of the present 'at once outside and within' this present.[79] By Osborne's reckoning, 'the truly new' does therefore return to the world to influence and enrich what is 'next'. 'Benjamin's "now"', he concludes, 'can thus be conceived as an integral moment within a new, non-traditional, future-oriented and internally disrupted form of narrativity.'[80] The challenge remains, nonetheless, for a latter-day modernism or avant-garde, as for 'New Modernist Studies', of how it will itself meet Benjamin's distinction between the commodified novelty of the 'ever-always-the-same' and the 'really new', and what equivalent social agency, if any, can be deemed to inspire a renewal of Benjamin's 'politicized art'.

We can say this much: that if, for all their different historical schema, the various modernisms and modernities entail a moment of rupture impelled by the call to newness, this newness was never and is not now born of nothing. Benjamin's revolutionary moment arrests the flow of time, but the 'dialectical image' which comprises this moment does not dispense with the past—far from it, it is engaged in a battle for the ownership of the past. What is 'new now' emerges from an active, contestatory remembering of the defeated or forgotten. A new late twentieth- or twenty-first-century modernism can only emerge, consequently, in a combined estrangement of and re-engagement with the past it inherits, a making the new new again. That is to say, its heterogeneous forms share not only a utopian impulse or quest towards the new at the moment of rupture or radical reform, but a self-consciousness of their own time and place in the dialectal movement of this history. Modernism must 'follow'; it must come after, and come to light out of the shadow of an earlier modernism or newness that is other to itself. The ill-fated 'post' sought to describe just this break and continuity together. The same double movement has characterized the modernist avant-garde, of course, but, whatever else, in its early twentieth-century manifestation, the historical modernist avant-garde did not, I believe, break from an earlier modernism. There is no fifteenth- or eighteenth-century artistic 'modernism'. Nor were Romanticism and Victorian realism 'modernisms', though they comprised the new art of a new phase of modernity. I suggest

[78] Walter Benjamin, 'Central Park', *New German Critique*, 34 (Winter 1985), 43.
[79] Osborne, *The Politics of Time*, 156, 158.
[80] Ibid. 158–9.

that to capture not simply the advent of multiple or polycentric modernisms, but their *self-conscious* relation, means recognizing the later modernisms in the West and the globalized world as 'reflexive modernisms'. What marks this self-conscious newness and distinguishes modernist cultural forms from modernity is the cluster of techniques by which, across the arts, existing and past materials are made new: what we might think of now, to echo Bertolt Brecht's conception of the *Verfremdungseffekt*, as the pedagogic, 'social' devices of collage, montage, and bricolage.[81] Commercial culture has availed itself, of course, of these same techniques. The difference in this sameness is a matter of purpose. Andreas Huyssen, reflecting on a world where relations between tradition and the modern, the global and local have altered, but where neither term is extinguished, suggests what this purpose must be. The contest over the modern is a contest over the past and which and whose past— and therefore future—this is to be. In the spirit of Walter Benjamin, he insists that what is at stake is cultural memory. Thus, he sees a fundamental difference between a type of commodified cultural memory that is produced and marketed for 'a media and consumer society that increasingly voids temporality and collapses space' and those artistic and cultural works which use memory as an essential way 'to imagine the future and to regain a strong temporal and spatial grounding of life and the imagination'.[82] Thinking this way might guide us in describing earlier and later modernisms as 'reflexive modernisms at large', which are always spatialized, always historicized.

[81] See, among many such instances, Bertolt Brecht, *The Messingkauf Dialogues*, trans. John Willett (London: Methuen, 1978), 103–5.

[82] Andreas Huyssen, *Present Pasts: Urban Palimpsests and the Politics of Memory* (Stanford, Calif.: Stanford University Press, 2003), 6. On the idea of a 'reflexive' modernity and modernism, see my *Modernity and Metropolis* (London: Palgrave, 2002), esp. pp. 11–16, 23–9.

BIBLIOGRAPHY

ABEL, ELIZABETH, *Virginia Woolf and the Fictions of Psychoanalysis* (Chicago: University of Chicago Press, 1989).

ABRAMS, M. H., *The Mirror and the Lamp* (Oxford: Oxford University Press, 1953).

ACHEBE, CHINUA, *The African Trilogy: No Longer at Ease* (1960; London: Picador, 1988).

——*Hopes and Impediments: Selected Essays 1965–1987* (London: Heinemann, 1988).

——*Home and Exile* (Oxford: Oxford University Press, 2000).

ACKROYD, PETER, *T. S. Eliot* (Harmondsworth: Penguin, 1993).

ACOCELLA, JOAN (ed.), *The Diaries of Vaslav Nijinsky: Unexpurgated Edition* (New York: Farrar, Straus, Giroux, 1999).

ADACHI MARIKO, 'Shashi to Shihon to Modan Gâru: Shiseidō to Kōiri Sekken', *Jendâ Kenkyū*, 9 (2006), 19–38.

ADES, DAWN, *Art in Latin America: The Modern Era, 1820–1980* (New Haven: Yale University Press, 1993).

ADORNO, THEODOR W., 'The Actuality of Philosophy', *Telos*, 31 (1977), 120–33.

——*Introduction to the Sociology of Music*, trans. E. B. Ashton (New York: Continuum, 1989).

——'Why Still Philosophy?', in Adorno, *Critical Models: Interventions and Catchwords*, trans. Henry W. Pickford (New York: Columbia University Press, 1989), 5–17.

——*Aesthetic Theory*, trans. Robert Hullot-Kentor (Minneapolis: University of Minnesota Press, 1997).

——'Fetish Character in Music and Regression of Listening', in Andrew Arato and Eike Gebhardt (eds), *The Essential Frankfurt School Reader* (New York: Continuum, 1997), 270–99.

——*The Culture Industry: Selected Essays on Mass Culture*, ed. and trans. J. M. Bernstein (New York: Routledge, 2001).

——*Minima Moralia* (London: Verso, 2005).

——and BENJAMIN, WALTER, *The Complete Correspondence, 1928–1940* (Cambridge, Mass.: Harvard University Press, 1999).

AGAMBEN, GIORGIO, *Means Without Ends: Notes on Politics (Theory Out of Bounds)* (Minneapolis: University of Minnesota Press, 2000).

AHMED, AIJAZ, *In Theory: Classes, Nations, Literatures* (London: Verso, 1992).

AITCHISON, JOHN, and CARTER, HAROLD, *A Geography of the Welsh Language, 1961–1991* (Cardiff: University of Wales Press, 1994).

A.J.O. [A. R. ORAGE], 'The Mystic Valuation of Literature', *Theosophical Review*, 31 (1903), 428–34.

ALDINGTON, RICHARD, *Life for Life's Sake* (1941; London: Cassell, 1969).

——*An Imagist at War: The Complete War Poems of Richard Aldington* (Madison, NJ: Fairleigh Dickinson University Press, 2002).

ALEXANDRESCU, SORIN, *Romanian Art from Modernism to Postmodernism in Figurative Art*, exh. cat. (Amstelveen: Cobra Museum for Modern Art, 1998).

ALGULIN, INGEMAR, *A History of Swedish Literature* (Stockholm: Swedish Institute, 1989).

ALLAN, DOT, *Makeshift* (1928; London: Melrose, 1928).

——*Hunger March* (1934; London: Hutchinson, 1934).

ALLEN, BROOKE, 'Vile Bodies: A Futurist Fantasy', *Twentieth-Century Literature*, 40/3 (Autumn 2004), 318–28.

ALLEN, WALTER, *Tradition and Dream: The English and American Novel from the Twenties to Our Time* (London: Phoenix House, 1964).

ALLFREY, PHYLLIS SHAND, *It Falls Into Place*, ed. Lizbeth Paravisini-Gebert (London: Papillote Press, 2004).

ALLIEZ, ÉRIC, *Capital Times: Tales From the Conquest of Time*, trans. Georges Van Den Abbeele (Minneapolis: University of Minnesota Press, 1996).

ALLNUTT, GILLIAN, D'AGUIAR, FRED, EDWARDS, KEN, and MOTTRAM, ERIC (eds), *The New British Poetry* (London: Paladin, 1988).

ALMS, BARBARA, and STEINMETZ, WIEBKE (eds), *Der Sturm: Chagall, Feininger, Jawlensky, Kandinsky, Klee, Kokoschka, Macke, Marc, Schwitters und viele andere im Berlin der zehner Jahre*, exh. cat. (Bremen: Hauschild; Städtische Galerie Delmenhorst, Haus Coburg Sammlung Stuckenberg, 2000).

ALONSO, CARLOS, *The Burden of Modernity* (Oxford: Oxford University Press, 1998).

ALTER, ROBERT, *Partial Magic: The Novel as a Self-Conscious Genre* (London, England: University of California Press, 1975).

ANDERSON, ANDREW A., *El veintisiete en tela de juicio* (Madrid: Gredos, 2005).

ANDERSON, BENEDICT, *Imagined Communities: Reflections on the Origin and Spread of Nationalism* (London: Verso, 1983).

ANDERSON, MARK, *Kafka's Clothes: Ornament and Aestheticism in the Hapsburg Fin de Siècle* (Oxford: Clarendon Press, 1992).

ANDERSON, PATRICK, 'The Graphic Arts', in *Drawings, Prints, Sculpture/Dessins, Estampe, Sculpture*, Contemporary Arts Society Catalogue, Fifth Floor Gallery, Montreal, 1–31 Dec. 1941, 4.

ANDERSON, PERRY, 'Modernity and Revolution', *New Left Review*, 144 (Mar.–Apr. 1984), 96–113; repr. in Cary Nelson and Lawrence Grossberg (eds), *Marxism and the Interpretation of Culture* (Urbana: University of Illinois Press, 1988), 317–33.

——*A Zone of Engagement* (London: Verso, 1992).

ANDRADE, JORGE CARRERA, *Reflexiones sobre la poesía hispanoamericana* (Quito: Casa de la Cultura Ecuatoriana, 1987).

ANDREWS, BRUCE, and BERNSTEIN, CHARLES (eds), *The L=A=N=G=U=A=G=E Book* (Carbondale: Southern Illinois University Press, 1984).

ANNA, SUSANNE (ed.), *Das Bauhaus im Osten: Slowakische und Tschechische Avantgarde 1928–1939* (Stuttgart: Hatje, 1997).

ANON., 'Discussion Groups', *Listener* (23 Jan. 1929), 60.

ANON., 'The Fusion of Music and Dancing: *Le Sacre du printemps*', *The Times*, 26 July 1913.

ANON., 'Justice for the Jew', *Jewish Chronicle*, suppl., 193 (Mar. 1939), 10.

ANON., 'Khronika', *Dom iskusstv*, 1(1921), 67–80.

ANON., Literaturnaia entsiklopediia, vii (Moscow: OGIZ, 1934).

ANON., 'Neglect of Science', *The Times*, 2 Feb. 1916, 10.

ANON., 'Russian Ballet: *Le Sacre du printemps*', *Daily Telegraph*, 12 July 1913.

ANTONOWA, IRINA, and MERKERT, JÖRN (eds), *Berlin Moskva, 1900–1950*, exh. cat. (Munich: Prestel, 1995).

ANZ, THOMAS, *Die Literatur der Existenz: Literarische Psychopathographie und ihre soziale Bedeutung im Frühexpressionismus* (Stuttgart: Metzler, 1977).

——'Berlin, Hauptstadt der Moderne', in Klaus Siebenhaar (ed.), *Das poetische Berlin: Metropolenkultur zwischen Gründerzeit und Nazionalsozialismus* (Wiesbaden: DUV, 1992), 85–104.

——*Literatur des Expressionismus* (Stuttgart: Metzler, 2002).

——and STARK, MICHAEL (eds), *Expressionismus: Manifeste und Dokumente zur deutschen Literatur, 1910–1920* (Stuttgart: Metzler, 1981).

APOLLINAIRE, GUILLAUME, *The Cubist Painters: Aesthetic Meditations, 1913*, trans. Lionel Abel (New York: Wittenborn, 1962).

——*Alcools* (Paris: Gallimard, 1987).

——*The Cubist Painters*, trans. Peter Read (London: Artists Bookworks, 2002).

APOLLONIO, UMBRO (ed.), *Futurist Manifestos* (London: Thames & Hudson, 1973).

APPADURAI, ARJUN, *Modernity at Large: Cultural Dimensions of Globalization* (Minneapolis: University of Minnesota Press, 1996).

APPIAH, KWAME ANTHONY, 'Is the Post- in Postmodernism the Post- in Postcolonial?', *Critical Inquiry*, 17 (Winter 1991), 336–57.

ARAGON, LOUIS, *Paris Peasant* (1926; London: Pan, 1980).

ARCHER, W. G., *India and Modern Art* (London: Macmillan, 1959).

ARDIS, ANN L., *New Women, New Novels: Feminism and Early Modernism* (Piscataway, NJ: Rutgers University Press, 1991).

——*Modernism and Cultural Conflict 1880–1922* (Cambridge: Cambridge University Press, 2002).

——and COLLIER, PATRICK (eds), *Transatlantic Print Culture, 1880–1940: Emerging Media, Emerging Modernisms* (London: Palgrave, 2008).

ARENAS, REINALDO, *Before Night Falls*, trans. Dolores M. Koch (New York: Viking Press, 1993).

ARMAH, AYI KWEI, 'Larsony, or, Fiction as Criticism of Fiction', *New Classic*, 4 (1977), 33–45.

ARMSTRONG, TIM, *Modernism, Technology and the Body: A Cultural Study* (Cambridge: Cambridge University Press, 1998).

——*Modernism: A Cultural History* (Cambridge: Polity Press, 2005).

ARNHEIM, RUDOLF, 'Disciplining the Gramophone, Radio, Telephone, and Television', *Sapere* (15 Dec. 1937), trans. Christy Wampole; repr. in *Modernism/Modernity*, 16/2 (2009), 422–6.

ASHCROFT, BILL, GRIFFITHS, GARETH, and TIFFIN, HELEN, *The Empire Writes Back* (London: Routledge, 1989).

ATKINS, JONATHAN, *A War of Individuals: Bloomsbury Attitudes to the Great War* (Manchester: Manchester University Press, 2002).

ATTRIDGE, DEREK, *Peculiar Language: Literature as Difference from the Renaissance to James Joyce* (London: Routledge, 1988).

——*Joyce Effects: On Language, Theory, and History* (Cambridge: Cambridge University Press, 2000).

——and HOWES, MARJORIE (eds), *Semicolonial Joyce* (Cambridge: Cambridge University Press, 2000).

AUDEN, W. H., *Collected Poems* (London: Faber, 1976).

——*Selected Poems*, ed. Edward Mendelson (London: Faber, 1979).

——'Psychology and Art To-day', in *The Complete Works of W. H. Auden: Prose and Travel Books in Prose and Verse*, i: *1926–1938*, ed. Edward Mendelson (London: Faber and Faber, 1996), 93–105.

——and ISHERWOOD, CHRISTOPHER, *Journey to a War* (New York: Random House, 1939).

——and MacNEICE, LOUIS, *Letters from Iceland* (London: Faber and Faber, 1937).

AUGUSTINE, *Confessions*, trans. R. F. Pine-Coffin (Harmondsworth: Penguin, 1961).

AVERY, TODD, *Radio Modernism: Literature, Ethics, and the BBC, 1922–1938* (Aldershot: Ashgate, 2006).

AYERS, DAVID, *Modernism: A Short Introduction* (Oxford: Blackwell, 2004).

BAETZ, JOEL, 'Battle Lines: English-Canadian Poetry of the First World War', Ph.D. diss., York University, 2005.

BAHUN, SANJA, 'Virginia Woolf and Psychoanalytic Theory', in Jane Goldman and Bryony Randall (eds), *Virginia Woolf in Context* (Cambridge: Cambridge University Press, forthcoming).

BAKER, HOUSTON A., JR, *Afro-American Poetics: Revisions of Harlem and the Black Aesthetic* (Madison: University of Wisconsin Press, 1988).

——*Modernism and the Harlem Renaissance* (Chicago: University of Chicago Press, 1989).

BAKER, JOSEPHINE, and BOUILLON, JO, *Josephine*, trans. Marianna Fitzpatrick (New York: Paragon, 1988).

BAKHTIN, MIKHAIL, and MEDVEDEV, P. N., *The Formal Method in Literary Scholarship: A Critical Introduction to Sociological Poetics* (Cambridge, Mass.: Harvard University Press, 1985).

BALAKIAN, ANNA, *Surrealism: The Road to the Absolute* (Chicago: University of Chicago Press, 1986).

BALDWIN, DAVARIAN L., *Chicago's New Negroes: Modernity, the Great Migration, and Black Urban Life* (Chapel Hill: University of North Carolina Press, 2007).

BALIBAR, ÉTIENNE, 'Citizen Subject', in Eduardo Cadava, Peter Connor, and Jean-Luc Nancy (eds), *Who Comes After the Subject?* (New York: Routledge, 1991), 33–57.

——CASSIN, BARBARA, and LIBERA, ALAIN DE, 'Subject', trans. David Macey, *Radical Philosophy*, 138 (July–Aug. 2006), 15–42.

BALLANTYNE, TONY, and BURTON, ANTOINETTE (eds), *Bodies in Contact: Rethinking Colonial Encounters in World History* (Durham, NC: Duke University Press, 2005).

BANN, STEPHEN, *Romanticism and the Rise of History* (New York: Twayne, 1995).

——(ed.), *The Tradition of Constructivism* (New York: Viking Press, 1974).

BARLOW, TANI E., *The Question of Women in Chinese Feminism* (Durham, NC: Duke University Press, 2004).

——(ed.), *Formations of Colonial Modernity in East Asia* (Durham, NC: Duke University Press, 1997).

BARMAN, JEAN, *Constance Lindsay Skinner: Writing on the Frontier* (Toronto: University of Toronto Press, 2002).

BARNES, DJUNA, 'Vagaries Malicieux', *Double Dealer*, 3/17 (May 1922), 249–60.

——*Ladies Almanack* (1928; Elmwood, Ill.: Dalkey Archive Press, 1992).

BAROOSHIAN, VAHAN D., *Russian Cubo-Futurism, 1910–1930: A Study in Avant-Gardism* (The Hague: Mouton, 1974).

BARRENECHEA, ANA MARÍA, 'La crisis del contrato mimético en los textos contemporáneos', *Revista Iberoamericana*, 48/118–19 (1982), 377–81.

BARRINGER, TIM, QUILLEY, GEOFF, and FORDHAM, DOUGLAS (eds), *Art and the British Empire* (Manchester: Manchester University Press, 2007).

BARRY, PETER, *Contemporary British Poetry and the City* (Manchester: Manchester University Press, 2000).

BARTELIK, MAREK, *Early Polish Modern Art: Unity in Multiplicity* (Manchester: Manchester University Press, 2005).

BATCHELOR, JOHN, *The Life of Joseph Conrad* (Oxford: Blackwell, 1994).

BATCHEN, GEOFFREY, *Burning with Desire: The Conception of Photography* (Cambridge: Mass.: MIT Press, 1997).

BAUDELAIRE, CHARLES, *Œuvres Complètes*, ed. Y. G. Le Dantec (Paris: Gallimard, 1961).

——*Art in Paris 1845–1862: Salons and Other Exhibitions Reviewed by Charles Baudelaire*, ed. and trans. Jonathan Mayne (London: Phaidon Press, 1965), 116–20.

——*Baudelaire: Selected Writings on Art and Literature*, trans. P. E. Charvet (New York: Viking Press, 1972).

——'The Modern Public and Photography', in Alan Trachtenberg (ed.), *Classic Essays on Photography* (New Haven: Leete's Island Books, 1980), 83–9.

——*The Painter of Modern Life and Other Essays*, ed. and trans. Jonathan Mayne (London: Phaidon Press, 1995).

BAYER, HERBERT, GROPIUS, WALTER, and GROPIUS, ISE (eds), *Bauhaus, 1919–1928* (Boston: Branford, 1952).

BECK, ALAN, *Listening to Radio Plays: Fictional Soundscapes* (1997), World Forum for Acoustic Ecology, <http://interact.uoregon.edu/mediaLit/wfae/library/articles/beck_list_radioplays.pdf>.

BECK, ULRICH, *World Risk Society* (Cambridge: Polity Press, 1999).

BECKETT, SAMUEL, *Endgame* (1952; London: Faber, 1964).

——*Disjecta* (1929–67; London: John Calder, 1983).

BECKSON, KARL, *London in the 1890s: A Cultural History* (New York: Norton, 1992).

BEER, GILLIAN, 'Science and Literature', in R. C. Olby, G. N. Cantor, J. R. R. Christie, and M. J. S. Hodge (eds), *Companion to the History of Modern Science* (London: Routledge, 1990), 783–98.

BEEVERS, JOHN L., 'Some Modern Verse', *New English Weekly*, 2 (19 Jan. 1933), 322–4.

BEGAM, RICHARD, and VALDEZ MOSES, MICHAEL (eds), *Modernism and Colonialism: British and Irish Literature, 1899–1939* (Durham, NC: Duke University Press, 2007).

BELASCO, SUSAN, and JOHNSON, LINCK, 'Introduction', in Belasco and Johnson (eds), *The Bedford Anthology of American Literature*, ii (Boston: Bedford and St Martin's Press, 2008), 2–39.

BELL, IAN, *Critic as Scientist: The Modernist Poetics of Ezra Pound* (London: Methuen, 1981).

BELL, MICHAEL, *Primitivism* (London: Methuen, 1972).

——*D. H. Lawrence: Language and Being* (Cambridge: Cambridge University Press, 1992).

BELLER, STEVEN, 'Big-City Jews: Jewish Big City—The Dialectics of Assimilation in Vienna *c*.1900', in Malcolm Gee, Tim Kirk, and Jill Steward (eds), *The City in Central Europe: Culture and Society from 1800 to the Present* (Aldershot: Ashgate, 2003), 145–58.

BENÍTEZ-ROJO, ANTONIO, *The Repeating Island: The Caribbean and the Postmodern Perspective*, trans. James E. Maraniss, 2nd edn (Durham, NC: Duke University Press, 1996).

BENJAMIN, ANDREW, and OSBORNE, PETER (eds), *Walter Benjamin's Philosophy: Destruction and Experience* (London: Routledge, 1994).

BENJAMIN, WALTER, *The Origin of German Tragic Drama* (1928), trans. John Osborne (London: New Left Books, 1977).

——*Understanding Brecht*, trans. Anna Bostock (1966; London: New Left Books, 1977).

——*One Way Street and Other Writings* (1928; London: New Left Books, 1979).

——'Central Park', *New German Critique*, 34 (Winter 1985), 32–58.

——*Das Passagen-Werk*, in Benjamin, *Gesammelte Schriften*, v (Frankfurt am Main: Suhrkamp, 1991).

——*The Correspondence of Walter Benjamin, 1910–1940*, ed. and trans. Manfred R. Jacobson and Evelyn M. Jacobson (Chicago: University of Chicago Press, 1994).

——*Selected Writings*, i: *1913–1926*, ed. Marcus Bullock and Michael W. Jennings (Cambridge, Mass.: Harvard University Press, 1996).

——*Charles Baudelaire: A Lyric Poet in the Era of High Capitalism*, trans. Harry Zohn (New York: Verso, 1997).

——*The Arcades Project* (1928), trans. Howard Eiland and Kevin McLaughlin (Cambridge, Mass.: Harvard University Press, 1999).

BENJAMIN, WALTER, *Illuminations*, ed. Hannah Arendt, trans. Harry Zorn (1968; London: Pimlico, 1999).

——*Selected Writings*, ii: *1927–1934*, trans. Rodney Livingstone, ed. Michael W. Jennings, Howard Eiland, and Gary Smith (Cambridge, Mass.: Belknap Press, 1999).

——*Selected Writings*, iii: *1935–1938*, iv: *1938–1940*, ed. Howard Eiland and Michael W. Jennings (Cambridge, Mass.: Belknap Press, 2002–3).

——*The Work of Art in the Age of its Technological Reproducibility and Other Writings on Media*, ed. Michael W. Jennings, Brigid Doherty, and Thomas Y. Leven (1936; Cambridge, Mass.: Belknap Press, 2008).

BENNINGTON, GEOFF, and DERRIDA, JACQUES, *Jacques Derrida* (Chicago: University of Chicago Press, 1993).

BENOIS, ALEXANDRE, *Reminiscences of the Russian Ballet* (London: Putnam, 1941).

BENSON, TIMOTHY O., 'The Text and the Coming of Age of the Avant-Garde in Germany', *Visible Language*, special exh. cat. issue, 21/3–4 (1988), 365–411.

——'Dada Geographies', in David Hopkins and Michael White (eds), *Dada: Virgin Microbe* (Evanston, Ill.: Northwestern University Press, forthcoming).

——(ed.), *Expressionist Utopias: Paradise, Metropolis, Architectural Fantasy*, exh. cat. (Seattle: University of Washington Press; Los Angeles: Los Angeles County Museum of Art, 1993).

——(ed.), *Central European Avant-Gardes: Exchange and Transformation, 1910–1930*, exh. cat. (Cambridge, Mass.: MIT Press; Los Angeles: County Museum of Art, 2002).

——and FORGÁCS, ÉVA (eds), *Between Worlds: A Sourcebook of Central European Avant-Gardes, 1910–1930* (Cambridge, Mass.: MIT Press; Los Angeles: County Museum of Art, 2002).

BENSTOCK, SHARI, *Women of the Left Bank: Paris, 1900–1940* (London: Virago, 1987).

——'Expatriate Sapphic Modernism: Entering Literary History', in Karla Jay and Joanne Glasgow (eds), *Lesbian Texts and Contexts: Radical Revisions* (London: Onlywomen Press, 1990), 183–203.

BENTIVOGLIO, MIRELLA, 'Innovative Artists' Books of Italian Futurism', in Günter Berghaus (ed.), *International Futurism in Arts and Literature* (Berlin: de Gruyter, 2000), 473–86.

BENTLEY, D. M. R., '*As for Me* and Significant Form', *Canadian Notes and Queries*, 48 (1994), 18–20.

——'"The Thing Is Found to Be Symbolic": *Symboliste* Elements in the Early Short Stories of Gilbert Parker, Charles G. D. Roberts, and Duncan Campbell Scott', in Gerald Lynch and Angela Arnold Robbeson (eds), *Dominant Impressions: Essays on the Canadian Short Story* (Ottawa: University of Ottawa Press, 1999), 27–51.

BENTON, CHARLOTTE, BENTON, TIM, and WOOD, GHISLAINE (eds), *Art Deco, 1910–1939* (London: V & A, 2003).

BENTON, MEGAN, *Beauty and the Book: Fine Editions and Cultural Distinction in America* (New Haven: Yale University Press, 2000).

BEREND, IVAN T., *Decades of Crisis: Central and Eastern Europe Before World War II* (Berkeley: University of California Press, 2001).

BERENSON, BERNHARD, *Aesthetics and History* (London: Constable, 1950).

BERG, CHRISTIAN, DURIEUX, FRANK, and LERNOUT, GEERT (eds), *The Turn of the Century: Modernism and Modernity in Literature and the Arts* (Berlin: de Gruyter, 1995).

BERGER, JOHN, *About Looking* (New York: Vintage, 1980).

BERGHAUS, GÜNTER, *Futurism and Politics: Between Anarchist Rebellion and Fascist Reaction, 1909–1944* (Providence, RI: Berghahn, 1996).

——*Italian Futurist Theatre, 1909–1944* (Oxford: Clarendon Press, 1998).

——(ed.), *International Futurism in Arts and Literature* (Berlin: de Gruyter, 2000).

BERGIUS, HANNE, 'The Ambiguous Aesthetic of Dada: Towards a Definition of its Categories', *Journal of European Studies*, 9 (1979), 26–38.

——and RIHA, KARL (eds), *Dada Berlin: Texte, Manifeste, Actionen* (Stuttgart: Reclam, 1977).

BERGSON, HENRI, *Mind-Energy: Lectures and Essays* (London: Macmillan, 1920).

——*Matter and Memory* (1911), trans. N. M. Paul and W. S. Palmer (New York: Zone Books, 1991).

——*Creative Evolution* (1910), trans. Arthur Mitchell (Mineola, NY: Dover, 1998).

——*Duration and Simultaneity: Bergson and the Einsteinian Universe* (1922), ed. Robin Durie, trans. Leon Jacobson (Manchester: Clinamen Press, 1999).

——*Time and Free Will: An Essay on the Immediate Data of Consciousness* (1910), trans. F. L. Pogson (Mineola, NY: Dover, 2001).

BERMAN, MARSHALL, *All That Is Solid Melts Into Air: The Experience of Modernity* (London: Verso, 1982).

——'The Signs in the Street: A Response to Perry Anderson', *New Left Review*, 144 (Mar.–Apr. 1984), 114–23.

BERNARD, SUZANNE, *Le Poème en prose de Baudelaire à nos jours* (Paris: Nizet, 1959).

BERNSTEIN, CHARLES, 'The Academy in Peril', in Bernstein, *Content's Dream* (Los Angeles: Sun & Moon Press, 1986), 247–9.

BERNSTEIN, J. M., 'Modernism as Aesthetics and Art History', in James Elkins (ed.), *Art History Versus Aesthetics* (New York: Routledge, 2006), 241–68.

——'Modernism as Philosophy: Stanley Cavell, Antonio Caro, and Chantal Akerman', in Bernstein, *Against Voluptuous Bodies: Late Modernism and the Meaning of Painting* (Stanford, Calif.: Stanford University Press, 2006), 78–116.

BETTS, GREGORY, '"The Destroyer": Modernism and Mystical Revolution in Bertram Brooker', Ph.D. diss., York University, 2005.

BHABHA, HOMI, *The Location of Culture* (London: Routledge, 1994).

BIELY, ANDREY, *St Petersburg*, trans. John Cournos (New York: Grove Press, 1989).

BINYON, LAURENCE, 'The Art of India', *Saturday Review* (8 Jan. 1909), 38–9.

BION, W. R., *A Memoir of the Future* (London: Karnac, 1991).

BIRGUS, VLADIMÍR (ed.), *Tschechische Avantgarde-Fotografie, 1918–1948*, exh. cat. (Stuttgart: Arnoldsche, 1999).

BIRKENMAIER, ANKE, 'From Surrealism to Popular Art: Paul Deharme's Radio Theory', *Modernism/Modernity*, 16/2 (2009), 357–74.

BIRKETT, JENNIFER, *The Sins of the Fathers: Decadence in France and Europe, 1870–1914* (London: Quartet Books, 1986).

——'Disinterested Narcissus: The Play of Politics in Decadent Form', in Patrick McGuinness (ed.), *Symbolism, Decadence and the Fin de Siècle* (Exeter: Exeter University Press, 2000), 29–45.

BISHOP, EDWARD, 'Re-covering Modernism', in Ian Willison, Warwick Gould, and Warren Chernaik (eds), *Modernist Writers and the Market Place* (London: Macmillan, 1996), 287–319.

——Review of Lawrence Rainey, *Institutions of Modernism: Literary Elites and Public Culture*, *Modern Philology*, 99/3 (Feb. 2002), 485–9.

BISHOP, PAUL (ed.), *Jung in Contexts: A Reader* (London: Routledge, 1999).

BISWAS, MOINAK (ed.), *Apu and After: Revisiting Ray's Cinema* (Oxford: Berg, 2006).

BJÖRLING, GUNNAR, *Kiri-ra!* (Helsinki: Författarens Förlag, 1930).

BLACKBURN, ROBIN, *The Overthrow of Colonial Slavery, 1776–1848* (London: Verso, 1988).

BLACKMER, CORINNE E., 'Lesbian Modernism in the Shorter Fiction of Virginia Woolf and Gertrude Stein', in Eileen Barrett and Patricia Cramer (eds), *Virginia Woolf: Lesbian Readings* (New York: New York University Press, 1997), 78–94.

BLAIR, SARA, 'Local Modernity, Global Modernism: Bloomsbury and the Place of the Literary', *ELH* 71 (2004), 813–38.

BLAKE, CAESAR, *Dorothy Richardson* (Ann Arbor: University of Michigan Press, 1960).

BLANCHOT, MAURICE, 'The Athenaeum', in Blanchot, *The Infinite Conversation*, trans. Susan Hanson (Minneapolis: University of Minnesota Press, 1993), 351–9.

BLAU, EVA, and PLATZER, MONIKA (eds), *Shaping the Great City: Modern Architecture in Central Europe, 1890–1937* (Munich: Prestel, 1999).

BLOOM, CLIVE, *Bestsellers: Popular Fiction Since 1900* (New York: Palgrave, 2002).

BLUM, CINZIA SARTINI, 'The Superman and the Abject: *Mafarka le Futuriste*', in Blum, *The Other Modernism: F. T. Marinetti's Futurist Fiction of Power* (Berkeley and Los Angeles: California University Press, 1996), 55–78.

BODKIN, MAUD, *Archetypal Patterns in Poetry* (Oxford: Oxford University Press, 1934).

BOEHMER, ELLEKE, *Colonial and Postcolonial Literature*, 2nd edn (Oxford: Oxford University Press, 1995).

——*Empire, the National, and the Postcolonial, 1890–1920: Resistance in Interaction* (Oxford: Oxford University Press, 2002).

BOHN, WILLARD, *The Aesthetics of Visual Poetry, 1914–1928* (Chicago: University of Chicago Press, 1986).

——*The Rise of Surrealism: Cubism, Dada, and the Pursuit of the Marvelous* (New York: Albany, 2002).

BOIME, ALBERT, *Art and the French Commune: Imagining Paris After War and Revolution* (Princeton: Princeton University Press, 1995).

BOLD, ALAN, *MacDiarmid: Christopher Murray Grieve: A Critical Biography* (London: John Murray, 1988).

——(ed.), *The Letters of Hugh MacDiarmid* (Athens: Georgia University Press, 1984).

BOOTH, ALLYSON, *Postcards from the Trenches: Negotiating the Space Between Modernism and the First World War* (Oxford: Oxford University Press, 1996).

BORDA, JUAN GUSTAVO COBO, *Letras de esta América* (Bogotá: Empresa Editorial, Universidad Nacional de Colombia, 1986).

BORNSTEIN, GEORGE, *Material Modernism: The Politics of the Page* (Cambridge: Cambridge University Press, 2001).

——(ed.), *Representing Modernist Texts: Editing as Interpretation* (Ann Arbor: University of Michigan Press, 1991).

BORUM, POUL, *Poetisk modernisme: En kritisk introduktion* (Copenhagen: Stig Vendelkærs Forlag, 1966); trans. into Swedish as *Poetisk modernism* (Stockholm: Wahlström och Widstrand, 1968).

BOSE, BUDDHADEVA, *An Acre of Green Grass: A Review of Modern Bengali Literature* (Bombay: Orient Longmans, 1948).

BOURDIEU, PIERRE, *The Field of Cultural Production: Essays on Art and Literature*, ed. Randal Johnson, trans. Richard Nice (Cambridge: Polity Press, 1993).

——*The Rules of Art: Genesis and Structure of the Literary Field*, trans. Susan Emanuel (Stanford, Calif.: Stanford University Press, 1995).

BOURKE, JOANNA, *Dismembering the Male: Men's Bodies, Britain, and the Great War* (London: Reaktion, 1996).

BOURRIAUD, NICOLAS (ed.), *Altermodern Tate Triennial*, exh. cat. (London: Tate, 2009).

Bowen-Struyk, Heather, 'Rethinking Proletarian Literature', Ph.D. diss., University of Michigan, 2001.

Bowie, Andrew, *From Romanticism to Critical Theory: The Philosophy of German Literary Theory* (London: Routledge, 1996).

Bowie, Malcolm, *Mallarmé and the Art of Being Difficult* (Cambridge: Cambridge University Press, 1978).

Bowlby, Rachel, *Just Looking: Consumer Culture in Dreiser, Gissing and Zola* (London: Methuen, 1982).

Bowler, Peter, 'Presidential Address: Experts and Publishers', *BJHS* 39/2 (June 2006), 159–87.

Bowlt, John E., and Misler, Nicoletta, *Twentieth-Century Russian and East European Painting* (London: Zwemmer, 1993).

Bradbury, Malcolm, and McFarlane, James (eds), *Modernism: A Guide to European Literature 1890–1930* (Harmondsworth: Penguin, 1976).

Bradford, Richard, *Roman Jakobson: Life, Language, Art* (London: Routledge, 1994).

Bradley, F. H., *The Presuppositions of Critical History* (Oxford: James Parker, 1874).

Bradshaw, David, 'The Best of Companions: J. W. N. Sullivan, Aldous Huxley, and the New Physics', *Review of English Studies*, 47 (1996), 188–206, 352–68.

——(ed.), *The Cambridge Companion to E. M. Forster* (Cambridge: Cambridge University Press, 2007).

Braithwaite, William Stanley, 'The Negro in American Literature', in Alain Locke (ed.), *The New Negro: An Interpretation* (New York: Albert and Charles Boni, 1925), 29–44.

Brandes, Georg, *Main Currents in Nineteenth-Century Literature*, 6 vols (London: Heinemann, 1901–5).

Brantlinger, Patrick, *Rule of Darkness: British Literature and Imperialism 1830–1914* (Ithaca, NY: Cornell University Press, 1988).

Brathwaite, Edward Kamau, *The Arrivants: A New World Trilogy* (Oxford: Oxford University Press, 1973).

——*Contradictory Omens: Cultural Diversity and Integration in the Caribbean* (Mona: Savacou, 1974).

——*History of the Voice: The Development of Nation Language in Anglophone Caribbean Poetry* (London: New Beacon, 1984).

——*Roots* (Ann Arbor: University of Michigan Press, 1993).

Braun, Edward, 'Futurism in the Russian Theatre, 1913–1923', in Günter Berghaus (ed.), *International Futurism in Arts and Literature* (Berlin: de Gruyter, 2000), 75–99.

Braun, Martha, *Picturing Time: The Work of Etienne-Jules Marey (1830–1904)* (Chicago: University of Chicago Press, 1992).

Brecht, Bertolt, 'The Radio as an Apparatus of Communication', in *Brecht on Theatre: The Development of an Aesthetic*, ed. and trans. John Willett (London: Methuen, 1964), 51–3.

——*Poems 1913–1956*, ed. John Willett and Ralph Manheim (London: Eyre Methuen, 1976).

——*The Messingkauf Dialogues*, trans. John Willett (London: Methuen, 1978).

Breslin, Paul, 'The Cultural Address of Derek Walcott', *Modernism/Modernity*, 9/2 (May 2002), 319–25.

Breton, André, *Premier Manifeste du Surréalisme* (1924; Paris: Jean-Jacques Pauvert, 1962).

——'Interview du Professeur Freud', in Breton, *Les Pas perdus* (1924; Paris: Gallimard, 1969), 94–5.

——*Manifestoes of Surrealism*, ed. Richard Seaver and Helen R. Lane (Ann Arbor: University of Michigan Press, 1972).

——*What Is Surrealism? Selected Writings*, ed. Franklin Rosemont (London: Pluto Press, 1978).

BRETON, ANDRÉ, Œuvres complètes, i, ed. Marguerite Bonnet (Paris: Gallimard/Pléiade, 1988).
——Conversations: The Autobiography of Surrealism, trans. Mark Polizzotti (New York: Marlowe, 1993).
——Communicating Vessels (1932), trans. Mary Ann Caws and Geoffrey T. Harris (Lincoln: University of Nebraska Press, 1997).
BRETZ, MARY LEE, Encounters Across Borders: The Changing Visions of Spanish Modernism, 1890–1930 (Lewisburg, Pa.: Bucknell University Press, 2001).
BRIGGS, JULIA, 'Hope Mirrlees and Continental Modernism', in Bonnie Kime Scott (ed.), The Gender of Modernism: A Critical Anthology (Bloomington: Indiana University Press, 1990), 261–9.
——Virginia Woolf: An Inner Life (London: Allen Lane, 2005).
BRIK, O., 'T. n. formal'nyi metod', LEF 1 (1923), 213–15.
BRISTOW, JOSEPH, Empire Boys: Adventures in a Man's World (London: HarperCollins Academic, 1991).
BROBY-JOHANSEN, RUDOLF, BLOD: EKSPRESSIONÆRE DIGTE (Copenhagen: Gyldendals Spættebøger, 1968).
BROCH, HERMANN, 'Kommentare', in Broch, Der Tod des Vergil (Frankfurt am Main: Suhrkamp, 1976).
BROCKINGTON, GRACE, '"A World Fellowship": The Founding of the International Lyceum Club', Transnational Associations, 1 (Mar. 2005), 15–22.
——(ed.), Internationalism and the Arts in Britain and Europe at the Fin de Siècle (Oxford: Peter Lang, 2009).
BRODSKII, N. L., and SIDOROV, N. P. (eds), Literaturnye manifesty: Ot simvolizma do 'Oktiabria' (Moscow: Agraf, 2001).
BRONFEN, ELISABETH, 'Seductive Departures of Marlene Dietrich: Exile and Stardom in The Blue Angel', in Gerd Gemünden and Mary R. Desjardins (eds), Dietrich Icon (Durham, NC: Duke University Press, 2007), 119–40.
BROOKER, JEWEL SPEARS, Mastery and Escape: T. S. Eliot and the Dialectic of Modernism (Boston: University of Massachusetts Press, 1994).
BROOKER, JOSEPH, Flann O'Brien (London: Northcote, 2005).
BROOKER, PETER, Modernity and Metropolis (London: Palgrave, 2002).
——Bohemia in London: The Social Scene of Early Modernism (Basingstoke: Palgrave Macmillan, 2007).
——and THACKER, ANDREW (eds), Geographies of Modernism: Literatures, Cultures, Spaces (London: Routledge, 2005).
————(eds), The Oxford Critical and Cultural History of Modernist Magazines, i: Britain and Ireland 1880–1955 (Oxford: Oxford University Press, 2009).
BROUGH, JOHN, 'The Emergence of an Absolute Consciousness in Husserl's Early Writings on Time-Consciousness', in Frederick Elliston and Peter McCormick (eds), Husserl: Expositions and Appraisals (Notre Dame, Ind.: University of Notre Dame Press, 1977), 83–100.
BROWN, EDWARD J., The Proletarian Episode in Russian Literature 1928–1932 (New York: Columbia University Press, 1953).
——'Mayakovsky's Futurist Period', in George Gibian and H. W. Tjalsma (eds), Russian Modernism: Culture and the Avant-Garde, 1900–1930 (Ithaca, NY: Cornell University Press, 1967), 107–31.
BROWN, J. DILLON, 'Exile and Cunning: The Tactical Difficulties of George Lamming', Contemporary Literature, 47/4 (Winter 2006), 669–94.
BROWN, NICHOLAS, Utopian Generations: The Political Horizon of Twentieth-Century Literature (Princeton: Princeton University Press, 2005).

BROWN, TERENCE, *Ireland: A Social and Cultural History, 1922–2002*, rev. edn (London: HarperCollins, 2004).

BROWN, TONY, '"Stories from Foreign Countries": The Short Stories of Kate Roberts and Margiad Evans', in Alyce Von Rothkirch and Daniel Williams (eds), *Beyond the Difference: Welsh Literature in Comparative Contexts* (Cardiff: University of Wales Press, 2004), 21–37.

BRU, SASCHA, 'A Map of Possible Paths: Modernism After Marxism', in Astradur Eysteinsson and Vivian Liska (eds), *Modernism*, 2 vols (Amsterdam: John Benjamins, 2007), i. 107–24.

BRUCE, DICKSON D., JR, *Black American Writing from the Nadir* (Baton Rouge: Louisiana State University Press, 1989).

BUCKLE, RICHARD, *Nijinsky* (Harmondsworth: Penguin, 1975).

BUCK-MORSS, SUSAN, 'Aesthetics and Anaesthetics: Walter Benjamin's Artwork Essay Reconsidered', *October*, 62 (Autumn 1992), 3–41.

BULLOCK, ALAN, 'The Double Image', in Malcolm Bradbury and James McFarlane (eds), *Modernism: A Guide to European Literature, 1890–1930* (Harmondsworth: Penguin, 1976), 58–70.

BÜRGER, PETER, *Theory of the Avant-Garde*, trans. Michael Shaw (Minneapolis: University of Minnesota Press, 1984).

BURKE, CAROLYN, *Becoming Modern: The Life of Mina Loy* (New York: Farrar, Straus, Giroux, 1996).

BURLIUK, DAVID, KRUCHENYKH, ALEXANDER, MAYAKOVSKY, VLADIMIR, and KHLEBNIKOV, VICTOR, 'A Slap in the Face of Public Taste' (1912), <http://www.unknown.nu/futurism/slap.html>.

BURT, RAMSAY, *Alien Bodies: Representations of Modernity, 'Race' and Nation in Early Modern Dance* (London: Routledge, 1998).

——'Modernism, Masculinity, and Sexuality in Nijinsky's *L'Après-midi d'un faune*', in Valerie Briginshaw and Ramsay Burt (eds), *Writing Dancing Together* (Basingstoke: Palgrave, 2009), 25–44.

BURTON, ANTOINETTE, *At the Heart of Empire: Indians and the Colonial Encounter in Late-Victorian Britain* (Berkeley: University of California Press, 1998).

BURY, STEPHEN (ed.), *Breaking the Rules: The Printed Face of the European Avant-Garde, 1900–1937* (London: British Library, 2007).

BUSH, BARBARA, 'History, Memory, Myth? Reconstructing the History (or Histories) of Black Women in the African Diaspora', in Stephanie Newell (ed.), *Images of African and Caribbean Women: Migration, Displacement, Diaspora*, Occasional Paper No. 4 (Stirling: University of Stirling, Centre of Commonwealth Studies, 1996), 3–28.

BUSH, RONALD, *T. S. Eliot: The Modernist in History* (Cambridge: Cambridge University Press, 1991).

BUTHLAY, KENNETH (ed.), *Hugh MacDiarmid: A Drunk Man Looks at the Thistle* (Edinburgh: Scottish Academic Press for ASLS, 1987).

BUTLER, CHRISTOPHER, *Early Modernism: Literature, Music, and Painting in Europe, 1900–1916* (Oxford: Oxford University Press, 1994).

BUTTERICK, GEORGE F., *A Guide to the Maximus Poems of Charles Olson* (Berkeley: University of California Press, 1978).

BYDŽOVSKÁ, LENKA, and SRP, KAREL (eds), *Český Surrealismus, 1929–1953*, exh. cat. (Prague: Galerie hlavního města Prahy, 1996).

——LAHODA, VOJTĚCH, and SRP, KAREL (eds), *Czech Art 1900–1990 from the Collections at the Prague City Gallery, House of the Golden Ring*, exh. cat. (Prague: Prague City Gallery, 1998).

CAIN, STEPHEN, 'Mapping Raymond Souster's Toronto', in Dean Irvine (ed.), *The Canadian Modernists Meet* (Ottawa: University of Ottawa Press, 2005), 71–86.

CALDER, ALISON, 'Reassessing Prairie Realism', *Textual Studies in Canada*, 12 (1998), 51–60.

CALL, FRANK OLIVER, 'Foreword', in *Acanthus and Wild Grape* (Toronto: McClelland and Stewart, 1920), 9–13.

CALLEN, ANTHEA, *Techniques of the Impressionists* (London: Orbis, 1982).

CALVINO, ITALO, *If on a Winter's Night a Traveler*, trans. William Weaver (London: Picador, 1982).

——'A Cinema-Goer's Autobiography', in Calvino, *The Road to San Giovanni*, trans. Tim Parks (London: Vintage, 1994), 35–73.

CAMPBELL, R. J., *The New Theology*, popular edn (London: Mills & Boon, 1909).

CAMPBELL, TIMOTHY C., *Wireless Writing in the Age of Marconi* (Minneapolis: University of Minnesota Press, 2006).

CANGIULLO, FRANCESCO, *Piedigrotta: Parole in libertà* (Milan: Edizioni futuriste di 'Poesia', 1916).

——*Caffeconcerto: Alfabeto a sorpresa* (Milan: Edizioni futuriste di 'Poesia', 1918).

——*Poesie pentagrammata* (Naples: Casella, 1923).

CAPELL, RICHARD, 'Cannibal Music: Amazing Production of the Russian Ballet', *Daily Mail*, 12 July 1913, 5.

CARDINAL, ROGER, and SHORT, ROBERT STUART, *Surrealism: Permanent Revelation* (London: Studio Vista, 1970).

CAREY, JOHN, *The Intellectuals and the Masses: Pride and Prejudice Among the Literary Intelligentsia, 1880–1939* (London: Faber and Faber, 1992).

CARLSTON, ERIN G., *Thinking Fascism: Sapphic Modernism and Fascist Modernity* (Stanford, Calif.: Stanford University Press, 1998).

CARMAN, BLISS, 'A Spring Feeling', *Saturday Night*, 14 (4 Apr. 1896).

CARPENTER, EDWARD, *Intermediate Types Among Primitive Folk* (1911–14; New York: Arno Press, 1975).

CARPENTER, HUMPHREY, *A Serious Character: The Life of Ezra Pound* (London: Faber, 1988).

CARR, HELEN, 'Modernism and Travel (1880–1940)', in Peter Hulme and Tim Youngs (eds), *The Cambridge Companion to Travel Writing* (Cambridge: Cambridge University Press, 2002), 70–86.

——*The Verse Revolutionaries: Ezra Pound, H.D. and the Imagists* (London: Jonathan Cape, 2009).

CARRÀ, CARLO, *Guerrapittura: Futurismo politico, dinamismo plastico, disegni guerreschi, parole in libertà* (Milan: Edizioni futuriste di 'Poesia', 1915).

CARROLL, NOEL, 'Globalization and Art: Then and Now', *Journal of Aesthetics and Art Criticism*, 65/1 (2007), 131–43.

CARSWELL, CATHERINE, *Open the Door!* (London: Melrose, 1920).

——*The Camomile* (London: Chatto & Windus, 1922).

——*Lying Awake: An Unfinished Autobiography and Other Posthumous Papers*, ed. John Carswell (Edinburgh: Canongate Classics, 1997).

CARUSO, LUCIANO, and MARTINI, STELIO M. (eds), *Tavole parolibere futuriste, 1912–1944*, 2 vols (Naples: Liguori, 1977).

CASARINO, CESARE, *Modernity at Sea: Melville, Marx, Conrad in Crisis* (Minneapolis: University of Minnesota Press, 2002).

CASETTI, FRANCESCO, *Eye of the Century: Film, Experience, Modernity* (New York: Columbia University Press, 2008).

CASTLE, TERRY, 'Husbands and Wives', *London Review of Books* (13 Dec. 2007), 11–16.

CATHER, WILLA, *The Professor's House* (1925; New York: Vintage, 1953).

CAVANAUGH, JAN, *Out Looking In: Early Modern Polish Art, 1890–1918* (Berkeley: University of California Press, 2000).

CAWS, MARY ANN, *The Poetry of Dada and Surrealism: Aragon, Breton, Tzara, Éluard, and Desnos* (Princeton: Princeton University Press, 1970).

——(ed.), *Manifesto: A Century of Isms* (Lincoln Nebr.: University of Nebraska Press, 2001).

CAYGILL, HOWARD, 'Benjamin, Heidegger and the Destruction of Tradition', in Andrew Benjamin and Peter Osborne (eds), *Walter Benjamin's Philosophy: Destruction and Experience* (London: Routledge, 1994), 1–31.

CÉLINE, LOUIS-FERDINAND, *Journey to the End of the Night* (1932), trans. Ralph Manheim (New York: New Directions, 2006).

CHABOT, C. BARRY, *Writers for the Nation* (Tuscaloosa: University of Alabama Press, 1997).

CHADWICK, WHITNEY, *Women Artists and the Surrealist Movement* (London: Thames & Hudson, 1985).

CHARGUINA, LUDMILLA, 'The Typology of Symbolism in Central and Eastern Europe', in Béla Köpeczi and György M. Vajda (eds), *Actes du VIIIe Congrès de l'Association Internationale de Littérature Comparée*, Proceedings of the 8th Congress of the International Comparative Literature Association (Stuttgart: Kunst und Wissen, Erich Bieber, 1980), 545–50.

CHEN XIAOMING, *Anxiety of Expression: Historical Disillusionment and Contemporary Literary Reform* (Beijing: Central Translation Press, 2002).

CHERNIAVSKY, EVA, *Incorporations: Race, Nation and the Body Politics of Capital* (Minneapolis: University of Minnesota Press, 2006).

CHESTERTON, GILBERT K., *Orthodoxy* (London: John Lane, 1909).

CHEVALIER, LOUIS, *Labouring Classes and Dangerous Classes*, trans. Frank Jellinek (London: Routledge & Kegan Paul, 1973).

CHINWEIZU, ONWUCHEKWA JEMIE, and MADUBUIKE, IHECHUKWU, *Toward the Decolonization of African Literature: African Fiction and Poetry and Their Critics* (Washington, DC: Howard University Press, 1983).

CHOW TSE-TUNG, *The May Fourth Movement: Intellectual Revolution in Modern China* (Cambridge, Mass.: Harvard University Press, 1960).

CHRISTIANSEN, RUPERT, *Tales of the New Babylon: Paris 1869–1875* (London: Sinclair-Stevenson, 1994).

CRISTIE, IAN, 'French Avant-Garde Film in the Twenties: from "Specificity" to Surrealism', in *Film as Film: Formal Experiment in Film, 1910–1975* (London: Hayward Gallery/Arts Council of Great Britain, 1979), 37.

CHRONOS, WILLIAM, *Nature's Metropolis: Chicago and the Great West* (New York: Norton, 1992).

CHU, PATRICIA E., *Race, Nationalism and the State in British and American Modernism* (Cambridge: Cambridge University Press, 2006).

CHUKOVSKY, K., *Sobranie sochinenie v shesti tomakh* (Moscow, 1965).

——'Futuristy', in *Sobranie sochinenie v shesti tomakh*, vi (Moscow: Izdatel'stvo khudozhestvennaia literatura, 1969), 234.

CIANCI, GIOVANNI, and HARDING, JASON (eds), *T. S. Eliot and the Concept of Tradition* (Cambridge: Cambridge University Press, 2007).

CIFUENTES, LUIS FERNÁNDEZ, *Teoría y mercado de la novela en España: Del 98 a la República* (Madrid: Gredos, 1982).

CLARK, JOHN (ed.), *Modernity in Asian Art* (Sydney: Wild Peony, 1993).

CLARK, T. J., *The Absolute Bourgeois: Artists and Politics in France, 1848–1851* (London: Thames & Hudson, 1973).

——*Image of the People: Gustave Courbet and the 1848 Revolution* (London: Thames & Hudson, 1973).

CLARK, T. J., *The Painting of Modern Life: Paris in the Art of Manet and His Followers* (New York: Knopf, 1985).

——*Farewell to an Idea: Episodes from a History of Modernism* (New Haven: Yale University Press, 1999).

CLARKE, BRUCE, *Dora Marsden and Early Modernism* (Ann Arbor: University of Michigan Press, 1996).

CLARKSON, THOMAS, 'The True State of the Case, respecting the Insurrection at St. Domingo', in Laurent Dubois and John Garrigus (eds), *Slave Revolution in the Caribbean, 1789–1804: A Brief History with Documents* (New York: St Martin's Press, 2006), 113–15.

CLAUSSEN, SOPHUS, *Antonius i Paris & Valfart* (Copenhagen: Danske Klassikere, Det danske Sprog- og Litteraturselskab, Borgen, 1990).

CLEARY, JOE, *Outrageous Fortune: Capital and Culture in Modern Ireland* (Dublin: Field Day, 2007).

——and CONNOLLY, CLAIRE (eds), *The Cambridge Companion to Modern Irish Culture* (Cambridge: Cambridge University Press, 2005).

CLEGG, ELIZABETH, *Art, Design, and Architecture in Central Europe, 1890–1920* (New Haven: Yale University Press, 2006).

CLIFFORD, JAMES, 'On Ethnographic Self-Fashioning: Conrad and Malinowski', in Thomas C. Heller, Morton Sosna, and David Wellberg (eds), *Reconstructing Individualism* (Stanford, Calif.: Stanford University Press, 1986), 140–63.

——*The Predicament of Culture* (Cambridge, Mass.: Harvard University Press, 1988).

——'Travelling Cultures', in Lawrence Grossberg, Cary Nelson, and Paula A. Treichler (eds), *Cultural Studies* (London: Routledge, 1992), 96–112.

CLINTON-BADDELEY, V. C., 'The Case for Wireless Drama', *The Listener* (11 June 1930), 1033–4.

COBEN, STANLEY, 'The Scientific Establishment and the Transmission of Quantum Mechanics to the United States, 1919–32', *American Historical Review*, 76/2 (Apr. 1971), 442–66.

COE, BRIAN, and GATES, PAUL, *The Snapshot Photograph: The Rise of Popular Photography, 1888–1939* (London: Ash & Grant, 1977).

COHEN, MILTON A., *Movement, Manifesto, Melee: The Modernist Group, 1910–1914* (Lanham, Md: Lexington, 2004).

COHN, DORRIT, *Transparent Minds: Narrative Modes for Presenting Consciousness in Fiction* (Princeton: Princeton University Press, 1983).

COLE, SARAH, *Modernism, Male Friendship, and the First World War* (Cambridge: Cambridge University Press, 2003).

COLLECOTT, DIANA, *H.D. and Sapphic Modernism, 1910–1950* (Cambridge: Cambridge University Press, 1999).

COLLIER, PATRICK, *Modernism on Fleet Street* (Aldershot: Ashgate, 2006).

COLLINI, STEFAN, *Common Reading: Critics, Historians, Publics* (Oxford: Oxford University Press, 2008).

COMENTALE, EDWARD P., *Modernism, Cultural Production, and the British Avant-Garde* (Cambridge: Cambridge University Press, 2004).

——and Gąsiorek, Andrzej (eds) *T. E. Hulme and the Question of Modernism* (Aldershot: Ashgate, 2006).

COMPTON, SUSAN, *The World Backwards: Russian Futurist Books, 1912–1916* (London: British Library, 1978).

——*Russian Avant-Garde Books, 1917–1934* (London: British Library, 1992).

CONGDON, LEE, *Exile and Social Thought: Hungarian Intellectuals in Germany and Austria, 1919–1933* (Princeton: Princeton University Press, 1991).

CONRAD, JOSEPH, *Tales of Unrest* (New York: Doubleday, Page, 1924).

——*Conrad's Prefaces to His Works*, ed. Edward Garnett (New York: Haskell House, 1971).

—— *The Secret Agent: A Simple Tale* (1907; Harmondsworth: Penguin, 1975).

—— *A Personal Record* (Marlboro, Vt.: Marlboro Press, 1982).

—— *The Collected Letters of Joseph Conrad*, ed. Frederick R. Karl and Laurence Davies, v (Cambridge: Cambridge University Press, 1996).

—— *Heart of Darkness and Other Tales*, ed. Cedric Watts (Oxford: Oxford University Press, 2002).

—— 'Some Reflections on the Loss of the *Titanic*', in *The Portable Conrad*, ed. Michael Gorra (New York: Penguin, 2007), 635–46.

CONRAN, ANTHONY, *The Cost of Strangeness* (Llandysul: Gomer Press, 1982).

CONTARINI, SILVIA, 'Avant-Garde: Chacun son lecteur', *Revue des Études Italiennes*, 43/1–2 (1997), 95–107.

COOK, MATT, *London and the Culture of Homosexuality, 1880–1914* (Cambridge: Cambridge University Press, 2003).

COOKE, RAYMOND, *Velimir Khlebnikov: A Critical Study* (Cambridge: Cambridge University Press, 1987).

COONROD MARTÍNEZ, ELIZABETH, 'The Latin American Innovative Novel of the 1920s', in Sophia McClellan and Earle E. Fitz (eds), *Comparative Cultural Studies and Latin America* (West Lafayette, Ind.: Purdue University Press, 2004), 34–55.

COOPER, DAVID E. (ed.), *Aesthetics: The Classic Readings* (London: Blackwell, 1997).

COOPER, DOUGLAS, *The Cubist Epoch* (London: Phaidon Press, 1971).

COOPER, JOHN XIROS, *Modernism and the Culture of Market Society* (Cambridge: Cambridge University Press, 2004).

CORBETT, DAVID PETERS, *The Modernity of English Art, 1914–30* (Manchester: Manchester University Press, 1997).

—— *The World in Paint: Modern Art and Visuality in England, 1848–1914* (Manchester: Manchester University Press, 2004).

—— HOLT, YSANNE, and RUSSELL, FIONA (eds), *The Geographies of Englishness: Landscape and the National Past in English Art, 1880–1940* (New Haven: Yale University Press, 2002).

CORK, RICHARD, *Vorticism and Abstract Art in the First Machine Age* (Berkeley: University of California Press, 1976).

—— *A Bitter Truth: Avant-Garde Art and the Great War* (New Haven: Yale University Press, 1994).

—— *Jacob Epstein* (London: Tate Gallery, 1999).

CORKERY, DANIEL, *Synge and Anglo-Irish Literature* (Cork: Cork University Press, 1931).

CORN, WANDA, *The Great American Thing: Modern Art and National Identity, 1915–1935* (Berkeley: University of California Press, 2000).

CORNIS-POPE, MARCEL, and NEUBAUER, JOHN, *Towards a History of the Literary Cultures in East-Central Europe: Theoretical Reflections* (New York: American Council of Learned Societies, 2002).

CORY, MARK, 'Soundplay: The Polyphonous Tradition of German Radio Art', in Douglas Kahn and Gregory Whitehead (eds), *Wireless Imagination: Sound, Radio, and the Avant-Garde* (Cambridge: MIT Press, 1992), 331–72.

COTT, NANCY, *The Grounding of Modern Feminism* (New Haven: Yale University Press, 1987).

COTTINGTON, DAVID, *Cubism in the Shadow of War: The Avant-Garde and Politics in Paris, 1905–1914* (New Haven: Yale University Press, 1998).

—— *Cubism and its Histories* (Manchester: Manchester University Press, 2004).

COUGHLAN, PATRICIA, and DAVIS, ALEX (eds), *Modernism and Ireland: The Poetry of the 1930s* (Cork: Cork University Press, 1995).

COURNOS, JOHN, *Babel* (New York: Boni and Liveright, 1922).

COWARD, NOEL, *Play Parade* (Garden City, NY: Garden City Publishing, 1933).

COWLEY, MALCOLM, *The Faulkner–Cowley File: Letters and Memories, 1944–1962* (Harmonds-
worth: Penguin, 1978).
——*Exile's Return: A Literary Odyssey of the 1920s*, ed. Donald W. Faulkner (London: Penguin,
1994).
CRAFT, ROBERT, 'Nijinsky and *Le Sacre*', *New York Review of Books*, 23/6 (15 Apr. 1976), 37.
CRANE, HART, *The Complete Poems* (Garden City, NY: Doubleday, 1966).
CRARY, JONATHAN, *Suspensions of Perception: Attention, Spectacle, and Modern Culture*
(Cambridge, Mass.: MIT Press, 1999).
CRAWFORD, ELIZABETH, *The Woman's Suffrage Movement: A Reference Guide 1866–1928*
(London: University College London Press, 1999).
CRONIN, ANTHONY, *No Laughing Matter: The Life and Times of Flann O'Brien* (London:
Grafton, 1989).
——*Heritage Now: Irish Literature in the English Language* (Dingle: Brandon, 1982), 155–60.
CROW, THOMAS, 'Modernism and Mass Culture in the Visual Arts', in Benjamin
H. D. Buchloh, Serge Guilbaut, and David Solkin (eds), *Modernism and Modernity: The
Vancouver Conference Papers* (Halifax: Press of the Nova Scotia College of Art and Design,
2004), 215–64.
CROZIER, ANDREW, and LONGVILLE, TIM (eds), *A Various Art* (London: Paladin, 1990).
CRUNDEN, ROBERT, *American Salons: Encounters with European Modernism, 1885–1917*
(New York: Oxford University Press, 1993).
CUCULLU, LOIS, *Expert Modernists, Matricide, and Modern Culture* (Basingstoke: Palgrave
Macmillan, 2004).
CUDDY-KEANE, MELBA, 'Virginia Woolf, Sound Technology and the New Orality', in Pamela
Caughie (ed.), *Virginia Woolf in the Age of Mechanical Reproduction* (New York: Garland,
2000), 69–96.
——*Virginia Woolf, the Intellectual, and the Public Sphere* (Cambridge: Cambridge University
Press, 2003).
CUMMINGS, E. E., *Eimi* (New York: Covici, Friede, 1933).
CUNNINGHAM, VALENTINE, *Reading After Theory* (London: Blackwell, 2002).
CURTIS, WILLIAM J. R., 'Modernism and the Search for Indian Identity', *Architectural Review*,
182 (Aug. 1987), 32–8.

DA COSTA MEYER, ESTHER, *The Work of Antonio Sant'Elia: Retreat into the Future* (New Haven:
Yale University Press, 1996).
D'ALBISOLA, TULLIO, *L'anguria lirica (Lungo poema passionale)* (Rome: Edizioni futuriste di
'Poesia', 1934).
——and MARINETTI, FILIPPO, TOMMASO, *Parole in libertà futuriste olfattive tattili termiche*
(Savona: Litolatta, 1932).
DALGLIESH, MELISSA, 'Revealing Reciprocity: Anne Wilkinson, Northrop Frye, and
Mythopoetics in Canada', MA diss., Dalhousie University, 2007.
DALI, SALVADOR, 'L'Âne pourri', *La Surréalisme au Service de la Révolution*, 1 (July 1930), 9–12.
DALY, ANN, 'Isadora Duncan and the Distinction of Dance', *American Studies*, 35/1 (Spring
1994), 5–23.
DAMON, S. FOSTER, *Amy Lowell: A Chronicle* (Boston: Houghton Mifflin, 1935).
DANIUS, SARA, *The Senses of Modernism: Technology, Perception, and Aesthetics* (Ithaca, NY:
Cornell University Press, 2002).
DAS, SANTANU, *Touch and Intimacy in First World War Writing* (Cambridge: Cambridge
University Press, 2005).
DAS, SISIR KUMAR, *A History of Indian Literature, 1911–1956: Struggle for Freedom: Triumph and
Tragedy* (New Delhi: Sahitya Akademi, 1995).

DASH, J. MICHAEL, *The Other America: Caribbean Literature in a New World Context* (Charlottesville: University of Virginia Press, 1998).

DATHORNE, O., 'Amos Tutuola: The Nightmare of the Tribe', in Bruce King (ed.), *Introduction to Nigerian Literature* (Lagos: University of Lagos and Evans Bros, 1971), 64–76.

DAVIDSON, JOHN, *Fleet Street Eclogues* (London: John Lane, 1893).

DAVIDSON, MICHAEL, *Ghostlier Demarcations: Modern Poetry and the Material Word* (Berkeley: University of California Press, 1997).

DAVIES, D. HYWEL, *The Welsh Nationalist Party, 1925–1945* (Cardiff: University of Wales Press, 1983).

DAVIES, IDRIS, *The Complete Poems*, ed. Dafydd Johnston (Cardiff: University of Wales Press, 1994).

DAVIES, JAMES A., 'Dylan Thomas and His Contemporaries', in M. Wynne Thomas (ed.), *Welsh Writing in English* (Cardiff: University of Wales Press, 2003), 120–64.

DAVIES, JOHN, *Cardiff* (Cardiff: University of Wales Press, 2002).

DAVIS, ALEX, *A Broken Line: Denis Devlin and Irish Poetic Modernism* (Dublin: University College Dublin Press, 2000).

——and JENKINS, LEE M. (eds), *Locations of Literary Modernism: Region and Nation in British and American Modernist Poetry* (Cambridge: Cambridge University Press, 2000).

DAVIS, JAMES C., *Commerce in Color: Race, Consumer Culture, and American Literature, 1893–1933* (Ann Arbor: University of Michigan Press, 2007).

DAVIS, MIKE, *Planet of Slums* (London: Verso, 2006).

DAWAHARE, ANTHONY, 'The Specter of Radicalism in Alain Locke's *The New Negro*', in Bill V. Mullen and James Smethurst (eds), *Left of the Color Line: Race Radicalism and Twentieth-Century Literature of the United States* (Chapel Hill: University of North Carolina Press, 2006), 67–85.

DAWSON, ASHLEY, *Mongrel Nation: Diasporic Culture and the Making of Postcolonial Britain* (Ann Arbor: University of Michigan Press, 2007).

DAY-LEWIS, C., *The Poetic Image* (London: Cape, 1947).

——and STRONG, L. A. G. (eds), *A New Anthology of Modern Verse, 1920–1940* (London: Methuen, 1941).

DEAK, FRANTISEK, *Symbolist Theater* (Baltimore: Johns Hopkins University Press, 1993).

DEAN, TIM, *Beyond Sexuality* (Chicago: University of Chicago Press, 2000).

DEANE, SEAMUS, *Strange Country: Modernity and Nationhood in Irish Writing Since 1790* (Oxford: Clarendon Press, 1997).

DE BLÁCAM, AODH, 'The Age-Lasting Peasant', *Capuchin Annual* (1935), 251–7.

DECAIRES NARAIN, DENISE, *Contemporary Caribbean Women's Poetry: Making Style* (London: Routledge, 2004).

DEEPWELL, KATY (ed.), *Women Artists and Modernism* (Manchester: Manchester University Press, 1998).

DEJONGH, JAMES, *Vicious Modernism* (New York: Cambridge University Press, 1990).

DELAP, LUCY, *The Feminist Avant-Garde: Transatlantic Encounters of the Early Twentieth Century* (Cambridge: Cambridge University Press, 2007).

DELEUZE, GILLES, *Nietzsche and Philosophy*, trans. Hugh Tomlinson (London: Athlone Press, 1983).

——*Cinema I: The Movement-Image*, trans. Hugh Tomlinson and Barbara Habberjam (London: Athlone Press, 1986).

——*Cinema II: The Time-Image*, trans. Hugh Tomlinson and Roberta Galeta (London: Athlone Press, 1989).

——*Proust and Signs*, trans. Richard Howard (Minneapolis: University of Minnesota Press, 2000).

DELEUZE, GILLES, and GUATTARI, FÉLIX, *Anti-Oedipus: Capitalism and Schizophrenia*, trans. Robert Hurley et al. (Minneapolis: University of Minnesota Press, 1983).

――――*A Thousand Plateaus: Capitalism and Schizophrenia*, trans. Brian Massumi (Minneapolis: University of Minnesota Press, 1987).

――――*What Is Philosophy?*, trans. Graham Burchill and Hugh Tomlinson (London: Verso, 1994).

DELVILLE, MICHEL, *The American Prose Poem: Poetic Form and the Boundaries of Genre* (Gainesville: University Press of Florida, 1998).

DE MAN, PAUL, *Blindness and Insight: Essays in the Rhetoric of Contemporary Criticism* (Minneapolis: University of Minnesota Press, 1983).

DEMOOR, MARYSA, 'In the Beginning, There Was *The Germ*', in Peter Brooker and Andrew Thacker (eds), *A Critical and Cultural History of Modernist Magazines*, i (Oxford: Oxford University Press, 2009), 51–65.

DEPERO, FORTUNATO, *Depero futurista: Libromacchina*, ed. Dinamo Azari (Milan: Edizione Italiana Dinamo Azari, 1927).

DERRIDA, JACQUES, 'Form and Meaning: A Note on the Phenomenology of Language', in *Speech and Phenomena and Other Essays on Husserl's Theory of Signs*, trans. David Allison (Evanston, Ill.: Northwestern University Press, 1973), 107–28.

――*Of Grammatology*, trans. Gayatri Chakravorty Spivak (Baltimore: Johns Hopkins University Press, 1974).

――*Margins of Philosophy* (Chicago: University of Chicago Press, 1982).

――*Glas*, trans. John P. Leavey, Jr, and Richard Rand (Lincoln, Nebr.: University of Nebraska Press, 1986).

――*Of Spirit: Heidegger and the Question*, trans. Geoffrey Bennington and Rachel Bowlby (Chicago: University of Chicago Press, 1989).

――*Dissemination*, trans. Barbara Johnson (Chicago: University of Chicago Press, 1991).

――*Archive Fever: A Freudian Impression*, trans. Eric Prenowitz (Chicago: University of Chicago Press, 1996).

DESAI, KIRAN, *Inheritance of Loss* (New York: Atlantic Monthly, 2006).

DETTMAR, KEVIN J. H., and WATT, STEPHEN (eds), *Marketing Modernisms: Self-Promotion, Canonization, Rereading* (Ann Arbor: University of Michigan Press, 1996).

DIAW, AMINATA, and SUTHERLAND-ADDY, ESI (eds), *Women Writing Africa: West Africa and the Sahel* (Paris: Karthala, 2001).

DIEPEVEEN, LEONARD, *Difficulties of Modernism* (New York: Routledge, 2003).

DIJKSTRA, BRAM, *Cubism, Stieglitz, and the Early Poetry of William Carlos Williams* (Princeton: Princeton University Press, 1978).

DIKÖTTER, FRANK, *The Age of Openness: China Before Mao* (Hong Kong: Hong Kong University Press, 2008).

DIKTONIUS, ELMER, *Stenkol* (Helsinki: Holger Schildts Förlagsaktiebolag, 1927).

DIMOCK, WAI CHEE, 'The Egyptian Pronoun: Lyric, Novel, the *Book of the Dead*', *New Literary History*, 39 (2008), 619–43.

DOAN, LAURA, and GARRITY, JANE (eds), *Sapphic Modernities: Sexuality, Women and National Culture* (New York: Palgrave Macmillan, 2006).

DOANE, MARY ANN, *The Emergence of Cinematic Time: Modernity, Contingency, the Archive* (Cambridge, Mass.: Harvard University Press, 2002).

DÖBLIN, ALFRED, 'Die Ermordung einer Butterblume', in Fritz Martini (ed.), *Prosa des Expressionismus* (Stuttgart: Reclam, 1970), 102–15.

――*Berlin Alexanderplatz*, trans. Eugene Jolas (London: Continuum, 2004).

DOCHERTY, THOMAS, *After Theory: Postmodernism/Postmarxism* (London: Routledge, 1990).

Dodd, Philip, 'The Views of Travellers: Travel Writing in the 1930s', *Prose Studies*, 5/1 (1982), 127–38.

Dolin, Anton, *Last Words: A Final Autobiography* (London: Century, 1985).

Dollase, Hiromi Tsuchiya, 'Early Twentieth Century Japanese Girls' Magazine Stories: Examining Shōjo Voice in *Hanamonogatari* (Flower Tales)', *Journal of Popular Culture*, 36/4 (2003), 724–55.

Donald, James, 'Jazz Modernism and Movie Art: *Ballet mécanique*', *Modernism/Modernity*, 16/1 (Spring 2009), 25–49.

——Friedberg, Anne, and Marcus, Laura (eds), Close Up, *1927–1933: Cinema and Modernism* (London: Cassell, 1998).

Donald, S. H., and Voci, P., 'China: Cinema, Politics and Scholarship', in J. Donald and M. Renov (eds), *The Sage Handbook of Film Studies* (London: Sage, 2008), 54–73.

Donnell, Alison, *Twentieth-Century Caribbean Literature: Critical Moments in Anglophone Literary History* (London: Routledge, 2006).

——and Welsh, Sarah Lawson (eds), *The Routledge Reader in Caribbean Literature* (London: Routledge, 1996).

Donnelly, Charles, 'Literature in Ireland', *Comhthrom Féinne*, 5/4 (May 1933), 65.

Doob, Leonard (ed.), *Ezra Pound Speaking: Radio Speeches of World War II* (Westport, Conn.: Greenwood Press, 1978).

Doolittle, Hilda [H.D.], *Tribute to Freud* (1956), rev. edn (Boston: David R. Godine, 1974).

——*Collected Poems, 1912–1944* (New York: New Directions, 1983).

——*Notes on Thought and Vision* (1919; London: Peter Owen, 1988).

Dorn, Edward, *Idaho Out* (London: Fulcrum Press, 1965).

——*The North Atlantic Turbine* (London: Fulcrum Press, 1967).

——*The Collected Poems, 1956–1974* (Bolinas, Calif.: Four Seasons Foundation, 1975).

——*Slinger* (Berkeley: Wingbow Press, 1975).

Doshi, Balkrishna Vithaldas, 'Identity in Architecture: Contemporary Pressures and Tradition in India', *Architectural Association Quarterly*, 13/1 (Oct. 1981), 20–2.

Dos Passos, John, 'The Radio Voice', *Common Sense* (Feb. 1934), 17.

Douglas, Ann, *Terrible Honesty: Mongrel Manhattan in the 1920s* (London: Picador, 1996).

Dower, John, *A Century of Japanese Photography* (New York: Pantheon, 1980).

Dowling, Robert, 'A Marginal Man in Black Bohemia: James Weldon Johnson in the New York Tenderloin', in Barbara McCaskill and Caroline Gebhard (eds), *Post Bellum, Pre Harlem* (New York: New York University Press, 2006), 117–32.

Dowson, Jane, *Women, Modernism and British Poetry, 1910–1939: Resisting Femininity* (Aldershot: Ashgate, 2002).

Doyle, Laura, 'Geomodernism, Postcoloniality, and Women's Writing', in Maren Linett (ed.), *The Cambridge Companion to Modernist Women Writers* (Cambridge: Cambridge University Press, forthcoming).

——and Winkiel, Laura (eds), *Geomodernisms: Race, Modernism, Modernity* (Bloomington: Indiana University Press, 2005).

Drakakis, John (ed.), *British Radio Drama* (Cambridge: Cambridge University Press, 1981).

Drake, Sandra E., *Wilson Harris and the Modern Tradition: A New Architecture of the World* (Westport, Conn.: Greenwood Press, 1986).

Dreiser, Theodore, *A Book About Myself* (1922; London: Read Books, 2007).

Droz, Jacques, *L'Europe centrale: Évolution historique de l'idée de 'Mitteleuropa'* (Paris: Payot, 1960).

Drucker, Johanna, *The Visible Word: Experimental Typography and Modern Art, 1909–1923* (Chicago: University of Chicago Press, 1994).

DRUCKER, JOHANNA, *Figuring the Word: Essays on Books, Writing and Visual Poetics* (New York: Granary Books, 1998).

DUBOIS, LAURENT, and GARRIGUS, JOHN (eds), *Slave Revolution in the Caribbean, 1789–1804: A Brief History with Documents* (New York: St Martin's Press, 2006).

DUDEK, LOUIS (ed.), *Dk/Some Letters of Ezra Pound* (Montreal: DC Books, 1974).

DULEY, MARGARET, *The Eyes of the Gull* (London: Arthur Barker, 1936).

DUNN, WALDO HILARY, *James Anthony Froude: A Biography*, 2 vols (Oxford: Oxford University Press, 1961–3).

DUPLESSIS, RACHEL BLAU, *The Pink Guitar: Writing as Feminist Practice* (London: Routledge, 1990).

DURIE, ROBIN, 'The Strange Nature of the Instant', in Robin Durie (ed.), *Time and the Instant: Essays in the Physics and Philosophy of Time* (Manchester: Clinamen Press, 2000), 1–24.

DURING, SIMON, *Modern Enchantments: The Cultural Power of Secular Magic* (Cambridge, Mass.: Harvard University Press, 2002).

DYDO, ULLA E., with RICE, WILLIAM, *Gertrude Stein: The Language That Rises, 1923–1934* (Evanston, Ill.: Northwestern University Press, 2003).

DZHIMBINOVA, S. B. (ed.), *Literaturnye manifesty ot simvolizm do nashikh dnei* (Moscow: Soglasie, 2000).

EAGLETON, TERRY, *Literary Theory: An Introduction* (London: Blackwell, 1983).

——*Heathcliff and the Great Hunger: Studies in Irish Culture* (London: Verso, 1995).

——JAMESON, FREDRIC, and SAID, EDWARD, *Nationalism, Colonialism, and Literature* (Minnesota: University of Minneapolis Press, 1990).

EBY, CECIL D., *Road to Armageddon: The Martial Spirit in English Popular Literature, 1870–1914* (Durham, NC: Duke University Press, 1987).

EDEL, LEON (ed.), *Literary Criticism: Essays on Literature, American Writers, English Writers* (New York: Library of America, 1984).

EDELMAN, LEE, *No Future: Queer Theory and the Death Drive* (Durham, NC: Duke University Press, 2004).

EDWARDS, FREDERICK R., 'A War of Wor(l)ds: Aboriginal Writing in Canada during the "Dark Days" of the Early Twentieth Century', Ph.D. diss., University of Saskatchewan, 2008.

EDWARDS, HYWEL TEIFI, ' "Y Pentre Gwyn" and "Manteg": From Blessed Plot to Hotspot', in Alyce Von Rothkirch and Daniel Williams (eds), *Beyond the Difference: Welsh Literature in Comparative Contexts* (Cardiff: University of Wales Press, 2004), 8–20.

EDWARDS, NADI, 'George Lamming's Literary Nationalism: Language Between *The Tempest* and the Tonelle', *Small Axe*, 11 (Mar. 2002), 59–76.

EDWARDS, PAUL, *Wyndham Lewis: Painter and Writer* (New Haven: Yale University Press, 2000).

——(ed.), *Blast: Vorticism, 1914–1918* (Aldershot: Ashgate, 2000).

EGEBAK, NIELS, *Eumeniderne* (Viborg: Arena, 1960).

EGLINTON, JOHN, *Irish Literary Portraits* (London: Macmillan, 1935).

EIKHENBAUM, B., *Moi vremennik* (Leningrad: Izd-vo Pisatelei, 1929).

EISENSTEIN, SERGEI, *Film Form* (Cleveland, Ohio: Cleveland World, 1957).

EKSTEINS, MODRIS, *Rites of Spring: The Great War and the Birth of the Modern Age* (Boston: Houghton Mifflin, 1989).

ELIOT, GEORGE, *Selected Essays, Poems, and Other Writings*, ed. A. S. Byatt and Nicholas Warren (London: Penguin, 1990).

ELIOT, T. S., 'Tarr', *The Egoist*, 5/8 (Sept. 1918), 105–6.

——'Contemporanea', *The Egoist*, 5/6 (June–July 1918), 84–5.

——'Studies in Contemporary Criticism', *The Egoist*, 5/9 (Oct. 1918), 113–14.

——'The Post-Georgians', *The Athenaeum*, 4641 (11Apr. 1919), 171–2.

——'Modern Tendencies in Poetry', *Shama'a*, 1/1 (Apr. 1920), 9–18.

——*The Sacred Wood: Essays on Poetry and Criticism* (London: Methuen, 1920).

——*For Lancelot Andrewes: Essays on Style and Order* (London: Faber and Faber, 1928).

——*After Strange Gods: A Primer of Modern Heresy* (London: Faber and Faber, 1934).

——'On Reading Official Reports', *New English Weekly*, 15/3 (11 May 1939), 61.

——'*Ulysses*, Order, and Myth', in Seon Givens (ed.), *James Joyce: Two Decades of Criticism* (New York: Vanguard, 1948), 198–202.

——*Christianity and Culture: The Idea of a Christian Society and Notes Towards the Definition of Culture* (New York: Harcourt Brace, 1949).

——*Selected Essays* (London: Faber and Faber, 1950).

——*The Waste Land and Other Poems* (New York: Harvest, 1955).

——*Knowledge and Experience in the Philosophy of F. H. Bradley* (New York: Farrar and Straus, 1964).

——*Notes Towards the Definition of Culture* (1948; London: Faber and Faber, 1972).

——*Selected Prose*, ed. Frank Kermode (London: Faber, 1975).

——*Collected Poems: 1909–1962* (1963; New York: Harcourt Brace, 1991).

——*To Criticize the Critic and Other Writings* (1965; Lincoln: University of Nebraska Press, 1992).

——*Inventions of the March Hare: Poems 1909–1917*, ed. Christopher Ricks (London: Faber, 1996).

——'Tradition and the Individual Talent', in Eliot, *Selected Essays* (London: Faber and Faber, 1999), 13–22.

ELLIS, DAVID, 'Lawrence and the Biological Psyche', in *D. H. Lawrence: Centenary Essays*, ed. Mara Kalnins (Bristol: Bristol Classical Press, 1986), 89–109.

ELLISON, RALPH, *Shadow and Act* (New York: Random House, 1953).

ELLMANN, MAUD (ed.), *Psychoanalytic Literary Criticism* (London: Longman, 1994).

ELLMANN, RICHARD, *James Joyce* (Oxford: Oxford University Press, 1976).

——*The Consciousness of Joyce* (London: Faber and Faber, 1977).

EMERY, MARY LOU, *Jean Rhys at 'World's End': Novels of Colonial and Sexual Exile* (Austin: University of Texas Press, 1990).

——*Modernism, the Visual and Caribbean Literature* (Cambridge: Cambridge University Press, 2007).

EMPSON, WILLIAM, 'Some Notes on Mr Eliot', *Experiment*, 4 (Nov. 1929), 6–8.

——*Seven Types of Ambiguity* (1930; New York: New Directions, 1966).

——*Some Versions of Pastoral* (1935; Harmondsworth: Penguin, 1966).

ENGELS, FRIEDRICH, *The Condition of the Working Class in England* (1887; London: Penguin, 1987).

ENGLISH, DAYLANNE K., *Unnatural Selections: Eugenics in American Modernism and the Harlem Renaissance* (Chapel Hill: University of North Carolina Press, 2004).

'AN ENGLISHMAN', 'M. Nijinski on Beauty', *Daily Mail*, 19 July 1913.

E.R. [EDGELL RICKWORD], Review of Laurence Binyon, *The Sirens*, and Alfred Noyes, *The Torch-Bearers*, *Calendar of Modern Letters*, 2/7 (Sept. 1925), 65–8.

ERLICH, VICTOR, *Russian Formalism: History, Doctrine* (Paris: Mouton, 1955).

——*Modernism and Revolution: Russian Literature in Transition* (Cambridge, Mass.: Harvard University Press, 1994).

ESMAN, AARON, 'Italo Svevo and the First Psychoanalytic Novel', *International Journal of Psycho-Analysis*, 82 (2001), 1225–33.

ESPAGNE, MICHAEL, and WERNER, MICHAEL (eds), *Transferts: Les relations interculturelles dans l'espace franco-allemand (XVIIIe–XIXe siècles)* (Paris: Éditions Recherche sur les Civilisations, 1988).

ESTY, JED, *A Shrinking Island: Modernism and National Culture in England* (Princeton: Princeton University Press, 2004).

EVANS, CARADOC, 'Un Père à Sion' ('A Father in Sion'), trans. Georges Limbour, in Nino Frank (ed.), *Bifur*, 2 (Paris: Éditions du Carrefour, 1929), 48–59.

——*My People* (Bridgend: Seren, 1987).

EVANS, MARGIAD, *Country Dance* (1932; Cardigan: Parthian, 2006).

EVANS, PATRICIA A., '*Coterie*, 1919–1921: A Study of an English Little Magazine', M.Phil. thesis, University of Birmingham, 2005.

EWBANK, INGA-STINA, 'The Last Plays', in James Walter McFarlane (ed.), *The Cambridge Companion to Ibsen* (Cambridge: Cambridge University Press, 1994), 126–53.

EYSTEINSSON, ASTRADUR, *The Concept of Modernism* (Ithaca, NY: Cornell University Press, 1990).

——*English and Nordic Modernisms* (Norwich: Norvik Press, 2002).

——*European and Nordic Modernisms* (Norwich: Norvik Press, 2004).

——and LISKA, VIVIAN (eds), *Modernism*, 2 vols (Amsterdam: John Benjamins, 2007).

FABRE, MICHEL, *From Harlem to Paris: Black American Writers in France, 1840–1980* (Urbana: University of Illinois Press, 1991).

FANON, FRANTZ, *The Wretched of the Earth* (1961), trans. Constance Farrington (Harmondsworth: Penguin, 1986).

FARGUE, LÉON-PAUL, *Le Piéton de Paris* (Paris: Gallimard, 1939).

FARIAS, VICTOR, *Heidegger and Nazism*, trans. Paul Burrell (Philadelphia: Temple University Press, 1989).

FAULKNER, PETER, *Modernism* (London: Methuen, 1977).

——*A Modernist Reader: Modernism in England, 1910–30* (London: Batsford, 1986).

FAVIER, JEAN, *Paris: Deux mille ans d'histoire* (Paris: Fayard, 1997).

FELDMAN, JESSICA R., *Victorian Modernism: Pragmatism and the Varieties of Aesthetic Experience* (Cambridge: Cambridge University Press, 2002).

FELDMAN, MATTHEW, *Samuel Beckett: The Inter-War Notebooks* (London: Continuum, 2006).

FELSKI, RITA, *The Gender of Modernity* (Cambridge, Mass.: Harvard University Press, 1995).

——*Doing Time: Feminist Theory and Postmodern Culture* (New York: New York University Press, 2000).

——'Modernist Studies and Cultural Studies: Reflections on Method', *Modernism/Modernity*, 10/3 (Sept. 2003), 501–17.

FER, BRIONY, 'The Language of Construction', in Briony Fer, David Batchelor, and Paul Wood (eds), *Realism, Rationalism, Surrealism: Art Between the Wars* (New Haven: Yale University Press in association with the Open University Press, 1994), 87–169.

FERGUSON, PRISCILLA PARKHURST, *Paris as Revolution: Writing the Nineteenth-Century City* (Berkeley: University of California Press, 1994).

FERGUSON, ROBERT, *The Short Sharp Life of T. E. Hulme* (London: Penguin/Allen Lane, 2002).

FERGUSSON, JAMES, *History of the Modern Styles of Architecture* (London: John Murray, 1891).

FERMAN, CLAUDIA (ed.), *The Postmodern in Latin and Latino American Cultural Narratives* (New York: Garland, 1996).

FERNÁNDEZ-MORERA, DARÍO, 'The Term "Modernism" in Literary History', in *Proceedings of the Xth Congress of the International Comparative Literature Association*, i (New York: Garland, 1985), 271–9.

FERRER, DANIEL, *Virginia Woolf and the Madness of Language* (London: Routledge, 1990).

FERRY, LUC, *The New Ecological Order*, trans. Carol Volk (Chicago: University of Chicago Press, 1995).

FEUERBACH, LUDWIG, 'Principles of the Philosophy of the Future', in *The Fiery Brook: Selected Writings of Ludwig Feuerbach*, ed. and trans. Zawar Hanfi (New York: Anchor Books, 1972), 175–245.

——'Towards a Critique of Hegel's Philosophy', in *The Fiery Brook: Selected Writings of Ludwig Feuerbach*, ed. and trans. Zawar Hanfi (New York: Anchor Books, 1972), 53–96.

FEWSTER, ERNEST, 'Foreword', in Lionel Stevenson (ed.), *The Vancouver Poetry Society 1916–1946: A Book of Days* (Toronto: Ryerson, 1946), pp. v–vi.

FINDLAY, ALEXANDER, 'The Claims of Pure Science', *New Statesman*, 7 (5 Aug. 1916), 419–20.

FINE, ANN M., 'Harriet Monroe and *Poetry: A Magazine of Verse*', in Barbara Probst Solomon (ed.), *America—Meet Modernism! Women of the Little Magazine Movement* (New York: Great Marsh Press, 2003), 25–42.

FINKELDEY, BERND (ed.), *Konstruktivistische internationale schöpferische Arbeitsgemeinschaft, 1922–1927: Utopien für eine europäische Kultur* (Stuttgart: G. Hatje, 1992).

FISHER, ALLEN, *Place* (Hastings: Reality Street Editions, 2005).

FITTS, NORMAN (ed.), *S4N* (Northampton, Mass.: S4N Society, Nov. 1919–July 1925).

FLINT, F. S., 'Verse', *New Age* (6 Jan. 1910), 234.

——'A History of Imagism', *The Egoist* (1 May 1915), 70–1.

FLOURNOY, THÉODORE, *Spiritism and Psychology*, trans. H. Carrington (London: Harper, 1911).

FOLEJEWSKI, ZBIGNIEW, *Futurism and its Place in the Development of Modern Poetry: A Comparative Study and Anthology* (Ottawa: Ottawa University Press, 1980).

FOLEY, BARBARA, *Spectres of 1919: Class and Nation in the Making of the New Negro* (Urbana: University of Illinois Press, 2003).

FORD, FORD MADOX, *The Soul of London* (London: Alston Rivers, 1905).

——[HUEFFER], 'Editorial', *English Review*, 1/1 (Dec. 1908), 157–60.

——[HUEFFER], *Ancient Lights* (London: Chapman & Hall, 1911).

——[HUEFFER], 'On Impressionism', *Poetry and Drama*, 2 (1914), 167–75.

——[HUEFFER], *Thus to Revisit: Some Reminiscences* (New York: Dutton, 1921).

——*Provence: From Minstrels to the Machine* (New York: Ecco, 1935).

——*Mightier Than the Sword* (London: George Allen & Unwin, 1938).

——*Critical Writings*, ed. Frank MacShane (Lincoln: University of Nebraska Press, 1964).

——*Parade's End* (1924–8; New York: Vintage, 1979).

——*The English Novel: From the Earliest Days to the Death of Joseph Conrad* (1930), ed. Charles H. Sisson (Manchester: Carcanet, 1983).

——*The Ford Madox Ford Reader*, ed. Sonda J. Stang (Manchester: Carcanet, 1986).

——*The March of Literature: From Confucius' Day to Our Own* (1938; Normal: Illinois State University Press, 1994).

——*The Good Soldier* (1915), ed. Martin Stannard (New York: Norton, 1995).

——*Return to Yesterday* (1931), ed. Bill Hutchings (Manchester: Carcanet, 1999).

——*England and the English* (1907), ed. Sara Haslam (Manchester: Carcanet, 2003).

FORDHAM, FINN, *I do, I undo, I redo: The Textual Genesis of Modernist Selves* (Oxford: Oxford University Press, 2010).

FORREST THOMSON, VERONICA, *Poetic Artifice: A Theory of Twentieth Century Poetry* (Manchester: Manchester University Press, 1978).

FORSTER, E. M., *A Passage to India* (1924; New York: Harcourt Brace & World, 1952).

——*Commonplace Book*, ed. Philip Gardner (London: Scholar Press, 1985).

FOSTER, JOHN WILSON, *Colonial Consequences: Essays in Irish Literature and Culture* (Dublin: Lilliput, 1991).

FOSTER, R. F., *W. B. Yeats: A Life*, 2 vols (Oxford: Oxford University Press, 1997–2003).

FOUCAULT, MICHEL, *The Order of Things: An Archaeology of the Human Sciences* (London: Tavistock, 1970).

——'Nietzsche, Genealogy, History', in Foucault, *Language, Counter-Memory, Practice: Selected Essays and Interviews*, trans. Donald F. Bouchard and Sherry Simon (Ithaca, NY: Cornell University Press, 1977), 139–64.

——'Kant on Enlightenment and Revolution', trans. Colin Gordon, *Economy and Society*, 15/1 (Feb. 1986), 86–96.

——'What Is Enlightenment?', trans. Catherine Porter, in Paul Rabinow (ed.), *The Foucault Reader* (Harmondsworth: Penguin, 1986), 32–50.

——'What Is Critique?', in Foucault, *The Politics of Truth* (New York: Semiotext(e), 1997), 23–81.

——*The Archaeology of Knowledge* (1969), trans. A. M. Sheridan Smith (London: Routledge, 2002), 147.

FOX, RALPH, *The Novel and the People* (London: Cobbett, 1944).

FRANCIS, HYWEL, and SMITH, DAVID, *The Fed: A History of the South Wales Miners in the Twentieth Century* (London: Lawrence & Wishart, 1980).

FRANK, GLENN, 'Radio as an Educational Force', *ANNALS of the American Academy of Political and Social Science*, 177/1 (Jan. 1935), 119–22.

FRANK, JOSEPH, *The Widening Gyre: Crisis and Mastery in Modern Literature* (Bloomington: Indiana University Press, 1963).

FRANK, LEONHARD, *Der Mensch ist gut* (Zurich: Max Rascher, 1918).

FRASER, JAMES, HELLER, STEVEN, and CHWAST, SEYMOUR, *Japanese Modern: Graphic Design Between the Wars* (San Francisco: Chronicle Books, 1996).

FRASER, ROBERT (ed.), *Sir James Frazer and the Literary Imagination* (Basingstoke: Macmillan, 1990).

FRASER, RUSSELL, *A Mingled Yarn: A Life of R. P. Blackmur* (New York: Harcourt Brace Jovanovich, 1981).

FRAZER, JAMES GEORGE, *The Golden Bough* (London: Macmillan, 1922).

FREIBERG, FREDA, 'China Nights (Japan, 1940): The Sustaining Romance of Japan at War', in John Whiteclay Chambers II and David Culbert (eds), *World War II, Film, and History* (Oxford: Oxford University Press, 1996), 31–46.

FRENCH, ALISON, *Seeing the Centre: The Art of Albert Namatjira, 1902–1959* (Canberra: National Gallery of Australia, 2002).

FRESHWATER, HELEN, 'The Allure of the Archive', *Poetics Today*, 24/4 (Winter 2003), 729–58.

FREUD, SIGMUND, *Civilization and its Discontents* (1930), ed. and trans. James Strachey (New York: Norton, 1961).

——'An Aetiology of Hysteria', in *The Standard Edition of the Complete Psychological Works of Sigmund Freud*, ed. and trans. James Strachey, 24 vols (London: Hogarth Press, 1943–74), iii. 188–201.

——*Leonardo da Vinci and a Memory of His Childhood* (1910), ed. James Strachey, trans. Alan Tyson (New York: Norton, 1964).

——*Three Essays on the Theory of Sexuality* (1905–1915), ed. and trans. James Strachey (New York: HarperCollins, 1975).

——*The Uncanny*, Penguin Freud Library, xiv (Harmondsworth: Penguin, 1990).

FRIEDMAN, LAWRENCE M., *The Horizontal Society* (New Haven: Yale University Press, 1999).

FRIEDMAN, SUSAN STANFORD, *Psyche Reborn: The Emergence of H.D.* (Bloomington: Indiana University Press, 1981).

——'Definitional Excursions: The Meanings of Modern/Modernity/Modernism', *Modernism/Modernity*, 8/3 (Sept. 2001), 493–513.

——(ed.), *Analyzing Freud: Letters of H.D., Bryher, and Their Circle* (New York: New Directions, 2002).

——'Periodizing Modernism: Postcolonial Modernities and the Space/Time Borders of Modernist Studies', *Modernism/Modernity*, 13/3 (2006), 425–43.

FRISBY, DAVID, *Cityscapes of Modernity: Critical Explorations* (Cambridge: Polity Press, 2001).

FROMM, GLORIA, *Dorothy Richardson: A Biography* (Urbana: University of Illinois Press, 1977).

FROULA, CHRISTINE, *Virginia Woolf and the Bloomsbury Avant-Garde: War, Civilization, Modernity* (New York: Columbia University Press, 2004).

FROW, JOHN, *Marxism and Literary History* (Oxford: Blackwell, 1986).

FRY, ROGER, 'An Essay in Aesthetics', *New Quarterly*, 2 (1909), 171–90.

——'Editorial Articles—Oriental Art', *Burlington Magazine*, 17/85 (Apr. 1910), 3–4.

——'Oriental Art', *Quarterly Review*, 212/422 (1910), 225–39.

FRYE, NORTHROP, *The Anatomy of Criticism* (Princeton: Princeton University Press, 1957).

——*The Bush Garden: Essays on the Canadian Imagination* (Toronto: Anansi, 1971).

FUSSELL, PAUL, *Abroad: British Literary Traveling Between the Wars* (New York: Oxford University Press, 1980).

——*The Great War and Modern Memory* (Oxford: Oxford University Press, 2000).

GABLIK, SUZY, *Has Modernism Failed?* (London: Thames & Hudson, 1984).

GADDA, CARLO EMILIO, *That Awful Mess on Via Merulana*, trans. William Weaver (London: Quartet Books, 1985).

GALE, MATTHEW, *Dada and Surrealism* (London: Phaidon Press, 1997).

GALIK, MARIAN, *Milestones in Sino-Western Literary Confrontation (1898–1979)* (Wiesbaden: O. Harrassowitz, 1986).

GALLO, RUBÉN, *Mexican Modernity: The Avant-Garde and the Technological Revolution* (Cambridge, Mass.: MIT Press, 2005).

GALVIN, MARY E., *Queer Poetics: Five Modernist Writers* (Westport, Conn.: Praeger, 1999).

GAONKAR, DILIP PARAMESHWAR, 'Alternative Modernities', *Public Culture*, 11 (1999), 1–18.

——(ed.), *Alternative Modernities* (Durham, NC: Duke University Press, 2001).

GARAFOLA, LYNN, *Diaghilev's Ballets Russes* (New York: Oxford University Press, 1989).

GARDNER, WILLIAM, *Advertising Tower: Japanese Modernism and Modernity in the 1930s* (Cambridge, Mass.: Harvard University Press, 2006).

GARTON, JANET (ed.), *Facets of European Modernism: Essays in Honour of James McFarlane* (Norwich: University of East Anglia, 1985).

GASCHÉ, RODOLPHE, *The Tain of the Mirror: Derrida and the Philosophy of Reflection* (Cambridge, Mass.: Harvard University Press, 1986).

GASCOYNE, DAVID, *Collected Poems, 1988* (Oxford: Oxford University Press, 1988).

GĄSIOREK, ANDRZEJ, 'The Politics of Cultural Nostalgia: History and Tradition in Ford Madox Ford's *Parade's End*', *Literature and History*, 11/2 (Autumn 2002), 52–77.

——*Wyndham Lewis and Modernism* (Tavistock: Northcote House, 2004).

——'The "Little Magazine" as Weapon: *Blast*', in Peter Brooker and Andrew Thacker (eds), *The Oxford Critical and Cultural History of Modernist Magazines*, i: *Britain and Ireland, 1880–1955* (Oxford: Oxford University Press, 2009), 290–313.

——REEVE-TUCKER, ALICE, and WADDELL, NATHAN (eds), *Wyndham Lewis and the Cultures of Modernity* (Aldershot: Ashgate, forthcoming).

GASS, WILLIAM H., *Finding a Form* (New York: Knopf, 1996).

GASSNER, HUBERTUS (ed.), *Wechsel Wirkungen: Ungarische Avantgarde in der Weimarer Republik* (Marburg: Jonas Verlag, 1986).

GEE, MALCOLM, KIRK, TIM, and STEWARD, JILL (eds), *The City in Central Europe: Culture and Society from 1800 to the Present* (Aldershot: Ashgate, 2003).

GEMZØE, ANKER, 'Modernism, Narrativity, and Bakhtinian Theory', in Astradur Eysteinsson and Vivian Liska (eds), *Modernism*, 2 vols (Amsterdam: John Benjamins, 2007), 125–41.

——'Der Ton der Stadt und der Duft des Waldes: Johannes V. Jensen: *Intermezzo* (1899), *Skovene* (1904) und *Skovene* (1910)', in Aage Jørgensen and Sven Hakon Rossel (eds), *'Gelobt sei das Licht der Welt . . . ': Der dänische Dichter Johannes V. Jensen. Eine Forschungsanthologie* (Vienna: Praesens Verlag, 2007), 83–110.

GENET, JEAN, *Prisoner of Love*, trans. Barbara Bray (Hanover, NH: Wesleyan University Press, 1992).

GENTILE, EMILIO, 'The Conquest of Modernity: From Modernist Nationalism to Fascism', *Modernism/Modernity*, 1, special issue: *Marinetti and the Italian Futurists* (1994), 55–87.

GEROW, AARON, *A Page of Madness: Cinema and Modernity in 1920s Japan* (Ann Arbor: Center for Japanese Studies, University of Michigan, 2008).

GEVIRTZ, SUSAN, *Narrative's Journey: The Fiction and Film Writing of Dorothy Richardson* (New York: Peter Lang, 1996).

GIBBON, LEWIS GRASSIC, 'Literary Lights', in Lewis Grassic Gibbon and Hugh MacDiarmid, *Scottish Scene, or, The Intelligent Man's Guide to Albyn* (London: Jarrolds, 1934), 194–207.

——*A Scots Quair (Sunset Song) (1932); Cloud Howe (1933); Grey Granite (1934)* (Edinburgh: Canongate Classics, 1995).

GIBBONS, TOM, '*The Waste Land* Tarot Identified', *Journal of Modern Literature*, 2 (1972), 560–5.

——*Rooms in the Darwin Hotel: Studies in English Literary Criticism and Ideas, 1880–1920* (Crawley: University of Western Australia Press, 1973).

——'"Allotropic States" and "Fiddle-Bow": D. H. Lawrence's Occult Sources', *Notes and Queries*, 233 (1988), 338–41.

GIBSON, ANDREW, *Joyce's Revenge: History, Politics, and Aesthetics in* Ulysses (Oxford: Oxford University Press, 2002).

——*James Joyce* (London: Reaktion Books, 2006).

GIDDENS, ANTHONY, *Modernity and Self-Identity: Self and Society in the Late Modern Age* (Cambridge: Polity Press, 1991).

GIEST, ANTHONY, and MONLEÓN, JOSÉ (eds), *Modernism and its Margins* (New York: Garland, 1999).

GIKANDI, SIMON, *Writing in Limbo: Modernism and Caribbean Literature* (Ithaca, NY: Cornell University Press, 1992).

——*Maps of Englishness: Writing Identity in the Culture of Colonialism* (New York: Columbia University Press, 1996).

——(ed.), *Encyclopedia of African Literature* (London: Routledge, 2003).

——'Picasso, Africa, and the Schemata of Difference', *Modernism/Modernity*, 10/3 (Sept. 2003), 455–80.

——'Africa and the Epiphany of Modernism', in Laura Doyle and Laura Winkiel (eds), *Geomodernisms: Race, Modernism, Modernity* (Bloomington: Indiana University Press, 2005), 31–50.

GILBERT, GEOFF, *Before Modernism Was: Modern History and the Constituency of Writing* (Basingstoke: Palgrave Macmillan, 2004).

GILBERT, SANDRA M., and GUBAR, SUSAN, *No Man's Land: The Place of the Woman Writer in the Twentieth-Century*, 3 vols (New Haven: Yale University Press, 1988–94).

GILES, STEVE (ed.), *Theorizing Modernism* (London: Routledge, 1993).

GILLIES, MARY ANN, *The Professional Literary Agent in Britain, 1880–1920* (Toronto: Toronto University Press, 2007).

——SWORD, HELEN, and YAO, STEVEN (eds), *Pacific Rim Modernisms* (Toronto: University of Toronto Press, 2010).

GILLIS, ALAN, *Irish Poetry of the 1930s* (Oxford: Oxford University Press, 2005).

GILROY, PAUL, *The Black Atlantic: Modernity and Double Consciousness* (Cambridge, Mass.: Harvard University Press; London: Verso, 1993).

GINZBURG, L., *Zapisnye knizhki: Vospominaniia. Esse* (St Petersburg: Iskusstvo-SPB, 2002).

GLASS, LOREN, 'Redeeming Value: Obscenity and Anglo-American Modernism', *Critical Inquiry*, 32/2 (Winter 2006), 341–63.

——'#$%ˆ&*!?: Modernism and Dirty Words', *Modernism/Modernity*, 14/2 (2007), 209–23.

GLASSCO, JOHN, *Memoirs of Montparnasse* (Toronto: Oxford University Press, 1970).

GLIENKE, BERNHARD (ed.), *Expeditionen in die Moderne* (Münster: Kleinheinrich, 1991).

GLISSANT, ÉDOUARD, *Caribbean Discourse: Selected Essays*, trans. J. Michael Dash (Charlottesville: University of Virginia Press, 1989).

GLUCK, MARY, *Popular Bohemia: Modernism and Urban Culture in Nineteenth-Century Paris* (Cambridge, Mass.: Harvard University Press, 2005).

GOLDING, ALAN, '*The Dial*, the *Little Review*, and the Dialogues of Modernism', in Suzanne Churchill and Adam McKible (eds), *Little Magazines and Modernism: New Approaches* (Aldershot: Ashgate, 2007), 67–81.

GOLDMAN, JANE, *Modernism 1910–1945: Image to Apocalypse* (Basingstoke: Palgrave, 2004).

GOLDMAN, JONATHAN, and JAFFE, AARON (eds), *Modernist Star Maps* (Aldershot: Ashgate, forthcoming).

GOLDRING, DOUGLAS, *South Lodge: Reminiscences of Violet Hunt, Ford Madox Ford, and the English Review Circle* (London: Constable, 1943).

GOLDSCHEIDER, IRENA, *Czechoslovak Prints from 1900 to 1970* (London: British Museum, 1986).

GOLDWATER, ROBERT, *Primitivism in Modern Art* (London: Vintage, 1967).

GOOCH, BRAD, *City Poet: The Life and Times of Frank O'Hara* (New York: Knopf, 1993).

GOODBY, JOHN, *uncaged sea* (Hove: Waterloo Press, 2008).

——and WIGGINTON, CHRIS, '"Shut, too, in a tower of words": Dylan Thomas' Modernism', in Alex Davis and Lee M. Jenkins (eds), *Locations of Literary Modernism* (Cambridge: Cambridge University Press, 2000), 89–112.

GOODING-WILLIAMS, ROBERT, *Nietzsche's Dionysian Modernism* (Stanford, Calif.: Stanford University Press, 1999).

——*Zarathustra's Dionysian Modernism* (Stanford, Calif.: Stanford University Press, 2001).

GORMAN, HERBERT, *James Joyce: A Definitive Biography* (London: John Lane/Bodley Head, 1941).

GOULD, JEAN, *Amy: The World of Amy Lowell and the Imagist Movement* (New York: Dodd, Mead, 1975).

GRACE, SHERRILL, '"The Living Soul of Man": Bertram Brooker and Expressionist Theatre', *Theatre History in Canada* (Spring 1985), 1–22.

GRAFF, GERALD, *Literature Against Itself: Literary Ideas in Modern Society* (Chicago: University of Chicago Press, 1979).

GRAHAM, COLIN, 'Literary Historiography, 1890–2000', in Margaret Kelleher and Phillip O'Leary (eds), *The Cambridge History of Irish Literature*, ii (Cambridge: Cambridge University Press, 2006), 562–98.

GRAMICH, KATIE, and HISCOCK, ANDREW (eds), *Dangerous Diversity: The Changing Faces of Wales* (Cardiff: University of Wales Press, 1998).

GRAMSCI, ANTONIO, 'Marinetti the Revolutionary', in *Antonio Gramsci: Selections from Cultural Writings*, ed. David Forgacs and Geoffrey Nowell-Smith (Cambridge, Mass.: Harvard University Press, 1985).

GRAY, CAMILLA, *The Russian Experiment in Art, 1863–1922* (London: Thames & Hudson, 1986).

GREEN, CHRISTOPHER, *Cubism and its Enemies: Modern Movements and Reaction in French Art, 1916–1928* (Ithaca, NY: Yale University Press, 1987).

——*Art Made Modern: Roger Fry's Vision of Art* (London: Merrell Holberton in association with the Courtauld Institute of Art, 1999).

——*Art in France, 1900–1940* (New Haven: Yale University Press, 2000).

GREEN, HENRY, *Loving, Living, Party Going* (Harmondsworth: Penguin, 1993).

GREEN, THOMAS HILL, *Works of Thomas Hill Green*, i (London: Longmans, Green, 1885).

GREENBERG, CLEMENT, 'Avant-Garde and Kitsch', *Partisan Review*, 6/5 (Fall 1939), 34–49.

——'Towards a Newer Laocoön', *Partisan Review*, 7/4 (Aug. 1940), 296–310.

——'Modernist Painting', in Greenberg, *The Collected Essays and Criticism*, iv: *Modernism with a Vengeance, 1957–1969*, ed. John O'Brien (Chicago: University of Chicago Press, 1993), 85–93.

——'To Cope with Decadence', in Benjamin H. D. Buchloh, Serge Guilbaut, and David Solkin (eds), *Modernism and Modernity: The Vancouver Conference Papers* (Halifax: Press of the Nova Scotia College of Art and Design, 2004), 161–4.

GREENE, GRAHAM, *The Lawless Roads* (1939; London: Penguin, 1947).

——*Journey Without Maps* (1936; London: Pan, 1957).

GREENHALGH, HOWARD, *Art Nouveau: International and National Styles in Europe* (Manchester: Manchester University Press, 1991).

GREENOUGH, SARAH, and WAGGONER, DIANE, *The Art of the American Snapshot, 1888–1978* (Washington: National Gallery of Art in association with Princeton University Press, 2007).

GREGH, FERNAND, *Portrait de la poésie moderne, de Rimbaud à Valéry* (Paris: Delgrave, 1939).

GRIEVE, C. M., *Northern Numbers*, ed. Hugh MacDiarmid (Edinburgh: Foulis, 1921).

——(ed.) *The Scottish Chapbook*, Aug. 1922—Dec. 1923 (Montrose: C. M. Grieve).

——(ed.) *The Scottish Nation*, May–Dec. 1923 (Montrose: C. M. Grieve).

——(ed.) *The Northern Review*, May–Sept. 1924 (Montrose: C. M. Grieve).

——'Contemporary Criticism I', *New Age*, 35 (June 1924), 65–7.

——'Contemporary Criticism II', *New Age*, 35 (June 1924), 78–9.

——'Edwin Muir', in Grieve, *Contemporary Scottish Studies* (London: Leonard Parsons, 1926), 108–19.

GRIFFIN, ROGER, *Modernism and Fascism: The Sense of a Beginning Under Mussolini and Hitler* (Basingstoke: Palgrave Macmillan, 2007).

GRISEWOOD, HARMAN, and HAGUE, RENÉ (eds), *The Roman Quarry* (London: Agenda Editions, 1981).

GROSS, JOHN, *The Rise and Fall of the Man of Letters: English Literary Life Since 1800* (Harmondsworth: Penguin, 1991).

GROYS, B., 'The Birth of Socialist Realism from the Spirit of the Russian Avant-Garde', in J. E. Bowlt and O. Matich (eds), *Laboratory of Dreams: The Russian Avant-Garde and Cultural Experiment* (Stanford, Calif.: Stanford University Press, 1996), 193–219.

GRYGLEWICZ, TOMASZ, *Malarstwo Europy Srodkowej, 1900–1914: Tendencje modernistyczne i wczesnoawangardowe* (Kraków: Nakladem Uniwersytetu Jagiellonskiego, 1992).

GUHA-THAKURTA, TAPATI, *The Making of a New 'Indian' Art: Artists, Aesthetics and Nationalism in Bengal c.1850–1920* (Cambridge: Cambridge University Press, 1992).

GUILBAUT, SERGE, *How New York Stole the Idea of Modern Art: Abstract Expressionism, Freedom and the Cold War* (Chicago: University of Chicago Press, 1983).

GUMBRECHT, HANS ULRICH, 'Shall We Continue to Write Histories of Literature?', *New Literary History*, 39 (2008), 519–32.

GUNN, NEIL M., 'Down to the Sea', *Scottish Nation*, 1/18 (4 Sept. 1923), 14–15.

——*Highland River* (Edinburgh: Porpoise Press, 1937).

——Review of Edwin Muir, *The Narrow Place, Scots Magazine*, 39/2 (May 1943), 163.

GUNNING, TOM, 'Never Seen This Picture Before: Muybridge in Multiplicity', in Phillip Prodger, *Time Stands Still: Muybridge and the Instantaneous Photography Movement* (New York: Oxford University Press in association with the Iris and B. Gerald Cantor Center for Visual Arts at Stanford University, 2003), 222–72.

GWYNN, STEPHEN, *Irish Literature and Drama in the English Language: A Short History* (London: T. Nelson, 1936).

HAAS, ROBERT BARTLETT, *Muybridge: Man in Motion* (Berkeley and Los Angeles: University of California Press, 1976).

HABERMAS, JÜRGEN, *The Philosophical Discourse of Modernity: Twelve Lectures*, trans. Frederick Lawrence (Cambridge, Mass.: MIT Press, 1987).

——'Taking Aim at the Heart of the Present: On Foucault's Lecture on Kant's *What Is Enlightenment?*', in Habermas, *The New Conservatism*, trans. Shierry Weber Nicholsen (Cambridge, Mass.: MIT Press, 1989), 173–9.

HACKETT, ROBYN, *Sapphic Primitivism: Productions of Race, Class, and Sexuality in Key Works of Modern Fiction* (New Brunswick, NJ: Rutgers University Press, 2004).

HACKING, IAN, 'Two Kinds of "New Historicism" for Philosophers', *New Literary History*, 21 (1989–90), 343–64.

HAEFS, WILHELM, 'Zentren und Zeitschriften des Expressionismus', in York-Gothart Mix (ed.), *Sozialgeschichte der deutschen Literatur* (Munich: Hanser, 2000), 437–53.

HAESE, RICHARD, *Rebels and Precursors: The Revolutionary Years of Australian Art* (Sydney: Allen Lane, 1981).

HAGEN, LYMAN B., 'The *New Yorker*', in Edward Chielens (ed.), *American Literary Magazines: The Twentieth Century* (Westport, Conn.: Greenwood Press, 1992), 214–20.

HAGIWARA KYŌJIRŌ, *Shikei Senkoku* (Tokyo: Nihon Kindai Bungakukan, 1972).

HAINE, W. SCOTT, *The World of the Paris Café: Sociability Among the French Working-Class, 1789–1914* (London: Johns Hopkins University Press, 1996).

HALLBERG, ROBERT VON, *American Poetry and Culture, 1945–1980* (Cambridge, Mass.: Harvard University Press, 1985).

HALLIWELL, MARTIN, 'Tourists or Exiles? American Modernists in Paris in the 1920s and 1950s', *Nottingham French Studies*, 44/3 (Autumn 2005), 54–68.

——*Transatlantic Modernism: Moral Dilemmas in Modernist Fiction* (Edinburgh: Edinburgh University Press, 2006).

HALPERIN, JOAN UNGERSMA, *Félix Fénéon, Aesthete and Anarchist in Fin-de-Siècle Paris* (New Haven: Yale University Press, 1988).

HAMMILL, FAYE, 'Between the Covers: Modernism, Celebrity and Sophistication in *Vanity Fair*, 1914–1936', in Jonathan Goldman and Aaron Jaffe (eds), *Modernist Star Maps* (Aldershot: Ashgate, forthcoming).

——and LEICK, KAREN, 'Modernism and the Quality Magazines: *Vanity Fair* (1914–36); *American Mercury* (1924–81); *New Yorker* (1925–); *Esquire* (1933–)', in Peter Brooker and Andrew Thacker (eds), *A Critical and Cultural History of Modernist Magazines*, ii (Oxford: Oxford University Press, forthcoming).

HAMPSON, ROBERT, and MONTGOMERY, WILL (eds), *Frank O'Hara Now: New Essays on the New York Poet* (Liverpool: Liverpool University Press, forthcoming).

——and SAUNDERS, MAX (eds), *Ford Madox Ford's Modernity* (Amsterdam: Rodopi, 2003).

HANDESTEN, LARS, *Johannes V. Jensen: Liv og værk* (Copenhagen: Gyldendal, 2000).

HANSCOMBE, GILLIAN, and SMYERS, VIRGINIA L., *Writing for Their Lives: The Modernist Women, 1910–1940* (London: Women's Press, 1987).

HANSEN, MIRIAM BRATU, 'America, Paris, the Alps: Kracauer (and Benjamin) on Cinema and Modernity', in Leo Charney and Vanessa Schwartz (eds), *Cinema and the Invention of Modern Life* (Berkeley: University of California Press, 1995), 36–56.

——'Fallen Women, Rising Stars, New Horizons: Shanghai Silent Film as Vernacular Modernism', *Film Quarterly*, 54/1 (Fall 2000), 10–22.

HARALOVICH, MARY BETH, 'Marlene Dietrich in *Blonde Venus*: Advertising Dietrich in Seven Markets', in Gerd Gemünden and Mary R. Desjardins (eds), *Dietrich Icon* (Durham, NC: Duke University Press), 162–84.

HARDY, THOMAS, *Poems by Thomas Hardy*, ed. Trevor Johnson (London: Folio Society, 1979).

——*The Life and Work of Thomas Hardy*, ed. Michael Millgate (London: Macmillan, 1984).

——*Tess of the D'Urbervilles* (1891), ed. Juliet Grindle and Simon Gatrell (Oxford: Oxford University Press, 2005).

HARNER, JAMES L. (ed.), 'Guides to Manuscripts and Archives', in *MLA Literary Research Guide*, 5th edn (New York: MLA, 2008), 33–42.

HARRIS, JOHN, 'Introduction', in Caradoc Evans, *My People* (Bridgend: Seren, 1987), 7–47.

——'Kate Roberts in Translation', *Planet: The Welsh Internationalist*, 29 (June–July 1991), 21–9.

——'Rhyfel y Tafodau: Ymatebion Eingl-Gymreig Cynnar i Ddiwylliant Llenyddol Cymru', in Geraint Jenkins and Mari A. Williams (eds), *Eu Hiaith a Gadwant: Y Gymraeg yn yr Ugeinfed Ganrif* (Cardiff: University of Wales Press, 2000), 421–44.

HARRIS, JOSÉ, *Public Lives, Public Spirit: A Social History of Britain, 1870–1914* (Oxford: Oxford University Press, 1993).

HARRIS, WILSON, 'History, Fable and Myth in the Caribbean and Guianas', in *Selected Essays of Wilson Harris: The Unfinished Genesis of the Imagination*, ed. A. J. M. Bundy (London: Routledge, 1999), 152–66.

——*Selected Essays of Wilson Harris: The Unfinished Genesis of the Imagination* (London: Routledge, 1999).

——'Tradition and the West Indian Novel', in *Selected Essays of Wilson Harris: The Unfinished Genesis of the Imagination*, ed. A. J. M. Bundy (London: Routledge, 1999), 140–51.

HARRISON, CHARLES, *English Art and Modernism, 1900–1939* (London: Allen Lane; Bloomington: Indiana University Press, 1981).

——'A Kind of Context', in Harrison, *Essays on Art and Language* (Cambridge, Mass.: MIT Press, 2001), 1–28.

——and WOOD, PAUL (eds), *Art in Theory, 1900–1990: An Anthology of Changing Ideas* (Oxford: Blackwell, 1992).

HARRISON, CHARLES YALE, 'Story for Mr. Hemingway', *Modern Monthly*, 8/12 (Feb. 1935), 731–7.

HARTMANN, SADAKICHI, 'A Plea for Straight Photography', *American Amateur Photographer*, 16 (1904), 101–9.

HARVEY, DAVID, *The Condition of Postmodernity* (Oxford: Blackwell, 1990).

——*Paris: Capital of Modernity* (New York: Routledge, 2003).

HARWOOD, LEE, *Collected Poems, 1964–2004* (Exeter: Sheersman, 2004).

HATLEN, BURT, 'A Poetics of Marginality and Resistance: Objectivist Poets in Context', in Rachel Blau DuPlessis and Peter Quartermain (eds), *The Objectivist Nexus: Essays in Cultural Poetics* (Tuscaloosa: University of Alabama Press, 1999), 37–55.

HAZELGROVE, JENNY, *Spiritualism and British Society Between the Wars* (Manchester: Manchester University Press, 2000).

HEALEY, E. CLAIRE, and CUSHMAN, KEITH (eds), *The Letters of D. H. Lawrence & Amy Lowell, 1914–1925* (Santa Barbara, Calif.: Black Sparrow Press, 1985).

HEATH, STEPHEN, *The Nouveau Roman: A Study in the Practice of Writing* (London: Elek, 1972).

——'Writing for Silence: Dorothy Richardson and the Novel', in Susanne Kappeler and Norman Bryson (eds), *Teaching the Text* (London: Routledge & Kegan Paul, 1983), 126–47.

HEGEL, G. W. F., *Enzyklopädie der philosophischen Wissenschaften im Grundrisse*, i: *Die Wissenschaft der Logik* (1817, 1827, 1830; Frankfurt am Main: Suhrkamp, 1970), 187.

——*Phenomenology of Spirit* (1807), trans. A. V. Miller (Oxford: Oxford University Press, 1977).

——*The Encyclopedia Logic: Part One of the Encyclopedia of Philosophical Sciences* (1816), trans. T. F. Geraets, W. A. Suchting, and H. S. Harris (Indianapolis: Hackett, 1991).

——*Introductory Lectures on Aesthetics* (1886), trans. Bernard Bosanquet (Harmondsworth: Penguin, 1993).

——*Lectures on the History of Philosophy*, iii, trans. E. S. Haldane and Frances H. Simson (Lincoln: University of Nebraska Press, 1995).

HEGGLUND, JON, 'Modernism, Africa and the Myth of Continents', in Peter Brooker and Andrew Thacker (eds), *Geographies of Modernism: Literatures, Cultures, Spaces* (London: Routledge, 2005), 43–53.

HEIDEGGER, MARTIN, *Being and Time*, trans. John Macquarrie and Edward Robinson (Oxford: Blackwell, 1962).

——*Poetry, Language, Thought*, trans. Albert Hofstadter (New York: Harper, 1971).

——'The Age of the World Picture', in Heidegger, *The Question Concerning Technology and Other Essays*, trans. William Lovitt (New York: Harper and Row, 1977), 115–54.

——*Nietzsche*, trans. David Farrell Krell, Frank A. Capuzzi, and Joan Stambaugh, 4 vols (San Francisco: Harper and Row, 1979–87).

——*Kant and the Problem of Metaphysics* (1973), trans. Richard Taft (Bloomington: Indiana University Press, 1990).

——*The Fundamental Concepts of Metaphysics: World, Finitude, Solitude*, trans. William McNeill and Nicholas Walker (1983; Bloomington: Indiana University Press, 1995).

HEILBRON, J. L., 'Fin-de-Siècle Physics', in Carl Gustaf Bernhard, Elisabeth Crawford, and Per Sörbom (eds), *Science, Technology and Society in the Time of Alfred Nobel: Nobel Symposium 52* (Oxford: Pergamon, 1982), 51–73.

HEILBRUN, CAROLYN, *Towards a Recognition of Androgyny* (New York: Knopf, 1973).

HEMINGWAY, ERNEST, *Winner Take Nothing* (New York: Scribner, 1933).

——*A Farewell to Arms* (1929; New York: Scribner, 1957).

——*A Moveable Feast* (1964; London: Arrow Books, 2004).

HENDERSON, LINDA DALRYMPLE, *The Fourth Dimension and Non-Euclidean Geometry in Modern Art* (Princeton: Princeton University Press, 1983).

HENDRICKS, GORDON, *Eadweard Muybridge: The Father of the Motion Picture* (London: Secker and Warburg, 1975).

HENRICH, DIETER, 'The Origins of the Theory of the Subject', in Alex Honneth et al. (eds), *Philosophical Interventions in the Unfinished Project of the Enlightenment* (Cambridge, Mass.: MIT Press, 1992), 29–87.

HENRY, MICHEL, *Philosophy and Phenomenology of the Body*, trans. Girard Etzkorn (The Hague: Martinus Nijhoff, 1975).

HERBERT, ROBERT L., *Impressionism: Art, Leisure and Parisian Society* (New Haven: Yale University Press, 1988).

HERF, JEFFERY, *Reactionary Modernism: Technology, Culture and Politics in Weimar and the Third Reich* (Cambridge: Cambridge University Press, 1984).

HERGENAN, L., *New Literary History of Australia* (Melbourne: Penguin, 1988).

HERMANN, ANNE, *Queering the Moderns: Poses/Portraits/Performances* (New York: Palgrave, 2000).

HERSCHEL, J. F. W., 'Instantaneous Photography', *Photographic News*, 4/88 (11 May 1860), 1.

HEWITT, ANDREW, 'Fascist Modernism, Futurism and "Post-Modernity"', in Richard J. Golsan (ed.), *Fascism, Aesthetics, and Culture* (Hanover NH: New England University Press, 1992), 38–55.

HEWITT, NICHOLAS, 'Montmartre: Artistic Revolution', in Sarah Wilson (ed.), *Paris: Capital of the Arts, 1900–1968* (London: Royal Academy of Arts, 2002), 22–38.

HEYMANN, C. DAVID, *Ezra Pound: The Last Rower: A Political Profile* (London: Faber and Faber, 1976).

HIBBERD, DOMINIC, 'The New Poetry, Georgians and Others', in Peter Brooker and Andrew Thacker (eds), *A Critical and Cultural History of Modernist Magazines*, i (Oxford: Oxford University Press, 2009), 176–96.

HIGONNET, PATRICE, *Paris: Capital of the World* (Cambridge, Mass.: Harvard University Press, 2002).

HILL, COLIN, 'The Modern-Realist Movement in English-Canadian Fiction, 1919–1950', Ph.D. diss., McGill University, 2003.

——'As for Me and My Blueprint: Sinclair Ross's Debt to Arthur Stringer', in Dean Irvine (ed.), *The Canadian Modernists Meet* (Ottawa: University of Ottawa Press, 2005), 257–77.

HINSHELWOOD, ROBERT, 'Virginia Woolf and Psychoanalysis', *International Review of Psycho-Analysis*, 17 (1990), 367–71.

HODGSON, JOHN, *Mastering Movement: The Life and Work of Rudolf Laban* (London: Methuen, 2001).

HODSON, MILLICENT, *Nijinsky's Crime Against Grace: Reconstruction Score of the Original Choreography for Le Sacre du printemps* (Stuyvesant, NY: Pendragon Press, 1996).

HOFFMAN, FREDERICK J., ALLEN, CHARLES, and ULRICH, CAROLYN F. (eds), *The Little Magazine: A History and a Bibliography* (Princeton: Princeton University Press, 1947).

HOFMANNSTHAL, HUGO VON, *Ein Brief: Reitergeschichte* (Stuttgart: Ernst Kett Verlag, 1981).

HOLTBY, WINIFRED, *South Riding: An English Landscape* (London: Cassell, 1936).

HONISCH, DIETER, and PRINZ, URSULA (eds), *Tendenzen der Zwanziger Jahre: 15. Europäische Kunstausstellung Berlin*, exh. cat. (Berlin: Dietrich Reimer Verlag, 1977).

HOOPS, REINALD, *Der Einfluß der Psychoanalyse auf die englische Literatur* (Heidelberg: Winters Universitätsbuchhandlung, 1934).

HOPPER, KEITH, *Flann O'Brien: A Portrait of the Artist as a Young Post-Modernist* (Cork: Cork University Press, 1995).

HORAK, JAN-CHRISTOPHER (ed.), *Lovers of Cinema: The First American Film Avant-Garde, 1919–1945* (Madison: University of Wisconsin Press, 1995).

HORNE, ALISTAIR, *The Fall of Paris: The Siege and the Commune, 1870–1871* (New York: St Martin's Press, 1965).

——*Seven Ages of Paris* (London: Macmillan, 2002).

HOUGH, GRAHAM, *Image and Experience: Studies in a Literary Revolution* (London: Duckworth, 1960).

HOVEY, JAIME, *A Thousand Words: Portraiture, Style, and Queer Modernism* (Columbus: Ohio State University, 2006).

HOVEY, RICHARD, 'Modern Symbolism and Maurice Maeterlinck', in *The Plays of Maurice Maeterlinck*, trans. Richard Hovey (New York: Herbert Stone, 1902), 3–11.

HOWARD, JEREMY, *Art Nouveau: International and National Styles in Europe* (Manchester: Manchester University Press, 1996).

HUEFFER, FORD MADOX [FORD MADOX FORD] *The Critical Attitude* (London: Duckworth, 1911).

HUGHES, ROBERT, *The Shock of the New* (London: Thames & Hudson, 1991).

HULLE, DIRK VAN, *Textual Awareness: A Genetic Study of Late Manuscripts by Joyce, Proust, and Mann* (Ann Arbor: University of Michigan Press, 2003).

HULME, T. E., *Speculations: Essays on Humanism and the Philosophy of Art*, ed. Herbert Read (London: Routledge, 1936).

——*The Collected Writings of T. E. Hulme*, ed. Karen Csengeri (Oxford: Clarendon Press, 1994).

——*Selected Writings*, ed. Patrick McGuinness (Manchester: Carcanet, 1998).

HULTEN, PONTUS (ed.), *Futurismo & futurismi* (Milan: Bompiani, 1986).

HUMESKY, ASSYA, *Majakovskij and His Neologisms* (New York: Rausen, 1964).

HUMPÁL, MARTIN, *The Roots of Modernist Narrative: Knut Hamsun's Novels Hunger, Mysteries, and Pan* (Oslo: Solum Forlag, 1998).

Hungarian Fauves from Paris to Nagybánya: 1904–1914, exh. cat. (Budapest: Hungarian National Gallery, 2006).

HUSSERL, EDMUND, *Cartesian Meditations*, trans. Dorion Cairns (1950; The Hague: Martinus Nijhoff, 1960).

——*The Phenomenology of Internal Time-Consciousness* (1928), trans. James S. Churchill (Bloomington: Indiana University Press, 1964).

——*Logical Investigations* (1913), trans. J. N. Findlay (London: Routledge, 1970).

——*Ideas Pertaining to a Pure Phenomenology and to a Phenomenological Philosophy* (1913), trans. F. Kersten (The Hague: Martinus Nijhoff, 1982).

——*On the Phenomenology of the Consciousness of Internal Time (1893–1917)* (1928), trans. John Brough (Dordrecht: Kluwer, 1991).

HUTCHINSON GUEST, ANNE, *Choreographics: A Comparison of Dance Notation Systems from the Fifteenth Century to the Present* (London: Routledge, 1989).

HUXLEY, ALDOUS, 'Poetry and Science', *The Athenaeum*, 4660 (22 Aug. 1919), 783.

——*On the Margin* (London: Chatto & Windus, 1923).

——*Along the Road: Notes and Essays of a Tourist* (London: Chatto & Windus, 1925).

——*Complete Essays*, i: *1920–1925*, ed. Robert S. Baker and James Sexton (Chicago: Ivan R. Dee, 2000).

HUYSSEN, ANDREAS, *After the Great Divide: Modernism, Mass Culture, Postmodernism* (London: Macmillan, 1999).

——*Present Pasts: Urban Palimpsests and the Politics of Memory* (Stanford, Calif.: Stanford University Press, 2003).

——'Geographies of Modernism in a Globalizing World', in Peter Brooker and Andrew Thacker (eds), *Geographies of Modernism: Literatures, Cultures, Spaces* (London: Taylor & Francis, 2005), 6–18.

HYNES, SAMUEL, *The Auden Generation: Literature and Politics in England in the 1930s* (London: Pimlico, 1992).

ILNYTZKYJ, OLEH S., *Ukrainian Futurism, 1914–1930: A Historical and Critical Study* (Cambridge, Mass.: Harvard University Press, 1997).

IRELE, F. ABIOLA, *The African Experience in Literature and Ideology* (London: Heinemann, 1981).

——'The Harlem Renaissance and the Negritude Movement', in F. Abiola Irele and Simon Gikandi (eds), *The Cambridge History of African and Caribbean Literature*, ii (Cambridge: Cambridge University Press, 2004), 759–84.

ISHERWOOD, CHRISTOPHER, *Christopher and His Kind* (New York: Farrar, Straus, Giroux, 1976).

—— *The World in the Evening* (1954; New York: Farrar, Straus, Giroux, 1988).

ISMOND, PATRICIA, 'Walcott versus Brathwaite', *Caribbean Quarterly*, 17/3–4 (Sept.–Dec. 1971), 54–71.

IVERSEN, MARGARET, *Beyond Pleasure: Freud, Lacan, Barthes* (Pittsburgh: Pennsylvania State University Press, 2007).

JACOBSEN, ROLF, *Jord og jern* (Oslo: Gyldendal Norsk Forlag, 1933).

JAFFE, AARON, *Modernism and the Culture of Celebrity* (Cambridge: Cambridge University Press, 2005).

JAMES, HENRY, *The Art of the Novel: Critical Prefaces*, ed. Richard P. Blackmur (New York: Scribner, 1934).

—— *The Wings of the Dove* (1902), ed. Peter Brooks (Oxford: Oxford University Press, 1984).

—— *The Complete Notebooks of Henry James*, ed. Leon Edel and Lyall Powers (Oxford: Oxford University Press, 1987).

—— *The Ambassadors* (1903), ed. Christopher Butler (Oxford: Oxford University Press, 1998).

JAMES, WILLIAM, 'Does "Consciousness" Exist?', *Journal of Philosophy, Psychology, and Scientific Methods*, 1 (1904), 477–91.

—— *Essays in Radical Empiricism and a Pluralistic Universe* (1912; New York: Longmans, Green, 1943).

—— *The Principles of Psychology*, 2 vols (1890; New York: Dover, 1950).

—— *Varieties of Religious Experience* (1902; Harmondsworth: Penguin, 1982).

JAMESON, FREDRIC, *Marxism and Form* (Princeton: Princeton University Press, 1971).

—— *The Political Unconscious: Narrative as a Socially Symbolic Act* (Ithaca, NY: Cornell University Press, 1981).

—— 'Third World Literature in the Era of Multinational Capital', *Social Text*, 15 (Fall 1986), 65–88.

—— *Late Marxism: Adorno, or, The Persistence of Dialectic* (London: Verso, 1990).

—— *Postmodernism, or, The Cultural Logic of Late Capitalism* (Durham, NC: Duke University Press, 1992).

—— *Signatures of the Visible* (London: Routledge, 1992).

—— *A Singular Modernity: Essay on the Ontology of the Present* (London: Verso, 2002).

JANACEK, GERALD, *The Look of Russian Literature: Avant-Garde Visual Experiments, 1900–1930* (Princeton: Princeton University Press, 1984).

—— *Zaum': The Transrational Poetry of Russian Futurism* (San Diego: San Diego University Press, 1996).

—— and OMUKA, TOSHIHARU (eds), *The Eastern Dada Orbit: Russia, Georgia, Ukraine, Central Europe and Japan* (New York: G. K. Hall; London: Prentice Hall International, 1998).

JANATKOVÁ, ALENA, *Barockrezeption zwischen Historismus und Moderne: Die Architekturdiskussion in Prag, 1890–1914* (Zurich: gta Verlag; Berlin: Mann Verlag, 2000).

JANGFELDT, BENGT, *Majakovskij and Futurism, 1917–1921* (Stockholm: Almqvist & Wiksell, 1976).

JANIS, MICHAEL, *Africa After Modernism: Transitions in Literature, Media and Philosophy* (London: Routledge, 2008).

JANSEN, M. (ed.), *The Socialist-Revolutionary Party After October 1917: Documents from the P.S.-R. Archives* (Amsterdam: Stichting Beheer IISG, 1989).

JANSSON, MATS, 'Swedish Modernism', in Astradur Eysteinsson and Vivian Liska (eds), *Modernism*, 2 vols (Amsterdam: John Benjamins, 2007), 837–45.

JÄRVINEN, HANNA, *The Myth of Genius in Movement: Historical Deconstruction of the Nijinsky Legend* (Turku: Turun Yliopisto, 2003).

——'Some Steps Towards a Historical Epistemology of Corporeality', in *Proceedings of the 30th Annual Conference of the Society for Dance History Scholars*, Paris, 21–4 June 2007, 145–8.

——'Stillness and Modernity in Nijinsky's *Jeux*', *Discourses in Dance*, 5/1–2 (forthcoming).

JAY, KARLA, 'Lesbian Modernism: (Trans)Forming the (C)Anon', in George F. Haggerty and Bonnie Zimmerman (eds), *Professions of Desire: Lesbian and Gay Studies in Literature* (New York: Modern Language Association of America, 1995), 72–83.

JAY, MARTIN, *Downcast Eyes: The Denigration of Vision in Twentieth-Century French Thought* (Berkeley: University of California Press, 1994).

JEFFREY, WILLIAM, 'Is a Renaissance Taking Place?', *Glasgow Bulletin* (17 Jan. 1921), 6.

JEKYLL, WALTER (ed.), *Jamaican Song and Story: Annancy Stories, Digging Sings, Ring Tunes, and Dancing Tunes* (London: D. Nutt, 1907).

JELAVICH, PETER, *Berlin Alexanderplatz: Radio, Film, and the Death of Weimar Culture* (Berkeley: University of California Press, 2006).

JENCKS, CHARLES, *The Language of Postmodern Architecture* (New York: Rizzoli, 1977).

——*The New Moderns: From Late to Neo-Modernism* (New York: Rizzoli, 1990).

JENKINS, GERAINT, and WILLIAMS, MARI A. (eds), *Eu Hiaith a Gadwant: Y Gymraeg yn yr Ugeinfed Ganrif* (Cardiff: University of Wales Press, 2000).

JENKINS, LEE M., *The Language of Caribbean Poetry: Boundaries of Expression* (Gainesville: University of Florida Press, 2004).

JENKINS, REESE V., *Images and Enterprise: Technology and the American Photographic Industry, 1839 to 1925* (Baltimore: Johns Hopkins University Press, 1975).

JENSEN, JOHANNES V., *Aarbog 1916* (Christiania, Copenhagen: Gyldendalske Boghandel, 1916).

——*Den gotiske Renaissance* (Copenhagen: Samlerens Bogklub, Gyldendal, 2000).

——*Samlede Digte*, i (Copenhagen: Gyldendal, 2006).

JENSEN, KJELD BJØRNAGER, *Russian Futurism, Urbanism and Elena Guro* (Aarhus: Arkona, 1977).

JENSEN, LINE, JENSEN, ERIK VAGN, MOGENSEN, KNUD, and TAYLOR, ALEXANDER D. (eds), *Contemporary Danish Poetry: An Anthology* (Copenhagen: Twayne, 1977).

JERVIS, JOHN, *Exploring the Modern: Patterns of Western Culture and Civilization* (Oxford: Blackwell, 1998).

JESSUP, LYNDA, 'Antimodernism and Artistic Experience: An Introduction', in Jessup (ed.), *Antimodernism and Artistic Experience: Policing the Boundaries of Modernity* (Toronto: University of Toronto Press, 2001), 3–9.

JEVTOVIĆ, JEVTA (ed.), *Zenit u avangarda 20ih godina—Zenit and the Avant-Garde of the Twenties*, exh. cat. (Beograd: Norodni muzej, 1983).

J.G.T. [JAMES THURBER], 'More Authors Cover the Snyder Trial', *New Yorker*, 3/12 (7 May 1927), 69.

JOHNSON, BARBARA, *Défigurations du langage poétique* (Paris: Flammarion, 1979).

——'The Liberation of Verse', in Denis Hollier with Howard Bloch et al. (eds), *A New History of French Literature* (Cambridge, Mass.: Harvard University Press, 1989), 798–801.

JOHNSON, GEORGE M., *Dynamic Psychology in Modernist British Fiction* (Basingstoke: Palgrave, 2005).

JOHNSON, JAMES WELDON, *The Book of American Negro Poetry* (New York: Harcourt Brace Jovanovich, 1959).

——*Along This Way: The Autobiography of James Weldon Johnson* (1933; New York: Penguin, 1990).

JOHNSON, JAMES WELDON, 'Harlem: The Culture Capital', in Alain Locke (ed.), *The New Negro: An Interpretation* (New York: Touchstone, 1997), 301–11.

——*Negro Poetry* (1922; New York: Harcourt Brace Jovanovich, 1959).

JOHNSON, R. BRIMLEY, *Some Contemporary Novelists: Women* (London: Leonard Parsons, 1920).

JOHNSTON, DAFYDD, 'Dwy Lenyddiaeth Cymru yn y Tridegau', in John Rowlands (ed.), *Sglefrio ar Eiriau* (Llandysul: Gomer, 1992), 42–62.

——'Moderniaeth a Thraddodiad', *Taliesin*, 80 (Jan.–Feb. 1993), 13–24.

JONES, ALUN R., and THOMAS, GWYN (eds), *Presenting Saunders Lewis* (Cardiff: University of Wales Press, 1973).

JONES, CAROLINE A., *Eyesight Alone: Clement Greenberg's Modernism and the Bureaucratization of the Senses* (Chicago: University of Chicago Press, 2005).

JONES, COLIN, *Paris: Biography of a City* (London: Allen Lane, 2004).

JONES, D. GWENALLT, *Cerddi Gwenallt: Y Casgliad Cyflawn*, ed. Christine James (Llandysul: Gomer, 2001).

——'Credaf', in *Gwenallt: Bardd Crefyddol*, ed. J. E. Meredith (Llandysul: Gwasg Gomer, 1974), 56–75.

——*Plasau'r Brenin* (Llandysul: Gomer, 1976).

JONES, DAFYDD GLYN, 'His Politics', in Alun R. Jones and Gwyn Thomas (eds), *Presenting Saunders Lewis* (Cardiff: University of Wales Press, 1973), 23–78.

JONES, DAVID, *The Anathemata* (London: Faber, 1952).

JONES, JACK, *Rhondda Roundabout* (London: Faber and Faber, 1934).

JONES, LEWIS, *Cwmardy* (London: Lawrence & Wishart, 1937).

JONES, PETER (ed.), *Imagist Poetry* (London: Penguin, 1972).

JONES, R. MERFYN, 'Beyond Identity? The Reconstruction of the Welsh', *Journal of British Studies*, 31/4 (Oct. 1992), 330–57.

JONES, RICHARD WYN, *Rhoi Cymru'n Gyntaf: Syniadaeth Plaid Cymru* (Cardiff: University of Wales Press, 2007).

JONES, ROBERT OWEN, *Hir Oes i'r Iaith: Agweddau ar Hanes y Gymraeg a'r Gymdeithas* (Llandysul: Gomer, 1997).

JONSON, BEN, *Ben Jonson*, ed. Ian Donaldson, Oxford Authors (Oxford: Oxford University Press, 1985).

JORDAN, STEPHANIE, *Stravinsky Dances: Re-Visions Across a Century* (Alton: Dance Books, 2007).

JOSEPHSON, MATTHEW, *Life Among the Surrealists: A Memoir* (New York: Holt, 1962).

JOYCE, JAMES, *The Letters of James Joyce*, ed. Richard Ellmann, 3 vols (London: Faber and Faber, 1962–6).

——*The Critical Writings*, ed. Ellsworth Mason and Richard Ellmann (New York: Viking Press, 1968).

——*Finnegans Wake* (1939; London: Faber and Faber, 1975).

——*Ulysses* (1922; London: Penguin, 1992).

——'The Day of the Rabblement', in Kevin Barry (ed.), *Occasional, Critical and Political Writing* (Oxford: Oxford University Press, 2000), 50–2.

——*Dubliners* (1914), ed. Jeri Johnson (Oxford: Oxford University Press, 2008).

JULIEN, ADOLPHE, 'Revue musicale', *Journal des Débats* (8 June 1913), 1–2.

JULIUS, ANTHONY, *T. S. Eliot, Anti-Semitism, and Literary Form* (Cambridge: Cambridge University Press, 1995).

JUNG, CARL, 'Wotan', in *Civilization in Transition, The Collected Works of C. G. Jung*, x, trans. Gerhard Adler and R. F. C. Hall (London: Routledge & Kegan Paul, 1970), 179–93.

——'*Ulysses*: A Monologue', in *The Spirit in Man, Art, and Literature*, *The Collected Works of C. G. Jung*, xv, trans. Gerhard Adler and R. F. C. Hull (London: Routledge & Kegan Paul, 1971), 109–34.

KAES, ANTON, '*The Cabinet of Dr Caligari*: Expressionism and Cinema', in Ted Perry (ed.), *Masterpieces of Modern Cinema* (Bloomington: Indiana University Press, 2006), 41–59.

——JAY, MARTIN, and DIMENDBERG, EDWARD (eds), *The Weimar Republic Sourcebook* (Berkeley: University of California Press, 1994).

KAFKA, FRANZ, *Hochzeitsvorbereitungen auf dem Lande* (1907–8; Frankfurt: Fischer, 1991).

——*The Castle* (1926), trans. Edwin and Willa Muir, in Kafka, *The Complete Novels* (New York: Vintage, 1999).

KAIWAR, VASANT, and MAZUMDAR, SUCHETA (eds), *Antinomies of Modernity: Essays on Race, Orient, Nation* (Durham, NC: Duke University Press, 2003).

KALAIDJIAN, WALTER (ed.), *The Cambridge Companion to American Modernism* (Cambridge: Cambridge University Press, 2005).

KALIA, RAVI S., *Bhubaneswar: From Temple Town to Capital City* (Delhi: Oxford University Press, 1994).

——*Gandhinagar: Building National Identity in Postcolonial India* (Columbia: University of South Carolina Press, 2004).

KALLINEY, PETER, 'Metropolitan Modernism and its West Indian Interlocutors: 1950s London and the Emergence of Postcolonial Literature', *PMLA* 122/1 (Jan. 2007), 89–104.

KALNINS, MARA, 'Introduction', in D. H. Lawrence, *Sea and Sardinia*, ed. Mara Kalnins (Cambridge: Cambridge University Press, 1997), pp. xvii–xli.

KANAGAWA KENRITSU KINDAI BIJUTSUKAN (eds), *Jidai to Bijutsu no Tamentai: Kindai no Seiritsu ni Hikari o Atete* (Kamakura: Kanagawa Kenritsu Kindai Bijutsukan, 2007).

KANDINSKY, WASSILY, and MARC, FRANZ (eds), *The Blaue Reiter Almanac* (1914), Documentary Edition, ed. and introd. Klaus Lankheit, trans. Henning Falkenstein with the assistance of Manug Terzian and Gertrude Hinderlie (London: Tate, 2006).

KANT, IMMANUEL, *The Critique of Judgement* (1790), trans. James Creed Meredith (Oxford: Clarendon Press, 1969).

——*Critique of Practical Reason* (1788), trans. Mary Gregor (Cambridge: Cambridge University Press, 1997).

——*Critique of Pure Reason* (1781), trans. Paul Guyer and Allen W. Wood (Cambridge: Cambridge University Press, 1997).

——*Critique of the Power of Judgment* (1790), trans. Paul Guyer and Eric Matthews (Cambridge: Cambridge University Press, 2000).

KAPLAN, ALICE, *The Collaborator: The Trial and Execution of Robert Brasillach* (Chicago: University of Chicago Press, 2000).

KAPUR, GEETA, *When Was Modernism? Essays on Contemporary Cultural Practice in India* (New Delhi: Tulika Books, 2000).

KASSÁK, LAJOS, *Kassák: 1887–1967, Arion 16: Nemzetközi Költői Almanach—Almanach International de Poésie* (Budapest: Corvina, 1988).

KAYMAN, MARTIN, *The Modernism of Ezra Pound* (London: Macmillan, 1986).

KAZIN, ALFRED, *On Native Grounds: An Interpretation of Modern American Prose Literature* (New York: Reynal and Hitchcock, 1942).

KEATING, PETER, *The Haunted Study: A Social History of the English Novel, 1875–1914* (London: Fontana, 1991).

KELLER, JAMES R., '"A Chafing Savage, Down the Decent Street": The Politics of Compromise in Claude McKay's Protest Sonnets', *African American Review*, 28/3 (1994), 447–56.

KENNEDY, LEO, 'The Future of Canadian Literature', *Canadian Mercury*, 5–6 (Dec. 1928), 99–100.

KENNER, HUGH, *The Invisible Poet: T. S. Eliot* (London: Methuen, 1966).

—— *The Pound Era* (London: Faber and Faber, 1975).

—— *The Mechanic Muse* (New York: Oxford University Press, 1987).

KER, DAVID I., *The African Novel and the Modernist Tradition* (New York: Peter Lang, 1997).

KERMODE, FRANK, 'With Slip and Slapdash', Review of *The Complete Works of W. H. Auden*, iii: *Prose, 1949–55*, ed. Edward Mendelson (Princeton: Princeton University Press, 2007), *London Review of Books* (7 Feb. 2008), 19–20.

KERN, STEPHEN, *The Culture of Time and Space, 1880–1918* (Cambridge, Mass.: Harvard University Press, 2003).

KEYNES, JOHN MAYNARD, *A Treatise on Money*, 2 vols (London: Macmillan, 1930).

—— *The Economic Consequences of the Peace* (Harmondsworth: Penguin, 1995).

KHLEBNIKOV, VELIMIR, *Zverinets* (Moscow, 1930).

—— 'The Radio of the Future', in Khlebnikov, *The King of Time: Selected Writings of the Russian Futurian*, ed. Charlotte Douglas, trans. Paul Schmidt (Cambridge, Mass.: Harvard University Press, 1985), 155–9.

—— 'Zangezi', in Khlebnikov, *Collected Works*, ii, ed. Charlotte Douglas and Ronald Vroon, trans. Paul Schmidt and Ronald Vroon (Cambridge, Mass.: Harvard University Press, 1989), 331–74.

—— 'Na priezd Marinetti v Rossiiu', in E. Arenzon (ed.), *Sobranie sochinenii v shesti tomakh*, vi/1 (Moscow: Nasledie, 2000), 345.

KIBERD, DECLAN, *Synge and the Irish Language* (London: Macmillan, 1979).

—— *Irish Classics* (London: Granta, 2000).

—— *The Irish Writer and the World* (Cambridge: Cambridge University Press, 2005).

KING, JOHN, *Sur: A Study of the Argentine Literary Journal and its Role in the Development of a Culture, 1931–1970* (Cambridge: Cambridge University Press, 1986).

KIRBY, LYNNE, *Parallel Tracks: The Railroad and Silent Cinema* (Exeter: University of Exeter Press, 1997).

KIRBY, MICHAEL, *Futurist Performance* (New York: Dutton, 1971).

KIRKEGAARD, PETER, *Knut Hamsun som modernist* (Copenhagen: Medusa, 1975).

KISIEL, THEODORE, *The Genesis of Heidegger's Being and Time* (Berkeley: University of California Press, 1993).

KITTANG, ATLE, *Luft, vind, ingenting: Hamsuns desillisjonsromaner frå Sult til Ringen sluttet* (Oslo: Gyldendal Norsk Forlag, 1984).

K.J., 'Art at Macy's—Dime Novel', *New Yorker*, 3/12 (7 May 1927), 63–6.

KLAUS, H. GUSTAV, 'Socialist Fiction in the 1930s: Some Preliminary Observations', in John Lucas (ed.), *The 1930s: A Challenge to Orthodoxy* (Hassocks: Harvester, 1978), 13–41.

KLEIN, MARCUS, *Foreigners: The Making of American Literature, 1900–1940* (Chicago: University of Chicago Press, 1981).

KLEINERT, SYLVIA, and NEALE, MARGO (eds), *The Oxford Companion to Aboriginal Art and Culture* (Melbourne: Oxford University Press, 2000).

KNAPP, JAMES A., '"Ocular Proof": Archival Revelations and Aesthetic Response', *Poetics Today: Between Thing and Theory, or, The Reflective Turn*, 24/4 (Winter 2003), 695–727.

KNIGHT, STEPHEN, *A Hundred Years of Fiction* (Cardiff: University of Wales Press, 2003).

KOCKELMANS, JOSEPH, 'Husserl and Kant on the Pure Ego', in Frederick Elliston and Peter McCormick (eds), *Husserl: Expositions and Appraisals* (Notre Dame, Ind.: University of Notre Dame Press, 1977), 269–85.

KOLOCOTRONI, VASSILIKI, GOLDMAN, JANE, and TAXIDOU, OLGA (eds), *Modernism: An Anthology of Sources and Documents* (Edinburgh: Edinburgh University Press, 1998).

KORITZ, AMY, *Gendering Bodies/Performing Art: Dance and Literature in Early Twentieth-Century British Culture* (Ann Arbor: University of Michigan Press, 1995).

KOSELLECK, REINHARD, *Futures Past: On the Semantics of Historical Time*, trans. Keith Tribe (Cambridge, Mass.: MIT Press, 1985).

—— *The Practice of Conceptual History: Timing History, Spacing Concepts*, trans. Todd Samuel Presner et al. (Stanford, Calif.: Stanford University Press, 2002).

KOVÁCS, ANDRÁS BÁLINT, *Screening Modernism: European Art Cinema, 1950–1980* (Chicago: University of Chicago Press, 2007).

KRACAUER, SIEGFRIED, *History: The Last Things Before the Last* (New York: Oxford University Press, 1969).

—— *The Mass Ornament: Weimar Essays*, ed. and trans. Thomas Y. Levin (Cambridge, Mass.: Harvard University Press, 1995).

—— *Theory of Film: The Redemption of Physical Reality*, ed. M. Bratu Hansen (Princeton: Princeton University Press, 1997).

KRAMRISCH, STELLA, 'Sunayani Devi', *Der Cicerone, Halbmonatsschrift für Künstler, Kunstfreude und Sammler*, 17 (1925), 1: 87–93.

KREILKAMP, IVAN, 'A Voice Without a Body: The Phonographic Logic of *Heart of Darkness*', *Victorian Studies*, 40/2 (1997), 211–44.

KREISEL, HENRY, 'Diary of an Internment', in Shirley Neuman (ed.), *Another Country: Writings By and About Henry Kreisel* (Edmonton: NeWest, 1985), 18–44.

KREYMBORG, ALFRED, *Troubadour: An Autobiography* (New York: Sagamore Press, 1957).

KROETSCH, ROBERT, 'A Canadian Issue', *Boundary 2*, 3/1 (Autumn 1974), 1–2.

KRONFELD, CHANA, *On the Margins of Modernism* (Berkeley: University of California Press, 1996).

KRUCHENYKH, ALEKSEI, 'Victory Over the Sun', trans. Ewa Bartos and Victoria Nes Kirby, *Drama Review*, 15 (1971), 106–24.

—— "O Khlebnikove i drvgikh', in V. V. Khlebnikov, Zverinets (Moskow, 1930), pp 13–4.

KUMAR, SHIV, 'Dorothy Richardson and the Dilemma of "Being versus Becoming"', *Modern Language Notes*, 74 (June 1959), 494–501.

KUNITZ, STANLEY (ed.), *Authors Today and Yesterday* (New York: XX, 1953).

KUNKEL, THOMAS, *Genius in Disguise: Harold Ross of the* New Yorker (New York: Carroll & Graf, 1995).

KUTTNER, A. B., '*Sons and Lovers*: A Freudian Appreciation', *Psychoanalytic Review*, 3 (1916), 295–317.

LABAN, RUDOLF VON, *Die Welt des Tanzers* (Stuttgart: Walter Sieffert, 1920).

LADENSON, ELISABETH, *Dirt for Art's Sake: Books on Trial from Madam Bovary to Lolita* (Ithaca, NY: Cornell University Press, 2007).

LAGERKVIST, PÄR, *Dikter* (Stockholm: Albert Bonniers Förlag, 1942).

LAMARRE, THOMAS, *Shadows on the Screen: Tanizaki Jun'ichirō on Cinema and 'Oriental' Aesthetics* (Ann Arbor: Center for Japanese Studies, University of Michigan, 2005).

LAMMING, GEORGE, 'The Negro Writer and His World', *Caribbean Quarterly*, 5/2 (Feb. 1958), 109–15.

—— *In the Castle of My Skin* (1953; Harlow: Longman, 1986).

—— *The Pleasures of Exile* (1960; Ann Arbor: University of Michigan Press, 1992).

LAMOS, COLLEEN, 'Queer Conjunctions in Modernism', in Bonnie Kime Scott (ed.), *Gender in Modernism: New Geographies, Complex Intersections* (Urbana: University of Illinois Press, 2007), 336–43.

LANDIS, LINDA, 'Futurists at War', in Anne Coffin Hanson (ed.), *The Futurist Imagination: Word + Image in Futurist Paintings, Drawings, Collage and Free-Word Poetry* (New Haven: Yale University Art Gallery, 1983), 60–75.

LANG, JON, DESAI, MADHAVI, and DESAI, MIKI, *Architecture and Independence: The Search for Identity—India 1880 to 1980* (Delhi: Oxford University Press, 1997).

LAPLANCHE, JEAN, 'Note on Afterwardness', in John Fletcher (ed.), *Essays on Otherness* (London: Routledge, 1999), 260–5.

LARSEN, FINN STEIN, *Dansk lyrik, 1915–55* (Copenhagen: Gyldendal, 1979).

LARSEN, PETER STEIN, *Modernistiske outsidere* (Odense: Odense Universitetsforlag, 1998).

LARSON, CHARLES, *The Emergence of African Fiction* (Bloomington: Indiana University Press, 1972).

LASSERRE, PIERRE, *Le Romantisme français: Essai sur la révolution dans les sentiments et dans les idées au XIX siècle* (Paris: Garnier Frères, 1919).

LATHAM, SEAN, 'Hating Joyce Properly', *Journal of Modern Literature*, 26/1 (Fall 2002), 119–31.

——'New Age Scholarship: The Work of Criticism in the Age of Digital Reproduction', *New Literary History*, 35/3 (Summer 2004), 411–26.

LATOUR, BRUNO, *Reassembling the Social: An Introduction to Actor-Network Theory* (Oxford: Oxford University Press, 2005).

ŁAWNICZAKOWA, AGNIESZKA, *Fin de Siècle in Polen: Poolse schilderkunst, 1890–1918, uit de collectie van het National Museum Poznań* (Zwolle: Waanders, 1996).

LAWRENCE, D. H., *Mornings in Mexico* (London: Martin Secker, 1927).

——*Sea and Sardinia* (1921; Harmondsworth: Penguin, 1944; London: Heinemann, 1950).

——'Nottingham and the Mining Country', in Lawrence, *Selected Essays* (London: Penguin, 1950), 114–22.

——*The Quest for Rananim: D. H. Lawrence's Letters to S. S. Koteliansky, 1914–1930*, ed. George J. Zytaruk (Montreal: McGill-Queen's University Press, 1970).

——*The Complete Poems of D. H. Lawrence*, ed. Vivian de Sola Pinto and Warren Roberts (Harmondsworth: Penguin, 1977).

——*Sons and Lovers* (1913; London: Heinemann, 1974).

——*Fantasia of the Unconscious and Psychoanalysis and the Unconscious* (1922; Harmondsworth: Penguin, 1975).

——*The Letters of D. H. Lawrence*, ed. James T. Boulton, 8 vols (Cambridge: Cambridge University Press, 1979–2000).

——*The Plumed Serpent* (1926), ed. L. D. Clark (Cambridge: Cambridge University Press, 1987).

——*Women in Love* (1920), ed. David Farmer, John Worthen, and Lindeth Vasey (Cambridge: Cambridge University Press, 1987).

——*The Rainbow* (1915), ed. Mark Kinkead-Weekes (Cambridge: Cambridge University Press, 1989).

——*Sketches of Etruscan Places and Other Italian Essays* (1932), ed. Simonetta de Filippis (Cambridge: Cambridge University Press, 1992).

——*Lady Chatterley's Lover* (1928; London: Penguin, 1994).

——*Study of Thomas Hardy and Other Essays*, ed. Bruce Steele (Cambridge: Cambridge University Press, 2002).

LAWRENCE, T. E., *Seven Pillars of Wisdom* (New York: Doubleday, 1935).

LAWTON, ANNA, 'Russian and Italian Futurist Manifestoes', *Slavic and East European Journal*, 20/4 (Winter 1976), 405–20.

——*Vadim Shershenevich: From Futurism to Imaginism* (Ann Arbor: Ardis, 1981).

——(ed.), *Russian Futurism Through its Manifestoes, 1912–1928* (Ithaca, NY: Cornell University Press, 1988).

LE BON, LAURENT (ed.), *Dada* (Paris: Éditions du Centre Pompidou, 2005).

LE CORBUSIER [CHARLES ÉDOUARD JEANNERET-GRIS], *Vers une Architecture* (Paris: G. Cres, 1923).

LEE, HERMIONE, *Virginia Woolf* (New York: Vintage, 1999).

LEE OU-FAN, *Shanghai Modern: The Flowering of a New Urban Culture in China, 1930–1945* (Cambridge, Mass.: Harvard University Press, 1999).

LEE, VERNON, *The Spirit of Rome* (London: Bodley Head, 1906).

LEED, ERIC, *No Man's Land: Combat and Identity in World War One* (Cambridge: Cambridge University Press, 1979).

LEE MORGAN, ANN, and NAYLOR, COLIN (eds), *Contemporary Architects* (Chicago: St James Press, 1987).

LEFEBVRE, HENRI, *Writings on Cities* (Oxford: Blackwell, 1999).

LÉGER, FERNAND, *Functions of Painting*, trans. Alexandra Anderson (New York: Viking Press, 1973).

LEICK, KAREN, 'Popular Modernism: Little Magazines and the American Daily Press', *PMLA* 123/1 (Jan. 2008), 125–55.

LeMAHIEU, D. L., *A Culture for Democracy: Mass Communication and the Cultivated Mind in Britain Between the Wars* (Oxford: Clarendon Press, 1988).

LEMAÎTRE, HENRI, *La Poésie depuis Baudelaire* (Paris: Armand Colin, 1975).

LEPPMANN, WOLFGANG, *Rilke: A Life* (New York: Fromm International, 1984).

LERNOUT, G., and VAN MIERLO, W. (eds.), *The Reception of James Joyce in Europe*, i (London: Thoemmes Continuum, 2004).

LEVENSON, MICHAEL, *A Geneaology of Modernism: A Study of English Literary Doctrine 1908–22* (Cambridge: Cambridge University Press, 1984).

——(ed.), *The Cambridge Companion to Modernism* (Cambridge: Cambridge University Press, 1999).

LEVINGER, ESTHER, 'Czech Avant-Garde Art: Poetry for the Five Senses', *Art Bulletin*, 81/3 (Sept. 1999), 513–32.

LEVITZ, TAMARA, 'In the Footsteps of Euridice: Gluck's *Orpheus und Euridice* in Hellerau, 1913', *Echo*, 3/2 (2002), <http://www.echo.ucla.edu>.

LEVY, PAUL, *G. E. Moore and the Cambridge Apostles* (Oxford: Oxford University Press, 1979).

LEWIS, DAVID LEVERING, *W. E. B. DuBois: Biography of a Race* (New York: Henry Holt, 1993).

—— *When Harlem Was in Vogue* (New York: Penguin, 1997).

LEWIS, PERICLES, *The Cambridge Introduction to Modernism* (Cambridge: Cambridge University Press, 2007).

LEWIS, SAUNDERS, 'Cyflwyniad i Molière', in Lewis, *Doctor Er Ei Waethaf* (Wrexham: Cyfres y Werin, 1924), 6–8.

—— *Is There an Anglo-Welsh Literature?* (Cardiff: Urdd Graddedigion Prifysgol Cymru, 1939).

——(trans.), *Wrth Aros Godot/En Attendant Godot* (Cardiff: University of Wales Press, 1970).

—— *The Plays of Saunders Lewis*, i, trans. Joseph P. Clancy (Llandybie: Christopher Davies, 1985).

—— *Cerddi*, ed. R. Geraint Gruffydd (Cardiff: University of Wales Press, 1992).

—— *Letters to Margaret Gilcriest*, ed. Mair Saunders Jones, Ned Thomas, and Harri Pritchard Jones (Cardiff: University of Wales Press, 1993).

—— *Dramâu Saunders Lewis*, ed. Ioan Williams (Cardiff: University of Wales Press, 1996).

Lewis, Saunders, and Roberts, Kate, *Annwyl Kate, Annwyl Saunders*, ed. Dafydd Ifans (Aberystwyth: National Library of Wales, 1992).

Lewis, Wyndham, 'A Later Arm Than Barbarity', *Outlook*, 5 (Sept. 1914), 294–300.

—— *Hitler* (London: Chatto & Windus, 1931).

—— *Filibusters in Barbary* (London: Grayson and Grayson, 1932).

—— *Left Wings Over Europe, or, How to Make a War About Nothing* (London: Jonathan Cape, 1936).

—— ' "Left Wings" and the C3 Mind', *British Union Quarterly*, 1/1 (Jan.–Apr. 1937), 22–34.

—— *The Hitler Cult* (London: Dent, 1939).

—— *Anglosaxony: A League That Works* (Toronto: Ryerson, 1941).

—— *America and Cosmic Man* (New York: Doubleday, 1949).

—— *The Letters of Wyndham Lewis*, ed. W. K. Rose (London: Methuen, 1963).

—— *Wyndham Lewis on Art: Collected Writings 1913–1956*, ed. Walter Michel and C. J. Fox (New York: Funk & Wagnalls, 1969).

—— *Blasting and Bombardiering* (1937; London: John Calder, 1982).

—— *Rude Assignment: An Intellectual Autobiography* (1950), ed. Toby Foshay (Santa Barbara, Calif.: Black Sparrow Press, 1984).

—— *Snooty Baronet* (1932), ed. Bernard Lafourcade (Santa Barbara, Calif.: Black Sparrow Press, 1984).

—— *The Caliph's Design: Architects! Where Is Your Vortex?* (1919), ed. Paul Edwards (Santa Barbara, Calif.: Black Sparrow Press, 1986).

—— *The Art of Being Ruled* (1926), ed. Reed Way Dasenbrock (Santa Rosa, Calif.: Black Sparrow Press, 1989).

—— *Creatures of Habit and Creatures of Change: Essays on Art, Literature and Society*, ed. Paul Edwards (Santa Rosa, Calif.: Black Sparrow Press, 1989).

—— *Tarr: The 1918 Version* (1918), ed. Paul O'Keeffe (Santa Rosa, Calif.: Black Sparrow Press, 1990).

—— *Time and Western Man* (1927), ed. Paul Edwards (Santa Rosa, Calif.: Black Sparrow Press, 1993).

—— (ed.) *Blast: Review of the Great English Vortex*, 1 (1914; Santa Rosa, Calif.: Black Sparrow Press, 2002).

—— *The Lion and the Fox* (1927; New York: Harper and Brothers, n.d.).

Lima, Jose Lezama, *Paradiso*, trans. Gregory Rabassa (Austin: University of Texas Press, 1988).

Lindberg, Kathryne V., *Reading Pound Reading: Modernism After Nietzsche* (New York: Oxford University Press, 1987).

Lindfors, Bernth (ed.), *Critical Perspective on Amos Tutuola* (Washington, DC: Three Continents Press, 1975).

Linebaugh, Peter, and Rediker, Marcus Buford, *The Many-Headed Hydra: Sailors, Slaves, Commoners, and the Hidden History of the Revolutionary Atlantic* (Boston: Beacon Press, 2000).

Lippard, Lucy (ed.), *Dadas on Art* (Upper Saddle River, NJ: Prentice Hall, 1971).

Lippit, Seiji M., *Topographies of Japanese Modernism* (New York: Columbia University Press, 2002).

Lissitzky, El, *Russia: An Architecture for World Revolution*, trans. Eric Dluhosch (London: Lund Humphries, 1970).

—— and Ehrenburg, Ilya, 'The Blockade of Russia Is Coming to and End' (1922), in Stephen Bann (ed.), *The Tradition of Constructivism* (New York: Viking Press, 1974), 53–7.

Lista, Giovanni, *Le Livre futuriste: De la libération du mot au poème tactile* (Modena: Panini, 1984).

Livshits, B., *Polutoraglazyi strelets: Stikhotvoreniia, perevody, vospominaniia* (Leningrad: Sovetskii pisatel', 1989).

Lloyd-Morgan, Ceridwen, *Margiad Evans* (Bridgend: Seren, 1998).

Lock, Margaret, 'Bliss Carman and Book Design in the 1890s', *DA: A Journal of the Printing Arts*, 61 (Fall–Winter 2007), 3–76.

Locke, Alain LeRoy, *The Philosophy of Alain Locke: Harlem Renaissance and Beyond*, ed. Leonard Harris (Philadelphia: Temple University Press, 1989).

——(ed.), *The New Negro: An Interpretation* (1925; New York: Touchstone, 1997).

Lodder, Christina, 'Art into Life: International Constructivism in Central and Eastern Europe', in Timothy O. Benson (ed.), *Central European Avant-Gardes: Exchange and Transformation, 1910–1930*, exh. cat. (Cambridge, Mass.: MIT Press; Los Angeles: County Museum of Art, 2002), 173–98.

Lodge, David, *The Modes of Modern Writing: Metaphor, Metonymy, and the Typology of Modern Literature* (London: Edward Arnold, 1977).

Logan, Rayford W., *The Negro in American Life and Thought: The Nadir, 1877–1901* (New York: Dial Press, 1954).

——*The Betrayal of the Negro: From Rutherford B. Hayes to Woodrow Wilson* (New York: Da Capo Press, 1997).

Longenbach, James, *Modernist Poetics of History: Pound, Eliot, and a Sense of the Past* (Princeton: Princeton University Press, 1987).

——*Stone Cottage: Pound, Yeats, and Modernism* (New York: Oxford University Press, 1998).

Longhurst, C. Alex, 'The Turn of the Novel in Spain: From Realism to Modernism in Spanish Fiction', in Anthony H. Clarke (ed.), *A Further Range: Studies in Spanish Literature from Galdós to Unamuno* (Exeter: Exeter University Press, 1999), 1–43.

——'Noventayocho y novela: Lo viejo y lo nuevo', in Joseph Harrison and Alan Hoyle (eds), *Spain's 1898 Crisis: Regeneration, Modernism, Post-colonialism* (Manchester: Manchester University Press, 2000), 170–80.

——'Ruptures and Continuities: From Realism to Modernism and the Avant-Garde', in Francis Clough (ed.), *Hacia la novela nueva* (Bern: Peter Lang, 2000), 19–41.

——'Coming in from the Cold: Spain, Modernism and the Novel', *Bulletin of Spanish Studies*, 79/2–3 (2002), 263–83.

Lorca, Federico García, *The Public and Play Without a Title*, trans. Carlos Bauer (New York: New Directions, 1983).

——*Poet in New York* (1940; Harmondsworth: Penguin, 1990).

Lott, Tommy L., and Pittman, John P. (eds), *A Companion to African-American Philosophy* (Oxford: Blackwell, 2006).

Lowell, Amy, *Selected Poems of Amy Lowell*, ed. Melissa Bradshaw and Adrienne Munich (New Brunswick, NJ: Rutgers University Press, 2002).

Loy, Mina, 'Songs to Joannes', *Others*, 3/6 (Apr. 1917), 3–20.

——*The Last Lunar Baedeker* (1923; Manchester: Carcanet, 1985).

Lubbock, Percy, *The Craft of Fiction* (London: Jonathan Cape, 1921).

Lucas, Gavin, 'Modern Disturbances: On the Ambiguities of Archaeology', *Modernism/Modernity*, 11/1 (2004), 109–20.

Lucas, John, *The Radical Twenties* (Nottingham: Five Leaves Press, 1997).

Lucie-Smith, Edward, *Art in the Seventies* (Ithaca, NY: Cornell University Press, 1980).

Luckhurst, Roger, *The Invention of Telepathy, 1870–1901* (Oxford: Oxford University Press, 2002).

Lukács, Georg, 'Franz Kafka oder Thomas Mann?', *Werke IV* (Neuwied: Luchterhand, 1971), 500–50.

LUKÁCS, GEORG, 'On Bertolt Brecht', *New Left Review*, 110 (July–Aug. 1978), 88–92.

—— *Writer and Critic* (1971), ed. and trans. Arthur Kahn (London: Merlin, 1978).

—— *History and Class Consciousness* (1923; Cambridge, Mass.: MIT Press, 1990).

LUNTS, L., 'Go West', in G. Kern and C. Collins (eds), *The Serapion Brothers: A Critical Anthology* (Ann Arbor: Ardis, 1975), 147–56.

—— 'Puteshestvie na bol'nichnoi koike', in *Obez'iany idut* (St Petersburg: Inapress, 2002).

LYON, JANET, *Manifestoes: Provocations of the Modern* (Ithaca, NY: Cornell University Press, 1999).

LYOTARD, JEAN-FRANÇOIS, *The Postmodern Condition: A Report on Knowledge*, trans. Geoff Bennington and Brian Massumi (Manchester: Manchester University Press, 1984).

—— *The Inhuman: Reflections on Time*, trans. Geoffrey Bennington and Rachel Bowlby (Stanford, Calif.: Stanford University Press, 1991).

MCALLISTER, ANDREW, *The Objectivists* (Newcastle: Bloodaxe, 1996).

MCALMON, ROBERT (ed.), *Contact Collection of Contemporary Writers* (Paris: Three Mountains Press, 1925).

MACAULEY, DELIA JARRETT, *The Life of Una Marson, 1905–65* (Manchester: Manchester University Press, 1998).

MACCABE, COLIN, *James Joyce and the Revolution of the Word* (London: Palgrave Macmillan, 1979).

MCCARREN, FELICIA, *Dancing Machines: Choreographies of the Age of Mechanical Reproduction* (Stanford, Calif.: Stanford University Press, 2003).

MCCULLOCH, MARGERY PALMER, *Modernism and Nationalism: Literature and Society in Scotland, 1918–1939* (Glasgow: Association for Scottish Literary Studies, 2004).

MACDIARMID, HUGH, 'Paul Valéry', in *Selected Essays of Hugh MacDiarmid*, ed. Duncan Glen (London: Cape, 1969), 49–52.

—— *Complete Poems*, ed. Michael Grieve and W. R. Aitken, 2 vols (Manchester: Carcanet, 1993).

—— *The Raucle Tongue*, ed. Angus Calder, Glen Murray, and Alan Riach, 3 vols (Manchester: Carcanet, 1996–8).

MCDIARMID, LUCY, *Saving Civilization: Yeats, Eliot, and Auden Between the Wars* (Cambridge: Cambridge University Press, 1984).

MCDONALD, PETER D., *British Literary Culture and Publishing Practice, 1880–1914* (Cambridge: Cambridge University Press, 1997).

—— 'Modernist Publishing: "Nomads and Mapmakers"', in David Bradshaw (ed.), *A Concise Companion to Modernism* (Oxford: Blackwell, 2003), 221–42.

MCGANN, JEROME, *The Textual Condition* (Princeton: Princeton University Press, 1991).

—— 'What Is Critical Editing?', *Text*, 5 (1991), 24.

MCGEE, PATRICK, *Paperspace: Style and Ideology in Joyce's* Ulysses (Lincoln: University of Nebraska Press, 1988).

MACGREEVY, THOMAS, *Jack B. Yeats* (Dublin: Victor Waddington, 1945).

—— *Collected Poems of Thomas MacGreevy*, ed. Susan Schreibman (Washington: Catholic University of America Press, 1991).

MACHEDON, LUMINIŢA, and SCOFFHAM, ERNIE, *Romanian Modernism: The Architecture of Bucharest, 1920–1940* (Cambridge, Mass.: MIT Press, 1999).

MCKAY, CLAUDE, *A Long Way From Home* (London: Pluto Press, 1985).

—— *Complete Poems*, ed. William J. Maxwell (Urbana: University of Illinois Press, 2004).

MCKIBLE, ADAM, *The Space and Place of Modernism: The Russian Revolution, Little Magazines and New York* (London: Routledge, 2002).

MACKIE, VERA, *Feminism in Modern Japan: Citizenship, Embodiment and Sexuality* (Cambridge: Cambridge University Press, 2003).

——'Shanghai Dancers: Gender, Coloniality and the Modern Girl', in Devleena Ghosh and Barbara Leigh (eds), *Shadowlines: Women and Borders in Contemporary Asia* (Newcastle upon Tyne: Cambridge Scholars Press, forthcoming).

MACLENNAN, HUGH, 'The Future of the Novel as an Art Form', in MacLennan, *Scotchman's Return and Other Essays* (Toronto: Macmillan, 1960), 142–58.

MACLEOD, GLEN, 'The Visual Arts', in Michael Levenson (ed.), *The Cambridge Companion to Modernism* (Cambridge: Cambridge University Press, 1999), 194–216.

MCLEOD, HUGH, *Religion and Society in England, 1850–1914* (Basingstoke: Macmillan, 1996).

MCLEOD, JOHN, *Postcolonial London: Rewriting the Metropolis* (London: Routledge, 2004).

MCMILLAN, DOUGALD, *Transition: The History of a Literary Era, 1927–1938* (London: Calder & Boyars, 1975).

MACNEICE, LOUIS, *The Collected Poems of Louis MacNeice*, ed. E. R. Dodds (London: Faber, 1966).

MADGE, CHARLES, *Of Love, Time and Places* (London: Anvil, 1994).

MAGEE, MAGGIE, and MILLER, DIANE C., *Lesbian Lives: Psychoanalytic Narratives Old and New* (New York: Analytic Press, 1996).

MAHAFFEY, VICKI, *Modernist Literature: Challenging Fictions* (Oxford: Blackwell, 2007).

MAINER, JOSÉ-CARLOS, 'La crisis de fin de siglo', in Francisco Rico (ed.), *Historia crítica de la literatura española*, vi: *Modernismo y 98* (Barcelona: Crítica, 1980), 5–15.

MAINGOT, ANTHONY, 'Haiti and the Terrified Consciousness of the Caribbean', in Gert Ootindie (ed.), *Ethnicity in the Caribbean* (London: Macmillan, 1996), 53–80.

MAKIN, PETER, *Pound's Cantos* (London: Allen & Unwin, 1988).

MALDONADO-TORRES, NELSON, 'On the Coloniality of Being: Contributions to the Development of a Concept', *Cultural Studies*, 21/2–3 (Mar.–May 2007), 240–70.

MALI, JOSEPH, *The Rehabilitation of Myth: Vico's 'New Science'* (New York: Cambridge University Press, 1992).

MALINOWSKI, BRONISLAW, *Argonauts of the Western Pacific* (London: Routledge, 1922).

MALLARMÉ, STÉPHANE, 'Le Livre, instrument spirituel', in Mallarmé, *Œuvres complètes*, ii (Paris: Éditions Gallimard, 2003), 224–8.

MALLEA, EDUARDO, *Obras completas* (Buenos Aires: Emecé, 1961).

MALLY, LYNN, *Culture of the Future: The Proletkult Movement in Revolutionary Russia* (Berkeley: University of California Press, 1992).

MALVERN, SUE, *Modern Art, Britain and the Great War: Witnessing, Testimony and Remembrance* (New Haven: Paul Mellon Centre for Studies in British Art and Yale University Press, 2004).

MANDLER, PETER, *History and National Life* (London: Profile Books, 2002).

MANGANARO, MARC, *Myth, Rhetoric and the Voice of Authority: A Critique of Frazer, Eliot, Frye and Campbell* (Princeton: Princeton University Press, 1990).

MANGANIELLO, DOMINIC, *Joyce's Politics* (London: Routledge & Kegan Paul, 1980).

MANKIEWICZ, HERMAN, and WELLES, ORSON, *Citizen Kane: The Complete Screenplay* (London: Methuen, 2002).

MANN, THOMAS, 'Freud and the Future', *International Journal of Psychoanalysis*, 37 (1952), 106–15.

——*Doktor Faustus* (1947; Frankfurt am Main: Fischer Verlag, 1967).

——*The Magic Mountain* (1924), trans. John E. Woods (New York: Vintage, 1996).

——'Death in Venice' (1912), in *Death in Venice and Other Stories*, trans. David Luke (London: Vintage, 1998), 192–266.

MANN, THOMAS, *Dr Faustus* (1947), trans. John E. Woods (New York: Vintage, 1999).

MANNING, SUSAN, *Ecstasy and the Demon: The Dances of Mary Wigman* (Minneapolis: University of Minnesota Press, 2006).

MANNING, SUSAN, and TAYLOR, ANDREW (eds), *Transatlantic Literary Studies: A Reader* (Edinburgh: Edinburgh University Press, 2007).

MANSBACH, STEVEN A., 'The Foreignness of Classical Modern Art in Romania', *Art Bulletin*, 80/3 (Sept. 1988), 534–54.

——*Standing in the Tempest: Painters of the Hungarian Avant-Garde, 1908–1930*, exh. cat. (Santa Barbara, Calif.: Santa Barbara Museum of Art, 1991).

——*Modern Art in Eastern Europe: From the Baltic to the Balkans, ca.1890–1939* (Cambridge: Cambridge University Press, 1998).

MANSFIELD, KATHERINE, 'Ask No Questions', in John Middleton Murry (ed.), *Novels and Novelists* (London: Constable, 1930), 274–9.

——*The Collected Stories of Katherine Mansfield* (Harmondsworth: Penguin, 1981).

——*The Stories of Katherine Mansfield*, ed. Antony Alpers (Auckland: Oxford University Press, 1984).

——*The Collected Letters of Katherine Mansfield*, ed. Vincent O'Sullivan and Margaret Scott, 4 vols (Oxford: Clarendon Press, 1984–96).

——*The Critical Writings of Katherine Mansfield*, ed. Clare Hanson (Basingstoke: Macmillan, 1987).

——*Stories* (New York: Vintage, 1991).

——*The Katherine Mansfield Notebooks*, ed. Margaret Scott (Canterbury: Lincoln University Press; Wellington: Daphne Brasell Associates, 1997).

MANTURA, BRUNO, ROSAZZA-FERRARIS, PATRIZIA, and VELANI, LIVIA (eds), *Futurism in Flight: 'Aeropittura' Paintings and Sculptures of Man's Conquest of Space* (Rome: De Luca, 1990).

MAO, DOUGLAS, and WALKOWITZ, REBECCA L. (eds), *Bad Modernisms* (London: Duke University Press, 2006).

MARCUS, LAURA, *The Tenth Muse: Writing About Cinema in the Modernist Period* (Oxford: Oxford University Press, 2007).

——and NICHOLLS, PETER (eds), *The Cambridge History of Twentieth-Century English Literature* (Cambridge: Cambridge University Press, 2004).

MARCUSE, HERBERT, 'Art as Form of Reality', *New Left Review*, 74 (July–Aug. 1972), 51–8.

MAREK, JAYNE E., 'Amy Lowell, *Some Imagist Poets*, and the Context of the New Poetry', in Adrienne Munich and Melissa Bradshaw (eds), *Amy Lowell: American Modern* (New Brunswick, NJ: Rutgers University Press, 2004), 154–66.

MARGOLIES, DAVID (ed.), *Writing the Revolution: Cultural Criticism from Left Review* (London: Pluto Press, 1998).

MARINETTI, FILIPPO TOMMASO, 'The Founding and Manifesto of Futurism', *Le Figaro*, 20 Feb. 1909.

——*Mafarka le futuriste: Roman africain* (Paris: Sansot, 1910).

——*Zang tumb tumb: Adrianopoli Ottobre 1912. Parole in libertà* (Milan: Edizioni futuriste di 'Poesia', 1914).

——*Les Mots en liberté futurists* (Milan: Edizioni futuriste di 'Poesia', 1919).

——*Mafarka the Futurist: An African Novel* (1909), trans. Carol Diethe and Steve Cox (London: Middlesex University Press, 1997).

——*Selected Poems and Related Prose*, ed. and trans. Elizabeth R. Napier and Barbara R. Studholme (New Haven: Yale University Press, 2002).

——'Technical Manifesto of Futurist Literature (May 1912)', in Lawrence Rainey (ed.), *Modernism: An Anthology* (Oxford: Blackwell, 2005), 15–19.

——*Critical Writings*, ed. Günter Berghaus, trans. Doug Thompson (New York: Farrar, Straus, Giroux, 2006).

——'Drama of Distances', trans. Jeffrey T. Schnapp, *Modernism/Modernity*, 16/2 (2009), 417.

——(ed.), *I poeti futuristi* (Milan: Edizioni futuriste di 'Poesia', 1912).

——(ed.), *I nuovi poeti futuristi* (Rome: Edizioni futuriste di 'Poesia', 1925).

——and MASNATA, PINO, 'La Radia', *Gazetta del Popolo* (Oct. 1933); repr. in Douglas Kahn and Gregory Whitehead (eds), *Wireless Imagination: Sound, Radio, and the Avant-Garde* (Cambridge, Mass.: MIT Press, 1992), 265–8.

MARK, ALISON, *Veronica Forrest Thomson* (Tavistock: Northcote House, 2001).

MARKOV, VLADIMIR, 'The Province of Russian Futurism', *Slavic and East European Journal*, 8/4 (1964), 401–6.

——*Russian Futurism: A History* (London: MacGibbon & Kee, 1969).

MARSHIK, CELIA, *British Modernism and Censorship* (Cambridge: Cambridge University Press, 2006).

MARTIN, ANN, 'Visions of Canadian Modernism', *Canadian Literature*, 181 (Summer 2004), 43–59.

MARTIN, GERALD, *Journeys Through the Labyrinth: Latin American Fiction in the Twentieth Century* (London: Verso, 1989).

——'Miguel Angel Asturias: El Señor Presidente', in Philip Swanson (ed.), *Landmarks in Modern Latin American Fiction* (London: Routledge, 1990), 50–73.

MARTIN, J. L., NICHOLSON, BEN, and GABO, NAUM, *Circle: International Survey of Constructive Art* (London: Faber and Faber, 1937).

MARTIN, MARIANNE W., *Futurist Art and Theory, 1909–1915* (Oxford: Clarendon Press, 1968).

MARTIN, WALLACE, The New Age *Under Orage: Chapters in English Cultural History* (Manchester: Manchester University Press, 1967).

MARTINI, ARTURO, *Contemplazioni* (Faenza: privately printed, 1918).

MARVIN, CAROLYN, *When Old Technologies Were New: Thinking About Electric Communication in the Late Nineteenth Century* (New York: Oxford University Press, 1988).

MARX, JOHN, *The Modernist Novel and the Decline of Empire* (Cambridge: Cambridge University Press, 2005).

MARX, KARL, *Writings of the Young Marx on Philosophy and Society*, ed. and trans. Loyd D. Easton and Kurt H. Guddat (New York: Doubleday, 1967).

——*Grundrisse: Foundations of the Critique of Political Economy (Rough Draft)* (1857), trans. Martin Nicolaus (Harmondsworth: Penguin/New Left Books, 1973).

——*Capital: Critique of Political Economy* (1867), i, trans. Ben Fowkes (Harmondsworth: Penguin in association with *New Left Review*, 1976).

——and ENGELS, FREDERICK, *The Communist Manifesto*, in Marx and Engels, *Collected Works*, vi (London: Lawrence & Wishart, 1976), 477–512.

MARX, URSULA et al. (eds), *Walter Benjamin's Archive: Images, Texts, Signs*, trans. Esther Leslie (London: Verso, 2007).

MATHEWS, TIMOTHY, *Reading Apollinaire: Theories of Poetic Language* (Manchester: Manchester University Press, 1987).

MATHUR, SALONI, 'Response: Belonging to Modernism', *Art Bulletin* (Dec. 2009), 558–60.

MATTHEWS, J. H., *Toward the Poetics of Surrealism* (Syracuse, NY: Syracuse University Press, 1976).

MATTHEWS, STEVEN, *Modernism* (London: Arnold, 2004).

MATZ, JESSE, *Literary Impressionism and Modernist Aesthetics* (Cambridge: Cambridge University Press, 2001).

MAUSS, MARCEL, *Sociology and Psychology: Essays* (London: Routledge & Kegan Paul, 1979).

MAX, D. T., 'The Injustice Collector', *New Yorker* (19 June 2006), 34–43.

MAYAKOVSKY, VLADIMIR, 'Doklad "Chto delaet Berlin?"', in *Polnoe sobranie sochinenii*, xii (Moscow: Gosudarstvennoe izdatel'stvo khudozhestvennoi literatury, 1959), 462–3.

——*The Bedbug and Selected Poetry*, ed. Patricia Blake, trans. Max Hayward and George Reavey (Bloomington: Indiana University Press, 1960).

——'Vladimir Mayakovsky: A Tragedy', in *The Complete Plays of Vladimir Mayakovsky*, trans. Guy Daniels (New York: Simon & Schuster, 1968), 19–38.

——*The Complete Plays of Vladimir Mayakovsky*, ed. Robert Payne (New York: Simon & Schuster, 1971).

MEAD, G. R. S., 'On the Nature of the Quest', *The Quest: A Quarterly Review*, 1 (Mar. 1909), 29–43.

——'The Rising Psychic Tide', *The Quest: A Quarterly Review*, 3 (Apr. 1912), 401–21.

MELLORS, ANTHONY, *Late Modernist Poetics from Pound to Prynne* (Manchester: Manchester University Press, 2005).

MELVILLE, STEPHEN, *Philosophy Beside Itself: On Deconstruction and Modernism* (Minneapolis: University of Minnesota Press, 1996).

MENAND, LOUIS, 'T. S. Eliot', in A. Walton Litz, Louis Menand, and Lawrence Rainey (eds), *The Cambridge History of Literary Criticism*, vii: *Modernism and the New Criticism* (Cambridge: Cambridge University Press, 2000), 17–56.

——*The Metaphysical Club* (New York: Farrar, Straus, Giroux, 2001).

MENDELSON, EDWARD, *W. H. Auden: A Biography* (London: George Allen & Unwin, 1981).

MENGHAM, ROD, and KINSELLA, JOHN (eds), *Vanishing Points: New Modernist Poems* (Cambridge: Salt, 2004).

MENSAH, ADJUA, 'The Blackman's Burden', in Women's Column, *Accra Evening News*, Ghana, 2 Aug. 1949.

MENZIES, JACKIE (ed.), *Modern Boy, Modern Girl: Modernity in Japanese Art, 1910–1935* (Sydney: Art Gallery of New South Wales, 1998).

MERCER, KOBENA (ed.), *Cosmopolitan Modernisms* (London: InIVA, 2005).

MEREDITH, J. E., *Gwenallt: Bardd Crefyddol* (Llandysul: Gwasg Gomer, 1974).

MESCHONNIC, HENRI, 'Modernity, Modernity', *New Literary History*, 23 (1992), 401–30.

MEXAL, STEPHEN J., 'Material Knowledge: Democracy and the Digital Archive', *English Language Notes*, 45/1 (Spring–Summer 2007), 129.

MEYER, RAIMUND (ed.), *Dada Global* (Zurich: Limmat Verlag, 1994).

MEYERHOLD, VSEVOLOD, *Meyerhold on Theatre*, ed. and trans. Edward Braun (London: Methuen, 1998).

MEYERS, JEFFREY, *Joseph Conrad: A Biography* (New York: Charles Scribner's Sons, 1991).

MICHELET, JULES, *Cours au Collège de France, 1838–1848* (Paris: Gallimard, 1995).

MIDDELL, KATHARINA, and MIDDELL, MATHIAS, 'Forschungen zum Kulturtransfer: Frankreich und Deutschland', in *Grenzgänge: Beiträge zu einer modernen Romanistik*, i/2 (Leipzig: Leipziger Universität Verlag, 1994), 107–22.

MIDDLETON, J. C., 'Dada versus Expressionism, or, The Red King's Dream', *German Life and Letters*, 15 (1961–2), 37–52.

MIDDLETON, PETER, 'From *Abaxial* to *Zeolite*: Poetry and Scientific Discourse' (Mar. 2003), <http://www.soton.ac.uk/english/docs/PMabaxial.doc>.

——'Can Poetry Be Scientific?', in Philip Coleman (ed.), *On Literature and Science: Essays, Reflections, Provocations* (Dublin: Four Courts, 2007), 190–208.

MILLER, CECELIA, *Giambattista Vico: Imagination and Historical Knowledge* (New York: St Martin's Press, 1993).

MILLER, HENRY, *Tropic of Cancer* (1934; London: Harper, 2005).

MILLER, TYRUS, *Late Modernism: Politics, Fiction, and the Arts Between the World Wars* (Berkeley: University of California Press, 1999).

MILLS HARPER, GEORGE, and BECKSON, KARL, 'Victor Plarr on "The Rhymers' Club": An Unpublished Lecture', *English Literature in Transition (1880–1920)*, 45/4 (2002), 379–85.

MILNE, DREW, 'The Art of Wit and the Cambridge Science Park', in Robert Crawford (ed.), *Contemporary Poetry and Contemporary Science* (Oxford: Oxford University Press, 2006), 170–87.

MILNER, JOHN, *A Slap in the Face: Futurists in Russia* (London: Philip Wilson, 2007).

MILUTIS, JOE, *Ether: The Nothing That Connects Everything* (Minneapolis: University of Minnesota Press, 2006).

MINOW, MAKIKO, 'Versions of Female Modernism', *News From Nowhere: The Politics of Modernism*, 7 (Winter 1989), 64–69.

MIRSKY, D. S., 'O sovremennom sostoianii russkoi poezii', in G. S. Smith (ed.), *Uncollected Writings on Russian Literature*, Modern Russian Literature and Culture: Studies and Texts, 13 (Berkeley: Berkeley Slavic Studies, 1989).

MITCHELL, P. M., *A History of Danish Literature* (Copenhagen: Gyldendal, 1971).

——'The Concept of Modernism in Scandinavia', in Janet Garton (ed.), *Facets of European Modernism: Essays in Honour of James McFarlane* (Norwich: University of East Anglia, 1985), 243–56.

MITTER, PARTHA, *The Triumph of Modernism: India's Artists and the Avant-Garde, 1922–1947* (London: Reaktion Books, 2007).

——'Interventions: Decentering Modernism: Art History and Avant-Garde Art from the Periphery', *Art Bulletin* (Dec. 2008), 531–48.

MOFFET, CHARLES, *The New Painting: Impressionism, 1874–1886* (San Francisco: Fine Arts Museums of San Francisco, 1986).

MOHOLY-NAGY, LÁSZLÓ, 'Production-Reproduction', in Christopher Phillips (ed.), *Photography in the Modern Era: European Documents and Critical Writings, 1913–1940* (New York: Museum of Modern Art and Aperture, 1989), 79–82.

MOI, TORIL, *Sexual/Textual Politics: Feminist Literary Theory* (London: Methuen, 1985).

——*Henrik Ibsen and the Birth of Modernism: Art, Theater, Philosophy* (Oxford: Oxford University Press, 2006).

MONK, RAY, *Bertrand Russell: The Spirit of Solitude* (London: Vintage, 1997).

MONTAIGNE, MICHEL DE, *Selected Essays of Montaigne*, ed. Walter Kaiser, trans. John Florio (Boston: Houghton Mifflin, 1964).

MOODY, A. DAVID, *Ezra Pound, Poet: A Portrait of the Man and His Work*, i: *The Young Genius, 1885–1920* (Oxford: Oxford University Press, 2007).

MOORE, EDWARD [EDWIN MUIR], *We Moderns: Enigmas and Guesses* (London: George Allen & Unwin, 1918).

MOORE, J. R., *The Post-Darwinian Controversies: A Study of the Protestant Struggle to Come to Terms with Darwin in Great Britain and America, 1870–1900* (Cambridge: Cambridge University Press, 1979).

MOORE-GILBERT, BART, 'Postcolonial Modernisms', in David Bradshaw and Kevin J. H. Dettmar (eds), *A Companion to Modernist Literature and Culture* (Malden, Mass.: Blackwell, 2006), 551–7.

MORAN, D. P., *The Philosophy of Irish Ireland* (Dublin: Duffy, 1899).

MORASSO, MARIO, *La nuova arma (la macchina)* (Turin: Bocca, 1905).

MORAVÁNSKY, ÁKOS, *Competing Visions: Aesthetic Invention and Social Imagination in Central European Architecture, 1867–1918* (Cambridge, Mass.: MIT Press, 1998).

MORE, CHANDLER (ed.), *Modernization by Design* (Ithaca, NY: Cornell University Press, 1969).

MORETTI, FRANCO, 'The Slaughterhouse of Literature', *Modern Language Quarterly*, 61/1 (2000), 207–28.

MORRIS, C. B., *Surrealism and Spain, 1920–1936* (Cambridge: Cambridge University Press, 1972).

MORRISON, NANCY BRYSSON, *The Gowk Storm* (London: Collins, 1933).

MORRISSON, MARK, *The Public Face of Modernism: Little Magazines, Audiences, and Reception, 1905–1920* (Madison: University of Wisconsin Press, 2001).

MORROW, JOHN H., JR, *The Great War: An Imperial History* (New York: Routledge, 2004).

MOSELEY, SIDNEY, 'Letters from a Fond Uncle, 11: Do We Listen Reasonably?', *Radio Times* (3 Feb. 1928).

MOSSE, GEORGE, 'The Political Culture of Italian Futurism', *Journal of Contemporary History*, 24 (1989), 5–26.

MOTTRAM, ERIC, 'The British Poetry Revival, 1960–1975', in Robert Hampson and Peter Barry (eds), *New British Poetries: The Scope of the Possible* (Manchester: Manchester University Press, 1993), 15–50.

MOUNT, NICK, *When Canadian Literature Moved to New York* (Toronto: University of Toronto Press, 2005).

M.P., 'The Art Galleries: A Little Bit of Philosophy While the Editor's Back Turned to Us', *New Yorker*, 3/12 (7 May 1927), 76–9.

MUECKE, STEPHEN, *Ancient & Modern: Time, Culture and Indigenous Philosophy* (Sydney: University of New South Wales Press, 2004).

MUGGERIDGE, MALCOLM, *The Thirties* (London: Hamish Hamilton, 1940).

MUIR, EDWIN [EDWARD MOORE], 'The Present State of Poetry', *Calendar of Modern Letters*, 2/11 (Jan. 1926), 322–31.

——*An Autobiography* (London: Hogarth Press, 1954).

——*The Complete Poems of Edwin Muir*, ed. Peter Butter (Aberdeen: Association for Scottish Literary Studies, 1991).

MUIR, WILLA, *Imagined Selves*, ed. Kirsty Allen (Edinburgh: Canongate Classics, 1996).

MUKAŘOVSKÝ, JAN, 'Art as a Semiotic Fact', in Mukařovský, *Structure, Sign, and Function*, ed. John Burbank and Peter Steiner (New Haven: Yale University Press, 1978), 82–8.

MULLAN, JOHN, 'Style Council', *The Guardian*, 25 Sept. 2004.

MÜLLER, HEDWIG, 'Émile Jaques-Dalcroze: The Beginnings of Rhythmic Gymnastics in Hellerau', *Ballett-International*, 8/6–7 (June–July 1985), 24–7.

MULVEY, LAURA, 'Satellites of Love', *Sight and Sound*, 10/12 (2000), 20–4.

MUNROE, ALEXANDRA (ed.), *Japanese Art After 1945: Scream Against the Sky* (New York: Harry N. Abrahams, 1994).

MURPHY, RICHARD, *Theorizing the Avant-Garde: Modernism, Expressionism, and the Problem of Postmodernity* (Cambridge: Cambridge University Press, 1999).

MURPHY, TIMOTHY S., 'Beneath Relativity: Bergson and Bohm on Absolute Time', in John Mullarkey (ed.), *The New Bergson* (Manchester: Manchester University Press, 1999), 66–81.

MURRAY, STUART, 'Postcoloniality/Modernity: Wilson Harris and Postcolonial Theory', *Review of Contemporary Fiction*, 17/2 (Summer 1997), 53–8.

MURRY, J. M., 'Literature and Science', *The Times*, 26 May 1922, 16.

MUSIL, ROBERT, *The Man Without Qualities* (1930–42), trans. Sophie Wilkins (New York: Vintage, 1996).

——*Diaries 1899–1941*, trans. Philip Payne (New York: Basic Books, 1999).

MYERS, F. W. H., 'The Subliminal Consciousness', chs 1–2, *Proceedings of the Society for Psychical Research*, 7 (1891–2), 298–355; chs 3–5, *PSPR* 8 (1892), 333–535; chs 6–7, *PSPR* 9 (1893), 3–128.

NABOKOV, VLADIMIR, *The Portable Nabokov*, ed. Page Stegner (New York: Viking Press, 1976).

NADEAU, MAURICE, *Histoire du Surréalisme* (Paris: Gallimard, 1947).

——*The History of Surrealism*, trans. Richard Howard (London: Jonathan Cape, 1968).

NAGATA ISSHŪ, *Puroretaria Kaiga Ron* (Tokyo: Tenjinsha, 1930; repr. Tokyo: Yumani Shobō, 1991).

NAIPAUL, V. S., *A Bend in the River* (London: André Deutsch, 1979).

NAIRN, TOM, *The Break-Up of Britain: Crisis and Neonationalism* (London: New Left Books, 1977).

NASTA, SUSHEILA, 'Setting Up Home in a City of Words: Sam Selvon's London Novels', in A. Robert Lee (ed.), *Other Britain, Other British: Contemporary Multicultural Fiction* (London: Pluto Press, 1995), 48–68.

NATARAJAN, NALINI (ed.), *Handbook of Twentieth Century Literatures of India* (Westport, Conn.: Greenwood Press, 1996).

NAUMANN, FRIEDRICH, *Mitteleuropa* (Berlin: Reimer Verlag, 1915).

NAVAJAS, GONZALO, *Teoría y práctica de la novela española posmoderna* (Barcelona: Ediciones del Mall, 1987).

NEAD, LYNDA, ' "Highways and Byways": London's Modern Life c.1900', in Robert Upstone (ed.), *Modern Painters: The Camden Town Group*, exh. cat. (London: Tate, 2008), 40–1.

NEEFS, JACQUES, and DEBRAY-GENETTE, RAYMONDE, *Romans d'archives* (Lille: Universitaires Presses, 1989).

NELSON, James G., *The Early Nineties: A View from the Bodley Head* (Cambridge, Mass.: Harvard University Press, 1971).

——*Elkin Mathews: Publisher to Yeats, Joyce, Pound* (Madison: University of Wisconsin Press, 1989).

NELSON, ROBERT S., and SCHIFF, RICHARD (eds), *Critical Terms for Art History*, 2nd edn (Chicago: University of Chicago Press, 2003).

NEUMANN, ERICH, *Creative Man: Five Essays* (Princeton: Princeton University Press, 1979).

NEVINSON, C. R. W., *Paint and Prejudice* (London: Harcourt Brace, 1938).

NEWHALL, BEAUMONT, *The History of Photography from 1839 to the Present* (New York: Museum of Modern Art, 1982).

NICHOLAS, M. A., 'Russian Modernism and the Female Voice: A Case Study', *Russian Review*, 53/4 (Oct. 1994), 530–48.

NICHOLLS, DAVID G., 'The Folk as Alternative Modernity: Claude McKay's *Banana Bottom* and the Romance of Nature', *Journal of Modern Literature*, 23/1 (Fall 1999), 79–94.

NICHOLLS, PETER, *Ezra Pound: Politics, Economics and Writing: A Study of The Cantos* (London: Macmillan, 1984).

——'State of the Art: Old Problems and the New Historicism', *Journal of American Studies*, 23/3 (1989), 423–34.

——'Beyond *The Cantos*: Pound and American Poetry', in Ira Nadel (ed.), *The Cambridge Companion to Ezra Pound* (Cambridge: Cambridge University Press, 1999), 139–60.

——*George Oppen and the Fate of Modernism* (Oxford: Oxford University Press, 2007).

——*Modernisms: A Literary Guide*, 2nd edn (Basingstoke: Palgrave Macmillan, 2009).

NICHOLSON, VIRGINIA, *Among the Bohemians: Experiments in Living, 1900–1939* (London: Penguin, 2003).

NIETZSCHE, FRIEDRICH, *The Portable Nietzsche*, ed. and trans. Walter Kaufmann (New York: Viking, 1954).

——*The Use and Abuse of History for Life* (1873), trans. Adrian Collins (Indianapolis: Bobbs-Merrill, 1957).

NIETZSCHE, FRIEDRICH, *The Birth of Tragedy Out of the Spirit of Music* (1872), trans. Walter Kaufmann (New York: Random House, 1967).

——*The Will to Power*, trans. Walter Kaufmann and R. G. Hollingdale (New York: Random House, 1968).

——*The Gay Science* (1882), trans. Walter Kaufmann (New York: Random House, 1974).

——*Twilight of the Idols and The Anti-Christ* (1888), trans. R. J. Hollingdale (Harmondsworth: Penguin, 1979).

——*Nietzsche*, trans. David Farrell Krell, 4 vols (San Fransisco: Harper and Row, 1979–87).

——*On the Genealogy of Morality* (1887), trans. Carol Diethe (Cambridge: Cambridge University Press, 1997).

——'On the Uses and Disadvantages of History for Life', in Nietzsche, *Untimely Meditations*, trans. R. J. Hollingdale (Cambridge: Cambridge University Press, 1997), 57–125.

——*Thus Spoke Zarathustra* (1883–5), trans. Adrian Del Caro (Cambridge: Cambridge University Press, 2006).

NIJINSKA, BRONISLAVA, *Early Memoirs* (London: Faber and Faber, 1981).

NIJINSKY, VASLAV, 'M. Nijinsky's Critics: "The word 'grace' makes me feel sea sick"', *Daily Mail*, 14 July 1913, 5.

NOAKES, JEREMY, and PRIDHAM, GEOFFREY, *Nazism, 1919–1945*, i: *The Rise to Power, 1919–1934: A Documentary Reader* (Exeter: University of Exeter Press, 1998).

NORA, PIERRE, *Rethinking France*, ii: *Space*, trans. David P. Jordan and Mary Seidman Trouille (Chicago: University of Chicago Press, 2001).

NORMAN, DOROTHY, *Alfred Stieglitz* (New York: Aperture, 1989).

NORRIS, MARGOT, *Writing War in the Twentieth Century* (Charlottesville: University of Virginia Press, 2000).

NORTH, MICHAEL, *The Dialect of Modernism: Race, Language and Twentieth-Century Literature* (New York: Oxford University Press, 1994).

——*Reading 1922: A Return to the Scene of the Modern* (Oxford: Oxford University Press, 1999).

——'Visual Culture', in Walter Kalaidjian (ed.), *The Cambridge Companion to American Modernism* (Cambridge: Cambridge University Press, 2005), 177–94.

OBIECHINA, EMMANUEL, 'Amos Tutuola and the Oral Tradition', in Bernth Lindfors (ed.), *Critical Perspectives on Amos Tutuola* (Washington, DC: Three Continents Press, 1975).

——*Culture, Tradition and Society in the West African Novel* (Cambridge: Cambridge University Press, 1975).

O'BRIEN, FLANN, *At Swim-Two-Birds* (1939; Harmondsworth: Penguin, 2000).

——*The Best of Myles na Gopaleen*, ed. Kevin O'Nolan (London: Picador, 1977).

——'A Sheaf of Letters', *Journal of Irish Literature*, 3/1 (Jan. 1974), 66–92.

OBSTFELDER, SIGBJØRN, *Skrifter*, i (Christiania, Copenhagen: Gyldendalske Boghandel, 1917).

Ó Conaire, Breandán, *Myles na Gaeilge* (Dublin: An Clóchomhar, 1986).

O'CONNELL, SEAN, *The Car in British Society: Class, Gender and Motoring, 1896–1939* (Manchester: Manchester University Press, 1998).

ODOM, MAGGIE, 'Mary Wigman: The Early Years, 1913–1925', *Drama Review*, 24/4 (1980), 81–92.

ODOM, SELMA, 'Wigman at Hellerau', *Ballet Review*, 14/2 (1986), 41–53.

O'FAOLÁIN, SEÁN, 'Style and the Limitations of Speech', *Criterion*, 4 (Sept. 1928), 67–87.

OGUNDIPE-LESLIE, OMALARA, 'The Female Writer and Her Commitment', in Eldred Jones, Eustace Palmer, and Marjorie Jones (eds), *Women in African Literature Today* (London: James Currey; Trenton, NJ: Africa World Press, 1987), 5–13.

O'HARA, FRANK, *The Collected Poems of Frank O'Hara* (Berkeley: University of California Press, 1995).

O'LEARY, PETER, *Irish Prose Composition* (Dublin: Irish Book Company, 1907).

—— *The Energies of Words*, <http://www.poetryfoundation.org/journal/article.html?id=181672>.

OLSCHOWSKY, HEINRICH, *Der Mensch in den Dingen: Programmtexte und Gedichte der Krakauer Avantgarde* (Leipzig: Verlag Philipp Reclam, 1986).

OLSEN, REDELL, 'Scripto-Visualities: Contemporary Poetics and Innovative Women's Writing', Ph.D. diss., University of London, 2002.

OLSON, CHARLES, 'Projective Verse', in *Selected Writings*, ed. Robert Creeley (New York: New Directions, 1966), 15–26.

OMER, RANEN, ' "It Is I Who Have Been Defending a Religion Called Judaism": The T. S. Eliot and Horace M. Kallen Correspondence', *Texas Studies in Literature and Language*, 39/4 (1997), 321–56.

OMER-SHERMAN, RANEN, 'Rethinking Eliot, Jewish Identity and Cultural Pluralism', *Modernism/Modernity*, 10/3 (Sept. 2003), 439–45.

ONDAATJE, MICHAEL, 'Afterword', in Howard O'Hagan, *Tay John* (Toronto: McClelland and Stewart, 1989), 265–72.

OOTINDIE, GERT (ed.), *Ethnicity in the Caribbean* (London: Macmillan, 1996).

OPHIR, ELLA ZOHAR, 'Toward a Pitiless Fiction: Abstraction, Comedy, and Modernist Anti-humanism', *Modern Fiction Studies*, 52/1 (2006), 92–120.

OPPENHEIM, JANET, *The Other World: Spiritualism and Psychical Research in England, 1850–1914* (Cambridge: Cambridge University Press, 1985).

ORAGE, A. R. [A.J.O.], *Consciousness: Animal, Human, and Superman* (London: Theosophical Society, 1907).

—— 'Towards Socialism', *New Age*, 3 (1907), 361.

—— 'In Search of God', *New Age* (22 Apr. 1926), 295.

ORTEGA Y GASSET, JOSÉ, *The Revolt of the Masses* (New York: Norton, 1964).

—— *The Dehumanization of Art and Other Essays on Art, Culture, and Literature*, trans. Helene Weyl (Princeton: Princeton University Press, 1972).

ORWELL, GEORGE, 'Inside the Whale', in Orwell, *A Collection of Essays* (New York: Harcourt, 1981), 210–52.

—— *Essays*, ed. John Carey (New York: Knopf, 2002).

OSBORNE, PETER, 'Small-Scale Victories, Large-Scale Defeats: Walter Benjamin's Politics of Time', in Andrew Benjamin and Peter Osborne (eds), *Walter Benjamin's Philosophy: Destruction and Experience* (London: Routledge, 1994), 59–109.

—— *The Politics of Time: Modernity and the Avant-Garde* (London: Verso, 1995).

—— 'Tactics, Ethics, or Temporality? Heidegger's Politics Reviewed', *Radical Philosophy*, 70 (Mar.–Apr. 1995), 16–28.

—— 'Modernism as Translation', in Osborne, *Philosophy in Cultural Theory* (London: Routledge, 2000), 53–62.

—— 'Remember the Future? *The Communist Manifesto* as Cultural-Historical Form', in Osborne, *Philosophy in Cultural Theory* (London: Routledge, 2000), 63–77.

—— *Idealism as Modernism: Hegelian Variations* (Cambridge: Cambridge University Press, 2004).

—— 'The Dreambird of Experience: Utopia, Possibility, Boredom', *Radical Philosophy*, 137 (May–June 2006), 29–44.

—— 'Neo-Classic: Alain Badiou's *Being and Event*', *Radical Philosophy*, 142 (Mar.–Apr. 2007), 19–29.

OSBORNE, PETER, 'Marx and the Philosophy of Time', *Radical Philosophy*, 147 (Jan.–Feb. 2008), 15–22.

——'Modernisms and Mediations', in Francis Halsall, Julia Jansen, and Tony O'Connor (eds), *Rediscovering Aesthetics: Transdisciplinary Voices in Art History, Philosophy and Art Practices* (Stanford, Calif.: Stanford University Press, 2009), 163–77.

——with ALLIEZ, ÉRIC, 'Philosophy and Contemporary Art, After Adorno and Deleuze: An Exchange', in Robert Garnet and Andrew Hunt (eds), *Gest: Laboratory of Synthesis* (London: Bookworks, 2008), 35–64.

OSOFSKY, GILBERT, *Harlem: The Making of a Ghetto*, 2nd edn (Chicago: Ivan R. Dee, 1996).

OUDITT, SHARON, *Fighting Forces, Writing Women: Identity and Ideology in the First World War* (London: Routledge, 1994).

OUTKA, ELIZABETH, *Consuming Traditions: Modernity, Modernism, and the Commodified Aesthetic* (Oxford: Oxford University Press, 2009).

OWEN, ALEX, 'Psycho-Analysis à la Mode', *Saturday Review* (21 Feb. 1921), 129.

——'The Sorcerer and His Apprentice: Aleister Crowley and the Magical Exploration of Edwardian Subjectivity', *Journal of British Studies*, 36 (1997), 99–133.

——*The Place of Enchantment: British Occultism and the Culture of the Modern* (Chicago: University of Chicago Press, 2004).

PALUMBO-LIU, DAVID, 'Atlantic to Pacific: James, Todorov, Blackmur and Intercontinental Form', in Wai Chee Dimock and Lawrence Buell (eds), *Shades of the Planet* (Princeton: Princeton University Press, 2007), 196–226.

PAPASTERGIADIS, NIKOS, *Modernity as Exile: The Stranger in John Berger's Writings* (Manchester: Manchester University Press, 1993).

PAPINI, MARIA CARLA (ed.), *L'Italia futurista, 1915–1918* (Rome: Edizioni dell'Ateneo & Bizzarri, 1977).

PARET, PETER, *German Encounters with Modernism: 1840–1945* (New York: Cambridge University Press, 2001).

PARISI, JOSEPH, and YOUNG, STEPHEN (eds), *Dear Editor: A History of Poetry in Letters: The First Fifty Years* (New York: Norton, 2002).

PARKES, ADAM, *Modernism and the Theater of Censorship* (New York: Oxford University Press, 1996).

PASSUTH, KRISZTINA, *Les Avant-Gardes de l'Europe centrale, 1907–1927* (Paris: Flammarion, 1988).

——*Treffpjunkte der Avantgarden Ostmitteleuropa, 1907–1930* (Budapest: Balassi Kiadó; Dresden: Verlag der Kunst, 2003).

——*Hungarian Fauves from Paris to Nagybánya, 1904–1914*, exh. cat. (Budapest: Hungarian National Gallery, 2006).

PATER, WALTER, *The Renaissance: Studies in Art and Poetry*, introd. Kenneth Clark (London: Collins, 1961).

PATTERSON, ANITA, *Race, American Literature and Transnational Modernisms* (Cambridge: Cambridge University Press, 2008).

PATTON, VENITRA, and HONEY, MAUREEN (eds), *Double Take: A Revisionist Harlem Renaissance Anthology* (New Brunswick, NJ: Rutgers University Press, 2001).

PAVITT, JANE, 'From the Garden to the Factory: Urban Visions in Czechoslovakia Between the Wars', in Malcolm Gee, Tim Kirk, and Jill Steward (eds), *The City in Central Europe: Culture and Society from 1800 to the Present* (Aldershot: Ashgate, 2003), 27–44.

PEASE, ALLISON, *Modernism, Mass Culture, and the Aesthetics of Obscenity* (Cambridge: Cambridge University Press, 2000).

PEPPIS, PAUL, *Literature, Politics, and the English Avant-Garde: Nation and Empire, 1901–1918* (Cambridge: Cambridge University Press, 2000).

PERELMAN, BOB, *Iflife* (New York: Roof, 2006).

PÉREZ FIRMAT, GUSTAVO, *Idle Fictions: The Hispanic Vanguardist Novel, 1926–1934* (Durham, NC: Duke University Press, 1982).

PERKINS, DAVID, *A History of Modern Poetry: From the 1890s to the High Modernist Mode* (Cambridge, Mass.: Belknap Press, 1976).

PERL, JEFFREY M., *The Tradition of Return: The Implicit History of Modern Literature* (Princeton: Princeton University Press, 1984).

PERLOFF, MARJORIE, *Frank O'Hara: Poet Among Painters* (Austin: University of Texas Press, 1979).

—— '"Fragments of a Buried Life": John Ashbery's Dream Songs', in David Lehman (ed.), *Beyond Amazement: New Essays on John Ashbery* (Ithaca, NY: Cornell University Press, 1980), 66–86.

—— *The Futurist Moment: Avant-Garde, Avant Guerre and the Language of Rupture* (Chicago: University of Chicago Press, 1986).

—— *21st-Century Modernism* (Oxford: Blackwell, 2002).

PERRY, TED (ed.), *Masterpieces of Modernist Cinema* (Bloomington: Indiana University Press, 2006).

PERSIN, MARGARET, 'Antonio Machado's "La tierra de Alvargonzález" and the Questioning of Cultural Authority', in John P. Gabriele (ed.), *Nuevas perspectivas sobre el 98* (Frankfurt: Vervuert; Madrid: Iberoamericana, 1999), 99–106.

PESSOA, FERNANDO, *The Book of Disquiet*, trans. Alfred MacAdam (Boston: Exact Exchange, 1998).

PETERSON, THEODORE, *Magazines in the Twentieth Century* (Urbana: University of Illinois Press, 1964).

PETO, JAMES, and LOVEDAY, DONNA (eds), *Modern Britain, 1929–1939*, exh. cat. (London: Design Museum, 1999).

PETRIC, VLADA, *Constructivism in Film: A Cinematic Analysis: The Man with the Movie Camera* (Cambridge: Cambridge University Press, 1987).

PETRO, PATRICE, *Aftershocks of the New: Feminism and Film History* (New Brunswick, NJ: Rutgers University Press, 2002).

PETRONE, PENNY, *Native Literature in Canada: From the Oral Tradition to the Present* (Toronto: Oxford University Press, 1990).

PEVSNER, NIKOLAUS, *Pioneers of Modern Design: From William Morris to Walter Gropius* (New Haven: Yale University Press, 2005).

PHILLIPS, JOHN, and STONEBRIDGE, LYNDSEY (eds), *Reading Melanie Klein* (London: Routledge, 1998).

PIELL WEXLER, JOYCE, *Who Paid for Modernism? Art, Money, and the Fiction of Conrad, Joyce, and Lawrence* (Fayetteville: University of Arkansas Press, 1997).

PIERRE, JOSÉ (ed.), *Investigating Sex: Surrealist Discussions, 1928–1932* (London: Verso, 1992).

PIKOULIS, JOHN, 'Lynette Roberts and Alun Lewis', *Poetry Wales*, 19/2 (1983), 9–29.

PINTHUS, KURT (ed.), *Menschheitsdämmerung: Ein Dokument des Expressionismus* (Reinbek: Rowohlt, 1983).

—— (ed.), *Menschheitsdämmerung: Dawn of Humanity, a Document of Expressionism*, trans. J. M. Ratych, R. Ley, and R. C. Conard (Columbia, SC: Camden House, 1994).

PIPPIN, ROBERT, *Modernism as a Philosophical Problem: On the Dissatisfactions of European High Culture* (Oxford: Blackwell, 1999).

PIPPIN, ROBERT, *Idealism as Modernism: Hegelian Variations* (Cambridge: Cambridge University Press, 2004).

PLARR, VICTOR, 'The Rhymers' Club', *English Literature in Transition, 1880–1920*, 45/4 (2002), 386–401.

PLATO, *Parmenides*, trans. R. E. Allen (New Haven: Yale University Press, 1997).

POGGI, CHRISTINE, *In Defiance of Painting: Cubism, Futurism and the Invention of Collage* (New Haven: Yale University Press, 1992).

POLI, BERNARD J., *Ford Madox Ford and the* Transatlantic Review (Syracuse, NY: Syracuse University Press, 1967).

POLIZZOTTI, MARK, *Revolution of the Mind: The Life of André Breton* (London: Bloomsbury, 1995).

POLLARD, CHARLES W., *New World Modernisms: T. S. Eliot, Derek Walcott, and Kamau Brathwaite* (Charlottesville: University of Virginia Press, 2004).

POLLOCK, GRISELDA, *Vision and Difference: Feminism, Femininity and the Histories of Art* (London: Routledge, 2003).

POLONSKY, R., *English Literature and the Russian Aesthetic Renaissance* (Cambridge: Cambridge University Press, 1998).

POMORSKA, KRISTINA, *Russian Formalism and its Poetic Ambivalence* (The Hague: Mouton, 1968).

PORTEUS, HUGH GORDON, Letter, *Times Literary Supplement*, 4 Feb. 1965, 87.

POUND, EZRA, 'I Gather the Limbs of Osiris', *New Age* (7 Dec. 1911), 224–5.

——'Prolegomena', *Poetry Review*, 1 (Feb. 1912), 72–6.

——'The New Sculpture', *The Egoist*, 4/1 (Feb. 1914), 67–8.

——'Mr Hueffer and the Prose Tradition in Verse', *Poetry*, 4/3 (June 1914), 111–20.

——*Instigations* (New York: Boni and Liveright, 1920).

——'Guido's Relations', *Dial*, 86/7 (July 1929), 561.

——*Jefferson and/or Mussolini: L'Idea Statale: Fascism As I Have Seen It* (1935; New York: Liveright, 1936).

——*The Selected Letters of Ezra Pound, 1907–1941*, ed. D. D. Paige (London: Faber, 1950).

——*Literary Essays of Ezra Pound*, ed. T. S. Eliot (London: Faber and Faber, 1954).

——'A Retrospect', in *Literary Essays of Ezra Pound*, ed. T. S. Eliot (London: Faber and Faber, 1954), 12.

——*Pavannes and Divagations* (New York: New Directions, 1958).

——*Gaudier-Brzeska: A Memoir* (1916; Hessle: Marvell Press, 1960).

——*ABC of Reading* (1934; London: Faber and Faber, 1961).

——*The Spirit of Romance* (1910; New York: New Directions, 1968).

——*Selected Prose, 1909–1965*, ed. William Cookson (New York: New Directions, 1973).

——*Selected Poems, 1908–1959* (London: Faber and Faber, 1975).

——*Guide to Kulchur* (1938; London: Peter Owen, 1978).

——*Collected Shorter Poems* (London: Faber, 1984).

——*Personae: The Shorter Poems of Ezra Pound* (1926; New York: New Directions, 1990).

——*The Cantos* (1975; New York: New Directions, 1995).

——*The Pisan Cantos* (1948; New York: New Directions, 2003).

——and FORD, FORD MADOX, *Pound/Ford: The Story of a Literary Friendship: The Correspondence Between Ezra Pound and Ford Madox Ford and Their Writings About Each Other*, ed. Brita Lindberg-Seyersted (London: Faber and Faber, 1982).

——and JOYCE, JAMES, *Pound/Joyce: The Letters of Ezra Pound to James Joyce, with Pound's Essays on Joyce*, ed. Forrest Read (New York: New Directions, 1967).

——and LEWIS, WYNDHAM, *Pound/Lewis: The Letters of Ezra Pound and Wyndham Lewis*, ed. Timothy Materer (London: Faber and Faber, 1985).

——and POUND, DOROTHY, *Ezra and Dorothy Pound: Letters in Captivity, 1945–1946*, ed. Omar Pound and Robert Spoo (New York: Oxford University Press, 1999).

POWER, ARTHUR, *Conversations with James Joyce*, ed. Clive Hart (London: Millington, 1974).

PRENDERGAST, CHRISTOPHER, *The Triangle of Representation* (New York: Columbia University Press, 2000).

PRICE, LORNA, and O'CONNOR, LETITIA (eds), *Taisho Chic: Japanese Modernity, Nostalgia and Deco* (Honolulu: Academy of Fine Arts, 2001).

PRIESTLEY, J. B., *Literature and Western Man* (1960; Harmondsworth: Penguin, 1969).

PRIMUS, ZDENEK (ed.), *Tschechische Avantgarde 1922–1940: Reflexe europäischer Kunst und Fotographie in der Buchgestaltung* (Hamburg: Kunstverein in Hamburg, 1990).

PRINCE, SUE ANN, *The Old Guard and the Avant-Garde* (Chicago: University of Chicago Press, 1990).

PRINTZ-PÅHLSSON, GÖRAN, *Solen i spegeln: Essäer om lyrisk modernism* (Stockholm: Bonniers, 1958).

PRODGER, PHILLIP, *Time Stands Still: Muybridge and the Instantaneous Photography Movement* (New York: Oxford University Press in association with the Iris and B. Gerald Cantor Center for Visual Arts at Stanford University, 2003).

PROFFER, ELLENDEA, and PROFFER, CARL R. (eds), *The Ardis Anthology of Russian Futurism* (Ann Arbor: University of Michigan Press, 1980).

PROKOPOVA, T. F. (ed.), *Serapionovy brat'ia. Antologiia: Manifesty, deklaratsii, stat'i, izbrannaia proza, vospominaniia* (Moscow: Shklola-Press, 1998).

PROUST, MARCEL, *Matinée chez la princesse de Guermantes*, ed. Henri Bonnet (Paris: Gallimard, 1982).

——*Le Temps retrouvé* (1927), ed. Jean-Yves Tadié, iv (Paris: Gallimard, 1989).

——*Within a Budding Grove* (1919), trans. C. K. Scott Moncrieff and Terence Kilmartin (London: Vintage, 1996).

——*Finding Time Again and In Search of Lost Time*, trans. Ian Patterson (Harmondsworth: Penguin, 2002).

——*In Search of Lost Time* (1913–27), v, trans. Carol Clark (London: Allen Lane, 2002).

——*The Way by Swann's* (1913), trans. Lydia Davis (Harmondsworth: Penguin, 2002).

PUCHNER, MARTIN, *Poetry of the Revolution: Marx, Manifestoes and the Avant-Gardes* (Princeton: Princeton University Press, 2006).

PURI, SHALINI, *The Caribbean Postcolonial: Social Equality, Post-Nationalism, and Cultural Hybridity* (Basingstoke: Palgrave Macmillan, 2004).

PUTNAM, SAMUEL, *Paris Was Our Mistress: Memoirs of a Lost and Found Generation* (London: Platin, 1987).

QUARTERMAIN, PETER, *Disjunctive Poetics: From Gertrude Stein and Louis Zukofsky to Susan Howe* (Cambridge: Cambridge University Press, 1992).

RABATÉ, JEAN-MICHEL, 'Joyce and Jolas: Late Modernism and Early Babelism', *Journal of Modern Literature*, 22/2 (1999), 245–52.

——*James Joyce and the Politics of Egoism* (Cambridge: Cambridge University Press, 2001).

——*The Future of Theory* (London: Blackwell, 2002).

RADFORD, GARY P., 'Flaubert, Foucault and the Bibliothèque Fantastique: Toward a Postmodern Epistemology for Library Science', *Library Trends* (Spring 1998), 616–34.

RAEBURN, MICHAEL (ed.), *Salvador Dali: The Early Years* (London: Thames & Hudson, 1994).

RAINE, CRAIG, *T. S. Eliot* (New York: Oxford University Press, 2006).

RAINEY, LAWRENCE, *Institutions of Modernism: Literary Elites and Public Culture* (New Haven: Yale University Press, 1998).

——(ed.), *Modernism: An Anthology* (Oxford: Blackwell, 2005).

RAITT, SUZANNE, *May Sinclair: A Modern Victorian* (Oxford: Oxford University Press, 2000).

RAJADHYAKSHA, ASHISH, 'Satyajit Ray, Ray's Films, and Ray-Movie', *Journal of Arts and Ideas*, 23–4 (Jan. 1993), 7–16.

——and WILLEMEN, PAUL, *Encyclopedia of Indian Cinema* (London: British Film Institute, 2008).

RALEIGH, J. H., 'The New Criticism as an Historical Phenomenon', *Comparative Literature*, 11/1 (Winter 1959), 21–8.

RAMAKRISHNAN, E. V., *Making it New: Modernism in Malayalam, Marathi and Hindi Poetry* (Shimla: Indian Institute of Advanced Study, 1995).

RAMAZANI, JAHAN, *The Hybrid Muse: Postcolonial Poetry in English* (Chicago: University of Chicago Press, 2001).

RAMBERT, MARIE, *Quicksilver* (Basingstoke: Macmillan, 1972).

RAMCHAND, KENNETH, 'Song of Innocence, Song of Experience: Samuel Selvon's *The Lonely Londoners* as a Literary Work', in Susheila Nasta (ed.), *Critical Perspectives on Sam Selvon* (Boulder, Col.: Lynne Reiner, 1988), 223–33.

RAMRAJ, VICTOR J., 'Short Fiction', in James A. Arnold (ed.), *A History of Literature in the Caribbean*, ii: *English- and Dutch-Speaking Regions* (Amsterdam: John Benjamins, 2001), 199–223.

RANK, OTTO, *The Double: A Psychoanalytic Study* (London: Maresfield Library, 1989).

RANSOM, JOHN CROWE, 'The Aesthetic of *Finnegans Wake*', *Kenyon Review*, 1 (Autumn 1939), 424–8.

RATHBONE, BELINDA, *Walker Evans: A Biography* (Boston: Houghton Mifflin, 1995).

RAY, SATYAJIT, *Our Films, their Films* (Bombay: Orient Longman, 1976).

READ, HERBERT, *Reason and Romanticism* (London: Faber and Gywer, 1926).

——'On Subjective Art', *The Bell*, 7/5 (Feb. 1944), 424–9.

REDMAN, TIM, *Ezra Pound and Italian Fascism* (Cambridge: Cambridge University Press, 2009).

REED, BRIAN, 'Hart Crane's Victrola', *Modernism/Modernity*, 7 (Jan. 2000), 99–125.

REED, CHRISTOPHER, *Bloomsbury Rooms: Modernism, Subculture, and Domesticity* (New Haven: Yale University Press, 2004).

REED, CHRISTOPHER ROBERT, *All the World Is Here! The Black Presence at White City* (Bloomington: Indiana University Press, 2002).

REED, DAVID, *The Popular Magazine in Britain and the United States, 1880–1960* (Toronto: University of Toronto Press, 1997).

REES, LAURENCE, *Auschwitz: The Nazis and 'the Final Solution'* (London: BBC Books, 2005).

REEVE, N. H., and KERRIDGE, RICHARD, *Nearly Too Much: The Poetry of J. H. Prynne* (Liverpool: Liverpool University Press, 1995).

REITH, JOHN, *Broadcast Over Britain* (London: Hodder and Stoughton, 1924).

——*Into the Wind* (London: Hodder and Stoughton, 1949).

REMY, MICHEL, *Surrealism in Britain* (Aldershot: Ashgate, 1999).

RENGER-PATZSCH, ALBERT, 'Ziele', repr. as 'Aims', trans. Joel Agee, in Christopher Phillips (ed.), *Photography in the Modern Era: European Documents and Critical Writings, 1913–1940* (New York: Museum of Modern Art and Aperture, 1989), 104–5.

REWALD, JOHN, *The History of Impressionism* (London: Secker and Warburg, 1973).

REYNOLDS, DEE, *Rhythmic Subjects: Uses of Energy in the Dances of Mary Wigman, Martha Graham, and Merce Cunningham* (London: Dance Books, 2007).

BIBLIOGRAPHY 1095

REYNOLDS, JONATHAN M., 'Japan's Imperial Diet Building: Debates Over Construction of a National Identity', *Art Journal*, 55/3 (Fall 1996), 38–47.

REZNIKOFF, CHARLES, *Poems*, i (Boston: Black Sparrow Press, 2005).

RHYS, JEAN, 'Let Them Call It Jazz', *London Magazine*, 1/11 (Feb. 1962), 69–83.

—— *Voyage in the Dark* (1934; London: Penguin, 2000).

—— *Wide Sargasso Sea* (1966; London: Penguin, 2000).

RICHARD, NELLY, 'Cultural Alteritry and Decentering', in Claudia Ferman (ed.), *The Postmodern in Latin and Latino American Cultural Narratives* (New York: Garland, 1996), 3–13.

RICHARDS, JOAN, *Mathematical Visions: The Pursuit of Geometry in Victorian England* (Boston: Academic Press, 1988).

RICHARDS, THOMAS, *The Commodity Culture of Victorian England: Advertising and Spectacle, 1851–1914* (London: Verso, 1991).

RICHARDSON, DOROTHY, *Pilgrimage*, 4 vols (1915–38; London: Virago, 1979).

—— *Journey to Paradise: Short Stories and Autobiographical Sketches*, ed. Trudi Tate (London: Virago, 1989).

—— 'Novels', in Bonnie Kime Scott (ed.), *The Gender of Modernism: A Critical Anthology* (Bloomington: Indiana University Press, 1990), 432–5.

—— 'Women and the Future', in Bonnie Kime Scott (ed.), *The Gender of Modernism: A Critical Anthology* (Bloomington: Indiana University Press, 1990), 411–14.

—— *Windows on Modernism: Selected Letters of Dorothy Richardson*, ed. Gloria Glikin Fromm (Athens: University of Georgia Press, 1995).

RICHARDSON, JOANNA, *The Bohemians: La Vie de Bohème in Paris 1890–1914* (London: Macmillan, 1969).

RICKWORD, EDGELL, *Literature in Society: Essays and Opinions*, ii: *1931–1978*, ed. Alan Young (Manchester: Carcanet, 1978).

RICŒUR, PAUL, *Memory, History, Forgetting*, trans. Kathleen Blamey and David Pellauer (Chicago: University of Chicago Press, 2004).

RIEGER, BERNHARD, *Technology and the Culture of Modernity in Britain and Germany, 1890–1945* (Cambridge: Cambridge University Press, 2005).

RIFFATERRE, MICHAEL, 'Compulsory Reader Response: The Intertextual Drive', in Michael Worton and Judith Still (eds), *Intertextuality: Theories and Practices* (Manchester: Manchester University Press, 1990), 56–78.

RILEY, DENISE, *The Words of Selves: Identification, Solidarity, Irony* (Stanford, Calif.: Stanford University Press, 2000).

RILKE, RAINER MARIA, and SALOMÉ, LOU ANDREAS, *The Correspondence* (New York: Norton, 2006).

RIMBAUD, ARTHUR, *Collected Poems* (London: Penguin, 1962).

RIVIÈRE, JACQUES, '*Le Sacre du printemps*', in Roger Copeland and Marshall Cohen (eds), *What Is Dance?* (Oxford: Oxford University Press, 1983), 115–22.

ROA BASTOS, AUGUSTO, 'Imagen y perspectivas de la narrativa latinoamericana actual', in Juan Loveluck (ed.), *La novela hispanoamericana* (Santiago de Chile: Editorial Universitaria, 1969), 193–211.

ROBERTS, CHARLES G. D., 'The Poetry of Sappho', in Bliss Carman, *Sappho: One Hundred Lyrics* (New York: De Vinne, 1903), pp. v–xi.

—— 'A Note on Modernism', in William Arthur Deacon and Wilfred Reeves (eds), *Open House* (Ottawa: Graphic, 1931), 19–25.

—— *Collected Poems of Sir Charles G. D. Roberts: A Critical Edition*, ed. Desmond Pacey (Wolfville, NS: Wombat Press, 1985).

ROBERTS, GWYNETH TYSON, *The Language of the Blue Books: The Perfect Instrument of Empire* (Cardiff: University of Wales Press, 1998).

ROBERTS, KATE, 'Tsiechoff yn Gymraeg', *Y Faner*, 29 (Sept. 1954), 1.

——'Gwilyn Rees Hughes yn Holi Kate Roberts', *Barn*, 139 (May 1974), 280–4.

—— *Traed Mewn Cyffion* (Llandysul: Gomer, 1988); trans. John Idris Jones as *Feet in Chains* (Ruthin: John Jones, 1996).

ROBERTS, LYNETTE, *Collected Poems*, ed. Patrick McGuinness (Manchester: Carcanet, 2005).

ROBERTS, MICHAEL, 'Beyond the Golden Bars', *Poetry Review*, 20/2 (Mar.–Apr. 1929), 109–18.

ROBINS, ANNA GRUETZNER, *Modern Art in Britain, 1910–1914*, exh. cat. (London: Merrell Holberton in association with the Barbican Art Gallery, 1997).

RODCHENKO, ALEXANDER, *Experiments for the Future: Diaries, Essays, Letters, and Other Writings*, ed. Alexander N. Lavrentiev, trans. Jamey Gambrell (New York: Museum of Modern Art, 2005).

RODKER, JOHN, *Poems & Adolphe 1920*, ed. Andrew Crozier (Manchester: Carcanet, 1996).

RODOWICK, D. N., *Gilles Deleuze's Time Machine* (Durham, NC: Duke University Press, 1997).

ROHRBACH, JOHN, '*Time in New England*: Creating a Usable Past', in Maren Stange (ed.), *Paul Strand: Essays on His Life and Work* (New York: Aperture, 1990), 161–77.

ROSE, JACQUELINE, *Why War? Psychoanalysis, Politics, and the Return to Melanie Klein* (Oxford: Blackwell, 1993).

ROSE, JONATHAN, *The Intellectual Life of the British Working Classes* (New Haven: Yale University Press, 2001).

ROSE, SHIRLEY, 'The Unmoving Center: Consciousness in Dorothy Richardson's *Pilgrimage*', *Contemporary Literature*, 10/3 (Summer 1969), 366–82.

——'Lady Chatterley's Broker: Banking on Modernism', *Common Review*, 6/3 (Nov. 2008), 13–24.

ROSENBAUM, S. P., 'Bertrand Russell in Bloomsbury', *Russell*, 4/1 (1984), 11–29.

——(ed.), *The Bloomsbury Group: A Collection of Memoirs and Commentary* (Toronto: University of Toronto Press, 1995).

ROSENBERG, FERNANDO, 'The Geopolitics of Affect in the Poetry of Brazilian Modernism', in Laura Doyle and Laura Winkiel (eds), *Geomodernisms: Race, Modernism, Modernity* (Bloomington: Indiana University Press, 2005), 77–95.

—— *The Avant-Garde and Geopolitics in Latin America* (Pittsburgh: Pittsburgh University Press, 2006).

ROSENBERG, LEAH, 'Caribbean Models for Modernism in the Work of Claude McKay and Jean Rhys', *Modernism/Modernity*, 11/2 (Apr. 2004), 219–38.

ROSENBLUM, NAOMI, 'The Early Years', in Maren Stange (ed.), *Paul Strand: Essays on His Life and Work* (New York: Aperture, 1990), 31–51.

ROSENBLUM, ROBERT, *Cubism and Twentieth-Century Art* (New York: Harry N. Abrams, 1966).

ROSENQUIST, ROD, *Modernism, the Market and the Institution of the New* (Cambridge: Cambridge University Press, 2009).

ROSS, CHAD, *Naked Germany: Health, Race, and the Nation* (Oxford: Berg, 2005).

ROSS, COREY, *Media and the Making of Modern Germany: Mass Communications, Society, and Politics from the Empire to the Third Reich* (Oxford: Oxford University Press, 2008).

ROSS, KRISTIN, *The Emergence of Social Space: Rimbaud and the Paris Commune* (London: Verso, 2008).

ROSS, W. W. E., *Irrealities, Sonnets, and Laconics*, ed. Barry Callaghan and Gregory Betts (Toronto: Exile Editions, 2003).

ROSSEL, SVEN H., *A History of Scandinavian Literature, 1870–1980* (Minneapolis: University of Minnesota Press, 1982).

ROTHKIRCH, ALYCE VON, and WILLIAMS, DANIEL (eds), *Beyond the Difference: Welsh Literature in Comparative Contexts* (Cardiff: University of Wales Press, 2004).

ROUDINESCO, ÉLISABETH, *Jacques Lacan* (Cambridge: Polity Press, 1997).

ROUSOVÁ, HANA (ed.), *Deviace kubismu v Čechách/Deviationen des Kubismus in Böhmen*, exh. cat. (Cheb: Staatsgalerie der bildenen Künste, 1995).

ROY, ARUNDHATI, *The God of Small Things* (New York: Harper Perennial, 1998).

RUBIN, JAMES H., *Impressionism* (London: Phaidon Press, 1999).

RUBIN, WILLIAM, *Picasso and Braque: Pioneering Cubism* (London: Museum of Modern Art, 1989).

RUDNITSKY, KONSTANTIN, *Russian and Soviet Theatre: Tradition and the Avant-Garde* (London: Thames & Hudson, 1988).

RUFFO, ARMAND GARNET, 'Out of the Silence—the Legacy of E. Pauline Johnson: An Inquiry into the Lost and Found Work of Dawendine—Bernice Loft Winslow', in Christl Verduyn (ed.), *Literary Pluralities* (Peterborough, Ont.: Broadview, 1998), 211–23.

RUSKIN, JOHN, *The Nature of Gothic: A Chapter from the Stones of Venice* (1853; London: George Allen, 1899).

—— *The Crown of Wild Olive* (1866; London: George Allen, 1900).

—— *The Two Paths: Being Lectures in Art, and its Application to Decoration, Delivered in 1858–9* (1859; London: George Allen, 1901).

RUSSELL, BERTRAND, 'Science as an Element in Culture', *New Statesman*, 1 (24, 31 May 1913), 202–4, 234–6.

RYAN, JOHN (ed.), *A Bash in the Tunnel: James Joyce by the Irish* (Brighton: Clifton Books, 1970).

SADÍLKOVÁ, PAVLA, *Vincenc Kramář: From Old Masters to Picasso*, exh. cat. (Prague: National Gallery, 2000).

SAID, EDWARD, *Culture and Imperialism* (New York: Vintage, 1994).

SALARIS, CLAUDIA, 'Marketing Modernism: Marinetti as Publisher', *Modernism/Modernity*, 1, special issue: *Marinetti and the Italian Futurists* (1994), 109–27.

SANCHEZ-PARDO, ESTHER, *Cultures of the Death Drive: Melanie Klein and Modernist Melancholia* (Durham, NC: Duke University Press, 2003).

SAND, JORDAN, *House and Home in Modern Japan: Architecture, Domestic Space and Bourgeois Culture, 1880–1930* (Cambridge, Mass.: Harvard University Asia Center, 2005).

SANDQVIST, TOM, *Dada East: The Romanians of Cabaret Voltaire* (Cambridge, Mass.: MIT Press, 2006).

SANTAYANA, GEORGE, *The Last Puritan* (New York: Charles Scribner's Sons, 1936).

SANTIÁÑEZ, NIL, *Investigaciones literarias: Modernidad, historia de la literatura y modernismos* (Barcelona: Editorial Crítica, 2002).

SAPIRO, GISÈLE, 'Portrait of the Writer as a Traitor: The French Purge Trials (1944–1953)', in Jennifer Birkett and Stan Smith (eds), *Right/Left/Right: Revolving Commitments: France and Britain, 1929–1950* (Newcastle: Cambridge Scholars, 2008), 187–204.

SARKAR, BENOY, 'The Aesthetics of Young India', *Rupam*, 9 (Jan. 1922), 8–24.

SARTRE, JEAN-PAUL, *The Transcendence of the Ego* (1937), trans. Forrest Williams and Robert Kirkpatrick (New York: Hill and Wang, 1960).

SASSOON, SIEGFRIED, *Selected Poems* (London: Faber, 1961).

SATO, BARBARA HAMILL, 'The Moga Sensation: Perceptions of the Modan Gâru in Japanese Intellectual Circles during the 1920s', *Gender and History*, 5/3 (Autumn 1993), 363–81.

—— *The New Japanese Woman: Modernity, Media and Women in Interwar Japan* (Durham, NC: Duke University Press, 2003).

SAUNDERS, MAX, *Ford Madox Ford: A Dual Life*, 2 vols (Oxford: Oxford University Press, 1996).

SAYER, DERIK, *The Coasts of Bohemia: A Czech History* (Princeton: Princeton University Press, 1998).

SAZHIN, V., and KARASIK, M. (eds), *Kharmsizdat predstavliaet: Avangardnoe povedenie. Sbornik materialov* (St Petersburg: M. K. Kharmsizdat, 1998).

SCANNELL, PADDY, and CARDIFF, DAVID, *A Social History of British Broadcasting*, i: *1929–1939: Serving the Nation* (London: Blackwell, 1991).

SCHADE, JENS AUGUST, *Kællinge-Digte eller Lykkelig Kærlighed* (Copenhagen: Thaning og Appels Forlag, 1944).

SCHEERBART, PAUL, *Glasarchitektur* (Berlin: Verlag Der Sturm, 1914).

SCHEUNEMANN, DIETRICH (ed.), *Expressionist Film—New Perspectives* (Rochester, NY: Camden House, 2003).

SCHIAVO, ALBERTO, *Futurismo e fascismo* (Rome: Volpe, 1981).

SCHILLER, FRIEDRICH, *Classical and Romantic German Aesthetics*, ed. J. M. Bernstein (Cambridge: Cambridge University Press, 2003).

SCHILLING, JÜRGEN, *Wille zur Form: Ungegenständliche Kunst 1910–1938 in Österreich, Polen, Tschechoslowakei und Ungarn*, exh. cat. (Vienna: Hochschule für Angewandte Kunst, 1993).

SCHIVELBUSCH, WOLFGANG, *Disenchanted Night: The Industrialization of Light in the Nineteenth Century* (Berkeley: University of California Press, 1992).

——*Three New Deals: Reflections on Roosevelt's America, Mussolini's Italy, and Hitler's Germany, 1933–1939*, trans. Jefferson Chase (New York: Metropolitan, 2006).

SCHLEGEL, FRIEDRICH, *Philosophical Fragments*, trans. Peter Firchow (Minneapolis: University of Minnesota Press, 1991).

SCHMIED, WIELAND, *Neue Sachlichkeit and the German Realism of the Twenties* (London: Arts Council of Great Britain, 1978).

SCHMITT, HANS-JÜRGEN (ed.), *Die Expressionismusdebatte: Materialien zu einer Marxistischen Realismuskonzeption* (Frankfurt: Suhrkamp, 1973).

SCHNAPP, JEFFREY T., 'Propeller Talk', *Modernism/Modernity*, 1 (1993), 153–78.

——SHANKS, MICHAEL, and TIEWS, MATTHEW, 'Archaeologies of the Modern', *Modernism/Modernity*, 11/1 (2004), 1–16.

SCHNITZLER, ARTHUR, *Anatol*, trans. Granville Barker (New York: Mitchell Kennerley, 1911).

SCHOLES, ROBERT, *Structuralism in Literature* (New Haven: Yale University Press, 1974).

——*Paradoxy of Modernism* (New Haven: Yale University Press, 2006).

——'Afterword: Small Magazines, Large Ones, and Those In-Between', in Suzanne W. Churchill and Adam McKible (eds), *Little Magazines and Modernism: New Approaches* (Aldershot: Ashgate, 2007), 217–25.

SCHUMPETER, JOSEPH, *Capitalism, Socialism and Democracy* (New York: Harper, 1975).

SCHWAB, GABRIELE, *Subjects Without Selves: Transitional Texts in Modern Fiction* (Cambridge, Mass.: Harvard University Press, 1994).

SCHWARZ, BILL (ed.), *West Indian Intellectuals in Britain* (Manchester: Manchester University Press, 2003).

SCHWARTZ, DELMORE, *Selected Essays of Delmore Schwartz*, ed. Donald Dike and David Zucker (Chicago: University of Chicago Press, 1970).

SCHWARTZ, VANESSA R., 'Walter Benjamin for Historians', *American Historical Review*, 106 (2001), 1721–43.

SCHWEIZER, BERNARD, *Radicals on the Road: The Politics of English Travel Writing in the 1930s* (Charlottesville: University of Virginia Press, 2001).

SCONCE, JEFFREY, *Haunted Media: Electronic Presence from Telegraphy to Television* (Durham, NC: Duke University Press, 2000).

SCOTT, ALEXANDER, and GIFFORD, DOUGLAS (eds), *Neil M. Gunn: The Man and the Writer* (Edinburgh: Blackwood, 1973).

SCOTT, BONNIE KIME (ed.), *The Gender of Modernism: A Critical Anthology* (Bloomington: Indiana University Press, 1990).

——*Refiguring Modernism*, i: *The Women of 1928* (Bloomington: Indiana University Press, 1995).

——(ed.), *Gender in Modernism: New Geographies, Complex Intersections* (Urbana: University of Illinois Press, 2007).

SCOTT, CLIVE, 'Symbolism, Decadence and Impressionism', in Malcolm Bradbury and James McFarlane (eds), *Modernism: A Guide to European Literature, 1890–1930* (Harmondsworth: Penguin, 1976), 206–27.

——*Vers Libre: The Emergence of Free Verse in France, 1886–1914* (Oxford: Oxford University Press, 1990).

SCOTT, H. G. (ed.), *Soviet Writers' Congress 1934: The Debate on Socialist Realism and Modernism* (London: Lawrence & Wishart, 1977).

SCOTT, WILLIAM B., and RUTKOFF, PETER M., 'Paris and New York: From Cubism to Dada', in Scott and Rutkoff, *New York Modern: The Arts and the City* (Baltimore: Johns Hopkins University Press, 1999), 44–72.

SCROGGINS, MARK, *The Poem of a Life: A Biography of Louis Zukofsky* (Emeryville, Calif.: Shoemaker & Hoard, 2007).

SEDGWICK, EVE KOSOFSKY, *Epistemology of the Closet* (Berkeley: University of California Press, 1990).

SELVON, SAM, *The Lonely Londoners* (1956; Harlow: Longman, 1985).

SHAKESPEARE, WILLIAM, *King Lear* (New York: Random House, 1964).

SHAPIRO, STEPHEN, *The Culture and Commerce of the Early American Novel: Reading the Atlantic World-System* (Pittsburgh: Pennsylvania State University Press, 2008).

SHARPE, JENNY, *Allegories of Empire: The Figure of Woman in the Colonial Text* (Minneapolis: University of Minnesota Press, 1993).

SHATTUCK, ROGER, *The Banquet Years: The Arts in France, 1885–1918* (London: Faber and Faber, 1957).

SHAW, GEORGE BERNARD, *Getting Married* and *Press Cuttings* (Harmondsworth: Penguin, 1986).

——*The Quintessence of Ibsenism* (1891; New York: Dover, 1994).

SHAW, DONALD L., *The Generation of 1898 in Spain* (London: Ernest Benn, 1975).

——'El 98 y la "conscience malheureuse" del siglo XX', in Jesús Torrecilla (ed.), *La generacion del 98 frente al nuevo fin de siglo* (Amsterdam: Rodopi, 2000), 293–300.

——'When Was Modernism in Spanish American Fiction?', *Bulletin of Spanish Studies*, 79 (2002), 395–409.

——'The Paradox of Spanish American Vanguardism', *A Contracorriente*, 1/2 (2004), 31–9.

SHEA, GEORGE T., *Leftwing Literature in Japan* (Tokyo: Hōsei University Press, 1964).

SHEPPARD, RICHARD, 'Dada and Expressionism', *Papers of the English Goethe Society*, 49 (1979), 45–83.

——'What Is Dada?', *Orbis Litterarum*, 34 (1979), 175–207.

——'The Problematics of European Modernism', in Steve Giles (ed.), *Theorizing Modernism*, 1–51.

——*Modernism—Dada—Postmodernism* (Evanston, Ill.: Northwestern University Press, 2000).

SHEPPARD, ROBERT, *The Poetry of Saying: British Poetry and its Discontents, 1950–2000* (Liverpool: Liverpool University Press, 2005).

SHERIDAN, NIALL, 'Brian, Flann and Myles', in Timothy O'Keeffe (ed.), *Myles: Portraits of Brian O'Nolan* (London: Martin, Brien & O'Keeffe, 1973), 32–53.

SHERRY, NORMAN, *Conrad* (London: Thames & Hudson, 1998).

SHERRY, VINCENT, *The Great War and the Language of Modernism* (Oxford: Oxford University Press, 2003).

SHIACH, MORAG, *Modernism, Labour and Selfhood in British Literature and Culture, 1890–1930* (Cambridge: Cambridge University Press, 2004).

——(ed.), *The Cambridge Companion to the Modernist Novel* (Cambridge: Cambridge University Press, 2007).

SHINER, LARRY, ' "Review" of Nicholas Thomas', *Journal of Aesthetics and Art Criticism*, 60/2 (Spring 2002), 196–7.

SHKLOVSKY, V., 'Paralleli u Tolstogo', in *Khod konia* (Moscow: Gelikon, 1923) 115–25.

——*Zoo, or, Letters Not About Love*, trans. R. Sheldon (Ithaca, NY: Cornell University Press, 1971).

——*A Sentimental Journey: Memoirs, 1917–1922*, trans. R. Sheldon (Ithaca, NY: Cornell University Press, 1984).

——*Theory of Prose*, trans. B. Sher (Normal, Ill.: Dalkey Archive Press, 1991).

——'Pochta veka. Iz perepiski Viktora Shklovskogo', in N. Panchenko and N. Bialosinskaia (eds) *Tarusskie stranitsy: Vtoroi vypusk* (Moscow: Grani, 2003).

——'Eugene Onegin (Pushkin and Sterne)', trans. E. Finer, *Comparative Critical Studies*, 1/1–2 (Feb 2004), 171–93.

——with GALUSHKIN, A. (eds), *Gamburgskii schet: Stat'i—vospominaniia—esse (1914–1933)* (Moscow: Sovetskii pisatel', 1990).

SHOWALTER, ELAINE, *A Literature of Their Own: British Women Novelists from Brontë to Lessing* (London: Virago, 1977).

——*The Female Malady: Women, Madness, and English Culture, 1830–1980* (New York: Pantheon, 1985).

SHUKMAN, ANN, *Literature and Semiotics* (Amsterdam: North-Holland, 1977).

SIBBALD, KAY, and YOUNG, HOWARD (eds), *T. S. Eliot and Hispanic Modernity, 1924–1993* (Boulder, Col.: Society of Spanish and Spanish American Studies, 1994).

SIDNEY, PHILIP, *A Defence of Poetry*, ed. J. A. van Dorsten (Oxford: Oxford University Press, 1966).

SIEBENHAAR, KLAUS (ed.), *Das poetische Berlin: Metropolenkultur zwischen Gründerzeit und Nazionalsozialismus* (Wiesbaden: DUV, 1992).

SIEBURTH, RICHARD, *Instigations: Ezra Pound and Rémy de Gourmont* (Cambridge, Mass.: Harvard University Press, 1978).

SIEGEL, LEE, 'The Blush of the New', *New York Times*, 30 Dec. 2007, <http://www.nytimes.com/2007/12/30/books/review/Siegel-t.html?pagewanted=print>.

SIEGEL, MARCIA, 'Afternoon of a Legend: Nijinsky, the Choreographer', *Dance Now*, 11/2 (Summer 2002), 3–11.

SILLIMAN, RON (ed.), *In the American Tree* (Maine: National Poetry Foundation, 1986).

SILVA, JOSÉ ASUNCIÓN, *Obra completa* (Caracas: Biblioteca Ayacucho, 1985).

SILVERBERG, MIRIAM, 'The Modern Girl as Militant', in Gail Lee Bernstein (ed.), *Recreating Japanese Women: 1600–1945* (Berkeley: University of California Press, 1991), 239–66.

——'The Café Waitress Serving Modern Japan', in Stephen Vlastos (ed.), *Mirror of Modernity: Invented Traditions of Modern Japan* (Berkeley: University of California Press, 1998), 208–25.

——*Erotic Grotesque Nonsense: The Mass Culture of Japanese Modern Times* (Berkeley: University of California Press, 2007).

SIMA CHANGFENG, *Zhongguo xinwenxue shi*, ii (Hong Kong: Shaoming shudian, 1978).

SIME, J. G., *Orpheus in Quebec* (London: George Allen & Unwin, 1942).

SIMMEL, GEORG, 'Die Großstädte und das Geistesleben', in *Die Großstadt: Jahrbuch der Gehe-Stiftung*, 9 (1903), 185–206.

——'The Metropolis and Mental Life', in *Simmel on Culture: Selected Writings*, ed. David Frisby and Mike Featherstone (London: Sage, 1997), 174–85.

SINCLAIR, MAY, *The Three Brontës* (London: Hutchinson, 1912).

——'Clinical Lectures on Symbolism and Sublimation, 1', *Medical Press*, 152 (9 Aug. 1916), 118–22; 2, *Medical Press*, 153 (16 Aug. 1916), 142–5.

——*A Defence of Idealism* (London: Macmillan, 1917).

——'The Novels of Dorothy Richardson', *The Egoist*, 5 (Apr. 1918), 57–9; *Little Review*, 4 (Apr. 1918), 3–11.

——Contribution to 'Christmas Symposium on Dreams, Ghosts and Fairies', *Bookman* (Dec. 1923), 142–9.

——*Mary Olivier: A Life* (1919; London: Virago, 1980).

——'The Novels of Dorothy Richardson', in Bonnie Kime Scott (ed.), *The Gender of Modernism: A Critical Anthology* (Bloomington: Indiana University Press, 1990), 442–8.

SITWELL, EDITH, *Fire of the Mind*, ed. Elizabeth Salter and Allanah Harper (London: Michael Joseph, 1976).

SKINNER, CONSTANCE LINDSAY, 'Foreword', in Skinner, *Songs of the Coast Dwellers* (New York: Coward McCann, 1930), pp. vii–ix.

SKINNER, DAMIEN, 'Making Modernism: Helen Stewart and the Wellington Art Scene 1946–1960', *Art New Zealand*, 96 (Spring 2000), 102–6.

SLEMON, STEPHEN, 'Modernism's Last Post', in Ian Adam and Helen Tiffin (eds), *Past the Last Post* (Hemel Hempstead: Harvester Wheatsheaf, 1991), 1–11.

SLOCOMBE, WILL, and HILL, JENNIE, 'Archive-Text: An Interdisciplinary Dialogue', *English Language Notes*, 45/1 (2007), 21–31.

SMART, JOHN, *Modernism and After: English Literature, 1910–1939* (Cambridge: Cambridge University Press, 2008).

SMITH, A. J. M., 'Introduction', in Smith, *The Book of Canadian Poetry: A Critical and Historical Anthology* (Chicago: University of Chicago Press, 1943), 3–31.

SMITH, BERNARD, *European Vision and the South Pacific, 1768–1850: A Study in the History of Art and Ideas* (Oxford: Oxford University Press, 1960).

SMITH, SIDONIE, *Moving Lives: Twentieth-Century Women's Travel Writing* (Minneapolis: University of Minnesota Press, 2001).

SMITH, STAN, *The Origins of Modernism: Eliot, Pound, Yeats and the Rhetorics of Renewal* (Hemel Hempstead: Harvester Wheatsheaf, 1994).

——'Burbank with a Baedeker: Modernism's Grand Tours', *Studies in Travel Writing*, 8/1 (Mar. 2004), 1–18.

SNAITH, ANNA, '"A Savage from the Cannibal Islands": Jean Rhys and London', in Peter Brooker and Andrew Thacker (eds), *Geographies of Modernism: Literatures, Cultures, Spaces* (London: Routledge, 2005), 76–85.

SNITOW, ANN BARR, *Ford Madox Ford and the Voice of Uncertainty* (Baton Rouge: Louisiana State University Press, 1984).

SÖDERGRAN, EDITH, *Samlade dikter* (Stockholm: Wahlström & Widstrand, 1989).

SOFFICI, ARDENGO, *BIF§ZF+18: Simultaneità e chimismi lirici* (Florence: Edizioni della 'Voce', 1915).

SOLLERS, PHILIPPE (ed.), *Tel Quel: Théorie d'ensemble* (Paris: Seuil, 1968).

SOLLORS, WERNER, *Ethnic Modernism* (Cambridge, Mass.: Harvard University Press, 2008).

SØRENSEN, PEER E., *Udløb i uendeligheden: Læsninger i Sophus Claussens lyrik* (Copenhagen: Gyldendal, 1997).

SORIA OLMEDO, ANDRÉS, 'Jorge Guillén y la "joven literatura"', in Antonio Piedra and Javier Blasco Pacual (eds), *Jorge Guillén, el hombre y la obra* (Valladolid: Valladolid University Press and the Fundación Jorge Guillén, 1995), 257–78.

SOUFAS, CHRISTOPHER, 'Tradition as an Ideological Weapon: The Critical Redefinition of Modernity and Modernism in Early Twentieth Century Spanish Literature', *Anales de la Literatura Española Contemporánea*, 23/1 (1998), 465–77.

——*The Subject in Question: Early Contemporary Spanish Literature and Modernism* (Washington, DC: Catholic University of America Press, 2007).

SOUSTER, RAYMOND, Interview with John Nause and J. Michael Heenan, *CV/2*, 3/2 (1977), 8–11.

SPACKMAN, BARBARA, 'Mafarka and Son: Homophobic Economics', *Modernism/Modernity*, 1, special issue: *Marinetti and the Italian Futurists* (1994), 89–107.

SPECTOR, SCOTT, *Prague Territories: National Conflict and Cultural Innovation in Franz Kafka's Fin de Siècle* (Berkeley: University of California Press, 2000).

SPIRES, ROBERT, *Beyond the Metafictional Mode: Directions in the Modern Spanish Novel* (Lexington: Kentucky University Press, 1984).

——*Transparent Simulacra: Spanish Fiction, 1902–1926* (Columbia: Missouri University Press, 1988).

SPOO, ROBERT, *James Joyce and the Language of History: Dedalus's Nightmare* (New York: Oxford University Press, 1995).

SPOTO, DONALD, *Blue Angel: The Life of Marlene Dietrich* (New York: Cooper Square Press, 2000).

SRP, KARL, 'Karel Teige in the Twenties: The Moment of Sweet Ejaculation', in Eric Dluhosch and Rostislav Švácha (eds), *Karel Teige: L'Enfant Terrible of the Czech Modernist Avant-Garde* (Cambridge, Mass.: MIT Press, 1999), 12–45.

STACEY, ROBERT, 'Afterword', in Dawendine [Bernice Loft Winslow], *Iroquois Fires: The Six Nations Lyrics and Lore of Dawendine (Bernice Loft Winslow)* (Ottawa: Penumbra Press, 1995), 143–52.

——SMITH, DONALD, and WINSLOW COLWELL, BRYAN, 'Introduction', in Dawendine [Bernice Loft Winslow], *Iroquois Fires: The Six Nations Lyrics and Lore of Dawendine (Bernice Loft Winslow)* (Ottawa: Penumbra Press, 1995), 11–21.

STALLYBRASS, OLIVER (ed.), *Aspects of E. M. Forster* (London: Edward Arnold, 1969).

STANISLAWSKI, RYSZARD, and BROCKHAUS, CHRISTOPH (eds), *Europa, Europa: Das Jahrhundert der Avantgarde in Mittel- und Osteuropa*, 4 vols, exh. cat. (Bonn: Stiftung Kunst und Kultur des Landes Nordrhein-Westfalen; Kunst- und Ausstellungshalle der Bundesrepublik Deutschland, 1994).

STAPANIAN, JULIETTE, *Mayakovsky's Cubo-Futurist Vision* (Houston: Rice University Press, 1986).

STAPE, JOHN HENRY (ed.), *Virginia Woolf: Interviews and Recollections* (Iowa City: University of Iowa Press, 1995).

——*The Several Lives of Joseph Conrad* (New York: Random House, 2007).

STEELE, CHARLES (ed.), *Taking Stock: The Calgary Conference on the Canadian Novel* (Downsview, Ont.: ECW, 1982).

STEFANILE, FELIX (trans.), *The Blue Moustache: Some Futurist Poets* (Manchester: Carcanet New Press, 1981).

STEIN, GERTRUDE, *Narration: Four Lectures by Gertrude Stein*, introd. Thornton Wilder (Chicago: University of Chicago Press, 1935).

——*The Geographical History of America, or, The Relation of Human Nature to the Human Mind* (1936; New York: Vintage, 1973).

——'I Came and Here I Am', *Cosmopolitan* (Feb. 1936);repr. in Robert Bartlett Haas (ed.), *How Writing Is Written*, vol. ii of *The Previously Uncollected Writings of Gertrude Stein* (Los Angeles: Black Sparrow Press, 1974), 71–2.

——*Stein: Writings*, ed. Catherine R. Stimpson and Harriet Chessman, 2 vols (New York: Library of America, 1998).

STEINBERG, STEPHEN COBBETT (ed.), *The Dance Anthology* (New York: New American Library, 1980).

STEPHENS, MEIC (ed.), *Rhys Davies: Decoding the Hare* (Cardiff: University of Wales Press, 2003).

STEPHENS, MICHELLE ANN, *Black Empire: The Masculine Global Imaginary of Caribbean Intellectuals in the United States, 1914–1962*, (Durham NC: Duke University Press, 2005).

STEVENS, WALLACE, *Notes Toward a Supreme Fiction* (Cummington, Mass.: Cummington Press, 1942).

STEWART, GARRETT, *Between Film and Screen: Modernism's Photo Synthesis* (Chicago: University of Chicago Press, 1999).

STIEGLITZ, ALFRED, 'The Photo-Secession', in Beaumont Newhall (ed.), *Photography: Essays and Images* (New York: Museum of Modern Art, 1980).

STOCK, NOEL, *The Life of Ezra Pound* (Harmondsworth: Penguin, 1974).

STOCKING, GEORGE, *Victorian Anthropology* (London: Macmillan, 1987).

STOKES, JOHN, *In the Nineties* (London: Harvester Wheatsheaf, 1989).

STOKES, RAYMOND G., 'Plastics and the New Society: The German Democratic Republic in the 1950s and 1960s', in Susan Reid and David Crowley (eds), *Style and Socialism: Modernity and Material Culture in Post-War Eastern Europe* (Oxford: Berg, 2000), 65–80.

STONEBRIDGE, LYNDSEY, *The Destructive Element: British Psychoanalysis and Modernism* (London: Routledge, 1998).

STRACHEY, JAMES, and STRACHEY, ALIX, *Bloomsbury/Freud: The Letters of James and Alix Strachey, 1924–1925*, ed. Perry Meisel and Walter Kendrick (London: Chatto & Windus, 1986).

STRACHEY, LYTTON, *Elizabeth and Essex* (San Diego: Harcourt Brace Jovanovich, 1956).

——*The Really Interesting Question and Other Papers* (London: Weidenfeld & Nicolson, 1972).

STRAGNELL, S., 'A Study in Sublimations', *Psychoanalytic Review*, 10 (1923), 209–13.

STRAND, PAUL, 'Photography', *Camera Work*, 49–50 (1917), 780.

STRINDBERG, AUGUST, *Samlade skrifter*, xiii (Stockholm: Albert Bonniers Förlag, 1913).

STRINGER, ARTHUR, 'Foreword', in Stringer, *Open Water* (New York: John Lane, 1914), 9–18.

STRUTT, R. J., 'A Popular Book on Radioactivity', *The Speaker*, 13/320 (18 Nov. 1905), 162–3.

STUDLAR, GAYLYN, 'Masochism, Masquerade, and the Erotic Metamorphoses of Marlene Dietrich', in Jane Gaines and Charlotte Herzog (eds), *Fabrications: Costume and the Female Body* (New York: Routledge, 1990), 229–49.

SUGAR, PETER F., and LEDERER, IVO J. (eds), *Nationalism in Eastern Europe* (Seattle: University of Washington Press, 1969).

SULEIMAN, SUSAN RUBIN, *Subversive Intent: Gender, Politics and the Avant-Garde* (New Haven: Yale University Press, 1990).

SULLIVAN, J. W. N., 'A Stylist in Science', *The Athenaeum* (11 July 1919), 593.

——'Science and Personality', *The Athenaeum* (18 July 1919), 624.

——'Marginalia', *The Athenaeum* (21 May 1920), 672.

——'Popular Science', *The Athenaeum* (1 Oct. 1920), 444–5.

——*Aspects of Science* (London: Cobden-Sanderson, 1923).

SULLIVAN, ROSEMARY, *By Heart: Elizabeth Smart, a Life* (Toronto: Viking Canada, 1991).

SUNDARAM, VIVAN, et al., *Amrita Sher-Gil* (Bombay: Marg, 1972).

SURETTE, LEON, *The Birth of Modernism: Ezra Pound, T. S. Eliot, W. B. Yeats and the Occult* (Montreal: McGill-Queen's University Press, 1993).

SUTCLIFFE, ANTHONY, *Towards the Planned City: Comparative Studies in Social and Economic History* (Oxford: Blackwell, 1981).

SUTHERLAND, JOHN, 'Doughy', *London Review of Books* (4 Dec. 2003), 14–15.

SUTHERLAND-ADDY, ESI, and DIAW, AMINATA (eds), *Women Writing Africa: West Africa and the Sahel* (Paris: Karthala, 2001).

SUZUKI, TOMI, *Narrating the Self: Fictions of Japanese Modernity* (Stanford, Calif.: Stanford University Press, 1996).

ŠVÁCHA, ROSTISLAV, *The Architecture of New Prague, 1895–1945* (Cambridge, Mass.: MIT Press, 1995).

——(ed.), *Devtsil—Czech Avant-Garde Art, Architecture and Design of the 1920s and 1930s*, exh. cat. (Oxford: Museum of Modern Art: London: Design Museum, 1990).

SVARNY, ERIK, *The Men of 1914: T. S. Eliot and Early Modernism* (London: Open University Press, 1988).

SVESTKA, JIRI, and VLČEK, TOMÁŠ(eds), *1909–1925 Kubismus in Prag: Malerei, Skulptur, Kunstgewerbe, Architektur*, exh. cat. (Düsseldorf: Kunstverein für die Rheinlande und Westfalen; Stuttgart: G. Hatje, 1991).

SWORD, HELEN, 'Modernist Mediumship', in Lisa Rado (ed.), *Modernism, Gender, and Culture: A Cultural Studies Approach* (New York: Garland, 1997), 65–77.

——'Necrobibliography: Books in the Spirit World', *Modern Language Quarterly*, 60/1 (1999), 85–112.

SYMONDS, JOHN ADDINGTON, *Male Love* (1901; New York: Pagan Press, 1983).

SYMONS, ARTHUR, *Studies in Prose and Verse* (London: J. M. Dent, 1904).

SZABADI, JUDIT, *Art Nouveau in Hungary: Painting, Sculpture and the Graphic Arts* (Budapest: Corvina, 1989).

SZASZ, THOMAS, *'My Madness Saved Me': The Madness and Marriage of Virginia Woolf* (London: Transaction, 2006).

TAGORE, RABINDRANATH, *Selected Writings on Literature and Language*, ed. and trans. S. Chaudhuri et al. (Delhi: Oxford University Press, 2001).

TAKAMURA KŌTARŌ, *A Brief History of Imbecility: Poetry and Prose of Takamura Kotaro*, trans. Hiroaki Sato (Honolulu: University of Hawai'i Press, 1992).

TALBOT, WILLIAM FOX, 'Some Account of the Art of Photogenic Drawing', in Vicky Goldberg (ed.), *Photography in Print: Writings from 1816 to the Present* (New York: Simon & Schuster, 1981), 36–48.

TALL, E., 'The Reception of James Joyce in Russia', in G. Lernout and W. Van Mierlo (eds), *The Reception of James Joyce in Europe*, i (London: Thoemmes Continuum, 2004), 244–58.

TANAKA, STEFAN, *Japan's Orient: Rendering Pasts into History* (Berkeley: University of California Press, 1993).

TASHJIAN, DICKRAN, *A Boatload of Madmen: Surrealism and the American Avant-Garde, 1920–1950* (New York: Thames & Hudson, 1995).

——'Authentic Spirit of Change: The Poetry of New York Dada', in Francis M. Naumann and Beth Venn (eds), *Making Mischief: Dada Invades New York* (New York: Whitney Museum of American Art, 1996), 266–71.

TATE, ALLEN, *On the Limits of Poetry: Selected Essays, 1928–1948* (New York: Swallow Press, 1948).

TATE, TRUDI, *Modernism, History and the First World War* (Manchester: Manchester University Press, 1996).

TAYLOR, GARY, *Orage and the New Age* (Sheffield: Sheffield Hallam University Press, 2000).

TAYLOR, RICHARD (ed.), *The Eisenstein Reader*, trans. Richard Taylor and William Powell (London: BFI, 1998).

TAYLOR, RONALD (ed.), *Aesthetics and Politics: The Key Texts of the Classic Debate Within German Marxism: Theodor Adorno, Walter Benjamin, Ernst Bloch, Bertolt Brecht, Georg Lukács* (London: Verso, 1977).

TEIGE, KAREL, *Film* (Prague: Václav Petra, 1925).

TEITELBAUM, MATTHEW (ed.), *Montage and Modern Life, 1919–1942* (Cambridge, Mass.: MIT Press, 1992).

THACKER, ANDREW, *Moving Through Modernity: Space and Geography in Modernism* (Manchester: Manchester University Press, 2003).

THELWELL, MICHAEL, 'Modernist Fallacies and the Responsibility of the Black Writer', in Thelwell, *Duties, Pleasures, and Conflicts: Essays in Struggle* (Amherst: University of Massachusetts Press, 1987), 218–32.

THOMAS, DYLAN, *Collected Poems* (London: Dent, 1952).

——'Blithe Spirits', *The Observer*, 6 July 1952; repr. in *New Welsh Review*, 60 (Summer 2003), 11–12.

THOMAS, M. WYNN (ed.), *Diffinio Dwy Lenyddiaeth Cymru* (Cardiff: University of Wales Press, 1995).

——'Hidden Attachments: Aspects of the Two Literatures of Modern Wales', *Welsh Writing in English: A Yearbook*, 1 (1995), 145–63.

——'The Welsh Anti-Capitalist', *New Welsh Review*, 56 (Summer 2002), 83–8.

——(ed.), *Welsh Writing in English* (Cardiff: University of Wales Press, 2003).

THOMAS, NED, *The Welsh Extremist* (Talybont: Y Lolfa, 1991).

THOMAS, NICHOLAS, *Possessions: Indigenous Art/Colonial Culture* (London: Thames & Hudson, 1999).

THOMPSON, JERRY, and HILL, JOHN T. (eds), *Walker Evans at Work* (New York: Harper and Row, 1982).

THOMSON, GEORGE H., *A Reader's Guide to Dorothy Richardson's Pilgrimage* (Greensboro: University of North Carolina, ELT Press, 1996).

THURMAN, WALLACE, *Infants of the Spring* (1932; Boston: Northeastern University Press, 1992).

THURSCHWELL, PAMELA, *Literature, Technology and Magical Thinking 1880–1920* (Cambridge: Cambridge University Press, 2001).

TICKNER, LISA, *Modern Life and Modern Subjects: British Art in the Early Twentieth Century* (New Haven: Yale University Press, 2000).

TILLOTSON, GILES H. R., *The Tradition of Indian Architecture: Continuity, Controversy and Change Since 1850* (New Haven: Yale University Press, 1989).

TINTEROW, GARY, and LOYRETTE, HENRI, *Origins of Impressionism* (New York: Metropolitan Museum of Art, 1994).

TIPTON, ELISE, and CLARK, JOHN (eds), *Being Modern in Japan: Culture and Society from the 1910s to the 1930s* (Sydney: Australian Humanities Research Foundation with Fine Arts Press in association with Gordon and Breach Arts International, 2000).

TOEPFER, KARL, *Empire of Ecstasy: Nudity and Movement in German Body Culture, 1910–1935* (Berkeley: University of California Press, 1997).

TOKYO KOKURITSU KINDAI BIJUTSUKAN (ed.), *Sugiura Hisui Ten: Toshi Seikatsu no Dezainâ* (Tokyo: Tokyo Kokuritsu Kindai Bijutsukan, 2000).

TOKYO-TO BIJUTSUKAN (ed.), *1920-nendai Nihon Ten* (Tokyo: Tokyo-To Bijutsukan, 1988).

TOMAN, JINDŘICH, *The Magic of a Common Language: Jakobson, Mathesius, Trubetzkoy, and the Prague Linguistic Circle* (Cambridge, Mass.: MIT Press, 1995).

Toomer, Jean, *Selected Essays and Literary Criticism*, ed. Robert B. Jones (Knoxville: University of Tennessee Press, 1996).

Torgovnick, Marianna, *Gone Primitive: Savage Intellects, Modern Lives* (Chicago: University of Chicago Press, 1990).

Towheed, Shafquat, 'Geneva vs. St. Petersburg: Two Concepts of Literary Property and the Material Lives of Books in *Under Western Eyes*', *Book History*, 10 (2007), 169–91.

Toye, Francis, 'The Newer Russian Ballets', *The Nation* (1 Aug. 1913), 675–6.

Travis, Alan, *Bound and Gagged: A Secret History of Obscenity in Britain* (London: Profile Books, 2000).

Trehearne, Brian, *Aestheticism and the Canadian Modernists: Aspects of a Poetic Influence* (Montreal: McGill-Queen's University Press, 1989).

—— *The Montreal Forties: Modernism in Transition* (Toronto: University of Toronto Press, 1999).

Trotsky, Leon, *Literature and Revolution* (New York: Russell and Russell, 1957).

Trott, Nicholas, 'Open Air Complex . . . Perilous Town Car', *New Yorker*, 3/12 (7 May 1927), 80–3.

Trotter, David, *Paranoid Modernism: Literary Experiment, Psychosis, and the Professionalization of English Society* (Oxford: Oxford University Press, 2001).

—— *Cinema and Modernism* (Oxford: Blackwell, 2007).

Tuck, Patrick J. N., *Warfare, Expansion, and Resistance* (London: Routledge, 2002).

Tucker, Paul, 'The First Impressionist Exhibition and Monet's *Impression, Sunrise*: A Tale of Timing, Commerce, and Patriotism', *Art History*, 7/4 (1984), 465–76.

Turner, Catherine, *Marketing Modernism Between the Two World Wars* (Amherst: University of Massachusetts Press, 2003).

Turner, Frank M., *Contesting Cultural Authority: Essays in Victorian Intellectual Life* (Cambridge: Cambridge University Press, 1993).

Turner, John, 'David Eder: Between Freud and Jung', *D. H. Lawrence Review*, 27/2–3 (1997–8), 289–309.

Turowski, Andrzej, *Existe-t-il un art de l'Europe de l'Est? Utopie & idéologie* (Paris: Éditions de la Villette, 1986).

Tylee, Clare M., *The Great War and Women's Consciousness: Images of Militarism and Womanhood in Women's Writings, 1914–1964* (London: Macmillan, 1990).

Tyler, William J., *Modanizumu: Modernist Fiction from Japan, 1913–1938* (Honolulu: University of Hawai'i Press, 2008).

Tynan, Katharine, *Late Songs* (London: Sidgwick & Jackson, 1917).

Tynianov, Iu., 'Literaturnoe segodnia', *Russkii sovremennik*, 1 (1924), 291–306.

Tyrrell, George, *The Programme of Modernism* (London: Fisher Unwin, 1908).

Ulmer, Gregory, 'The Object of Post-Criticism', in Hal Foster (ed.), *The Anti-Aesthetic: Essays on Postmodern Culture* (Washington, DC: Bay Press, 1982), 83–101.

Underhill, Evelyn, 'A Note Upon Mysticism', *The Quest*, 1 (July 1910), 742–52.

—— *The Essentials of Mysticism, and Other Essays* (London: Dent, 1920).

Unerwartete Begegnung: Lettische Avantgarde 1910–1935: Der Beitrag Lettlands zur Kunst der Europäischen Moderne, exh. cat. (Neuen Gesellschaft für Bildende Kunst, Cologne: Druck- & Verlagshaus Wiennand, 1990).

Unruh, Vicky, *Latin American Vanguards* (Berkeley: California University Press, 1994).

Ushakov, D. N. (ed.), *Tolkovyi slovar' russkogo iazyka* (Moscow: OGIZ, 1934–40), 229–34.

Vallier, Dora, 'Dans le vif de l'avant-garde', *L'Arc*, 2 (Apr. 1990), 9–13.

Van Delden, Maarten, 'The Spanish-American Novel and European Modernism', in Astradur Eysteinsson and Vivian Liska (eds), *Modernism*, 2 vols (Amsterdam: John Benjamins, 2007), ii. 947–65.

VARGISH, THOMAS, and MOOK, DELO E., *Inside Modernism: Relativity Theory, Cubism, Narrative* (New Haven: Yale University Press, 1999).

VARIAS, ALEXANDER, *Paris and the Anarchists: Aesthetes and Subversives during the Fin-de-Siècle* (Basingstoke: Macmillan, 1997).

VASARI, RUGGERO, *L'angoscia delle machine: Sintesi tragica in tre tempi* (1925), in Mario Verdone (ed.), *Teatro italiano d'avanguardia: Drammi e sintesi futuriste* (Rome: Officina, 1970), 168–87.

VASUDEVAN, RAVI S., 'Shifting Codes, Dissolving Identities: The Hindi Social Film of the 1950s as Popular Culture', *Journal of Arts and Ideas*, 23–4 (Jan. 1993), 51–79.

VERLAINE, PAUL, *Romances sans paroles: Œuvres poétiques* (Paris: Éditions Garnières Frères, 1969).

——*Paul Verlaine: Œuvres completes* (1902; Paris: Laffont, 1992).

VERTOV, DZIGA, 'In Defense of Newsreel', in *Kino-Eye: The Writings of Dziga Vertov*, ed. Annette Michelson, trans. Kevin O'Brien (Berkeley: University of California Press, 1984), 145–7.

VICKERY, JOHN B., *The Literary Impact of the Golden Bough* (Princeton: Princeton University Press, 1973).

VIETTA, SILVIO, 'Großstadtwahrnehmung und ihre literarische Darstellung: Expressionistischer Reihungsstil und Collage', *Deutsche Vierteljahrsschrift für Literaturwissenschaft und Geistesgeschichte*, 48 (1974), 354–73.

——(ed.), *Lyrik des Expressionismus* (Tubingen: DTV, 1976).

——and KEMPER, HANS-GEORG, *Expressionismus* (Munich: Fink, 1975).

——and MEIXNER, HORST (eds), *Expressionismus: Sozialer Wandel und Künstlerische Erfahrung* (Munich: Fink, 1982).

VLČEK, TOMÁŠ, 'Art Between Social Crisis and Utopia: The Czech Contribution to the Development of the Avant-Garde Movement in East-Central Europe, 1910–1930', *Art Journal*, 49/1 (Spring 1990), 28–35.

——*Voices of Freedom: Polish Women Artists and the Avant-Garde* (Washington, DC: National Museum of Women in the Arts, 1991).

VOADEN, HERMAN, 'Symphonic Expressionism: A Logical Non-Realistic Stage Method, or, Notes on a New Theatre', *The Globe* (Toronto), 17 Dec. 1932, 5.

——*A Vision of Canada: Herman Voaden's Dramatic Works 1928–1945*, ed. Anton Wagner (Toronto: Simon and Pierre, 1993).

VROON, RONALD, 'The Manifesto as a Literary Genre: Some Preliminary Observations', *International Journal of Slavic Linguistics and Poetics*, 38 (1995), 163–73.

WACHMAN, GAY, *Lesbian Empire: Radical Cross-Writing in the Twenties* (New Brunswick, NJ: Rutgers University Press, 2001).

WAITE, A. E., 'The Life of the Mystic', *Occult Review*, 1 (1905), 29–34.

WAKABAYASHI, JUDY, 'Translational Japanese: A Transformative Strangeness Within', *Portal Journal of Multidisciplinary International Studies*, 6/1 (2009), 1–20.

WALCOTT, DEREK, *Another Life* (London: Jonathan Cape, 1973).

——*What the Twilight Says: Essays* (London: Faber and Faber, 1998).

WALD, ALAN M., *The New York Intellectuals: The Rise and Decline of the Anti-Stalinist Left from the 1930s to the 1980s* (Chapel Hill: University of North Carolina Press, 1987).

WALKOWITZ, JUDITH, *Prostitution and Victorian Society: Women, Class, and the State* (Cambridge: Cambridge University Press, 1982).

WALLACH-SCOTT, JOAN, *Gender and the Politics of History* (New York: Columbia University Press, 1988).

WALLER, M., 'The -Isms of Stalinism', *Soviet Studies*, 20/2 (Oct. 1968), 229–34.

WALLER, PHILIP, *Writers, Readers, and Reputations: Literary Life in Britain, 1870–1918* (Oxford: Oxford University Press, 2006).

WALMSLEY, ANNE (ed.), *Guyana Dreaming: The Art of Aubrey Williams* (Sydney: Dangeroo, 1990).

WARNER, MARINA, *Phantasmagoria: Spirit Visions, Metaphors and Media into the 21st Century* (Oxford: Oxford University Press, 2006).

Warszawa-Moskwa: 1900–2000, exh. cat. (Warsaw: Zachęta Narodowa Galeria Sztuki, 2004).

WATSON, SHEILA, 'What I'm Going to Do', *Open Letter*, 3rd ser., 1 (Winter 1974–5), 181–3.

——*Four Stories* (Toronto: Coach House Press, 1979).

WATSON, STEVEN, *Strange Bedfellows: The First American Avant-Garde* (New York: Abbeville Press, 1991).

WAUGH, EVELYN, *Waugh in Abyssinia* (1936; London: Penguin, 1986).

——*Vile Bodies* (1930; New York: Back Bay, 1999).

WEBBER, ANDREW J., *The European Avant-Garde, 1900–1940* (Cambridge: Polity Press, 2004).

WEBER, MAX, 'Science as a Vocation', in *From Max Weber: Essays in Sociology*, trans. H. H. Gerth and C. Wright Mills (London: Routledge & Kegan Paul, 1948), 129–56.

WEISENFELD, GENNIFER, 'Touring "Japan-as-Museum": NIPPON and Other Japanese Imperialist Travelogues', *positions: east asia cultures critique*, 8/3 (Winter 2000), 747–93.

——*Mavo: Japanese Artists and the Avant-Garde, 1905–1931* (Berkeley: University of California Press, 2002).

WEISS, ANDREA, *Paris Was a Woman: Portraits from the Left Bank* (London: Pandora, 1995).

WELLEK, RENÉ, *A History of Modern Criticism, 1750–1950*, 4 vols (London: Jonathan Cape, 1955–66).

——'The New Criticism: Pro and Contra', *Critical Inquiry*, 4 (1978), 611–23.

——and WARREN, AUSTIN, *Theory of Literature* (London: Harcourt, 1955).

WELLS, H. G., *The First Men in the Moon* (1901; New York: Penguin, 2005).

WELLS, IDA B., *The Reason Why the Colored American Is Not in the World's Columbian Exposition* (1893), <http://www.hartford-hwp.com/archives/45a/149.html>.

WEST, ALICK, *Crisis and Criticism* (London: Lawrence & Wishart, 1937).

WEST, NANCY MARTHA, *Kodak and the Lens of Nostalgia* (Charlottesville: University of Virginia Press, 2000).

WEST, REBECCA, 'Imagisme', *New Freewoman* (15 Aug. 1913), 86–7.

——*Listening and Broadcasting*, Rebecca West Papers, McFarlin Library, University of Tulsa, ser. 2, box 36, folder 28, 1929.

——*The New Meaning of Treason* (New York: Viking Press, 1964).

——*The Young Rebecca: Writings of Rebecca West, 1911–17*, ed. Jane Marcus (Bloomington: Indiana University Press, 1982).

——*The Strange Necessity: Essays and Reviews*, introd. G. Evelyn Hutchinson (London: Virago, 1987).

——*The Return of the Soldier* (1918; London: Virago, 1996).

WESTON, JESSIE L., 'The Quest of the Holy Grail', *The Quest*, 1 (Mar. 1910), 524–35.

——*From Ritual to Romance* (Cambridge: Cambridge University Press, 1920).

WESTWOOD, J., *Endurance and Endeavour: Russian History 1812–1980* (Oxford: Oxford University Press, 1981).

WEXLER, JOYCE PIELL, *Who Paid for Modernism? Art, Money, and the Fiction of Conrad, Joyce, and Lawrence* (Fayetteville: University of Arkansas Press, 1997).

WHITE, JOHN J., *Literary Futurism: Aspects of the First Avant-Garde* (Oxford: Clarendon Press, 1990).

WHITE, PATRICK, 'The Prodigal Son', *Australian Letters*, 1/3 (1958), 37–40.

WHITWORTH, GEOFFREY, *The Art of Nijinsky* (New York: B. Blom, 1972).

WHITWORTH, MICHAEL H., 'The Clothbound Universe: Popular Physics Books, 1919–1939', *Publishing History*, 40 (1996), 53–82.

——'*Pièces d'identité*: T. S. Eliot, J. W. N. Sullivan and Poetic Impersonality', *English Literature in Transition*, 39 (1996), 149–70.

——*Einstein's Wake: Relativity, Metaphor, and Modernist Literature* (Oxford: Oxford University Press, 2001).

——*Virginia Woolf* (Oxford: Oxford University Press, 2005).

——'Three Prose Sources for Hugh MacDiarmid's "On a Raised Beach"', *Notes and Queries*, 54 (2007), 175–7.

WIGGINTON, CHRIS, *Modernism from the Margins: The 1930s Poetry of Louis MacNeice and Dylan Thomas* (Cardiff: University of Wales Press, 2007).

WIGMAN, MARY, *The Language of Dance* (Middletown, Conn.: Wesleyan University Press, 1966).

——*The Mary Wigman Book: Her Writings*, ed. and trans. Walter Sorell (Middletown, Conn.: Wesleyan University Press, 1975).

WILDE, OSCAR, 'Salome', in *Oscar Wilde: The Complete Works*, ed. J. B. Foreman (London: Collins, 1990), 552–75.

WILIAMS, GERWYN, 'Gwerin Dau Garadog', in M. Wynn Thomas (ed.), *Diffinio Dwy Lenyddiaeth Cymru* (Cardiff: University of Wales Press, 1995), 42–79.

WILL, BARBARA, *Gertrude Stein, Modernism, and the Problem of 'Genius'* (Edinburgh: Edinburgh University Press, 2000).

WILLIAMS, DANIEL, 'Beyond National Literature? Dylan Thomas and Amos Tutuola in Igbo Masquerade', *New Welsh Review*, 60 (Summer 2003), 5–12.

WILLIAMS, GWYN A., *When Was Wales? A History of the Welsh* (London: Black Raven Press, 1985).

WILLIAMS, IOAN, *A Straitened Stage: A Study of the Theatre of J. Saunders Lewis* (Bridgend: Seren, 1991).

WILLIAMS, LEE, *Post-War Riots in America: 1919 and 1946* (Lewiston, NY: Edwin Mellen, 1991).

WILLIAMS, LOUISE BLAKENEY, *Modernism and the Ideology of History* (Cambridge: Cambridge University Press, 2002).

WILLIAMS, PATRICK, '"Simultaneous Uncontemporaneities": Theorising Modernism and Empire', in Howard J. Booth and Nigel Rigby (eds), *Modernism and Empire* (Manchester: Manchester University Press, 2000), 13–38.

WILLIAMS, RAYMOND, *Marxism and Literature* (Oxford: Oxford University Press, 1977).

——*Culture* (London: Fontana, 1981).

——'Metropolitan Perceptions and the Emergence of Modernism', in Williams, *The Politics of Modernism: Against the New Conformists*, ed. Tony Pinkney (London: Verso, 1989), 37–48.

——'When Was Modernism?', *New Left Review*, 1/175 (May–June 1989), 48–52.

——*The Modern Latin American Novel* (New York: Twayne, 1998).

——*Television: Technology and Cultural Form* (London: Routledge, 2003).

——*Who Speaks for Wales? Nation, Culture, Identity*, ed. Daniel Williams (Cardiff: University of Wales Press, 2003).

WILLIAMS, RAYMOND L., *The Modern Latin American Novel* (New York: Twayne, 1998).

WILLIAMS, THOMAS L., 'Rajah in a Low Back Chair', *Radio Digest Illustrated* (17 Apr. 1926), 18.

WILLIAMS, WILLIAM CARLOS, *The Autobiography of William Carlos Williams* (New York: Random House, 1951).

WILLIAMS, WILLIAM CARLOS, *Selected Essays* (New York: New Directions, 1954).

——*Imaginations* (New York: New Directions, 1970).

WILLMOTT, GLENN, *Unreal Country: Modernity in the Canadian Novel in English* (Montreal: McGill-Queen's University Press, 2002).

——'Modernism and Aboriginal Modernity: The Appropriation of Products of West Coast Native Heritage as National Goods', *Essays on Canadian Writing*, 83 (2004), 75–139.

——*Modernist Goods: Primitivism, the Market, and the Gift* (Toronto: University of Toronto Press, 2008).

WILSON, EDMUND, *Axel's Castle: A Study of the Imaginative Literature, 1870–1930* (New York: Charles Scribner's Sons, 1931).

WINNING, JOANNE, *The Pilgrimage of Dorothy Richardson* (Madison: University of Wisconsin Press, 2000).

WINTER, JAY, *Sites of Memory, Sites of Mourning: The Great War in European Cultural History* (Cambridge: Cambridge University Press, 1995).

WITKOVSKY, MATTHEW S., *Foto: Modernity in Central Europe, 1918–1945*, exh. cat. (Washington, DC: National Gallery of Art in association with Thames & Hudson, 2007).

WITTGENSTEIN, LUDWIG, *Philosophical Investigations* (1953), trans. G. E. M. Anscombe (Oxford: Blackwell, 1967).

——*Remarks on Frazer's Golden Bough* (1967), ed. Rush Rhees, trans. A. C. Miles (Hereford: Brynmill Press, 1979).

WOHL, ROBERT, *A Passion for Wings: Aviation and the Western Imagination, 1908–1918* (New Haven: Yale University Press, 1994).

——*The Spectacle of Flight: Aviation and the Western Imagination, 1920–1950* (New Haven: Yale University Press, 2005).

WOLFF, LARRY, *Inventing Eastern Europe: The Map of Civilization on the Mind of the Enlightenment* (Stanford, Calif.: Stanford University Press, 1994).

WOLLAEGER, MARK (ed.), *Oxford Handbook of Global Modernisms* (Oxford: Oxford University Press, forthcoming).

WOODS, TIM, 'Memory, Geography, Identity: African Writing and Modernity', in Peter Brooker and Andrew Thacker (eds), *Geographies of Modernism: Literatures, Cultures, Spaces* (London: Taylor & Francis, 2005), 126–45.

WOOLF, LEONARD, *Economic Imperialism* (London: Swarthmore Press, 1920).

——'Freud's *Psychopathology of Everyday Life*', in S. P. Rosenbaum (ed.), *A Bloomsbury Group Reader* (Oxford: Blackwell, 1993), 189–91.

WOOLF, VIRGINIA, *Collected Essays*, ed. Leonard Woolf, 4 vols (London: Hogarth Press, 1966–7).

——*Moments of Being: Unpublished Autobiographical Writings* (London: Chatto & Windus, 1976).

——*The Question of Things Happening, The Letters of Virginia Woolf*, ii: *1912–1922*, ed. Nigel Nicolson and Joanne Trautmann Woolf (London: Hogarth Press, 1976).

——*The Sickle Side of the Moon, The Letters of Virginia Woolf*, v: *1932–1935*, ed. Nigel Nicolson (London: Hogarth Press, 1979).

——*Women and Writing*, introd. Michèle Barrett (London: Women's Press, 1979).

——*The Diary of Virginia Woolf*, ed. Anne Olivier Bell and Andrew McNeillie, 5 vols (London: Hogarth Press, 1979–85).

——*A Haunted House: The Complete Shorter Fiction*, ed. Susan Dick, introd. Helen Simpson (London: Vintage, 1985).

——*The Essays of Virginia Woolf*, ed. Andrew McNeillie, 6 vols (London: Hogarth Press, 1986–94).

——*Mrs. Dalloway* (1925; Oxford: Oxford University Press, 1992).

——*Orlando* (1928; New York: Harcourt, 1992).

——*A Room of One's Own* [1929]; *Three Guineas* [1938], ed. Morag Shiach (Oxford: Oxford University Press, 1992).

——*To the Lighthouse* (1927; Oxford: Oxford University Press, 1992).

——*The Voyage Out* (1915), ed. Lorna Sage (Oxford: Oxford University Press, 1992).

——*A Woman's Essays*, ed. Rachel Bowlby (London: Penguin, 1992).

——'The Cinema', in Woolf, *The Crowded Dance of Modern Life*, ed. Rachel Bowlby (London: Penguin, 1993), 54–8.

——*Jacob's Room* (1922; Oxford: Oxford University Press, 1999).

——*Selected Essays*, ed. David Bradshaw (Oxford: Oxford University Press, 2008).

——*The Death of the Moth and Other Essays* (New York: Harcourt, 2009).

——*The Years* (1937), ed. Hermione Lee (Oxford: Oxford University Press, 2009).

WORDSWORTH, WILLIAM, *William Wordsworth*, ed. Stephen Gill (Oxford: Oxford University Press, 1984).

WRIGHT, ELIZABETH, *Psychoanalytic Criticism: A Reappraisal* (Cambridge: Polity Press, 1998).

XIROS COOPER, JOHN, *Modernism and the Culture of Market Society* (Cambridge: Cambridge University Press, 2004).

YAGODA, BEN, *About Town: The New Yorker and the World It Made* (New York: Scribner, 2000).

YAMAMOTO TAKEO, et al. (eds), *Shiseidō Sendenshi*, i: *Rekishi* (Tokyo: Shiseidō, 1979).

YEATS, W. B., 'Ireland After the Revolution', in Yeats, *Explorations* (London: Macmillan, 1962), 438–43.

——*A Vision* (1925; New York: Macmillan, 1966).

——*The Collected Poems*, ed. R. Finneran (New York: Collier, 1989).

——*Yeats's Poems*, ed. A. Norman Jeffares (London: Gill and Macmillan, 1989).

YOKOMITSU RIICHI, *Shanghai: A Novel by Yokomitsu Riichi*, trans. Dennis Washburn (1928–31; Ann Arbor: Center for Japanese Studies, University of Michigan, 2001).

YOSHIOKA, AIKO, 'Cross-Cultural Encounters: Multiple Star Identities of Yamaguchi Yoshiko', Ph.D. diss., La Trobe University, 2003.

YOUNG, ALAN, *Dada and After: Extremist Modernism and English Literature* (Manchester: Manchester University Press, 1981).

YOUNGS, TIM, 'Auden's Travel Writings', in Stan Smith (ed.), *The Cambridge Companion to W. H. Auden* (Cambridge: Cambridge University Press, 2004), 68–81.

YUASA KATSUEI, *Kannani* [1934]; *and Document of Flames* [1935]: *Two Japanese Colonial Novels*, trans. Mark Driscoll (Durham, NC: Duke University Press, 2005).

YURKIEVICH, SAÚL, *Fundadores de la nueva poesía latinoamericana* (Barcelona: Barral, 1971).

ZAHAVI, DAN, *Husserl's Phenomenology* (Stanford, Calif.: Stanford University Press, 2003).

ZAVALISHIN, VYACHESLAV, *Early Soviet Writers* (New York: Praeger, 1958).

ZDANEVICH, ILYA MIKHAILEVICH [ILIAZD], *LidantJU fAram* (Paris: 41°, 1923).

ZELDIN, THEODORE, *France 1848–1945*, 3 vols (Oxford: Clarendon Press, 1977).

ZICHY, FRANCIS, 'MacLennan and Modernism', in Frank M. Tierney (ed.), *Hugh MacLennan* (Ottawa: University of Ottawa Press, 1994), 171–9.

ZIMA, PETER V., *The Philosophy of Modern Literary Theory* (London: Athlone Press, 1999).

ZINNES, HARRIET (ed.), *Ezra Pound and the Visual Arts* (New York: New Directions, 1980).

ZOLA, ÉMILE, *The Experimental Novel and Other Essays*, trans. Belle M. Sherman (New York: Haskell House, 1964).

ZUSI, PETER, 'Towards a Genealogy of Modernism: Herder, Nietzsche, History', *Modern Language Quarterly*, 67/4 (2006), 505–25.

ZWERDLING, ALEX, *Virginia Woolf and the Real World* (Berkeley: University of California Press, 1986).

INDEX
.................

Note: the cities London, Paris, New York and Berlin have been referred to so extensively in this book that not all references have been included in the index, only particularly in-depth discussions.